The Triumph of the Baroque

Architecture in Europe 1600-1750

The Triumph of the Baroque

Architecture in Europe 1600-1750

edited by Henry A. Millon

Rizzoli
NEW YORK

First published in the United States of America in 1999 by
Rizzoli International Publications, Inc.
300 Park Avenue South, New York, NY 10010

© 1999 R.C.S. Libri S.p.A.

Library of Congress Cataloging-in-Publication Data

Triumph of the Baroque: architecture in Europe, 1600–1750/
edited by Henry A. Millon
 Includes bibliographical references and index.
 ISBN 0-8478-2219-2 (hc)
 1. Architecture, Baroque—Exhibitions. I. Millon,
 Henry A.
 NA590.T75 1999
 724'.16'0744512—dc21 99-14173
 CIP

Published to accompany an exhibition at
Palazzina di Caccia di Stupinigi July 1999–November 1999
Montreal Museum of Fine Arts December 1999–April 2000
National Gallery of Art, Washington May 2000–October 2000
Musée des Beaux-Arts, Marseille February 2001–May 2001

Printed in Italy

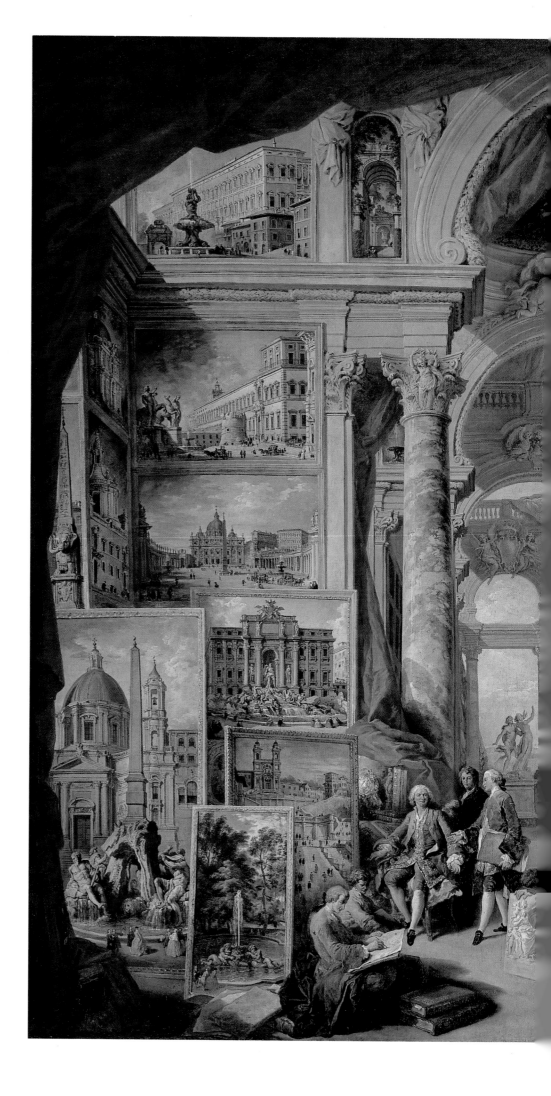

Giovanni Paolo Pannini
Roma moderna, 1757
New York, The Metropolitan
Museum of Art
cat. 1

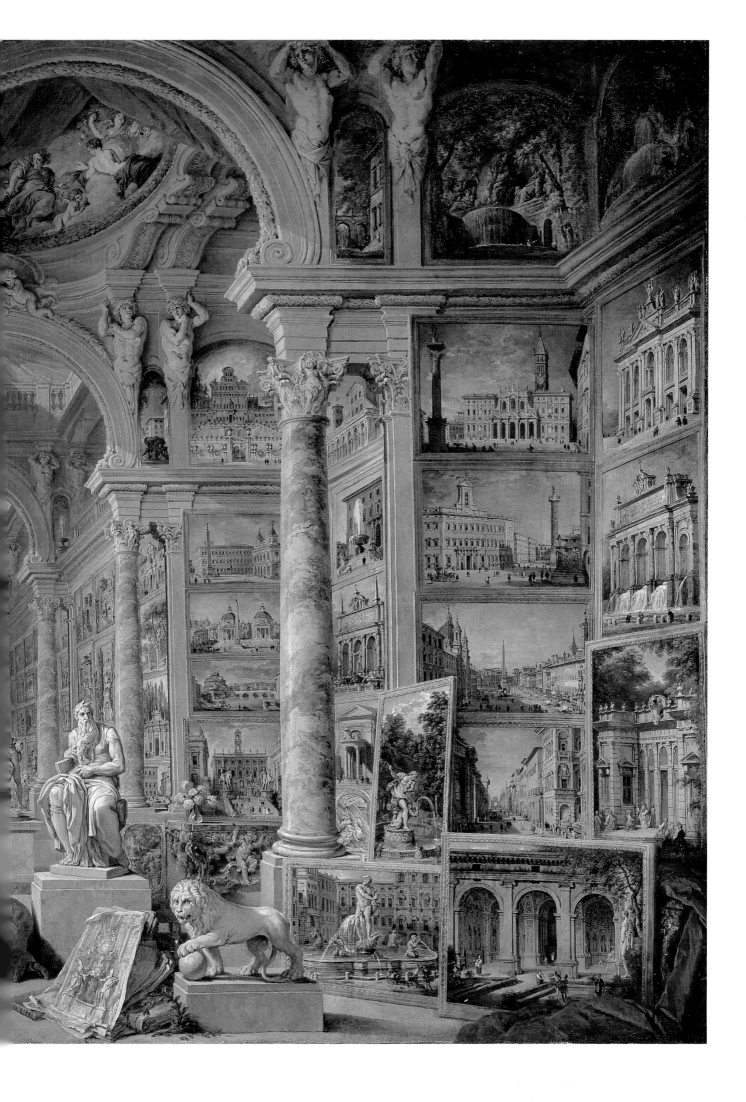

Acknowledgements

The exhibition has been organized with

Musée des Beaux-Arts
Museum of Fine Arts
Montreal

National Gallery of Art
Washington, D.C.

Musée des Beaux Arts
Marseilles

successive venues for the exhibition

Cardinale Giovanni Saldarini
Arcivescovo di Torino

Enzo Chigo
Presidente Regione Piemonte
Mercedes Bresso
Presidente Provincia di Torino
Valentino Castellani
Sindaco di Torino

Mario Moscatelli
Prefetto di Torino
Gen. Domenico di Napoli
*Comandante Regionale
Carabinieri per il Piemonte
e la Valle d'Aosta*
Nicola Izzo
Questore di Torino
Col. Tullio Del Sette
*Comandante Provinciale
Carabinieri di Torino*

Giuseppe De Maria
*Presidente Associazione
Commercianti della Provincia
di Torino*
Francesco Devalle
*Presidente Unione Industriale
di Torino*
Giuseppe Pichetto
*Presidente Camera
di Commercio di Torino*
Bruno Rambaudi
*Presidente Federazione
Piemontese
delle Associazioni Industriali*

Rinaldo Bertolino
*Rettore Università degli Studi
di Torino*
Rodolfo Zich
Rettore Politecnico di Torino

Giovanni Agnelli
Presidente d'Onore Fiat S.p.A.
Paolo Fresco
Presidente Fiat S.p.A.
Paolo Cantarella
*Amministratore Delegato
Fiat S.p.A.*

Pilot committee

Cesare Annibaldi
*Direttore Centrale per le Politiche
Sociali e Culturali del Gruppo Fiat*

Emilia Bergoglio
Presidente Ordine Mauriziano

Andrea Comba
Presidente Fondazione CRT

Vera Comoli Mandracci
Politecnico di Torino

Enrico Filippi
Università di Torino

Walter Giuliano
*Assessore Risorse naturali e culturali
della Provincia di Torino*

Andreina Griseri
Accademia Nazionale dei Lincei

Giampiero Leo
*Assessore Cultura e Istruzione
della Regione Piemonte*

Pasquale Bruno Malara
*Soprintendente per i Beni ambientali
e architettonici del Piemonte*

Filippo Beraudo di Pralormo
Fiat Relazioni Esterne

Ugo Perone
*Assessore Cultura e Sport
del Comune di Torino*

Carla Enrica Spantigati
*Soprintendente per i Beni artistici
e storici del Piemonte*

Elda Tessore
Presidente Turismo Torino

Gian Paolo Zanetta
Direttore Generale Ordine Mauriziano

Exhibition Committee

Henry A. Millon
with Giuseppe Dardanello
and Andreina Griseri

Guy Cogeval
Earl A. Powell III
Marie Paule Vial

Giovanni Agosti
Hilary Ballon
Richard Bösel
Christine Challingsworth
Vera Comoli Mandracci
Michel Conan
Frédéric Dassas
Cesare De Seta
Jörg Garms
Charles Hind
Elisabeth Kieven
Michael Krapf
Fernando Marías
Claude Mignot
Christian Norberg-Schulz
Werner Oechslin
Konrad Ottenheym
Simon Pepper
Paolo Portoghesi
Lionello Puppi
Marianne Roland Michel
Andrea Stockhammer
Dmitry Shwidkovsky
T. Barton Thurber

Lenders

Agliè, Parrocchia Madonna della Neve e San Massimo
Amsterdam, Historisch Museum
Amsterdam, Koninklijke Nederlandse Akademie Van Wetenschappen
Amsterdam, Municipal Archives
Amsterdam, Rijksmuseum
Amsterdam, Stichting de Oude Kerk te Amsterdam
Arnhem, Rijksarchiev in Gelderland
Augsburg, Staats-und Stadtbibliothek
Bad Homburg, Wilhelmsthal Castle
 Calden Verwaltung der Staatlichen Schlösser und Gärten
Bene Vagienna (Cuneo), Confraternita di San Bernardino
 dei Disciplinanti Bianchi
Berlin, Kunstbibliothek, SMPK
Bologna, Accademia di Belle Arti, in deposit at the Pinacoteca Nazionale
Bologna, Archivio Storico del Teatro Comunale
Bressanone, Museo Diocesano, Palazzo Vescovile
Burghhausen, Stadtmuseum
Burghhausen, Stadtmuseum
 on loan from Filialkirchenstiftung Marienberg
Cambridge, courtesy of the Provost and Fellows of King's College
Campertogno, Parrocchia di San Giacomo Maggiore in Campertogno
Caserta, Museo Vanvitelliano
Caserta, Palazzo Reale
Chambord, Collection Direction de l'Architecture et du Patrimoine
 Château de Chambord
Copenhagen, City Museum
Durham, The Bowes Museum, Barnard Castle
Edams, Edams Museum
Edinburgh, National Gallery of Scotland
Florence, Biblioteca Marucelliana
Florence, Biblioteca Nazionale Centrale
Florence, Galleria degli Uffizi
Florence, Giovanni Pratesi
Florence, Museo degli Argenti–Palazzo Pitti
Florence, Museo di San Marco
Florence, Museo Nazionale del Bargello
Gotha, Museum für Regionalgeschichte und Volkskunde
Gotha, Thüringisches Staatsarchiv
Greenwich, National Maritime Museum
Hannover, Katholische Kirchengemeinde St. Clemens
Kassel, Staatliche Museen, Graphische Sammlung
Kassel, Staatliche Museen, Museum für Astronomie und Technikgeschichte
Krems an der Donau, Weinstadtmuseum
Kremsmünster, Sternwarte, Stift Kremsmünster
Leyden, Rijksmuseum Het Koninklijke Penningkabinet
Leyden, University Library, Collectie Bodel Nijenhuis
Lyons, Musée des Beaux-Arts
Lyons, Musée Gadagne
Lisbon, Museu de S. Roque, Santa Casa de La Misericordia
London, Bristish Architectural Library Drawings Collection, RIBA
 on loan from the Vicar and the Churchwarden, St. Martin-in-the-Fields
London, British Architectural Library Drawings Collection, RIBA
London, British Architectural Library Drawings Collection, RIBA
 courtesy of the Trustees of Burghley House
London, British Library
London, Lord Hesketh Collection
London, Courtauld Gallery, Blunt Collection
London, courtesy of the Trustees of Sir John Soane's Museum
London, courtesy of Her Majesty Queen Elizabeth II
London, Christopher Mendez
Madrid, Biblioteca Nacional

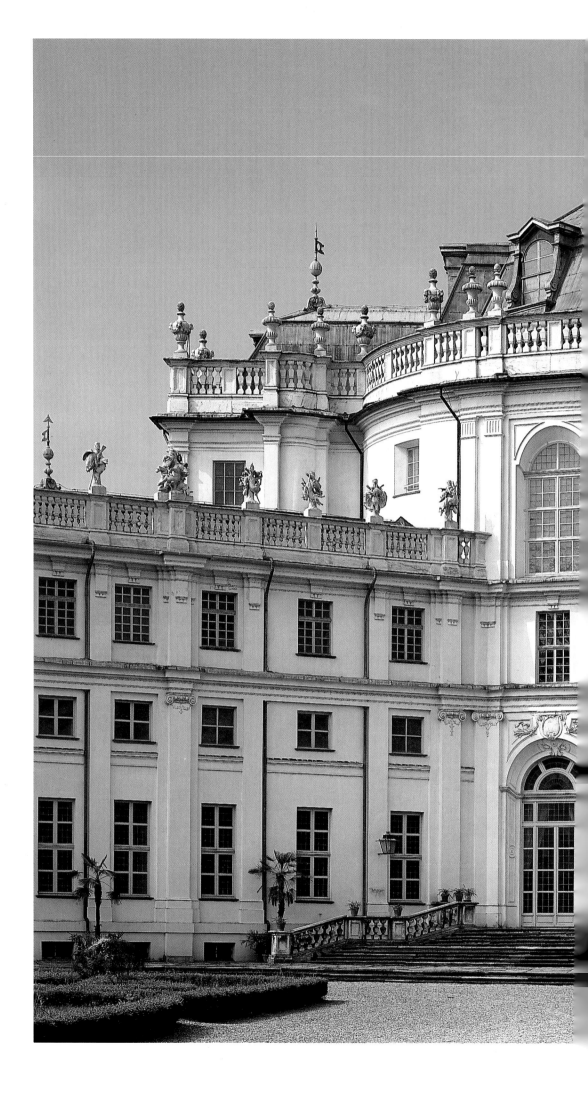

Stupinigi Hunting Lodge
detail of the façade

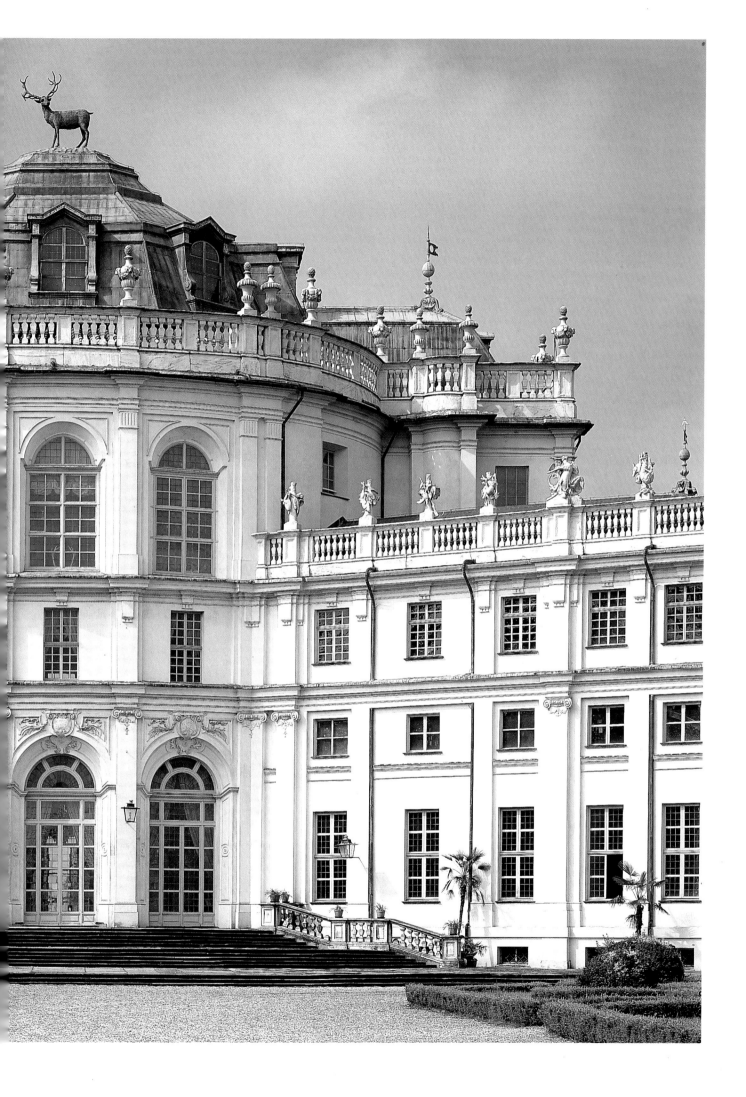

Catalogue

Editorial Director
Mario Andreose

Coordinating Editor
Simonetta Rasponi

Editorial Staff
Bruno Balzano
Andrew Ellis
Gianna Lonza
Simona Pagano
Rossella Vignoletti
Valérie Viscardi

Iconographic Research
Valentina Del Pizzol
Maria Grazia Pellizzone
Evelina Rossetti

Cover design
Italo Lupi

Catalogue lay out
Monica Maltarolo

Translations
from Dutch
Jonathan Hunt
from French
Stephen Wright

from German
Adrian Cook
Melissa Hause
Jonathan Hunt
from Italian
Rhoda Poezl Billingsley
Daniela Brovedani
Andrew Ellis
Harriet Graham
Jonathan Hunt
Madeleine Johnson Saravalle
Gianna Lonza
from Spanish
Debra Nagao
from Russian
Marian Schwartz

Programming
Milena Bongi

Production
Eriberto Aricò
Sergio Daniotti
Carmen Garini
Valerio Gatti
Daniele Marchesi
Stefano Premoli
Enrico Vida

Secretary
Marcella Cipolla
Luisa Gandolfi

Contents

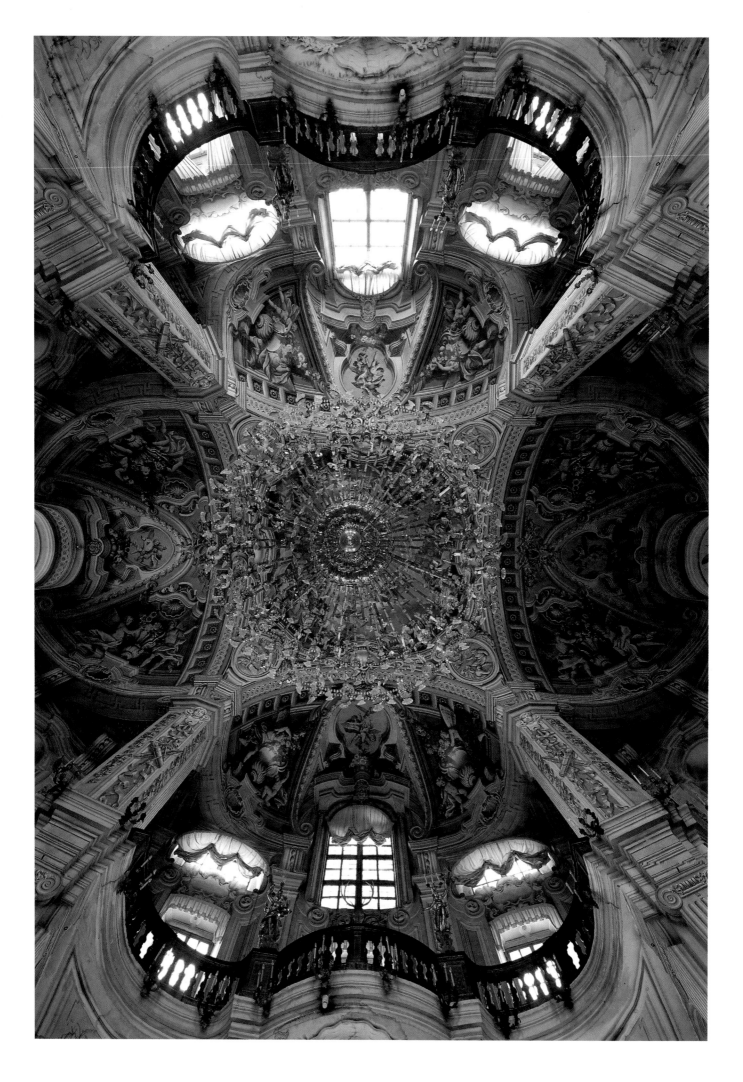

Introduction

Architecture built during the age of the Baroque and Rococo in Europe includes some of the most celebrated and admired works in the history of architecture. The grandeur and magnificence of the regal palaces of Versailles, Schönbrunn, Caserta, Würzburg and St. Petersburg are unequaled. Also unrivaled is the integration of painting, sculpture, decoration and architecture found in many churches, chapels, and palaces of the period, among others, Bernini's Cappella Cornaro, Santa Maria della Vittoria, Rome (1647–52), the interiors of the château at Versailles (1660–90), by Louis Le Vau, J. H. Mansart, Charles Lebrun, the Benedictine abbey church at Ottobeuren (1748), completed by J. M. Fischer, J. J. Zeiller, J. J. Christian and J. M. Feichtmayer, and the Transparente by Narciso Tomé in the Cathedral of Toledo (1721). The Rococo interiors realized at the Hôtel de Soubise in Paris by Germain Boffrand (1735), and in the Amalienburg hunting lodge at Nymphenburg near Munich with its exquisite silver and blue mirrored circular salon (1734–39) designed by François Cuvilliés were envied by princes and prelates alike throughout Europe. These interiors, and others of their like, established a standard for artistic refinement and elegance that has yet to be surpassed.

From its inception, the new architecture implied a new urbanism. In contrast to the Renaissance, architects in the Baroque envisioned buildings that were expansive and inclusive. They sought to incorporate adjacent buildings, to dominate open spaces, to order urban distribution and circulation through avenues, vistas and foci. This necessity to embrace may be seen in the design of church façades that extend their influence by incorporating subsidiary wings into the design, as in Carlo Maderno's Santa Susanna, Rome (1603) and in palaces where the design includes approaches and axes that extend the dominion of the principal structure into surrounding urban areas and gardens, as at Versailles, Karlsruhe, and Caserta.

Architecture in Europe in the seventeenth and eighteenth centuries is today a well examined and usually admired phenomenon. But it has not always been so appreciated. In the latter part of the eighteenth century as notions and awareness of the architecture of Ancient Greece and the Roman east were enriched by archaeological discoveries and publications, the architecture of the preceding century and a half came to be thought of as excessively emotional, dramatic, luxurious and, in its most imaginative and provocative realizations, out of control, licentious.

The rejection of, and distaste for, what would later come to be called Baroque architecture persisted for over a hundred and fifty years, until the end of the nineteenth century. In the interval, it came to be castigated, condemned, and finally ignored as a fascination with the architecture of the ancient world developed into a passion of the latter half of the eighteenth and early nineteenth centuries. The Neoclassic was in. The Baroque was definitely out and was to remain so throughout much of the nineteenth century, a period that included a reawakened interest in both Romanesque and Gothic architecture and society. This medieval rebirth was spurred partly by burgeoning conceptions of "national" architectural styles. By the final decades of the 1800s, the rediscovered enthusiasm for medieval architecture, coupled with the lingering distaste for the Baroque, led to a "restoration" crusade on the behalf of many churches and civic buildings in Western Europe. This so-called "reign of vandalism," led by zealous medievalists destroyed many Baroque and Rococo applied exteriors and interiors that had in their time been executed to restructure or redecorate Romanesque and Gothic buildings in an effort to transform the past to the taste of the seventeenth and eighteenth centuries. Not until the final decades of the nineteenth century, when, successively, fifteenth- and then sixteenth-century Italian art and architecture began to be studied, did the Baroque emerge as a clustering of forms and ideas and become a legitimate field for historical and scientific inquiry.

Developing notions of empire a short hundred years ago in the last quarter of the nineteenth century served to inspire increasing interest in looking backward at the rhetorical forms of seventeenth- and early eighteenth-century European architecture. An awakening attention was given to the politically sensitive expression of public and governmental structures. Scholarship in Baroque architecture began to flourish in the same period; documentation and research of an architecture of such grandeur and persuasion followed naturally. Contributing to a growing interest in the Baroque were reports in the 1880s from

opposite
The Stupinigi hunting lodge
The ceiling of the main hall

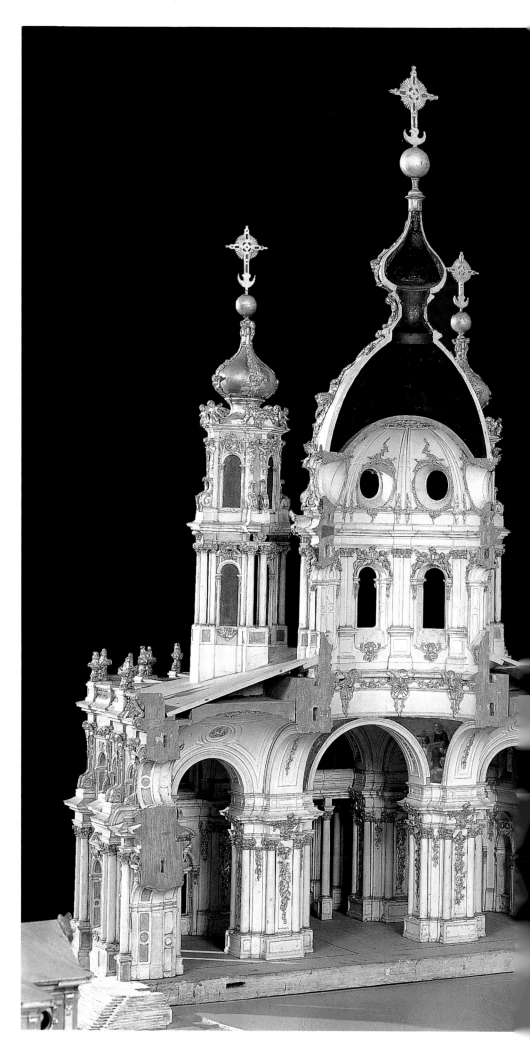

Francesco Bartolomeo Rastrelli
Detail of the wooden model
of the monastery of Smol'ny
in St. Petersburg
cat. 38

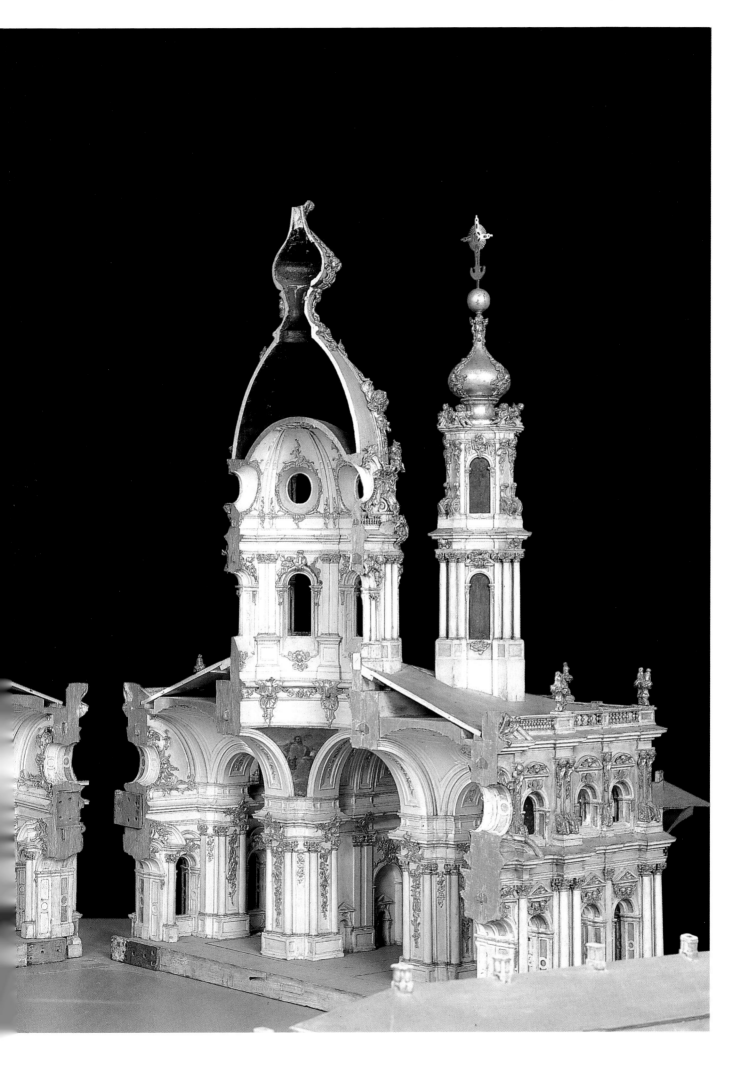

21

archaeological excavations of Late Antique sites that cited the finding of architecture with forms and elements similar to seventeenth-century European architecture. The newly discovered architecture with curvilinear plans, dramatic sitings, and rich sculptural decoration was labeled "Baroque" by archaeologists. The new findings led, as well, to the notion that the Baroque might be a recurring developmental phase in the history of each style of architecture. Given that Baroque architecture had been criticized for its lack of classical lineage, the discovery of classical precedents for its architectural forms further legitimized a developing interest in the Baroque.

As art and architectural historians in the final decades of the nineteenth century and early years of the twentieth century differentiated themselves from cultural historians and developed a separate discipline, they resolutely and contentiously addressed issues resident in the study of the origins of architecture, change in architecture, psychological response to architecture, periodization, concepts of style and the characterization of formal properties of architecture. The relationship (or non-relationship) of architectural form, decoration, and space to political, social, and economic conditions, and the potential role of the latter in initialing change in architecture, inspired dispute then as it continues to do today. A number of publications in the late nineteenth century examined what was judged then to be Baroque art and architecture, usually commencing in the mid-sixteenth century. The period of intensive study only started between the two world wars, when both period and regional studies as well as monographs on principal architects began to appear. Since World War II, a rolling wave of art and architectural historians continue to publish new documentation and interpretation in the field.

The history of the evolution of theoretical (philosophical) approaches to the history of architecture, as well as recording the development of the history of architecture of the seventeenth and eighteenth centuries, have now become subjects of study in their own right. The following historical overview situates current scholarship, as represented in the essays and catalogue entries in this publication, within the general history of Baroque architecture.

Painters and architects in seventeenth-century Rome lived in an opinionated, articulate and competitive milieu; praise and criticism were their companions even during their lifetimes. At least two principal currents of a new approach that characterized the first half of the seventeenth century in Rome were distinguished by contemporaries: adherence to classical principles, and a freer, looser study of nature. In painting, for example, Giovanni Bellori in his *Vite de' pittori [...] moderni* (1672), praised Poussin's classicism and the historical painting of the Carracci, but slighted the work of others such as Caravaggio, Pietro da Cortona, and Bernini, who did not feel bound by classical conventions. In his life of Bernini, published in 1682, two years after the death of the artist, Filippo Baldinucci reports that Bernini responded to a prelate who criticized Borromini's designs by saying "it is better to be a bad Catholic than a good heretic." Teofilo Gallacini's manuscript, *Trattato [...] sopra gli errori degli architetti*, written in 1621, pointed out a range of errors in architectural grammar made by the leading architects of seventeenth-century Rome, lapses from what he felt should be adherence to correct ancient architectural principles. It was these lapses from real and imagined precedent, most said to have originated with Michelangelo and his followers, that fueled the later polemic against seventeenth- and eighteenth-century architecture. By the middle of the eighteenth century, the architecture that would later be called Baroque had become hugely successful and spread across Europe from Britain to Russia and from Stockholm and Copenhagen to Valencia and Cádiz. Divisive criticism of that architecture and the extolling of the virtues of correct usage of the classical orders and principles thereafter became increasingly frequent.

An account of the transformation of thought about seventeenth- and eighteenth-century architecture should be considered in the context of critical moments in the development of a theory of the history of architecture. The influential *Geschichte der Kunst des Altertums* of 1764, by the art historian Johann Joachim Winckelmann (1717–68), brought to light and nurtured a developing interest in the art and architecture of Ancient Greece. It celebrated the calm grandeur found in ancient painting, sculpture, and architecture and criticized the artists and architects who "abandoned nature and classical antiquity." As appreciation rose for classical antiquity, it was followed by a declining interest among savants and connois-

seurs in the freedoms taken by Baroque painters and architects. However, the view painters from Venice – Canaletto, Tiepolo, Bellotto and Guardi – appear to have been exceptions. Their continuously sought-after canvases were prized in Italy, Germany, and Britain and continuing into the nineteenth century were made welcome in the great international collections in France, England and elsewhere.

Winckelmann postulated a parallel between what he called the "plague" of Hellenistic poetry and the "depraved taste of Giuseppe d'Arpino, Bernini and Borromini, in painting, sculpture, and architecture, respectively," who "abandoned nature and classical antiquity in the same way as did [Giambattista] Marini and others in poetry." In France, and of like mind, Quatremère de Quincy (1755–1849) published a similar evaluation of this period in the *Dictionnaire historique de l'architecture* of 1788 using the following definition: "The Baroque in architecture is a subtle variation of the bizarre or, if one might say so, the refinement, or if it is possible to say, the abuse of it. The Baroque bears the same relationship to the bizarre as austerity to good taste; it is its most extreme form. The concept of the Baroque implies that of absurdity carried to excess. Borromini has given us the most outstanding examples of the bizarre. Guarini may be considered the grand master of the Baroque." As far as we know, this is the first time architects of the period are identified as "Baroque."

Nine years later, when Francesco Milizia (1725–98) published his *Dizionario delle belle arti del disegno* (1797), it seems likely, as suggested by Otto Kurz (1960), that he had read Quatremère de Quincy's *Dictionnaire*. Milizia's entry, though adding the architects Andrea Pozzo and Carlo Marchioni, echoes the earlier definition with the words: "Baroque is the ultimate of the bizarre: it is the ridiculous carried to extremes. Borromini went delirious, but Guarini, Pozzi and Marchione in the sacristy of St. Peter's went 'Baroque'." In an earlier publication, *Le vite degli architetti più celebri [...]* of 1768, Milizia had already denounced Borromini, Bernini and others by stating that "the century of corruption had begun [...] Borromini in architecture, Bernini in sculpture, Pietro da Cortona in painting, the Cavalier Marini in poetry represent a diseased taste-one which has infected a great number of artists." Milizia was a member of an artistic and intellectual circle in Rome that included the sculptor Antonio Canova, the painter Anton Raphael Mengs and, among others, the authoritative Winckelmann, each a spokesman for an interest in the noble serenity of the art and architecture of the ancient classical world.

In France by the middle of the eighteenth century two opposed groups, both rejecting the exuberant fringe of the Baroque and Rococo development in architecture of the previous century and a half, defined an intellectual and theoretical controversy. The Ancients led by the Comte de Caylus, who has been called the Gray Eminence of Neoclassicism, included the Abbés LeBlanc and Barthélemy and the collector Pierre-Jean Mariette. They were opposed by the Moderns or Philosophers who supported what they felt to be the French tradition found in the "classical" strain of architecture stemming from the work of François Mansart, Claude Perrault and Louis Le Vau. This group included the influential encyclopedist Denis Diderot, Jacques-François Blondel, professor of architecture at the newly founded École d'architecture, and the critic La Font de Saint-Yenne.

Fuel for the controversy was provided by a theoretical essay of the Abbé Marc Antoine Laugier (1713–69) that appeared in 1753. His essay not only prescribed an architecture that should be grammatically correct, solid, simple and light, but also cited a multitude of errors and lapses made by architects in France as well as elsewhere. He praised the works of Philibert de l'Orme, Le Vau, and Perrault, which supported the position of the Moderns, but his advocacy of a columnar architecture that eschewed pilasters, niches and wall articulation in general, confirmed the positions taken by the Ancients.

Disdain for what was now seen as the decadence of the Baroque was the rule for the remainder of the eighteenth and most of the nineteenth century. When Jacob Burckhardt (1818–97) published *Der Cicerone* in 1855, the volume that was to be carried by many of the travelers to Italy from the German-speaking world, he noted that Baroque architecture speaks "the same tongue as the Renaissance, but in a dialect gone wild." Borromini's churches of San Carlino and Saint'Ivo were perceived as "infamous." According to Burckhardt, on looking at Bernini's Cornaro chapel with its statue of Saint Theresa "one forgets mere questions of style [in front of] the shocking degradation of the supernatural."

overleaf
The Castle of Versailles
The garden façade

23

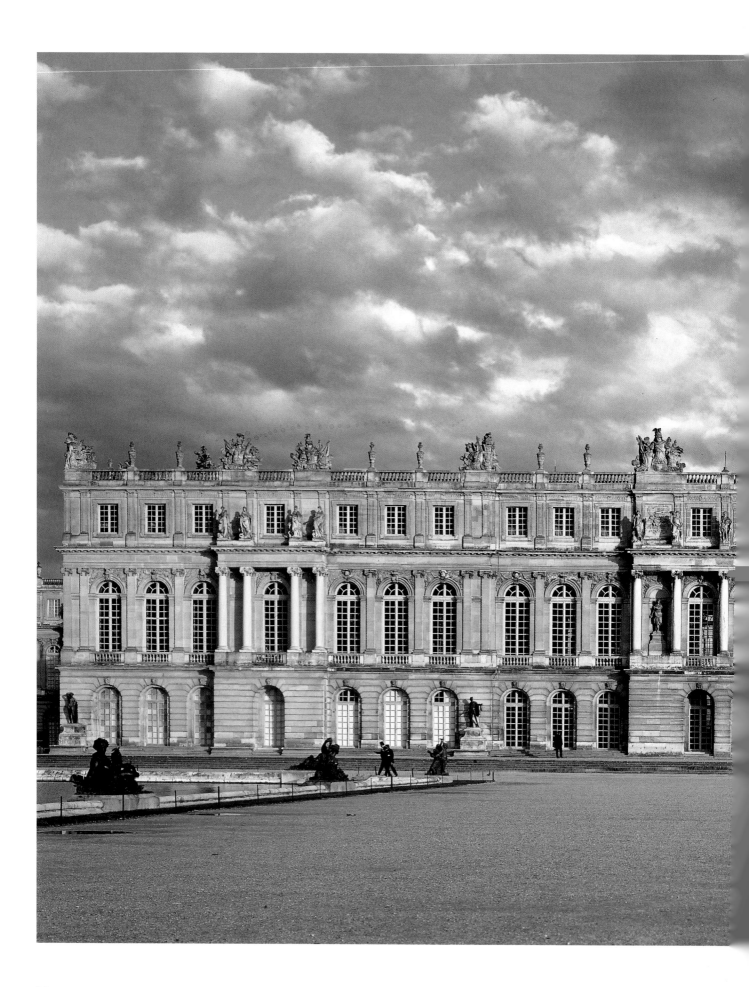

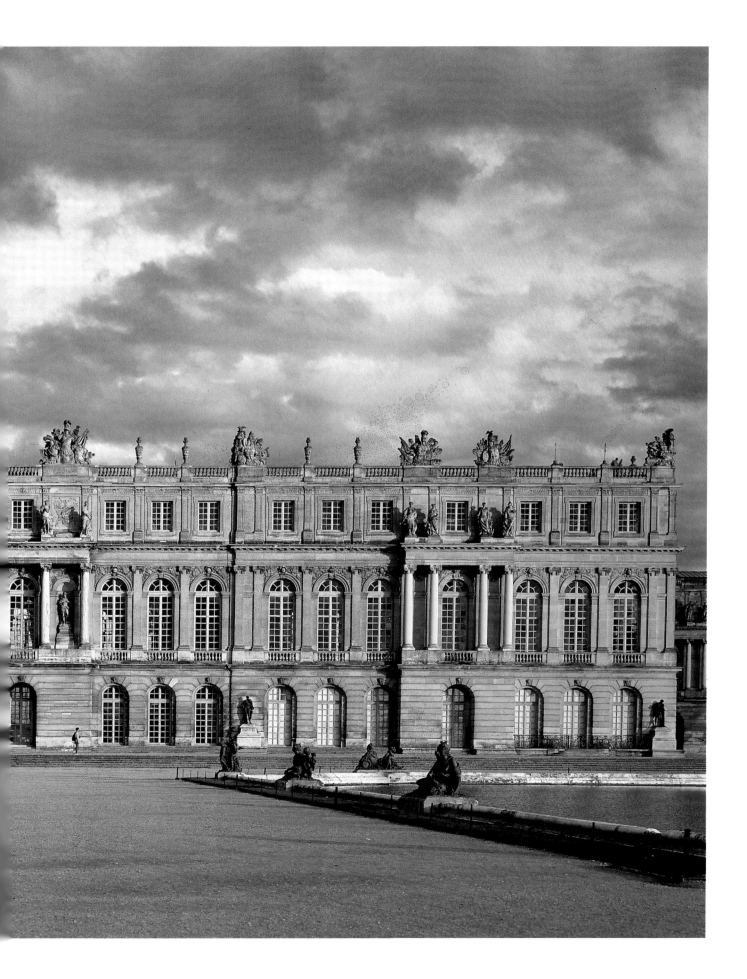

James Ferguson (1808–86), in a comprehensive *History of Modern Styles of Architecture*, published in 1862, thought little of the more exaggerated Baroque architects in Britain such as Wren, Hawksmoor, and Vanbrugh. In commenting on Hawksmoor's St. George-in-the-East (1715–23), Stepney, Ferguson says: "The term vulgar expresses more correctly the effect produced than perhaps any other epithet that could be applied to it." As late as 1912, Aymer Vallance (1862–1943), writing of Hawksmoor's work at All Souls' College in *The Old Colleges of Oxford*, characterizes it as a "puerile caricature of the kind that only brings the noble name of Gothic into contempt" and draws the conclusion that "it would be uncharitable to judge [All Souls'] too seriously as architecture."

In Italy, where the Baroque was born, the energy to malign it carried well into the twentieth century. Benedetto Croce (1866–1952), the voice of Italian philosophy of this century, as late as 1929 in his *Storia dell'età barocca in Italia*, felt the Baroque to be "an artistic perversion, a kind of artistic ugliness" characteristic of the social, political, and religious temper of a debased period.

Baroque architecture in France, Italy, England, and Germany had already become of interest to architects building the new imperial capitals of Berlin, Vienna, and London when Heinrich Wölfflin published *Renaissance und Barock* in 1888. In the introduction he pulled his punch to say "as an art historical term *Baroque* has lost its suggestion of the ridiculous, but in general use it still carries a suggestion of repugnance and abnormality," and "it has become customary to use the term *Baroque* to describe the style into which the Renaissance resolved itself or, as it is more commonly expressed, into which the Renaissance degenerated." His re-evaluations of the Baroque contributed to the development of a concern for an imposing architecture of majesty and grandeur.

As study of the history of Baroque architecture progressed, philosophers and theoreticians applied concurrent theories of psychology to the experience of architecture in developing notions of empathy, of response to form, of a human sense of form, and the beauty of pure form. But it was not only architectural form that occupied their thoughts and scholarly debates. Similar propositions about space were closely argued with contesting ideas about human sense of space, spatial form and spatial direction, as well as the relation between interior space and exterior mass form. Structural and lighting systems, daylight and ornamentation, decoration, the placement of painting and sculpture, were all drawn into the discussions. Specimens of Baroque architecture were often used to illustrate specific points.

Heinrich Wöfflin (1864–1945), August Schmarsow (1853–1936), Alois Riegl (1858–1905), Adolf Göller (1846–1902), and Paul Frankl (1879–1962) were the five major figures engaged in the development of analytical tools for the study of the history of architecture in general and of Baroque architecture in particular. Though each of these authors proposed theories, either implicitly or directly, to explain change or evolution of an architectural style, the emphasis here is placed on characterizing their contributions to notions of architectural form, mass, space, structure, light, ornament and decoration as they reconstituted the Baroque during the critical years from 1886 to 1915.

Alois Riegl (professor of art history, Vienna) with *Die Spätrömische Kunstindustrie* (1901) effected a reassessment of Late Antique art through an approach that distinguished two different ways of seeing, tactile and optical, both based on the physiology of the eye. In postulating a predisposition to a mode of seeing, Riegl's thought had a profound effect on the theory of art. In addition, his proposal that *kuntswollen* (artistic will or the will to art) was responsible for changes in style, received considerable critical attention in ensuing years. In 1894–95 Riegl lectured in Vienna on the history of the Baroque and, again in 1898–99, on the history of Italian art between 1550 and 1800. These and other related lectures formed the basis of Riegl's posthumous publication in Vienna in 1908 of *Die Entstehung der Barockkunst in Rom* that treated art in Rome from Michelangelo to the 1630s.

Adolf Göller (architect and professor, Stuttgart), in 1887, the year after Wölfflin's dissertation, also sought to explain change in architecture. He distinguished the associative or intellectual context of the forms found in painting or sculpture from the pleasure in architecture that derived from the beauty of pure, unmediated form.

Heinrich Wöfflin presented his dissertation in Munich in 1886, *Prolegomena zu einer Psychologie der Architektur*, in which he sought to refute a mechanistic theory of architectural

form resulting from "material, climate, and purpose," and propose a psychology of architecture that would enable historians to "trace individual events to general principles or laws." Two years later, however, his purpose in writing *Renaissance und Barock* was "not to describe the whole course of [the] development [of the Baroque] but to clarify its origins," and to do so through "a formal analysis of the complex of symptoms that constitute the Baroque." He concentrated his attention on Rome between the years 1520 to 1630 and used his perceptive analyses to distinguish the architecture of the later sixteenth century from that of the High Renaissance. (These differences were sorted through and later identified by art historians as belonging to a period between the Renaissance and the Baroque that would be called Mannerism, a period and a style with its own premises, beliefs, and contradictions that were resolved only in the very late sixteenth and early years of the seventeenth century.) Wölfflin's four attributes that defined the nature of the change in style to the Baroque – a painterly style, a grand style, massiveness, and movement – sustained his formal analysis of churches, palaces, villas, and gardens through the early Baroque in Rome.

In the development of Wölfflin's thought, the four attributes discussed in *Renaissance und Barock* lead to the five pairs of formal concepts that distinguish his immensely influential *Kunstgeschichtliche Grundbegriffe (Principles of Art History)* of 1915. The pairs or categories of form (linear/painterly, planar/recessional, closed/open, multiplicity/unity, and clearness/unclearness) describe specific defining characteristics of the art and architecture of the Renaissance and of the Baroque throughout Western Europe. In devising a non-judgmental comparative descriptive system for the analysis of works of art, Wölfflin provided a method that continues to be of interest to art historians for more than historiographical reasons.

August Schmarsow (professor of art history, Leipzig) is likely to have found Wölfflin's *Renaissance und Barock* wanting because of its focus on the reading of architectural forms rather than on the space the forms enclosed. Schmarsow, also utilizing contemporary psychological theory, focused his attention on the "human sense of space."

The conclusion of Schmarsow's inaugural lecture at Leipzig in 1893 includes a statement that the "history of architecture is the history of the sense of space." In this lecture, "The Essence of Architectural Creation," Schmarsow's proposal that "architecture is the creation of space, in accordance with ideal forms of the human intuition of space" flatly opposes Wölfflin's theory, though neither Wöfflin nor his theory are mentioned by name.

Wölfflin had also been an aspirant for the chair at Leipzig and later in the same year received an appointment to succeed the famous Burckhardt at Basel. In his new, prestigious position, the younger Wölfflin reviewed Schmarsow's inaugural lecture upon its publication in 1894. Critical exchanges and appraisals of each others theoretical stances were published over the next several decades.

Schmarsow believed that the ability of the viewer to project himself through imagination into a perceived space and move through it was critical. The imagination transcended the physiology of the eye. "The spatial construct is, so to speak, an emanation of the human being present, a projection from within the subject, irrespective of whether we physically place ourselves inside the space or mentally project ourselves into it." Schmarsow argues that imagined motion enables an assessment of the dimensions of a perceived space. "We cannot express [the spatial] relation to ourselves in any way other than by imagining that we are in motion, measuring the length, width, and depth, or by attributing to the static lines, surfaces, and volumes the movement that our eyes and our kinesthetic sensations suggest to us, even though we survey the dimensions while standing still."

Schmarsow further developed notions of space, axiality and perception in his *Grundbegriffe der Kunstwissenschaft (Basics of the Science of Art)* of 1905 that he applied to painting (horizontality) and sculpture (verticality) as well as architecture (depth and directionality). He argued that in different periods one or another of the axialities might be dominant. In the Baroque, Schmarsow contended, the vertical was dominant as was the sculptural. Rococo architecture was seen to be painterly with its lack of sharp demarcations, multiple unresolved images and interpenetrating, confusing spatial definitions.

When Wölfflin published *Principles of Art History* in 1915, the preface, which cited the major art historians, included Schmarsow as well as Riegl, Wickhoff, and his student Frankl. Paul Frankl's analysis of plan forms, direction and focus, marked a new phase in the study

of Renaissance and Baroque architecture. His first important theoretical work was published in 1915, *Die Entwicklungsphasen der neueren Baukunst (Principles of Architectural History, the Four Phases of Architectural Style, 1420–1900)*. It had been submitted to Wölfflin as Frankl's *habilitationsschrift* in 1914. Frankl's preface acknowledged his indebtedness to Wölfflin's *Renaissance und Barock* (which suggested to him that he undertake a study of the period 1400–1900), to Wölfflin's lecture in 1912 that developed the five polarities of his later book, and Schmarsow's *Grundbegriffe der Kunstwissenschaft* with its assignment of elements and dimensions to each of the plastic arts. Frankl also recognizes his debt to the more general theoretical studies of Burckhardt and Riegl, his "godfathers," and the works on the history of architecture of the Italian Renaissance by Heinrich von Geymüller, and by Cornelius Gurlitt on the Baroque.

Frankl's introduction lists the four analytical categories that he used for comparison in the periods he identifies. They include 1) space form, 2) the tectonic shell or structural and enclosing body, 3) that which light and color reveal, and 4) the purpose, or content, meaning and spiritual significance. The first category was developed from Schmarsow's theories, the second from those of Wölfflin, the third from contemporary psychological theory, but his fourth is an original attempt to distinguish specific relationships between change in social structures (political, religious and economic) and change in architecture.

Frankl's four historical periods conformed to contemporary thought. His first and second periods, 1420–1550 and 1550–1700, to mark the end of the Renaissance and beginning of the Baroque at 1550, followed a precedent set by Wölfflin in *Renaissance und Barock*. The third period discusses buildings of the Late Baroque and Rococo and the fourth period concludes the nineteenth century.

The application of Frankl's four categories to the four periods resulted in four pairs of concepts. In Frankl's words, "spatial addition and spatial division, center of force and channel of force, one image and many images, freedom and constraint – these are the pairs of concepts by which I distinguish and characterize the phases of post-medieval architecture."

The numerous examples cited by Frankl include buildings from east and north Europe as well as Italy and Spain, many drawn from the publications of Cornelius Gurlitt. Between 1887 and 1889, Gurlitt published three volumes on Baroque architecture in Italy, Germany and throughout Europe. Frankl's closely argued analysis made the assumption that all the works he cited were equally valid manifestations of the characteristics of the period studied. The publication in 1915 of the theoretical investigations of both Wölfflin and Frankl attest to Baroque art and architecture as an established, legitimate field of art historical study.

The historical base for the theoretical studies of Schmarsow, Wölfflin and Frankl was provided by a series of publications on seventeenth- and eighteenth-century architecture in Europe, works that placed a new value on the Baroque and would become reference works for the next generation. In addition to the surveys by Gurlitt and Schmarsow's own *Barock und Rokoko* (1897), publications on Baroque architecture in German-speaking countries included works by Wilhelm Pinder (1911), Albert Erich Brinckmann, a student of Wölfflin (1911), Hermann Popp (1913), Georg Biermann (1914), and Martin Wackernagel (1915). Also in 1915 Brinckmann published a volume on Baroque architecture in Italy, France and Spain. In France, Louis Hautecœur's early writings were on the Renaissance and Baroque in Italy (1912), and the eighteenth century in St. Petersburg in Russia (1912). French architecture of the seventeenth century was studied by Henry Lemonnier (1893 and 1911), and by Paul A. Planat with Ernst Rümler (1912). Eighteenth-century architecture and decoration in France was the focus of Léon Deshairs' publication (1908). Otto Schubert's volume on Baroque architecture in Spain appeared in 1908. In 1913 in Britain, Martin Briggs (1882–1977), a respected architectural historian and the first to publish a book on Baroque architecture, published a volume on Baroque architecture in Europe that was significant enough to be translated into German the next year. Though Briggs had praise for much of the architecture of the period, he was unable to appreciate the work of Borromini, Guarini, their followers and the works of the more "eccentric" architects they may have inspired in other nations.

But the tides change, and the next year Geoffrey Scott (1883–1929), in *The Architecture of Humanism* (1914), notes that "of late years a slightly more worthy appreciation of the

opposite
James Gibbs
Wooden model
for St. Martin-in-the-Fields
London, British Architectural Library
Drawings Collection, RIBA
on loan from the Vicar
and Churchwardens
St. Martin-in-the-Fields
cat. 551

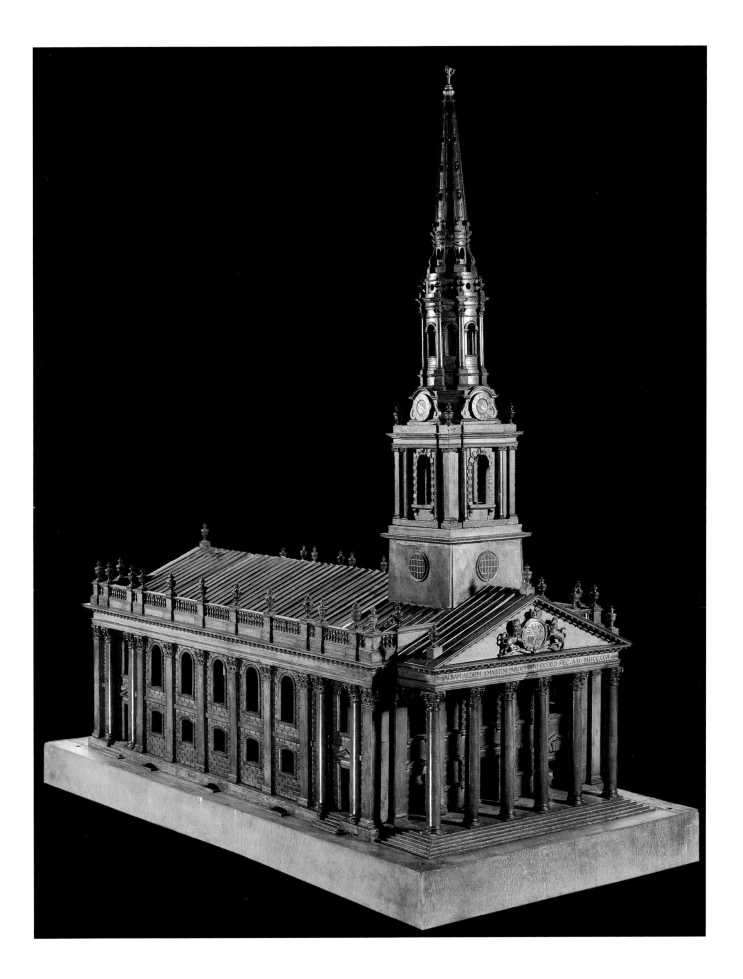

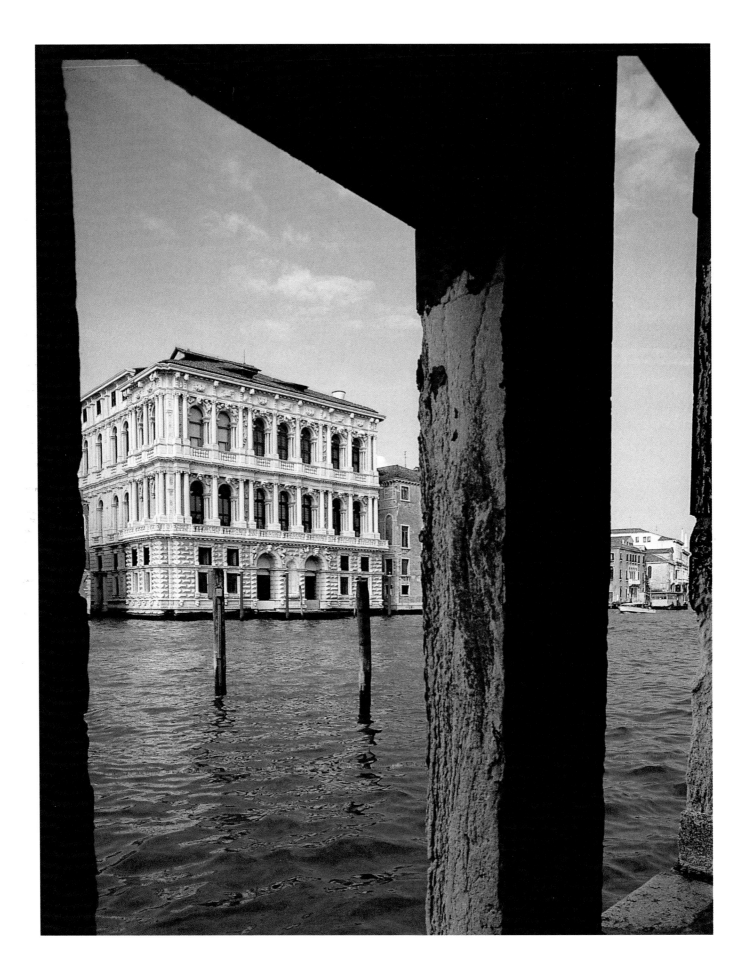

Baroque style – it would be truer to call it a mitigation of abuse than an appreciation – has crept from German into English criticism." Scott's own appreciation of Baroque architecture is evident throughout his volume as he appeals for an architecture of line, mass, and space. Scott's text does not identify the authors or publications from Germany he may have read, though in his preface he acknowledges debts to both Burckhardt and Wölfflin, citing the latter's *Renaissance und Barock*. Scott's study emphasizes space, mass, line and intellectual coherence as the legitimate values to be sought in architecture. He sees the enclosure of space as the object of building – "the architect designs space as a work of art [...] space is [seen to be] the liberty of movement" – notions that, as we have seen, Schmarsow had explored earlier.

While Wölfflin had, by 1915, abandoned the notion of massiveness postulated in *Renaissance und Barock*, Scott had probably appropriated this idea as one of his four elements of Renaissance (and Baroque) architecture. Sparked by both Briggs and Scott, a re-evaluation of the Baroque was under way in Britain before World War I, as it was also in France and had been in Germany for over twenty years.

Monographs on the architects of the seventeenth and eighteenth centuries in Europe appeared as early as the 1890s with Gurlitt's *Andreas Schlüter* (1891) and Albert Ilg's *J. B. Fischer von Erlach* (1895). Monographs became more frequent in the years before the war and almost commonplace between the world wars. Monographs on individual buildings of the seventeenth and eighteenth centuries also appeared with increasing frequency. Thereafter publications on Baroque art and architecture in Europe were absorbed into the art history industry. The search for a theoretical base for the history of art and architecture, the growth of the history of art and architecture as a separate discipline, and the developing rehabilitation and appreciation of Baroque architecture evolved concurrently between 1880 and 1920.

Seventeenth- and eighteenth-century architecture is different in Lecce than in Rome, different in Vienna than in Salzburg, different again in Paris than in Bordeaux. Local identity is a characteristic of the Baroque in each of the countries and regions of Europe. As might be expected, buildings in the seventeenth and eighteenth centuries are realized in forms that while new, resonate with the tradition and expectations of the inhabitants of a region. There are virtually as many varieties of Baroque buildings as there are peoples to make and use them.

The new architecture of the seventeenth century began in Rome in the work of Carlo Maderno at Santa Susanna, St. Peter's, and the Mattei and Barberini palaces. By mid-century it was flourishing in the work of Borromini, Bernini, Cortona and others. By the last quarter of the century architects were constructing Baroque buildings throughout Southern Italy, Sicily, Central and Northern Italy.

Buildings that reveal a knowledge and understanding of the earlier work of Italian architects are found, by the end of the seventeenth century, in many locations in Western and Central Europe, in Protestant as well as Catholic areas. At the same time, knowledge of and appreciation of the work of architects in France began to appear in designs for churches, palaces, and castles in the Netherlands, Scandinavia, Germany, and Central Europe.

An increase in number and wider dissemination of publications and prints on architecture, decoration, and ornament made representations of the work of architects throughout Europe readily available. Before 1730 knowledge of the work of German and Austrian architects had spread from Britain to Russia, Spain, and Italy, as well as to Scandinavia. Similarly, publications documenting work in Spain, Portugal, Italy, Germany, Austria, France and Britain were abroad in both the New World and Asia. Architects and builders designed and constructed Baroque buildings in Spanish and French America and at sites of European influence in Asia. By 1750 to 1770, architecture containing Baroque forms and elements was familiar in much of the known world.

BIBLIOGRAPHY: Laugier 1753; Lemonnier 1893; Deshairs 1908; Schubert 1908; Brinckmann 1911; Lemonnier 1911; Pinder 1912; Hautecœur 1912a and 1912b; Planat and Rümler 1912; *Die Architektur der Barock- und Rokokozeit* 1913; Briggs 1913; Biermann 1914; Wackernagel 1915; Brinckmann 1915; Kurz 1960: 414–44

opposite
View of the Ca' Pesaro, Venice

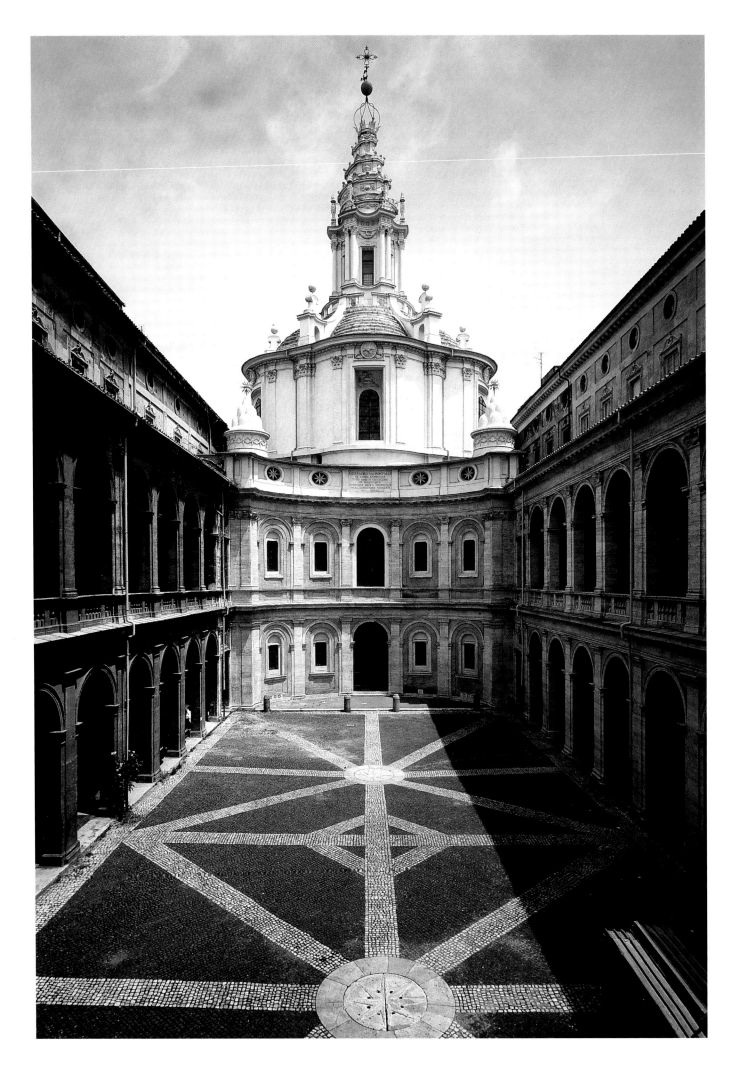

Gaspare Morone
Medal with the colonnade
of St. Peter's Square (*recto*)
and the image of Alexander VII
(*verso*)
Munich, Staatliche Münzsammlung
cat. 14

For European civilization, the seventeenth century was an age rich in events, both from the point of view of politics and religion and of literary, philosophical, and scientific production. Art and architecture were certainly affected by the changes in sensibility and taste and by the cognitive sciences and historical events, but it is also true that those innovations were creative solutions for problems inherent in the individual artistic disciplines. In any case, no rigorous investigation can ignore what occurred in each sphere of autonomy that every artistic discipline enjoys by its very nature.

The advent of the Baroque, whatever interpretation one gives to this posthumous label that was given to a stylistic climate that had no need of labels, was primarily a succession of congruous works and therefore a history of the great personalities of artists and patrons who attempted to resolve the problems that the preceding generation had left unsolved and who made significant choices within their patrimony of inherited experiences.

An advent – that of the Baroque – that was divided into two periods in which considerable confusion and contradictions took place in sculpture, painting and architecture as well as in literature and music. In architecture, the first period, which spanned the sixteenth and seventeenth centuries, was dominated by two architects in Rome who were close relatives and came from the (Italian-speaking) Canton of Ticino: Domenico Fontana and Carlo Maderno. It is to their credit and to that of another Lombard architect, Flaminio Ponzio, that Roman architecture regained the central position it had lost at the time of the death of Michelangelo, and started the new century off with an ambitious program of restoration. Michelangelo's legacy had been taken over with deep-felt intensity by Giacomo del Duca, and cautiously administered by Vignola, Giacomo Della Porta, and Francesco da Volterra; whereas in Veneto and Lombardy architects had opposed academic Mannerism, exorcised of its doubts and whims, and initiated research that was paradoxically more open to the needs of the Church in Milan and to the wealth of ideas springing from contemporary painting in Venice. During the crucial years of the Sistine pontificate (1575–80), the inseparable team of Sixtus V and Domenico Fontana brought impetus and creativity back to the Roman architectural scene. This was not implemented with works of great formal quality, rather its horizon was widened in directions that would prove to be decisive. Construction techniques and spectacularity were exalted and attention was turned to the city as an organism that could be re-

Giovanni Maggi
Map of Rome, 1600
Milan, Civica Raccolta Stampe
Achille Bertarelli

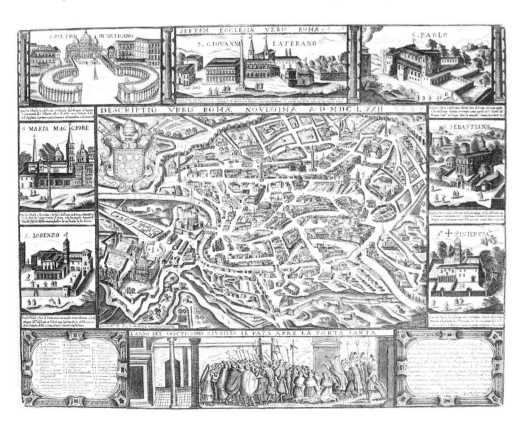

opposite
Church of Sant'Ivo alla Sapienza,
Rome

33

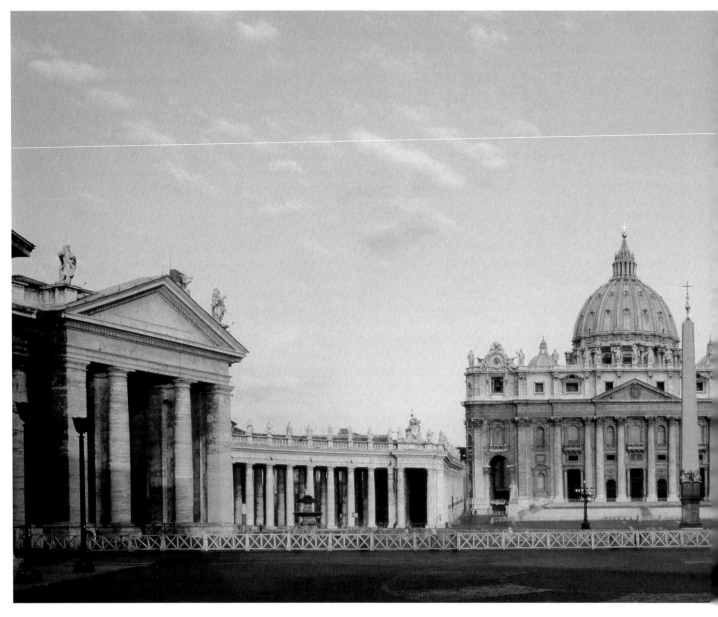

newed by utilizing and composing its existing parts together with new ones by means of a careful study of existing relationships and possible future ones.

Although Domenico Fontana renounced the subtle issues of architectural language and its renewal in his *ante litteram* pragmatism, his nephew Carlo Maderno tackled them with great ability, and found patrons in Clement VIII Aldobrandini and Paul V Borghese. In 1607, after having won the competition for the completion of St. Peter's, the Ticinese architect confronted two of the problems that would feed the architectural debate for more than a century: the synthesis between centralized and longitudinal plans, and the façade as a perspective scene in an urban space. The theme of finishing Christianity's greatest temple necessarily led back to Michelangelo's legacy. Twenty years later Bernini, Borromini and Pietro da Cortona would venture upon the same theme albeit with a different intensity and different results. Maderno interpreted this theme in the most conventional and reductive manner: he picked up and simplified the dialectic contrast between the masonry mass and the architectonic order, and by lengthening one of the four arms beyond measure did not compromise Michelangelo's centralized space. Thus the dramatic impact of Michelangelo's language, so evident in his treatment of the apse both inside and outside, subsided into a distilled equilibrium in the added parts.

Maderno gave the best of himself in the articulation of the orders, in his very careful study of plastic effects, and in the introduction of the portico and papal loggia which provided a brilliant solution for functional and celebratory requirements.

His experience in confronting such a complex and difficult theme made it possible for him to make a very successful *in vitro* experiment: the greatly admired and often overrated façade of Santa Susanna. The classic order was used finely there pursuing an effect of plastic unity that Mannerism had neglected to the advantage of the composition of relatively autonomous and at times openly dissonant parts. With didactic clarity, Maderno orchestrated his façade by sub-

The Baldacchino in St. Peter's
Engraving by Filippo Bonanni
Milan, Civica Raccolta Stampe
Achille Bertarelli

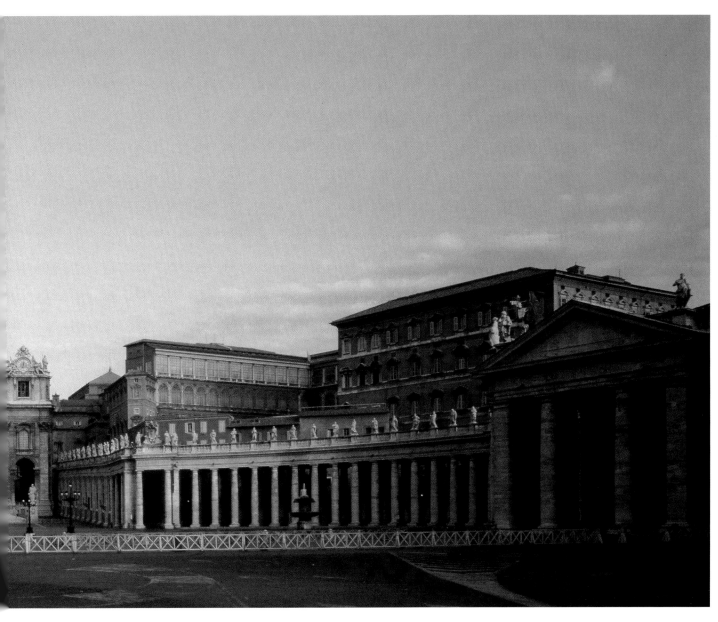

Panoramic view across Piazza
San Pietro

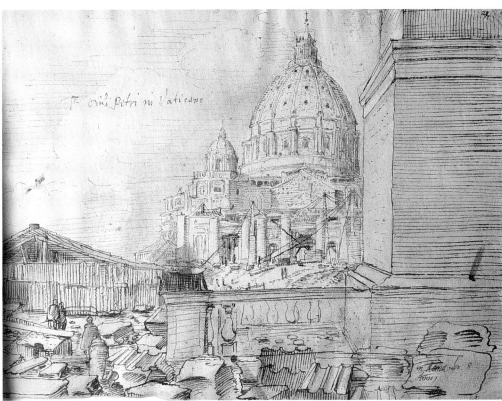

Unknown Artist
View of New St. Peter's under
construction
Wölfenbuttel, Herzog August
Bibliothek
cat. 5

opposite
Church of Santa Susanna, Rome
The façade

ordinating the parts to an overall plan of marked three-dimensional virtuality, a plan one might say of the gradual "advancement" of the sides toward the center: a kind of visual "crescendo." By analyzing the architectural elements that were used in succession from the extremes toward the center, one notes in fact an ever-increasing progression. The first element is a corner pilaster which marks the separation between the façade and the lateral wings constructed in brick. Next to it is a pilaster set into the wall in correspondence to which is a free-standing column. The third element is identical, but is coupled with a full pilaster on the edge which in turn is coupled with the free-standing column of the central aedicule.

The progression of plastic intensity from the sides toward the center and from the top toward the bottom had never reached such a programmed clarity. This example was treasured by the following generation whose own resounding debut took place during the pontificate of Urban VIII Barberini, a humanist who was sensitive by virtue of his own personal experience to the need for freedom which is indispensable for cultural development. That generation of master architects made their debuts between 1630 and 1640 with three exemplary works: the Baldacchino of St. Peter's, San Carlo alle Quattro Fontane, and the church of Santi Luca e Martina. However, it was not until the completion of the Cornaro chapel in Santa Maria della Vittoria in 1646 that Bernini reached the apex of his architectural creativity.

Gian Lorenzo Bernini was already renowned as a sculptor when he started to work with a contemporary architect by the name of Francesco Borromini, who had been trained in the studio of Carlo Maderno, a near relative. The Bernini-Borromini couple later became famous for the implacable conflict between those two equally talented personalities; however, from 1624 to 1631 their collaboration was pacific and probably precious for both parties.

The commission to create a baldacchino which would substitute the provisory one by Ambrogio Buonvicino above the main altar in St. Peter's was given to Bernini by Urban VIII in 1624. The sculptor's early drawings reflected his desire to revive the old Constantinian *pergula* in the new construction, and maintain the precariousness and lightness of character that Buonvicino had obtained by imagining the appearance of four angels carrying a rigid metallic lambrequin. His basic idea was to duplicate the vine-covered columns of the *pergula* on a gigantic scale and to place angels on top of the columns so that they would hold the lambrequin from the top as celestial creatures should and not from the bottom like ordinary mortals. The four columns were raised and inaugurated in 1627 on four stupendous bases on which Francesco Borromini worked as a simple stone-carver. Apart from the work executed by Borromini, the bases and columns clearly represent the most Berninian part of the Baldacchino, and that which is most consistent with the future developments of the great sculptor's architectural ideas. The elementary composition of the cross-ribbed structure fits this premise perfectly; as seen in Bonanni's engraving, it is reminiscent of the Constantinian *pergula*. The sculptural motifs are superimposed on the columns as autonomous decorations, setting the visionary language of the sculpture, the asymmetrical rhythm of the dancing figures in contrast with the architectural abstraction.

What happened to make Bernini and his patrons change the iconological program, and in particular the architectural design of the work after 1630?

From 1631 to 1633, Francesco Borromini's name appeared in the accounts of the Fabbrica of St. Peter's for payments received for the execution of models and studies of the Baldacchino, and in 1633 he was also mentioned for having received a monthly pay of 25 *scudi* "for some hundred drawings, plans, cornices, foliage and other intaglios to go inside the ribs and molding and what is more he is obliged to mark them on the branches and render them so that the carpenters and those who hammer copper do not err." In some notes that Bernardo Borromini added to a biography written by Baldinucci,[1] as explicit as they were factious, he maintained basically that Borromini was the author of all of Bernini's architectural work in St. Peter's, and that he had finally abandoned his more fortunate contemporary because of the petty way in which he had been treated. It was written in those notes that "then Maderno died and Pope Urban appointed in Maderno's place *signor* Gianlorenzo Bernini – the famous sculptor – [...] who finding himself with that commission and acknowledging the fact that as a sculptor he was incapable [as an architect] – and knowing that Borromini had been working in the Fabbrica of St. Peter's for Maderno – as well as at the Palazzo Barberini – he begged him on that occasion not to leave, promising him that he would recognize his

[1] Cf. R. Wittkower, *Studi sul Borromini*, I, Accademia di S. Luca, Rome 1967: 134ff.

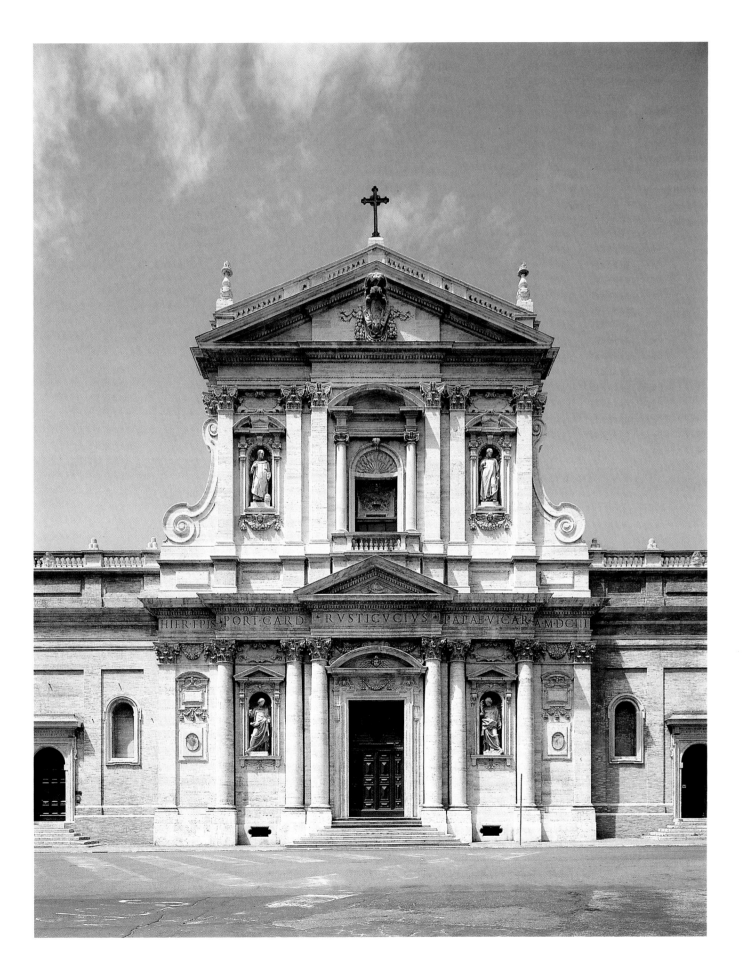

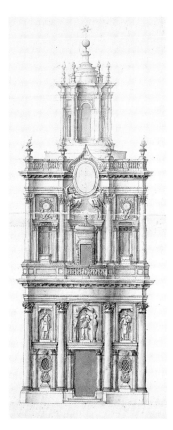

Pietro Bracci
Elevation of the façade of San Carlo
alle Quattro Fontane, Rome
Montreal, Collection Centre
Canadien d'Architecture
Canadian Center for Architecture
cat. 59

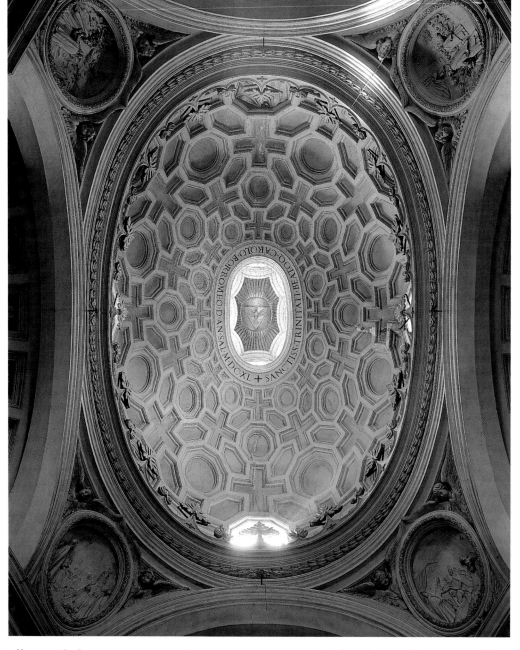

Interior of the dome of San Carlo
alle Quattro Fontane

efforts with due recompense; so Borromini was won over by his pleas and he promised that he would continue his work in the Fabbrica of St. Peter's, which he had already started for said pontiff, because he had already been informed of everything – and Bernini attended to his sculpture; and left all the architectural work to Borromini [...] and in fact at the time Bernini was an innocent in that profession. When the works of that pontificate had been brought to a conclusion by Borromini, Bernini took the wages and salaries of both the Fabbrica of St. Peter's and Palazzo Barberini and also the money for the measurements – and never gave anything to Borromini for the efforts of so many years – but only good words and great promises – and Borromini feeling disappointed and ridiculed went away, leaving Bernini with these words: I am not sorry that you have had the money, but I am sorry that you are enjoying the honor of my efforts."

Although it may be considered one-sided, Bernardo Borromini's version cannot be entirely without truth. In substance, it expressed the opinion of Francesco Borromini, an artist so jealous of his own intellectual work that he would never have extended his own paternity to something that was not the fruit of his own fantasy. And had he done so, in our opinion, he

Pietro Bracci
Plan of the church and monastery
of San Carlo alle Quattro Fontane,
Rome
Montreal, Collection Centre
Canadien d'Architecture
Canadian Center for Architecture
cat. 58

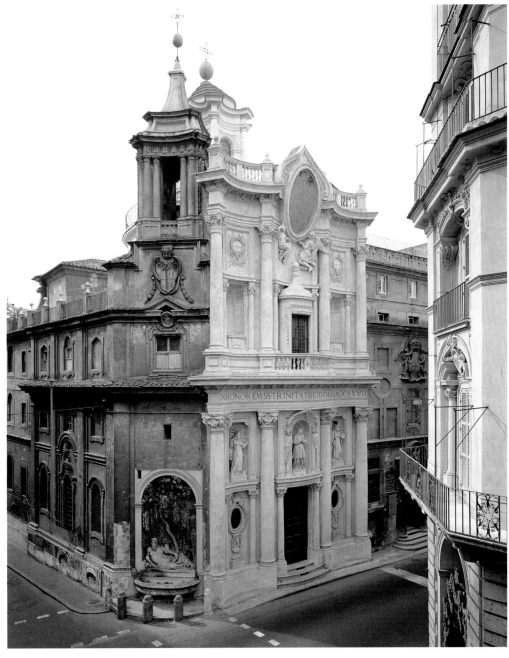

San Carlo alle Quattro Fontane,
Rome
View of the façade

[2] *Francesco Borromini die Handze-ichnungen*, Herausgegeben H. Thelen, Akademische Druck, 1967.

would have done so only out of love, out of the love for an idea and a form born out of a fruitful conflict of tastes and vocations.

Even though Bernini's autograph drawings are presented as evidence against the theory that Borromini was totally responsible for the architecture, many other elements contribute to the theory of a creative collaboration. In the first place, numerous drawings by Borromini at the Albertina in Vienna[2] reveal a scrupulous study of the relationship between the Baldacchino and the space of the Basilica, and secondly, the plastic and architectural characteristics of the crowning element, with its set of triple "dolphin-back" volutes that are connected above by a mixtilinear cornice, anticipate the parts of the lanterns of San Carlo and Sant'Ivo alla Sapienza. With respect to the project published by Bonanni, the sculptural structure has lost its provisional character and become architecture in the full sense of the word. The flying lambrequin in the engraving has become the stable connection of the columns, and above it, like some kind of transparent cupola, the diagonal structure of the volutes continues the plastic tension of the supports upward, gradually reducing the multiplicity of the elements to a unity. Looking down at the top of the Baldacchino from the balcony of the cupola, Bernini's four

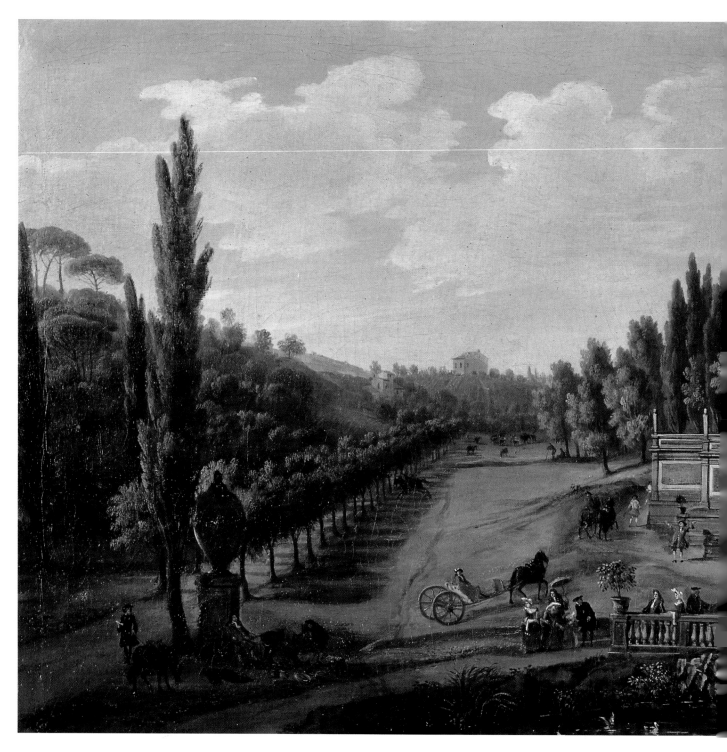

Gaspar van Wittel (Vanvitelli)
View of Villa Sacchetti del Pigneto
Rome, Collezione Sacchetti
cat. 20

angels seem to be competing with Borromini's volutes. The same burst of vital energy is rendered by means of naturalism and abstraction with sculpture and architecture confronting each other. Sculpture has conquered an essential role for itself in the architectural image and architecture has decided to exasperate its plastic potential so as to emulate and surpass sculpture. We can already see here *in nuce* Bernini's approach toward the "total spectacle" in which all the arts fused together, and Borromini's approach toward an all-embracing architecture in which thought and narrative, mathematics and pathos, withdraw within the austere gentleness of the serpentine form. Apart from the Baldacchino of St. Peter's and Palazzo Barberini, where it is not easy to separate their individual contributions, the architectural debut of the three masters can be dated between 1634 and 1644 with three works which took a fair amount of time to complete. Borromini's San Carlino was begun in 1634 and finished in six years except for the façade. The church of Santi Luca e Martina took some fifteen years to build from the time of the original project to its completion, and the Cornaro chapel in Santa Maria della Vittoria was inaugurated eight years after being commissioned.

In San Carlino, Borromini had to face many of the great problems that would soon animate the architectural debate of the new century, not only in Rome but also in the Po "melting pot." These included the synthesis between the centralized and the longitudinal plans, the

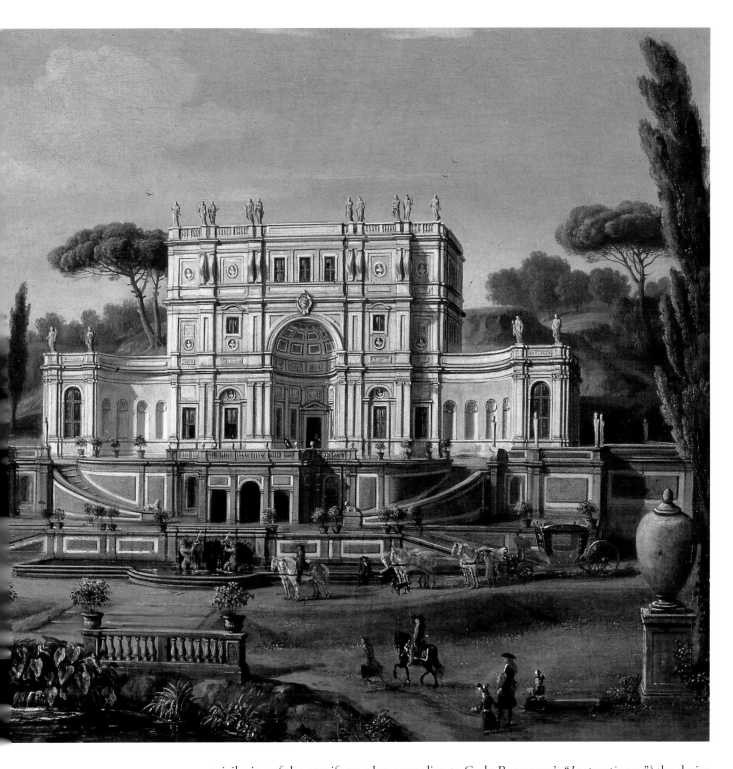

[3] C. Borromeo, *Instructiones Fabricae Eccclesiasticae*, Milan 1577.
[4] Cf. S. Kuppner, "Francesco Borrominis Ausbildungsjahre an der Mailänder Dombahutte," in *Arte Lombarda* (1994): 108-109; and S. Kummer, "Mailänder Vorstufen von Borrominis S. Carlo alle Quattro Fontane in Rom," in *Munchner Jahrbuch der Bildenden Kunst* 28 (1977): 153–90.

privileging of the cruciform plan according to Carlo Borromeo's "*Instructiones*,"[3] the desire to return to a new simplicity after the Mannerist complexities in order to provide an innovative answer to the liturgical and celebratory needs of the Roman Catholic Church, one that did not involve a renunciation of the freedom of art that had seemed inevitable to the preceding generation, at least in Rome. Whereas, in the past, the lack of information about Borromini's Milanese years had led many to maintain that he was an autodidact who had been trained with Maderno, today the important contributions of Sabine Kuppner and S. Kummer[4] make it possible to correct these affirmations in part. The architect who, at the age of thirty-five, set about to build the church of San Carlo alle Quattro Fontane was no outsider, but rather a full-fledged architect. It may be an exaggeration to turn Borromini into some kind of Mozart of architecture who at only fourteen years of age was able to make original suggestions to Mangone for the altar of the Albero in the Duomo of Milan. However, there is no denying that his admission as an "altar-boy" in 1613 to the Latin school and his successive apprenticeship as a stone-carver at the school of the Duomo, where he also studied mathematics, enabled the twenty-year-old Borromini to join the circle of architects in Borromeo's employ in Rome where he was in a position to offer precious help to Maderno. On the other hand, the chronicler Fra Giovanni dell'Annunciazione, who wrote about the

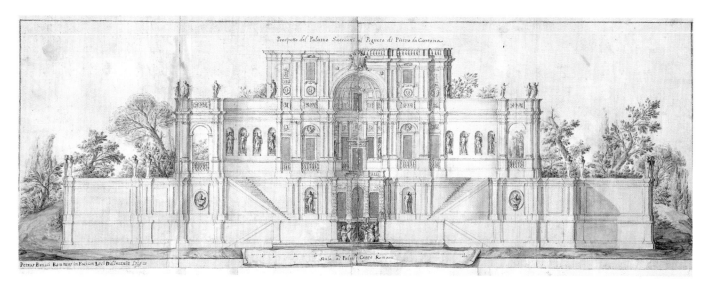

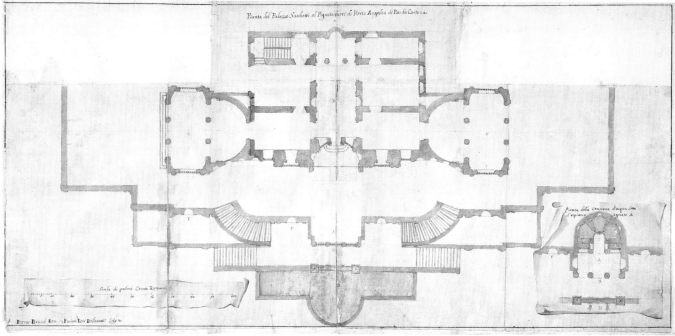

Pietro Bracci
Elevation of Villa Sacchetti
del Pigneto
by Pietro da Cortona
Montreal, Collection Centre
Canadien d'Architecture
Canadian Center for Architecture
cat. 22

Pietro Bracci
Plan of Villa Sacchetti del Pigneto
by Pietro da Cortona
Montreal, Collection Centre
Canadien d'Architecture
Canadian Center for Architecture
cat. 21

[5] P. Portoghesi, *F. Borromini*, Milan 1990: 13–19; 155.

construction of San Carlino, mentions Borromini's great cultural dignity and his sensitivity toward religious problems, as well as the attention he paid to the iconological aspect of the architecture. San Carlino – as Kummer has also recently pointed out – owed much to the research work conducted by the circle of architects who had put Carlo Borromeo's precepts into practice in the early seventeenth century in Lombardy. In particular, this involved a line of reasoning and research dealing with the compatibility of centrality with the longitudinal development of ecclesiastical buildings as requested by the liturgy. This very relationship revealed how radical Borromini's method of composition was: it took the juxtaposition of heterogeneous parts, the montage of pieces each ignorant of the presence of the other – the way Ricchini had presented in his churches – and fused it into a fluid plastic continuity.

The truth is that when Borromini reached Rome armed with a Milanese training that was open to new needs and sensibilities, he was able to test its validity by comparing it to two fundamental sources. First, he re-examined Michelangelo's legacy with an open mind, and secondly, he turned to antiquity – and this is what was new – not to further rigidify the system of rules set down in the treatises, but rather to open that system up and make it more flexible on the basis of a philological observation of the pluralistic complexity of the classical legacy which he had rediscovered in Hadrian's Villa and in Montano's collections of antiques.[5]

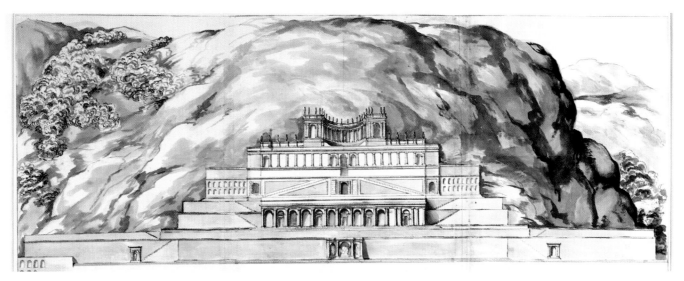

Pietro da Cortona
Project for the reconstruction
of the Temple of Fortune
in Palestrina
Windsor Castle, Royal Collection
H. M. Queen Elizabeth II
cat. 27

Martin Raspe[6] has explained the importance of the monopteral temple, the ring of columns that surrounds a space and unifies the inside and outside, as one of the motifs that reappear continually in Borromini's works, even in filigree. San Carlino, like the project for Bramante's temple at San Pietro in Montorio, derives from a reflection of this classical archetype. While Bramante revived it by multiplying the rings of columns surrounding the cylindrical walled cell, Borromini created a dynamic symbiosis between the colonnade and the cell, between the cylindrical shafts and surrounding wall, and by the use of alveoli. He took the ring and bent it into a four-apsed shape with four rectilinear lines emphasizing the diagonal according to Michelangelo's example in the Sforza chapel and the project for San Giovanni dei Fiorentini.

The fusion between the centralized and the longitudinal plans was therefore not achieved in the ambiguous formula of the oval but rather in a stronger and more synthetic spatial configuration in which the theme of the cross, indicated by Carlo Borromeo himself, and that of the octagon existed together with an iconic allusion to the dove of the Holy Ghost.

In order to create a structure in which the monopteral archetype could be modeled, dilated along one axis and compressed along the other and with all other elements either stretched or twisted, Borromini needed a language that was profoundly changed, a freer and more flexible one in which each molding could become, so to speak, sensitive to the others. It was not Borromini's intention to derogate Mannerism in order to achieve this linguistic revolution, but rather to reread the classic legacy with an adventurous spirit. The ancient became, as it had been for the architects of the fifteenth century, a forest to explore, a system characterized by a continual and infinite accumulation. Contemporary documents attest to the artist's interest in the ancient, and references to antiquity were frequent in his handwritten notes and writings, such as the text of the *Opus Architectonicum*. In the giant order of San Carlino, the moldings of the cornice copy those of the entablature of the Temple of the Sun, located nearby on the Quirinal Hill, while the capitals of the columns placed on the diagonal sides of the octagon repeat the overturned volutes at Hadrian's Villa which, instead of turning outward, turn inward, as if to underline the different role the eight columns supporting the arches play with respect to those inside the four apses. Strangely enough, some important art historians, like Sedlmayr and Wittkower, consider Borromini's abandonment of the Renaissance system of modules as a departure from Humanistic anthropomorphism. In my opinion, Borromini's objective in San Carlino was not to revive the additive method of the Gothic nor to return to a workshop mentality, but rather to push forward into the logic of organicity and anthropomorphism, and conceive the work therefore as a living body made of inseparable and oriented parts, each bound to the other by the necessity of movement.

The comparison in the text of the *Opus*[7] between the façade of the Oratory and the human body ("and to give form to said façade, I imagined the human body with open arms, as if to embrace all those who enter; that body with open arms is divided into five parts, that is,

[6] M. Raspe, *Das Architektursystem Borrominis*, Munich 1994.
[7] F. Borromini, *Opus Architectonicum*, Rome 1964 (sec. ed.): 38.

the chest in the middle, and both arms in two pieces where they are jointed; however, in the façade the middle part is in the shape of the chest, and the lateral parts in the shape of arms, each separated into two parts, by means of certain pilasters that stand out between them") is not to be considered, as has often happened, as a conventional reminder of an obsolete aesthetic, but rather as an explanation of what anthropomorphism could become within the new language.

Pietro da Cortona's debut occurred at almost the same time at two complementary places: the suburban Villa del Pigneto built in 1626 and the church of the Accademia di San Luca. The Villa del Pigneto (ridiculed by Bernini who, on seeing it, exclaimed: "*Petruccio* [poor little Peter] has made a Nativity scene") was a small building felicitously immersed in the landscape of the Pineta Sacchetti. For the first time in Rome a motif appeared in it that would interest both Bernini and Borromini: the "Palladian" motif of a central structure flanked by concave wings which Cortona had probably taken from a study of the great hillside complex that had already inspired Palladio: the Praeneste Temple of Fortuna Primigenia. The exaltation of concavity as a metaphor of a welcoming embrace was achieved here with special grace by means of substructures, staircases, and loggias. It culminated in the central niche which copied the model of the Belvedere courtyard in terms of a contracted perspective depth of exquisitely theatrical taste, with a silvery chiaroscuro to which the artist would remain faithful, and which he would use when he returned to a synthetic technique in his frescoes.[8] While designing the church of Santi Luca e Martina, Pietro went through an ordeal of self-criticism that started with the first project, known from the drawings in Munich and Milan, and continued to the definitive one, which was not terminated until 1646. There are affinities with Borromini's early work, above all in his option for an "oriented centrality," an option with very precise Lombard precedents and one that probably reflected the architectural tastes of Cardinal Federico Borromeo who, in 1593, played the role of protector of the Accademia di San Luca. While Lombard inspiration was more than natural for Borromini (and here his relationship with Ricchini should be clarified chronologically), a previous project designed by Ottavio Mascherino was probably more significant for Pietro.

References to Michelangelo were as meaningful to him as they were to Borromini, especially with regard to the designs for San Giovanni dei Fiorentini. In his first project, Pietro tended toward a Mannerist interpretation of Michelangelo's legacy, following the example of Giacomo del Duca in Santa Maria di Loreto; but his most profitable contribution was that which gradually led the architect-painter toward a new conception of the wall surface.

While the point of departure was to be found in Michelangelo's apses in St. Peter's, the arrival point expressed a different sensitivity. Cuts and contrasts were substituted by continual transitions between contiguous surfaces so as to obtain a new result: the wall no longer existed as a division between the inside and the outside, it became a filter that suggested the continuity of the space. This solution which enriched the surface of the building so that it became a three-dimensional fabric permitted Pietro to achieve what was manifested potentially and more abstractedly in Palladio, and what Fiocco referred to as "architecture that breathes."

Bernini's debut was certainly the most protracted of the three masters of the Baroque. It literally coincided with the visual reorganization of the interior of St. Peter's, but apart from the Baldacchino, which has already been discussed, the first moves of this reorganization – the piers and the loggias of the relics – were still uncertain and uneven in quality. Bernini's unique architectural vision had to wait to reach its culmination; this would not occur until he had executed some minor commissions, and the unfortunate episode of the bell tower of St. Peter's and the demolition of the chapel of the Propaganda Fide by Borromini had taken place at the time of the latter's greatest fortune. A series of chapels commissioned by nobles gave the sculptor an opportunity to put his experience as a director into practice; it would culminate in his masterpiece at Santa Maria della Vittoria, where he transformed the left transept into a sacred representation of the ecstasy of Saint Theresa of Avila.

Irving Lavin[9] has reconstructed this entire itinerary with exceptional rigor and dissected Bernini's program which united architecture, painting and sculpture in order to represent an event that Saint Theresa had described in detail in her autobiography. The event takes place contemporaneously in three different spaces, but only in one time: sacred time, that

[8] Cf. K. Noehles, *La chiesa dei Ss. Luca e Martina*, Rome 1969.
[9] I. Lavin, *Bernini e l'unità delle arti visive*, Rome 1980.

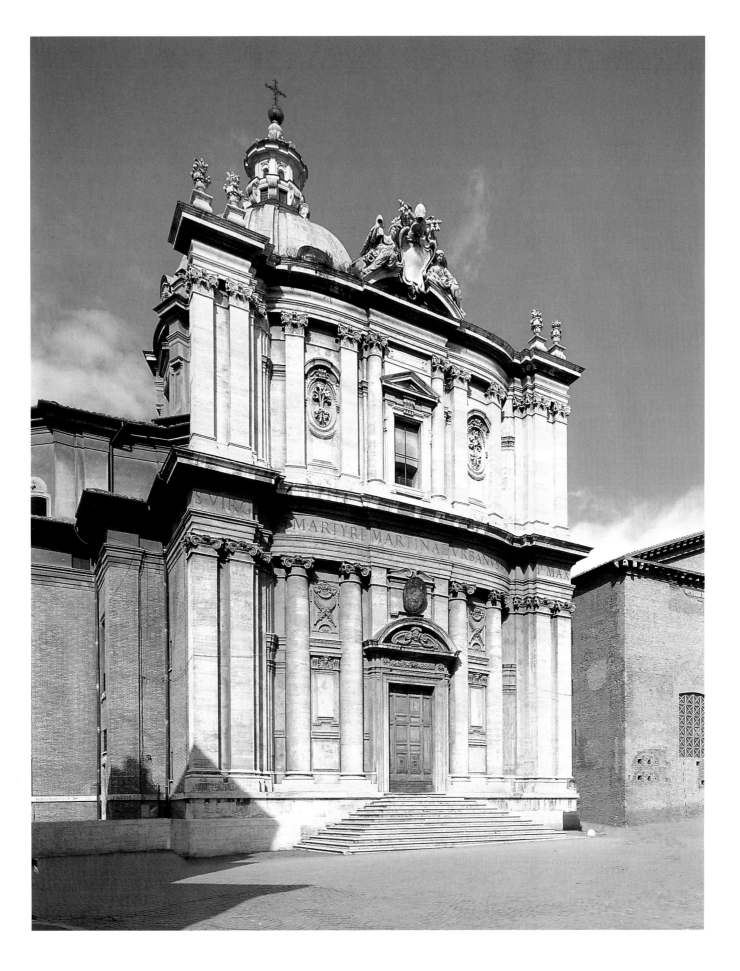

Gian Lorenzo Bernini
Ecstasy of Saint Theresa
St. Petersburg, The State Hermitage
Museum
cat. 66

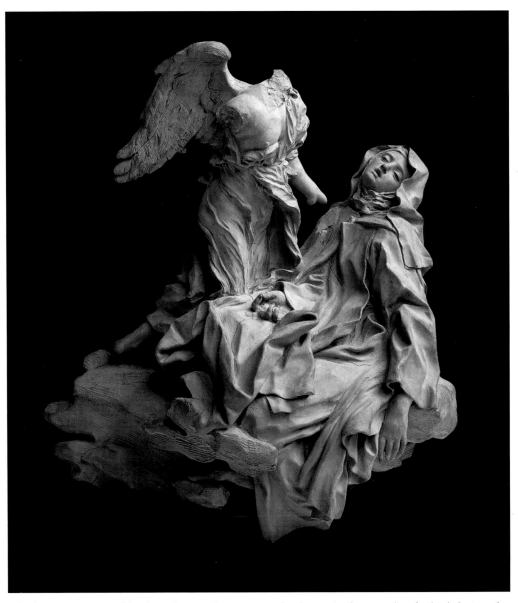

which can repeat itself infinitely anywhere on earth, the typical example of which being the time of the Mass.

The times of sacred representation are distributed into four principal "strata:" that of the stories from the life of the saint, inserted in the conventional decoration of the vaults; that of the members of the Cornaro family, who belong to different generations (a doge and six cardinals, among whom the one who commissioned the chapel) and witness the supernatural event of "transverberation" (the moment in which the saint is pierced by the angel's flaming dart) from the tribunes placed on the minor sides of the chapel; and that of the apparition of the Holy Ghost, visible through an opening in the vault. Lastly, the fourth time is that of the angels who are represented as they finish decorating the inside of the arch of the chapel with festoons: a theatrical reminder of the fact that imaginary time and real time are interlaced in every spectacle. Bernini also achieved a precise architectural objective in the Cornaro chapel: the temporalization of space and therefore the masterly direction of the complex play of relationships between the architectural container and the event represented. In order to obtain this, architecture must be the guiding instrument of a vision that involves all the visual arts and potentially the same liturgical action which together with music is meant to complete the "total spectacle."

Bernini succeeded in adapting architecture to this role at the zenith of his style with the invention of an altar that, unlike the classical model of the aedicule of the Pantheon, was trans-

opposite
Unknown Artist
*View of the Cappella Cornaro
in Santa Maria della Vittoria
by Gian Lorenzo Bernini*
Schwerin, Staatliches Museum
Schwerin
cat. 65

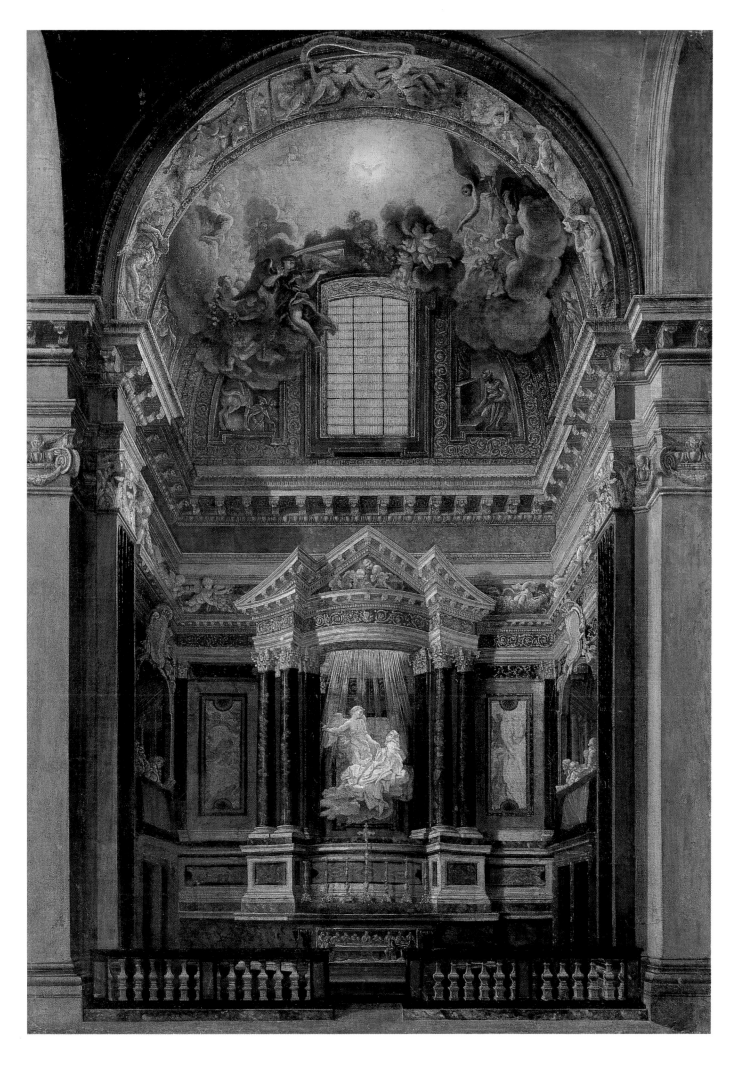

formed into a "space within space." This spatial cell was distinctly defined in its elliptical centrality and presented a convex façade toward the church while forming an intimate concavity within itself in the space delegated to the miracle of transverberation.

The complex spatiality of the altar marks one of the moments in which Bernini comes closest to Borromini's aesthetics, motivated perhaps by the success his rival had obtained during the pontificate of Innocent X. However, the theory that the concave-convex solution of the chapel of Santa Teresa derived directly from Borromini's invention of the tabernacles in the central nave of San Giovanni has no factual support. Virgilio Spada, who was bound to Borromini by a close friendship, though one filled with misunderstandings and differences, was convinced to the contrary. From an artistic point of view, it may simply have been a matter of different expressions and different ideas whose similarity does not necessarily imply that they originated from one artist or the other. On the other hand, the historiography that will not admit that similar ideas can appear independently at different times and places seems vitiated today by a reductionistic determinism that has been refuted by many even in the field of scientific research.

This comparison of the debuts of the three masters of the Roman Baroque highlights the wealth and versatility of ideas that appeared in Rome during the pontificates of Urban VIII and Innocent X. It marked the beginning of an ever vaster field of experimentation that was made possible by the exceptionally intense period of building that was going on in Rome. After San Carlino, Borromini would demonstrate the virtualities of an architecture that could be modeled in order to satisfy the needs of space and light, and at Sant'Ivo he would attempt a radical renovation of ecclesiastical typology by recurring to the biblical theme of the *Domus Sapientiae*. At Santa Maria della Pace, Pietro da Cortona would counter Bernini's theatricality which fused all the visual arts with a rigorous architectural theatricality of his own. Bernini's architectural activity would prevail over the rest of his production when he became involved in the ambitious urbanistic building program of his patron Alexander VII. As a young man this pope had been initiated into architecture and therefore he tended toward a return to the tranquil port of classicism which was certainly more congenial to a dilettantish artistic formation than the outspoken experimentalism that had emerged in Rome in the preceding decades. Bernini created the cosmic setting of the Vatican square for Alexander VII, as well as a series of temples whose architecture no longer paid heed to the norms of the Counter-Reformation. Under his direction, the Baroque reinterpretation of the interior space of St. Peter's was masterfully finished, while at Sant'Andrea al Quirinale he reproposed the ecstatic theme of the Cornaro chapel in a milder form.

At the death of Alexander VII, and also in virtue of Carlo Rainaldi's and Carlo Fontana's contributions, the revolutionary cycle of Baroque Rome came to an end: the city would live on its legacy and slowly consume what it took three decades to create. Of all the European capitals, it would become the city in which the Baroque was most strikingly present. Europe would long reflect about what Rome had proposed. It could be said that the different nations and regions expressed their identities by what each chose to keep and develop and by what each rejected from the new Roman synthesis. A brief appendix is, however, necessary in order to provide a dimension that is not only Roman of the "Baroque in its nascent state." Two personalities in particular are indispensable to complete the picture. One, Guarino Guarini, because of his continuation of Borromini's research; the other, Baldassarre Longhena, who, although almost totally autonomous with respect to Rome, managed at the same time to accomplish within the closed Venetian microcosmos something similar to what the three Baroque masters had done in Rome, starting from the Renaissance and Mannerist legacies. Baldassare Longhena was the same age as Bernini and belonged to the same generation of Roman architects. The construction of his greatest work, the church of Santa Maria della Salute, started in 1631 and finished in 1638, thus occupies the same decade as their early works. However, Longhena's faithfulness to the Venetian lexicon makes it very difficult to include his masterpiece among the works we have already described. Just one tiny detail links it to a contemporary Roman work: the star that is inserted in the ocular windows of both the church of the Salute and the façade of Sant'Ivo alla Sapienza (where some Borrominian connection may be hypothesized, but a coincidence of inventions is equally probable). Nonetheless, it would be an error not to include this building and some of

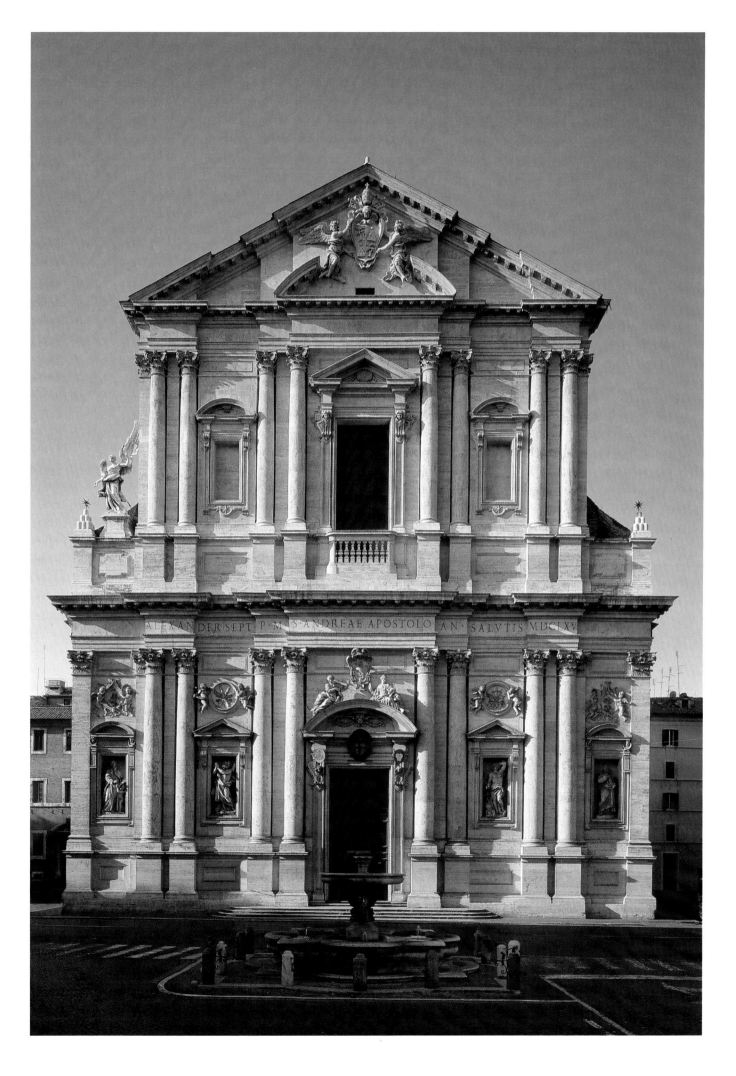

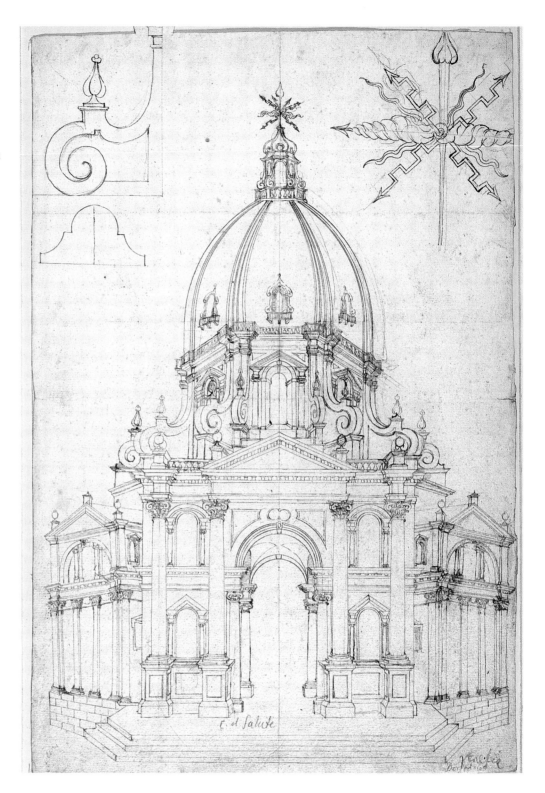

Longhena's Venetian palaces in the catalogue of Baroque masterpieces, since a label that can unite personalities as diverse as Bernini and Borromini has proved to be useful. It has connected different and in part diverging phenomena not so much on the basis of a common unifying nucleus but rather because it has interrelated the many hypotheses they came up with within a pluralistic patrimony of ideas.

One of the specific qualities of the Baroque is in fact the regional differentiation of its schools, or better yet, the flexibility demonstrated by some of its guiding ideas in interpreting very different conditions and tastes. One of the many features of Longhena's style that became part of the Baroque heritage was his search for a chiaroscuro density. He obtained this through a new compositional freedom, one that was careful in its control of diagonal views. In his search for centrality, Longhena, somewhat like Borromini, used geometry to legitimize his design, although he contrasted Borromini's plastic continuity with the radiant discontinuity of his visual perspectives and the "staccato" of his theatrical wings on the Grand Canal. Geometric legitimization, like a taste for the assembly of autonomous units (the motif for example of the triumphal arch outside the Venetian temple), binds Longhena

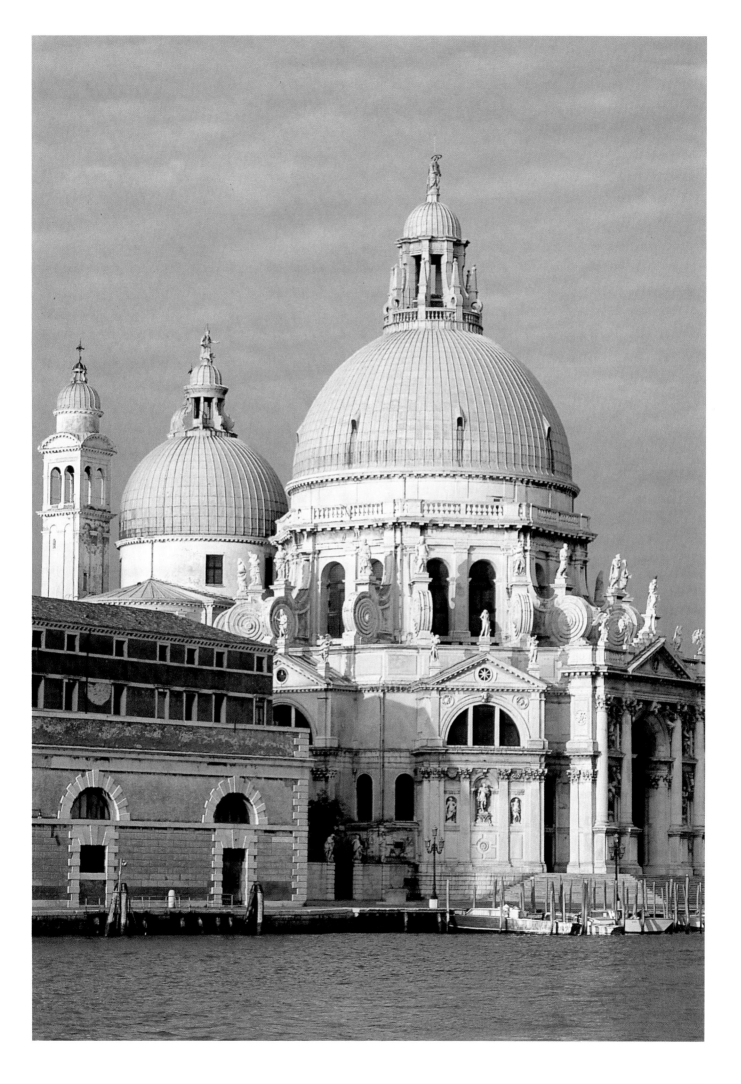

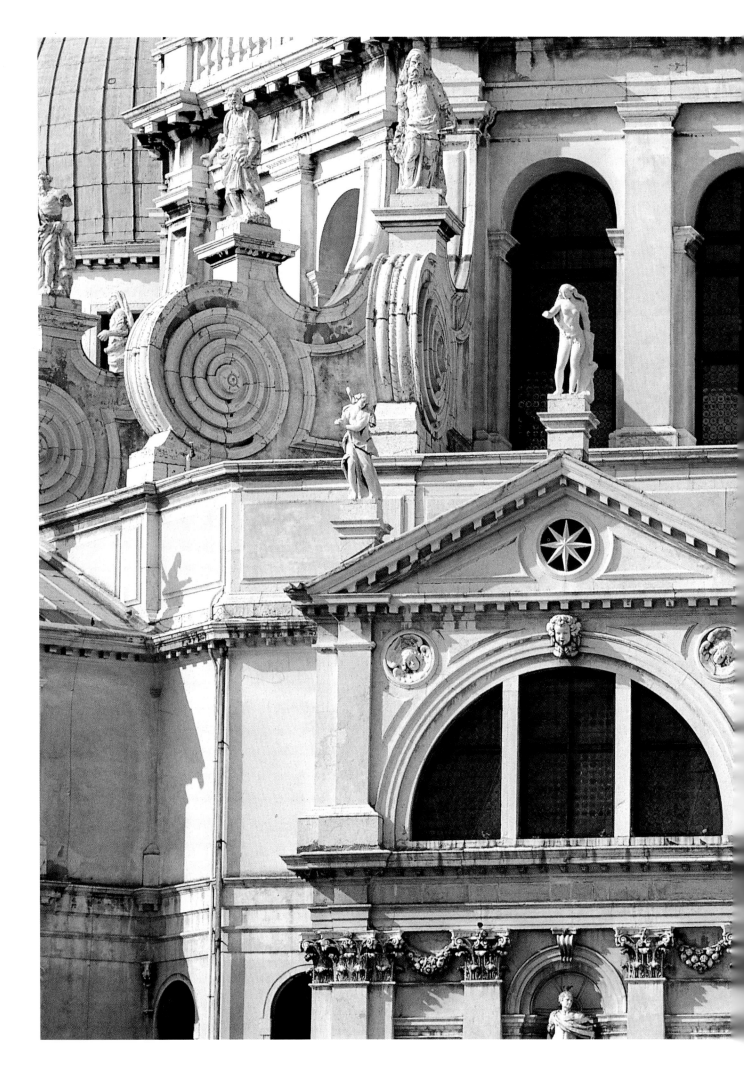

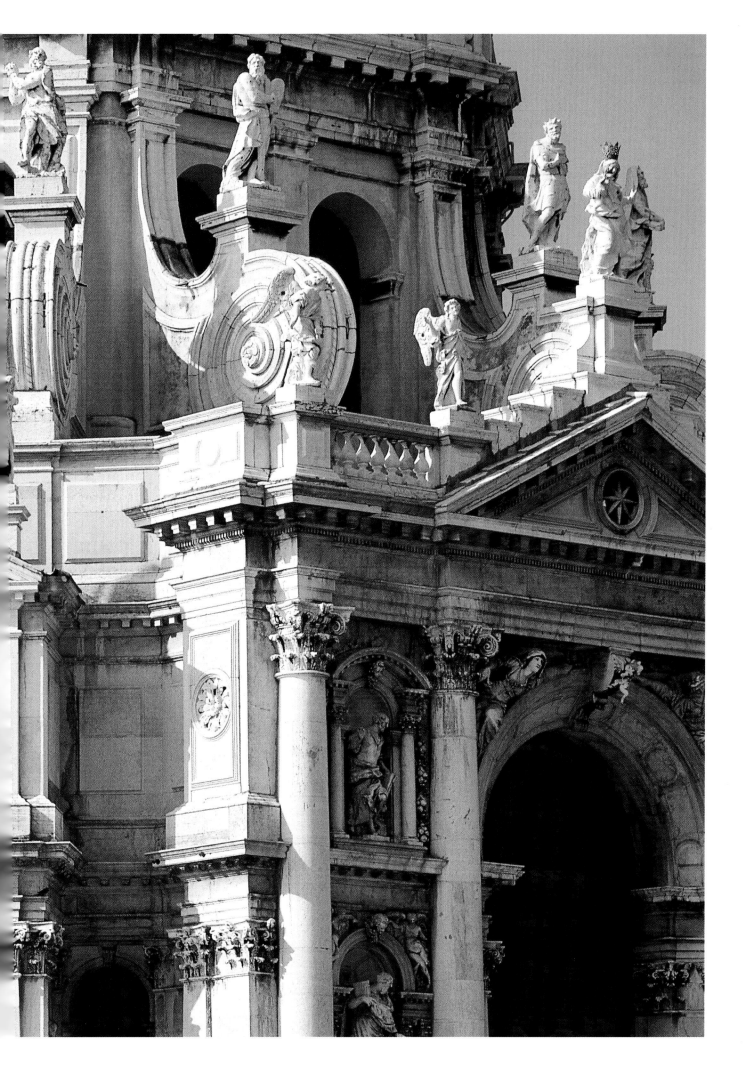

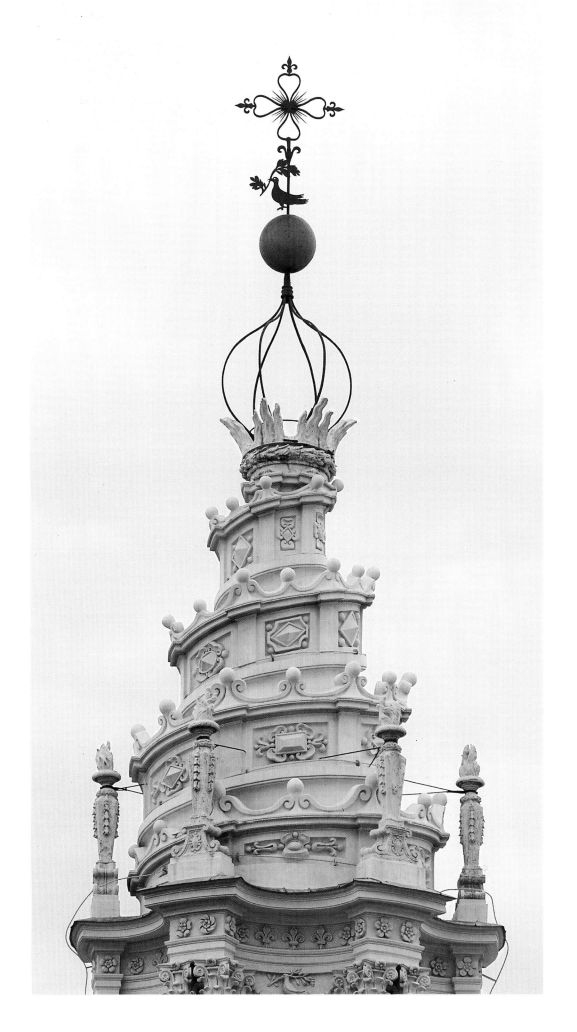

Detail of the dome of Sant'Ivo
alla Sapienza, Rome

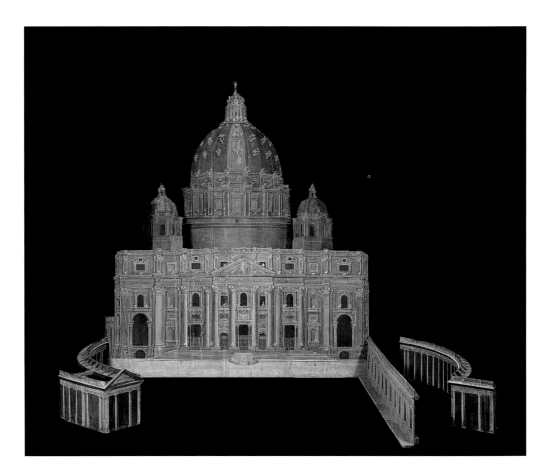

Luigi Vanvitelli
Model of the lighting inside
St. Peter's
Vatican City, Reverenda Fabbrica
di San Pietro
cat. 360

and Guarini together, two personalities who were incompatible in many other aspects. The latter, who was born in Modena in 1624, belonged to the second generation of protagonists of the seventeenth century and became active on the European scene starting in 1650, first in Paris, and then permanently in Turin. Guarini, who was in Rome from 1639 to 1647 for his novitiate, witnessed the debuts of the three masters at an early age, but his passion for philosophy and mathematics turned him into a theoretician whose message did not coincide with their experience, and tried to surpass it with a rigorous methodology that left little space for empiricism. Architecture was indeed the art that "enchants" and does not want to "disgust the senses," but it was a "disciple of mathematics" and required the full possession of its technical instruments: "Indeed," he wrote,[10] "the more perfect the artist's knowledge is of things relative to his art, to all the ways of applying them and their different applications, the more excellently and the more perfectly will his works be judged." Although he continued to defend the Ptolemaic system in his *Placita Philosophica*, Guarini was one of the first theoreticians of architecture to embrace Cartesian rationalism, in the version elaborated by Malebranche who corrected its accentuated dualism, making geometry that "universal science" which, according to the illuminated words of Malebranche himself, "opens the spirit, renders it attentive and endows it with the dexterity to direct its imagination."[11]

Once geometric systematicism had been withdrawn from the secrecy that had made its application arduous, it became a formidable didactic instrument in Guarini's hands. Through the publication of his treatises, a chain reaction determined the development of a method of spatial configuration through a series of combined cells, and its rapid diffusion throughout Catholic Europe. The exaltation of the technique and the scientific aspect of architectural composition, on the other hand, which was at the base of Guarini's virtuoso construction, foreshadowed developments that went far beyond the art of his century. It could be said, at the conclusion of this introduction regarding the complexity of the Baroque, that Guarini, Longhena, and the Roman masters did not formulate a Baroque theory – which might be a contradiction of terms – but by means of their personal theories they showed that Baroque culture was first and foremost a pluralistic liberation from restrictions and the free development of a received legacy. It authorized "the correction of ancient rules and the invention of new ones," but did not postulate the substitution of one system of rules for a different one: it was a culture of synthesis, diversity, and variation as a profound, perpetually unfulfilled exigency. This aspect explains why Classical, Mannerist, and even Gothic compositional methods survive in Baroque art, and it also explains why whoever has sought to define a unified grammar and syntax of the Baroque has had to effect dramatic exclusions, and thus cause the collapse of the "sandcastle" he has so patiently tried to construct.

[10] Cf. G. Guarini, *Architettura civile*, Milan 1968 (sec. ed.): 10.
[11] Cf. G. Guarini, *Architettura civile*, op. cit.: 455.

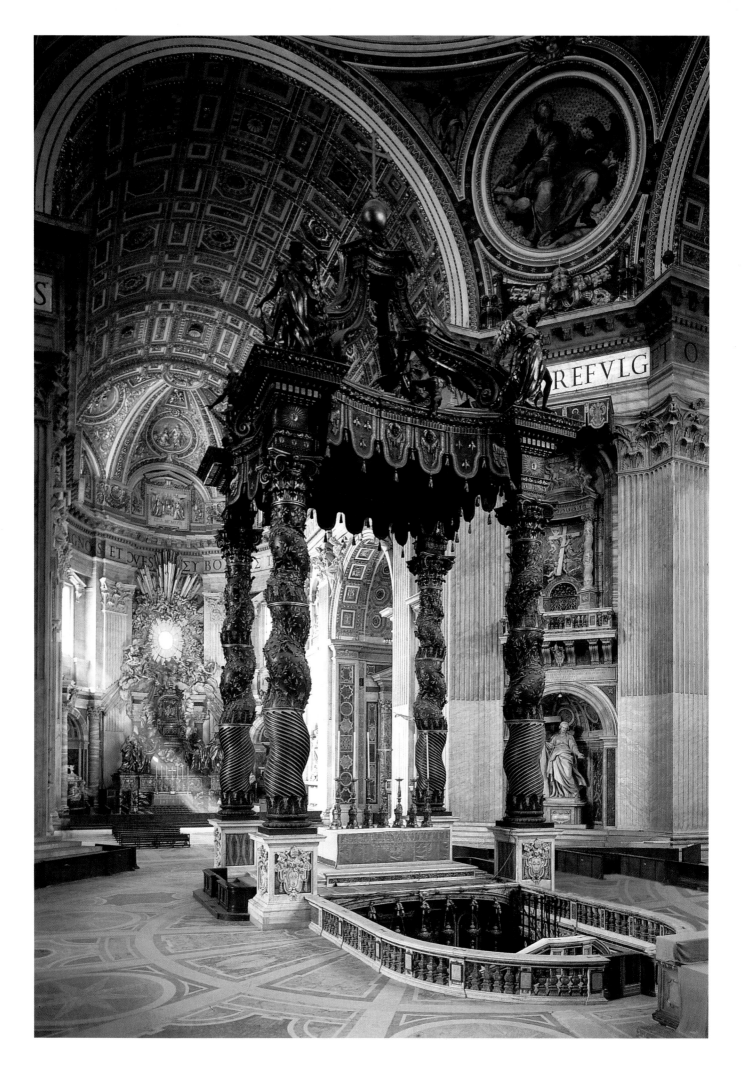

56

Christian Norberg-Schulz # The Baroque and its Buildings

The seventeenth century was characterized by a diversity unknown before. The unified and hierarchically ordered *cosmos* of the Middle Ages had disintegrated during the Renaissance, and a new element of choice had been introduced into the life of man. "In the religious system of the Middle Ages as it crystallized in scholasticism, every phase of reality was assigned its unique place; and with its place goes a complete determination of its value, which is based on the greater or lesser distance which separates it from the First Cause. There is no room here for doubt and in all thinking there is the consciousness of being sheltered by this inviolable order which it is not the business of thought to create but only to accept." [1] With the rise of Humanism, however, the question of man's free will came to the fore, and in Florence it received a social and political foundation. In his funeral oration for Nanni Strozzi (1428), Leonardo Bruni said: "Equal liberty exists for all – the hope of gaining high office and of rising is the same for all."[2]

Even a hundred years before this, the Florentines had gone as far as to appoint their magistrates by lot. The absolute system of the Middle Ages was thus replaced by an active political life, which found a new basis in the *studia humanitatis.*

The idea of the ordered universe, however, was not relinquished by the Renaissance. Rather it obtained a new interpretation based on geometry and musical harmony, whereby a new scale of values was introduced, assigning everything a place according to its degree of 'perfection.'[3] Within this framework man had his freedom of choice, as expressed in the famous paraphrase on the Creation by Pico della Mirandola: "He therefore took man as a creature of indeterminate nature and, assigning him a place in the middle of the world, addressed him thus: 'Neither a fixed abode nor a form that is thine alone nor any function peculiar to thyself have we given thee, Adam, to the end that according to thy longing and according to thy judgment thou mayest have and possess what abode, what form, and what functions though thyself shalt desire [...] Thou shalt have the power, to degenerate into the lower forms of life, which are brutish. Thou shalt have the power out of thy soul's judgement, to be reborn into the higher forms, which are divine.'"[4]

But the Renaissance idea of freedom within a harmonious and meaningful universe did not last long. Erasmus and Luther represent doubt in the freedom and "dignity of man," and Copernicus (1545) removed the earth from the center of the universe.[5] The political foundation of Florentine civilization broke down, and the division of the Church ratified the disintegration of the unified and absolute world. During the sixteenth century the new diversity was experienced as a frightening split giving man a sense of doubt and alienation. The general attitude found its artistic manifestation in the phenomena which are usually brought together under the label of "Mannerism." In the tragic world of Michelangelo, it comes forth with singular intensity: "Rend Thou the veil, my Lord! Break down that wall / whose thickness delays the light / of Thy sun, which the world sees not."[6]

Toward the end of the sixteenth century, the attitude changed. The case of Descartes is particularly illuminating. Having found that everything can be doubted, he concludes that his own doubt being a "thought" represents the only certainty! "Examining attentively what I was, and seeing that I could pretend that I had no body and that there was no world or place that I was in, but that I could not for all that, pretend that I did not exist, and that on the contrary, from the very fact that I thought of doubting the truth of other things, it followed very evidently and very certainly that I existed [...][7] On the basis of this certainty he goes on constructing a comprehensive system of "facts."

"The great originality of Descartes, and that which enables him to avoid the conclusions of Montaigne and the Sceptics is that, instead of considering the objects of doubt, he detaches the act of doubting from anything external to itself, and in that way cuts the ground from beneath the feet of scepticism."[8]

The general spirit of the seventeenth century, however, rarely possessed this originality. Rather, man sought security by a choice between the current alternatives of the period. The new state of affairs was accepted none the less, and the old unified world was gone forever. But this does not mean that the conflicts were over, since the disintegration of the old world actually culminated with the Thirty Years' War (1618–48), which paralyzed a great part of central Europe during the first half of the seventeenth century. But nobody any longer believed in a re-establishment of the old order, and man again started to look ahead. The new

[1] Ernst Cassirer, *The Philosophy of the Enlightenment* (1932), Boston 1955: 39.

[2] Leonardo Bruni: "Aequa omnibus libertas [...] Spes vero honoris adipiscendi ac se attallendi omnibus par," 1428.

[3] Alberti thus says: "It is manifest that nature delights principally in round Figures [...]," in *Ten Books on Architecture*, VII/iv, London 1755: 138.

[4] Pico della Mirandola, *Oration on the Dignity of Man* (1486) (English translation by Elizabeth Livermore Forbes), in *The Renaissance Philosophy of Man* (ed. E. Cassirer, P. O. Kristeller, J. H. Randell Jr.), Chicago 1948.

[5] Goethe calls the heliocentric world of Copernicus "*die grösste, erhabenste, folgenreichste Entdeckung, die je der Mensch gemacht hat, wichtiger als die ganze Bibel*" (Letter to von Müller, 1832).

[6] Michelangelo, *Complete Poems and Selected Letters* (English translation by Creighton Gilbert), 1965.

[7] René Descartes, *Discourse on Method* (English translation by F. E. Sutcliffe), Harmondsworth 1968: 54.

[8] F. E. Sutcliffe, *Introduction to Descartes: Discourse on Method*, 19.

Portrait of René Descartes
Milan, Civica Raccolta Stampe
Achille Bertarelli

9 See D'Alembert's "Discours préliminaire" to the French *Encyclopédie* (1751), where he distinguished the interest in the system as such from the *esprit systématique* of his own century.
10 Today pluralism has entered a new phase, thanks to the new means of communication.
11 Giordano Bruno, *De l'infinito universo e mondi*, Dialoghi I, 51; III, 12; 1584.
12 Thus Galileo says: "Non sono io che voglia che il Cielo come corpo nobilissimo, abbia ancora forma nobilissima, quale è la sferica perfetta, ma l'istesso Aristotele [...] ed io quanto a me, non avendo mai lette le croniche e le nobiltà particolari delle figure, non so quale di esse sieno più o men nobili, più o men perfette; ma credo che tutte siano antiche e nobili a un modo, o per dir meglio, che quanto a loro non sieno nè nobili e perfette, nè ignobili ed imperfette." *Opere*, Florence 1842–56: IV, 293.
13 There are a few important exceptions, such as the treatises of Blondel, Perrault and Guarini, but we may notice that these authors were not professionals in the ordinary sense of the word.

world of the seventeenth century, therefore, may be called "pluralistic," in so far as it offered man a "choice" between different alternatives, be they religious, philosophical, economic, or political. All the alternatives were characterized by the aim we have found in Descartes' thinking: to arrive at a complete and secure "system" based on *a priori* axioms or dogmas. Man wanted absolute security, and he could find it in the tradition of the restored Roman Church, in one of the schools of the Reformation which were all based on the belief in the absolute truth of the Biblical word, in the great philosophical systems of Descartes, Hobbes, Spinoza or Leibniz, or in the absolute monarchy "by divine right." The attitude was most natural; in fact, it represented different but analogous attempts at establishing a substitute for the lost *cosmos*.

In spite of the new pluralism, we may therefore consider the seventeenth century a unified epoch, the Baroque Age. In doing this we neither evoke a mystic "spirit of the age," nor refer to mere "stylistic similarities." Rather we have in mind the basic human "attitude" which prevails in spite of the differences of choice, the *esprit de système*, to use the term of D'Alembert.[9]

Through the freedom of choice, man immensely widened the possibilities for structuring his own life, at least in theory; in reality the choice was limited by his immediate situation. In other words, all the alternatives were not available everywhere, but were confined to particular geographic areas, whose general distribution was settled after the Thirty Years' War.[10] The seventeenth century, therefore, experienced certain migrations of human groups, such as the expulsion of the Huguenots from France (1685). Although they were connected with particular "areas," the systems were in a certain sense "open." Not being single units, their "propagation" was essential, and a dynamic, centrifugal character became general. Propagation, however, only becomes meaningful and effective in relation to a "center," which represents the basic axioms and properties of the system. The religious, scientific, economic and political centers were focuses of radiating forces, which, seen from the center itself, had no spatial limits.

The systems of the seventeenth century, thus, had an open and dynamic character. Departing from a fixed point, they could be infinitely extended. This new relation to the infinite first appears in the writings of Giordano Bruno, who says: "Infinite space has infinite potentiality, and in this infinite potentiality may be praised an infinite act of existence." He then goes on to imagine a plurality of worlds: "Thus there are innumerable suns, with countless planets likewise circling about these suns [...]"[11] In this infinite world, "movement" and "force" are of prime importance. Related ideas are found in the philosophy of Leibniz a hundred years later; also in the simpler and more rational world of Descartes we find the idea that spatial "extension" is the basic property of all things and that their differences are based on different movements. Geometry, therefore, is the appropriate tool for understanding the world. Whereas the geometrically ordered universe of the Renaissance was closed and static, Baroque thought makes it open and dynamic.

We thus understand that the two seemingly contradictory aspects of the Baroque phenomenon, systematism and dynamism, form a meaningful totality. The need for belonging to an absolute and integrated but open and dynamic system was the basic attitude of the Baroque Age.

This attitude was nourished by the characteristic achievements of the period: exploratory travels (opening up an even larger and more complex world), colonization (extending the social and cultural borders of European pluralism), and scientific research (substituting empirical study and research for the traditional idea of harmony and degrees of perfection).[12] This general "expansion" had as a necessary correlation a growing specialization of human activities; every discipline, every activity was forced to define its own field. In our context it is important to point out the split of that unity of art and science which had formed the basis for the *uomo universale* of the Renaissance. The artist no longer dared to be a philosopher or scientist, and as a consequence artistic theory lost much of its impetus during the seventeenth century. In fact, if we want to understand the intentions of Baroque architects, we must infer them from the treatises of the previous or following centuries.[13] Rather than pursue the ideal of "universal man," the Baroque age therefore assigned the individual a fixed place within the social hierarchy. To a certain ex-

Frontispiece of the original edition
of the *Discours de la méthode*
by René Descartes
printed in Leyden, 1637
Paris, Bibliothèque Nationale
de France

[14] F. E. Sutcliffe, *Introduction to Descartes*, op. cit.: 14.
[15] *Canons and Decrees of the Council of Trent,* Session XXV, Tit. 2, quoted from A. Blunt, *Artistic Theory in Italy 1450–1600*, Oxford 1956: 108.
[16] Albert Schweitzer has in fact demonstrated how the works of Bach are based on the use of "naturalistic" and "literary" images, whereby they possess the two basic Baroque characteristics: systematic structure based on an "axiomatic" theme, and persuasive expression. See A. Schweitzer, *J.S. Bach*, Leipzig 1908.
[17] The Royal French Academy of Painting and Sculpture was founded in 1648, and the Academy of Architecture in 1671.
[18] For a general theory of "environments," see T. Parsons, *Societies*, New York 1966. Also A. Rapoport, *House Form and Culture*, New York 1969.

tent, he could choose his preferred system, but hardly his own place within it. Socially the Baroque Age was still closed.

Virtually no other epoch has to the same extent aimed at making its form of life visible or manifest. "Persuasion" was the basic means used by all the systems to make their alternatives operant. Science and philosophy certainly ought to demonstrate rather than persuade, but even Descartes uses a "common" language and he begins his *Discourse* with an account of his own life to strike a note of sympathy in his reader. In fact, "the ultimate aim of Descartes was to persuade men that, in their task of reconstructing the world, a method, his method, was alone effective. That is to say that his method was essentially an instrument for action."[14] Leaving in principle what can be demonstrated to science, religion became more dependent on persuasion than ever before.

This was already realized by St. Ignatius Loyola, and motivated his *Spiritual Exercises* which were first written in plain Spanish and which aim at an imitation of Christ by means of imagination and empathy. Later the Roman Church came to give particular importance to the visual images a means of persuasion. "And the bishops shall carefully teach this: that, by means of Stories of the Mysteries of our Redemption, portrayed by paintings or other representations, the people are instructed and confirmed in the habit of remembering, and continually revolving in mind the articles of faith [...]."[15]

But even the Protestant churches practiced persuasion by means of sermons in the common language and sacred music.[16] The absolute monarchies, finally, used great festivals and fêtes to make the glory of the system visible.

Persuasion has "participation" as its goal. The Baroque world, in fact, may be characterized as a great theater where everybody was assigned a particular role. Such a participation, however, presupposes "imagination," a faculty which is educated by means of art. Art, therefore, was of central importance in the Baroque age. Its images were a means of communication more direct than logical demonstration, and furthermore, accessible to the illiterate. The art of the Baroque, therefore, concentrates on vivid images of situations, real and surreal, rather than on "history" and absolute form. Descartes says: "The charm of fables awakens the mind." The general aim was to instigate a way of life in conformity with the system. Art thereby became official and was institutionalized in the "academies."[17] At the same time, however, the character of Baroque art brought forth a "phenomenization" of experience, which made man more conscious of his own existence. Baroque participation, which should have secured the system, in the end therefore led to its disintegration.

We have already pointed out that the seventeenth century was characterized by a great diversity. The differences were due to various factors. Theoretically we could distinguish between five kinds of environmental determinants: physical, personal, social, cultural, and historical. These factors obviously are interdependent, but may to a certain extent be studied separately.[18]

The physical factors can be described in terms of climate, topography, resources, etc., and determine what is usually called "regional character," namely typified use of building materials, location and size of openings, and roof shapes. The personal factors stem from differences in needs and attitudes, and determine what is called "personal style." The client as well as the architect are relevant in this connection. The social factors may refer to social differences or to a way of life common to the members of a particular group. They determine the more general properties of a "milieu," such as separation or togetherness, but also formal distinctions which express a particular social role. The cultural factors consist in ideas and values, and determine "meanings" which are expressed through formal languages or "styles."

All these factors obviously operate in the temporal dimension and are therefore historical. With historical factors in particular, we intend certain artistic influences, or extra-artistic events that initiate, accelerate or retard significant changes in the human environment. During the seventeenth century all these factors contributed to architectural development, according to the circumstances. In a politically centralized country like France, the regional variations were slight, whereas Italy presents characteristic local models of expression. Regardless of country, however, the "cultural" factors were of prime importance.

Carlo Rainaldi
Prospect for one of the towers
of the façade of St. Peter's
Vatican City, Biblioteca Apostolica
Vaticana
cat. 13

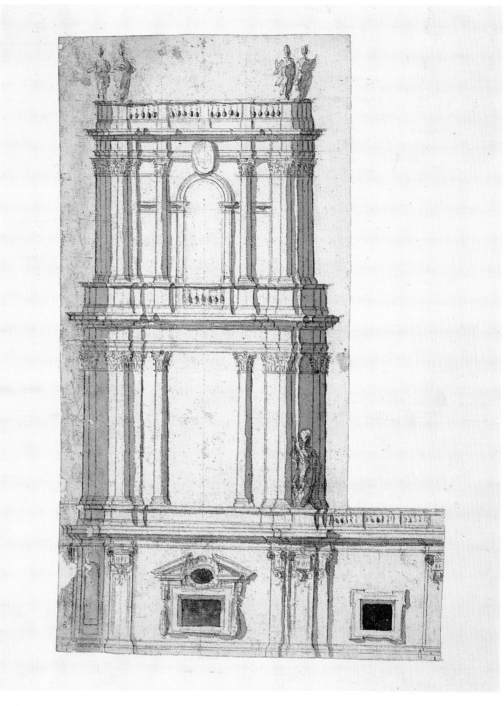

opposite
Detail of the church
of Sant'Andrea delle Fratte, Rome

following pages
left
Interior of the dome
of the presbytery of San Lorenzo
in Turin, by Guarino Guarini

right
Interior of the dome over the
transept
of the church of San Lorenzo, Turin
by Guarino Guarini

Italy

Toward the end of the sixteenth century, the development of Italian architecture became centered on Rome. The main force behind this process was the Counter-Reformation which brought forth a centralization of ideas and artistic potential. As a result, a vigorous Roman Baroque architecture evolved, which extended its sphere of influence to the whole Catholic world, and even beyond. Although Roman Baroque architecture produced its main works after 1630, many of the basic intentions had been manifest quite a lot earlier.

In general, the aim was to create an environment having a stronger emotional and persuasive impact, and to make every single building appear as an expression of a universal system of values. Churches and palaces started to interact with their urban environment, mainly because of the introduction of a longitudinal axis that "opened" the traditional self-sufficient architectural form. The inner disposition of the buildings also became a function of the main axis. The churches, however, constituting the principle focuses of

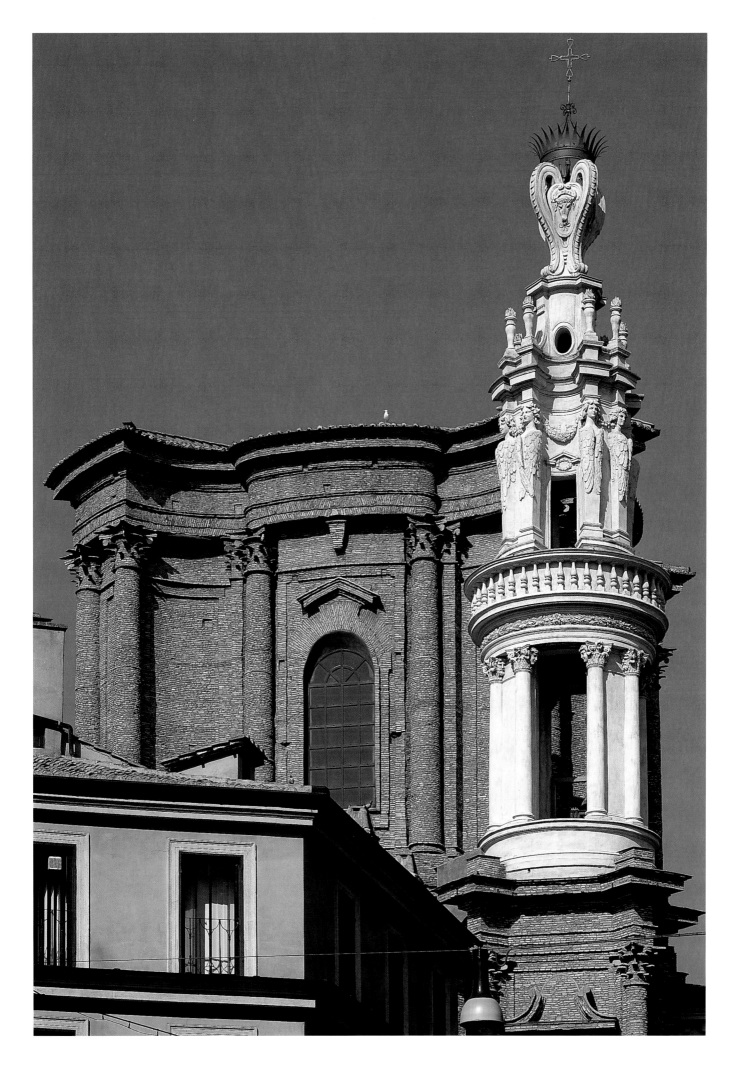

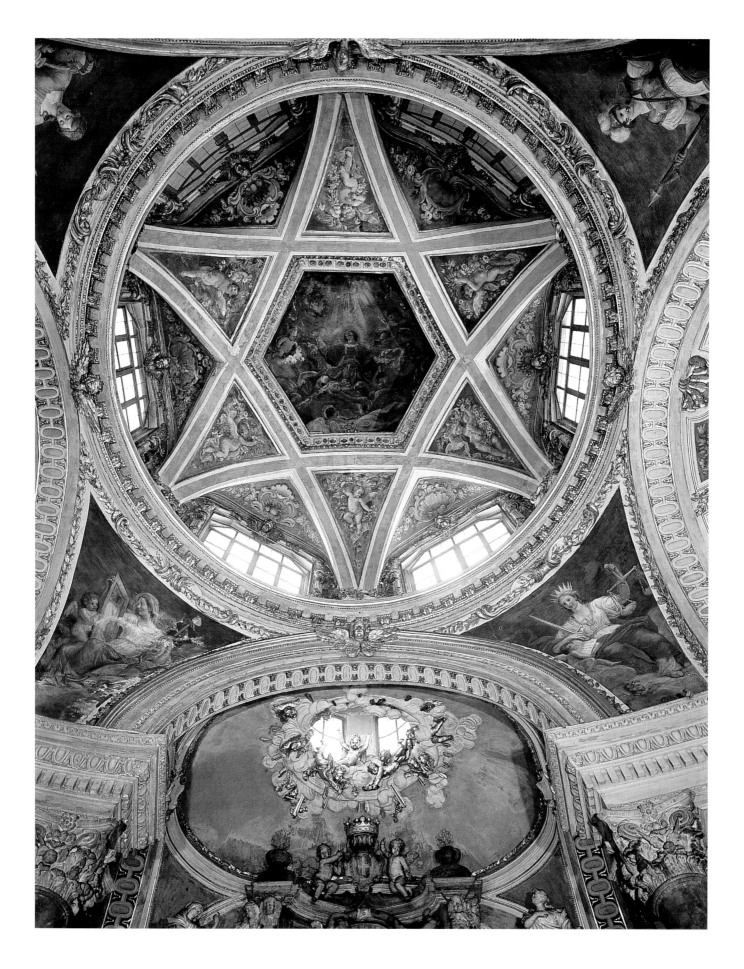

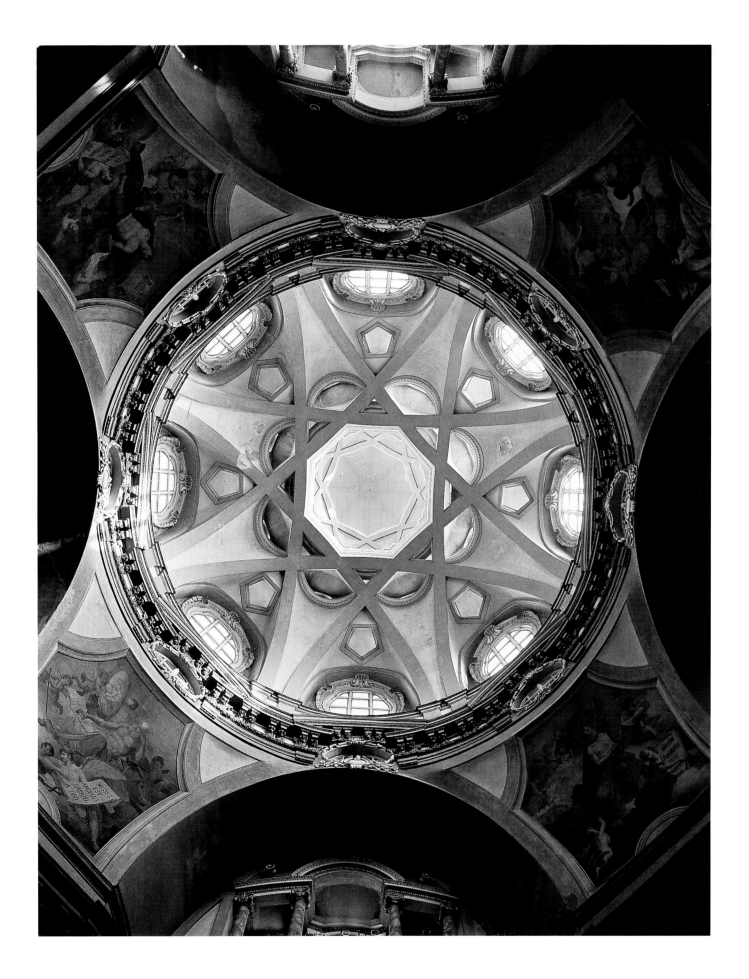

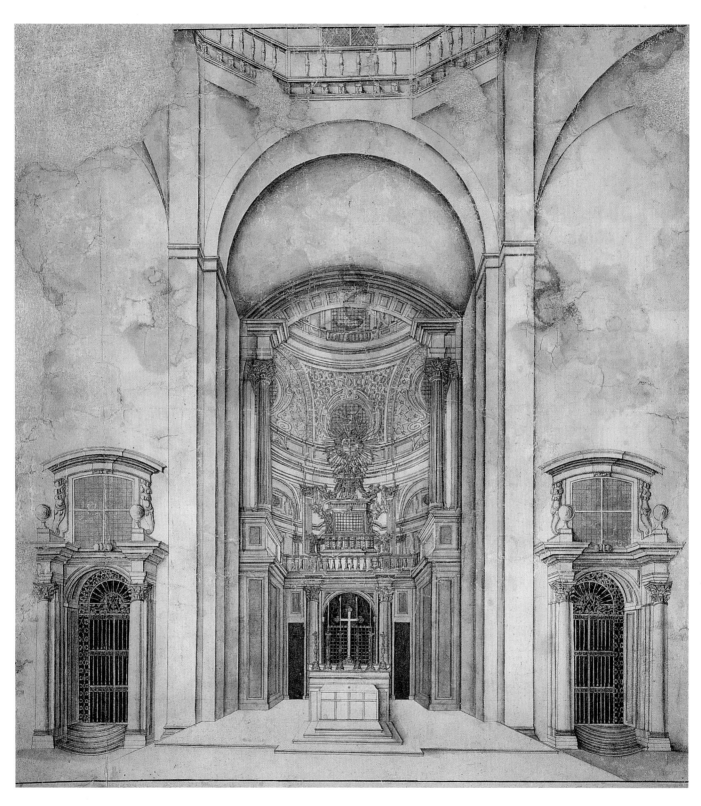

Unknown Artist
Perspective view of the transept
and choir
of Turin Cathedral toward
the chapel of the *sindone*
(Turin Shroud)
Turin, Archivio Capitolare
cat. 114

the meaningful system, also needed a dominant vertical axis around which spatial exten-
sion was organized.

The new approach is evident already in the first architectural work of Gian Lorenzo Berni-
ni (1598–1680), the Baldacchino in St. Peter's (1624–33). The four twisted bronze columns
repeat the shape of the early Christian columns, which had served in the Pergola of Old St.
Peter's. They have, however, grown to giant size "expressing symbolically the change from
the simplicity of the early Christians to the splendor of the Counter-Reformatory Church,

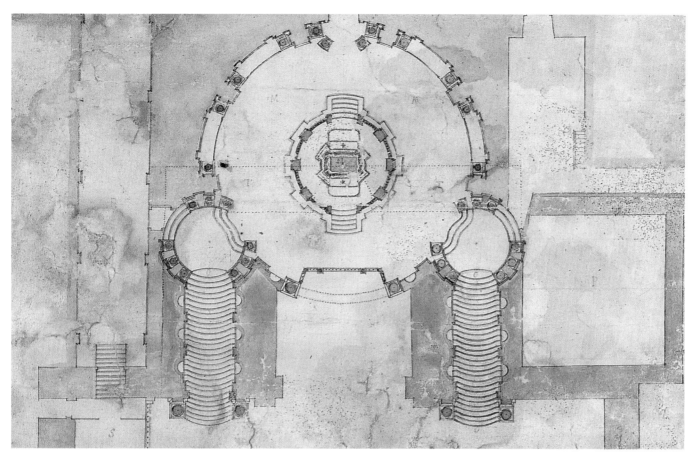

Unknown Artist
Plan of the chapel of the Turin
Shroud
Turin, Archivio Capitolare
cat. 115

implying the victory of Christianity over the pagan world."[19] At any rate, the Baldacchino
may be considered "il manifesto dell'architettura barocca."[20] Its rich and persuasive form
stems from a transformation of the basic elements, rather than added decoration, and the re-
sult is a simple, integrated whole characterized by plastic continuity. The Baldacchino rep-
resents in equal measure a point of departure for the antipodes Bernini and Borromini. It
has the grand simplicity and powerful impact of Bernini's later designs, but also the dy-
namism and synthetic character which mark the works of Borromini.

In the works of Francesco Borromini (1599–1667), the irrational, "synthetic" content is ex-
pressed by a correspondingly complex form. Borromini, however, overcomes complexity as
such by means of spatial and plastic continuity. He thereby unifies heterogeneous elements
into synthetic wholes that represent new psychic and existential characters. In his work at
Sant'Andrea delle Fratte (1653), for example, Borromini transformed the traditional static
and enclosed drum into a dynamic, radiating organism. The convex bays in the middle in-
dicate the expansive movement of interior space that interacts with exterior space to create
a strong radiation along the diagonal axes. By adding a freestanding campanile, Borromini
moreover realized an urban focus that changes according to our position.[21]

A truly inventive follower of Borromini was Guarino Guarini (1624–83), who continued
Borromini's research into the creation of new synthetic "characters," as well as the possi-
bility of using space as the constituent element in architecture. The articulation and deco-
ration of Guarini are highly personal and the content expressed, however profound, is
rarely directly comprehensible. Guarini, as seen in the chapel of the Sacra Sindone, con-
cretized his complex and highly irrational contents by ingenious but rational systems of
spatial extension. Like Bernini and Borromini, his basic aim was an objectification of the
irrational, but whereas Maderno, Bernini and Borromini were representatives of a "Ro-
man" Baroque architecture, Guarini's works do not belong to any particular place or re-
gion. In spite of his personal style, Guarini therefore expressed the universality of the
Counter-Reformatory Church.

Roman Baroque architecture always retained a characteristic identity through all personal

[19] R. Wittkower, *Art and Architec-
ture in Italy 1600–1750*: 115.
[20] Portoghesi, *Roma Barocca*: 86.
[21] The general motif was repeated
by Kilian Ignaz Dientzenhofer
in St. Nicholas, Malá Strana in
Prague (1739).

Exterior view of the dome
of the chapel of the Turin Shroud
by Guarino Guarini

Guarino Guarini
Plan and cross section
of the chapel of the Turin Shroud
Turin, Biblioteca Reale
cat. 110

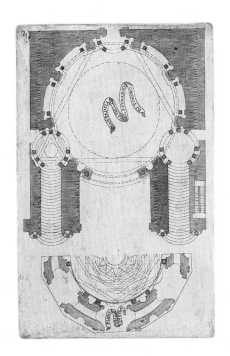

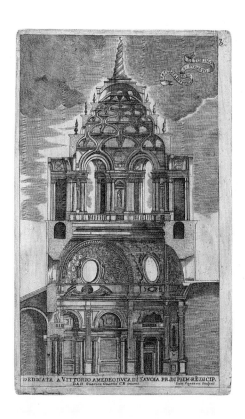

opposite
Guarino Guarini
View inside the dome
of the chapel of the Turin Shroud

following pages
View of the façade of the Palais
du Luxembourg in Paris

[22] The villa was in ruins already at the end of the seventeenth century, but is known from several prints.

[23] Similar intentions are found behind the art of the Roman and Byzantine empires. In fact, Louis XIV imitates ancient Roman symbolism.

variations. As a primary property of the Roman character, we may mention the emphasis on mass and plasticity. A true plastic integration characterizes the works of Pietro da Cortona (1596–1669). Instead of taking spatial cells or wall membranes as his point of departure, Cortona composes with continuous series of plastic members, whose variations in density constitute a space that seems eminently alive. This is already evident in his first building, the Villa Sacchetti (1625–30).[22] A complex interaction of spaces that foreshadows his later works is constituted by groups and rows of pilasters and columns that create a rich, vibrating play of light and shadow.

A pronounced local character is found in Venice, where the traditional picturesque and decorative approach was given a Baroque interpretation by Baldassare Longhena (1598–1682). His Palazzo Pesaro (1663) shows a rich but controlled interplay of mass and space, light and shadow, and has a true Baroque plasticity, in spite of the somewhat conventional composition. The Baroque architecture of Southern Italy mainly belongs to the eighteenth century. We should, however, mention the Neapolitan Cosimo Fanzago (1591–1678), Baroque in versatility but without real creative talent. Toward the end of the century, Roman architecture was dominated by the classically-minded Carlo Fontana (1638–1714).

France

In France the process of centralization was stronger than in Italy. A certain regional activity existed up until the death of Mazarin (1661), but the artistic potential had been centered on Paris since the beginning of the century. French seventeenth-century architecture, therefore, has an unequivocal character and development. The driving force was the idea of absolute monarchy by divine right, and the result was a new kind of state architecture. [23] It unified the poles of reason and transcendence.

The leading building type was the palace, which formed the focus of an infinitely extended space. Extension presupposes that the constituent elements have a certain uniformity, and, in fact, French seventeenth-century architecture does not present the plastic modeling and emphasis that characterized contemporary Italian buildings. It is therefore often regarded as less "Baroque" and more "classical." Such a judgment, however, stems from a superficial

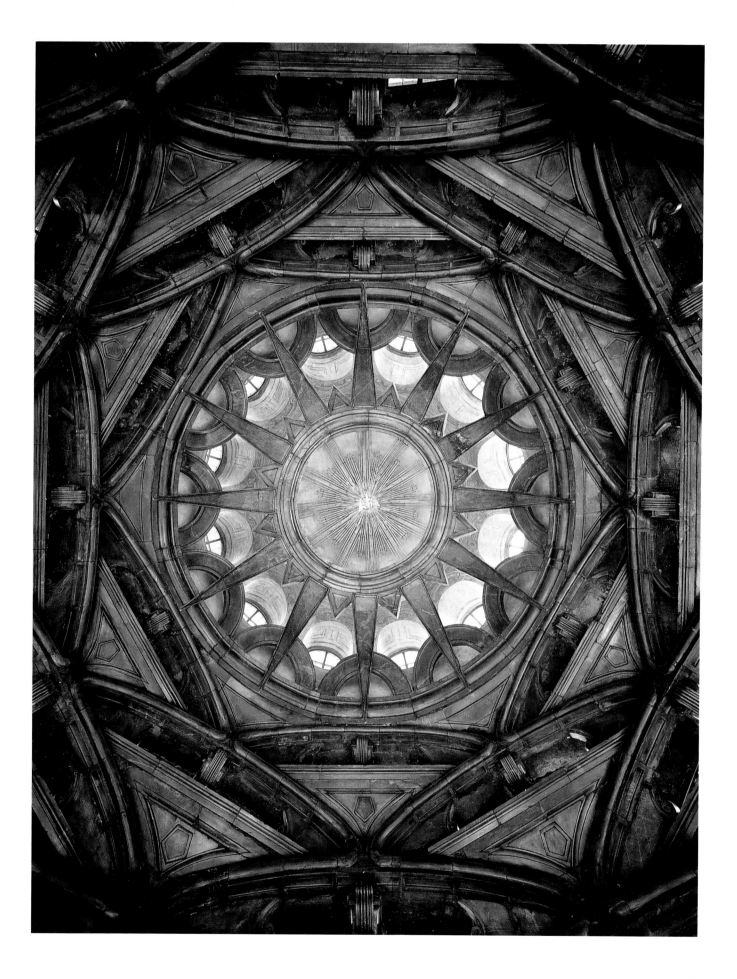

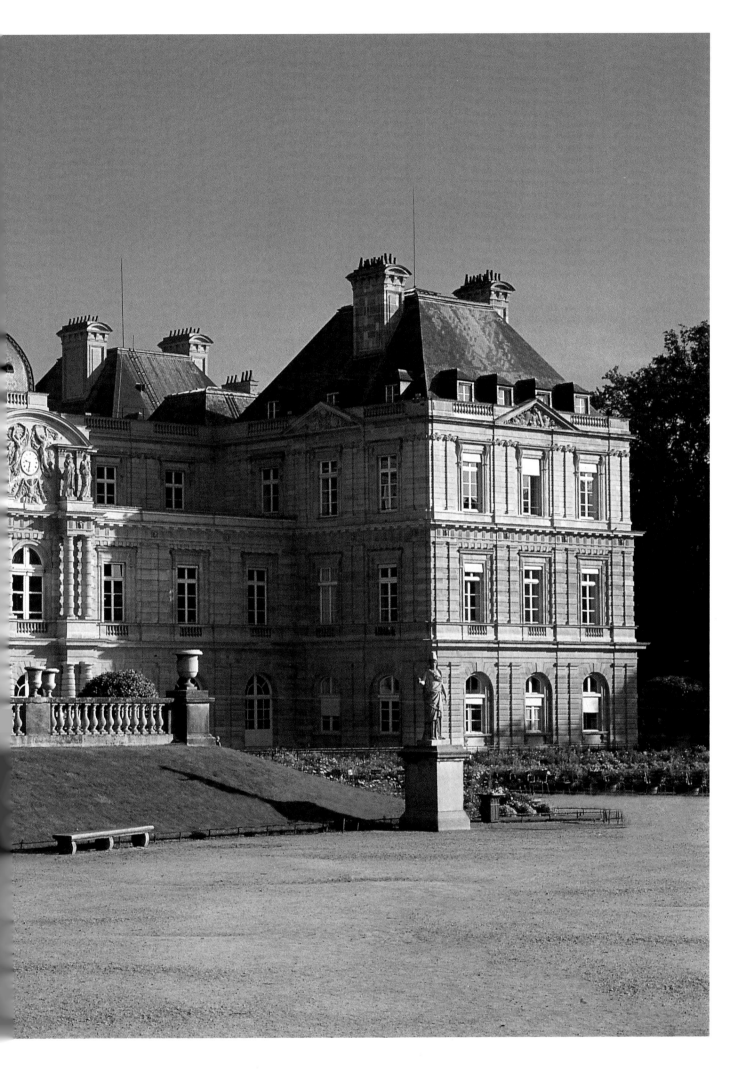

Pietro da Cortona
Prospect of the east façade of the
Louvre
Paris, Musée du Louvre
Département des Arts Graphiques
cat. 103

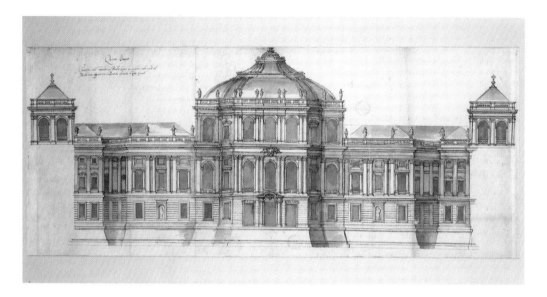

definition of the categories in question. "Baroque architecture" only becomes a useful concept if it denotes concretizations of a certain kind of existential space, rather than particular formal traits.

The typical French approach is evident already in the works of Salomon de Brosse (1571–1626). His façade for St. Gervais in Paris (1616)[24] shows a "correct" superimposition of the three classical orders. Vertically as well as horizontally, the composition is based on regular repetition, although the façade as a whole gives emphasis to the longitudinal axis of the building.

François Mansart (1598–1666) belongs to the generation of Bernini, Borromini and Cortona, and played an analogous role in making architecture a flexible and subtle tool for expressing the contents of the epoch. His works are characterized by great inventive power, but also by a restraint that makes the radical traits less evident. Althouth his articulation is highly original, a "correct" use of the orders creates a general classical character. Mansart, thus, manages to objectify the dynamism and irrational variations inherent in Baroque architecture by the employment of a rational, well-known vocabulary of forms.

Louis Le Vau's pupil Antoine Le Pautre (1621–91) developed the Baroque aspects of his work. Most famous of Le Pautre's works is the project for a château, published in his *Les Œuvres d'Architecture* (1652).[25] The general disposition is derived from the Luxembourg

Gian Lorenzo Bernini
First project for the east façade
of the Louvre
Paris, Musée du Louvre
Département des Arts Graphiques
cat. 99

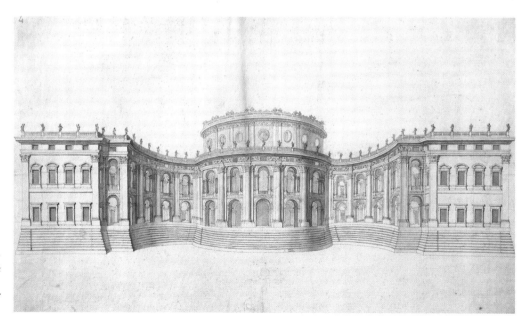

[24] The façade was built by Clément Métézeau, probably on the design of Salomon de Brosse.
[25] See R.W. Berger, *Antoine Le Pautre*, New York 1969.

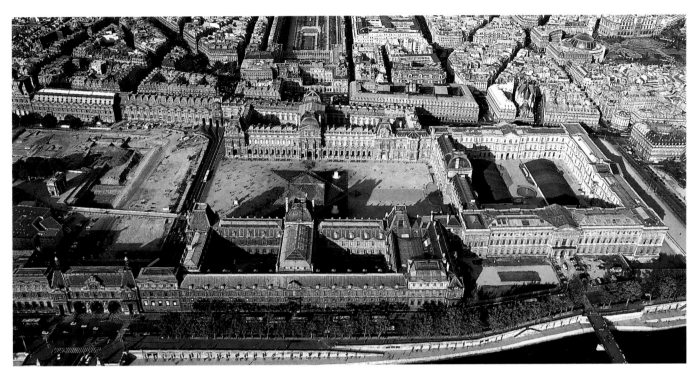

Aerial view of the Louvre, Paris

Jean Varin
First medal commemorating
the building of the Louvre
Paris, Bibliothèque Nationale
de France
cat. 108

palace with corner apartments and a central vestibule, and the wall articulation follows the usual scheme of Le Vau with a giant order on the wings. The desire for plastic and spatial systemization, however, surpasses anything conceived previously. The grand circular vestibule that is crowned by a "drum-without-dome" defines the center of a system of radiating directions, among which the main axis has prime importance. Along the transverse axis one rises up to the first floor through a series of varied spaces. The use of *dégagements* is very progressive, but as a whole the plan has a somewhat theoretical character. The whole complex bi-axial organism is unified by a continuous entablature. We may assume that Bernini knew the publications of Le Pautre and that the château project influenced his first design for the Louvre.

The last decades of the seventeenth century were dominated by Jules Hardouin Mansart (1646–1708). He is often considered a somewhat dry and uninspired designer. However, his uniformly extended structures were the result of deliberate intentions. "He served the needs of his time perfectly, and applied to them vast talents: an exceptional sense of grandeur, great skill in directing a team of craftsmen and, when it was called for, considerable mastery of the strictly practical side of the architect's profession."[26] His clear and assured style is particularly evident in the chapel at Versailles (1689–1710). The chapel had to consist of two storeys, the ground floor for the courtiers and the public, and the upper floor for the king, in direct communication with his apartment. Hardouin Mansart solved the problem in a manner that recalls the Louvre façade, not only on account of the clarity of the design, but equally because of the relation between massive base and "transparent" main story. The king, so to say, rises with full self-assurance over his followers, a content that is emphasized by the "Gothic" proportions of the space. With the Louvre façade and the chapel at Versailles, French classical architecture reached a culmination point. The two works give a consummate concretization of the rational and transcendental *esprit de système* of seventeenth-century France.

Spain

Spain experienced its peak of imperial power in the sixteenth century under Philip II. Under Philip III, who ruled from 1598 to 1621, greatness turned into decline. The country was threatened by military and economic collapse, and the wretched Spanish world found its expression in Cervantes' *Don Quixote* (1605). The conditions, therefore, were not favorable for the development of a true Baroque architecture. The great intentions of Philip II's Es-

[26] Blunt, *Art and Architecture in France 1500–1700*: 216.

Andrés García de Quiñones
Wooden model for the Salamanca
council
Salamanca, Ayuntamiento
de Salamanca
cat. 404

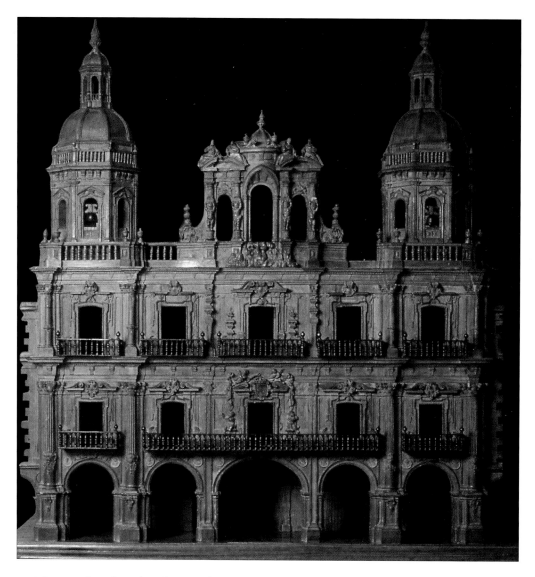

corial were abandoned and Spanish architecture was reduced to secondary importance.[27] In 1585 Herrera planned the cathedral of Valladolid on an interesting bi-axial layout, giving emphasis to movement in depth as well as centralization. The concept had a certain following, as for instance in the cathedral of Mexico City and the interesting Pilar Church in Saragossa (1680). Herrera's successor, Juan Gómez de Mora (1580-1648), however, returned to a more conventional scheme when he planned the Jesuit Clerecía in Salamanca in 1617. The disposition follows Il Gesù, without having the rhythmical richness and spatial unity of the Roman church. In general, Spanish seventeenth-century architecture tended increasingly toward a decorative approach, which represented a variation on the Baroque theme of persuasion.

England

Up until the beginning of the seventeenth century, English architecture had lived its own life. In spite of the general cultural contact with the Continent during the reign of Queen Elizabeth, architecture remained isolated. During the second decade of the century, the situation suddenly changed, due to the fundamental contribution of a single architect: Inigo Jones (1573–1652). Jones had visited Venice between 1597 and 1603, and in 1613–14 he again spent a year and a half in Italy. In the meantime (1609), he had also visited Paris. Jones' formation, thus, took place before the real development of Roman and French Baroque, and he found his source of inspiration in the theoretical approach and works of Palladio.

[27] A general survey is given in G. Kubler and M. Soria, *Art and Architecture in Spain and Portugal 1500–1800*, Harmondsworth 1959.
[28] J. Summerson, *Inigo Jones*, Harmondsworth 1966: 139. To compare this approach with the principles of Palladio's architecture, see R. Wittkower, *Architectural Principles in the Age of Humanism*, London 1949.

From then on, Palladio was always present, in one way or another, in English architecture. It is significant that Palladio was the only architect to create "a complete architectural system without Baroque rhetoric." His combination of versatility and self-restraint fitted the character of English society and the English psyche particularly well. In seventeenth-century England, in fact, we find neither a dominant Church nor an absolute monarchy. Rather, religion and aristocracy appeared as factors in a more complex totality, which also included the burgher, the merchant, and the free thinker. The resulting pluralism, however, did not present England from possessing a powerful "system" of its own kind.

Although the country experienced civil war and the decapitation of its king, we may still talk of a more democratic society than in the other European countries. Inigo Jones built for the court, but his "Palladian" style makes the desire for a corresponding "democratic" architecture manifest. The aim was to create an architecture possessing a neutral universality. "Jones saw certain things clearly – more clearly than his Italian and French contemporaries with their immensely richer and more sophisticated backgrounds could do. He saw that antiquity offered, in the five orders and in their attachment to specific forms of spatial arrangement, a language of timeless validity. His was not the spirit of revolution, but such was the force of his example that, sustained through two generations of eclectic experiment and Baroque adventure, it showed the way, in a new age, to a new enlightenment."[28]

English architecture of the seventeenth century was split into two distinct phases by the Civil War. As Inigo Jones dominated the first, Christopher Wren (1632–1723) was the protagonist of the second. Wren started as an astronomer and mathematician, and became a member of the Royal Society when it was founded in 1662. As an architect, he must be considered a learned dilettante, since his only education outside England consisted of a trip to Paris in 1665, where he met Bernini. In a letter he wrote: "I have busied myself in surveying the most esteem'd Fabricks of Paris, and the Country round. The Louvre for a while

London in the 18th century
Engravings
Milan, Civica Raccolta Stampe
Achille Bertarelli

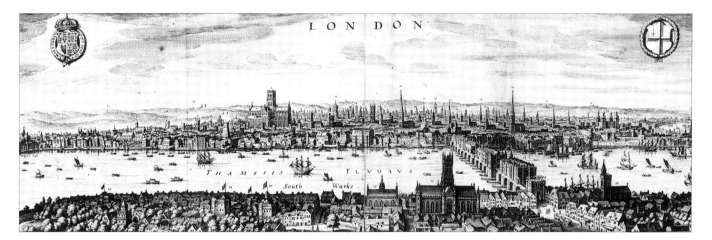

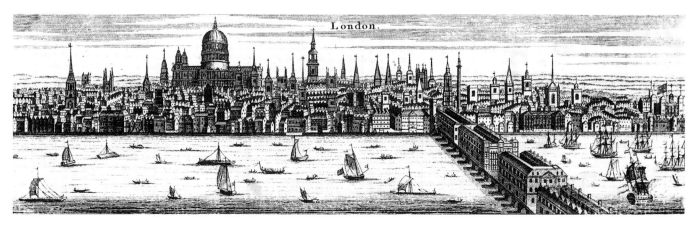

was my daily Object, where no less that a thousand hands are constantly employ'd in the Works [...] Mons. Abbé Charles introduc'd me to the Acquaintance of Bernini, who shew'd me the designs of the Louvre [...] Bernini's design of the Louvre I would have given my skin for [...][29] After a few tentative attempts, Wren's golden opportunity came after the Great Fire of London in September 1666. In a few days, more than thirteen thousand houses and eighty-seven churches were destroyed by the fire, as well as the great cathedral, St. Paul's. About two hundred thousand people became homeless. Shortly afterward Wren presented a plan for the New City to King Charles II. The solution shows a Baroque system of *piazze* and radiating streets, with the Royal Exchange serving as the main focus. The new St. Paul's also had a prominent position between the streets leading from Ludgate in the west to the Tower and the Exchange. Many of the secondary streets were centered on parish churches.

When planning the new St. Paul's, Wren aimed at a similar synthesis, only on a much larger scale. In 1673 he presented his project in the form of a Great Model. The centralized main space is clearly derived from Michelangelo's project for St. Peter's, but smaller domed spaces on the diagonals open onto the main center. A "Baroque" desire for spatial integration, thus, is present. But while Michelangelo's plan is centripetally enclosed, Wren makes his spatial group interact with the surroundings by means of concave external walls. A domed vestibule and a classical portico introduce a longitudinal axis. The articulation of the exterior is also derived from St. Peter's, as is the general relationship between the main building and the dome. Unfortunately the clergy did not find the magnificent project "enough of cathedral-fashion." Wren, thus, had to remake the project. The final solution (1675) is a rather awkward combination of longitudinal basilica and domed center. The dome has a regularity that makes it an expression of the ideals of English architecture. Its "external effect has never, in the opinion of Englishmen (and even some foreigners), been equaled."[30]

Wren's most interesting design, however, was for the Royal Naval Hospital at Greenwich (1695). After a preliminary project, Wren arrived at a solution where the Queen's House by Inigo Jones is used to terminate an axis defined by a wide "avenue" between colonnades and a courtyard opening on the river Thames. The transition between the two spaces is marked by tall domes over the chapel and the hall. The design is a magnificent variation of Baroque themes, and shows a mature handling of the relation between mass and space. A strong sense of unity is achieved by the use of coupled columns throughout, even in the domes which have a certain affinity to Hardouin Mansart's Invalides. The Hospital in Greenwich was completed by Vanbrugh and Hawksmoor, but the general layout is Wren's and it must be considered his most successful work.

Christopher Wren
Drawing of the Royal Naval Hospital
Greenwich
detail
London, courtesy of the Trustees
of Sir John Soane's Museum
cat. 420

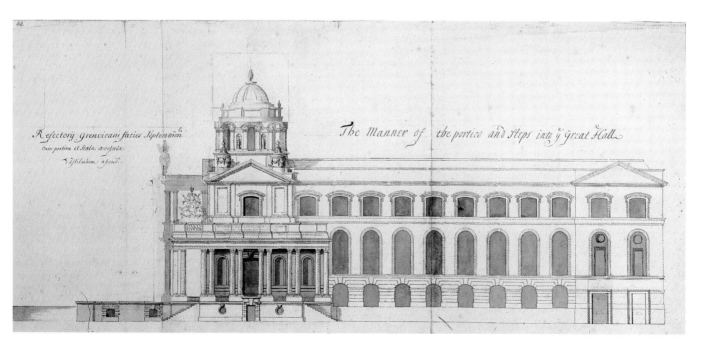

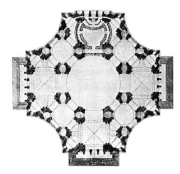

Plan of the cathedral of St. Paul, London

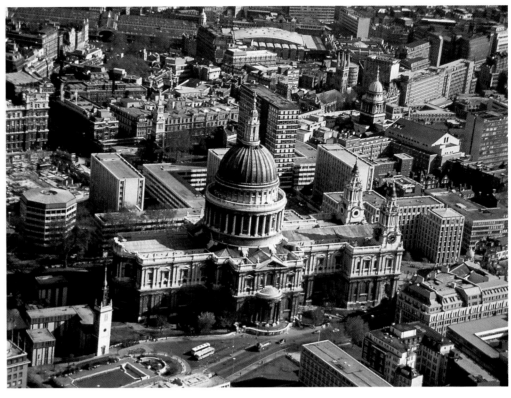

Aerial view of St. Paul's, London

following pages
Canaletto
Greenwich Hospital from the north bank of the Thames
Greenwich, National Maritime Museum
cat. 421

[29] Quoted after P. Murray, *A History of English Architecture*, part II, Harmondsworth 1962: 188ff.
[30] Summerson, *Inigo Jones*, op. cit.: 133.
[31] G.C. Argan, *L'Europa delle Capitali 1600–1700*, Geneva, 1964: 45.
[32] The word "monument" is used here in its original sense, that is, something which makes us remember.

The city

In the Baroque city the single building loses its plastic individuality and becomes part of a superior system. This means that the *space* between the buildings acquires a new importance as the real constitutive element of the urban totality. The freestanding volumes of Late Baroque residences acquire meaning as of a comprehensive system. The Baroque façade is thus just as much a function of the urban space in front as of the building to which it belongs. In general, we may say that the Baroque city converges on (or radiates from) monumental buildings which represent the basic values of the system. "The monument constitutes a focal point of the very greatest prestige within the framework of a city and is generally placed in the center of a vast area, planned so as to enhance the monument's aesthetic values [...]"[31] Argan justly recognizes St. Peter's as the prototype of such monuments.[32]

The structure of the Baroque city consists thus of focuses (monumental buildings and squares) which are interconnected by straight and regular streets. The Baroque environment, therefore, is ordered in terms of hierarchic centralization. The city as a whole is the focus of a territorial network. Within the city, we find a more condensed network which is focused on monumental buildings, which in turn are geometrically organized into still more condensed systems, until the very center is reached.

The church

The development of Baroque church architecture is based on the longitudinal and centralized plans. The larger churches are usually derived from the traditional basilica scheme, while the smaller ones and the chapels show centralized solutions. It is essential to recognize, however, that the disposition of the large longitudinal churches as a rule consists of a strong center, marked by a dome or an incorporated rotunda, while the smaller churches usually contain a longitudinal axis.

In Baroque churches, "space" gains a new constitutive importance. In contrast to a construction of plastic "members," the building is made up of interacting spatial elements which are modeled according to the outer and inner "forces" which form the particular building. The critical spatial problems are the transitions between different realms, such as outside and inside, or between the spatial elements of a complex architectural organism. In

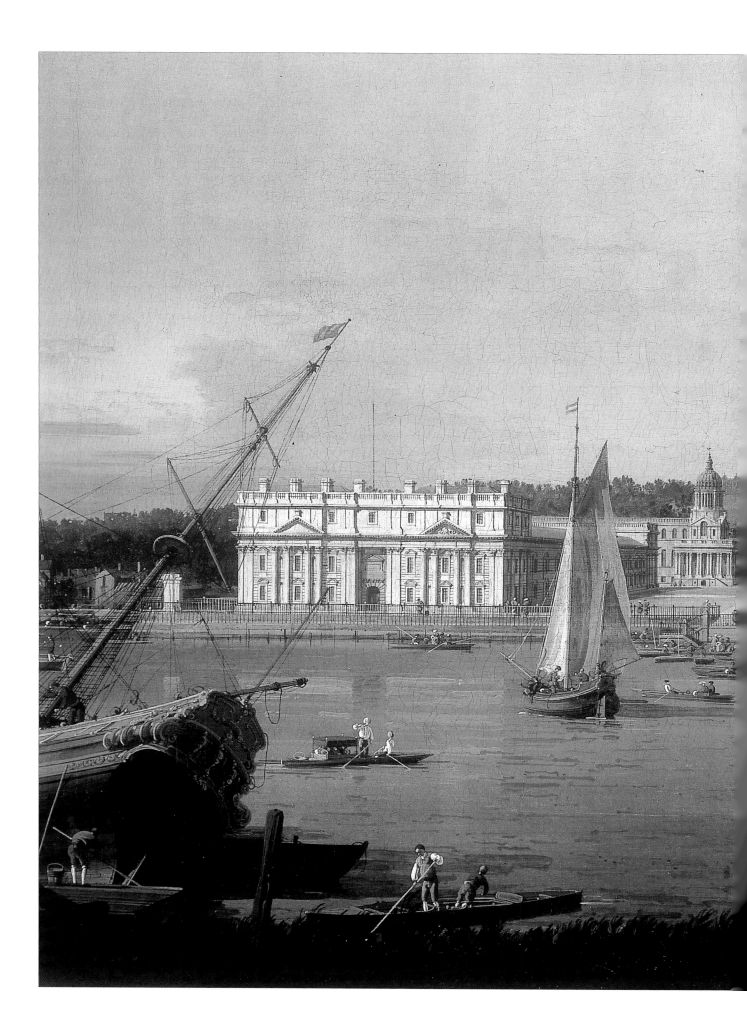

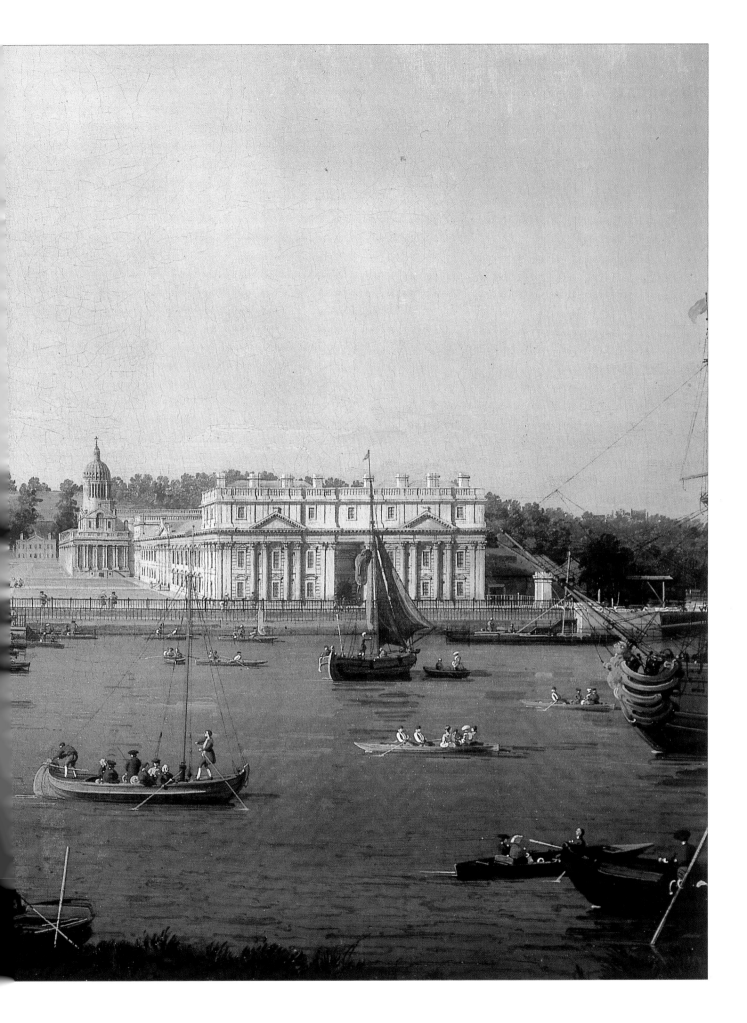

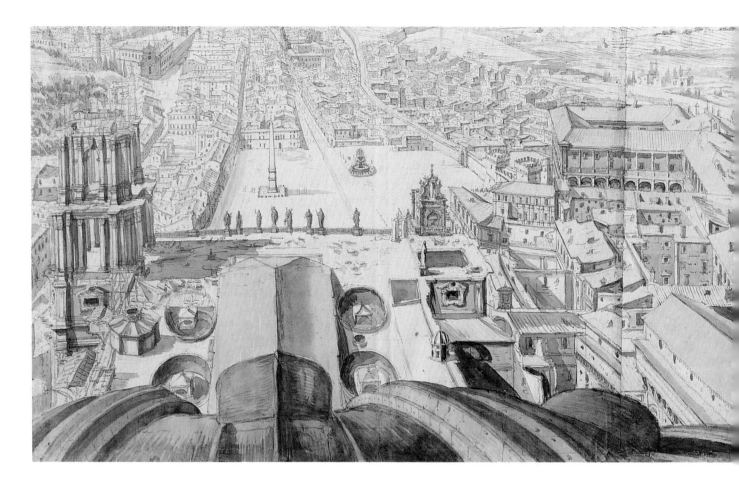

Israël Silvestre
View across the Vatican
from the dome of St. Peter's
Cambridge, Mass., Fogg Art Museum
cat. 6

the church, the problems are particularly evident and may lead to strong and consequent solutions, as the building task is relatively simple and does not include many separate or qualitatively different spaces.[33] We therefore find that Baroque architecture obtains its first strong "momentum" in the sacred buildings of the fully developed Roman Baroque, that is the works of Bernini, Borromini and Pietro da Cortona. The ultimate conclusions are drawn later in the seventeenth century by Guarino Guarini, who extends his activity to a great part of the Catholic world.

The palace

Two building types dominate seventeenth-century secular architecture, the city-palace (*palazzo, hôtel*) and the country house (*villa, château*). We also find interesting transitions between the two types (*villa suburbana*). Three basic environments are thereby related to each other: the private world of the dwelling, and the public world of the city and the natural world of the garden and the landscape. The city-palace gives man his "place" in a social context, the villa relates him to nature, and in the transitory cases, all three elements are brought together. It should be pointed out that the city-palace and the villa did not provide different people with dwellings; the represented two aspects of the same form of life.

The development of the city-palace and the villa is related to the significant change in political, economical and social structure which we have referred to earlier, and which we have found behind the rise of the capital city. In this context it meant a loss of importance of the feudal seat, the castle, and the need for a substitute within the city, that is, a city-palace. This development is basically similar, whether the palace was the seat of a new type of "capitalist" (Florence), a "prince" of the Church (Rome), or an aristocratic member of a centralized court (Paris). In the seventeenth century, the villa found its solution in garden palaces such as the Palazzo Barberini in Rome and the Palais du Luxembourg in Paris, which became the models of the great European residences from Versailles to Schlaun's Schloss in Münster (1767).

[33] Basically the church is an extension of the "public" space of the city, although with a particular sacred qualification, as the private "house of God."

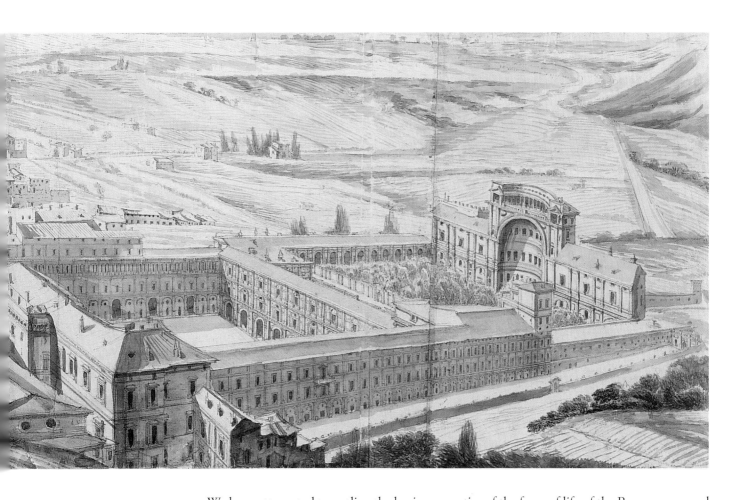

We have attempted to outline the basic properties of the form of life of the Baroque age and its spatial counterpart, architecture. All forms of life have spatial consequences. In fact, any human activity has spatial aspects, because it implies movements and relations to places. Heidegger says: "The single world always reveals the spatiality of the space that is proper to it."[34] From childhood on, man constructs a spatial image of his environment, which we may call his "existential space."[35] Certain basic properties of this existential space necessarily have to be public, in order to allow for social participation and integration. The structure of existential space may be analyzed in terms of "places," "paths" and "domains." The places are the focuses of man's activities, the paths describe his possibilities of taking possession of the environment, and the domains are qualitatively defined areas which are more or less well known. All these elements appear on different environmental levels. "Landscape" is the most comprehensive level we generally have to consider, and it is determined by man's interaction with his natural environment. It contains the "urban" level, which is mainly determined by social interaction. Finally we should consider the level of the "house," which basically is a private space within the urban context. On all levels, the relation between "inside" and "outside" is of prime importance, that is, the relation between a place and its environment. We may define architectural space as a concretization of existential space.[36]

Baroque architecture presents, as we have seen, a clear system of places, paths and domains, organized to form a hierarchy focused on a dominant center. The building types of past periods are transformed to fit within this general scheme. The traditionally enclosed city is thus opened up whenever possible, the church is organized relative to an axis which integrates it with the urban environment, and the palace becomes a center of radiating movements, rather than a massive fortress. The landscape, finally, during the seventeenth and eighteenth centuries in many parts of Europe was saturated with Baroque elements, either as extended paths of profane gardens, or sacred "objects" such as road crucifixes, chapels and sanctuaries. Although authoritarian, the Baroque world was dynamic and open, and contained elements which have been of basic importance to our present world.

[34] M. Heidegger, *Sein und Zeit* (1927), Tübingen 1967: 104 (eleventh edition).
[35] See C. Norberg-Schulz, *Existence, Space and Architecture*, London 1970.
[36] See C. Norberg-Schulz, *Existence Space...*, op. cit. We may also refer to Susanne K. Langer who says: "A culture is made up factually of the activities of human beings; it is a system of interlocking and intersecting actions, a continuous functional pattern [...] The architect creates its image; a physically present human environment that expresses the characteristic rhythmic functional patterns which constitute a culture." (*Feeling and Form*, New York 1953: 96.)

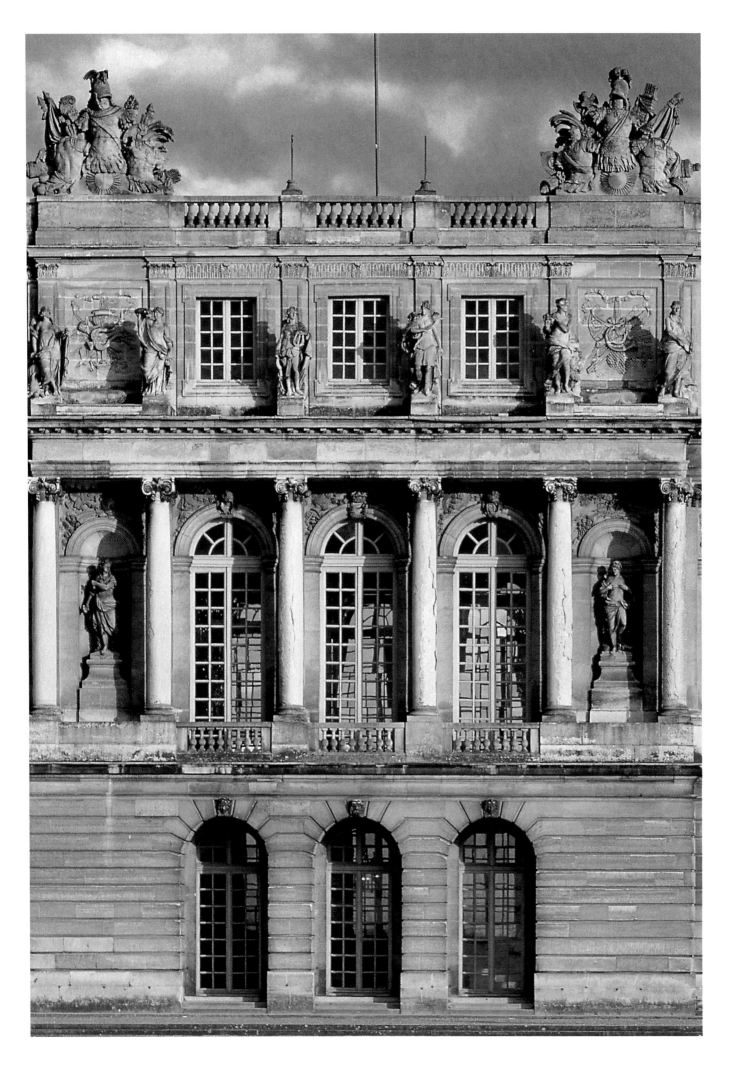

A century of war hardly changed the map of seventeenth-century Europe. Boundaries may have shifted a bit: England and Scotland formed a unified kingdom, and Portugal became an independent state; France acquired parts of Alsace and Roussillon, and the edges of the Baltic nations became more sharply defined. But the territorial picture remained stable, in striking contrast to the architectural map of Europe which was entirely recast. Plot the new sites of architectural interest at the beginning and the end of the century, and you will find that those maps look nothing alike.

In 1600, notable buildings were thinly scattered across western Europe but only concentrated in and around Rome. By 1700 sites of significant building activity thickly covered the Continent: London, Oxford, Paris, Versailles, Amsterdam, Stockholm, Dresden, Munich, Prague, Vienna, Turin, Seville.

Thus the geographical scope of this exhibition reflects a distinguishing feature of Baroque architecture: its triumph across Europe, from England to Russia and from Sweden to Sicily and Spain, conquering regions where Renaissance forms had hardly penetrated. Indeed, on the basis of its widespread manifestations, the Baroque might be deemed a more influential stylistic phenomenon than the Renaissance. What accounts for the explosion of architectural activity in the seventeenth century and the international success of Baroque? By way of introducing this sprawling and remarkably fertile subject, this essay will consider four structural features which contributed to the triumph of the Baroque: the norms of court society; the process of urbanization; the renewal of religion; and the methods of Baroque design.

Court society

In a century which endured uninterrupted military conflict – only four years passed without a battle in Europe – it is not surprising that states directed the major share of their resources to the enterprise of war. Yet military might could not fulfill the rhetorical demands of rulership, and the need to translate abstract ideas of power into tangible and awesome forms meant that architecture was enlisted as a critical tool of state. When Henri IV of

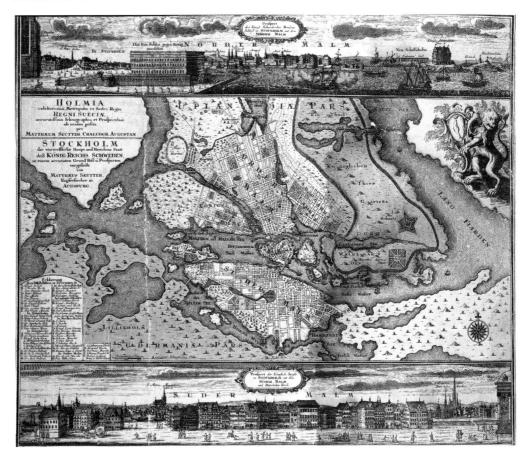

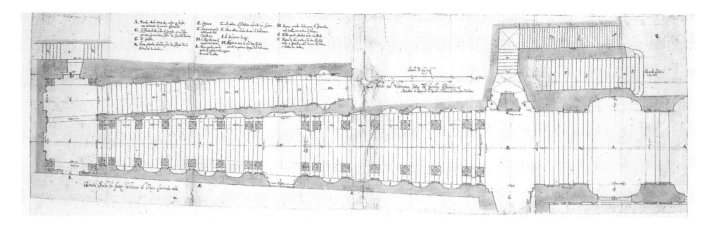

Nicodemus Tessin
Plan of the Scala Regia
Stockholm, Nationalmuseet
cat. 88

France acknowledged war and architecture as his twin obsessions, he was not confessing to expensive personal habits but asserting the dual obligations of a ruler in the Baroque age – to win wars and to build magnificently.

The process was laid bare in Sweden, a newcomer in the power politics of the seventeenth century. A brilliant commander-in-chief, Gustavus Adolphus (1611–32) succeeded in establishing Sweden as the leading Baltic state by reorganizing both the army and the system of government. But these successes essentially remained invisible, as an English visitor was dismayed to learn in the 1680s. "He that hath read in the histories of this last age the great exploits of Gustavus Adolphus and his Swedes perhaps may have a fancy that it must be an excellent Countrey which hath bred such warriors; but if he approaches it, he will soon find himself undeceived;" rocks, forest, and lakes were to be seen, not recognizable signs of power.[1] The heirs of Gustavus Adolphus launched the next stage of state-formation by planning a monumental capital to register Sweden's presence on the European stage.

The effort was directed by Nicodemus Tessin the Younger (1654–1728), whose position as royal architect of Karl XII encompassed the broader role of serving as Sweden's cultural ambassador to Europe and imagemaker at the court. To prepare for a task he had probably envisioned as a youth – his father and namesake was also a royal architect – Tessin thoroughly schooled himself in European architecture. He spent nine of the years between 1673 and 1690 abroad, not just in Italy and France, but also in Germany, Austria, and England – an itinerary which reflects the expanding world of the Baroque.[2] That cosmopolitan formation and outlook is conveyed in sketchbooks where Tessin seems to switch effortlessly among several foreign languages – Italian, French, and German. In the studio of the elderly Bernini and of Carlo Fontana in Rome, he learned how to compose buildings, express mass, and deploy architectural ornament. In Paris he learned to design gardens, plan interior spaces, and decorate their surfaces. His attention was above all captured by the problem of the Louvre.

The completion of the French royal palace had been the seminal architectural event of the 1660s, but the dossier of rival schemes by Bernini, Rainaldi, Le Vau, and Mansart among others had a long afterlife, as the case of Tessin makes clear. Bernini's designs in particular were a touchstone for the Swede, and the detailed drawings he commissioned of Bernini's models were the starting point of Tessin's designs of the royal palace in Stockholm beginning in 1690.

Over the next twenty years his evolving projects synthesized lessons he had learned from both contemporary French and Italian design and culminated in an ambitious plan to remodel the central city, the Gamla Stan. On one side the palace adjoins a complex of governmental buildings and stables laid out on an island; on another side a formal square coordinates the palace with Stockholm cathedral and the homes of ministers, including the residence of Tessin himself, a fitting honor for the man who shaped the image of the Swedish state. Scholars have parsed Tessin's designs for the Stockholm royal palace to determine what descends from Bernini and Fontana and what derives from Louis XIV's France. In addition to Bernini's last Louvre design, we find traces of an impressive *corpus*

[1] Quoted in David Kirby, *Northern Europe in the Early Modern Period. The Baltic World 1492–1772*, London-New York 1990: 260.
[2] On Tessin's travels see Oswald Sirén, *Nicodemus Tessin d.y:s studieresor*, Stockholm 1914; Ragnar Josephson, "Tessin in Deutschland," *Baltische Studien* (1928): 27–52; Josephson, *L'Architecte de Charles XII. Nicodème Tessin à la cour de Louis XIV*, Paris-Brussels 1930; Josephson, *Tessin*, 2 vols., Stockholm 1938–39; Roger-Armand Weigert and Carl Hernmarck, *Les Relations artistiques entre la France et la Suède, 1693–1718*, Stockholm 1964.

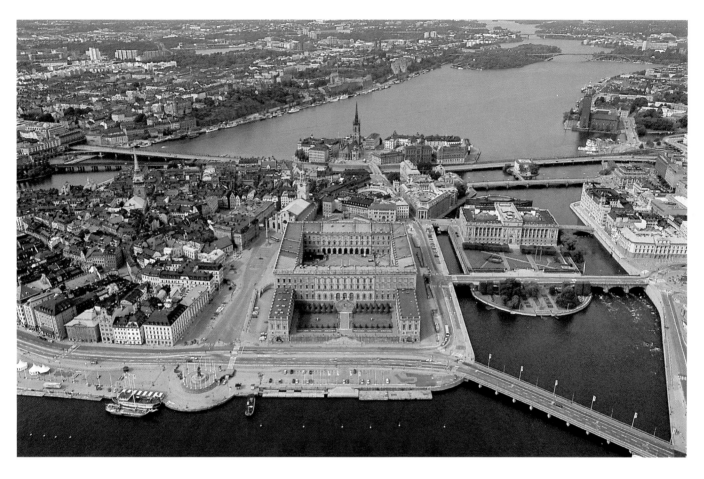

Aerial view of the Royal Palace in Stockholm

of buildings including Caprarola, Palazzo Barberini, Borromini's Palazzo Falconieri, projects by Fontana, and Hardouin Mansart's Place Louis le Grand (Vendôme). But the emphasis on genealogy tends to diminish first, the imaginative force of Tessin's vision which turned an insignificant Baltic port into a gilded European capital, and second, the rhetorical power of Baroque forms which could be flexibly combined and implanted in differing contexts to great effect.

Tessin's Stockholm encapsulates major themes of the Baroque age: the importance of the royal palace as the seat of government, its dominance in the capital city, the unity of Church and Crown, and the architect's strategic role at court. By the time Tessin's palace was complete in 1753, Sweden had ceased to be a superpower. Here again Stockholm illustrates a fundamental paradox of Baroque power, namely the contradiction between the enormous scale of the architecture and the weakness of the state. In this regard, the correspondence between the immensity of Versailles and French supremacy in Europe was the exception not the rule.

Other large states – Stuart England or Hapsburg Austria – failed to complete construction of a major palace, whereas minor territorial courts of the Holy Roman Empire realized monuments of surprising grandeur. Much more work needs to be done on the economics of court culture; it would be useful to have comparative figures on the financial investment in architecture and hard information on the purported secondary economic benefits of construction. Based on patchy data, one historian has concluded that the minor courts in Germany dedicated in aggregate a larger share of their income to court-related cultural activities than did the wealthiest and largest states – England, France, Spain, and Austria.[3]

What utility did the Wittelsbach dynasty derive from building palaces in Aschaffenburg and Munich, or the Schönborn family, prince-bishops of Franconia, from their network of palaces in Bamberg, Pommersfelden, and Würzburg? Grand stairhalls converted the mechanics of ascent into a spatial and ceremonial drama, and magnificently decorated Kaiser-

[3] Jürgen Freiherr von Krüdener, *Die Rolle des Hofes im Absolutismus*, Stuttgart 1973: 13–17.

John Crämer
Wooden model for a pleasure pavilion
Uppsala, Skoklosters Slott
cat. 203

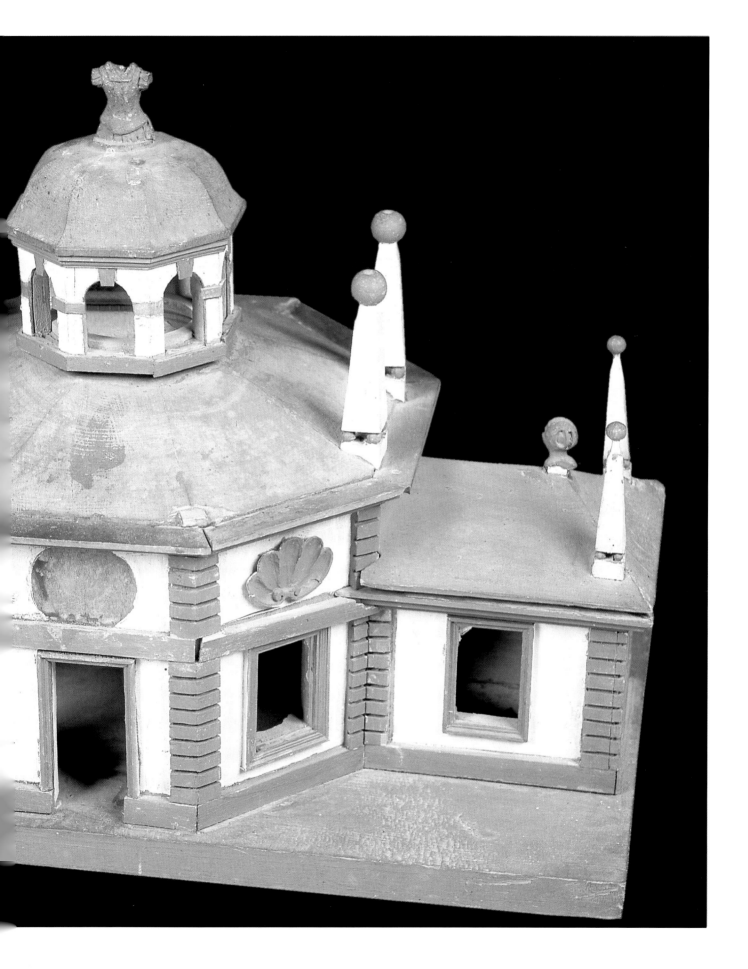

säle awaited the appearance of a spectral emperor who often failed to arrive. In these small electorates and bishoprics, architectural grandeur and elaborate ceremonial were disconnected from economic and military power, but a German commentator articulated in 1721 the rationale for such expenditures: "The average person, dependent on his senses and unable to reason, is incapable of comprehending the majesty of the king. But through the things that meet the eye and in turn activate the other senses, he receives a clear, if imprecise idea of this majesty or power and authority. We see then that an impressive court with its ceremonies is not something superfluous, much less reprehensible."[4]

It is true that this perspective, especially as it has been retheorized by Norbert Elias, explains lavish building programs that appear irrational or at least uneconomic.[5] The long, apparently redundant suites of rooms enfilade at the Residenz in Munich, the Palazzo Barberini in Rome, or at Versailles can be understood in relation to court etiquette: these rooms translate a social and political hierarchy into spatial layers and degrees of access to the sovereign.[6]

Whereas the Baroque building mania could not be adequately explained either by the Renaissance concept of princely magnificence or by the capitalist notion of conspicuous consumption, Elias's sociological analysis of the mechanisms of court culture revealed the utility in acts of great extravagance. As he put it, "the prestige value eclipses purely utilitarian values."[7]

But this interpretive framework, which assumes a correspondence between architecture and social structure and emphasizes etiquette over administrative function, misses two significant features of Baroque palaces and aristocratic residences. First, it cannot be assumed that buildings neutrally mirrored or reinforced the hierarchy at court. By building to the standard of a higher rank, patrons often intended their palaces to elevate their position at court and to recalibrate the social order. Elias implicitly acknowledges this more fluid, competitive model. "In a society in which every outward manifestation of a person has special significance," he writes, "expenditure on prestige and display is for the upper classes a necessity which they cannot avoid. They are an indispensable instrument in maintaining their social position, especially when – as is actually the case in this court society – all members of the society are involved in a ceaseless struggle for status and prestige."[8]

A survey of city palaces and country estates confirms the dynamic role of architecture as a tool of social promotion. Financiers in late seventeenth-century Paris built hôtels that outdid those of noblemen at least in part to improve their social image, and exiled ministers built châteaux with an eye to reinstatement or dynastic reinvention, as at Maisons and Castle Howard. While inevitably inscribing a social order, residences often challenged the *status quo* by means of their majestic scale or aggrandizing formal references and iconography. One of the most famous stories about Baroque architecture highlights the issue of decorum. Nicolas Fouquet was arrested and condemned to death supposedly because the grandeur of his château, Vaux-le-Vicomte (1656–61), slighted Louis XIV, whose buildings paled by comparison. The Crown covered up the facts about Fouquet's demise – it actually related to a power struggle with his nemesis at court – with a cautionary tale of hubris. In the standard reading, Vaux demonstrates the dangers of overreaching, but the story exposes what it seeks to deny, namely the power of architecture to challenge the social hierarchy and alter perceptions of rank and power.

Second, court ceremonial may explain the treatment of reception rooms, but does not account for the size of most Baroque palaces, which encompassed a range of administrative functions. The palace had evolved from the sovereign's residence into the center of government administration, which meant accommodating large numbers of people and a variety of activities. In addition to a theater, library, galleries, stables, rooms for Swiss guards, and studios for court artists – all more traditional elements, royal palaces typically contained printing works, the mint, and offices for ministers of state. In terms of building typology, the palace essentially shifted from the realm of domestic to that of governmental architecture.

As an optic on court society, etiquette occludes not only this fundamental transformation of the palace into administrative center, but also the extension of the state into varied as-

[4] Christian Wolff, *Vernünftige Gedanken von dem gesellschaftlichen Leben der Menschen* (Halle, 1721), cited and translated by Samuel John Klingensmith, *The Utility of Splendor. Ceremony, Social Life, and Architecture at the Court of Bavaria, 1600–1800*, Chicago 1993: XVI.

[5] The key work is Norbert Elias, *Die höfische Gesellschaft. Untersuchungen zur Soziologie des Königtums und der höfischen Aristokratie*, Darmstadt 1969, translated by Edmund Jephcott as *The Court Society*, Oxford 1983. For an assessment of Elias's theory, see Jeroen Duindam, *Myths of Power. Norbert Elias and the Early Modern European Court*, Amsterdam 1994.

[6] These examples make reference to three noteworthy publications that explore the relationship between planning and ceremonial, which has been a dominant theme of the literature on Baroque architecture published in the 1980s and 1990s: Samuel John Klingensmith, *The Utility of Splendor...*, op. cit.; Patricia Waddy, *Seventeenth-Century Roman Palaces. Use and the Art of the Plan*, New York, Cambridge (Mass.), London 1990; and Robert Berger, *Versailles: The Château of Louis XIV*, University Park (Penn.), London 1985.

[7] Elias, *The Court Society*, op. cit.: 57.

[8] Elias, *The Court Society*, op. cit.: 63.

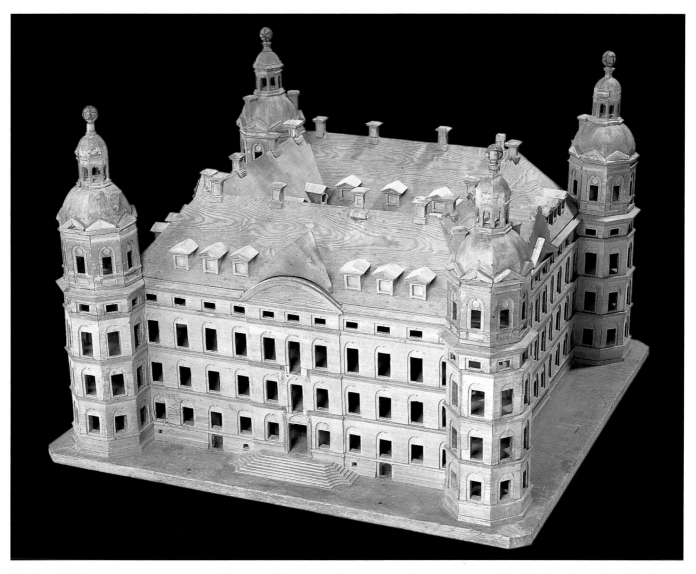

Nicodemus Tessin
Caspar Vogel
Wooden model for Skoklosters Slott
cat. 246

pages 88-89
French school, 17th century
*View of the royal residence
of Versailles from the gardens*
before 1678
Paris, Réunion des Musées
Nationaux

pages 90-91
Detail of the façade of the Cour
Louis XIII, or Cour de Marbre
Versailles

[9] Geoffrey Parker, *The Military Revolution. Military Innovation and the Rise of the West, 1500–1800*, Cambridge 1988: 45–46.

pects of society, from manufacturing and commerce to scientific inquiry and medical care. Historians have properly insisted that the concept of absolutism falsifies a more complicated political reality since the Crown invariably faced limitations on its power. Nevertheless, the building programs demonstrate some tangible results in the centralizing process of state-formation.

Consider briefly three examples which demonstrate the enlarged ambit of the state.

First, fortresses. Among the most important developments of the seventeenth century was the formation of professional standing armies in lieu of part-time regiments which were only convened upon demand. The major European states supported enormous numbers of full-time soldiers: Philip IV had an army of about 200,000 men, and in 1696 Louis XIV commanded 395,000 soldiers – one of every four Frenchmen was in the army.[9]

Obviously these men required weapons and places to sleep, hence the establishment of large, standing armies precipitated massive infrastructural investment in defense. Governments built arsenals, foundries, barracks, naval yards, ports, and fortifications; in terms of capital outlay, these largely anonymous structures were by far the most important building projects the Crowns pursued.

France set the lead, first under Colbert, who built Atlantic ports and arsenals at Rochefort, Brest, and Lorient in the 1660s and 1670s for the fledgling navy he was determined to make into a powerhouse, then under the prodigious Vauban, who built a network of over 160 fortresses, including 33 new citadels, along the frontier during the last decades of the century.

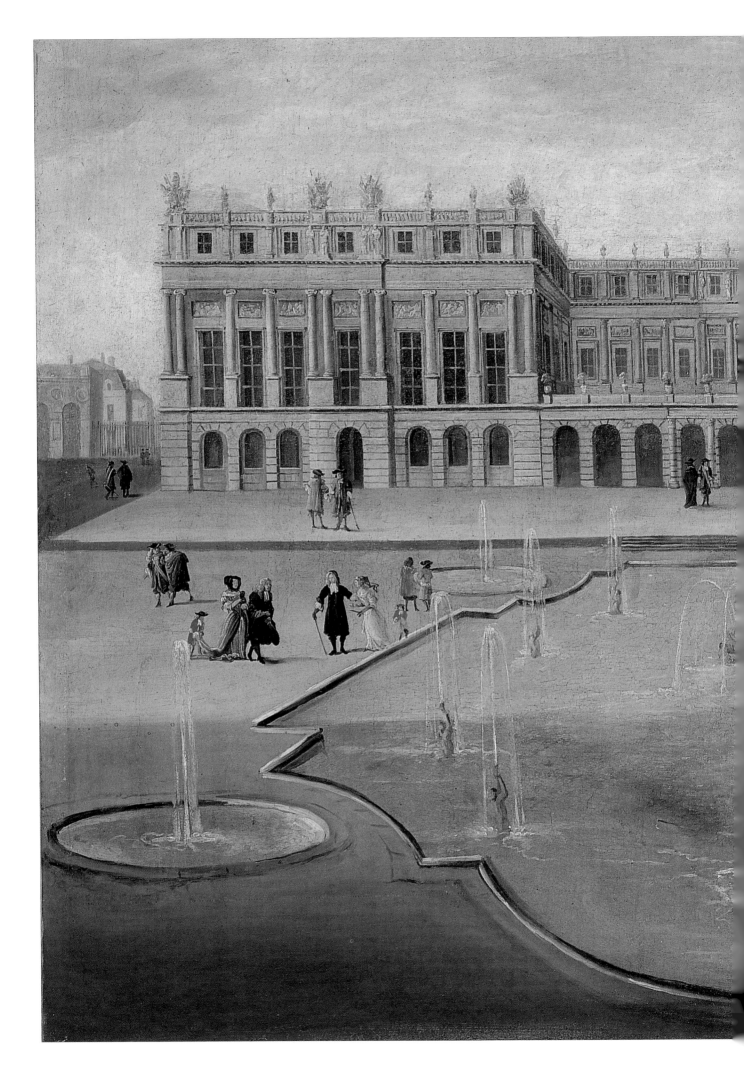

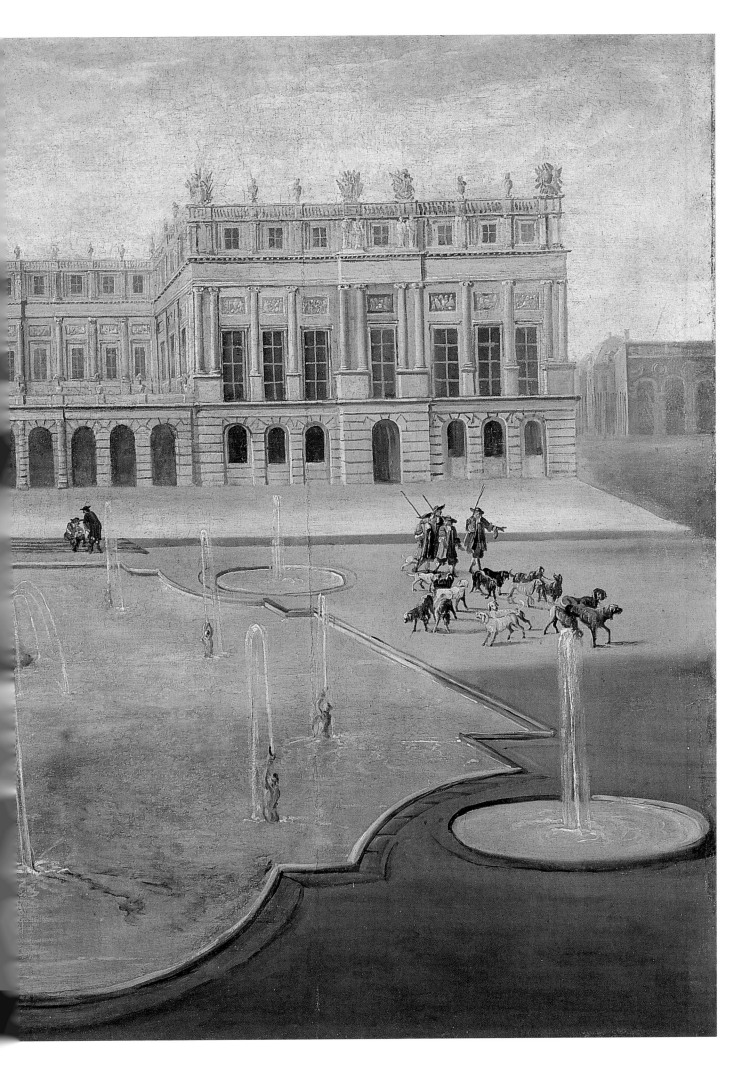

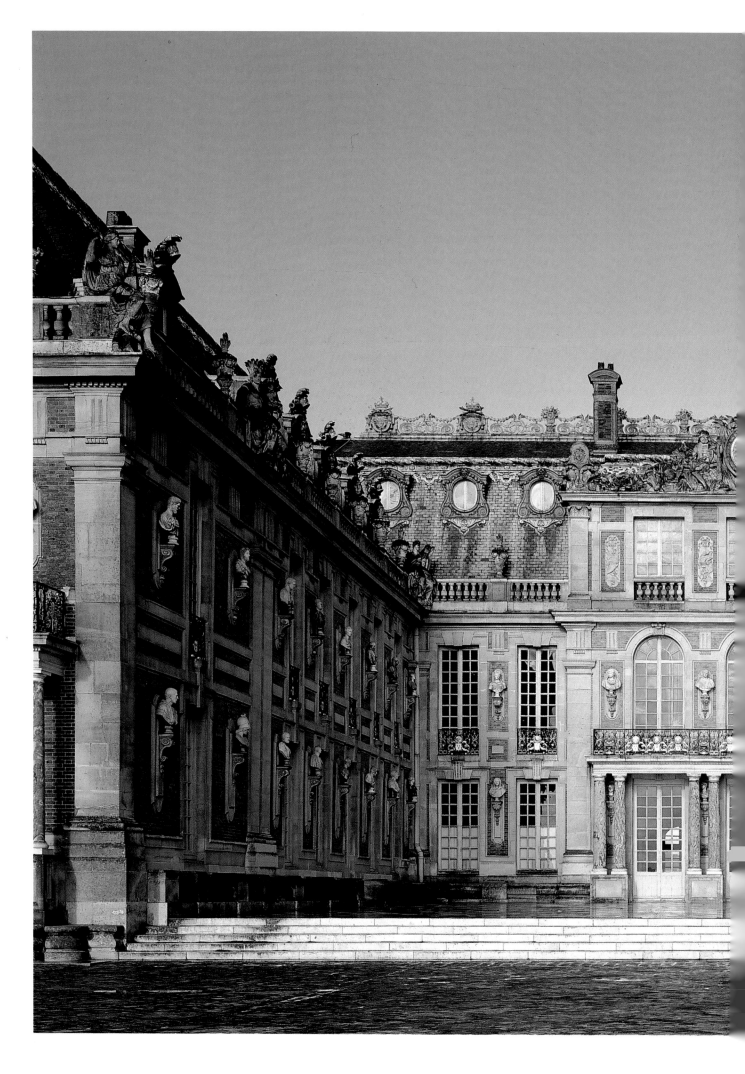

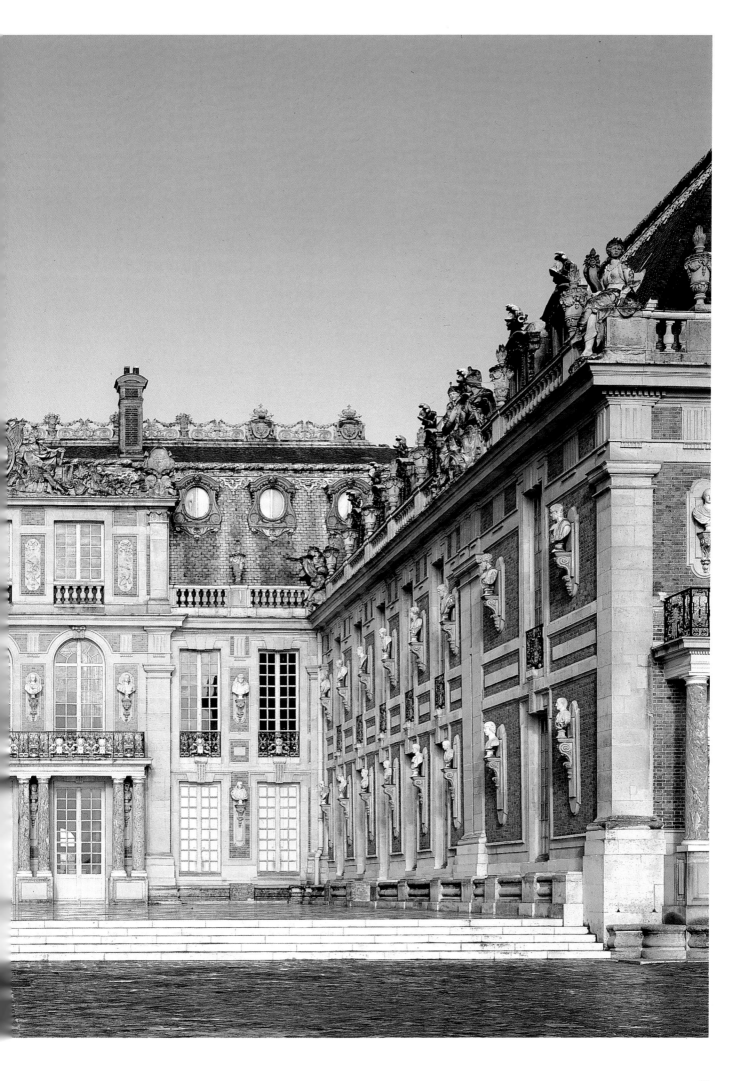

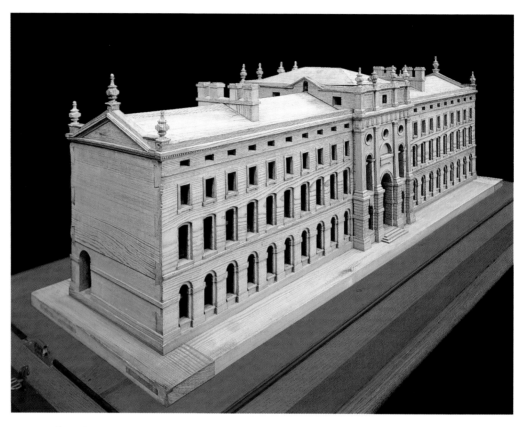

Yet Vauban felt that citadels were ill-suited to the new methods of war which depended on explosives and heavy firepower. In fact, it was said that no fortress could resist a Vauban-led assault, an irony which underscores the symbolic force of his building program: Vauban's citadels embodied the power of France.

Second, hospitals. Louis XIV fundamentally changed the imagery of this building type at the Hôpital des Invalides in Paris which he dedicated to wounded and retired soldiers. The main axis of the hospital comprised a two-part church: a nave for soldiers and a great domed space which was conceived as the Bourbon mausoleum. Although the dome never served this purpose, Hardouin Mansart's configuration underscores the royal identification with the hospital. Hospitals had previously been the province of the Church; at the Invalides, the Crown took over and transformed the building into a paradigmatic sign of royal power. The implications were even more fully drawn out at Greenwich Naval Hospital in London. After the regicide of Charles I, the political weakness of the English Crown made it impossible to realize the palace projects conceived by Christopher Wren and Nicholas Hawksmoor. The representational function of the palace was, in effect, displaced onto Greenwich Hospital, supposedly built to raise the standard of living of Britannia's retired sailors. The architectural grandeur of the hospital so effectively symbolized monarchical beneficence that the question of the actual impact of the hospital and the related restructuring of the pension system on the lives of the sailors has been deferred (the same is true of the Invalides). Moreover, Wren's bifurcated composition focused on the Queen's House which had been built by Inigo Jones and which had assumed the status of a royal relic. Greenwich Naval Hospital probably ranks as the most effective architectural symbol of the seventeenth-century English Crown.

Third, observatories. The sphere of culture and learning produced some of the finest interiors of the Baroque age; art galleries, libraries, and theaters were usually lodged within palaces hence did not develop as freestanding forms. Beyond supporting these court-based cultural entities, some monarchs established learned academies for the purpose of conducting research, developing knowledge, and promoting the glory of the Crown. In both France and England, the countries which took the lead in this area, the royal academies of

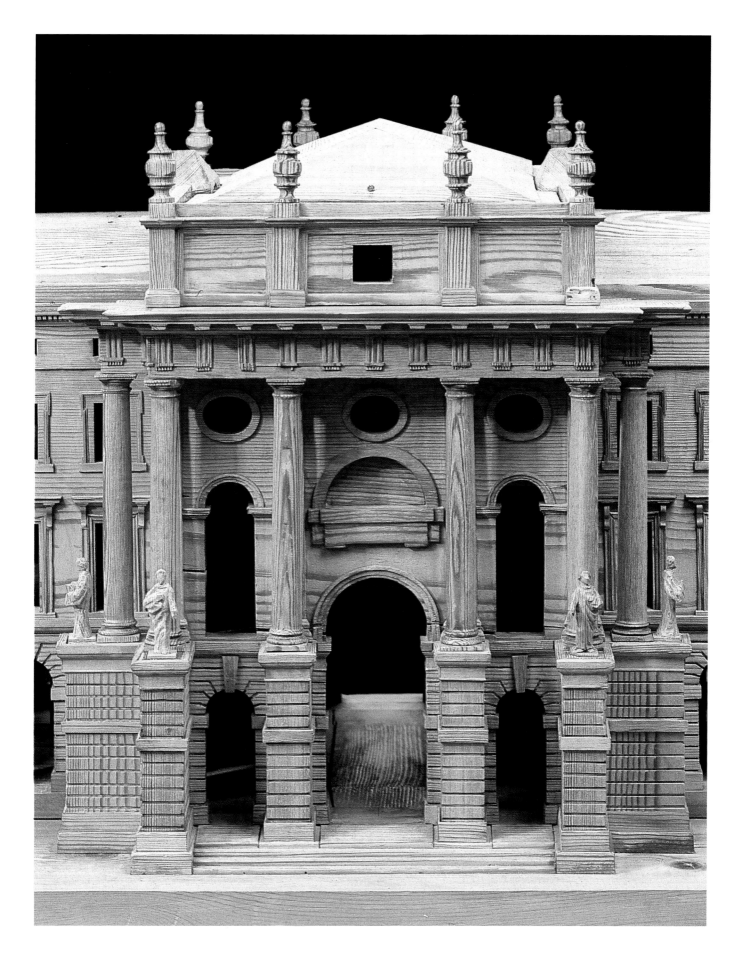

Henri Testelin
*Inauguration of the Academy
of Science and the foundation
of the Observatory in Paris*
Versailles
Musée National des Châteaux
de Versailles et de Trianon

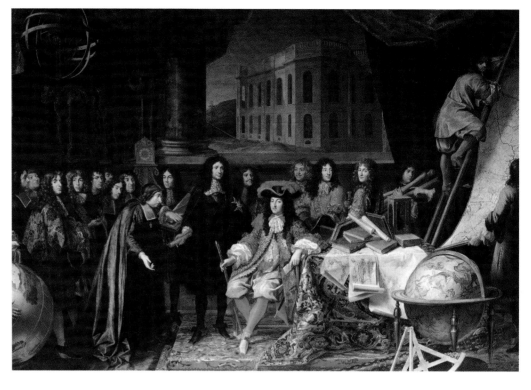

opposite
Johan Gotthard Hayberger
Model for the observatory
at Kremsmünster, not realized
Kremsmünster, Sternwarte, Stift
Kremsmünster
cat. 437

Johan Blasius Franck
Drawing for the model of the
Kremsmünster Observatory
Kremsmünster, Sternwarte, Stift
Kremsmünster
cat. 438

[10] Population statistics from the
early modern period are not based
on scientific data and can fluctu-
ate depending on the source. The
statistics provided here are drawn
from D.H. Pennington, *Europe in
the Seventeenth Century*, second
edition, London, New York 1989:
28.

science built observatories, emblematic of an age which sought to magnify the heavens and discern the hidden structures of nature. Christopher Wren, himself a great astronomer, designed the Greenwich Observatory (1675) as a kind of machine for viewing, with a sliding roof and central pole to lift and lower the telescope, but Wren's observatory was modest compared to the Observatory in Paris built in 1667 by Claude Perrault, also a scientist turned architect. A cubic block with tall windows suitable for taking measurements and a roof terrace for sky-gazing, the monumentality of the Observatory was unprecedented and clearly demonstrated the Crown's interest in astronomical research. Although the Church had reservations about this enterprise, as Galileo discovered, secular rulers appreciated the potential material benefits; after all, navigation of naval and commercial ships depended on the stars.

Urbanization

With a population of about half a million people in 1600, Constantinople was bigger than any European city. The most populous cities in Europe – Naples, Paris, and London – ranged in size from 200,000–300,000 people, but by the end of the century the population of London and Paris had doubled, while Amsterdam had grown from a town of 50,000 to a metropolis four times that size.[10]

Except in Rome, which had yet to fill in the vast area enclosed by the Aurelian walls, the urban influx required cities to expand their territory. The demolition of the medieval wall around Paris in the 1670s and its replacement by a planted boulevard may have symbolically referred to the national system of defense focused on the borderlands, but in concrete terms it was the propulsive dynamic of urbanization that brought down the walls as well as the entrenched ideal of the self-contained city unit.

The three canals of Amsterdam (the Herengracht, Keizersgracht, and Prinsengracht) and the Borgo di Pio in Turin were atypical in as much as these extensions were planned on a large scale. More often the process involved smaller-scale accretions no more than a few blocks in area, but even this type of growth was structured. New subdivisions, bordered by wider and straighter streets, yielded rectilinear lots and fostered some degree of architectural standardization in streetscapes and housing plans, as Pierre Le Muet recorded in his codification of housing schemes, *Manière de Bien Bastir* (Paris 1623; rev. ed. 1641).

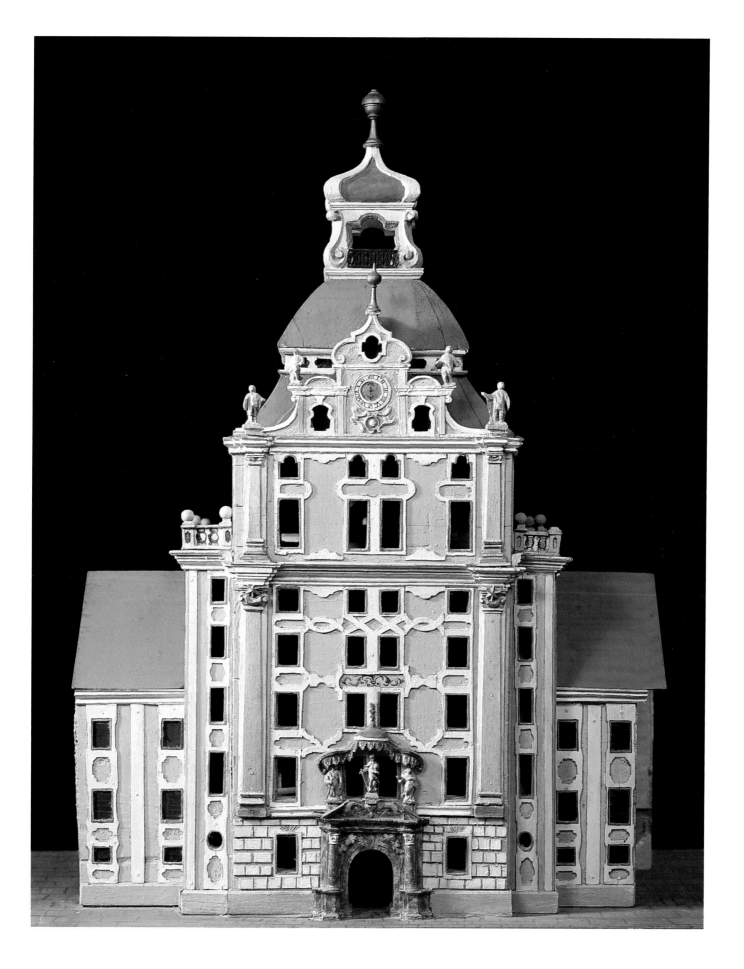

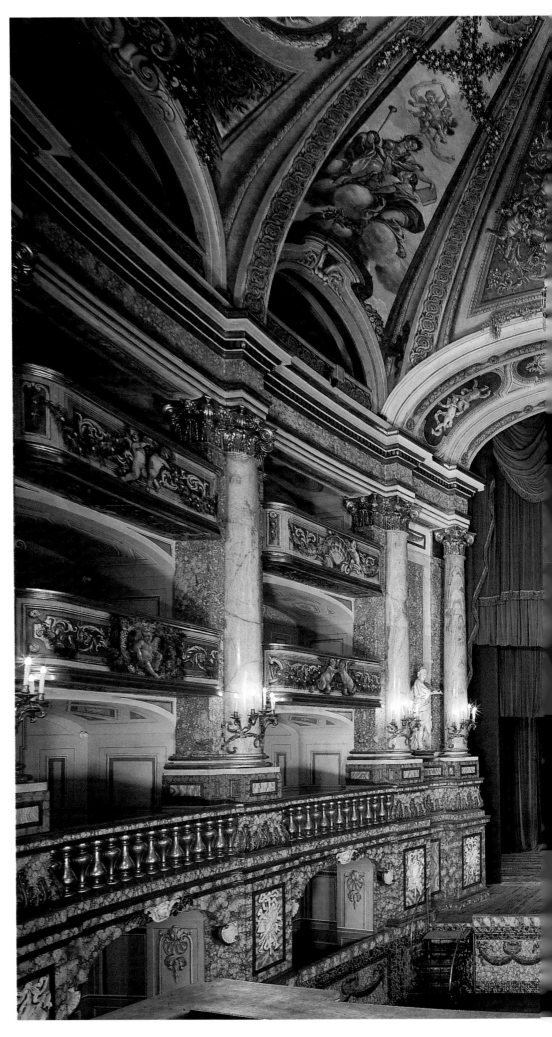

Axial view of the court theater
of the Reggia di Caserta, seen from
the royal box

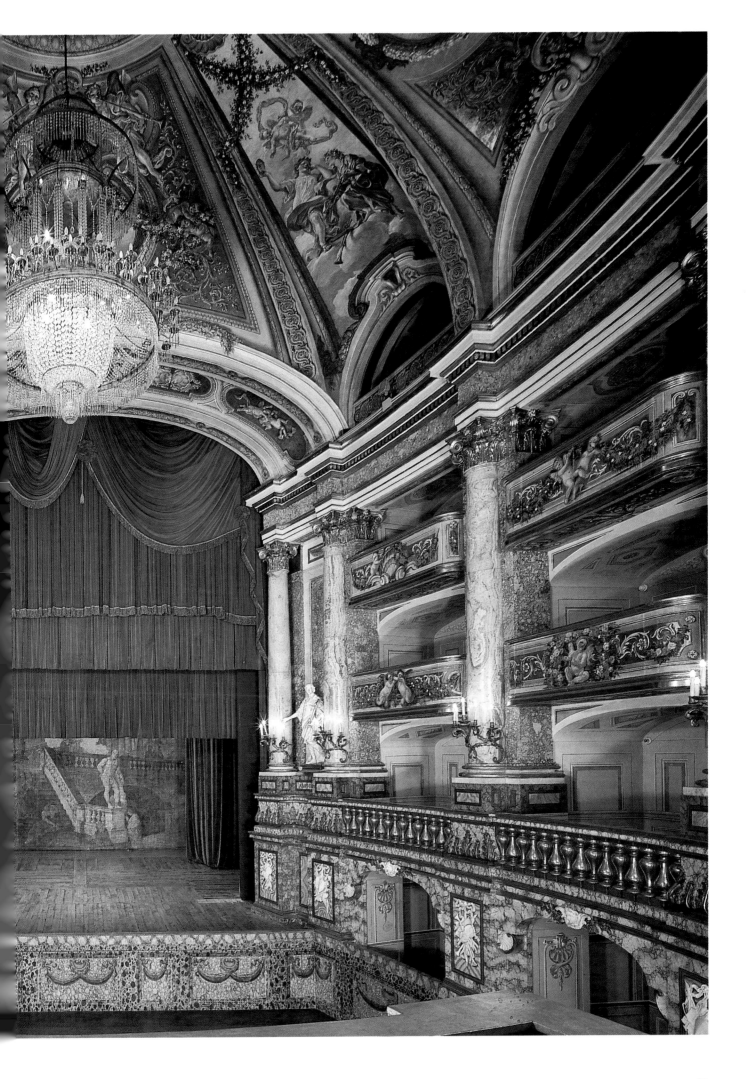

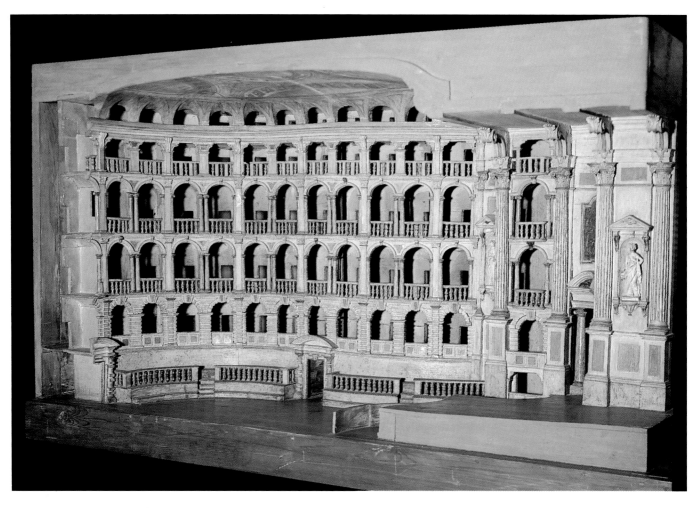

Antonio Galli da Bibiena
Model for the new public theater
in Bologna
Interior and detail
Bologna, Archivio Storico del Teatro
Comunale
cat. 450

Urbanization was good for architecture and made the townhouse the privileged site of architectural innovation and design. The proliferation of building manuals, model books, and treatises, mostly French, which convey information about construction, cost, and design; the residential squares of Paris, London, and Spain; the Parisian townhouses of Le Vau and Mansart and the aristocratic residences of Fischer von Erlach and Santini-Aichel in Vienna and Prague: all arise from the converging forces of urbanization and court society. It is demystifying to recall that the monumental palaces, however beautiful, were often bitterly cold or disturbed by malodors, but in the cities the upper classes began to enjoy a higher standard of comfort and hygiene as a result of new room layouts and amenities such as running water and flush toilets.

The pleasure of a Turkish coffee and sweet, hot chocolate, a warm bed and pump-operated commode – these were fundamentally urban experiences made possible by a developing infrastructure of roads and bridges, quais and ports, fountains and markets with imported goods. These systems sustained urban life and were essential elements in the Baroque laboratory of residential design and occasionally became monumental architecture themselves: the Fontana di Trevi and Porta di Ripetta in Rome; the Haarlem Meat Hall; Amsterdam Exchange; the Custom-House and Royal Exchange in London.

The avenue, according to Lewis Mumford, was "the most important symbol and the main fact about the baroque city." He conceived the Baroque street as an abstraction of power and movement: "The hastening of movement and the conquest of space, the feverish desire to 'get somewhere,' were manifestations of the pervasive will-to-power [of the Baroque age]."[11]

But this bird's-eye view has it all wrong. On the ground, Baroque streets were less about movement than prospect and place. They were usually short, bumpy, and slow, nothing like the infinite axis in Le Nôtre's gardens which implied but did not deliver unimped-

[11] Lewis Mumford, *The City in History*, New York 1961: 421 and 422.

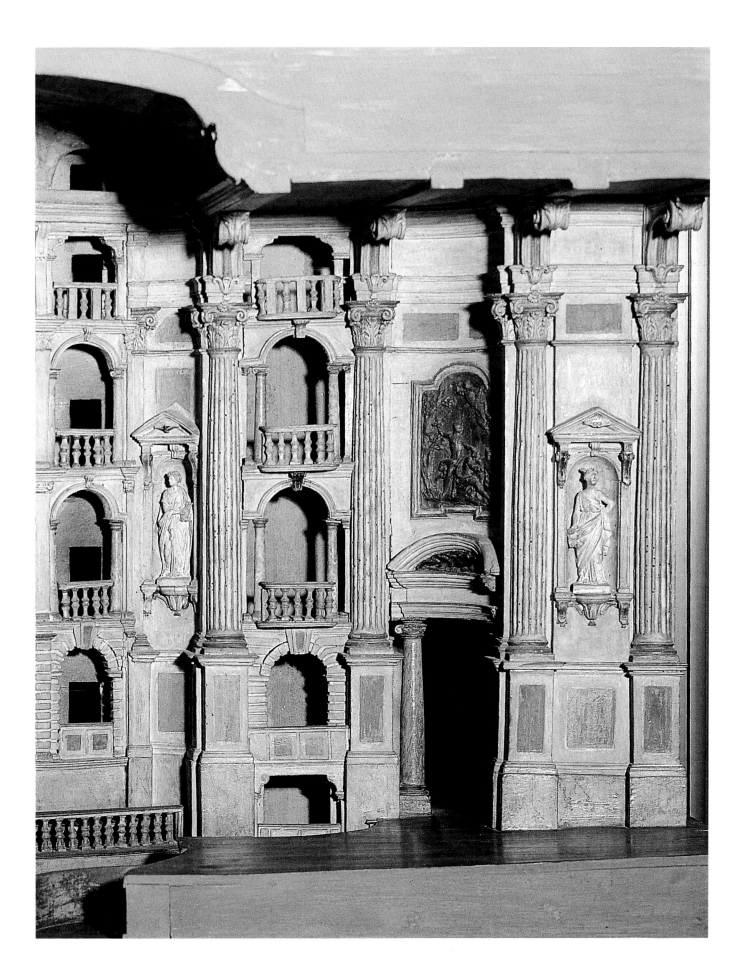

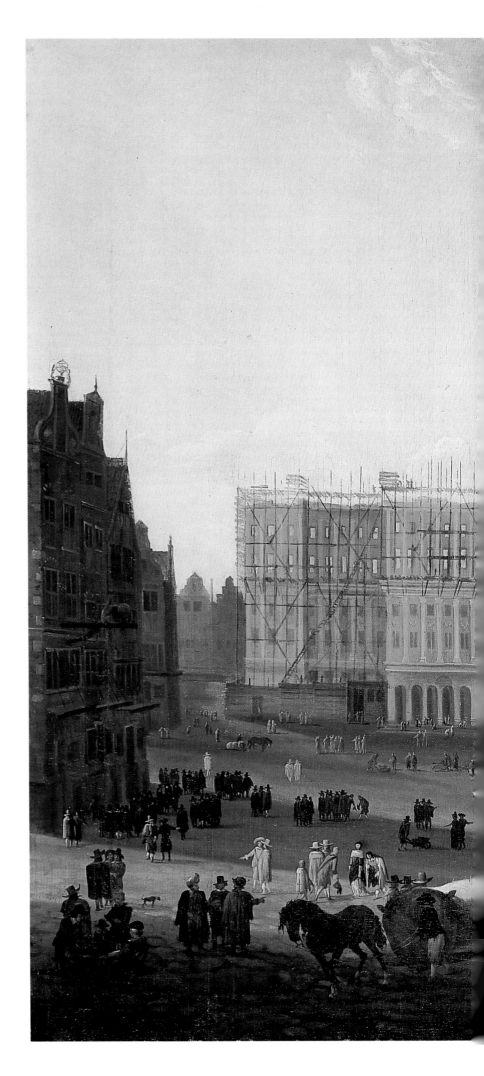

Johannes Lingelbach
*The dam at Amsterdam,
with the new Town Hall under
construction*
Amsterdam, Historisch Museum
on loan from the Rijksmuseum
cat. 400

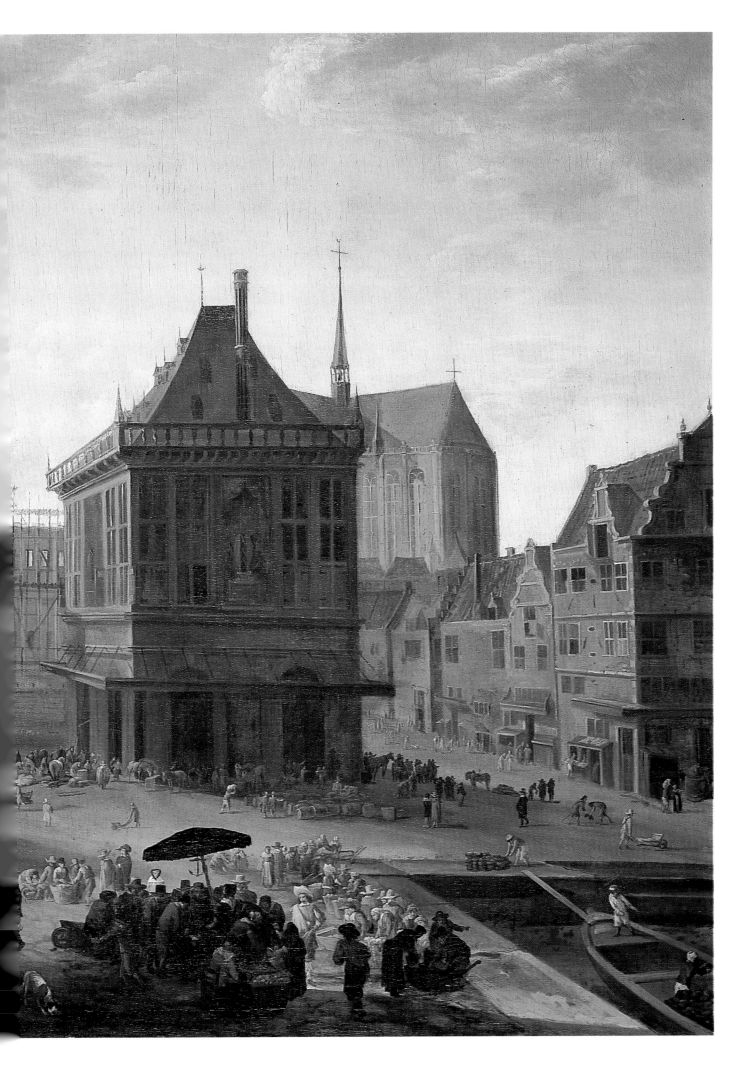

G. Pool (?)
Medal commemorating
the inauguration of Amsterdam
Town Hall
Paris, Collection Frits Lugt Institut
Néerlandais
cat. 396

ed movement. And streets were basically not conceived as plastic space but as service-able voids. Palace, townhouse, and piazza – these were the primary figures of Baroque urban form.

Religious renewal

The third structural factor which drove Baroque architecture and, in fact, accounts for its most wondrous buildings, was the renewal of religion after a half-century of religious conflict. It took several decades for the Reform orders to mature sufficiently to the point of being able to build monumental churches. Thus the Jesuits, Discalced Carmelites and Trinitarians, Oratorians, Minims, Visitadines, and Theatines, among other Reform orders, emerged in the seventeenth century as adventurous patrons, for they were in need of a new architectural image – a building to set them apart from the old orders, attract believers, and satisfy the revised liturgy of the Church. The liturgy was refocused on eucharistic devotion and on sermons, and these changes were not compatible with the traditional Latin cross plan, which distanced congregants from the chancel. Baroque architects accommodated mass, communion, and preaching in centralized spaces and deployed the full repertoire of architectural and decorative effects – light, color, surface decor, statuary, stuccowork, fresco, vaults and domes – to create a *theatrum sacrum*, theater of salvation. What modern visitors may regard as Baroque excess was meant to transport the believer to a sacred realm.

Although the art historical literature has focused attention on the centralized church in the Renaissance, this building type did not dominate church construction until the seventeenth century when Baroque architects fully explored the formal possibilities of circle, oval, and dome, and built countless examples (very few had been built in the Renaissance). The parallels between Catholic and Protestant churches arise from the fact that the Protestant emphasis on preaching had been absorbed by the Church of Rome: similar planning and liturgical considerations guided Wren and Hawksmoor when designing the London city churches, although Anglican churches eschewed rich decoration.

The pope may well be the prime example of the paradox between real and symbolic power: while their secular power was largely eroded, the architectural patronage of Popes Urban VIII, Innocent X, and Alexander VII provided influential models for all of Christendom. The Piazza Navona and Piazza San Pietro were urban paradigms because their combination of church (Sant'Agnese and San Pietro respectively) and palace (the Palazzo Pamphilj and the Vatican Palace) embodied a principle of monarchical rule, namely the unity of Church and state. This formula was widely adapted and accounts for the particular grandeur of Baroque palatine chapels – think of Guarino Guarini's Cappella della Sacra Sindone in Turin, Balthasar Neumann's chapel at the Würzburg Residenz, and Hardouin Mansart's chapel at Versailles – as well as the prominent role of the Crown in funding church construction.

Design methods

The political, social, and religious factors discussed above, all exogenous forces, only created a demand for architecture; the triumph of Baroque in turn depended on a supply of good architecture. Hence, it remains to consider the professional and artistic factors – call them internal factors – which equipped architects to meet the demands of state, city, and Church, and spread the Baroque far across Europe. First, let me suggest that one factor concerns the relationship of Baroque architecture to the past. The continental spread of Baroque architecture was comparable to that of Gothic, still the dominant vocabulary and building tradition in 1600. The overlap points to a significant feature of Baroque culture: its successful engagement with medieval building traditions and forms. Like the Modern movement in the early twentieth century, the Renaissance had presented itself as a rupture with the Gothic past, and although we now tease out connections with what was repressed, the Renaissance system and the Classical language of forms were perceived at the time in opposition to Gothic style. By contrast Baroque architects seemed to appreciate the Gothic and creatively responded to it.

This adaptation takes myriad forms depending on local contexts: the rich surfaces of the

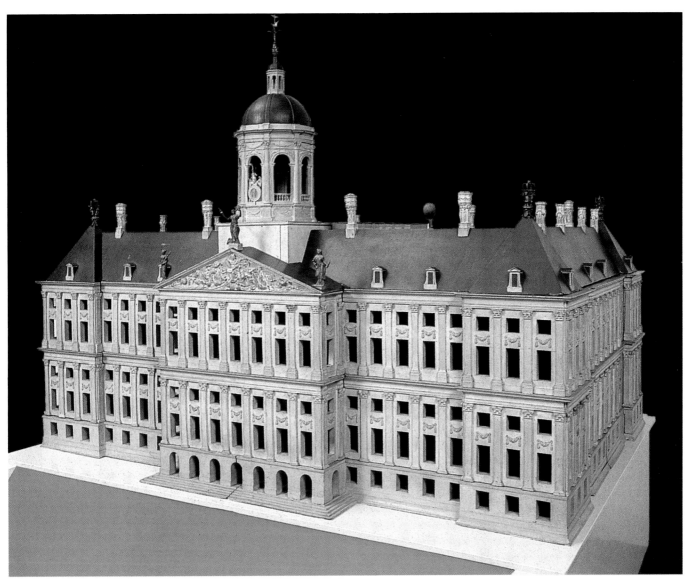

Jacob van Campen
Model of Amsterdam Town Hall
Amsterdam, Historisch Museum
cat. 389

Cartuja in Granada reflect the decorative wall treatment of Spanish medieval design; the perforated forms and open vaults of Borromini and Guarini evoke lofty Gothic vaulting interpolated through interpenetrating geometries; Santini-Aichel's dazzling ribwork explicitly responds to Bohemian Gothic; Claude Perrault explains the Louvre Colonnade in terms of Gothic intercolumniation; Wren modernizes Gothic vaults in St. Paul's Cathedral while Hawksmoor renders All Souls' in Oxford in medieval style; and the fabulous Baroque variations on the bell tower give new life to a medieval form. Since Baroque was not the first but the second wave of Classical design, seventeenth-century architects were no doubt better able to appreciate and make use of the medieval past. Indeed, one of the formal strengths of the Baroque is precisely the manifold ways the ancient and modern, Classical and Gothic are creatively fused.

Another internal factor relates to the disciplinary formation of architecture which over the course of the seventeenth century arrived at a new stage of professionalization. In addition to the architectural publications which disseminated knowledge more broadly than ever before, three major teaching and research institutes – the Académie Royale d'Architecture in Paris, and the Accademia di San Luca and the Académie de France in Rome – established a common vocabulary and approach to design. They also produced a cohort of nomadic architects who brought the flexible and expressive forms of Baroque architecture to courts far and wide. After winning the *concorso* of 1696 at the Accademia, Pompeo Ferrari went to Poland. Peter the Great imported numerous architects – Trezzi-

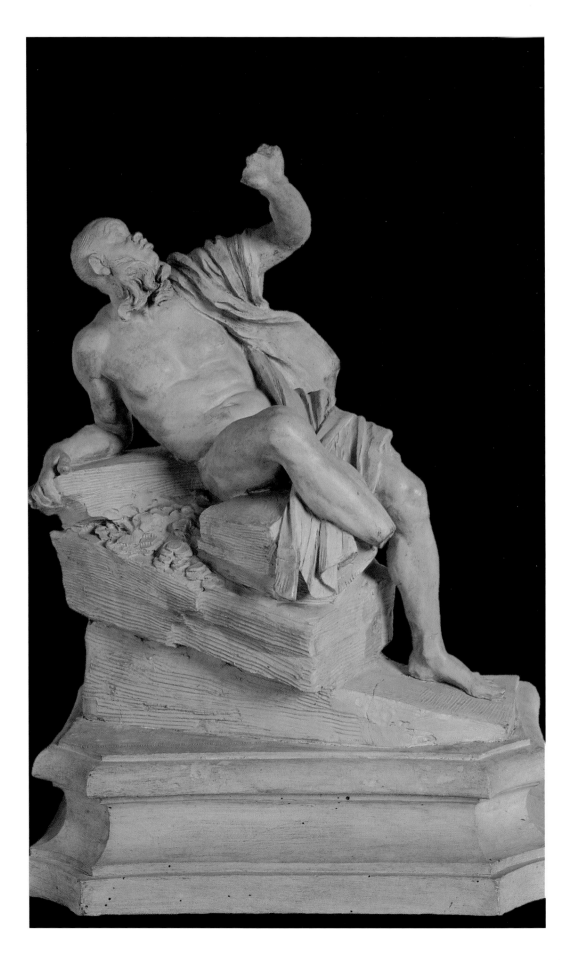

Gian Lorenzo Bernini
Rio della Plata
Sketch for the Fountain
of the Four Rivers
Venice, Galleria G. Franchetti
Ca' d'Oro
cat. 70

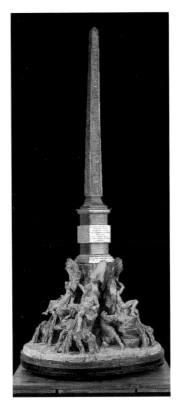

Gian Lorenzo Bernini
First model
for the Fountain of the Four Rivers
Full view and detail
Rome, Private collection
cat. 68

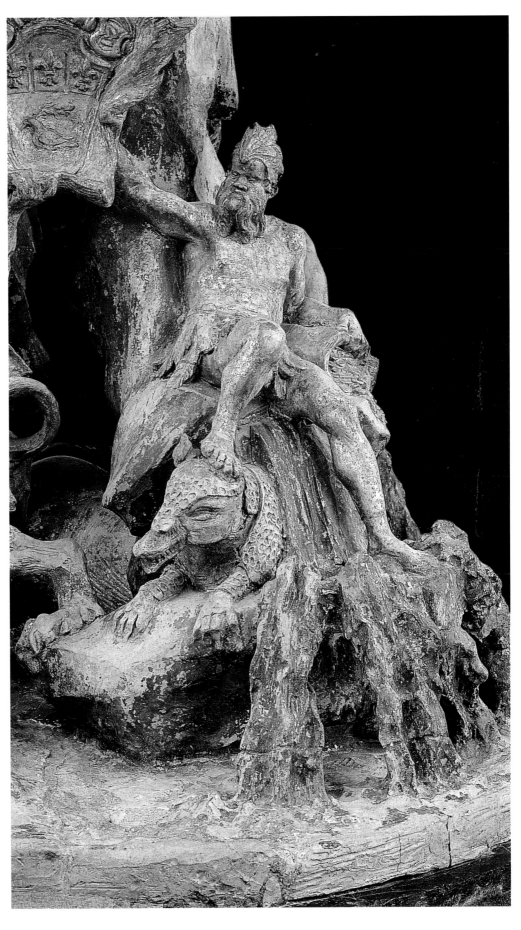

following pages
Giovanni Paolo Pannini
*Pope Benedict XIV visits the Trevi
Fountain in Rome*
Moscow, Pushkin State Museum
of Fine Arts
cat. 445

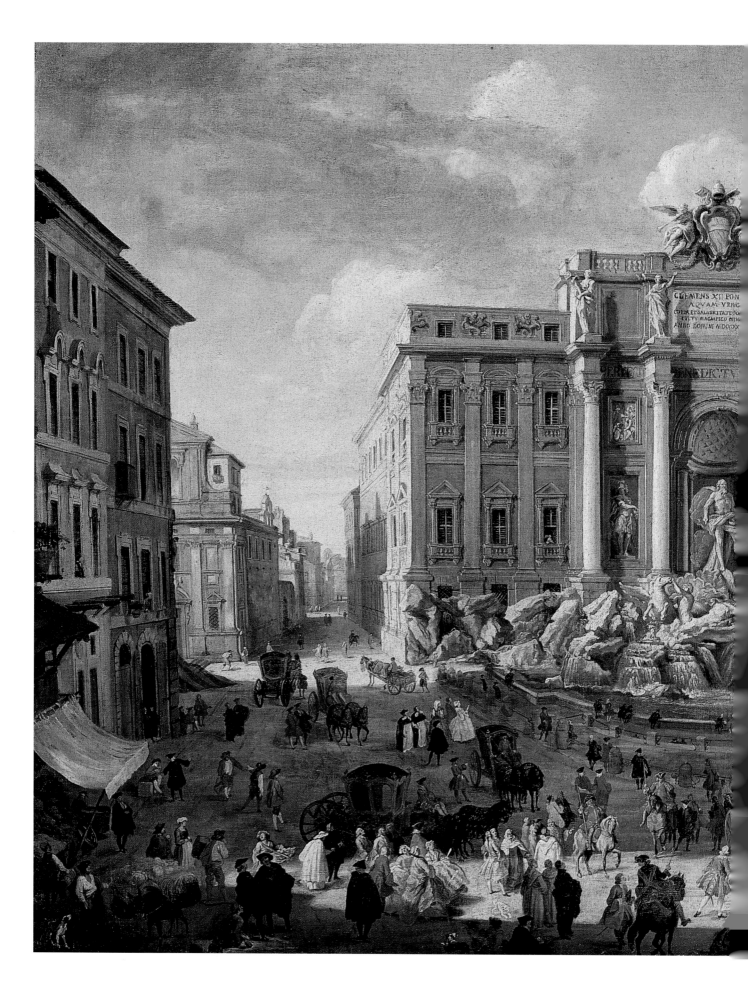

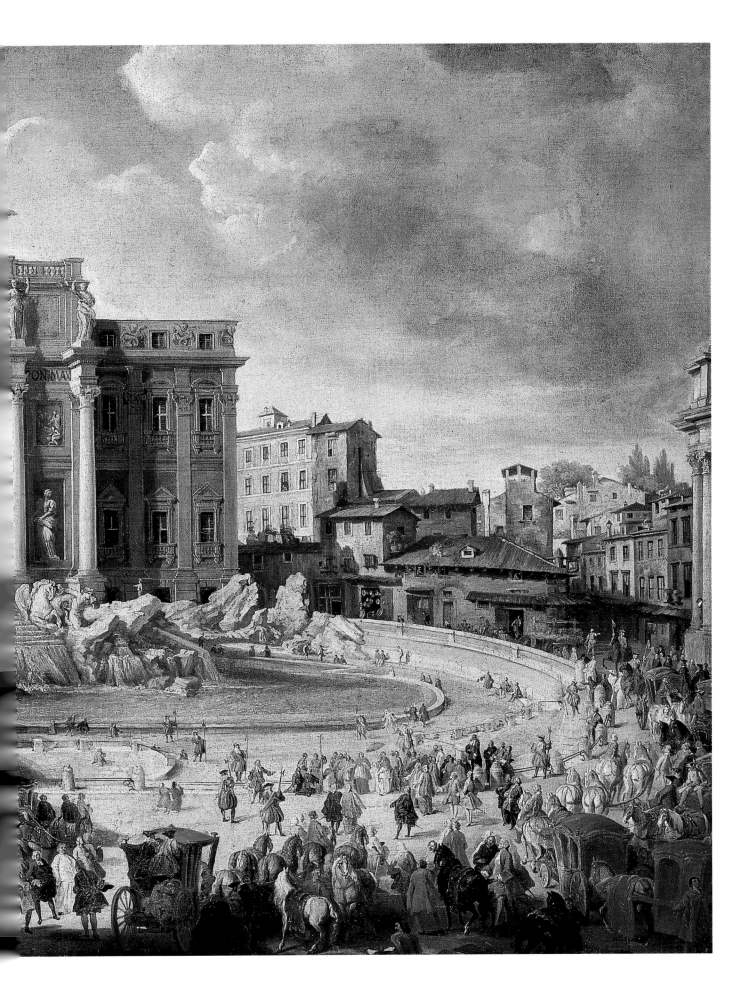

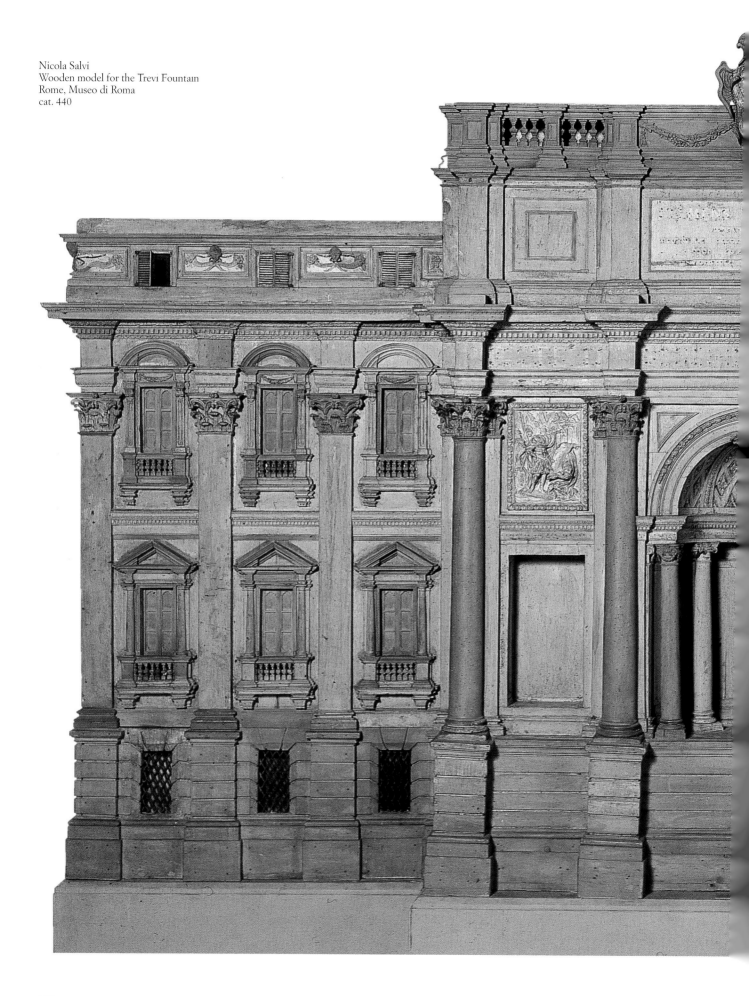

Nicola Salvi
Wooden model for the Trevi Fountain
Rome, Museo di Roma
cat. 440

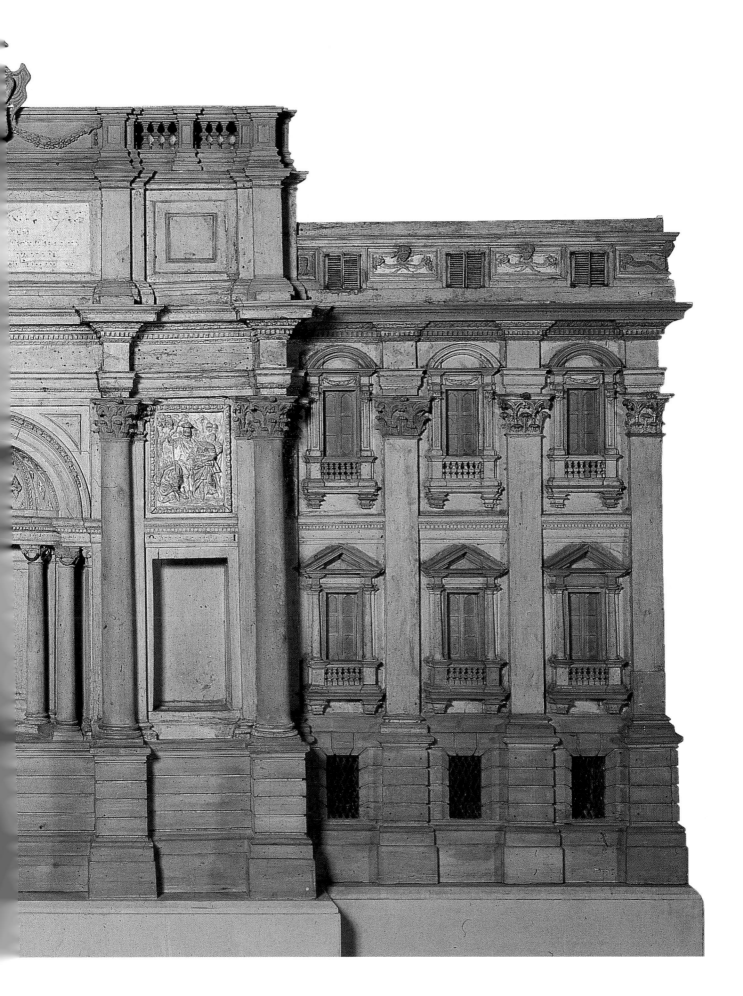

Robert de Cotte
Project for the Exchange Loggia
in Lyons
Paris, Bibliothèque Nationale
de France
cat. 483

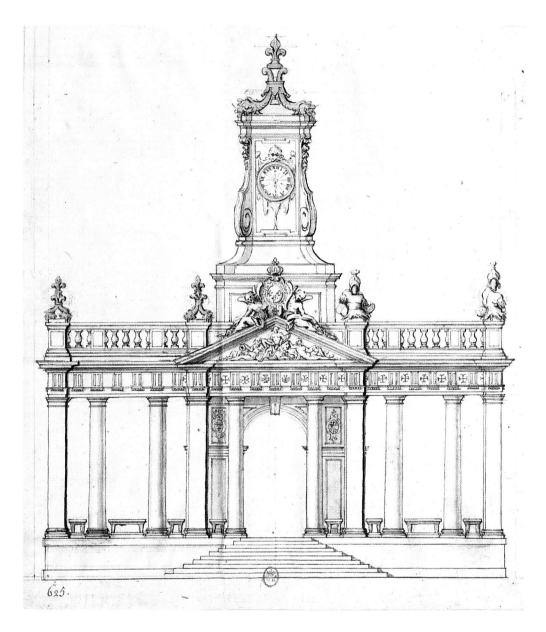

ni, Le Blond, Michetti, and Rastrelli to mention a few – to create a western city at St. Petersburg, and imperial and royal architects – Robert de Cotte, Balthasar Neumann, Fischer von Erlach, and Lucas von Hildebrandt – served foreign clients and often traveled abroad. Thus we encounter another paradox of Baroque culture: on the one hand it manifested a politically charged interest in national style, reflected for instance in Le Brun's French order, Colin Campbell's *Vitruvius Britannicus* (London 1715–25), or the imperial iconography celebrated in Fischer von Erlach's *Entwurff einer historischen Architectur* (Vienna 1721).

Yet at the same time, the institutional structures of Baroque architecture fostered a more international culture than ever before. Nationalism and internationalism were closely intertwined.

In this respect as well Nicodemus Tessin embodies the Baroque phenomenon. He forged a Swedish court based on cosmopolitan models and developed designs for Stockholm's royal palace by thinking through the Louvre.

Were it not for his obsession with the French palace, we would know almost nothing about the models by Bernini, Le Vau, and Perrault, all long ago destroyed but which Tessin thought to record. It is fitting that scholars now journey to Stockholm to learn from Tessin's extraordinary collection of drawings of French and Italian buildings, including

[12] The letter from Cronström to Tessin on 19 June 1706 is cited by Josephson, *L'Architecte de Charles XII*, op. cit.: 53.

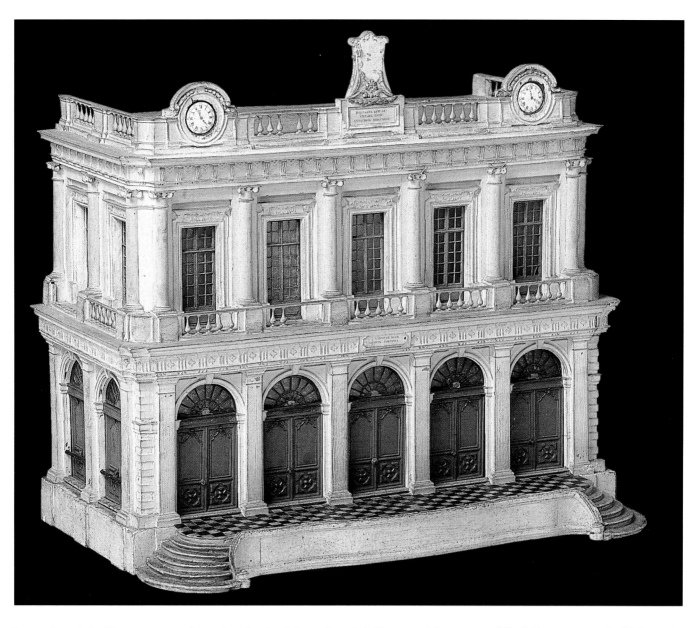

Jacques-Germain Soufflot
Wooden model for the Exchange
Loggia in Lyons
Lyons, Musée Gadagne
cat. 482

sheets he obtained from Bernini, Fontana, Mansart, and Le Nôtre, some of which are in this exhibition.

Tessin made a wooden model of his own design for the Louvre in 1705. It was tinted like stone, and the ornament was gilded "in order to please women at court."[12]

Borrowing presentational ideas from the realm of stagecraft, Tessin intended to populate the model with moving figures, but was advised they would detract from the grandeur of the scheme.

This tension between grandeur and delight reflects another paradox or, rather, resource of Baroque architecture: it was both an elite and a popular art. Baroque buildings glorified the state and organized its growing administrative apparatus; they sought to impress and overpower, yet they also knew how to please, entertain, and induce wonder on the stage, in the church, or at home. National and international, Classical and Gothic, intimidating and inviting, ceremonial and comfortable – Baroque architecture encompassed a range of divergent terms.

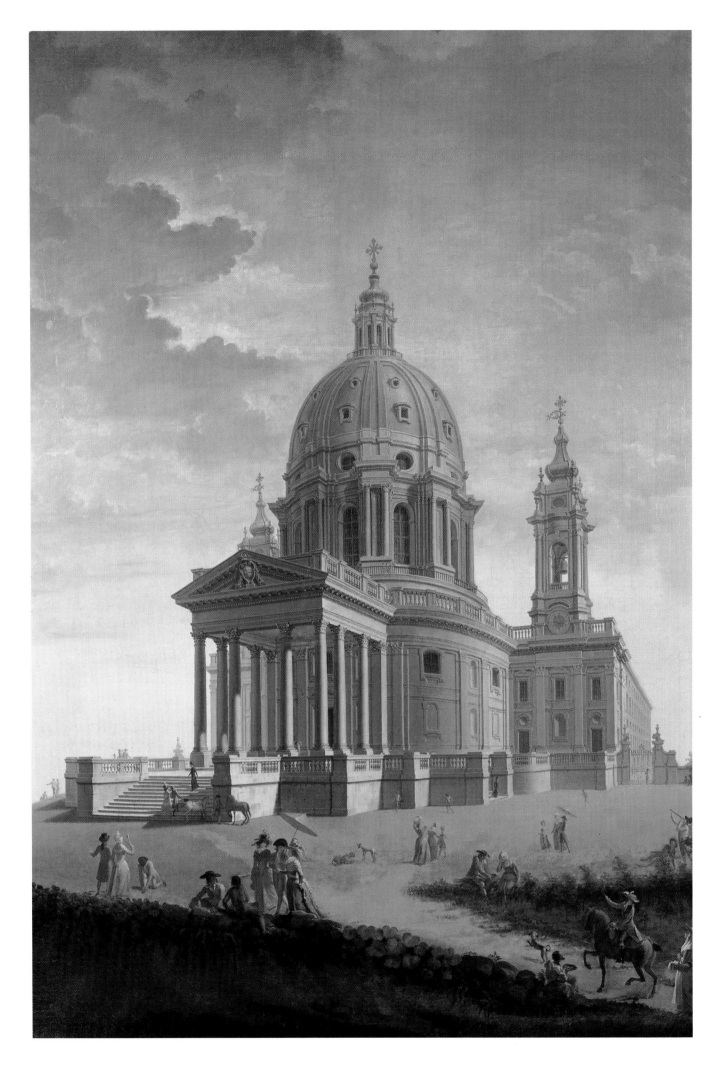

opposite
Giovanni Battista Bagnasacco
*Panoramic view of
the Basilica di Superga*
Turin, Palazzo Reale
cat. 539

The eighteenth century is generally known as the Enlightenment or the Age of Reason. This does not imply, of course, that man for the first time started to think, but rather that he invented a new way of using his power of reasoning. The significance of the new approach was clearly understood by contemporaries. Thus D'Alembert wrote that the *esprit de système* of the seventeenth century ought to be replaced by a new *esprit systématique*.[1] He thereby pointed out the very essence of the problem: in spite of its unrest and variety, the seventeenth century had been characterized by a general attitude – the belief that the world might be understood as a system deduced from a few immutable *a priori* axioms or dogmas. The Baroque age offered a multitude of such models: the philosophical systems of Descartes and Spinoza, the absolute monarchy by divine right, the dogmatic structures of Lutheranism, Calvinism, and the Counter-Reformatory Roman Church. A possibility of choice, thus, was introduced, and critical minds were soon led to the conclusion that systems have a relative rather than an absolute value. In the long run, therefore, the *esprit de système* could not satisfy man's need for a secure existential basis. But the lost certainty had to be replaced by something, and the solution was found in the liberation of reason from the fetters of preconceived ideas. Thus Voltaire wrote: "We must never say: let us begin by inventing principles according to which we attempt to explain everything. We should rather say: let us make an exact analysis of things."[2] Reason, thus, should be applied to the phenomena themselves, rather than to the deduction of "facts" from *a priori* axioms. Man suddenly realized that the conclusions ought to come at the end of the investigation, instead of being stated at its beginning. Reason thereby became the tool of a new empiricism, which already was conceived toward the end of the seventeenth century by John Locke, who said: "Whence has it [*i.e.*, the mind] all the materials of reason and knowledge? To this I answer in one word, from *experience*."[3] The classical British empiricism which was initiated by Locke derived all the contents of the mind from experience, and thus "replaced the metaphysics of the soul with the history of the soul."[4] At the same time natural science was led away from the arbitrary and fantastic assumptions of the past to a new method of observation and analysis. The great protagonist of the new approach was Newton, who replaced metaphysical explanations with systematic description and correlation of phenomena. His importance was immediately recognized, as demonstrated in these lines by Alexander Pope:

"Nature and Nature's laws lay hid in night;
God said, 'Let Newton be!' and all was light."

The empiricism of Newton, however, did not imply that he rejected philosophy and religion. But he regarded these subjects as the end of human knowledge, rather than as the foundation on which it must be built. Thus he wrote:

"The main business of Natural Philosophy is to argue from Phaenomena without feigning Hypotheses, and to deduce causes from Effects, till we come to the very first cause, which certainly is not mechanical. Does it not appear from Phaenomena that there is a being incorporeal, living, intelligent, omnipresent, who in infinite space as in his Sensory, sees the things themselves intimately, and thoroughly perceives them, and comprehends them wholly by their immediate presence to himself?"[5]

It would therefore be wrong to interpret the new scientific attitude as directed against religion. Even Voltaire's battle cry of "Écrasez l'infame" was directed against superstition rather than faith, and against the Church (that is, the system) rather than religion.[6] The basic innovation was the rejection of *a priori* ideas and "knowledge," introducing instead a systematic study of nature as it is. The aim was the discovery of regularity in the phenomena themselves, that is, natural laws. Baroque persuasion, thus, was replaced by the free exercise of reason, emancipated from the fetters of dogmas and authority.

The new scientific outlook was closely related to a new idea of freedom. Voltaire defended the doctrine of the freedom of the human will and said: "In fact, what does it mean to be free? It means to know the rights of man, for to know them is to defend them."[7] And the basic right is the right to influence others by words and teachings.

The philosophy of the Enlightenment, thus opposed the power of convention, tradition, and authority. But rather than consider this opposition as an act of destruction, the enlightened mind wanted to rediscover the "natural" foundation of knowledge. Rousseau considered the state of nature as a standard and norm according to which one can show what is truth and

[1] Jean-Baptiste D'Alembert, "Discours préliminaire" to the French *Encyclopédie* (1751).
[2] Voltaire, *Traité de Métaphysique*, quoted in E. Cassirer, *The Philosophy of the Enlightenment* (1932), Boston 1955: 12.
[3] John Locke, *An Essay Concerning Human Understanding*, 1690.
[4] Cassirer, *The Philosophy of Enlightement*, op. cit., 99.
[5] Isaac Newton, *Opticks*, London 1730: Query 28.
[6] There were, of course, others – such as Holbach and Diderot – who rejected any form of religious faith.
[7] Cassirer, *The Philosophy of Enlightement*, op. cit., 251.

Newton analyzes a ray of light
Engraving, late 17th cent.
Milan, Civica Raccolta Stampe
Achille Bertarelli

Cover of the *Mathematical Principles
of Natural Philosophy*
by Isaac Newton
1687 edition
Milan, Civica Raccolta Stampe
Achille Bertarelli

Gottfried Heinrich Krohne
Detail of a book of drawings
for the orangery in Gotha
Gotha, Thüringisches Staatsarchiv
cat. 221

law and what is mere illusion and convention. No wonder, hence, that the old dogmatic systems tended to disintegrate during the eighteenth century.

Already during the French Régence royal power was undermined and the court lost its role as the very center of the system. New patrons and new centers of culture replaced the absolute ruler and his palace. In general, the middle class took over from the impoverished and decayed nobility, and the city regained some of its cultural life.

Even the Roman Church was secularized, and the great advocates of the Counter-Reformation, the Jesuits, were expelled from most countries.[8] In 1781, Joseph II of Austria closed all convents because their members "were devoted to an exclusively contemplative way of life and did not contribute to the good of their neighbor or civil society."[9] What, then, should replace the traditional organizations? Rousseau offered an answer in the concept of a society where the individual is protected by the united power of the political organization and where the individual will exist only within the framework of the *volonté générale*. "In short, each giving himself to all, gives himself to nobody; and as there is not one associate over whom we do not acquire the same rights which we concede to him over ourselves, we gain the equivalent of all that we lose, and more power to preserve what we have."[10] The centralized and hierarchic system of the seventeenth century, thus, gave place to a multitude of interacting, equal elements.

A profound psychological change resulted. While the Baroque attitude may be characterized by the word "persuasion," the enlightened mind centered on "sensation." Accordingly, the illusive, allegorical image was replaced by the natural, true image. Truth and beauty, reason and nature, are but different expressions for the same thing, for one and the same order of being, different aspects of which are revealed in natural science and art. The attitude is well expressed in Newton's maxim: "Nature is always in harmony with itself." Since experience was taken as the point of departure, sensation gained a new fundamental importance, and the eighteenth century offers many valuable studies on the nature of perception, the most famous being Berkeley's *New Theory of Vision* (1709). The attitude of the epoch is well expressed in Berkeley's statement, "Without experience we should no more have taken blushing for a sign of shame, than of gladness."[11] In art the empirical approach led to genres, which correspond to the species of natural objects. Neither the scientist not the artist created order; he only ascertains things as they are. This search for the true phenomena led to a study not only of nature, but also of history. In this context we must understand the characteristic dream of the century: the golden age when man lived in close contact with na-

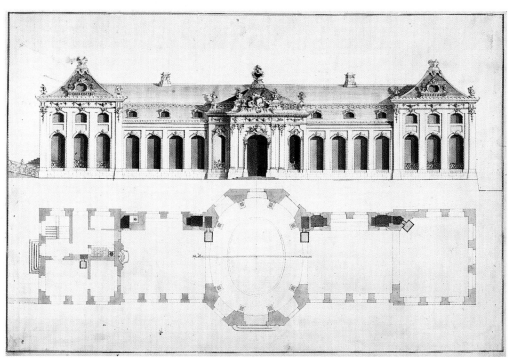

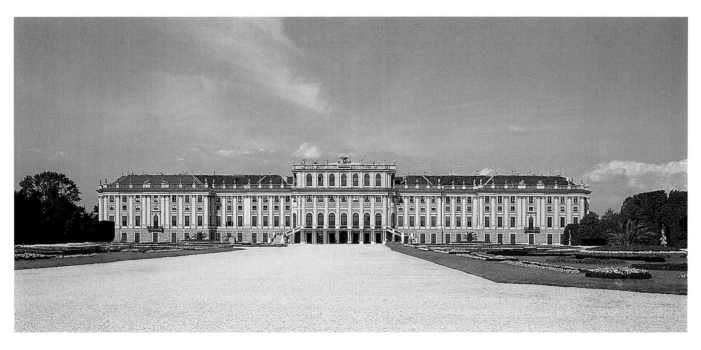

The castle of Schönbrunn by Johann Bernhard Fischer von Erlach

ture and was guided by his natural instincts only. It was the dream of Rousseau and also of the architectural writer Laugier, who went back to the primitive hut to rediscover the true, natural elements of architecture: column, entablature, and pediment.[12] The Greek temple inherited the simple logic of the primitive hut, and thus we understand why Neoclassicism formed the natural goal of eighteenth-century architecture.[13]

But the old system did not fade away at once. The creation of a new philosophy and science was not accomplished overnight, and the old political systems survived most of the century. Up until about 1760, thus, Late Baroque and Rococo architecture dominated the scene. The Rococo is an interesting transitional phenomenon.[14] It abolished Baroque rhetoric and reflects many characteristic intentions of the Age of Reason, but at the same time its forms express a certain nostalgia for the *Grand Siècle*. We may liken it to Voltaire, who said: "I do not like heroes, they make too much noise in the world;" but thereupon he wrote his great book, *Le Siècle de Louis XIV*. The Rococo, thus, shows the empirical interest in sensation, but transforms scientific observation into the enjoyment of sensuous stimuli – visual, auditory, gustatory, olfactory, and, last but not least, erotic – which became a main justification of life. At the same time, however, Rococo dwellings are based on a true empirical study of comfortable living, and show a functional differentiation unknown before. Rococo spaces also have an intimacy which contrasts strongly with the infinite extension of Baroque architecture, and reflect the desire for a return to a more natural state of affairs. The form that gave Rococo its name, the *rocaille*, may in fact be characterized as a caprice of nature.

Rather than illustrating nature's grand design, however, it expresses its transitory and perishable aspects, thereby defining the Rococo as the end of a development rather than a new beginning. The Rococo must be distinguished from the Late Baroque architecture which flourished in Central Europe during the first half of the eighteenth century. It represents the natural expression of a belated Counter-Reformation, and reflects as well the ambition of many small monarchies to imitate the Versailles of Louis XIV. But the German Baroque also assimilated ideas from the current Enlightenment and Rococo, and thereby arrived at a singular synthesis which fused monumentality and intimacy, rhetoric and charm, abundance and clarity.

This versatile movement marks the culmination of the great European tradition. It may be compared to the philosophical system of Leibniz, which also represents a singular synthesis of the *esprit de système* and the *esprit systématique*. Leibniz still accepted the existence of general principles and considered pure reason greater than sensory perception. But his system had a character different from those of Descartes and Spinoza.

While these still operated with simple, static identities, Leibniz introduced a new "dynamic

[8] The Jesuits were expelled from Portugal in 1759, from France in 1764, from Spain in 1767, and from Austria in 1773.
[9] Quoted in W. Braunfels, *Abendländische Klosterbaukunst*, Cologne 1969: 265.
[10] Jean-Jacques Rousseau, *Social Contract*, quoted in Cassirer, *The Philosophy of Enlightment*, op. cit., 261.
[11] Berkeley, *Essay Towards a New Theory of Vision*, LXV, 1709.
[12] See W. Herrmann, *Laugier and 18th-Century French Theory*, London 1962: p. 50.
[13] In 1770 the Elector of Bavaria ordered that all churches be built in "classical" style.
[14] The best general introduction to the Rococo is the article by Hans Sedlmayr and Hermann Bauer in the *Enciclopedia Universale dell'Arte*, vol. XI, Venice-Rome 1963.

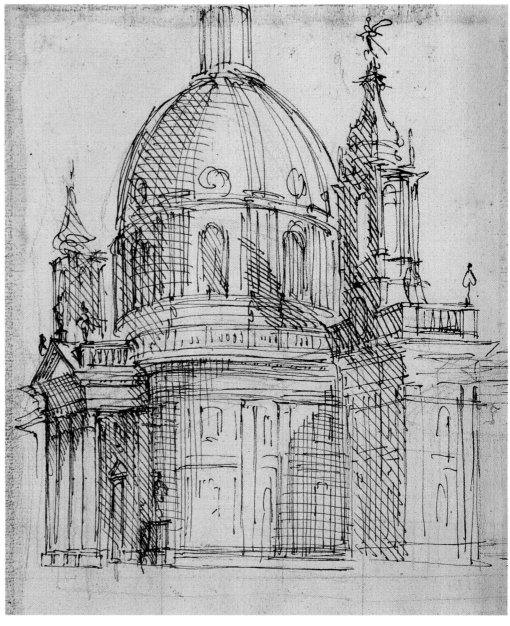

[15] See Gottfried Wilhelm Leibniz, *Monadologie* (1720), Hamburg 1958.
[16] The term stems from A. Dorner, *The Way Beyond Art*, New York 1949.
[17] This fact was acknowledged by S. Giedion in *Space, Time and Architecture*, Cambridge (Mass.) 1941.
[18] E. Guidoni, "Modelli Guariniani," in *Guarino Guarini e l'internazionalità del barocco*, Turin 1970.

pluralism." His monads are living centers of energy, and the world is constituted by an infinity of such monads.[15] They are all different, but interact and undergo a continuous process of transition from one state to another. Every monad therefore contains its own past and is pregnant with its future. We understand, thus, that Leibniz goes far beyond the Baroque concept of a basically stable, hierarchical system, at the same time that he supersedes the idea of a universe in harmony with itself. His monadology, in fact, points toward the modern idea of a whole which is "more than the sum of its parts," and which consists of an interaction of "self-changing forces."[16] The philosophy of Leibniz, thus, links the Baroque age with our present world, just as Late Baroque architecture forms one of the "constituent facts" of modern architecture.[17] Both aspects were already brought together in the works of Guarino Guarini. His *Placita Philosophica* (1665) described the world as an *ars combinatoria* expressing itself as an incessant, undulating rhythm, and his buildings concretize this concept in pulsating organisms, which are open and indeterminate, but also characterized by a particular formative principle, inherent in the single spatial cell: "Architecture, therefore, is like the encyclopedia, the construction of the new scientific world: a building, precarious in so far as its single parts are concerned, but pregnant in future developments on account of its deliberately systematic nature."[18]

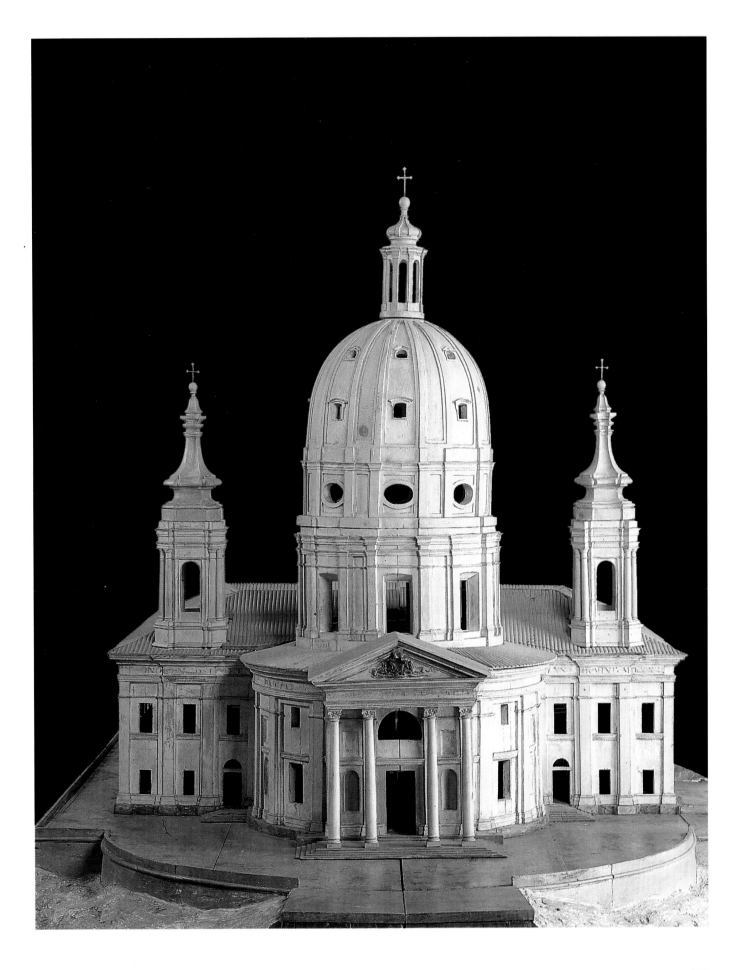

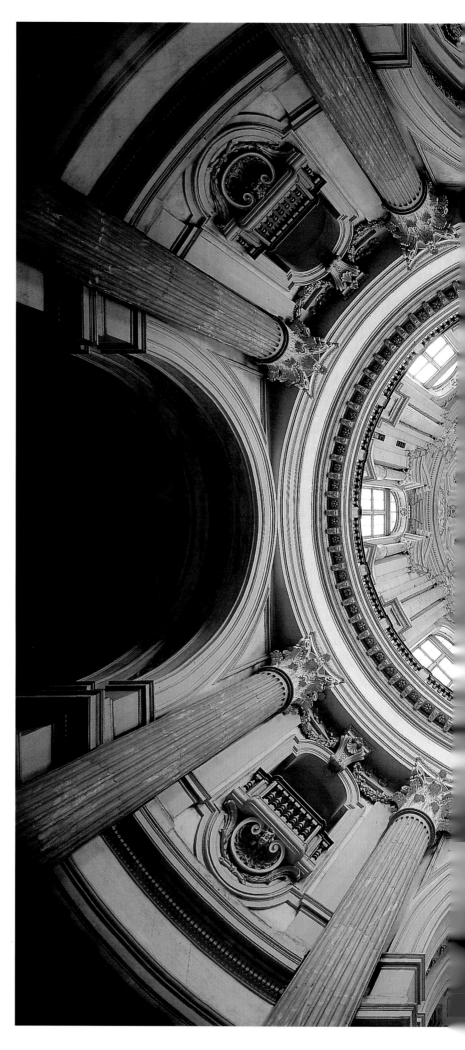

Interior view
of the dome of the Basilica
di Superga

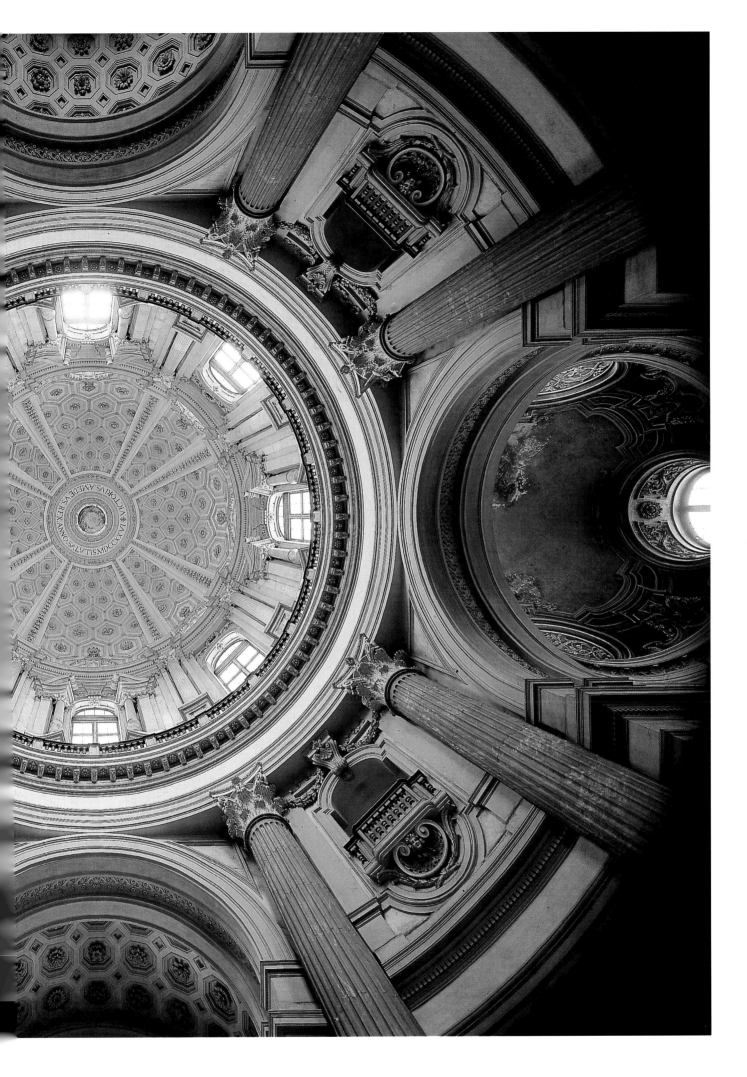

Benedetto Alfieri
Wooden model of the palace
of the Curia Maxima in Turin
Turin, Museo Civico d'Arte Antica
Palazzo Madama
cat. 407

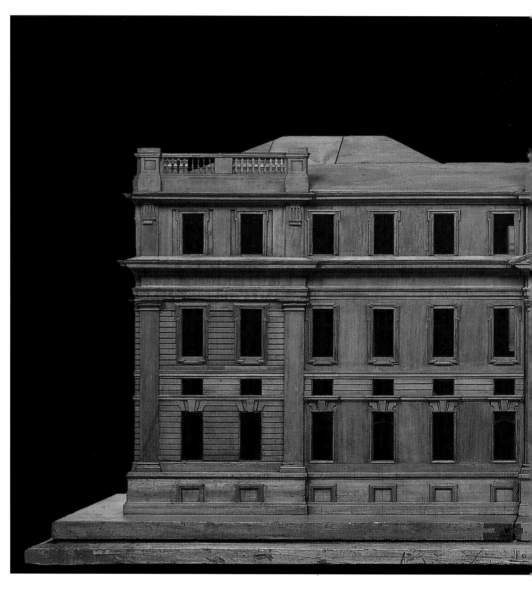

The basic spatial and typological problems of Late Baroque and Rococo architecture form a continuation of seventeenth-century intentions, but are characterized by a new pluralism of expressive means. We must distinguish here between two currents. Firstly, we find the wish for an historical synthesis which is already evident in the works of Borromini and Guarini, and which culminates with Johann Bernhard Fischer von Erlach's *Entwurff einer historischen Architektur*, 1721. The book, in fact, is the first comprehensive history of architecture, and it ends with his own synthetic projects. Secondly, we encounter a general attempt at giving each building, and every room within it, an individual characterization. Although buildings have always differed according to the practical and symbolic functions they have had to fulfill, eighteenth-century pluralism is something essentially new, pointing toward the historicism of the nineteenth century. As a particularly successful representative of the pluralistic approach we may mention Filippo Juvarra (1678–1736), whose activity comprises all the main building types of the epoch. Instead of thinking in terms of abstract systems, Juvarra gave each type an individual character, to which he first gave a general definition in brilliant sketches, which show an extraordinary sensitivity for the function of the building as well as for the site in question. The Basilica di Superga (1715), for instance, is primarily intended as a vertically directed focus in relation to the landscape. Its retrained classical forms and elevated position give it the pure, spiritual appearance of a shrine which gives confirmation to the strength and integrity of belief. The large, inviting portico echoes the forms of a Roman temple, while the *campanili* add a note of Baroque rhetoric. The Su-

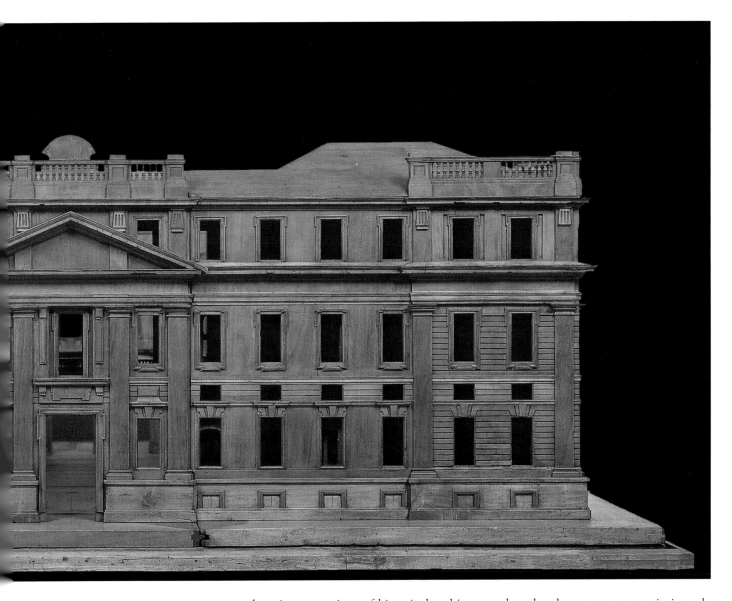

[19] See H. Bauer, *Rocaille*, Berlin 1962: 47.

perga, thus, is a true piece of historical architecture, but the elements are more intimately fused than in the compositions of Fischer. In fact, Juvarra transcends the level of persuasive allusion and arrives at a true psychological synthesis that expresses the range of the human mind. In his great façade and staircase for the Palazzo Madama in Turin (1718–21), Juvarra defines the exterior in terms of representative monumentality approaching the character of French classical architecture. In the interior, however, the forms become plastically alive and accompany the festive movement of the splendid stairs. The public dignity of the façade, thus, is transformed into a more intimate, albeit grandiose, Baroque interior world full of surprises and expressive details.

Many words have been used to draw a demarcation line between Late Baroque and Rococo architecture. In general, we may say that the Late Baroque conserved the belief in a great comprehensive synthesis, while the Rococo takes differentiation and individuality as its point of departure. As a consequence, the latter tends to abolish the classical orders and replace their tectonic quality with figured ornaments on a neutral wall surface.[19] In reality, however, it is hardly possible or necessary to make a clear distinction. The German sacred architecture of the eighteenth century certainly represents a last great synthesis, although its treatment of wall, ornament, and color to a large extent has a Rococo character. Even in France it is hard to point to a pure example of Rococo architecture. The "inventor" of Rococo forms, Juste-Aurèle Meissonnier (1695–1750), did not leave any concrete achievement behind, and we must turn to the old master Germain Boffrand (1667–1754) to find what is

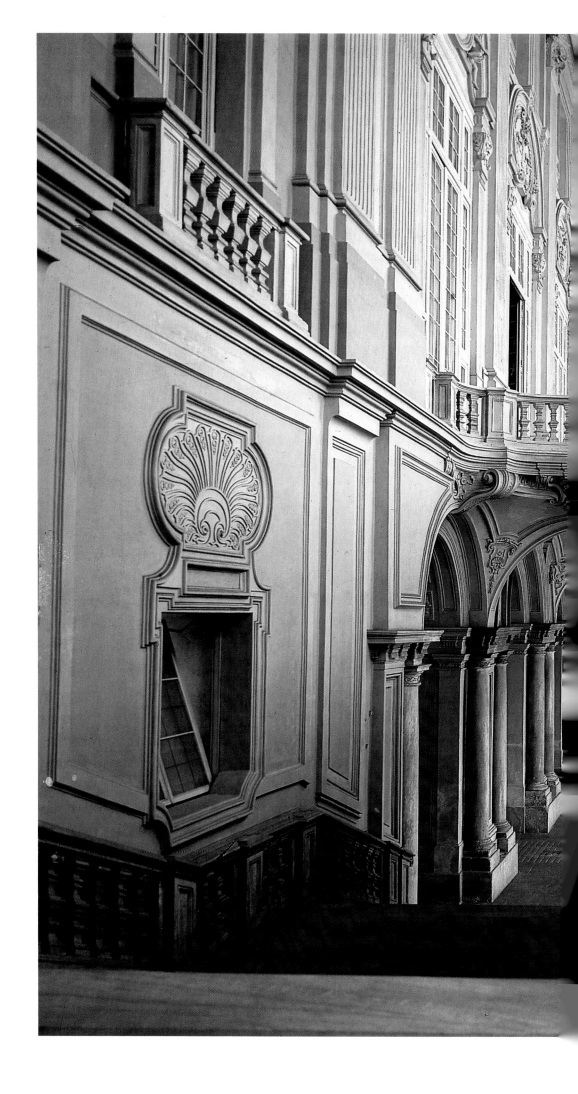

Perspective view
of the staircase
in Palazzo Madama, Turin
by Filippo Juvarra

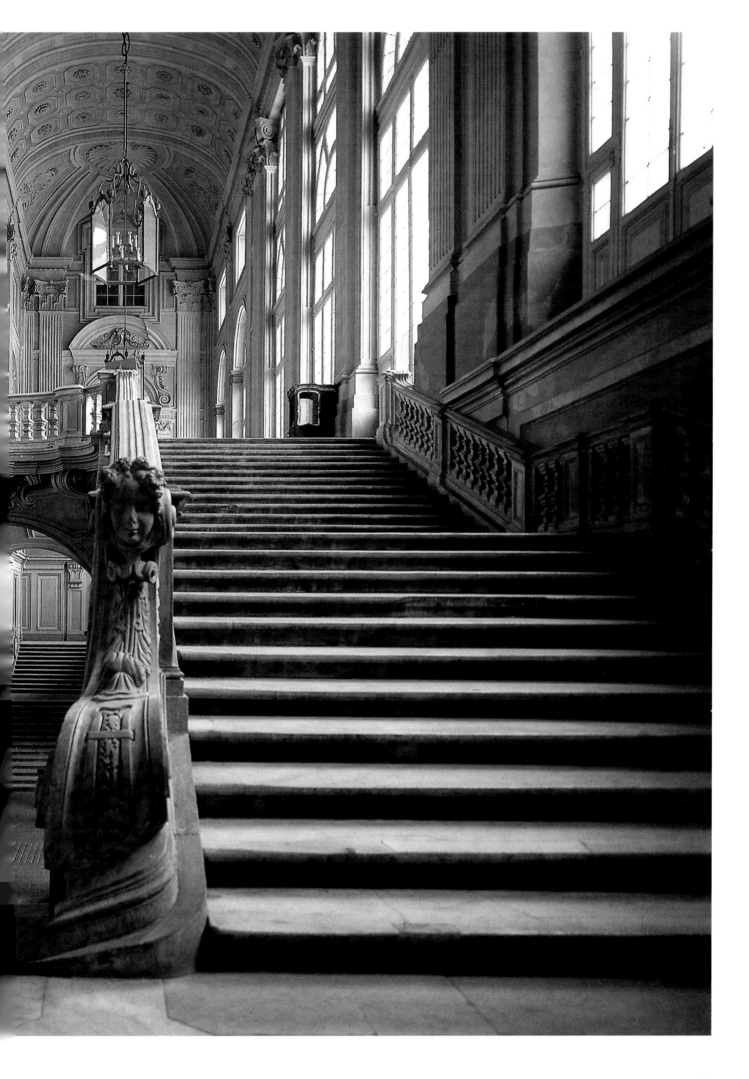

Longitudinal section
of the Vierzehnheiligen sanctuary
by Balthasar Neumann

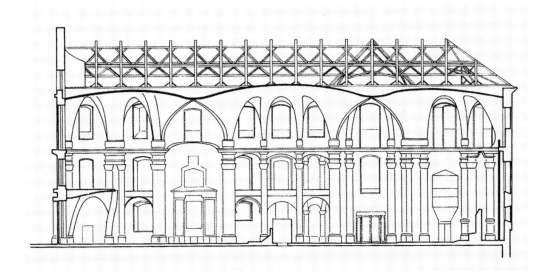

generally considered the masterpiece of French Rococo interior decoration. In Boffrand's oval salon in the Hôtel de Soubise in Paris (begun 1735) a continuous wall of large windows (or mirrors) alternates with narrow panels. The wall is united with the richly adorned ceiling by means of a series of freely shaped paintings by Charles Natoire. In general, the space seems to fuse indoor and outdoor characters. An ambiguous character is also found in the high altar of the pilgrimage church of Vierzehnheiligen, one of the few examples of a three-dimensional *rocaille* (designed by Johann Jakob Michael Küchel, 1744–63). Built without any tectonic substance, it expresses a total dissolution of classical form. In relation to the strong spatial and skeletal system of Balthasar Neumann's (1687–1754) church, however, the altar appears as an expression of a meaningful extreme of human sentiment.

The dissolution of the classical tradition also took place as a Neo-Gothic current. It is particularly visible in England, where it already appeared in Sir Christopher Wren's (1632–1723) Tom Tower at Christ Church in Oxford (1681–82). The movement culminated with Nicholas Hawksmoor's (1661/2–1736) All Souls' College in Oxford (1716–35) and with his towers for Westminster Abbey, completed by John James (1734–45). Independently of the English development, we find quite an interesting Gothic current in Bohemia. As early as 1703 Johann Santini-Aichel (Giovanni Santini, 1677–1723) rebuilt the large church of the Cistercian abbey in Sedlec near Kutná Hora, which had been destroyed during the Hussite wars, and in 1712 he took charge of the reconstruction of the Benedictine abbey in Kladruby.[20] In both cases he was requested to build *more gotico* ("in the Gothic manner") to revive the monastic tradition of the Middle Ages. He solved this problem in a very personal way: the splendid system of interlacing ribs that is used to articulate the vaults of the two churches has no structural function; it is purely decorative. In reality the buildings consist of continuous surfaces on which lines are drawn. They lack classic plasticity as well as a true Gothic skeleton, and the result is of an almost surreal character.

Although apparently different, the Neo-Gothic buildings thus have important formal properties in common with the contemporary Régence and Rococo. And both styles are basically nostalgic and irrational in character. The Rococo is a play of the transitory and perishable, while the Neo-Gothic current turns to surreal abstractions, creating thereby an expression of frigidity and alienation – two manifestations, therefore, of the dissolution of the anthropomorphous classical tradition. No wonder that man again sought new security through a Neoclassical revival. The new classical architecture, however, did not solve the problem. Rather than arriving at a true human synthesis, it put together devalued fragments by means of academic rules and considerably narrowed the range of expression attained by Baroque architecture. Being an architecture of "reason," it did not sufficiently take the psychological need for a meaningful environment into consideration. The split between basic form and expressive decoration found in Rococo and Neo-Gothic architecture was not conquered, but was succeeded by a one-sided emphasis on rational structure. The

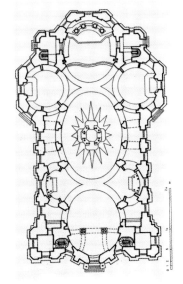

Plan of the Vierzehnheiligen
sanctuary
Milan, Civica Raccolta Stampe
Achille Bertarelli

[20] See C. Norberg-Schulz, *Kilian Ignaz Dientzenhofer e il barocco boemo*: 42ff.

View of the main nave
of the Vierzehnheiligen sanctuary

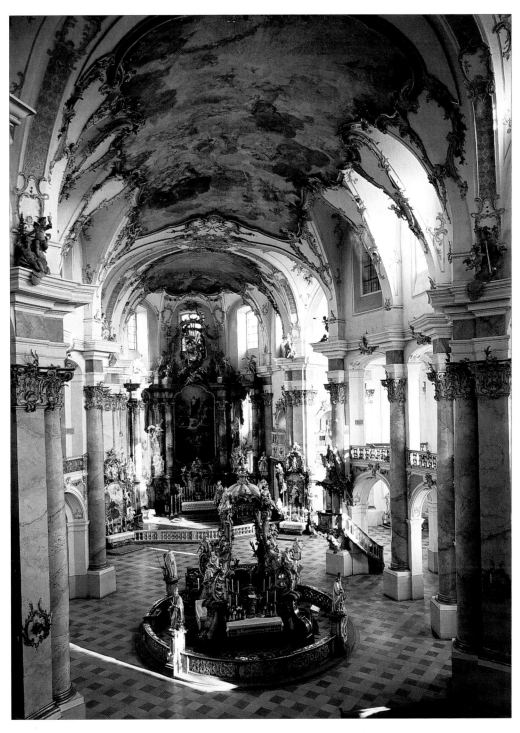

last organic style in the history of European architecture, therefore, is the Late Baroque of the eighteenth century.

The church

The most important manifestations of Late Baroque and Rococo sacred architecture are found in Central Europe. After the Thirty Years' War (1618–48) a great Catholic restoration took place, which in many respects represented a continuation of the Counter-Reformation. Architecture, therefore, must be understood as part of a missionary activity, and until the end of the epoch, about 1770, it maintained its Baroque persuasive rhetoric. To accomplish its object, it had to arrive at a synthesis of local and Roman elements. The medieval tradition, which had been interrupted by the Reformation, had to be revived, and its Gothic

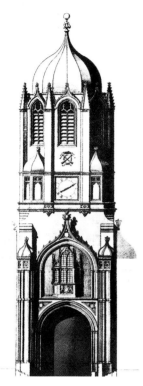

Reconstruction
of the Tom Tower
at Christ Church, Oxford
by Christopher Wren

opposite
View of the staircase
of College Hall,
Christ Church, Oxford

forms fused with the classical importation. So it was natural that the Central European architects were particularly open to those Italian works which had an affinity to Gothic architecture, that is, the architecture of Borromini and Guarini. But the general aim of persuasion also made them adopt the illusional means of Bernini's *theatrum sacrum*. The Late Baroque of Central Europe, therefore, represents an exceptionally rich synthesis.

Great themes of architectural history are brought together in the churches of the Baroque. The concepts of center, path, and extension are fused into a last comprehensive synthesis. During the seventeenth century the longitudinal movement had primary importance. The Counter-Reformatory church required this symbol of God's people on their way. The vertical axis represented an ideal center which accompanied the journey, and the apparent infinite extension concretized the spirit of conquest and rapture. The rhetorical and persuasive character of High Baroque architecture was assimilated in Central Europe before the turn of the century, and can be found in the works of Christoph (1655–1722) and Johann Dientzenhofer (1663–1726), for example, Christoph's St. Nicholas on the Kleinseite in Prague and Johann's Benedictine church at Banz. The buildings of these architects form part of a profound and popular renewal of religious values. In the early churches of Kilian Ignaz Dientzenhofer (1689–1751), such as St. John Nepomuk in Prague, we find an ideal synthesis of centralization and longitudinality within a general, infinitely extended multilateral system. His churches radiate the forces represented by the ideal center, and their undulating walls express this process. Therefore they belong to a truly Late Baroque architecture, and in a certain sense mark the culmination of the Baroque epoch.

After 1730, however, we find a growing interest in turning the movement inward, and the dominant rotunda appears in the works of both Balthasar Neumann and Johann Michael Fischer (1692–1766). The longitudinal axis, however, remained a necessary component in their projects for large pilgrimage churches, seen for example in Fischer's Benedictine church at Rott am Inn (1759–66). Yet instead of aiming at truly synthetic Borrominian solutions, the architects tried to integrate centralization and longitudinality without sacrificing their individual identity. We find the same tendency in all the great churches of the period. Buildings of this kind are still Baroque, in spite of Rococo or Neoclassical decoration, but in some cases the longitudinal movement and the feeling of substantial extension are abolished. The movement really turns inward and is concretized in diaphanous, centralized structures. To a certain extent this holds true for the churches of Domenikus Zimmermann (1685–1766), and certainly for most of Bernardo Antonio Vittone's (1702–70). To classify such buildings as Rococo is hardly satisfactory. They may have lost the persuasive rhetoric of the Baroque proper, and as a substitute offer a sort of spiritualized sensualism, which certainly is related to the Rococo. But we should understand that this aim can be attained in various ways, from the evident Rococo of the Wieskirche to the somewhat arid classicism of San Michele at Rivarolo. In Paris we might also cite Jacques-Germain Soufflot's (1713–80) Ste-Geneviève (project 1757) in this connection. The content of the works of art sometimes lies beyond their stylistic categories.

To conclude, we may point out that the architectural development of the Catholic church arrives at a final solution which has a certain affinity with the typical Protestant church. The centralized of the latter types also represent a gathering around an inner center (dedicated to the Biblical word), and their bright illumination was certainly intended, consciously or unconsciously, to be something more than a mere practical aid for easier reading. The greatest of all Protestant Baroque churches, the Frauenkirche in Dresden, begun in 1726 by Georg Bähr (1666–1738), may also be characterized as a diaphanous centralized structure, in which the main space is surrounded by a complex system of light-chambers.[21] Thus we see here an unconscious ecumenical spirit that prefigures the Enlightenment.

The palace

The basic constituent types of eighteenth-century secular architecture are the French *hôtel* and the Italian *palazzo*. Both types were fully developed during the seventeenth century. The Late Baroque and the Rococo offer no fundamentally new typological contribution. We find, however, many interesting attempts at combining the main elements of the tradition, as well as a further development of basic intentions, such as the functionally differentiated plan. Particularly important is the new relationship between the inside and the outside

[21] The church was destroyed during World War II. See H. G. Franz, *Die Frauenkirche zu Dresden*, Berlin 1950.

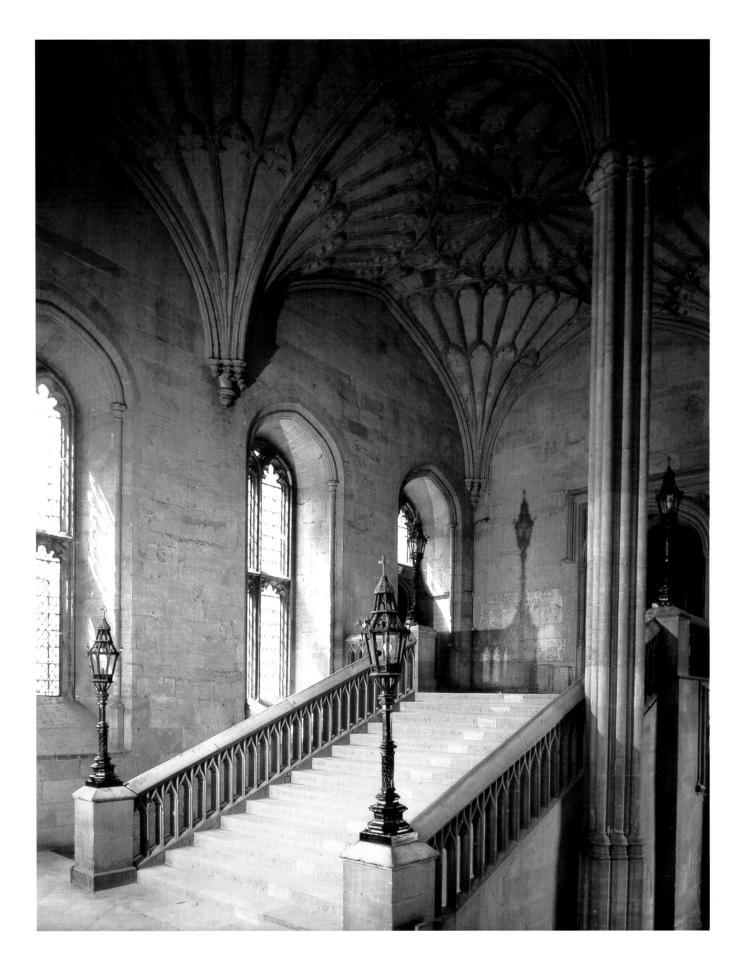

The sanctuary of Wies, Bavaria
by Dominikus Zimmermann

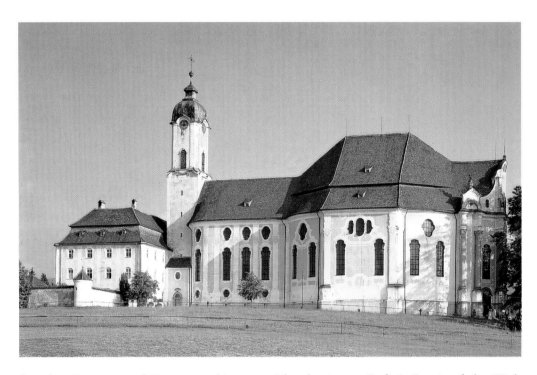

found in Régence and Rococo architecture. The dominant, "infinite" axis of the High Baroque, thus, is succeeded by a more intimate contact with the immediate surroundings. The development followed the social system and way of life of the country in question. Austria offers a particularly rich palace architecture which reflects the influence of Catholic Rome, as well as the wish to imitate and surpass the forms of the French monarchy. Thus, Austrian state architecture is basically Baroque, although its historical synthesis, seen for example in the great Belvedere palace in Vienna by Johann Lukas von Hildebrandt (1668–1745), also expresses the new pluralism of the eighteenth century. The German scene is dominated by the palatial residences of the many small capital cities, which indeed reflect the great model of Versailles. Thanks to the genius of Balthasar Neumann, some of these buildings, such as the Residenz in Würzburg, are true masterpieces which may be considered the culmination of Baroque palace architecture. In Russia a very colorful Late Baroque palace architecture was created about the middle of the century under the Tsarina Elizabeth. Although an Italian, Bartolomeo Rastrelli (1700–71), was mainly responsable for it, his works such as the Winter Palace in St. Petersburg have an unmistakably Russian flavor. In England we also find a characteristic Late Baroque architecture, mainly during the reign of Queen Anne. Its great manifestation is Blenheim Palace, built for the Duke of Marlborough by John Vanbrugh (1664–1726).

The Late Baroque palace displays many individual and regional approaches, but also some basic common trends. In general we may say that the longitudinal axis of the High Baroque tended to lose its dominant importance, even in the residences of the absolutist princes and monarchs, for example in the Hunting Lodge at Stupinigi by Juvarra. It no longer formed the core of an infinitely extended system; the range became more restricted and intimate. The love for intimate and comfortable living even led many French architects such as Robert de Cotte (1656/7–1735) in the Palais de Rohan in Strasbourg to block the axis entirely, a tendency usually found in conjunction with other Rococo characteristics, such as the abolition of the classical orders and the introduction of a continuous enveloping wall. In Central Europe, however, the longitudinal axis was maintained to give the palace the desired representative distribution of spaces. But the system to which it belongs no longer pretends to be universal and infinite. The great residences of Neumann like the Residenz in Würzburg, for instance, are not timeless solutions like Versailles, but have an empirical relationship to a concrete environment. Without trying to communicate actively with the surroundings, the palace turned inward, so to speak – a tendency which is also expressed by the growing interest in splendidly decorated salons. In these interiors a brilliant but transitory life took

opposite
The nave of the Wieskirche
Bavaria

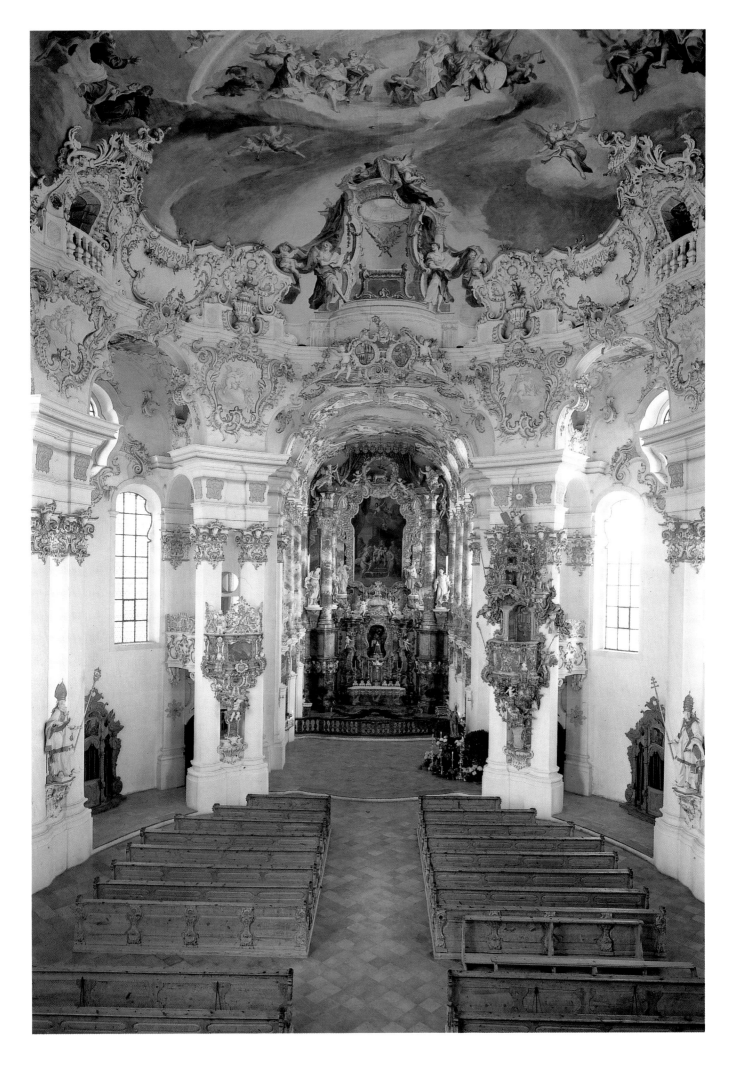

The Belvedere Palace in Vienna
in an 18th-century engraving
Milan, Civica Raccolta Stampe
Achille Bertarelli

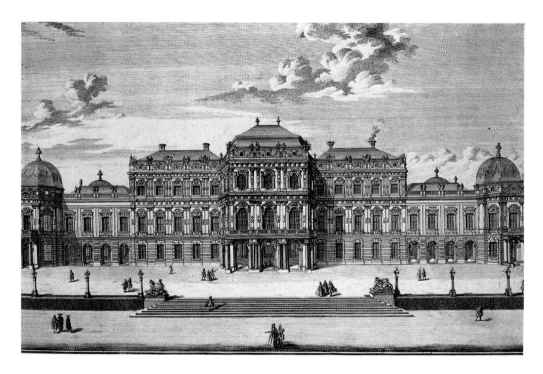

place; it is deeply significant that a transitional space such as the staircase became the focus of many residences. The weakening and gradual abolition of seventeenth-century dogmatism was also combined with a new pluralistic approach which aimed, at a fuller understanding of all phenomena and an adequate characterization of the individual situation.

Varieties of Late Baroque architecture
The seventeenth century offered a certain degree of choice between different systems or ways of life, yet each system claimed to have absolute and comprehensive validity. The pluralism of the Baroque age, therefore, represented a possibility rather than a reality. During the eighteenth century, however, Baroque pretensions faded away. Man realized that life can be lived in different ways and thus made pluralism operative. But of course he still needed a synthesis. Instead of a dogmatic synthesis by exclusion, the new synthesis became one of inclusion – that is, a result of experience and empirical research. This is the background for the new historical approach that distinguishes Late Baroque architecture. As experiences differed from place to place, so architecture also attained a more pronounced original color than before. Some architects, however, tried to create an all-inclusive synthesis, viewing their situation as being determined by the total inheritance from the past. Others tried to abstract universal and natural elements from history. Believing that the Greek temple was derived from the primitive hut, they arrived at Neoclassicism. Others again must have felt the death of the old systems as a tragic loss, or the new freedom as a state of uncertainty and conflict. As a result the architecture of the eighteenth century presents an extremely complex picture, not easily reduced to a few common denominators. Because of the slow change in society and the strong vestiges of an architectural tradition, we can, however, still point out the significant structural types, and we can study the varieties of their interpretation. The church and the palace were inherited from the seventeenth century, and both originally represented the chief Baroque systems: Counter-Reformatory Catholicism and absolutist monarchy. Although they were in a certain sense opposed to the ideas of the Enlightenment, these two systems had such a powerful momentum in their rich traditions that they could not merely wither away. But the church and the palace had to adapt to the new psychic and social climate, and profound changes took place during the first decades of the eighteenth century.

The dogmatic systems still exist, but consciously or unconsciously they tend to give up their absolutist pretensions, and to a certain extent they also begin to form more or less inclusive syntheses. Existence, thus, becomes psychologically differentiated and individualized, and

opposite
The staircase of the bishop's
residence in Würzburg, Franconia
by Balthasar Neumann

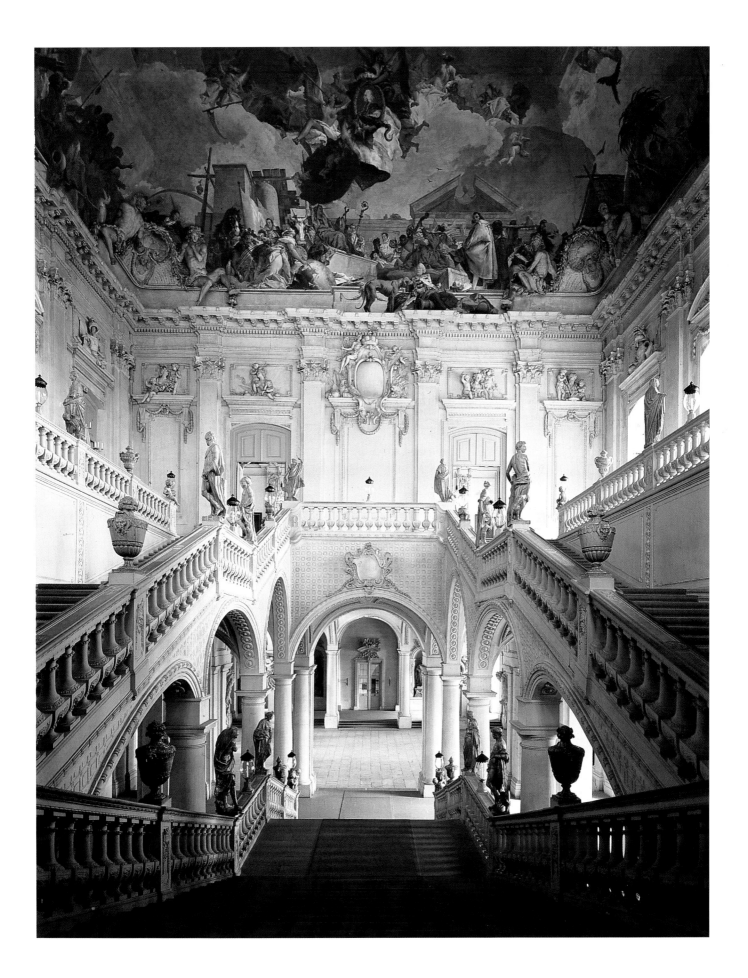

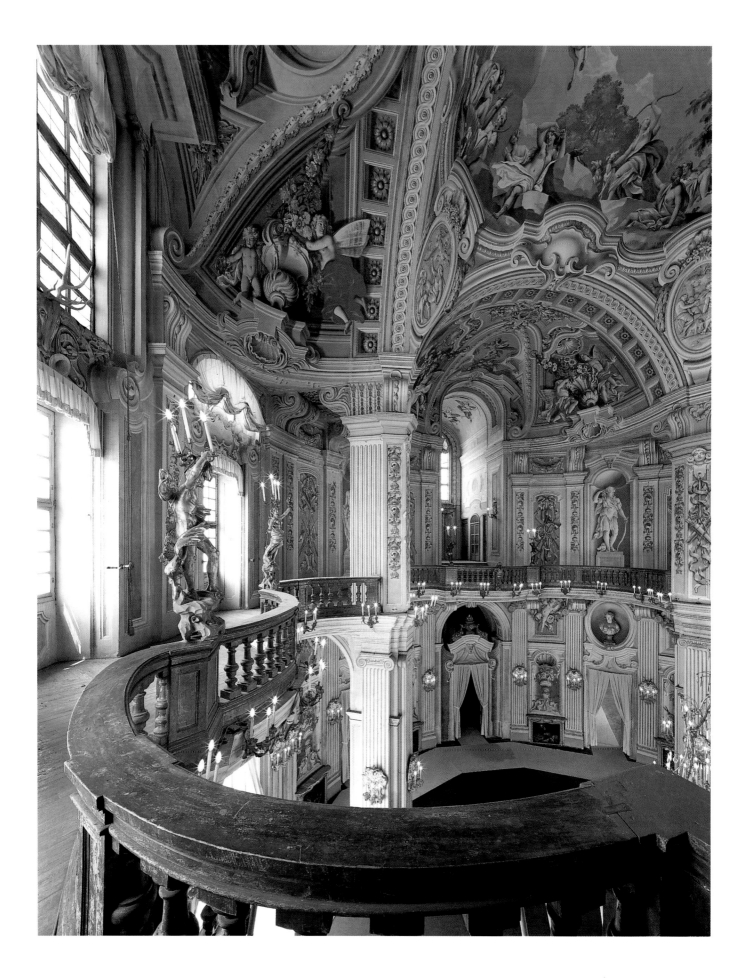

opposite
Interior of the *grande salone*
of the Stupinigi hunting lodge

man's ideas correspondingly relativized. We may quote Jacques-François Blondel here: "All peoples have a character of their own, a way of feeling which is proper to them."[22]

The architectural forms, therefore, also tend toward more pronounced individual characterization. Centralization, which symbolizes man's belonging to a place, becomes still more important, whereas the longitudinal movement loses it strength. The forces represented by the center, thus, are turned inward and no longer form part of an infinitely extended system. In other words, the buildings become more intimate and functional. This process naturally happened in different ways in different countries; we can, however, point out a general development which corresponds quite well to generations of architects.[23]

The first generation produced the great pioneers of architectural synthesis, who wanted to unify different traditions and create an inclusive architecture. These were born in the 1650s, and their foremost representatives are Fischer von Erlach and Christoph Dientzenhofer. In a certain sense Vanbrugh also belongs to this generation, but at the same time he forms a link with the succeeding one, which is marked by the desire for pluralistic characterization and corresponding formal differentiation, that is, a new *esprit systématique*. Born about 1670, the architects of the second generation are numerous and show many varieties of approach. Their foremost representatives are Boffrand, Hildebrandt, Juvarra, and Santini-Aichel. The third generation could perhaps be characterized as integrators. Their aim was to unify the different possibilities into a new kind of thematic whole, and their approach is characterized by a combination of the *esprit de système* and the *esprit systématique*. Of those born about 1690, the main representatives are Neumann, Kilian Ignaz Dientzenhofer, and Johann Michael Fischer. In a certain sense Vittone also belongs to this generation, but he is marked as well by the desire for "archetypal simplicity" so dear to the Neoclassical generation born about 1700.

In France the second and fourth generations were important: thus we find a differentiated and sophisticated Rococo which leads directly to Neoclassicism. In Austria the first and second generations were decisive and created a wonderfully articulate historical synthesis. In Germany the third generation accomplished a singular integration which represents the culmination of Late Baroque architecture.

The complex aims, attitudes, and local circumstances make it futile to classify the different manifestations of the epoch by means of stylistic categories. To talk about German Rococo would be to grasp only one of the components of the comprehensive works created by German eighteenth-century architects. In any case, stylistic categories are approximations. The whole Baroque epoch is, in fact, characterized by many diverse currents which during a shorter or longer period had some basic aspects in common. The psychological and formal differentiation of the Late Baroque, thus, is already apparent in the works of Borromini. In general, it may be considered the most important aspect of the development. But we understand that it may be concretized in various ways, from the sensuousness of the Rococo to the frightening alienation of Santini-Aichel.

The true aim of the Enlightenment was to free man from the systems, to allow him a better understanding and deeper feelings. The danger, of course, was of a split between thought and feeling, a danger which later became a tragic reality. In the Late Baroque, however, thought and feeling were still united, perhaps more fully than in any other epoch.

[22] J.-F. Blondel, *Cours d'architecture*, Paris 1771–77: III.
[23] For the problem of "generations" in the history of art, see W. Pinder, *Das Problem der Generation in der Kunstgeschichte*, Leipzig 1928.

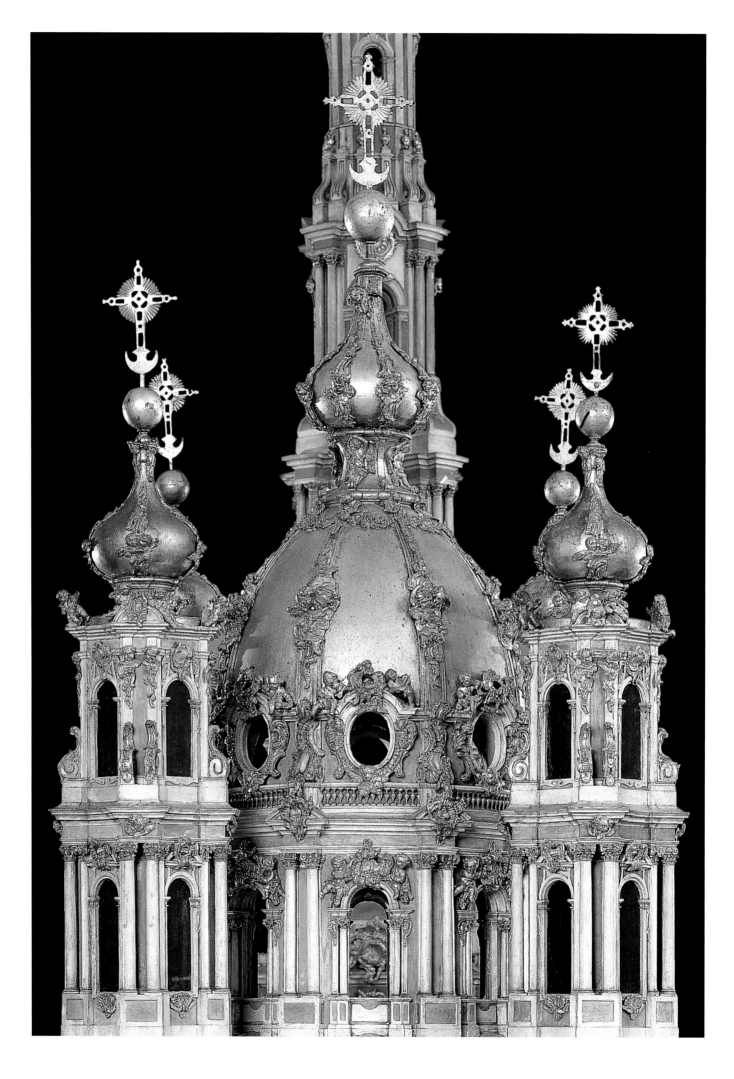

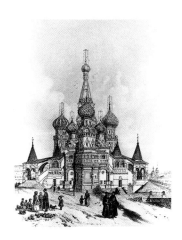

The cathedral of St. Basil
in an engraving by A. Durand
Milan, Civica Raccolta Stampe
Achille Bertarelli

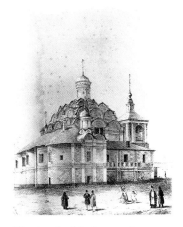

The church of the Intercession
of the Vergin in Rubcovo
in an engraving by N. Martynov

opposite
Francesco Bartolomeo Rastrelli
Detail of the dome of the cathedral
in the model of the Smol'ny
monastery, St. Petersburg
St. Petersburg, Scientific Research
Museum of Academy of Arts
cat. 575

[1] Stone architecture Russia was primarily ecclesiastical from its inception in the late tenth century right until the sixteenth. It was founded on the Orthodox tradition brought from Byzantium. In ancient Russia the types of churches characteristic of Constantinople in the tenth and first half of the eleventh centuries were further developed. In the mid-twelfth century, when the locus of power shifted from Kiev to the northwest, Vladimir, Prince Andrei Bogoliubsky established

The inclusion in an exhibition devoted to the Baroque in Europe of architectural models created in St. Petersburg and Moscow reflects the change of view of Russian culture that has come about in recent years. For a very long time, Russia's isolation from the West kept scholars from recognizing the European characteristics in the structures erected on Russian soil in the seventeenth and early eighteenth centuries. In point of fact, these characteristics had been in the making in Russian architecture for almost its entire history, when over the course of seven centuries the art of Russia balanced on the boundary between East and West.

Ordinarily, the development of Russian architecture is divided into two radically divergent parts. The turn of the eighteenth century – the era of Emperor Peter the Great – functions as an abrupt boundary between construction in the "Russian" and "European," the "Eastern" and "Western" taste, and is perceived as a period of architectural "revolution" (Cracraft, 1988). This is not to imply, however, that connections with Europe did not play a significant role in the preceding development of Russian architecture.[1] The transformation of Russia's architecture in the Western spirit began significantly earlier, and the logic of the artistic development of the sixteenth and seventeenth centuries was largely connected with processes already under way in the art of the West.

European construction experience was first put to use in Moscow in the late fifteenth century, when the centralized state was being created, a period coinciding chronologically with the Italian Renaissance. Innovations were brought in by master-builders of the Bolognese, Lombard, and Venetian Renaissance, who created the fortifications, principal churches, and palaces of Moscow's Kremlin.[2] On the basis of their ideas an artistic language was worked out that expressed in architecture the symbols of Russian tsardom, the "Third Rome" (Byzantium was considered the Second Rome), as the motto of this new empire proclaimed.[3] Architects made use of the compositional principles of the Renaissance in their building plans, but their ornamentation was a mixture of Classical, Gothic, and ancient Muscovite motifs. This type of architecture was used to convey political and theocratic programs in structures of state significance[4] (Church of the Ascension in Kolomenskoe, Cathedral of St. Basil the Blessed in Moscow).

In sixteenth-century Russia, there existed simultaneously another form of architectural "language" that was based in the traditions of Muscovite building of the fourteenth and early fifteenth centuries and used in monasteries and parish churches. Resting on the ancient Russian interpretation of Byzantine cross-and-dome churches, architects strove to develop the exterior appearance of their buildings. Gradually they found ways to make the traditional design elements more decorative. The increasing complication of religious concepts and the desire of clients to express their closeness to the court meant that new motifs borrowed from the Kremlin buildings would penetrate this sphere as well.

The sixteenth century closed with the coexistence of these two forms of architectural "language." The early years of the seventeenth century – the brief reign of Boris Godunov (1598–1605) – witnessed attempts to combine traditionally Muscovite images and the decorative motifs connected with the ideology of the "Third Rome" (the church at Khoroshovo, the upper section of the Ivan the Great bell tower in the Kremlin). Nonetheless, the "voice" of Renaissance art, which was heard in Russia in the compositions of the Italian master-builders, was not lost. Under Boris Godunov, a new wave of "Italianisms" appeared in Russian architecture (Batalov 1996), as could be felt in the use of the elements of the Classical order in the ornamentation of churches that were traditionally Muscovite in composition (the church at Vyazemy outside Moscow).

Playing a significant role here was the fact that Boris Godunov, who was chosen tsar after the death of Fedor Ioannovich, the son of Ivan the Terrible and the last representative of Moscow's ruling family, was anxious to found a new dynasty. In his mind, the architectural details borrowed from the most important structures in the Kremlin served as "signs" that spoke of the succession of power. As a consequence, the motifs used by Italian master-builders in Kremlin structures of the late fifteenth and early sixteenth centuries became "sacred," that is, symbols of legitimacy.

The concept of the "Third Rome," of Russian tsardom as heir to the Orthodox empire, remained vital for the ideology of Boris Godunov. It assumed an "imperial universalism," a unification of East and West. Along with the use of architectural symbols that expressed the

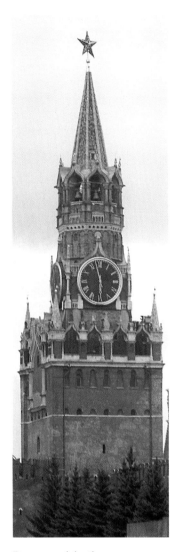

Prospect and detail
of the Spasskaja tower
at the Kremlin, Moscow

contacts with Emperor Frederick Barbarossa, thus signaling a change of political orientation from that of previous contacts with Byzantium. Architecture reacted to this immediately. Andrei Bogoliubsky asked Frederick Barbarossa to send him master builders, and thus the interaction between Russian architects and the West began. In Vladimir, exterior Roman sculpture appeared, but its utilization was interrupted by the Tatar invasions of the thirteenth century.

2 Contacts between Muscovite Russia and the Italian states of the Renaissance were intensive due to the trade interests of Venice, Genoa, and Milan, and as well as the persistent desire of the Ro-

idea of state power, attempts were made in very early seventeenth-century Russia to convey Moscow's role as the center of the Eastern Christian world. It was in this period that imitations of holy sites in Jerusalem (the "holy of holies" in the Kremlin) first appeared in Russian church architecture. As a result, the role of decorativeness increased in buildings' artistic images. With respect to style, traditional Muscovite and Renaissance motifs transformed by Russian master-builders continued to be combined. The preservation of this practice may have been facilitated by the activity of the English builders in Moscow in the latter half of the sixteenth century. Led by Thomas Chafin (Harvy 1987, 50), these men had been sent to Russia from London on order of Elizabeth I.[5] After a period of direct influence from Italian Renaissance architects, there ensued a time when an artistic system was worked out on the basis of the works they had created in Moscow whose logic was similar to that of Mannerism (Tananaeva 1987). The use of this term is purely conventional, of course, but it makes it easier to compare Russian and Western architecture of this period.[6] All these phenomena of the previous era were significant for the entire seventeenth century, despite the fact that after Boris Godunov's death construction activity in Russia was interrupted by the events of the interregnum – the "Time of Troubles." Wars, uprisings, and the appearance of self-proclaimed pretenders to the throne brought with them much destruction. Recuperating from the Time of Troubles occupied the first years of rule of Tsar Michael Fedorovich, the founder of the Romanov dynasty (1613–48).

The architecture specifically characteristic of the seventeenth century developed in Russia between 1613 and 1689, from the end of the Time of Troubles to the coming to power of Peter the Great. During the first decade of Michael Romanov's reign, the architecture of Boris Godunov was imitated. This had to do with the desire to revive broken traditions. The idea of the succession of power was expressed in the copying of early seventeenth-century structures (Church of the Intercession in Rubtsovo, Church of St. Nicholas Nadein in Yaroslavl). However, if Tsar Michael's master-builders were successful at reproducing the compositions of the Godunov structures, then the elegance of their details was lost. "Italianisms" either disappeared altogether from their arsenal of motifs or else were significantly coarsened. Court architecture demanded new forms worthy of its "tsarist" status.

In the mid-1620s, when a time of political stability ensued in Russia, a new artistic style began to arise. Its first representative structure proved surprising in its characteristics. In the years 1624–25, the main entrance to the Moscow Kremlin was rebuilt – the Spassky Gate, which had been erected in the late fifteenth century in the forms of the Lombardian fortress architecture of Pietro Antonio Solaro. As a result of the work of the master-builders of Tsar

Michael, the Renaissance tower became "Gothic" in the early seventeenth century, with the addition of a grandiose top section decorated with sharp pinnacles and pointed arches. Earlier, the use of Gothic motifs had been rare and intermittent in Russia. True, looking closely at the ornament of the Spassky Gate you can see that despite its overall "Gothic" nature, some of its elements are Classical. Moreover, we know that a sculpture was used here that depicted naked figures, which are associated more with Classical mythology. Muscovites were so outraged at these nude bodies, which were here appearing for the first time on the outside of a building, that the tsar was forced to order fabric garments made for these statues, and later to remove them altogether.

The nature of the top portion of the Spassky Gate is explained by the name of its creator: Christopher Galloway of Edinburgh,[7] who erected it together with the Russian Bazhen Ogurtsov. The Scottish master-builder evidently was one of those architects whom John Summerson defined as "artisan Mannerists" (Summerson 1956: 155–70) because they combined late Medieval and Classical motifs. Working at the same time as Galloway was yet another foreign architect, John Taller, his fellow countryman possibly, who began the rebuilding of the tsar's palace in the Kremlin.[8] The "Gothic" quality of the Spassky Gate involved features that would prove important for the development of Russian architecture. The saturation of the ornament and the complexity of the composition created a majestic and positive image. The Mannerist freedom in combining forms of diverse "stylistic origin" provided the possibility of creating an artistic "language" without being inhibited by the traditions of Muscovite architecture or the laws of construction of Classical ornament. This was taken advantage of by a group of Russian architects[8] in erecting the Terem Palace – the central section of the tsar's residence in the Kremlin – in the years 1635–37. It is probably important that previously many of them had worked with Galloway and Taller. No less significant is the fact that the new complex was built, as if on a platform, on the roof of the two-storey palace created in the early sixteenth century by Italian master-builders and in the midst of the churches they built. Imita-

Map of the city of Moscow in the 18th century
Milan, Civica Raccolta Stampe Achille Bertarelli

man throne to spread the 1453 Union of Florence between the Catholic and Orthodox churches to Moscow. Grand Duke Ivan III took advantage of his relations with the Italian states to acquire technical innovations, especially artillery. Moreover, he obtained significant ideological advantage by marrying Sophia (Zoe) Paleologus, niece of the last Byzantine emperor, who was reared in Rome and who smoothed the way for inviting the Italian master-builders. We can delineate three groups of Italian architects and engineers in the service of Ivan III. The first to arrive, in 1474, were Aristotele Fiorovanti and his assistants (*Arte Lombarda* 1979; Zemtsov 1985) from Bologna, where Fiorovanti was municipal engineer. Closely acquainted with Filarete, Fiorovanti built the Cathedral of the Assumption of the Virgin, the coronation church in the Kremlin. After his death in 1491, builders arrived from Lombardy, led by the

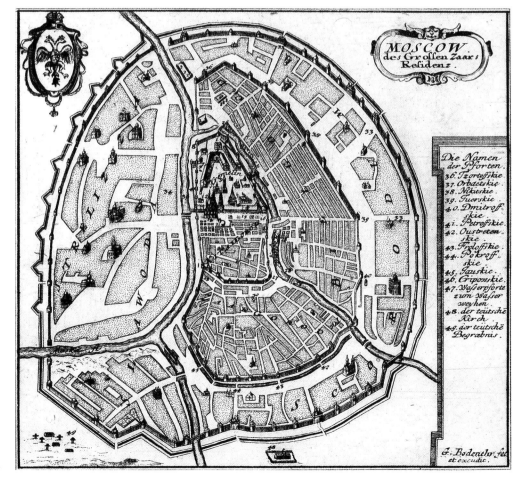

Detail of the architectural decoration of the Trinity church at Nikitniki

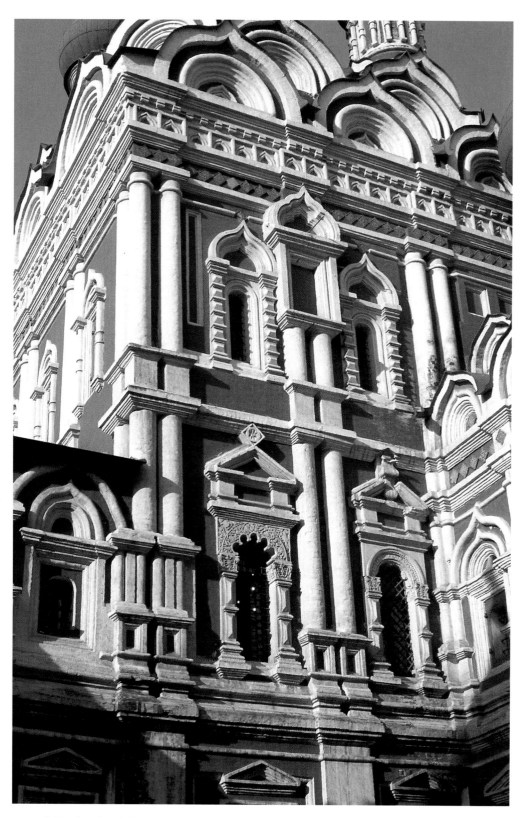

architect Pietro Antonio Solari and his son, Guiniforte Solari, and began to build the fortifications and grand dukes' main palace in the Kremlin. In 1504, Aloizio Lamberti da Montagna and his crew of Venetian stonemasons appeared in Moscow. It was they who created the burial vault for the Russian sovereigns, the Cathedral of the Archangel Michael in the Kremlin. In all, we know of about thirty masterbuilders who arrived in Russia from Italy between 1475 and 1539.

[3] Ivan III and his son, Vasily III, felt that their state was Byzantium's heir after the Turks took Constantinople.

[4] Complex ideological programs for major construction sites were typical of the building done by Muscovite sovereigns in the sixteenth century. The last church erected by Italian master-builders in Moscow – the Church of the Ascension in Kolomenskoe (1532) – fully expressed the "language" of the architectural ideology of Muscovite tsardom. The church has a central floor plan, a Classical arcade serves as the surrounding gallery, and antique motifs can be noted in the ornament of the windows and the capitals of the pilasters. There is a Gothic quality to the vertically elongated pediments (*vimpergi*) on the main façade between the pilasters. Above them one can see Muscovite elements – the keel-shaped arches. This kind of combination of diverse elements, which was unprecedented in Russia, was programmatic. To a great degree there are similar features in the architecture of the Church of St. Basil the Blessed on Red Square in Moscow. There, elements borrowed from Renaissance, Gothic, Muscovite, and Oriental sources, as well as from fortress architecture, conveyed an extremely complex ideological program. The image of the real Jerusalem, as the Russians imagined it, combined here with the ideal of the heavenly Jerusalem. This invocation of the principal

tion of the details of these structures, which had become sacred tsarist sites,[9] became a symbolic means of conveying the court character of the new palace's architecture.

The architects of the Terem Palace took the Renaissance elements of the fifteenth- and sixteenth-century Kremlin structures out of their original context and intensified their decorative qualities. The Tuscan pilasters, for example, were transformed into elongated frames when deeply inset niches were placed inside them. The small columns by the double "Venet-

View of the church of the Nativity of the Virgin in Putinki

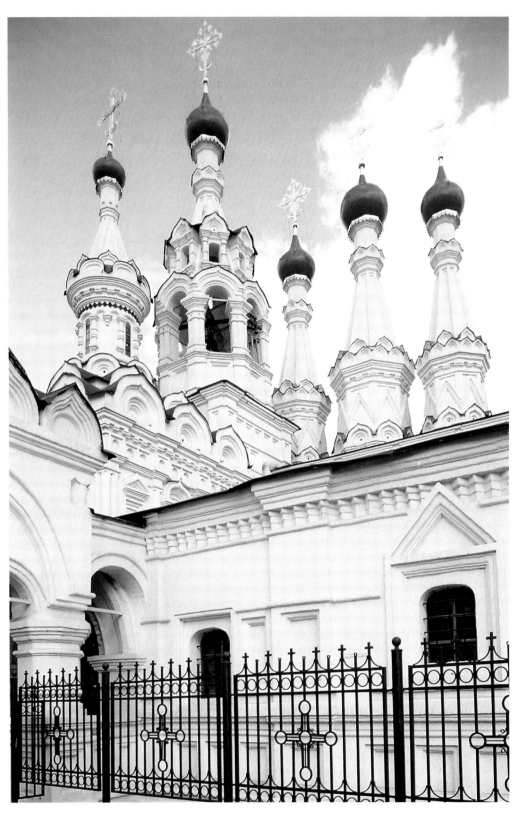

Christian saints was intended to symbolize the sacred nature of Ivan IV's rule. The dedication of the cathedral's altars to the saints and their holy days when the victories of this monarch over the Tatars occurred was a way of linking the idea of the divine rule of the Muscovite sovereigns to notions about divine assistance in the battle against the "infidels." The architectural forms elaborated in the church at Kolomenskoe and the Cathedral of St. Basil the Blessed largely determined the character of Russian structures of the seventeenth century.

[5] As a consequence of the conflicts with Catholic Poland, the war against the knights of the monastic orders in the Baltics, the Turks pushing the Genoan merchants from the shores of the Black Sea, and especially Moscow's continuing hostility toward Catholicism under Ivan IV, Russia's contacts with the Italian states were severely curtailed. Englishmen came to replace Italians in Moscow, a phenomenon facilitated by the conflict between Henry VIII and Rome and the opening of the northern sea route to Archangel through the White Sea. The London Moscow Company was granted exclusive trading privileges. Having no more Italian master-builders, Ivan IV asked Elizabeth I to send English builders and jewelers. The queen fulfilled his request in 1568, and the influence of these master-builders was felt in Moscow right down to the very end of the sixteenth century (Batalov and Shvidkovsky 1992, 22).

[6] Unfortunately, information about exactly what was built in Russia by the master-builders who came from London has not been preserved, despite their long years of work in Moscow. Nonetheless, it is obvious that they brought with them the artistic ideas current in London in the 1560s. We can talk about English architecture before Robert Smithson and the period that is sometimes called "late Medieval Mannerism." It is in this very free and broad interpretation

ian" windows were covered with patterns in which the Italian carvers' grotesques were practically transformed into ornaments from Oriental carpets. The cornice was held to its Renaissance proportions, but each of its entablatures was covered with abundant carving. All these Classical elements, now transformed to the point of the "decorative absurd," were set closely together. They formed the ornamental "carpet" of the Terem Palace's façades. The attraction to this kind of unbroken, massed ornament became the foundation for the style

The cathedral of the Resurrection
of Christ
in the New Jerusalem monastery
near Moscow

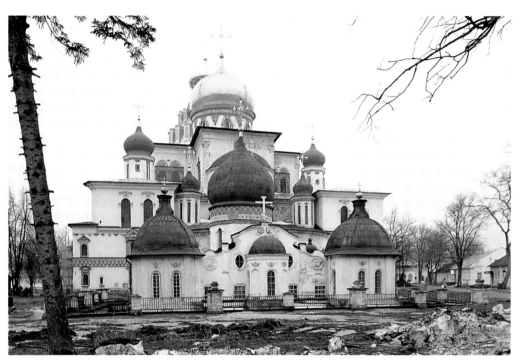

that the term "Mannerism" itself can be applied to any degree at all to a few phenomena of Russian architecture in the sixteenth and seventeenth centuries. If we can talk about phenomena of the late fifteenth and early sixteenth centuries as being connected with the Renaissance, then in the later Russian buildings of the sixteenth and seventeenth centuries, where attempts to make use of European decorative forms left their mark, one can pick out features of Mannerism. This is important as a matter of principle because it allows us to understand the non-Classical and non-Baroque characteristics of many seventeenth-century structures. It should be emphasized that we are by no means talking about any specific form of European Mannerism being asserted in Russia. All we can talk about is the penetration of Mannerist elements that proved acceptable in Moscow due to their heightened decorative quality and lack of stylistic definition.

[7] The surge in immigration from Scotland in the early seventeenth century was felt in Moscow as well. Scottish officers had already been encountered in the troops of Boris Godunov. In the Guards of the first Romanovs, throughout the seventeenth century, Scots played a noteworthy role. The invitation to master-builders from Edinburgh to come to Moscow was connected with the fact that despite a deterioration in relations with London, the memory of the work of the builders and sculptors from the British Isles lived on in the tsar's court. Michael Romanov's desire to imitate the last monarchs of the vanished dynasty, including their choice of foreign master-builders, was probably not unimportant.

[8] Immediately after Tsar Michael ascended to the throne in 1614, work began on the restoration of the Kremlin, which had suffered in the storming by Russian troops during their siege of the Poles who had occupied Russia's capital. Rebuilding of the tsar's palace began

of seventeenth-century Russian architecture. There is no point looking for the features of the "flaming" late Middle Ages in the forms of seventeenth-century Russian architecture. This was not the culmination of a previous age but the beginning of a new era, the creation of a new style that strove to make use of European achievements, albeit on the basis of a transformation of its motifs, but not a direct connection to Western art. The Terem Palace – the most important structure of built by Moscow's court architects – was the impetus for the "architectural revolution" of Peter the Great. In it one can see individual Baroque details, doubtless borrowed from engravings that had come to Russia, beginning to appear in the Mannerist ornament. Not far from the Kremlin, in the trading district of Moscow known as Kitai-gorod, or "China-town," the Church of the Holy Trinity at Nikitinki was built (1625–53), more than likely created by the same master-builders responsible for the Terem Palace, who used the same forms but here in religious architecture. The fundamental features of the seventeenth-century Russian church can be said to have been defined by the Church of the Holy Trinity. This was especially important because church architecture was nonetheless significantly more developed than court architecture.

In this parish church, the floor plan is more subdivided and the volumetric composition more painterly than buildings from the early years of the seventeenth century. Here we have the traditionally Muscovite *kokoshniki*-rows of arches mounding up outside under the vaults of the church. At the same time, it utilizes "quotations" from tsarist structures, from details of the Cathedral of Archangel Michael to the ornamentation of the newly built top section of the Spassky Gate. Added to the elements of traditional artistic language and the utilization of symbolic forms connected with the ideology of power here is the transformation of Classical ornamentation. The main volume of the church is dominated by paired columns on pedestals that support the cornice, which has been transformed into a heavy, multilayered decorative belt.

Under Alexei Mikhailovich, the second tsar in the Romanov dynasty, seventeenth-century Russian architecture achieved a new flowering. Its luxuriant decorative style developed to its full extent, embracing all architectural elements, including the pyramidal tops of churches, the so-called *shatry*, or "tent roofs." They became smaller, were entirely covered with ornament, and instead of one opening to the interior, they became several (the Church of the Virgin of Hodigitria in Vyazma, the Church of the Nativity of the Virgin at Putinki in Moscow). The luxuriance of forms was supplemented by polychromy of an Oriental nature. Red brick structures with white stone or figured brick details are decorated with multi-colored glazed tiles[10] (Church of St. Georgy Neokessariisky in Moscow, and the famous churches of Yaroslavl, St. John the Baptist, St. Elijah the Prophet, and so forth).

Detail of the exterior decoration
of the cathedral of the Resurrection
of Christ
in the New Jerusalem monastery
near Moscow

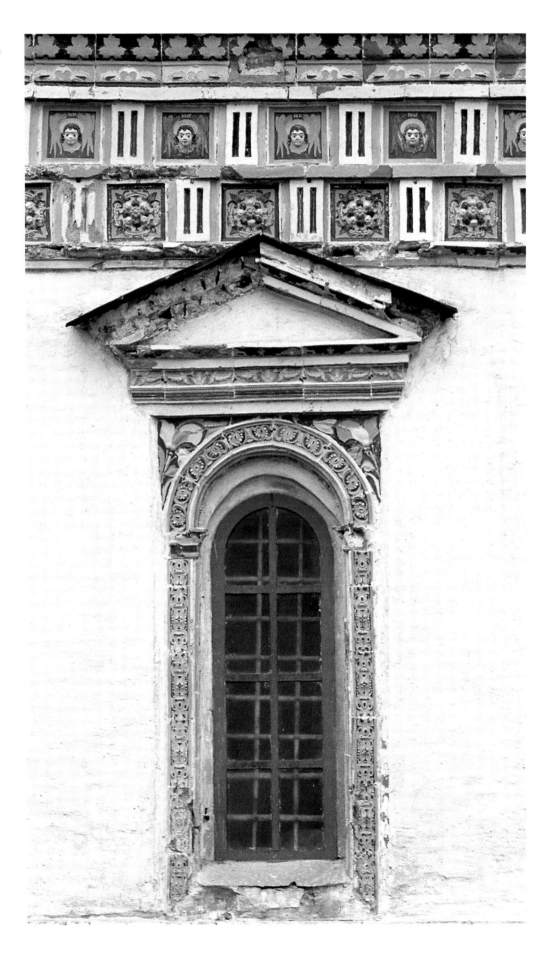

The church of the Intercession
of the Virgin at Fili

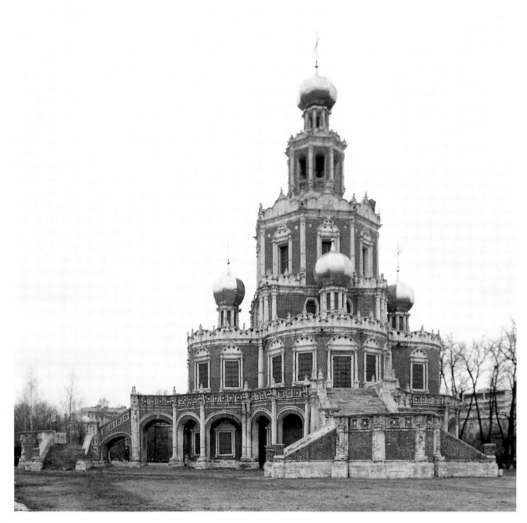

with the household chapels, the so-called Terem churches. In 1624, John Taller built the Church of St. Catherine. The complete history of the creation of the Terem Palace is not altogether clear. There is no doubt that Bazhen Ogurtsov, Trofim Sharutin, and Larion Ushakov spent 1635 and 1636 building it, under the guidance of the "sovereign's master-builder" Antipin Konstantinov. What was done here and between 1635 and 1635, to what degree Russian architects participated in the construction done by Taller in the 1620s, and whether he had anything to do with their activities in the 1630s remains obscure.

[9] Traditionally, Assumption Cathedral was the place where grand dukes, tsars, and emperors were crowned, as well as the pulpit for the heads of the Russian church, the metropolitans, and later the patriarchs of Moscow and All Russia. The Cathedral of the Archangel Michael, the divine protector of the Muscovite dynasty, was designated for the burial of sovereigns from the late thirteenth to the early eighteenth centuries. The final radical alteration in the outward appearance of these two cathedrals was carried out by Italian master-builders in the final quarter of the fifteenth and first few years of the sixteenth centuries. And although the Renaissance architects were forced to work from the structure and even the dimensions of the churches from preceding Russian tradition, many details, especially the order elements of the façades on Archangel Cathedral were completely new and unusual for Russia. It was these that were noticed above all. These forms became "signs" expressing the Kremlin cathedrals' sacred significance for the Russian sovereigns. The same can also be said about the architecture of the Great Palace, in particular its throne room, the Palace of Facets.

[10] The origins of the architectural polychrome ceramics of the seventeenth century in Russia demon-

Along with increasingly complex compositions, ornament, and coloration in mid-seventeenth-century Russian architecture, there also appeared increasingly developed messages. Characteristic in the latter respect are the structures erected on instruction from the reformer of the Russian church, Patriarch Nikon.[11] Distinguishing itself among these is the ensemble of New Jerusalem, a convent erected in imitation not only of the Church of the Holy Sepulcher but also of the image of the actual topographical Jerusalem as a whole. The location for this complex was selected for its resemblance to the landscape of the holy city. The dozens of churches brought together in this single complex were supposed to tell the events of the history of the Gospels. A grandiose attempt was made to create a new symbolic center of the Orthodox world in accordance with Nikon's views on theocratic empire. Despite the fact that the patriarch was exiled due to his political pretensions, this architectural program continued to be implemented. Moreover, it carried over into tsarist construction, influencing the conception of the Moscow Kremlin.

The "Third Rome" absorbed the features of "New Jerusalem." This is significant for our understanding of the Russian architecture of the age of Alexei Mikhailovich, which preceded the proclamation of the Russian Empire by his son, Peter the Great. Even then the transformation of Russia's entire environment had been started by the grandiose construction being carried out by state power. At the same time the religious element was playing an enormous role in it through the creation of the sacral topography of Russian towns and even large territories.

Over the course of the seventeenth and eighteenth centuries, the history of Russian architecture was defined by the characteristics of the state's development. At this time, the country was constantly expanding, seizing the area from the Amur to the Dnieper, continuously integrating diverse peoples into the empire as well as colonizing vast, sparsely populated

Triumphal arch erected in Moscow
in honor of Peter the Great's victory
against the Turks at Azov
print, 1710
Private collection

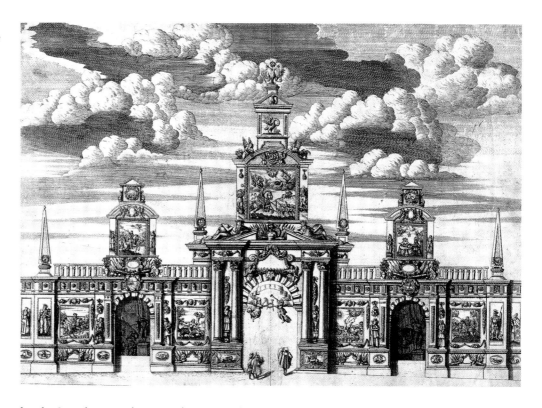

lands. Simultaneously, central Russia, which retained as a consequence of its economic inefficiency its medieval features, was in dire need of radical transformation. In the seventeenth and eighteenth centuries, programs for transforming Russia followed one after the other in the form of notions about the ideal image for the country. Moreover, its outward, visible, even architectural features were especially important to Russia's rulers, who felt that it was sufficient to create new forms for buildings, towns, and estates for life itself to ensure the country's well-being. The government was constantly busy improving the network of roads, elaborating town plans, and constructing fortresses and monasteries, which transformed remote locales into outposts of the state. Under Tsar Alexei Mikhailovich, the state program for rebuilding Russia was theocratic in nature, being connected with the sacralization of tsarist power. This explains the further expansion of church and convent construction, which achieved grandiose proportions by the latter half of the seventeenth century. The entire country was covered with new churches built according to tsarist examples. Ancient Orthodox monasteries were expanded. They were given monumental walls and towers and

Vasily Ivanov Bazhenof
Project for the south façade
of the Kremlin
Moscow, A. V. Shchusev State
Research Museum of Architecture
cat. 197

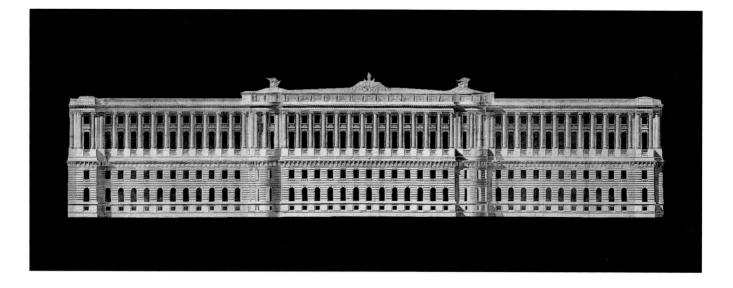

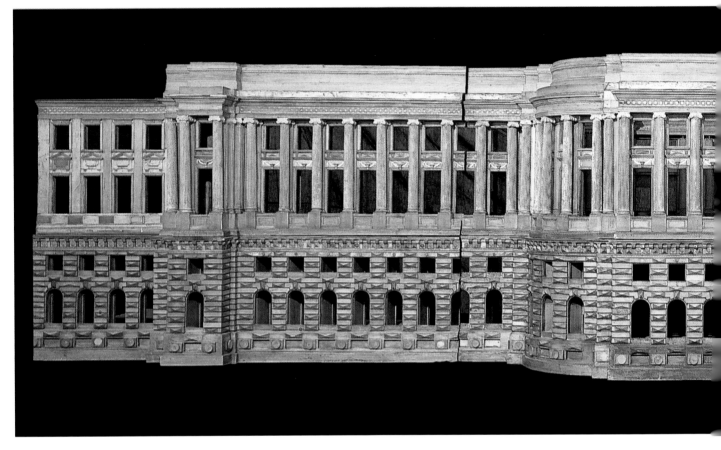

Vasily Ivanov Bazhenof
Model for part of the Kremlin façade
Moscow, A. V. Shchusev State
Research Museum of Architecture
cat. 189

strate with especial visual clarity the country's position at the crossroads of influences from West and East. Tiles were used most widely to decorate churches in the towns on the Volga, i.e., on the main Oriental trade route, above all in Yaroslavl. Scholars have shown that the technology for manufacturing tiles coated with colored glaze was brought by Tatar artisans from Central Asia. In the seventeenth century, their design underwent the impact of Classical motifs, acquiring a fantastic quality. Moreover, they were used in friezes, cornices, and lintels – where architectural elements that harked back to European examples had been applied most often.
[11] Patriarch Nikon changed many customs of the Russian church. He tried to free the liturgy from diver-

were transformed into "holy cities" (Trinity-St. Sergius, Kirillo-Belozersky, Savvino-Storozhsky, and dozens of other monasteries). The motifs of "New Jerusalem," "New Constantinople," and the "Third Rome," as well as themes connected with local Russian saints, predominated in the ideology of Russian tsardom. This helped to preserve the traditional traits of Russian church architecture that dated back to Byzantium and medieval Moscow.

The proclamation of the Russian Empire by Peter the Great was the culmination of the idea of Moscow as the Third Rome that had gripped the thinking of the Russian state for two centuries. However, the tsar changed the points of orientation for this concept. He consciously turned not to Constantinople but to the first Rome, the Roman Empire, as was reflected not only in his adoption of the title of ancient Rome's emperors[12] but also in his buildings.

After his victory in the first war against Turkey in 1696 (seven years before the founding of St. Petersburg), Peter the Great ordered triumphal monuments built in Moscow, following the Roman example (*Pis'ma i bumagi ...* 1887: 109). Triumphal arches were erected – the first direct reference to antiquity in Russian architecture. In the inscriptions and depictions on them, the tsar was compared with Emperor Constantine and particularly insistently (in several places) with Julius Caesar (Bodrova 1978: 41).

In previous times, only churches had been built to memorialize victories of Russian arms. For the first time now, secular structures were erected that were oriented toward the Western tradition, although one could not attribute these structures to a single seventeenth-century European architectural style. There was as yet in place here no system of artistic principles connected with the Baroque or Classicism. The program of building in the Classical spirit appeared before the imitation of any European style.

During the early years of Peter the Great's reign, a series of buildings were erected at the behest of relatives of the tsar's mother, the Naryshkin family. More often than not, tall centrally planned churches consisting of several geometrically distinct volumes with an open surrounding gallery built for them. Inasmuch as their luxurious ornament utilized interpretations of Baroque motifs, as early as the early twentieth century the style of these churches was called "Naryshkin Baroque," from the name of their principal patrons (Church of the

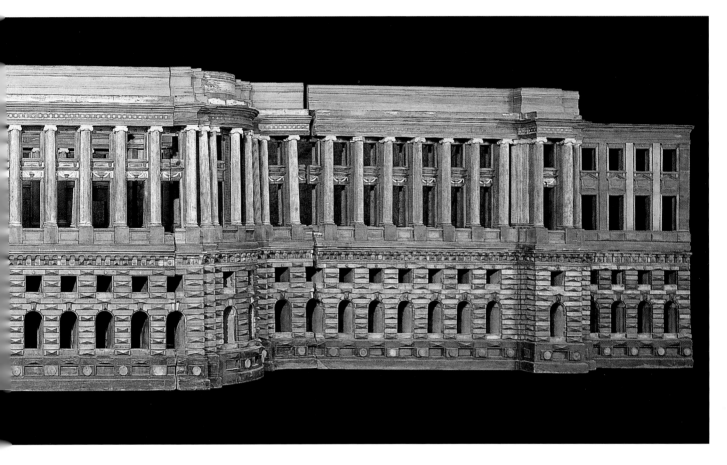

Matvei Fedorovich Kozakov
*Preparations for the inauguration
of construction works in the Kremlin*
Moscow, A. V. Shchusev State
Research Museum of Architecture
cat. 199

following pages
Vasily Ivanov Bazhenof
Model for the throne room
of the Kremlin
Moscow, A. V. Shchusev State
Research Museum of Architecture
cat. 191

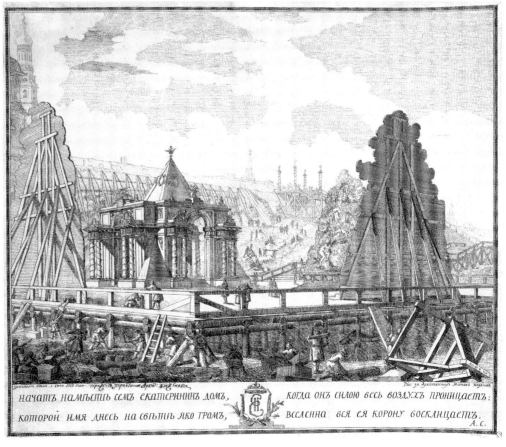

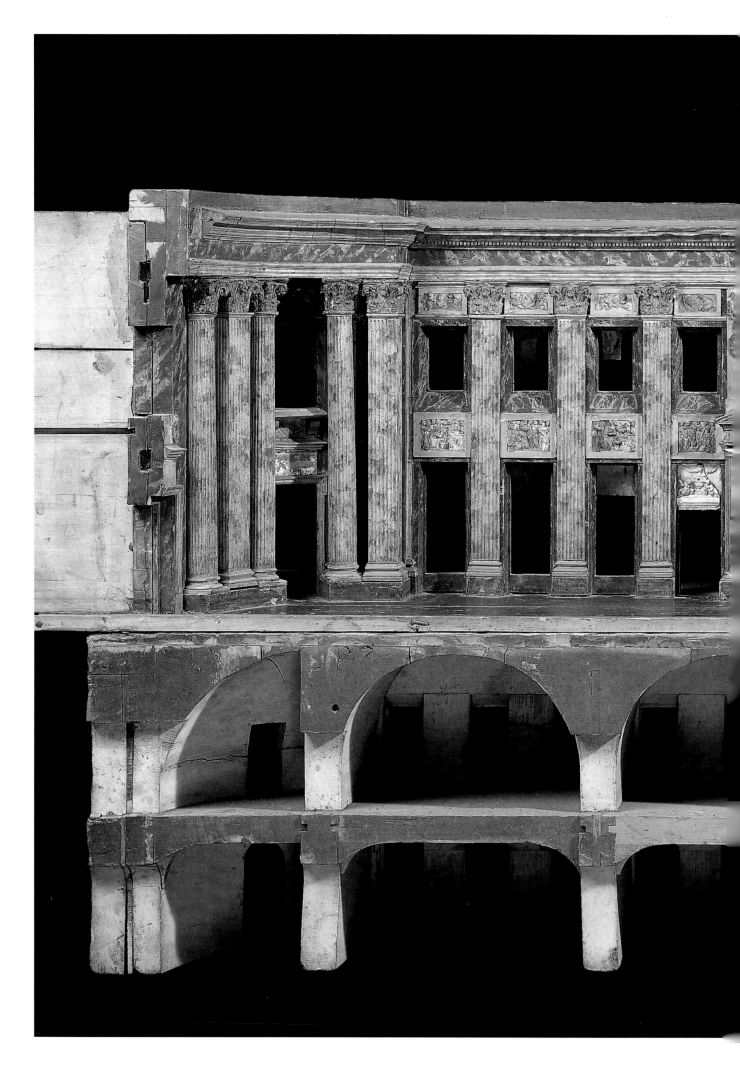

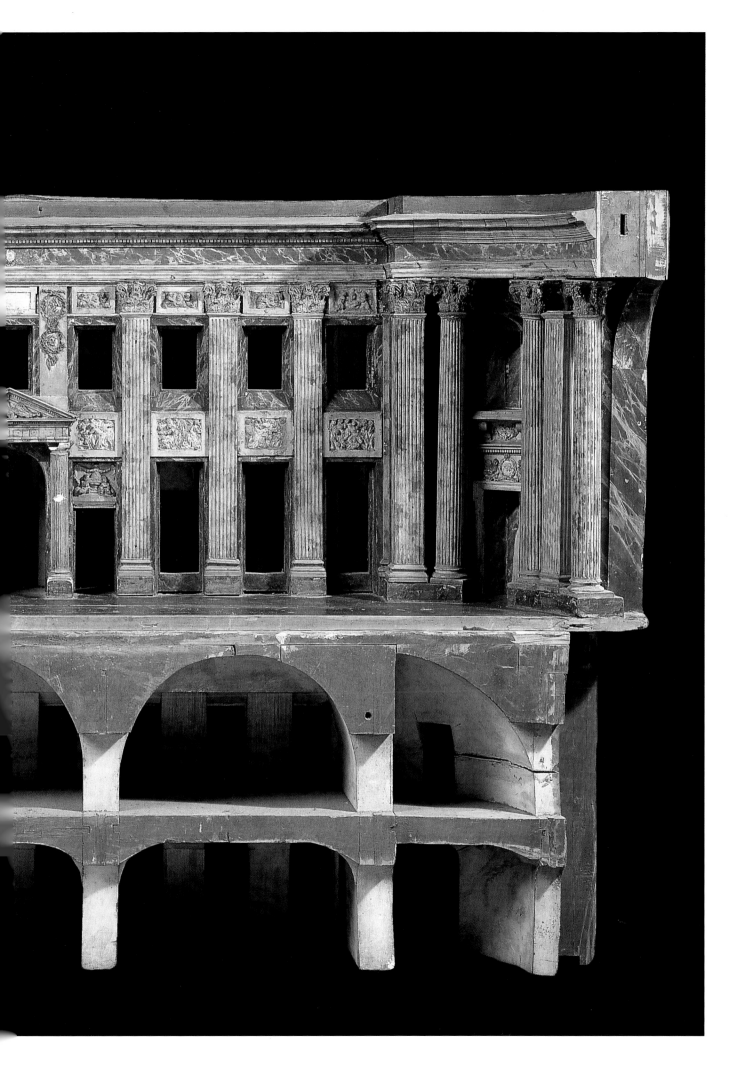

Vasily Ivanov Bazhenof
Model for the staircase
in the Kremlin
Overall view and detail
Moscow, A. V. Shchusev State
Research Museum of Architecture
cat. 190

following pages
Vasily Ivanov Bazhenof
Model of the exedra
in the Kremlin
Moscow, A. V. Shchusev State
Research Museum of Architecture
cat. 192

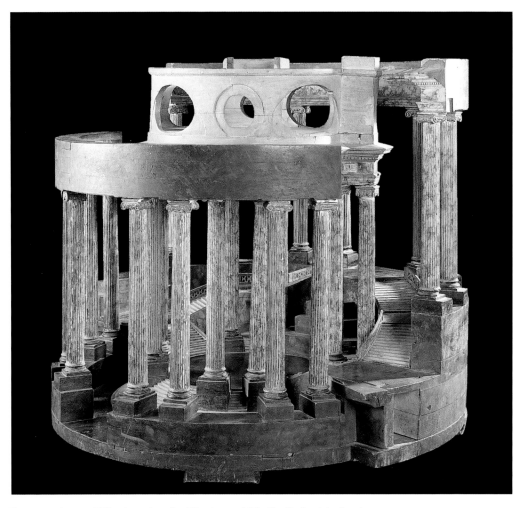

gences from the original canons and to correct the mistakes of the translators and scribes of the holy texts. He attempted to follow the ancient traditions of Orthodoxy in all he did. Connected with this was the construction of New Jerusalem and the imitation of the Church of the Holy Sepulchre. In architecture, Nikon also strove for authenticity in his ancient examples. He sent his representatives to Jerusalem, and they brought back to Russia precise drawings and models. At the same time, the patriarch was familiar with Western European books about Jerusalem and its holy sites. Information has been preserved in his library as to what they were; unfortunately, his list does not allow us to determine precisely which treatises were in his possession (Ilin 1959, 60). All this was utilized in the creation of the convent of New Jerusalem as the new symbolic center of the Orthodox world.
[12] In the full title of Peter the Great and the court "mythology" of his era, the image of the emperor was linked both with he-

Intercession at Fili, churches in Ziuzin and Troik-Golenishchev).

The use of the term "Baroque" here is conventional, as was that of "Mannerism" previously. The structure of the volumes of the "Naryshkin Baroque" churches speak more of their connection with the drawings for centrally planned buildings from architectural treatises of the Renaissance. The forms of the "Naryshkin" structures came to Moscow from Italy via Poland and Ukraine. In any event, the presence of Ukrainian architects in Moscow at the turn of the eighteenth century is not subject to question. However, although one can find in their works a similarity with Baroque ornament, one must speak merely of searches for an artistic manner connected with the program of looking to the West. Only gradually did these searches take on the "flesh and blood" of genuine Baroque, initially existing merely as a rich concept.

This last notion also applies to all the architecture of Peter the Great, including St. Petersburg. If the role of the new capital in the establishment of the empire was clear for the monarch, then the expression of this intent in its planning and construction changed numerous times (Lupnov 1957). The arrival of each new team of foreign builders introduced new features into St. Petersburg's architecture. One cannot discern any preference for master-builders from one particular country in Peter the Great. The system of selection consisted in a concerted attempt to invite individuals of high status in their respective homelands. Moreover, he hired those who could best solve a specific task. The emperor also yearned to surpass other European monarchs. In 1720, he ordered an architect sent for from China to build pavilions in his gardens, which, alas, the Russian consulate was never able to do. On the whole, a "mosaic" of diverse varieties of the Baroque brought in by master-builders from many European countries came about in Russia's new capital in the first quarter of the eighteenth century.

In the beginning, the leading role was played by Domenico Trezzini and his assistants, who arrived in 1703, immediately after the founding of St. Petersburg. Trezzini was a native of Lugano, had worked in Copenhagen, and brought with him a manner that was connected

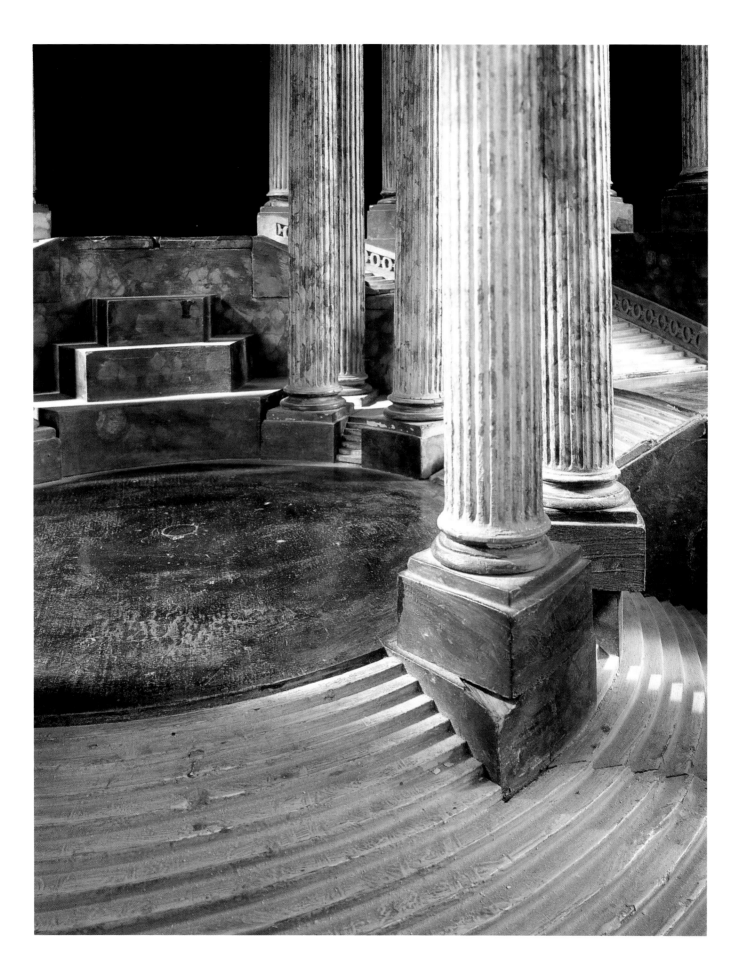

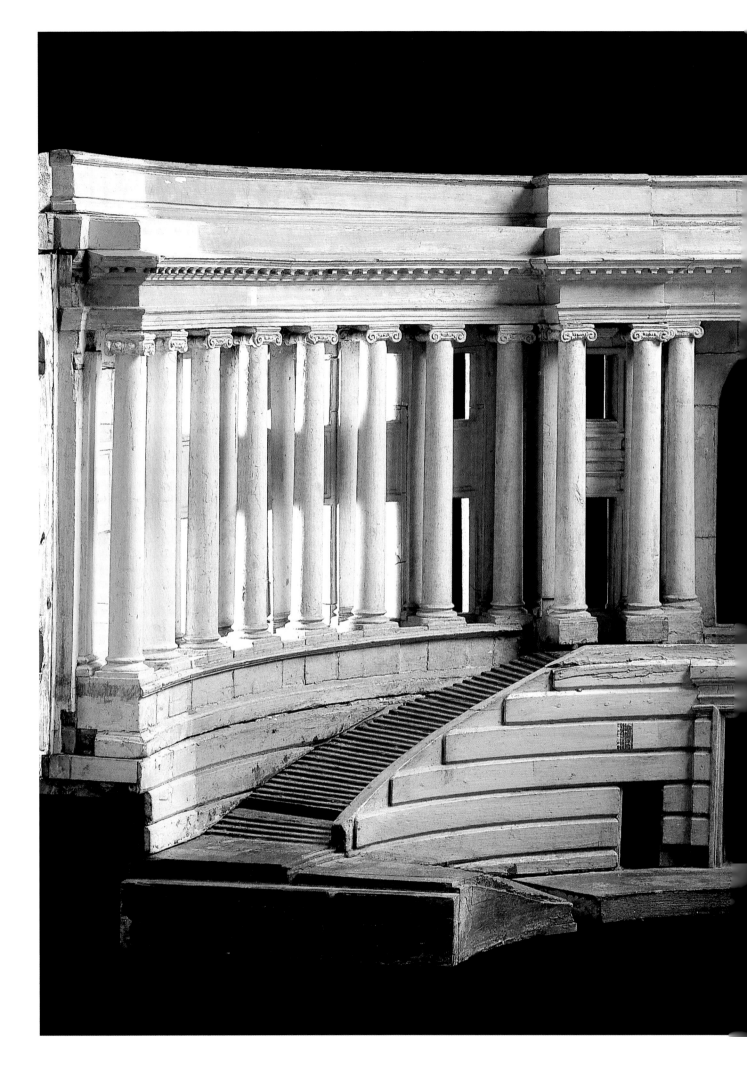

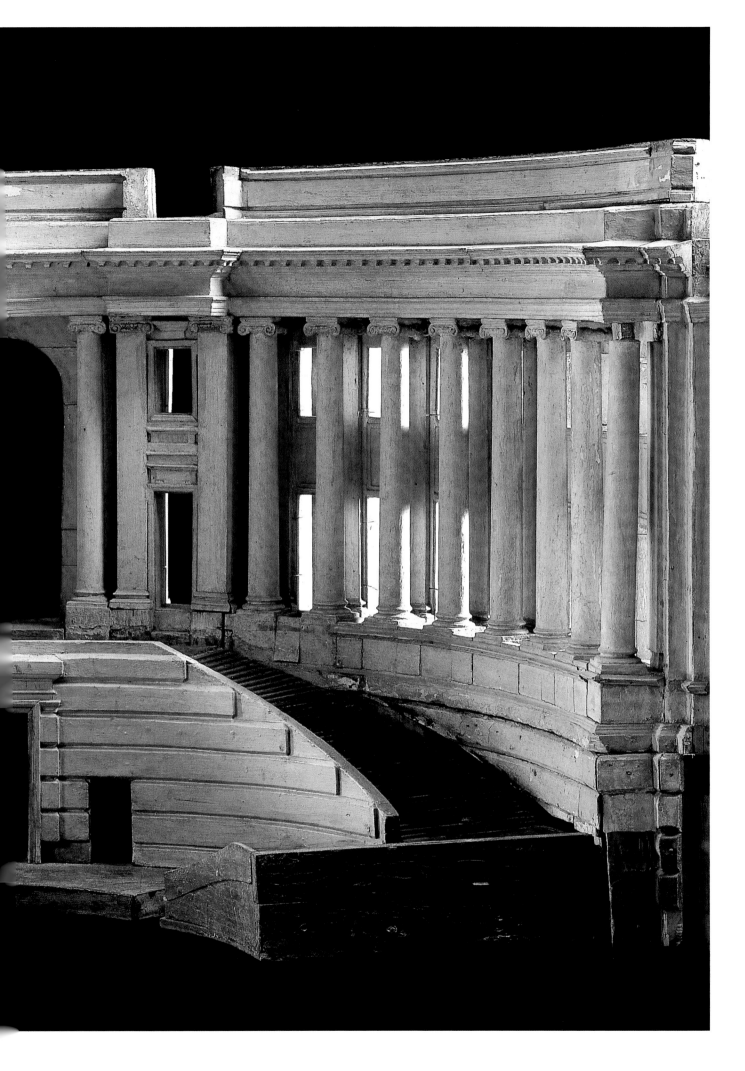

to the northern Italian Baroque and that had acquired more of a graphic than a volumetric nature during his activity in Denmark (Cathedral of Sts. Peter and Paul and the Twelve Colleges building, both in St. Petersburg).

In 1713, Andreas Schlüter, who had been the *oberbaudirektor* for the King of Prussia, was invited to St. Petersburg. With the appearance of this master, the architecture of St. Petersburg became more luxurious and its Baroque features were intensified both in the sculptural ornament and in the increasing complexity of the buildings' volumes. After Schlüter's untimely death, this manner was further developed by his assistant, Johann Braunstein (the Mon Plaisir and Marly palaces at Peterhof). In 1716, yet another important architect of Petrine Petersburg arrived from Prussia – Teodor Shvertfeger, who remained in Russian service until 1733. At first he worked for Peter the Great's favorite Menshikov, but in 1720 he was appointed architect for the Alexander Nevsky convent, the new capital's religious center. The cathedral Shvertfeger constructed in it is known from its model. Present in it are numerous "quotations" from Italian Renaissance and Baroque churches, although its overall character is closer to the southern German variety of Baroque.

It would be hard to list all the architects Peter the Great invited from various parts of the Germanic world. Among them were Gottfried Schädel of Hamburg, Nikolas Gerbel of Basel, Johann Schumacher of Colmar, and Christopher Conrad from Saxony. Significantly fewer were Dutch. We know only Stefan van Zviten, Kharman van Boles, and the Flemish François de Vaal. In 1716, Jean Baptiste Alexandre Le Blond was invited to be "architect general." He had attracted the emperor's attention with his book, *The Theory of the Art of the Garden*. At the time, Peter was trying to improve the Summer Palace's garden and plan out his seaside residence at Peterhof. The French architect made a new master plan for St. Petersburg in the spirit of the ideal cities of the seventeenth century, with fortifications implemented according to the principles of Voban. Despite the beauty of his drawing, Le Blond's proposal could not possibly have been to Peter the Great's liking, since it bore little relation to the structures already built. In 1719, the architect died of typhus. Le Blond's work was important in principle, though. He was the first to introduce features of French Classicism in the manner of François Blondel the elder into the architecture of eighteenth-century Russia, thus strengthening the Classicist tendency in the Russian Baroque.

Tsar Peter the Great lays
the foundations
for St. Petersburg, 1703
18th-century engraving
Milan, Civica Raccolta Stampe
Achille Bertarelli

roes of antiquity and with Biblical rulers. On the triumphal arch erected in honor of the victory over the Swedish king Charles XII outside Poltava, Peter the Great was called "Mars without Venus, Romulus without fratricide, Alexander without hubris... Julius Caesar without unjust lust for power" (Golikov, vol. 16, p. 204). One of the main figures in the Russian church in the first half of the eighteenth century, Archbishop Feofan Prokopovich, said: "For us, Peter is Romulus, Numa, David, and Solomon in one" (Derzhavin 1979, 297).

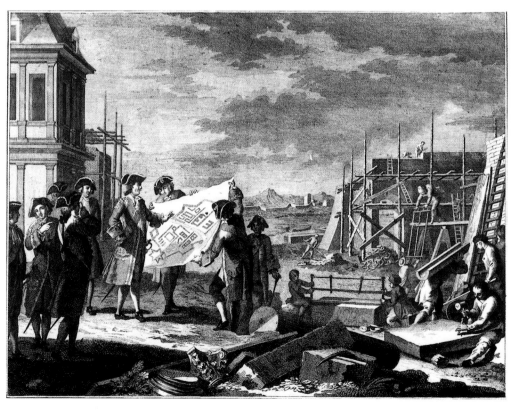

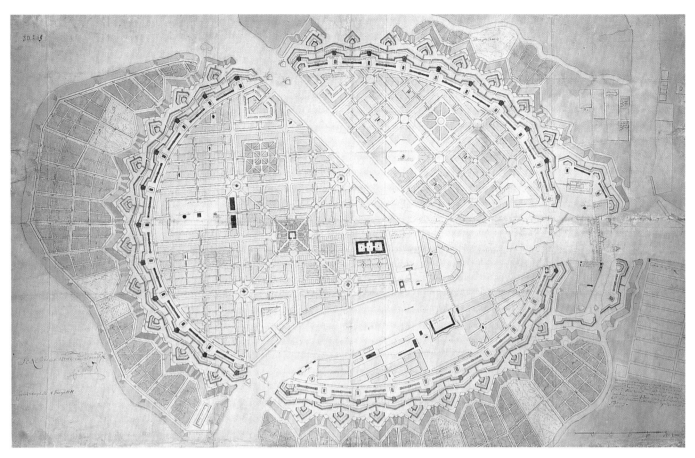

Alexandre Le Blond
Map of St. Petersburg, 1717
St. Petersburg, Scientific Library
of the Russian Academy of Sciences

Le Blond was replaced by the Italian Nicolo Minetti, whom the Russian ambassador had discovered in Rome, where he was the assistant to the aging Carlo Fontana. In Minetti's works in St. Petersburg we encounter motifs similar to Fontana's, primarily in the interiors. A "northern" restraint manifests itself in the façades of the Minetti buildings, only rarely permitting himself dramatic Baroque spatial resolutions (the palace at Strelna, the open portico over the grotto). Yet another Roman architect arrived with him at the same time, Gaetano Chiaveri, who was later famous for his buildings in Warsaw and Dresden.

Peter the Great made an effort to train Russian architects. Equal groups of young men were sent to study the construction business in Italy and Holland. The emperor did not live to see the successes of these young men, however. Most of them began working shortly before his death in 1725.

Peter the Great invited just as many architects from abroad as had been in Moscow at the turn of the sixteenth century, when several dozen Italians were working there. The difference was that in the early eighteenth century in St. Petersburg, natives of many countries of Europe were building together. Each of them brought along one of the "nuances" of European architecture of the turn of the eighteenth century. In St. Petersburg, these features were transformed into "letters" from which the "alphabet" of the new architectural "language" of the Russian Empire was compiled. Although the Baroque predominated, it is hard to speak of an indissoluble unity of style. A "polyphony" of artistic trends became the characteristic feature of Peter the Great's era (Evangulova 1974: 67–84). Meanwhile, strange transformations occurred with the foreign master-builders in St. Petersburg. The works of the Germans became "Italianized," and the Italians began to favor northern variations of the Baroque. And all of them had to reckon with the emperor's bias in favor of Holland. True, the French, especially Le Blond, were unwavering.

On the whole, what stands out among the traits of the Petersburg style of Peter the Great's era is the rationalistic quality of the interior floor plan and the striving for simplicity in the contours and rhythm of decorative elements. In addition, a general quality is the primarily linear, graphic nature of the façades. It would have been difficult to implement complex ornament

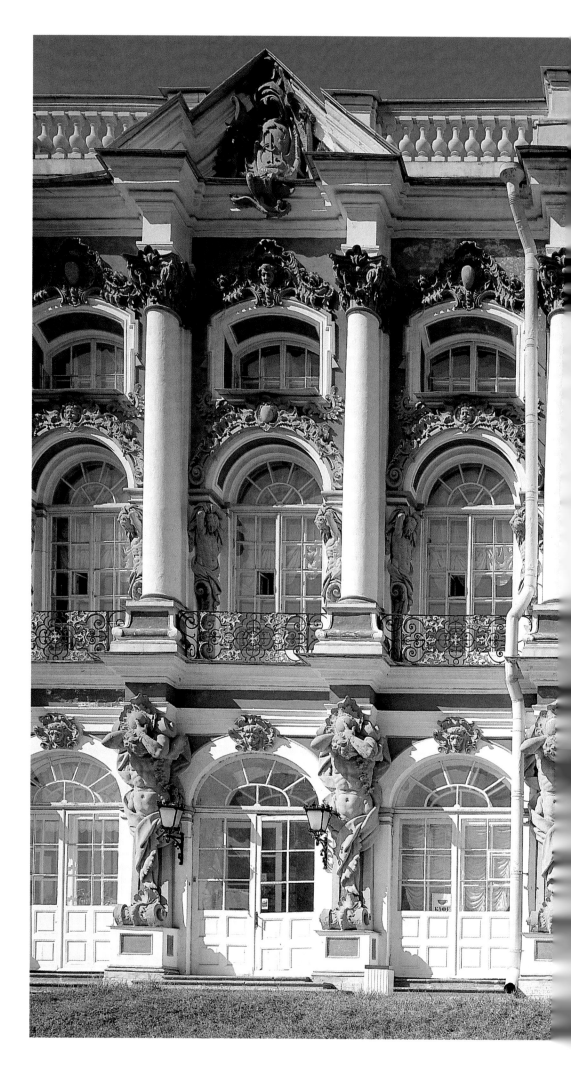

Francesco Bartolomeo Rastrelli
Exterior detail of the palace
of Carskoe Selo in St. Petersburg

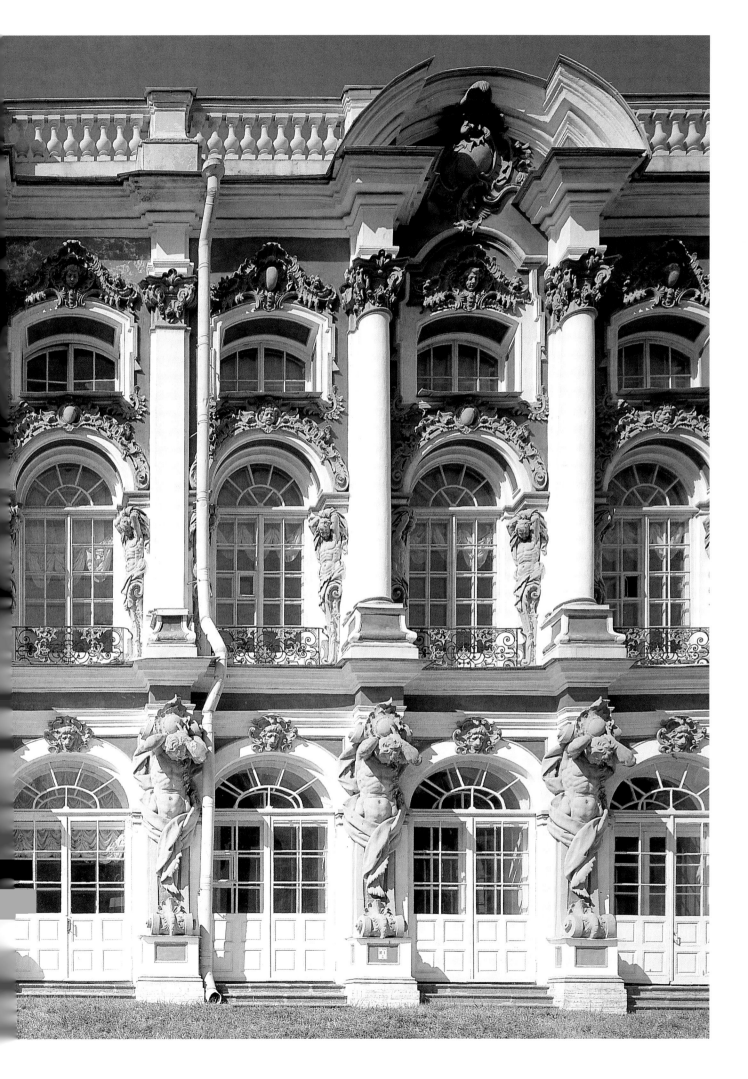

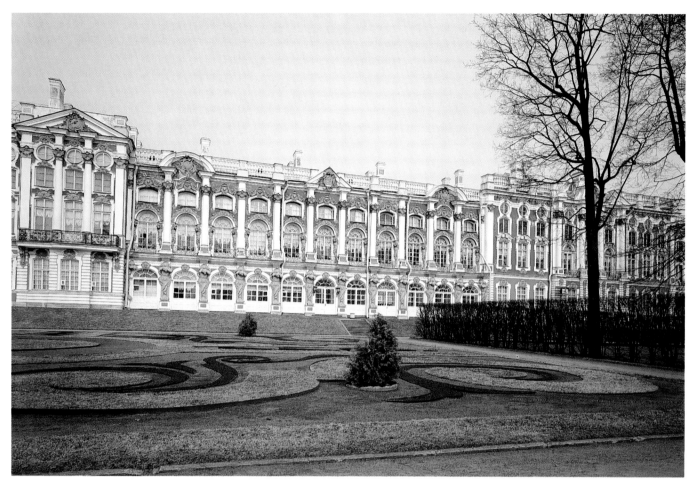

Francesco Bartolomeo Rastrelli
The garden front of the palace
of Carskoe Selo in St. Petersburg

given the frightfully fast tempo of construction. Even the emperor made no effort to do this. In his dreams, Petersburg was to become a stern, uniform, and precisely organized city.

This may have been how Peter the Great imagined ancient Rome. A similarity can be found between the images of the architecture of early Petersburg and the reconstructions of the buildings of antiquity in German and Dutch engravings of the seventeenth century that were in the emperor's library (Bodrova 1978).

True, he was able to implement only a few of his intentions. After the death of its founder, Petersburg found itself on the brink of extinction. Emperor Peter II returned the capital to Moscow. The unfinished city suffered devastating fires. Only Empress Anna I (1730–40) restored the luster to Petersburg when she ascended to the throne in 1730. Peter the Great's daughter, Elizabeth I, who succeeded Anna as Russia's ruler (1740–62), completed the creation of the new capital as well as the transformation of Russian architecture. In her reign, the Baroque was affirmed decisively in the country (Alekseeva 1977).

Petersburg Baroque from the ages of Empresses Anna and Elizabeth was different from the European forms of this style (Vipper 1978), basing itself as it did on the supremacy of two artistic categories: "regularity" and "grandeur" (Grabar 1954; Eneeva 1994: 136-57). The significance of the former was determined by the need to master Western technical achievements in all spheres of life, including city-building and the construction business. Rationality became an aesthetic principle, and a complex "mechanics" was created of the geometric structures applicable in architecture. Unlike many forms of European Baroque, the Petersburg version of the style was dominated by the straight line, the right angle, and the equal-angled ray structure. There was not even much roundedness, and curved lines were encountered only very rarely.

Nonetheless, the combination of expansive boulevards, precisely outlined rectangular plots, standardized dimensions, and geometrically regular gardens made the plan of Petersburg one of rare beauty and wealth. The chief proponent of Baroque regularity in city-building was Peter Eropkin, a Russian architect who had studied in Italy and who was the

opposite
Detail of the interior of the palace
of Carskoe Selo in St. Petersburg

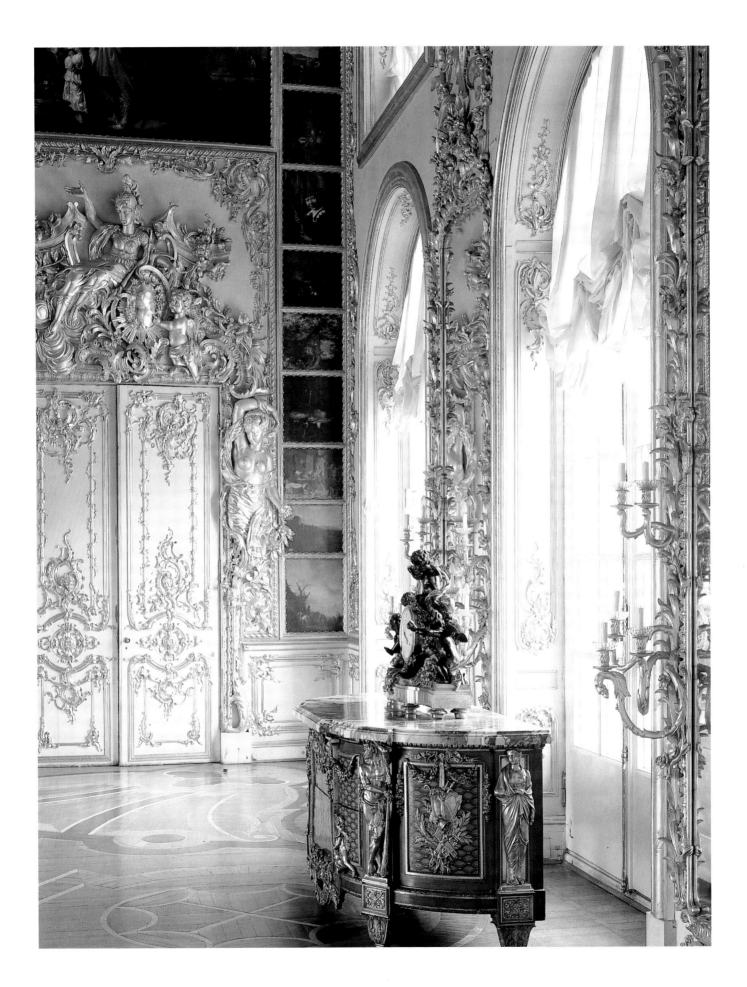

Francesco Bartolomeo Rastrelli
Exterior view of the Peterhof palace
in St. Petersburg

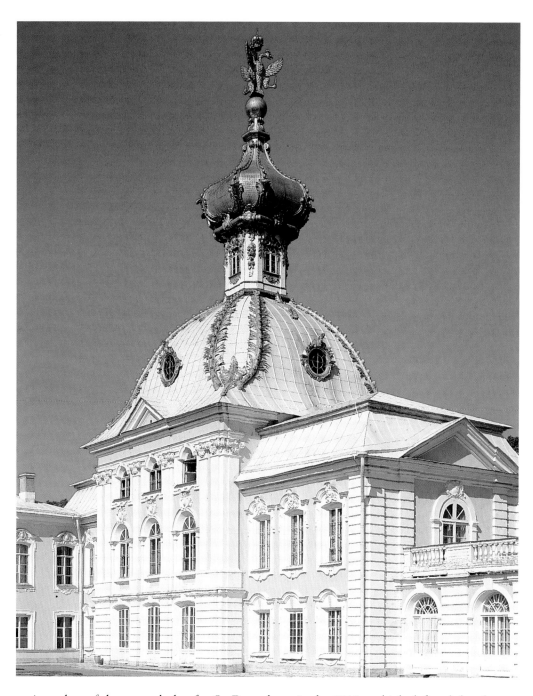

main author of the general plan for St. Petersburg in the 1730s, which defined the charac-
ter of the city's space. "Grandeur" was the principle they tried to apply to the fullest possi-
ble extent in the main entrances of the imperial residences, the palaces of the aristocracy,
and the churches. Implementation of this principle is linked with the name of Francesco
Bartolomeo Rastrelli, the style of whose works became the style of Russian architecture in
the mid-eighteenth century. Rastrelli was born in Paris, where he spent fifteen years
(Denisov and Petrov 1974), and was the son of an Italian sculptor who had been invited to
St. Petersburg by Peter the Great. It was from Russia that Rastrelli was sent to Italy and
Germany to study architecture (Grabar 1903: III, 182). Apparently he devoted most of his
attention there to the works of the German master-builders. It is hard to see any similarity
between his work and the Roman Baroque, whereas general features can be noted, for ex-
ample, from Neumann's structures in Würzburg or Pöppelmann's in Dresden. This is not
surprising since in the 1730s, when Rastrelli was beginning to work in Russia, there was a
strong German influence. Germans occupied key positions, and the tastes of Empress An-

opposite
Detail of the interior of the Peterhof
palace in St. Petersburg

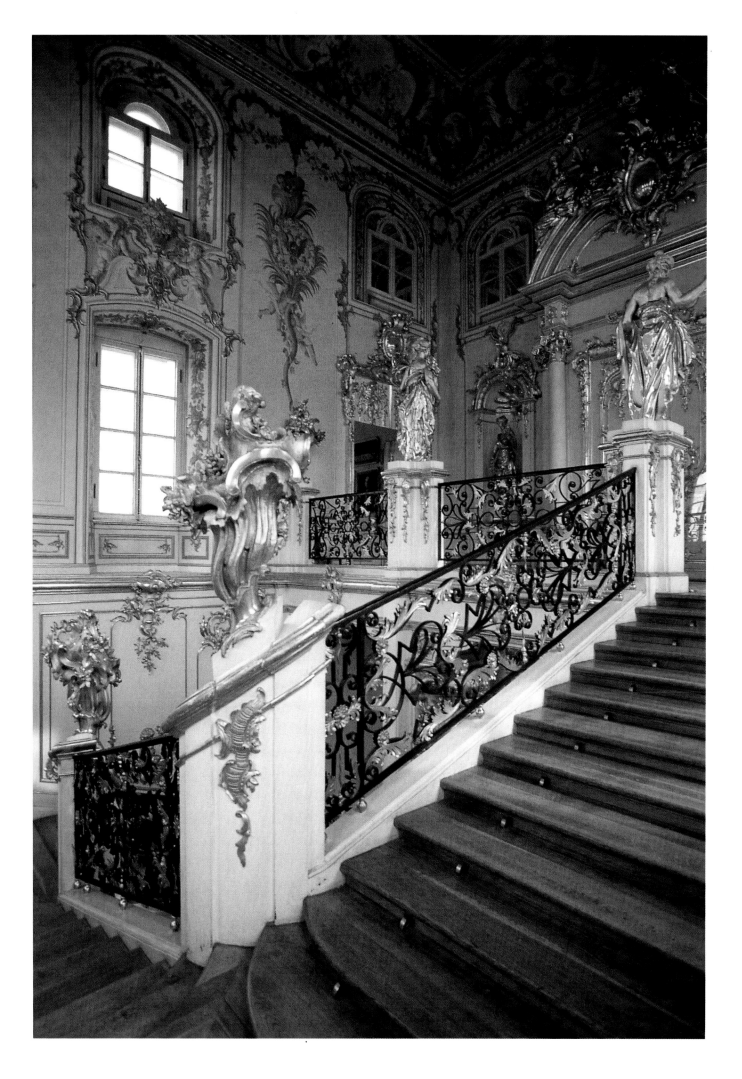

St. Isaac's Cathedral
in St. Petersburg

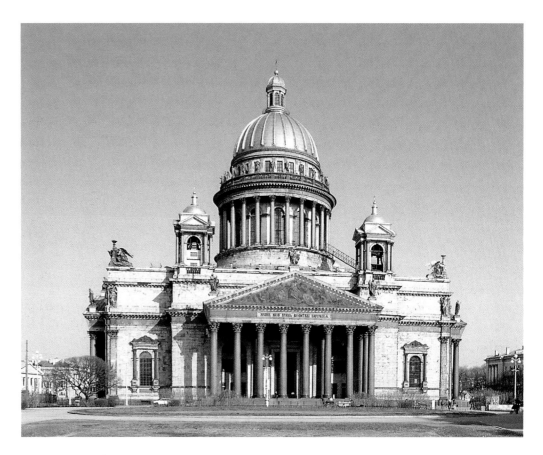

opposite
Antonio Rinaldi
Design model for St. Isaac's Cathedral
St. Petersburg
Scientific Research Museum
of Academy of Arts
cat. 608

na I had been formed during her youth, when she was the Duchess of Kurland. Rastrelli's talent reached its apogee in the 1750s, under Empress Elizabeth I, who had a taste for opulence and sweep. When she died, she left behind more than five thousand dresses embroidered with gold and decorated with precious stones. In architecture, she preferred grandiosity, bright colors, and an abundance of gilt. Rastrelli's Baroque lent civilized features to the empress's vivacious but somewhat vulgar taste (Winter Palace in St. Petersburg, Stroganov Palace on Nevsky Prospect).

His grandiose compositions were elaborated along precise axes, like elegant proofs of geometric theorems (Tsarskoe Selo, Peterhof). They were distinguished by an unwavering unity of style at all levels, from the overall planning down to the details. The strict hierarchy of spaces and the extended series of repeated elements conjoined with an infinity of variations on the detailing for each of them. In accordance with Empress Elizabeth's wishes, Rastrelli returned purely Russian elements to the set of forms in use, for example, the onion cupolas and five domes of churches. This was bound up with political considerations. Rastrelli's architecture was the artistic expression of the completion of the Russian Empire's formation that came about under Elizabeth I. The triumph of "European" reforms was conveyed by the triumphant grandeur of the Baroque of Rastrelli and his Russian contemporaries Savva Chevakinsky, Dmitry Ukhtomsky, and Andrei Kvasov.

In the 1750s, this style reached its greatest flowering in the ensemble of the Smol'ny convent, the imperial residences outside Petersburg, and the Winter Palace. Nothing foretold its decline. But Empress Elizabeth died, and once her nephew was out of the way, as well as Peter III, his wife, Sophie Anhelt-Zerbst, ascended to the Russian throne, entering history as Catherine the Great. The style characteristic of Elizabeth's rule could not possibly suit her. Moreover, the new empress had every intention of achieving significantly greater intimacy with Europe. Once again master-builders were invited to Russia from nearly every nationality, and they created the Russian architecture of the Enlightenment, whose most vivid expression was the model for the rebuilding of the Kremlin done by a pupil of Ch. de Vailly, the great Russian architect Vasily Bazhenov. It could be said that on the night of the government coup that brought Catherine the Great to power, Classicism took Baroque's place in

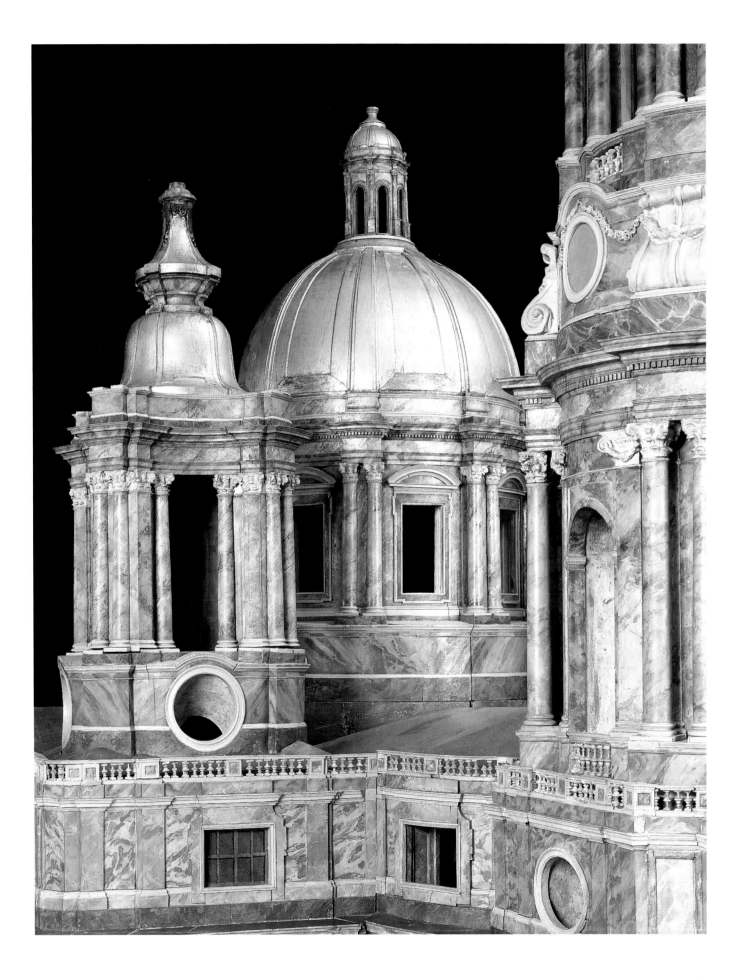

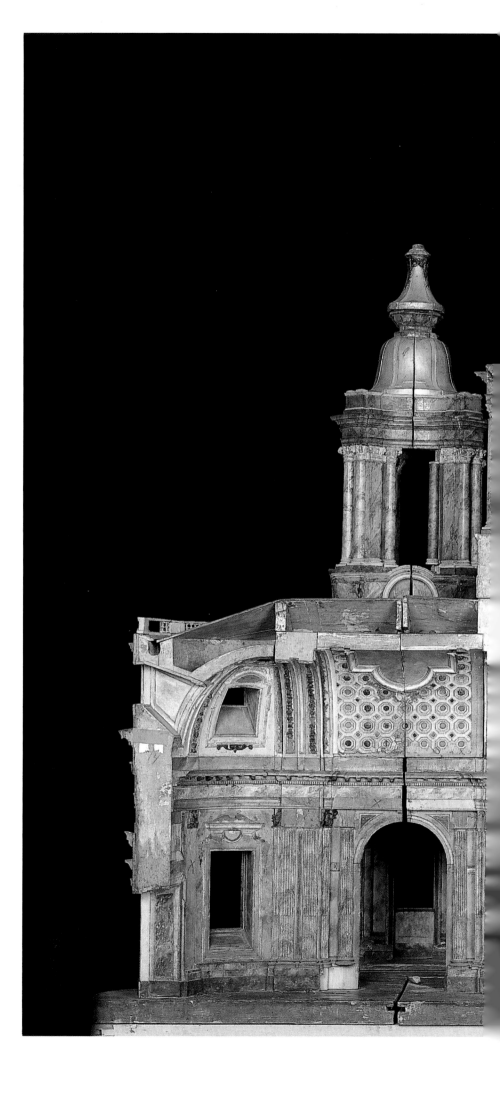

Antonio Rinaldi
Model for St. Isaac's Cathedral
Section of the interior
St. Petersburg
Scientific Research Museum
of Academy of Arts
cat. 608

following pages
Antonio Rinaldi
Model for St. Isaac's Cathedral
Detail of side, and frontal perspective
St. Petersburg
Scientific Research Museum
of Academy of Arts
cat. 608

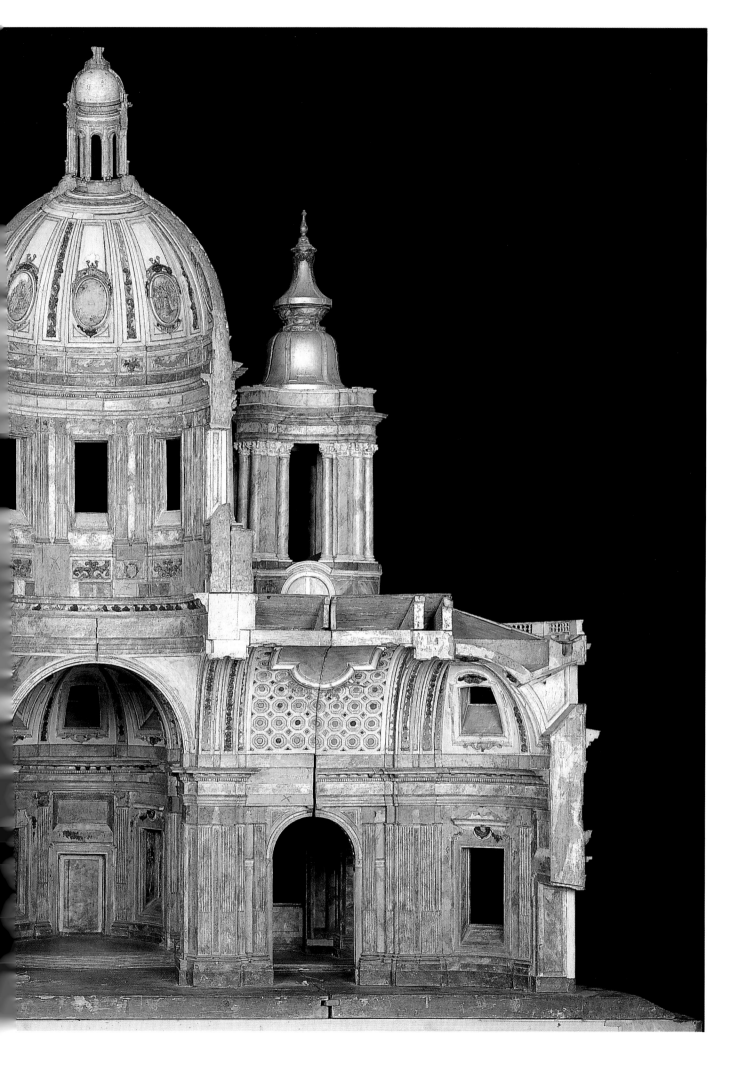

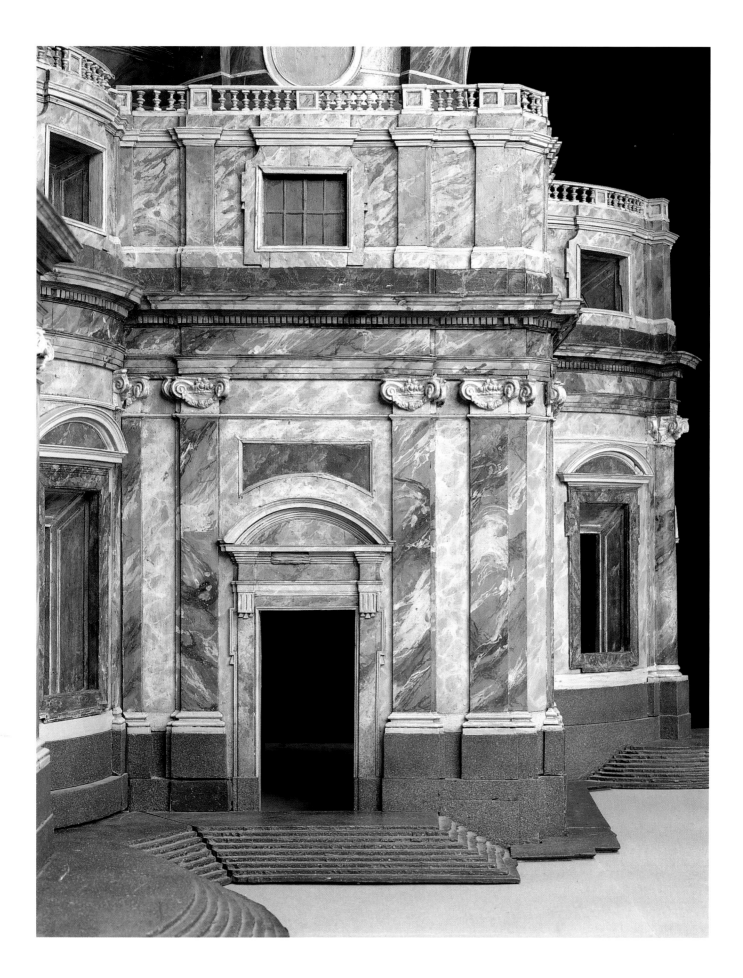

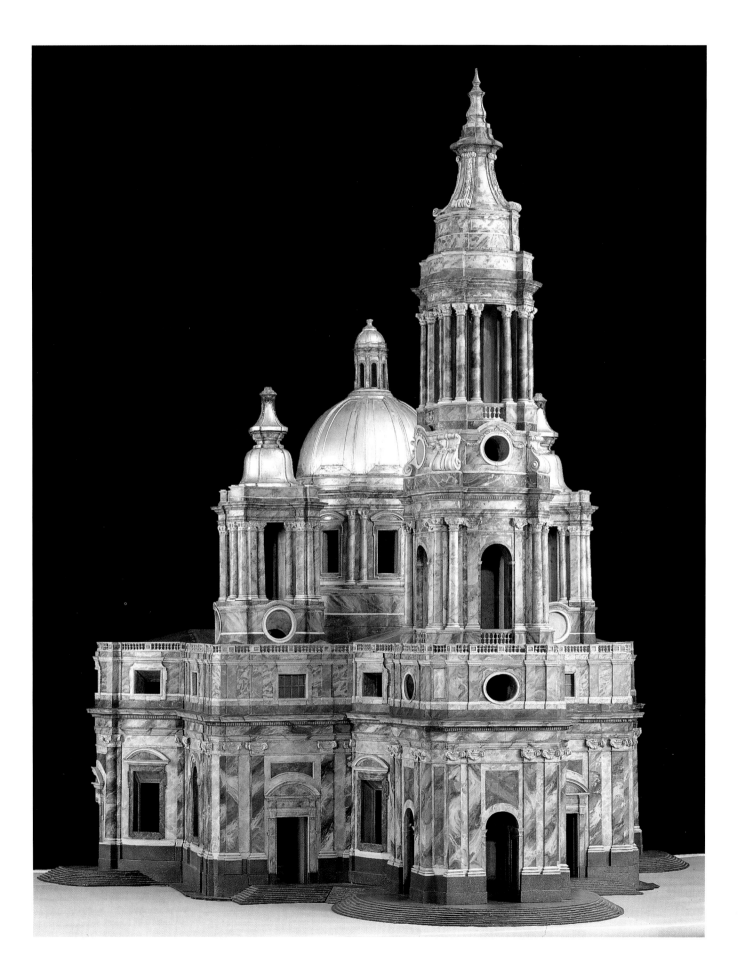

Smol'ny Cathedral
St. Petersburg
by Francesco Bartolomeo Rastrelli

following pages
Francesco Bartolomeo Rastrelli
Model for the Smol'ny monastery
complex
St. Petersburg, Scientific Research
Museum of Academy of Arts
cat. 575

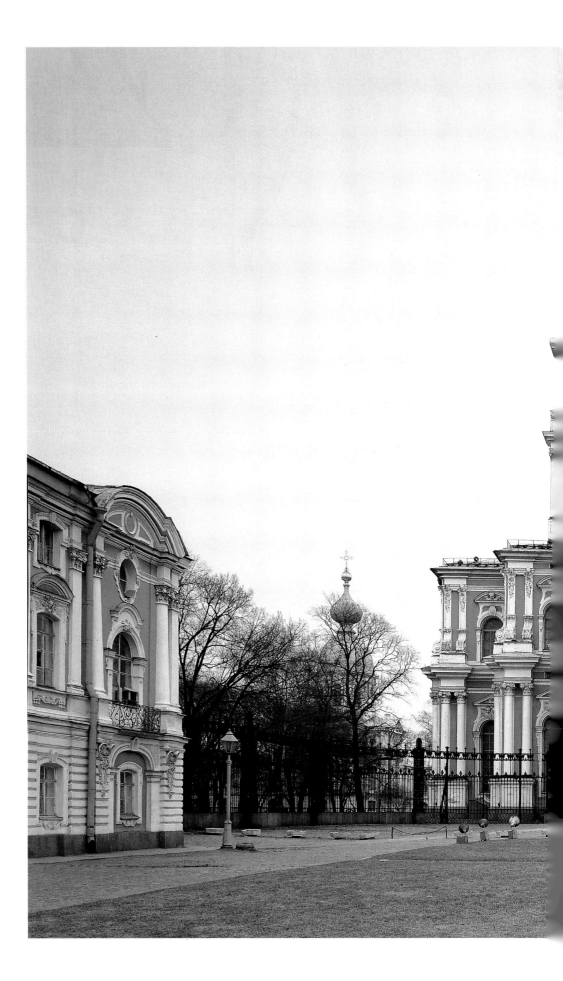

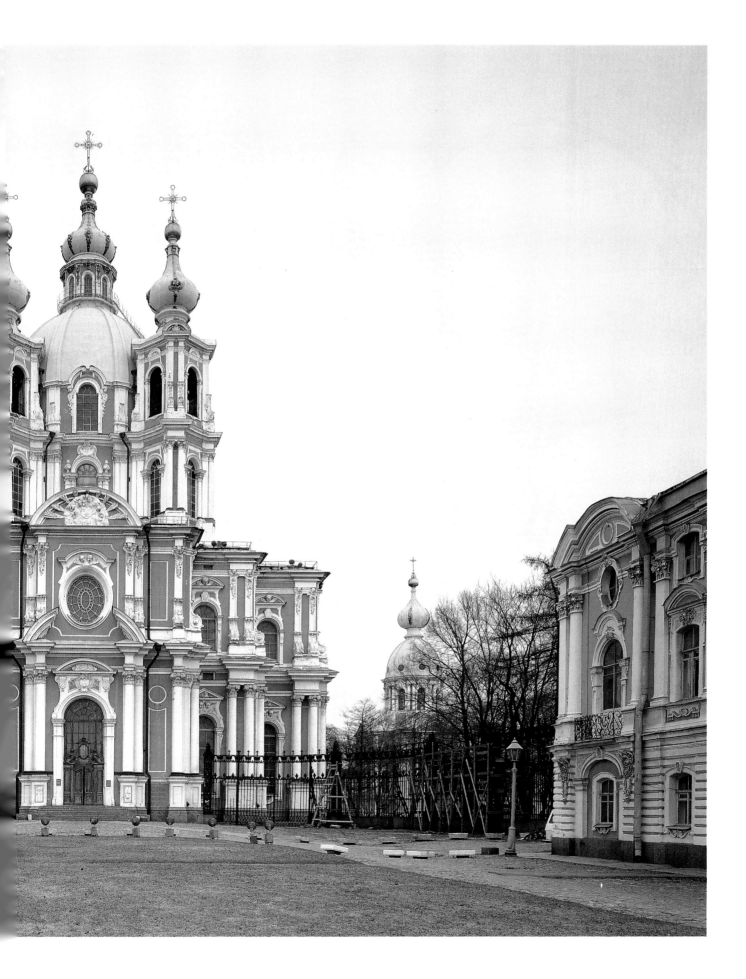

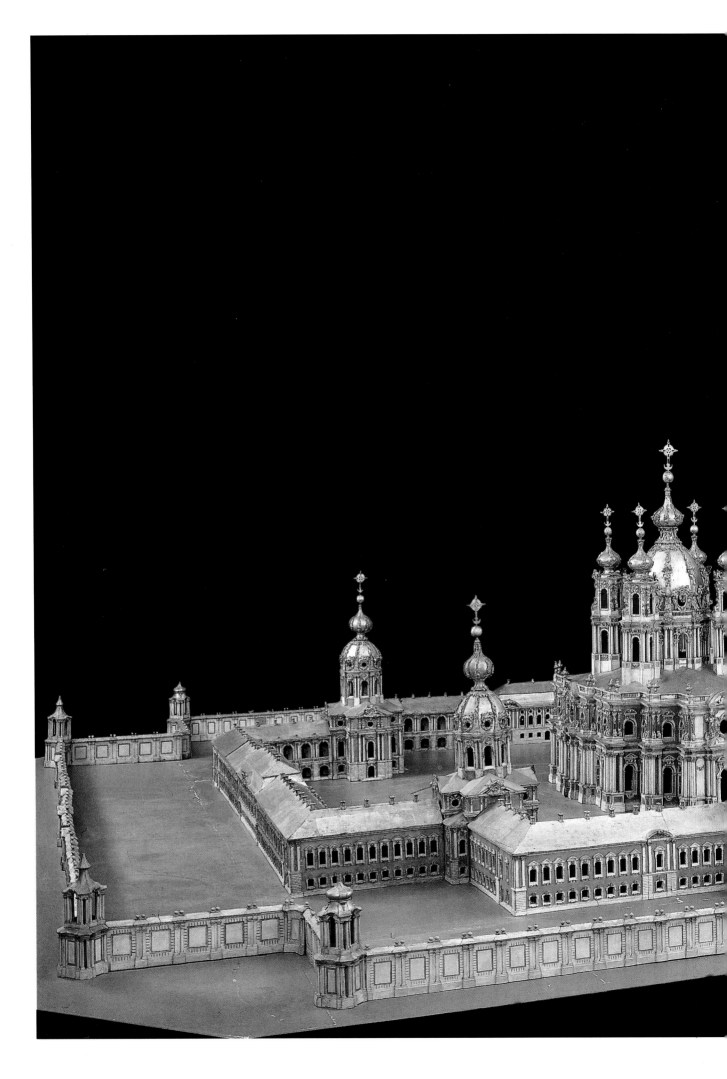

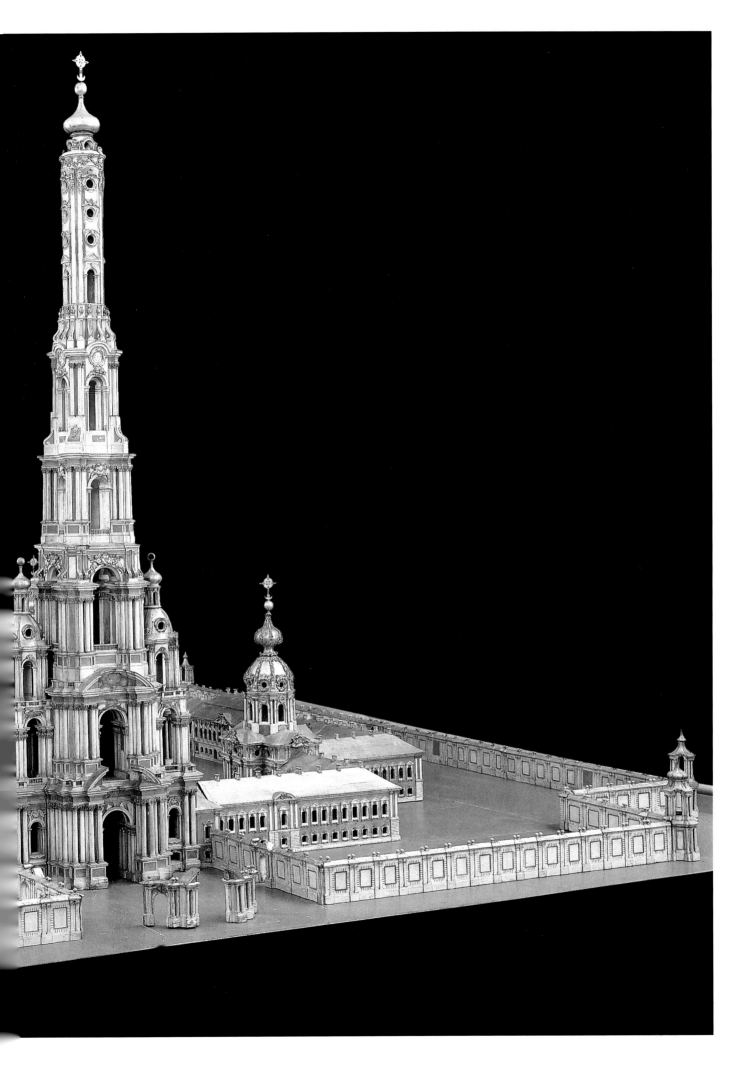

Francesco Bartolomeo Rastrelli
Model for the Smol'ny monastery
complex
Overall view and detail
St. Petersburg, Scientific Research
Museum of Academy of Arts
cat. 575

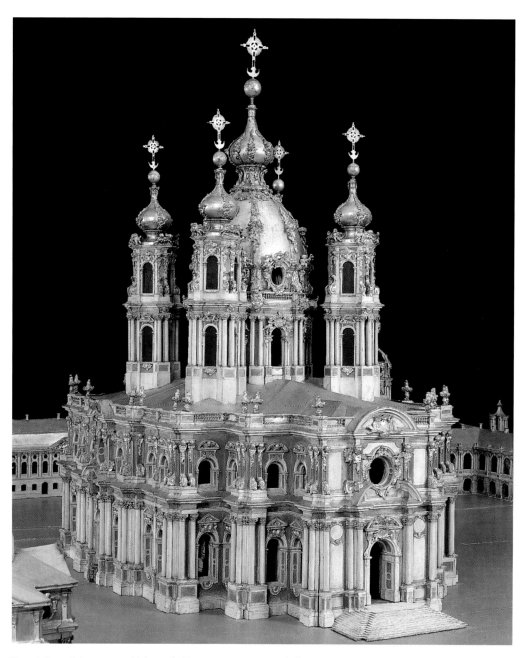

Russia's architecture. Although Baroque continued down to the late 1780s in the provinces, especially in the construction of rural churches, virtually every building erected in the cities on order of the government or especially the empress herself starting in the mid-1760s was given the form of Classicism. Nonetheless, in the work of the master-builders popular in the early reign of Catherine the Great, one still catches Baroque reminiscences, especially in Antonio Rinaldi, who studied with Luigi Vanvitelli in Naples and wound up in St. Petersburg in the mid-1750s. What makes his work in Russia especially interesting is the fact that in it Catrine "state" classicism gradually squeezes out the Baroque that had been inculcated in the master-builder in his homeland, and his manner evolves from the decorative style of Oranienbaum to the severity of the fully Classicist Marble Palace in St. Petersburg.

BIBLIOGRAPHY: Golikov 1788–1795; *Pis'ma i bumagi* 1887; Grabar' 1903; Nekrasov 1926; Grabar' 1954; Summerson 1956; Luipov 1957; Il'in 1959; Lazarev 1964; Denisov and Petrov 1974: 67-84; Evangulova 1974: 67-84; Alekseeva 1977; Bodrova 1978; Vinner 1978; *Arte lombarda* 1979; Derzhavina 1979; Zemcov and Glazychev 1985; Harvy 1987; Tananaeva 1987; Cracraft 1988; Batalov and Shwidkovsky 1992: 241-56; Eneeva 1994: 136–46; Batalov 1996

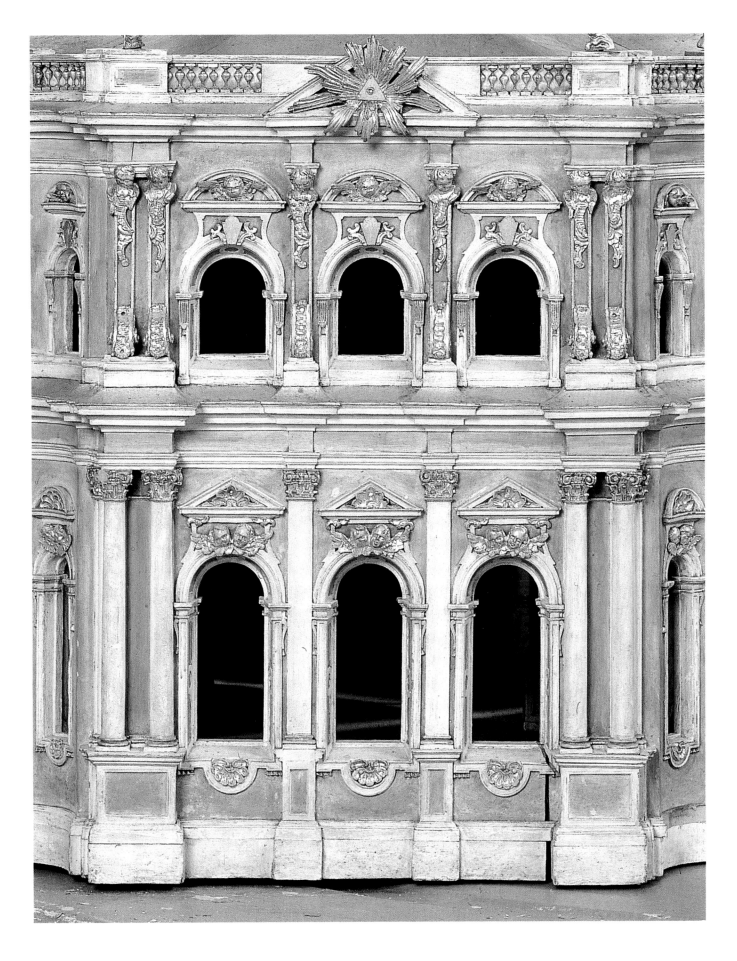

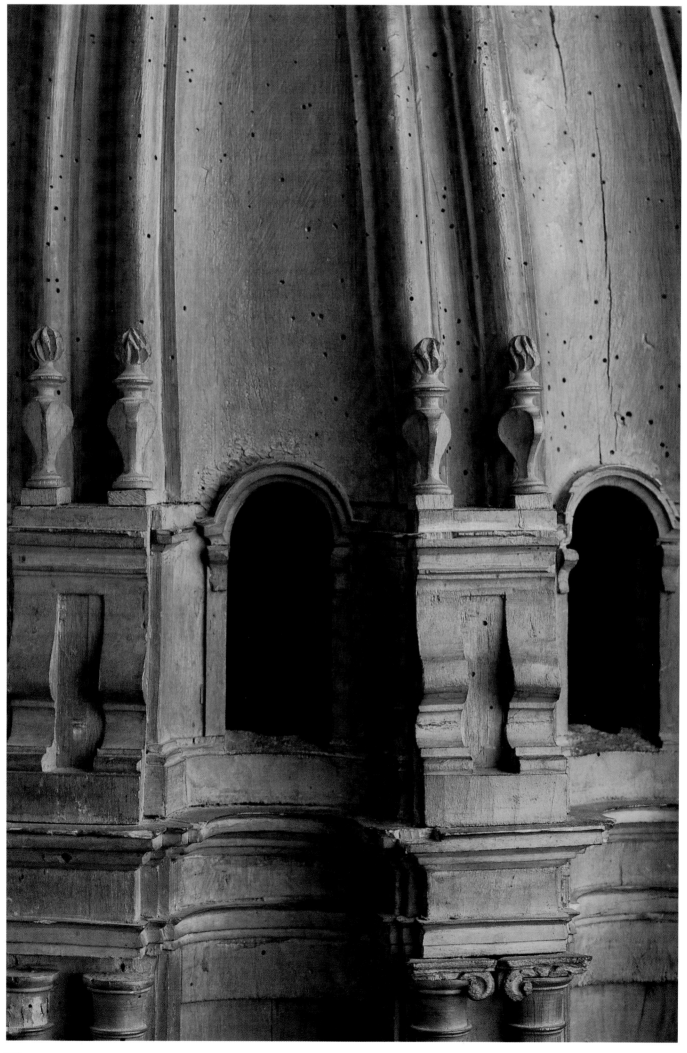

Elisabeth Kieven

"Mostrar l'inventione" – The Role of Roman Architects in the Baroque Period:
Plans and Models

Knowledge in which practicing architects must prove proficient (1744).

"Il perito architetto, in quanto alla teorica, deve essere versato in aritmetica, geometria, meccanica, architettura, e prospettiva, e ancora nelle parti più essenziali dell'idrometria.

"Quanto poi alla pratica, conviene, che sappia perfettamente misurare, e le regole generali, e particolari per altre tali misure, relativamente alla diversità de' casi, che possono accadere in genere di architettura, come ancora disegnare nello stesso genere, cioè mettere in pianta edifici, disegnare le alzate, o prospetti, e così li spaccati, e simili.

"Conviene inoltre, che allo studio teorico della meccanica abbia eziando, congiunto una somma pratica, cosicché sia perfetto in essa scienza, tanto nell' intenderla, che nel saperne far uso secondo le diversità de' casi e de' accidenti, che possono accadere.

Fà pure d'uopo, che sappia quali siano le parti essenziali, nelle quali consista tutto il modo di edificare, che principalmente sono la ragione, il sito, lo scompartimento, le mura, le coperture, ed i vani, e che conseguentemente sappia le regole, ed avvertenze da aversi in ciascheduna di esse parti, seconda la diversità de' casi, e de' luoghi, e così ancora quali siano le principali considerazioni da aversi nel fabbricare, le quali sono la perpetuità (che principalmente riguarda a fondamenti) la utilità, e la bellezza." (As far as theory is concerned the expert architect must be well versed in arithmetic, geometry and mechanics, architecture and perspective, and moreover in the most essential parts of hydronomy.

As far as practice is concerned it befits him to have a perfect knowledge of measurement, and the general rules, and particulars, of the measures, as relates to the diversity of instances, that may generally occur in the field of architecture; and moreover to create designs in the same field: i.e. to draft plans of buildings, design elevations, division of rooms, and suchlike.

Moreover, it is well that he should devote himself to study the theory of mechanics, together with a complete competence in practice, thus becoming perfected in this science, both in the understanding and in knowledge of its application in the different cases and eventualities that may occur. It is also to his advantage that he know the essential parts of which the general methods of architecture consist, which are, principally, the region, the site, division of space, the walls, the roofing and the rooms; and that consequently he know what rules and what attention must be given to each of these parts, according to different cases and places; and moreover what the main considerations are which he should give to the building in order to ensure it the longest possible life [this mainly relates to the foundations], utility and beauty.)

"Non è consuetudine d'Architetti dar un piccol' disegno talmente in proportione, che s'habbia a riportare de piccolo in grande per vigor de una piccola misura, ma solamente si usa per far li disegni per mostrar l'inventione."[1] (It is not the practice for architects to make a small drawing, so much in proportion that it can then be exactly reproduced, from small to large, on the strength of its reduced measurements. Drawings are only used to show the invention.)

We are particularly well informed about the job profile of architects and their training from the sixteenth through to the eighteenth centuries.[2] Of these, by far the best researched were the architects working in Rome,[3] and especially in the eighteenth century.[4] It was certainly a very long time before the sort of regular training enjoyed by painters and sculptors was extended to architects; the Rome Academy only began regular architectural courses in the second half of the seventeenth century. Anyone wanting to become an architect usually began by learning the crafts of stonemasonry or stuccowork, painting and sculpture, and changed over later, once he had proved proficient in drawing and had acquired a basic knowledge in the workshop of a practicing architect. Here he would first be set to work as a draftsman, then, by furthering his training and experience in the techniques and practice of construction, he would most likely be put in charge of construction work or the inspection of buildings. Many became collaborators, and later followers, of their teacher. This much-extended training course meant that an architect reached independence at a relatively late stage, and many spent the rest of their lives in minor positions.[5]

As most of the information we possess only comes from written accounts of the lives of artists and their training, the mechanisms of these artist legends must of course be seen in the light of the reliability of sources. Again and again we find the stress is laid on the self-taught element of their professional training. Initially, private study with the help of treatises (first and foremost those of Vitruvius, Alberti, Serlio, and later of Palladio) is emphasized, and in fact Scamozzi's treatise of 1615 reads like a guide to self-study. Then followed drawings from the works of the

[1] Letter from Giacomo Barozzi da Vignola, 1 February 1547, to the work site of San Petronio in Bologna (G. Gaye 1840: 359).
[2] S. Kosstoff (ed.), *The Architect. Chapters in the History of the Profession*, Oxford 1977.
[3] For the sixteenth cent., see Ackerman (1953); his observations require further documentation, however; Lotz, 1953–56, 194–95; Schwager 1975: 111, 117ff; for the seventeenth cent. see Jh. Pollak 1910; Scavizzi, 1983, with thoroughly researched data on building practice; G. Curcio and L. Spezzaferro 1989; G. Curcio, "Giacomo e Giovanni Battista Mola: due diversi modi di essere architetti a Roma nella prima metà del XVIII secolo," in *Pier Francesco Mola 1612–1666*, 1989: 28–39.
[4] *In Urbe Architectus. Modelli–Disegni–Misure. La professione dell'architetto, Roma 1680–1750*, edited by B. Contradi and G. Curcio, Roma 1991.
[5] G. Curcio, "La città degli architetti," in *In Urbe Architectus*, op. cit.: 143–54.

Unknown Artist
Model for a dome
Milan, Private Collection
cat. 603

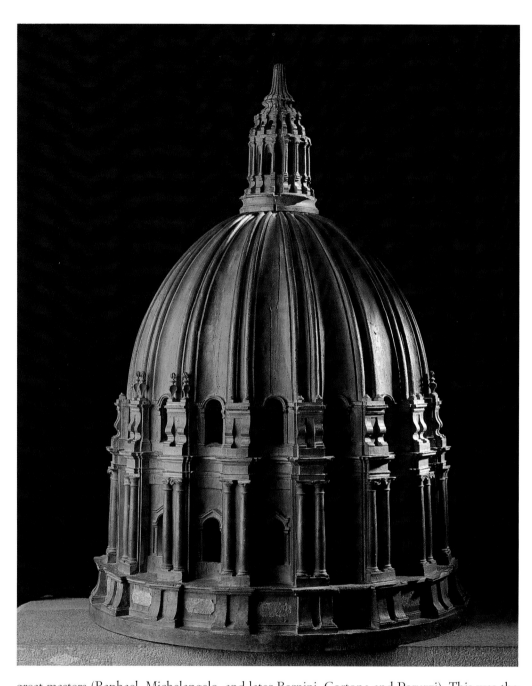

great masters (Raphael, Michelangelo, and later Bernini, Cortona and Peruzzi). This was the real basis of architectural training. As for studying the technical or practical aspects, there was no further possibility. In the scale of values of pure art, these were considered much too close to common craftsmanship. While a preliminary training in painting and sculpture were highly esteemed, it is significant that any previous activity as a bricklayer, carpenter or cabinet-maker, which involved a far more solid technical preparation, was looked upon as a rather negative qualification. As Cellini pronounced on Antonio da Sangallo: "Ma per non essere stato nè scultore nè pittore, anzi maestro di falegname solamente; però non si vide mai di lui nelle sue opere di architettura una certa nobil vertù" (But he was no sculptor and no painter, in fact no more than a master carpenter; that is why you never find a certain nobility in his architectural works). Even as far on as the mid-eighteenth century Monsignor Bottari spoke scathingly of that "stucco worker," Maderno, in comparison with Michelangelo.[6]

So one did not become an architect as a result of training, but through practicing the profession.[7] The new assessment of the social and professional status of the artist in the Renaissance had left the professional image of the architect undefined for a particularly long time. With the

[6] Quoted from Lotz, 1953–56, 226, no. 89; Bottari 1754: 46; G. Curcio, "Le contraddizioni del metodo. L'architettura esatta di Domenichino," in *Domenichino 1581-1641*, catalog of the exhibition in Rome, Pal. Venezia 1996–97, Milano 1996: 151–61.
[7] Pollak, 1910: 207.
[8] The carpenters' tasks included laying the timber for the roof, which required expertise in stereometrical visualization.
[9] Significant in this conflict was the bitter résumé written by An-

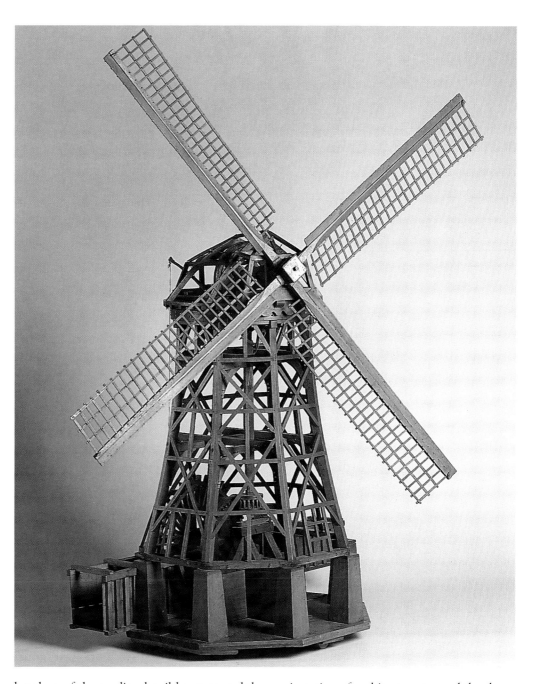

tonio da Sangallo after the death of Raphael concerning his plans for the construction of St. Peter's, and, in Sangallo's view, their inadequate technical components; in spite of all his expert professional experience, Sangallo was unable to prevail against the non-experts (see Fromel, Tafuri and Ray 1984: 253 and further 296); also Scamozzi's complaints about the non-experts).

[10] Hibbard 1971: 33–34; in detail V. Spezzaferro in Curcio and Spezzaferro 1989, "Introduzione."

breakup of the medieval guild system and the reorientation of architecture toward the documented sources and buildings of the ancient world, the accent was placed less on the use of techniques, but rather on the quality of design and a sound knowledge of history. The artist possessing a rich invention and culture could be relied upon to produce good architectural designs. Raphael and Michelangelo offered exemplary proof of this. The business of putting up the building could be safely left in the hands of less imaginative specialists. In Giuliano and Antonio da Sangallo, specialists trained from scratch with a solid experience in carpentry[8] behind them, Bramante and Raphael had particularly well-versed technical experts at their side. Here in fact we already see the beginnings of the emphasis laid on the *disegno-ingenio* (design-inventiveness) aspects of architectural activity which paved the way for the clean split between architecture and engineering in the eighteenth century.[9]

In the second half of the sixteenth century practicing architects arrived in Rome – the most notable among them coming from Lombardy and Ticinese area – with a training far more oriented toward practical experience than artistic. A good example was Domenico Fontana (1543–1607),[10] who had had more experience as an engineer than as architect. This led to es-

Robert de Cotte
Wooden model for the Thurn
und Taxis palace
Main façade
Regensburg, Fürst Thurn und Taxis
Zentralarchiv-Hofbibliothek-Museen
cat. 257

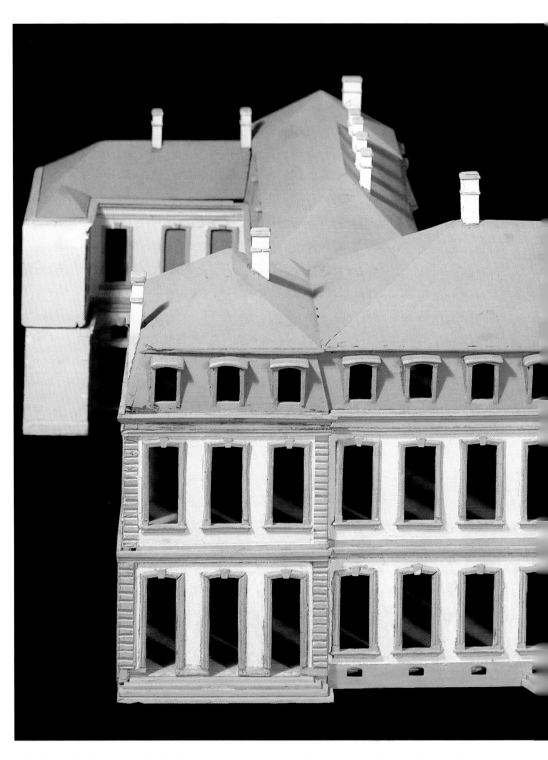

tablishing the high standard of Roman architecture of the time. The tendency to found art academies for painting and sculpture had begun toward the end of the sixteenth century, but it was not until the end of the seventeenth century that they slowly started to include courses in architecture and engineering. None of the artistically creative professions underwent so many changes as that of the architect. And at the end of this cycle the divorce between art and technology only became absolute in the late eighteenth century.

Professional practice in Rome
From the sixteenth to the mid-eighteenth century an architect's work included military and civil buildings, port installations, and road construction, at one and the same time, so it meant they

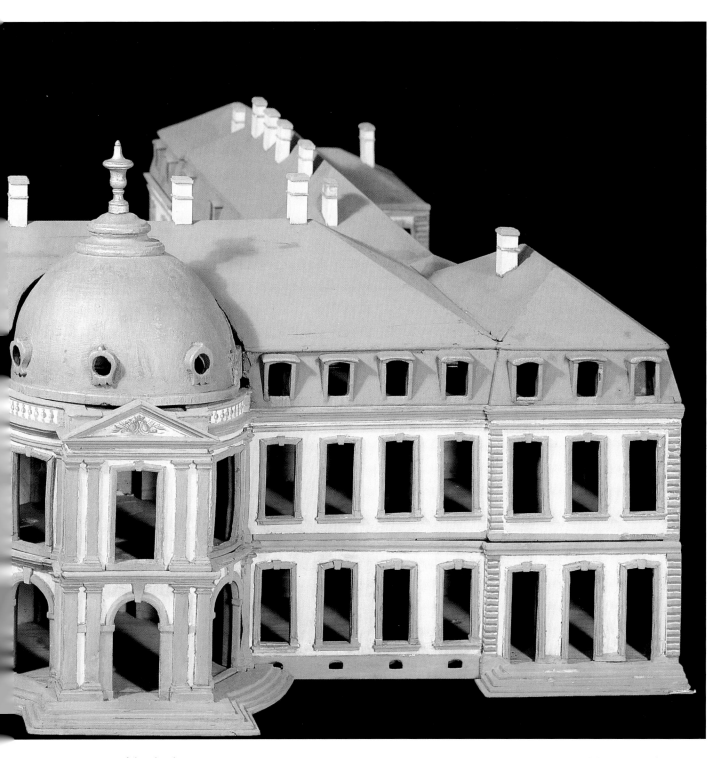

[11] For an account of this development see U. Forti 1957; H. Straub 1952; G. Bozza, J. Bassi, "La formazione e la posizione dell'ingegnere e dell'architetto nelle varie epoche storiche," in *Il centenario del politecnico di Milano, 1863–1963*, 1964: 59–62.
[12] On the role of *misuratori* see Pollak 1910; Scavizzi 1983: 19ff.
[13] Mancini 1968: 480; Zanella 1988: 32.

also had to serve as engineers.[11] The complexity of the job, and the public responsibility that went with it, assured architects in official positions of a high social status. But not of course those who were only gradually entrusted with non-independent work, like the building inspection carried out by *misuratori* (surveyors), since they were regarded as lacking in artistic creativity.[12] *Misuratore* was generally used as a term of disparagement, or even downright invective. "Michetti misuratore e non architetto" (Michetti is a surveyor, not an architect), P. L. Ghezzi complained to the Camera degli Architetti in 1731, and to the papal architect Raguzzini, "Architetto per breve, ma io lasserei passare per mediocre misuratore" (He has just become an architect, but I'd only let him pass as a commonplace surveyor). Again in 1776 Giacomo Quarenghi explained, "A Roma basta saper tassar un conto che subito è architetto,"[13] (In Rome

Robert de Cotte
Wooden model for the Thurn
und Taxis palace
Rear elevation
Regensburg, Fürst Thurn und Taxis
Zentralarchiv-Hofbibliothek-Museen
cat. 257

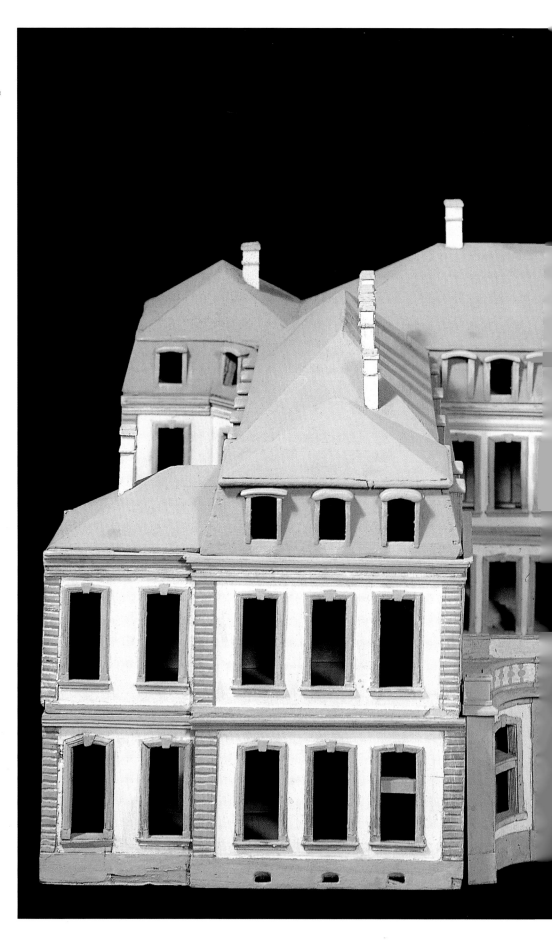

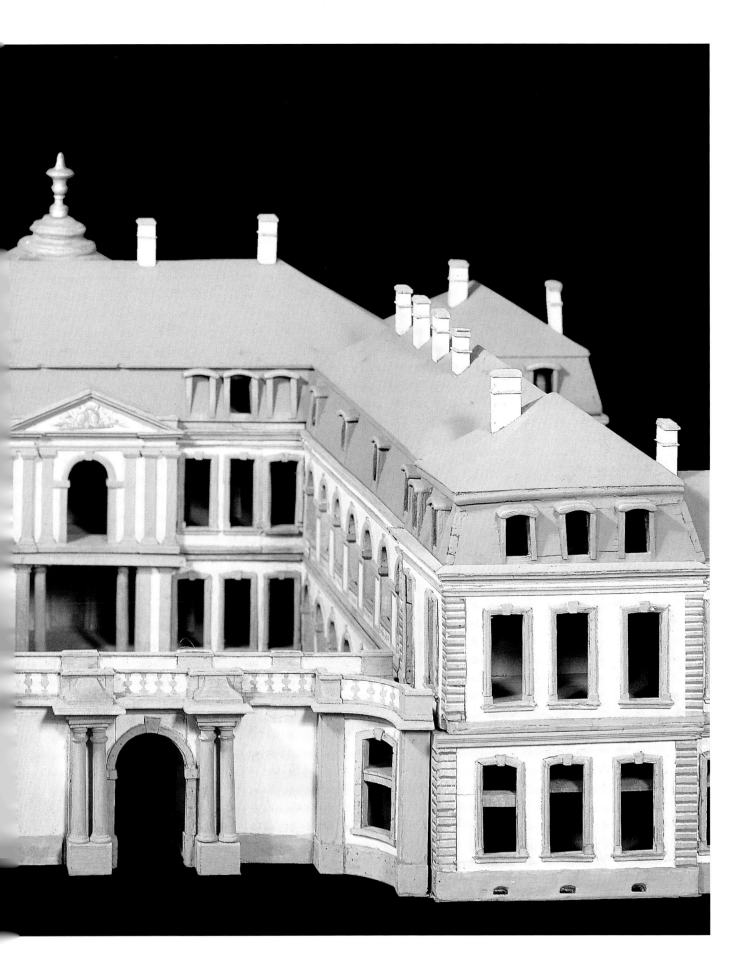

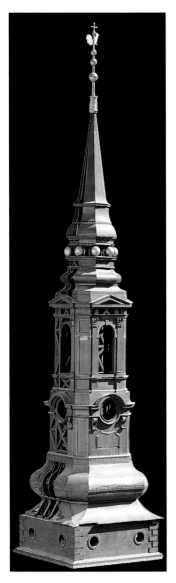

Johann Boye Junge
Wooden Model for St. Peter's Tower
in Copenhagen
Copenhagen, Copenhagen City
Museum
cat. 595

[14] Krause 1990.
[15] As an architect of Prince Gio-
vambattista Pamphili, Mattia De
Rossi received a monthly provi-
sion of 2.5 *scudi* plus the "per-
centuale dei lavori" Menichelli
1985: 71.
[16] A. Anselmi, "Gli architetti della
Fabbrica di San Pietro," in *In
Urbe Architectus*, op. cit.: 272–80.
[17] Also called *architetto del Papa*
or papal architect; in the eigh-
teenth century the official title of
*architetto dei sacri palazzi aposto-
lici* was used.
[18] Under Urban VIII, the *architet-
to di palazzo* received a monthly

all you need to know is how to add up a list of figures and immediately you become an archi-
tect). This explains why Borromini, for instance, who started out as a stonemason before rising
to fame as an architect, would immediately turn down any job that smacked of *misuratore* work.
In this connection it is interesting to note that in France the expression *dessinateur* (designer)
was often adopted for disparaging comment.[14]

Architects were unable to work freelance; it was essential to be a member of the papal or civil
authorities, or else of a Congregation, a noble family, a cardinal, or the chapter of a church or
convent, as their closely associated or fixed architect. All these jobs brought in a secure, though
often paltry, income, so that according to whatever possibilities turned up, they all did their ut-
most to accumulate several posts at the same time to boost their incomes.[15]

Posts with the Camera Apostolica authorities were not usually life appointments, but held good
as long as the pontificate lasted. A new pope could confirm the architects in their positions, or
else replace them with men of his own choosing. The most eminent post of all was the archi-
tect in charge of the building of St. Peter's, and this was a life appointment. Although the main
construction work on the Basilica had been completed by the mid-seventeenth century, and
thereafter the principal concern was maintenance, only high-ranking architects were appoint-
ed to direct it until the mid-eighteenth century.[16]

The highest post among the Camera authorities was *architetto del palazzo*,[17] and was held by
one or two architects with an assistant each. They saw to maintenance and also undertook the
various arrangements for building new papal residences and ministries.[18] Moreover, as a mem-
ber of the papal family the *architetto del palazzo* shared in payments in kind, such as firewood,
candles, cloth, hay, wine and oil. In addition to this he was entitled to the use of the service
coaches, coachmen and horses from the papal stables.[19]

The administration of the Camera Apostolica offered further job possibilities in contracts for
road and canal construction, or for the ports of Rome and the Papal States. In the inner city,
the town-planning authorities, and highway and traffic tribunals, responsible for vetting build-
ing applications and issuing permits, had the greatest influence on the development of town
planning in Rome.[20] It was to these authorities that all building applications had to be submit-
ted, since it was a question of converting public land into streets and squares, and these au-
thorities held the power to veto any plans they found unsuitable.[21]

Religious congregations and convents owned a good part of the landed property in Rome and
the surrounding country;[22] they relied on an architect to carry out any important repairs, apart
from rebuilding, new buildings and alterations, for a stipulated year's salary. The architect was
also expected to provide expert advice. For example, the contract between Giuseppe Pannini
and the Chapter of Santa Maria Maggiore in 1782 stated: "Che debba far tutte, e singole oper-
azioni, funzioni, disegni, perizie, scandagli, misure, stime, elevazioni di Piante, e qualunque al-
tra cosa, benché insolita, e straordinaria, che in qualunque maniera e tempo sarà per occurrere
in servizio del Nostro capitolo, tanto in città che fuori."[23] (He must do everything, simple op-
erations, functions, designs, surveys, inspections, soundings, Measurements, Estimates, eleva-
tions from Plans, and everything else, even things that are unusual or extraordinary but which,
in any way and at any time, will be of service to our Chapter, both within the City and without.)
For large-scale construction work the architect did not receive an additional fee,[24] but was en-
titled to a certain percentage of the total cost of the building. As a rule this usually worked out
to one or two per cent, but according to previous arrangement it could also come to much
more. This fee was paid directly by the masters of the various crafts employed on the building.
This is why these payments were not entered into the official accounts and consequently we sel-
dom find any documentation for them. A situation that has led both Ackerman and Pollack
somewhat astray in their mistaken assumption that architects were hardly ever paid for their
work. Wills and legacy inventories of eminent architects show they enjoyed a sound to wealthy
financial status.[25] There can be no doubt that this was the result of accumulating official posts,
since participation in many different building projects brought prosperity with it, as Girolamo
Rainaldi states: "Perchè li Architetti fanno le piante, alzati, et Modelli, ma le borse fanno loro
le fabriche."[26] (Because architects make the plans, elevations and models, but it takes the mon-
ey-bags to put up the building.) Even less prominent architects worked on at least two or three
commissions at the same time. This would suggest they ran large-scale construction firms,
though usually only the names of, at most, one or two collaborators are known. Concerning

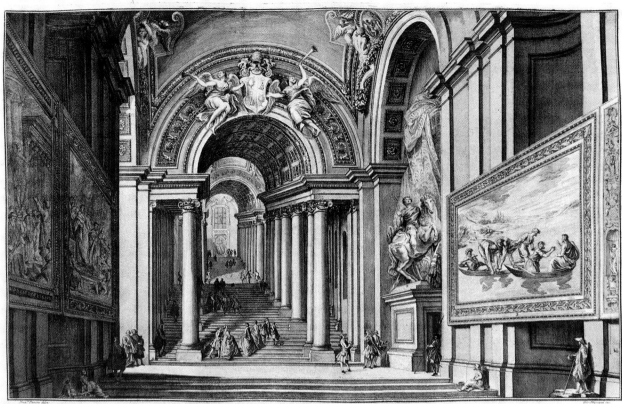

VEDUTA
Della Scala Regia ordinata da Alesandro VII architettura del Cavalier Lorenzo Bernini, e Statua di Costantino Magno fatta dal sudetto Bernini

Francesco Pannini
View of the Scala Regia in the Vatican, from the north gallery
Rome, Istituto Nazionale
per la Grafica
cat. 91

fee of 12 *scudi*, plus a daily wine allowance; his *coadiutore* received the same sum; under Innocent X the fee rose to 30 *scudi* per month, as did for the *coadiutore*. For work not foreseen by the contract a gift (gold coins, golden chains) was customary (Pollak 1910: 208–209).

[19] For these jobs, cf. ASR, Camerale I, Giustificaz. Tesoreria; ASV, Fondo Sacri Palazzi Apostolici, Computisteria.

[20] R. Lanciani 1902: I, 47ff.; E. Rè, "Maestri di strade," in *Archivio della Società Rom.* XLIII (1920): 5–102; A. Buschow, "Irdische Götter des Straßenwesens. Das tribunale delle strade im Rom des 18. Jhs.," in *Daidalos* 10 (1983): 42–53; T. Manfredi, "L'architetto sottomaestro delle strade," in *In*

how many collaborators were employed in one construction outfit, how the division of labor was organized,[27] how many draftsmen drew plans for them – on all these aspects we can find very little to report, not even on the extraordinarily well-documented construction works of St. Peter's. Payrolls offer no information since the architect obviously had to pay any delegated secondary work out of his own pocket; or else it was tacitly included in an agreed lump sum.[28] Surveying and preparation of true-to-scale plans were included in the contracted price. If this sort of contract was issued without a commission for the building, an estimate was made of work time and costs.[29] Architects tended to call themselves pupils of a certain master mason with whom they have certainly been working for a while in his studio; Garms has researched this in the case of Vanvitelli's studio, but there are seldom more than two pupils that he detected at the one time.[30] Since these were working in an apparently minor capacity, no mention is made of them in the accounts. Payment for the work must have been very little – if indeed they were paid at all – as it was considered part of their apprenticeship.

Many architects were also building contractors[31] who could run several big commissions at the same time, like Girolamo and Carlo Rainaldi, or, as Passeri described it of Domenico Fontana: "Perché il Fontana era comunemente occupato in varie incombenze considerabili dategli da quel generoso Pontefice, si voleva di molti in fare disegni per occasioni diverse. Era il Fontana a questo poco atto, e privo anche di quel tempo che richiede una fissa applicazione per inventare, e ridurre a compimento un bello ed esatto disegno con le sue perfezzioni e pulizie."[32] (Because Fontana was most often occupied with various important commissions granted him by that generous pope, he relied on many assistants to make designs for him on various occasions. Fontana himself had little aptitude for this, as well as being pressed for the time required for designing and completing an exact drawing in a perfectly clean fair copy.) What the earnings were for collaborators trained as draftsmen, we can find out from the sources. In 1637 the *fattore* of the construction works at St. Peter's, Pietro Paolo Drei, was paid a total of 74 *scudi*

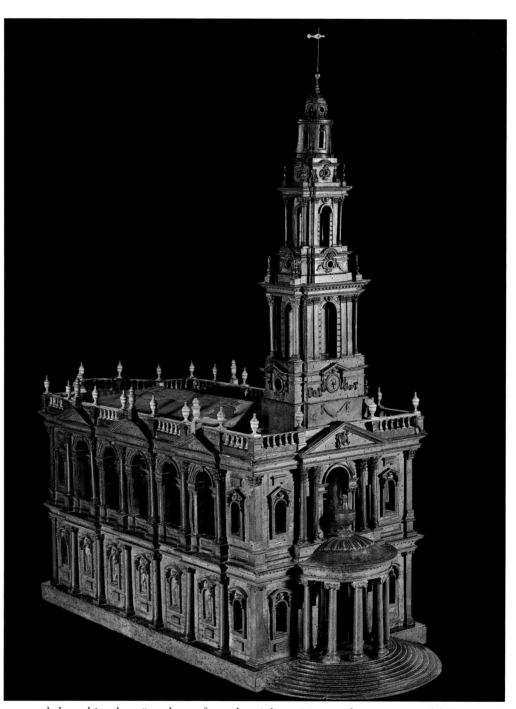

Urbe Architectus, op. cit.: 281–90; E. Da Gai, "L'architetto dell'Annona (1680-1750)," in *In Urbe Architectus*, op. cit.: 291–95; S. Pascucci, "L'architetto della Presidenza degli acquedotti urbani," in *In Urbe Architectus*, op. cit.: 296–300.

[21] See also H. Hibbard, "Di alcune licenze rilasciate dai maestri di strade per opere di edificazione a Roma (1586–89, 1602–1634)," in *Bollettino d'arte* n.s. 5, 52 (1967) 2: 99–117.

[22] For an example of this see Curcio 1985; Curcio 1988.

[23] Rome, Chapter Archives Santa Maria Maggiore, *Atti capitolari*, vol. 12 (29): 245. Pannini received an annual payment of 8 *scudi* and 20 *baiocchi*, as well as the usual percentage share. He had managed the post since 1772 on behalf of his father-in-law Ferdinando Fuga, then working in Naples, and it was only after the latter's death that the appointment was transferred to him (*ibid.*: 192, 26 aprile 1772).

[24] But gifts such as golden chains and gold coins, etc., were customary. After the large-scale extensions to Santa Maria Maggiore in 1749, Fuga asked for a free family tomb in the basilica, just as Bernini had been given (Rome, Chapter Archives of Maria Maggiore, Atti cap., vol. 28/11: 409).

[25] When it was discovered after the death of the architect A. Galilei in 1737 that he had left a legacy of 40,000 *scudi*, the Curia magistrate, Valesio, observed self-righteously that the man had also spent 500,000 *scudi* for building the Lateran façade. For the legacy of the architect see L. Rusconi Sassi; see also Vanvitelli's letters, which evidence a considerably elevated life style (Kelly 1980: 15–16). See also Vanvitelli's letters, which evidence a considerably elevated life style.

[26] BAV, Vat. Lat. 11257, fol. 106.

[27] In 1742 Antonio Ducci, "giovane di Giuseppe Ruggieri architetto" received money "per aver co-

over and above his salary, "per haver fatto alcuni disegni in grande per servitio del Campanile per ordine del Sig. Architetto." (For making some large-scale designs for the bell tower at the orders of the Signor Architetto). Drei also had to take on drafting the plans of the bell tower from Bernini's design,[33] and was paid for it, with an amount that corresponded to the half year's salary of the *soprastante* (overseer). Whether this entitled him to help from other draftsmen can only be assumed on the basis of the amount received. Borromini, for example, was commissioned by Bernini to draft designs for the Palazzo Barberini in 1631 and received 25 *scudi*;[34] in 1636 Borromini paid Taddeo Landi 10 *scudi* and 50 *baiocchi* "per diversi disegni e modelli fatti per la Capella del Santo" (for various drawings and models made for the Chapel of the Saint) in the oratory of Saint Filippo Neri.[35] Clearly it was difficult to emerge from the shadow of the master. Passeri observed that it was something of a rarity when Domenico Fontana named his pupil, Girolamo Rainaldi, to Pope Sixtus V, as the creator of a certain design the pope had taken a liking to. This marked the beginning of Rainaldi's career. "Questa candidezza, e bontà di

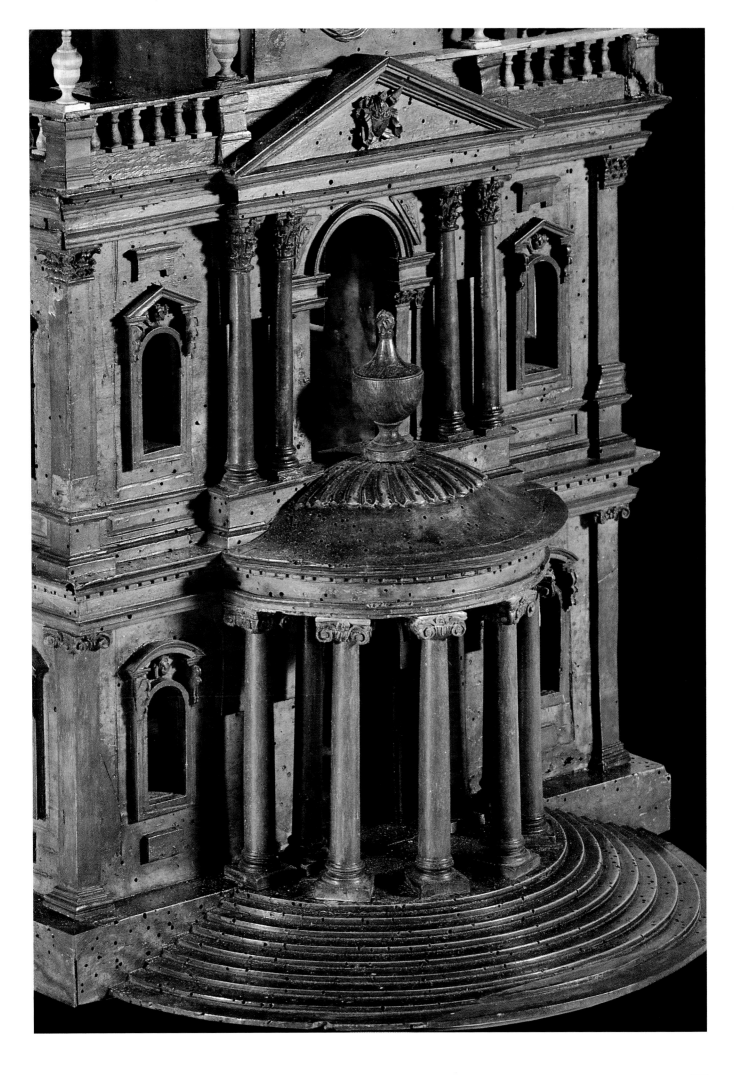

Pietro da Cortona
Self-portrait
Florence, Gallerie degli Uffizi
cat. 347

Gian Lorenzo Bernini
Self-portrait
Florence, Gallerie degli Uffizi

Andrea Pozzo
Self-portrait
Florence, Gallerie degli Uffizi
cat. 348

trattare del Cavaliere Fontana in esser così pronto ad aiutare gl'altri della medesima sua professione, la vedo restare in lui unica, e senza imitazione degl'altri, li quali quando veggono spuntare qualche papavero, che possa rendere ombra di gelosia, procurano non solo di sollevarlo; ma di reciderlo dal suolo fin all'ultima radice."[36] (This candor and goodness in the dealings of Cavalier Fontana, in being so prompt to help others of his own profession: I see it rests with him alone, and imitated by none of the others, who, seeing a poppy sprout from the soil that might give rise to a tinge of jealousy, do their utmost not only to pluck it off, but cut it from the very soil, down to its deepest roots.)

For a young architect it was imperative to find a patron to seek out commissions, promote the fledgling architect's cause, and pave his way by means of his personal connections with the great Roman families, the papal court and authorities.[37] The most promising breakthrough of all was if the cardinal the architect worked for became pope. From then on a splendid career opened out before him. Although the clientele system was predominant in Rome it was also a matter of honor for cardinals to try to procure important commissions for "their" architects, largely because such actions demonstrated their personal power and influence. We are seldom informed on these matters since they were all conducted in the background, and very often negotiations were rife with intrigue. The rebuilding of Sant'Appollinare (1742) is a case in point. The archives allow us to follow the battle between Cardinal Acquaviva and Cardinal Albani for the assignment of the rebuilding commission to their own (respective) architect. Thanks to being remarkably quick off the mark and to his closer association with the pope, the winner was Cardinal Acquaviva, and his architect Ferdinando Fuga was appointed against the Albani candidate, Carlo Marchionni.[38] It was also a considerable advantage to come from the same part of Italy as the pope.[39] Benedict XIII (1725–30) brought his own architect Raguzzini with him from Benevento, and sought out any distinguished commissions exclusively for him. Clement XII (1730–40) backed his Florentine countrymen Ferdinando Fuga and Alessandro Galilei; and despite being present in Rome for some twenty years, the Mestre-born Piranesi was granted his first architectural commission only when Clement XIII, a Venetian, was elected in 1758. At the end of a pontificate these privileges could be withdrawn as abruptly as they had been bestowed, and this was yet another reason why holding several posts was so necessary.

The role of Capitol architect, *architetto del Popolo Romano*, was first established in the sixteenth century, was a life appointment conferred by the pope on recommendation from the consuls.[40] But even while the Capitol architect held office a definitive decision could be made on his successor. On the other hand, the architect chosen to succeed to this important post was obliged to work without pay until he eventually took office. Pensioning was rare; and we normally find that holders of this elevated post were active until the end of their lives. Usually the position of the prospective candidates for the right of succession also meant years of unpaid work. One year before his death in 1729 Alessandro Specchi resigned from the post of *architetto del Popolo Romano*. Since the pope's favorite, Filippo Raguzzini, immediately stepped into his place, it seems unlikely that his resignation was a voluntary decision.

Noble families and cardinals often kept their architects in work for decades. City palaces, villas, chapels, and country estates outside Rome offered them constant commissions and possibilities of intervention. The ongoing expansion of Rome as a residential city had begun in the fifteenth century and continued through the seventeenth and the eighteenth centuries, attracting architects from all over Italy. There was strong competition and the struggle for commissions and posts was a bitter one. "Questi virtuosi sono tra loro gelosi e bizarri," wrote the French agent, Abbé Benedetti, to Paris in 1664;[41] James Gibbs expressed the situation more drastically in 1710: "There is such a pack of us, and so jealous of one another, that one would see the other hanged."[42] Draft plans are the architect's principal means of presenting his work. However, new designs enjoyed no form of copyright protection. A property developer could invite several architects to submit projects at the same time, but was only obliged to pay the one whose plans were chosen for execution. As a result, important as it was to produce plans that corresponded visually with the concept, it was even more important to keep the project's visual "preparation" out of sight from competitors. For large-scale commissions it was usual to draw up the plans, show them to various experts,[43] then recommend a previously selected architect for their execution, whereupon he could adopt motives from the designs of the others. Substantial projects were prepared directly by the ecclesiastical members of building congre-

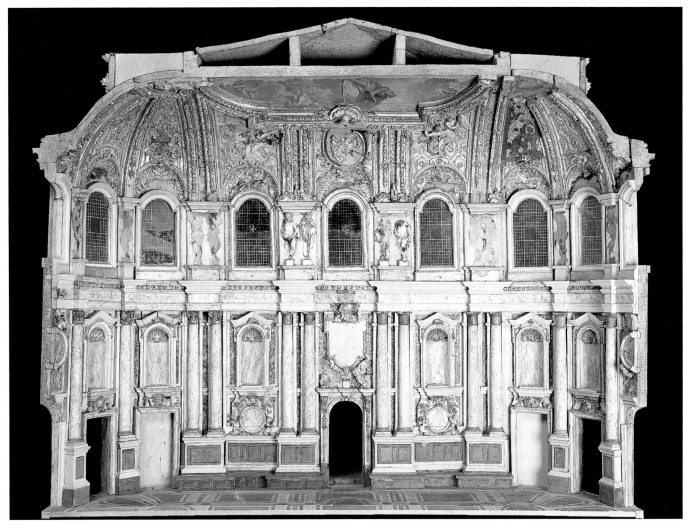

Filippo Juvarra
Model for the sacristy of St. Peter's
Vatican, Reverenda Fabbrica
di San Pietro
cat. 530

lorito i 2 disegni fatti dal Ruggieri per terminare l'ornato interno della Real Cappella" (for painting the 2 designs made by Ruggieri to complete the interior decoration of the Royal Chapel). The apprentice was not allowed to do the drawing, but probably only its final coloring (U. Baldini and others 1979: 327).
[28] In 1738 two "giovani" of the papal architect Ferdinando Fuga were paid 50 *scudi* for their collaboration in building the Palazzo della Consulta (ASV, Fondo Sac. Pal. Apost., vol. 523, c. 300).
[29] In 1653 an assistant of Girolamo Rainaldi received 22 *scudi* for a 25 half days for surveying and drafting. The bill was paid by Rainaldi (Cerroti 1860: 8).

gations, where they were subjected to detailed discussion.[44] For projects of even greater importance, as for example the façade of St. Peter's (1607), the Spanish Steps (1723), the Trevi Fountain (1732), and the façade of the Lateran Basilica (1732), a competition was held in which certain architects were specifically invited to participate. Others were allowed to submit their projects for perusal uninvited; only in exceptional cases were their efforts rewarded with remuneration, even in cases where expensive models had been made.[45]

Some building commissioners like Pope Alexander VII also had a direct influence on the planning; consequently, in following the development of a project up to the definitive designs we can see it as the result of phases of joint preparation.[46] Immediately before this stage, the drawing itself was the only proof of authorship – the likely reason why presentation plans were so often drafted by the architects themselves, entirely in their own hand, except perhaps for the preparation of the drawing paper. In spite of an attack of gout in his hands, Pietro da Cortona managed to draft his project for the Louvre in a fair copy that he had drawn himself.[47] Fearing architectural espionage, he sent the plans to Paris with the diplomatic courier of the grand duke of Tuscany. Luigi Vanvitelli traveled secretly from Rome to Naples in 1750 and, in the utmost haste, personally drew up the preliminary design for the Royal Palace of Caserta, in order to overtake his competitors.[48] Given these conditions, it seems inconceivable that architects were not in the habit of signing their sheets of drawings, and yet this was done only in cases where landed property and survey plans were required to be officially registered; the architect's signature certified the validity of the data documented by the drawing. As a result, only very few such drawings have come down to us, most of them for small works such as altars and chapels,[49] signed with the names of the commissioner, the craftsmen, and the architect. Felice Della Greca, architect to the Camera Apostolica in the first half of the seventeenth century, is practically

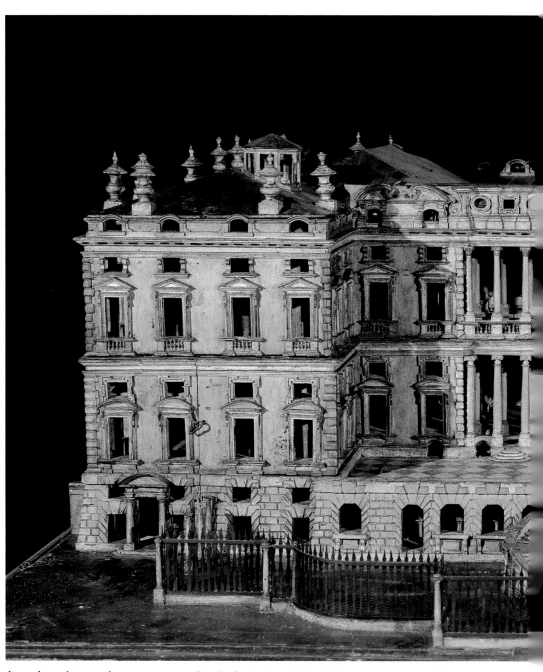

[30] Garms 1974a, chap. II; see also Curcio 1991: 149.

[31] The building contractors were mostly master bricklayers or stonemasons, see cf. F. M. Apollonj Ghetti, "Santi Ghetti, scarpellino e imprenditore," in *L'Urbe* 40 (1977): 3–4, 22–39; for Nicola Giobbe see Brunel 1978: 7–146.

[32] Passeri 1772: 217–18.

[33] In August 1637 a large drawing board was made especially for him (Pollak 1910: II, 111, reg. 173). For the preliminary designs of the bronze casting for the Throne, he was also provided with a special drawing board (*ibid.*: 185, reg. 527).

[34] 10 February 1631 (paid to Francesco Borromini, assistant to the architect [Bernini] as total payment for what he may claim for various drawings and models made by him in service to the said construction) "pagati a Francesco Borromini aiutante del architetto [Bernini] per intero pagamento di quanto possa pretendere per diversi disegni e modelli fatti da lui per servitio di detta fabrica" (Pollak 1910: I, 263, reg. 867).

[35] Pollak 1910: I, 431. In 1634 (*ibid.*: 429) Landi was paid for bricklaying and stuccowork, and also for carpentry.

[36] Passeri, Hess 1934: 213.

[37] One example is the case of the Florentine architect, Ignazio De Rossi, who on coming to Rome in 1721 immediately turned for protection to his "natural" sponsor, the Florentine Cardinal Lorenzo Corsini (Z. De Rossi 1739: Introduzione).

[38] Bösel, Garms 1981: 350–54.

[39] Fasolo (1961: 2) mentions that at the end of the sixteenth century there was a "predominant Lombard clan" in Rome, from whom Carlo Maderno, for example, could reap advantage. For the situation in 1673, see Tessin (Eimer, I: 210–11). In the *Vita* of the Florence-born Francesco Mochi, Passeri mentions this situation: "S'invogliò di venirsene a Roma nel Pontificato di Clemente ottavo e perché era di Nazione Fiorentino ciascheduno della sua Patria sperava qualche appoggio, e sollievo dalli compatrioti, che dominavano in quel tempo Palazzo [...] fu Sucessore Gregorio decimo quinto per poco più di due anni, e perché era Bolognese, vi era poco da far bene per quelli d'altra Nazione. Morto Gregorio

the only architect who put names to his drafted plans;[50] Carlo Fontana continued the practice, but these are outstanding exceptions. It is only in the eighteenth century that signatures begin to appear, although it had still not become the standard practice.

Payment for plans and drawings depended on the size, technique, and degree of difficulty of the commission. In 1580 Monsignor Giustini paid Giacomo Della Porta six *scudi* "per far il disegno per Acconciar detta Casa; [...] il disegno delli balaustri sopra la porta grande, et il disegno delle finestre ultime vicino al tetto" (for drawing the design for the decoration of the house [...] to prepare a drawing of the balusters above the main doorway, and to design the upper windows below the roof): at a cost of two *scudi*; in 1583 three *scudi* went to the design of the loggia "et per altri consigli et pareri."[51] In 1631 Francesco Contini received the sum of 12 *scudi* for twenty-five topographical drawings of Comacchio valley, whereas he was paid 26 *scudi* for two large-scale maps of the Papal States, "fatte con la penna e colorite di colori fini."[52] Here the material value of the colors must have been included in the bill.

In the course of the eighteenth century discussions about payments for plans and designs, and what they should come to, became more frequent. In these cases expert opinion was sought

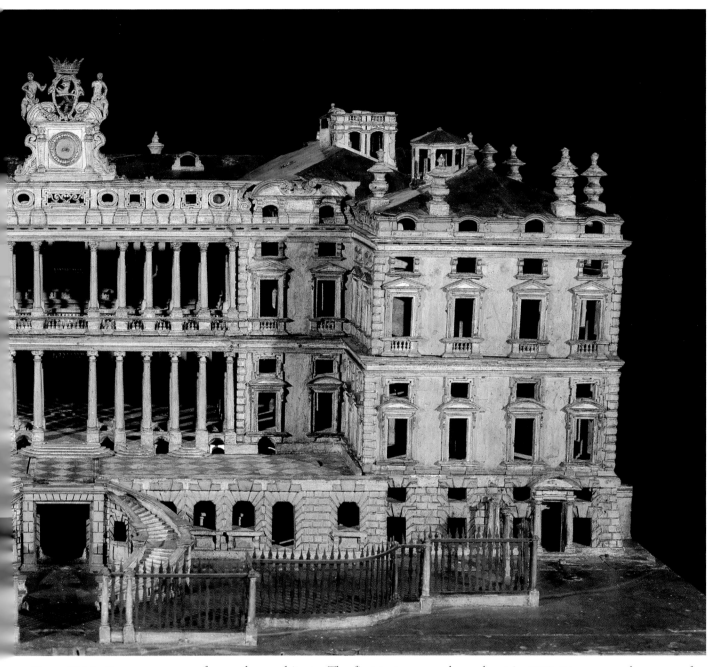

Giovanni Frigimelica
Francesco Maria Preti
Model for Villa Pisani at Stra
Venice, Musei Civici Veneziani
Museo Correr
cat. 253

fu eletto Papa il Card. Maffeo
Barberini [...] e perché il Mochi
l'haveva servito da Cardinale,
prese animo di continuare a ser-
virlo da Papa; ma s'ingannò, per-
ché vennero occupati li miglior
luochi da altro soggetto di mag-
gior fortuna, che tenne, rigorosa-
mente, indietro tutti [Bernini]"
(Passeri, Hess 1934: 132).

from other architects. The first test case we hear about in 1748–54 concerned payment for
plans and additional work for the building of the church, in which procedures were discussed
by the architect Emmanuele Rodriguez and the convent of Trinitarians in Via Condotti. It end-
ed in a verdict which considerably reduced the amount claimed by the architect.[53] In 1751 the
architect Francesco Nicoletti went to court for a payment of 300 *scudi* for a total of twenty-one
plans and designs he had drafted for alterations to the Villa Doria Pamphilj. He had been re-
fused his three-per-cent discount on the craftsmen's fees. He was awarded 120 *scudi*.[54]

A similar problem occurred some years later with the construction of a tomb for the Portuguese
chargé d'affaires in Rome, Commendator Sampajo, who died in 1750.[55] As executor of the
man's will, Cardinal Neri Corsini was entrusted to grant the commission. In 1757 he refused to
pay the architect Luigi Vanvitelli the amount claimed for the preparation of the plans. The de-
signs had been requested from Vanvitelli, only to be rejected when they proved much too ex-
pensive. Upon this, Vanvitelli handed over further planning to his assistant Carlo Murena. An
architect was bound to produce as many drawings as the commission required. His fee was the
percentage discount which he raised on the craftsmen's bills. Only in cases where costs total

187

[40] Gaetana Scano, "L'architetto del Popolo Romano," in *Capitolium* 39 (1964): 118–23. In the seventeenth century the payment amounted to 25 *scudi* pro quarter, hence it brought in 100 *scudi* a year (Güthlein 1985: 129); S. Pasquali, "L'architetto del Popolo (1680–1750)," in *In Urbe Architectus*, op. cit.: 301–12.

[41] Noehles 1961: 41.

[42] Terry Friedman 1984: 7.

[43] These commissions also came in from outside Rome. In 1650 the duke of Modena allowed the extension plans for his Roman residence, prepared by his court architect Borromini, and Cortona and requested their advice, "stimando io questi per li primi huomini dell'Europa" (Biondi 1987: 199).

[44] See planning for Sant'Ignazio (Frey 1924: 11–43; Pollak 1910: 148, reg. 411; Bösel 1986: 192ff.).

[45] After the competition for the Lateran façade the unsuccessful participants were entitled to a compensation for their expenses (ASV, Fondo Bolognetti). The winning model was paid for by the pope (E. Kieven, "Il ruolo del disegno: il concorso per la facciata di S. Giovanni in Laterano," in *In Urbe Architectus*, op. cit.: 78–123).

[46] Just how determined a building commissioner could be in regard to details is made evident by Maderno's dispute with Cardinal Barberini over the form of the capitals for the façade of St. Peter's (Hibbard 1971: 69–70). The recent reference of H. Lorenz in regard to Baroque buildings in Vienna sheds light on this seldom-mentioned aspect. For the aspect of collective planning in Baroque architecture, see B. Manitz, in *Kunstchronik* 41 (1988): 382.

[47] Noehles 1961: 41. Scamozzi also warned against plan spies.

[48] Vanvitelli, *Lettere*, I; see Appendix no. 7.

[49] Klaus Schwager, "Unbekannte Zeichnungen Jacopo Del Ducas. Ein Beitrag zur Michelangelo-Nachfolge," in *Stil und Überlieferung in der Kunst des Abendlandes* II (1967): 56–64.

over 100,000 *scudi*, was a gift customary. If an architect presented unnecessarily expensive plans exceeding the allocation for the commission, he had no claim whatever to additional payment. Obviously, for the practice of building, the important thing is the design. With increasing insistence architects demanded payment for their drawings, and not only for the construction work. Plans were no longer considered a tool for construction but came to be esteemed as a creation on their own account. In this way they slowly broke free from the merely functional and became a means of expression of the architect's creativity.

This new departure began with the development in academic training in the second half of the seventeenth century. The center of learning was the Accademia di San Luca, in Rome. The emphasis on practice rather than on theory in architectural training, however, remained a typically Roman characteristic, even at the Academy.

The position of architects at the Academy

Toward the end of the seventeenth century, a hundred years after its foundation, the Accademia di San Luca dominated the artistic life of Rome, and had practically monopolized the training of novices.[56] Membership to the Academy assured a certain degree of social prestige and later professional advantages. It was made clear that commissions could only be carried out by members of the Academy, or at least needed to be approved by them. Furthermore, only the Academy could train and assess talent,[57] and all publications dealing with artistic matters had to be submitted for the Academy's approval. Thus the Academy enjoyed a role of definitive authority. At the time of its foundation, the tone of the Accademia di San Luca was set by painters. For quite some time, architects had no influence upon the organization of academic activities. Naturally, painters became the first *principi*, and although they might also work as architects – like Ottavio Mascherino – they were inevitably chosen for membership on the basis of their activities as artists. Discussion of theory at the Academy was largely devoted to issues regarding painting. In the course of the discussions on the comparison between painting and poetry (which played a decisive role in improving the cultural background of the academics), architecture was generally overlooked. Similarly, in the matter of "disegno e colore" no reference was made to the art of building; nor in the basic definition of original as opposed to copy, which became manifest in the artistic reassessment of the Renaissance legacy;[58] neither was the *disegno-concetto* (design-concept) to be applied to architecture.

It was not until the first half of the seventeenth century that the first architects – Girolamo Rainaldi (1641) and Giovanni Battista Soria (1648) – were elected to the position of *principe*, and exclusively as architects while Borromini had taken no interest in any of the Academy's activities.[59] Until his death in 1669, Pietro da Cortona was the most distinguished member of the Academy holding the position of *principe* from 1634 to 1637, exclusively on the basis of his architectural works. Cortona identified himself directly with the Accademia di San Luca, to whose church he bequeathed a legacy in his will,[60] while Bernini viewed the business of the Academy from a coolly critical distance.[61] It was only in the second half of the seventeenth century that architects gradually acquired more and more influence. In 1672 Carlo Rainaldi became director of the Academy; in 1683 Bernini's former collaborator, Giovanni Battista Contini,[62] and in 1686 Carlo Fontana were elected *principi*. In the latter case, this only took place only after the painter Filippo Lauri had renounced the office.[63] There can be no doubt that, more than anyone else it is thanks to Mattia De Rossi, first *principe* in 1681 and once again in 1690–93, as well as Carlo Fontana, that the influence of architects could be strengthened at the Academy; certainly the Chigi pontificate (1655–67) also considerably contributed with the pope's promotion of architectural commissions. After De Rossi had declined re-election in 1693, Fontana was able to assume directorship of the Academy, from 1693 to 1698. This is the period of his ambitious publications on the technical aspects of port and river installations, and his historical articles on the architectural history of St. Peter's, as well as his antiquarian completion of the long unfinished Palazzo Montecitorio, which revealed his sound experience in the practical side of building as well as his considerable scholarship.[64] Fontana enjoyed international fame as one of the leading architects of Europe. Apart from his Italian pupils, a number of foreign architects came to work for him in his studio; in chronological order we find: Nicodemus Tessin the Younger, Johann Bernhard, Fischer von Erlach, Lucas von Hildebrandt, and James Gibbs. In 1698 it was debated whether Carlo Fontana should be appointed *principe*

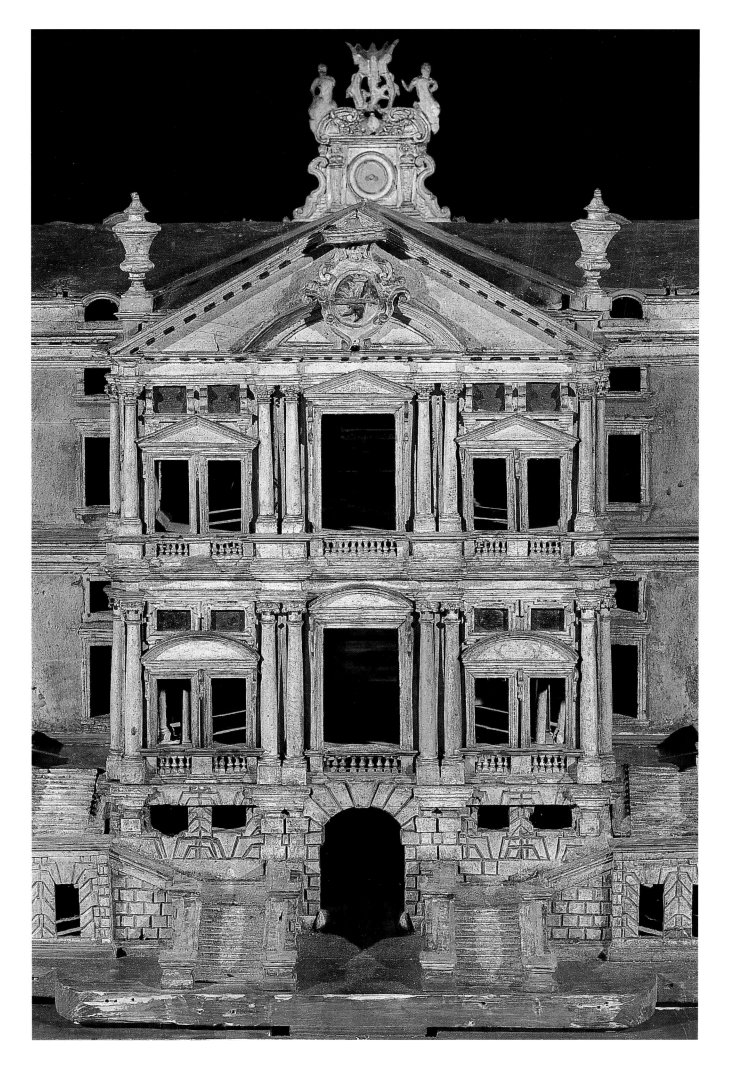

189

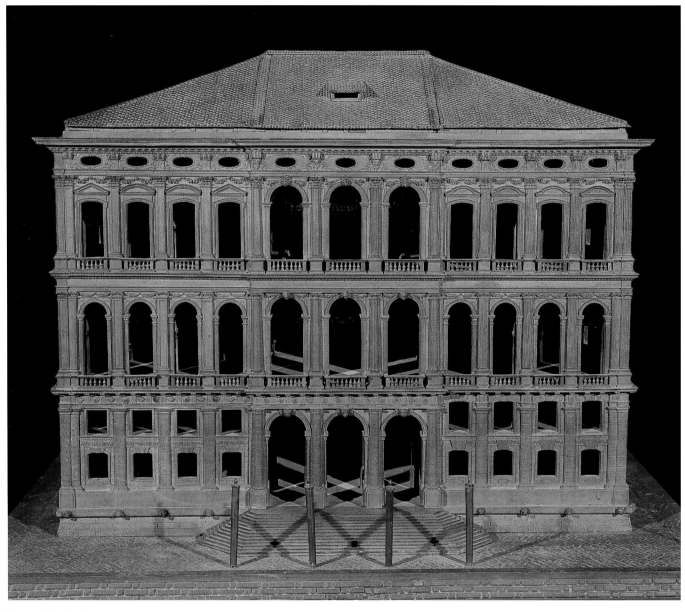

Lorenzo Boschetti
Model for Ca' Venier dei Leoni
in Venice
Venice, Musei Civici Veneziani
Museo Correr
cat. 265

opposite
Lorenzo Boschetti
Model for Ca' Venier dei Leoni
in Venice
Detail of the rear façade
Venice, Musei Civici Veneziani
Museo Correr
cat. 265

[50] Della Greca also worked as a cartographer, cf. Sladek 1989.
[51] Domenico Tesoroni 1894: 7–8.
[52] Pollak 1910: I, 346, reg. 1023–1024.
[53] A. Donò, A. Marino, "Note su

for life but, through papal intervention, this honor was transferred to the painter Carlo Maratta, and Fontana instead held the office of permanent *primo consigliere*. Visual confirmation of architecture's equal footing with painting and sculpture was given expression for the first time in 1705, the year the Accademia's newly designed emblem was created. Beneath the motto "Aequa Potestas" appeared the figure of a paintbrush, chisel, and compasses forming an equilateral triangle.[65] In the eighteenth century architects were to dominate the Academy, mainly because Rome could no longer boast any outstanding personalities in Italian painting, but also because the new emphasis on scientific viewpoints placed architecture alongside the other representational art forms, and much to its advantage.

Training
Unlike the Académie d'architecture in Paris, there is scant information on the Roman academy's teaching activities as regards both theory and practice. There was almost no Roman parallel to Blondel's *Cours d'architecture enseigné dans l'Académie Royale d'Architecture*.[66] At first, in Rome instruction in architectural theory and practice was not organized along the same lines as painting and sculpture;[67] under *principe* Carlo Rainaldi it was laid down in 1672 "che li studi si facciano tanto le Feste di Precetto che le Feste di devozione" when building activity was at a halt.[68] Subsequent to the morning study of anatomy and the nude, the afternoon was de-

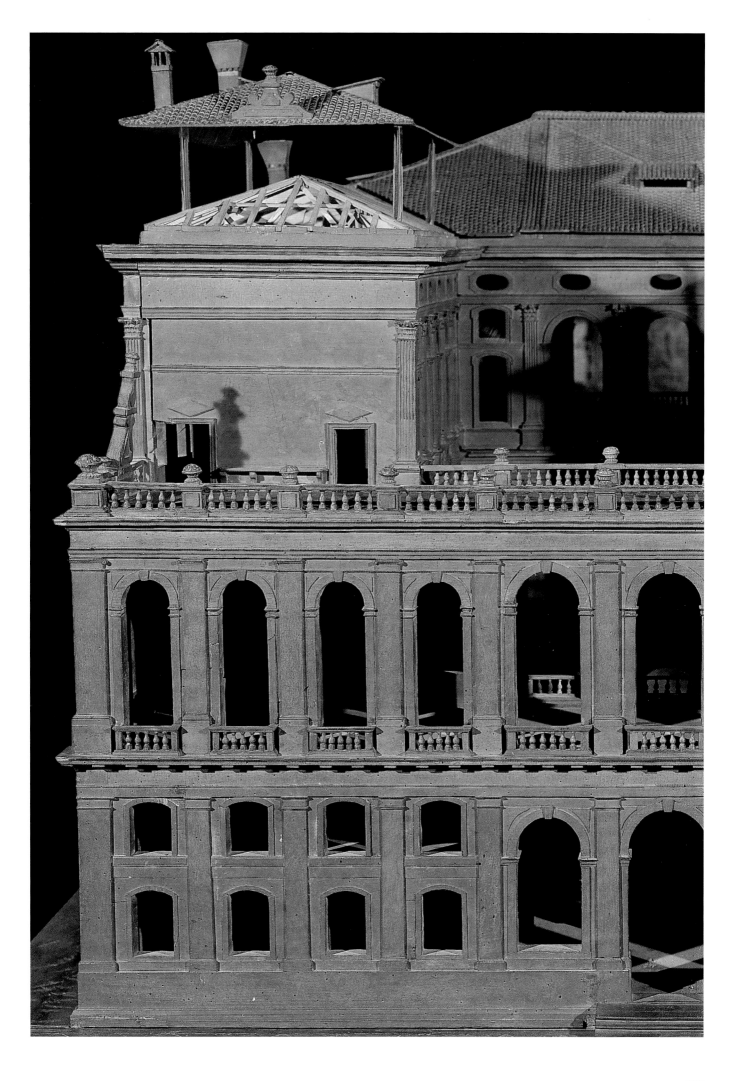

Unknown Artist
Portrait of Balthasar Neumann
Würzburg, Mainfränkisches
Museum
cat. 349

E. Rodriguez Dos Santos, architetto lusitano in Roma," in *Studi sul Settecento Romano* 5 (1988) doc. 1–4c: 115–19); P. Ferraris, "Il contenzioso legale tra architetti e committenti," in *In Urbe Architectus*, op. cit.: 239–71.

54 C. Benocci, "Francesco Nicoletti e Paolo Anesi a Villa Doria Pamphili (1748-1758)," in *Studi sul Settecento Romano* 4 (1988): 214, 235.

55 Garms 1975: 185–92.

56 V. Golzio, "L'Accademia di San Luca come centro culturale e artistico nel Settecento," in *Atti del I congresso nazionale di studi romani*, Roma 1929: I, 749ff.

57 The Academy retained a percentage from the payments for these assessments (Pietrangeli, op. cit.: 19).

58 On this complex, see Passeri, Hess 1934; Mahon 1947: 161ff.; Noehles 1970: 3, E. Cropper 1984.

59 Note his revealing comment in the foreword to the *Opus architectonicum*: "E io al certo non mi sarei posto a quella professione, col fine d'esser solo copista, benchè sappia che, nell'inventare cose nuove, non si può ricevere il frutto della fatica se non tardi".

60 Noehles 1970.

61 Passeri, Hess 1934, XXII. In 1630, under Urban VIII, Bernini was once made *principe* at the request of Cardinal Francesco Barberini, but he rejected later proposals for election (Noehles 1970: 97).

62 For Contini, see Hager in *DBI* 28 (1983): 515–23. "Tutto inteso alla pratica dell'arte sua nulla per l'Academia operò" (Missirini 1823: 147).

63 Missirini 1823: 115–16, 131, 147; Braham, Hager 1977: 11.

64 *Discorso del Mons. C. Vespignano sopra la facile riuscita di restaurare il Ponte Senatorio*, 1692; *Il Tempio Vaticano e sua origine*, 1694; *Discorso sopra le cause delle innondatione del Tevere*, 1696; *Utilissimo trattato delle Acque Correnti*, 1696; *Descrizione della nob. Cappella della Fonte Battesimale in S. Pietro*, 1697; *Discorso sopra l'antico Monte Citorio*, 1698 e 1708 (H. Hager, "Le opere letterarie di Carlo Fontana come autorappresentazione,"

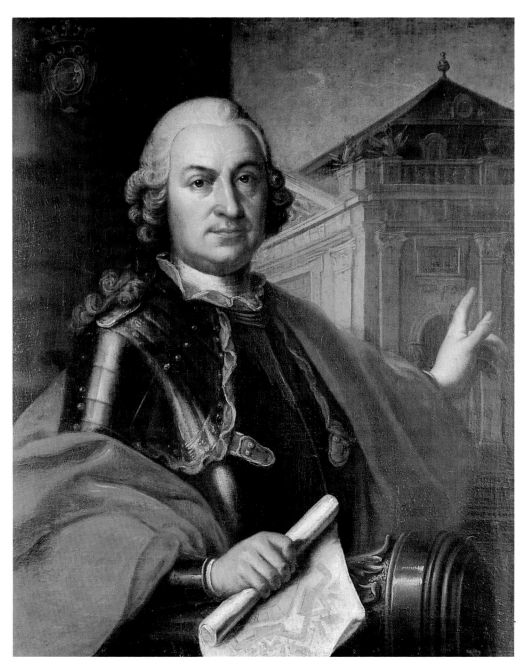

voted to "lessons in architecture and perspective."[69] At that time Mattia De Rossi was responsible for the course in architecture, the painter Pietro del Pò for perspective, and Carlo Cesi for anatomical studies.[70] The Academy's early years were marked by the influence of theories from the treatises of Lomazzo[71] and Zuccari, which polemically emphasized the priority of painting over architecture. In the early years, as Academy members, the architects found themselves on the defensive. By no means in vain had Giacomo Della Porta refused to challenge Zuccari's theoretical treatise[72] with a corresponding ideologically motivated architectural theory.[73] The speculative abstraction of Zuccari's standpoint certainly could not be applied to architecture, and basically Zuccari had excluded architecture from the category of fine arts.

It has often been observed that Roman Baroque lacked an underlying aspect of theory.[74] It comes as no surprise, therefore, that the Academy's teaching seems to have been entirely oriented toward practice, as we conclude from Passeri's observation: "Ciascheduno introduce precetti a suo genio, et ogni ammaestramento dell'uno è negato dall'altro […] non sono stabilite le vere ragioni d'una buona scuola"[75] (Each teacher introduces precepts of his own invention, and the teaching of each is contradicted by another […] the true functions of a good

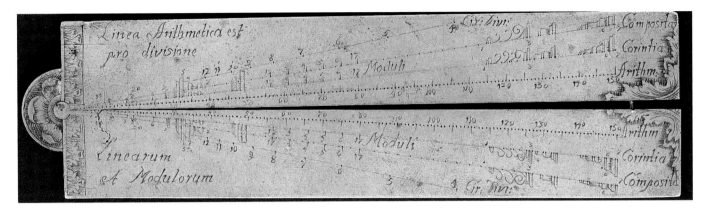

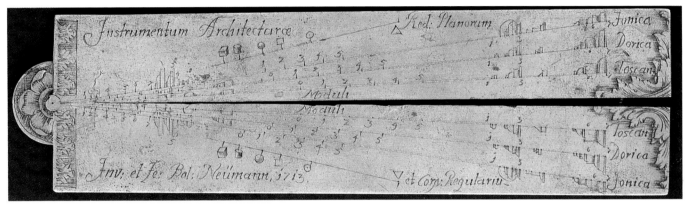

Balthasar Neumann
Tools for architectural measurements
Würzburg, Mainfränkisches Museum
cat. 350

following pages
Dominikus Zimmermann
Model for the
Prämonstratenserklosters
Ulm, Staatliches Schlösser und
Gärten
Baden-Würtenberg, Germany
cat. 569

in *In Urbe Architectus*, op. cit.:
155–203); Curcio 1997.
[65] *L'Accademia*, op. cit.: 19.
[66] Paris 1675 and 1683. The second edition appeared in 1698.
[67] For the first half of the seventeenth century we have no information concerning the architectural courses.
[68] Missirini 1823: 131. See Ghezzi's comment on a drawing in the Berlin Kunstbibliothek (Jacob 1975: no. 793). In the Paris Architecture Academy lessons were held on two days (Kruft 1986: 144).
[69] For the teaching, see G. Scano, "Insegnamento e concorsi," in *L'Accademia*, op. cit.: 31ff.; Oechslin 1972.
[70] Missirini 1827: 131.
[71] G. P. Lomazzo, Trattato dell'arte de la pittura, 1584, e Idea del

school have not been observed). Be that as it may, architecture's role in the Academy was enhanced considerably by the art theory of the secretary, Giovanni Pietro Bellori. In a lecture given in 1664 Bellori sharply attacked the High Baroque, postulating the perennial example of ancient classical art,[76] and demanding a return to the rational, basic values of nature. Bellori also addressed himself to the position of architecture: "Quanto l'Architettura, diciamo che l'Architetto deve concepire una nobile Idea, e stabilirsi una mente, che gli serva di legge e di ragione, consistendo le sue inventioni nell'ordine, nella dispositione, e nella misura, ed euritmia del tutto e delle parti. Ma rispetto la decoratione, & ornamenti de gli ordini sia certo trovarsi l'Idea stabilita, e confermata su gli esempi de gli Antichi, che con successo di lungo studio, diedero modo a quest'arte; quando li Greci le costituirono termini, e proportioni le migliori, le quali confermate da i più dotti secoli, e dal consenso, e successione de' Sapienti, divvennero leggi di una mervigliosa Idea, e bellezza ultima, che essendo una sola in ciascuna specie, non si può alterare, senza distruggerla. Onde pur troppo la deformano quelli che con la novità la trasmutano, mentre la bellezza sta vicina la brutezza, come li vizii toccono le virtù. Tanto male riconosciamo pur troppo nella caduta del romano impero, con quale cadero tutte le buone arti, e con esse più d'ogn'altra l'architettura."[77] (As far as Architecture is concerned, we may say that the Architect must first conceive a noble idea, and a concept be established which serves him as law and procedure, so that his inventions are evident in the ordering, the disposition, and the measure and the harmonious proportions of the whole and the parts. But in respect to the decoration and ornaments of the orders the architect will certainly accept the idea established and confirmed by examples from the ancients, who reaped success from long study to give a style to their art; when the Greeks stated rules, and observed the finest proportions, as has been long confirmed by centuries of learning, by common consent and the succession of sages, these then became the laws of a marvelous idea, and ultimate beauty; and since there was one, and one only, of each type, it could not be altered without destroying it. Alas, those who will transform it with novelty, will only deform it, since ugliness lies so close to beauty, and the vices touch upon the virtues. And so, unhappily, we can only recognize the fact that with the fall of the Roman Empire, all the finest arts fell too, and with them, but more than any of the others, architecture).

Consequently, architecture was to return to a mathematic rationale, and to the tradition found-

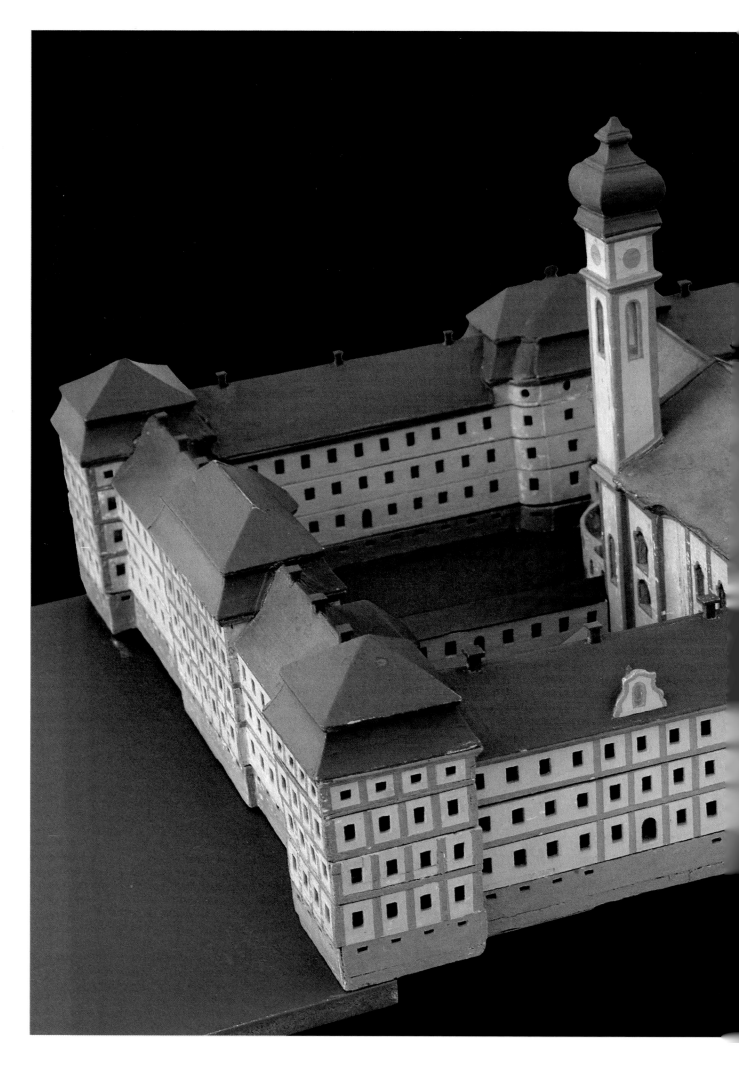

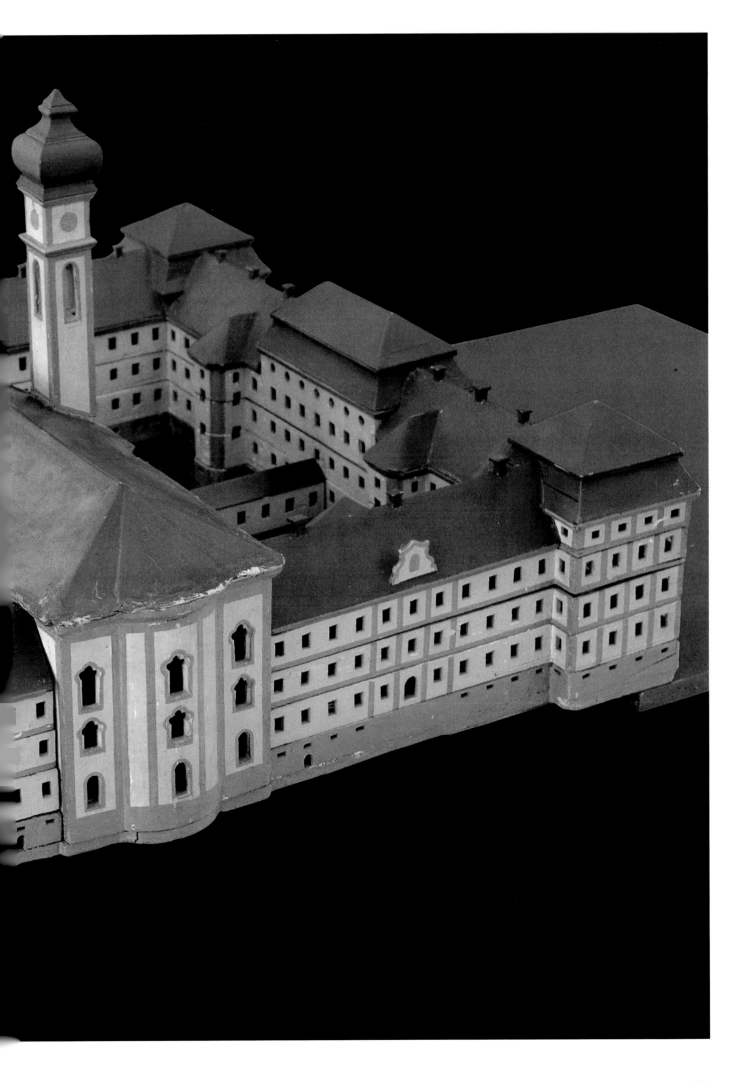

tempio della pittura, 1590 (Kruft 1986: 107).

72 F. Zuccari, *L'idea de' pittori, scultori et architetti*, published in 1607, but already given as an Academy lecture (Missirini 1823; Heikamp 1961).

73 Mahon 1947: 167.

74 A. Blunt, "Gianlorenzo Berni- ni: Illusionism and Mysticism," in *Art History* 1 (1978): no. 1, 67–89; Kruft 1986: 103ff., 113.

75 Passeri, Hess (1934), XXII: no. 4. In this connection, cf. an un- published treatise by the Camera architect Vincenzo della Greca (Londra, Courtauld Institute, Blunt Coll., no. 138: *Lezioni d'ar- chitettura*). This was a manuscript ready for publication of a Vigno- la-type treatise on the five orders of columns, dating from the time of the Barberini pontificate. As Della Greca was a member of the Academy in 1633 (Lefèvre 1971) it could very well have been writ- ten then. For treatise information on Felice Della Greca in Stock- holm, see Curcio 1978–79.

76 Published in 1672 as proemium for his *Vite de' pittori, scultori e ar- chitetti moderni*: "L'idea del pit- tore, dello scultore, e dell'architet- to scelta dalle bellezze naturali su- periore alla Natura" (The idea of the painter, the sculptor and the ar- chitect, selected from the beauties of nature but superior to nature).

77 Borea 1972: 23–24.

78 Attacks against Bernini, who was favored by Alexander VII, were less frequent than those against Borromini, but nevertheless very daring; the speech was only published after the pope's death.

79 This revived a principle for painting which Annibale Caracci had laid down toward the end of the sixteenth century (Noehles 1970: 2).

80 "Education had become the metaphor for the discovery and establishment of true methods" (Cropper 1984: 173). It is inter- esting to note how much value Passeri attributes to good school- ing and academic training in his *Vite*, op. cit.

81 Smith 1993; Schöller 1993.

82 Juvarra's are the only drawings of military architecture that have been preserved (Millon 1984).

83 One exception to this are Juvar- ra's detailed comparative studies of the Tuscan order (Millon 1984: 250ff.), but which he clearly did not develop any further.

ed by Vitruvius. At the same time, in opposition to the highly individual "irregular" architec- ture of Borromini, and also Bernini,[78] it urged a more formal, regular syllabus of training that was prompted by references to the masters of classical antiquity. Fundamental to architectural training must have been Bellori's insistence that examples from the High Renaissance style of Bramante, Raphael, and Michelangelo likewise belonged to these obligatory examples and models of ancient works. Thus he established a canon[79] that was to remain in force for nearly two hundred years.[80] It was certainly no coincidence that only a few years later regular courses in architecture were introduced. A further incentive must have been the foundation of the Parisian Académie in 1671.[81] The painter Carlo Maratta and the architect Carlo Fontana start- ed out as heirs of the Roman High Baroque, together with a stylistic interpretation of this phase in their oeuvre, thereby creating a synthesis which enabled reconciling the works of Cortona, Bernini, and Borromini in painting and architecture. This integration of seemingly untransfer- able individual creations into a repertory of forms, resulted in the adoption of Roman forms and motives in the plans and designs used throughout the whole of Europe.

Pascoli's observation that Carlo Rainaldi "disegnava da pittori, inventava con fecondia, esegui- va con facilità, et ornava con sodezza" (designed like a painter, was fertile in invention, felici- tous in execution, and solid in decoration) can be regarded as a motto for the Academy's ar- chitectural training in around 1670.

We possess practically no information about the teaching syllabuses, and though some of the drawings used for teaching have been preserved, others can be reconstructed. The subjects taught were: geometry, arithmetic, perspective, architectural theory, military and civil architec- ture.[82] Teachers were engaged for each branch of instruction. After an introduction to Euclid- ean geometry and perspective, study began on the treatises; here it appears that the main texts were those of Vitruvius, Serlio, Vignola, and Scamozzi. We can conclude this from references made in the lives of artists. Palladio was barely mentioned in Rome. Juvarra refers to him once in 1725 and Giacomo Quarenghi describes Palladio's treatise as an important literary source for his studies. Here, however, one must bear in mind that Quarenghi's note dates from the end of the eighteenth century; at that time no mention of Palladio would have branded the author as an ignoramus. It seems no attempt was ever made to develop a system from these texts for the theoretical basis of the teaching.[83] Probably they relied on Fréart de Chambray's *Parallèle de l'architecture antique et de la moderne*,[84] but the attention at the time was clearly geared to application, rather than to theoretical study. A particularly thorough introduction to geometry occurs in the teaching material of Filippo Juvarra, who taught at the Academy from 1707 to 1709, and again from 1711 to 1712.[85] Juvarra began with a Serlio-oriented introduction to flat and solid figures, as well as the measurement of heights. Then came a course in layout, the cal- culation of solid figures, and the incidence of shadow.

The Academy archives possess teaching material by Mattia De Rossi (1670–73), Gregorio Tom- massini,[86] Domenico Martinelli (1684) and Francesco Fontana (1694).[87] These "Lezioni di ar- chitettura" mostly dealt with studies of pedestals, bases, and capitals, while the orders were handled in the most exemplary way. The very large, neat and painstakingly drafted ortho- graphic presentation sheets served as demonstration material. The drawing sheets of Domeni- co Martinelli present diagrams which, unlike those of Tommassini or De Rossi, are very care- fully washed over with bistre, with particularly fine results.[88] But we have no information on how the technique of drawing was imparted. Above all, in Martinelli's drawing sheets one notes the meticulous and expert shading, the high level of draftsmanship which turns up again and again in the students' competition presentations. The Academy's style of drafting, as repre- sented in competition projects, seems mostly influenced by Domenico Martinelli, Francesco Fontana, and Filippo Juvarra – all pupils of Carlo Fontana. Domenico Martinelli (1650–1718)[89] was teaching there after 1678. First he taught perspective from 1683 to 1689, and later archi- tecture, from 1710 to 1716. Besides their fine wash technique, Martinelli's teaching sheets were remarkable for their incorporation of ornamental elements: richly figured capitals and deco- rated friezes. The role of Francesco Fontana (1668–1708) appears to have been even more in- fluential.[90] In spite of his early death at the age of forty, Carlo Fontana's widely admired son taught at the Academy after 1694 and rose to become its vice-president in 1703. Among the teaching material of Francesco Fontana[91] the most outstanding is the first critique he made of Andrea Pozzo's new scenographic style of painted architecture,[92] where the modeled figuration

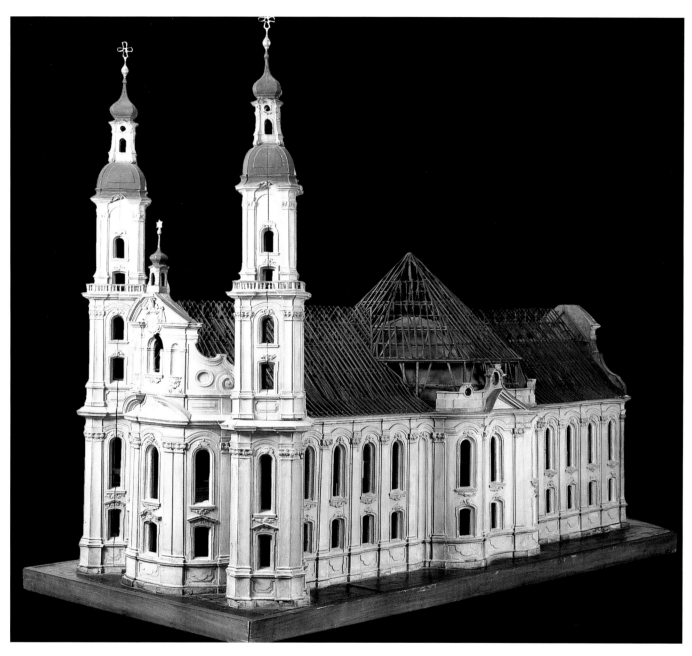

P. Gabriel Loser
Model for the church of St. Gall
St. Gallen, Stiftsbibliothek St. Gallen
cat. 590

[84] Published in Paris in 1650; English edition by John Evelyn, London 1664. Both the English and the French volumes were issued in a second edition in 1702 and 1714.
[85] Hager 1970: 17, 53, no. 65; Millon 1984: 17–18.
[86] Smith 1993: 27–33, *passim*; Tommassini (d. 1698) was a member of the Academy after 1660 and held a number of posts there (Missirini 1827: 473; Thieme-Becker:

of graduated orders of columns is discussed in a much more forceful way than in the other teaching sheets, which tend to center exclusively on the manipulation of forms. The spectacular character of single forms released from their continuity prepares for the isolation of the motive, and this was to become exalted into the stylistic principle of Rococo.[93]

Once the bases of the architectural orders and their systems of proportion were properly studied, the practical side of the teaching began. A series of didactic drawings by Mattia De Rossi demonstrate his instructions for ground plans, elevations, and sections, as well as the layout of ground plan and elevation on the drawing board. The lessons[94] held on five Sundays during July and August 1675 began with the presentation of a ground plan for a small, square country villa, "pianta e disegno per fare un Casino da Villa che mostri quattro facciate". The main interest lay in the development of a central axis and the symmetrical layout of the inner space, that is, the group of rooms whose series of doorways were aligned around a circular, two-storeyed central area and included the placement of the front and secondary façades. Thus the true-to-scale plan for a system of hierarchical division was used for the distribution of rooms, the spatial forms and the arrangement of the façades.

The following week De Rossi lectured on designing the "Facciata Principale del Casino".[95]

197

William Kent
Wooden model for Richmond Palace
London
courtesy of H.M. Queen Elizabeth II
cat. 175

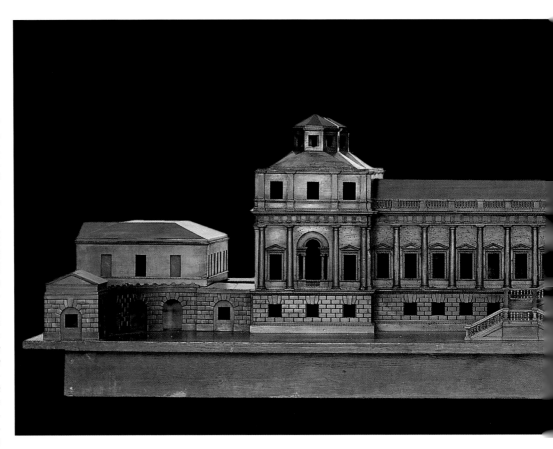

XXXIII, 262). Under Alexander VII he was involved in the planning of Santa Maria in Campitelli and San Salvatore (BAV, Chigi P. VII.; Wittkower 1937, 1975: 32ff.).
[87] In addition there is unpublished material for teaching perspective by Carlo Cesio (cart. 5), Francesco Benetti (cart. 6) and Francesco Cozza (cart. 7). Cesi (or Cesio, 1626–86), was a pupil of Pietro da Cortona, belonged to the Bellori circle, and in 1675 became *principe* of the Academy. He published his anatomical studies in engravings (Thieme-Becker: VI, 315; C. *Cesi, pittore e incisore del Seicento tra ambiente cortonesco e classicismo marattiano, 1622–1682*, 1987). In 1657 he published the engravings *Argomento della Galleria Farnese dipinta da A. Caracci disegnata & intagliata da C. Cesio* (Mahon 1947: 189, no. 87) with an accompanying text by Bellori. Francesco Cozza (1605–82), a pupil of Domenichino, was mentioned in the Academy after 1636 (Thieme-Becker: VIII, 36).
[88] ASL, Cart. Martinelli, quattordici fogli, "Lezioni Di Architettura/ No. 13 di/D. Domenico Martinelli"; the sheets were signed and partly dated 1684 (Smith 1993: 108, ff. 61–62). The teaching papers of De Rossi, dated 1670 and 1673 (*ibid.*: cart. 10) are simple, like the ones we have of Tommassini and Francesco Fontana (*ibid.*: cart. 9, 11).
[89] Smith 1993: 106–13; *passim.* From 1690 and 1705 he stayed at the court of Vienna and in Austria (H. Lorenz 1991: 8–14).
[90] Smith 1993; Fontana was mostly mentioned in connection with his father, and he has no monograph of his own (Braham, Hager 1977: 14). His eighteenth-century masterpiece, the church of Santi Apostoli, is among the most interesting church buildings in the tradition of Sant'Ignazio. G. Curcio is preparing a work on Francesco Fontana.
[91] Smith 1993: 149, figs. 98–100 (ASL, cart. 11, tavola II: "Toscano" e tavola V: "Ionico").

Here the main interest lay in the vertical arrangement of the façade, through an order of pilasters surrounding the ground floor and the mezzanine, and the horizontal arrangement through the flattened continuous plinth band and the entablature. The internal differentiation of the façade is worked out with the emphasis on the principal bay in contrast to the flanking bays at each side. Framing each bay, the vertical wall strip encloses the pilasters from the rear to provide relief interest for the wall, and is intended to present the structural element of the hierarchically subordinate side façades. The utilization of the belvedere features that dominate the building can be shown as the orthographic development of a rounded form.[96]

The lessons that followed were devoted to the sectional view, whereby the cladding of the cylindrical core of the building is made more impressive by the lateral extensions. Here De Rossi used a touch of color: a yellowish tint for the intersection areas, otherwise the sheets are penned in brown ink – over a preliminary pencil drawing, partly scratched in – and washed with light brown and light gray inks. The two August lessons took the example of an altar and a doorway in ground plan and elevation, both drawn on one sheet.[97] Washes were used on the presentation sheets, with the incidence of light falling at an angle of almost forty-five degrees.[98]

After the plan had been developed from the layout components, the students were expected to compile a repertory of forms in which the various orders of this particular building were distributed, thus varying the size of the proportions and, wherever suitable, trying out richer or plainer ornamental elements of the arrangement. At the same time, the choice of conditions for the ground plan in relation to the building as a whole was to be developed from the arrangement of the parts. Here we find a considerable difference from the didactic program followed at the Académie in Paris, which starts out with topologically fixed terms of reference.[99] This step-by-step procedure corresponds to Bellori's instructions: "Ordine, dispositione, misura, euritmia del tutto e delle parti."

Two large-format drawings by Filippo Juvarra have survived; dating from 1708, they are very carefully prepared for these exercises, and provide an excellent example of the procedure applied at the Academy.[100] Both sheets must have formed part of a series of drawings now lost, but a few copies showing further studies of doorways by the Roman architect Filippo Vasconi have come down to us.[101] The arrangement of Juvarra's representational sheets recalls the dia-

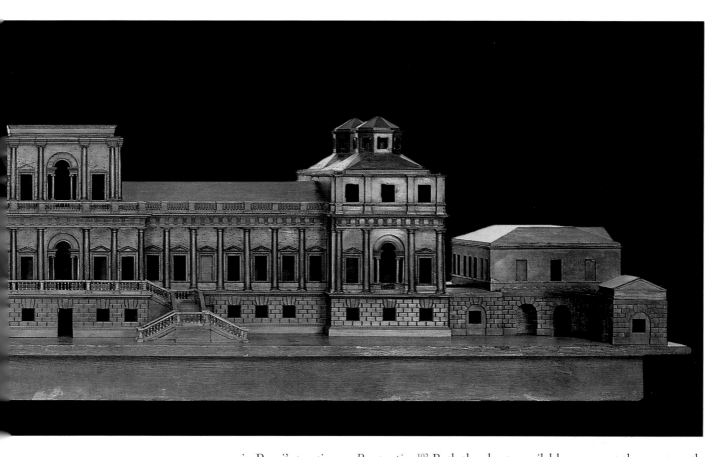

92 A. Pozzo 1693–98.

93 On Filippo Juvarra, see below.

94 The sheets are dated 7, 14, 28 July, 4 and 11 August 1675 and signed by Mattia De Rossi. These dates all fall on a Sunday. Until now the drawings have been considered as a donation of De Rossi on the occasion of his reception in the Academy. (Menichelli 1985: 52–53, tav. VIII; Smith 1993: 119, fig. 74; there erroneously dated 1673).

95 The sheet is to scale for the ground plan (scala: 100 *palmi* = 20 cm; 1:111).

96 De Rossi applied a slight perspective to the lintel brackets of the doorway, which he achieved through robust modeling. The side *oculi* of the belvedere are drawn freehand in De Rossi's characteristic sketching style.

97 Hager (1982) has observed that the design for the doorway is very like the one De Rossi produced for the main door of Palazzo Muti, not far from the church of Santi Apostoli; in Berlin there is a variant of the altar design, which ressembles De Rossi's altar in Santa Maria della Vergine (Jacob 1975: no. 380).

98 Here, as is unusually the case

grams in Pozzi's treatise on *Perspective*.[102] Both the sheets available represent the most costly and graphically demanding teaching material ever produced by the Academy of Rome. While fully maintaining the traditional academic text-book training, the drawings also demonstrate the flexibility in the invention of forms postulated by Juvarra: "Non vorrei […] che alcune credesse che, sotto il nome di ragione d'Architettura io intendessi di prescrivere le forme de' Greci, e de' Romani come leggi dell'arte, sebbene sono esemplari. Per ciò che appartiene alle forme, io stabilisco che questi debban dipendere dall'uso, e dal modo diverso col quale ce ne serviamo"[103] (I should not like […] anyone to think that, in the name of the purpose of Architecture, I intend to prescribe the forms of the Greeks and the Romans, as the laws of art, however exemplary they may be. As for what pertains to these forms, I conclude that these depend upon their use and the different ways we use them). Thus Juvarra modified the strictures of Bellori's idea when he also demanded, that even for the "decorazione ed ornamenti" the "idea stabilita, e confermata su gli esempi de gli antichi."[104]

The idea of an academically based training in architecture necessitated constant reference to the classical masters, in order to distinguish the "true" from the "false." Besides teaching the proportional relations of architectural elements, and their functional, as well as their aesthetically satisfying arrangement, the works of the "great" masters, past and present, were discussed. In Rome a totally different emphasis fell to the copying of ancient and modern buildings for study, quite unlike the situation in other European academies.[105] At the time, outside Italy the famous works of classical antiquity, the Renaissance and the Baroque were only known through published engravings, whereas in Rome students could refer to the monuments themselves and copy them directly. In spite of this, no systematic accounts of the study and investigation of ancient buildings were ever undertaken by the Academy. On behalf of the Académie, however, and as a consequence of Fréart's *Parallèle*, the designs of ancient buildings were painstakingly studied and surveyed, item by item, by Antoine Desgodet. His publication *Les édifices antiques de Rome* was to remain the authoritative standard work until the nineteenth century.[106]

At the end of the seventeenth century and the beginning of the eighteenth, interest centered on the buildings of the Roman High Renaissance, according to the plans of Bramante, Raphael, Giulio Romano, and above all Michelangelo. St. Peter's and the Capitol, and also Michelange-

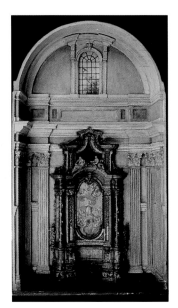

Andrea Pozzo
Wooden model for the altar
to Saint Luigi Gonzaga
Rome, Museo Nazionale di Castel
Sant'Angelo
cat. 501

with De Rossi, the wash is applied with a paintbrush for greater impact.
[99] A. Drexler (ed.), *The Architecture of the Ecole des Beaux-Arts*, Londra 1977.
[100] Both sheets are signed, one of the drawings is dated 30 April 1708. For a long time the drawings have not been considered in this connection. Millon (1984: 349) has suggested that it could be because they were presented to the Academy.
[101] Berlin, Kunstbibliothek OZ 81, fols. 73, 74, 75, pen, brown ink, 217 x 153 mm. One sheet, (fol. 73) is an exact copy of the Cooper-Hewett drawing 1938-88-7300. Vasconi, a nephew of Carlo Fontana, worked as an engraver for Juvarra, and may well have been the original engraver of this series. The pages come from a sketchbook containing drawings from various hands (Berckenhagen 1970: 119). My attribution to Vasconi is based on stylistic similarities (cf. Jacob 1975: nos. 765-770 and sheets in the hands of Milanese art dealers.
[102] A reflection of these can also be found in a study book of the same type, kept by Juvarra's pupil Filippo Cesari in 1733 (Kieven 1988: 87–91, no. 103).

lo's model for San Giovanni dei Fiorentini, were constantly copied and analyzed. When Filippo Juvarra first arrived in Rome he was advised by Carlo Fontana to study Michelangelo's Palazzo dei Conservatori.[107]
But there were not only these "maestri antichi" to be studied, there were also the buildings of the "maestri moderni." From the second half of the seventeenth century these included, first and foremost, Bernini, Cortona, and Rainaldi. Juvarra's intensive attention to Borromini's architectural works was first introduced to the Academy courses in 1706.[108] The standard repertory of canonical examples around the mid-eighteenth century is reflected in the collection of study sheets by the Roman architect Girolamo Toma.[109] Examples from antiquity were now only represented by drawings of the Pantheon; of the sixteenth century Roman buildings we find copies of Raphael's Chigi chapel in Santa Maria del Popolo and the Villa Madama, the façade of the Palazzo Cenci Maccarani by Giulio Romano, the Palazzo Farnese, the huge entrance gates to the Farnese Gardens on the Palatine attributed to Vignola, and a detailed study of Domenico Fontana's Villa Negroni-Montalto near Santa Maria Maggiore, together with his main entrance to the Palazzo della Cancelleria. Of further interest was the Holy House in Loreto, and a copy of a drawing by Michele Sanmicheli of one of the city gates of Verona.
The seventeenth century is represented by studies from Borromini (San Carlino,[110] the spiral staircase in Palazzo Barberini, the Palazzo della Propaganda Fide), from Bernini (altar in the transept of Santa Maria del Popolo, the cenotaph of the Blessed Maria Raggi in Santa Maria sopra Minerva, and the central window of the Palazzo Chigi-Odescalchi),[111] from Cortona (entrance to the theater in Palazzo Barberini, the Alexander VII gallery in the Quirinal Palace), and from Carlo Fontana (Santa Marta in the Collegio Romano, the entrance doorway to the Annona in 1705). To these should be added Antonio del Grande's drawing of the gallery in Palazzo Colonna. Representing the eighteenth century are copies of Filippo Juvarra's coat-of-arms cartouche in a publication of 1715; apart from this Toma had made a detailed study of the works of Nicola Salvi – most of all his Trevi Fountain and Santa Maria dei Gradi in Viterbo. If we compare the other study drawings that have come down to us it appears that the Palazzo Farnese and the Palazzo Barberini were taken as models for the construction of palaces in Rome; in fact the staircases in Palazzo Barberini immediately became standard models.
Competitions offered the Academy students a chance to display their talents in public.[112] A test assignment was given, corresponding to their particular stage of training; most of these assignments involved the presentation of a building type (palace, church, convent) in ground plan, elevation, and section. With the introduction of the *concorsi clementini*, the competitions founded by Pope Clement XI, came a steady rise in the demand for new buildings. Filippo Juvarra's competition entry of 1705 for a "Regio palazzo in villa per il deporto di tre personaggi" (Royal palace in the country for the recreation of three eminent people) produced not only the largest scale drawing sheets (1.30 m x 1 m) ever submitted, but a quality of draftsmanship and design that excelled anything known until that time.[113] In the course of a few decades the Academy in Rome had refined its teaching far beyond the levels of 1670. More and more, skills in draftsmanship became a means of winning commissions, and the cost of producing them increased steadily. Where architecture was formerly regarded as a form of stage painting, it very gradually became a picture in its own right. The development toward paper architecture, to the purely pictorial form of architecture, which occurred toward the end of the eighteenth century, had its origins in these Academy show pieces.
Roman architecture of the sixteenth to eighteenth centuries was generally regarded as the obligatory basic repertory of European architecture. Young architects from abroad came to study in Rome. The Academy taught them a synthesis of ancient Roman architecture, but in the course of the eighteenth century the old treatises increasingly gave way to French publications, particularly Blondel's *Cours*. Hence the interest for contemporary French architecture which now made Paris a rival center for study travel. However, right up to the end of the eighteenth century the Rome Academy – and the repertory of Roman architecture it proposed – remained the universal reference point for all European architecture.

Drawings and models
The ever greater skills demonstrated in architectural drawings boosted esteem for the profession, and greater became the importance attributed to drawing. The modes of presentation and

Salomon de Brosse
Model for the façade
of the church of St. Gervais
Paris
Paris, Patrimoine de France

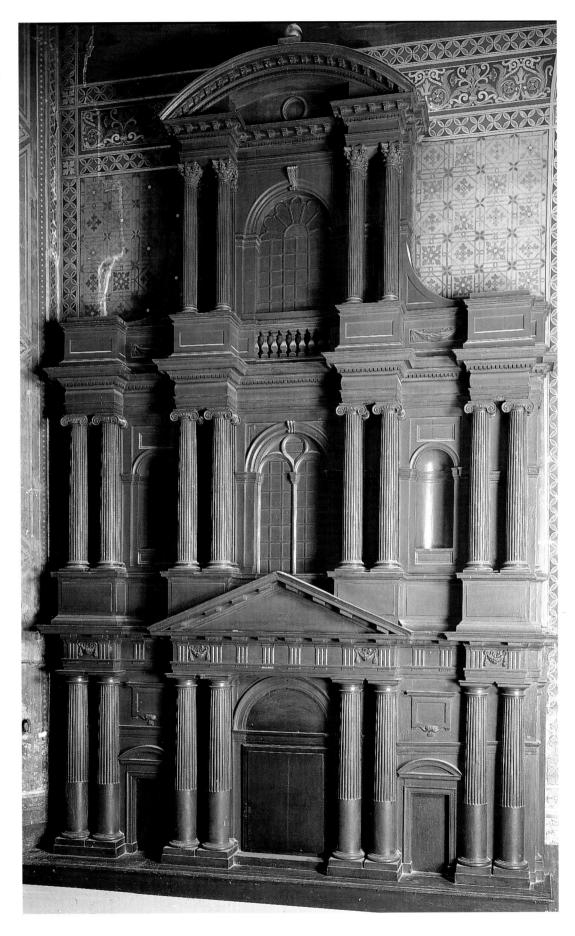

[103] The quotation was written down by Juvarra's pupil G. B. Passeri in his Roman teaching experiences of 1714 (Carboneri 1983: 110).

[104] Borea 1972: 23.

[105] See also the passage in the *Piermarini* catalog: "Roma: la formazione di un architetto," by V. Mazzenga, P. Micalizzi, S. Tedde.

[106] W. Hermann, "A. Desgodets and the Académie royale d'Architecture," in *Art Bulletin* (1958): 23–58; Pasquali 1992.

[107] Pascoli 1981: 260.

[108] Millon 1984: 13–22.

[109] In 1758 Toma won the first prize in the second class of the *Concorso Clementino* (Marconi, Cipriani, Valeriani 1974: nos. 551–56). He seems to have been a pupil of Carlo Murena and possibily worked with Murena in Vanvitelli's studio in Rome (Garms 1974: chap. II). There are drawings by him in the Gabinetto Comunale delle Stampe, Rome (Kieven 1991: 89–114) and in the New York Cooper-Hewitt Museum (unpublished). A further collection of teaching drawings of this type were preserved from the estate of the Vanvitelli-Murena pupil, Giuseppe Piermarin (*Piermarini* 1983: 130ff.), and also from the estate of another Vanvitelli-Murena pupil, Andrea Vici (Busiri Vici 1956). The material is so extraordinarily similar that one has no hesitation in considering the Toma bequest as an authentic case study.

[110] Copied from De Rossi's "Studio di architettura civile."

[111] Here we have a case of Bernini "quoting" Michelangelo (Palazzo Farnese). For the influence of Michelangelo's architecture on Bernini, see Thoenes 1983.

[112] Marconi, Cipriani, Valeriani 1974; Hager, Munshower 1991.

[113] Hager, Munshower 1981: 30ff.; Millon 1984: 313–14.

[114] E. Kieven, *Von Bernini bis Piranesi. Römische Architekturzeichnungen des Barock*, Stoccarda 1993.

[115] Significantly, Ghirlandaio's talent for freehand drawing when he copied ancient classical works was considered astonishing: his sketches were so exact that it was as though he had taken measurements (Vasari-Mil: II, 271).

[116] Scamozzi 1615: lib. I, cap. XIV, 46.

[117] Scamozzi 1615: *ibid.*, 48.

[118] For the various instruments

the information content of architectural drawing varied according to the function and purpose.[114] First, the idea of the overall plan was represented in design sketches; in the course of the planning further developments and sketches of ideas and details would follow. Sketches, or the "recording" of ideas in a concise if limited form, reproduce essential points, as well as logic, proportions and planning methods. Since they are mostly drawn freehand they betray characteristics and essential elements of the artist's personal style. Consequently, sketches are not only the key to understanding how a project develops, but also to the talent of their author, revealing his strengths and weaknesses. It is the spontaneity of the statement, the immediacy of the planning process visualized in the sketches, that lends sketches their special charm.

Architectural treatises rarely discuss architectural sketches as such. They are not mentioned by Alberti, who shows greater interest in the plan as a spiritual concept, and in the extent to which spiritual representation can be depicted in the finished drafts: through drawing to scale and mathematical measurement the draft acquires a "scientific" character.[115] Furthermore, in Scamozzi's practice-related treatise of 1615 the plan was called "la più nobil parte delle cose artificiose", but sketches were only mentioned in passing.[116] The sketch can be defined as the embryo that reveals the creative capacity of its author. This said, Scamozzi, whose treatise bears all the imprint of a scientific approach, refuses to allow himself to become further involved in digression concerning a subject that cannot be comprehended on a rational basis.

The transference of a spiritual concept to a visible, fully structured form passes through various planes of abstraction, until the assignment can be described as complete and ready. The fair copy, true-to-scale and cleanly drafted, marks the end of the planning period and presages the presentation of the project proper. For the fair copy is to architectural drawing what the "model" and "sketch" are to painting. On a small scale the idea, now ripe and ready for execution, is presented for appraisal and the eventual stipulation of the contract.

Scamozzi was the only architect of his day to give thorough instructions for the presentation of architectural drawings,[117] and stated the methods of presentation still in use today; thus, light falls from the left, i.e., in reading direction, usually indicated at an angle of thirty or forty degrees; the initial layout of the drawing, its execution in pen and ink, and a wash which helps to model the design. The drafting of architectural drawings is conditioned by the available instruments and materials, whose characteristics and limitations must be taken into account when assessing a drawing. In their treatises, both Scamozzi and Guarini devoted exhaustive explanations of the architect's "tools of the trade." The final graphic effect of a presentation also depends on the quality of the instruments and the media employed. Until the introduction of the graphics computer the architect's tools had changed little since ancient times, such as the employment of geometry for presentation on a flat surface. According to Euclid the geometrical elements are point, line, planes, and solids. Transferring these to the flat sheet on a drawing board requires the use of a T-square, set square, ruler, compasses and a drawing pen.[118]

For presentation to commissioners a fair copy can be prepared that is graphically charming to look at with the addition of extra elements such as human figures, vegetation, and landscape. A drawing that is figuratively pleasing is precisely what a presentation plan aims at: to communicate the building to the lay mind. In eighteenth-century Germany the expression "appetite whetters"[119] was used for these deliberately seductive drawings. The development of High Baroque architecture with its sinuous flow of movement, the convex-concave arrangement of the façades, heralded the problem of devising a form orthographic projection in ground plan, elevation, and section over the techniques used since the sixteenth century. But the characteristic spatial quality as well as the intended effect of Baroque architecture could not be represented pictorially in the two-dimensional abstraction of architectural drawing.

In the course of the sixteenth to the eighteenth century new emphasis was laid on perspective. Alberti had avoided using perspective in drawings for architecture, since he considered it a device of the painter.[120] However, in 1567 Pietro Cattaneo stressed the importance of this form of presentation, in preference to the three-dimensional model, on the grounds that such a technique gives a better visualization of space.[121] Scamozzi devoted a detailed description to what he termed *scaenographia*[122] as a workable conventional means of communicating plans, relating it to stage design.[123] while Guarini's treatise provides a mild warning against overdoing theatrical effects. "La Prospettiva, purchè inganni l'occhio, e faccia apparire la superficie del corpo, ottiene il suo fine, e conseguisce quanto intende [...] non ha da riguardare alla solidità, e

Filippo Juvarra
Prospect and elevation of a "Regio palazzo in villa"
Santena (Turin)
Fondazione Camillo Cavour
cat. 279

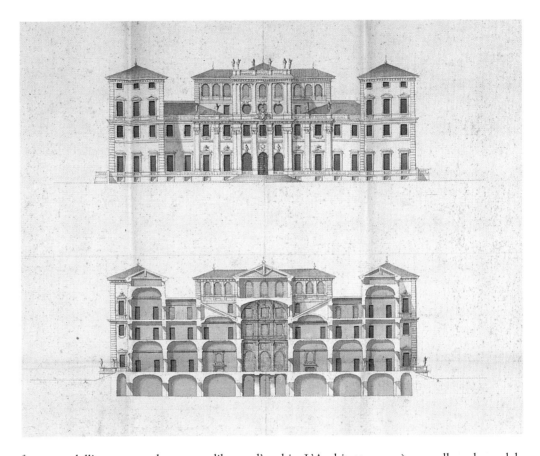

fermezza dell'opra, ma solamente a dilettare l'occhio. L'Architettura però pena alla sodezza dell'opera, onde non può liberamente fare quanto la Prospettiva inventarsi."[124] (Perspective obtains its ends and intentions by deceiving the eye and reproducing the surface of the body, it has no need to consider the solidity and stability of the work, but only to delight the eye. Architecture, however, makes every effort to promote the solidity of the work, and lacks the freedom perspective has for invention.) Bernini was in fact the only architect who used perspective in his presentation sketches. Fair copy and presentation drawing are both aspects of the same thing, and complement each other's function. So the relation between the "professional" orthographic projection of the fair copy and the one drafted for lay people is not always satisfactory, since perspectives used in the projects communicate the way it *is* on the one hand, and the way it *seems* on the other. The commissioner of the building reacts to the effect the building makes on him, the architect reacts to how strictly the plans stick to the rules. This divergence of interest emerges in the discussion between Cardinal Maffei Barberini (later Urban VIII) and the architect Carlo Maderno concerning the publication of the latter's 1613 engraving of the newly built façade of St. Peter's. Maderno had sent the cardinal an orthographic representation of the design, in which the entire volume of Michelangelo's dome rears up above the façade. The cardinal complained about the false effect, claiming that the dome is by no means completely visible from the square as the engraving suggested. In his answering letter Maderno explained the function of the architectural drawing from an architect's point of view, at the same time providing important information on architectural practice of the day: "In risposta dela sua dico che la Cupola grande e le cupolette picole de san Pietro, da star sul Ponte Santo Angelo si vedeno tutte nel modo che stano desegniate, et anco da tutta Roma de dove se possono scoprire. S'è fatto il disegno proportionato con le sue misure, aciò che ogni uno possi sapere quanto è alto et largo tutta la fabrica et ogniparte di essa. Se si fusse fatta con la ragione dela prospetiva non si poseva oservar le misure, et a molti che non intendono gli sarebbe parso più alto li Campanili che la Cupola per eser più inanzi, e le cupolette sarebeno state quasi nascoste dal tanburo in giù per rispeto de la faciata. In quanto a le medaglie, non hano oservato le misure per l'apunto la veduta da un luogo determinato.

"Gli edifitij in tre modi si poseno rapresentare: uno detto inchinographia, che si dice la pianta,

used by architects, see above all Guarini (Appendix no. 1); Jean-Jacques Lequeu 1782; Adams (1795), Feldhaus 1967, Sellenriek 1987; Hambly 1988.
[119] H. G. Franz, "M. D. Pöppelmann und die Architektur des Zwingers in Dresden," in *Kunsthistorisches Jahrbuch Graz* XXII (1986): 12.
[120] Alberti 1966: lib. II, cap. 1; Lotz 1953–56: 194. See also the following Chapter.
[121] L. H. Heydenreich, "Architekturmodelle," in *RDK* 1 (1937): 927. Here the contrast and emphasis of the drawing compared with the model goes against Alberti.
[122] Scamozzi 1615: lib. I, 47.
[123] This was the real meaning of *scaenographia* according to Vitruvius.
[124] Guarini 1737: cap. III, 7, osserv. X. Here Guarini issues a warning against the independence of drawings in perspective, as it was used in stage sets and engravings of his time.

Carlo Fontana
Caricature of Borromini
Private Collection
cat. 346

125 Quoted from Hibbard 1970: 70. The engraving bears the inscription: "Ritratto della famosiss. Fabbrica della Chiesa/ di S. Pietro di Roma in Vaticano/ rappresentata con le sue misure proportionate tanto nella parte fatta secondo il disegno [...]" (Picture of the highly renowned building of St. Peter's of Rome in the Vatican / represented with its measurements in proportion to the part built according to the drawing [Hibbard 1971: fig. 54]).
126 Scamozzi 1615: lib. I, 51. This is something that Bartolomeo Vanni (1662–1736) also described in his instructions for the funerary monument for the prince: "La Macchina va veduta compita nel suo Modello per far vedere tutto a i Maestri e quello in opera si corregge, s'abbrevia e facilita e si megliora ove più ben riesce fare non solo per l'ingegno dell'Architetto quanto per la destrezza e saperne di valenti e pratici Maestri" (The building was presented complete in its model, in order to show it to all the Masters, and to show how it could be corrected in construction, reduced in scale, facilitated and improved where it had proved most successful, not only through the talents of the Architect, but also through the proficiency and knowledge of the skilled and expert Masters. [Zangheri 1972: 42]).
127 Also in 1736 at the church of Santo Nome di Maria and in 1744 at the Oratory of the Santa Annunziata in Rome, "e per tutto il

la quale ci mostra le lungheze et largheze del tutto et dele parti del edificio. L'altra è detta Ortografia, che è l'alzato, e mostra l'altezza et larghezza de tutto l'edifitio e di ciascuna parte de quello con suo membri: queste doi ho fatto stanpare perche spetano al Architetto. L'altra si dice Sciografia, overo Prospetiva, che mostra per forza de onbre et resalti li rilevi esporti et le grosezze neli scurzi, si serve più dela ragione optica che dele misure; questa apartiene più al Pitore che al Architetto. Non ho oservato questa per satisfare a quelli che desiderano avere le misure tanto de tutto l'edifitio come de la parte di esso, perche queli che non l'ano visto, sapendo le misure, cognioserano eser cosa maravigliosa, e masime l'Altezza dela cupola grande et larghezza, di quella che non è altra simile."125 (In reply to your letter I can only say that if you stand on the Castel Sant'Angelo bridge the great dome and the small domes of St. Peter's are all seen exactly the way in which they were drawn, and also from any point of Rome from where they can be discerned. The drawing has been made in proportion with its measurements, so that everyone can tell how high and broad the whole building is, as well as every part of it. If it were drawn from a perspective point of view the measurements could not be observed, and to many people who are not architects, and do not know the building, the bell towers would seem higher than the dome, since they are placed so much further in front of it, and the small domes would be almost hidden by the drum in respect to the façade. As for the medallions, here the exact measurements have not been observed, but they conform to a view from a determined place. Buildings can be represented in three different ways: one is called clinography, known as the plan, and shows us the length and breadth of the whole and parts of the building. The other is called orthography, which is the elevation, and shows the height and width of the whole building, and each part of it with its members: I have had these two printed because they concern the architect. The other is called section drawing, or perspective; using light and shade it shows the relief thus produced and the dimensions in foreshortening, and is more concerned with the optical effect than with measurements; this is more interest to the painter than to the architect. I have not written down these observations simply to satisfy people who wish to know the correct dimensions of all and parts of the building. Those who have not seen it but already know its dimensions are perfectly aware what a wonderful thing it is, and the enormous height and breadth of the great dome, like none other in existence.)

The increasing dynamic of progress at this time posed completely new problems in the architect's methods of presentation. Since drawings were found to be limited as a means of presentation, architects turned once more to using the three-dimensional model. Francesco Borromini used wax or clay models in his planning process. For him they were not a form of presentation for the patron commissioning the work, but basically an aid to the planning. Here it is worthwhile recalling Baldinucci's observation, that Borromini shaped his models "with his own hands" out of materials that were malleable, but provided a strong tool for planning. However, Borromini's shift from drawing to model was probably an attempt to blend "cose grandi e minime" in his buildings. So far it is unverified whether this method was used by other architects, or whether Borromini was an exception.

In the case of large-scale projects, a model was almost always made, on the basis of which the commission was granted. Often the model was deemed the final authentic document. The model enabled the assessment of the building's volume, together with the estimate of costs, calculated with the craftsmen.126 At the laying of the foundation stone the contract model "represented" the projected building for this public occasion.127

As large models were mostly made of wood, clay, wax, or cardboard, only relatively few have survived. The big models that remain (e.g., Balthazar Neumann's), however, illustrate that curvilinear Baroque buildings with their complex vaulting systems could only be properly understood in models form, and drawings were inadequate. And so, with the gathering movement toward the *Gesamtkunstwerk* (total art work), the fusing of design concepts with construction itself could only be represented in a three-dimensional model. And for this reason the overall use of models must have become a necessity.

Models also played a major part in the architectural competitions. Here they resumed their traditional role of mediator between architect and patron. The exhibition of the model afforded the public a clear impression of the design, albeit on a much smaller scale. In the major competition organized for building the new façade of San Giovanni in Laterano in 1732, three plans were shortlisted: of these the two projects of Alessandro Galilei and Ludovico Rusconi Sassi,

Philips Vingboons
Rear elevation of Vredenburg palace
Zeist, Rijksdienst
voor de Monumentenzorg
Nederlands
cat. 237

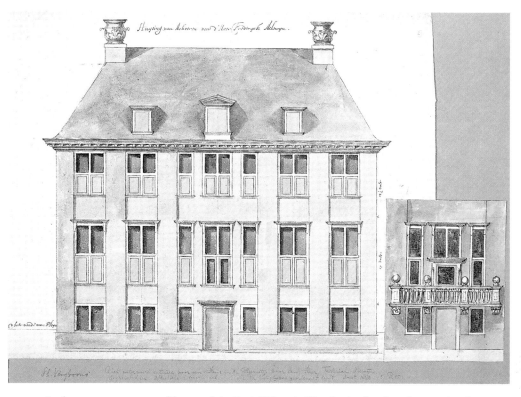

tempo, che durò la Funzione fu esposto al publico sopra il fondamento il Modello..." (And for all the time the Function lasted, the model was placed upon the foundations and thus exposed to the public [...] [Mallory 1982: 134]).
[128] The most widely read book on the subject was by M. Buchotte *Regles du Dessein et du Lavis tant de l'Architecture militaire que civile*, Paris 1722, 1754; however it was preceded by the publication in 1687 of Hubert Gautier's *Art de laver*.
[129] The pope had a bodyguard at his disposal; moreover there were garrisons in the fortresses and ports, but no standing army in the modern sense. The Camera Apostolica architects were also responsible for the building and maintenaince of fortresses and port installations, but one would never have described them as military architects. For the role of officers, see *Die Bildung des Offiziers in der Aufklärung. Ferdinand Friedrich von Nicolai (1730–1814) und seine enzyklopädischen Sammlungen*, exhibition catalog (Stuttgart, Württembergische Landesbibliothek, 1990), edited by D. Hohrath in collaboration with R. Henning.
[130] Germann 1980; Nerdinger 1985.
[131] Bottari 1754: 143. The text had already been written in 1734 and was published anonymously in 1754 (A. Costamagno, "Agesia Beleminio [G. G. Bottari] e l'Accademia dell'Arcadia nel Settecento," in *Quaderni sul Neoclassico*, misc. 3, 1975: 43–63). Bottari is one of the few Italian theorists of the eighteenth century who took it upon themselves to discuss the function of architectural drawing.
[132] Whenever Bottari means the planning quality of a drawing, he mostly uses the word "invenzione".
[133] Bottari 1754: 127.

respectively, were represented by models. Luigi Vanvitelli, who had only submitted a drawing, was directed to convert his plan into a model, so that conditions would be equal for the final decision. This suggests the sheer power of suggestion of the three-dimensional representation. In the late eighteenth century the emphasis laid on effect and appearance in Baroque design earned it an accusation of *inganno*, or deception. In a particular projection procedure involving contours and planes, an illustrative and elucidating role is played by the use of color. Color as an aid to projection was used for drafting military buildings, and a system had developed whereby conventionalized coloring identified construction data. Walls were red, wood a yellowish-brown, water blue, earth black; unbuilt parts or projects were drawn in yellow, etc. Here the French military architects were leaders in the field; their manuals offer the most precise information on the charting and drafting of architectural drawings.[128]

Such a convenient coloring system found only very limited application in architectural planning in Rome, perhaps because the Papal States kept no great army, nor was there a corps of military engineers and architects who, in other countries and particularly in the seventeenth and eighteenth centuries, also played an important role in civil architecture.[129]

As architectural drawing increasingly adopted these painterly devices, at the end of the eighteenth century the use of coloring became a standard.[130]

"L'architettura richiede molto studio, molta applicazione, molto ingegno, e molte notizie, le quali si riducono a due capi, cioè a saper perfettamente la geometria [...] e al disegnare," explained Giovanni Gaetano Bottari in 1754.[131] Here the term *disegno* tends to mean "drawing" rather than design.[132] Michelangelo and Bernini were also quoted as authorities: "Tutti si sono esercitati lungamente, e con una ostinata attenzione nel disegno [...] chi non sarà un grande disegnatore non farà mai in genere d'architettura cosa, che abbia garbo, nè si potrà mai chiamare architetto."[133] Here we could not find a more explicit reference in support of the expressive capacity of drawings, although it was seldom brought up in the earlier treatises. Bottari was, however, writing at a time when the idea of *disegno* had already become part of a common heritage, and the finest drawing had long entered the cultural patrimony at its highest level. So the complex concept of *disegno* and all that it implied in the more restricted sense of sketch, plan and concept, had in fact passed through a long process of development.

The end of the road saw the separation of the "technical" from "artistic" aspects in eighteenth-century architectural training. It was not only in the planning and building, but also in drawing that Baroque architecture swept European architecture to its peak.

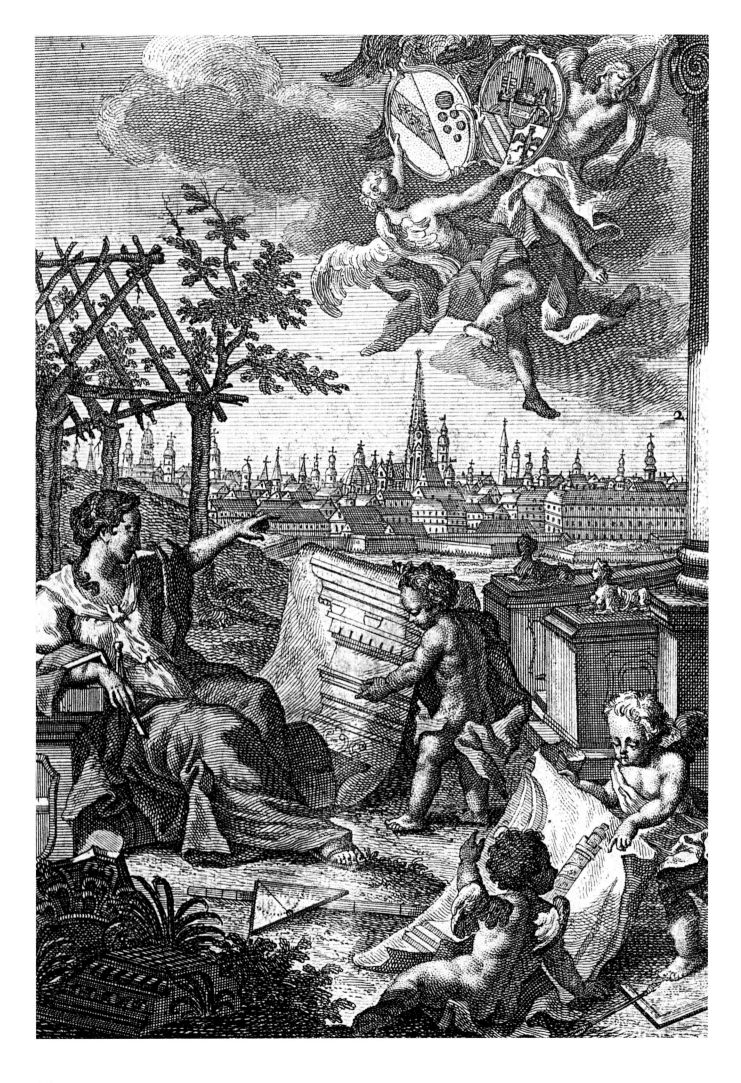

Werner Oechslin

Architectura est scientia aedificandi: Reflections on the Scope of Architectural and Architectural-Theoretical Literature

"Classical" literature in the Vitruvian tradition

"Classics" in architectural literature are found early. The canon that includes Vitruvius, Alberti, Serlio, Vignola, Palladio, and Scamozzi is a familiar one, establishing itself wherever the Vitruvian tradition – reduced to the five classical orders – is embraced and codified into a doctrine. Yet to limit the scope and dissemination of architectural literature to this one strain would inappropriately narrow the field of vision. Upon closer examination, such a perspective fails to do justice even to France, where the founding of the Académie Royale d'Architecture in 1671 provided an institutional framework for the most significant attempt to establish the discipline of architecture as a science.

In the subtitle to the first part of his famous *Cours d'Architecture* of 1675, François Blondel refers to a "doctrine de Vitruve" and adds – in an obvious qualification – "et de ses principaux Sectateurs." In so doing he invokes a term used in philosophy to distinguish between the various "sects" of the Stoics, Epicureans, and so on, one that suggests the formation of a particular school with its own adherents.[1] According to Blondel, the company of orthodox Vitruvians is confined to Vignola, Palladio, and Scamozzi, or rather to their books. Shortly before, Roland Fréart de Chambray had struggled to include all the relevant literature in his discussion, a total of ten works ranging from Pietro Cattaneo to Viola-Zanzini. Yet even he had entertained the notion of limiting the system of classical orders to the three Greek orders, an idea Blondel essentially revived with his reference to the "preceptes les plus conformes à la beauté," the elements of pure orthodoxy in Vignola, Palladio, and Scamozzi.[2]

Yet the term "sectateur" was tainted with negative connotations from the outset,[3] and the weaknesses of a such a rigorous theoretical approach quickly became apparent. The reading of the classics systematically incorporated into Blondel's Académie failed to produce useful results, despite the availability of Claude Perrault's new translation of Vitruvius. In the preface to his *Ordonnance des Cinq Especes de Colonnes selon la Methode des Anciens* of 1683, Perrault himself conceded that the doctrine of the classical orders was of little use in regulating anything outside these narrow premises: "Tout le reste qui consiste dans les mesures precises de tous les membres & dans un certain contour de leurs figures, n'a point encore de regles dont tous les Architectes conviennent."[4] To be sure, Perrault – proceeding from the (contradictory) requirements of the "classics" – attempted to bring a certain degree of order into these regulative systems. But even long thereafter, a naive practitioner was to note: "In the several treatises written by Palladio, Scamozzi, Serlio, Vignola, Le Clerk [sic!], and Evelyn, there is no Word mentioned for the instructing of a young Architect how to module, or find the Diameter of an Order; which to me is greatly surprising."[5]

To use this Colbertian cultural-political orthodoxy as a criterion for defining architectural literature, therefore, is hardly feasible and inevitably gives rise to "academicism" and the corresponding reactions. Le Corbusier, in fact, celebrated its demise with the victory cry: "Et Vignole – enfin – est foutu! Merci! Victoire!"[6] At the same time, however, he expressed his admiration for the xylographs in Jean Martin's edition of Vitruvius: "La libération est dans ce dessin; il apporte le salut, la renaissance, la renaissance!"[7] This differentiated assessment constitutes a rejection, not of the Vitruvian literature and certainly not of architectural illustration in general, but only of an overly narrow interpretation and application.

The second major attempt to found an architectural "school" in Paris, undertaken by the younger Blondel, drifted much further from the party line. Jacques-François Blondel's *Discours sur la Nécessité de l'Etude de l'Architecture* – full of recommendations of all kinds – also expands the range of books to be studied. The definition of a theory of architecture is extended to include a familiarity with architectural history, for the comparison of old and new and indirectly to satisfy all the requirements of "société civile," "utilité" as much as "magnificence."[8]

Accordingly, the reading list Blondel prescribes with a view to the "connoissance des meilleurs Auteurs" has also grown. In order that the aspiring architect will be able to make use of the books, Blondel adds that they are available either in public libraries or at a particular bookseller's.[9] The "livres anciens" he cites include first of all the French – his

[1] "Secte terme collectif qui se dit de ceux qui suivent les opinions ou les maximes de quelque docteur ou maître particulier, soit théologien, soit philosophe," D. Diderot, Jean Le Rond D'Alembert, *Encyclopédie, ou Dictionnaire Raisonné des Sciences, des Arts et des Métiers*, XIV, 1765: 876.

[2] Cf. W. Oechslin, "'C'est du Palladio': An Approach to the Phenomenon of Palladianism," in *Palladio nel Nord Europa. Libri viaggiatori, architetti*, exh. cat., 1999: 64ff.

[3] "Sectaire, celui qui est attaché à quelque secte. Il se prend presque toujours en mauvaise part: on dit sectateur d'une école de philosophie; un sectaire de dogme religieux," *Encyclopedie*, op. cit.: 876.

[4] C. Perrault 1683: I.

[5] W. Salmon 1762 (1734), "Preface."

[6] Le Corbusier, *Le poème de l'angle droit*, Paris 1955: 66; cf. W. Oechslin, *Stilhülse und Kern*, 1994: 36ff.

[7] Le Corbusier, *Une maison-un palais*, 1928: 30-31.

[8] "Par la théorie de l'Architecture, nous exigeons la connoissance de l'histoire de cet Art [...]" J.-F. Blondel, *Discours sur la Nécessité de l'Etude de l'Architecture*, 1754: 71.

[9] "Leurs ouvrages se trouvent pour la plupart dans nos Bibliotheques publiques, dont nous avons fait mention dans la note (page 60) ou enfin chez Charles-Antoine Jombert, rue Dauphine à Paris" Blondel, *Discours...*, op. cit.: 83.

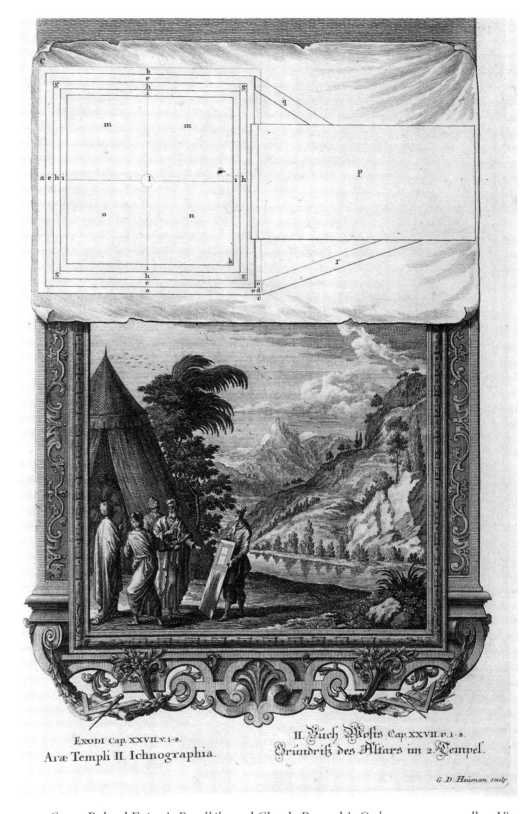

EXODI Cap. XXVII.v.1-8.
Aræ Templi II. Ichnographia.

II. Buch Moſis Cap. XXVII.v.1-8.
Grundriß des Altars im 2 Tempel.

G.D.Heuman sculp.

own *Cours*, Roland Fréart's *Paralléle*, and Claude Perrault's *Ordonnance* – as well as Vitruvius. A number of other works, however, are also named, with brief annotations listing the special advantages of each. Desgodets' *Les Edifices antiques de Rome*, for example, is described as the work with the most precise plans and drawings after the most exemplary antique buildings visible in Rome, and is recommended for this very reason ("pour la précision des mesures"). Pozzo's treatise on perspective is also described as an "ouvrage excellent," while – somewhat surprisingly – even Fischer von Erlach's *Historische Architectur* is listed, if only for the sake of familiarity with the most notable monuments of Egypt, Greece, and Italy.[10] The scope of architectural literature is expanded even further when Blondel addresses the category "Œuvres d'estampes," including in it the entire range of architectural picture-books from Le Pautre to Piranesi.

Almost unnoticed, as it were, the definition of the architectural book has been stretched to breaking point. In light of this, the remarks by the classicist Comolli at the beginning

[10] "Ouvrage estimé pour la collection des plus célèbres monumens de l'Egypte, de la Grece & de l'Italie," Blondel, *Discours...*, op. cit.: 85.

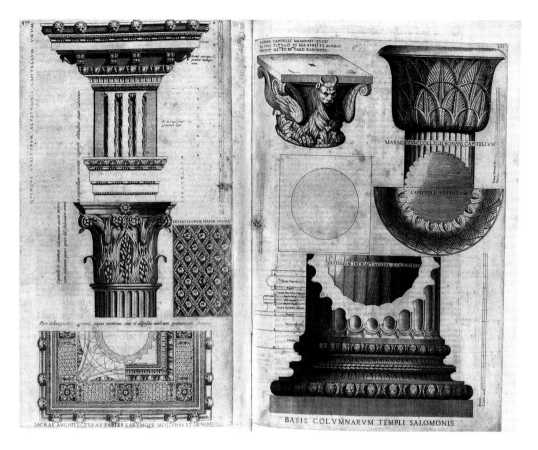

Jerónimo Prado
Giovanni Battista Villalpando
Apparatus Urbis
ac Templi Hierosolymitani
tome III, Rome, 1604
Einsiedeln, Stiftung Bibliothek
Werner Oechslin
cat. 345b

of his well-known early bibliography of architecture take on particular significance: "Se per elementi d'architettura io intendessi soltanto co' cattedratici quelle pratiche, e teoriche istituzioni, che o formate sulle traccie de' migliori maestri, e de' modelli più sicuri, e più autorevoli dell'arte, o dettate dalle riflessioni profonde di qualche nuovo pensatore, danno di questa scienza le regole, e i precetti, assai ristretta sarebbe la materia componente il piano di questa prima parte della Bibliografia architettonica."[11] The architectural book has by no means confirmed a correspondingly narrow conception of architectural theory. What finds its way into a book is not limited to "theory," but comprises virtually everything which – between imagination and reality – can be represented in word and image.

"Goût des nations": cultural-historical distinctions
The architectural bibliographies confirm this supposition at a single glance. These, however, are oriented according to their own criteria, according to location and the specific needs in question. A brief comparison of the "Déclaration des principaux Autheurs" in Louis Savot's much-printed *L'Architecture Françoise* – with notes by François Blondel from 1673 on – with P. J. Marperger's appendix of 1711 to the German version of Jean-François Félibien's *Historie und Leben der berühmtesten Europäischen Baumeister* suffices to illustrate this point.[12] The overlappings and divergences, emphases and omissions – based in the final analysis on the compiler's access to and familiarity with architectural books – document both the rich range of architectural literature and its diversity in the various cultural landscapes of Europe. Bullant and Du Cerceau, for example, are absent from Marperger, as is Furttenbach from Savot. On the other hand, both bibliographies include Blum and Dietterlin and – more surprising from a present-day perspective – Johann Heinrich Alsted.

The question of scope arises once more, both in general and from the perspective of cultural-historical distinctions. Savot traces the entire classical literature on mechanics (including the Aristotle commentaries) and pneumatics;[13] Marperger, on the other hand, includes a number of contemporary treatises on fortification. The difference in emphasis leads us to expect comparatively more literature on woodworking in Germany – and with good reason. In his preface to Johann Wilhelm's *Architectura Civilis*, Johannes Haisten of Nuremberg praises German skill in carpentry in the following verses:
"Ja! an dem Zimmer-Bau den Meisterlichen Fleiss / Der Teutschen rühmen muss der Schott, der Pol, der Reiss, / Der toller Spanier, der klug Italiener, / Der hurtige Frantzos, wie offt allda so schöner / Tachwerck ein gantzer Wald gleich ineinander ist / Geschrencket, hoch hinauff das oberste Gerüst [...]"[14]
By this point, cultural chauvinism[15] had long served as a means of distinction and com-

[11] A. Comolli 1788: I, 1.
[12] L. Savot 1673: 338ff.; P. J. Marperger 1711: 515ff. Marperger's translation of Félibien was produced by the same publisher and in the same format as the various parts of *Der Geöffnete Ritterplatz, Worinnenn Die vornehmsten Ritterlichen Wissenschaften und Übungen. The Geöffnete Baumeister-Academie* (1706, 1715) likewise contains a list of "Scribenten" relevant to this comparison.
[13] Savot 1673: 352.
[14] "Zugab, an den Leser, der den Bau verständig liebt, Sich in der Wissenschafft der Baukunst mit Lust übt," J. Wilhelm, *Architectura Civilis, das ist: Beschrieb, oder Vorreissung fürnembsten Tachwerck [...]*, 1662.
[15] Cf. W. Oechslin 1995: 365ff.,

Der Tempel Salomonis
Halle 1718
Einsiedeln, Stiftung Bibliothek
Werner Oechslin
cat. 345c

petition; already in 1548, in the preface to his German translation of Vitruvius, Ryff had stated that the "so herrlichen, trefflichen Ingenien Teutscher Nation" not only matched, but by far outstripped their rivals.[16] Yet the "nations" and their cultural options cannot in fact be so precisely separated. And naturally it is not the case that France laid exclusive claim to the literature on stonecutting, and Germany to that on carpentry. Mathurin Jousse, born in La Flèche, produced standard works in both genres. *Le Secret d'Architecture* of 1642 numbers among the classic works on the stonecutter's art, while *Le Théâtre de l'Art de Charpentier*, first published in La Flèche in 1627, was reprinted in numerous editions until 1751. To be sure, Johann Wilhelm enjoys an equally notable reputation, and states that no other land has produced a work on carpentry to match, "darumb dass an Ausländischen Orten der Holtzbau so starck nicht, als in unserm Teutschland gebräuchlich."

More important than this statement itself, however, is the question of the architectural-historical and theoretical significance of this special treatment of the art of carpentry. What may come as a surprise to readers of architectural literature is self-evident to carpentry journeymen, the "junge und angehende Meister" whom Wilhelm addresses. In his very first illustration, Wilhelm shows an architectural model and describes its most important features:

"Zeiget demnach die erste Figur an, ein Modell von Holtz/oder Papyr gemacht, nach dem verjüngten Zollstab,/welcher durch das gantze Buch bey jeglichem Riss/zufinden ist: Vermittelst welchen Modells man einen/Bauherrn oder Verleger alle Zimmer und Gemächer eines/Jeglichen Stockwercks vorweisen und zeigen kan:/Dessgleichen wie die Stockwercke übereinander kommen,/oder auffgesetzt werden. Ist auch zusehen, wie der Bau/ausswendig in Augenschein zu nehmen."[17]

Architectural literature, encyclopedic and scientific literature on architecture

Cultural, "national" differences appear again and again in architectural literature, a phenomenon in which widely diverging conceptions of the architect's profession play a decisive role. (In Germany, for example, the so-called *Hausvater* literature advocates and describes a broad architectural education for the building patron).[18] Despite the almost unmanageable broadening of scope, recourse is again and again to the solid core of "classical" literature with its easily recognizable standards. This tendency manifests itself in bibliographic entries such as those listing the various editions of Scamozzi: "Scamozzi Vincent. Speculum Architecturae Venet. 1615. Englisch 1669. Holländisch. Amsterdam. 1640. Teutsch. Nürnberg 1678."[19]

Scamozzi, it appears, is ubiquitous; yet this observation in itself confirms only a very superficial view of things. For it is precisely in the translations and adaptations of particu-

[16] Such statements occur with remarkable frequency in the letter to Johann Neudörffer with which Ryff prefaces his "Von rechtem verstandt, Wag und Gewicht etliche Büchlein […]," in *Der Fürnembsten notwendigsten der gantzen Architectur angehörigen mathematischen und mechanischen Künst eigentlicher Bericht* (1547).

[17] J. Wilhelm 1673: A iii *verso*.

[18] "Dass der Hauss-Vatter von der Bau-Kunst einigen Verstand haben solle," cf. F. Ph. Florinus, *Œconomus prudens et legalis. Oder Allgemeiner Cluger und Rechstverständiger Haus-Vatter…*, 1722: I, xxii, 128ff.

Claude Perrault
Ordonnance des Cinq Especes de Colonnes selon la Methode des Anciens
Paris 1683
Einsiedeln, Stiftung Bibliothek
Werner Oechslin

Geöffnete Baumeister-Academie
Hamburg, 1706
Einsiedeln, Stiftung Bibliothek
Werner Oechslin

[19] *Geöffnete Baumeister-Academie*, 1706: 224.
[20] On this point and the following, cf. W. Oechslin 1997: xiv: "L'on ne s'est arrêté qu'à ceux [ecrits] qui appartiennent à l'Architecture, & qui sont nécessaires & utiles aux Architectes, à l'ordonnance des Edifices, & à la distribution des Pièces qui les com-

lar works that a considerable divergence arises. Cultural-geographical comparison of the various versions indirectly reveals another, theoretically much more significant difference, namely the distinction between an architectural perspective and a more general encyclopedic or scientific view.

In their selection – and rigorous abridgement – of Scamozzi's *Idea dell'Architettura universale*, Charles Auguste d'Aviler and his followers claim to have limited themselves to those portions applicable to architecture (in the narrower sense) which could be subsumed under Vitruvian categories such as "ordonnance" and "distribution."[20] Later, in the classicistic period – when a comprehensive (aesthetic) theory was consistently derived from architectural literature in the narrow (Vitruvian) sense – this distillation was viewed as exemplary: "en séparant cette partie vraiment classique, de ce volumineux amas de notions dont personne ne soutiendroit aujourd'hui la lecture." This, according to Quatremère de Quincy, was D'Aviler's greatest achievement.[21]

A "partie vraiment classique" – a theoretical core of classical Vitruvianism – is thus contrasted with an inferior remainder, a "volumineux amas de notions." The elements that are rejected and those that remain valid for (other!) broad areas of architectural literature can easily be determined by a comparison with the original edition of Scamozzi from 1615. In good humanistic form – a tradition represented by Alberti and Daniele Barbaro as well – Scamozzi, who invokes Plato and Aristotle, focuses his attention on fundamental questions. The "universal" idea of architecture announced in the title and the comprehensive line of questioning it suggests is in fact pursued, taking Aristotle's *Metaphysics* as a point of departure: "Ars est universalium cognitio, experientia vero singularium, come dice Aristotele."[22] Scamozzi demonstrates his ability to deal with these philosophical categories when he establishes the distinction "per via delle causa in universale, & in particolare, & anco in atto." He is familiar with the definition and purpose of a "filosofia morale" and is fundamentally interested, in an explicitly Platonic sense, in the relation between theory and practice, between "scientia cognoscens" and "scientia agens." And it is on this philosophical foundation that Scamozzi explores the significance of the "speculative," in order to identify "praecognitio" as the architect's duty and responsibility. Thus it is no coincidence that it is Scamozzi who, for the first time after Alberti, speaks of the model and the drawing at great length and in a philosophically correct manner, identifying their fundamental significance as "design" and "anticipation," as "in atto" and "dimostrative al senso."[23]

French academic doctrine, on the other hand, drawn for the most part from Vitruvius alone, showed little interest in the inclusion of philosophical principles in architectural-theoretical discourse. Instead, throughout the course of the eighteenth century it sought for new, primarily aesthetic theoretical foundations, taking the old question of musical proportions as its point of departure. Yet these various attempts and the call for an alternative to Vitruvius from Lodoli to Boullée could not prevent later writers from lamenting the absence of a "philosophy": "Il manquait à l'architecture [...] d'être connue dans son ensemble, et d'être considérée selon son véritable caractère. La Philosophie de l'Art vient remplir cette lacune," wrote J. A. Coussin in 1822 in the prospectus to his *Du Génie de l'Architecture et de la Philosophie de cet art*.

Elsewhere, philosophical discussion of this sort had commenced long before, particularly with regard to the question of the place of architecture within a comprehensive system of learning. Here, too, a variety of perspectives can be discerned.

For Alsted, architecture is conceived within the tradition of the seven liberal arts (or sciences).[24] Since the time of Martianus Capella, the place of architecture had been undecided and ambivalent. There, Apollo's suggested inclusion of architecture (and medicine) in the ranks of the *artes liberales* had been rejected – in favor of "harmony" – as an all too human occupation.

Vitruvius's unequivocal definition "architectura est scientia," on the other hand, was more conducive to a "scientific" treatment of architecture.[25] In German-speaking lands, special consideration was already devoted to architecture in the later editions of the *Margarita Philosophica* of Gregor Reisch, and appears in virtually every great systematic catalogue of human activity, including the *Margarita Philosophica in Annulo. Sive Synopsis*

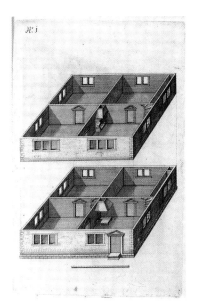

Johann Wilhelm
Architectura Civilis, Frankfurt 1662
Einsiedeln, Stiftung Bibliothek
Werner Oechslin
cat. 345l

posent;" cf. D'Aviler 1713: "Préface."
[21] Oechslin 1997: xiii.
[22] Oechslin 1997: xiii.
[23] Oechslin 1997: xxxii. Cf. also Oechslin, "Das Architekturmodell zwischen Theorie und Praxis," in B. Evers (ed.), *Architekturmodelle in der Renaissance*, 1995b: 40ff.; on Scamozzi, *ibid.*: 47–48.
[24] Cf. here and in the following J. H. Alsted 1620: 1571ff.: "Liber decimusquintus, In quo Architectonica." The work by Alsted cited in Savot (1673: 348), the *Baumeister-Academie* (1706: 228), and Marperger (1711: 516) is a short treatise of 1613, *Methodus admirandorum Mathematicorum*, likewise published in Herborn.
[25] Vitruvius, *De Architectura*, I, I, 1; here quoted after the traditional reading (in contrast to the one now agreed to be correct, "Architecti est […]").
[26] A. Reyher 1669: 637ff.: "Architectonicae Epitome."
[27] T. Hobbes 1651: plate following p. 40.
[28] Diderot, D'Alembert 1751: "Système figuré des Connoissances Humaines," plate following p. lii (cf. also p. lii: "Voilà dans son ordre naturel, & sans démembrement ni mutilation, l'Arbre du Chancelier Bacon").
[29] G. J. Vossius, *De Universae*

totius Philosophiae (1669) of the Gotha rector Andreas Reyher, a work whose title was inspired by that of Gregor Reisch.[26]

In the ramification of the various sciences and branches of knowledge in Thomas Hobbes' *Leviathan, or The Matter, Forme, & Power of a Common-Wealth Ecclesiasticall and Civill* of 1651, architecture takes its place at the end of the following sequence: "Science-Philosophy" – "Naturall Philosophy" – "Quantity-Motion" – "Motion, and Quantity determined" – "Motion, and Quantity of Bodies in speciall" – "Motion of Speciall kinds, and Figures of Body" – "Mechaniques-Doctrines of Weight" – "Science of Engineers-Architecture-Navigation."[27]

In the "Discours préliminaire" of the *Encyclopédie* a hundred years later, d'Alembert's no less famous catalogue of human activity – credited to Bacon – lists various aspects of architecture simultaneously under three categories: "Mémoire-Histoire" ("Architecture pratique," under "arts, métiers, manufactures"), "Raison-Philosophie" ("Architecture militaire," under mathematics and geometry), and "Imagination-Poésie ("Architecture civile").[28] Hobbes's categorization corresponds to the second branch of Alberti's designation of architecture "tum et opere," the movement of loads and the production of bodies. D'Alembert, on the other hand, demonstrates – though in a scarcely satisfactory way – how variously architecture can be situated between practical, theoretical, and artistic considerations.

Yet it is precisely the ambiguous character of architecture that explains the varying approaches taken in the literature, beginning with the systematic scientific and encyclopedic works. In the widely disseminated *De Universae Mathesios Natura & Constitutione Liber* of Gerard Johann Voss, the question of architecture is approached from the perspective of mechanics and its applications. Here, too, all the relevant previous literature since Politian's *Panepistemon* is taken into account; Vitruvius, too, is cited when appropriate. This angle of approach is described as "de utilitate Mechanices in architectura, arte nautica, ac militari."[29]

Among the authors who engage in this kind of systematic investigation, Johann Heinrich Alsted is particularly notable for his efforts to invest architecture itself with the status of a science. This may well explain Alsted's inclusion in the lists of architectural works given in Savot and Marperger.[30] His first description of the practical science of architecture – which here, however, is considered from a theoretical perspective – reads "Architectonica est bene aedificandi scientia." His *Methodus Architectonicae* divides the question into the aspects "generalis" and "specialis," referring on the one hand to principles such as the problem of matter and form, and on the other to the concrete circumstances of building ("de aedificio").

This division corresponds to the conventional approach to architecture in the general scientific literature, and is likewise found in all those books that adopt the form of a textbook or manual of instruction. Today, the importance of this literature is generally underestimated, composed in Latin until well into the eighteenth century in accord with its didactic aspirations. The advantages of the systematic approach, moreover, manifest themselves in definitions that are often surprisingly precise and "modern" and occur nowhere else in the literature. In his *Tabulae Architecturae Civilis* of 1757, the Prague Jesuit professor Stephan Schmidt defines the building in a concise, modern, and abstract manner as an artificially delimited space, a notion completely alien to Vitruvian doctrine and terminology: "Aedificium est spatium arte inclusum, ut quaedam vitae humanae negotia in eo tute, atque commode peragere liceat."[31]

Here, too, it is fruitful to examine the value and potential of this systematic approach with a view to those questions either absent from Vitruvian doctrine or mentioned only in passing. The architectural model, for example, addressed at great length in Alberti and Scamozzi but largely neglected in the French architectural literature, is in fact conceptually developed and codified in those works that unite the mathematical and mechanical sciences in compendium form.[32]

One such compendium is the oft-printed *Mathesis Compendiaria* of Johann Christoph Sturm, revised in various Latin and German editions by his son Leonhard Sturm and finally integrated into the comprehensive *Civilbaukunst*, at first an edition and then an ex-

Franciscus Philippus Florinus
Oeconomus prudens et legalis. Oder Allgemeiner Cluger und Rechtsverständiger Haus-Vatter
Nuremberg, Frankfurt, Leipzig, 1722
Einsiedeln, Stiftung Bibliothek Werner Oechslin

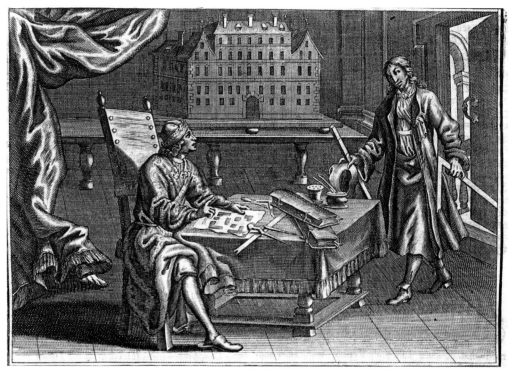

pansion of a manuscript by Nikolaus Goldmann. In this process of continual conceptual refinement, the mere (historical) reference to the model of Solomon's temple ("des Abrisses/ oder vielleicht eines geschnitzten Muster des gantzen Gebäues") becomes the occasion for a recommendation of a "corporea seu materialis forma sive modulus aut typus totius aedificii (ein Modell oder Muster)" to supplement the three representational modes of ichno-, ortho-, and scaenographia. This addition to the traditional canon quickly makes the rounds.

In his *Anleitung zu den fürnehmsten Mathematischen Wissenschaften*, Benjamin Hederich lists the model at the end of the corresponding "definitiones:" "Modell, Muster, Modulus, s. Typus, ist die massive Vorbildung eines Gebäudes, aus Dohne, Wachse, Holtze, und dergleichen Materie."[33] Similarly, in 1718 Leonhard Christoph Sturm incorporates this definition, now clarified and refined, into his comprehensive, quintilingual architectural terminology. In a philosophically convincing manner, the model is now defined as "idea materialis" and takes second place among the modes of architectural representation, after the most general concept of "idea" but before the more specific terms "schema," "delineatio," "ichnographia," "orthographia," "intersectio," "orophegraphia," and "scaenographia." Here the scientific character of this systematic architectural literature becomes apparent.

This literature, moreover, by no means exists in complete isolation; the authors are extremely well informed. Among the more recent publications quoted in Christian Rieger's *Universae Architecturae Civilis Elementa* of 1756 – conceived as a textbook for the Vienna Theresianum – are Laugier's *Essai* of 1753 and even J.-F. Blondel's *Discours sur la Nécessité de l'Etude de l'Architecture* of 1754, "in quo simul plena atque perspicua totius Architecturae cognitio traditur."[34] Rieger is also familiar with his worthy predecessors: Henry Wotton's *Elements of Architecture* of 1624, for example, is quoted with remarkable frequency, showing the pride that this "universal," systematic and scientific approach to architecture takes in its own tradition. And while said tradition does not follow Vitruvian doctrine, it nonetheless incorporates Vitruvius wherever he provides sufficient information.

Sacred history and the science of architecture

The question of the scientific authority of Vitruvius and its clear insufficiencies is posed with virtually unsurpassed clarity as early as 1607 in the *Bibliotheca selecta* of Antonius

Mathesios Natura & Constitutione Liber: 278. The work was published in 1660 together with others under the title *De Quatuor Artibus popularibus, de Philologia, et Scientiis Mathematicis*, which was later was changed to *De Artium et Scientiarum Natura et Constitutione Libri quinque* in the collected works of Voss, Amsterdam 1686.
30 Cf. above; Savot's critical undertone (1673: 348): "[…] il parle en discours fort vaste des preceptes generaux de l'Architecture") is nonetheless unmistakable.
31 S. Schmidt 1757: 5.
32 Cf. here and in the following W. Oechslin, *"Idea materialis". Das Architekturmodell – Instrument zwischen Theorie und Praxis* (forthcoming).
33 B. Hederich, *Anleitung Zu den fürnehmsten Mathematischen Wissenschaften […] Andere und verbesserte Auflage*, Wittenberg 1714: 235.
34 Ch. Rieger 1756: 275ff.: "Syllabus Scriptorum Architectonicorum."

Possevinus.[35] Later, François Blondel has good cause for his vehement defense of Vitruvius's primacy; in his first note to Savot's architectural bibliography, he remarks: "Il a raison de mettre Vitruve le premier, comme le pere des Architectes, non pas tant à cause qu'il est le seul de tous les anciens, dont nous ayons les ouvrages ecrits sur cette matiere, que parce que sa doctrine est admirable quasi par tout."[36]

This, however, was the very thing Possevin had doubted: "An aedificandi ratio peti debeat ex uno Vitruvio?" His doubt is rooted in sacred-historical and, in a narrower sense, biblical-historical considerations – and directs our attention to another significant area of the architectural literature of the time. Addressing the question of the origin of architecture, Possevin had previously delineated a historical sequence based on the Bible: "ab Abrahamo […] doctos fuisse Aegyptios, a quibus Graeci, inter quos fueri qui Architecturae inventores sunt habiti, Scientias, atque artes cunctas accepisse." The primacy of the Bible is thus re-established for architecture in an entirely concrete, historical sense. Consequently, the temple of Solomon emerges as the origin and model of architecture: concretely in its specific form, and in general as "ratio Architecturae," the epitome of architecture, and as "Architecturae methodus."

The principles of architecture are thus exemplified by the Jerusalem temple, a path retraced again and again by the architects who availed themselves of the comprehensive numerical data in the monumental work of Prado and Villalpando. Possevin literally states that the (Vitruvian!) categories of architecture were prefigured in the temple in a marvelous way: "Elucebat videlicet in eo aedificio ea omnia ad miraculum quae optimae architecturae legibus praecepta sunt: ordinatio, dispositio, eurythmia, decor, distributio, symmetria."

The Jesuit Possevin is by no means alone in his conception of a divinely revealed architecture. Alsted, as well, whose presentation of the science of architecture shows the temple of Solomon as its sole pictorial illustration, notes at the end of his discussion that these considerations must inevitably lead "ad coelestem illam 'acheiropoieton' domum," "cuius architectus est Deus."[37]

This wide-ranging conception of the Bible as the foundation of architecture appears in the literature of Catholic, Protestant, and Anglican Europe. Possevin, and especially Villalpando, moreover, provide concrete specifications above and beyond general principles. The "mysterium" leaves no iota ("iota nullum") unconsidered; all is specified in measure and number, providing Villalpando with his "apparatus."[38] Villalpando's illustrations show the reconstructed temple of Jerusalem with reliable measurements, as well as an architectural order in the familiar, modern sense. On this basis, architectural theorists such as Juan Caramuel de Lobkowitz could develop an architectural treatise in the narrower sense, one that included an "orden Hierosolymitano."[39] Prado and Villalpando's engravings – supplemented with additional images of St. Peter's in Rome (the new Jerusalem temple) and collected in a volume of images – themselves constitute a highly significant architectural work.[40]

In the same way, Scheuchzer's elaborate picture Bible should likewise be reckoned among the architectural literature, since here the procedures of planning, measuring, and construction described in detail in the Biblical texts are illustrated in an impressive and competent way.[41] The criteria of historical proof – based on every conceivable calculation, reconstruction, and pictorial illustration – are the same, and are represented to an equal extent in works by Athanasius Kircher such as the Arca Noë of 1675.

Thus in 1771, when the younger Blondel speaks of the usefulness of history at the beginning of his Cours d'Architecture, it should be recalled that by this time an extensive literature already existed – if far outside the French academic milieu – that not only studied and described history, but also examined and appropriated it from a systematic, "architectural" point of view. Only in this way can the deeper meaning of Fischer von Erlach's Historische Architektur be grasped.

Even apart from sacred-historical considerations, however, the architectural book often relies upon both of these elements: the (historical) illustration with its "model-like character," and its inherent, principial, "exemplary" significance. Hardly an illustrated work does not secretly harbor this ambition, a claim that often comes to open expression in the

[35] A. Possevinus, *Bibliotheca selecta de ratione studiorum* [...] *recognita novissime ab eodem, et aucta*, 1607: II, 246ff.
[36] Savot 1673: 340.
[37] Alsted, 1620: col. 1604.
[38] H. Prado, J. B. Villalpando, 1596–1604.
[39] J. Caramuel de Lobkowitz, Vigevano 1678: II, 44.
[40] A copy is found in the Stiftung Bibliothek Werner Oechslin, Einsielden.

Johann Heinrich Alsted
Cursus Philosophici Encyclopædia
libris XXVII
Nassau 1620
Einsiedeln, Stiftung Bibliothek
Werner Oechslin
cat. 345n

lofty words of prefaces. Leon Battista Alberti's double characterization of the architectural model – three-dimensional, corporeal – recurs often enough as the double meaning of the architectural engraving: as "exemplar" and "modulus," example and model.[42]

The architecture book as object

Seen in this light, the scope of architectural literature threatens to – and must! – expand almost uncontrollably. A book is a highly complex thing. It begins, if we follow the *Ency-clopédie*, with the distinction between "book" and "codex"; for Isidore of Seville, the latter contains a number of writings in a single volume, while for Scipione Maffei the term merely refers to the (square) form of the object.

Is the book a work or an object, an object that can also unite a number of works? Do

[41] J.-J. Scheuchzer, *Physique Sacrée, ou Histoire Naturelle de la Bible* (Amsterdam 1732–37); German (ed).: *Kupferbibel…*, 1731–35; Latin ed.: *Physica sacra*, 1732–35).

[42] Cf. W. Oechslin 1995b: 40 ff.

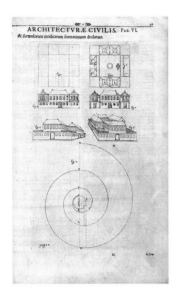

Johann Christoph Sturm
Joh. Christoph. Sturmii Philos. Natur. & Mathem. P. P. Mathesis Compendiaria, Altdorf 1703
Einsiedeln, Stiftung Bibliothek Werner Oechslin
cat. 3450

Stephan Schmidt
Tabulæ Architecturæ Civilis et Militaris, Prague 1757
Einsiedeln, Stiftung Bibliothek Werner Oechslin

43 Cf. W. Oechslin, "Et Visui Et Usui 'comparanda eruditio' – auf der Suche nach der verlorenen Ordnung der Bücher und ihrem Sinn," in J. Jung (ed.), *Ulrico Hoepli 1847–1935*, 1997: 327ff.
44 Cf. M. Grivel, *Le commerce de l'estampe à Paris au XVIIe siècle*, 1986: 229.

those who produce and disseminate books in increasingly elaborate form seek to propagate the content of the book, or the book itself – with its binding and gold leaf, dedication and preface, and everything only indirectly related to the content (or, from a present-day perspective, everything that elucidates the content in the first place, within its historical context)?

"On dit un vieux, un nouveau livre, un livre grec, un livre latin; composer, lire, publier, mettre au jour, critiquer un livre; le titre, la dédicace, la préface, le corps, l'index ou la table des matières, l'errata d'un livre. Voyez PREFACE, TITRE, &c."

References of this type multiply. The book is a broad field; in 1765, it is abundantly clear how diverse books can be even apart from any consideration of content, whether with respect to the "reliure" or the organization of the interior in the broadest sense: "A la forme des livres appartient aussi l'arrangement de leur partie intérieure, ou l'ordre & la disposition des points ou matières, & des lettres en lignes & en pages, avec des marges & d'autres dépendances." The *Encyclopédie* uses the term "ordre," like the classical "orders," in accord with the "passion for order" known to every philosopher. In architecture, too, this concern for order overcomes all aesthetic prejudices to claim validity as "ordonnance" from Perrault to Le Corbusier – with and without columns. The book, taken in itself, represents an "order," to say nothing of the library, the book's appointed place which incorporates its individual, internal order into the comprehensive, universal order of a definitive whole – "mentalmente architettato," as Paciaudi, librarian of the Estense, was to formulate it.[43]

This, then, is the point of departure for the (specific) question of the architectural book. For indeed, long before particular volumes can be singled out, other, more general definitions of content come into play. How is the quality of a book determined? According to the *Encyclopédie*, one must first distinguish between "livres clairs & détaillées" and "livres obscurs" (since Alberti at the latest, it is a topos to describe Vitruvius's ten books as "obscure" or incomprehensible), between "livres prolixes" and "livres utiles," "livres complets," "livres relativement complets," and "livres incomplets." The appropriateness of such distinctions becomes clear when we recall Cardanus' statement that while Vitruvius should be praised for his copious knowledge, he would deserve far more praise if the whole were not so chaotically organized. "Livres prolixes" are books that contain "choses étrangères & inutiles"; "livres utiles" are those "qui traitent des choses nécessaires ou aux connoissances humaines, ou à la conduite des mœurs." Such definitions are reminiscent of Alberti's extensive "Prœmium," in which he seeks to show the usefulness of architecture to man and society, or of the emphasis inherent in the title of Ledoux's work, which he – a new Dinocrates – dedicates to the new Alexander!

"Habent fata sua libelli:" books are not only full of history, they are themselves first-class historical documents with their dedications, introductions, and elaborate presentation. Thus it is no surprise that in a period of tremendous blossoming of art, the book quite literally blossoms along with it; and where the greatest elaborateness is found – in the courtly festivals, the realm of the ephemeral – the book becomes the permanent, and therefore all the more cultivated, artifact. "La noble ambition de s'immortaliser," as Pierre Bizot, speaking for many, called it in his *Histoire métallique de la République de Hollande* (1687), permeates the history of the book in this very area. At times, the format of the book itself reveals the significance of the occasion and the patron. In 1722, *Le Sacre de Louis XV* found expression in a publication virtually unsurpassed in luxury and display. The corresponding publication in 1775 of the *Sacre et couronnement de Louis XVI* was reduced to quarto and octavo format, reflecting a changed view of the ceremony as outmoded and "gothique." This, too, is telling and confirms what De Cahusac said of festivals in general, that they are "témoignages réelles."

Cost and elaborateness can of course be manipulated – the book as propaganda! (Today, we would call it rigging the market.) In 1678, the *Mercure Galant* reported concerning the financing of the elaborate *Cabinet du Roi*: "On a employé les plus excellents ouvriers pour graver ces planches, et il ne se peut dire que ce travail n'ait beaucoup cousté. Cependent le prix qu'on y a mis est si médiocre, qu'on voit bien que c'est un effet de la liberalité du Roy qui en veut faire présent au public."[44]

M. Benjamin Hederich
Anleitung zu den fürnehmsten Mathematischen Wissenschaften
Wittenberg 1714
Einsiedeln, Stiftung Bibliothek
Werner Oechslin

François Blondel
Cours d'Architecture
Paris 1675
Einsiedeln, Stiftung Bibliothek
Werner Oechslin
cat. 345m

This aspect, too, needs to be considered. The book is produced, sold, and often takes strange detours before arriving at its destination – in the library, for example, where others concern themselves with its correct placement and with the "comparanda eruditio" proper to a (systematically organized) library.[45] That salubrious "Battle of the Books," moreover, with which Jonathan Swift flogged the deadly seriousness of the "querelle" ("the Army of the Antients was much fewer in Number, Homer led the Horse […]"), has always been a force for change.[46] Often the significance attributed to a book is a function of chance or mere circumstance.

Yet this much is clear: our knowledge of architecture is defined to a considerable extent "by mediation of writers." For, as Robert Burton melancholically noted, the theater of Pericles, the harbor of Piraeus, and many other "brave monuments are decayed all, and ruined long since, their builders names alone flourish by mediation of writers."[47] Such praises are accorded to the book – and its images – precisely when the objects of desire themselves are unattainable and remote. As Cardinal Angelo Maria Quirini wrote from Rome on September 10, 1750, in an almost sentimental vein: "Anche lontano da Brescia mi diletta al sommo ogni occhiata, ch'io getti su quella Stampa, rendendomi presenti oggetti di mia indicibile compiacenza […]"[48]

Dream or reality? The new cathedral, the public library, and all the other buildings that give Brescia its importance and dignity are to be found in a book.

And all too often, the opposite is true as well: the things that are omitted from books finally disappear from history itself. "Habent fata sua libelli" – an adage that is even truer of the monuments themselves.

[45] C. Clément, *Musei sive Bibliothecae tam privatae quam publicae Extructio, Instructio, Cura, Usus*, 1635: 7ff.

[46] J. Swift, *A Full and True Account of the Battle Fought last Friday, Between the Antient and the Modern Books in St. James's Library*, 1710: 273.

[47] R. Burton, *The Anatomy of Melancholy*, 1638: 427.

[48] *Lettera del Cardinale Angelo Maria Quirini all'illustrissimo signore Pietro Paolo Marcolini*, 1750: xix.

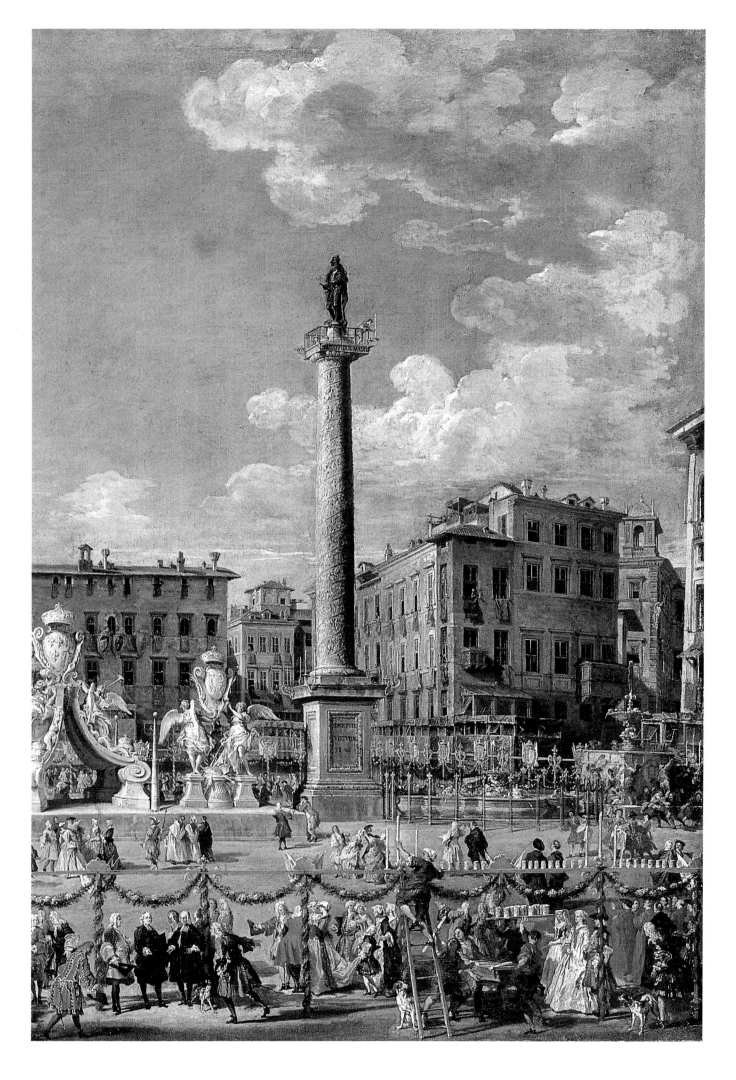

218

Fernando Marías

From the "Ideal City" to Real Cities:
Perspectives, Chorographies, Models, Vedute

Giovanni Paolo Pannini
Preparations for the Festivities
in Piazza Navona [...] on the Occasion
of the Birth of Louis, the Dauphin
of France
Detail
Paris, Musée du Louvre
cat. 365

[1] Their date ranges between a little before 1413 (Tanturli 1980: 125) and around 1413 (Damisch 1987), although Filippo Brunelleschi's biographer, Antonio Manetti, places the Brunelleschian examples "nella sua giovanezza" (and in 1404 he was registered in the guild), within the framework of his activity as a goldsmith, and before the challenge of his early intervention as an architect in a project for the loggia with columns for the Monte del Palazzo della Signoria. His angles of vision (between 53 and 90 degrees for the former and 90 degrees for the latter) are also doubtful, and consequently the extension of the urban surroundings represented as well (Kemp 1990: 20–23 and 381–82), although his "views" extend beyond their limits to demonstrate the exact correspondence between artificial images and the natural vision of the surrounding urban reality. It does not cease to be curious that within the framework of recent discussions on this subject (apparently reaching a dead end), there has been a tendency to reconstruct objects and their visual function as a result in itself, more than as a recovery of the intentions of the original experiments and of the instruments and tentative methods for their initial "discovery" and their subsequent construction of images, perhaps for this reason silenced by Manetti precisely for its mechanical character – even beginning with his experiments with the mirror, as Antonio Averlino (Filarete) understood soon afterward – more than with geometric and theoretical methods (Damisch 1987; Kemp 1990: 382–83; Pérez-Gómez and Pelletier 1997: 25–26 and 403). If they were devices that permitted demonstrating the specular coincidence of viewpoint and vanishing point, it does not seem logical that the "need" to depict points of distance be excluded in the reconstruction – these points could perhaps be

The representation of the city underwent a revolutionary change after the invention of modern perspective, with which it established an intimate, although problematic relationship, from the moment of its Quattrocentro inception. Particularly noteworthy is that the first works employing this new method of representation which attempted to achieve the exact correspondence between artificial images and natural vision, namely the lost panels of Filippo Brunelleschi (1377–1446), not only depicted architectural images of the Baptistery and the Palazzo della Signoria of Florence but also, to a greater or lesser extent, of its surroundings as seen in two particularly significant sectors of the city.[1]

Until that time, cities had been represented by way of conventional images, in terms of "iconic views" and "typical views". In the former there was no interest in the individualized representation of a city as a whole, but rather only in the concept of a city (as in representations referred to in Latin as *icons*), and they constituted schematic images that could even be interchanged with minor modifications – land instead of a river, a sea instead of a river, etc. – and they needed a *titulus* for their identification. In the latter, *typus*, there was no interest in the homogeneous, global description of its image, nor in making it coincide with the visual experience of its viewers, but rather in precise *metonymic* identification, by way of its schematic extension with a virtually regular geometric, or later an approximate plan – and its main emblematic buildings, on which fell the burden of recognition of the whole group.[2] Although these images would not disappear completely in the modern era in certain contexts (maps, navigator's charts, navigation charts, etc.), their authority was put into doubt due to other types of *imagines urbis*, which relegated them to the realm of the purely conventional.[3]

Vedute ideate and chorographies

On the one hand, they were displaced by the perspective views of imaginary urban zones that we conventionally know as "ideal cities" and that would culminate in the three Urbino panels (Galleria Nazionale delle Marche), Baltimore (Walters Art Gallery) and Berlin (Staatliches Museum). Their interpretation was finalized by Krautheimer himself (1948: 327ff. and 1994: 233ff.) as a representation of the comic and tragic scenes of classical theater in the case of the first two, while the third is still open to historiographic debate on its group or independent character, its chronological placement (between 1470 and 1518) and its geographical location (Urbino or Florence), its authorship or its contingent function (utopian or virtual city, architectural project or theatrical scene with ideal images of Florence, Rome, and Pisa).[4] Also unresolved is whether its images – as those of so many contemporary *intarsia*[5] – should perhaps be analyzed as urban fantasies, as *vedute ideate* more than ideal;[6] that is to say, imagined but presented to the spectator as visually real, perhaps by including some traits possible to interpret as "local," and that could be contrasted with portraits of cities of the moment, real but shown in forms that were visually possible, but impossible to experience directly in this way.[7]

On the other hand, they were also substituted by global representations of the cross-sections of real cities, theoretically in perspective and shown from a humanly feasible, distant point of view (Nuti 1996: 69–99). These were a predominantly northern product that made their appearance in 1474 with the Cologne of the *Fasciculus temporum* of Werner Rolevink. Here the city unfolded, still precariously and only very partially, in terms of a silhouette, of skyline. Seen from the outside, with buildings in the foreground hiding the density of its urban fabric, from which only oversized towers projected, the cross sections, to suggest greater detail and apparent proximity, had to elongate themselves horizontally, resorting to an accumulation of views more than to a single *veduta*, as if they were reproduced with their successive changes in viewpoint to a spectator who strolled on its outskirts. Even when they maintained the fiction of being rendered in a life-like manner (Swan 1995: 353–72), they were actually falsifying a correct construction in monofocal perspective as the model with which they began, but from which they tended to deviate.

In fact, artificial perspective was better adapted to the invention of architectonic and urban spaces of limited extension, ordered according to a few simple orthogonal or oblique coordinates (in which its lines were directed to points of distance at an angle of 45 degrees with respect to the plane of the image) than to the portrayal of global urban reality. The latter was too extensive, articulated in a way that went against any orthogonal or oblique constancy,

found by finding the linear extension of the 45 degree oblique planes of the Baptistery, and again made evident with the angular image of the Palazzo Vecchio – in the lateral edge of his paintings; since if Brunelleschi – as architect more than as painter of *still undiscovered* monofocal perspectives – began to graphically "fix" architectural visions, he would have needed to propose as a goal not only the "identification" of the eye and the vanishing point, but also the control of the visual effect of diminution of real objects in the distance, an achievement possible only with the "invention" of points of distance that allow definition of the rhythm of its proportional reduction.

[2] For their history, see Nuti 1996: 43–67; for this classification, Marías 1996: 109–13.

[3] In addition to the four types to which we referred in more detail, two other absolutely exceptional types could be added. In the first place, the "impossible" hybrid between perspective – as an image that could be truly experienced – and seen from a bird's-eye view – impossible for the spectator to experience – in the manner of the anonymous xylograph of *Il disegno di Ferrara nel 1490* (Modena, Biblioteca Estense, a. H.5.3). In the second place, the also exceptional type of "fish eye" images, represented by images of *Vienna in 1529* (1530) of Hans Sebald Beham, Edgar Schön and Giovanni Andreas di Vavassore, after a drawing by Niklas Meldemann; *Strasbourg* (1548), engraved by the Monogrammist MH based on a design by Conrad Morant; or *Nuremberg* (1560, anonymous artist). What may also be considered in this category is the view of Mexico-Tenochtitlán based on the letter of Hernán Cortés, printed in Venice in 1524, the possible starting point of this group of heterogeneous images unsystematic in their portrayal of cities, completely alien to the idea of "verisimilitude" in their vision.

[4] For Damisch (Damisch 1987 and Damisch in *Rinascimento* 1994: 539–40), the three panels would constitute a "group of transformations," in the vocabulary of scholars of geometry, and would participate – hailing a new pictorial "genre" – in a close form

placed at random, not easy to submit to the order required by perspective. This intrinsic contradiction between the real city and perspective would become even more evident in a second type of *chorographicae* views,[8] which similarly promised the correction of perspective by offering bird's-eye views, which raised the spectator from the earth, a tower or an adjacent hill to a fictitious perception of the city. A genre probably begun in Florence, with works such as the "ritratto di prospettiva" – as defined by documentation from 1473 – of *Napoli "della Tavola Strozzi"* (1472, Naples, Museo di Capodimonte), *Firenze* (ca. 1472, Beer Collection of London; engraved as *Fiorenza "della Catena"* by Lucantonio degli Uberti, c. 1482, Berlin, Kupferstichkabinett) and *Roma* (1482, copy in Mantua, Palazzo Ducale), attributed to the Florentine painter and cartographer Francesco Rosselli (d. 1497), would pass directly to the north, where the first printed works were published in which they were disseminated throughout Europe, as in the engravings of Erhard Reuwich of the *Peregrinationes in Terram Sanctam* (1486) of Bernhard von Breydenbach or those of Michael Wolgemut of *Liber Chronicarum* (1493) of Hartmann Schedel. The enormous view of *Venezia* (1500) by Jacopo de' Barbari, despite the additional burden of his "emblematic" or "allegorical" imagery, in relation with the *moralized* geography of the Middle Ages (Schulz 1978: 425–72), immediately constituted one of his first great artistic achievements, which were followed by both canvases – of *Amsterdam* by Cornelis Anthonisz (1538, Amsterdam, Amsterdams Historisch Museum) to the complex, plural *Vista y plano de Toledo* (ca. 1610, Toledo, Museo Casa del Greco) by Domenico Theotocópuli "El Greco" or the majestic *Napoli* of Didier Barra (1647, Napoli, Museo di San Martino) as well as a series of frescoes that adorned the walls of the palatial galleries of the Palazzo Farnese in Caprarola to the Galleria delle carte geografiche and the Biblioteca of the Palazzo Vaticano, from the Alcázar of Madrid of Philip II – with the huge tempera paintings of Anton van den Wyngaerde – to the Louvre of Louis XIII.

The chorographer who executed a bird's-eye view preserved the idea of the life-like image, based on the recording of data *in situ* and reinforced by the concentration of a detailed microrealism, although manipulated from the start, by enlarging it, the vertical, "spatial" arc of the real vision of the city, without losing its "scientific" or artistic qualities.[9] In the second place, he tended to improve, clean up, modify, restore and fill in some of the data, or to project information about the future that could not be visually substantiated onto the present, compromising if the not the verisimilitude of the images, then their absolute specular exactitude and their *attendibilità* as historical testimonies, and subjecting the "portrayed" image to a process of selection that pertains to artistic invention.

But, even if in these cases of internal consumption of views a city "reconstruction" was made, its distancing was accentuated in the production of chorographic images destined for the consumption of foreigners, beyond their walls and national boundaries. In these cases – and the situation became more serious when images were derived from other earlier ones – not only was a disjunction produced between the image and reality, but also data were frequently modified to allow foreign eyes to interpret what was alien as their own, transmuting architectural structures and forms into something different, even unrecognizable for their neighbors, but recognizable as something their own by people from other latitudes. Nevertheless, the basic medium of its diffusion would be "atlanti" and "theaters" of cities, of which the *Civitates orbis terrarum* (1572–1617) of Georg Braun and Franz Hogenberg would be the paradigm and the model for more than a century (Nuti 1988: 545–70 and 1996: 165ff.), forming repertoires of images that allowed the vicarious experience of a trip around the world without ever having to leave a chair.[10]

Predicaments: platforms or ground plans with elevations
Although thanks to drawn, engraved, or painted bird's-eye views, hundreds of European cities had their own image at their disposal, as a symbol of possession on the part of their leaders, as the equivalent and graphic complement of literary *laudes* and even as an instrument of knowledge for some incipient tourists (Fragenberg 1994: 41–64), nevertheless they suffered from another of the constitutional elements of the system of perspective representation: dimensional exactitude, geometric reason. The chorographies, attempting to recreate a homogeneous and legible image, ended up by overlooking distances, at the same time that they made the detailed knowledge of plots of land and transportation impossible. These features

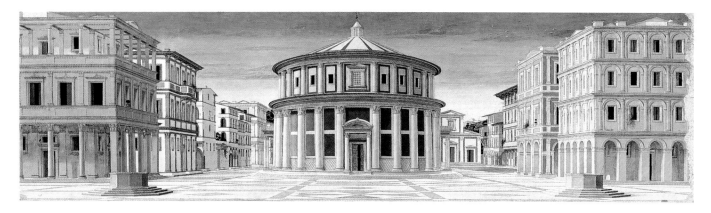

Anonymous
Ideal city
end of 15th century
Urbino
Galleria Nazionale delle Marche

of "ideality," which would underscore less the utopia in terms of a work based on the scene in perspective, that would result in the definition of classical theatrical scenography, among others.

5 See Chastel 1978; Ciati 1980; Ferretti 1982 and 1986: 73–104; De Seta 1996: 41–57. In these, imaginary buildings are intermixed with real ones in an extremely varied way but with accurate perspective in their totality or in some historical or contemporary elements, so that the spectator could at times establish connections with the cities from which they came.

6 It would probably be anachronistic to designate them both as *capricci* and "virtual" cities (De Seta 1996: 66–76). It would be a matter of fragments of "possible" cities more than strictly ideal or even utopian ones; ideal cities (of Plato and Aristotle, Saint Augustine and Saint Isidore of Seville, to Alberti, Thomas More, or Giovanni Botero) were concerned more with the idea of the city as a unit of socio-political or spiritual coexistence, of *civitas* (whether as *res publica* or as a city of God established on earth), than as possible material *urbs*, although improbable in its execution, in the manner of the projects of Antonio Averlino (Filarete) or Francesco di Giorgio Martini. Recently Tafuri (1992: 146 and 202, no. 21) has recovered a text in which there was talk of the execution of fantastic, architectonic, possibly also urban, images for Florence, products of the anti-Medici fantasy of the "Piagnone" Luca Lan-

could only be witnessed by way of another system quite different from orthographic and non-perspective representation, so the plan or *ichnographia*, was added – as in the *Civitas Londini* (1600) of John Norden or the Toledo of El Greco – to the chorography, as proof of the "irrepresentability" of the city by way of a unique system of representation,[11] or else it was based on it in an improbable way, by superimposing two different systems on a single image.

As we will see later, urban plans required considerable investments of time, labor, and money, and therefore it is not unusual that platforms as a genre did not have the same diffusion as bird's-eye views, of which they wanted to be indisputably better. It is possible that the first platform was made in France in the lost *Parigi "de la Grand Gouache* (ca. 1535, "en plate forme [...] par art de geometrie & vrai mesure [...] sans user de perspective que bien peu" would pray its copy "de la Tapisserie") (Ballon 1991: 212–49),[12] but Rome was the city that produced the largest quantity during the second half of the sixteenth century, right after the publication of the *Pianta* by Leonardo Bufalini (1551).[13] With the exception of the *Colonia* (1571) of Arnold Mercator or the *"Topographia" di Firenze* (1584, engraved in 1598 by Bonaventura Billocardi) of Stefano Bonsignori, very few cities could have allowed itself the luxury of enjoying this genre, which would produce works of enormous size and extraordinary quality.[14] In the *"Ichnoscenografia" di Bologna* (1702), Filippo de' Gnudi made clear his intention to produce "delight" by "seeing the city of Bologna exactly as it is," and the "useful" nature of its image, since "by means of scale [...], it is possible to know its perimeters, its area... and even the distance between any location and another," highlighting its verification of the irreconcilable character of attempts to be precise and true, and the failure of "olographic desire" in the representation of the city (Ricci 1989: 281–82). Cross sections, bird's-eye views and platforms were renovated and perfected until the eighteenth century, to later give way to panoramas or to the fantastic images *à vol d'oiseau* of Alfred Guesdon (1801–76). Nevertheless, the perspective transgression of the former and the visual contradiction of the third had to give way to other means of representation of the city, its strictly stereographic "construction" or the return to those already remote origins of the difficult marriage between perspective – with its union of natural vision and geometric exactitude – and the city.

Cities in three dimensions

In the "global" images of cities, as in those of buildings, it would be necessary to distinguish between symbolic representations of cities – logically metonymic – and chorographies, and between their representations in architectural models, whether three-dimensional objects or shown in the form of two-dimensional images or in relief; both, in turn, could show cities in metonymic form or in their entirety. Beyond approximate maquettes of magico-funerary purposes and known from the cultures of the Fertile Crescent and pre-Columbian America, the Romans seem to have used three-dimensional models of a symbolic character in processions as reductive representations of real cities or of conquered regions. Andrea Mantegna included them in his canvases of *The Gallic Triumph of Julius Caesar* (1478–1505, Hampton Court), based on the text by Appiano ("*Ferebantur et ligneae turres captarum urbium simulacra praeferentes*") or in ancient examples such as that of the Great Frieze of Trajan of Constantine's Arch in Rome (Martindale 1979: 157); other Renaissance artists – Giulio Romano – imitated his predecessor, and even some – Lorenzo Lotto – situated such processions in a

ducci of 1505 and 1509; this had occurred, first to Simone del Pollaiuolo and later to G. Piffero di Palagio "un ricordo e un disegno, perché egli era architettore, e parvemi che lui fusse atto a conducere questa mia *invenzione* […], che in quello luogo dov'è San Giovanni Evangelista in Firenze, si dovessi fare un bello tempio e una bella cupola a onore di San Giovanni Vangiolista […], che levando tutte le case e botteghe, quanto tiene la piazza di San Lorenzo, ch'è un quadro di circa 100 braccia per ogni verso, si farebbe un bel tempio […] E cosí gli detti ad intendere tutta la mia *fantasia*, onde gli piacque assai e dissemi piú volte non aver mai avuto piú bella invenzione" (Landucci 1969: 272 and 296–97). Three drawings of the Musée Wicar di Lille (809, 811–12), of the church hexagonal on the inside transformed into a dodecagon on the outside, have been identified with the project of Pollaiuolo (Günther 1988: 91– 97), but they do not negate the possibility of painting a scene in which such a church could appear in the middle of a square as fantastically remodeled and measuring 58 m on the side.
[7] The hypothesis that both types of images formed part of a same type of movable objects – bedsteads, chests – would be abundant in this type of "conversational" relationship on different types of places and experiences.
[8] These were intended to be portrayals of the city as a whole, employing the term of the third Ptolemaic genus of the scientific representation of reality. For the recently rediscovered Claudius Ptolemy, cosmography (the representation of the universe) and geography (the global representation of the earth) was joined with chorography (the representation of a part of the earth), although this union was not derived from a community of shared method (mathematic for the first two, pictorial for the latter), but from the analogy of their objectives. It is logical that modern urban chorographers of the sixteenth century – such as the Englishman William Cuningham, in

contemporary context *all'antica*. Christians also used images of royal cities as ex-votos, "dedicated" to religious figures and above all, to protective saints and intercessors of specific urban communities. One of the first examples known appears in a Justinian mosaic in Hagia Sophia in Istanbul, in which Constantine offers Byzantium to the Virgin, but it is not easy to determine if these images represented cities or models of cities, as also occurred in cases in which the object of the *dedicatio* was only a building (Bloch 1961: 471–94). Since the fourteenth century, the Bologna of St. Petronius, fifth-century bishop and legendary planner of the Emilian city based on the image of Jerusalem, was represented as a rectangle of obtuse angles, perhaps attempting to display its military origin, and including the famous Asinelli and Garisenda towers; and from at least the seventeenth century, thanks to El Guercino, the Reggio Emilia of St. Prosper. But we cannot be totally certain about the nature of what is represented, for we do not have testimonies on the prior existence of a real model, such as that of Parma in silver described at an early date by Salimbene (Nuti 1996: 60–61). Others have been preserved, such as the two of Reggio Emilia of the sixteenth century (the first an anonymous work of 1515, in wood and in a circular shape, and the second, in papier mâché by P. Clementi of 1560; Reggio Emilia, Museo Civico e Galleria d'Arte), or that of Soissons of 1560 (Soissons, Cathédrale de Saints Gervais et Protais). For the Sanctuary of Monte Berico of Vicenza, a model of the city (1577–81) was executed in wood and silver in an act of thanks for freeing the city from the plague, an event perhaps represented years later in a commemorative canvas by Francesco Maffei (1626–30, Vicenza, Museo Civico, from the Palazzo del Podestà), with the Basilica and other Palladian buildings (Lavin 1994: 680). They also appeared from the Renaissance in political representations, such as "The Surrender of the Duchy of Parma (1550) by Julius III to Ottavio Farnese" by Taddeo Zuccari (1562–63, Sala delle Geste Farnese of the Villa de Caprarola; Partridge 1978: 494–529). These images responded to the still restricted practice of building three-dimensional urban models, much less reductive than in the case of those that were religious offerings. Essentially militaristic in purpose more than strictly urbanistic, almost all of them focused on three-dimensional representations of fortifications and fortified cities, built since the sixteenth century and motivated by the appearance of artillery with metallic projectiles and modern bastioned fortifications. They were kept alive as a strategic tool until the mid-nineteenth century appearance of the new type of artillery. Although their primordial function was the study of tactics that could be

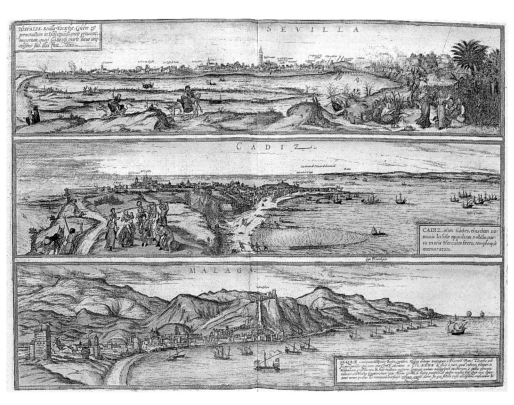

Georg Braun
View of Lisbon
Engraving
from *Civitates orbis terrarum*
second half of 16th century
Genoa, Museo Navale

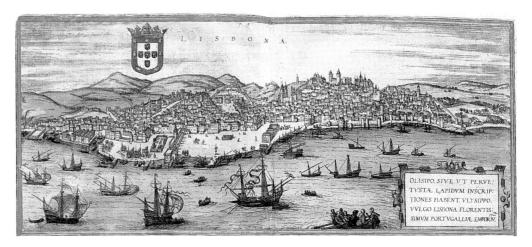

his *The Cosmographical Glasse* (London 1559) – were interested in lending prestige to their new activity with the ancient Ptolemaic term, covering it with a mantle scientific in character that emanated from their mathematically oriented colleagues. The image – shifting both activities to the realm of the pictorial – which Pietro Apiano had published in *Cosmographicus Liber* of 1533, in which chorography would occupy itself with drawing an ear, while geography would design the whole face of a man, could lead to the confusion that if both disciplines were reducible – in a visual metaphor – to the pictorial, they could also be – in an optical illusion – scientific.

[9] On the scientific or artistic character of chorographies and the construction of bird's-eye views (lowering and perspective deformation based on a plan or empirical "elevation" of a cross section), there was no agreement in the era between topographers and painters, nor is there agreement today between historians on terminology or classification (Nuti 1994 and 1996; De Seta and Marías, *Città d'Europa* 1996; Marías 1999). For example, the type that we have called "bird's-eye view" does not coincide exactly with any category used by other authors. Skelton, for example, has proposed four types: 1) stereographic views (cross sections, views, panoramas); 2) plans (diagrams or floor plans); 3) views in perspective or bird's-eye views; and 4) map views, in which a bird's-eye view for buildings is superimposed on a general plan (Skelton 1965: Xff.). Marin, three types of urban representation: 1) the panoramic perspective, as a type of report with an implicit "narrator;" 2) the plan as a description with an absent "narrator;" and 3) the commitment between both that would constitute the bird's-eye view, without defining platforms or floors with raised buildings, therefore, as another category (Marin 1973: 283–90 and 994: 204–18). Nuti, three other types: 1) cross sections; 2) oblique views (from a higher viewpoint

used with existing defenses and the planning of new fortifications, soon they began to include more details of the urban complex to be defended, and eventually – although it was not represented in their images – large extensions of surrounding territory, with a precise description of topography, as the scene of attacks that they were intended to repel.

The first war-oriented urban model that seems to be recorded is that of 1521 of Rhodes, executed by engineer Basilio della Scuola at the request of the knights besieged by the Turks on the island and to be sent to Leo X. In 1529 at the time of the siege of Florence, Clement VII commissioned Benvenuto della Volpaia to make a model, which took him many months to build in collaboration with Nicolò Tribolo (Vasari, Milanesi 1906: IV, 608); the inclusion of a wide area of surrounding land – a mile all around – with its hills and rivers, seems to support the military character of this representation in wood. Soon afterward, the "Roman" engineer Giambattista Pelori at the request of the Spanish governor of Siena Diego Hurtado de Mendoza, son of the First Marquis of Mondéjar (who had ordered the construction of the architectural model of the Palace of Charles V in the Alhambra of Granada), had made a model of the city and its fortifications, which were sent to the imperial court of Brussels of Charles V and Prince Philip II, at war with Pope Julius III (Pepper, Adams 1986: 60). Giorgio Vasari tells that this same architect had made several models of fortifications and the besieged city of Siena, which he had sent to Cosimo I de' Medici (Vasari, Milanesi 1906: IV, 608), and in fact, the painter represented Duke Cosimo studying the plans and the model of Siena for its conquest in a fresco (Florence, Salone dei Cinquecento del Palazzo Vecchio).

Soon this practice was followed in other European and Italian milieus. Around 1570 Duke Albert V of Bavaria commissioned Master Jacob Sandter to make a series of models of the main fortified cities of the duchy, in marquetry, some of which are preserved in the National Museum of Munich (Reuther 1987). For the Republic of Venice, between the last two decades of the sixteenth century and 1759, 184 models were made (of which some fifteen are preserved in the Museo Storico Navale), some with plans of fortifications that were never actually built, such as those of Suda and Canea, in Crete, or that of Famagusta, in Cyprus (Gerola 1930–31: 217–21). It is not strange that on the façade of the church of Santa Maria del Giglio of Venice (1678–83) by architect Giuseppe Sardi, built in memory of Sea Captain Antonio Barbaro and his family, representations were sculpted in relief of the cities of Iráklion (Crete), Corfu, Split, Zara, Padua and of the ruins of Rome, places where the captain had occupied political posts (Hugueney 1956). Although they were taken from city views (which is clearest in the case of Rome), in the manner of pictorials of so many palatial halls, their nature in relief and their insistence on the representation of fortifications endows them with a different appearance, as if they were models transformed into relief.

In the middle of the seventeenth century, the practice had extended with topographic context, as demonstrated by the models of Orzinuovi, or the fortress of Peschiera, preserved in Rome (Istituto Storico e di Cultura dell'Arma del Genio), that of Ostend (Florence, Museo di San Marco) or that of Lübeck of 1650. However, it was spread above all during the eighteenth century, beginning with French *plans-reliefs* of the reign of Louis XIV, promoted by the Minister of War Louvois and Monsieur Sébastien La Preste de Vauban; models of the era representing

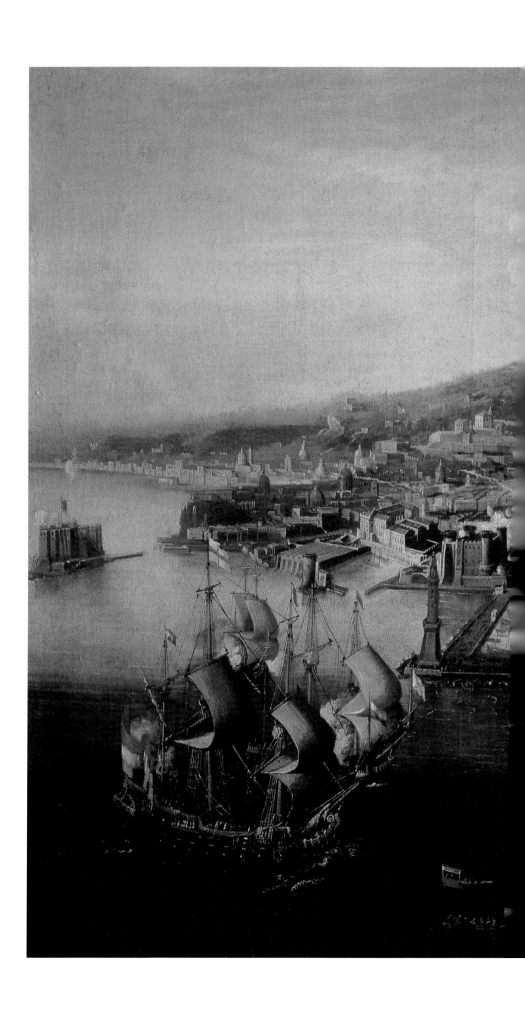

Jan van Essen
View of Messina
Florence, Private Collection
cat. 384

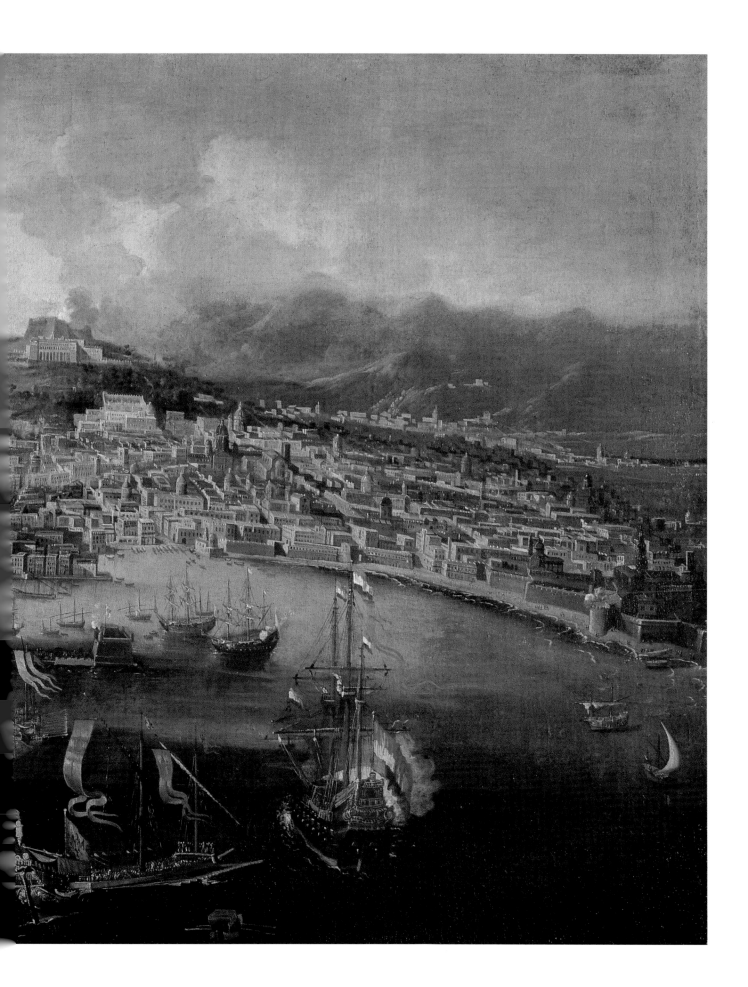

Pieter Post
Project for the plan of Vredenburg
Leyden, Universiteitsbibliotheek
Leiden, Collectie Bodel Nijenhuis
cat. 242

but without showing the transportation network of the city, based on a supposed geometric control of visual space; and 3) *piante prospettiche*, in which the streets would be displayed and which would join the two categories of "bird's-eye view" and all types of map views, with plan and raised buildings. De Seta has returned to four: 1) cross sections; 2) plans; 3) *vedute in prospettiva* (with an angle between 60 and 90 degrees, and 4) *vedute a volo d'uccello* (with angling between 40 and 60 degrees) (De Seta, cit.: 17).

[10] This does not cease to be symptomatic that the *civitates* of the title of the first volume (1572) became the *urbes* in the remaining five volumes (1581–1617).

[11] In the *Ritratto ovvero profilo di Bologna* (1636) by the painter Francesco Dal Buono, the plans were criticized as the method of representation of the city ("fintioni né ancho probabili"), alien to the "occhio humano" and to "senso" (Ricci 1989: 283–84).

[12] Copied in the *Plan de la Tapisserie* (1569–88) and source of different derivations: engravings by Sebastian Münster (1550), plan of Basel (ca. 1550), of Saint-Victor (ca. 1550) perhaps by Jacques Androuet Du Cerceau, of the *Civitates orbis terrarum* (1572), by François Belleforest (1575), etc.

[13] Of the *situs*, *descriptio* and *imago* of ancient and modern Rome of Pirro Ligorio (1552, 1553 and 1561), or the *forma* of Francesco Paciotto (1557), to the *sciographia*, *descriptio* and *topographia* of E. Dupérac (1574 and 1577) and M. Cartaro (1575, 1576 and 1579).

[14] Contemporary terminology employed for this type seems to have tended first to conserve the traditional idea of "visual unity" ("portrait" for the image of Paris by Vassalieu "Nicolay" and *carte ou description* for that of François Quesnel, both of 1609), to later emphasize the double component of these images: "disegno e pianta" (Roma, 1618, of Matteus Greuter), "planta et facies" and "ichnographia et hypsographia sive planta & facies" (Roma, 1667, of Giovanni Battista Falda) or "pianta e

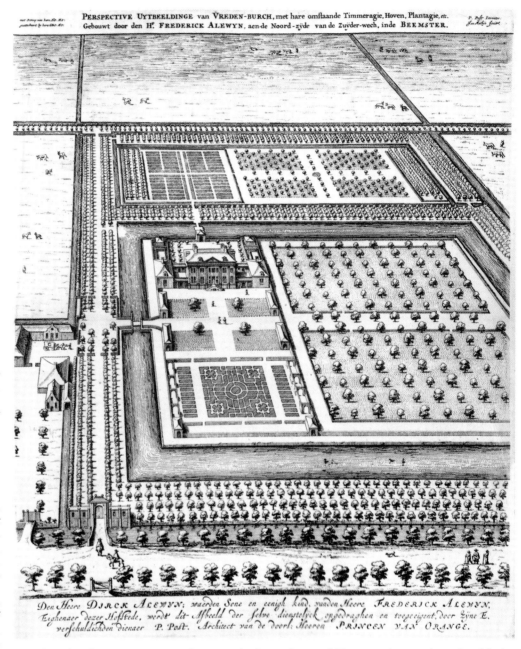

PERSPECTIVE UYTBEELDINGE van VREDEN-BURCH, met hare omstaande Timmeragie, Hoven, Plantagie, etc. Gebouwt door den H^r FREDERICK ALEWYN, aen de Noord-zyde van de Zuyder-wech, inde BEEMSTER.

Den Heere DIRCK ALEWYN; waerden Sone en eenigh kind, vanden Heere FREDERICK ALEWYN, Eighenaer dezer Hofstede, werdt dit Afbeeld der selve dienstelyck opgedraghen en toegeeigent, door zyne E. verschuldichden dienaer P. Post. Architect van de doorl. Heeren PRINCEN VAN ORANGE.

a multitude of European cities, from Madrid, Naples, and Turin to Amsterdam, Stockholm and St. Petersburg, have been preserved. While Henri IV had hung a series of maps of the border regions of the kingdom in the Galérie du Bord de l'eau between the Louvre and the Tuileries and Louis XIII – like so many other sovereigns from the sixteenth century – took pleasure in contemplating images of the 96 most beautiful and renowned cities in France, in the Grand Galerie of the Louvre, Louvois and the engineer-in-chief Vauban began to build true models of the major cities of military interest, both French and foreign (Turin, from 1700–1706) as well as overseas (Quebec, from 1720, and Montreal, from 1721).[15]

In 1663 the plan was inaugurated with the model of Pinerolo (Piedmont), executed by Alain Manesson-Mallet based on the idea of an anonymous Italian engineer and given to the king by his governor, the Marquis of Pienne (Manesson-Mallet 1686: I, 173, 180). This model was followed by those of Bergues, Furnes, and Gravelines (1668) until reaching a total of 144 models by 1697. A specifically standardized program-unifying scale, for example, to 1:600 (1 foot=100 *toises*) – was begun between 1684 and 1696, to end, still in the eighteenth century, during the period of the War of Austrian Succession (1740–56), although it continued to be practiced (sporadically?) for several decades in the nineteenth century.

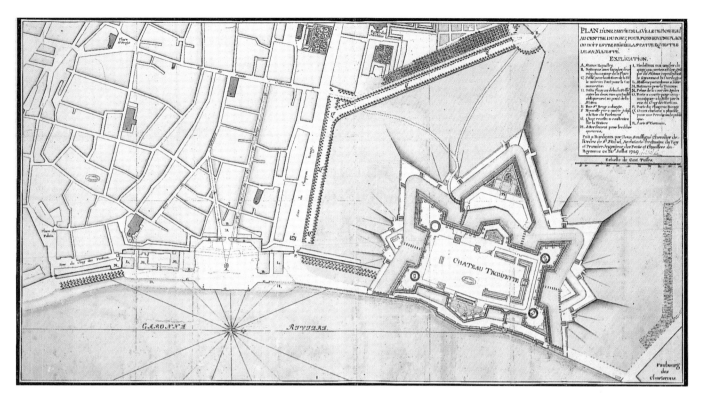

Jacques Gabriel
Place Royale and the Château
Trompette in Bordeaux
Paris, Archives Nationales
cat. 382

alzata" (Roma, 1676, by the same Falda). There are no references to their theoretical categories of knight and soldier, and on the other hand, there does not seem to have been a perfect execution of these subtypes, due to the inherent difficulties in the systematic maintenance of their projections: the necessary increase in the width of streets, so that the elevations of buildings not be superimposed, nor completely hidden; the verticality required for the representation of buildings put in doubt its three-dimensional quality. It is not unusual that to counteract this effect, light and shadow would be dramatically and artistically accentuated, insisting thanks to this resource on their visual "tangibility"…, as with the platforms of Paris by Vassalieu "Nicolay" and Quesnel or of *Rome* by Falda.
[15] They were gathered first, in the Galerie du Bord de l'eau in 1706, to pass in 1715 to the Grand Galerie of the Louvre and in 1774 to the Invalides (where today the majority are held (45 models), of the collection of the Musée des Plans-Reliefs aux Invalides of Paris,

Of the first two generations, some models have been preserved (Paris, Musée des Plans-Reliefs), such as those of Auxonne (Côte d'Or, 1676–77); or Perpignan (Roussillon, 1686, of Jacques Laurens), although others have been lost, such as that of Marseilles (c. 1670), a highly schematic model; or that of his Château d'If (1681), which, because of its small dimensions, used a scale of 1:95. It was built on the property (until in 1750 a specific workshop was opened in Mezières) and although some were built in exceptionally few days, their execution usually lasted for a year on an average, using wood, cardboard and primed paper as well as wool (later silk) and sand for the countryside, glass for large areas of water and tin for trees. Despite the standardization, some large cities, such as Barcelona (1697), built strangely in wax, reduced its scale (1:6000; 6 inches for each 150 *toises*), but from the third generation, the scale was respected both for small enclaves and small cities (of some 10,000 inhabitants) as well as large ones (from some 50,000 inhabitants and above). The model of Ostend (ca. 1700) reached 20.8 square meters, that of Besançon (1720–22, of François de Ladevèze), 26.7 square meters, that of Tournai (1701, by Jean-François de Montaigu), 38 zuare meters, with 900 hectares of countryside, and that of Ypres (1701, by Tessier de Derville) 51.7 square meters, but occupying the representation of the city with only a twelfth of the model, which included 1200 hectares of surrounding countryside. This relationship was not modified in the case of cities of larger dimensions and a population of some 50,000 inhabitants, as in the models of Lille (1670, by Charles Sauvage, or the 1740–43 model, by Nicolas de Nézot, originally measuring 65 square meters although only 18 square meters has been preserved) or of Strasbourg (1725–28, by François de Ladevèze, of 72 square meters), in which the urban fabric occupied only some 200 hectares, more or less a tenth of the model, which was focused on the theater of war with 2,000 hectares dedicated to the countryside.

Despite the fidelity in the description of topography and fortifications, and of the main monuments, the cities were simplified and they were inexact in details in the relationship both with the structures of streets and plazas, and with the division into plots and houses, whose vertical scale was augmented and for which only three types of housing were used (De Roux, Faucherre, Monsaingeon 1989: 127–31).[16] The effectiveness of planning these models seems to have been a minor consideration, given that they soon became obsolete, as the five made of Pinerolo (1663–96) would demonstrate, as well as the four of Dunkirk (1670–86) or the three of Arras (1670–1716) and Perpignan (1670–86). Each real change, due to its largely military function, would require a continuous "remodeling" of the model, so as to make it

while another 18 are kept in the Musée des Beaux-Arts of Lille).

[16] In some models of the second decade of the eighteenth century, ten different types of houses were used, although they kept an exaggerated vertical scale in their description, something that would be corrected during the second half of the century when this exactitude would be looked down upon, which was probably justified for reasons of visibility from a strategic point of view.

[17] In this pedagogical line, the ideal models of fortified cities may be situated, such as the one made of different metals that around 1770 Empress Maria Theresa of Hapsburg sent to Charles IV of Spain, in which different fortresses would be represented as planned by Vauban, Pagan, Tensini, Marolois, Pietro Sardi, Lorini, Manesson [-Mallet], [Fernández] Medrano, Villa, Blondel, Dogen and Fritach (Madrid, Museo del Ejército). But for games, there were others of greater magnitude. During the Sevillian stay of the court of the Bourbon king of Spain Philip V, grandson of Louis XIV, the Sicilian engineer Juan Antonio Medrano Fernández (ca. 1703–51) began to occupy himself with the military and architectonic education of the Infante Don Carlos (future king of the Two Sicilies and later of Spain) and his brothers; for the "instruction and entertainment of the Most Serene Prince our lord and the Lord Infants," a fortification was built between 1729 and 1730 in Buenavista near Seville. It measured some 400 meters in length and it included a ravelin dedicated to Charles himself, of which two projects are preserved on a scale of 1:600 (Madrid, Servicio Geográfico del Ejército) (Serrera, Oliver, Portúes 1989: 250, nos. 241–42; Marías 1998); the princes could do without little lead soldiers and substitute them with soldiers of flesh and blood on a human scale.

[18] According to its inscription, it had been commissioned by Charles III, by way of the secretary of state Count Ricla Ambrosio Funes de Villalpando, who had ordered "a general collection of low relief of all the plazas in his kingdoms;" nevertheless, only that of Cadiz was carried out, probably because of the delicate situation of the city at that time. The material and formal characteristics of the

apt to precise and appropriate defensive or offensive tactics; but this dynamic character soon made them into useless objects more than representations of real cities, into "regal toys" or almost abstract generic models didactic in nature.[17] They are not *plan-reliefs*, thus, completely equivalent to architectonic models, nor to the exceptional city models, as the gigantic model of Cadiz – a city located in an isthmus and almost surrounded by the Atlantic Ocean – built by military engineer Alfonso Jiménez (1777–79), to be sent to Madrid to Charles III (Cadiz, Museo Histórico Municipal).[18] With its 86 square meters (692 x 1,252 cm), with a minimal representation of the surrounding ocean, the city occupies roughly – at a scale of 1:250 – more than 500 hectares, including the areas of future *barrios*. By that time, when Spain continued to be the greatest power in the world, but not in Europe, Cadiz was the fourth Spanish city – after Madrid, Barcelona and Seville – based on number of inhabitants – some 72,000 – and a nucleus of primary importance from the naval and economic perspective, to have shifted its port from Seville in 1680, the capital of the Carrera de las Indias (trade between Spain and South America) and in 1717, the Casa de Contratación (House of American Commerce), a monopoly that would be broken in 1778 with the Free Trade Decrees of Charles III. It is not strange that in these worrying circumstances, its City Hall wanted to defend its privileged position before the Crown with an expensive gift – the materials used to make it included woods of different types (acana, mahogany, cedar, ebony, beech, and pine), ivory and bone for the cathedral and other important buildings and silver for the water of the sea and some details. This gift displayed the works, both military and civil, carried out to date, those in progress (including a new cathedral), as well as those planned for the immediate future, with several buildings that could be opened and seen on their interior. The bas-relief of Cadiz constitutes one of the most outstanding examples of urban and architectonic models of a city important for its size and population. It also points to the real unfeasibility of such undertakings, that could only lead to the impossible map of China desired by the emperor on a 1:1 scale, and only imagined in the fantasies of Jorge Luis Borges.

Plans and vedute: impossible totality and real fragments

Both urban chorographies and city models possessed an element in common beyond that of their desire for totality: to create an experience impossible to achieve in reality but that still depended on a natural reading in "perspective" of its images that we could interpret from our visual experience. Ichnographic, orthographic, zenith plans also sought globality – adding exactitude in measurable terms – but they required the spectator, with his system of "notational" transference, several different abilities; modern plans show us images not possible to visually experience from the land and even in their reading, we have difficulties to put the data provided in the plan in relation to those gathered by our direct visual experience of the city. The precise ichnographies of the cities – if we exclude the lost, inaugural plan of Rome (1441–55) by Leon Battista Alberti – also arose from military needs.[19] They required specialists (architects, military engineers, cartographers, topographers), and the use of time and money as well as instruments to measure angles (of *circumferentur* to the compass) and distances (of the odometer to the telemeter) and triangulation techniques (Pinto 1976). Very few cities of importance had plans throughout the sixteenth and seventeenth centuries, despite the assumption that they were necessary for the creation of bird's-eye view images (Nuti 1996; de Seta, 1996: 15)[20] and it was necessary to wait until the eighteenth century to be able to use truly exact ichnographies that included the plan of their most important buildings, or even of all of them, as in the prodigious Rome by Giovan Battista Nolli (1748) or Naples of the Duke of Noja Giovanni Carafa (1775).

Another artistic current, in drawings, engravings and paintings, tended to preserve the memory of the visual experience of the city not so much in its totality as in its fragments: its main buildings. Now Giulio Mancini in his *Considerazioni sulla pittura* (ca. 1620) and by referring to the art of Paul Bril, established for landscape painters a simple distinction: Flemish painters tended to represent the landscape in terms more of "maestà scenica che un prospetto di paese," as the Italians had done (de Seta 1996: 17); northern landscape painters – just as chorographers – were more inclined to use an extremely elevated point of view, with an extremely high horizon, excluding the truthful and normal representation of what a spectator was seeing, *ex sede commune* in the terminology of Jean Pélerin Viator, who the Italians tended to follow and, who

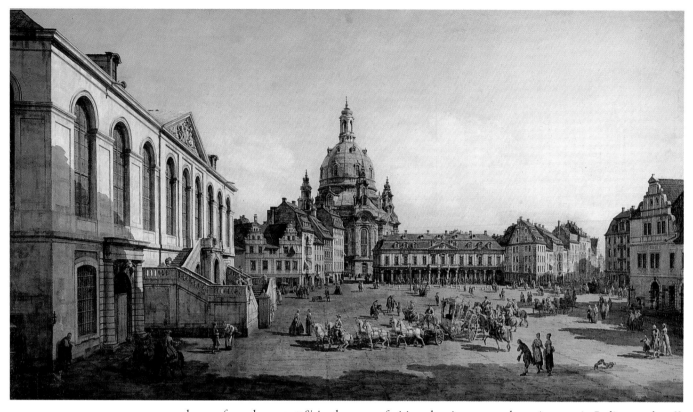

Bernardo Bellotto
*View of Neumarkt in Dresden
seen from the Jüdenhof*
1749–51
Dresden, Staatliche Kunstsammlungen

model seem to demonstrate a change of intention, although the king would have been inspired by the *plan-reliefs* of the French. On the other hand, Lieutenant Colonel Jiménez based his execution of the city plan and the plans of the cathedral (Cadiz, Archivo Municipal) on the survey of the military engineer Ignacio Sala in 1749 (Moreno Criado 1977).
[19] From the plan of Imola (1502, perhaps based on an earlier one by Danesio Maineri of 1472–74) of Leonardo and the lost ones of Florence (1530, by Nicolò Tribolo and Benvenuto di Lorenzo della Volpaia), and Siena under siege (ca. 1550, by Giovanni Battista Pelori) to those preserved of Vienna under siege (1547 by Bonifaz Bohlmuet and 1549 by Augustin Hirschvogel, engraved in 1552 with an explanation of the method employed – measuring the wall and triangulation with a compass – and elevation of the bastions) or the cities of Flanders by Jacob Deventer, for Philip II, with elevations of the main buildings. Only that of

also preferred *prospetti*[21] in the case of cities, that is to say urban views or in Italian, *veduta*.[22] Beyond this "nationalistic" opposition and its extrapolation of urban "landscape," the *veduta* as a new genre opted for presenting the possible city. Engravings with portraits of old buildings and to a lesser extent, modern ones, had appeared in the sixteenth century, above all in Rome (Deswarte-Rosa 1989), reaching in the seventeenth century and at the beginning of the eighteenth – in works by Giovanni Battista Falda and De Rossi to Alessandro Specchi – an outstanding degree of perfection in pictorial terms in their description and visual quality of light (Consagra 1992). At the same time they were diluting their original models by excluding archaeological or architectural monuments as protagonists to give the contemporary urban surroundings to which they belonged the privileged place, a trend pictorially cultivated by Northern artists who preferred description-almost in terms of genre paintings – of Roman life; northern artists from the 1600s, such as miniaturist Johann Wilhelm Baur and draftsman Lieven Cruyl, also increased the architectonic and spatial registers of their works, respectively.

In the Netherlands, meanwhile, what we might call an inverse process was taking place, one of fragmentation – in consonance with what was happening in other genres (Stoichita 1993) – instead of amplification. Although since the sixteenth century, maps had included ornamental borders with small images of chorographic views of the major European cities and of individuals with clothing typical of each region, Holland began at the beginning of the seventeenth century, coinciding with the Twelve Year's Truce, to include in its maps of the United Provinces or in its cross sections or bird's-eye views of Amsterdam, small urban scenes, converting them into a sort of *caert figuratief*, of *veduta figurative*; this was done by Claes Jansz. Visscher (1587–1652),[23] who also gave his collection of twelve etchings of *Lieux plaisants*, with historical, industrial and tourist sites around Haarlem to the printers in 1611. At the same time, cross sections and bird's-eye view began to pass from paper to canvas, such as the two profiles of the *Views of Delft* (1615 and 1617, Delft Stedelijk Museum) by Hendrick Vroom or the "aerial" view of *Amsterdam* (Amsterdams Historisch Museum) of Jan Christiaensz. Micker, with splendid atmospheric effects and visual discoveries, such as shadows cast by clouds placed above the visual level of the "spectator."[24] It is possible that the *View of Delft* (ca. 1662, The Hague, Mauritshuis) by Jan Vermeer could be placed halfway between the most characteristic cross section – always at a distance – and urban landscape-from a point of view that is not elevated.[25]

Bernardo Bellotto
*View of the Catholic church
and the bridge over the Elbe, Dresden*
Dresden, Staatliche Kunstsammlungen

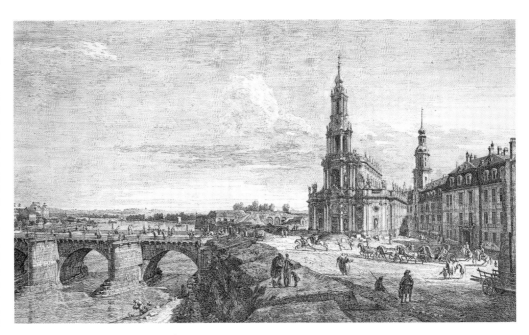

Verona (1538–40) by Giovanni Caroto-Torello Sarayna and the *Rome* engraved (1551) by Leonardo Bufalini, marked a change; this was followed by the absolutely public plans of Cremona (1583, by Antonio Campi), Nuremberg (1594, by Paul Pfinzing), London (1600, by John Norden), Parma (1601, by Smeraldo Smeraldi, executed in 1589–92), Milan (1603, by Francesco Richini), Ferrara (1605, by G. B. Aleotti l'Argena), Lyons (1607, by Philippe Lebeau), Antwerp (1624, by N. Jansenius), Amsterdam (1620, by C. J. Visscher and 1625, by Baltasar Florisz.), Venice (1627, by A. Badoer), Paris (1652, by Jacques Gomboust), Rome (1668, by Matteo Gregorio de Rossi), many of them still with elevations of buildings. Another category would correspond to plans of urban projects for new towns or the expansion of pre-existing cities, such as that of Amsterdam of 1610–11 (ca. 1620, Amsterdam, Gemeentearchief).

[20] According to this hypothesis, the *piante prospettiche* required the prior existence of a zenith plan that would be slanted with respect to the plane of the image and that would be deformed in perspective.
[21] *Prospectus magni canalis venetiarum* is the title of the great publication – engraved by Antonio Visentini – of the views of Canaletto (Venice, 1735 and 1742).
[22] If the Latin term employed by Canaletto in his 1735 publication of engravings of Venice was that of a *prospectus*, its translation would be "view" or *veduta*. Nevertheless, there are problems in the characterization of the differences between terms such as townscape, cityscape or *veduta*, without having reached a precise classification – if it is possible – of each one of them; compare, for example, the sources dedicated to "Townscape" (de Lyckle de Vries) and "Veduta" (of J. Wilton-Ely) in *The Dictionary of Art*, ed. J. Tuner, MacMillan, London 1996: 31, 246–49 and 32, 110–14, who respectively identify Rome as the place where the *veduta* (characterized by its spatial amplitude and its inclusion of landscape) flourished, and Holland and Venice, where the town-

Holland and Italy: images for neighbors and travelers
Nevertheless, the Dutch view as a new pictorial genre did not arise in the strict sense of the word until the third quarter of the seventeenth century, taking advantage of the interior architectonic views of Pieter Saenredam[26] or Gerard Houckgeest and of the new landscape trend – with cities in the distance – of Jan van Goyen or Aelbert Cuyp, and remaining fundamentally defined with the works of Jan van der Heyden (1637–1712) and Gerrit van Berckheyde (1638–98). Without entirely abandoning the optical concerns that were also the origin of some Dutch experiments concerning urban views,[27] perhaps an added interest in works not destined for a local client, who would not venerate the landmarks of a given city in the same way, was the representation of basically "interior" urban sectors (streets, plazas, markets, house groupings) in Dutch paintings. These scenes were depicted in such a way that the spectator could feel as if a visual participant in the urban space, limited in its depth and open only to him, so that he was integrated by way of his relative physical proximity, accentuated by the meticulous description of the artifacts and of the immediacy of the people, his fellow townsmen.[28] If its images, always *ad vivum* seen from the ground or a house, could simply show an anonymous piece – but at the same time identifiable as characteristic – of a city facing its viewer, they were also honoring historical or modern buildings, the significant spaces of common civic and religious or group life. These images, capable of converting themselves into "synecdoches" of the group for their special "imageability" (Lynch 1960: 9), were erected as symbols and not only materials of the social and moral community, as in the *View of the Amsterdam City Hall* (1665–68, Paris, Musée du Louvre) of Van der Heyden, the foreshortened building, the new Church of Solomon, or in the *View of the Amsterdam Town Hall from the Dam* (ca. 1674, Amsterdam, Rijksmuseum) by Berckheyde, with the frontal view of the town hall. Incarnations of the totality, they kept the spectator aware of the space beyond the "frame" of the canvas, by "cutting" the sides of some of these buildings that served as "protagonists" in the image, such as in the *View of the Town Hall of Amsterdam* (1667, Firenze, Gallerie degli Uffizi) by Van der Heyden.[29] In other cases, as in the *View of the West Church of Amsterdam* (1670, London, Wallace Collection) by Van der Heyden, the Protestant church of Hendrick de Keyser, the largest constructed at the time, is mixed in with fictitious buildings (as if seen from the imposing and new Keizersgracht, or Emperor's Canal, instead of in the middle of the modest neighborhood of Jordaan). The "fictitious" intervention of the artist transformed the *ritratto* – of which it maintained its appearance – into an *imitazione*, a selective, corrective representation of reality. However, this "improvement" was not introduced only occasionally on the topography of the scene, but was also constantly applied to the urban fragments themselves, offering images of sunny, clean, amenable cities, where bad health and signs of filth, poverty, or disorder had been eradicated; all "indecorous" elements or anything contrary to urban and moral "public order" of

Anonymous
Model of a Swedish town
18th cent.
Paris, Direction de l'architecture
et du Patrimoine
Ministère de la Culture

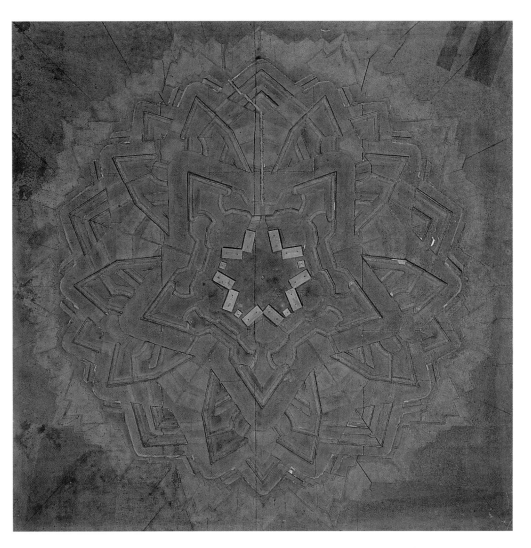

scape was most common, and Venice as the birthplace and site of the development – with Rome in the background – of the *veduta*. See Tongiorgi Tomasi 1990: 9–12.
[23] Claes Jansz. Visscher published 4 views of the urban interior of Amsterdam in 1611, together with a cross section, others appearing in his *Forma Plana* of ca. 1620. Similarly, he included in the map *Leo Belgicus* (1609–21), 18 cross sections and 2 interior urban views.
[24] This depended on the bird's-eye view of the engraving of Amsterdam (1544) by the painter-cartographer Cornelis Anthonisz., published – modifying the inclination of the city plan – on the basis of a canvas painted in 1538, to be given to Charles V, and of which only one copy survives, one that was probably a municipal commission (Amsterdam, Historisch Museum).
[25] *The Small Street* (ca. 1660, Amsterdam, Rijksmuseum), or its lost painting of *A View of Some Houses*, without identifiable buildings, could be placed at the other end of the scale, beyond typical urban landscapes. On the other hand, there is still some doubt as to whether its view of Delft was done on the ground – distorting the representation of the foreground – with the aid of a camera oscura (*Johannes Vermeer* 1996: 25–27 and 69–74); what could be testimony of this is the luminous gush of light from the clouds that fill the central band of the canvas, or the points of bright light that dot the houses and ships placed in shadow; the possible circles of diffused light formed around the unfocused reflections in the image obtained by the optics of the camera oscura, employed with artistic awareness by Vermeer also contribute to widening the impression of finding ourselves before a piece of reality captured at an instant, that takes on a life of its own in the canvas. The distortion of the foreground, seen from above, does not invalidate the point of view of the image at ground level, which is the only way for the heights of the buildings and its reflections in water to coincide.

the markets in the style of Jan Steen, full of carnal material of the human element, would disappear in them. These images were fictions intended for a clean-thinking and clean-living elite, who celebrated the economic boom and tranquillity of local life; not opposing but rather identifying their *civitates* – their spiritual communities – with their material *urbes* (Kagan 1998: 75–77), whose well-ordered and built appearance would constitute a precise reflection of a well-ordered and self-complacent community. In a certain sense it would be possible to speak of a communal or "communicentric" urban view (Mundy 1996: 116), without referring to the image of its celebrations or civic festivities or to the anecdotal quality of what is exceptional or characteristic of daily life, but without ceasing to be basically descriptive, and therefore, supposedly objective and constant. While the model forged by Van der Heyden was maintained without too many ups and downs, as witnessed by works from the middle of the eighteenth century by Paulus La Fargue or Isaak Ouwater, the role of the renovation of the *veduta* fell to Italy, although many of its foundations were modified. The Dutchman Gaspar van Wittel (1653–1730), in Italy since 1674, had been the first artist to develop the Roman topographic-architectonic view as a pictorial specialty in tempera, with its buildings and ruins inserted into the landscape and contemplated from afar, as a mixture of natural landscapes and urban architecture, even "expanding" city spaces as in *Piazza Navona* (Rome, Galleria Colonna). His series of seven views acquired in 1716 by the future First Earl of Leicester shows the dependence of this new genre on a clientele of foreign visitors, who wanted to concentrate on an image or to accumulate a series, upon their return, as mementos of their grand tours, as proposed by *Gallery of Views of Modern Rome* (1758–59, Paris, Musée du Louvre) by Giovanni Paolo Pannini (1691–1765).[30] This, formed as set design with the Galli da Bibiena, dominated *vedute ideate* or *capricci* with monuments in imaginary scenarios, panoramic views of great topo-

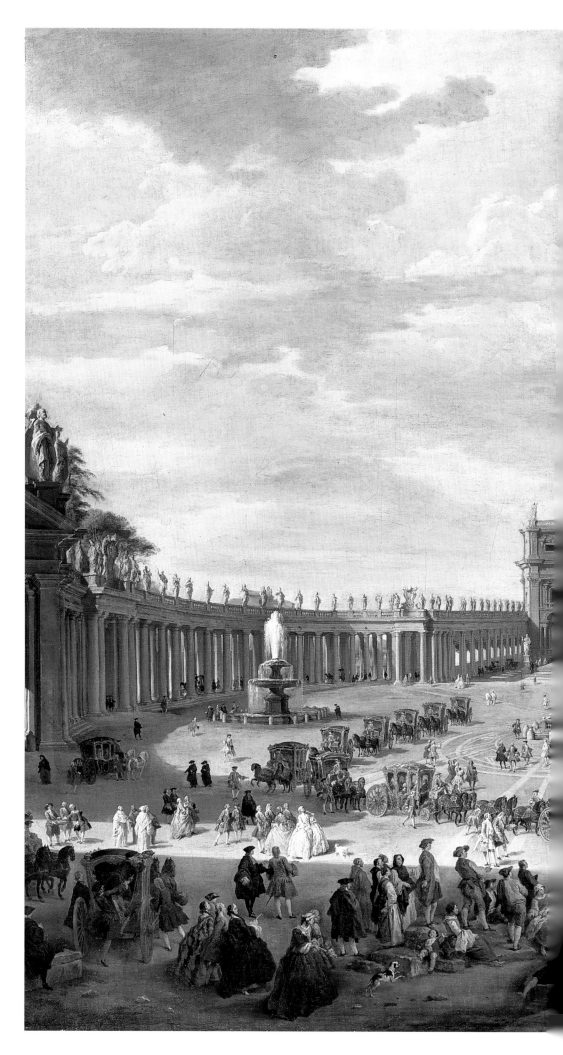

Giovanni Paolo Pannini
*The arrival of the duke of Choiseul
in Piazza San Pietro*
Berlin, Staatliche Museen zu Berlin
Preußischer Kulturbesitz
Gemäldegalerie

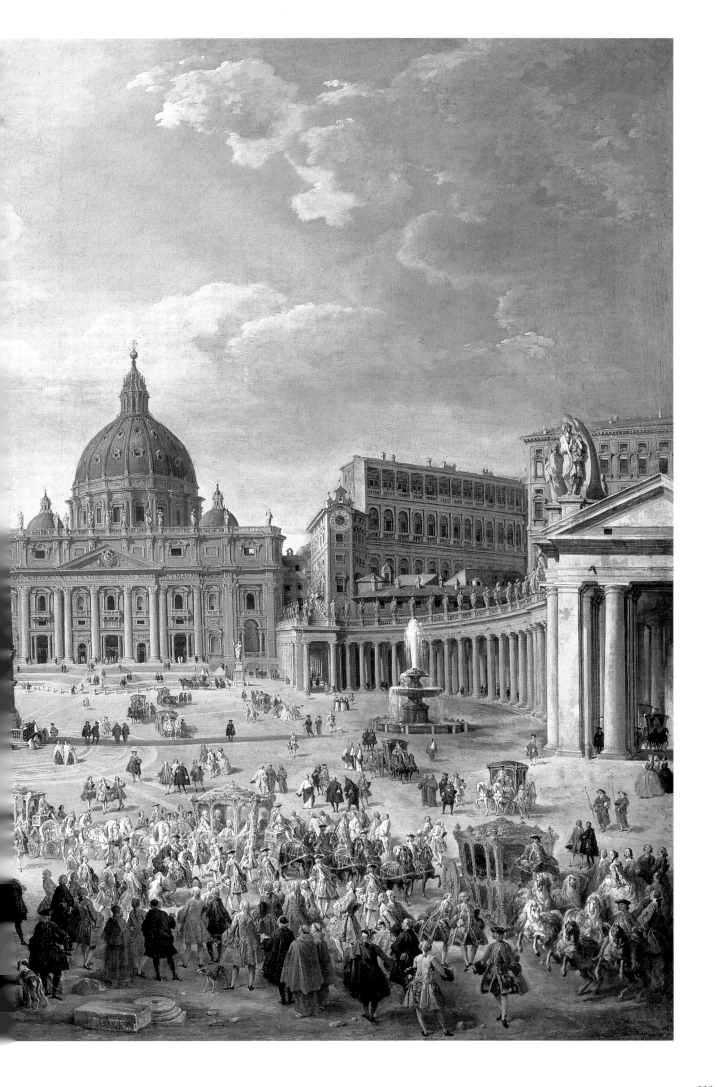

[26] Saenredam produced urban scenes such as those of *The Old Town Hall of Amsterdam* (1657, Amsterdam, Rijksmuseum) and *The Square of Santa Maria in Utrecht* (1663, Rotterdam, Boymans-van Beuningen Museum – based on drawings made respectively in 1641 and 1636.

[27] En early example of such experimentation would be *View of the Old Pier of Delft* (1652, London, National Gallery) of Carel Fabritius (1622–54), whose scene, as if seen with a wide-angle lens, perhaps should be contemplated with its "concave" surface and whether by way of a peephole in a perspective box, whether reflecting – as other anamorphosis – in a vertical cylinder or simply frontally, with a demonstration of the lack of equivalence between visual perception and traditional linear perspective (Leidtke 1976; Wheelock 1977: 4ff and 191ff; Kemp 1990: 325–26). Still in 1667 Jan van der Heyden, in his *View of the Amsterdam Town Hall* (Florence, Gallerie degli Uffizzi) experimented with the construction of eccentric perspective and the vision of his painting from a fixed point of view through a visor, situated on the frame next to its lower right corner, as was indicated to Cosimo III de' Medici on the part of his agent in Amsterdam (Kemp 1990: 228–29 and 375–76). The new Town Hall (1647–55) by architect Jacob van Campen was shown strongly foreshortened, with its hemi-spherical cupola and its tall cylindrical drum transformed, as a function of its marginal location and its frontal as well as foreshortened position, in forms deformed laterally and obliquely of elliptical section, from the peephole, these distortions – clearly visible from a frontal viewpoint – remained corrected, stretching their width and returning their inclined planes to the horizontal, while the "horizontal" lines of the foreshortened façade were kept inclined. This perspectively deformed image in its marginal section – in fact, doubly marginal in horizontal and vertical – was "self-corrected" by being seen correctly, in accord with the marginal narrowing of our real perception of this form, Van der Heyden could "demonstrate" the "adjustment" of the perspective practice geometrically

graphic precision and images of urban festivals and celebrations, such as that of the *Preparations for the Festivities in Piazza Navona [...] or the Occasion of the Birth of Louis, the Dauphin of France* (1729, Paris, Musée du Louvre) for the ambassador and Cardinal Melchior de Polignac, which converted the experiences of the city's most important visitors into personal mementos. Nevertheless, generally there was a tendency to produce "impersonal" groupings, seen from afar and from above, which could be sold in the form of replicas or reproductions *ad infinitum* in the form of prints, turning into volumes with the main views of Rome, such as the ten books of *Delle magnificenze di Roma antica e moderna* that Giuseppe Vasi (1710-82) published between 1747 and 1760, alongside his broad panorama, entitled *Prospetto dell'alma città di Roma dal Gianicolo* of 1765. His first assistant, Giovanni Battista Piranesi (1720–78) continued this trend with his *Vedute di Roma* (1747) and his almost 150 images later engraved, in which ancient and modern monuments took on a new quality of aesthetic and emotional expressivity, thanks to his original and dramatic use of framing, contrasting illumination and his manipulation of proportions, constructing with them almost an unparalleled experience, in terms of both the past and of the present.

Although Rome and, to a secondary degree, Florence and Naples – where Van Wittel or Vanvitelli would go in 1700 – [31] were the three stages of the Grand Tour of prime importance for the development of the Italian *veduta* of the 1700s, Venice was the city that was key for its special topographic and picturesque characteristics. The work of Van Wittel – a *View of Venice* (Madrid, Museo del Prado) is dated to 1697 – seems to have leijd Luca Carlevaris (1663–1730), mathematician, architect, painter and above all engraver, to the path of collecting panoramic *esatte* views, civic festivities and state ceremonies of personalized meaning,[32] such as processions of ambassadors, such as those of the Englishman Charles Montagu, Count of Manchester (1707) or the Austrian Count Colloredo (1727), so that they even engraved on one occasion in 1703 the publication of a group of prints celebrating the splendor of the Republic. This example facilitated the activity of the most important Venetian *veduta* artist, Antonio Canal (1797–68) known as "Canaletto", whose career as set designer converted into a *vedutista* depended upon his success among foreign travelers and the patronage of individuals such as Consul Joseph Smith. Both for his images of festivals and for his *vedute*, Canaletto began with innumerable preparatory drawings done *in situ*, directly or with the help of the camera oscura.[33] Perhaps he also used oil sketches to later construct canvases in his studio, based on his knowledge of perspective, given that the traces of the ruler and compass are still visible on the cloth. His urban landscapes and wide panoramas, obtained at times from the union of two adjacent views taken from the same point, combined rotund and geometric structures apparently of great topographic precision,[34] with the theatrical use of foreshortening and diagonal compositions – with lateral points of view but without reaching the view from the angle of the scenography of the era – [35] and a luminous treatment that achieved surprising aesthetic effects that guided the eye over the canvas.

Although we recognize Venetian monuments, these lack the protagonistic role and significance of their Dutch counterparts, giving greater value to the whole than to its different parts, the "ever distant" environment and the atmosphere – which with Francesco Guardi (1712–93) transformed Venice into more of an imaginary than a real city, going beyond the recognition, proximity, or identification of scenarios or their different components. They seem to try to evoke aesthetic and "picturesque" sensations more than being capable of capturing deep experiences worthy of being remembered. From there the scenarios could also be improved from an "externally" artistic point of view, with buildings foreign to the city, such as the new genre of *veduta* whose invention was claimed in 1759 by Count Francesco Algarotti, based on an extant *veduta* – which distanced him from the architectonic *capriccio* by not resorting at the same time to an imaginary scene – and enriched it with buildings of renown beauty, a new "meeting of nature and art." This had been suggested to Canaletto and he painted it in his *Capriccio with the Great Canal and Rialto Bridge* (ca. 1749, Parma, Galleria Nazionale): with the Basilica and the Palazzo Chiericati of Vicenza, by Palladio, on both sides of the Great Canal by Rialto bridge reshaped on the basis of the architect's plan (never executed) (Kemp 1990: 163).

These characteristics made the views of Canaletto, as well as those of his nephew and disciple Bernardo Bellotto (1720–80), apparent memories of a journey more than of a stay in a place, and images eventually destined for external consumption. From there arose the possibility of

Jacob van der Ulft
Dam Square in Amsterdam with a view of the Weigh-House, the Town Hall, and the Nieuwe Kerk Tower
Amsterdam
Gemeentelijke Archiefdienst
cat. 402

regulated with visual perception both of its images as of reality.
[28] That "interiorization" of the spectator and his becoming fixed in the place, without "permitting" him to escape, is apparent if we compare two views, such as that of *Market Square* and the *Great Church of Haarlem* (1674, London, National Gallery) by Berckheyde, and that of *Campo dei Santi Giovanni e Paolo* (1735–38, Collection of Her Majesty the Queen) by Canaletto; and if we analyze the occlusion of the visual exit and the role of the building in the foreground and the shadow it casts on it.
[29] In his *View of the Dam* (Amsterdam, Rijksmuseum) he would leave only a segment of the Town Hall, focusing on the image of the Nieuwekerk.
[30] See *Grand Tour* 1997.
[31] He was summoned by Luis de la Cerda y Aragón, Duke of Medinaceli and Viceroy of Naples. On the history of the Neapolitan *veduta* – and his main vedutisti of the 1700s such as Antonio Joli, Claude-Joseph Vernet and Giovan Battista Lusieri – see *All'ombra* 1990, and De Seta 1991.
[32] In the Victoria and Albert Museum of London there are different oil sketches and preparatory drawings by Luca Carlevarijs in which he carefully studied in detail the figures – institutional or anecdotal – that he was going to include in his images of civic rituals.
[33] A camera oscura with the inscription "A. Canal" is held in the Museo Correr of Venice, while a series of his drawings are in the Gallerie dell'Accademia, constituting proof – to which may be added the written testimony of Antonio Maria Zanetti – of his use of this instrument, at least as a learning method, but above all as a means of optically fixing the image of the whole in perspective as well as the details of his views. Some of these drawings of buildings, with lines extended by hand, were joined to create panoramas, although they added successive images with a very tight angle of vision, because primitive lenses

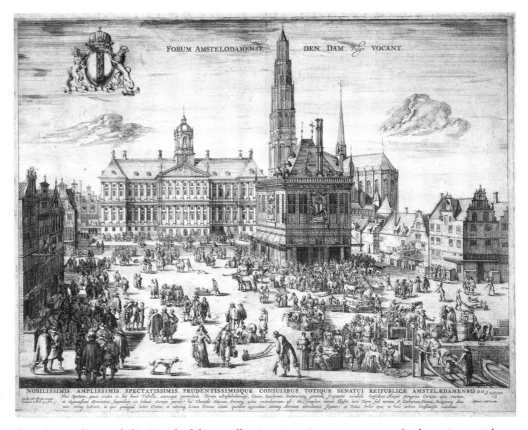

their "interchangeability" and of their collection in series – mementos of urban views without apparent links beyond a random or tourist itinerary – and even of their "exportability." Canaletto not only produced a series of twenty-four paintings for a single client, the Fourth Duke of Bedford, but also increased his market giving his twelve painted images of the Great Canal of 1735 to the presses of Antonio Visentini (re-published in 1742) and from the next decade beginning his own engravings, which included his whimsical *vedute ideate*, while the deceased Michele Giovanni Marieschi (1710–43) had already added to the task, with his series of twenty-one engravings of 1742 to satisfy a growing demand, although tending toward *vedute di fantasia*. At the same time, because of the crisis produced by the War of Austrian Succession, Canaletto went to London several times between 1746 and 1756, where he demonstrated the exportability of his method, working for clients such as the Second Duke of Richmond, and creating different views of the city, panoramas of the banks of the Thames, or images of aristocratic houses, which left a deep impression on English production, capable of fantasies in the Venetian style such as the *Capriccio with St. Paul's of London and a Venetian Canal* (London, Tate Gallery) by William Marlow. In turn, Bellotto left Venice in 1747 to establish himself in Dresden (at the service of the Great Elector of Saxony and King of Poland Frederick Augustus II), to travel to Vienna (at the service of empress Maria Theresa) and Munich, to then set up his permanent residence in Warsaw in 1767 (at the service of King Stanislas II August). There he kept – for example in his *Dresden from the Elba* (1748, Dresden, Gemäldegalerie) – the type of distant views from above, accentuating topographic precision, stereographic values, and wide horizons of the paintings of his uncle, just as Canaletto put forth even in his English images such as *The Thames from Somerset House* (1750–51, Windsor Castle). Despite executing works for "local" clients, and thus excluding the evocative character of what could only be recovered by avoiding it, from afar, by way of the pictorial image, these views do not seem "internal" but rather externally objective, emotionally and ideologically neutral, dramatized solely thanks to the artistic use of framing, illumination, and shadows.[36]

It would be the *veduta*, with its return to perspective, that would offer the only real possibility of the urban image as an expression of an era such as that of the eighteenth century. This is because as an artistic expression, the painter was not limited to an "essential copy" of reality,[37] but rather it was elaborated although it kept the same material appearance; as an expression not on-

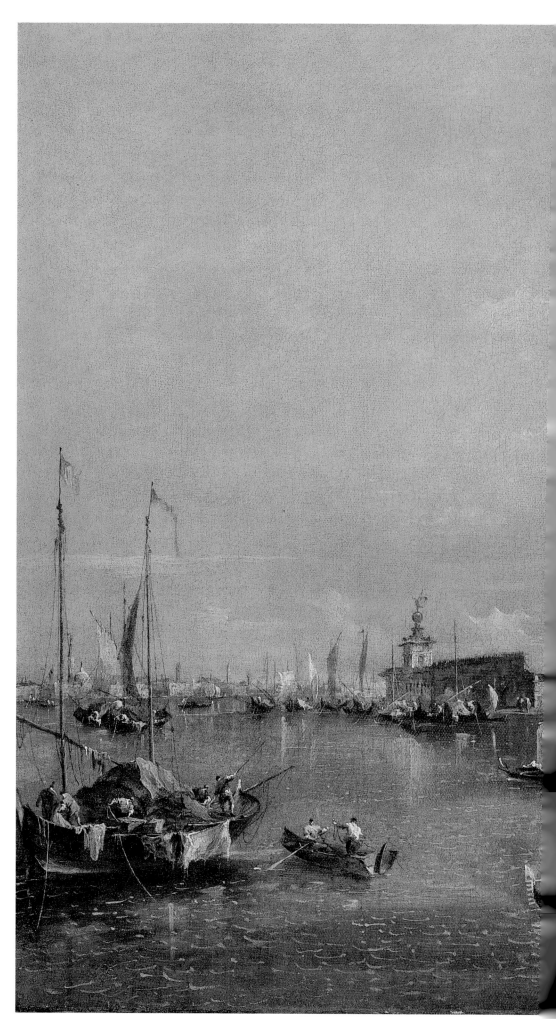

Francesco Guardi
*The church of Santa Maria
della Salute in Venice*
Ottawa, National Gallery of Canada
Musée des Beaux-Arts du Canada
cat. 31

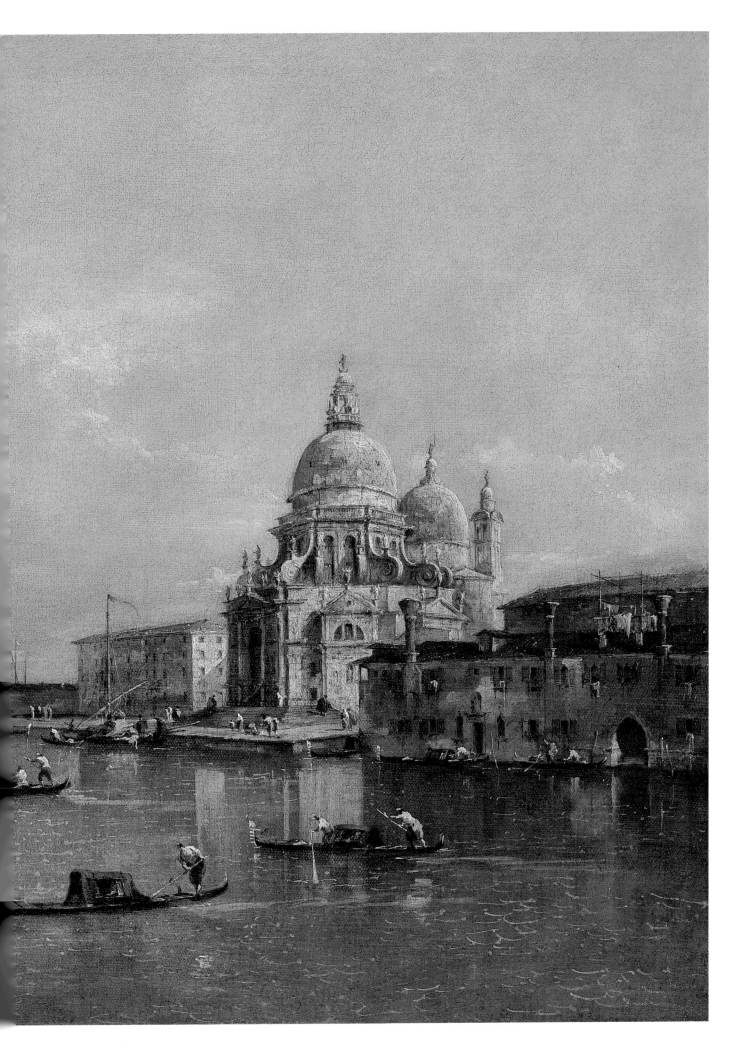

Gaspar van Wittel
Campovaccino
Rome, Private Collection
cat. 49

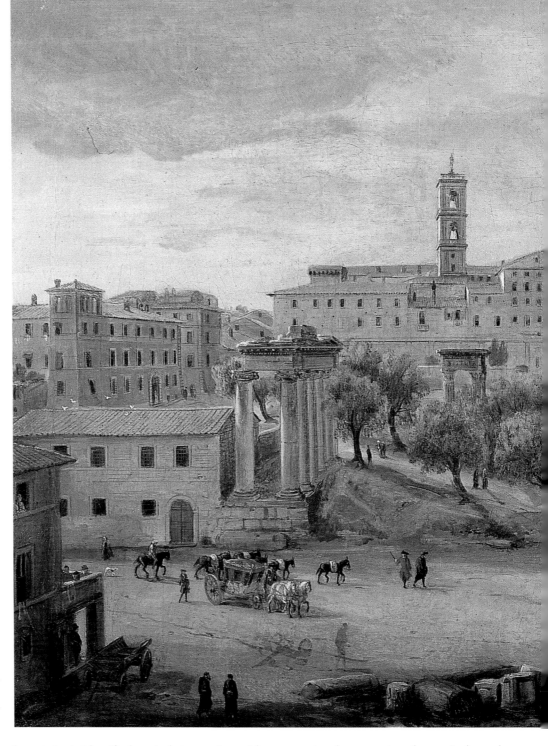

limited the angle of vision to roughly 35 degrees (Pignatti, 1958; Gioseffi 1959; Kemp 1990: 163–65 and 218–19). A contemporary image of the prints of the *Delizie del fiume Brenta* by Francesco Costa (ca. 1755) shows two figures with the tent of a camera oscura placed in front of the canal and the parish of the villa of Mira in the Venetian Terraferma.

[34] Compare in detail his *Campo dei Santi Giovanni e Paolo* (1735–38, Collection of Her Majesty the Queen) and his *Two preparatory drawings for il campo dei Santi Giovanni e Paolo de Venecia* (ca. 1735, Venezia, Gallerie dell'Accademia, *Quaderno*, 504-51v). The manipulation of his prior images are discernible, such as the partial overlapping, behind the equestrian monument of Colleoni by Verrocchio, of the building attached to the Franciscan church, the windows of which have undergone a process of joining; the adjustments between the verticals of the exterior of the central nave and those of the gable wall and the lower lateral wall of the church; the new equilibrium of masses of the church and over-elevated houses of the wall on the right; the new placement of the fountain in the middle ground with respect to the house at the back of the campo or of the Colleoni with respect to the great semicircular bay window of the lateral apse of the church, and so forth.

[35] By imagining a central vision of his work *Campo dei Santi Giovanni e Paolo* we might be able to realize the transcendental changes (acceleration and narrowing of the Scuola di San Marco, the adulteration of the "itinerary" toward the exit of the *campo*, the loss of three-dimensionality, the disappearance of the relational function granted to cast shadows, etc.) which had been produced in this never executed *veduta*.

[36] As if Bellotto, in his image of a predominantly Protestant Dresden, had been alien to the significance of the construction of the new Catholic church of the Hofkirche (1738–54, by the Roman Gaetano Chiaveri), promoted by the converted elector, his wealthy patron, opposite the Lutheran

ly artistic, it identified optical perception with perspective, by accepting the equivalence between the world of visual appearance, controlled by "reversible" perspective," and the geometric reality of the world, ultimately knowable only beginning with perception and perspective, as the phenomenology of Johan Heinrich Lambert attempted to demonstrate (Pérez-Gómez and Pelletier 1997: 211 and 274–77).

Although the artistic characteristics of the *veduta* were lost only to be transformed into others, its urban "form of truth" has been maintained beyond the end of the classic era. Its vogue has been transferred to the world, whether artistic or banal, photographic or cinematographic; its nature provides perspective in the framework of an enunciative system (Damisch 1987: 40–44). These traits allowed it and continue to allow it to establish an irreplaceable relationship between the "I" of the spectator and the "you" of at least a fragment of the city, the only urban place where a personalized relationship may be established.

BIBLIOGRAFIA: Fritz s.d.; Cuningham 1559; Manesson, Mallet 1686; Landucci 1883 (1969); Pearsall Smith 1907; Gerola 1930–31: 217–21; Bachmann 1939 (1965); Krautheimer 1948: 327ff.; Lavedan 1954; Hugueney 1956; Pignatti 1958; Gioseffi 1959; Lynch 1960; Bloch 1961; *Les Trésors* 1965; Chiarini 1967;

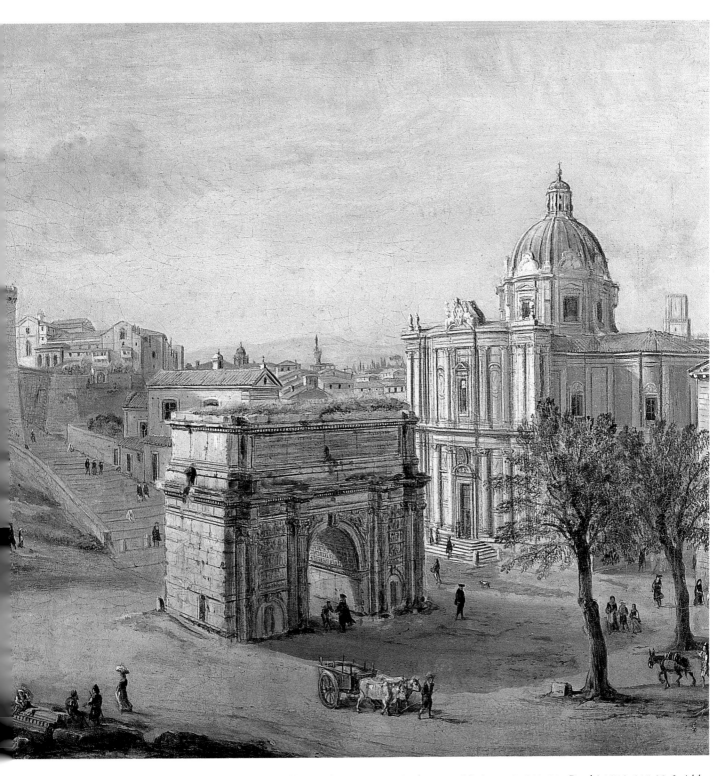

church of Frauenkirche (1726–43, by the local architect George Bähr).[37] As the art expert Sir Henry Wotten commented to Francis Bacon after seeing in Linz in 1620 a landscape produced by scientist Johannes Kepler and anxious about the fact that it had been done with the aid of the camera oscura, "non tamquam pictor, sed tamquam mathematicus," dictating the sentence that such method could be employed with great usefulness in chorography, although its use in landscapes would not be liberal, despite the fact that no painter would be capable of imitating them in such a precise way (Smith 1907: II, 205–206).

Skelton 1965: Xff.; Kozakiewicz 1972; Links 1972; Marin 1973: 283–90; Gambi 1976: 215-28; Leidtke 1976: 61–73; Pinto 1976: 35–50; *The Dutch Cityscape* 1977; Moreno Criado 1977; Wheelock 1977; *The Origins of Italian Veduta* 1978; Chastel 1978: 317–22, 497–503; Partridge 1978: 494–529; Schulz 1978: 425–74; Martindale 1979; Ciati 1980: 201ff.; Tanturli 1980; *The Panoramic Image* 1981; Ferretti 1982; Alpers 1983; Corboz 1984; De Vries 1984; Haak 1984; *Gilded Scenes* 1985; Corboz 1985; *Ciudades del Siglo de Oro* 1986; *Dutch Landscape* 1986; De Seta, Ferretti, Tenenti 1986; Ferretti 1986; Pepper and Adams 1986; Pernot 1986; Walther, Bettagno, Bechmann and others 1986; Alpers 1987: 51–96; Damish 1987; Reuther 1987; *Il mondo nuovo* 1988; Günther 1988; Hyde and Wilcox 1988; Nuti 1988: 545–70; Spinosa 1988; Deswarte, Rosa 1989: 47–62; Ricci 1989; *All'ombra del Vesuvio* 1990; De Roux, Faucherre and Monsaingeon 1989; Elliott 1990; Kuhn 1990: 114–32; Tongiorgi Tomasi 1990; Schulz 1990; Kemp 1990 (1994); Ballon 1991; De Seta 1991; Lawrence 1991; *Monarchs* 1992; Consagra 1992; Jatta 1992; Tafuri 1992; *Actes du Colloque International* 1993; Arisi 1993; Morassi 1993; Stoichita 1993; *La Galleria delle carte geografiche* 1994; Adams and Nussdorf 1994: 205-30; Aronberg Lavin 1994: 676–80; Boutier and Teissere-Sallmann 1994; Elkins 1994; Frangenberg 1994: 41–64; Krautheimer 1994: 233–57; Links 1994; Marin 1994: 204–18; Nuti 1994: 105–28; Reuther and Berckenhagen 1994; *The Glory of Venice* 1994–1995; Swan 1995: 353–72; *Città d'Europa* 1996; *Johannes Vermeer* 1996; *Las casas del alma* 1996; Briganti, Laureati, Trezzani 1996; De Seta 1996a, 1996b and 1996c; Mundy 1996; Nuti 1996; Pérez-Gómez and Pelletier 1997; Warmoes 1997; *Das Bild der Stadt* 1998; Kagan 1998; Kagan and Marías 1998; Marías forthcoming

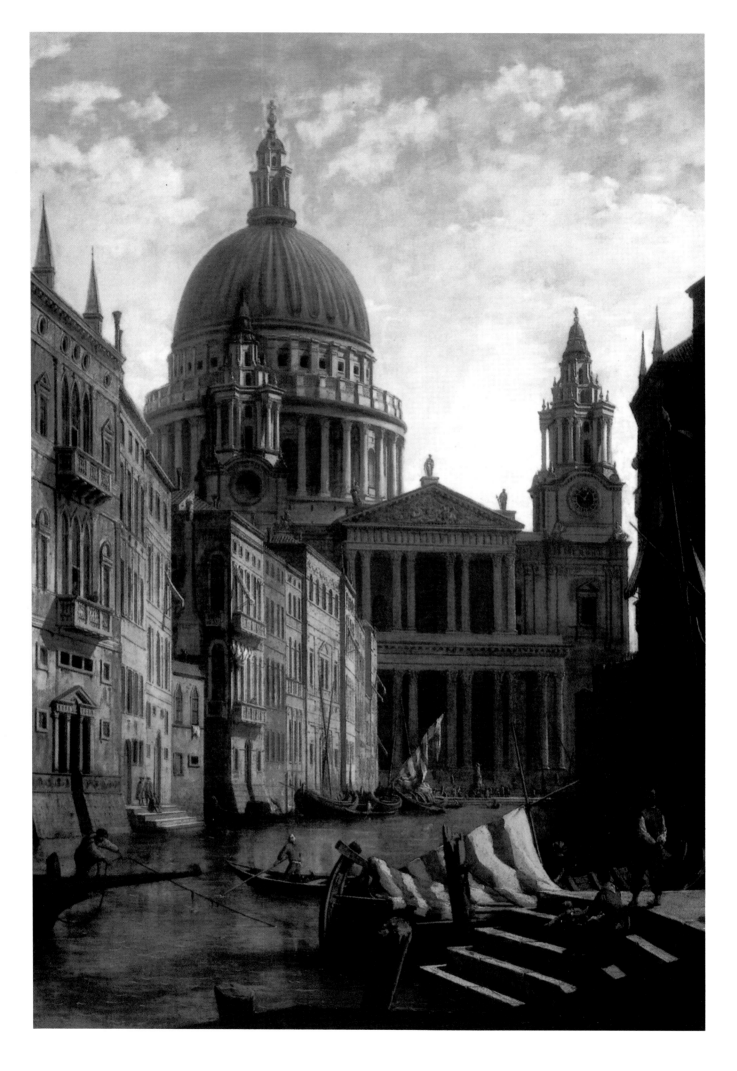

The easel painting with architecture as its sole or main subject touched its zenith as a wall decoration and collector's item in the Baroque period, first in Italy and the Netherlands, later in France and Germany; less so in Spain and England.

Along with some other "minor" genres, it achieved independence at the turn of the seventeenth century and in the succeeding years, in the context of a broad social shift from the client who commissioned works from the artist to the customer who bought his products ready-made. Popular for its sumptuous character, rather like flower paintings and battle scenes, it furthermore made intellectual demands which these other genres did not: scientific perspectives, the system of the architectural orders, and the historical styles.

The earliest and most important written discussions of the subject has emerged from the circle of the learned, knowledge-hungry *virtuosi* and *curiosi*, the collectors and *dilettanti* in the circle of the Barberini in the Rome of Pope Urban VIII: the great collector Marchese Vincenzo Giustiniani wrote, probably during the 1620s, a letter on the various genres of painting to Theodor van Ameyden, a member of the curia who had wide-ranging historical interests and was himself an active writer; in a list of twelve skills in ascending order of difficulty, between flower painting to landscape, he mentions: "Sixth, the ability to paint perspective and architecture well, a skill which requires one to have experience of architecture, and to have read books on the subject, as well as books on perspective, so that one knows all the regular and visual angles, and can ensure that everything fits together and is flawlessly painted."[1]

In 1629 Cassiano del Pozzo, a friend and collaborator of the Barberini in their cultural enterprises, who had commissioned and organized in his own right a curious Paper Museum, wrote to a friend of his in Florence offering to buy on his behalf paintings by the young Lemaire: "Perspective paintings of the antiquities that we have here in Rome with very attractive little stories and figurines [...] incomparably better than those which Tassi and other painters produce in this genre [...] these relics of ancient buildings, such as arches, the Colosseum, temples, aqueducts and such like, are wonderfully eye-catching and a source of great delight;" and "in my opinion this sort of painting gives much more pleasure than landscapes do; indeed, I think that if one distributed them around the rooms, putting on each wall one perspective painting between two landscapes, it would produce a quite beautiful effect.

Painters will continue to put in these pictures the finest views of buildings, whether ancient or modern, which can be found in this city."[2]

Both Giustiniani and Cassiano were themselves owners of such *prospettive*, and most buyers belonged to the class of the intellectual public servants, courtiers, ministers, ambassadors, and financiers. There were royal customers too: a large commission of twenty-four pictures by Rome-based painters for Buen Retiro, Philip IV's pleasure-palace in Madrid – which was to shine above all through its artistic treasures – included Lemaire, and the Spanish viceroy in Naples commissioned four paintings from Codazzi for the same palace.[3]

A hundred years were to pass between this first flowering of the genre in the second quarter of the seventeenth century and its second and greatest bloom: the works of Pannini and Piranesi, Canaletto and Bellotto were sought after by an international audience in their day, and by the highest ranks of society.

These particular names have never lost their luster, but most of the them have fallen into oblivion, rather more, perhaps, than those of even second-rate painters in other genres; and only now are their artistic personalities being laboriously reconstructed; even the two most important artists of the first period, Jean Lemaire (1601–59 ca.)[4] and Viviano Codazzi (1604–70)[5], or such painters of the second period as Marco Ricci (1676–1730)[6] and Jacques Lajoüe (1686–1761),[7] have only been thoroughly studied in very recent years.

Although the great discovery of the Renaissance – perspective – is the basis of their art, the aim of these painters is no longer the rigorous construction of a standard reality; perspective is treated freely, and each painter has his own formula, which he may change during the course of his career. Closely related are *quadratura*[8] and *scenografia*[9] (together with the art of ephemeral decoration), that is to say, the illusionistic expansion and adornment of a real space – of salons, galleries, church vaults, etc. – and the architec-

[1] G. G. Bottari 1822: 121–29.
[2] Fagiolo dell'Arco 1996: 248.
[3] J. Brown and H. J. Elliott, 1980: 123ff.; Marshall 1993: 68–82.
[4] Fagiolo dell'Arco 1996.
[5] Marshall 1993.
[6] Scarpa Sonino 1991; *Marco Ricci* 1993.
[7] R. Michel 1984.
[8] Negri Arnoldi 1963.
[9] C. C. Malvasia 1971: 453.

tural structuring of the stage. Both had their Italian centers in the Veneto and Emilia, and many of the painters of architectural paintings either studied under the masters of these disciplines, in which the virtuoso treatment of perspective was taken to its furthest extremes, or plied one or other of these trades for a time (Tassi, Pannini, Marco Ricci, Marieschi, Canaletto, Bigari, Lajoüe, etc.). But they also learned from their own private reading of the treatises: thus Malvasia writes of Girolamo Curti, known as "il Dentone" (1576–1652), one of the founders of Bolognese *quadratura*: "He bought copies of Vignola and Serlio, and set about studying the orders of architecture and applying the rules of perspective;"[10] and the Neapolitan Gennaro Greco (1665–1739), known as "il Mascacotta," is reported to have acquired the rudiments of his art through the study of Pozzo's *Prospectiva pictorum et architectorum*.[11]

For the content of their paintings, too – their choice of buildings to paint – they drew on the great sixteenth-century treatises and engraving collections: Sebastiano Serlio's *Architettura et Prospettiva* (1540–84) and Jacques Androuet Du Cerceau's *Livre d'Architecture* (1559-89); the works of Hans Vredeman de Vries, from the *Scaenographiae sive Perspectivae* (1560) to his last book on architecture, then the *Speculum Romanae Magnificentiae* by Lafréry (1575) begun before the middle of the century; Etienne Dupérac's *I vestigi dell'antichità di Roma* (1575); and Giacomo Lauro's *Antiquae Urbis Splendor* (1618–37).

The types of architectural picture are diverse, and a strict classification is impossible. But one can at least attempt a survey. The possibilities range from the *veduta* – the more or less precise, more or less intentionally deformed view of a real place – to the *capriccio*, which may mingle real and invented buildings, possible and structurally or functionally impossible structures, in real or imaginary places. Known buildings of different provenances are brought together in one place, *topoi* are accumulated. A building may be painted for its own sake, perhaps for the representative needs of the owner or client; a building that is only in the planning or initial stages may be imagined as complete, or a completed building as a ruin; it may be corrected according to the academic theories or the taste of the times, purged of accidentals or, conversely, embellished and enriched in details, changed in character. The ruin-genre may show columns and dilapidated vaults

Antoine Caron
The Tiberine Sibyl
Paris, Musée du Louvre

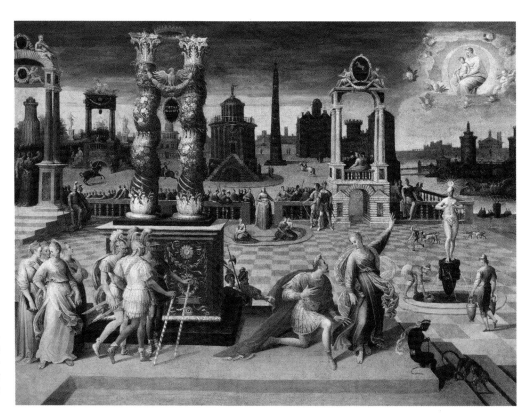

[10] O. Giannone 1941: 181.

[11] Crispolti 1959; more recent exhibitions have been devoted to the subject of the caprice: *Capricci Veneziani* 1988; *Roma antica* 1994; *Phantasie und Illusion* 1995–96, *Das Capriccio* 1996.

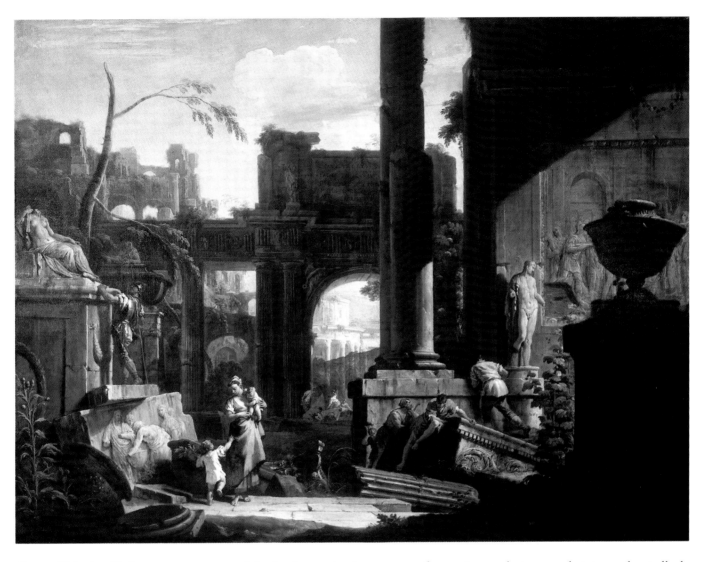

Marco and Sebastiano Ricci
Architectural fantasy with Roman ruins
Vicenza, Direzione Civici Musei
cat. 635

as parts of the landscape in the process of reverting to their natural state, and yet allude to well-known localities, especially in Rome or Tivoli. Such famous and familiar places as the Roman Forum, with the nearby Colosseum, Arch of Constantine, and Capitol, or St. Mark's Square and Quay, with the Dogana and Santa Maria della Salute and even San Giorgio on the periphery, themselves come to resemble products of the fantasy, such is the variety of architectural objects assembled in them. Large may seem small; more often small seems gigantic; ornament is blown up into architecture. The intention may be simply picturesque and entertaining, or it may be educational and reforming; at any rate, it is always a demonstration of the artist's imagination and inventiveness, his wit and playful fantasy – *capricciose invenzioni*.[12]

If it is difficult to draw clear lines of demarcation between the types of architectural painting, it is equally hard to do so between history or genre pictures with an architectural background or frame and, conversely, representations of architecture which are enlivened and enriched with *macchie*.

Architecture may complement, explain, or extend the theme of the history, or it may provide a setting for the simple everyday life of the genre picture – when it is not simply a question of providing an additional attraction for the observer. The two parts of the picture tend to be painted by different artists, often working as equal partners: though Lemaire and Pannini were themselves excellent figure-painters, Codazzi worked first in Naples with Domenico Gargiulo, known as "Micco Spadaro,"[13] and later in Rome with Michelangelo Cerquozzi, and after the latter's death, with Filippo Lauri; Magnasco collaborated with Clemente Spera; Marco Ricci with Sebastiano Ricci, and so forth. In the

[12] Marshall 1993; Sestieri, Daprà 1994.
[13] Mazza 1976.

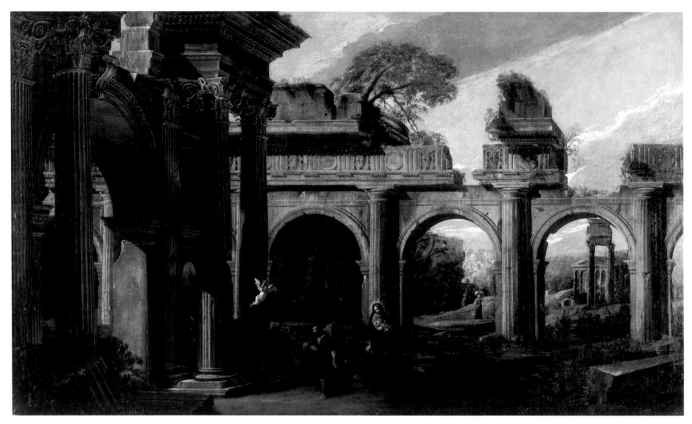

Viviano Codazzi
and Michelangelo Cerquozzi
*Triumphal Arch and ruined archway
with scene of the Flight into Egypt*
Turin, Collezione dell'Accademia
Albertina delle Belle Arti
Istituto di Alta Cultura
cat. 631

[14] R. Krautheimer in *Rinascimen-
to* 1994: 223–58; M. Herrmann in
Architekturmodelle 1995: 50–55.
[15] These themes were usually re-
stricted to the sixteenth and the
early seventeenth centuries, but
as late as 1725 Joli painted a pair
of pictures entitled *The Burning
of Troy* and *Samson Brings Down
the Temple of the Philistines* (Gal-
leria Campori, Modena).

1720s, when the London theater impresario Owen MacSwiny was in Venice and Bologna
organizing his idea of "allegorical tombs" of great Englishmen of recent history into a cy-
cle for the English market, and wanted to involve as many artists as possible from both
cities, he strove to get three specialists working on each painting: one for the figures, one
for the perspectives, and one for the landscape.[14]

The idealism and purism of the three great architectural paintings of the early Renais-
sance in the museums of Urbino, Baltimore, and Berlin – paintings which are still myste-
rious to us in many respects[15] – repressed the human presence, along with all other acci-
dentals. Perhaps they are meant to suggest the utopia of a future urban society of the
virtues; the magnificent ruins in the wide sixteenth-century landscapes, on the other
hand, especially those painted by Dutch artists, recall past greatness, and embed the sub-
ject in the context of the general course of history.

In the architectural paintings of the early seventeenth century there is little trace of such
nostalgia and temporal distance. The presence and beauty of the individual buildings and
complexes, which combine extant ancient monuments, ruins and reconstructions with
modern elements and archaizing inventions, certainly demonstrate the fragmentary na-
ture of the situation; but on the whole they express optimism for life and for architecture,
accompanying and supporting the enthusiasm of the contemporary world.

There is, however, an affinity between the representation of architecture and certain figural
themes. Monumental architecture heightens and underlines the importance of great history,
sets the tone for the actions of heroes and princes, especially those of the Old Testament and
classical antiquity. This is most evident when a temple is used to enrich a scene with the rel-
evant divinity, as in the original pair of pictures by Filippo Gagliardi (ca. 1606-59) and Gio-
vanni Battista Castiglione, *The Temple of Pan* and *The Sacrifice to Pan* (Rome, Galleria
Pallavicini, ca. 1650); or – in a more accidental manner – the *Triumph of Venus* and *Triumph
of Bacchus*, where Magnasco painted the figures against a background of groups of columns
and other ruins painted by Spera (Los Angeles, Getty Museum). From Veronese to Gaetano
Gandolfi two hundred years later, banquets are usually shown against a magnificent row of
arcades or columns, or, in the north, in a vaulted gallery, whether they were held by Balt-
hazzar, Cleopatra, or the Rich Man, in the House of Levi, or at the wedding of Cana.

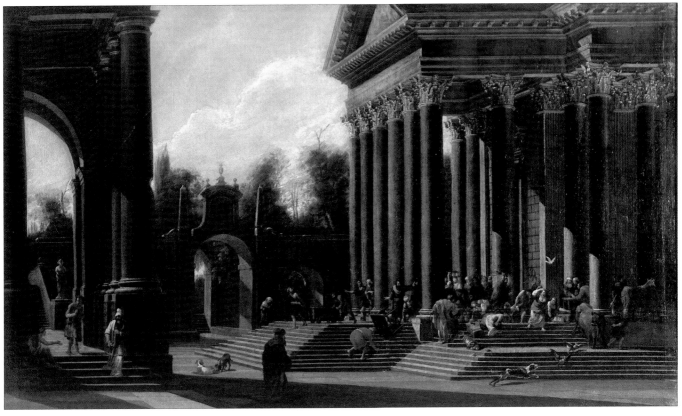

Viviano Codazzi
and Michelangelo Cerquozzi
*Christ driving the money-changers
from the Temple*
Turin, Collezione dell'Accademia
Albertina delle Belle Arti
Istituto di Alta Cultura
cat. 630

Conversely, the fame and durability of the great stone monuments may also be contrasted with violence and catastrophe, murder and fire.

In 1565, Vredeman de Vries (in an engraving) and Antoine Caron (1565, Louvre) showed the *Massacre of the Triumvirate* on a forum-like square of the classical type; Paris Bordone painted a gladiatorial contest (Vienna, Kunsthistorisches Museum) in a similar setting.[15] In each case, the treatment was so similar that there was almost certainly a sequence of dependence between them. A hundred years later, Lauri's figures of the *Massacre of the Innocents* give "life" to a harmonious square by Codazzi; and in 1631 Poussin – perhaps with the assistance of Lemaire – locates the *Plague in Ashod* (Paris, Musée du Louvre) – as well as *The Rape of the Sabines* – in the most elaborate architectural framework of his whole oeuvre, a city square modeled on the descriptions made for the Renaissance theater by Peruzzi and Serlio.

A case apart, which straddles the two centuries in spirit, is that of the hallucinatory and obsessive paintings of the Naples-based Lorrainer François Nomé, known as "Monsù Desiderio:" he blends architecture and ornament, Gothic and Renaissance, living figures, reliefs and chiaroscuro painting. His scenes, ranging from martyrdoms of the saints to the *Flight from Burning Troy*,[16] unfold in front of the plane of the architecture, which shown in feverish plays of light behind which the substance loses itself in darkness.

When Desiderio spent eight years in Rome at the beginning of the seventeenth century, he could have been able to absorb the existing classical landscape with its architecture; in this landscape painting there is usually placed a compact group of buildings consisting of bastion wall, palace block, and church rotunda with campanile, to emphasize and monumentalize a hill or a narrow strip of coastline. As to their subjects, these landscapes from Paul Bril to Caracci and Domenichino, Agostino Tassi and Gottfried Wals[17] are neutral.

The robustness of these landscapes gives way in Claude (Claude Gellée, or Lorrain), to landscapes where architecture plays a constitutive role (especially in the years 1636–48, then again in his later work) in a process of spiritualization. The sublimation of the whole picture corresponds to a dematerialization of the architecture, which thus becomes kindred to the broad surfaces of water and sky. The most striking paintings are the harbor scenes,

[16] Sluys 1961; Nappi 1991. Dated works from 1619 to 1623. Compare also Sebastian Vrancx *The Sack of Rome* 1600 or Pieter Schonbroeck *The Burning of Troy*, both probably painted in Rome.
[17] Salerno 1977–80; Pugliatti 1978; *Fiamminghi* 1995; Cavazzini 1998.

with a solid line of buildings attributable to the palace area on one side; scenes of farewell have a prominent place, and there predominates a sense of great, mythical distance.

In stark contrast, the northerners of the Schilderbent and the Bamboccianti loosen the solid structure of the classical landscape, accumulate accidentals, allude to familiar Roman places and monuments like the Forum and the Palatine and locate in them a colorful peasant scene of morra-players and artists, flocks of sheep and shepherds. The contrast between the ruins, witnesses of a great past, and the lowly present, is not a nostalgic or critical statement but an expression of bucolic jollity (Cornelis van Poelenburgh, Bartholomeus Breenbergh, Jan Both, Jan Asselijn, and Nicolas Berchem).

In the works of the leading masters of architectural painting, Lemaire and Codazzi, the figures only have a limited function as regards content. Lemaire accompanies ancient architecture with couples from mythology or simply with figures in classical costume, or with pointing or drawing figures who underline the antiquarian interest and artistic value of the buildings.

A similar repertoire of unconnected figures, idlers, soldiers, and women with children, but also groups listening to a sermon, and again observers and sketching artists, appear in Pannini's ruins. Conversely, Hubert Robert brings out more strongly the contrast between the humble everyday scenes of washerwomen, carts at rest, and planks, and the remains of antiquity, together with the most important buildings of the Roman Renaissance, as a picturesque accentuation or as a criticism of the present day.[18]

In essence, however, the architecture itself in its individual elements and *topoi* is intended to activate the spirit and feelings of the observer, through an emphatic appeal, as Georges de Scudéry demonstrates in his description of a fictional painting "A perspective picture by the hand of Le Maire" in his *Cabinet* (1641): "What a superb portico... rows of columns... glorious dome... rich garlands... sumptuous frontispieces, friezes and capitals... marble, jasper, porphyry... Oh, how wonderful the bas-relief is to behold!" This is

Alessandro Magnasco
The bandits' repose
St. Petersburg
The State Hermitage Museum

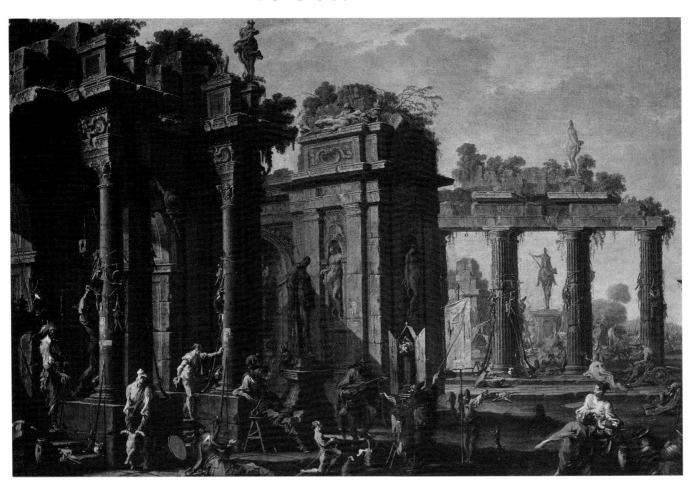

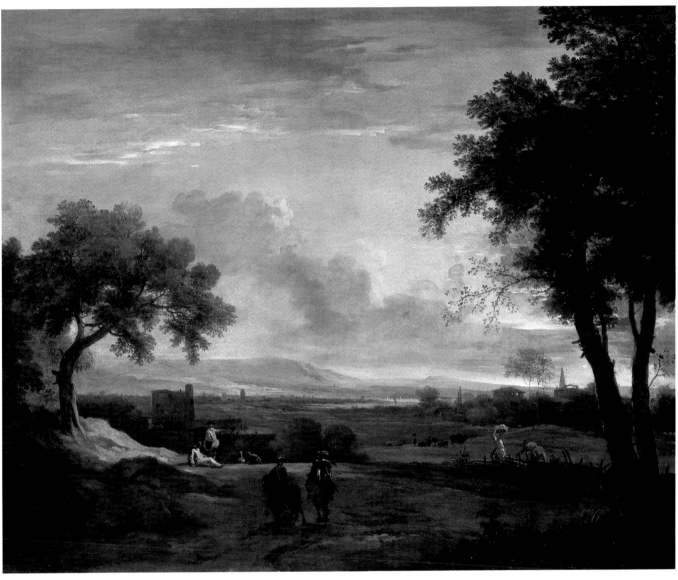

Marco Ricci
Landscape at dusk
Berlin, Staatliche Museen
Preußischer Kulturbesitz

followed by a classical reflection on the experience of Rome: "See how much time, this cruel destroyer, has destroyed of so many beautiful things. He alone is the barbarous author of this disorder... These great walls burst open, these broken-off capitals... Marble and metal have not been able to resist him."[19] But this reflection only has limited relevance: what prevails is the appearance of the well-ordered, the clear light and the luminous stone, a few recurring, always newly grouped examples of ancient architecture and sculpture, short perspective lines and transversely positioned elements. Stylobates and stone slabs on the ground counterbalanced the irregularity of the heaps of earth and the vegetation on the monuments.

Clean sections instead of crumbling masonry. These take on an absolutely demonstrative character in Codazzi; they make clear the structure of the building, even when they show no obvious signs of their derivation from the didactic archaeological engraving of the sixteenth century, as happens in the extreme case of the four pictures for Buen Retiro – Circus, Gymnasium, Amphitheater, Thermae. Codazzi's art is more varied, though it lacks the intense poetry of Lemaire's. He is more interested in the different typologies (arcade and portico, palace with and without portico, church and bath) and therefore works more from the models provided by the printed collections of engravings; he even combines buildings of varying status: ancient with modern, grand with everyday. Interior and exterior – as in Dutch art – are not always clearly distinguished. But the buildings are depicted more for their own sakes than they are in Lemaire. One of his finest pic-

[18] Held 1990.
[19] Fagiolo dell'Arco 1996: 258.

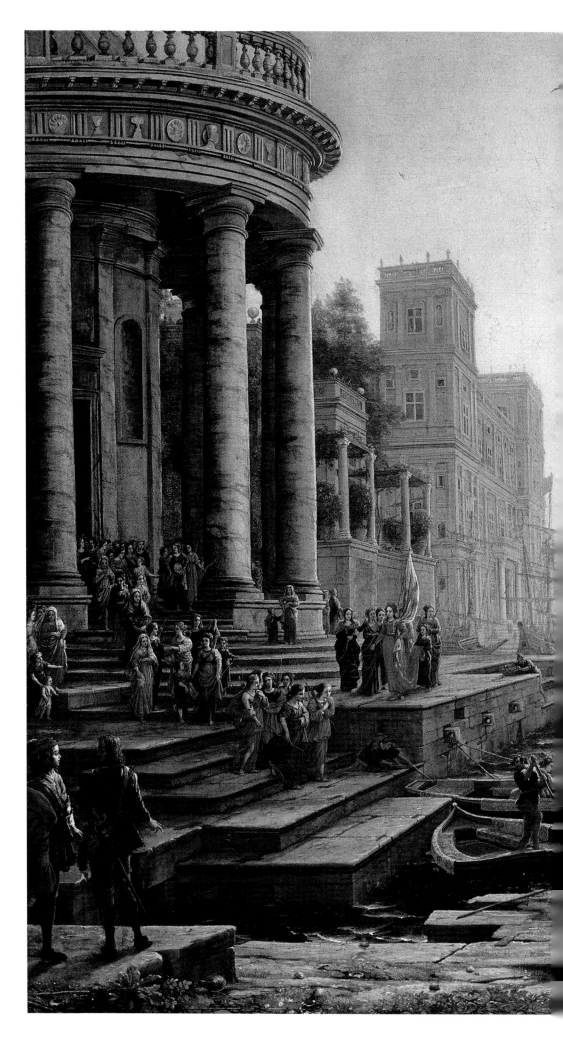

Claude Lorrain
Port with Saint Ursula embarking
London, The National Gallery

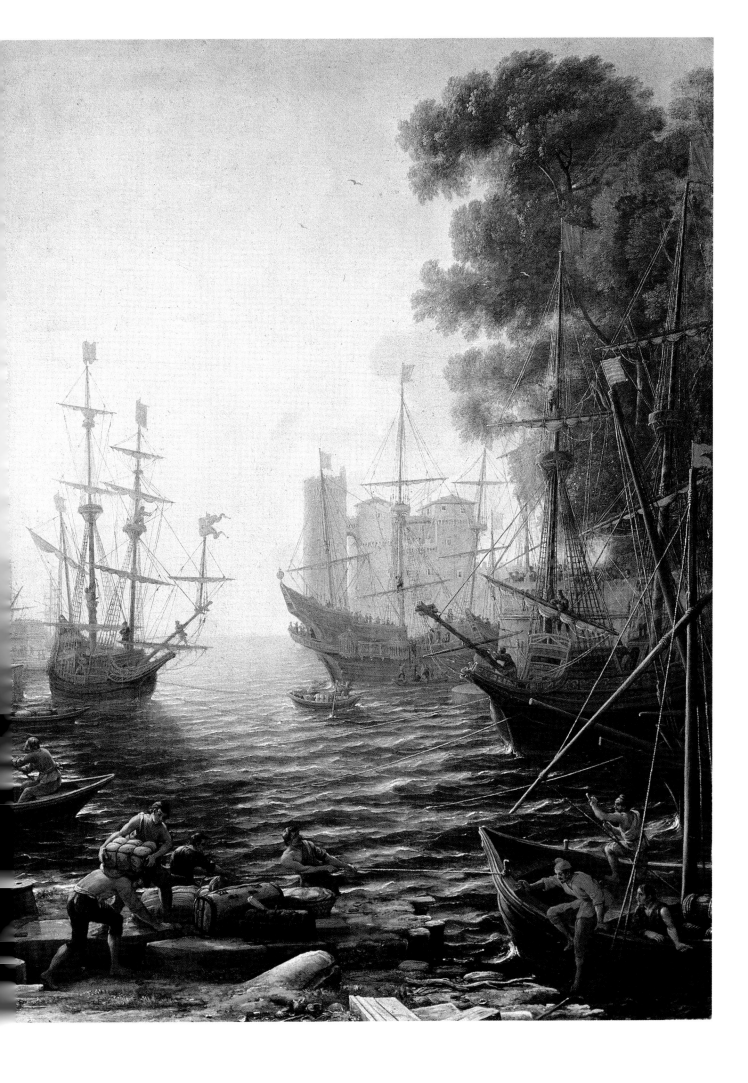

tures shows Poggioreale, the Renaissance villa of the kings of Naples (1641), revived in a free way with its garden and pool. On one occasion he paints a view of Piazza del Popolo in Rome looking toward the city gate and the church, but places an entirely imaginary palace gatehouse opposite the church. There are interiors, porticoes and open-ended galleries, baths (*Christ Healing at the Pool of Bethesda*); pools surrounded by arcades, become a favorite theme of Viviani Codazzi's son Niccolò, and are transmitted through him to Northern Italy[20].

Interiors, which are rare in the work of Codazzi and Lemaire, form the main subject of the Dutch architectural fantasy of the same period; specifically the interiors of churches and palace galleries. The churches, ranging in style from Gothic to Renaissance, form a wide space in the foreground filled with visitors, pulpits, and platforms, altars and tombs; it is closed off by a barrier reminiscent of the transverse rows of columns in contemporary stage-sets (e.g., Torelli): in this case it is a choir-screen, behind which the perspective of the nave dominates. The fittings and ornamentation mark the church out as Catholic or Protestant. The richness of the architecture and furnishings diminishes toward the middle of the century; a standard obliquely placed space replaces the partition and diminishes the sharp perspective just as effectively, the subtle representation of light and space replacing the sumptuousness of the multitude of ornamental objects. Realistic – though often equally imaginary – "democratic" space, which first appears in the Delft school of Houbraken, Saenredam, and De Witte, takes the place of the "princely" fantasy architecture of the first half of the century.[21]

The second great theme of the Flemish architectural painting is the palace, the representation of which is much less uniform and logical than that of the church: lateral loggias, a

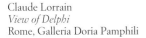

Claude Lorrain
View of Delphi
Rome, Galleria Doria Pamphili

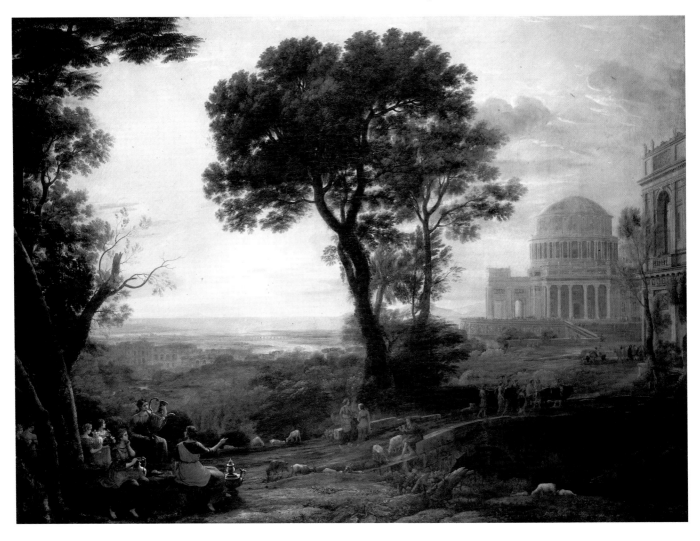

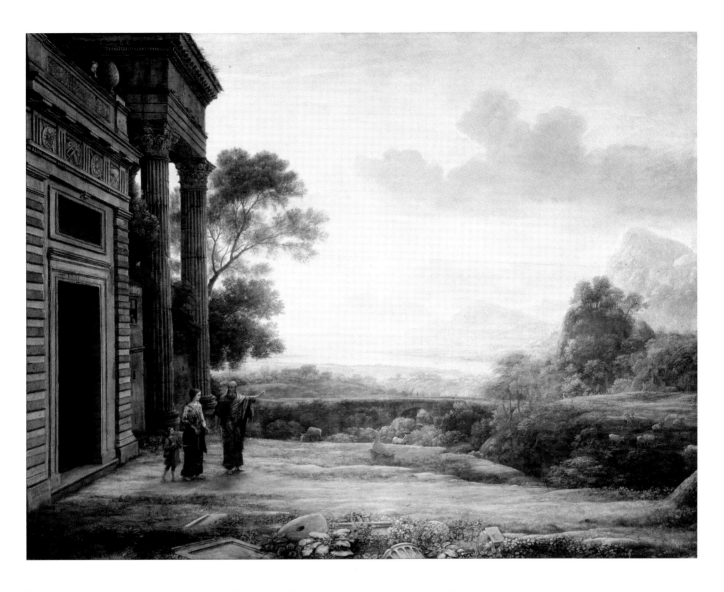

Claude Lorrain
*Abraham expels Hagar
and Ishmael*
Munich
Alte Pinakothek Bayerisches
Staatsgemäldesammlungen

following pages
Hubert Robert
The monuments of Paris
Montreal
Power Corporation du Canada
cat. 641

[20] Marshall 1991.
[21] Jantzen 1910; Liedtke 1970;
Schreiner 1980; Liedtke 1982;
Perspectives 1991.
[22] Ballegeer 1967; Liedtke 1970;
Fuhring 1997.
[23] Hoogewerff 1923; Grosshans
1980; Zweite 1980; Blade 1987;
Wied 1990.

central open gallery and conclusive façades loosely grouped around courtyards and gardens, with an abundant presence of courtly life (here too we find banquets, music-making, and promenades, or a biblical theme such as the return of the Prodigal Son). Architectural themes such as the loggia and the orthogonally placed, receding gallery (sometimes two-storeyed in both cases) are much more recognizably derivative of the architectural treatises than those painted by contemporary Italian artists. Their main source is Hans Vredeman de Vries[22] (1527–before 1609), who painted some pictures of this type himself (four of them, dating from 1596, can be seen in the Kunsthistorisches Museum of Vienna); his engravings remained influential throughout the seventeenth century, partly because, unlike the Italian engravings of Lomazzo or Montano, they provided ready-made examples of complete pictorial compositions.

He was the inspiration behind the dominant Antwerp school of architectural painting, together with its ramifications in southern Holland (for example Rotterdam, Middelburgh, The Hague, etc.): Hendrick van Steenwijck Father and Son, Hendrick Aerts, Bartholomaeus van Bassen, Anthonie de Lorme, Dirck van Delen, and Daniel van Blieck, among others.

Dutch architectural painting is therefore older as a fixed genre than the Italian. Simultaneously with Tintoretto, Veronese and above all Paris Bordone, who is particularly close in spirit to the northern artists, architecture is already present, and is accorded equal status with the figural theme, in Flemish compositions of the second half of the sixteenth century.[23]

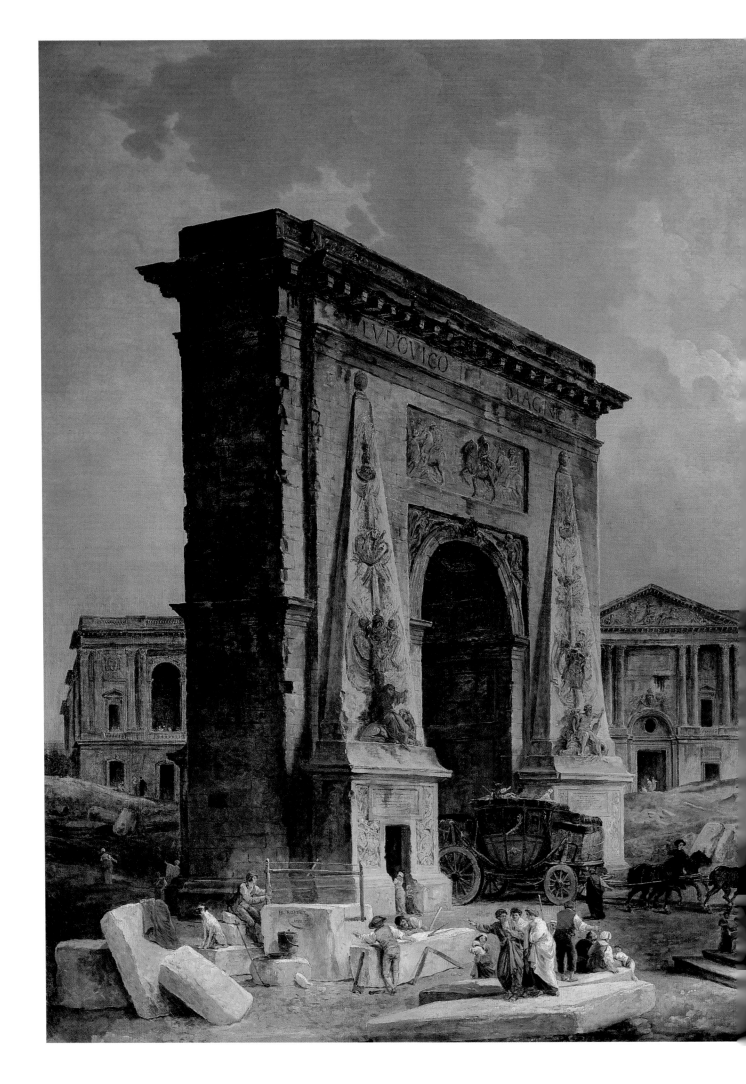

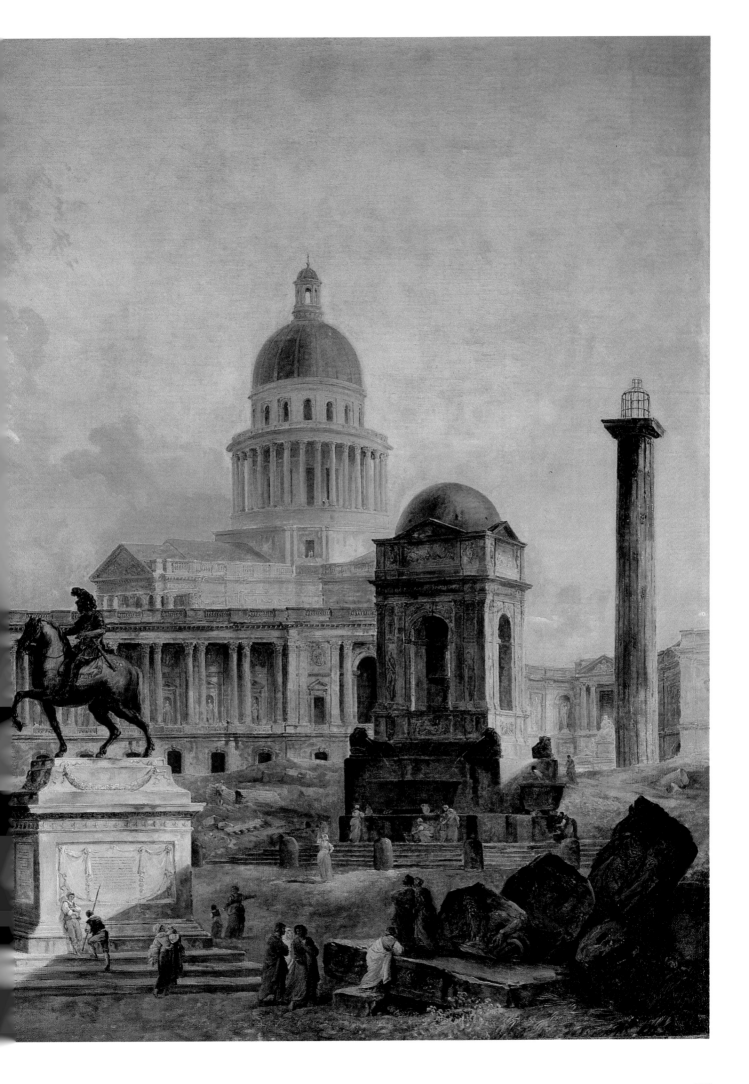

Gerrit Houckgeest
Architectural fantasy with figures
Edinburgh
National Gallery of Scotland
cat. 627

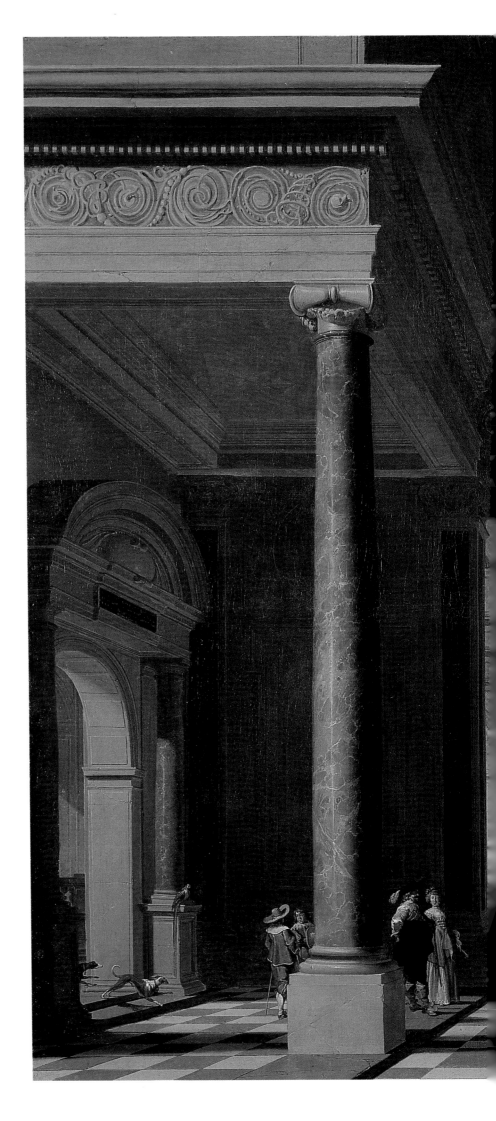

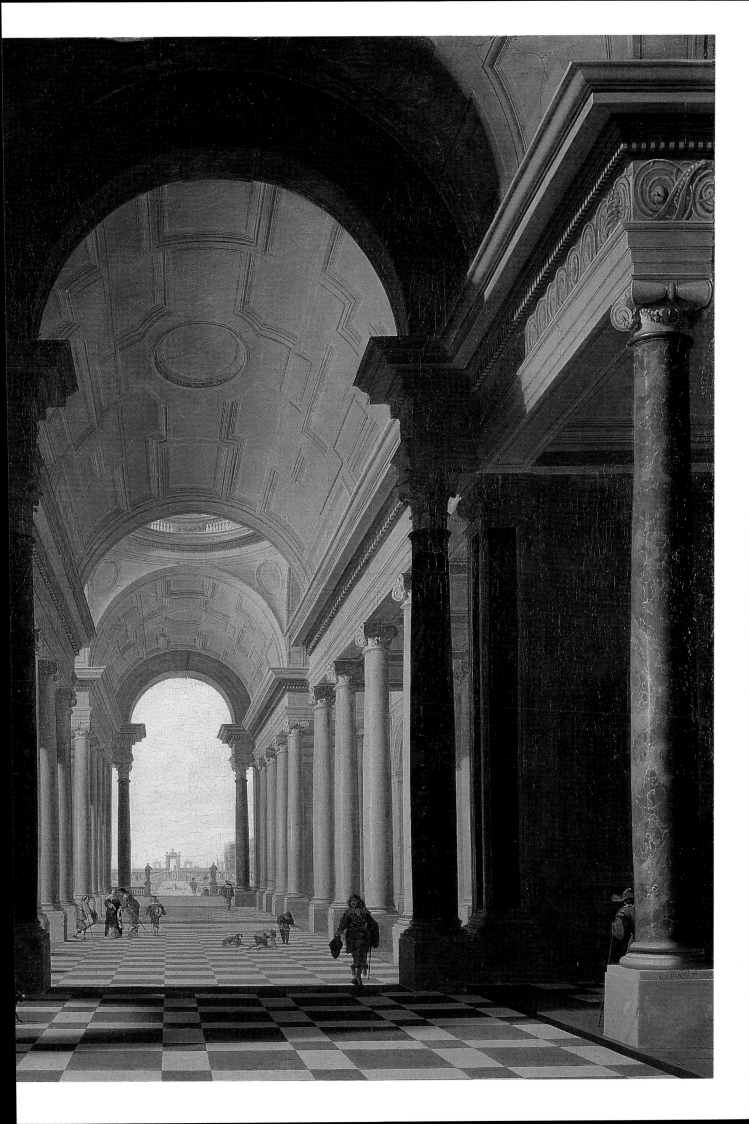

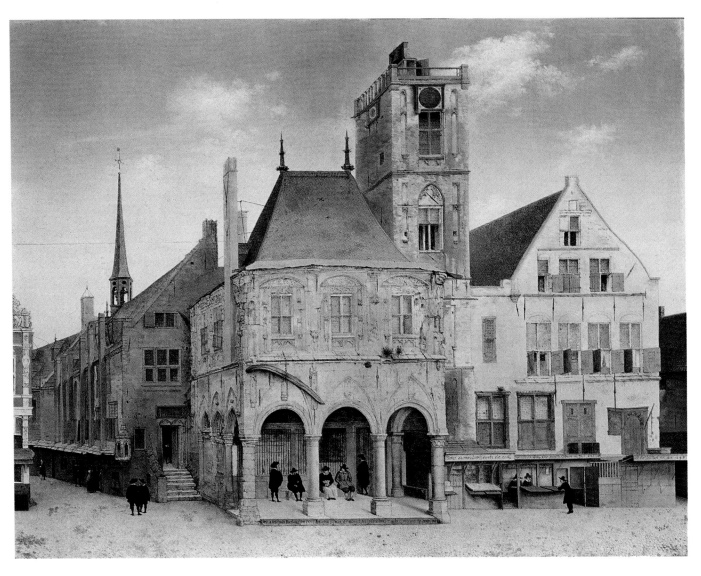

Pieter Saerendam
The Old Town Hall in Amsterdam
Amsterdam, Rijksmuseum

This can be seen in the scenes of the construction of the Tower of Babel depicted by such artists as Pieter Bruegel the Elder, Jan van Scorel, Michiel de Coxcie, Hendrick van Cleve, Lucas and Martin van Valckenborch, Dirk Aerts, and Dirck van Delen; or the extensive city landscapes of Maerten van Heemskerck (1498–1573) on the theme of the *Rape of Helen* (Baltimore, Walters Art Gallery) and the *Good Samaritan* (Haarlem, Frans Hals-Museum). Their art is continued in the seventeenth century in Treviso through the work of Lodewijk Toeput, known as Pozzoserrato, a pupil of De Vos and Tintoretto (*The Rich Man's Banquet*, Kassel, Gemäldegalerie).[24] As late as the 1630s the Alsatian Johann Wilhelm Baur (1607–42)[25] – incidentally a pioneer of the autonomous *veduta* – had great success painting small parchment gouaches of biblical scenes and martyrdoms with an extreme perspective of streets and arcades (there is one such series in the Escorial), as well as harbor quays, where he blends the style of Claude Lorrain with the older one of Vredeman de Vries. So although in the mid-seventeenth century in the Netherlands the autonomous evolution of "architectural fantasy" led to the realistic church picture and the *veduta*, its later manifestations show a growing Italian and French influence, as in the work of Isaac de Moucheron (see also the painting by Quellinus and Huysmans); or alternatively they flow into the pseudo-vedute of Dutch places (Jan van der Heyden, 1637–1712).[26]

In France the architectural picture was not particularly popular, and preserved the erudite and intellectual character which had characterized it in the sixteenth century. Artists like Rémy Vuibert (ca. 1600–52) or Thomas Blanchet (1614–89) had worked in Rome alongside Poussin and the young Lemaire, but their work, like that of Lemaire after his return to France, has a cool remoteness; no longer does any poetic life emerge from the

24 Menegazzi 1958; *Toeput a Treviso* 1988.
25 Bonnefoit 1997.
26 Wagner 1970.

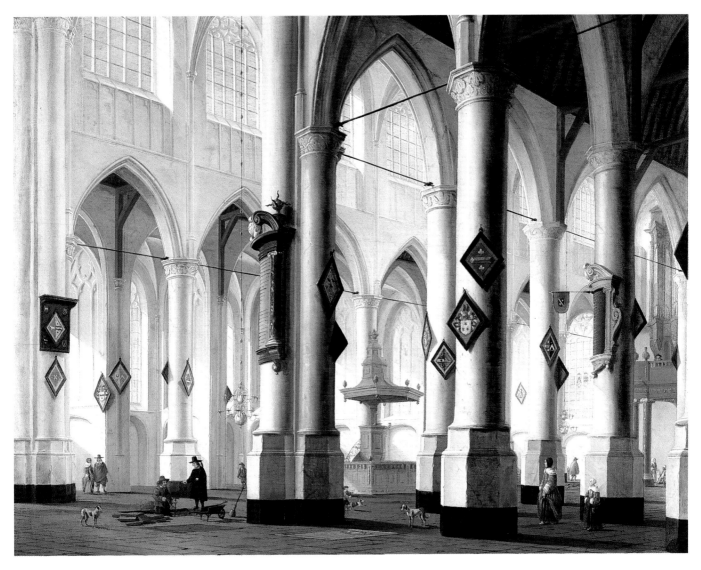

Daniel de Blieck
Interior of a church
Private Collection

world of ruins, it is replaced by perfect reconstructions of complete city squares, an "Attic" world. In the last quarter of the century this extreme rigor diminishes in the few easel paintings of Jacques Rousseau (1631–93), who was mainly a painter of imaginary architectures in monumental contexts – he too had visited Italy – and of his pupil Philippe Meusnier (ca. 1656–1734). Again it was an engraver who provided an abundance of models in his numerous published series, which were sometimes *à la romaine*; the engraver in question was Jean Le Pautre (1618–82).[27] With his mausoleums, tombs, sepulchers, grottoes, fountains, alcoves, fireplaces, tabernacles, vases, etc., he exerted an influence which crossed national boundaries (for example, it was probably felt by Carlieri).

In Rome Codazzi followed a similar line to late Lemaire. Working alongside him were a number of other less specifically architectural painters whose work was less austere and sophisticated, including the Bamboccianti. Filippo Gagliardi (Filippo delle Prospettive, ca. 1606–59) is close to Codazzi.[28] Alessandro Salucci (or Saluzzi) is most clearly exemplified by two paintings in the Galleria Pallavicini in Rome.[29] A more inventive successor of his in the latter half of the century is Pietro Francesco Garoli (1638–1716); compare his *Triumph of David* and *David Dances before the Ark of the Covenant* in the Galleria Spada in Rome (1698-99).[30]

The most common kind of painting, however, was the pure ruin painting, which typically showed an accumulation of architectural and sculptural fragments in the foreground, and behind them isolated columns or rows of columns, arcades, and perhaps a rotunda or a pyramid.

[27] Préaud 1993.
[28] Marshall 1993: 519–55.
[29] F. Zeri 1959: 446-47; Busiri Vici 1962.
[30] F. Zeri 1954: figs. 96–97; commissioned by Cardinal Spada as "quadri di prospettiva."

Emmanuel de Witte
Interior with woman at clavichord
Montreal, Musée des Beaux-Arts
Museum of Fine Arts
cat. 270

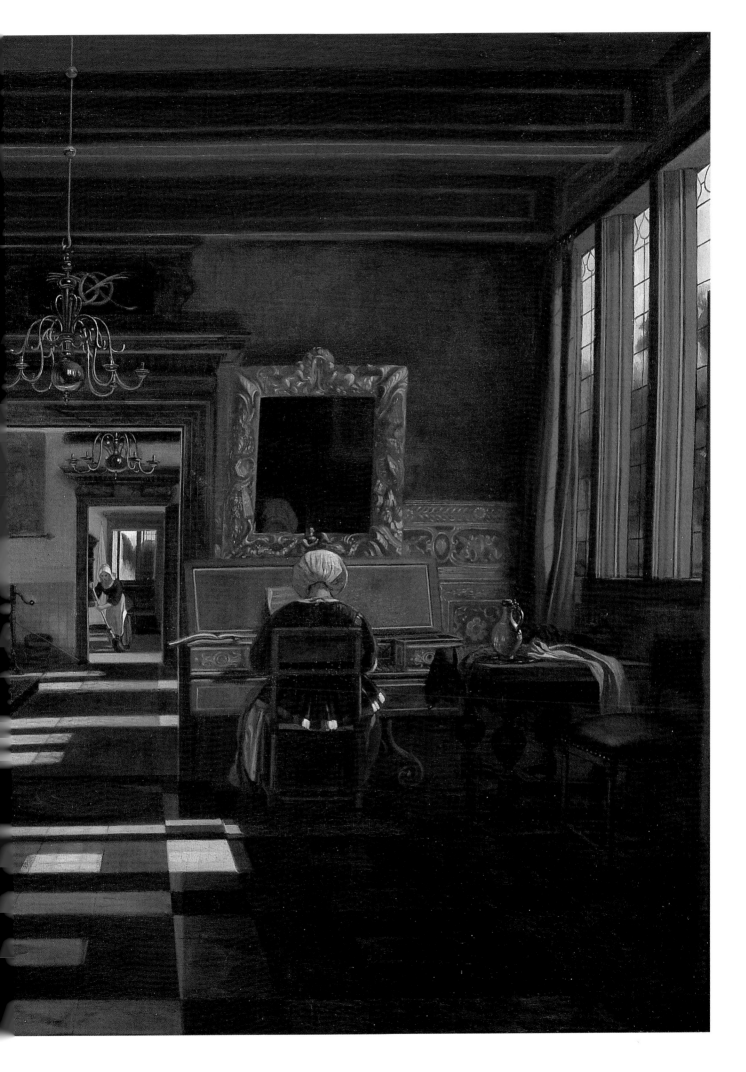

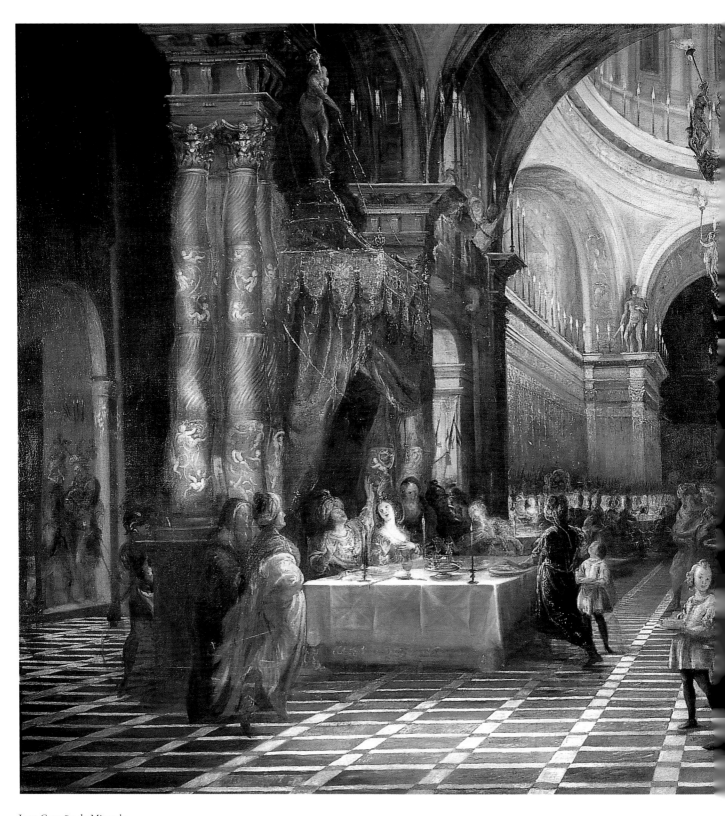

Juan Carreño de Miranda
Balthazzar's Feast
Durham
The Bowes Museum Barnard Castle
cat. 629

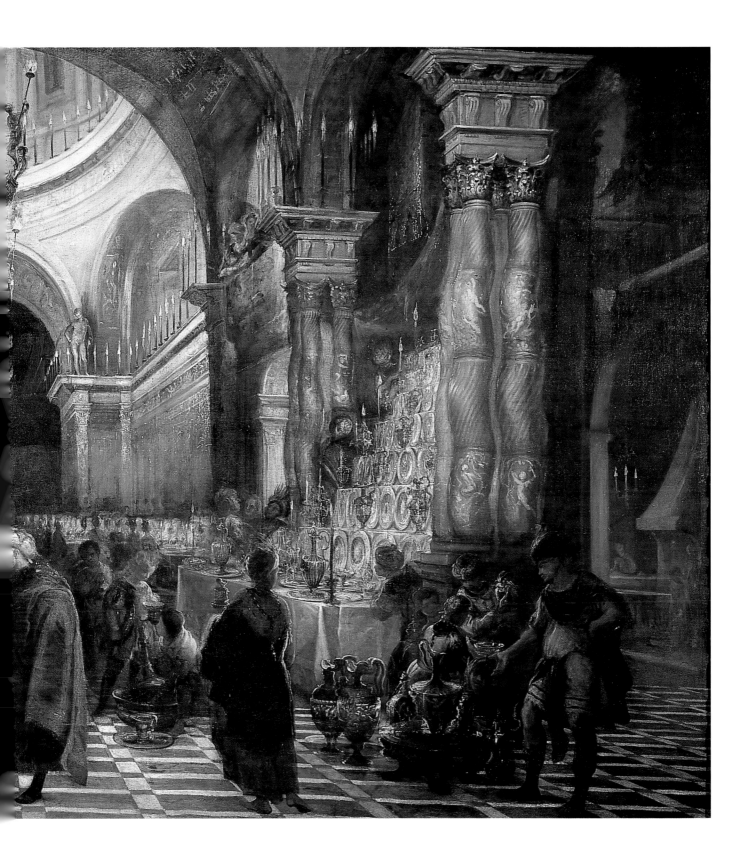

The basic scheme is that of a horizontal row of arches in the middle ground through which one sees further architectures or a landscape from which a row of columns runs forward (this formula, too, is already present in Lemaire and Codazzi). The strictest and most influential practitioner of this type of painting was the Milanese Giovanni Ghisolfi (1621–83),[31] who spent the 1650s, a crucial period in his artistic development, in Rome. Alberto Carlieri (1642–after 1720) gave a more Baroque and complicated twist to this simple formula by overlaps and breaks.[32] In general the growing tendency of this type of painting to run wild and become banal goes hand in hand with an increasing predominance of purely pictorial interest, of the picturesque and the landscape.

This is particularly the case in the Neapolitan school with Angelo Maria Costa (d. after 1721), Gennaro Greco, known as "Mascacotta" (d. 1717), Pietro Cappelli (d. 1727), Onofrio Giannone, Nicola Viso, a follower of Codazzi, and Leonardo Coccorante (1680–ca.1750).[33] "Frayed" ruins overgrown with vegetation, foaming waves, and figures in dance-like movement create a playful, Rococoesque atmosphere. The same is true of Luca Carlevarijs (1663–1730)[34] in Venice, though in his work the *veduta* gains the upper hand; he is fond of putting the aforementioned ingredients into fantasy views of harbors (one group of such works is dated 1713–14). Antonio Stom (1688–1734)[35] shows similarities to the Neapolitans. Finally the genre spreads, through Ghisolfi himself, Costa, Raffaello Rinaldi (known as "Menia", in Modena, 1648–1722), and others, to Lombardy and Emilia Romagna. Here it meets up with the tradition of *quadratura* and *scenografia*, which was just then nearing its zenith. With the Piacenza-born Giovanni Paolo Pannini (1691–1765),[36] who settled in Rome in 1711, the ruin painting reaches its highest perfection and becomes an integral part of the artistic representation of Rome. Garoli, followed by Carlieri and then Pannini, taught perspective at the Roman academy of art. Carlieri studied under Andrea Pozzo in Rome, and Pannini had come into contact in his home town with Rinaldi and also with Fernando Galli da Bibiena, or other exponents of Bolognese *quadratura*. The *quadro di prospettiva* around the seventeenth century was participating in the enrichment and the increasing virtuosity of perspective construction. With Pannini the ruins acquired a new dignity and monumentality. He gives them a more real presence, which however does not – as it does in Codazzi – connect them with the world of everyday architecture.

The idea of *vanitas* in his work is neither sentimental nor playful; rather, it hints at a philo-

Luca Carlevarijs
The quay of Palazzo Ducale
St. Petersburg
The State Hermitage Museum

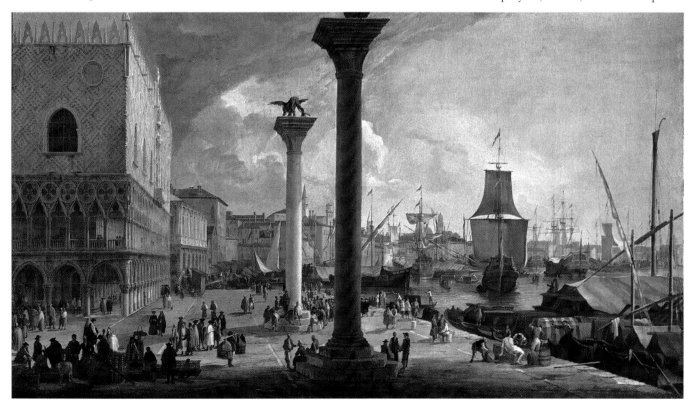

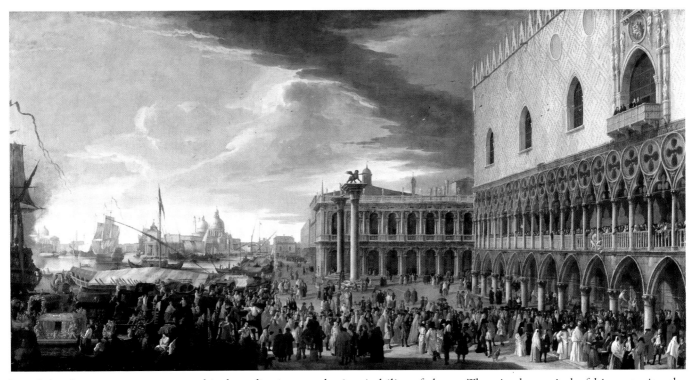

Luca Carlevarijs
*Arrival of the Count of Manchester
in Venice in 1707*
Birmingham
City Museum and Art Gallery

[31] Busiri Vici and Cosmelli 1992;
Marshall 1992; Marshall 1997.
[32] Voss 1959; Murawska 1989;
Marshall 1997.
[33] Ferrari 1954.
[34] Rizzi 1967; *Luca Carlevarijs*
1994.
[35] *Marco Ricci* 1993.
[36] *Pannini* 1992; Arisi 1993; Marshall 1997.
[37] Arisi 1993: 243–47; preliminary
stages are no. 160 dated 1724 and
no. 192 dated 1728. Pannini certainly won the Spanish commission through Juvarra.
[38] Bandera 1990; Casali Pedrielli 1991.
[39] See also note 6; for all the
Venetian painters see also *Capricci veneziani* 1988.
[40] Barcham 1977; *Canaletto* 1982;
Corboz 1986; Constable, Links
1989.
[41] Kozakiewicz 1972.
[42] *Canaletto & Visentini* 1986–87;
Capricci veneziani 1988: 203–51.
[43] Toledano 1988.
[44] *Capricci veneziani*: 325-83.

sophical meditation on the inevitability of decay. Thus in the period of his maturity, the 1720s, a common theme is that of the missions of Christ and Saint Paul, who build their new world on the ruins of the old, declining one; whereas in his later work the Arcadian mood of life in the ruins once again predominates. The familiar settings are combined in an infinite number of ever-changing ways, while the objects are increasingly identifiable as specific monuments of Rome: the Colosseum and the Pantheon, the Janus Quadrifrons, the Temple of the Dioscuri in the Forum, and so forth.

The viewpoint is often low down, thus increasing the weight of the lower areas, the pedestal and the shafts of the columns; on the other hand, he is also fond of stilting the arches with other inserted connecting pieces. An ancient beginning is given a modern addition; from the themes of ancient architecture there develops a new, reformed architecture. The low viewpoint, the use of groups of four columns (instead of massive pillars), stilted arches and the accompanying attics, tetrapyla, massive volutes, etc., derive from the repertoire of Bolognese *scenografia*; with rows of architrave-supporting columns and open column-rotundas they combine to create a new kind of ancient-modern architecture. In a few cases, notably when working on commission, Pannini intensifies these innovations to achieve a magnificent effect: see the set of four scenes of Christ preaching in the temple which he painted in 1734 for the royal Spanish castle La Granja.[37]

Although Bibbiena and the quadraturists generally specialized in wall-painting, it was only natural that there experiences in Bologna should influence easel painting too; and their influence can be seen in Pietro Paltronieri, known as "il Mirandolese" (1673–1741), and Vittorio Bigari (1692–1776).[38] Mirandolese was employed by MacSwiny for his "Tombs," and the attribution of some ruin paintings is disputed between him and Bigari; possibly they are collaborative efforts. The finest work of these painters, however, consists in three large tempera paintings by Bigari (Bologna, Pinacoteca Nazionale), which show sumptuous imaginary reception rooms growing out of real Bolognese rooms, and a Gothic church covered in Rococo ornamentation.

As in sixteenth-century Rome, so in seventeenth-century Venice the architectural fantasy reached its peak during a period when the fine arts in general were flourishing, with Marco Ricci (1676–1729),[39] Antonio Canaletto (1697–1768)[40] and his nephew Bernardo Bellotto (1721–80),[41] Antonio Visentini (1688–1782),[42] Michele Marieschi (1710–43),[43] and, lastly, Francesco Guardi (1792).[44]

Generally speaking, architecture in Venice is much more part of a town or country con-

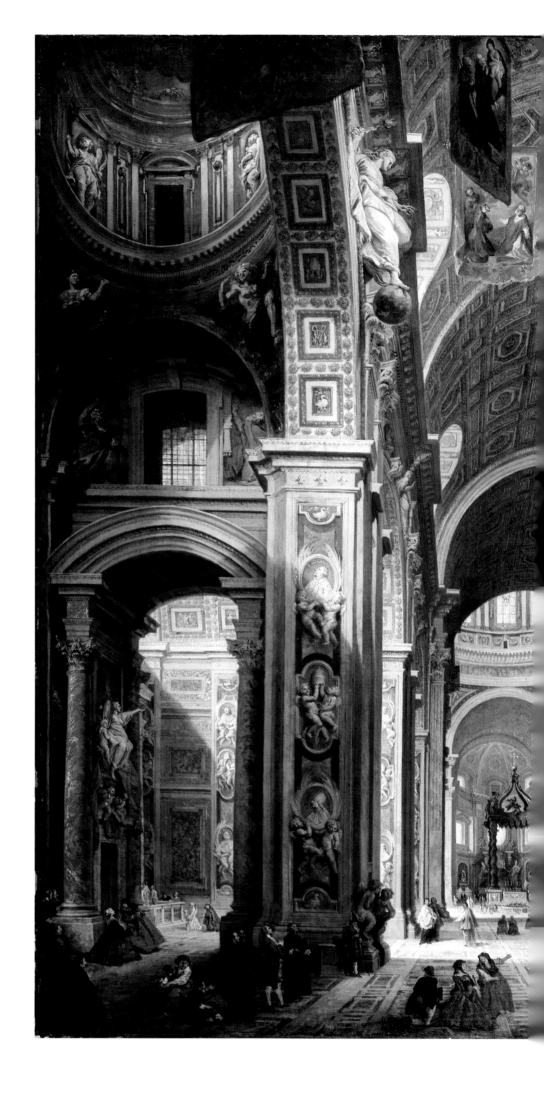

Giovanni Paolo Pannini
Interior of St. Peter's
Washington, D.C.
National Gallery of Art
cat. 8

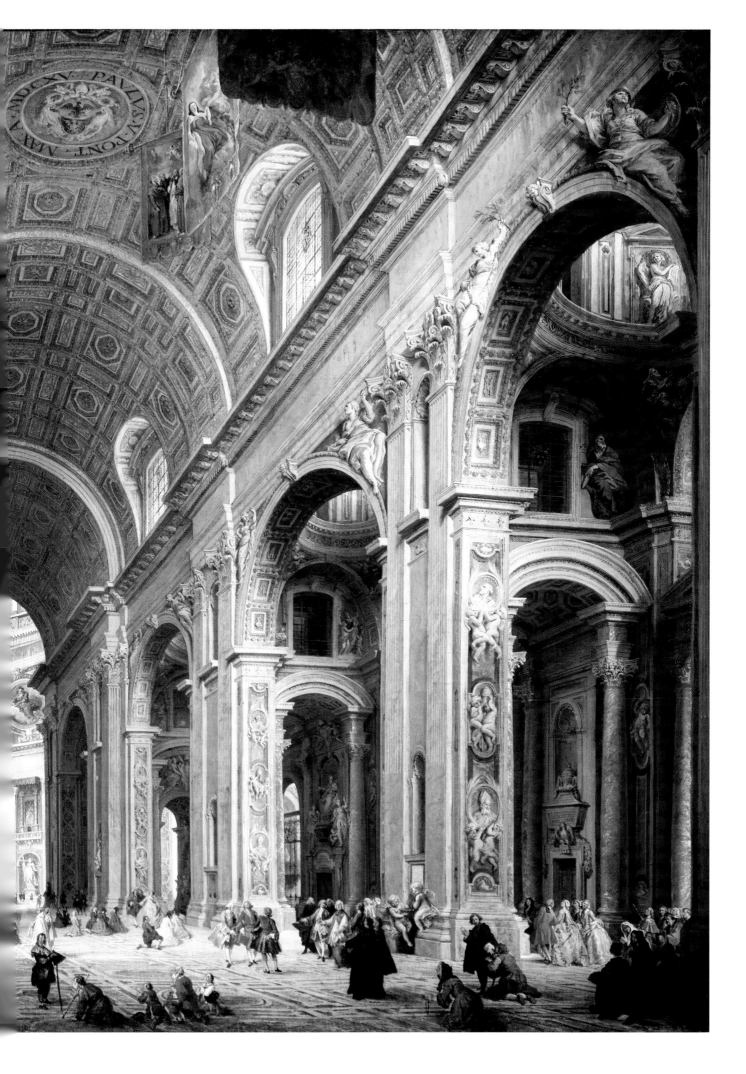

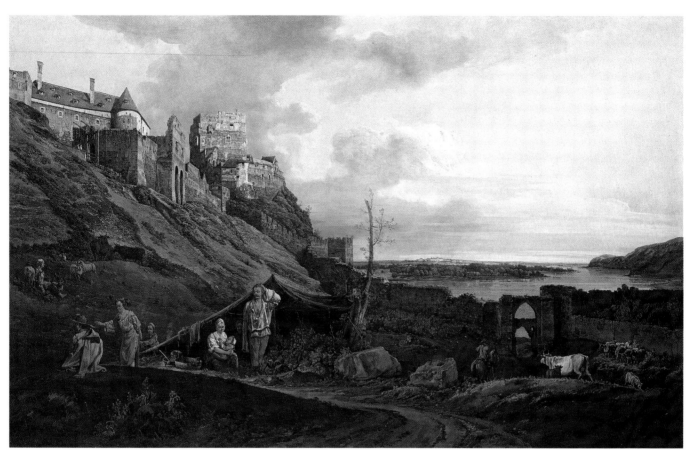

Bernardo Bellotto
Ruines of Thebes
Vienna, Kunsthistorisches Museum

Andrea Pozzo
*Fictive architecture for the vault
of Sant'Ignazio*
Washington, D.C.
National Gallery of Art
cat. 505

text – a *veduta ideata* – than it is in Pannini, where it has a more markedly plastic life of its own which complements that of the figures. Pannini is primarily a painter of imaginary architectural scenery, and only secondarily of *vedute*, whereas Marco Ricci is primarily a landscape painter; Canaletto, Bellotto and Guardi are primarily vedutisti, Marieschi is both landscape painter and vedutista, and Visentini is an architectural theorist.

A fine early example of this embedding of architecture in an urban landscape which is open to nature is a *capriccio* by Carlevarijs datable to 1712, showing an old curved bridge, the Arch of Constantine, and an equestrian statue (Vicenza, Museo Civico d'Arte e Storia), and an adaptation of this painting by Marco Ricci into a picture which gives the impression of representing a real scene: now there is a medieval tower at a bridge, and the bridge leads to a classical-looking town (1719?, Windsor Castle).

From 1710 or thereabouts[45] Ricci paints tempera pictures of villas or farmyards, and, probably during the same period, others with ancient columns, vaulted rooms, etc.; clear, simple elements, whose effect derives in particular from the play of light and shade on the surfaces of the walls. The large oil paintings of ancient ruins characteristic of his last decade are more complicated, almost chaotic in their dense layers of columns, statues, porticoes, and so on, broken up by views of the background. He differs from Pannini in that his primary concern, in paintings whose subject matter always remains more or less the same, is with pictorial texture and the light. So it is doubtful whether he had a part in the far more monumental, Veronesesque architectural backgrounds and sumptuous imaginary buildings which we find in the historical paintings of his brother Sebastiano of the mid-1720s (e.g., *Christ at the Pool of Bethesda*, Chatsworth; *Susanna before Daniel*, Turin, Galleria Sabauda).[46]

At the beginning of his career, probably soon after his stay in Rome in 1723, Canaletto created unconventional ruin-landscapes entirely out of his own pictorial imagination. He repeatedly returned to this subject, especially from the mid-century onward, after his great vedutista and Palladian phases: a few buildings vignettistically created from ancient, medieval and modern forms are set in the open lagoon landscape. He was imitated in this,

Bernardo Bellotto
The Colosseum, Rome
Parma, Galleria Nazionale

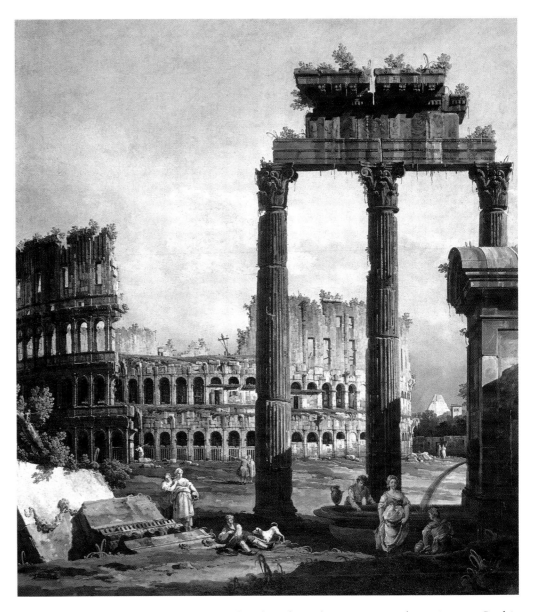

[45] The date "1702" on the picture of *Marco Ricci* 1993: no. 62 was acknowledged by Delneri as useless for the purposes of dating.
[46] Daniels 1976: figs. 171 and 284 (nos. 406 and 434).
[47] In his harbors inspired by Carlevarijs (Gazzada, Villa Cagnola) the single architectural object is completely lost.
[48] A similar style is found in the Modenese Antonio Joli (ca. 1700– 77), a pupil of Rinaldi and Pannini.

though even more delicately, by Guardi, who often places just a single ancient or Gothic arch in the wide open space.[47]

Canaletto's great importance as a painter of architectural *capricci*, however, rests on his *vedute ideate* of 1743–46, where, the strict construction of the vedutista lends credibility to a reformed, Palladian architecture. Painting on commission by, and under the instructions of, the British consul Smith and the artistic theorist Algarotti, he transferred classic buildings of the Italian Renaissance and English neo-Palladianism to the urban context of Venice or the border area between town and country; these lead to the collective views of Palladio's buildings on the Rialto.

Visentini, working in collaboration with the landscape painter Zuccarelli, also carries out commissions of this kind. Like many others, he paints pictures of simple rows of columns running horizontally or receding into the distance. In the same years, ca. 1765–66, Canaletto, Visentini, and – in Paris – Hubert Robert present architectural *capricci* as commemorative gifts on their admission to the academies.

Visentini's most attractive works, however, show freely invented modern, open architectures of great variety, in Rococo vein with scenes of contemporary life (ca. 1740, Venice, Palazzo Contarini);[48] one senses an affinity with Giuseppe Galli da Bibiena and Juvarra, though there was probably no direct influence. Less freely, but with charming inventiveness, Marieschi in his early years adorns his landscapes picturesquely with ruined bridges,

triumphal arches, little quadratic temples and tetrapyla, campanili, lighthouses, and obelisks, in ancient or Gothic style, then in his later years moves on to strangely austere palace blocks and courtyards.

Lastly, Bellotto: again the *capriccio* begins and ends a career the middle portion of which was entirely devoted to the *veduta*. Already in his Venetian beginnings, but especially during and after his journey to Rome in 1742, Bellotto paints imaginary views of Rome, particularly of the ancient parts of the city, usually modifying reality only by minor shifts and additions (thus a realistically depicted Capitol hill is seen through a portico at its foot; Parma, Galleria Nazionale); or similar views of northern Italian towns, which appear enhanced by ancient features. In his final Dresden years, 1762–65, he turns to splendid fantasies of modern palaces with stairways and porticoes; they are far more monumental than those of Visentini, but similarly reminiscent of Bibiena and Juvarra, and through them of Hubert Robert. In a period of personal hardship he invents the most sumptuous architecture of all, places himself in it in the costume of a Venetian nobleman, and proclaims, through inscriptions taken from Horace, his awareness of the value of his art: "Pictoribus atque poetis quodlibet audendi semper fuit aequa potestas" (Painters and poets have always had an equal right to invent whatever they like"; Warsaw, Muzeum Narodwe).

The last steps in the architectural fantasy, however, are taken by French painters. There are two names, whose oeuvre embodies the extreme: Jacques Lajoüe (1686–1761) and the said Hubert Robert (1733–1808).[49]

In the former, architecture becomes ornamentation, Rococo invention; the latter swells

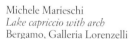

Michele Marieschi
Lake capriccio with arch
Bergamo, Galleria Lorenzelli

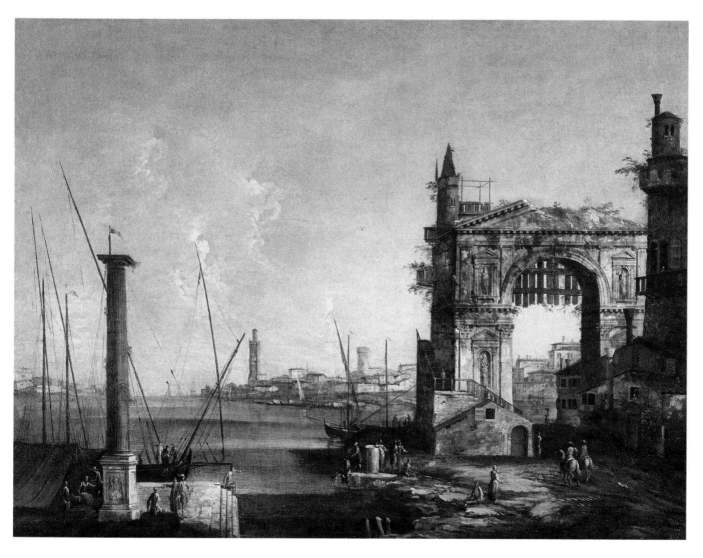

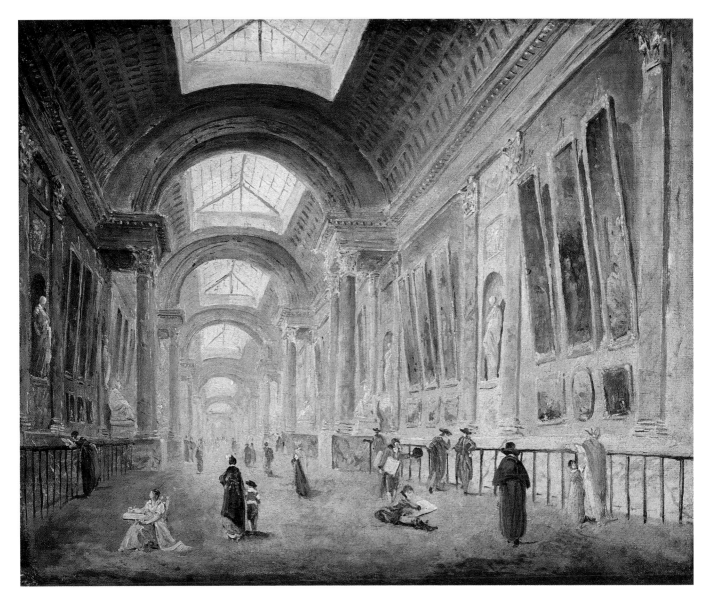

Hubert Robert
Lighting project
for the Grande Galerie of the Louvre
Paris, Musée du Louvre

existing buildings or types of building to superhuman size, taking a route from Piranesi toward Boullée.

Lajoüe was only a few years older than Pannini, Visentini and Bigari; Bigari had the closest affinity to him of all the Italians, and imitated his fantastically amorphous library, apparently via an engraving. Lajoüe's "library" and "natural history specimen-cabinet" were over-door panels in the relevant rooms of the Paris house of the collector and *curieux* Bonnier de la Mosson (1734; now Russborough, Alfred Beit Coll.). The allegories in the palace of his brother-in-law, the Duc de Picquigny (1735–37, only extant in an engraving) demonstrated the essence of Lajoüe's inventiveness: rooms viewed in a continual curvilinear movement between ground plan and elevation with round windows and oculi; the allegory of *Architecture* as a park staircase in the process of construction with huge volutes, which could serve as a leitmotif for the formal principle. The paintings *Modern Architecture* and *Ancient Architecture* (Private Collection) are depicted respectively in the process of being erected and being destroyed. The ideal place of his architectural fragments is the park with steps and niches, foliage, and above all spring-water in movement, and vegetation.

If Lajoüe's buildings, despite their swollen ornamentation, always remain small, Hubert Robert achieves the effect of gigantic size by showing parts of a whole from a close-up or low-down viewpoint: walls, or the domes, the apse, and the steps in front of the façade of

[49] Held 1959; Burda 1967; *Fragonard* 1990–91; Herzog 1989.

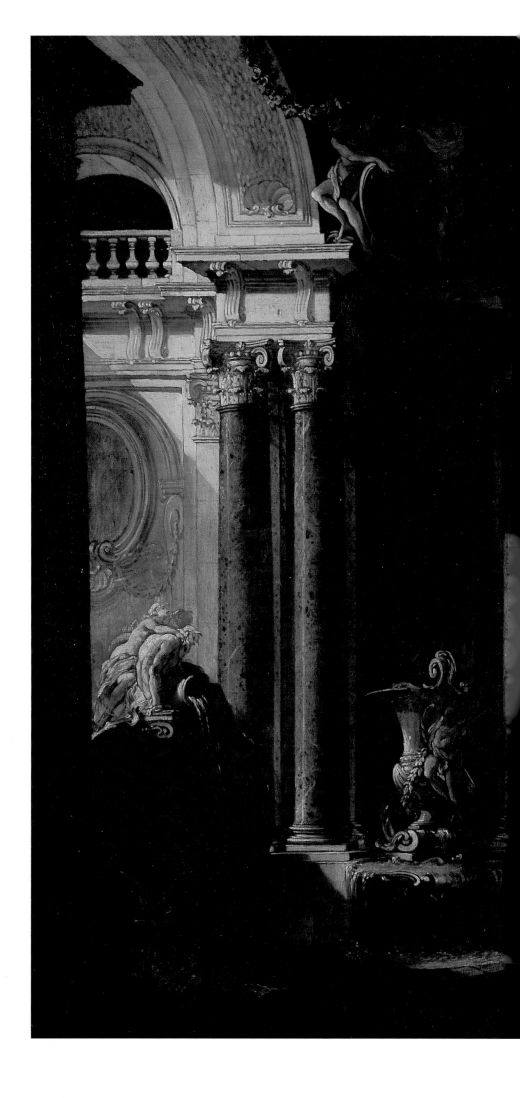

Jacques Lajoüe
Intérieur de Palais donnant
sur des jardins
Munich, J. P. Brasseur & M. Gregor
Kunstfonds & Galeriehandelsges
mbH
cat. 638

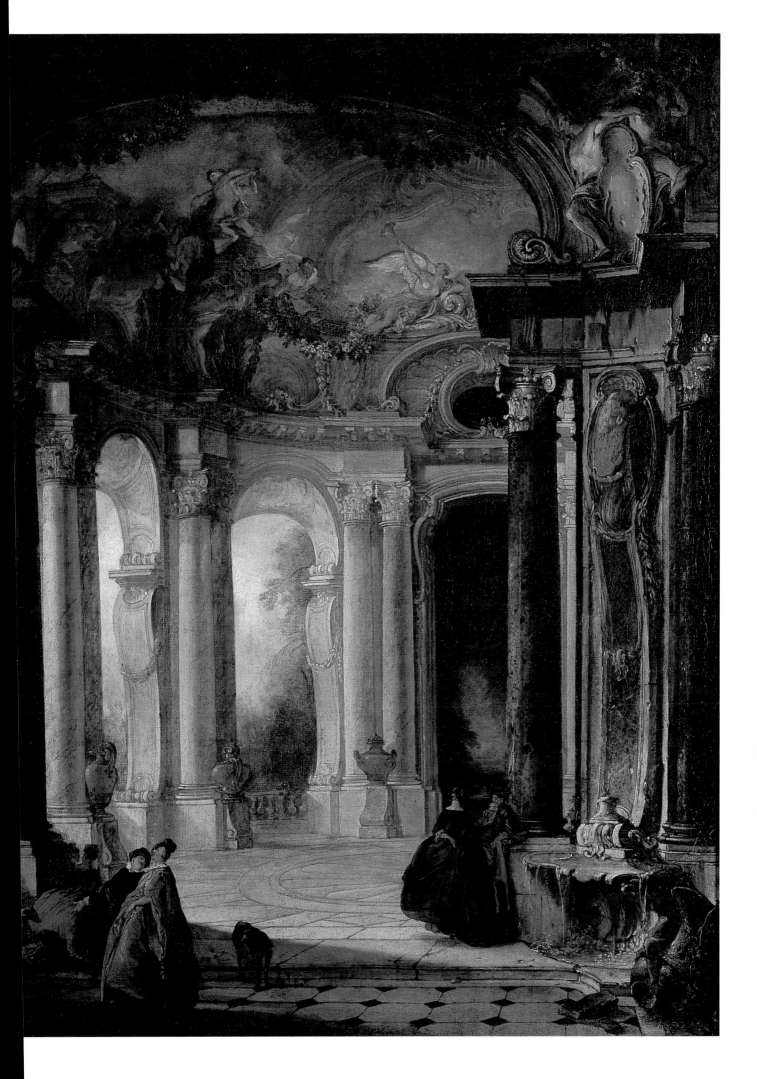

Anonymous
after Giuseppe Galli da Bibiena
Project for a set design
Montreal, Collection Centre
Canadien d'Architecture
Canadian Centre for Architecture
cat. 467

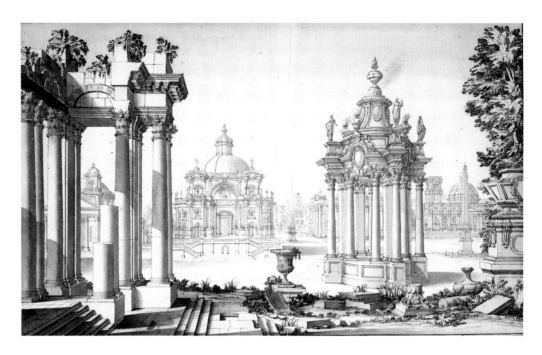

Gilles Marie Oppenord
Project for a fire hearth in the Hôtel
de Pomponne
in Place des Victoires, Paris
New York, Cooper-Hewitt, National
Design Museum
Smithsonian Institution – Art Resource
Gift of the Council
cat. 328

St. Peter's, as well as Villa Madama, Caprarola, etc. In the *Ancient Bridge* (1760; New Haven, Yale University Art Gallery) there is a similar formal principle of continually curving walls to that which we find in Lajoüe, and the same use of park stairways; the little Pyramid of Cestius, so beloved of Pannini and other painters of Roman ruins, is replaced in his work by a pyramid of Egypt which is cut off and seems all the larger for it (Northampton, Museum of Art, Smith Coll.). Robert starts out in the manner of Pannini, but the decisive influence on him was the art of Piranesi. His *Port Adorned with Architecture* (ca. 1760, Dunkirk, Musée des Beaux-Arts) combines several of the engraver's compositions, and already shows the massive rows of columns and arches receding into the background. After coming to Paris after ten years in Rome he repeatedly returned to such themes, especially that of the ruined gallery with coffered vaulting over freestanding columns and architrave.

No paintings of this type by the other *Piranésien*, Charles Michel-Ange Challe (1718–78) have yet been identified with certainty. Pierre Antoine De Machy (1723–1807) paints more *vedute* than architectural fantasies, but – again one is reminded of Lajoüe – he chiefly concentrates on Parisian buildings in the process of construction or demolition, in other words "ruins," but ruins not in a state that has become virtually timeless, but rather one that is given a realistic motivation as a contemporary event.[50] Last of all, Robert anticipates the future, when he represents the newly built Grande Galerie of the Louvre as a ruin: the experience of the past takes on a new pregnancy (1796; Paris, Musée du Louvre).

In the course of the eighteenth century architecture as an object of artistic representation acquires a new magnificence and a new popularity. But what appears in the paintings discussed above is only part of a general change: not only the audience for architectural paintings, but architecture itself becomes increasingly international at the turn of that century. Already in the last quarter of the seventeenth century the urban view establishes itself as a genre and quickly achieves wide popularity, in Holland with Jan van der Heyden and Berckheide, in Italy with the Dutch emigrant Vanvitelli (Gaspar van Wittel). Even more significant, however, is the development of the architectural fiction into the ephemeral media of stage scenery and illusionistic decoration, the copying and diffusion of these ephemeral designs through graphic art, and then the independent development of architecture in the latter medium. Fra Andrea Pozzo's painted imaginary architecture in the ecclesiastical rooms, his designs for the ecclesiastical theater of the Quarantore (the ceremony of the forty-hour exposition of the Host), and the systematic presentation of them in the textbook used all over Europe, *Perspectiva Architectorum et Pictorum* (1691–1700), provided models and ideas.

Ferdinando Galli da Bibiena
Palace hall, with staircase
Montreal, Collection Centre
Canadien d'Architecture
Canadian Centre for Architecture
cat. 470

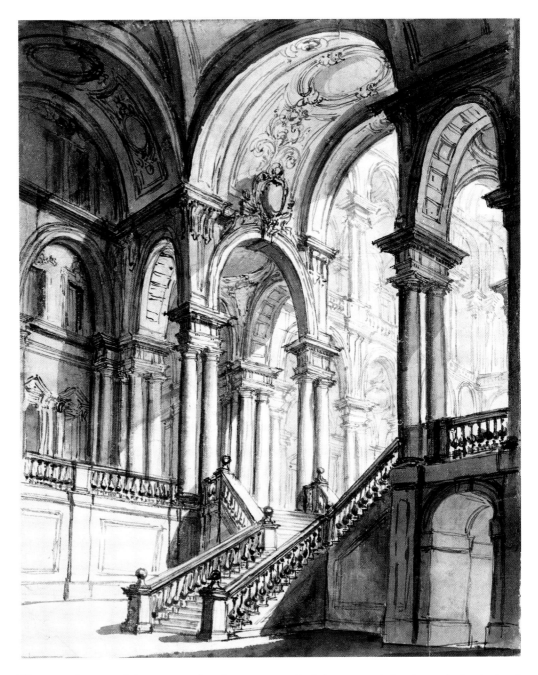

The same is true of the scenery for the court musical theater and the dynastic festivals of the Galli da Bibiena, together with the treatise by the head of the family, Ferdinando *Architettura civile* (1711), which was also universally known. Ferdinando was followed by other members of the family, as well as by Pietro Righini and the brothers Domenico and Giuseppe Valeriani, Giovanni Battista Natali, Antonio Joli and others. The scale of these media far exceeded the possibilities of the easel painting. The same is true of the often-engraved ceremonial decorations of the Chinea (the feudal presentation of a white horse to the pope by the kings of Naples on the piazzas of Rome, 1722–87), or Servandoni's plotless architectural displays in the theater of the Tuileries in Paris (from 1737 onward, the first being an interior of St. Peter's after Pannini's *veduta*). The great architect Filippo Juvarra (1678–1736) was no painter, nor did he have engravings made of his designs, but his stage sets for the little theater in Palazzo della Cancelleria in Rome (1708–14) must have been seen by many people, as must his excellent drawings, mainly dating from the same period. The same is true of the prize projects of the Roman Accademia di San Luca (from 1677 onward, its finest year being in 1732), where Juvarra himself made his

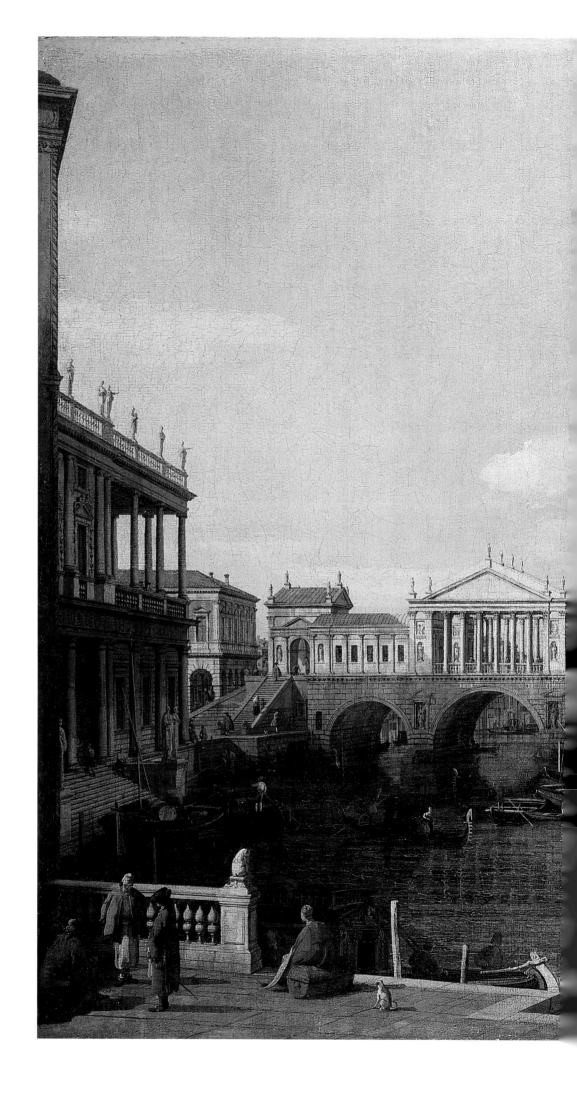

Canaletto
Palladian fantasy
Parma, Galleria Nazionale
cat. 658

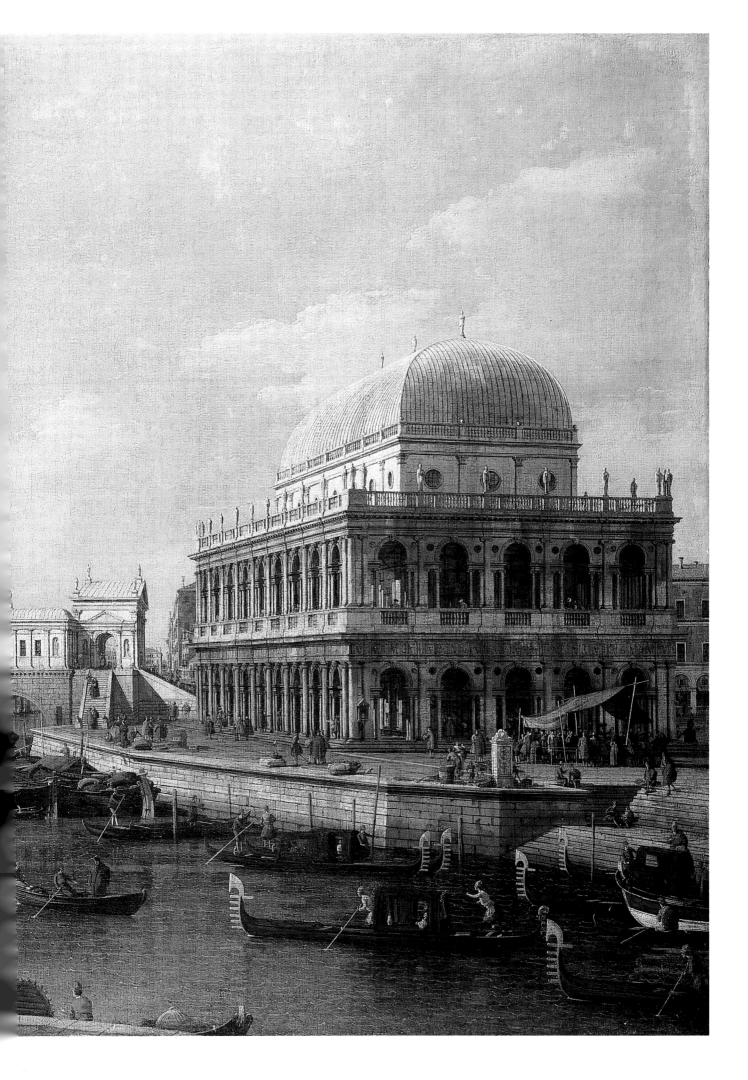

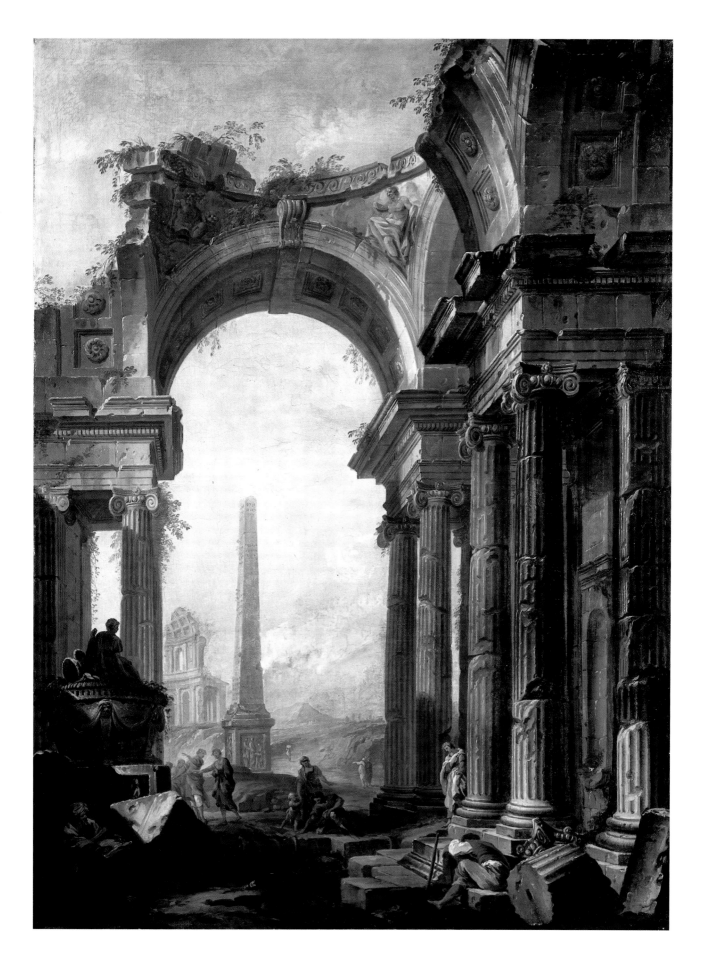

Giovanni Niccolò Servandoni
Roman ruins
Lyons, Musée des Beaux-Arts
cat. 632

name with the winning design of 1705; its example was later followed by the Parisian Academy, where, for example, De Wailly's prize-winning design of 1751, *Palace Façade*, was later displayed in the *Salons* among the paintings. In 1721 Johann Bernhard Fischer von Erlach (1656–1723), who had been trained in the Roman circle of Bernini and Carlo Fontana, published his *Entwurff einer Historischen Architektur* which contained magnificent, vivid reconstructions of famous buildings from ancient civilizations as far afield as China.

Juvarra and Giuseppe Galli da Bibiena (1698–1757) themselves took the step of creating pictorial compositions freed from their original context, *vedute ideate*, though they did this not in painting but in drawings and engravings: Juvarra produced two albums of *Disegni di prospettiva ideale* which he dedicated to Lord Burlington (1730, Chatsworth) and to August III, King of Poland and Elector of Saxony (1732, Dresden, Kupferstichkabinett);[51] Giuseppe Bibbiena published a series of engravings entitled *Architetture e prospettive* (from 1740 onward).

Such publications could provide far more effective imaginations than was possible for the painted picture, and this was particularly true of two works by Giovanni Battista Piranesi (1720–78), the early *Prima Parte di Architetture e Prospettive* (1743) and, above all, the visions of the *Carceri* (1745 and 1761). It is also true of the transformation of architecture into ornamentation and of ornamentation into architecture, where painting could only selectively emulate graphic invention. Thus even Lajoüe's place is exceptional among such French ornamental engravers as Oppenord,[52] Meissonier, Babel, and so forth. Only the ruin picture, because of its content, which was more picturesque and sentimental than constructional, could escape the dominance of graphic art.

It is true that the free invention of architecture and the systematic treatment of the themes had already found a home in the graphic arts at an earlier date, for example in Vredeman de Vries and Jean Le Pautre; but theirs generally were isolated models rather than complete pictures.

What predominates in the seventeenth century is a delight in depicting architecture; architecture being seen as a new genre which comprehends reality while modifying it, freely developing it, and reassembling it. Certainly even Claude Lorrain in his harbors presents an ideal image of purified ensembles; and in their very isolation the colonnades and rows of arcades in so many pictures, whether they are derived from ruin painting or the more monumental *quadrature*, hold up the legacy of the ancient world as a model to the modern world. But in the splendidly depicted buildings of Pannini, Joli, Visentini, Bellotto, or Robert, the propositive intent seems much clearer and also more attractively realized. With Canaletto's Palladian Rialto, and with Robert's Ripetta with the Pantheon and buildings by Michelangelo, such Baroque fantasies come up against a stricter, more academic drawing of boundaries.

[50] *Piranèse* 1976.
[51] Rovere, Viale, Brinckmann 1937: pls. 24–30; Wittkower 1949. For Giuseppe Galli da Bibiena see most recently Scotti Tosini 1998.
[52] Gilles-Marie Oppenord (1672–1742), *pensionnaire* of the French Academy in Rome between 1692–99, was an essential link to the transmission of the Roman modern vocabulary to France. See latest publication by Connors (1996) and first publication by Linfert (1931).

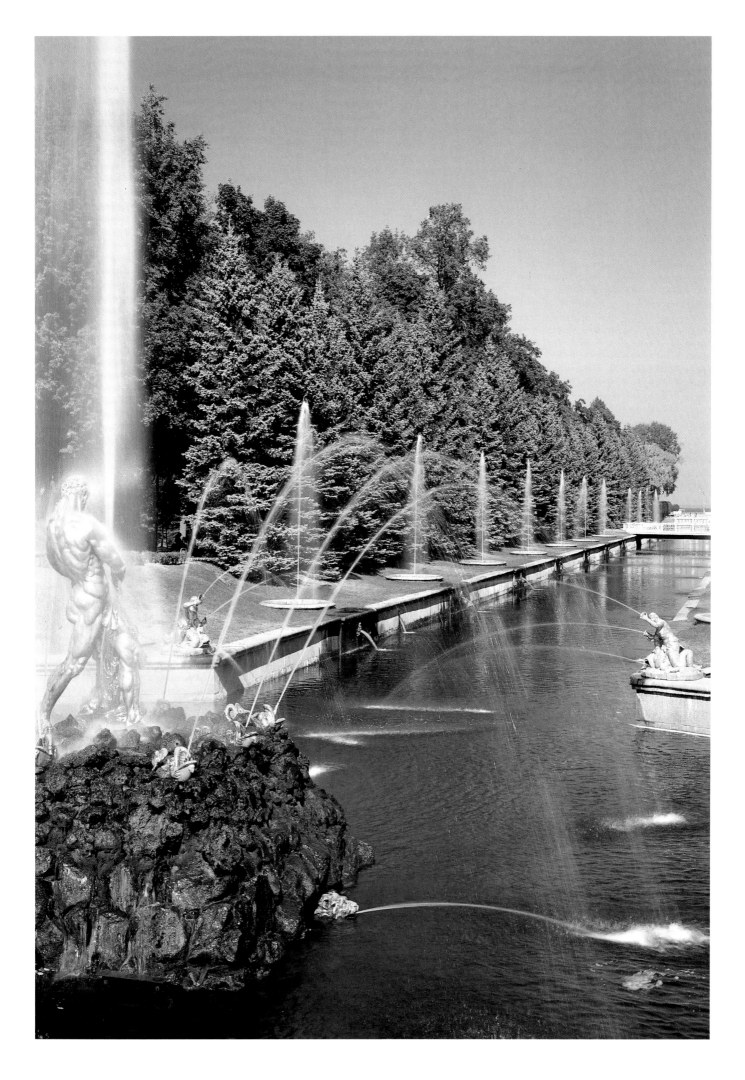

opposite
Peterhof Palace in St. Petersburg
View of the gardens

Villa Borghese
in an 18th-century print
Milano, Civica Raccolta Stampe
Achille Bertarelli

[1] Gilles Deleuze has initiated a new approach for the interpretation of Baroque culture with the celebrated opening phrase of his study of Leibniz: "Baroque does not imply an essence, but rather an operational function, a trait." Pursuing this idea in the introduction to an edited volume *Puissance du baroque, les forces, les formes, les rationalités*, Paris 1996, Christine Buci-Glucksman suggests that the notion of form itself changes with the advent of a Baroque culture. Form as embodiment of Idea, gives way to "an operation that temporalizes space and gives rise to its own process of appearance/disappearance." In this perspective a study of Baroque gardens should pay attention to the streams of interactions between visitors and users of gardens, sovereigns creating them and the gardens in all their aspects. It should give as much attention to reception as to material form. There is still a long way of scholarship to achieve in order to reach such a goal.

[2] José Maravall has defended the idea that Baroque culture is the expression of a social and political system. José Antonio Maravall, *La cultura del Barroco, una estructura histórica*, Barcelona 1975. This system results from an effort at conjuring up an harmonious vision of the world as an object of will. It mobilizes the arts for all members of society to share in a deep admiration for the powers to which they are subjected. This may explain why in Baroque gardens forms are no longer only representations of ideas, but at a deeper level of significance display the will to power in a seductive way. Their presentation is meant to please at first sight, to lead into uncritical admiration. This is the specific interaction between garden user and art work that artists may have had to trigger by their creations in these gardens.

[3] Cesare D'Onofrio, *La Villa Aldobrandini di Frascati*, Rome 1963.

[4] Mirka Benes, "The Social Significance of Transforming the Landscape at the Villa Borghese, 1606-

Flows of tumbling waters, cascades, fountains, overflowing basins, spurting jets, *bouillons*, *lances*, *cierges*, *chandeliers*, flows of visitors gazing into unending perspectives, flows of clouds mirroring themselves in still waters in the *ronds d'eau*, *bassins*, canals, flows of flowers bedded out with the seasons, flows of admiration for nature imitating the arts, for the richness of invention in parterres of embroidery, the mysteries of the *bosquets*, the wonders of the menageries, the grandeur of a prince. Baroque gardens seem intent upon displaying forms in motion.[1] Note the unending passion for the expression of movement in garden sculpture. All forms of motion crown a display of majestic will.[2] It is never more obvious than in the *feux d'artifice*, or the *fêtes*, but it is also presented to the gaze of visitors through a skillful manipulation of scale, composition of parts and whole, expanse over the countryside, geometric appropriation of nature, accumulation of works of art and of wealth, repetition of small topiaries, mannikin trees, vases, urns upon pedestals in such numbers that they cannot be counted even less remembered.

Baroque gardens: a debated category

Despite all discussions about the definition of Baroque as a general category of art history there is little doubt that the gardens of Villa Aldobrandini in Frascati (1598–1604),[3] of Villa Borghese in Roma (1606–30),[4] of Peterhof near St. Petersburg (1716–19), of the Belvedere near Vienna (1716–32), of La Granja near Segovia (1721–46),[5] of the Bom Jesus do Monte near Braga (1784),[6] of Veitshöchheim at Würzburg (1763–67)[7] can be acknowledged as masterworks of the Baroque. They are utterly different in scale, in the relationship they entertain with the site, and in design, but they share a clear intent to provide visitors with a display of majestic will that they cannot but admire at first sight, bowing in awe.[8] They seem to speak to the mind through the senses without calling for an intellectual effort of interpretation.[9] We may nevertheless wonder whether such a far-fetched kinship allows lumping all large princely gardens from the end of the sixteenth century to the later eighteenth century together into one stylistic category. There are a few good reasons to doubt it. Some of the most impressive princely gardens of that period are known as outstanding examples of classicism in the arts. From the gardens of Richelieu in Touraine (1628–39),[10] or Vaux near Fontainebleau (1656–61), to the gardens of William III at Het Loo (1686–95), and at Hampton Court (1689–1702)[11] or the gardens illustrated by Kip and Knyff in *Le Nouveau Théâtre de la Grande Bretagne* (1714–16, 1724–28),[12] or in the gardens of Drottningholm near Stockholm (1681) or Eriksdahl (around 1650), we can see a variety of classical styles of gardening which have been

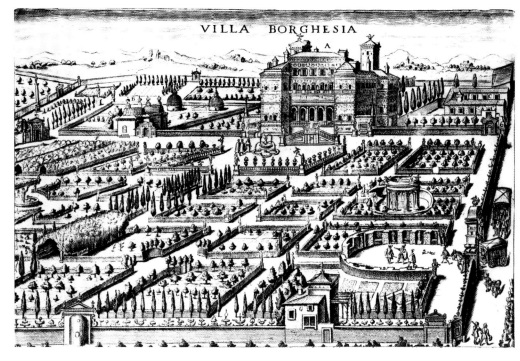

The Bom Jesus do Monte sanctuary
in Braga, Portugal
View of the gardens with steps

opposite
The royal residence of La Granja
near Segovia

1630: Territory, Trees and Agriculture in the Design of the First Roman Baroque Art," in Attilio Petruccioli (ed.) *Il Giardino islamico: architettura, natura, paesaggio*, Milan 1994.
[5] La Granja was built for Philip V of Spain, a grandson of Louis XIV, starting in 1721. On a steep hillside the garden architect Etienne Boutelou and two sculptors, René Frémin and Jean Thierry, created a garden with twenty-six fountains decorated with sculptures in keeping with the spirit of Bernini.
[6] The sanctuary of Bom Jesus do Monte was built between 1784 and 1811 by Carlos Luis Ferreira Amarante for Archbishop Rodrigo de Moura Teles near a monastery at Braga in Portugal. It is one of the most theatrical among several gardens of the seventeenth and eighteenth century that were constructed to offer a substitute to a pilgrimage, in Portugal, Italy, Germany, and Bohemia. See Germain Bazin, *Paradeisos: The Art of the Garden*, London 1991: 190–91.
[7] The gardens of the castle of Veitshöchheim were begun around 1720, and re-modeled into a most delightful Rococo garden between 1763 and 1767 for the bishop of Würzburg, Philipp von Greifenklau. It was decorated with about three hundred sculptures of the gods, the arts, the seasons, the continents, courtiers and musicians who seem to be engaged in an endless series of conversations. The most extraordinary group of sculpture is a Mount Parnassus with the Muses and Pegasus taking its flight in a way that recalls the same figure at the Villa d'Este, which is set in an irregularly shaped piece of water.
[8] Germain Bazin contrasts attitudes of Renaissance artists who sought to achieve truth in their works, to attitudes of Renaissance artists who rather than seeking to attain truth aimed at persuading their audience of some truth. Artists borrowed ideas from rhetorics which were disseminated by classical art theories, because they aimed at a dialogue between the observer and the creator of the work. Germain Bazin,

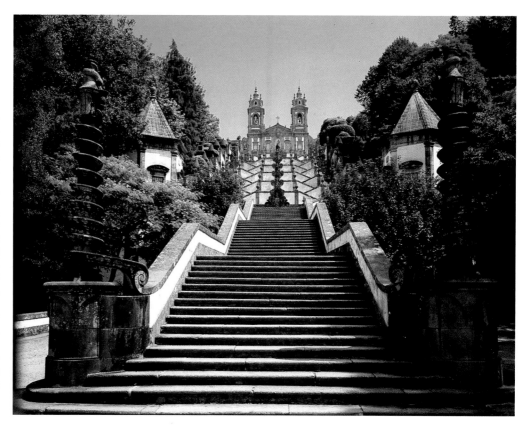

emulated throughout Europe. This is not to say that a particular national style, say the French style of gardening,[13] would have instilled a measure of classicism into the otherwise Baroque style of European gardens. No, there are several classical styles that developed and cross-bred one another during the seventeenth century and the early eighteenth, and it remains to be seen whether they qualify as national styles or if this designation is simply anachronistic, putting a nineteenth-century label upon earlier phenomena.

The encounters between Baroquism and Classicism[14] can be documented through a series of oppositions[15] that apply to most princely gardens[16] of that period because they were born out of a political use of the arts as sources of awe-inspiring experiences that testify to the transcendence of the prince, and also out of a search for unity and for an economy of means that is present even in cases of outrageously conspicuous consumption. Starting always with a classical feature followed by a Baroque feature one may observe oppositions between unification and multiplication, effort at structuring and at decorating, intellectual and sensorial appreciation, realistic representation and imaginary metamorphosis, concentration and inflation, expression of universality and of particularity, careful sorting of categories and deliberate aggregation. Many of these oppositions can be documented in the first Italian Baroque gardens[17] as well as in the German or Russian Late Baroque gardens of the end of the eighteenth century. This tension, however, is not to be found in the same way everywhere. We may then seriously doubt that all princely gardens of Europe in the seventeenth and eighteenth centuries could be subsumed under a single category.

Instead of taking an a priori attitude in this debate one may simply try to start from very general observations about garden art to see whether some major changes can be perceived between the fifteenth and the end of the eighteenth century that would bring to light any distinctive features of gardens in Europe and help anchor the definition of Baroque to observations of gardens. How did major aspects of garden art change between the classical Renaissance garden, and the gardens of the Enlightenment?[18] This should be answered at four levels. Like any other art, gardening calls upon definite elements, they are each designed according to principles of order, and fitted together according to principles of composition.[19] Besides, gardens give rise to special social practices that are a distinguishing feature of this art, which it shares to a degree with architecture. After asking how garden elements, princi-

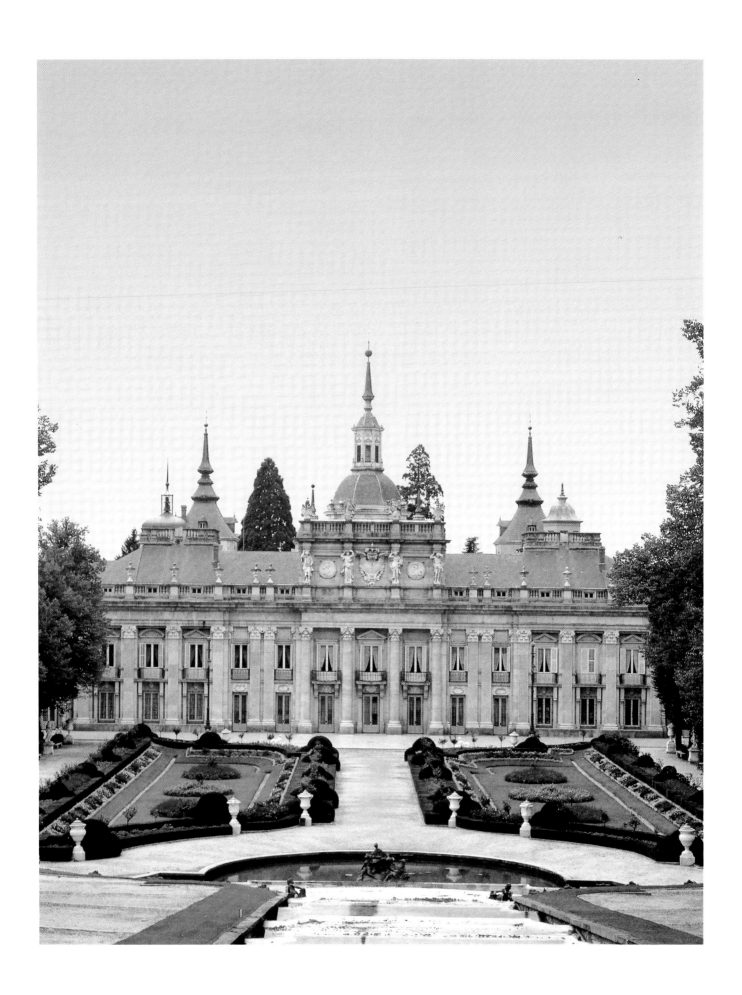

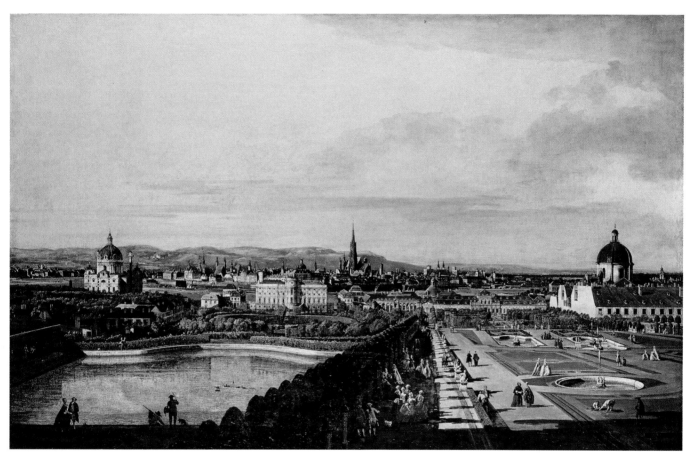

Bernardo Bellotto
Vienna from the Belvedere
Vienna, Kunsthistorisches Museum

The Baroque, Principles, Styles, Modes, Themes, New York 1978.
[9] Of course this primary evidence, which Bachelard saw as the first epistemological roadblock on the way to scientific knowledge, triggered a flow of personal reflection. This was precisely its aim: setting delighted minds in the right direction. J. R. Jones notes that at Hampton Court "the relationships between the buildings (by Wren) and the gardens (by Talman), park, river, canals, avenues and gates was contrived to make an impression first on the visual, and then, on reflection, on the intellectual faculties. The whole concept was based on the appeal to sense and reason [...]" J. R. Jones, "The Building Works and Court Style of William and Mary", in *The Anglo-Dutch Garden in the Age of William and Mary*, catalog edited by John Dixon Hunt and Erik de Jong, special issue of *Journal of Garden History*, 8, nos. 2 and 3 (1988): 1–13.
[10] Kenneth Woodbridge, *Princely Gardens*, New York 1986: 143–58.

ples of order, principles of composition, and social uses have gone through major changes we shall conclude to a definite structure of garden art which can be observed between 1590 and 1790, a period during which a constant search for variety has explored a certain set of design problems. Owing to historical circumstances this has led to great moments of garden invention in many European countries. Yet it is possible to show that these garden genres have never been the only styles of gardening in these countries. We shall conclude with a short interpretation of this development of garden art when it is put in perspective of larger social, political and of course cultural changes[20] in this period, showing, hopefully, why garden art was not yet, despite some claims by garden designers and their princely commissioners, an expression of national culture.

Structural changes in garden arts, 1500–1750
Spanning the years 1500 to 1750, we shall seek for obvious changes related to social uses of gardens, and move into more and more subtle changes, starting with principles of composition, following with principles of order, and ending with changes of garden elements.

Social uses of gardens
Gardens of the Renaissance were meant for the enjoyment of small courts with a strong interest in Humanistic pursuits and who could take as much delight in intellectual *concetti* as in sensory surprises. Gardens became open to larger numbers of courtiers during the sixteenth century inviting visitors and courtiers to admire the owner by acknowledging the gardens as an expression of his mind. Italian courts in Naples, Florence and Rome set a pattern of pleasurable life that was imitated in France after the invasion of Italy by Charles VIII and the alliances between the Medici family and French kings. Sophisticated garden entertainments inspired by Italian practice at the French court, combining seduction of the senses with ostentatious spectacle of princely grandeur, were put to profit by the first sovereigns that experimented with a modern state under a rule of absolute monarchy. This was true in England as well as in France and in Austria, simply the history of absolute regimes differs in the three countries, and ex-

Gottfried Heinrich Krohne
Drawing for the Orangerie in Gotha
Gotha, Thüringisches Staatsarchiv
cat. 221/2

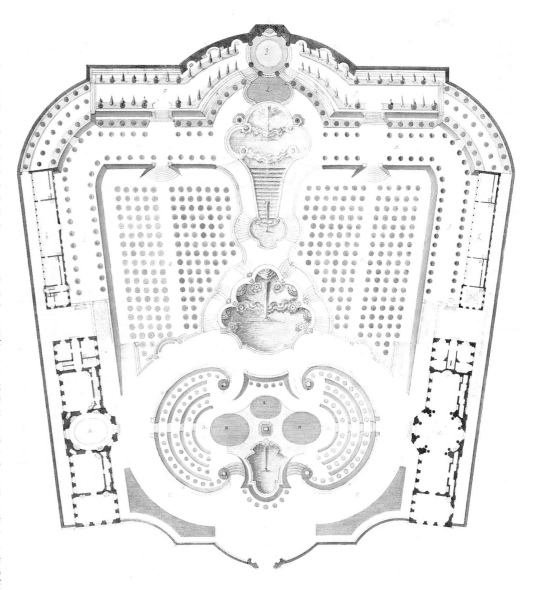

[11] See Hunt and de Jong, *The Anglo-Dutch Garden*, op. cit. See also David Jacques and Arend Jan Van der Horst (eds.), *The Gardens of William and Mary*, London 1988.

[12] *Nouveau theatre de la Grande Bretagne, ou, Description exacte des palais du Roy et des maisons les plus considerables des seigneurs & des gentilshommes de la Grande Bretagne: le tout dessine sur les lieux, & grave en quatre-vingt planches ou l'on voit aussi les armes des seigneurs & des gentilshommes,* London 1714–16.

[13] There is beyond any doubt a royal style of gardening during the reign of Louis XIV. This style is adapted by courtiers and by many bourgeois or nobles of lesser standing. Yet it is not universally adopted throughout the country. The idea of French style of gardening is confusing because it seems to accept as evidence the absolutist claim of a king ruling the arts and nature. René Huyghe has shown how different the attitudes of the French bourgeois in Paris and in the provinces were with respect to the arts. Because the king made cultural policy into a symbol of his ruling, opposition to the king could be expressed symbolically by artistic choices. Artists like Puget or Lafage were spurned by Parisian elites, and acclaimed in Marseilles or Toulouse. "Provinces are in the hands of the bourgeoisie; they are the more so since, starting from the reign of Louis XIV, aristocracy has abandoned its roles and duties in the provinces." René Huyghe, "Classicisme et baroque dans la peinture française au XVIIème siècle," *XVIème siècle, Revue trimestrielle publiée par la société d'études du XVIème siècle* 20 (1953): 274–92.

[14] The ambiguities of the meanings attached to the word "Baroque" since its doubtful origins are well known. The word "Classical" on the contrary is supposed to have a clear historical meaning. It has not. In Latin *classicus* designated the first among five classes of Roman citizens. Since the sixteenth century, it has been used metaphorically to describe domains of excellence in the arts and in literature. It was used, on the contrary, by the Romantics to describe an aesthetic

presses itself through garden art and usage at different times.[21] Whenever absolute monarchy was adopted its gardens were used to bring as many influential aristocrats as possible under the gaze of the prince,[22] or to express the courtiers' adoption of the philosophy of state of their prince which they disseminated in their own domains for lesser courtiers.[23] The choice of garden designs became as much a part of courtly deference to a prince as the participation in feasts he organized in his own palace.[24] Moreover internal resistance to this cultural dependence to a kingly cultural dictate could be observed since its inception, and led after a time to identification of the dominated aristocrat to the dominating prince,[25] creating more demands for lordly gardens and conspicuous consumption within a limited circle of gentility, allowing an intimate[26] use of Baroque strategies.[27] At the same time during the eighteenth century, other people in Europe, following a strong lead by a few members of the English gentry,[28] and material and intellectual concerns of the Enlightenment, led to a very different approach of gardens. They offered symbols of social, political and economic improvement and of their owners' striving for a patrician life in a paternalistic world. They were meant to be visited by small groups of like-minded garden owners rather than courtiers, meant for shared entertainment of the owners with them, and also open to individual explorations. Visits were supposed to lead to reflection upon self-determination and natural law, rather than to submitting oneself

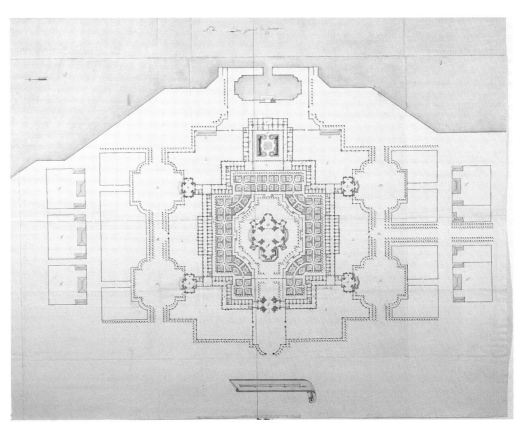

Francesco Bartolomeo Rastrelli
Project for the Smol'ny complex
Vienna, Graphische Sammlung
Albertina
cat. 585

that they rejected. These historical circumstances have allowed great variations of the sets of works that were called Classical. However, they have always been designated as Classical in opposition to some other set of works. The couple Baroquism/Classicism offers a shorthand for describing a broad system of cultural oppositions; a multidimensional structure which is not explored or used in the same way by all the wealthy elites of Europe. See Claude-Gilbert Dubois, *Le baroque en Europe et en France*, Paris 1995: 61–63.

[15] Claude-Gilbert Dubois has presented a table of oppositions between Classical and Baroque art as a result of literary studies. Most categories apply as well to garden studies even if there are unavoidably changes of meaning that follow a change of mode of expression. Dubois, *Le baroque en Europe et en France*, op. cit.: 21.

[16] The refusal of the project for the Louvre and of the equestrian statue of Louis XIV by Bernini could be interpreted as signs of a cultural rejection of Baroque art by Louis XIV. V. L. Tapié has shown that such a simple explanation was missing the complexity of these decisions. Hélène Himmelfarb further remarks that at the same time that Louis rejected this equestrian portrait by Bernini, he ordered his bust done by Bernini in 1665 to be placed at the top of the *haut degré* at Versailles. Hélène Himmelfarb, "Compte rendus," *XVIIème siècle, Revue trimestrielle publiée par la société d'études du XVIIème siècle* 165 (Oct.-Dec. 1989): 446.

[17] Elizabeth MacDougall, *The Villa Mattei and the Development of the Roman Garden Style*, Ph.D. Thesis, Harvard University, 1970.

[18] There are certainly many different ways of answering this question. Michel Baridon offers a comparison between the course of scientific imagination and garden design. This is certainly a fruitful approach. It privileges the philosophy of Idea and we shall try to follow a broader line of study. These are questions of methods, not of content. Michel Baridon, "The Scientific Imagination and Baro-

to some arbitrary despotic law. An ambivalent concern for the rural population and for opening the gardens to them also replaced the display of an exclusive attention for the privileged classes in the gardens of the absolute monarchy, such as was symbolized by the various imitations of Marly[29] with its pavilions reserved for the happy few as emulated at La Favorite near Mainz[30] or at Lunéville.

Principles of garden composition

Changes in principles of garden composition are as dramatic. Renaissance gardens were meant to create a setting for a life in a villa allowing the experiencing of a renewal of Classical Antiquity.[31] House and garden merged into the villa, offered an orderly view of nature which took its measure in the house itself. The main alley could proceed directly from the house, allowing to move into the garden under the protection of a bower or a trellised pergola so that one would discover the open rooms of the garden from an interior space made of nature. Planting was the main instrument of composition, and the contrast between clearly delineated square compartments forming a regular grid and the shifting slopes of the terrain were an important device in the creation of an illusion of nature imitating the shapes of art. Design composition was made visible by the interplay between strong geometric planning of the alleys, and the seemingly haphazard encounters of objects or places strongly bringing to mind associations with the world of fable, such as statues, grottoes, nymphaea, mounts dedicated to the Muses, or labyrinths of greenery which were considered as symbols of architectural mastery in Antiquity. Many gardens drawn by Du Cerceau,[32] as well as gardens by Vredeman de Vries expressed this approach of composition. At the end of the sixteenth century Mannerist gardens evinced an interest for more sophisticated composition. The most important developments took their origin in Italy at such places as Pratolino,[33] Villa Lante, or the Villa d'Este,[34] and they found one of their most fascinating expression at Heidelberg, in the Hortus Palatinus[35] with its magical theme that garnered the wrath of the Catholic armies. This mode of design proceeded from an attempt to make the garden composition itself an utmost signifier of the owner's intent. Composition was a device leading the minds of visitors from sensual delight into intellectual admiration for him or for his ideas. Thus the allegorical meaning of the garden took precedence over the mingling of house and garden that was achieved by an axial bower

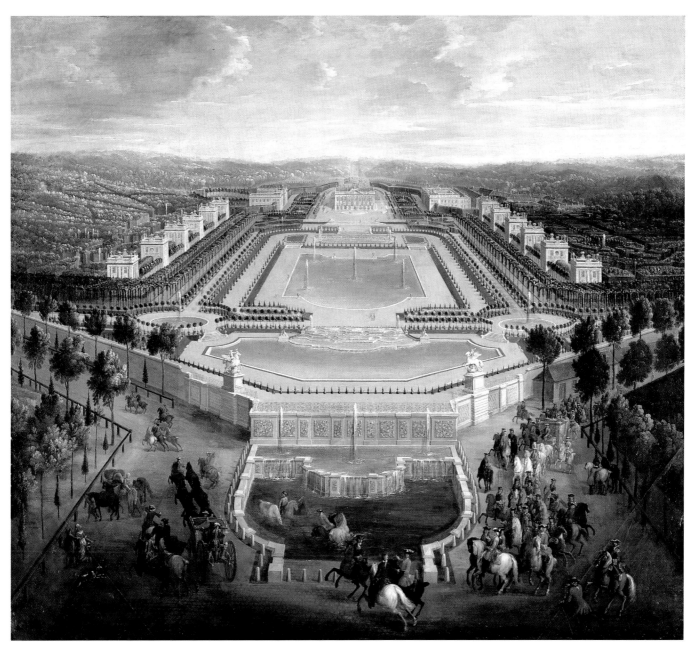

Pierre-Denise Martin
Marly Château, perspective view
Versailles, Musée National
des Châteaux de Versailles
cat. 201

que Gardens," in *Journal of Garden History* 18, no. 1 (1998).
[19] This structural approach for studies of gardens, which arises from an attempt to bridge the gap between studies of garden design and of garden reception, has been presented in the forthcoming volume of the Studies in Landscape Architecture symposium series at Dumbarton Oaks on "Perspectives on Garden Histories": Michel Conan, "From Vernacular Gardens to a Social Anthropology of Gardening."

running from the garden into the house. Creating surprises along the path to the house in order to let visitors slowly and pleasurably discover a hidden truth that was encapsulated in the garden as a whole became a springboard for design invention. Garden architects created successive terraces, and discovered how to break the walk along the axis in such a way that the house might be discovered and lost to view in succession when progressing toward it through the garden. They also experimented with contrasts between open parterre gardens, and solid compartments planted with trees; and with an organization of gardens around the presentation of engineering mastery of the "reasons of moving forces" in nature. Pratolino can be seen as the central laboratory wherefrom this knowledge spread out throughout Europe.[36] This intricate relationship between overall composition and allegorical meaning was conducive to a very great richness of invention. However, it also demanded a sophisticated visitor able to understand its full effect.

The principles of composition of gardens for the absolute monarchy were in many ways derived from these formal experiments with terraces, alleys, open and wooded spaces, and the patterning of visual effects that can be obtained with water, and yet they sought to achieve a fundamentally different reception leading to new principles of composition. They aimed at

The fountain of Venus and Adonis in the park of the Royal Palace Caserta

ophy of Idea and we shall try to follow a broader line of study. These are questions of methods, not of content. Michel Baridon, "The Scientific Imagination and Baroque Gardens," in *Journal of Garden History* 18, no. 1 (1998).

[19] This structural approach for studies of gardens, which arises from an attempt to bridge the gap between studies of garden design and of garden reception, has been presented in the forthcoming volume of the Studies in Landscape Architecture symposium series at Dumbarton Oaks on "Perspectives on Garden Histories": Michel Conan, "From Vernacular Gardens to a Social Anthropology of Gardening."

[20] Victor L. Tapié has shown in his study of the arts in Europe from the seventeenth to the eighteenth centuries how a narrative history of the arts of this period embedded in social and political history can be conducted. Marc Fumaroli summarizes his method in the preface: "In the foreground of his fresco, Victor L. Tapié places Rome, both to redress the Germanocentrism to which the *Barockpegriff* is attached in Germany, and the *Versaillais* heliocentrism to which the "classical myth" is attached in France. This mid-way is the way to historical truth." Victor L. Tapié, *Baroque et Classicisme*, préface by Marc Fumaroli, (fifth edition), Paris 1990.

[21] Starobinsky has called attention to the impact of important setbacks of experiments with absolutism suffered with the Fronde and the beheading of Charles I, which pushed sovereigns to seek a parade: "Pompous display was at the same time magical warding off and defiance." Following the strategy set by the Catholic Church in the Counter-Reformation, absolutist sovereigns chose to pursue their autocratic project and to proclaim their own success in front of a death threat by their adversaries. Princely gardens display a Baroque confrontation with death. At Versailles, Latona and the fountain of the Dragon were clear gestures of defiance at the

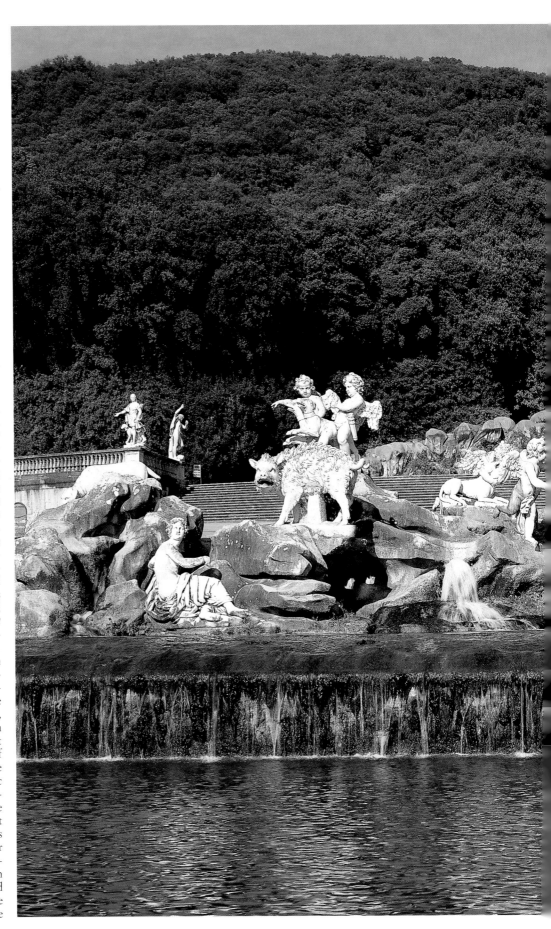

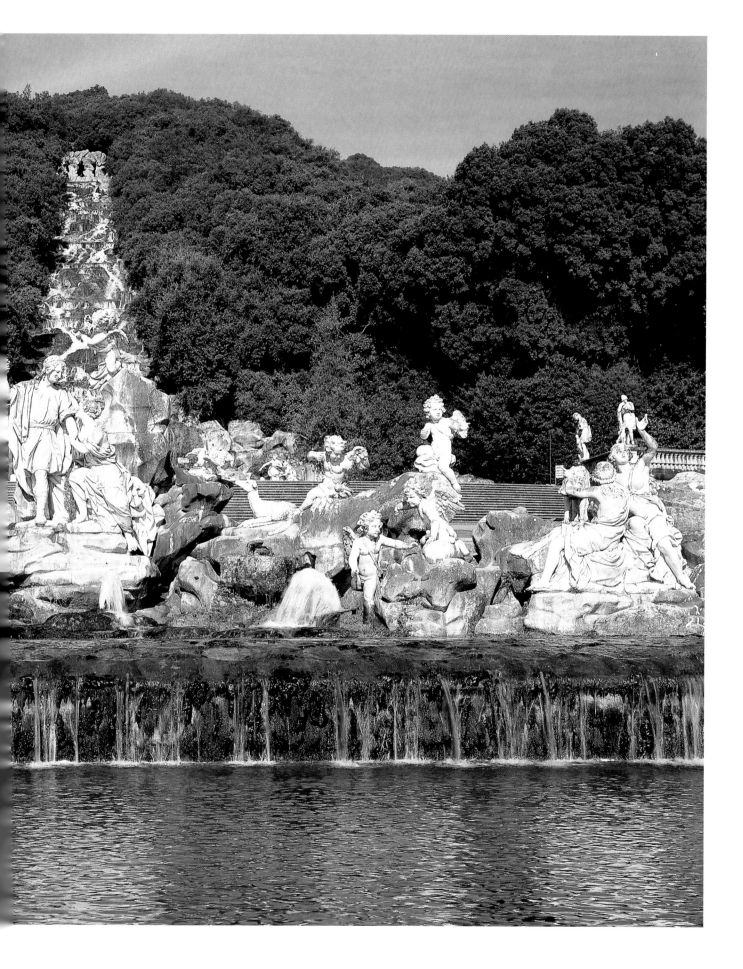

Villa d'Este
Detail of the garden
with a fountain and an edicola

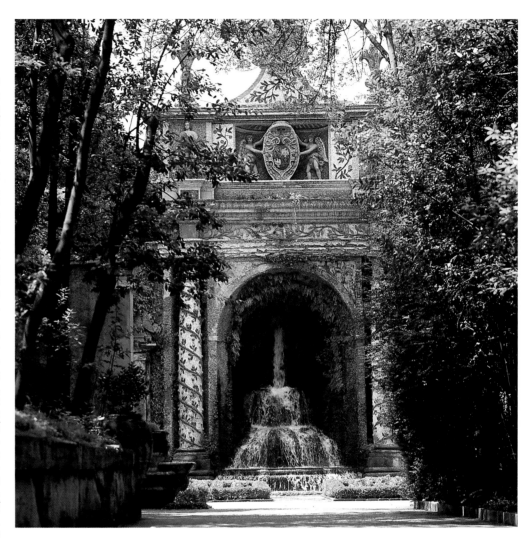

[20] Victor L. Tapié has shown in his study of the arts in Europe from the seventeenth to the eighteenth centuries how a narrative history of the arts of this period embedded in social and political history can be conducted. Marc Fumaroli summarizes his method in the preface: "In the foreground of his fresco, Victor L. Tapié places Rome, both to redress the Germanocentrism to which the *Barockpegriff* is attached in Germany, and the *Versaillais* heliocentrism to which the "classical myth" is attached in France. This mid-way is the way to historical truth." Victor L. Tapié, *Baroque et Classicisme*, préface by Marc Fumaroli, (fifth edition), Paris 1990.

[21] Starobinsky has called attention to the impact of important setbacks of experiments with absolutism suffered with the Fronde and the beheading of Charles I, which pushed sovereigns to seek a parade: "Pompous display was at the same time magical warding off and defiance." Following the strategy set by the Catholic Church in the Counter-Reformation, absolutist sovereigns chose to pursue their autocratic project and to proclaim their own success in front of a death threat by their adversaries. Princely gardens display a Baroque confrontation with death. At Versailles, Latona and the fountain of the Dragon were clear gestures of defiance at the aristocracy. Jean Starobinsky, *L'invention de la Liberté, 1700–1789*, Geneva 1964.

[22] The strategic use of gaze was a central aspect of absolutist state development, which applied in princely gardens. Jay M. Smith, in an effort to revise traditional historiography which sees Versailles and its way of life as a symbol of the victory of the king over aristocrats attached to particularism and privileges, insists on its worth as a tool of power. "The novel aspect of the regime of Louis XIV was not the existence of a bureaucratic machine of public administration but the use of the king's line of vision to demarcate and divide society and the state [...] Louis XIV and his deputies sought to constitute society by rendering it visible for the king." Jay M. Smith, "Our Sovereign's Gaze: Kings, Nobles, and State Formation in Seven-

striking at first sight, and producing an impression that imposed itself as an evidence before and beyond any effort at interpretation.[37] It is worth introducing at this point a note on the significance of Dutch experiments with canals in the early seventeenth century, in great garden compositions around noble houses, for the development of Baroque design ideas despite the fact that the Netherlands were not contributing at the time to the development of the absolute monarchy, quite to the contrary. The circulation of garden designers throughout Europe allowed exchanges of models[38] outside of the realm of political influences, and we should refrain from a functionalist reading of art, trying to explain forms by the political functions that they have later achieved, even though such functions may account for the replication and the development of some forms. The same remark applies to religious influences. Many features of Baroque composition of gardens can be found in the gardens of Prince Mauritz at the Hague in 1620 or of his brother Fredrich Heinrich at Honselaarsdijk[39] which were to be a source of inspiration for the first published design of a composition for a garden designed *à la française* by André Mollet in 1651, at Stockholm in honor of Queen Christina's coronation. However important this model may be for the further developments of Baroque gardens throughout Europe after it had been enriched by inventions of Le Nôtre,[40] Mansart and Francini,[41] it cannot be taken as a typical composition pattern for Baroque gardens. Actually, such a pattern does not apply even to describe princely gardens in France. Versailles embodies a strategy of garden seduction of a large court that has been emulated by Prince Eugene (Duke of Savoy and Piedmont, and conqueror of the Turks) in his palace on the hills in Vienna. Yet the design by Girard, a French garden designer, follows a composition that was originated by Bramante for the Belvedere in Rome[42] and that was widely developed and reused in the Netherlands during the seventeenth century and in Germany at the beginning of the eighteenth. Imitating Ver-

Villa d'Este
View of the avenue of 100 fountain

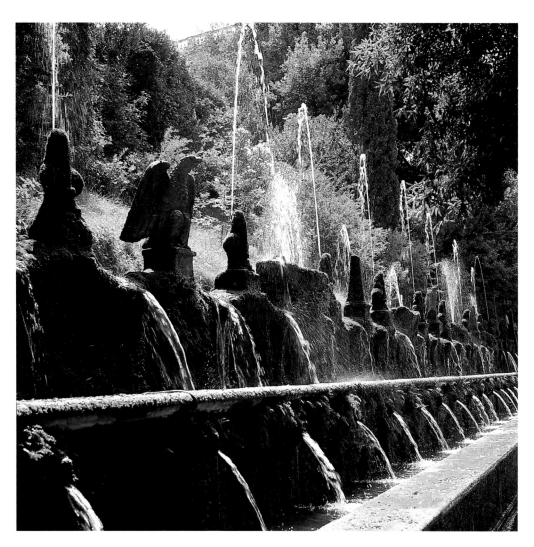

teenth-century France," in *French Historical Studies* 18, no. 2 (Fall 1993): 396–415. One may interpret gardens as "acting symbols," since they are both instruments of power in the royal strategy and symbols of power to which it is a pleasure to surrender, because there is nothing sweeter to the aristocracy than the gaze of the king as the deputies at the Etats Généraux of Burgundy reminded a reluctant Louis XIII in 1614.

[23] *Le paraître*, presenting of self, became part of techniques of power under the absolutist monarchies, and gardens as well as public walks were created as places where one could display his public self, if we may borrow from E. Goffman, and where each subject of the king should present himself in a way fitting his or her rank. It was an ordering device. The arts in princely gardens were a display of the owner's ideal self, and visitors could present themselves to one another in such an appropriate setting, as one can see on engravings of the seventeenth and eighteenth centuries. See Dubois, *Le baroque en Europe et en France*, op. cit.: 52.

[24] The adoption of several attributes of the iconography of the Orange family, after the rise of William III to the throne of England, in the Netherlands and in England could provide an illustration of this as much as the spread of distinct garden design compositions in France and Austria.

[25] Dieter Hennebo has pointed out the development of a private sphere of life by princes. He calls attention to the coexistence in the same princely gardens of the pomposity of the overall composition and the secrecy of shady *bosquets*, and even more of *casinos, trianons, lusthus* and *hermitages* that allowed the prince and his closest retinue to enjoy escapism. He gives Marly, Lunéville and La Favorite at Mainz as examples. Dieter Hennebo, "Tendencies in Mid-eighteenth-Century German Gardening, in *Journal of Garden History* 5, no. 4 (1985): 355–370. It is striking to note that Rapin in 1665 was precisely advocating retreat in country villas and gardens to his bourgeois readers as a way of escaping the pressure of "official duty" life in the city.

sailles did not imply a precise pattern of garden composition. This was only one among different remarkable patterns. Others could be seen at Marly, La Granja,[43] Het Loo,[44] Gaibach or La Favorite near Mainz.[45] Principles of composition cannot be inferred from a single example however celebrated it might have been in Europe during the seventeenth and eighteenth centuries. A few features can be singled out. The renewed importance of the axis, previously found in classical gardens, is obvious. However, this is no longer an interior space emanating directly from the house, but rather an open space, an epiphany that derives its presence from the visual symmetry of the view over the garden that it offers whenever one discovers it from the palace or strolls along it. It provides such a powerful sense of balance of the overall composition that it creates the illusion of an overall symmetry of the whole garden even when the site prevents that both sides of the axis be laid out according to an axial symmetry. It enforces the primacy of the palace, and of its façade toward the garden, over the landscape that it commands. It distributes secondary axes that span the whole garden either with a grid or through transverse axes that seem to proceed from it. The gardens at Schönborn in lower Austria by Von Hildebrandt (1717) with their spindle-like axis and its secondary axis firmly establishing the palace as the imaginary center of a composition that spans the landscape with large St. Andrew crosses provides a telling example.[46] Thus the axis gives rise to a pattern of routes forcing choices into a network of ways that gives the illusion of a totally ordered geometrical pattern exploring the passages from the stonework of the palace, to the world of fantasy of fountains, garden pavilions, orangeries, canals, or even small pleasure gardens that can be discovered at a distance from the palace. This passage from architectural reality to garden fantasy is elaborated through several dialectical relationships between elements of composition which engage into a reversible play of ground and figure. A dialectic of solid woods and

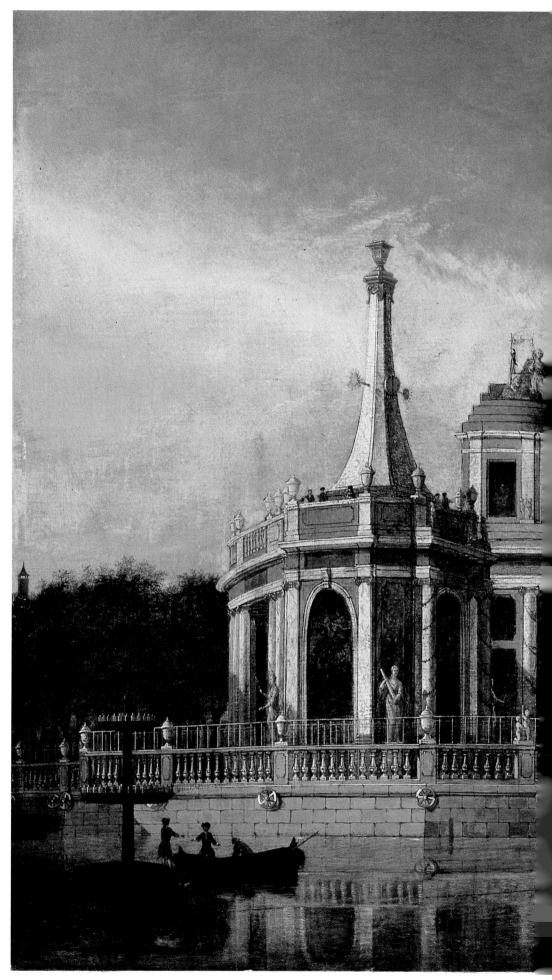

Jan ten Compte
View of the Firework Pavilion
in the Hague
The Hague, Historisch Museum
cat. 358

gold, silver, marble, columns, paintings or statues to be seen, this grotto was carved out of the rock into a vault full of *rocailles* and seashells, it was lined with a young vine that spread its soft boughs equally on all sides. Light zephyr kept this place, in spite of the ardors of the sun, deliciously cool." J. Charles Nonferran, "L'ecphrasis du livre I du *Télémaque* de Fénelon, ou le détournement romanesque de la grotte de Calypso," in *XVIIème siècle, Revue trimestrielle publiée par la société d'études du XVIIème siècle* (1991): 387–399.

[27] In a passage about the *Rocaille* style, Starobinsky summarizes its development: "Roughly sketched out at the end of the XVII century by Berain, a virtuoso at arabesque, and by Lepautre draughtsman of the King's buildings, developed by Oppenard and Vassé, culminating in the 'pictoresque' and assymétrique genre cultivated by Pineau, Meissonnier and Cuviliés, Rococo could be defined as a blazing and miniatured Baroque style" and he pursues "Rococo strives to accommodate a pleasing giddiness and a trustful intimacy." Starobinsky, *L'invention de la Liberté*, 1700–89, op. cit.: 22.

[28] Even if garden art and its development are intimately bound to large shifts in state politics in Europe, they result to a degree from cultural changes independent of political will. The interest expressed by English minds who contributed to the new garden culture of the Enlightenment for a well-known French author of the mid-seventeenth century, whose work was very well received in France as well, invites a study of cultural changes that is not framed a priori by state boundaries, or linguistic culture. Father Rapin's poem in four books on garden is the heir of a long-lasting European interest for the happy rural retirement ideal and bucolic poetry. Very close ideas were expressed in his *Plantarum Libri VI* by Abraham Cowley in 1668. The very quick translation of Rapin into

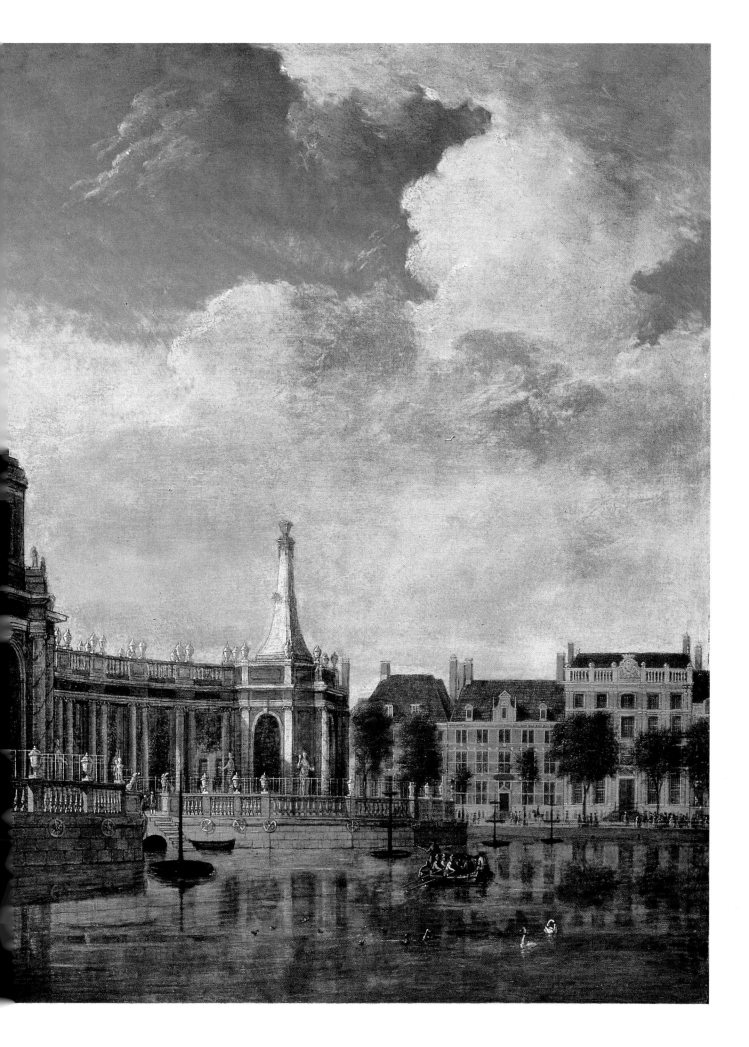

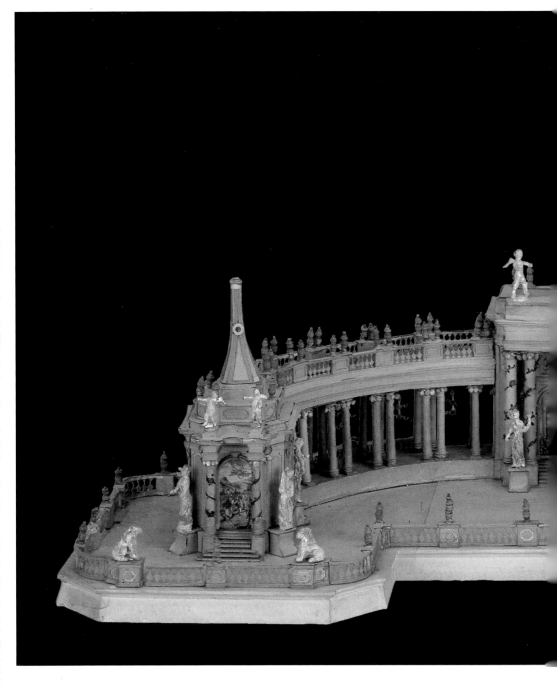

Pieter de Swart
and Juffrou Duijvenstein-Valkenaar
Model for the Firework Pavilion
of the Temple of Peace
The Hague, Historisch Museum
cat. 353

[26] Exercising power stimulates developments of counter-power. The links between Baroque garden art and power invite a particular attention to counter-cultural currents. The *Télémaque* by Fénelon is the more fascinating for its dual purpose: educating the heir to the crown of Louis XIV and leading him to adopt an opposite political philosophy. Fénelon unfolds all the tools of a patient rhetoric. It extends to a criticism of the aesthetics of life at Versailles, opposing to the setting of courtly pomp an intimate version of Baroque art. One may observe large changes in style within Baroque culture itself! The description of the grotto of Calypso (to whose charms Telemachus should not succumb, but the reader might) calls for the development of a new aesthetic of natural forms, of raw materials, of irregularities: "They arrived at the door of the grotto of Calypso, where Telemachus beheld with surprise how an air of rustic plainness could offer everything that may charm the eyes. There was no gold, silver, marble, columns, paintings or statues to be seen, this grotto was carved out of the rock into a vault full of *rocailles* and sea-shells, it was lined with a young vine that spread its soft boughs equally on all sides. Light zephyr kept this place, in spite of the ardors of the sun, deliciously cool." J. Charles Nonferran, "L'ecphrasis du livre I du *Télémaque* de Fénelon, ou le détournement romanesque de la grotte de Calypso," in *XVIIème siècle, Revue trimestrielle publiée par la société d'études du XVIIème siècle* (1991): 387–399.

[27] In a passage about the *Rocaille* style, Starobinsky summarizes its development: "Roughly sketched out at the end of the XVII century by Berain, a virtuoso at arabesque, and by Lepautre draughtsman of the King's buildings, developed by Oppenard and Vassé, culminating in the 'pictoresque' and assymétrique genre cultivated by Pineau, Meissonnier and Cuviliés, Rococo could be defined as a blazing and miniatured Baroque style" and he pursues "Rococo strives to

open spaces, of light and shadow, of hide-and-seek with the castle. Again the gardens of the castle of Schönborn come to mind. Rather than a simple interplay between opposite terms which can be taken each in turn as the central figure, composition builds upon the construction of a series of intermediate terms. Between the open space of a parterre, and the solid space of a *bosquet* one may find, for instance, a *boulingrin* which creates a volume of air by slightly carving out the ground plan; or a *bosquet à l'anglaise* which offers the same appearance of sheer surface that a parterre would but is surrounded with hedges and tree alignments that give it a volume of its own; or an orchard planted in quincunx; or a *bosquet* of palisades; or even a *bosquet* of tilted hedges. None of these are compulsory. To the contrary, garden composition demands an invention of the elements that make transition between two terms in a dialectical pair with which the garden designer is engaging. One may see this interplay as an outgrowth of another design principle: the well-tempered dialectic of nature and human will. Any element in the garden can be seen in the garden from any one perspective, but it invites consideration of the variety of interplay between the two, where human will may express either the power of reason, or the power of imagination when it matches and surpasses the variety of natural phenomena. Whether the accent is put upon the expression of the human will through reason or through imagination it creates very significant differences. But it rarely encompasses the whole of a garden composition and of its elements. So, most fantastic gardens evince a display of mastery in the geometric handling of nature, and most geometrically designed gardens display flights of fancy that were most appreciated by owners and visitors alike. However, none of these principles would have been sufficient unless the composition bedaz-

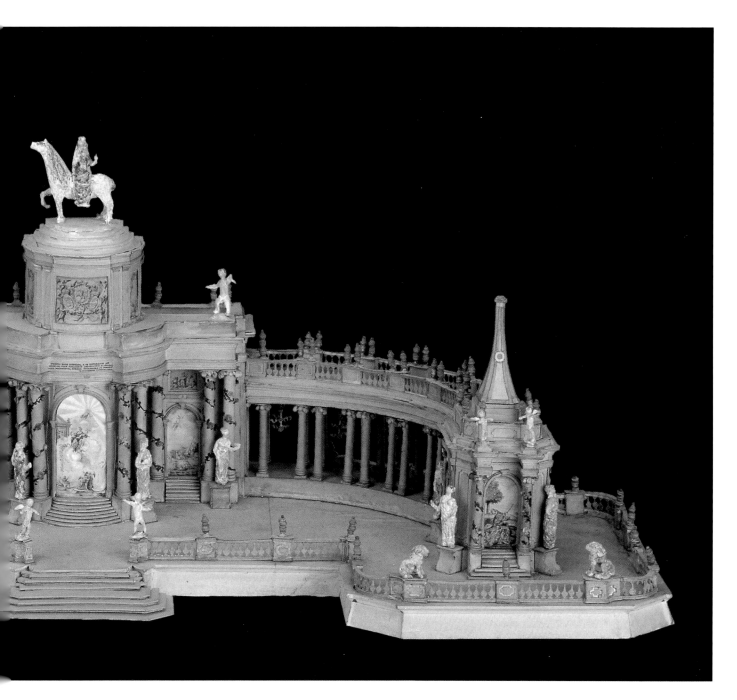

accommodate a pleasing giddiness and a trustful intimacy." Starobinsky, *L'invention de la Liberté*, 1700–89, op. cit.: 22.

[28] Even if garden art and its development are intimately bound to large shifts in state politics in Europe, they result to a degree from cultural changes independent of political will. The interest expressed by English minds who contributed to the new garden culture of the Enlightenment for a well-known French author of the mid-seventeenth century, whose work was very well received in France as well, invites a study of cultural changes that is not framed a priori by state boundaries, or linguistic culture. Father Rapin's poem in four books on garden is the heir of a long-lasting European interest for the happy rural retirement ideal and bucolic poetry. Very close ideas were expressed in

zle the visitors. This called for a display of contrasts that would pass the ordinary experience.[47] This begged altogether for non-dialectic visual games, opposing a sense of measure and a sense of infinity by allowing, for instance, a view of topiary trees at regular and measurable intervals along an alley that extends into infinity; or, opposing the numinous and the material worlds by contrasting fantastic fountains where some deities are dwelling with the view of merchant boats carrying their riches on the Rhine river beyond the lower garden wall at La Favorite.

Baroque garden composition was an explicit embodiment of a political idea that became glaringly obvious to any sensible visitor: it resulted from a power that participated of a divine order, and that extended its glory upon the land and upon its subjects. Such a view was anathema to the minds of the Enlightenment. Versailles as a paragon of absolutist strategies of bedazzlement had been the beacon capturing the admiration of all European absolutist courts, for the same reason it was to provide the most execrated example of garden art for the English inventors of a new classical art of garden design.[48] As in classical Renaissance gardens, composition of house and nature had to express a deep unity which carried universal value and could be grounded in a renewed understanding of Antiquity, political rather than literary.

However, the primacy had been reversed. It was no longer the house but nature that took primacy. Composition derived its model from the visual arts, painting, theater, opera, Italian gardens and Roman landscapes themselves rather than from geometry. It sought to invite an active exploration of nature, of its diverse sensual forms, and of a dialectic of movement through an itinerary and of sights discovered when standing at leisure.

Jan Caspar Philips
View of the Firework Pavilion
The Hague, Gemeentearchief
Historisch-Topographische Bibliotheek
cat. 355

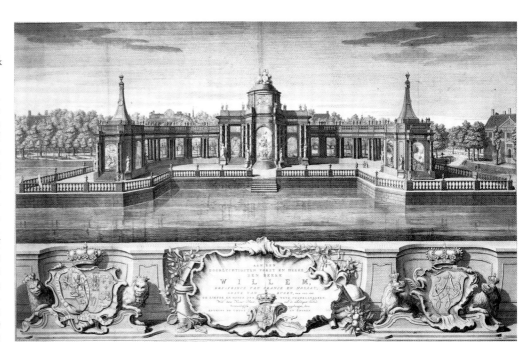

his *Plantarum Libri VI* by Abraham Cowley in 1668. The very quick translation of Rapin into English (in 1673) and quotation of this work by John Evelyn, Worlidge and Switzer shows that these cultural interests were shared by several circles in different European countries. These aesthetic inclinations have later provided symbols for an artistic follow-up of Enlightenment ideas which took off in England several decades before it happened on the Continent. See E. T. Dubois-Pichler, "Influence exercée en Angleterre par les *Hortorum Libri IV* du P. Rapin," in *XVIIème siècle, Revue trimestrielle publiée par la société d'études du XVIIème siècle* 20 (1953): 330–40.
[29] See Stéphane Castellercio, "Marly, un instrument de pouvoir enchanteur," in *XVIIème siècle, Revue trimestrielle publiée par la société d'études du XVIIème siècle* 192 (1996): 633–57.
[30] Salomon Kleiner, *Representation naturelle et exacte de la Favorite de Son Altesse Electorale de Mayence: en quatorze differentes vues et autant de plans sur les dessins [...] pris sur les lieux [...] Wahrhaffte [...] Abbildung Der [...] Chur Furstlich Mayntzischen Favorita [...] nach Denen*, Augsburg 1726.
[31] James S. Ackerman, *The Villa: Form and Ideology of Country Houses*, Bollingen series XXXV, 34, Princeton (N. J.) 1990.
[32] Jacques Androuet du Cerceau, *Le Premier volume des plus excellents bastiments de France..., [et, Le Second volume des plus excellents bastiments de France]*, Facsimile reprint, Farnborough 1972. Jacques Androuet du Cerceau, *French chateaux and gardens in the XVIth century, a series of reproductions of contemporary drawings hitherto unpublished. Selected and described with an account of the artist and his works*, by W. H. Ward, London 1909.
[33] Luigi Zangheri, *Pratolino: il giardino delle meraviglie*, Florence 1979.
[34] David R. Coffin, *The Villa d'Este at Tivoli*, Princeton monographs in art and archaeology 34, Princeton (N. J.) 1960.
[35] Richard Patterson, "The 'Hortus Palatinus' at Heidelberg and the Reformation of the World. Part 1:

It called forth a rhetorical succession of visual experiences, allowing a visitor to discover through simple inspection the natural origins of ideas that would bring some light to his own existence.[49]

Principles of order

No study of European architecture starting from the Renaissance could ignore the importance of order. The same does not seem to hold true for garden studies.[50] Yet, some principle of order must be followed in order to compose different elements together, and to design each of them. Horticulture can be seen as a source of such order in any garden. However, many other principles contribute to displays that may even render invisible horticultural order. Such was not the case of the Renaissance garden. Different compartments which were the most common and elementary parts of a garden were devoted either to large trees, in the *bosco*, or to fruit trees in the orchard, or to herbs and flowers in the beds of parterres. One may see in the books by Etienne and Liebault[51] that husbandry and agriculture extended their order into the design and maintenance of a villa garden. There was a "georgic" order that was always felt in the composition of a garden, stressing the presence of the owner and the unescapable attention for utility that stemmed out of house life. It was not the only one. One can see three other sources of order at work: the Pythagorean geometry with its emphasis on the square and the circle, which was wonderfully exemplified in Dutch gardens of the early seventeenth century,[52] as well as in compositions of parterres by Serlio (1537)[53] or overall design of the garden of the Villa Medici in Rome;[54] the revival of the ancient gods that introduced random encounters with the world of the fable, and opportunities for literary games, the best example of which may be provided by conspicuous allusions to the Muses, Apollo, Mount Parnassus, and Mount Helicon; and the mysterious order of the inner secrets of the earth,[55] of the works of water and of the wonders of a natural geometry it produced in rocks, creating fossils looking like seashells to be found even in mountain caves. The Mannerist garden did not innovate upon these orders but rather developed them into fantastic directions. The georgic order receded, or rather it was relegated to a special garden, the *vigna* in Italy. The other three were inflated. Geometry extended into a search for refinement in the design of parterres that would ensnare the eye, and into a search for more complex geometrical forms and constructions than previously executed, where allegory rather than chance organized numinous encounters in the garden and the moving waters could be called upon to reveal a magical order of nature. Baroque gardens followed two main concepts of order. First, order proceeded from the person of the prince: the arts extending their dominion upon all nature and its creatures merely expressed his will. A panoptical conception of power introduces further visual order into the gardens, imposing itself whether visitors look at the wild an-

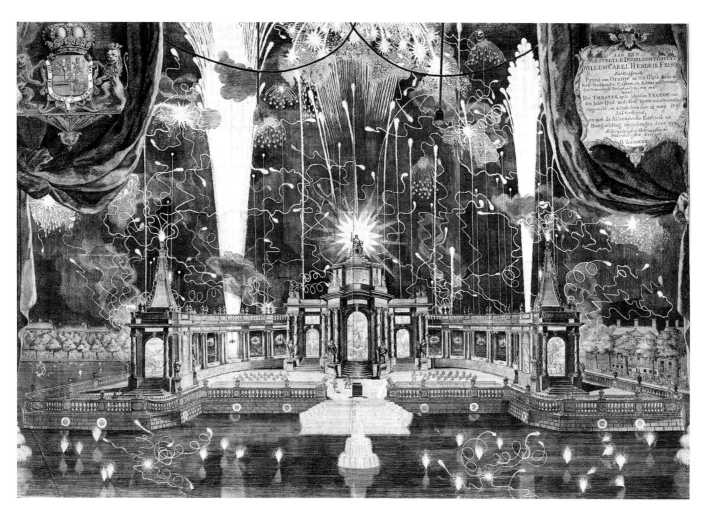

Jan Caspar Philips
The Firework Pavilion
during a fireworks display
on 13 June 1749
The Hague, Gemeentearchief
Historisch-Topographische
Bibliotheek
cat. 356

The Iconography of the Garden,"
in *Journal of Garden History* 1, no.
1 (Jan.–Mar. 1981), 67-104.
[36] Gardens were composed in
such a way that the interplay of
geometric design and of the mas-
tery of natural forces came to the
fore. Vitruvianism provided sym-
bols for expressing the depth of
wisdom that had come into being
under the patronage of the garden
owner, as well as the abundance it
bestowed upon the countryside.
Luigi Zangheri, "I giardini d'Eu-
ropa: una mappa della fortuna
medicea nel XVI e XVII secolo,"
in *Il giardino d'Europa, Pratolino
come modello nella cultura Euro-
pea,* Milan 1981: 82–92.
[37] Starobinsky insists on the inter-
active nature of Baroque pomp.

imals in the menagerie, or the prince looks down from the palace upon his courtiers strolling in
the gardens. Second, his will is expressed through a thorough geometrization of plants, and a
metamorphosis of all other natural materials into objects of art or representations of life.[56] The
prince gives life to inanimate objects and extends a geometric rule[57] upon all living beings, and
upon all forms of motion.[58] Order in the enlightenment garden proceeds from two totally dif-
ferent principles: art should reveal the beauty of a natural order, and landscape rather than
geometry is taken to reveal the essence of nature. It is worth noting that the military engineering
that had been instrumental in revealing the geometrical nature of a terrain during the Baroque
age was abandoned for a new interest in irrigation and agricultural engineering.

Changes in the elements of garden design
Rather than attempt to describe changes in all possible garden elements, one may note how
some elements present in Renaissance gardens have disappeared during the Baroque age, and
how other elements were created during this period and disappeared at the next. Architectur-
al grottoes erected in the midst of a garden, like the one at Eriksdahl in Sweden, disappeared
during the Baroque age, the trellised bower which had been covering the main alleys in many
Renaissance gardens were used differently, either as a special promenade in a small part of the
garden, or a high decorated passage linking pavilions of trellises decorated with architectural
detailing. Knot parterres and flowery labyrinths which had been very common during the Re-
naissance period, almost vanished from Baroque gardens to be replaced by three major in-
ventions: the embroidery parterre, the parterre *à l'anglaise*, the *boulingrin*. Each of these ele-
ments was amenable to an infinite variety of decorations and formal inventions: a history of
embroidery design by itself would enable one to trace stylistic changes during the Baroque age.
Bosquets leading into *salles vertes* where visitors would discover magical sights were intro-
duced in gardens offering delightful places in the shade of trees.

The Royal Palace of Versailles
View of the Neptune fountain

following pages
Anonymous
View of the Castle and Orangerie
in Versailles the time of Louis XIV
Versailles, Musée National des Châteaux
de Versailles
cat. 215

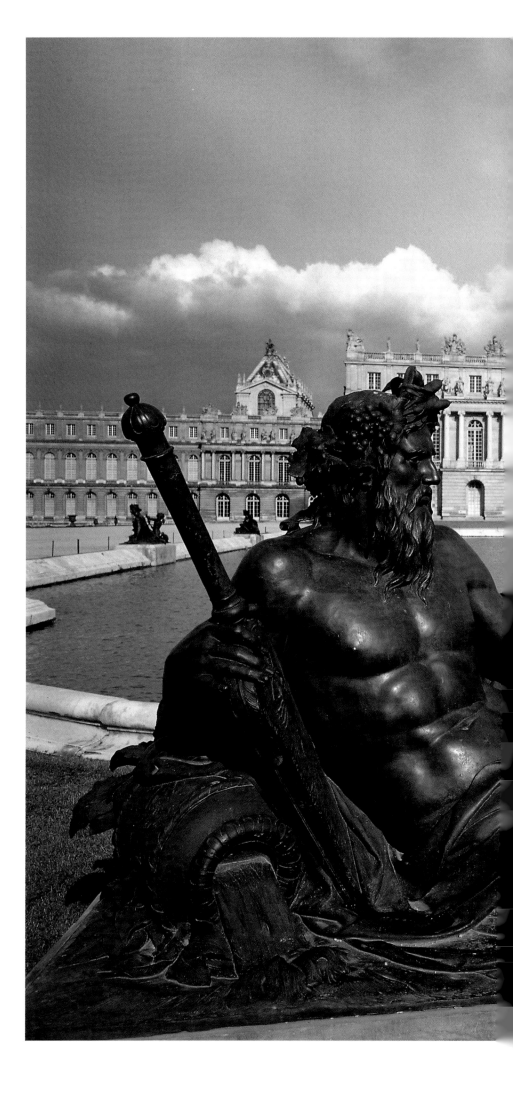

after 1695. Salomon Kleiner, *Representation au naturel des chateaux de Weissenstein au dessus de Pommersfeld, et de celui de Geubach appartenants a la maison des comtes de Schonborn: avec les jardins, les ecuries, les menageries, et autres dependances [...]* Augsburg 1728. See also note 30.
[46] Marie Louise Gothein, *A History of Garden Art*, New York 1979: 146.
[47] Baroque gardens exhibit all sorts of contrasts. They contribute to two different aesthetic functions. Either they allow a clear differentiation between garden elements otherwise similar in many respects, creating registers of forms as signs carved out of nature, or they introduce an encounter between an orderly art world and its other, creating sublimity. Dubois says that Baroque and Classical forms entertain a dialectical relationship, "the two genres reinforce each other, one is the repressed of the other." Dubois, *Le baroque en Europe et en France*, op. cit.: 19.
[48] In his influential work, "*The Moralists, a Philosophical Rhapsody,*" 1709, the Earl of Shaftesbury, a disciple of John Locke, introduced a clear philosphical and

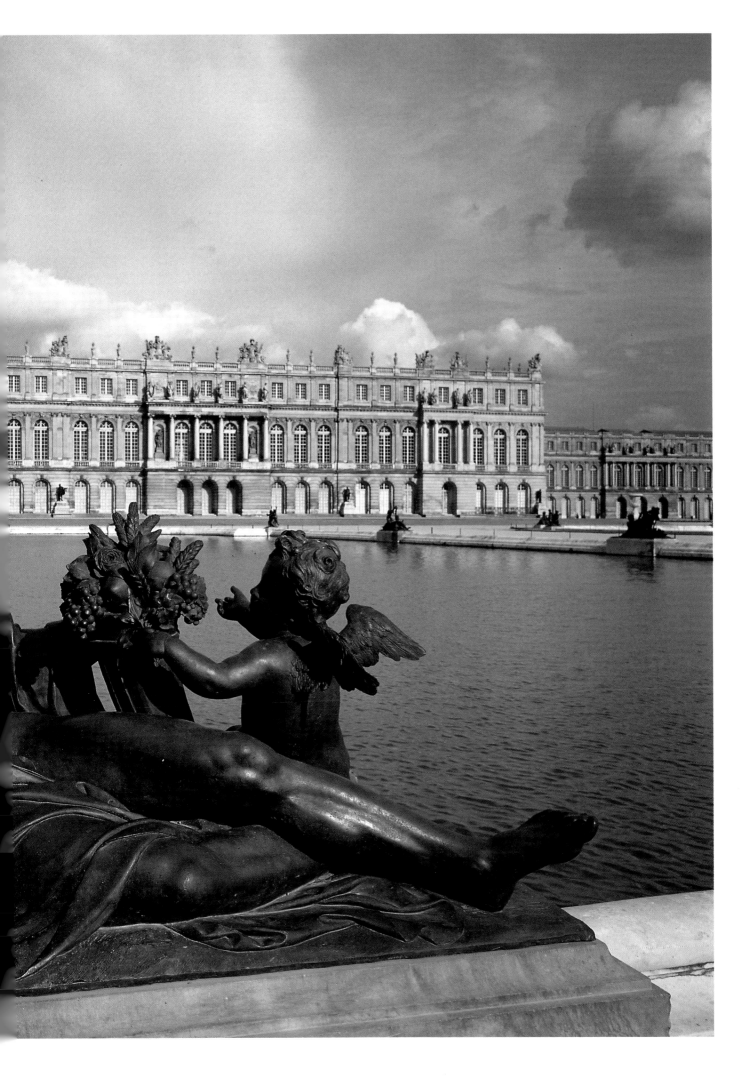

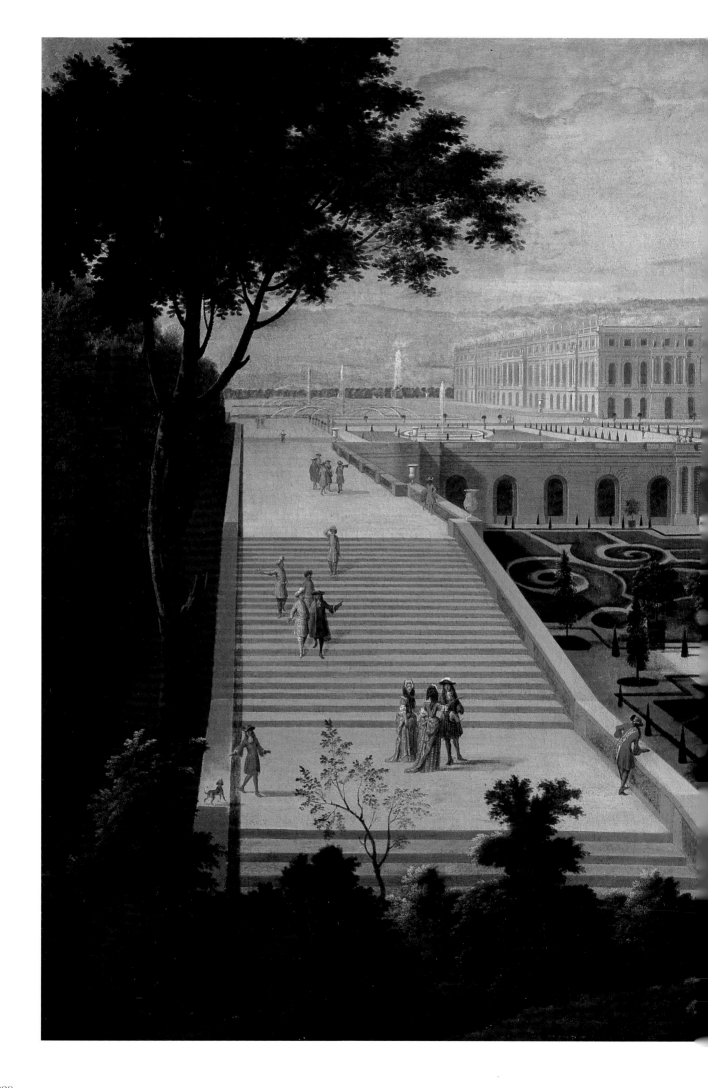

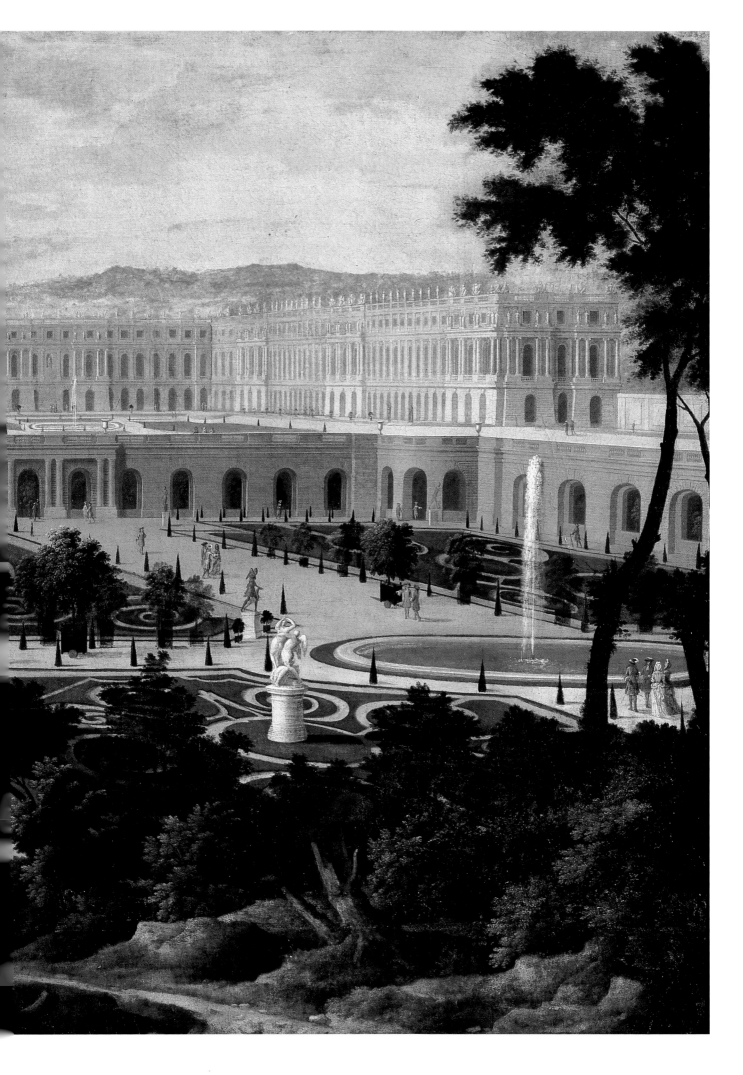

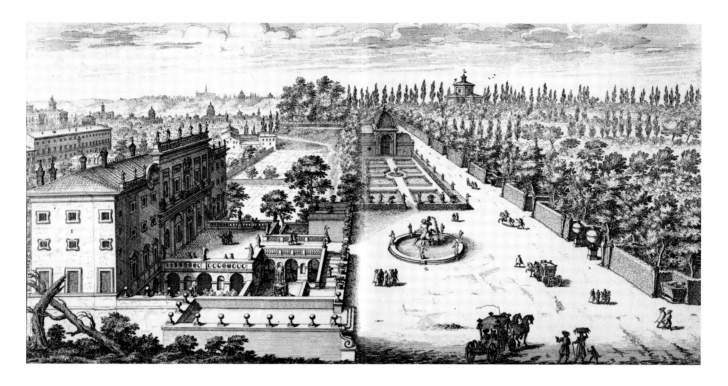

Villa Ludovisi, Rome
Milan, Civica Raccolta Stampe
Achille Bertarelli

Villa Pamphili, Rome
Milan, Civica Raccolta Stampe
Achille Bertarelli

Each show of splendor demands from its spectators that they engage in a submissive ritual, thus demonstrating the glory of an irresistible will. "According to the mythical view of absolute power this expanding glory should win approval of the spectator as soon as it is perceived, transforming beholders into grateful subjects and aggregating them to the circle of royal dominions." Starobinsky, *L'invention de la Liberté*, 1700–89, op. cit.: 14.
[38] Princely garden art after 1660 has given rise to very specific developments in France, in the Netherlands, in England and in Germany. The first three present more Classical features, the last one more Baroque. However, decorative French art for feasts, fireworks and interior decoration by Berain and Marot have been widely distributed and imitated in Germany (there are 35 counterfeited editions known to have been made in Augsburg alone). Jacques Vanuscem, "Baroque allemand et baroque français dans l'art de la fin du XVIIème siècle," in *XVIIème siècle, Revue trimestrielle*

Labyrinths, so highly prized during the Renaissance, went through a double change. First, the search for elaborate symmetries of unicursal labyrinths was abandoned for a search for labyrinths offering dead ends and multiple paths where it was easy to lose one's way; second, bosquets were cut out into labyrinths where alleys, some straight and others curving, allowed wandering from room to room. All sorts of promenades were created either between palisades or between tree alignments, or among simple parterres in the shade of tilted hedges. Waterworks were disciplined in such a way that instead of demonstrating fascinating or joking uses, water forms demonstrated the capacity of art to rule the forms of its movement and to contrast wild and civilized forces of the liquid element. All of these forms were ignored by the enlightenment gardens.

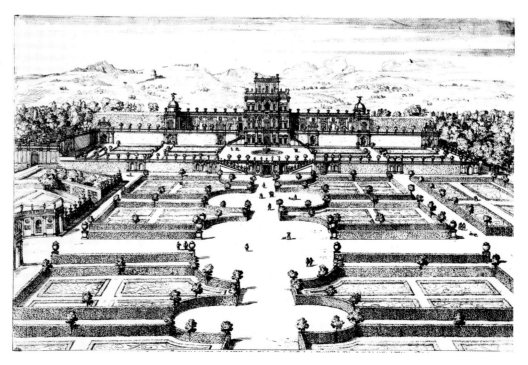

Plan of the garden of Villa Farnese
in Rome
Milan, Civica Raccolta Stampe
Achille Bertarelli

publiée par la société d'études du XVIIème siècle 20 (1953): 306–18.
[39] Florence Hopper, "The Dutch Classical Garden and André Mollet", in Journal of Garden History, 2, N1 25–40, 32.
[40] Franklin Hamilton Hazelhurst, Gardens of Illusion: The Genius of André Le Nôtre, Nashville 1980.
[41] Alessandro Francini, Livre d'architecture, Farnborough (England) 1966.
[42] James S. Ackerman, The cortile del Belvedere, Studi e documenti per la storia del Palazzo apostolico vaticano 3 (Vatican City: Biblioteca aspostolica vaticana, 1954). See also Salomon Kleiner, Residences memorables de l'incomparable heros de nôtre siecle, ou, Representation exacte des edifices et jardins de Son Altesse serenissime monseigneur le Prince Eugene François Duc de Savoye et de Piedmont: premiere partie, contenant les plans, elevations et veües de la maison de plaisance de Son Altesse sere situèe dans un de fauxbourgs de Vienne: le bâtiment a eté inventé et ordonné par le sieur Jean Lucq de Hildebrand [...]: les jardins et toutes les eaux ont été inventés par le sieur Girard [...], Augsburg 1731– 40.
[43] Jeanne Digard, Les Jardins de La Granja et leurs sculptures decoratives, Paris 1934. See also John Dixon Hunt, Garden and Grove: the Italian Renaissance Garden in the English Imagination, 1600–1750, Philadelphia 1996.
[44] Charles Allard, Neerlands veldpracht, of 't lusthof gesticht door Z.B.M. Willem III op 't Loo [...], Amsterdam 169-?.
[45] Both Gaibach and La Favorite were designed for Franz Lothar, Archbishop of Mainz, and Elector after 1695. Salomon Kleiner, Representation au naturel des chateaux de Weissenstein au dessus de Pommersfeld, et de celui de Geubach appartenans a la maison des comtes de Schonborn: avec les jardins, les ecuries, les menageries, et autres dependances [...] Augsburg 1728. See also note 30.
[46] Marie Louise Gothein, A History of Garden Art, New York 1979: 146.
[47] Baroque gardens exhibit all sorts of contrasts. They contribute to two different aesthetic functions. Either they allow a clear dif-

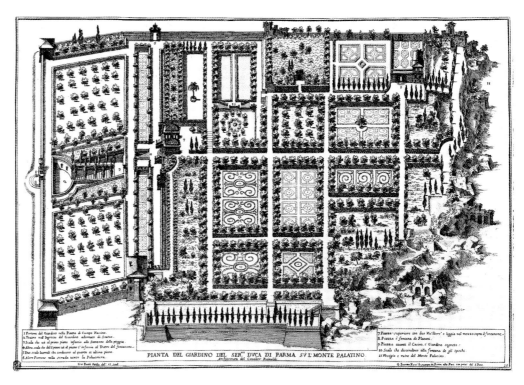

Beacons among Baroque gardens

The history of Baroque gardens in Europe is still to be fully documented before it can be written.

There are important regional differences in the passage from Renaissance to Baroque and Enlightenment gardens, but we should also be aware of the coexistence of these different modes in each country reflecting social differences. The greater visibility of princely gardens for historians should not hide cultural variance. The importance of the old *romans* in France was still so strong in the seventeenth century that gardens were made to illustrate the *Astrée* by Honoré d'Urfé,[60] the *Orlando Furioso* by Ariosto, and *Télémaque* by Fénelon[60]; and when describing royal gardens visitors would not hesitate to compare them to the gardens of Appolidon in the Spanish novel *Amadis des Gaules.* They should at least remind us that different versions of pastoral were also entertained by land-owners of lesser wealth who developed garden art in other directions. Claims to an absolute control of culture were figures of speech, we cannot take them as a basis to account for the state of garden art.

Baroque gardens comprehend a large variety of princely gardens that were created between 1580 and 1790. Different historical circumstances, princely rivalry expressed through conspicuous consumption of gardens in Europe, crossbreeding between the decorative and the visual arts and the circulation of artists from court to court created several occasions for a brilliant development of garden art that stand as beacons in the wider landscape of Baroque garden inventions.[61] One should distinguish two types of Baroque gardens in Rome between 1600 and 1640: gardens of suburban villas set in the middle of a huge rural domain, such as Villa Borghese (1605), or Villa Doria Pamphili (1634), and princely domains built on the site of Frascati which have been an endless source of emulation for garden owners of Central Europe, introducing a deep unity between fantastic cascades falling through a wilderness, a hillside and a house. Gardens of the absolutist breakthrough in France saw the victory of Henri IV and Louis XIII over warring aristocrats, the dismantling of fortresses, the rise to nobility the bourgeoisie who bought these ruins and created courtly houses and gardens between 1590 and 1651. Montjeu belonging to Pierre Jeannin, a president of the parliament in Dijon provides a fitting example.[62] François Mansart (1598–1666) is the most famous garden designer then, but a new pattern of gardens emerged slowly and became established as a tradition among a strong group of royal gardeners.

Between 1620 and 1680, after the truce with Spain was signed, princely Dutch gardens were created. They rose from a different interpretation of the Renaissance garden. Geometry is

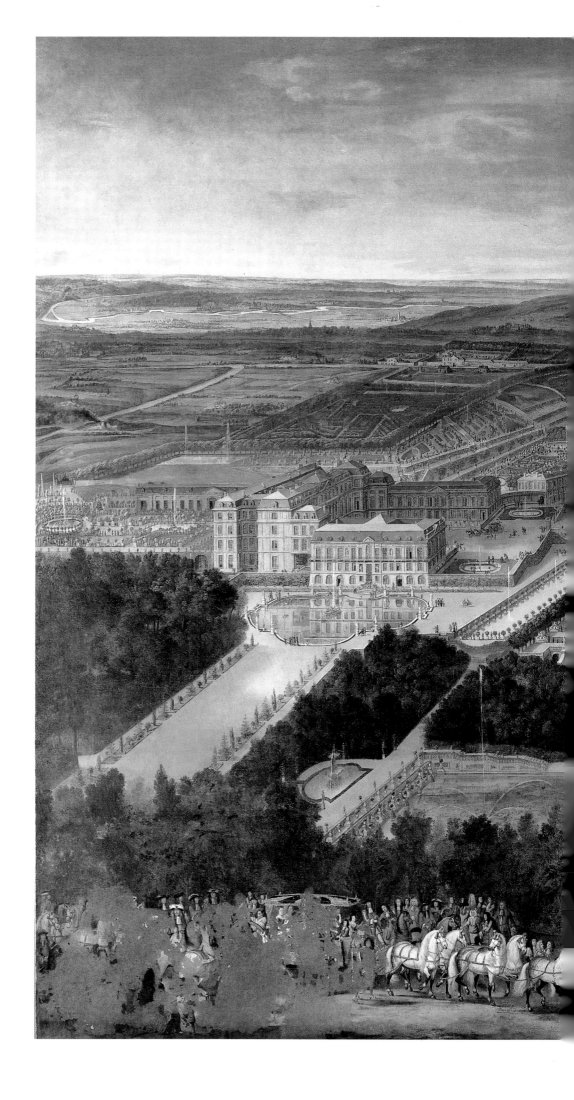

Allegrain
View of Saint Cloud
with the gardens
Turin, Palazzo Carignano
cat. 230

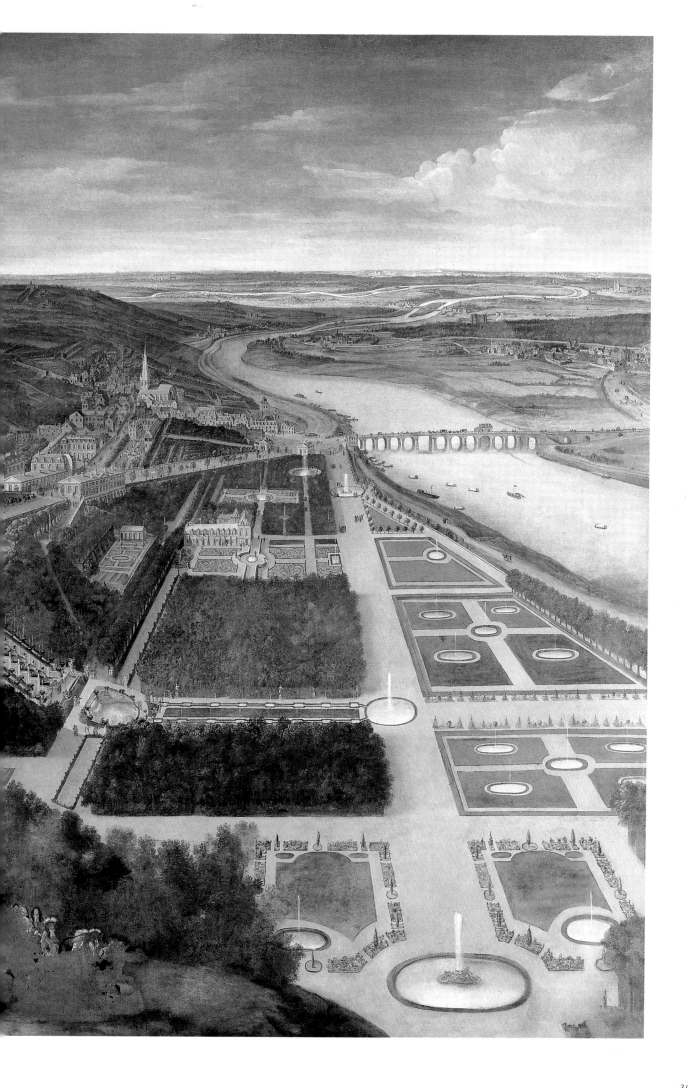

The castle of Vaux-le-Vicomte
with the gardens

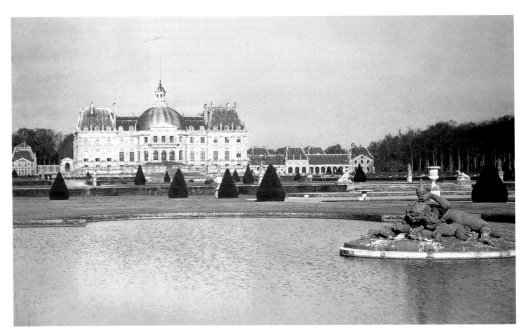

ferentiation between garden elements otherwise similar in many respects, creating registers of forms as signs carved out of nature, or they introduce an encounter between an orderly art world and its other, creating sublimity. Dubois says that Baroque and Classical forms entertain a dialectical relationship, "the two genres reinforce each other, one is the repressed of the other." Dubois, *Le baroque en Europe et en France*, op. cit.: 19.

[48] In his influential work, "*The Moralists, a Philosophical Rhapsody,*" 1709, the Earl of Shaftesbury, a disciple of John Locke, introduced a clear philosphical and political distinction between "princely gardens" and a more natural art of gardening that anticipates the English landscape gardening: "I shall no longer resist the Passion growing in me for Things of a *natural* kind: where neither Art, nor the *Conceit or Caprice* of man has spoil'd their *genuine Order*, by breaking in upon that *primitive State*. Even the rude *Rocks*, the mossy *Caverns*, the irregular unwrought *Grottos*, and broken *Falls* of Waters, with all the horrid Graces of the *Wilderness* itself, as representing nature more, will be the more engaging, and appear with a Magnificence beyond the formal Mockery of Princely Gardens." Quoted by Kenneth Woodbridge, *Landscape and Antiquity, Aspects of English Culture at Stourhead 1718 to 1838*, Oxford 1970: 5.

[49] For an example of a French interpretation of English ideas on this aspect of garden art, see chapter XV, "Du pouvoir des paysages sur nos sens et par contrecoup sur notre âme", in Réne Louis Girardin, *De la composition des paysage*, Geneva 1777.

[50] However, Claudia Lazzaro has introduced the notion of order in her studies. Claudia Lazzaro, *The Italian Renaissance Garden: From the Conventions of Planting, Design and Ornament to the Grand Gardens of Sixteenth-Century Central Italy*, New Haven 1990.

[51] Charles Etienne et Jean Liébault, *L'Agriculture et maison rustique*, Paris 1583.

[52] Florence Hopper has shown how Huyghe, Stevin, Van Campen have transported Vitruvianism

paramount, and symmetrical canals display a mastery over nature that has been widely emulated later in Germany, and that may have been influential in France.[63] A few years later after the Fronde was over, Louis XIV succeeded in drawing under his gaze the French aristocracy at his court at Versailles and in establishing the administrative basis of a centralized state. Gardens played a pivotal role in his strategy of bedazzlement, and garden art flourished since aristocrats, ministers and rich ennobled bourgeois followed suit. André Le Nôtre (1613–1700),[64] who designed Vaux (1650–61) and the first Versailles (1661–68), and Jules Hardouin Mansart (1645–1708), who designed Marly (1679–90), are the two most famous among a large number of garden architects, ornamentists, sculptors and fountain engineers who developed great skills which they exported throughout Europe during the following decades. A first important period for the creation of gardens coincides with the time of major royal commissions, from 1660 to 1695. However, different developments took place after this date, and in particular during the middle of the eighteenth century, when German inventions were emulated in Lorraine under Stanislas Leczsinsky.

The importance of the rise to power of William and Mary in England for garden art has only been recognized recently. It came after a long period of civil war and brought back a new period of buoyant optimism that is echoed in a new interest for gardens as instruments of royal propaganda by William III both in England and in the Netherlands. It stimulated the creation of lordly gardens in both countries from 1680 to 1702, such as Het Loo (1686-95) by Jacob Roman (1640–1716) and Daniel Marot (1661–1752),[65] or Hampton Court (1689–94) by Talman (1650–1719).[66]

Germany had been depopulated and ruined by the Thirty Years' War, and the wars of Louis XIV. Austria had suffered greatly from the wars since the beginning of the Thirty Years' War until the victory over the Turks and the end of the siege of Vienna in 1683. Peace made all sorts of new lives possible and great desires to reconstruct a better world. Many of the small princes and bishops emerged with greater independence after these wars, and they embraced the new absolutist ideas. Austrian aristocrats and the Emperor emulated the absolutist strategies of Louis XIV to celebrate their glory. Leopold I (1658–1705) and later on Maria Theresa (1740–80) and the imperial nobility ruled Vienna and commissioned two major landscape architects, Fischer von Erlach (1656–1723), and Lukas von Hildebrandt (1666–1745) to build a number of large gardens around the city, who led the creation of imperial Austrian gardens (1690–1745). Some of their compositions are derived from Italian precedents, while others are inspired by French designs. The Belvedere in Vienna provides a wonderful example of a very original art by Von Hildebrandt showing how conversant he was with Italian compositions and French order and art of visual illusions.[67] Versailles was also a source of envy among German princes, but garden designers there, even if inspired

Jean Cotelle
The copse with the three fountains
Versailles, Musée National
des Châteaux de Versailles
cat. 211

in a Calvinist context creating gardens with squares, circles inscribed in a square, double square and (Pythagorean) harmonic proportions. Florence Hopper, "The Dutch Classical Garden and André Mollet," in *Journal of Garden History* 2, no. 1 (1982): 25-40.
[53] Lazzaro; *The Italian Renaissance Garden*, op. cit.: 39
[54] Lazzaro; *The Italian Renaissance Garden*, op. cit.: 57
[55] Lauro Magnani, *Il tempio di Venere, giardino e villa nella cultura genovese*," Genova 1988, cap. VII: "Immagini del creato e dei misteri della natura", 93-102.
[56] Relationships between art and nature go through a deep and subtle change. Allegorical art in Mannerist grottoes at Pratolino, Saint-Germain-en-Laye or Heidelberg could demonstrate the hidden wonders of nature. The wonderful was an aesthetic category accounting for art surpassing nature: water-organs playing music for instance. At Versailles and later on in Europe, the king creates a new fable, he is perceived as the source of a new nature that gives rise to a renewed sense of wonder, a sense that does not depend upon a fleeting belief in allegorical truth, but emanates from the belief in a mythical and glorious figure of the state. See Anne-Elizabeth Spica, "Les rêveries du promeneur enchanté. Symbole, Allégorie et Merveilleux dans le premier Versailles de Louis XIV (1664-1683)," in *XVIIème siècle, Revue trimestrielle publiée par la société d'études du XVIIème siècle* 184 (1994): 437–60.
[57] Erik de Jong remarks that garden composition was seen as a science in the Netherlands and that Daniel Marot, an engraver and garden designer, was referred to as a mathematician. Erik de Jong, "'Netherlandisch Hesperides,' Garden Art in the Period of William and Mary, 1650–1702", in *The Anglo-Dutch Garden*, op. cit.: 20.
[58] A parallel between rhetorics and garden art may be drawn because in the Baroque age both are instruments of absolutist propaganda. "Baroque rhetorics – originating from the primeval figure of pilgrimage – would constitute a form aiming at regulating, containing,

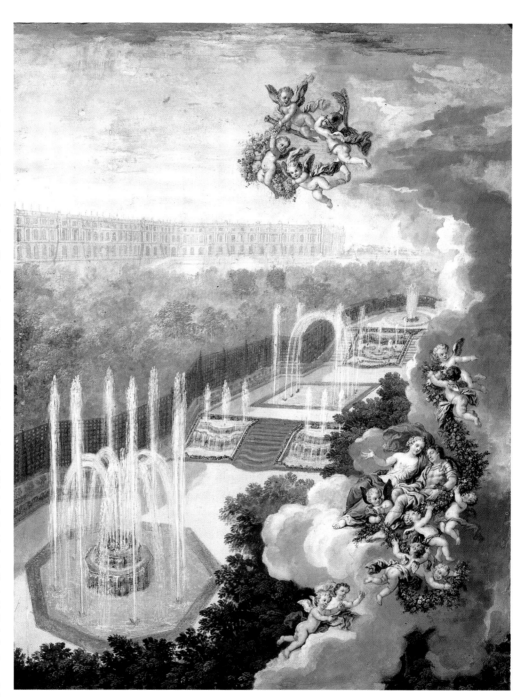

by Dutch, French, Italian or Austrian precedents, have boldly developed different elements of Baroque garden composition during a long period of German princely gardens (1680–1760). At Herrenhausen (1680–92), a French garden architect, Charbonnier, followed a general Dutch pattern of composition as André Mollet had adapted them, including in the garden a very interesting hedge theater decorated with figures from the Netherlands. At Nymphenburg (1701–39) a monumental entrance around a canal develops the layout of pavilions in the gardens of Marly, while the parterres on the other side of the castle are organized along a Dutch pattern, and a huge *patte d'oie* leads into the woods to two pavilions with their own gardens. At Marquadsburg (ca. 1700) near Bramberg the house was placed in the center of a garden offering two double symmetries; at Karlsruhe the place was laid according to a panopticon design within a huge circle of gardens and radiating alleys cut into the woods; at Wilhelmshöhe (1701–15) near Kassel, Guerniero, inspired by Baroque Italian precedents, stressed fantastic cascades tumbling down the untutored landscape of

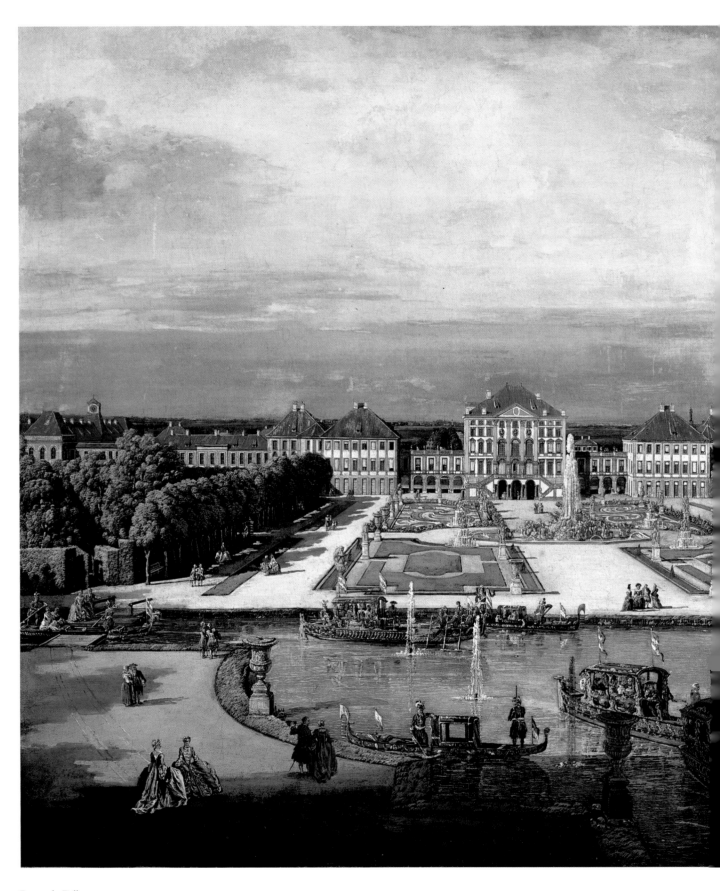

Bernardo Bellotto
View of Nymphenburg Castle
Washington, D.C., National Gallery of Art
Samuel H. Kress Collection
cat. 228

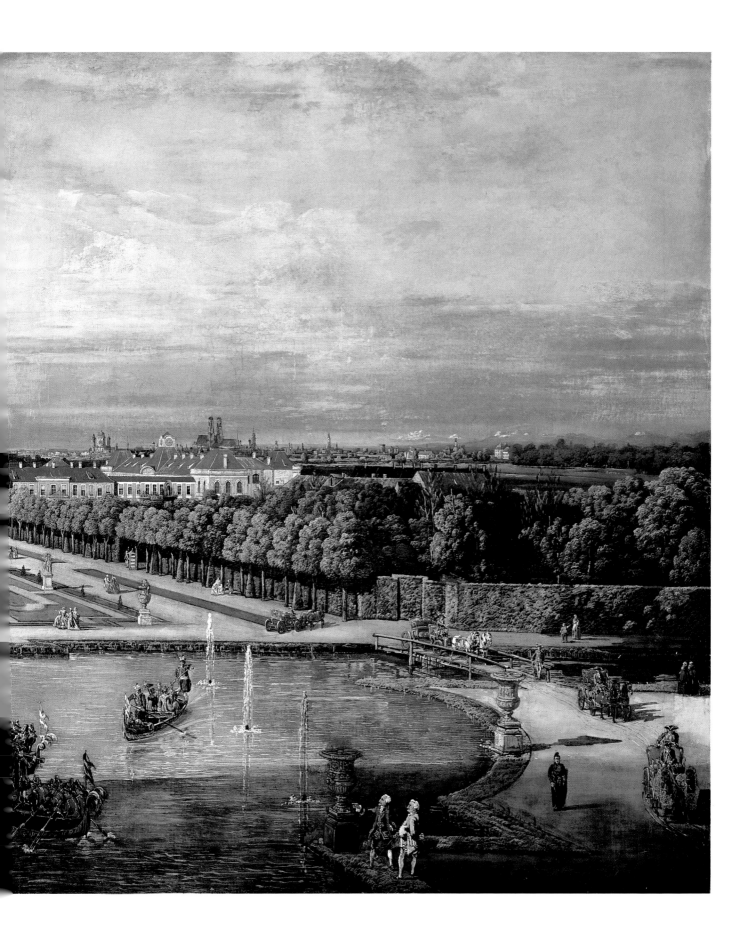

François de Cuvilliès
The "Pavillon de Plaisance"
in the gardens of the Amalienburg
The hunting lodge
at Nymphenburg castle

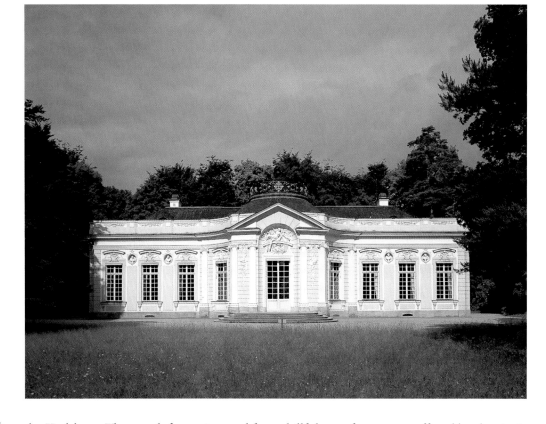

opposite
The Medici fountain
in the Luxembourg Gardens, Paris

following pages
Gottfried Heinrich Krohne
Model for the Orangerie
and the garden of Gotha
Gotha
Museum für Regionalgeschichte
und Volkskunde
cat. 220

channeling movement, flow of elements of meaning whose existence preceded its own into a re-oriented sequence, relative to a unique focus of signification." Carole Martin, "Figures Baroques," in *XVIIème siècle, Revue trimestrelle publiée par la société d'études du XVIIème siècle* 185 (1994): 759–72.

[59] Anne Despreschins has studied a very interesting garden that is mentioned by Mademoiselle de Scudéry. It belonged to Abbé Bayard, a friend of Madame de La Fayette, who had transformed his house in Bourbonnais into the palace of Adamas the wise Druid in l'*Astrée* simply by cutting a two-tiered terrace in front of the house in the middle of the wild and poor vegetation of the hillside. Madame de Sévigné perceives it immediately as an implicit criticism of the aesthetics of Versailles.
Anne Despreschins, "Langlard, un jardin au pays de l'illusion romanesque," in *XVIIème siècle, Revue trimestrelle publiée par la société d'études du XVIIème siècle*, 165 (1989): 401–16.

[60] The sister of Frederik II, the Margravine Wilhelmina, commissioned a French architect, Joseph Saint-Pierre, in 1745–47 to build SansPareil, a literary park comprising winding paths under

the Karlsberg. The search for variety and for a skillful use of resources offered by the site is always obvious. La Favorite in Mainz provides a clear example, with a garden axis parallel to the Rhine uniting three perpendicular terrace gardens opened toward the Rhine and each of a different design. This is a clear departure from all models of garden composition, and yet the orangery is a deliberate imitation of Marly.

A wonderful art and its divisive uses
Much more should be said about each of these periods and about many other countries in order to provide a glimpse into the richness of the art of gardens during one and a half centuries in Europe. A clear pattern of change emerges from this birds'-eye view of European garden history. It shows that a clear difference can be established between three modes of gardening pertaining to the classical Renaissance, the Baroque, and the Enlightenment. There is a certain overlap of the periods corresponding to each of these modes of garden design. Classical Renaissance gardens are still created in Northern Europe in the early seventeenth century, and Baroque gardens are created at the end of the eighteenth century in Eastern Europe, fifty years after a new approach to gardening in keeping with Enlightenment ideas had been initiated in England.[68] However, there is neither an ideal-type pattern nor a concept subsuming Baroque gardens. They emerge as a domain of design variation structured by specific issues touching social use, composition principles, order, and elements which always engage the memory of Renaissance gardens. Patrons' and artists' strivings for variety and emulation between European princes may account for much diversity among the most ostentatious gardens. But we can also see how beyond the princes themselves, courtiers, lesser nobilities, clerical and bourgeois audiences have adopted Baroque arts and appropriated them to their own ways of life, their stance toward absolutist rule and their own artistic leanings. Yet despite all this diversity, crossbreeding influences between artists, emulation between patrons, and similar agenda for garden creation derived from the absolutist program, for the arts have imprinted this endless search for variety with design problems, such as capturing the sense of motion or imposing a sense of awe to spectators, that we are tempted, three centuries later, to seek for the unity of a European style.

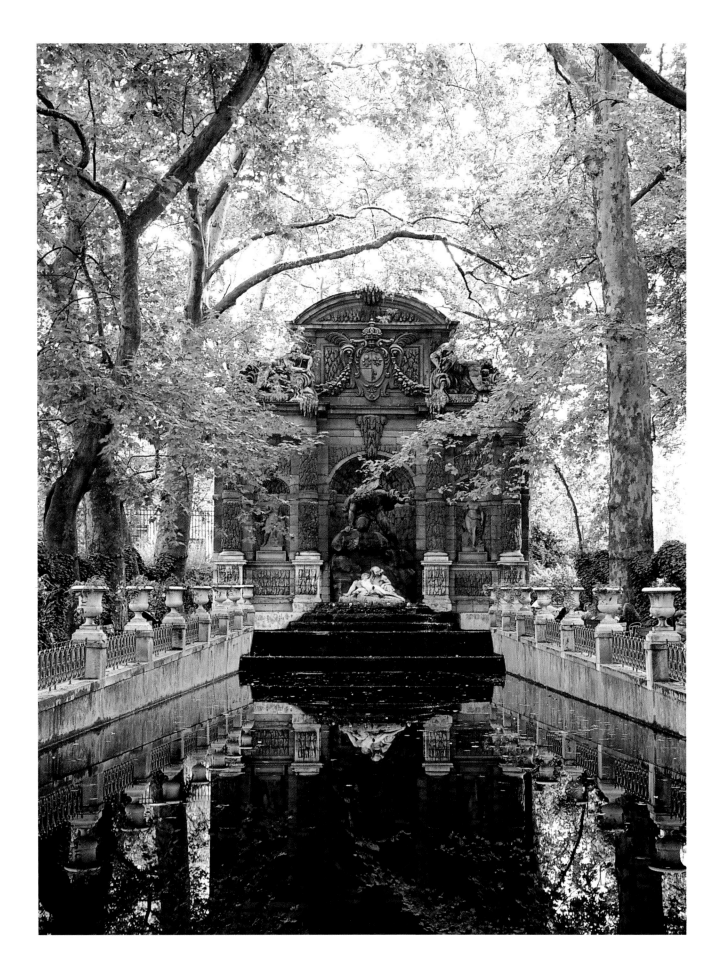

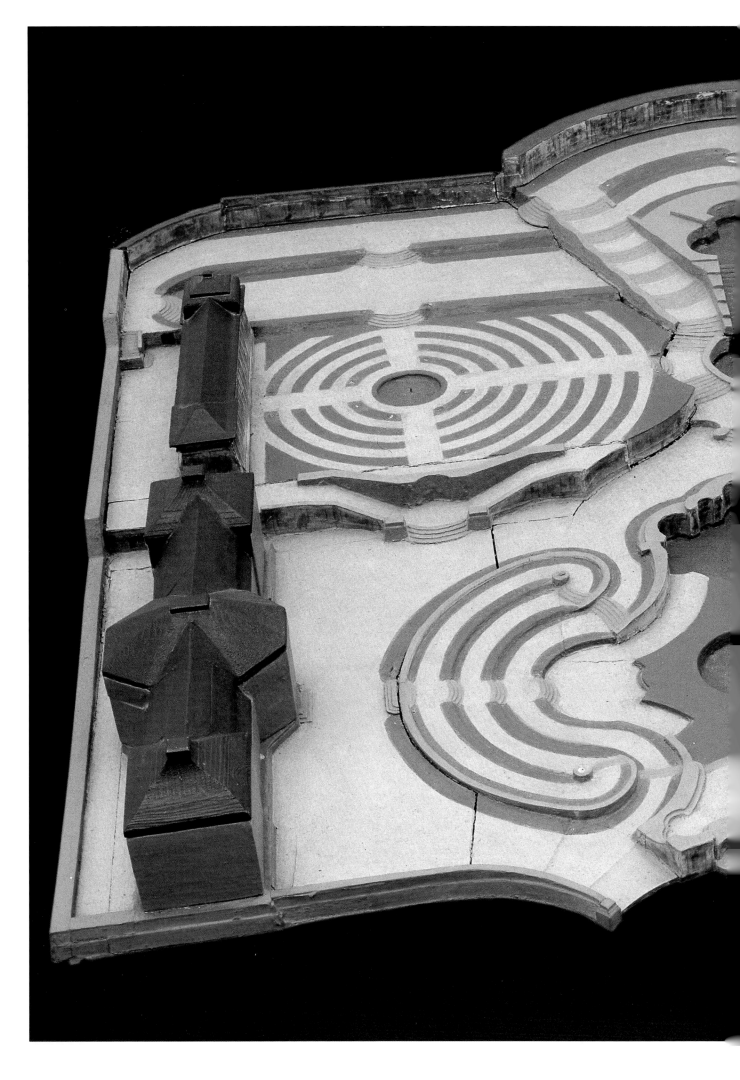

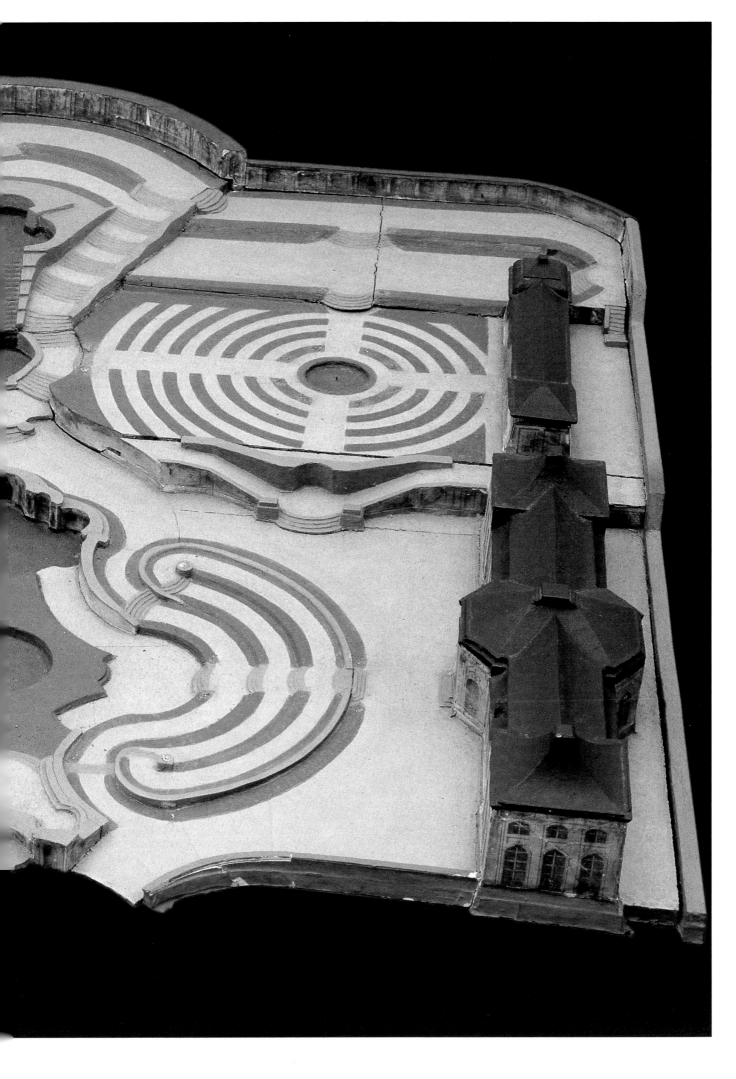

The Aeolus fountain
in the gardens of the Royal Palace
Caserta

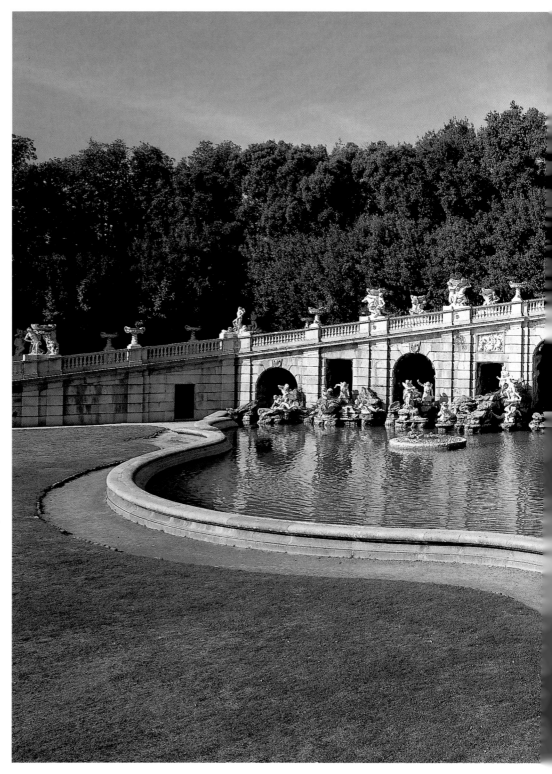

beech trees leading to *rocaille* grottoes that helped remind the adventures of Telemachus, meant to help the visitor experience the purifying and enlightening process through which Mentor had taken the son of Ulysses, Telemachus, in the novel.

[61] Hunt, *Garden and Grove*, op. cit.
[62] See Woodbridge, *Princely Gardens*, op. cit., chap. 9 "The gardens of the new financial elite:" 161–79.
[63] The gardens of Perigny in Burgundy for the President du Parlement De Gagne recall undoubtedly Dutch garden patterns. See *L'Architecture françoise ou recueil des plans, élévations, coupes et profils des églises, palais, hôtels & maisons particulieres de Paris & des châteaux & maisons de campagne ou de plaisance des environs, & plusieurs autres endroits de France*, Paris 1727: 123.
[64] Hazelhurst, *Gardens of Illusion, the Genius of André le Nôtre*, 1980.
[65] Florence Hopper, "Daniel Marot: a French Garden Designer in Holland," in John Dixon Hunt (ed.), *The Dutch Garden in the Seventeenth century*, Dumbarton Oaks colloquium on the history of Landscape Architecture, XII, 1988.
[66] David Jacques and Arend Jan van der Horst (eds.), *The Gardens of William and Mary*, London 1988.
[67] The garden extends on a hill between a palace at its foot and at its top a large pavilion, the Belvedere, that served for great festivities. The layout combines with great originality different garden elements showing a richness of invention. A special mention can be made of the use of the irregular shape of the domain of which it was taken advantage to create two accelerated perspectives, one from the Belvedere when looking toward the exit, and the second in the garden of the orangery.
[68] For instance, Charles d'Arenberg designed at Enghien in Belgium in 1630 a Dutch Mannerist garden full of wit and imagination that was only finished in 1685. On the other hand, the Reggia di Caserta for Charles III, King of Naples, was designed in 1752 where the most Baroque Dolphin cascade was built in 1779 and the basin of the Peschiera Grande with its temple in 1782. The gar-

However, the more detailed the study the more difficult it is to perceive its overall contribution to the history of art in Europe. During the Baroque age, Europe was divided by religious and secular conflicts that engendered successive bursts of destruction and of creativity. The arts were caught in these storms because rulers of state attempted to use the arts as instruments in order to gain a hold over the minds of their subjects. Gardens were awarded an eminent role in these strategies of domination; which created soaring demand for gardens.

Their study does not reveal a European essence, or a European character; it shows rather

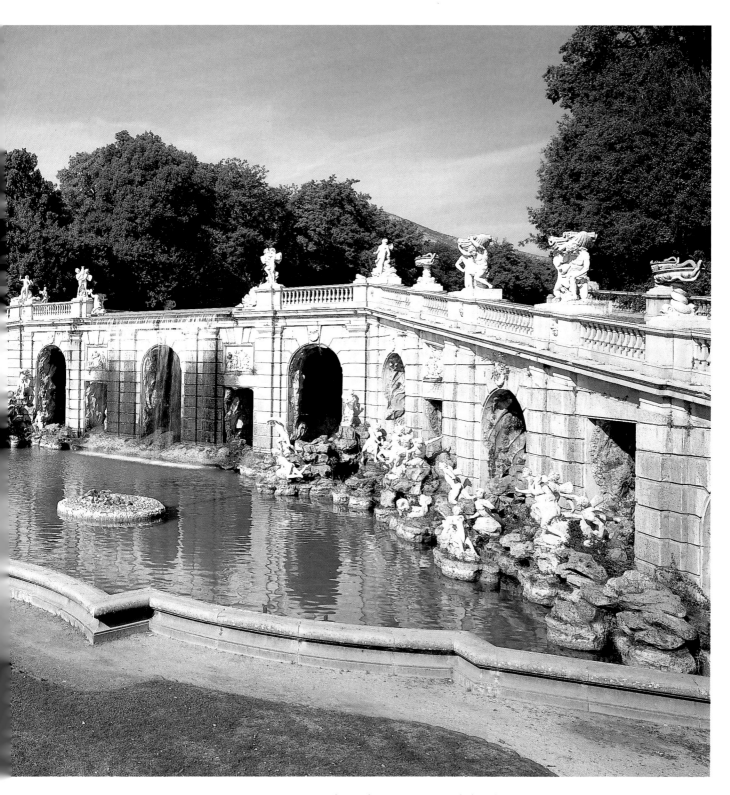

den of Veitshöscheim was built between 1763 and 1767, and the gardens at Würzburg by Johan Prokopp Mayer in 1773, both of them striking German Baroque gardens. In Russia the park of Yekaterininsky at Tsarkoye Selo near St. Petersburg was built between 1762 and 1796.

Europe as an arena where the arts were mobilized in the construction of modern states. The art of gardens has provided more than a symbol to this cultural construction, a theater where visitors were turned into participants in public celebration of the glory of their prince, so that they could take pride in the state to which they belonged. Even though the idea of a nation is still very vague at times when linguistic and legal integration of all populations under each European state are far from achieved, we may see this as a contribution of garden art to the development of a European self-awareness divided along national lines.

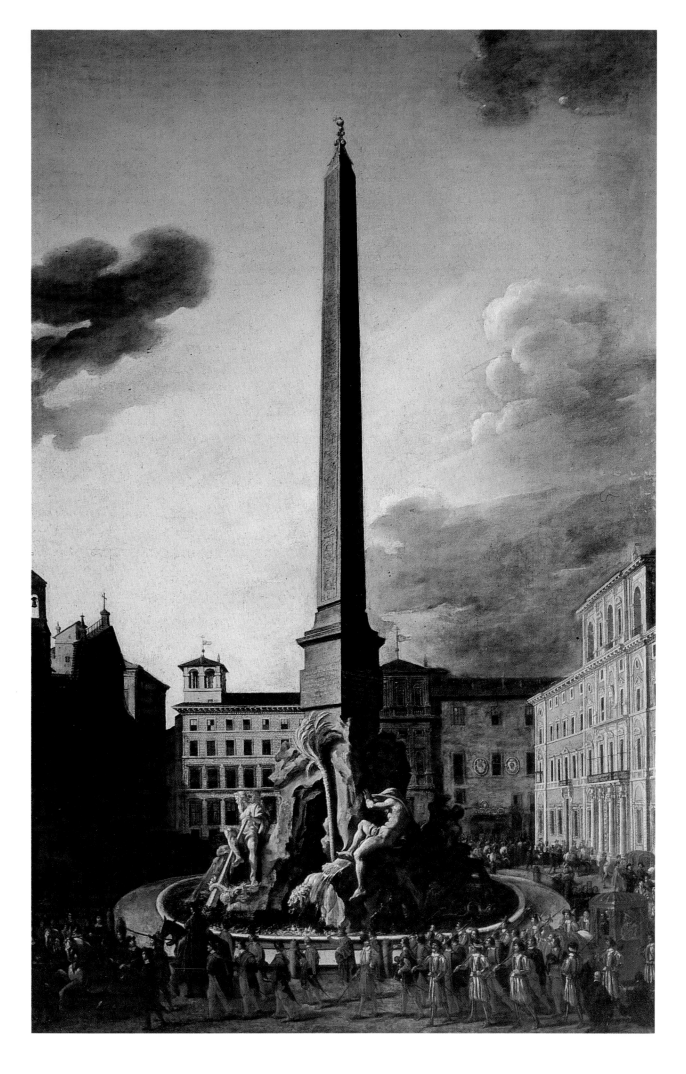

In the seventeenth century, architectural treatises paid great heed to questions of ornament and molding, but overlooked the city, which was given scant attention except in treatises on fortification. The city nevertheless constituted a background which little by little was to emerge into the foreground, ultimately coming to hold center-stage among the concerns of the century of the Enlightenment, from Voltaire to Laugier. Let us recall the factual data, with all its attendant uncertainty due to the nature of the demographic sources of the time (Chaunu 1966). Europe's urban population grew from six to ten million between 1600 and 1750, less than that of a single megalopolis today. In 1600, a dozen European cities had more than 100,000 inhabitants: Naples, Paris, Venice, London, Palermo, Rome, Milan, Madrid, Lisbon, Seville, and Amsterdam, which outstripped Antwerp. By 1750, the order of the front-runners had changed: Naples, Europe's largest city at the turn of the century, went from 300,000 to 450,000 inhabitants before being decimated by the great plague of 1656 which reduced its population by half; Paris, which had been the largest European city since the Middle Ages and which the religious wars had reduced to some 250,000 inhabitants, grew measurably to 500,000 or 600,000 inhabitants, until London, growing from 200,000 to some 800,000 inhabitants, assumed first place from the end of the seventeenth century on. Also joining the list of cities having 100,000 inhabitants or more were Moscow and St. Petersburg, the former and new capitals of the Russian empire, Vienna, elected as capital by the Habsburgs after the Turkish defeat of 1683, and Lyons, nexus of north–south overland trade.[1]

Urban density remained characteristic of Italy. But while Turin, capital (since 1713) of the "kingdom" of Savoy-Piedmont-Sardinia, grew considerably (25,000 inhabitants in 1625, 40,000 in 1673, 60,000 in 1713), the populations of other Italian and Spanish cities stagnated, only to experience moderate growth once again in the eighteenth century.[2] Urban dynamism shifted from the south toward Northern and Central Europe – a trend which would be still more striking on a map of cities with over 30,000 inhabitants – in France, Great Britain, the Netherlands[3] and Germany where the cities debilitated by the Thirty Years' War were being rebuilt over the course of the eighteenth century.[4] As an indication of this shift, the seaports on the Baltic and the North Sea (St. Petersburg, Danzig, Lübeck, Hamburg, Amsterdam, Rotterdam, London) all experienced steady development. In the history of European cities, the year 1600 is something of an artificial cut-off point: the city being a perpetual "palimpsest" (Adams and Nussdorfer 1994), the general history of urbanism always runs up against the challenge of the particular and the long duration. The new surrounding walls, bastioned with weathering and brought to the point of perfection by Vauban, were invented by Italian engineers toward 1530. The paving of the streets of Paris – celebrated by a token in Louis XIV's "metallic history"

[1] Whereas Antwerp dropped to 50,000 inhabitants, Vienna reached 100,000 in around 1700 and Lyons 130,000 in 1750. Moscow had 80,000 inhabitants toward 1600, 200,000 toward 1750, at a time when the population of St. Petersburg was 100 000.
[2] Palermo stagnated at around 100,000 inhabitants; Milan went from 100,000 in 1600 to 120,000 in 1750; Venice dropped from 140,000 in 1624 to 130,000 in the mid-eighteenth century. Rome had between 100,000 and 120,000 in the seventeenth century, then grew during the first half of the eighteenth century, reaching 153,000 inhabitants in 1759; in Jubilee years, however, the number of pilgrims would double the city's population. In Spain, decimated by recurrent plague epidemics (60,000 deaths out of 120,000 inhabitants in Seville in 1649-50), Madrid grew rapidly from 60,000 inhabitants in 1567 to 150,000 in 1621, before peaking.
[3] In the course of the seventeenth century, Dublin went from 10,000 to 40,000 inhabitants, Edinburgh and Bristol from 10,000 to 30,000. The cities in the Northern Netherlands showed population growth of between 50 and 100 per cent between 1557 and 1622, Leiden and Haarlem each having some 40,000 inhabitants.
[4] Hamburg reached 60,000 toward 1700.

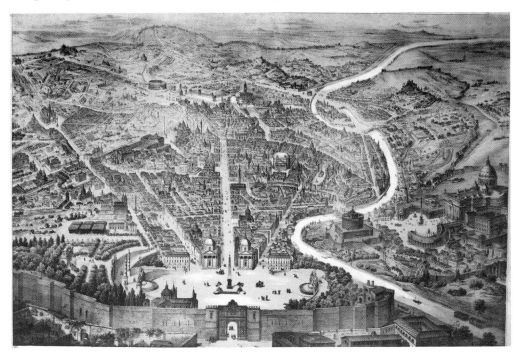

Les Invalides
detail of an aerial view
Paris

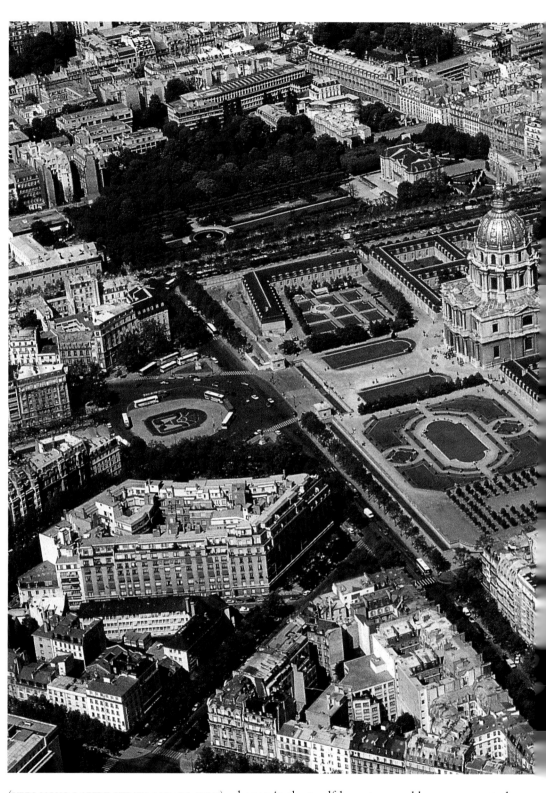

[5] In 1644, John Evelyn expressed
admiration for the perspective of
the via Pia (Girouard 1985: 115).
"The beauty of cities lies princi-
pally in the alignment of the
streets." (Fréminville 1758: 518).

(URBS NOVO LAPIDE STRATA M.D.C.L.X.I.X) – began in the twelfth century and became a central occupation in the Italy of the fifteenth century. The aesthetics of straight, wide streets lined with palaces – still considered a city's principal beauty in the eighteenth century[5] – found its first monumental expressions in Rome, Geneva, Naples and Palermo in the course of the sixteenth century. And the "rhetoric of the façade," which guided the work of Alexander VII in Rome and of Colbert in Paris, came together in the mid-fifteenth century in Central Italy. Moreover, two of the most specific components of seventeenth-century urbanism came together over the course of the last third of the sixteenth century: the invention of the regular, ordered square sur-

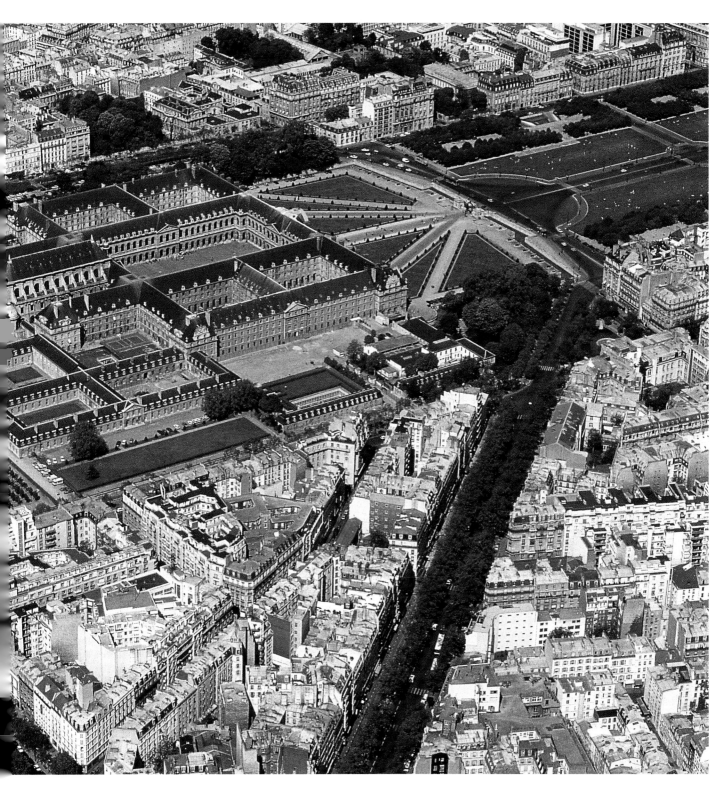

rounding the statue of the sovereign – of which Michaelangelo's Piazza del Campidoglio is the prototype – and the multiplication of establishments of the new regular orders of the Counter-Reformation which came to disrupt the urban landscapes of Catholic Europe.

The year 1750, however, corresponds to a more relevant dividing line for what we are dealing with here. If the urbanism of the Enlightenment continued to play with the alignment of streets, regular public squares and the poetics of the façade,[6] the rethinking of the classical antiquity's urbanism, the new role played by public opinion, and the differentiation of public buildings all clearly mark the advent of a new phase.

[6] George Elliott, *Proposals for Carrying on Certain Public Works in the City*, Edinburgh 1752; Voltaire, *Des embellissements de la ville de Cachemire*, Paris, 1756.

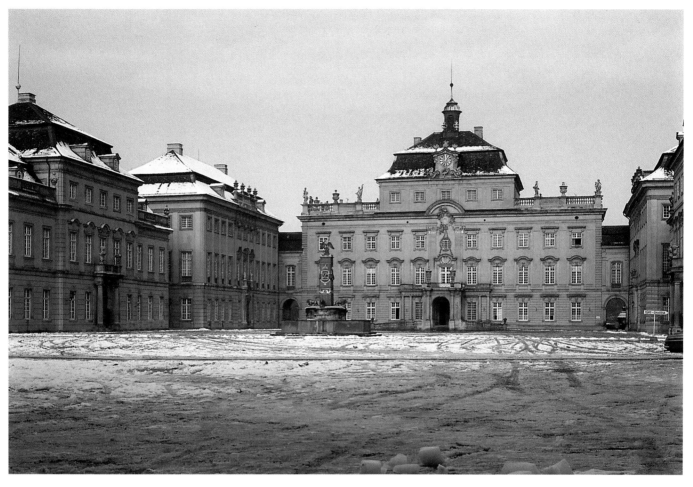

The façade of the castle
of Ludwigsburg in Germany

New cities; renewed cities

In 1637, René Descartes stressed the central paradox of the century and a half of interest to us here, arguing that the large cities were not even as well laid out as the most modest new fortified town: "Thus these ancient cities – which have gone from being nothing but villages to becoming, with the passing of time, big cities – are usually shoddily laid out instead of having regular squares plotted out on a prairie at the engineer's whim." A century later, Voltaire would raise the issue once again with irony: "If half of Paris burned to the ground, we would rebuild it superb and advantageous, but today we do not want to provide it, at a price a thousand times lower, with the advantages and the magnificence it requires." (Voltaire 1749: XXXI B, 232). It took a natural disaster, a fire (Oslo, 1624; London, 1666; Brussels, 1695; Rennes, 1720, etc.), or an earthquake (Catania, Noto, Occhiala in Sicily in 1693; Lisbon in 1755) to give birth to the opportunity to build the ideal city which the real city often felt satisfied to dream it was, or to measure the indifference toward an ideal city – as was made clear in the reconstruction of London.

In the seventeenth century, treatises on fortifications continued their role as the principal urban laboratory,[7] but innovations were mostly in the realm of the weathering and the ramparts of the city walls rather than in terms of the urban structure, still torn – as it had been in the sixteenth century – between radial layouts and checkerboard layouts. Thus Dillich's treatise contains a total of 410 plates with eleven city maps, four of which are radial and seven checkerboard-like. The new cities, whether they had a bastioned surrounding wall or not, continued to be divided between one type and the other: radial layouts in the style of Palmanova (Kalmar in Sweden, 1614, destroyed in 1647; Glückstadt in Holstein, 1616–30; Taganrog in Russia on the Azov Sea), checkerboard layouts, issuing from the Roman colonial system (Mülheim on the Rhein, opposite Cologne, 1612; Fredericia, founded in 1648, principal market-town of Jutland; Kalmar in Sweden, reconstructed in 1660 by Nicolas Tessin, and so on) or mixed layouts (Grammichele, Sicily, 1693).

[7] J. Errard, *La Fortification démontrée et réduite en art*, Paris 1594; Frankfurt am Main 1604; J. Perret, *Des fortifications et artifices*, Paris 1601, Frankfurt am Main, 1602; F. Tensini, *La Fortificatione*, Venice, 1623; Antoine de Ville, *Les Fortifications*, Lyons, 1628; Amsterdam 1672; M. Dögen, *L'Architecture militaire moderne*, Antwerp 1647-48.

Work on foundations of cities and fortified towns moved ahead rapidly in Scandinavia where Denmark and Sweden were battling one another. Christian IV (1588–1648) expanded foundations throughout Denmark (Christianopel, 1600; Christianstad, 1614, in a checkerboard layout; Gluckstadt on the Elbe/Glystad, 1616, in a radial layout) and in Norway (Oslo reconstructed under the name of Christiana after 1624; Christiansand, 1641). In Sweden, Gustavus Adolphus founded sixteen cities, including Göteborg (1620), a policy carried on by Christine and Charles XII (Eimer: 1961).

The establishment of borders between French and Spanish territories led to the dismantling of inland fortifications and to the reinforcement of border towns as well as to the construction of eight fortified cities by Vauban (1633–1707), in charge of all French fortifications from 1668 on: Sarrelouis, Huningue in Alsace, and Longwy in the Ardennes in 1679; Mont-Louis in the Pyrénées in 1680, Montdauphin in the Alps in 1692, Neuf-Brisach (Neubreisach) in Alsace, as well as Fort-Louis and Montroyal on the Rhine and the Mosel in 1698. Though Vauban (*Traité de l'attaque et de la défense des places*, 1739) and his Dutch archrival Coëhoorn (*Nouvelle fortification sur terrain bas et humide*, 1685) contributed to the development of poliorcetics, the urbanism of these fortified cities fit right into the continuity of sixteenth-century schemas. In the Southern Netherlands, Charleroi – founded by the Spanish in 1666 – adopted a radial layout with eleven streets radiating out from a central square, and which Louis XIV sought to populate, after the city became French, by giving the land away and erecting the fronts of the houses; while Neuf-Brisach, founded by the French in 1698 on the left bank of the Rhine, was built in keeping with a checkerboard layout featuring a central square without any axial monument. Religious divisions also laid ferment for urban creation. In the Netherlands, urban expan-

Anonymous
The Saint Denis gate in Paris
17th century
Paris, Musée Carnavalet

Aerial view of Westminster
Palace, London

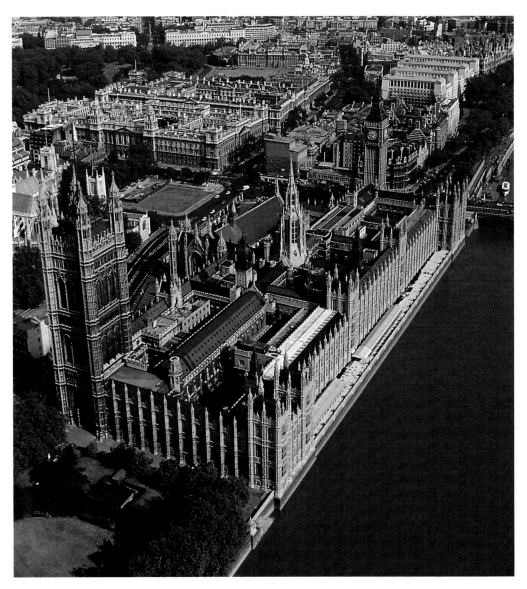

[8] R. Coope and C. Grodecki, in
*Cahiers d'architecture et d'histoire
du Berry*, no. 41, 1975.
[9] To which the collection of relief-
maps brought together for Louis
XIV and subsequently kept up to
date and exhibited for many years
in the grand hall of the Louvre
provides striking testimony.

sion took place around existent centers, which took in members of the Reformed Church
who had fled the southern Catholic countries. But in France, Sully founded the city of Hen-
richemont as a refuge for the Reformed Church in 1608;[8] in Germany, Frederic de Wied
founded Neuwied on the Rhine in 1653, between Cologne and Koblenz, in a spirit of toler-
ance; and the arrival of the French Huguenots, following the revocation of the Edict of
Nantes (1685), led to the creation of Erlangen near Nuremberg (1686).

Though the role of the fortifications in the design of cities was reinforced in border cities or
seaports,[9] a new conception of the open city was slowly coming into existence; and it was
doing so, curiously enough, simultaneously at the two extremities of the urban scale: a me-
tropolis like Paris lost its ramparts and its walls, while Versailles, the village of a château that
was to develop into a small city and the administrative capital of the kingdom, was open on-
to the countryside. From Richelieu, capital of the new duchy-treasury of the cardinal-minis-
ter (1631), to Versailles, and to St. Petersburg, the new Baltic capital of Peter the Great
(1703), the development of government cities – the urban expression of monarchical pow-
er – characterized the century (Lavedan 1959). In Richelieu, the city – a rectangle enclosed
by walls more for ornament's sake than for reasons of defense, divided by a street lined with
uniform houses between two squares – was situated on an axis perpendicular to that of the
château. On the other hand, in Versailles, whose urban planning came together between
1665 and 1693, three very wide avenues with parallel-running service roads converged to-
ward the château, and the builders were made to keep to a strict list of specifications.

Hubert Robert
The Ripetta port
Rome
Paris, Ecole des Beaux-Arts

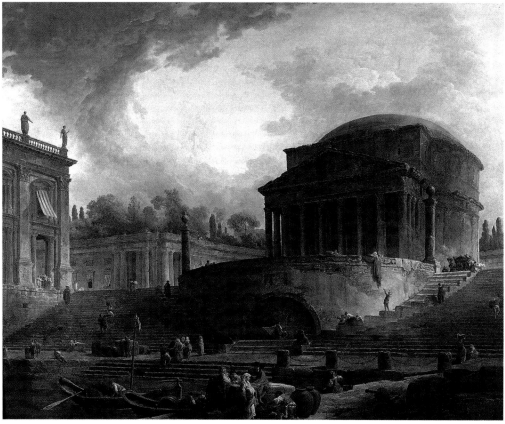

Several German sovereigns saw in Versailles a model for their own cities of residence. Mannheim was reconstructed at the junction of the Rhine and the Neckar rivers in 1699, following a checkerboard layout behind a stalwart oval enclosing wall, in front of the residence of the Electors Palatine – who set up residence there in 1721. Ludwigsburg, the Swabian Potsdam, was created in 1709 near the castle, five years after the first stone had been laid in the latter's construction. Karlsruhe was founded in 1715 by Karl Wilhelm of Bade Durlach following a concentric layout radiating around the margrave's palace, an option which was also adopted in Neustrelitz in Mecklenburg and Karlsruhe in Silesia. Further echoes of the Versailles option are to be found in Piedmont, where a wide single avenue leads onto a semi-circular esplanade in front of the Stupinigi residence (1720) or in Aranjuez – the Spanish Versailles – rebuilt after the fire of 1748, where three avenues converge toward the castle.

The urban undertaking with the most potent future ahead of it was the creation of St. Petersburg in 1703. Its beginnings, however, were shaky and the layouts followed one upon the other (Trezzini's work; Le Blond's proposed layout in 1721; the Imperial Academy's proposed layout in 1753), while the most original experience was a once-off endeavor, the hot springs at Bath, renovated by John Wood, father and son, beginning in 1725, on the basis of a supple layout-plan which gave priority to the contrast between monumental architecture and the landscape.[10] "One might say that in Paris a new city has in some sense replaced the old one over the past forty years," noted the Englishman Martin Lister (Lister 1699 [1873]: 31). Cities also underwent continual renewal on their own, expanding at the edges through multitudes of individual initiatives, though such growth was sometimes supervised – if for instance there were defensive or commercial issues at stake. In Turin, three successive expansions (in 1620, 1673 and 1714), which doubled the city's surface and led to as many modifications of its sturdy lines of fortifications, adopted a checkerboard layout, spaced apart by very wide orthogonal streets and a thirty-meter-wide oblique avenue, the Contrada del Po (Cavallari-Murat: 1968). In Amsterdam, the municipality adopted a growth development plan in 1607 organized around three concentric canals, looking after the construction of the canals, organizing land development and regulating housing construction on the lots sold. The London fire of 1666 was the occasion for a great vying of ideas. Sir Christopher Wren came up with a plan

[10] J. Wood, *Description of Bath*, London 1761 (second edition).

Piazza Navona, Rome
engraving
Milan, Civica Raccolta Stampe
Achille Bertarelli

opposite
Gian Lorenzo Bernini
Statue of the Nile
model for the Fountain
of the Four Rivers
Venice, Galleria G. Franchetti
in the Ca' d'Oro
cat. 71

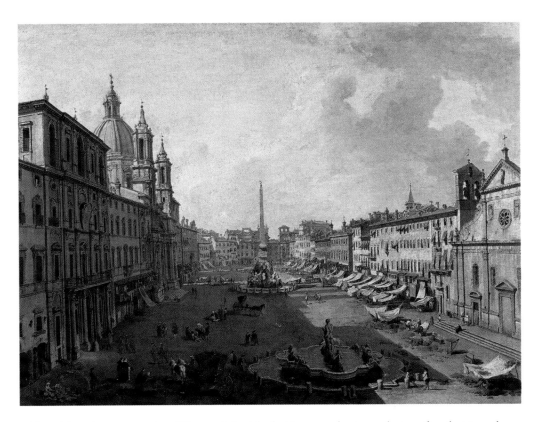

with neither the systematic stiffness of the ideal cities nor the irregularity of real cities whose development had been left to chance. Relying upon the previous reference points, he organized the city in the west on the basis of a flexible checkerboard layout, irregularly dotted with churches, and sketched in streets radiating from squares in the east. But the royal power was unable to impose an overreaching plan and the city ended up being reconstructed at the whim of private initiatives, which nevertheless preserved large green spaces.

An urbanism of aedility and an urbanism of embellishment
"It cannot be said of a city that it be beautiful [...] if the bridges, ports and quays are not spacious, adapted and well kept; if the storehouses, markets and fountains are not regularly distributed for the commodity of the inhabitants," one reads in the classic *Traité de police* (Delamare and Le Cler de Brillet 1738: IV, 349). The urbanism of aedility remained a major preoccupation, but it went hand in hand with a concern for embellishment (Harouel 1993). When Henri IV made known his intention to visit Paris, he declared that he wanted to "render the city beautiful [...] and fill it with all the advantages and ornaments as will be possible" (Ballon 1991, 325, n. 24). Pope Alexander VII had a wooden model of Rome in his bedroom ("tutta Roma di legno"), "as if there were nothing more important for him than embellishing the city" as a Genoese visitor put it (Krautheimer 1985: 79). Spaces of celebration, spaces of contemplation and spaces of leisure create points of clarification which restructure the so-called Baroque city. Recalling the provisional arches at the royal entrance-ways, city gates came to resemble permanent *arcs de triomphe* (the Saint-Denis and the Saint-Martin gates in Paris; the Peyrou gate in Montpellier), fountains became monuments (the Trevi Fountain in Rome), squares provided room to contemplate palace and church façades, promenades were planted where ramparts had been and bridges opened like balconies onto rivers, while theaters – at the junction of temporary ceremonial urbanism and the new urbanism of urban leisure – were built on public squares (Naples).
The European cities which, at the beginning of our period, often had their backs turned to the rivers which flowed through them, monumentalized their banks into quays and opened bridges onto the river following the model of the Trinity Bridge in Florence (1567): the Pont-Neuf in Paris (1599–1606), with its little balconies to "watch the river flow" (Ballon 1991); the Toulouse bridge, designed by Jacques Lemercier (1614);[11] the bridge over the Main at

[11] In his 1684 *Description de Paris*, Germain Brice hailed the Pont-Neuf as one of the three most beautiful views in the world beside Constantinople and Goa. The Englishman Martin Lister stressed the beauty of the intersecting views offered between the Pont-Neuf and the Pont Royal: "the views one has on the river are admirable, for instance those from the Pont-Neuf while looking toward the Tuileries, or the view one obtains from the Pont Royal in the opposite direction (Lister 1699 [1873]: 23).

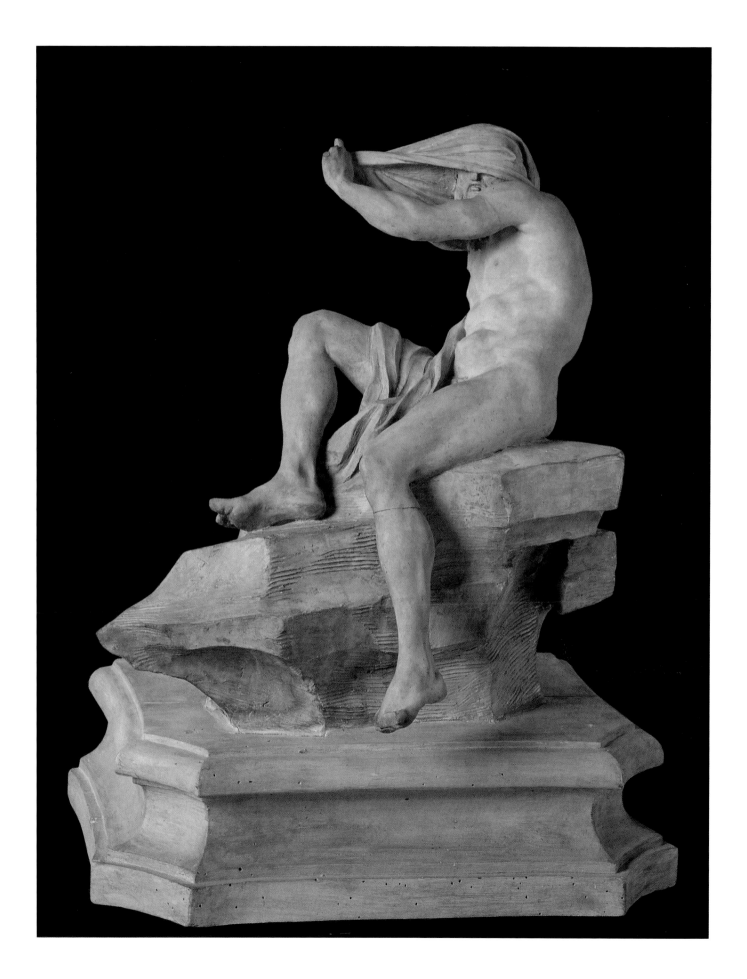

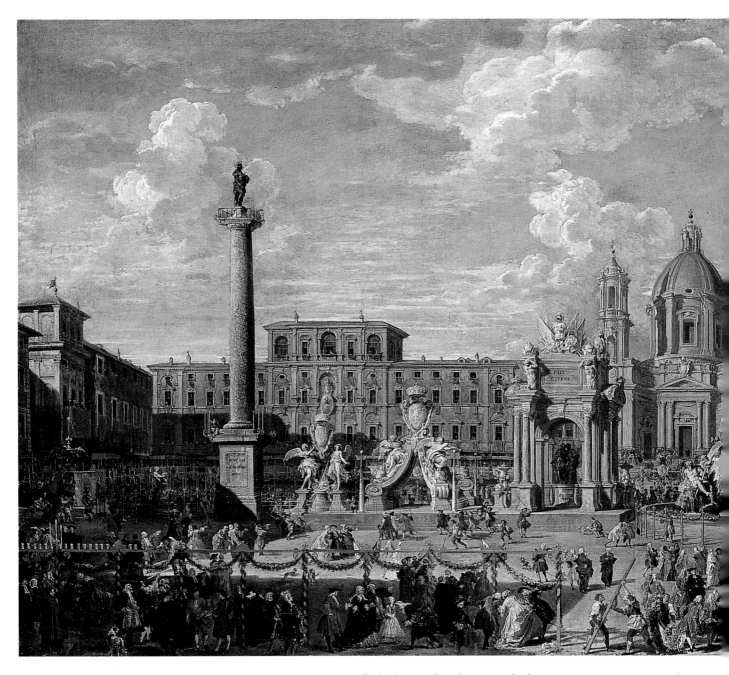

Giovanni Paolo Pannini
Preparations for the Festivities
in Piazza Navona [...] on the Occasion
of the Birth of Louis, the Dauphin
of France, 1729
Paris, Musée du Louvre
cat. 365

Frankfurt, the central portion of which was already set out before 1646; Westminster Bridge in London in 1738–50. In Rome, Bernini bedecked the Sant'Angelo bridge with ten statues of angels bearing the instruments of passion (1668), whereas at the Ripetta gate, undulating steps lead right down to the water (1706).

Fountains remained the primary component of urban fixtures. They became more numerous in Rome, to the extent of eliciting the odd pasquinade: "Noi volemo altro che Guglie et Fontane; Pane volemo, pane, pane, pane." With their plentiful waters, drawn from the squares to which they lend their names, the Acqua Paola (1610–13), the Barcaccia (1627–29), the fountain of the Four Rivers at Navona square (1651), the Trevi Fountain (1732–51), appear as models. At the time of the construction of the Grenelle fountain in Paris, Voltaire argued that "Parisians should contribute more to the embellishment of their city, to the destruction of the monuments of Gothic barbarism, and particularly of those ridiculous village fountains that disfigure our city. I have no doubts that Bouchardon could turn the fountain into a nice bit of architecture, but what is a fountain built up against a wall in a street and half hidden by a house? What is a fountain which only has two spouts for the water-carriers

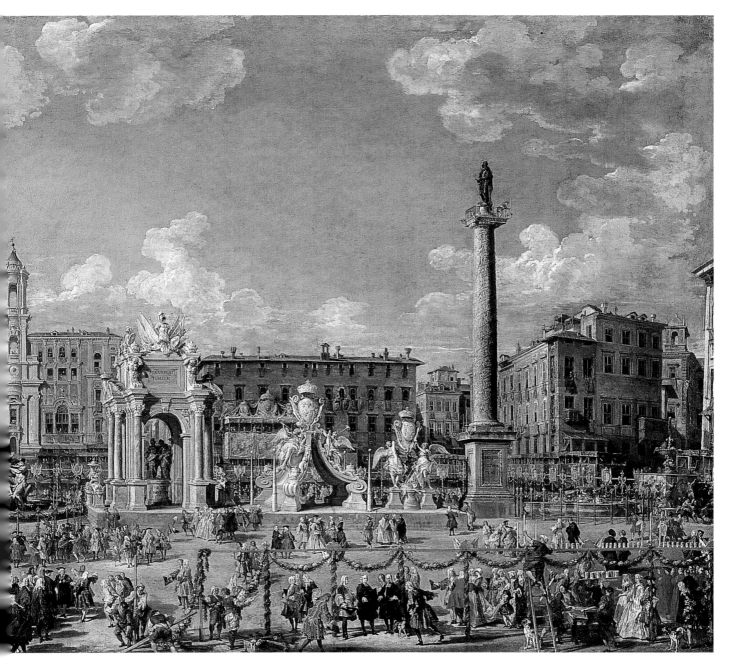

to fill their pails? That is not how the fountains which embellish Rome were constructed [...] Fountains have to be built in public squares and these beautiful monuments be seen from all sides (Voltaire, *Lettre au comte de Caylus*, 9 January 1739).

Individual houses, particularly if they were built "of the same stuff," were considered to contribute to the city's beauty. When Pierre Le Muet published his collection of models of houses, *Manière de bâtir pour toutes sortes personnes* (1623), he was aiming at the "embellishment" of the kingdom; and in his *Conseiller d'état* (1633), Philippe de Béthune recommended the mandatory harmonization between neighboring houses as to the "height of the doors, windows, cornices, storeys and other exterior parts [...] after the fashion customary in many cities in Flanders and the Netherlands," beauty residing "more in certain proportions than in any enriching of materials or craftsmanship" – in short, he sketched out a theory of sizes and rules for ordinary urbanism (Thuillier: 311). The reconstruction of the center of Brussels after the bombing of August 1695 was the occasion for the very clear affirmation of an urban aesthetic of concertation: "As it is in no way appropriate to allow the square to be deformed by overly different buildings or gables, but is reasonable to combine them harmoniously with each

View of Piazza del Campidoglio
(the Capitol), Rome

another as much as is possible," owners had to be forbidden to "reconstruct gables or hous-
es before the model of the gable they intended to build was presented to the magistrates and
deemed to be acceptable and hence approved by them" (Lavedan 1982: 196).
But the idea emerged that a city's beauty is principally in its public buildings. "London, to-
day the largest city in the universe, would also be the most beautiful if the public buildings
matched the private homes in splendor, and if we had the noble concern to erect magnifi-
cent and superb edifices for the public," wrote Swift in 1726, and then amusingly proceed-
ed to suggest that public latrines be built in all the quarters, even laying out the proposal.

Place Vendôme in Paris

The triumph of the "place royale"
The square was not a new urban factor. The idea that monuments, churches and palaces ought to be set off by a square allowing them to be fully visible was taken for granted. In 1640, announcing to Cardinal de Richelieu that the street being put in along the axis of the new chapel of the Sorbonne in Paris was soon to be finished, one of the engineers wrote to him that "without the opening of this street and square, the church would not have been half as apparent as it now appears;" and in 1665 Bernini claimed that clearing a space equal to one and a half times the palace's height would suffice to allow the façade he was planning for the Louvre of

Louis XIV to be clearly seen. But there was also a sensitivity for accompanying buildings, which transformed the square into a *teatro*. When Pope Alexander VII decided to rebuild Santa Maria in Porticu, he asked that there be a "spacious square in front, surrounded by ornate palaces" (Krautheimer 1985, 82); and in front of Santa Maria della Pace, Pietro da Cortona built a unified layout where the streets all disappear into the distance as if in a theater set (1657). The optical adjustment, as discussed by Vitruvius, became the object of acute attention. François Mansart wondered about the incidence of the angle of vision on the perception of his drawings of urban space (Babelon, Mignot: 1998) and Bernini calculated the visual angles of his buildings both on St. Peter's square and in front of the Assunta d'Ariccia.

"What is admirably understood here," wrote Salomon de Brosse, "is the manner of arranging points of view and of putting in views of singular objects. This art is not the least significant factor in providing the city with its sense of grandeur. This is something that is not understood at all in Paris: there are no beautiful views apart from that of the quays."

It was in the 1660s that the English "square" was first developed, hemmed by rows of houses set slightly back behind a narrow strip of land, with a garden behind the buildings and garages and stables at the back, accessible by an alley – a style with a great future before it in the British capital. On the continent, however, it was the French-style *place royale* – of Roman and Tuscan origin – which won the day. Doubtless inspired by the precedent of Michelangelo's Campidoglio square, organized around the equestrian statue from antiquity (1540–1655), the Medici were the first to make reigning sovereign's statue the most noble adornment of a public square: the Piazza della Signoria (1594) and the Piazza dell'Annunziata (1608) in Florence, the Piazza dei Cavalieri in Pisa (1596). They were soon imitated by Marie de Médicis in Paris (the Pont-Neuf terreplein, 1614) and by Ranuccio Farnese (Piazza dei Cavalli in Plaisance, 1620).

Though the Campidoglio square was indeed set up around the equestrian statue of Constantine, the Place Royale in Paris, lined with symmetrical brick and stone houses (1606–12), the eponym of the genre, was only later adorned with an equestrian statue of Louis XIII (1639), like the Annunziata square, the outcome of a progressive focus (Porticos of the Innocent, 1418, of the Servites, 1517, of the Santissima Annunziata, 1601–07, an equestrian statue of Duke Ferdinand, 1608, symmetrical fountains, 1643). The crystallization of the consummate model of the *place royale* was linked to the conjunction of the treatises of Nijmegen where Louis XIV established himself as the arbiter of all Europe (1678–79). In conceiving the new square as the showcase for the monarch's statue – whether on horseback or on foot – Jules Hardouin Mansart created the classical form of the French-style *place royale*: the Place des Victoires (1685) and the Place Vendôme (1688–99; 1699–1720) in Paris, the Place Royale in Dijon (1686–1725). The painted canvases hung for the inauguration of the Place des Victoires preceded the actual completion of the square, but also show the link between the provision-

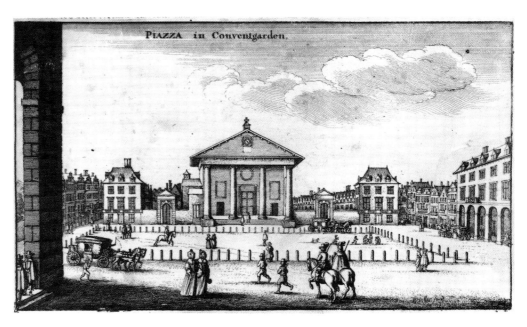

The Covent Garden in London
18th-century engraving

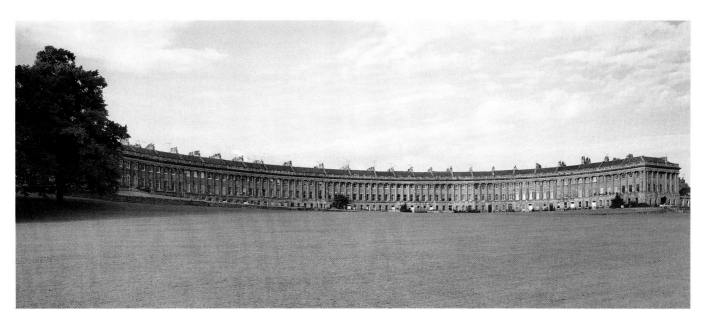

Royal Crescent in Bath

al architectural structures in the entrance-ways and the theme of the *place royale*. Similar enterprises multiplied in the provinces, in Dijon (1686–1725), Rennes (1726–44), Bordeaux (1728–43), and the decision taken in 1748 to raise a statue in honor of Louis XV and to create a new place royale in Paris was the occasion for an extraordinary competition of ideas (Lavedan, Hugueney 1982). In Madrid, the Plaza Major was dissociated from the equestrian statues of the sovereign which had been erected in his palaces, while in London, Covent Garden was originally the square in front of a church, Queen Square in Bath, adorned with a commemorative obelisk (1735), Amalienborg in Copenhagen (1749–68), and, later, Commerce square in Lisbon, the *place royale* in Brussels, Schlüter's projects in Berlin, and so on, all attest to the formula's success. It was, however, given the most various forms of expression: shopless ceremonial squares (the Soufflot project in Reims) or merchant squares with shops (the Legendre project in Reims), closed squares (Place Vendôme and Place Amélie) or squares opening out onto a river (Place Louis XV in Paris and in Bordeaux).

Whether they were furnished with the statue of the sovereign, with an obelisk or a fountain, the squares most often adopted simple shapes: most often rectangular, often square, round or octagonal, sometimes oval (the Puget project for a *place royale* in Marseilles). More complex configurations were rare, such as the Sant'Ignazio square in Rome. But the most inventive Roman square was the stairway of the Spanish Steps, where ample flights (Trinità dei Monti) and wide landings forming balconies are deployed on a skillfully decentered plane (1725), but by including a fountain and an equestrian statue of Louis XIV, triumphant after the Peace of the Pyrenees – whose political message was too explicit for the pope to accept (Krautheimer 1985: 100) – Bernini's 1660 proposal placed it in the invention chain of the *place royale*, the newest urban form of the time.

The parkway and the invention of the boulevard

The place of gardens in the space of the city in the seventeenth and eighteenth centuries has to be reevaluated – convent gardens and aristocratic gardens, botanical gardens and public promenades on the ramparts – but the invention which was to have the most promising future were the boulevards, typical of "leisure time" (Girouard 1985: 181–210). With the invention of coaches, combining the convenience of litters and the rapidity of horses, the perception of the city changed early in the seventeenth century: on the broad streets, traveling by coach took on a new function, while at the same time the *promenade* first appeared.[12] In 1581, in the course of his journey to Italy, Montaigne had remarked on the trees planted on the ramparts of Lucca; and in Antwerp, in 1578, the municipality had decided to plant on the ramparts – a decision admired by John Evelyn in 1641: "There was nothing in this city which delighted me more than these delightful shady areas and these paths of majestic trees which make of the fortifications of this city one of the most charming spots in Europe." But

[12] The *"paseo con alamos"* (the promenade beneath the poplars) can be attested to as from the end of the sixteenth century in Seville. See the articles "Promenade" in Diderot's *Encyclopédie*, and "Poète," 1913.

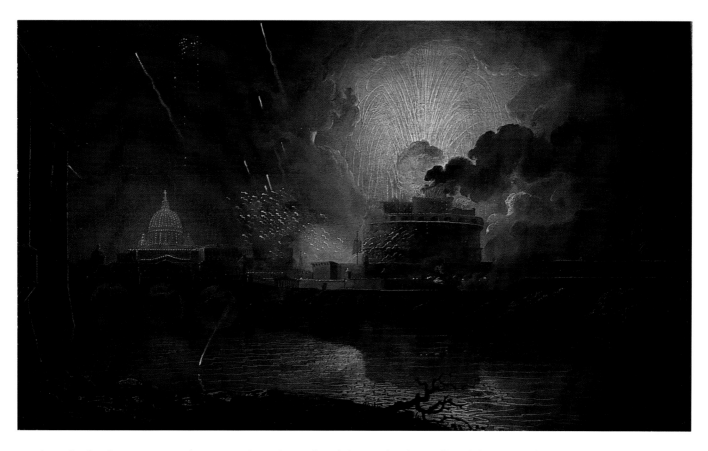

Joseph Wright of Derby
Firework display at Castel Sant'Angelo
Birmingham
Birmingham Museums
and Art Gallery
cat. 366

in Paris, where the paths of the castle, the mall and the Cours-la-Reine had launched a tradition of tree-lined avenues suitable for coaches, these plantations on the city's edge became coach-suitable boulevards. Toward 1670, on the site of the former city wall of Charles V, between Saint-Antoine's gate and Saint-Denis' gate, two rows of trees were planted on both sides of a wide avenue with space enough for four coaches to pass, while pedestrians could walk along the service roads. In this regard, Paris created one of the matrixes of the nineteenth-century city.

If the Parisian boulevards set the tone in France (Rabreau 1991), parkways cropped up all over Europe. These green streets, whose various names – malls (mail), boulevards (boulevert, rampart), courses, avenues – betray their different origins, were situated either at the city limits like the approaches to a castle (Champs-Elysées, Cours de Vincennes), or at the city's fortress wall on the ramparts (Antwerp, Lucca, Périgueux), at the foot of the ramparts (Riom in the Auvergne) or instead of them (the Tourny alleys in Bordeaux), and occasionally in the heart of the city, for instance when a rampart was made obsolete through expansion (the Cours Mirabeau in Aix-en-Provence). In London, Charles II had a mall laid out. Pall Mall – whose name is derived from the game played there – was bordered with an alley for spectators, but soon walkers came to outnumber the players, though the promenade maintained its pedestrian rather than equestrian character like the Parisian boulevards and alleys.[13] London's Pall Mall was soon copied in Dublin (Gardiner Mall in Sackville Street – today's O'-Connell Street) and in Berlin (Unter den Linden), whereas in Hamburg, the Jungfernstieg ran alongside a dike. In 1656, Alexander VII initiated a program for the planting of alleys of elm trees, to provide shade for pilgrims throughout the Forum, from the Arch of Septimius Severus to the Arch of Titus, from the Arch of Constantine to Circus Maximus (Krautheimer 1985: 110–11), but Salomon de Brosse bemoaned the lack of genuine boulevards: "I am thoroughly astonished that the most beautiful cities I have yet seen in this country are lacking public promenades able to rival those of even our smallest cities" (Boyer 1959).

The role of nature in the city became such that Abbé Laugier recommended in his *Essai sur l'architecture* (1755: 209) that "a city be looked at as a forest [...] that the design of our parks serve as a blueprint for our cities."

[13] In 1787, Arthur Young noted that "because of their public promenades, French cities are far superior to those of England."

Looking at the city

In 1690, in Furetière's *Dictionnaire* (and once again in Diderot's *Encyclopédie*), the city was still defined by its enclosure walls: "it is an area surrounded by walls and comprising various quarters, streets, public squares and other edifices." Efforts to the contrary notwithstanding, the "Baroque city" often remained a medieval city: "Our cities are still what they were," wrote Laugier (1755: 209), "a jumbled heap of houses, lacking any system, economy or design."

Nonetheless, urbanism based upon embellishment was in full swing. "The taste for embellishment has become general," wrote Voltaire. "And it is to be hoped for the progress of the arts that this taste will persevere and be perfected. But this taste must in no way be restricted to individual houses, it must spread to entire cities." The city began to emerge as an object for debate among citizens: "Whose responsibility is to embellish cities if not that of its inhabitants?" (Voltaire 1749, XXXI B, 232). In a century and a half, the pleasure procured by the eye had superseded the role of discourse, the tourist guide had replaced the panegyric and modern monuments drew as much attention as the antiquities. Pannini's two pendants, *Galerie de vues de la Rome antique* and *Galerie de vues de la Rome moderne* (at the Musée du Louvre) are exemplary of this major displacement of the way the city was looked at.

Instead of the rather imprecise maps obliquely showing the city from above, more exacting maps were drawn up (John Rocque's map of London, 1746; Jacques Gomboust's map of Paris, 1652; and the so-called Turgot-map, 1739; Lieven Cruyl's map of Rome, 1665, which shows in detail the most important monuments in the manner of Gomboust from a raised and oblique perspective; and G.B. Nolli's exemplary city map, 1748). Collected engravings gave cities more and more varied and accurate portraits: in Rome, Giovanni Battista Falda's *Il nuovo teatro delle fabriche ed edificii in prospettiva di Roma moderna sotto il felice pontificato di N.S. Papa Alessandro VII* (1665; 1667) was complete by two further volumes: in Paris, by the successors of Israël Silvestre, who poeticized the city by treating it like a Roman landscape; and by Jean Marot's architectural anthologies, the efforts of whom were carried on by Pérelle, Rigaud and Mariette. But it was a European movement, spanning from Venice to Naples, from the Netherlands to Sweden (Erik Dahlbergh's *Suecia antiqua et hodierna*, 1715).

The city invaded the paintings of the vedutisti: Naples and Rome in the work of Gaspar van Wittel, Venice in that of Guardi, Venice and London in the work of Canaletto, Turin, Dresden, Vienna and Warsaw in that of Bellotto. Conversely, the city tended to look more and more like the *vedute*: Alexander VII asked that Piazza del Popolo be restructured "per colmare di bellezza l'ingresso in Roma alla vista delle nazioni forestiere" (Krautheimer 1985: 131) As the sixteenth century drew to a close, Montaigne judged that in terms of "number and grandeur of public squares and beauty of streets and beauty of houses, Rome carries the day by far" over Paris. Throughout the following century, Rome remained the city to imitate; already, though, voices were suggesting that Paris had surpassed Rome. Louis XIV's royal squares eclipsed their Roman and Tuscan prototypes and the Parisian boulevard asserted an urban form with a brilliant future before it.

If the urbanism of embellishment triumphed in the mid-eighteenth century in papal Rome (Giuseppe Vasi's *Magnificenze di Roma antica e moderna*, 1747) and in the Paris of Louis XV (Pierre Patte's *Monuments à la gloire de Louis XV*, 1755), and if, in the half century that was to follow, capitals new and old – randomly London, Paris, Berlin, St. Petersburg, and even Rome and Naples – continued to improve point by point, nothing short of a catastrophe was needed to bring about a shift to a different scale. On 1 November – All Saints' day – 1755, ten minutes of earthquakes followed by five days of fire, and Lisbon, a city of some 250,000 inhabitants, was half destroyed. Voltaire may have scoffed at Providence; the reconstruction of Lisbon was to become the supreme demonstration of the urbanism of the Enlightenment.

BIBLIOGRAPHY: Le Muet 1623; Lister 1699; Delamare 1705–1738; Swift 1726; De Brosses 1749; Voltaire 1749; Laugier 1755; De la Poix de Freminville 1758; Patte 1765; Young 1787; Poète 1913; Lavedan 1959; Boyer 1959–60: 162–86, 241–71; Eimer 1961; Thuillier 1961: 311–12; Chaunu 1966; Cavallari-Murat 1968; Lavedan, Hugueney, Henrat 1982; Garms and Garms 1982; Girouard 1985; Krautheimer 1985; Ballon 1991; Rabreau 1991: 301–12; Harouel 1994; Adams and Nussdorfer 1994; Babelon and Mignot 1998

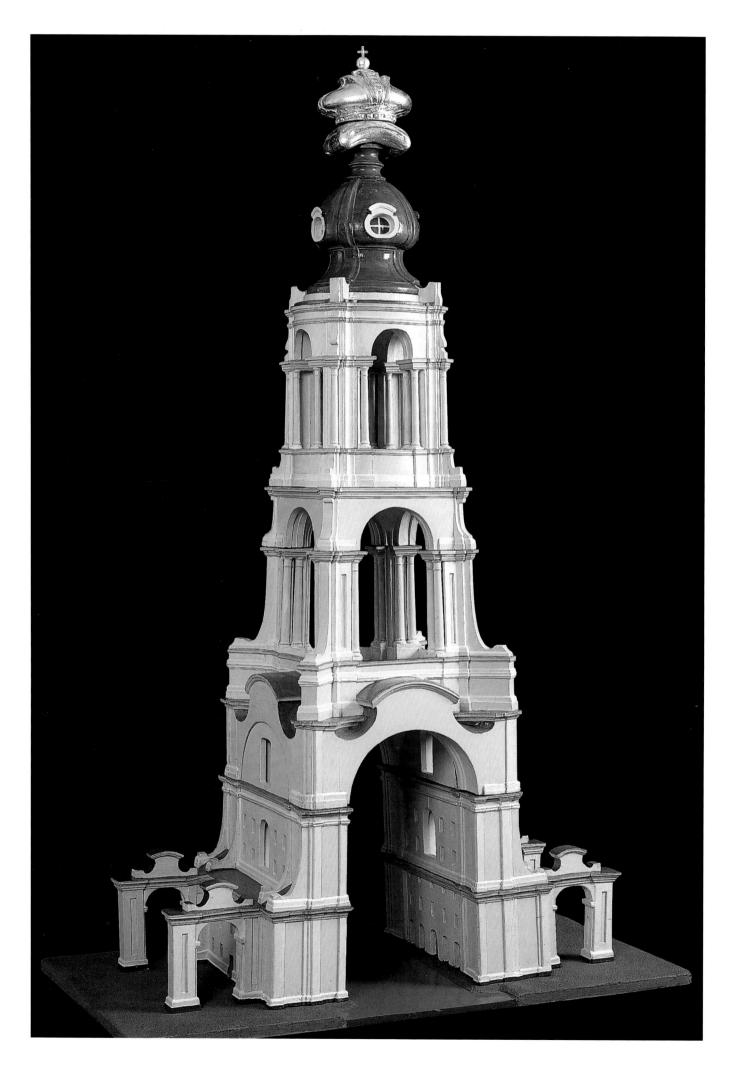

opposite
Nicola Michetti
Model for the lighthouse
at the entrance
to the Petrovsky port, Kronstadt
St. Petersburg
Central Naval Museum
cat. 376

Georg Braun
View of Lübeck
engraving from *Civitates orbis
terrarum*
Genoa, Museo Navale

[1] Geoffrey Parker, *The Thirty Years' War*, New York 1984: 205.
[2] Horst De la Croix, "The Literature of Fortification in Renaissance Italy," in *Technology and Culture* 6 (1963): 30–50; De la Croix, "Military Architecture and the Radial City Plan in Sixteenth-Century Italy," in *Art Bulletin* 42 (1960): 263–90, for the importance of the early printed treatises in disseminating Italian military architecture. See also John Hale, "The Argument of Some Military Title Pages of the Renaissance," in *The Newberry Library Bulletin* 6 (1964): 91–102; Hale, "Printing and Military Culture of Renaissance Venice," in *Medievalia et Humanistica: Studies in Medieval and Renaissance Culture* n.s. 8 (1977): 21–62; Martha D. Pollak, *Turin 1564–1680: Urban Design, Military Culture, and the Creation of the Absolutist Capital*, Chicago 1991: 18–26; Pollak, *Military Architecture, Cartography and the Representation of the Early Modern European City: A Checklist of Treatises on Fortification in the Newberry Library*, Chicago 1991; Pollak, "Military Architecture and Cartography in the Design of the Early Modern City," in David Buisseret (ed.), *Envisioning the City: Six Studies in Urban Cartography*, Chicago 1998: 109–24.
[3] Jeremy Black *European Warfare 1660–1815*, London 1994: 70.

Baroque society, it is often said, was preoccupied with "geometrical forms – whether in building, riding, dancing, painting, fencing or fighting."[1] Fortification and other seventeenth- and eighteenth-century military architecture would seem to be a classic illustration of this general truth, for the geometrical elaboration of the essentially simple sixteenth-century Italian bastioned system is a notable feature of the Baroque age. The explosion of what has been called the "print culture" played an important part here by making available to Europe's reading classes a mass of printed literature on military topics, including treatises on fortification in all of the major languages, which allowed opinion-formers to become familiar with the terminology, and the debates, as well as the fascination of complex architectural plans with their criss-crossing lines of fire.[2] It requires no great leap of imagination to conceive of the excitement generated by paintings, treatise illustrations, atlases of city views and other physical manifestations of military architecture and siege operations before air photography. The parterre military garden at the Duke of Marlborough's Blenheim Palace, and the star-shaped play castle at Peter the Great's childhood home of Presshpurkh, remind us forcefully that at both poles of Baroque Europe there was a strong element of fashion (in the sense of style as well as conventionality) in this as in other military and architectural fields. Yet preoccupation with the intricacies of rival fortification "systems" and geometries can be as misleading as the suggestion (more often implied than clearly stated) that Baroque warfare itself was more about style than substance. As Jeremy Black has recently pointed out: "Ultimately [...] the problem is cultural. It is difficult for many to accept that warfare was 'for real' in a world in which artifice, convention and style played such a major role; and this is particularly the case because it has been contrasted so often with the apparently more vital, clear-cut and successful warfare of the 'Age of Revolution' [...] In artistic terms, the formality of linear formations and conventions of warfare can be seen as 'Baroque' warfare, and essentially limited goals and methods behind the exuberant show as the 'Rococo,' both being displaced in the late eighteenth century by 'Neo-Classical' rigour and 'Romantic' enthusiasm; in cultural terms there is a tendency to underrate the determination and ability of aristocratic societies."[3]

In this short essay, an attempt will be made to place some of the finest physical artifacts of Baroque military art into a context which also recognizes the fundamental seriousness of purpose of military activity. If the artifice and style of the parade ground – with its music, uniforms and medals – has a place in this picture, so too does the danger and discomfort of the trenches, the exposed benches of galleys at sea, and the perilous isolation of outpost duty on Europe's long frontier with Tartar and Turk. Military construction of all kinds – but particularly fortification – represented one of the heaviest burdens of public expenditure for Baroque states, and the emergence of players in the major league of this particular game was intimately linked both to the military geography of Early Modern Europe, and to the ability of the key players to pay the bill.

Only under the unremitting pressure of war amongst the emerging great powers of Early Modern Europe did so many of the Continent's leading cities achieve complete state-of-the-art fortifications. Leadership in fortification design, initially almost an Italian monopoly, shifted gradually northward with the wars. The Eighty Years' War waged by Catholic Spain and Austria against their rebellious Protestant subjects in the United Provinces (1567–1648) witnessed a large number of new and improved works on both sides of the constantly shift-

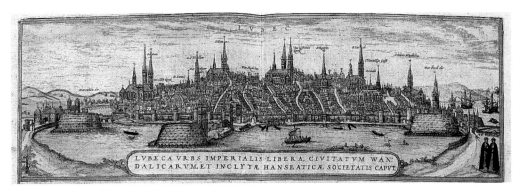

Georg Braun
View of Hamburg
engraving from *Civitates orbis terrarum*
Genoa, Museo Navale

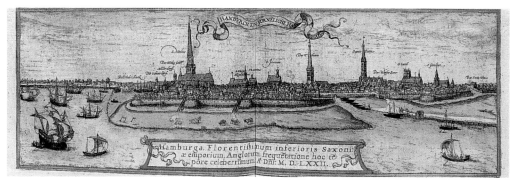

ing frontier. Fortification was particularly important to an emerging military power like the Dutch, who could expect often to fight on the defensive, usually with smaller reserves of manpower than were available to their Hapsburg opponents.[4] Much the same circumstances faced Gustavus Adolphus and his heirs whose successes as military leaders belied their small native Swedish population. During the Thirty Years' War (1618–48) and the later campaigns of the Great Northern War (1700–21), Sweden equipped many German and Polish cities with new fortifications on a scale the citizens could never have provided for themselves without foreign expertise, some Swedish resources, and a great deal of extortionate pressure from the occupying forces.[5] From 1667 Louis XIV's aggressive campaigns against the Hapsburg Low Countries and the Rhineland provided the occasion for an ambitious program of fortification along France's much extended northern and eastern frontiers, which was never to be matched on the same scale by their neighbors.[6] Philipsburg, Mainz and Kehl were the only major Imperial fortresses in the Rhineland and they received substantial attention: the fortifications of the smaller Rhineland states lagged far behind. Spain struggled to maintain fortresses in Northern and Southern Europe as well as the new world. Austria's resources were spread thinly over the vast theater which extended from Italy to Hungary. Not surprisingly, therefore, the area of Europe which initially witnessed the most important technical developments was the congested battleground of the Low Countries, Alsace and Lorraine. Here French leadership in military architecture had as much to do with the re-

Model of Tallin fortress
in Estonia
Stockholm
The National Maritime Museum

[4] Jonathan I. Israel, *The Dutch Republic: Its Rise, Greatness and Fall 1477–1806*, Oxford 1995 and 1998, second edition: 262–67 and 273–74. For Spanish fortifications in the Low Countries, Marino Viganò (ed.), *Architetti e ingegneri militari italiani all'estero dal XV al XVIII secolo*, Istituto Italiano dei Castelli, Livorno 1994: 25, notes 55–57.
[5] C. Duffy, *Siege Warfare: The Fortress in the Early Modern World, 1494–1660*, London 1979: 182–85 and Michael Roberts, *Gustavus Adolphus: A History of Sweden 1611–1632*, 2 vols., London 1953 and 1958, *passim*.

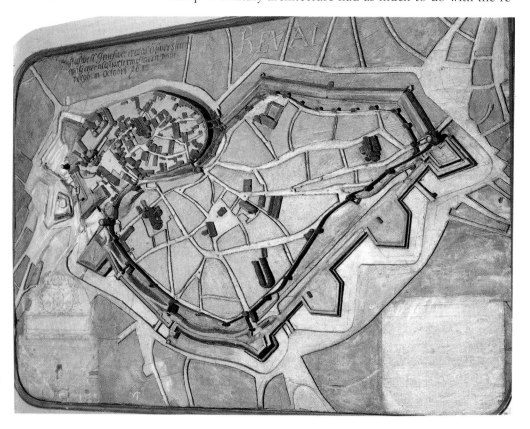

Georg Braun
View of Amsterdam
engraving from *Civitates orbis terrarum*
Genoa, Museo Navale

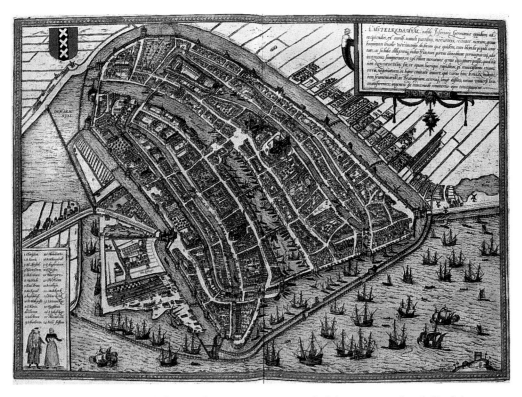

[6] G. Zeller, *L'Organisation Défensive des Frontières du Nord et de l'Est au XVIIe Siècle*, Paris 1928. For details Pierre Rocolle, *2000 Ans de Fortification Française*, Paris 1973 and C. Duffy, *The Fortress in the Age of Vauban and Frederick the Great, 1660–1789*, London 1985.

[7] An extensive literature in De la Croix (1960 and 1963) and J. Hale, "The Early Development of the Bastion: An Italian Chronology ca. 1450–ca. 1534," in J.R. Hale, L. Highfield, and B. Smalley (eds.), *Europe in the Late Middle Ages*, London 1965: 466–94 and more recently, S. Pepper and N. Adams, *Firearms and Fortifications: Military Architecture and Siege Warfare in Sixteenth Century Siena*, Chicago 1986: 3–31.

[8] Duffy, *The Fortress...*: 71–97.

[9] N. Faucherre, "La Construction de la Frontière: De l'Usage Stratégique des Plans en Relief," in Antoine de Roux, Nicolas Faucherre and Guillaume Monsaingeon, *Les Plans en Relief des Places du Roy*, Paris 1989: 25.

[10] A. Manesson-Mallet, *Les Travaux de Mars ou l'Art de la guerre*, 1696: I, 73.

[11] G. Gerola, "I plastici delle fortezze venete al Museo storico navale di Venezia," in *Atti dell'Istituto veneto di Scienze, Lettere ed Arti* XC, II (1930–31): 217–21.

sources dedicated to the defence of Louis XIV's extended frontiers as the skill of their most important military engineer, Sébastien le Prestre Vauban (1633–1707). Vauban managed to build his mass of projects because of the solid backing he received from Louis XIV, the Marquis of Louvois (Secretary of State for War), and Colbert (Navy Secretary, with responsibility for home bases). Even so, the scale of Vauban's activity is breathtaking. Wounded himself no less than eight times, he directed forty-eight sieges, and designed or improved some 160 fortresses.

Vauban's fortress building work is often described in terms of three "systems." However, his hallmark as a designer was a pragmatic disregard for the academic systems which embroiled so many of his contemporaries. The key component of modern fortification since the late fifteenth century had been the Italian bastion. In its simplest form the bastion was little more than an earth-filled gun platform with a triangular or arrow-head footprint, which projected in front of new ramparts or old walls. Guns fired forward from its pointed faces, and along the walls from batteries concealed in the flanks, while the pointed shapes of the so-called *trace Italienne* denied any section of the perimeter shelter from defensive gunfire.[7] Vauban struck an easy compromise between the obtuse-angled Italian sixteenth-century bastions and the more sharply-pointed seventeenth-century Dutch ones (his first system), reintroduced enclosed tower-like structures for the hilly Alpine and Pyrenean sites where open bastions would have been exposed to fire from above (his second system), and finally combined features from both first and second "systems" to form the third at Neuf-Brisach (1698–1705), which was to prove the most sophisticated and comprehensive of his many designs.[8]

At Neuf-Brisach Vauban's inner defensive line had "tower bastions" at the angles, and a cranked rampart between them forming additional flanks, each equipped with bombproof internal casemates as well as open gun platforms. Pointed counterguards and long thin *fausse-brayes* formed islands in the deep ditch into which all of these works were sunk. Further out in the "archipelago" of outworks stood the triangular ravelins, with enclosed casemates behind them from which flanking fire could be delivered along the outer sections of the ditch. Beyond the ditch ran the covered way (a protected passageway on the outer lip of the ditch), the advanced infantry positions, and a network of underground countermine passages. In other schemes the works were extended even further by means of hornworks, crownworks, crowned hornworks, and so on in a bewildering array of technical terms beloved of the siege veterans and armchair tacticians satirized in Lawrence Sterne's novel,

John Rudyerd (attr.)
Prospect and section of the
Eddystone lighthouse
Edinburgh
National Gallery of Scotland
cat. 478

Tristram Shandy. On its flat site, Neuf-Brisach needed none of these and was laid out as an octagon, with a gridded interior, deceptively simple in its regularity but marking substantial progress from schemes built by the Venetians at Nicosia (1570) and Palmanova (1593) which in their own day had been among the most ambitious and expensive projects. Palmanova had been laid out as a radial city inside its ramparts, but progress never matched Venice's ambitions and much of the road layout was never fully developed. At Neuf-Brisach, however, Vauban and his collaborators planned and built an "ideal city" with monumental gates (by Mansart), square, church, quarters for senior officers, barracks, and standardized housing blocks for the civilians displaced by France's enforced retreat from old Brisach on the "German" bank of the Rhine under the terms of the Treaty of Rijswijk (1697).[9]

Like other parts of the so-called *frontière de fer*, this section responded to the accidents of war. That said, Vauban's general policy for what became known as the *pré carré* – literally, the "square field" – attempted to make sense of the constantly shifting frontier by establishing two rows of fortresses and fortified towns behind the critical northern and eastern frontiers, together with fortresses commanding the Alpine and Pyrenean passes, and defences for the key military ports on the southern, western and northwestern coasts. The result when plotted on a map of France looks something like a square, with an empty space in the middle. Here numerous older interior fortifications had been slighted, both to remove potential rebel strongholds, and so that munitions and garrison troops could be concentrated on the frontiers.

At one level, therefore, the wonderfully detailed models now conserved in Les Invalides and in Lille were an obvious pragmatic response to the centralised control of an ambitious frontier construction program. Alain Manesson-Mallet claims in his treatise to have proposed to the king a program of model construction, following an Italian's suggestion, and his own fabrication of a model of the fortress at Pinerolo (Piedmont) in 1663.[10] It was by then certainly

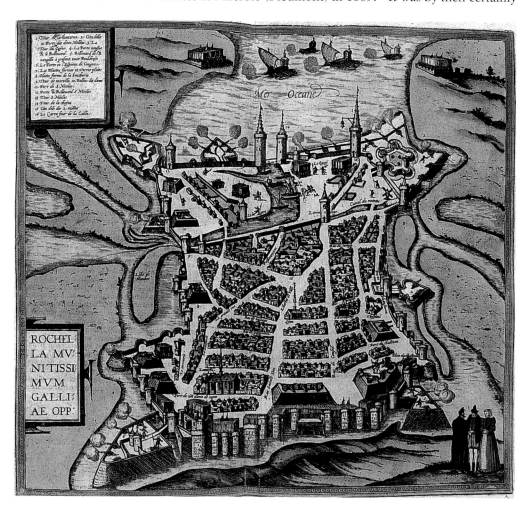

Georg Braun
View of La Rochelle
engraving from *Civitates orbis terrarum*
Genoa, Museo Navale

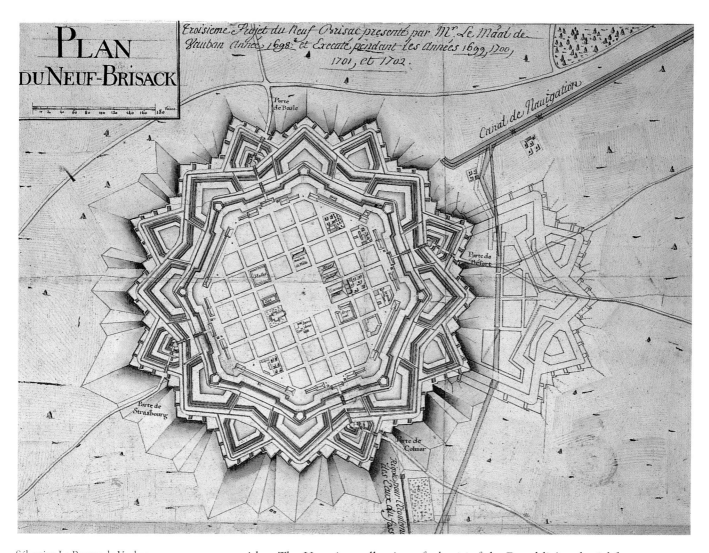

PLAN
DU NEUF-BRISACK

Troisieme Projet du Neuf-Brisac presenté par Mr. Le Maal de Vauban Anné 1698, et Executé pendant les années 1699, 1700, 1701, et 1702.

Porte de Basle

Canal de Navigation

Porte de Béfort

Porte de Strasbourg

Porte de Colmar

Sébastien Le Prestre de Vauban
Plan of the town of Neuf-Brisach
(Neubreisach)
Paris
Direction de l'architecture
et du Patrimoine, Ministère
de la Culture

[12] Faucherre "La Construction de la Frontière...," op. cit.: 25. For other collections: Teresa Colletta, *Piazzeforti di Napoli e Sicilia, le "Carte Montemar" e il sistema difensivo meridionale al principio del Settecento*, Naples 1981; Brita Englund, "Fästningsmodeller Fran Erik Dahlberghs Tid: En preliminär undersökning," in *Meddelanden fran Armemuseum* 28 (1967): 11–52.
[13] R. K. Massie, *Peter the Great*, London 1981: 648.
[14] Duffy, *The Fortress...*: 63-71.

not a new idea. The Venetian collection of *plastici* of the Republic's colonial fortresses was sixteenth-century in origin, and some even earlier models are recorded in *Cinquecento* literature.[11] But the idea was taken up with enthusiasm by the French fortress administration from 1668, when Louis XIV made his first substantial gains in Spanish Picardy. By 1698 Vauban himself was able to inventory 144 models in the Tuileries.[12] In addition to their strategic usefulness, these models could be used – perhaps even better than the frontier fortresses themselves – to demonstrate just those qualities of "gloire" that so appealed to the Baroque mind. When that eager student of advanced western civilisation, Peter the Great, visited Paris on his "great embassy" he was conducted through the Tuileries collection.[13]

Vauban established France at the summit of late-seventeenth-century bastioned military architecture, but the Netherlands were the focus of another important engineering tradition. Like Vauban, Menno van Coëhoorn (1641–1704) began his career as an infantry officer, winning fame as an artillerist and director of siege operations before being commissioned in the 1690s by William II to reorganize and systematize the Netherlands fortresses.[14] Although most of Coëhoorn's building work took place late in his career and mainly involved improvements to existing fortifications, he systematized the northern tradition of wet ditches (as a defense against underground mines), and the use of low profile ramparts and bastions built of brick up to a short distance above the water-line, and then covered with mounds of earth. Hence their much vaunted cheapness; at least when compared to the complete masonry defenses preferred by French, Spanish and Italian designers. The main defensive artillery in Coëhoorn's Dutch system was housed in large, curved, two-level batteries, well concealed behind shoulders (a return to Italian sixteenth-century tradition) and capable because of their weight of armament of delivering a very heavy cross-fire over the ditches

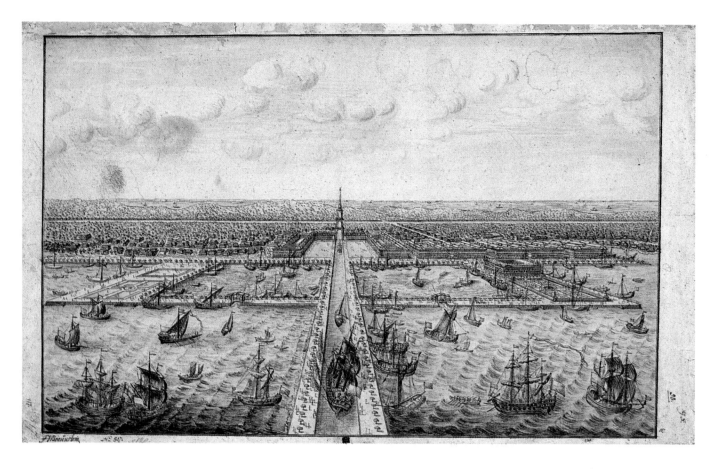

Johann Friedrich Braunstein
Perspective view of the lighthouse
in Kronstadt by Nicola Michetti
St. Petersburg
The State Hermitage Museum
cat. 380

[15] Duffy, *The Fortress...*, op. cit.:
176–217. For Dahlbergh see also
Roberts, *Gustavus Adolphus*, op.
cit., and for the Swedish fortress
cities, Gerhard Eimer, *Die Stadt-
planung im Schwedischen Ost-
seereich 1600–1715, mit Beitra-
gen zur Geschichte der Idealstadt*,
Stockholm 1961.
[16] E.M. Lloyd, *Vauban, Mon-
talembert, Carnot: Engineer Stud-
ies*, London 1887.
[17] For useful surveys of eigh-
teenth- and nineteenth-century
fortification: Quentin Hughes,
Military Architecture, London
1974: 151–230 which is Euro-
pean in scope; Andrew Saunders,
*Fortress Britain: Artillery Fortifi-
cation in the British Isles and Ire-
land*, Liphook 1989: 130–208;
Amelio Fara, *La metropoli difesa,
architettura militare dell'Ottocen-
to nelle città capitali d'Italia*, Ro-
ma 1985. For Schweidnitz, Duffy,
The Fortress..., op. cit.: 120–30.

(which could of course be stormed over winter ice). The ravelins also mounted substantial flanking batteries which swept the vulnerable zone in front of the bastion salient. The Dutch system of fortifications was widely copied by other northern Protestant powers, including the English and the Swedes. Its relative cheapness appealed to the English. In the low, sandy, semi-inundated coastal regions of the Southern Baltic, where Sweden fought so many campaigns, it often made very good tactical sense.

The Baltic theater was home to the third interesting Baroque development, which eventually was to prove a point of departure for designs which went well beyond the principles of continuous lines of bastioned fortification. The distinctive feature of the fortifications designed by Erik Dahlbergh (1625–1703) was the use of guntowers, in which artillery was stacked at three or more levels, giving a considerable concentration of firepower from positions which were well protected against small arms fire and the increasingly popular mortar shells.[15] Little in the fortification design of almost any period is entirely new, and Dahlbergh's guntowers represented the revival of a northern tradition in military architecture which had probably never completely disappeared in the Germanic and Slav worlds. Peter the Great's circular fort at Kronstadt, protecting the sea approaches to St. Petersburg and the main Russian naval base on the Gulf of Finland, employed a similar form. Guntowers were also developed into a key element in the unorthodox proposals of the Frenchman, Montalembert, in the mid-eighteenth century.[16]

Dahlbergh's and Montalembert's designs relied even more than those of Vauban and Coëhoorn on a plentiful supply of cannon. By the late-seventeenth century relatively cheap iron cannon, produced using much stronger solid castings and mechanically reamed-out bores, had virtually replaced the much more expensive hollow bronze castings of the fifteenth and sixteenth centuries. Although the mass-produced iron guns looked little different – save in their relative lack of elaborate surface decorations – improvements in the quality of castings, consistent barrel bores, and more powerful gunpowder, all added considerably to the effective range of eighteenth-century smooth-bore artillery. When coupled with the development of mortars, this opened up the possibility of mutually defensive clusters of

Nicola Michetti
Model for the lighthouse tower
at the entrance of the Petrovsky
port, Kronstadt
detail of the lamp
St. Petersburg
Central Naval Museum
cat. 376

following pages
Gabriello Ughi
Plan of the fortress at Ostend
Florence, Museo di San Marco
cat. 373

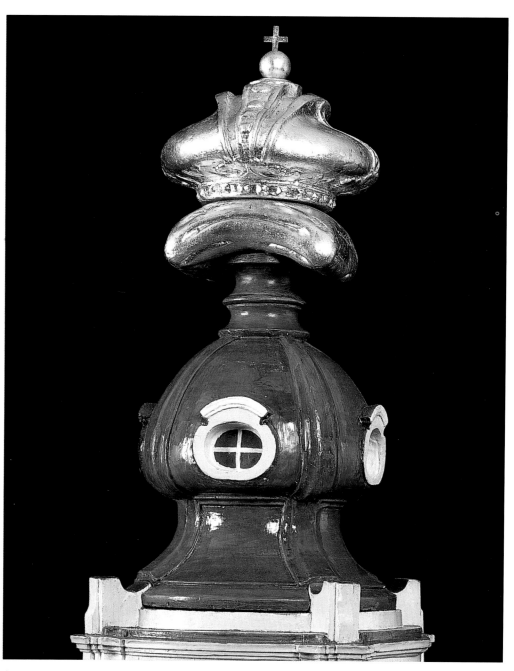

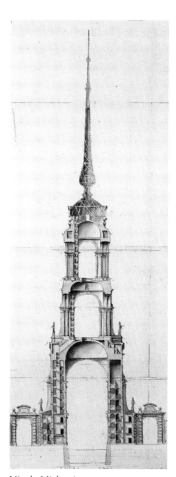

Nicola Michetti
Cross section of Kronstadt lighthouse
St. Petersburg
The State Hermitage Museum
cat. 378

forts, defending areas of ground by gunfire, rather than solely by means of solid physical barriers. By the mid-eighteenth-century, the most advanced fortresses already relied on completely detached forts, separated much more widely than any of the outworks in Vaubanesque designs, and standing far enough in front of the main fortress or town to represent satellites that would have to be taken before the main objective could be engaged. Schweidnitz in Prussia (now in modern Poland) was one of the pioneering schemes which pointed the way forward to nineteenth-century design, although it should be said that the Napoleonic Wars were fought over fortresses that were mostly Vaubanesque, if not earlier in inspiration.[17]

The early part of our period witnessed a number of epic sieges which have conditioned conventional attitudes to the slow pace of Baroque siege warfare. Ostend was held against the Imperialists for over three years (1601–1604) by a Dutch and English garrison, constantly reinforced by sea. Ostend was much the longest siege in Northern Europe. Antwerp held out against Spain for nearly two years in 1584–85, Breda for almost a year against Spain in 1624–25. The Venetian fortress of Candia was closely invested by the Turks from 1648 un-

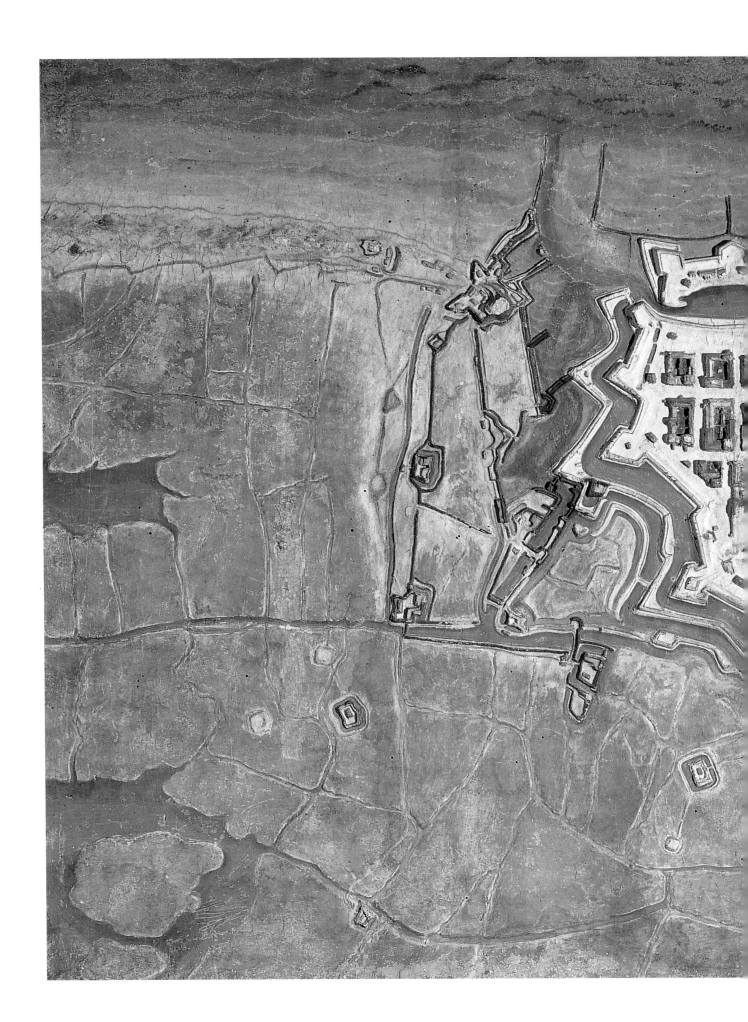

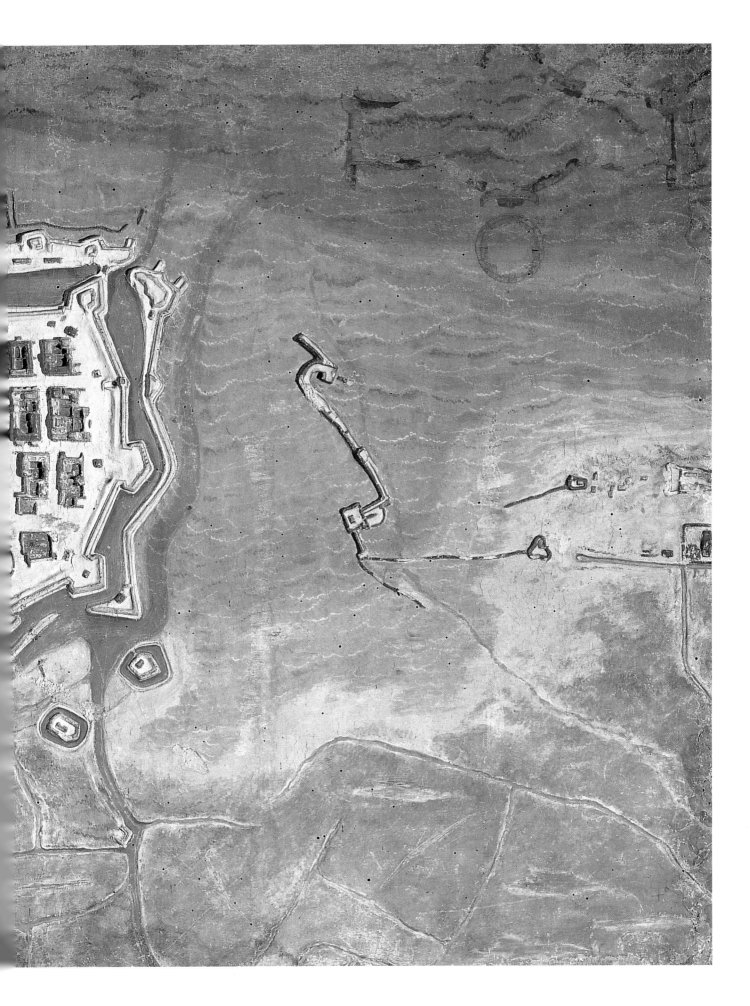

til 1669. Like Ostend, however, Candia was sustained from the sea until the intensive attacks of the last fifteen months in 1668–69 forced the defenders to surrender on terms. Venetian superiority in gunnery and their ability to provide supporting fire from ships had forced the Turks to fight underground for much of the final phase, an aspect of siege warfare which often tends to get overlooked but which was to prove critical at Baroque Europe's most spectacular formal contest with the Ottomans at Vienna in 1683. Here, the Turks were again outgunned by the defenders, but resolutely sapped and mined their way into the ditch from mid-July to mid-August. By early September three weeks of hand-to-hand trench warfare had established a Turkish lodgment in the smallest (and hence weakest) bastion in an *enceinte* that had been scarcely modernised since the sixteenth-century. The Austrian capital would probably have fallen by the middle of the month had not Jan Sobiesky's international relief force stormed out of the forests on 12 September and put the exhausted and overextended Ottomans to flight.

The two-month siege of Vienna was in its duration actually much more typical of Baroque siege operations than the much publicized protracted operations.[18] Shock action was sometimes effective in siege warfare too, achieving a rapid result at the cost of heavy casualties – albeit no greater than in many field engagements of the period. The length of any siege, however, has to be set within the overall context of what was often a slow moving campaign involving numerous siege actions. Hence the mileage yet to be extracted in the long-running historical debate initiated by Geoffrey Parker's thesis that bastioned fortifications were a key factor in slowing the pace of war in the sixteenth century, increasing the size of standing armies, and by this means playing its part in the emergence of the militarized seventeenth-century Baroque state.[19]

Anonymous
*Model of the Venetian fortress
at Canea or Candia*
Venice, Museo Storico Navale
cat. 374

[18] J. Lynn, "The *trace italienne* and the Growth of French Armies: The French Case," in *Journal of Military History* 55 (1991), reprinted in Rogers, 1995: 169–99, analyses French sieges 1445–1715. The sieges of Marlborough and Eugene (1695–1734), the Peninsular War (1811–13) and the Franco-Prussian War (1870–71) are analyzed in (Sir) George Sydenham Clarke, *Fortification: Its Past Achievements, Recent Developments and Future Progress*, London 1890 and 1907, second edition: 278–295. Sydenham Clarke's book is a polemic against permanent fortification, advocating for Britain reliance upon the "blue water" fleet for national defence. Both authors, of course, rely on secondary sources for their data rather than the primary records of entire campaigns, which may convey a somewhat different picture.

[19] The "Military Revolution" was coined by M. Roberts in a 1955 lecture, and published as "The Military Revolution, 1560–1660" in his *Essays in Swedish History*, Minneapolis 1967: 195–225. In a series of publications culminating

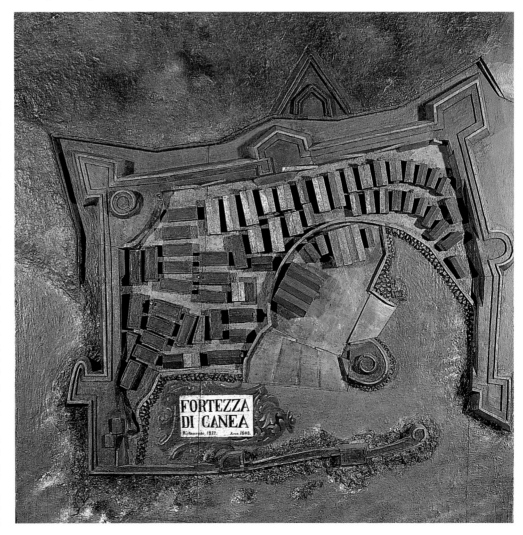

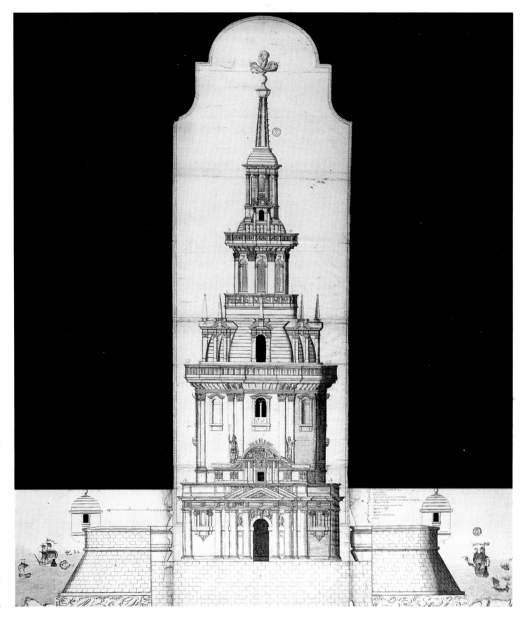

in his award winning book, *The Military Revolution: Military Innovation and the Rise of the West, 1500–1800*, Cambridge 1988, G. Parker has argued that the beginnings of the considerable growth in the size of armies observed by Roberts in the seventeenth century are to be found in the sixteenth century, and are attributable to the slowing down in the pace of war which accompanied the spread of bastioned fortifications. More troops were needed to besiege the extended bastioned urban *enceintes* as well as to garrison the increased numbers of fortified lines, contributing directly to the exponentially rising costs of early modern warfare. Parker's thesis (initially drawn from his own researches in the wars between Spain and the Dutch) has been challenged by a variety of historians, some of whose publications are collected in Clifford Rogers (ed.), *The Military Revolution Debate: Readings on the Military Transformation of Early Modern Europe*, Boulder, San Francisco, Oxford 1995.

[20] Charles de Brosses, quoted in Pollak, *Turin 1564–1680*: 1.

[21] Pollak, *Turin: 1564–1680*: 1.

[22] Charles Van Der Heuvel, "Il problema della cittadella: Anversa. La funzione di disegni e relazioni nella seconda metà del Cinquecento," in C. De Seta and J. le Goff (eds.), *Le città e le mura*, Bari 1989: 166–86; and "Bartolomeo Campi Successor to Francesco Paciotto in the Netherlands. A Different Method of Designing Citadels: Groningen and Flushing," in Marino Viganò (ed.), *Architetti e ingegneri militari italiani*

Whether cause or symptom of new patterns of warfare and statehood, extensive systems of bastions, ramparts, ravelins and other outworks certainly changed the face of many Early Modern cities. The *cordon sanitaire* of new fortifications constrained subsequent urban development (often until late in the nineteenth century) and, meanwhile, contributed to a fundamentally Baroque style of high density urbanism which combined regular streetscape, fortifications, gates and citadel in a perfect diagram of a militarized absolutist society.

Today, it is the surviving gates which most frequently excite admiration for Baroque military architecture and, when the other fortifications were increasingly sunk in deep ditches and covered in grassy banks, gates were often the only prominently visible elements. But the regularity of Baroque streetscape was clearly something that Le Blond strove to achieve in his "ideal" plan for St. Petersburg, which tackled the formidable task of joining the Peter and Paul fortress, the Admiralty and shipyard complex, and the planned royal palace despite their separation by substantial waterways.

When it was achieved, regularity gained high praise in its time: "Turin seems to me the prettiest town in all of Italy, and, I believe, in all of Europe," wrote one Frenchman in 1739 in admiration for "the alignment of its streets, the regularity of its buildings, and the beauty of its squares [...]"[20] To Nietzsche, Turin was "a city after my own heart [...] a

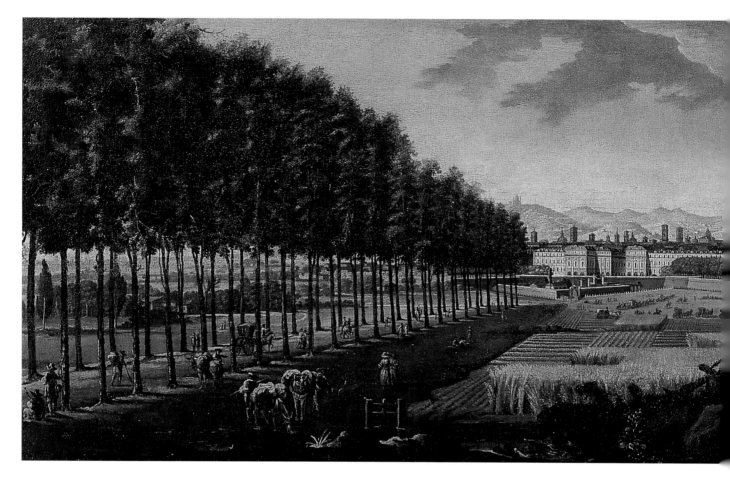

Ignazio Sclopis di Borgostura
*Panorama of the city of Turin
from the Susa Gate*
Turin, Private Collection
cat. 386

all'estero dal XV al XVIII secolo,
Livorno 1994: 153–67.
[23] According to Parker "a well-developed system of medical care – with a permanent military teaching hospital, mobile field-surgery units, and resident doctors in every regiment" covered the Spanish army in the Low Countries and Italy as early as the 1570s (1979: 89–90): the activities of military hospitaller orders are much older. But the Baroque age contributed a number of splendid permanent institutions. The Hôtel des Invalides in Paris (architects Libéral Bruant and J. Hardouin Mansart) was founded in 1671 by Louis XIV as a home for disabled soldiers, housing at one time as many as 6,000 *invalides*. This was closely followed by Christopher Wren's Chelsea Hospital (1682–92) for soldiers and Greenwich

princely residence of the seventeenth century, which has only one taste giving commands to everything, the court and its nobility. Aristocratic calm is preserved in everything [...]" Indeed among Europe's great cities, Turin, perhaps even more than St. Petersburg, succeeded in achieving total Baroque consistency in the successive extensions which followed its selection shortly after 1559 as capital of the newly-restructured state of Savoy. Over the next 150 years the original tight grid of the Roman-Medieval *castrum* was enlarged, the historic palace area preserved as a setting for Baroque urban theater, and new squares and vistas from the gates incorporated into the expanded grid – all within one of the more advanced urban fortification systems of Early Modern Italy. Occupying a strategic site overlooking the city, but separated from it by its own *cordon sanitaire*, was the star-shaped citadel which was designed by Francesco Paciotto and built by Francesco Horologgi between 1564 and 1566.[21] By then many other Italian cities were already dominated by citadels of various ages and designs, but Paciotto's five-bastioned, regular, star-shaped citadel was the first of a type which was quickly to be copied by Antwerp (in 1567, also designed by Paciotto)[22] and would become the model for dozens of "ideal" pentagonal fortresses throughout Baroque Europe.

The citadel is frequently seen simply as the seat of authority, and often enough it was built – as in Lille, in 1667 – to secure the loyalty to France of a city which enjoyed strong ties with its Spanish former owners, or – as in Messina – in the immediate aftermath of rebellion. Frequently, however, it represented merely the most rapid and cost-effective means of securing a city which had not yet been equipped with complete modern fortifications. Typically the citadel served as warehouse for the provisions, guns, ammunition, wagons and bridging trains needed for modern war. The citadel also housed barrack blocks for the garrison troops of armies which increasingly relied upon long-term regular enlistment (often by enforced draft) as the core of the much enlarged military establishments. Barracks are now synonymous in most contemporary cultures with the *existenzminimum* of civilized life, but in seventeenth- and eighteenth-century Europe they

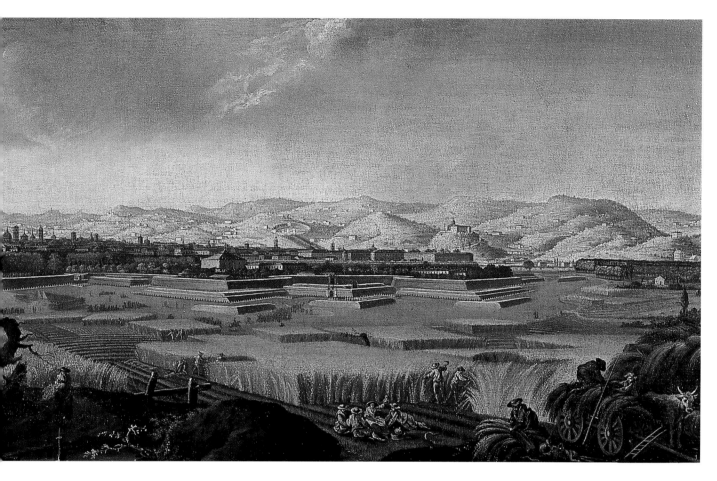

Hospital (from 1696) for sailors, the latter being among the very finest of all of Britain's Baroque buildings. Eighteenth-century military hospitals for serving sailors, such as the naval hospital at Haslar, near Portsmouth, were equipped with rails and hoists for ameliorating the pain of wounded men. Because experienced seamen represented a valuable asset, the hospital was enclosed in a high security wall. Any suggestion that barracks or hospitals represented a "soft" approach to the care of veteran servicemen is countered by C. Jones, "The Military Revolution and the Professionalisation of the French Army under the Ancien Régime," in M. Duffy (ed.), *The Military Revolution and the State, 1500–1800*, Exeter 1980: 29–48 who cites Foucault on the program of the strictly enforced discipline at Les Invalides: *Discipline and Punish: The Birth of the Prison* (English translation, 1979).
[24] F. Braudel, *The Mediterranean and the Mediterranean World in the Age of Philip II*, Paris 1949 (English trans. by Sian Reynolds, London 1973: II, 844–45).

probably represented for most rank and file a better quality of accommodation (sometimes with hospitals or pensioners' wings) than that obtained by billeting troops on an unwilling civil population, leaving them vulnerable to the wastage that was rooted in drink, crime and desertion.[23]

Architecturally, the barracks, stables, arsenals, powder magazines and officers' quarters ranged around the parade grounds of the citadels which dominated so many European cities represented an opportunity for large-scale Baroque design which was only rivaled by great palaces and a handful of civilian urban schemes. Well into the late-eighteenth century, new fortresses assumed this impressive urban character. The Austrian defenses of Northern Bohemia included Leopoldstadt and Theresienstadt (of sinister memory in World War II) which were built from 1780 with interiors laid out on "ideal city" lines. Fort George, built in Scotland between 1747 and 1769 following the suppression of the 1745 rebellion, is one of the purest as well as most northerly examples of this military Baroque layout – both in terms of its by then standard post-Vauban fortifications, and of its "urbanism" framed in an empty landscape.

The elaborate defense systems of Northwest Europe are an obvious and potent physical manifestation of Baroque military might. But they are only one part of the broad picture conveyed by the exhibition. Baroque fortification was quintessentially a programme of frontier defense, and the mass of advanced works still to be found in the congested "inner" frontier zones of the Low Countries, the Alpine and Pyrenean passes and parts of the upper Danube, should not cause us to overlook the enormously extended fortified lines which marked the "external" borders of Early Modern Europe.

"To meet the Turkish threat," says Braudel of the sixteenth century, "Mediterranean Christendom erected a chain of fortresses, now to be one of the characteristic marks of its approach to war. As well as fighting, it was constantly extending its defensive and protective lines, encasing itself within a shell of armor."[24]

This "shell of armor" remained an important feature of seventeenth- and eighteenth-centu-

Salomon Gouin
Medal presented
to Admiral Matvei Simont
in memory of the construction of the
port of Taganrog, on the Sea of Azov
St. Petersburg
The State Hermitage Museum
cat. 388

25 Ennio Concina (ed.), *Arsenali e città nell'occidente europeo*, Roma 1987; Jonathan Coad, *Historic Architecture of the Royal Navy: An Introduction*, London 1983.

26 Joanna Woods-Marsden, "Pictorial Legitimation of Territorial Claims in Emilia: the iconography of the *camera peregrina aurea* in the Castle of Torrechiara," in *Renaissance Studies in Honor of Craig Hugh Smyth*, Florence 1985: II, 553–68.

27 Commemorative and foundation medals are often a valuable source of visual information. The Russians pioneered medals as marks of loyal military service, first as special coin mintings (with a money value) which were awarded to all ranks (and to next of kin). The medals themselves were often pierced or fitted with a ring so that they could be stitched onto a soldier's coat. Peter the Great insti-

ry Europe. Throughout the Western Mediterranean a chain of coastal towers, forts and heavily fortified port and arsenal complexes staked out Christendom's frontier with the Ottoman Empire. The Venetian-held island and promontory outposts in the Adriatic, Ionian and Aegean seas, the Spanish *fronteras* on the North African coast, and the pivotal strongpoints of Malta and Crete were the advanced guards of this southern defensive system. The projection of power through mobile naval forces – then as now – relied for its effectiveness on a close symbiosis between warships and the signal stations, watering points, fortified anchorages, careening beaches, munition stores and repair yards which provided for their operational support.

The main line of defense was the coast itself, of course, where many of the most extensive and impressive pre-industrial construction projects of Early Modern Europe were to be found.[25] A few of these early arsenals – notably that of Venice – survive in something approaching their original form, but most have been altered out of all recognition by subsequent port development. Some of the early dockyard schemes survive vividly in the descriptive fresco cycles initiated by Philip II in the Escorial, and by the Papacy in the Vatican Map Gallery. Even earlier, of course, magnates had marked out their territorial holdings visually in fresco cycles such as that of Torrechiara, near Parma, where the owner's numerous other castles – including those still under construction – are depicted and named.[26] These programs set the pattern for even more extensive artistic campaigns sponsored by the Crowns of Baroque Europe in paintings, maps, and medals[27] recording the essential infrastructure of coastal fortification and naval warfare.

If this tradition had Mediterranean origins, it quickly spread to Northern Europe. Indeed, apart from artists with local links northerners increasingly tended to dominate this particular art form. In the 1670s Charles II employed Hendrick Danckerts to record the coastal fortifications of England and Wales in a series of paintings that are notable for their topographical and architectural accuracy.

The French Royal commission for Joseph Vernet's *Ports of France* (1753) was one of the largest and most important artistic undertakings of Louis XV's reign and, at one level, can be seen as official propaganda for the French merchant and royal navies. Although only fifteen paintings had been completed when the program was terminated in 1765, the full series of twenty-four commissioned paintings, however, illustrates very forcefully the enormous investment in port and arsenal facilities in its Mediterranenan, Atlantic and Channel installations that a major eighteenth-century naval power was compelled to maintain. The stockpile of cannon in the foreground to Vernet's view of the New Arsenal at Toulon reinforces the point already made about the numbers of guns needed to arm modern, round-bottomed warships as well as the siege trains and fortresses of land warfare. Lorenzo Fratellini's view of the harbor and arsenal complex at Livorno shows the scale of facilities provided by a relatively minor Mediterranean power.

Florence had absorbed Pisa's much lengthier seagoing tradition, but the modern Tuscan naval initiative dated from Cosimo de' Medici's foundation of the Order of Santo Stefano in 1562, a transparent attempt to match the Order of St. John's mixture of profitable piracy and naval crusade.

An equally comprehensive network of sixteenth- and seventeenth-century defensive installations ran along Europe's extensive Balkan land frontier with the Turks. Both sides in Danubian warfare, it should be noted, maintained substantial galley fleets on a scale not far short of that required for maritime campaigns, together with inland arsenal facilities at half a dozen points on the great river.

Here Europe's back-door needed to be locked. Stretching for many hundreds of miles from Croatia, through Hungary, Transylvania, and Poland, to the junction of the northern forest with the southern steppes of Muscovy, a chain of timber watchtowers, staked ditches, forts, defended villages, and a handful of permanently fortified base camps provided the infrastructure for the ceaseless raiding which characterized land operations in the periods of "peace" between the main eastern campaigns. This was the so-called "Military Frontier."[28]

Here the armed peasantry of the Christian Balkans (often located far from their Turkish-occupied homelands) were organized into militia colonies and – under only nominal con-

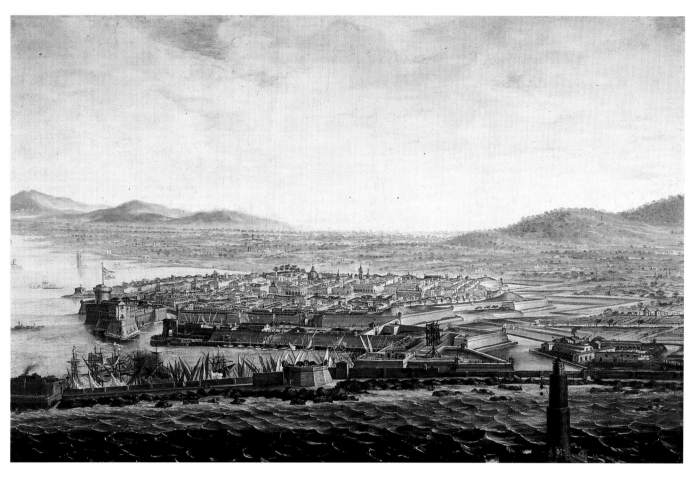

Anonymous
View of the port and town of Livorno
Turin, Fondazione Giovanni Agnelli
cat. 383

tuted properly designed medals for successful campaigns or battles, often in different sizes for colonels, officers and other ranks. They were nevertheless awarded to all who served. Consistent with his introduction of the table of ranks, the medals bearing his own image on the front quickly became prized marks of service and – particularly among the lower orders – helped further to reinforce his concept of modern statehood. Most other European countries restricted medals to officers (often only senior officers) until the nineteenth century.
[28] G. E. Rothenburg, *The Austrian Military Border in Croatia 1522–1747*, Urbana IL 1960.
[29] Giuseppe Gerola, "Le fortificazioni di Napoli di Romania," in *Annuario della Regia Scuola Archaeologica di Atene* XIII-XIV (1930–31): 347–410.

trol from Vienna or Moscow – enjoyed a measure of autonomy and religious tolerance in return for a way of life in which the entire community remained constantly in a state of instant readiness to take up arms. Of the physical remains of the Military Frontier, however, little is now to be seen.

What can still be seen in Southeast Europe, is the chain of Austrian fortresses which were built or rebuilt as the Hapsburg Empire pushed the Ottomans back down the Danube valley after the Turkish failure to take Vienna in 1683. A second Christian front had been re-opened in Greece in 1686, when a Venetian expedition under Morosini recaptured the Morea and Athens and, using French engineers, constructed the experimental new works on the heights of Palimidi overlooking their principal base at Napoli di Romania, modern Nauplia.[29] These were among the earliest of the mutually-supporting detached works described above.

The Russian Black-Sea coast witnessed its own Baroque initiatives. Peter the Great captured Azov in 1696, and to provide an open-sea base for his Black-Sea fleet between 1698 and 1709 constructed an artificial harbor and base port at Taganrog on the Sea of Azov. The medal cast in honor of the Italian-born naval officer in Russian service who supervised its construction shows moles extending into the sea in front of a radially planned port, surrounded by bastioned defences.

Most official commemorative Russian medals of this era made a serious attempt to achieve topographical accuracy, usually based on published prints. Thus it is likely that something like this ambitious scheme was constructed, if only to be demolished a few years later when Peter was compelled to return both Taganrog and Azov to the Ottomans under the Treaty of Pruth (1712). Whether or not the image on the reverse of the Taganrog medal records actual construction is, of course, less important here than the ambition it represents. It is perhaps appropriate that the Taganrog medal, with its image of an Italianate radial fortress city, should stand as the monument to Baroque Europe's farthest southeastern outpost.

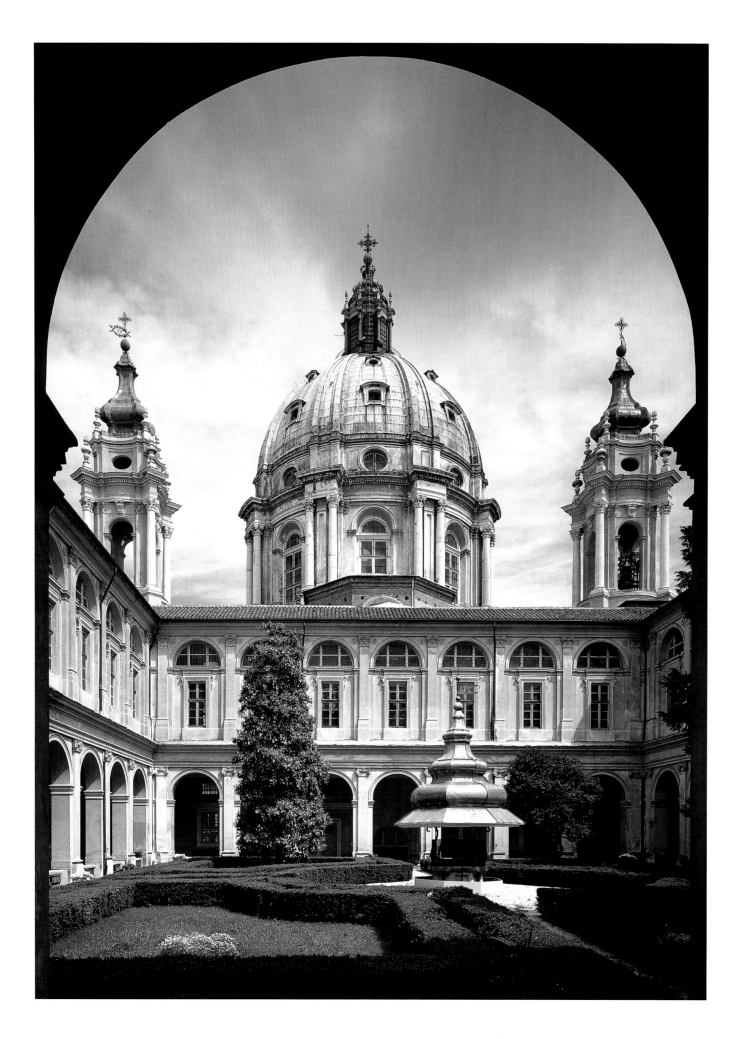

Vera Comoli

Turin: an Example for the Town Planning and Architectural Models of European Capitals in the Seventeenth and Eighteenth Centuries

A traveler in Italy during the Baroque period would only have recognized Turin as meriting the title of capital city, in spite of there being numerous ruling towns throughout the country. For the capital of Savoy this term meant exactly the same thing as it meant for the nascent national states in Europe. It is important to keep in mind, for today's well-informed study of history, the debate about the meaning of the words "state" and "nation" and the lengthy persistence of a financial and personal character, which the term "state" had right up into the heart of the modern period. In any case, it is possible to speak of a new urban phenomenon for Turin, in comparison to the past, as a decisive characteristic that distinguished European states between the sixteenth and seventeenth centuries, which, on the point of becoming absolute monarchies, emphasized their centralizing dimension. While Charles V had felt the need to sojourn in many capitals for long periods under the guise of a substantially itinerant court, his son, Philip II, instead felt the need to create a single city-capital for the new dimension of Spain's separate monarchy, thus establishing a stable center for the central magistrature, which was not linked to the court's movements.

By the middle of the sixteenth century, therefore, the principle of the importance of a princely state appears to have been acquired and the personal dimension of a prince's power overcome, together with the identification of a prince's interests with those of the state's. The city-capitals asserted themselves, together with the culture they produced; both would be fundamental, also in an artistic sense, for the Baroque (Argan 1964; Griseri 1967; Berengo 1995). The desire and need for territorial centralization were so greatly felt as to make the sovereign's decisions decisive not only for the local communities but also for the great military aristocracy, who in the past had been the bearers of uncontested local authority and powers.

For Savoyard Piedmont, in particular, consolidation and re-organization of the state under Duke Emanuele Filiberto of Savoy (1553–80) and the subsequent policies of re-arrangement and territorial expansion under Carlo Emanuele I (1580–1630) were founded on principles strongly identified with the princely state. The essential requirements of this process were to create a single, unified block of territory by eliminating isolated enclaves; a functional road network guaranteeing access to the sea; consolidation of economic and manufacturing resources; construction of a system of new fortresses designed and sited throughout the territory with the sovereign's prerogative to enlist mercenary armies; liquidation of the military aristocracy; and, finally, creation of a city-capital (Comoli Mandracci 1983; Merlin, Rosso, Simcox, Ricuperati 1994; *Dalla dominazione francese* 1998; Comoli Mandracci 1998).

The Savoyard and Piedmontese territories handed back to Emanuele Filiberto as a result of the Treaty of Cateau Cambrésis, which ended the long war between France and the Empire,

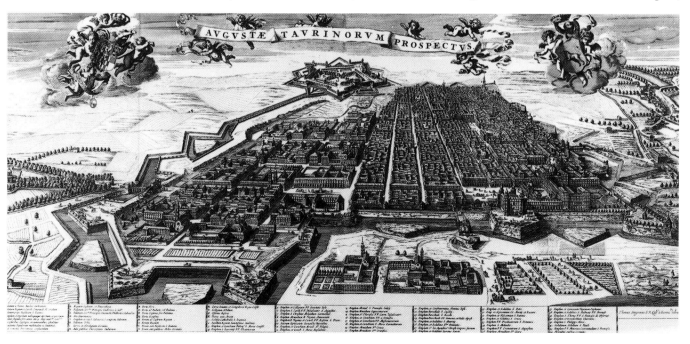

Piazza Castello and the junction
with the enlargement scheme
toward the Po River
exemplifying the absolutism
of the 17th century
engraving after a drawing
by Tommaso Borgonio
from *Theatrum Sabaudiae*, 1682

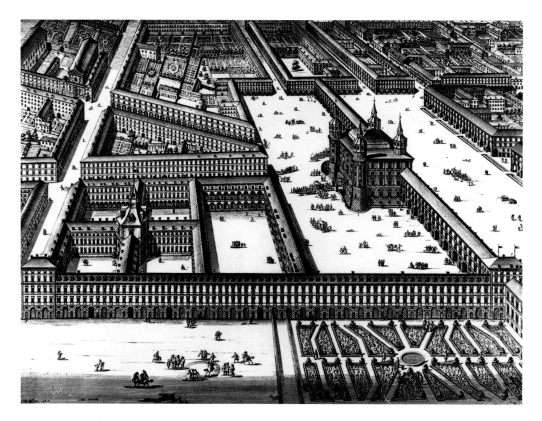

were not fortified in any way. One, in particular, of the codicils to the treaty of 3 April 1559, which returned his father's lands to the duke, obliged him to disarm the fortresses that had been built with French and Spanish financing. In this way, even if all the fortresses were not handed over immediately, the territory was to all extents unarmed, or rather, armed according to the old style, which the advances of siege craft had by then rendered obsolete.

A Venetian ambassador present at the court of Turin during the early years of the Savoyard period (1563–66), Giovanni Correr (Correr 1858), had well noted how weak the Piedmontese fortresses were and how inefficient the defensive structures for the city of Turin. This problem also influenced the choice itself of the capital of the dukedom. The duke in fact lived in Nice and Vercelli before deciding to make Turin his capital (after 1562); bearing in mind also that a male heir had been born, guaranteeing a more assured political autonomy.

The regular and fixed skyline
of the new Via Po
by Amedeo di Castellamonte
F. Juvarra, A. Aveline. *Dessein
de l'illumination de la rue de Pô
conduisant au Château de Madame
pour l'entrée de S.A.R. Madame
la Princesse de Piedmont*, ca. 1722

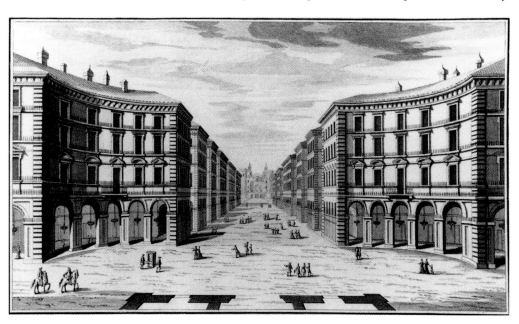

Pieter Bolckmann
*View of Piazza Castello
showing the axial arrangement
of the "contrada nova"*
ca. 1705
Turin, Museo Civico di Arte Antica
Palazzo Madama

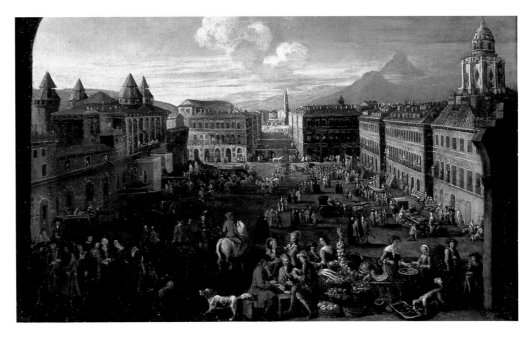

This decision led to the construction of a citadel in 1564 to defend the city. The building of the citadel, which was both a strategic and a symbolic factor, in fact related to the requirements of a centralizing state tending toward absolutism.

By the middle of the sixteenth century Turin was still a predominantly medieval city in terms of town planning. Even though it had gained importance during the fifteenth and sixteenth centuries due to the introduction of various bureaucratic and commercial practices with a resulting increase in population growth, the city had remained inside the boundaries of the old Roman town, covering an area of about 700 by 760 meters. It had less than 20,000 inhabitants and already occupied a fairly central position among all the properties belonging to the House of Savoy. In the town the original axes of the Roman *decumanus* and *cardo* were still visible; the first in the Dora Grossa road (road-bed of the present-day Via Garibaldi) and the second, less obviously, in a stretch corresponding to today's Via San Tommaso and Via Porta Palatina. In the Middle Ages, other secondary gateways had been added to the original four Roman ones and the old Porta Pusterla, which resulted in a gradual decline of the main Roman *cardo maximus* along the north-south axis. Instead, the town had retained the *decumanus* along the east-west axis as its main road, which led uninterruptedly from Porta Susina to the castle (today's Palazzo Madama) and to the neighboring area of buildings and squares which had arisen around the pre-Romanesque and Romanesque basilicas, replaced in 1499 by the cathedral. All the main commercial and local government activities were grouped in this quarter; it was not by chance that the regular road network of the Roman plan was here distorted to accommodate the dual polarities of the cathedral and the municipal Piazza delle Erbe.

Francesco Paciotto (1521–91) was responsible for fortifying the city-capital with the construction of the citadel (1564–66), which, with its dominating position on the diagonal of the old city, left areas open for future expansion parallel to the axes of the orthogonal urban system of the old roads (Comoli Mandracci 1983; Scotti Tosini 1998). It immediately appears evident that the construction of the citadel complemented a more up-to-date and efficient fortification of the whole city, also in view of its probable expansion. It was also closely connected with the construction of a ducal palace worthy of a prince emerging on to the European scene. Emanuele Filiberto's intentions in this respect emerge clearly from archival documents and from the reports of ambassadors at the court of the House of Savoy.

However, the duke then abandoned this project for a monumental ducal palace, although he continued with other useful projects that would consolidate within the city its symbolic and functional character of an emerging power. The historian, Tonso, also emphasized how the duke had enlarged and improved his out-of-town residences in which he "commode et decenter habitavit" (could "comfortably and decently live," Tonso 1596). The years of

Anonymous
*The castle of the Venaria Reale
(Stupinigi Hunting Lodge)*
18th cent.
Turin, Museo Civico di Arte Antica
Palazzo Madama

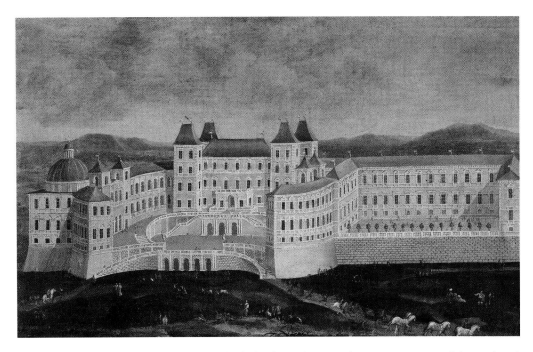

Emanuele Filiberto's reign in fact marked the first phase in the construction of those ducal properties around the town which would become the basis for the seventeenth-century development of what Amedeo Castellamonte would later call the *corona di delitie*, ("crown of delights") or ring of ducal residences (Di Castellamonte 1674). These were the hallmarks of all the city-capitals of all the European seventeenth-century courts; they differentiated these cities and made them recognizable from all the other urban settlements.

The duke's control also extended to the hill on the other side of the River Po; known in contemporary terms as that important "mountain." From here it was possible for the cannons of the artillery to "batter" the city and jeopardise the defenses of the bridge below the Bastida (then Monte dei Cappuccini). In fact all the lower stretches of the hill, from the great ducal *vigne*, or country house properties, to the north, such as the Margherita or Emanuela, right up to the castle of Moncalieri to the south, were placed under the duke's control and reserved as domain of the duke or the ducal family. As Giovanni Botero observed in his *Relazione di Piamonte*, this stretch of territory was in fact composed of that "montagna, che per la varietà incredibile de' siti, che qua si alzano, là s'abassano, qua si ritirano, là si avanzano

Overhead view of Turin
in the closing phase
of the new town expansion plan
ca. 1670
Paris, Bibliothèque Nationale
de France, Cabinet des Estampes

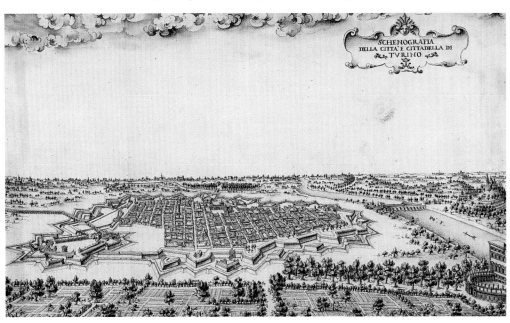

Carlo Giuseppe Plura
after a drawing by Filippo Juvarra
Model for one of the side
altars of the chapel of St. Hubert
in the Venaria Reale
Aglié, Church of Madonna
della Neve e San Massimo
cat. 516

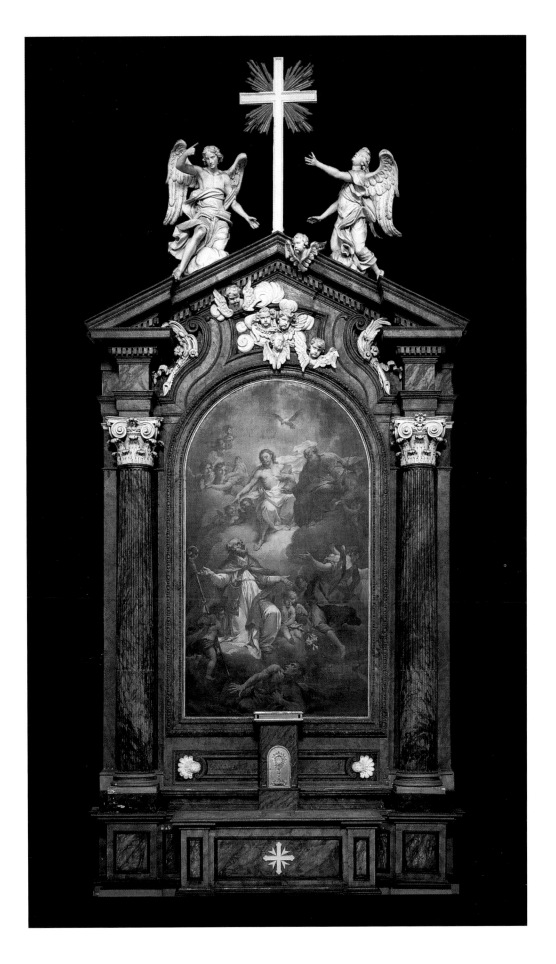

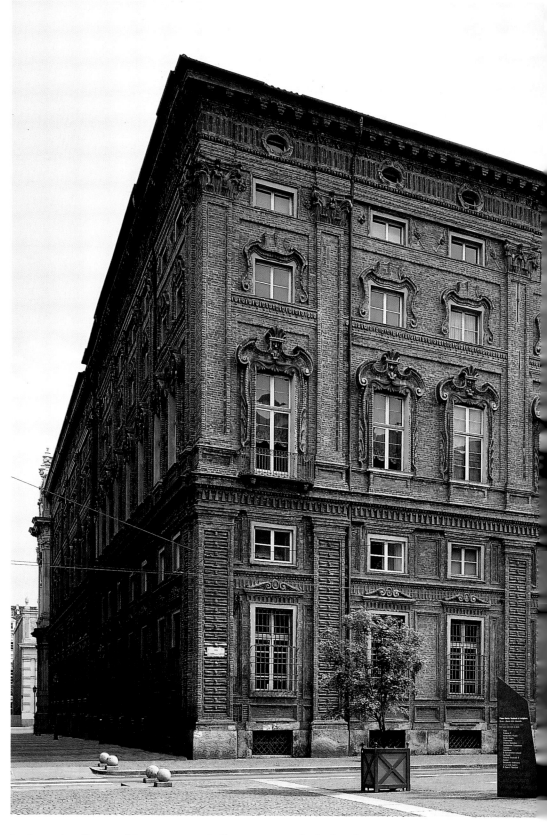

View of the façade
of Palazzo Carignano
in Turin

[…] merita d'esser chiamata aurea" ("mountain, which for the astonishing variety of its countryside, here high up, there low down, here rather laid back, there more prominent, […] truly merits being called perfect," Botero 1607).

Nevertheless, it was not until Ascanio Vitozzi's arrival in Turin, in 1584 under Carlo Emanuele I's reign, that the project for a great new palace began to be concretely realized within a radical restructuring programme of the old area of the pre-existing bishop's residence in which the invention of a new urban model for the entire city was implicit. The complete restructuring project realized within the sixteenth-century boundaries, appropriate to the principles behind the concept of a monarchy in the making, with the creation of a grander district where all court powers were condensed, was a tangible image of the new ideology of the ruling classes. A competition for the design of the new residence was

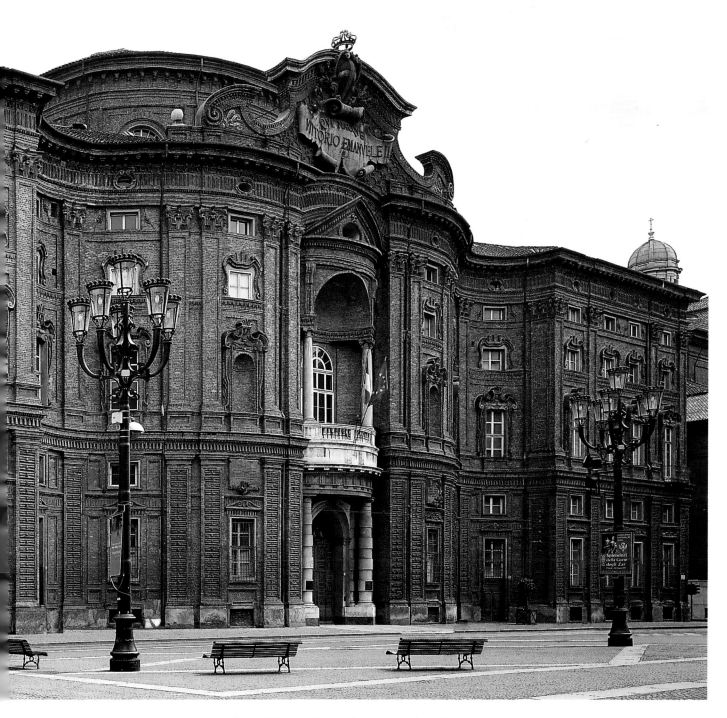

proclaimed by Duke Carlo Emanuele I, between 1583 and 1584. It was open to all the "valent'huomini della professione chiamati da noi da diverse parti d'Italia" ("skilled men in the profession called by us from different parts of Italy"), as a subsequent decree of 1619 makes clear.

Construction of the palace and a totally new town planning programme for Turin were inseparable in Ascanio Vitozzi's project. A decree of 1587 reveals the existence of a complex and costly urban project, which illustrated both reform of the old city, especially in the area around the bishop's palace and Piazza del Duomo, and the creation of two new streets. The more important of these two new streets, toward the south, aimed at creating an extremely long perspective view toward the "leisure" residence of Mirafiori; the much loved ducal palace outside the city (Turin, Archivio di Stato, Patenti Piemonte, reg. 1584 in 1587, XII,

Guarino Guarini
Central façade section and lateral
cross section of Palazzo Carignano
from *Architettura civile del Padre
D. Guarino Guarini Cherico regolare
Opera postuma
dedicata a Sua Sacra Reale Maestà*
Turin, Biblioteca Reale
cat. 111

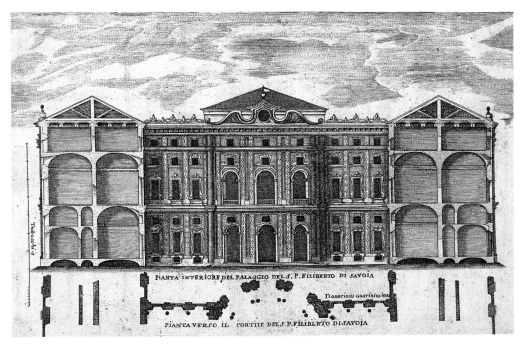

fol. 446, 10 June 1587). Vitozzi's project abandoned the earlier direct relationship that the group of old ducal residences had had with the barycenter of the pre-existing town and created a new outlook and relationship that bestowed more importance on Piazza del Castello as well as on the territory and villas outside the southern walls, which were thus included within a far-sighted and complex project. The decision to change the outlook of the main façade of the *palazzo novo grande*, or great new palace, around, compared to the previous ducal seats, was all-important because it also determined the direction of the main road in Turin. This became the governing axis of the city's modern and contemporary town plan, consolidated over time with the result still evident and unchanged up to today in the present, equally important, Via Roma.

Vitozzi's ideas stem from Late Renaissance thinking and the invention of an authentic overall urban dimension. This was supported by streets cut into the existing fabric and by the creation of a completely new space for all the ceremonies and new court rituals and representation of power: Piazza Castello. The two, *contrade nove*, or new streets, were cut into the heart of the Roman *insulae*. One joined the *palazzo novo grande* to the area of future urban

Guarino Guarini
Prospect and profile of the façade
of Palazzo Carignano
from *Architettura civile del Padre
D. Guarino Guarini Cherico regolare
Opera postuma
dedicata a Sua Sacra Reale Maestà*
Turin, Biblioteca Reale
cat. 111

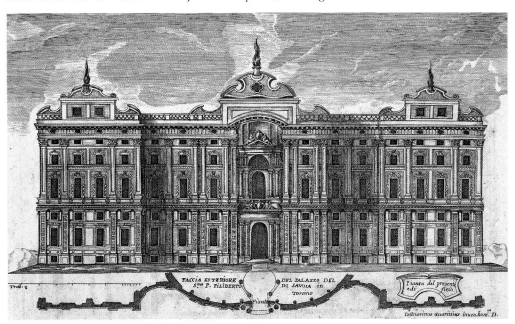

Tommaso Borgonio
*Gli Hercoli domatori de mostri
et Amore domatore degli Hercoli
Festa a cavallo per le reali nozze
della Serenissima Principessa
Adelaide di Savoia
e del Serenissimo Principe
Ferdinando Maria
Primogenito dell'Altezza Elettorale
di Baviera*
Turin, 15 December 1650
cat. 471

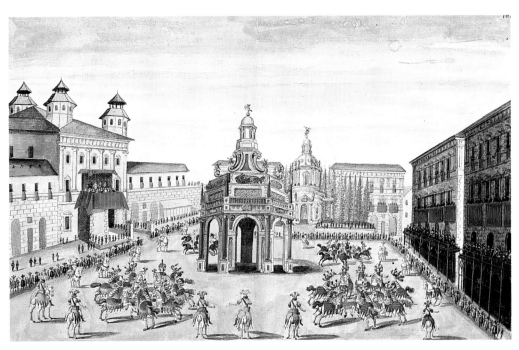

expansion by crossing three older blocks; the other joined the new square of Piazza del Castello to the fulcrum of municipal power, which was Palazzo Civico, or the Town Hall, in Piazza delle Erbe (Comoli Mandracci 1987).

In the realization of the project, much attention was paid to the architectural decoration and grandness of the squares, intended as real spaces appropriate for the ceremonies of the city in its new ducal role. Vitozzi's façades for the buildings overlooking this new urban space were marked by severe skylines and architectural uniformity. His town plan was continued after his death (1615) by other court architects, first of all Carlo di Castellamonte, who also realized the fundamental features of interventions that had not yet been finished or were still only on paper. Thus, due to his position as first architect, he became recognizedly responsible for the early city expansion projects already implicit in Vitozzi's design as well. This overall design had decided the new town planning trends of the city-capital according to a theoretical concept that was immediately put into practice, based above all on the pre-eminence of precise bipolar axialities. In this design, adherence to the concept of a Mannerist and Baroque city was what counted – an idea quite new and up-to-date – rather than to connect up with the *cardines* and *decumani* of the Roman *castrum*, as has too often been sustained.

The city's expansion, already outlined at the end of the sixteenth century, was concretely designed and realised at the end of the 1620s by a military engineer, Ercole Negro di Sanfront. His town plan adhered perfectly to Vitozzi's ideas, strengthening the principle of physical and functional integration of the old plan with the new, which also satisfied military and civil requirements. All the subsequent development of the city was based on this principle. The expansion projects in the first place of Vitozzi, Sanfront and the Castellamontes, and then their subsequent realization, in fact all demonstrate this structural integration of the new with the old plan as a precise choice, which never even considered ideas or projects for the addition of distinct, autonomous parts.

The fact that the city's expansion in the seventeenth century was seen to be a global town planning project, more typological than topographical, has been demonstrated many times over the years (Comoli Mandracci 1982; 1983: especially 29–44; Dardanello 1988; Comoli Mandracci 1989 and 1998). It was even in discussion under Duke Emanuele Filiberto's rule although affronted only concretely by Carlo Emanuele I with Ercole Negro di Sanfront when new lands to the south and east right up to the bridges over the River Po and the River Dora were incorporated (1618–19).

This urbanistic fusion of the old town with the new, and then with the eastern expansion – the *città nuova di Po* – was carried out following the criterion of uniformity in uninterrupted façades, a precarious idea in Europe. Behind this practice lay not only a new building cul-

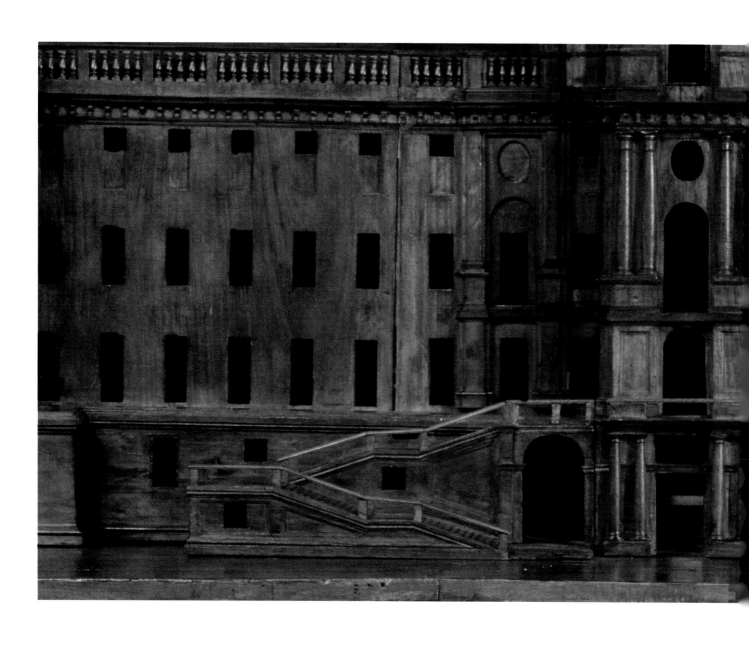

Filippo Juvarra
and Carlo Maria Ugliengo
Model of Rivoli Castle
detail and interior
Turin, Museo Civico di Arte Antica
Palazzo Madama
cat. 152

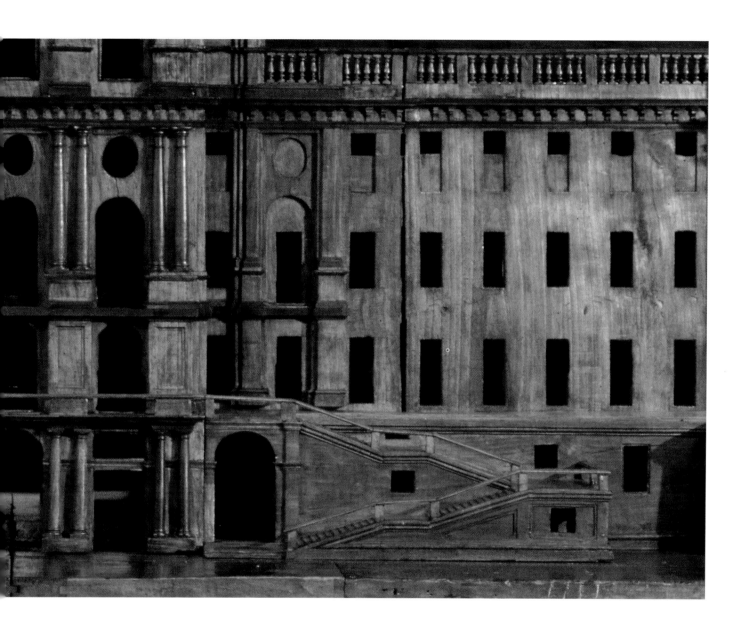

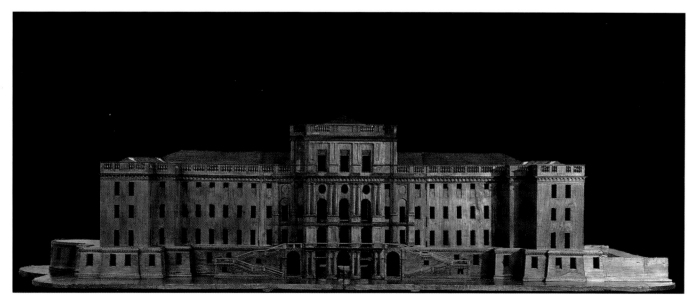

ture, but also ideological confirmation of the sovereign's position in the absolute state. This method imposed, as its main characteristic, an image and structure in which the urban town plan as a whole was more important than single architectural solutions and resulted in the creation of a real stage set for showing off power. The system of the governing road axes in every expansion was focused on the complex of the ducal palace situated on the edge of the old nucleus, according to the prevalent idea that wanted the palaces of governments concentrating power in a prince, to the detriment of the aristocratic classes, placed off-center in the city. Search for an urbanistic barycenter, which was functional and symbolic rather than geometrical, permitted the physical and functional dichotomy between the complex of the ducal palaces and the areas of expansion, and the fragmentary nature itself of the newly planned *insulae*, to be overcome. The *insulae* were connected along their blocks with great, architecturally uniform, palace façades following a design solution that had never been seen before in the theory or building practice of any other contemporary city-capital. Along these lines, therefore, the characteristic town planning feature of the Savoy seventeenth and eighteenth centuries was, for Turin, a real project of productive, cultural and urban expansion, which left its mark not only on the creations, generally unfinished in the seventeenth century, but above all on a very strong ability for planning, as well as, obviously, on the underlying cultural model.

The process of building a capital did not touch only the city itself but the whole of its political, economic and symbolic sphere as well. In the seventeenth century, when the initial prerogative power of the prince was definitively organized into the methods of absolutism, art, science and culture were also used, from different cultural standpoints but toward one aim by Filippo d'Agliè and Emanuele Tesauro, to support the dynastic programme of the dukes (Griseri 1967; *Diana Trionfatrice* 1989). A precise effect of this political concept had already been visible during the latter half of the sixteenth century in town planning projects and the assertion of immediate spatial control of the surrounding territories with the building of the residences of *loisir*, or leisure. For these reasons the city and the external ducal residences, the *maisons de plaisance*, form an inseparable system, which is much more articulated and complex than the historical and material nature of the single elements alone. It must be considered a real system both in historical-critical analyses, and in restoration programs and in its value for today's cultural visitors.

An extremely clear dynastic and patrimonial program in site choice and land investment, different from father to son, together with choices in "taste" and different approaches to the concept of *loisir*, would lead to complete construction of the *corona di delitie*, or ring of ducal residences. Similarly, within the capital, the desire to diversify patrimony, together with changes toward architectural styles or formal choices, would guide the course of the formation and transformation of the architectural and town planning results. Gardens and parks had been an important aspect of the "leisure" residences. Different in size, layout and design, these gardens marked the passage from an initial conformity to models of the Italianate garden (Regio Parco, Mirafiori, Valentino), to the influence of Roman examples for the *vigne*, or country-house estates, on the hill of Turin (Cardinal Maurizio's Vigna and the Vigna of Madama Reale at San Vito) to comparison with French models (Venaria Reale). The building of Venaria Reale (from 1658) in fact marked, also in its great size, a passage in scale conforming to the examples that the great European capitals were in the process of creating according to the concept of the absolute state and to the new taste of the courts (Griseri 1988; Roggero Bardelli, Vinardi, Defabiani 1990).

The final decades of the seventeenth century opposed the *magnificenza* (magnificence) and *teatro della ragione* (theater of reason) with a new way of thinking interpreted by Guarino Guarini, which was capable of exploiting Turin's rigid urban layout inherited from Vitozzi and consolidated by the Castellamontes under discussion. With intuition and new architectural experimentation, Guarini inserted more independent, and thus highly effective, buildings into the characteristic Mannerist and Baroque features, which mirrored court ideology. After a period of French influence under the regency of Christine and Duke Carlo Emanuele II, Vittorio Amedeo II turned toward Rome, through the new trends in Viennese culture and that of the Central European courts. This was a political and operative choice, which opened to welcome new trends and features in the royal buildings, parks and "leisure" residences

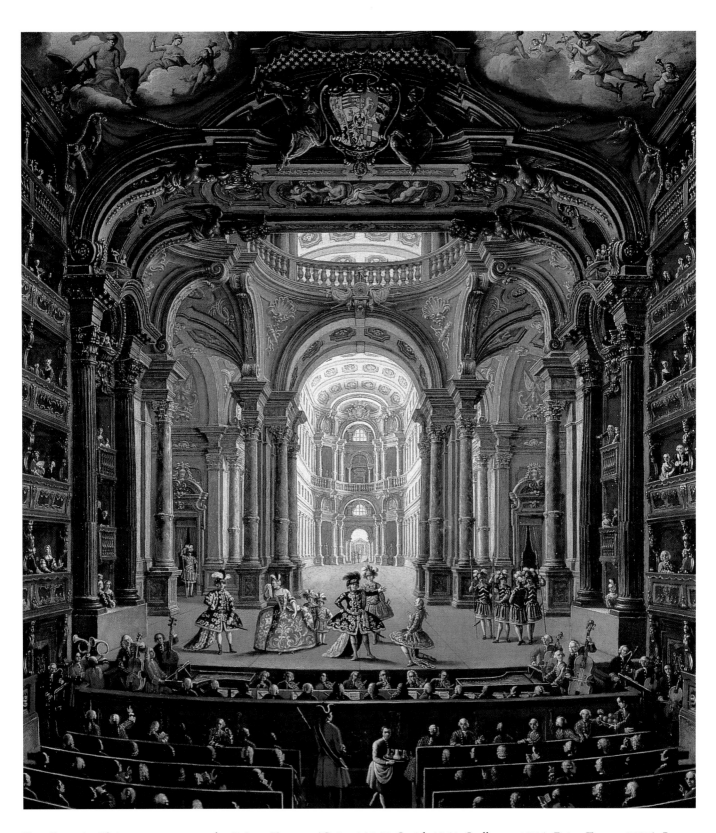

Pietro Domenico Oliviero
Interior of the Teatro Regio, Turin
Turin, Museo Civico di Arte Antica
Palazzo Madama
cat. 457

under Prince Eugene (Griseri 1967; Smith 1961; Sedlmayr 1976; *Prinz Eugen*: 1985). Juvarra would confront these new trends openly in the period after Utrecht.

In the new political and cultural climate of the early eighteenth century and within an enlarged and strengthened state with respect to the European political equilibrium, Juvarra set out a new code, which was explosive for its capacity to propose ideas. His sketchbooks of architecture, broadened to include a new skill in design control and representation of the

Filippo Juvarra
View of the central hall
of Rivoli Castle
Turin, Museo Civico di Arte Antica
Palazzo Madama
cat. 155

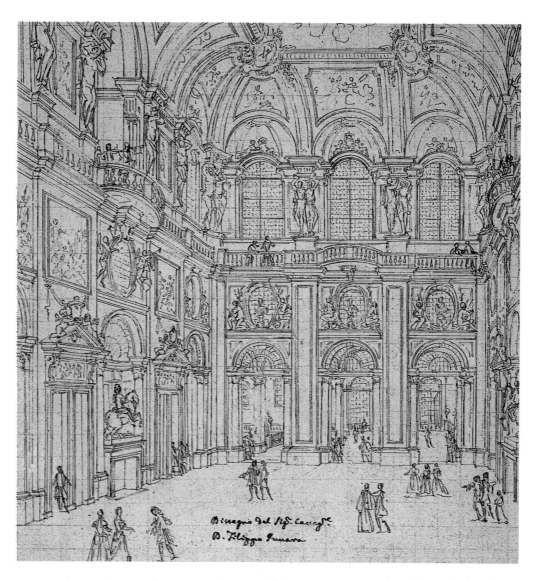

territory, bear witness to this. Long views, which are not only axes but also multifocal perspectives, mark Juvarra's new style from the villas in Lucca, Lisbon and Turin.

In Vittorio Amedeo II's new royal capital Juvarra succeeded in inserting himself into the already projected town plan of the city with great vigor, introducing new components. He effectively managed to interpret the new policy of Vittorio Amedeo II's kingdom. The king's long reign (1684–1730) was in fact marked by complex political events that transformed Piedmont from a dukedom into a kingdom. The person of the duke, then king, was important as a tireless promoter of works to be realized within the inherited architectural and town planning programs, which he then built. This phenomenon underlined in an exemplary way especially the period that coincided with the "multiplying" factor due to Filippo Juvarra being called to Piedmont with a decree of 14 December 1714 (*Filippo Juvarra 1678–1736* 1994; *Filippo Juvarra. Architetto delle Capitali* 1995; Comoli Mandracci, in *Filippo Juvarra* 1995). However, the period before Juvarra's arrival, between the Piedmontese and allied Austrian victory in the battle of Turin in 1706 and the definitive consolidation of the international diplomatic negotiations at the end of the war in Europe (1713–14), was also a decisive moment for new ideas and projects reflecting the new politics. Whereas Michelangelo Garove was the court architect in this first important phase, together with a large school of architects and military and civil engineers, Juvarra was certainly the symbolic reference of the age. He carried out a global program on a magnificent architectural level for the city-capital, which also interested certain residences outside the city, and the insertion of Rivoli, already rebuilt and redesigned by the Castellamontes and

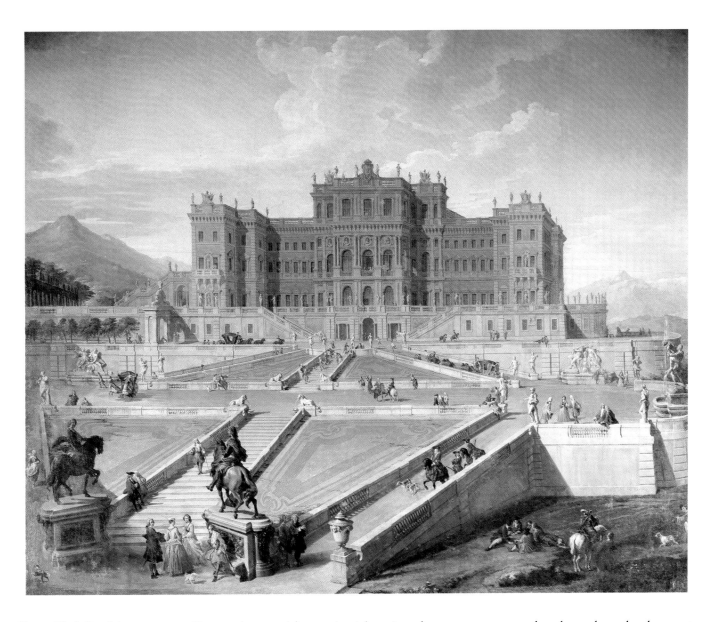

Giovanni Paolo Pannini
View of Rivoli Castle from the south
Turin, Castello di Racconigi
cat. 167

Garove, into a wider territorial project that was to connect the planned royal palace not only with the city-capital, but also visually with the Basilica di Superga along a perspective view of unheard-of length compared to the typical measurements of European Baroque. Vittorio Amedeo II had already decided after 1706 to situate his royal palace in Rivoli and had rapidly initiated construction of a great road (Michelangelo Garove 1711–12) to connect Turin directly with Rivoli (Comoli Mandracci 1983; Roggero Bardelli 1989). The new palace was to be an extremely majestic solution for the whole court, not merely a "leisure" residence for the king. Clear references to Versailles and Schönbrunn, and also to the more contemporary Belvedere of Prince Eugene in Vienna can be seen. The great tree-lined road was laid perfectly straight and flat and quite independent of all the agricultural properties it crossed. It led to Rivoli as a place representing power and the state, typical of eighteenth-century absolutism, and no longer to a place for leisure as the hunting palace of Venaria Reale had been earlier for Carlo Emanuele II.

Juvarra added a completely new territorial and symbolical component in the Rivoli-Turin-Superga relationship to this project, emphasizing the ideological relationship between the palace and the royal tombs at Superga with modern design elements made evident by a perspective of almost twenty kilometers (12 miles). The axis of this great road entered the capital through Porta Susina, skirted the center of government and proceeded ideally right up to Superga. The choice of position for Superga, therefore, appears far from the mere fulfil-

opposite
Interior of the dome
of the church San Bernardino
in Chieri, near Turin

ment of a religious vow and much more as a precise planning choice calculated to site the basilica at the point where the Rivoli-Turin axis meets the brow of the hill, thus creating a place which would be a long-term, visual reference point on a scale with the landscape. In this way Juvarra's selective scheme of a great, tree-lined axis converging on Rivoli was superimposed on to the single-centered plan of the seventeenth-century *maisons de plaisance*, which had defined the Castellamontes' *corona di delitie*. A second axis was to lead to Stupinigi, designing a road network of intersecting axes, which signified a truly territorial project indicating, also for the territory, the typological difference between the preceding period and Juvarra's.

Together with Rivoli, Stupinigi became a visible emblem of the state and court. Designed in a first moment as a princely hunting pavilion, this palace soon became a symbolic state building where hunting as a collective court ritual rather than just a special prerogative of the sovereign was celebrated. Stupinigi formally and ideologically completed the seventeenth-century *corona di delitie*. With new elements, which were more attentive to the agricultural countryside and built up environment, it marked out the territory with another long "allea" of trees "plantés en ligne droite" (avenue of trees planted in a straight line) complementary to the one leading to Rivoli.

The marvelous drawing by Juvarra, which virtually connects Vitozzi's pre-existing church of the Cappuccini (with its dome not yet enclosed by the drum) to the Basilica of Superga and an imaginary Rivoli castle, demonstrates his ability both to control the territory on a small scale, in the style of geographical maps, and his precise architectural renderings on a large scale of buildings either merely designed or actually built. This drawing demonstrates Juvarra's ability to clearly understand the sense of an idea, which was not only architectural or to do with town planning, but also political and symbolic on the highest level. The three buildings appear to float on a large expanse of rippling water, which recalls the misty haze of a hot Piedmontese summer. They are definitely not separate elements in any way but buildings connected to each other by a clear territorial project. This project is still visible today; as we drive along Corso Francia we can perceive the strong bipolar trajectory visibly linking Rivoli with Superga.

Turin set itself to be a concrete, and not just a formal, town planning model for seventeenth-century Europe, along with a handful of other royal residences (Richelieu, Nancy, Mannheim, Baden-Württemberg, Versailles, Ninphenourg). "*Klar und lichtvoll [...]*" 1990; Comoli Mandracci, Roggero Bardelli, Barghini, in "*Klar und lichtvoll*" 1990). At a very early date rules and norms had come into force which were only much later to become generalized throughout Europe; they were taken up in the mid-eighteenth century by Laugier, who paid particular attention to the ground rent and real feasibility of projects: "Tout ce qui donne sur la rue doit être déterminé et assujetti par autorité publique au dessein qu'on aura réglé pour la rue entière. Il faut non seulement fixer les endroits où il sera permis de bâtir, mais encore la manière dont on sera obligé de bâtir" (Everything that looks on to a street must, by law, be defined by and be in accordance with the project which shall be drawn up for the entire street. The places where building will be allowed must be established as will the way in which the buildings must be built, Laugier 1753–55; 1765). Turin had anticipated this model throughout the seventeenth century, offering its long, uniform palace fronts with their severe skylines to Europe as an example. Discussion and experiments in the city entailed the definition of more up-to-date and functional structures at the beginning of the eighteenth century. Later, alongside practical aspects, a new way of looking at "variety" was introduced, which in turn led beyond the idea of the city until then resolved very regularly. The single, hierarchical center that had been typical of absolute regimes in the preceding century and at the beginning of the eighteenth was abandoned in favor of a new, diffused centrality, which then became an important feature in town planning for the last part of the modern period. It answered different social and political requirements requested by the steadily diversifying social classes. Filippo Juvarra was the first, important interpreter of this new town planning principle and of the city's and the territory's new organization, which would become a decisive notion for the whole of eighteenth-century Europe (Comoli Mandracci 1989).

In this sense, Turin's seventeenth-century layout appeared extremely modern at the be-

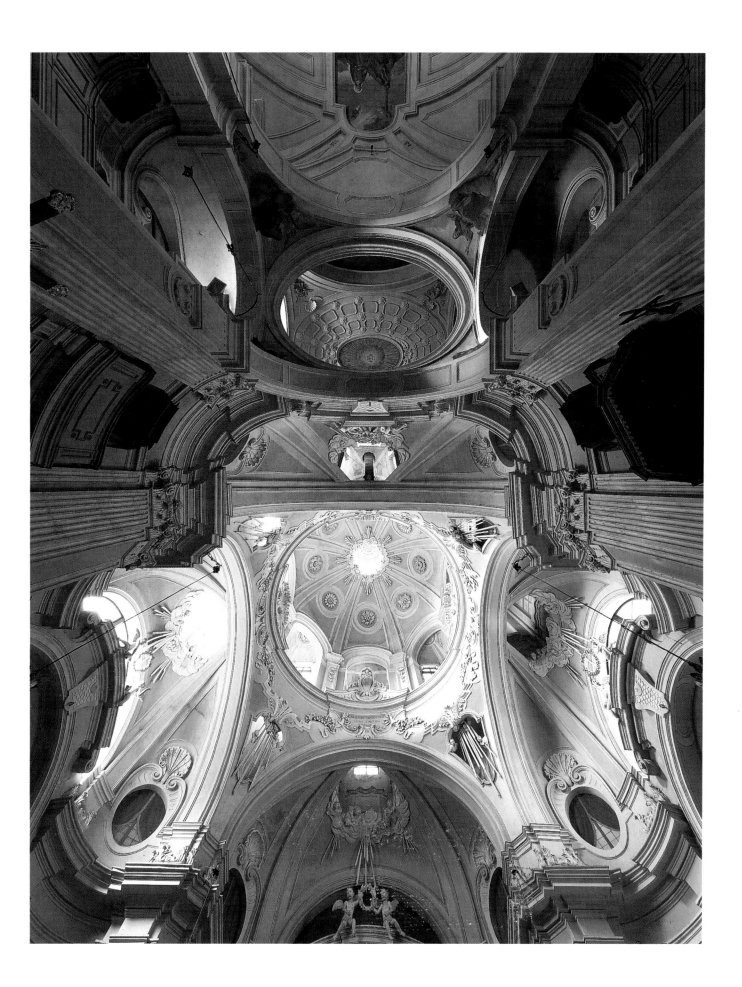

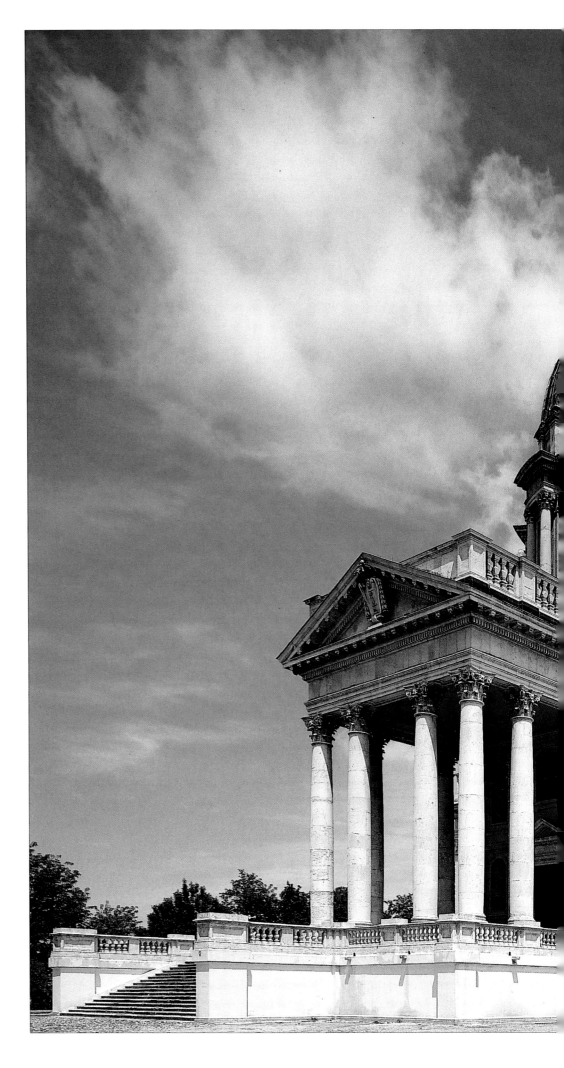

The Basilica of Superga
exterior

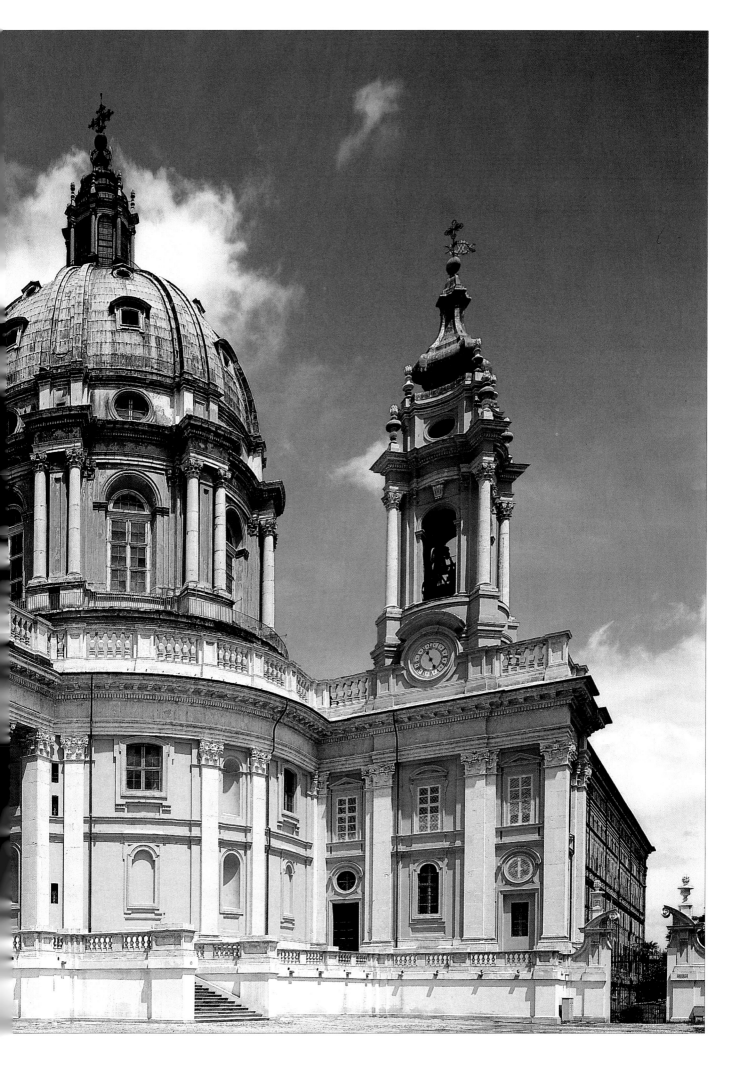

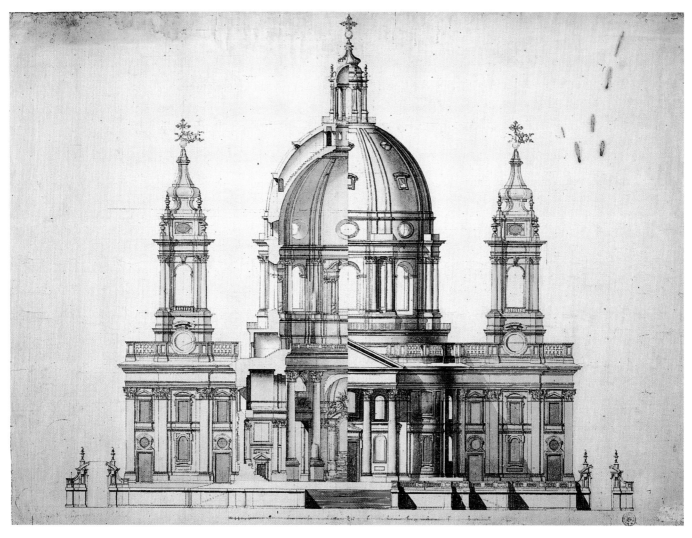

Pietro Giovanni Audifredi
Half-prospect and half-section
of the Basilica di Superga
Turin, Biblioteca Reale
cat. 544

ginning of the eighteenth century. It could be seen in the flesh, but also observed much better in the extremely clear, lucid plates depicting and anticipating it in the *Theatrum Sabaudiae* (1682). Although important culturally and structurally, Filippo Juvarra's urbanistic interventions convincingly fitted into that model. They understood the values and meanings (functional hierarchy; uniform, uninterrupted façades; pre-eminence of important governing road axes; scenographic feeling; regularity) in an innovative way and with innovative features that were always careful to intelligently add, and never subtract, quality and value.

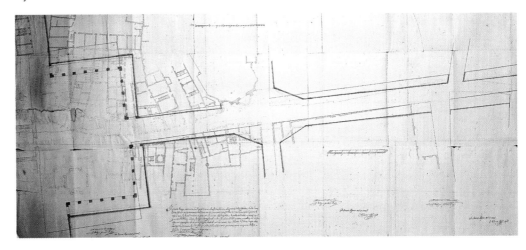

Executive project for the
reorientation of the gate and piazza
of Porta Palazzo and vicinity
and the Senate building, 1729
detail
Turin, Archivio di Stato

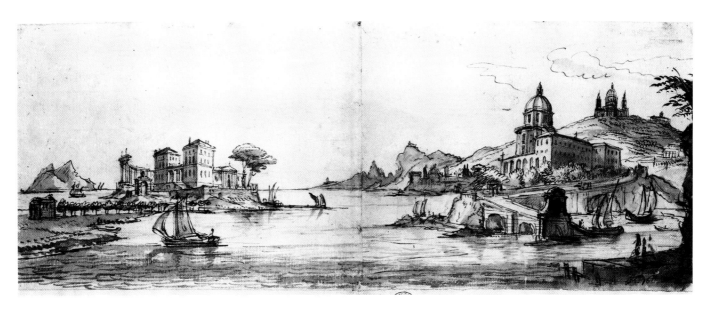

Filippo Juvarra
Symbolic representation of the Savoy
capital with the main landmarks
of Rivoli Castle, the Superga
and the Capuchin church
Turin
Biblioteca Nazionale Universitaria

For Turin, the existence of a single urban center was still, at the beginning of the eighteenth century, fully in accord with Vittorio Amedeo II's politics. However, the charismatic figure of the king was no longer the only reference; there was also the desire to express the sense and vigor of the state. Town planning and territorial planning, too, were abandoning French references and looking more to Vienna and England, with renewed interest in Rome, in a comparison which was, however, more European than Italian.

After the siege of 1706 and before Utrecht, the years around 1710 had already signaled a remarkable renewal in building activities and town planning projects: the canals and road network had been rebuilt, particularly in the western sector, which was being enlarged. By the end of 1712, therefore before Juvarra's arrival in Piedmont, the plan for the blocks in the new enclosure toward Porta Susina had already been defined, with estimates of the sites that could be built on. Realization of the third expansion of the city, with the design and building of the square at Porta Susina and the army barracks of San Celso and San Daniele by Juvarra, represented an exemplary phenomenon of the stratification of functions and concrete results, which testify to the great skill of this Messina-born architect in picking up and working on projects that had already been started, and in understanding their cultural legacy and intrinsic value. Juvarra worked on these previously defined schemes, developing the ideas in them and creating a new, square, military parade ground (Piazza Susina, now Piazza Savoia) on the axis of the Quartieri Militari (Military Zone). His plan for this, together with the architectural design of the Quartieri, decided the characteristics of the new eighteenth-century image of the city and opened the way for the process of urban restructuring in the old city during the eighteenth century.

The choices of planned rebuilding derived not only from the desire for rethinking an efficient town plan, but also from the need to improve the confused structure of the medieval city and connect the bastions of the fortifications, and especially the gateways, with the citadel, Palazzo Reale, the arsenal, and the military parade ground. All this was realized in perfect harmony with the functional principles correlating to the theoretical discussion about the city, but interpreted by Juvarra in a comprehensive and systematic idea about town planning, which went beyond the importance of each single architectural intervention and foreshadowed the contemporary era.

BIBLIOGRAPHY: Tonso 1596; Botero 1607 (1979: 33–47); Di Castellamonte 1674; Laugier 1753–55 and 1765; Correr 1858: 1–46; Smith 1961; Argan 1964; Griseri 1967; Sedlmayr 1976; Comoli Mandracci 1982: 257–80; 1983; *Prinz Eugen* 1985; Comoli Mandracci 1987: I, 59–189; *Figure del Barocco* 1988; Griseri 1988; Dardanello 1988: 163–252; *Diana Trionfatrice* 1989; *Filippo Juvarra a Torino* 1989; Comoli Mandracci 1989a: 53–74; 1989b: 304–11; Roggero Bardelli 1989: 75–130; "*Klar und lichtvoll*" 1990; Roggero Bardelli, Vinardi, Defabiani 1990; *Filippo Juvarra 1678–1736* 1994; Merlin, Rosso, Symcox, Ricuperati 1994; *Filippo Juvarra* 1995; Comoli Mandracci 1995: 42–67; *Dalla dominazione francese* 1998; Comoli Mandracci 1998: 355–86; Scotti Tosini 1998: 414–17.

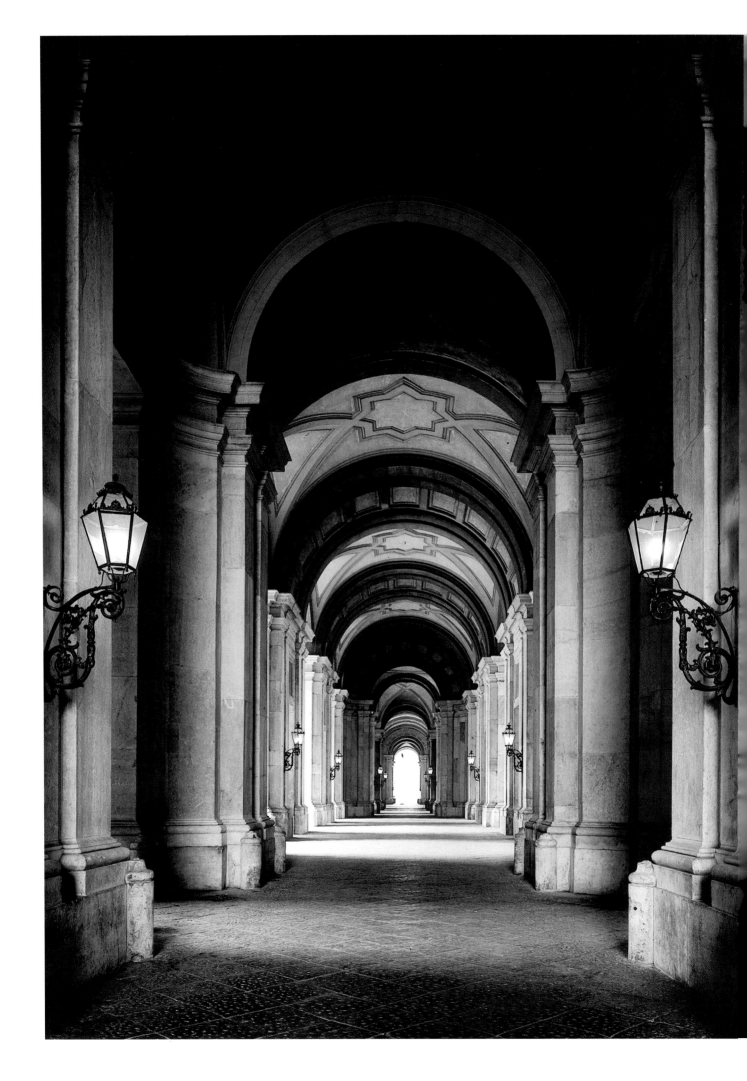

The Royal Palace of Caserta by Luigi Vanvitelli: the Genesis and Development of the Project

opposite
Perspective view of the so-called telescopic portico
of the Palazzo Reale (Royal Palace) of Caserta

Filippo Juvarra
Capanne
Rome, Teatro della Regina di Polonia
London, Victoria and Albert Museum

Filippo Juvarra
Temple
Scene 11 of *Ciro*
Teatro Ottoboni, Rome in 1712
Turin, Biblioteca Nazionale

[1] Cf. A. Schiavo, "Progetto di Mario Gioffredo per la Reggia di Caserta," in *Palladio*, II, 1952. G. De Nitto, *I Disegni di Mario Gioffredo per la Reggia di Caserta presso la Biblioteca Nazionale di Napoli*, Naples 1981. C. Robotti, I disegni di Mario Gioffredo architetto napoletano, in C.Robotti and F. Starace, *Il disegno di ar-*

In memory of Anthony Blunt and Rudolph Wittkower

When Charles III of Bourbon (1716–88) decided to build a great palace worthy of his reign, he turned in different directions, giving the project first to Mario Gioffredo,[1] a Neapolitan architect of solid repute, whose project, a fortress-palace of mammoth proportions measuring some five hundred meters per side, was eliminated when the idea of a royal residence set in a huge park and part of an articulated town plan came to prevail. Charles, the king of an independent monarchy since 1734, had originally also turned to Niccolò Salvi but the elderly architect had declined his offer. Only later did Charles accept the suggestion of Cardinal Gonzaga who, for diplomatic reasons, was striving to ease tensions between the Papal State and the Kingdom of Naples. The Cardinal suggested Luigi Vanvitelli (1700–73), a student of Salvi's and the most famous architect in Rome at that moment whose reputation was based on a number of works he had built in the Papal States and who was working at St. Peter's at the time.

In Luigi Vanvitelli, King Charles found an intelligent and talented architect capable of interpreting his wishes. Encomiastic tradition would have it that the king himself drew what he wanted: "With a compass and pencil in his hands, King Charles made the first sketches for the great palace, establishing a spatial center, which was to be at the foot of the Royal Staircase, from which four wide passages would extend to the four respective courtyards. He also designed the four towers, in order to make the Royal Palace more majestic, with a tribune towering in the middle, or rather a dome."[2] A scheme that may refer, as has been argued,[3] to the plan of the Buen Retiro in Madrid by Robert de Cotte, who had designed a palace with a square plan, corner towers, four courtyards, and a central octagonal vestibule placed at the intersection of the arms.

The extraordinary epistolary[4] between Vanvitelli and his brother, Don Urbano, a resident of Rome, is eloquent in regard to the role that the sovereigns had in the design and definition of the project. In addition, a memorandum exists in the architect's hand, *Idea del piano di una reggia residenza de' monarchi*,[5] which probably accompanied the preliminary drawings. Vanvitelli designed the project on a three-kilometer (1.8 mile) perspective axis which connected the tree-lined avenue that came from Naples, the axial gallery of the palace, and the central avenue of the park that led to the waterfall. The palace appeared in its entire grandeur like a perspective scene that separated and, at the same time, joined two enormous spaces, that of the city which was to arise around the palace and that of the park. Vanvitelli's method of composition, regardless of whether it had to do with natural or artificial space, was based on the experience he had gained from his father Gaspar's *vedute* which were of an extraordinarily analytical quality. The Enlightenment implicit in his architectural plan is the first genetic datum to be noted in Vanvitelli's project. The major façade of the palace, which extends in front of the wide avenue leading to the capital, is 253 meters (about 750 feet) long, 41 meters (120 feet) high with five storeys rising above the ground, and 202 meters (600 feet) long on the lateral fronts. Slight projections provide depth to the main front at the corners where towers were supposed to have been placed, and at the center with its huge balcony-niche which was destined for the public appearances of the king. The volumes are compact and regular, but the four courtyard-piazzas, connected to one another and the outside by secondary halls, and the orthogonal cross-arms are an original solution which opens the palace dramatically onto the external spaces. Because of the axiality of the three-naved covered passage, articulated by the alternation of pilasters with arches and architraved passages, the staircase hall is placed in a lateral position. The arrangement of piazzas and passages which are modulated like a telescope in the architectural framework has its complement in the slightly rusticated base that picks up the exterior motif, the design of the windows and the motif of the large niche in the corners of the courtyard-piazzas and in correspondence to the large central vestibule. On one side is the great staircase that leads to the *piano nobile* and from there to the entrance to the chapel and the state apartments. The modulation of the light, the richness of the decorative motifs, and the sensation of energy and elegance all confer a sumptuous regal dignity to the tripartite portico with its succession of three octagonal vestibules, and to the vertical sequence of the peristyle, upper vestibule, and crowning dome. Although the palace has a rectangular plan, many visitors qualify it as a square: the idea of a perfect form is obviously stronger than metric evidence. The dimensions are, however, such

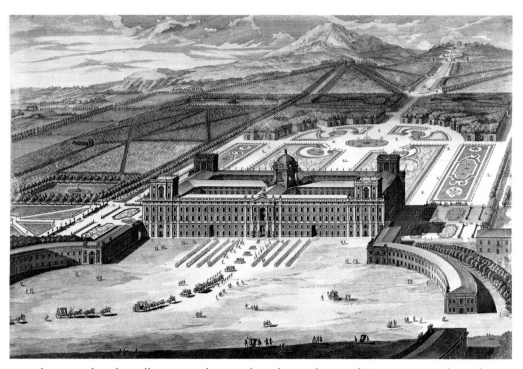

Luigi Vanvitelli
Bird's-eye view of the Royal Palace
of Caserta from the rear prospect
Engraving from the *Dichiarazione
dei disegni del Reale
palazzo di Caserta*
Caserta, Palazzo Reale

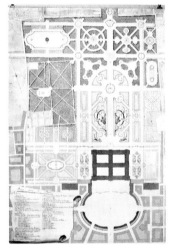

Luigi Vanvitelli
General plan of the Reggia
and the park at Caserta
Caserta, Palazzo Reale
cat. 178

*chitettura. L'antico, i giardini, il
paesaggio*, Lecce 1993: 35–59. J.
Garms, *Der neapolitanisches Ar-
chitect Mario Gioffredo (1718–
1785) zwischen Spätbarok und
Frühklassizismus*, in "An Archi-
tectural Progresss in the Renais-
sance and Baroque Sojourns In
and Out of Italy," edited by Hen-
ry A. Millon and S. Scott Mun-
shower, Paper in "*Art History
from Pennsylvania State Universi-
ty,*" VIII, 857–87.
[2] P. D'Onofri, *Elogio estempora-*

as to be considered totally new with regard to the tradition of European royal residences which had never before reached such a compact vastitude. But that was not the only thing that was new: in designing the palace, Vanvitelli had placed it within a town plan – howev- er, one that would be only partially implemented and at that over a long period of time – and with a great park behind it, impressive in the refinement and boldness of its composition. It was the queen herself who took an interest in this: "The Queen said to the King: 'When Van- vitelli has gone I want us to have a look, and we shall see everything on the spot.' The Queen told me even more; she wants me to make a design of the city of Caserta and its streets, so that whoever builds there will be well-directed so that his building will be neither too high nor too low, with everything in order. The King, on seeing the plan for the garden, which pleased him greatly, told me he had found a never-ending supply of water the size of a piaz- za" (22 May 1751). There was an explicit intention therefore to provide rules for the terri- tory so that everything would be built "in order."

The perimeter of the building encloses four large courtyards which the architect had wished to build in a non-uniform manner. "I repeated my intention to have the four courtyards dif- ferent from one another, offering as an example the excellent view which from one point would not only be new but magnificent, almost as if the four great buildings were combined, which with the great royal staircase would be a unique innovation of its kind, by means of the judicious project of His Majesty, whose lead I have always followed in this proceeding." The queen seemed willing to support this idea of his, but Charles, be it with tact, replied nega- tively: "No, I recognize the charm and fertility of your talent; however, it is my desire that the courtyards be similar to one another, for by the union of things and symmetry one enhances the other" (5 February 1752). Vanvitelli, on the other hand, in his discussions with the king, never seemed to be determined about defending his opinions. Indeed, he never defended them at all, choosing rather to comply to the will of the sovereign: "Majesty, this lesson that you have deigned to give me will be kept in my head and executed without alteration." It was a decisive step in understanding the king's culture, his rigidly classical conception of architec- ture where uniformity and symmetry were inviolable norms that were not to be infringed for any reason. Although Vanvitelli was unreservedly part of that order, his proposal was com- pletely original: the idea of combining four separate palaces into one royal residence with an octagonal peristyle and royal staircase at its central connection point was certainly suggestive and extraordinarily modern. What is more, it confirms my interpretation of Vanvitelli as an architect of "proto-eclectic" taste who, it seems to me, had moved the old *querelle* between the Baroque Vanvitelli and the Neoclassical Vanvitelli onto a more profitable terrain. The idea

Luigi Vanvitelli
Bird's-eye view of the Royal Palace
of Caserta and its grounds
Engraving from the *Dichiarazione
dei disegni del Reale
palazzo di Caserta*
Caserta, Palazzo Reale

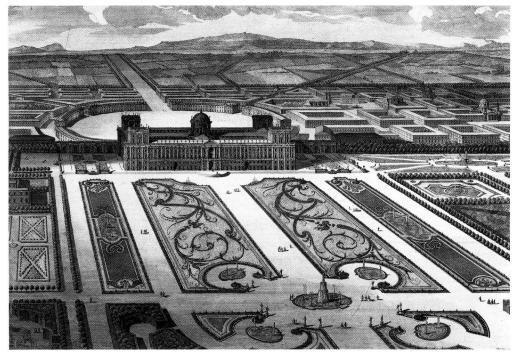

*neo per la gloriosa memoria di
Carlo III*, Naples 1789.
[3] Cf. M. Fagiolo dell'Arco, *Funzioni, simboli, valori della Reggia
di Caserta*, Rome 1963.
[4] Cf. F. Strazzullo, *Le lettere di
Luigi Vanvitelli della biblioteca
palatina di Caserta*, 3 vols., Galatina 1976. Constant reference will
be made to this precious repertoire with the dates of the letters
indicated between parentheses.
[5] Biblioteca Nazionale di Napoli,
Sec. Manuscripts, X A 8 bis. The
document is published in the
"Appendice documentaria" of
my recent *Luigi Vanvitelli*, edited
by V. Tempone and P.C. Verde,
Naples 1998: 305.

of making four different courtyards, which was so unusual and in many ways contradictory to his confirmed–classicism, was never realized at Caserta or anywhere else. It is an indication of how fervid Vanvitelli's talent was – although he was so bound to the Enlightenment tradition of his father's *vedute*, his school had been that of great Roman architecture. However, new compositional requirements seeking to surpass the constrictions of a certain formal conformism also stimulated him as is evidenced by the general plan of the palace.

Vanvitelli was a man who was exclusively and passionately dedicated to his work, but one lacking the fire and fury of a fighter: from his correspondence emerges the character of a man ready to mediate and compromise. His interlocutors were the sovereigns, the prime minister, Bernardo Tanucci, and the superintendent of the works, Cavalier Neroni. Luigi had a tenacious temperament, yet he harbored absolute respect for whatever authority there might be, a respect bordering on panic. His rivalry with Ferdinando Fuga was a recurring and almost obsessive topic in his letters. He feared suspicion, felt slandered, and was offended by the criticisms that were more or less covertly made about his works. However, all things considered, Luigi had much more luck with his hypochondriacal personality than Cavalier Bernini who arrived in Paris covered with glory only to find himself attacked head-on by the architect Charles Perrault, in spite of the fact that Louis XIV and Colbert himself had welcomed him like a prince. The Bourbon court gave Vanvitelli a welcome that was less ostentatious and pompous than that which accompanied the Paris sojourn of the architect of the piazza of St. Peter's. They appreciated his work and the king and queen backed him at all times, even when it was evident that the prime minister, Marchese Tanucci, was contrary for, as a good administrator of public works, he was constantly trying to stem the flow of money that was pouring into Caserta. Vanvitelli was protected as long as the "good king" was present. When the latter left for Madrid, the prime minister, who was also acting as regent, tightened the purse strings thus antagonizing Vanvitelli. In Luigi's eyes, Tanucci, because of his Florentine origins, tended to favor Fuga, who was an integral part of the "Tuscan party" which had always been hostile to him, starting with the leader of the group, Monsignor Giovanni Bottari who, according to Vanvitelli, had obstructed and openly criticized him at the Vatican during his restoration of Michelangelo's dome. The queen's support was also constant: from the very beginning Maria Amalia had encouraged him to do things in a big way and to design a real city around the palace. Indeed, after Maria Amalia had seen his preliminary drawings, Vanvitelli wrote: "When I design Caserta, I shall see to it to make piazzas, churches, monasteries and so on, but right now I cannot do so. The King, before leaving Caserta, ordered Cavalier Neroni to have estimates made of some lands that are includ-

Luigi Vanvitelli
Detail of the central cross section
of the Reggia
Engraving from the *Dichiarazione
dei disegni del Reale
palazzo di Caserta*
Caserta, Palazzo Reale
cat.181

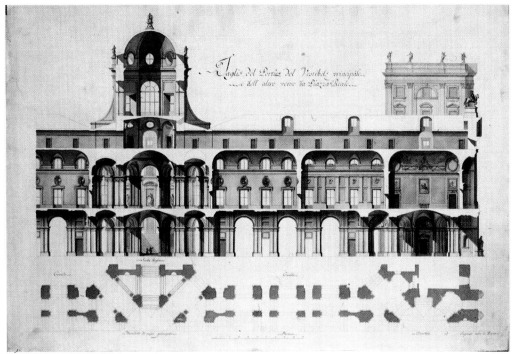

ed in the area of the garden and the piazza, and to offer the corresponding proprietors either other lands or payment in cash, but not to do violence to anyone" (1 June 1751).

Bernini's works often provided inspiration for Vanvitelli both for the project of the Foro Carolino and the façade of the palace at Caserta, especially in regard to the third and definitive project for the Louvre with the elliptical piazza opening in front of the palace. The scheme of the rusticated base and the architectural order arising from it, including the two storeys in which closely-spaced windows of equal size and importance are inserted, and the centrality of the entrance are all elements that derive from Bernini. These and others from the third project of the Louvre were variously "inserted, reused and recast," as Renato Bonelli[6] has pointed out, according to a practice or method typical of Vanvitelli. Many cases could be cited: I shall mention only his use of some decorative and syntactic elements rem-

Luigi Vanvitelli
Plan of the "piano nobile"
of the Royal Palace of Caserta
Engraving from the *Dichiarazione
dei disegni del Reale
palazzo di Caserta*
Caserta, Palazzo Reale
cat.179

[6] R. Bonelli, "Vanvitelli e la cultura europea: proposta per una lettura europeista della Reggia di Caserta," in *Luigi Vanvitelli e il '700 europeo*, Atti del congresso internazionale di studi, Naples 1979: I, 135–47; R. Bonelli, "Presentazione degli Atti del congresso internazionale di studi Luigi Vanvitelli e il '700 europeo," in *Restauro*, fasc. 50, (July-August 1980), 46–55.

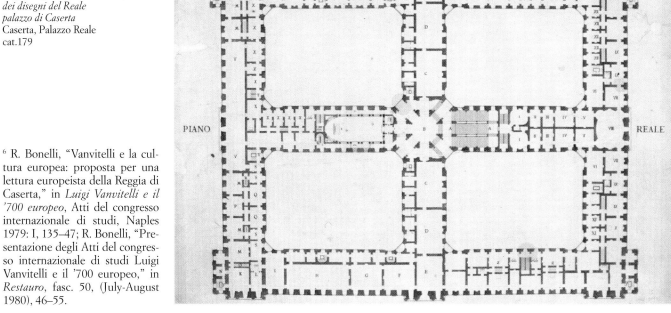

PIANO REALE

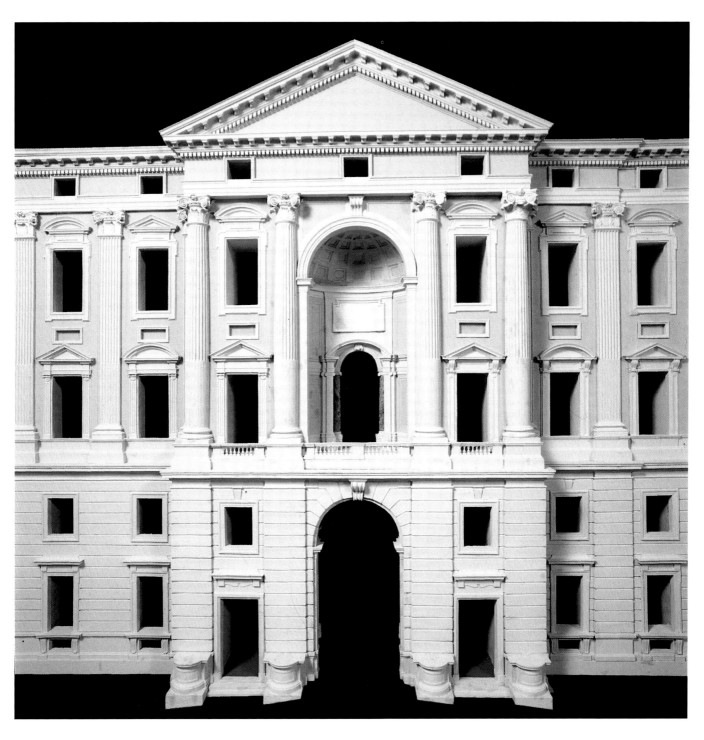

Antonio Rosz and assistants
Model of the façade
of the Royal Palace of Caserta
Central section
Caserta, Palazzo Reale
cat. 176

iniscent of Pietro da Cortona and Borromini, and the recurrence of typological solutions deriving from Baldassarre Longhena and Filippo Juvarra. The equivalence of the first and second floors, as developed in the façade of the palace, was undoubtedly in response to the growing requirements of a court that needed more than one *piano nobile*, traditional in royal residences between the sixteenth and seventeenth centuries. Bernini had anticipated this in his third project for the Louvre, in response both to functional reasons and to the architectural magniloquence of the *grand-gôut* imposed in France at the time of the Sun King.

The construction of the Royal Palace of Caserta represented the last of the ambitious undertakings of the absolute monarch, Charles of Bourbon, and Vanvitelli was able to interpret the royal intention of *magnificentia* in an excellent manner by conferring a stentorean monumentality to the project. The idea of the great central axis that crosses through the building

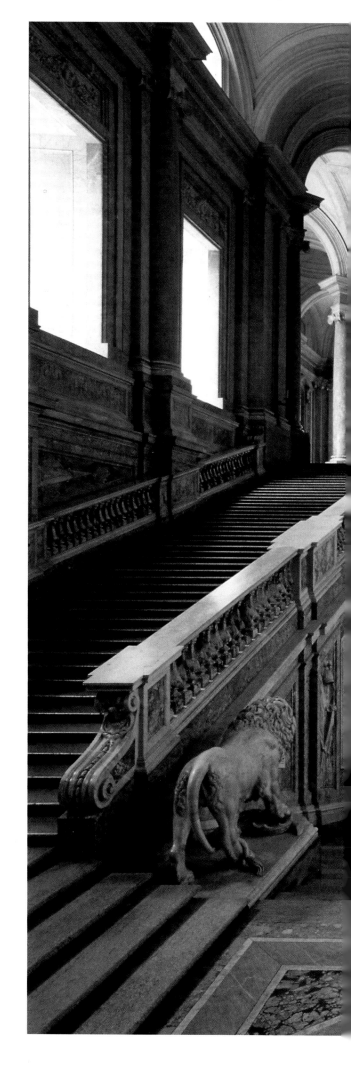

Monumental stairway
of the Royal Palace of Caserta

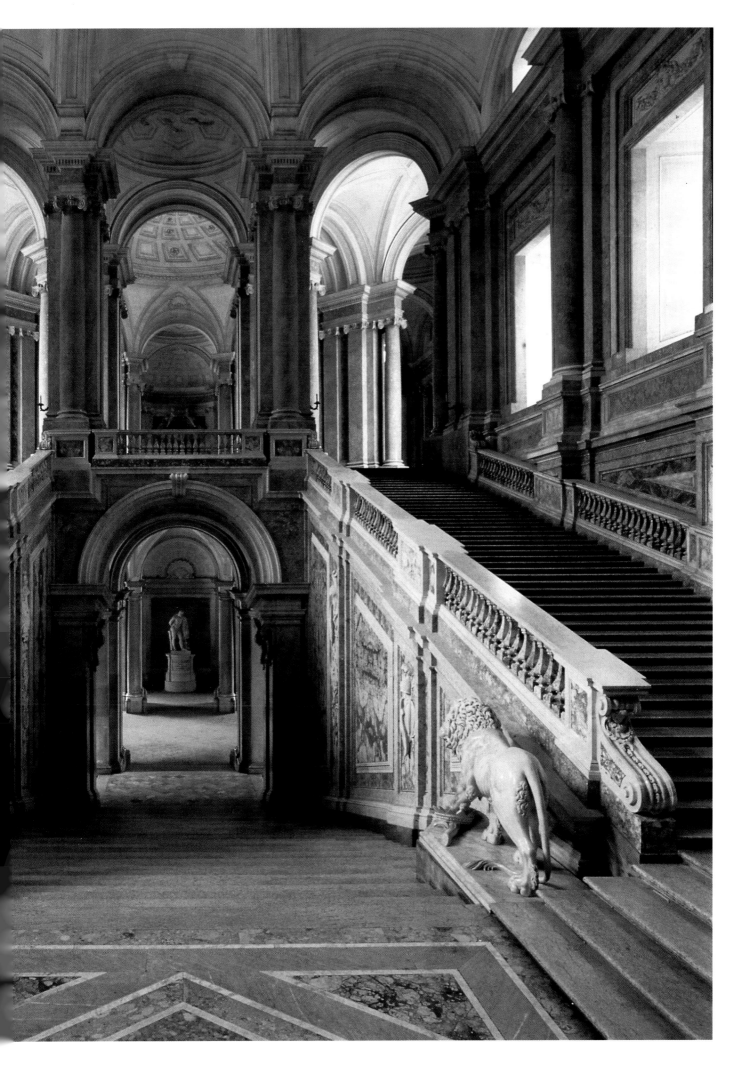

[7] Cf. J. Garms, *Der neapolitanisches Architect Mario Gioffredo*, op. cit.: 857–87.

[8] R. De Fusco has written convincingly regarding the reasons for this hostility, *Vanvitelli nella Storia e la critica del Settecento*, in Aa. Vv., *Luigi Vanvitelli*, Naples 1976: 30–31.

[9] The paper is listed with a new inv. no. 1681 (previously no. 316) in the general catalogue of the Reggia of Caserta fund whose papers have finally been restored. Cf. *L'esercizio del disegno. I Vanvitelli*, edited by C. Marinelli, Rome 1991: 120 no. 283. Cf. C. de Seta, "Disegni di Luigi Vanvitelli architetto e scenografo," in Aa. Vv., *Luigi Vanvitelli* Naples 1972: 296–98, nos. 109–112. I have covered the same theme more amply in "I disegni di Luigi Vanvitelli per la Reggia di Caserta e i progetti di Carlo Fontana per il Palazzo del Principe di Liechtenstein," in *Storia dell'Arte*, no. 22 (1974). The essay with some additions also appears in C. de Seta, *Architettura, ambiente e società a Napoli nel '700*, Turin 1981: 42–63. Cf. now for an updated file C. de Seta, *Luigi Vanvitelli*, op. cit.: 261–62 no. 202 a, b, c, d.

[10] I refer to the ground floor plan and to that of the *piano nobile* (corresponding to tables II and III in the *Dichiarazione*) with one inv. no. 374. The series of seven designs countersigned by letters a to g was restored together with the entire fund.

[11] Cf. M. Fagiolo Dell'Arco, *Funzioni, simboli, valori della Reggia di Caserta*, op. cit.: 24ff., cf. G. L. Hersey, "Carlo di Borbone a Napoli e Caserta," *in Storia dell'arte italiana*, III, V *Momenti di architettura*, Turin 1983: 213–64. The American scholar furnishes his initial interpretation in the light of the historical theories of Giovan Battista Vico: an original idea, certainly, but also a rather unconvincing one. Along this line by the same author: "Ovid, Vico and the Central Garden at Caserta," in *Journal of Garden History*, I, (1981); G.L. Hersey, *From Vico to Vanvitelli: Poetry and Number in the Royal Palace of Caserta*, Cambridge (Mass.) 1983. A. V. Trasancos, "Entorno a unos planos para el Palacio del Buen Retiro y su impacto en la Reggia de Caserta", in *Archivo Español de Arte*, nos. 233–36, tome LIX, (1986): 69–76.

from the entrance to the garden was not in itself a new typology, but when one takes into consideration the division of the floors and the infinite field of vision opening on and well beyond the park, it was absolutely new. A kind of covered way can indeed be found in Diocletian's Palace in Salona (Split), but Vanvitelli conferred a particular solemnity to his covered passage as well as the function of a telescope. The Great Portico, divided into three naves – the larger central one being destined for carriages, the side ones for pedestrians – is characterized by two entrance vestibules, and from the principal central vestibule branch four passages to the courtyards and the entrance to the royal staircase which, according to what Vanvitelli himself wrote in the *Idea*, had to be "comfortable, grandiose, luminous and without inconveniences." It was the undisputed geometric and ideal center of the entire building, the centripetal fulcrum on which the entire project was based. Evidence can be seen in one of the surviving preliminary sketches made by the architect. The outline of the palace is drawn in pencil, in some parts the lines are drawn with a ruler, and in the lower right corner, a wall projection extends beyond the façade in correspondence to the corner tower. There is no indication of a projection in correspondence to the principal entrance. The shape of the building is square as are the four inner courtyards, proof that Vanvitelli had been working on this idea from the very beginning. A square plan was also at the basis of the project of Mario Gioffredo,[7] one of the most intelligent and cultured of the Neapolitan architects for whom Vanvitelli had a declared aversion, calling him *"presuntuosissimo"* (extremely presumptuous).[8] In the above-mentioned drawing, the importance that the architect attached to this center is clearly evident by his use of ink, by the clearly defined octagonal vestibule, and also by the solution of the canted corners in the four courtyards. The octagonal vestibule, the royal staircase, and the landing with the ramps leading to the upper peristyle and the chapel entrance are all marked in ink. The sketch is significant in that it permits us to follow Vanvitelli's procedure in designing the project. He had already on other equally important occasions shown how he started off from elements that were graphically insignificant in scale and in the quality of his notes, but quite revealing in understanding how the definitive project developed from the original idea. This is true in the case of the much debated and controversial Palatine Chapel, the first miniscule sketch of which can be seen on a single surviving paper (*recto* and *verso*, inv. no. 316). The plan of the chapel has the colonnade of the gallery continuing behind the apse like Jules Hardouin Mansart's prototype for the chapel at Versailles. It was a typological scheme that Vanvitelli would modify by interrupting the gallery in correspondence to the apse. One tends to think that in this first sketch the architect was simply jotting down his idea, much like a memorandum, rather than making a sketch of the project itself. The chapel at Versailles was clearly a source of inspiration for the architecture of the Caserta chapel, yet Vanvitelli was irritated when accused of plagiarism, and not without reason as will be seen. On 21 February, 1761, two years after the departure of the monarch he called the Great King, who had left in his stead the *"re piccirillo"* (the child King), the future Ferdinand IV, and all the problems that the regency had brought to bear on the construction of Caserta, Vanvitelli gave vent to an outburst of pride and arrogance in his private correspondence. "It is necessary to know about everything, and I reply that only at Rome can good things be done, because everything must give way to a taste for the ornate; here it is not like that. My chapel at Caserta will certainly be its best piece and the one at Versailles is so bad, and entirely out of proportion, although full of gilded bronzes, which is absolutely a terrible thing, but it was not the chapel of Versailles that led me to put the surrounding loggia; it was the King's order, for he wanted the Court to be under his eyes when there was courting and hand-kissing. Therefore these gentlemen speak evil; what is more, I have reduced everything to good and comfortable architectural symmetry, and they may search for such comfort elsewhere." Vanvitelli was obviously referring to a certain hearsay that was irritating him and wanted to point it out. He referred to the king's will in the matter: that the solution of the loggia, a balustrade with the women's gallery, was in response to a specific order and a privileged functional necessity of the sovereign. Furthermore, the above-mentioned preliminary sketch of the plan proves he was right since the chapel is of the same width as the staircase. Nevertheless his defense was rather weak, given the similarity of the plans, and his judgment of Mansart petty, yet there was a reason for his irritation. Even if he had never visited Versailles and seen the French architect's work, Vanvitelli knew very

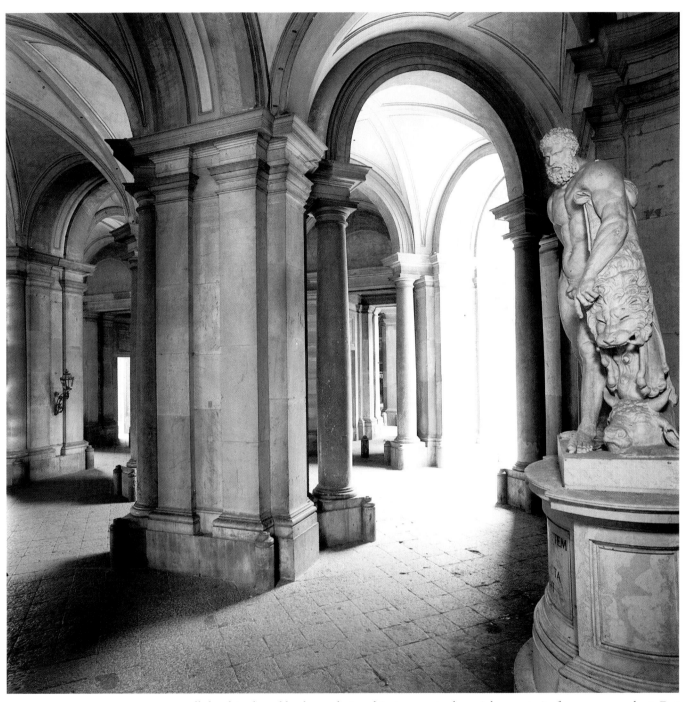

Caserta, Palazzo Reale (Royal Palace)
View of the vestibule
with the Roman statue of Hercules

well that his chapel had no relationship in an actual spatial sense to its famous precedent. But he was unable to express this concept, and thus persisted in denying that the plan of his chapel and its tectonic articulation had been inspired by Mansart's typology. It was not much of a reply, however it did not impair the absolute compositional and decorative autonomy of his chapel. His was airier, the orders majestically and elegantly articulated, and there was a serene luminosity in a space that had nothing in common with the Versailles chapel. A sense of pomp and ostentation and a desire for a scenographic effect – so evident in the vigorous contrast between light and shade in the heavy stereotyped decoration – characterized the latter chapel in a totally different way, yet one with extraordinarily effective results. A century separated the two chapels, a century in which a different sense of space, orders and decoration had matured in European architecture. The solution of the Caserta chapel with its Mediterranean luminosity and the serene rhythm of its architectural framework was totally incompatible with the architecture of the Parisian architect. A simple comparison of the two

chapels shows that their typological uniformity is in itself only a very vague reference to the qualification of a space; at times it can be deceiving to be taken in by "typologies" for they can lead to a misunderstanding of the most important quality of an architectural work.

In any case, there is no denying that the compositional layout of the park and the design of the gardens echoed the French model, which Luigi must have known well before 1760 when he came into possession of a volume illustrating both the Louvre and Versailles: "I have procured a book infolio in which are portrayed the Louvre and the Tuileries of Paris, Bernini's thoughts about the Louvre which were not carried out, the Palace of Versailles in all its parts. Oh God what a Rome this is!" he exclaimed. "It has cost me 23 ducats, they have sold it dearly; however, it has given me a consolation; at Versailles there is nothing, and there is little in the rest; Bernini's design has some beautiful things, but there are others that are not imitable; moreover, the composition is worthy of Bernini, although the French author criticizes it greatly, in order to praise the façade of the Louvre of Monsieur Perrault, I say what the Vitruvius I have has commented" (13 May 1760). He went on to criticize Perrault's famous colonnade severely, and was equally negative about the entire complex of Versailles, all the parts of which, he had learned, were about to be printed in a volume: "If it is printed, I have ordered it brought to me, and that will be enough of that beautiful stuff, since I know clearly that the French will never do anything good in architecture. My eyes having been poisoned by this lot, which I have seen up to now, they will never have the fine manner with these deformed examples" (20 May 1760).

The single aforementioned paper in the rich Palatine fund of Caserta corroborates the genesis of the project. It is certainly unusual that only four sketches exist on a paper (*recto* and *verso*)[9] for a building of such importance. Different conjectures can be made in this regard, however, there is no question that all of the designs for the palace have been lost given that the architect must have made hundreds of sketches for such an important and long-term construction. Although extremely synthetic, this single drawing is sufficiently rich in details and corresponds to a great extent with the later plan on large format designed by Vanvitelli[10] before 7 December, 1751, the day on which, according to the epistolary, the architect presented his project for the palace to the king and his royal consort.

This paper is decisive as far as the genesis of the project is concerned for two reasons. In the first place, it shows a distinct preliminary idea, one that would undergo numerous but not significant variations, except for that in which the layout was changed from a square (800 x 800 Neapolitan palms) to a rectangle (900 x 700 Neapolitan palms).[11] To continue therefore in or-

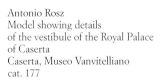

Antonio Rosz
Model showing details
of the vestibule of the Royal Palace
of Caserta
Caserta, Museo Vanvitelliano
cat. 177

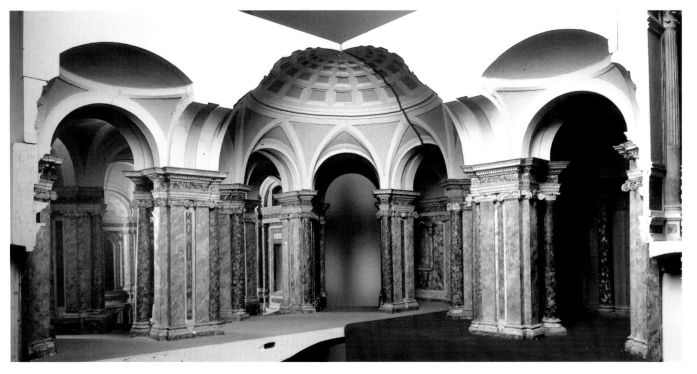

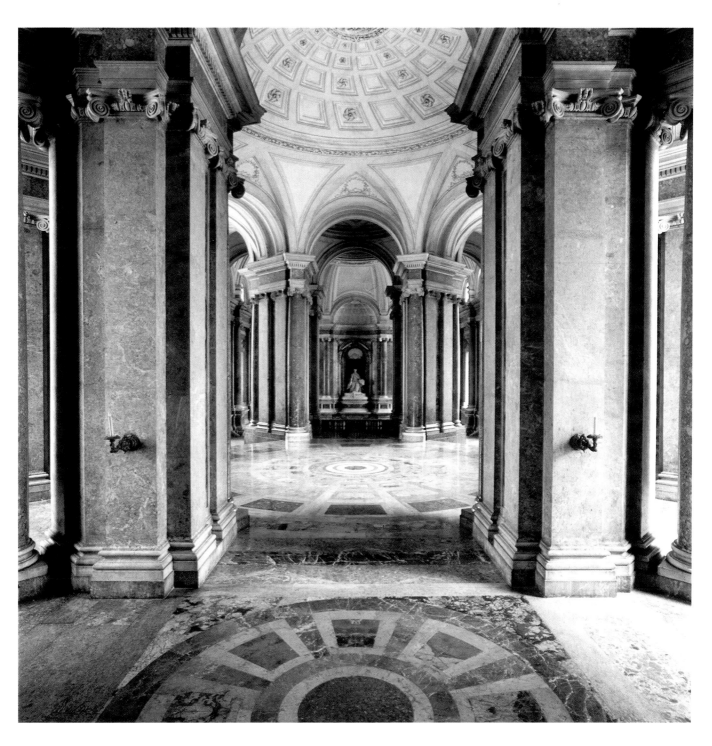

Caserta, Palazzo Reale
View of the upper vestibule
with the statue symbolizing
the sovereign

der: the central vestibule is well marked in the design; Vanvitelli's use of ink on this motif would seem to underline the importance he attached to it from the very beginning of his project as the core of the building, and it is clear that it was the departure point from which the complicated articulation of the construction radiated, and the entire project proceeded. In the sketch, moreover, the arms and wings of the construction have the same dimensions and correspond to the courtyards that are not as wide as the actual ones; but that relationship has nothing to do with the change from a square plan to a rectangular one. Indeed, on the corresponding table in the *Dichiarazione* (table II) the minor side of the courtyard measures 200 Neapolitan palms (the major side 300) and the arms 100 Neapolitan palms. In the drawing, the arms have the same dimensions, but the courtyard measures 250 Neapolitan palms.
At that preliminary stage, Vanvitelli felt he had to make the courtyards larger so as to offer to

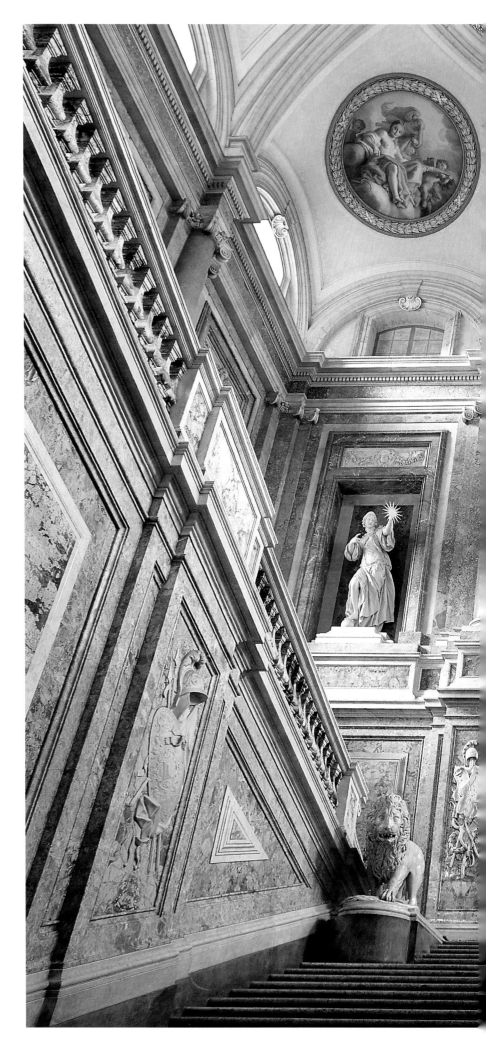

Caserta, Palazzo Reale
Perspective vista
of the ceremonial staircase

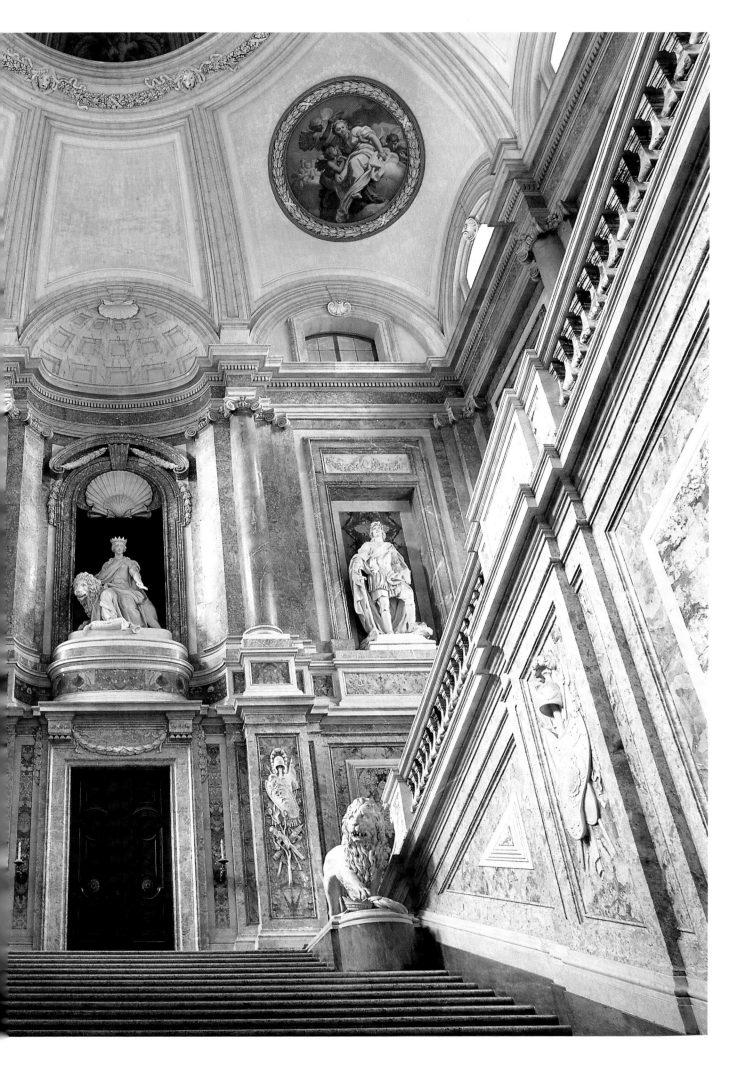

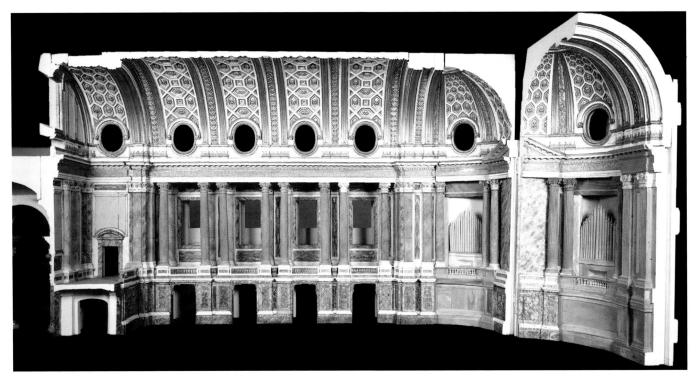

Model with detail
of the Cappella Reale (Royal Chapel)
of the Royal Palace of Caserta
Caserta, Museo Vanvitelliano
cat. 177

those who walked along the long vertical three-naved gallery a perfectly focused perspective of the interior façades and a perfect view of the great central dome that was never executed. It was a requirement that Vanvitelli would feel he should also exalt in the finished project since the longer side of the courtyards measured some 300 Neapolitan palms, and whoever crossed through the gallery and stopped to look at the courtyard had a perfect perspective of the opposite façade, while the adjacent floors of the courtyard were seen foreshortened through the lateral naves. Vanvitelli had calculated these effects with the expertise of one who had privileged the scenic apparatus as a space for experimentation for years, and numerous scenographic motifs were repeated in his stage-sets which assumed the solid complexity of constructed architecture at the Reggia of Caserta. The octagonal peristyle above was reached by the monumental staircase; however, although the space the latter occupied in the hall remained

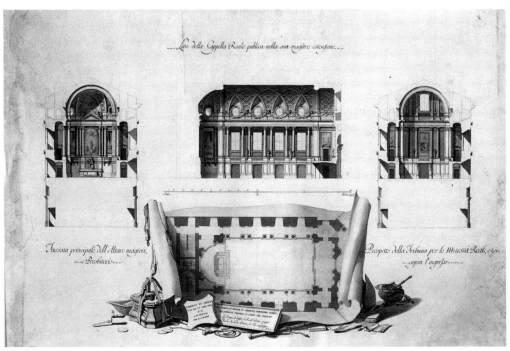

Luigi Vanvitelli
Section and plan of the Cappella
Palatina (Palatine Chapel)
Caserta, Palazzo Reale
cat. 182

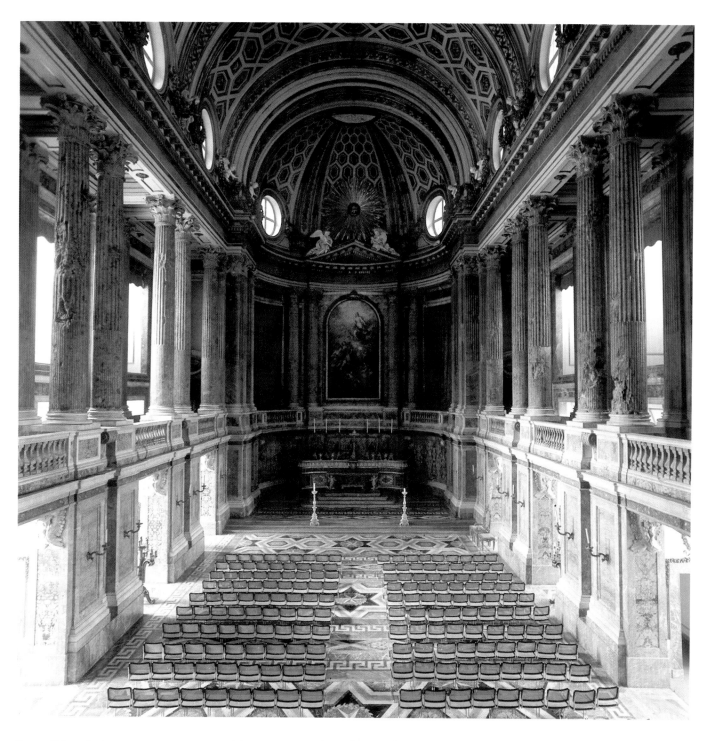

Caserta, Palazzo Reale
View of the Cappella Palatina

[12] Cf. *Dichiarazione dei disegni del reale palazzo di Caserta etc. alle Sacre Reali Maestà di Carlo Re delle Due Sicilie*, Naples 1756, table XI. Cf. the reprint which I edited, Milan 1998.
[13] In his letter of 21 February 1761, Vanvitelli wrote: "My chapel at Caserta will be its best piece and

unvaried (80 x 80 Neapolitan feet, excluding the external walls) in passing from the landing to the two flights leading to the *piano nobile*, the two pairs of four steps of the final project are not indicated. This was a solution that invited guests to linger in front of the allegorical statues in the three niches, His Royal Highness in the center and on either side "*li simulacri*" ("the images") of Truth and Merit, as can be read in the caption on the corresponding engraving.[12]

On the *piano nobile* the square hall (more or less the same size as the staircase hall) can be interpreted as either a wide narthex, anomalous though that may be, leading to the chapel or as the actual chapel itself, which would have therefore had a square plan with the altar in the rear and a series of chapels or small aisled on the two sides. This second hypothesis was upheld by Vanvitelli in his epistolary when he mentioned the sovereign's specification that he use Versailles as a model.[13]

Caserta, Palazzo Reale
View of the ambulacrum
in the English garden

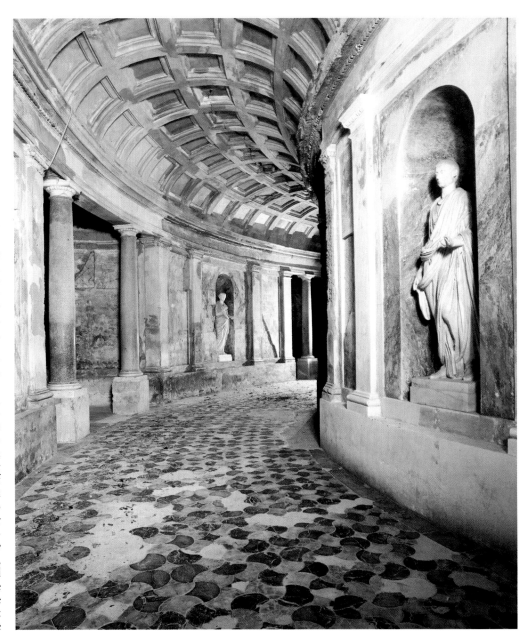

the one at Versailles is so bad and entirely out of proportion, although full of gilded bronzes, which is absolutely a terrible thing, but it was not the chapel of Versailles that led me to put the surrounding gallery; it was the king's order, for he wanted the court to be under his eyes when there was courting and hand-kissing. These gentlemen, therefore, speak evil; reducing much or everything to good and comfortable architectural symmetry, and they search for such comfort elsewhere." (Strazzullo, *Le lettere di Luigi Vanvitelli*, op. cit.: II, 667).

[14] R. Wittkower, *Art and Architecture in Italy: 1600 to 1750*, Harmondsworth 1958.

[15] In his letter of 29 January, 1752, Vanvitelli wrote to his brother Urbano. "The book of architecture by P. Guarino, which is in large folio, covered with sheepskin with a red label, you will wrap it in paper and have it placed in the bottom of the trunk of Michel'Angelo Colata with the following written on top of it: to His Excellency Signor Conte Gazzola. Artillery Commander – Naples" (Strazzullo, *Le lettere di Luigi Vanvitelli*, op. cit.: I, 101). Vanvitelli most likely owned the 1737 second edition of the work by the Theatine since the 1686 first edition was already at that time extremely rare (cf. D. De Bernardi Ferrero, *I "disegni d'architettura civile et ecclesiastica" di Guarino Guarini e l'arte del maestro*, Turin 1956: 7–8).

[16] Cf. M. Rosci, *Filippo Juvarra e il nuovo gusto classico*, in Atti dell'VIII Convegno nazionale di Storia dell'Architettura, Rome 1956: 239-57, in particular 241, figs. 1 and 2. I should like to point out that while the first drawing published by Rosci refers to Vanvitelli's sketch, the other one (fig. 2), which clearly refers to the studies for Stupinigi (cf. N. Carboneri, "Architettura", in *Mostra del barocco piemontese*, catalogue edited by V. Viale, Turin 1963: tome I, 51, no. 109 and table 110), in my opinion, has no direct connection with the Caserta sketch.

Another detail in the plan that should not be ignored is the canting of the four corners in order to satisfy a specific functional and structural need imposed by the octagonal peristyle and the tripartite gallery. There are many explanations regarding the origin of this solution, and it is worth recalling them while underlining the fact, and the drawing is emphatic proof of this, that it is the octagonal vestibule itself that conditions the complex articulation created between the center of the building, the gallery and the courtyards. That Vanvitelli had in some way assimilated Longhena's lesson seems to me to be well-founded both in regard to the octagon of the vestibule and the royal staircase "which ultimately points back to Longhena's scenographic staircase in San Giorgio Maggiore"[14] of which there are splendid paintings by his father Gaspar. Naturally, that does not detract from the autonomy of Vanvitelli's solutions which maintain an unequivocal and original constructive and spatial identity of their own. In connection with Longhena, the hexagonal plan of the church of the Somaschi Fathers in Messina comes to mind which Vanvitelli certainly must have known about since he had a copy of *L'architettura civile* by Guarino Guarini[15] in his private library. Similarly, Rosci's idea of comparing some of Juvarra's sketches with Vanvitelli's also merits attention.[16] Some of those studies by the Messina architect, which are reminiscent of similar studies by Serlio,[17] refer to a residential building typology with four arms that emerge in an axis with the diagonals in an octagonal plan that

Caserta, Palazzo Reale
Fake ruins in the ambulacrum
of the English garden

following pages
Caserta, the park of the Reggia
The Fountain of Venus and Adonis

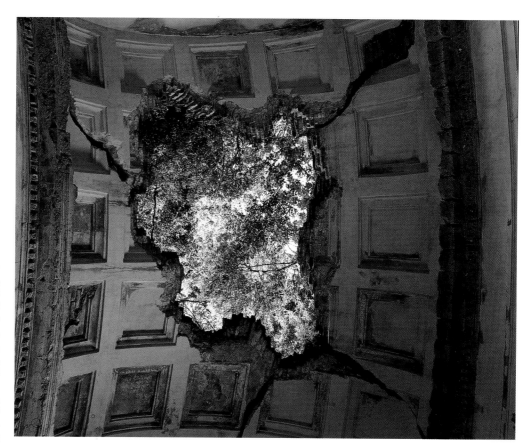

[17] Cf. M. Rosci, *Il trattato di architettura di Sebastiano Serlio*, Milan 1966: 33. And now, M. Van Rosenfeld, *Sebastiano Serlio on Domestic Architecture*, preface by A. K. Placzek, introduction by J. Ackerman, Cambridge (Mass.), London 1978. Cf. S. Frommel, *Sebastiano Serlio*, Milan 1998: *passim*.
[18] S. Boscarini, *Juvarra architetto*, Rome 1973: 35 and tables 349 and 350. Fundamental for Juvarra is the *Mostra di Filippo Juvarra architetto e scenografo*, exhibition catalogue edited by V. Viale with essays by F. Basile and M. Viale Ferrero, Messina, October 1966.
[19] Wittkower, in referring to the prototype of the Santa Maria della Salute, had written: "The salient feature of the plan is a regular octagon surrounded by an ambulatory. This seems to be unique in Renaissance and post-Renaissance architecture, but the type is of Late Antique ancestry (Santa Costanza, Rome) and is common in medieval, particularly Byzantine, buildings (San Vitale, Ravenna)" (Wittkower, *Art and Architecture*, op. cit.: 246).
[20] Wittkower, *Art and Architecture*, op. cit.: 249.
[21] Boscarino, *Juvarra architetto*, op. cit.: 133–37; see also his typological sketches: tables XII and XIII and the corresponding drawings, tables 73–74.
[22] I refer to the designs in the Biblioteca Nazionale di Torino (Riserva 59.5 nos. 9 and 10) already cited by H. Hager, *Filippo Juvarra e il concorso di modelli bandito da Clemente XI per la nuova Sacrestia di San Pietro*, Rome 1970: 76, note 19.
[23] Boscarino, *Juvarra architetto*, op. cit., 239, as well as note 26.

Longhena would later adopt for the Villa Contarini at Mira.[18] The return to an archetype typical of Longhena is further confirmation of Wittkower's interpretation.[19]

Well before influencing Juvarra and Vanvitelli, the model of Santa Maria della Salute had left its mark on the Jesuit Sanctuary that Carlo Fontana had built in Loyola, Spain, which "could not have been designed without the model of Santa Maria della Salute. Thus a Late Antique plan, common in Byzantine architecture, and revised in seventeenth-century Venice, was taken up by a Roman architect and transplanted to Spain."[20] Fontana's passage was of considerable importance because it was through the Roman architect that Juvarra and probably Vanvitelli himself assimilated the Venetian model. As for Juvarra's sketches, their antecedent is to be found in the plan for the chapel he presented in 1707 on the occasion of his appointment to the Academy of San Luca: a scheme that the architect from Messina adopted that very same year for the palace with eight courtyards that he designed for the Prince Landgrave of Hesse-Kassel.[21] But much more immediate is the reference which has been ignored until now to a project of his for the competition for the new sacristy of St. Peter's promoted by Clement XI in 1715.[22] It had an octagonal plan as did Vanvitelli's project, and both architects came up with almost identical solutions. There is no doubt that Vanvitelli knew Juvarra's project well, given his familiarity with the difficulties involved in the building of St. Peter's. Furthermore, the similarities between the two are so close as to exclude their being the result of mere coincidence. The details of the structural solution are, however, different: Juvarra placed a group of three columns flanking one another in correspondence to the intersection of the square hall and the triangular segment while Vanvitelli resolved that static knot with a triangular pilaster with a column on top that projected over the vestibule. He placed a corresponding column on the other side of the triangular pilaster so as to underline the square space of the ambulatory. It was a solution that offered proof of a coherent constructive capability and know-how on his part in dosing the visual and lighting effects according to whether the visitor was approaching from the central gallery or one of the lateral aisles. Lastly, and it has already been noted[23] in reference to the square plan of Vanvitelli's project, it is important to remember the design – but only the design – of his first solution for the palace of the Conclave adjacent to the basilica of St. John in Lateran, which

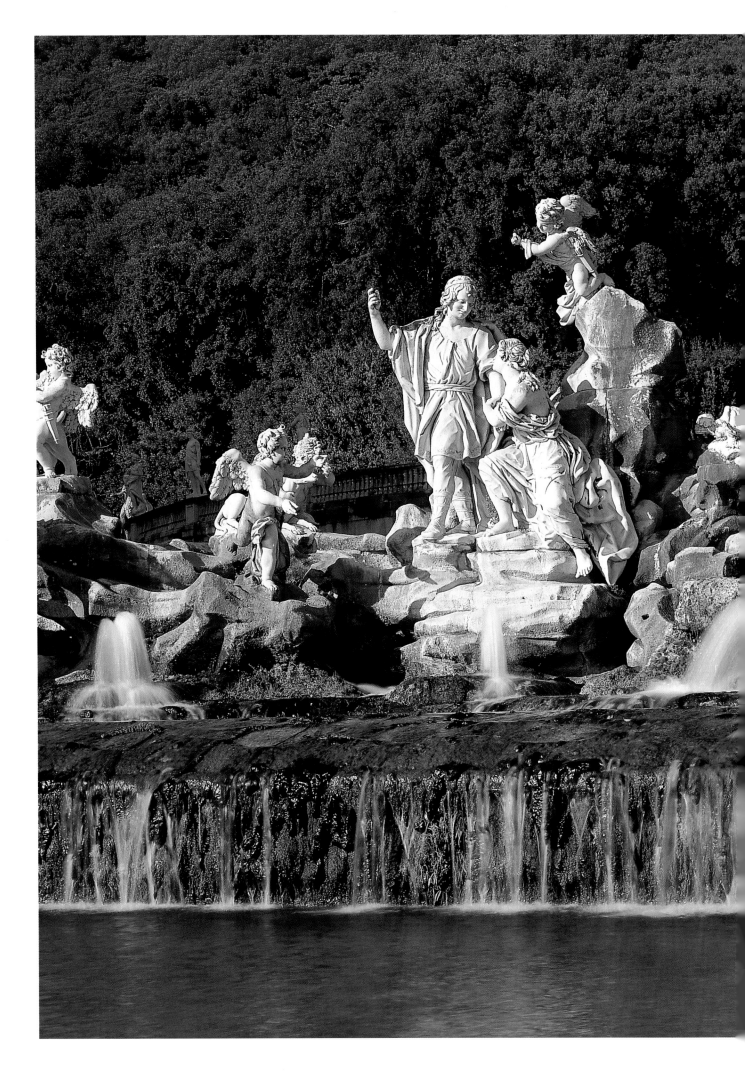

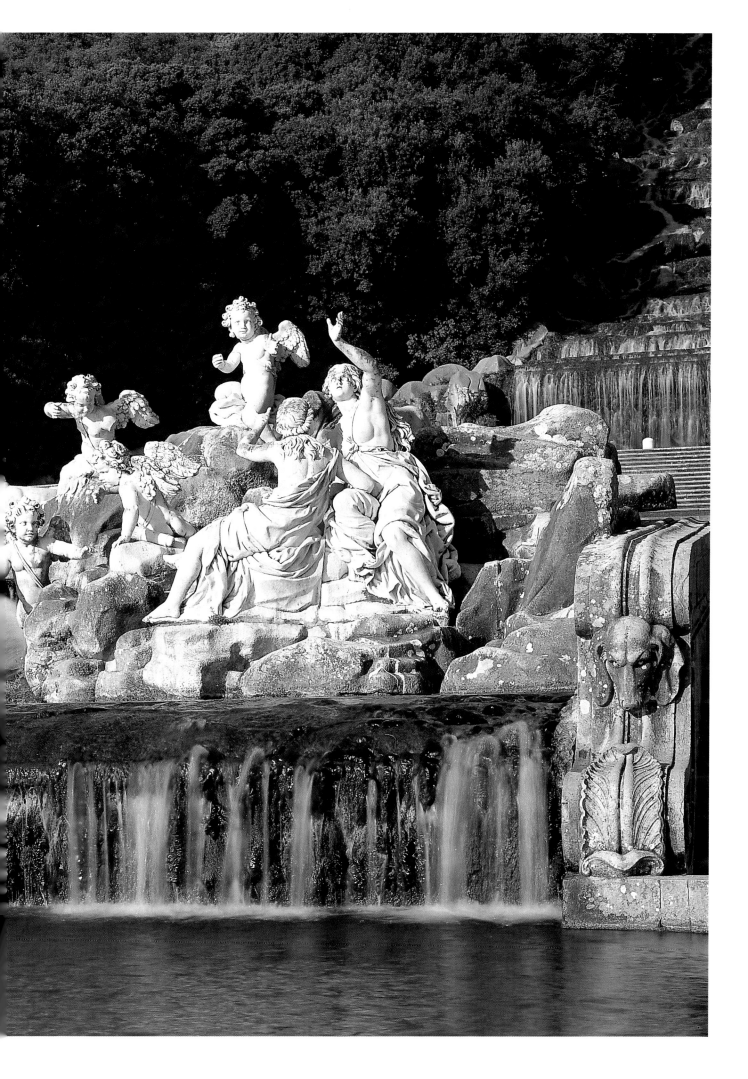

Antonio Rosz
Model of the Chinese Tower
Caserta, Museo Vanvitelliano
cat. 226

[24] Cf. R. Pane, "L'attività di Luigi Vanvitelli fuori dal Regno delle Due Sicilie", in AA. VV., *Luigi Vanvitelli*: 45. For an updated reading cf. D. Stroffolino, "L'opera di Vanvitelli a Napoli: opere pubbliche, restauri, chiese e residenze signorili," in C. de Seta, *Luigi Vanvitelli*, op. cit.: 117–56.
[25] Cf. Lione Pascoli, "Primi cenni biografici su Luigi Vanvitelli" (1738), republished in the Appendix to my *Luigi Vanvitelli*, op. cit.: 306.
[26] With regard to Juvarra's work, the catalogs are now available of three important exhibitions held in Madrid, Turin and Naples with updated entries of the drawings I have mentioned: *Filippo Juvarra 1678-1736. De Mesina al Palacio Real de Madrid*, Madrid 1994; *Filippo Juvarra architetto delle capitali da Torino a Madrid, 1714– 1736*, edited by V. Comoli Mandracci and A. Griseri, Milan 1995; and lastly, *Filippo Juvarra e l'architettura europea*, by A. Bonnet Correa, C. Blasco Esquivias and G. Cantone, Naples 1998.
[27] Cf. Wittkower, *Art and Architecture*, op. cit.: 321–25; R. Pommer, *Eighteenth Century Architecture*, London 1967: 2ff.; A. Griseri, *Le metamorfosi del Barocco*, Turin 1967: 228–30, 287–89, 310.
[28] Fontana's drawings, moreover, were a constant reference during the apprenticeships of the second generation architects: Pommer himself, *Eighteenth Century*, op. cit.: 122, indicates that Vittone studied them attentively; and it is also mentioned by F. Borsi, *Montecitorio ricerche di storia urbana*, Rome 1972: 25. The volume is by F. Borsi, M. Del Piazzo, E. Sparisci, E. Vitale.
[29] J. Fleming, *Robert Adam and His Circle*, London 1962: 296– 297; J. Fleming, "Cardinal Albani's Drawings at Windsor, their purchase by James Adam for George III," in *Connoisseur*, 142 (1958): 164–69, and by the same, "Mssrs. Robert and James Adam: Art Dealers" (I), *Connoisseur* 144 (1959): 168–71.
[30] Cf. A. E. Popham, "The Roy-

was dated 1725 and commissioned by Pope Benedict XIII on the recommendation of Cardinal Albani. Vanvitelli was known to be active in the latter's circle, and in a few years' time (1729) would receive his first commissions for the partial rebuilding of Palazzo Albani in Urbino.[24] The relations between Juvarra and Gaspar Van Wittel[25] were well known and documented, and it is more than likely that the young Luigi was very familiar with the by then famous architect's projects which had aroused great interest.[26]

During his Roman apprenticeship, Juvarra had in his way assimilated the modules of the academic Baroque from his master Carlo Fontana[27] but with an impartial originality. Vanvitelli's formation was in many ways similar to that of the Messina architect: partly because only a generation separated the two men, and partly because he too had been profoundly influenced by Borromini's work and Carlo Fontana's lesson. He was acquainted not only with the latter's Roman works but also, as I believe I have pointed out, with the wealth of drawings that at the time of Fontana's death had passed into the collection of Cardinal Albani. It is quite likely that Annibale Albani[28] had shown Carlo Fontana's volumes of drawings to the young Roman architect. As a matter of fact, it was not until the middle of the eighteenth century (1752) that the twenty-seven volumes were purchased by Robert and James Adam[29] for the collection of King George III of England, and later acquired by the Royal Library of Windsor Castle.[30] But some of Fontana's projects, today at Windsor, are fundamental in order to fully understand the formative genesis of Vanvitelli's greatest work and not only that one.[31] Volume no. 174 of the Royal Library collection contains projects that Carlo Fontana had elaborated for the residence of the prince of Liechtenstein in Vienna. Having already made this analytical comparative study elsewhere, I shall take the liberty of referring to what I have already written.[32]

In addition to his drawings, an integral part of Vanvitelli's meticulous work was comprised of the wooden models and their designs, which had been made in order to give the royal sovereigns of Naples a concrete image of the essential parts of the palace that was to be built at Caserta. The models that the architect had had made as soon as the building of that complex was underway still exist today. Vanvitelli, who was almost in daily contact with Charles of Bourbon and Maria Amalia, was in fact aware that in order to communicate the architecture to those who had commissioned it, a model would have a "much better effect than a drawing," no matter how accurately the latter had been executed, as he wrote to his brother Urbano. He had most certainly been trained to use models when he first started to work as a scene-designer, and indeed these constitute important evidence of his major work. They made it possible to verify the architect's intentions as the work proceeded and are an essential source of references and comparison with the table engravings of the *Dichiarazione* and the project drawings.

Never before has such a complete itinerary been available: from the seminal idea to the final approved project, and subsequently to the execution of the watercolor, the engravings for the tables of the *Dichiarazione*, the wooden models, and lastly, the architect's own words. As far as I know, there are only a few cases of works of such import that have been so completely documented. When the author's own testimony from his epistolary is added to this, one then has a detailed and complete picture of the enterprise from start to finish. Vanvitelli used the models as propaganda for his ideas in order to increase the monarchs' interest in the palace and consequently to accelerate the allocation of the necessary funds and the rhythm of the works in construction.[33]

The palace of Caserta has its typological antecedents, and I myself have endeavored to seek them out. Reference has already been made to the amplification of the palace of Buen Retiro in Madrid (1712–15) by Robert de Cotte for Philip V. In addition to the typological similarities of the two buildings, I believe that the fact that the young future sovereign was acquainted with the architecture of that palace should also be taken into consideration when assessing the importance of this theory. In any case, much more is known today about Luigi's relationship with Charles and Amalia, and how influential their opinions were during the period the project was being designed. Charles's ideas about architecture were certainly not superficial, indeed in some cases his suggestions or "orders," as the architect chose to call them, proved to be consequential to the plan. But in the light of the epistolary, the question comes to mind whether Vanvitelli would have hidden from his beloved brother, or even neglected to mention to him, the fact that an important issue had ever been the cause of discussion. For those who have read the epistolary, this conjecture is hard to believe. Luigi was

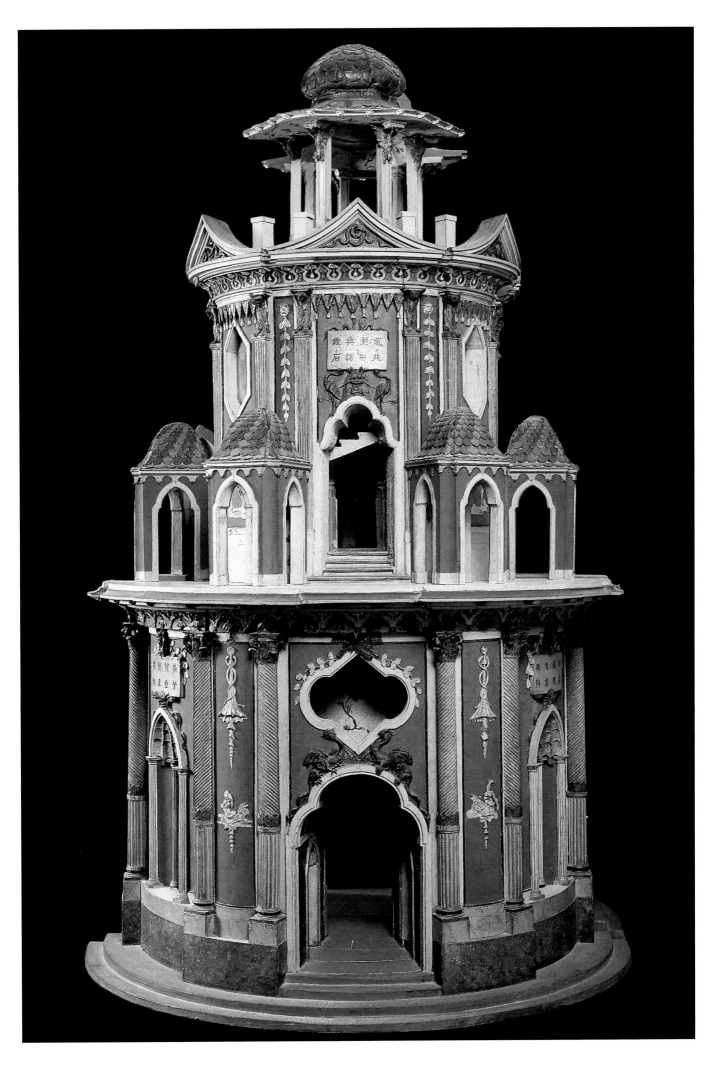

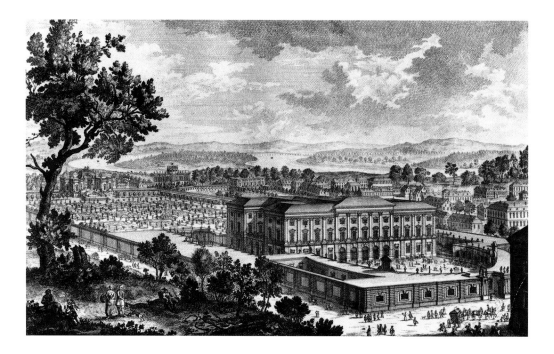

extremely meticulous, repeating the king's every word; indeed, when it came to the king, Vanvitelli succumbed to that very human vanity of feeling that he was part of the world scene, in his case in an undertaking in which he proudly felt himself to be a protagonist along with Charles. Some parts of his dedication in the *Dichiarazione* can be singled out as examples inasmuch as they summarize his attitude toward his "Holy Royal Majesties," his relationship with them, and the role he endowed them with as patrons sharing in the conception of his architectural project. Vanvitelli began by saying that the tables were "real mirrors in which YOUR TRUE GREATNESS may be recognized," a ritual and stereotyped formula, and went on to add that "my merit shrinks at my being the only executor of the sublime ideas conceived by the magnificence of Your Majesties and in having observed the dimensions prescribed to me in the favorable site assigned to me [...]" This too was a ritual dedication except for his insistence on "dimensions" understood here as the project in a figurative sense. After having stated what the terms were for the palace and the gardens, Vanvitelli persevered on this note: "In truth, as far as the project is concerned, these should remain among my private papers; but then Italy, indeed Europe, would never have known what sublime heights Your Majesties' thoughts had reached nor fully recognized how right your orders were," and he continued further on with "sublime conceptions." It seems to me, in conclusion, that this is much more than the usual rhetoric flattering of an absolute monarch. Vanvitelli, who by temperament was always so timorous and biased, wanted to present himself to the eyes of the world, and in particular to the court, as the executor of the royal will. I would also underline the fact that had King Charles ever spoken to him about the residence of his youth or even mentioned his father Philip V's project, Vanvitelli would have most certainly made reference to it in his interminable correspondence. Without excluding the possibility of the palace of Buen Retiro, I continue to believe that Vanvitelli's real inspiration came from Carlo Fontana's drawings for the Prince of Liechtenstein's palace near Vienna.[34] The *Dichiarazione dei disegni* must be considered in every respect an important chapter of the undertaking. Before the engravings were made, the architect had drawn the tables which he had presented to the king. We know from his letters that the watercolors which were an equally precious part of the proceedings were painted by the architect himself and given to the sovereign on 11 October, 1751. Most probably those tables, which Vanvitelli presented with frames and crystal he had had sent from Rome through the good services of patient Don Urbano, were originally fourteen in number. When the possibility arose of transferring the tables to copperplates, a secret wish of Vanvitelli's was fulfilled, and he dedicated himself wholly to the realization of the volume.

Naturally, his first thought was to ask the accredited engraver Giuseppe Vasi to make the cop-

al Collections II, the Drawings," in *Burlington Magazine*, LXVI (1953): 218-28.
[31] This problem was underscored in the introduction to the corpus of the drawings. Cf. Cesare de Seta, *Disegni di Luigi Vanvitelli*, cit.: 275–77.
[32] Cf. Cesare de Seta, *Luigi Vanvitelli*, op. cit.: *passim*.
[33] Cesare de Seta, *Luigi Vanvitelli*, op. cit.: 80–87.
[34] Cf. Cesare de Seta, *I disegni di Luigi Vanvitelli per la Reggia di Caserta etc.*, op. cit.: *passim*.

Luigi Vanvitelli
Prospect of the façade of the Reggia
Engraving from the *Dichiarazione
dei disegni del Reale
palazzo di Caserta*
Caserta, Palazzo Reale

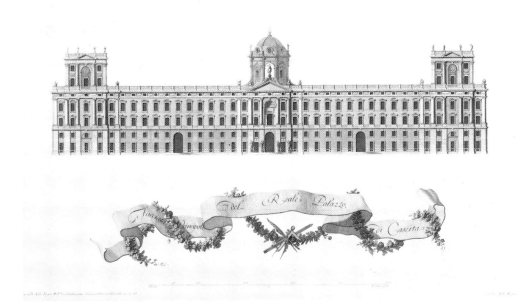

perplates for him, for he had already made an engraving in the past, unfortunately not without recriminations, of the view of Ancona with the project for the Lazzaretto (1738).[35] But for reasons unknown to us, nothing came of this and Vanvitelli had to make do with other hands that proved to be not quite up to the task. The chief engraver in that undertaking was Carlo Nolli,[36] whose father Giovan Battista Nolli had made the monumental plan of Rome (1748), and he was assisted by Rocco Pozzi,[37] and marginally by Carlo D'Onofri and the young Filippo Morghen. The work proceeded slowly. Vanvitelli wrote: "We are expecting copper engravers from Portici to make engravings of the drawings, Pozzi and someone else; their arms will fall off because the job is immense, especially the two perspectives" (29 January 1752). Only two days later did his recurring state of anxiety seem to subside: "They will come here to engrave the plates, which gives me pleasure, as long as they do not make stupid mistakes. The copperplates, 12 in number, were ordered from Rome because their Majesties desired that the engravings be the same size as the drawings" (1 February 1752). Thus he was able to check the work and follow it meticulously as was his wont. From Rome came glass to frame the drawings as well as the copperplates, for there were excellent workshops in that city, while Naples was evidently judged to be inadequate for such an important undertaking. Vanvitelli's correspondence documents the work step by step making it possible to follow its daily evolution. As the tables were slowly prepared, Vanvitelli expressed his satisfaction. In regard to the drawing for the chapel and the royal staircase, he wrote: "Thank God the drawing is better than the others I have done" (18 March 1752); the table was engraved by Nolli in October of the following year. By the summer of 1754, the dedicatory text preceding the tables was ready: "I am now drawing the initial letters in capitals, that is a Q and an A, which must be engraved on the plate, and therefore I am doing a village with architecture, fountains and things that are correlated to the work. In similar fashion, I have begun the vignette that goes at the top of the first page. I have inserted in it the medallion that was placed in the foundation, with the portraits of the monarchs on the obverse and the design of the palace and gardens on the reverse. I have put four putti there with some flowers and underneath a lion sleeping on its paws; above a ladder leaning against a palm tree; I have one of the putti holding the caduceus of peace, the others have crowns of laurel. I hope it will be harmonious" (31 August 1754). Vanvitelli, therefore, wrote the text, designed the initial letters and vignette, planned the layout and, as always, did not neglect to ask for approval from the sovereigns, Prime Minister Bernardo Tanucci, and sometimes Minister Marchese Fogliani. By then Nolli and his collaborators had finished engraving the plates, and in September the king expressed his desire that the volume be ready for November inasmuch as he wanted to make a gift of it during the Christmas holidays. Vanvitelli moved to the Stamperia Reale (the Royal Printing Works), located in the Palazzo Reale in

[35] Cf. de Seta, "Disegni di Luigi Vanvitelli architetto e scenografo," in AA.VV., *Luigi Vanvitelli,* op. cit.: 286, no. 47.
[36] G. Pane, "Vanvitelli e la grafica," in *Luigi Vanvitelli e il '700 europeo,* op. cit.: 380.
[37] Pane, "Vanvitelli e la grafica," op. cit.: 381.

Naples, where he checked the quality of the paper and revised the proofs, and then returned with them to court, complaining bitterly that the king had decided to have only one hundred copies printed (31 July 1756). He feared that he would not be entitled to enough copies for all his influential friends among the clergy and laity. However, the plan was to eventually print some two thousand copies, an impressive number for a volume in large format and of great value. But Vanvitelli also expressed his regret that so many copies of the book were being given to people who were really unable to appreciate its quality. In any case, the volume was bound by the end of November in compliance with the king's request, and the architect was able to turn it over in his hands, pleased that the work was completed. However, he continued to complain that he had received only a few copies, commenting laconically: "I'll get a hold of some" (22 November 1757). His worries proved to be well founded, although he did manage to get his hands on some proofs and loose tables which he hurriedly sent off to some of his "Most Eminent" interlocutors. To his dismay, Tanucci begrudged him the copies due him and drastically reduced the list of people he had drawn up to receive them. The first edition contained fourteen numbered tables,[38] in the second printing, the theater and the spiral staircase which were added to the project afterward figure in tables II and VIII, and in the third printing two unnumbered tables illustrating the viaduct Ponti della Valle were added. Further damage was done when the copies on Vanvitelli's list were sent out in the name of the court and at that only in dribs and drabs. What is more, the ten copies he had received for his own use were not bound: "The work was printed on imperial folio but because of the many double tables the binding had to be made of paper which made it unmanageable." That splendid volume was a constant torment to him since everything possible was done at court to minimize his role as its author, in some cases, going so far as to block the shipment of the books. But Vanvitelli was tenacious and notwithstanding all these difficulties he dedicated himself passionately to the drawing of two more tables depicting *The Prospect of the Acquedotto Carolino* and *The View of the Aqueduct*. Originally, these were supposed to have been part of another volume illustrating that impressive architectural and engineering feat which many of Vanvitelli's contemporaries judged to be "worthy of the Romans".[39] When he received the king's approval for the engraving of the two tables, he was overjoyed: "Oh, how magnificent! I shall have to finish the other two drawings of the course of the aqueduct, which I shall fill with tunnels, with the bridge on the *faenze* and the bridge of Durazzano etc., I shall do my best to fill the space adequately" (1 January 1760). As was his style, he thought of everything, making a detailed plan of how the work should proceed, and indicating the subjects of the tables: "The copperplate of the arcades with the geometrical measurement has been finished; the one with the view is about to be. I am making the two drawings of the Via dell'Acquedotto which shall shortly be engraved, since they are not very difficult. This is the state of things [...] Furthermore, I shall make a small drawing of the view of Monte Taburno, pointing out the source of the waters, which shall decorate the medals; and I shall also design the capital letter, and then if there is space I shall make a finale, which cannot be anticipated; I shall make it according to the space that remains after the printing of the letters" (29 August 1760). But with the departure of King Charles, the architect lost his protector and advocate. The projected volume, like the one for the palace gardens,[40] came to nothing in the face of Tanucci's parsimony. The prime minister was Vanvitelli's bête noir and during the years prior to his death the architect was forced to deal with that difficult Tuscan who was not at all inclined to be as munificent as King Charles, who had left him as regent until such time as the *re piccirillo* would be old enough to reign as Ferdinand IV. Proof that the project really existed can be seen in the tables, although the great central dome and the four corner towers that appear in the engravings would never be built.

Luigi Vanvitelli, scenographer and painter, architect, hydraulic engineer and town planner, was able to combine all those remarkable talents into one work which was unquestionably his greatest. That the architect knew how to exploit his talent as a great scenographer can be seen by walking through the courtyards and vestibules, up the royal staircase – in itself of a prodigious formal purity and an equally solid tectonic energy – and in the chapel and theater. Juvarra's legacy, more than evident in so many stage designs, was a fundamental source of experimentation for what Vanvitelli would achieve in his maturity. Some scenographic sketches from his Roman years prefigured spaces that later became concrete architecture in solutions of great refinement and vigorous monumentality like the central vestibule that

[38] All the original tables of these in Vanvitelli's hand are extant except for no. X which has not been found.
[39] An analysis of these testimonies is included in my book *Il Real Palazzo di Caserta*, with photographs by L. Ghirri, Naples 1991.
[40] With regard to the gardens, see my writings in M. Mosser and G. Teyssot, *L'architettura dei giardini d'Occidente*, Milan 1990: 323–26.

Hermenegildo Hamerani
Model of the medal
for the foundation stone-laying
celebration of the Royal Palace
of Caserta
Naples, Museo Nazionale
di San Martino
cat. 188

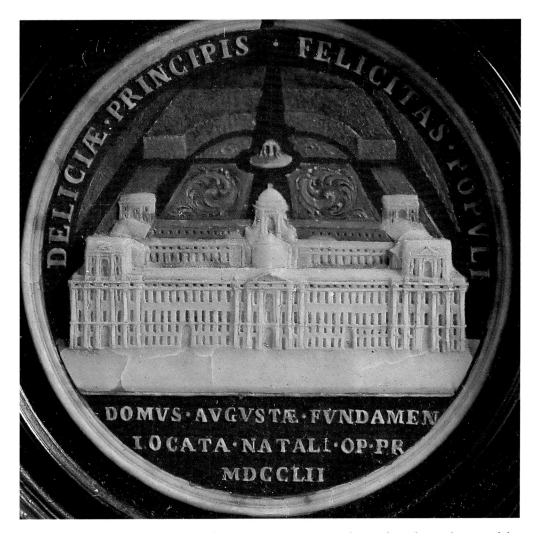

opens onto the royal staircase. His formation as a Roman architect, but also as the son of the Dutch Gaspar, made it possible for him to create his own very original type of architecture which, as I have already argued, I would define as "proto-eclectic." The industriousness and flexibility with which he undertook the most diversified works – festival decorations, engineering, pictorial works, and building models [41] – together with his dedicated passion for the *Dichiarazione* make it possible to say that there was no other "technician" of such great versatility equal to him in Italy during the eighteenth century. He was a master in the true sense of the word and many of his students – from Francesco Sabatini in Madrid to Antonio Rinaldi in St. Petersburg, not to mention Francesco Collecini and Giuseppe Piermarini – were active internationally where they propagated a language of great professional rigor although none of them ever possessed his stature or melancholy talent.

Unfortunately, for many years the palace was abandoned and left to deteriorate. Raphael Mengs, the German painter, wrote a letter which reflects how the European culture felt about this work and its architect. The letter carried the date of 1 March, 1773, the same day as Luigi's death. "Your Most Illustrious Sire will have heard from others that today between one and two in the afternoon Signor Luigi Vanvitelli passed on to the other life, and until the very last moment he had the palace in his mind and his desire to finish it. It is truly a shame to lose him now when the building was expected to be finished; and it would be a pity if some other architect should put his hand to the project with new ideas that might upset those of the deceased [...] But it would be even worse if the sovereign were made to lose interest in continuing this sumptuous building, because it will always do immortal honor to our king, who conceived such great ideas; for it is in the undertakings of men that the images of their hearts are reflected." Regrettably, Mengs proved to be a good prophet in predicting the Crown's loss of interest; on the other hand, he did know how to pay just homage to the great architect.

[41] Cf. C. de Seta, "La piccola fabbrica," in *FMR*, no. 78 (1990).

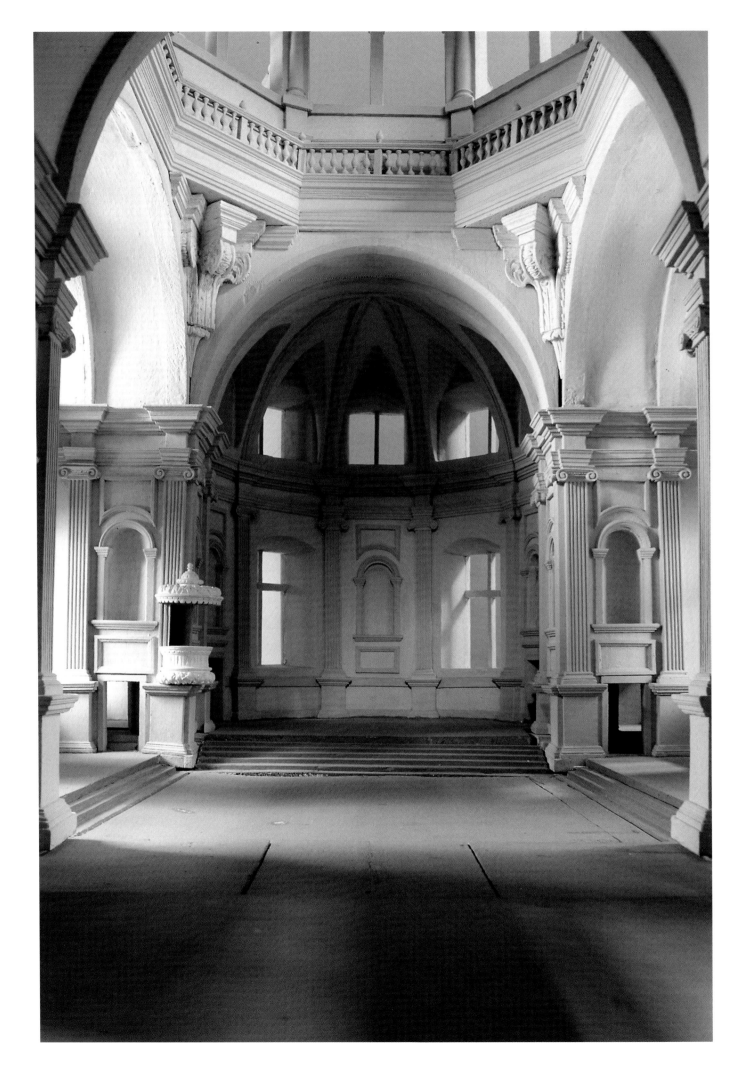

The Architectural Model
in the Sphere of Influence of the Imperial Court in Vienna

Gottfried Wilhelm Leibniz
18th-century engraving
Milan, Civica Raccolta Stampe
Achille Bertarelli

opposite
Matthias Gerl
Wooden model of the Piarist
church in Vienna
Vienna
Piaristenkollegium Maria Treu
cat. 570

It is an astonishing but hitherto neglected fact that, although the Baroque model, as this essay will try to show, is a standard tool of everyday building in the extant eighteenth-century sources, not a single model of "imperial Vienna," of "Vienna gloriosa Hasburgica" has survived (for "spiritual Vienna" we do at least have one, that of the Piaristenkirche. As to why this should be so, one can only advance hypotheses; one is that carelessness and indolence are to blame: that the models were preserved for a while, but then, especially during the nineteenth-century contempt for the Baroque, simply "disposed of" because of their relative bulk and fragility. This is suggested by a "Pro notitia" referring to Johann Lucas von Hildebrandt's model for the Karlskirche in Vienna; the note reads: "The church model described above can still be found and seen on request in the imperial building control office." When this model was lost or destroyed or even used as firewood we do not know; we can only assume that it had either been damaged by careless handling, or that it was removed for lack of space. The competition for the Karslkirche project was also, if we exclude some seventeenth-century forerunners,[1] the first declaration of imperial intent which shows us how and in what circumstances an imperial contract was awarded. The vow had been made by Emperor Charles VI in the year 1713; the inscription on the plaque in the pediment of the church, "Vota mea reddam in conspectu timentium deum" ("my vows will I perform in the sight of them that fear him," Ps. XXI [XXII]), alludes to the emperor's intentions; and the actual building had begun in 1715 (Aurenhammer 1956-57: 61; Lorenz 1992: 50). At least three well-known architects participated in the competition, contributing plans and models: the Italian Ferdinando Galli da Bibiena, the aforementioned Johann Lucas von Hildebrandt, and the imperial architect Johann Bernhard Fischer von Erlach. At the end of November or the beginning of December 1715 the emperor personally selected Fischer von Erlach's project, as the imperial antiquarian and numismatist Carl Gustav Heraeus reported on 5 December 1715 in a letter written in French to the philosopher Gottfried Wilhelm Leibniz, who expressed great interest in the competition: "His Imperial Majesty has just given a demonstration of his good taste in declaring himself, against the opinions of many others, in favor of Monsieur von Fischer's designs for the Karlskirche. He began to put them into practice yesterday outside the Carinthian Gate, not far from the Trautson Hotel. Here is a good omen for the arts" (Ilg 1895: 635). It is astonishing, and indicative of the importance of the matter, that Fischer's friend Heraeus should have sent this interesting news to Northern Germany just

Exterior view of the Karlskirche
in Vienna
by Fischer von Erlach

[1] The plague column at the Graben in Vienna, a monument to "Austrian religiosity," like other columns (such as the Mariensäule at the Hof, and the Josephsäule at the Hoher Markt), was such an imperial commission from the late seventeenth century in Vienna. On 10 October 1679 Emperor Leopold I vowed to have a column in honor of the Trinity erected (with an allusion to similar dedications in Venice and Naples). The reason for this dedication was to beg for an end to an outbreak of the plague which had caused many deaths. A first temporary column made of wood was set up by J. Frühwert; the definitive marble Wolkenpyramide (cloud-pyramid) on the

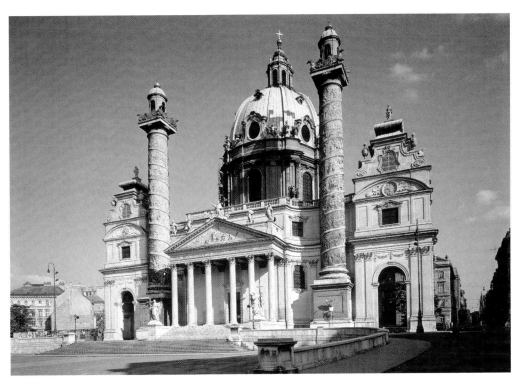

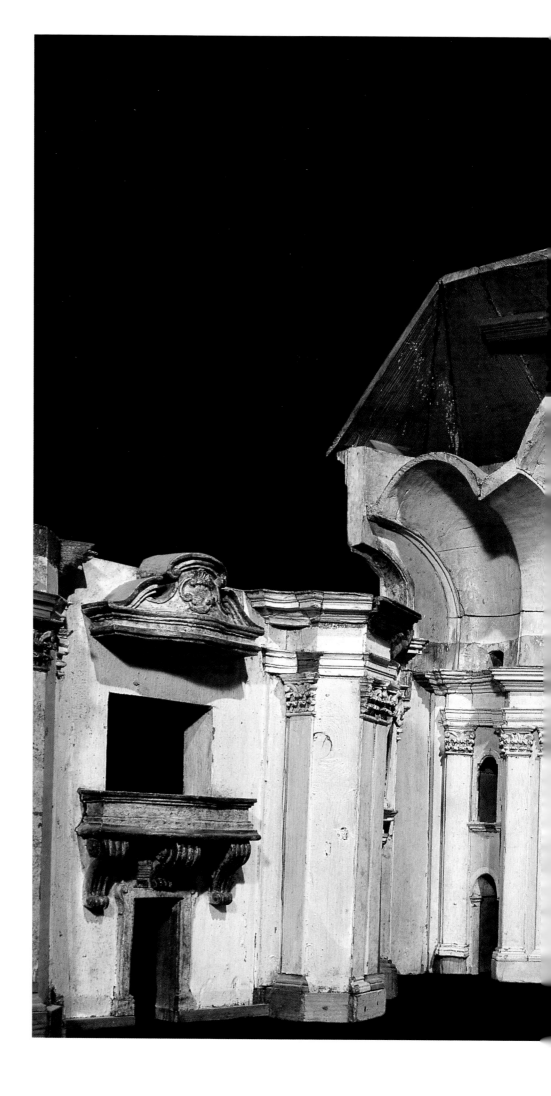

Matthias Gerl
Wooden model of the Piarist
church in Vienna
Detail of interior
Vienna
Piaristenkollegium Maria Treu
cat. 570

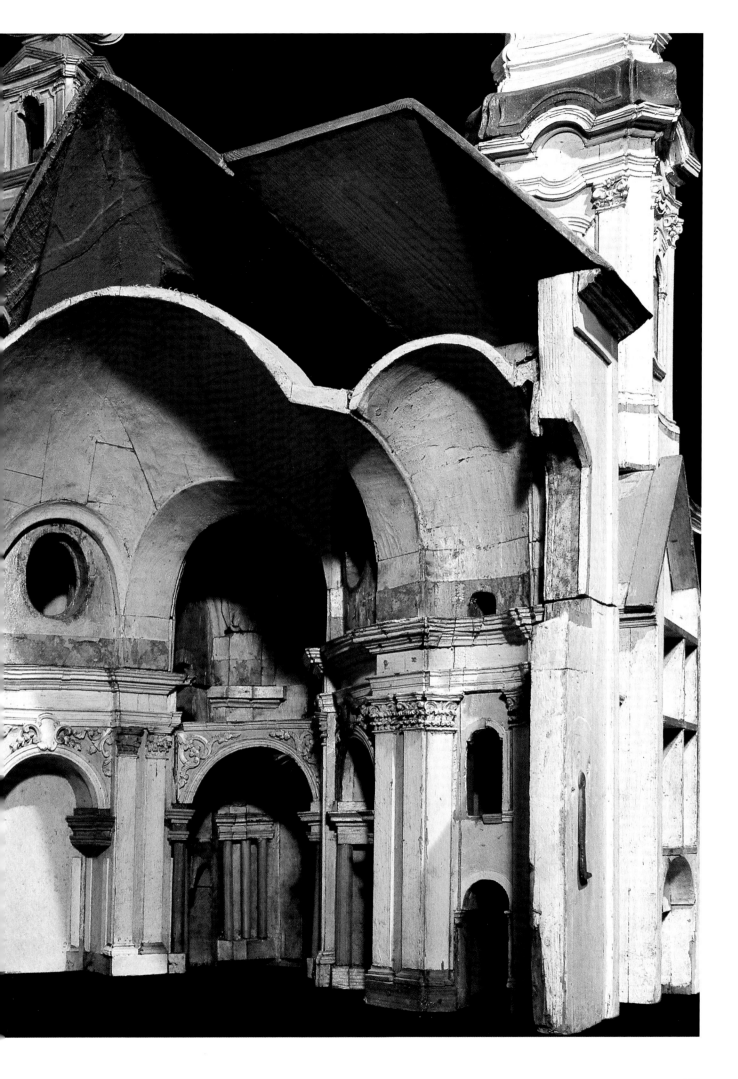

one day after work on the new Viennese church began. Equally noteworthy is the particular emphasis laid on the emperor's good taste. Heraeus's attribution to the emperor of *bon gout* and his interpretation of his decision as a good omen for the flowering of the arts under his rule needs no comment. The agricultural secretary Johann Höllinger subsequently cited, in his balance-sheet of expenditure on the Karlskirche, the following interesting details, which show, among other things, that in 1715 and 1716 costly models of the projected church were made. The balance-sheet, which was first published in 1853 by J. E. Schlager, reads: "To Bonaventura Gamp, the theatrical cabinet-maker, for the making of a model of the church of St. Charles Borromeo, on the orders of the imperial architect and painter Herr Ferdinando Galli da Bibiena, for the work of cabinet-maker, turner, sculptor and painter [...] 150 florins." The making of the model, which was commissioned by Galli da Bibiena, can thus be clearly divided into the tasks of cabinet-maker, turner, sculptor, and painter. The third competitor named alongside Fischer – and "many others," as the report states – was Johann Lucas von Hildebrandt, who is also mentioned apropos of a payment for an architectural model in Höllinger's inventory: "To Benedikt Stöber, sculptor, who helped to make the model designed by Johann Lucas von Hildebrandt, 50 florins." As late as 1718 a large expenditure – 450 florins in all – was made on Hildebrandt's model (Schlager 1853: 129): "Expenditure on the church model rejected by His Imperial Majesty and executed by the architect Johann Lucas von Hildebrandt. First, to Hildebrandt himself, for the cabinet-maker's work, because he had himself paid the cabinet-makers [...] 230 florins. And to the cabinet-maker Rueffen [...] 50 florins. To the sculptor Benedikt Stöber the outstanding payment of 30 florins. To the painter Johann Carl Jacobi, for painting Hildebrandt's church model [...] 30 florins. Lastly, to the civic turner Heinrich Ullmann, for work on the same model [...] 10 florins" (Schlager 1853: 130; see also Luigi Ronzoni in *Triumph der Phantasie* 1998: 32). Thus, in addition to the cabinet-makers and the sculptor Stöber, a turner had also been employed, probably for making the columns, knobs, and other architectural details. The statement that the emperor himself had been responsible for the rejection of Hildebrandt's model is extremely significant, for it shows that he had taken the competition for the building of "his" church very seriously. We can only guess as to why he decided in favor of Fischer. Perhaps it was Fischer's more austere conception which impressed the emperor, who may have objected to Hildebrandt's softer, more Viennese style. For Hildebrandt this defeat at the hands of his arch-rival Fischer must have been highly embarrassing, a bitter pill to swallow. In the competition it may be assumed that there was a set program of a central domed church with built-on wings, as was often the case in churches of this type.[2] In September of the

Anonymous
after Kilian Ignaz Dientzenhofer
Plan of the Piarist church
in Vienna
Vienna
Piaristenkollegium Maria Treu

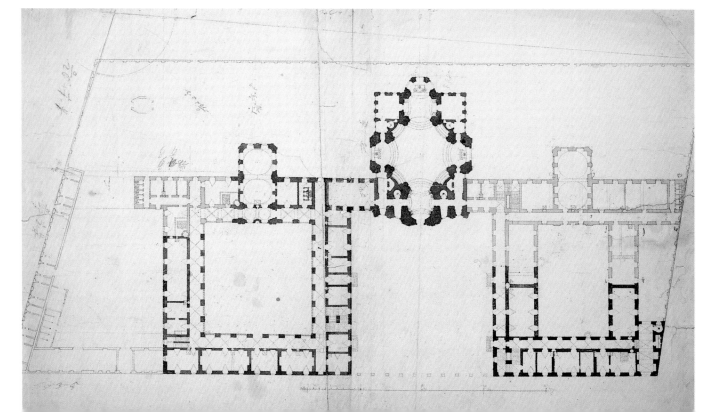

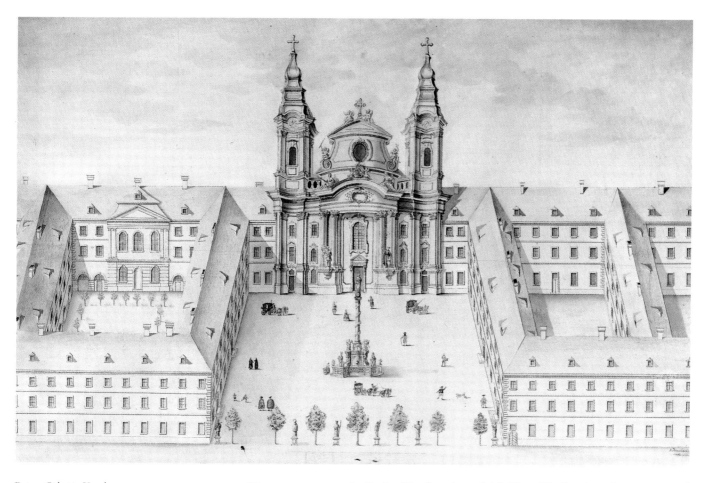

Petrus Cölestin Vogel
View of the Piarist church
in Vienna
Vienna
Piaristenkollegium Maria Treu
cat. 573

pedestal was the work of P. Strudel. He had also introduced the motif of the kneeling emperor casting the plague into the chasm with the help of Faith. The monument was finally completed, after delays due to the war against the Turks, in 1692 (at a cost of about 120,000 florins). It is interesting that in this case the emperor's personal decision was the decisive factor: he preferred Burnacini's sketch with the introduction of the cloud-pyramid. A model of the column once existed (it was made of wood and stucco, painted in stone colors and gilded, and was 35 cm high) but has since been lost. See E. Tietze-Conrat 1920: 505; Schikola 1970: 102; Birke 1981: 41.
[2] The best-known example is Superga, near Turin.

same year Heraeus wrote to Leibniz: "In the plan which Herr Fischer has drawn up, and which I am sure you will like, I shall follow your advice in devoting one of the colossal columns used in it to Charlemagne" (Ilg 1859: 636). Thus one of the columns was to be decorated with a relief of the life of Charlemagne. At about the same time Leibniz again concerned himself with the colossal columns – an idea influenced by the precedent of Trajan's Column – at the side of the central drum under the dome: "I should be glad to hear your opinion, sir, and that of Fischer, on the question as to whether it might not be appropriate to pay some tribute to Saint Charlemagne and Saint Charles, Count of Flanders, both of whom are predecessors of the Emperor, the one in the Empire, the other in some of the hereditary countries." The task of executing the relief on the columns was eventually given to Christoph Mader, as overall director, though the actual stonework on the two memorial columns was carried out by Jakob Christoph Schletterer (Fueßli 1802: II, 19). Contrary to Leibniz's suggestion, they were decorated with episodes from the life of the man from whom the church took its name, Charles Borromeo, or Carlo Borromeo, the plague saint, after whom Charles had himself been christened; this was a more appropriate subject for a sacred building than the political program proposed by the philosopher (the two columns, which have a "Herculean" and "Caroline" significance, symbolize at another level the two key concepts of the monarch's motto, "constantia" and "fortitudo," and in a further interpretation Jachin and Boas, the two columns in front of Solomon's temple in Jerusalem). Leibniz had been in Vienna from the beginning of 1713 to the end of 1714, associating with statesmen such as Prince Eugene of Savoy and the Prince of Liechtenstein, and attempting unsuccessfully to found an academy of sciences there. It is highly interesting that he should have paid such close attention to the Karlskirche competition: in this period of high absolutism it took on a political dimension of imperial and indeed world-wide significance. Thus the philosopher thought there ought to be a sun gnomon on the spire of the church.

Fueßli (1802: II, 19) expressly wrote that "Schletterer himself invented all the models (of

Johann Bernhard Fischer von Erlach
Detail of one of the colossal columns
made for the Karlskirche
in Vienna

opposite
Tommaso Giusti
Wooden model
for the Clemenskirche
in Hanover
Hanover, Historisches Museum
cat. 529

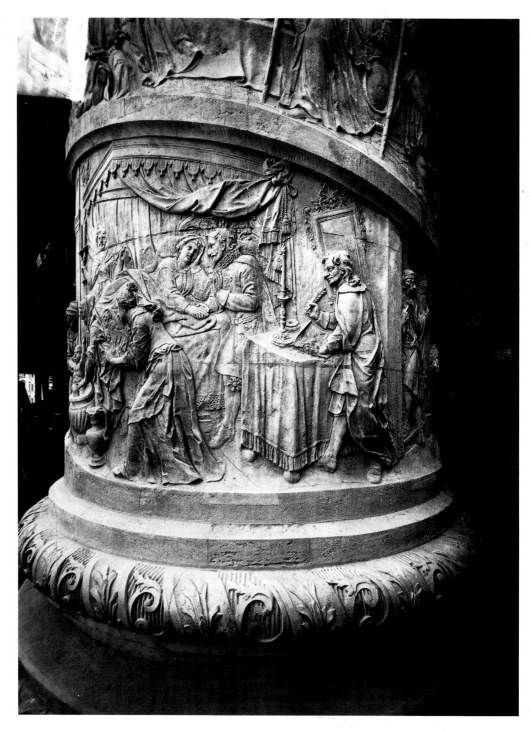

the giant columns), and executed many of the stone pieces with his own hand." However, it was Mader, the overseer of the work, who received the payment, as we learn from the sculptor's bill of 1729: "To the sculptor Christoff Maderer, who had been commissioned to carve on the two large stone pyramids (columns) the clearly recognizable bas-reliefs according to the previously made models, in addition to the 950 florins paid him last year, a further payment of [...] 2,000 florins" (Schlager 1853: 139). After Schletterer had made all the models, Mader thought he no longer needed his assistance. He tried to remove him from the job on the grounds that he had been causing trouble, and in this he finally succeeded, as Fueßli (1802) writes: "He succeeded in this base design, and Schletterer took the opportunity he had been offered to travel to Salzburg with Raphael Donner, whither the latter had been summoned for an important commission" (1802: 20).

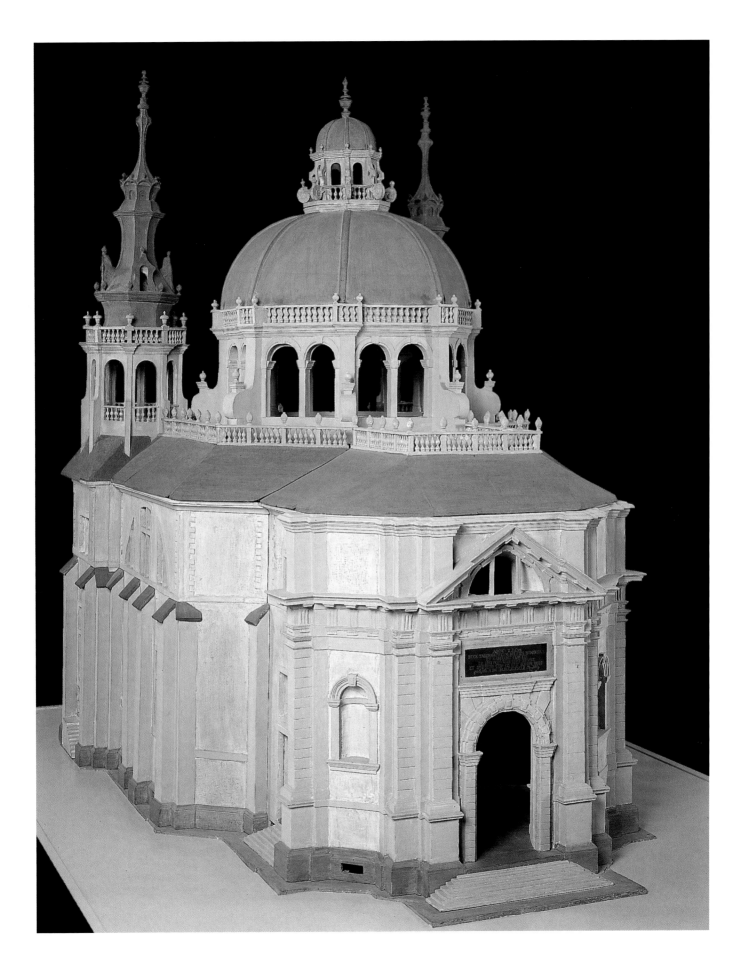

The art critic Johann Joachim Winckelmann gives us, in his early work *Gedanken über die Nachahmung der Griechischen Werke der Malerey und Bildhauerkunst* (1756: 67), a fairly complete account of how, on the orders of Charles VI, models for the columns of the Karlskirche were requested from the finest artists. The Italian Lorenzo Mattielli was considered to be one of the most distinguished contributors, but his project was not accepted, because the deep cuts it required would have reduced the mass of the stone and thereby weakened the columns. The way was thus clear for Mader and later Schletterer.

Elsewhere, however, Mattielli did prevail, for he was given the job of making the tops of the columns. Their execution, too, was linked to a model that was sent in advance (1727): "To Lorenzo Mattielli, another sculptor, for a model of the eagles and crown to be placed on top of the stone pyramids [...] 125 florins" (Schlager 1853: 137). Shortly afterward, an alteration to the model is mentioned, which proves that an inspection of the model might be followed by modifications: "Sculptor: to Lorenzo Mattielli, for changes to the wooden model of the eagles [...] 30 florins." The payment for the model of the high altar of the church, designed by F. M. Prokoff, followed one year later, in 1728: "To Ferdinand Prokoff, for the model of the high altar [...] 100 florins" (Schlager 1853: 138). The entire end wall of the church was occupied by a halo and clouds with the patron saint of the church, Carlo Borromeo (in the manner of the Kollegien- and Johannesspitalskirche in Salzburg).

In the competition for the fountain for the Flour-Market in Vienna (the original is in the Austrian Belvedere Gallery), which took place in 1737, we again come across the Italian sculptor Mattielli, who first entered into negotiations with the magistrate of the city of Vienna. He stated that he was prepared to make the stone figures for the new fountain at a price of 600 florins.[3] Here too we must assume that a model would have been the basis of the contract. But at this point the Viennese Georg Raphael Donner made a rival bid, offering to supply "statues in ordinary or hard bronze for the same price as that for which Mattielli had offered to make them." The city council decided in favor of Donner, judging him "without doubt the superior craftsman and artist," who "would be able to win himself everlasting renown here in this public place" (Ilg 1893: 38). The decisive factor for the city fathers was that in the first place Donner was offering to do the work at the same price as Mattielli, and secondly that the metal that was to be used, i.e., bronze (in the event Donner actually cast the statues in lead, probably for aesthetic reasons), would hold its value over time (*G.R. Donner* 1993: 366). The fountain, a masterpiece of eighteenth-century European sculpture and a precursor of classicism, was finally completed in 1739 and

Graben street in Vienna
18th-century print
Vienna
Österreichische National Bibliothek

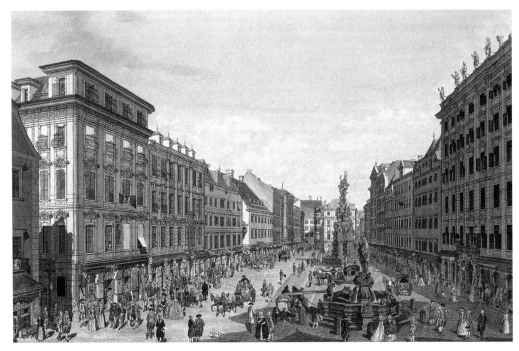

[3] Grimschitz 1959; Baum 1980: 124; Krapf 1996: 63. J. V. Berger, who in a ceiling fresco (1890) in the Kunsthistorisches Museum in Vienna gathered together the patrons of the house of Hapsburg, portrays, in addition to other sculptors (Cellini with his saltcellar, Giambologna, Gilg Sesselschreiber with a model of Rudolf of Hapsburg for the Hofkirche in Innsbruck, G. R.

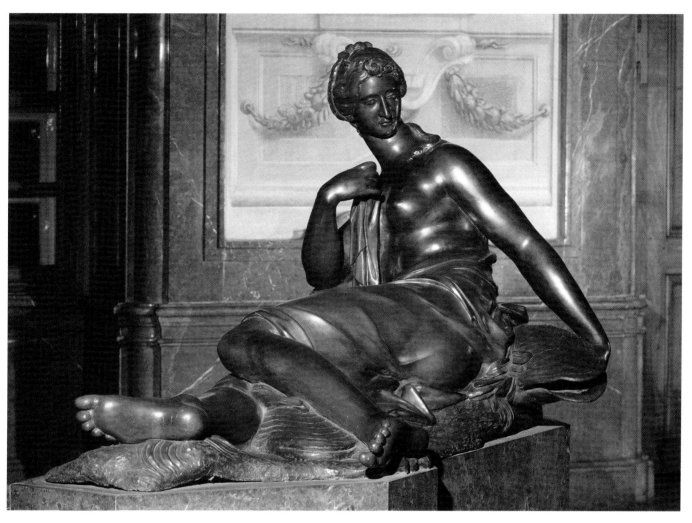

Georg Raphael Donner
Marine deity
Detail of the River Fountain
in the Neuer Markt, Vienna
Vienna
Österreichisches Barockmuseum

Donner next to Prince Eugene of Savoy with the little model of Providence). The numerous models show how common this kind of presentation of a real building or sculpture was at the imperial palace in Vienna even at the end of the monarchic period.

unveiled on 4 November of that year, the name-day of emperor Charles VI. It is clear from this that it was the intention of the city of Vienna to dedicate this costly work to the emperor. Mattielli was so offended at being passed over that he left Vienna and went to Dresden, where he executed the sculptural decorations in the Catholic Hofkirche which had been built by Chiaveri.

On another occasion, during the planning of the courtyard of the imperial castle at Schönbrunn near Vienna, a model was used as a basis for making a decision. When Wenzel, Prince Kaunitz, sought a sculptor to make a fountain, the ambitious young Tyrolean Franz Anton Zauner applied for the job, and was given the task of making a model in the very short time of fifteen days (Fueßli 1802: 53). It was to show the three main Austrian rivers and their attributes, together with "some children" (i.e. putti): the program recalls Donner's Flour-Market Fountain, though the style is different. The model met with the prince's approval, and Zauner carried out his first work, before being sent on a scholarship to Rome to "purify his taste" in the direction of the new classical doctrine (Burg 1915).

A striking indication of the status of the model in imperial Vienna is given by the picture on the cover of the *Codex Albrecht*, which is preserved in the Austrian National Library in Vienna (Matsche 1981: 376; Garretson 1380–81: 19; Krapf 1991: 15). This is a collection of sketches for decoration programs of buildings of Emperor Charles VI. In the background are two columns, symbolizing the emperor's motto "Constantia et Fortitudine." In the center, surrounded by models and plans, are two of the emperor's virtues: in front of the left column stands Pietas with a flame over her veiled head. Also entitled "Andachts Eyffer," the virtue points to a perspective, or rather a model, of the Karlskirche. To the right of this, on an ancient sacrificial altar, stands what is described as a model of the

Karlskirche
and the Belvedere Palace
in Vienna
Vienna
Bibliothek und Kupferstichkabinett

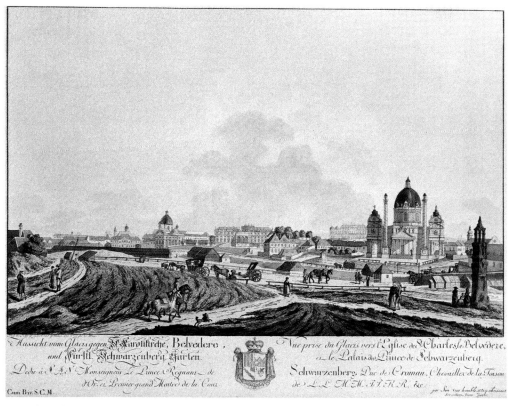

Joseph Column in the High Market in Vienna, erected at the command of the emperors Leopold I and Charles VI (Lorenz 1992: 126). In front of the right-hand column sits Imperial Wisdom: in her hand she holds a scepter with a snake twined round it (which appears in a similar form both in the apotheosis of Charles VI and on Donner's Flour-Market Fountain, as a symbol of Providence). Wisdom points to a model, displayed by a Genius, of the Viennese Court Library,[4] whose pictorial decoration by Daniel Gran, highly praised by Winckelmann, celebrated the emperor's peacetime and wartime accomplishments (with the wings of war and the wings of peace). The inscription on the plaque on the façade of this temple of books proudly proclaims that the library is to serve "publico commodo," for the common good. There follows a representation of the sketch of the façade of the Imperial Chancellory wing of the Viennese Hofburg, where Charles VI and his civil servants carried out their official duties (behind this is the Semmering monument, which alluded to the building of the road network stretching down to Trieste and the open sea). Under the model of the Court Library is the imperial Austrian eagle, which bears the order of the Golden Fleece: in front of this is a branch with a pomegranate as an allusion to Emperor Maximilian (he had been represented by Albrecht Dürer with such a branch). A putto in front of the Karlskirche, in a further display of regalia, empties out a cornucopia containing coins and medals, which allude to the emperor's contribution to numismatics. A fragment of an ancient relief recalls the renowned imperial collection of antiquities which was to astound Winckelmann (the relief shows the stealing of the Golden Fleece by Jason).[5]

Christian devotion, ubiquitous in Europe, found its highest expression in pilgrimage, and the most important destination for pilgrims in the Hapsburg empire was Mariazell. The pilgrimage church of Mariae Geburt was an especially popular destination in the seventeenth and eighteenth centuries, and both the emperors Leopold I and Charles VI paid it great honor. Leopold was a great devotee of the Virgin, and, when he was worshipping her in Altötting in Bavaria, Passau or Mariazell, would often utter the words: "I, the greatest of all sinners, I the lowliest creature, I the most unworthy creature Leopold." He signed his name during a pilgrimage to Mariazell as "The Holy Virgin Mary's lowliest and most unworthy servant Leopold."[6] These expressions must be seen as part of the *pietas Austriaca*, in which everything was depersonalized, out of respect to God, to whom all things

[4] Krapf, *Triumph der Phantasie*: 19, pl. 3 (D. Gran also portrayed Wisdom in the dome of the imperial Hofbibliothek; next to her are "The Emperor's Love of Splendor" and the necessary "Executio"). On diagrammatic and model-like aspect of views, see J. B. Fischer von Erlach 1910).

[5] J. J. Winckelmann, *Geschichte der Kunst des Altertums*, Vienna 1776, "Preface".

[6] G. E. Rinck, *Leopolds des Grossen Röm. Kaysers Leben und Thaten*, Leipzig 1709: 99.

Joseph Mathias Götz
Model for the Assumption
altar in Krems an der Donau
Krems an der Donau
Weinstadtmuseum
cat. 518

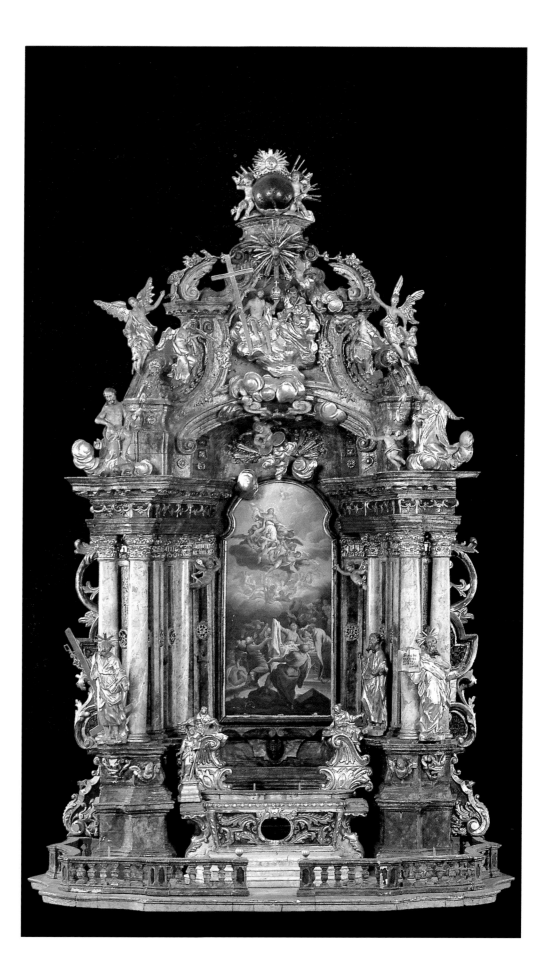

Johann Georg Lindt
Model for the high altar
of Marienberg
Burghhausen, Stadtmuseum
cat. 601

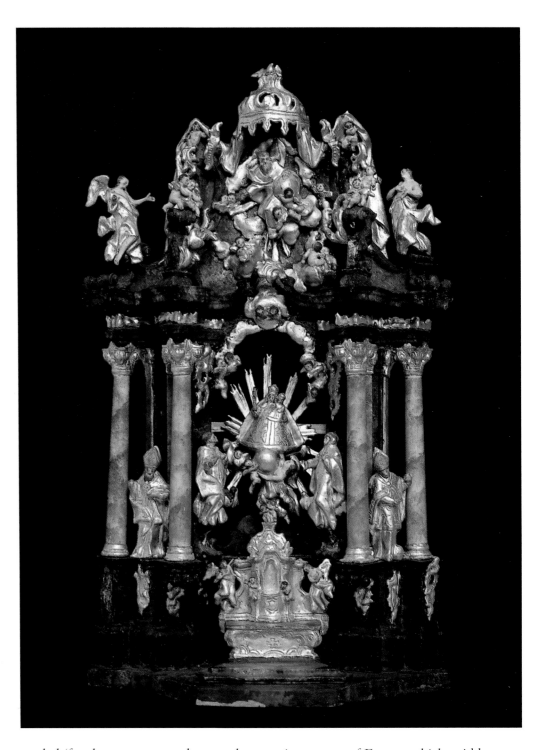

tended (for the same reason the proud equestrian statues of France, which paid homage to the cult of personality, were rejected in Austria as corrupt).

When the high altar of the church Magna Mater Austriae was rebuilt at the end of the seventeenth century, the project attracted enormous interest from the imperial court. On New Year's Day 1693 J. B. Fischer von Erlach was paid 30 ducats by Franz von Kaltenhausen, the abbot of the Benedictine monastery of St. Lambrecht, which controlled Mariazell, for a design for the new high altar of the pilgrimage church. Fischer also supplied a model, which is mentioned in the archives, though it has not itself survived. It had been made, as we learn from a bill of 1702, by the Viennese cabinet-maker Andreas Ruspilati and the sculptor Adam Kracker, who was responsible for carving the figures. Thus the delicate work of building the model required the combined work of both a sculptor

Frantisek Preiss
Model for the altar of the convent
church of the Premonstratensians
in Doksany
Prague
Kralovska kanonie premonstratu
na Strahove
cat. 510

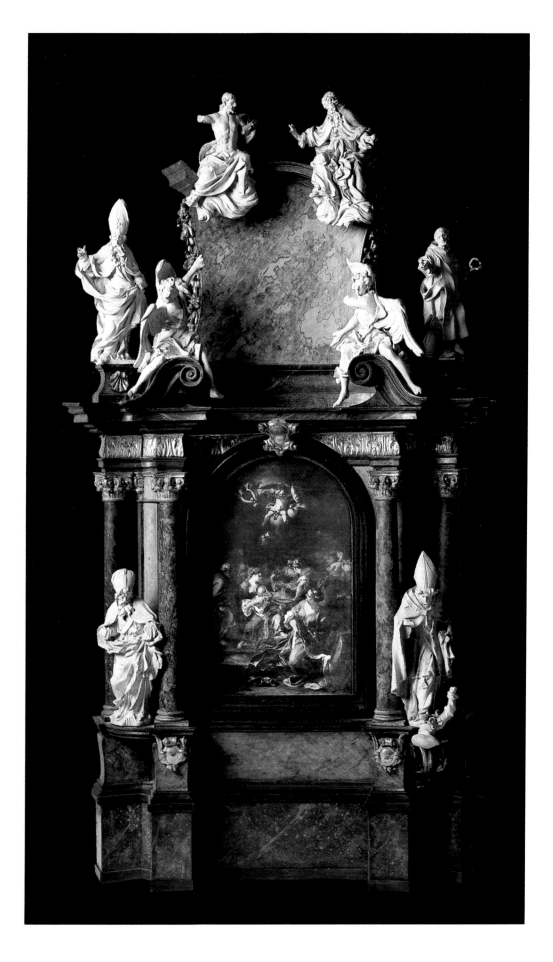

and a cabinet-maker (there is no mention of a painter). The sketch, which is extant (Joanneum in Graz, *Triumph der Phantasie* 1998: 89) is more painterly than architectural in nature, with its free-flowing line, in which sun and moon, as an allusion to the turning of the heavens, are linked with the dove of the spirit. H. Sedlmayr (1976: 109) describes it as one of the densest works in Fischer's oeuvre. In a letter to the Salzamtmann in Vienna, Bartholotti Freiherr von Barthenfeld, Fischer specifically states that the high altar of Mariazell had been designed and executed in its entirety by him (Samma 1979: 23; Aurenhammer 1973: 13). He, Fischer, had had complete control over the project. The actual building of the enormous structure was carried out in the years 1700–1702.

On 6 September 1700 Fischer wrote in his letter on the altar that it was "a work, the like of which is rarely to be seen," an expression of his pride in the successful design. The theme of the high altar is the redemption of the fallen world through the sacrificial death of Christ: this scene occupies the central place over a terrestrial globe, which originally served as a tabernacle (adorned with a Devil's serpent and a crown of thorns). One probable model for the cosmic dimension of the picture is G. Campagna's high altar for the church of San Giorgio in Venice, where the four Evangelists act as bearers of the terrestrial globe (the central figure in this case is the blessing Savior). The overall conception was undoubtedly based on Lorenzo Bernini's work in St. Peter's in Rome; Bernini had been Fischer's first teacher in Italy. Bernini's father before him had held that in drawing up a plan a good architect must always try to provide it with a real meaning ("significato vero"), or an allusion to something exceptional, whether that something was drawn from reality or from the imagination. Fischer's high altar in Mariazell is undoubtedly such a creation of his imagination.[7]

For J. L. von Hildebrandt, too, the architectural model played an important role as an aid to visualization in the development of the work and in the decision-making process. The Deanery archive in Gabel in Northern Bohemia preserves a *Protocollum Conventus Jablonensis*, in which mention is made of a model for the building of the church: "Only a wooden model of this church was sent here from Vienna and carefully considered by the emperor himself; it is said to cost 1,200 florins." The fact that Emperor Leopold I personally inspected the model again shows how thoroughly these high-level controls were carried out (the laying of the foundation stone followed on 18 November 1699).

Further mention is made of a model when Leopold I was considering an extension to the Hofburg in Vienna (three vaults were in danger of collapsing). In 1702 Hildebrandt received a payment of 200 florins for a now lost "model for the building of the castle" (Grimschitz 1959: 112).

In connection with the extension of the Residenz in Würzburg Hildebrandt supplied plans for a large watering place for horses in front of the courtyard. On 16 August 1734 he received 39 florins "for making a model of the watering place" (Grimschitz 1959: 143). The model itself has unfortunately not survived. But the facts listed above prove that Hildebrandt, like Balthasar Neumann, appreciated the value of architectural models (as opposed to sketches, which were comprehensible only to the expert).

Only one of Hildebrandt's presentation models has survived: that of a column in honor of the Immaculate Virgin for the cathedral square in Salzburg, the attribution of which to Hildebrandt was established by Wilhelm Georg Rizzi (*Triumph der Phantasie* 1998: no. 39). This is an earlier design for the Mary column by the brothers Wolfgang and Johann B. Hagenauer which was later (1766–71) erected on the same spot. It bears on its pedestal the coat of arms of Franz Anton Harrach, who had been archbishop since 1709. The allegories on the pedestal, which are explained by inscriptions, are aimed at unbelief: Superstitio, Idolatria, Heresis, and Pec[catum] original[e] (original sin). The model is made of wood, painted and gilded, and measures, together with the wax figures (painted in oils), 191 cm (Salzburg, Museum Carolino Augusteum). It was made, "according to the Imperial Court Engineer," by the Viennese court cabinet-maker Matthias Rueff, who was paid 45 florins 56 crowns for forty working days by his journeyman for the turning work, various kinds of material, and a case (in which he sent it to Salzburg). The wax figures were made, for the sum of 60 florins, by the sculptor Benedikt Stöber (whom we have already met as a model-maker for the Karlskirche project).

[7] A. Riegl 1912: 34. In addition to the high altar, the altar of mercy at Mariazell, designed by J. E. Fischer von Erlach (1726–27) is also noteworthy. There is a reduced devotional version of this altar showing the family of Count Karatsonyi (1882), made by R. von Weyr (Krapf 1994: 299). This model, made of gilded silver, is evidently a keepsake. A further model was made for the Geistliches Schatzkammer (Kunsthistorisches Museum in Vienna), as is proved by a model or copy of the Mariensäule in Vienna (silver, gilded, with precious stones, Augsburg, ca. 1670–80).

Franz Alois Mayr
Model for the pilgrimage church
of Mariae Himmelfahrt
Marienberg
Filialkirchenstiftung Marienberg
on loan to the Stadtmuseum
Burghausen
cat. 600

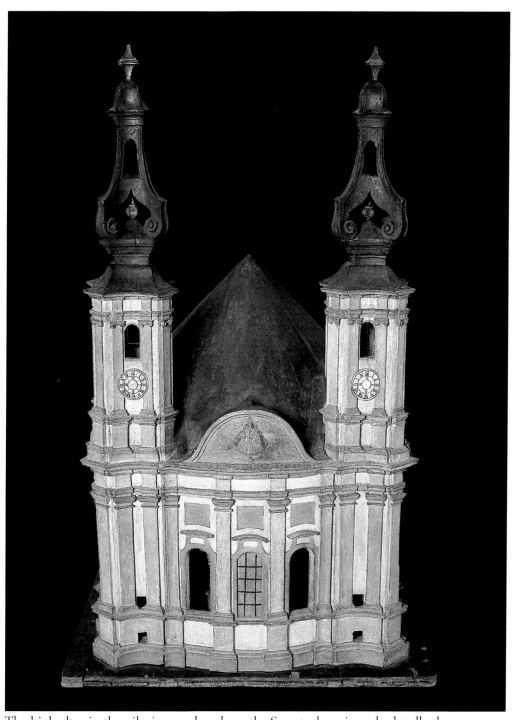

The high altar in the pilgrimage church on the Sonntagberg is undoubtedly the most ambitious example of altar-building in the mid-eighteenth century after Fischer's altar in Mariazell. Once again it follows in the tradition of Italian altar-building, as M. Kern has recently shown,[8] tracing its inspiration to the altar in Santa Maria in Traspontina in Rome. It was the work of the pioneering iron-smelter, sculptor and architect Melchior Hefele, a transitional figure between the Baroque and Protoclassicism whose importance has never hitherto received the attention he deserves. The altar, in the form of an apse-filling ciborium, was made in the years 1751–57 after a court case which Hefele won against the Viennese silversmith Franz Rätzesperger.

The latter, we learn from Hefele, had made, from Hefele's sketch, the model which was the center of debate during the trial: it was transported by ship from Vienna to Ybbs, then carried by four men up the Sonntagberg. The quarrel broke out when Abbot Dominik

[8] M. Kern, in Krapf 1994: 73. Ciboria are known from the Romanesque period onward: compare the examples at San Nicola in Bari, St. Mark's in Venice, Santa Cecilia in Rome, or San Michele in Florence, and Santo Spirito in Florence.

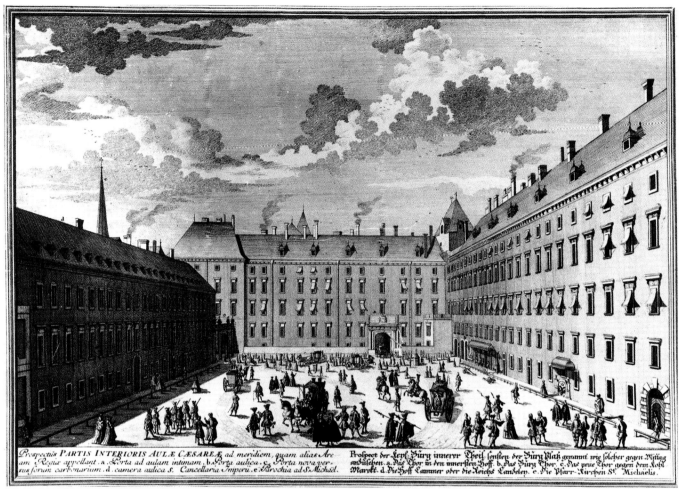

Prospectus PARTIS INTERIORIS AULÆ CÆSAREÆ ad meridiem, quam alias Arcem Regiæ appellant. a. Porta ad aulam intimam. b. Porta aulica. c. Porta nova versus forum carbonarium. d. camera aulica S. Cancellaria Imperii. e. Parochia ad S. Michaël.

Prospect der Kayl. Burg innerer Theil sonsten der Burg Platz genannt wie solcher gegen Mittag anzusehen. a. Das Thor in den innersten Hoff. b. Das Burg Thor. c. Das neue Thor gegen dem Kohl Marckt. d. Die Hoff Cammer oder die Reichs Canzeley. e. Die Pfarr-Kirchen St. Michaelis.

Courtyard of the Imperial Palace
in Vienna
Engraving
Vienna
Bibliothek und Kupferstichkabinett

⁹ Windisch-Graetz 1950: 170. In the Stiftsarchiv in Seitenstetten there is a sketch for the outline of the high altar in Sonntagberg, and in Berlin (Kunstgewerbemuseum) there is an original-size picture-frame carved in limewood (later executed in silver). Little research has yet been done on this very common type of architectural aid.

Gußmann revoked his contract with Hefele and handed over the supervision of building to Rätzesperger, who had lodged a complaint against Hefele. Thereupon the architect took legal proceedings against the abbot before the government of Lower Austria, and on 29 May 1752 he was reinstated in the contract which he had been awarded in 1751. The quarrel over the altar was the talk of the town in Vienna: the altar was nicknamed the "castrum doloris" of the Sonntagberg.

The role played in the affair by the professors of the Imperial Academy in Vienna is particularly interesting and instructive: they acted as judges in the legal dispute, in accordance with Empress Maria Theresa's educational program for the early Enlightenment. The Academy was responsible for the formation of good taste and held the highest authority on artistic matters. It transpired that Rätzesperger had, without Hefele's authorization or knowledge, acted as general supervisor and made a contract with J. G. Mollinarolo (even though as a silversmith he had, according to Hefele, no expertise in such large projects). The professors of the Academy ruled decisively in favor of Hefele: Franz Kohl, an "academic sculptor," was full of praise for Hefele's art; Matthäus Donner, "the imperial medallist," admired Hefele for his skill in drawing the sketches, in making the model, and even in the molding of the ornaments. He further commented that the whole "manages the relevant history impeccably, for sculpture blends with architecture in masterly fashion [...] which is sufficient proof that he is a complete architect both in his knowledge of history and in the theory and practice of his profession" (Windisch-Graetz 1950: 153, 163ff.).

The mode of organization adopted by Hefele, who was always proud of his work and never allowed himself to be deflected in his aims, was based on a division of labor, with a "director" who was in overall control. Even in the scale of the overall project he never yielded an inch to his rivals "it is well known [...] that I was not only the maker of the model

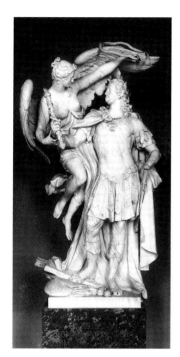

Georg Raphael Donner
The Apotheosis of Charles VI
Vienna
Österreichische Nationalbibliothek

(!) but the sole inventor of this work of art [...]".[9] The stonework was entrusted to the mason Gabriel Steinbockh in Vienna, while Jakob Christoph Schletterer was responsible for making four large wooden statues (from the Old Testament: Moses with the tablets of the law, Aaron with a censer, Melchisedech with a sacrificial altar and Ezechiel with the measurements of the temple) and two pairs of alabaster angels (placed on the tabernacle, beside the miraculous picture, which is of seventeenth-century origin). The central part of the altar structure alludes to the Temple of Jerusalem: twelve columns bear the names of the twelve tribes of Israel on cartouches. The reliefs of the pediment area are by Hefele himself: they show the sermon of John the Baptist, the Annunciation, Christ on the Mount of Olives, and the Vision of Saint John on Patmos. The inscription on the entablature refers to the patronage of Saint Michael and reads: "Quam terribilis est locus iste! Non est hic aliud, nisi domus dei et porta coeli" (How terrible is this place! It is none other than the house of God and the gate of Heaven). Thus the ambitious project of the twenty-meter-high ciborium was a team effort carried out under the direction of its inventor and architect, who assigned the various craftsmen their tasks in subcontracts. The "absolutist" dominance of the Imperial Viennese Academy ensured that the project was carried out successfully.

This altar has always been considered the most magnificent and ingenious (notably in its blending of the Old and New Testaments) example of altar-building produced by Hapsburg piety in the eighteenth century: classical rigor blends with the elegant charm of the courtly Late Baroque.[10]

The concluding question that arises is that of how or to what extent the Hapsburg Austrian architectural model differs from the Italian idiom, which was always the dominant influence, as against the French. For one thing, the Italian model is more sonorously serious in its effect, and depends more on the constructive understanding, whereas the Austrian is playfully decorative, though always observing the requisite *decorum*, without being petite and quaint, as is sometimes the case in Bavaria (compare the Marienberg model in the catalogue). The Italian model – as was illustrated particularly well by the 1994 exhibition in Palazzo Grassi – is calculated, ambitious, and with a wooden appearance (often treated with beeswax as a stabilizer); there is no emphasis on the outer appearance by means of paint or gilt, as one finds in the Austrian models (Wiener Neustadt, Sonntagberg, Zwettler Series, etc.).

In short, the Italians in the seventeenth and eighteenth centuries produced genuine ar-

Am Hof in Vienna
18th-century engraving
Vienna
Graphische Sammlung Albertina

[10] The first example in this development of altar-building (together with Mariazell and Maria Taferl) is the high altar of the Stiftskirche in Melk. In 1727 it was reported of this church that "a start was made with the main or high altar." Here too it is specifically stated that the altar was based on a previously constructed model. The same is said of the two side-altars in the Presbyterium (Krapf 1994: 20). For bibliography on the Sonntagberg, see Riesenhuber 1924: 377; Pühringer-Zwanowetz 1960: no. 240; Überlacker 1968: 128; M. Koller 1985: 5ff., 9; *M. Hefele (1716–1794)* 1994.

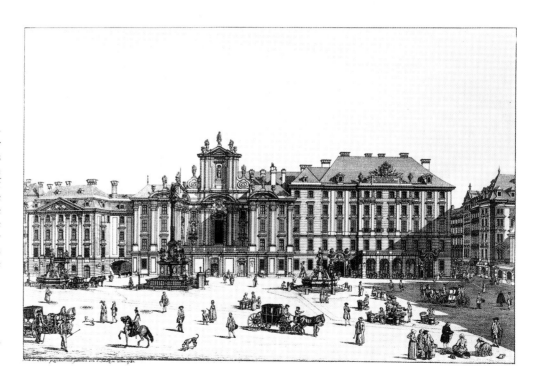

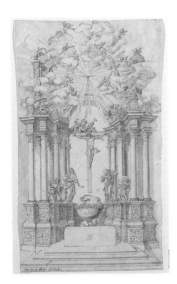

Melchior Hefele
Project for the altar
of the Sontagberg sanctuary
Vienna
Österreichische Nationalbibliothek

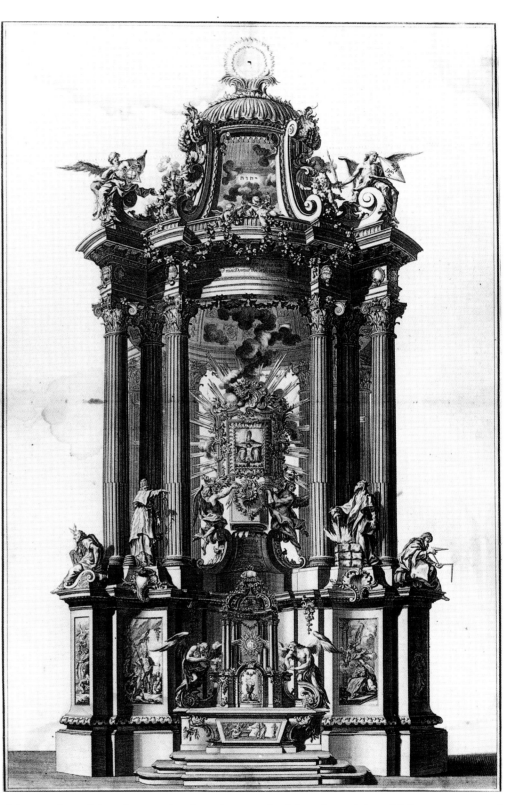

Melchior Hefele
Altar for the Sonntagberg sanctuary
Engraving
Vienna
Österreichische Nationalbibliothek

chitectural models, whereas the Austrians made "show" models, which are concerned with effect. This is how it is described already in the Renaissance in the *Life of Brunelleschi*: he made models of buildings "[...] in which there was not much to be seen apart from the general outline; he was solely concerned with showing the main walls, and the relationship between the individual parts, without ornaments, capitals, architrave, frieze and entablature" (Lepik 1994: 85). If one may generalize from this description, the Italians were preoccupied with the essence of the statement, the monumentality of the

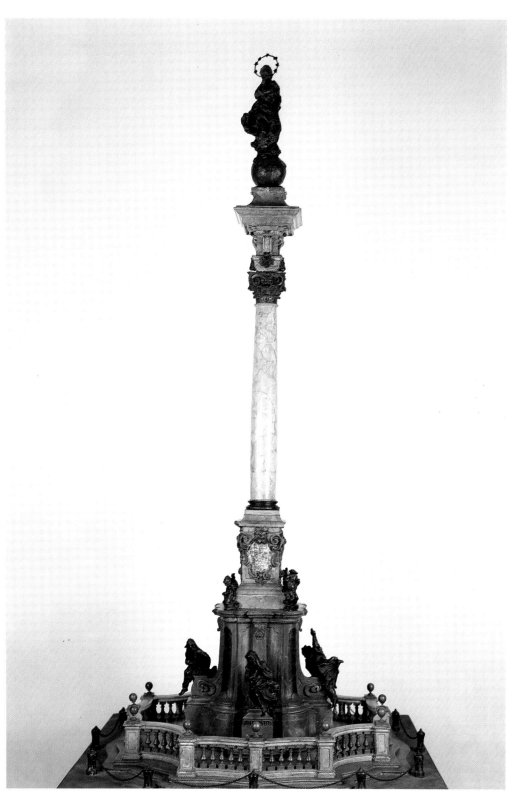

ideogram, whereas the Hapsburg model is ingratiating, tries to "convince" by means of its preciosity. In the South Tyrol and the Trentino these two underlying concepts blend together, as can be clearly seen in the façade model for Santa Maria Assunta in Bressanone. It shows the generous proportions of the Italians together with the intricately playful execution of the Hapsburg idiom (*Triumph der Phantasie* 1998: 228; Montagu 1990). The relationship between original and copy in mimesis has always been produced varying solutions.

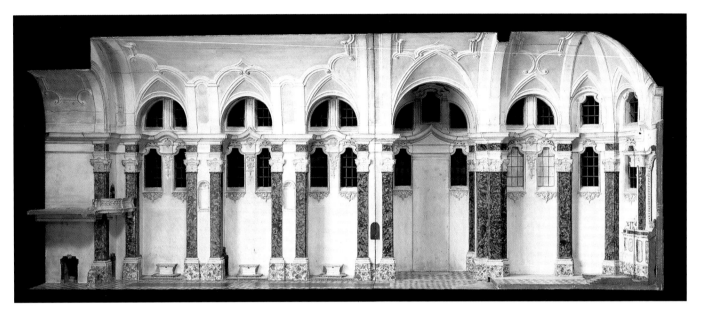

Stefan Föger
Model of the cathedral
of Bressanone
Detail of the interior decoration
Bressanone
Museo Diocesano Palazzo Vescovile
cat. 567

A further question still remains to be examined: which client considered which specific architectural models to be worth preserving? It may be that the practice followed in Austria, and especially in Vienna, differed from that which was current in Bavaria, where the church still carried weight as an institution, even after secularization. The predominance of ecclesiastical models as against secular ones in Austria again shows that the stabilizing role played by the many territories ruled by monasteries made a vital contribution to the preservation of the models. The worldly aspect of power, including the imperial court and later the bureaucracy with its artistic administration, was much more cavalier in its handling of such objects, as we saw at the beginning in the competition for the contract to build the Karlskirche.

BIBLIOGRAPHY: Fischer von Erlach 1721; Fueßli 1802: II; Schlager 1853; Ilg 1893 and 1895; Fleischer 1910; Riegl 1912; Burg 1915; Tietze-Conrat 1920; Riesenhuber 1924; Heydenreich 1937; Windisch-Graetz 1950; Aurenhammer 1956–1957; Grimschitz 1959a and 1959b; Pühringer-Zwanowetz 1960; Überlacker 1968; Schikola 1970; Aurenhammer 1973; Sedlmayr 1976; Sammer 1979; Garretson 1980–1981; Birke 1981; Matsche 1981; *Bayerische Rokokoplastik* 1985; Koller 1985; Montagu 1990; Krapf 1991; Lorenz 1992; *G.R. Donner* 1993; Bischoff 1993; *M. Hefele* 1994; Krapf 1994; Lepik 1994; *Kunstjahrbuch* 1995; *Architekturmodelle* 1995–1996; Krapf 1996; *Triumph der Phantasie* 1998

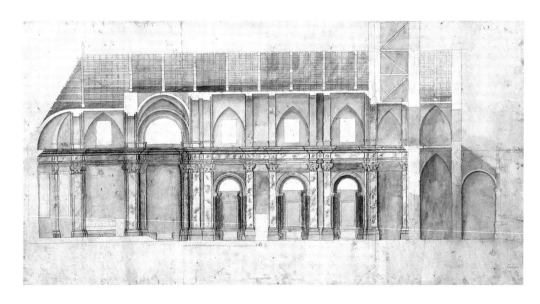

Giuseppe Delai (?)
Project for the cathedral
of Bressanone
Lengthwise section
Bressanone
Museo Diocesano Palazzo Vescovile
cat. 568

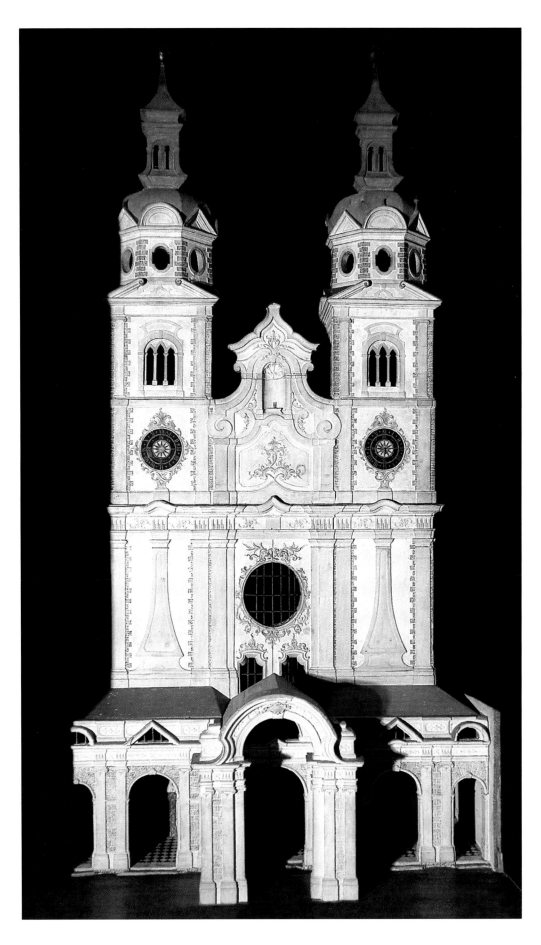

Stefan Föger
Model for the façade
of the cathedral of Bressanone
Bressanone
Museo Diocesano Palazzo Vescovile
cat. 566

The cartographic convention that places north at the top of a map of Europe has led inhabitants of Western Europe to read Central and Eastern Europe as large appendages. Orienting the map with east at the upper edge demonstrates, according to Norman Davies (*Europe: A History*, Oxford and New York: Oxford University Press, 1966: 47), that Western Europe is actually a peninsula of the Eurasian continent.

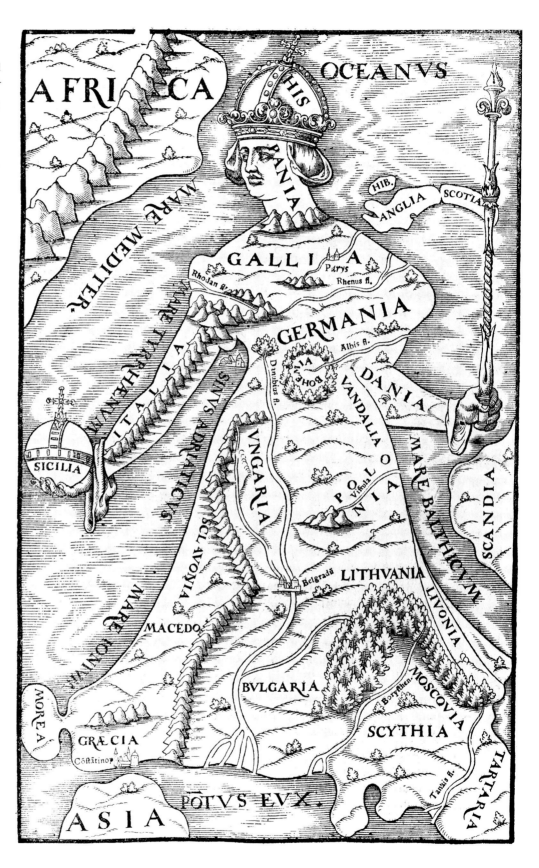

Illustration of "Regina Europa" in Book VI of *Cosmographey* by Sebastian Münster, Basel, 1614 (Rare Book and Special Collections Division, Library of Congress, Washington, D.C.)

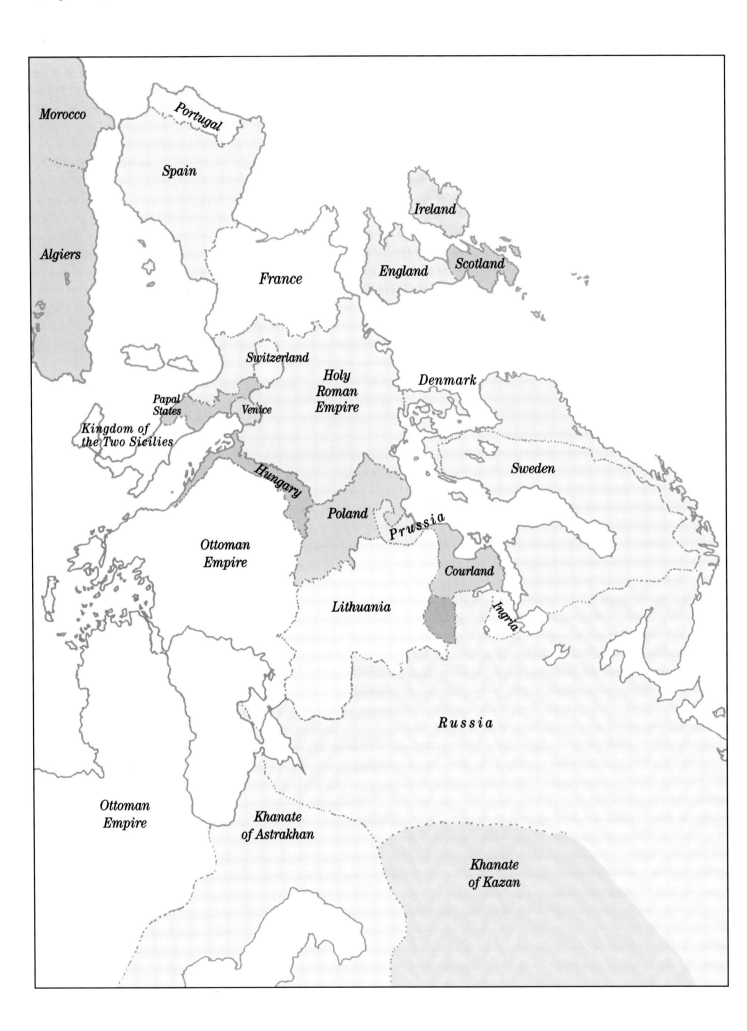

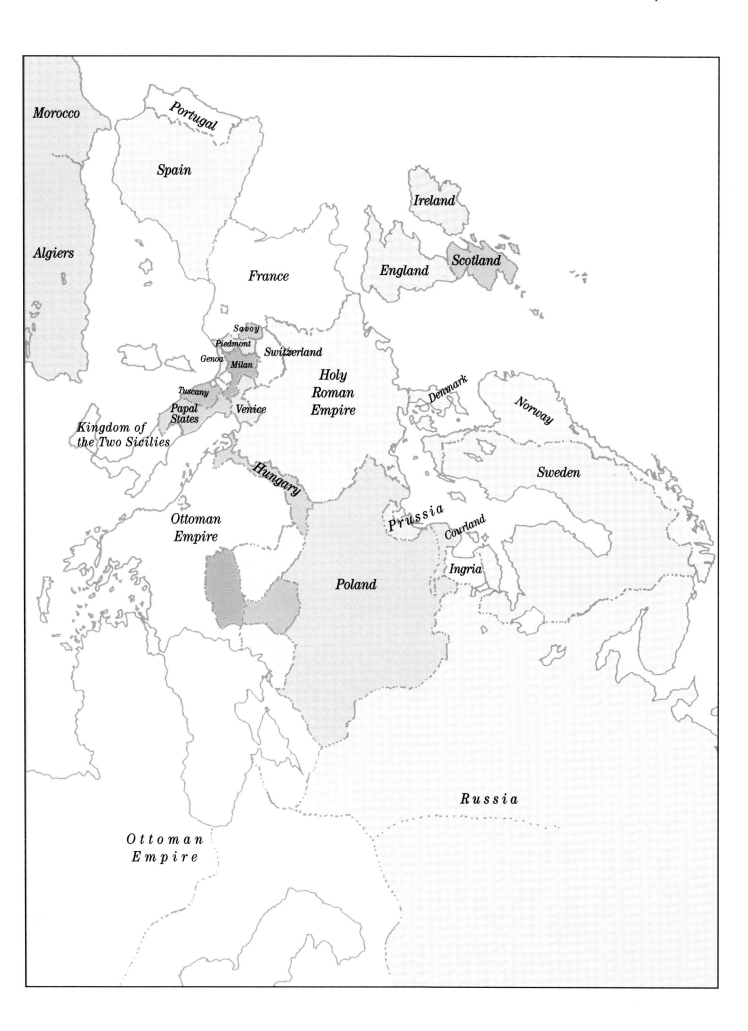

Morocco

Algiers

Portugal

Spain

France

Ireland

England

Scotland

Savoy

Piedmont

Genoa

Milan

Switzerland

Holy
Roman
Empire

Denmark

Norway

Tuscany

Papal
States

Venice

Kingdom of
the Two Sicilies

Hungary

Sweden

Ottoman
Empire

Prussia

Courland

Ingria

Poland

Russia

Ottoman
Empire

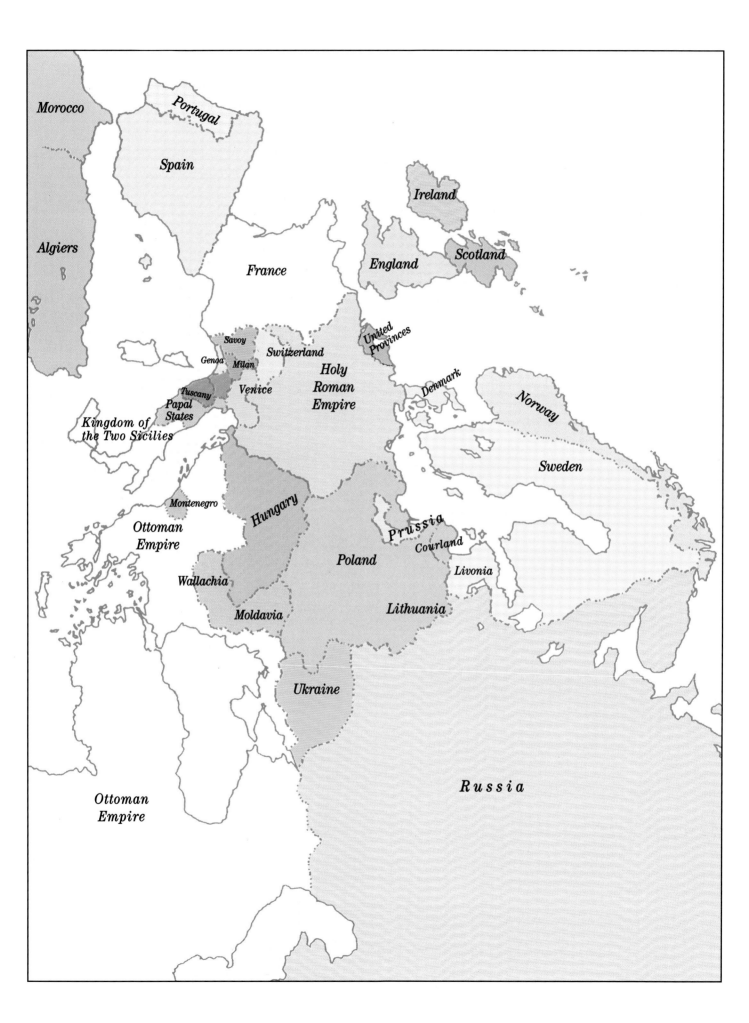

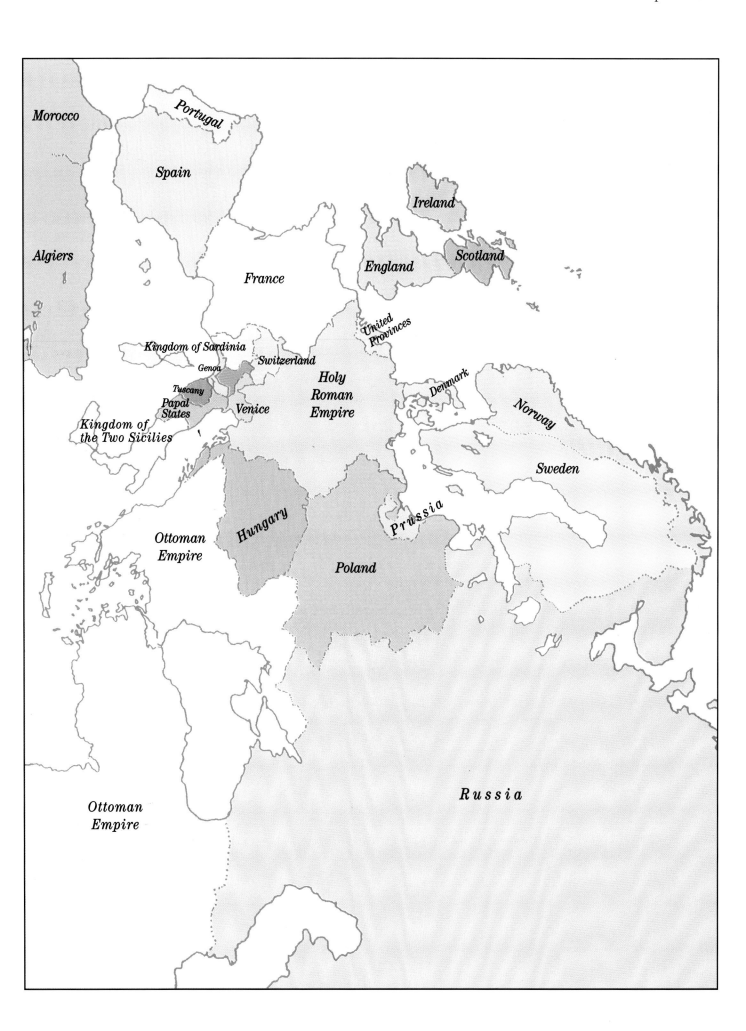

AUTHORS OF THE ENTRIES

AG	Andreina Griseri
AL	Andres Lepik
ALPDS	Anne le Pas de Sécheval
AngG	Angela Griseri
AR	Aurélia Rostaing
AS	Allen Simpson
ASt	Andrea Stockhammer
CC	Christine Challingsworth
CP	Chiara Passanti
DF	David Freedberg
DG	Donald Garstang
DRM	David R. Marshall
DŠ	Dmitry Shwidkovsky
EE	Edward Eigen
EK	Elisabeth Kieven
EPB	Edgar Peters Bowron
FD	Frédéric Dassas
FM	Fernando Marías
FP	Felipe Pereda
FS	Freek Schmidt
GD	Giuseppe Dardanello
HB	Hilary Ballon
HH	Hellmut Hager
HM	Henry A. Millon
IL	Iris Lauterbach
IRM	Isabella Ricci Massabò
JC	Joseph Connors
JFB	Jean-François Bédard
JG	Jörg Garms
JP	John Pinto
JWE	John Wilton-Ely
KN	Karl Noehles
KO	Konrad Ottenheym
LC	Louis Cellauro
LL	Laura Laureati
LLe	Laurent Lecomte
LP	Lionello Puppi
MA	Martin Angerer
MDM	Michela di Macco
MG	Maurizio Gargano
MIB	Maria Ida Biggi
MK	Michael Krapf
MO	Melanie Oelgeschläger
MRM	Marianne Roland Michel
PB	Per Bjurström
PGB	Peter Germann-Bauer
PL	Pascal Liévaux
PM	Patrizia Mair
PV	Pieter Vlaardingerbroek
RN	Robert Neuman
RT	Rossella Todros
SA	Sébastien Allard
SCS	Susan Clare Scott
SFO	Steven F. Ostrow
SG	Sébastien Gresse
SK	Susan Klaiber
SM	Sarah McPhee
SP	Simon Pepper
TAM	Tod A. Marder
TBT	Timothy Barton Thurber
TH	Tomás Hladík
VR	Vladimir Rezvin
WOe	Werner Oechslin
YLF	Yves Le Fur
ZVZ	Z. V. Zolotnickaya

The following catalogue documents all the works on exhibit in the four separate venues: Turin, Montreal, Washington, Marseilles. Each work is marked with a letter denoting where it will be exhibited: T, M, W, MAR. *Unmarked catalog entries identify items that will be exhibited in all four venues.*

Works on exhibit

The Development of the Baroque in Rome and its Diffusion in Northern Italy and throughout Europe

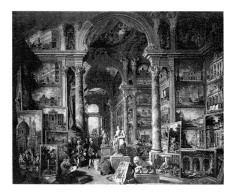

1 W–M–MAR
Giovanni Paolo Pannini (1691/92–1765)
Imaginary Picture Gallery with Views of Baroque Rome (*Roma moderna*)
1757
New York, Metropolitan Museum, acc. no. 52.63.2, Gwynne Andrews Fund, 1952
Oil on canvas
172.1 x 233 cm
INSCRIPTION: "I.P. PANINI. 1757" (on pedestal of Michelangelo's *Moses*)
PROVENANCE: See Metropolitan Museum of Art *Roma antica*
BIBLIOGRAPHY: *The Third Hundred of Paintings* 1896: 92, nos. 73 and 74; Arisi 1961: 216, no. 250, figs. 312–13; Baetjer 1980: I, 138; II, ill.; Arisi 1986: 467, no. 475, ill.

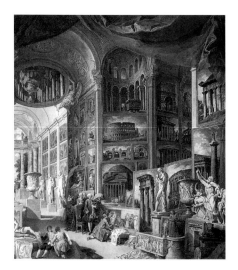

2 W–M–MAR
Giovanni Paolo Pannini (1691/92–1765)
Imaginary Picture Gallery with Views of Ancient Rome (*Roma antica*)
New York, Metropolitan Museum, acc. no. 52.63.1, Gwynne M. Andrews Fund, 1952
Oil on canvas; 172.1 x 229.9 cm
INSCRIPTION: "I.P. PANINI ROMÆ / 1757" (on pedestal of Farnese Hercules left)
PROVENANCE: Commissioned by Etienne-François de Choiseul-Stainville (1719–85), later Duc de Choiseul; possibly Choiseul sale, Paris, 18 December 1786, lot 1; possibly Hubert Robert, his sale Paris, 5 April 1809, lot 9; Casimir Périer (1777–1832), his sale, Paris 18-21 April 1838, lot 1; Famechon sale, Paris, Hôtel des Ventes, 10–13 December 1855, Part II, lot 1; Alexander Baruchson Esq., exhibited Manchester 1857: nos. 832 (*Roma antica*), 833 (*Roma moderna*), labels in Museum files and Manchester 1857; A. Murray, his sale 1877, according to Redford (1888: II, 242–43, not in Lugt), and again in 1882; Paris, Galerie Sedelmeyer (Sedelmeyer 1896: 92, nos. 73, 74); Camille Groult sale, Paris, Galerie Charpentier, 21 March 1952, lot 87 (*Roma antica*), lot 81 (*Roma moderna*), acquired by Metropolitan Museum
BIBLIOGRAPHY: Sedelmeyer 1896: 92, nos. 73 and 74; Arisi 1961: 215–16, cat. no. 249, figs. 310–11; Baetjer 1980: I, 138; II, ill.; Arisi 1986: 467, no. 474, ill.

The Metropolitan Museum's *Roma antica and Roma moderna* are one of two sets of these subjects painted for Etienne-François de Choiseul-Stainville. Later Duc de Choiseul (1719–85), French ambassador in Rome from the end of 1753 to 1757; the other is divided between Stuttgart, Staatsgalerie (*Roma antica*), and the Museum of Fine Arts, Boston (*Roma moderna*, dated 1757). A third, larger, pair now in the Louvre, dated 1758 (*Roma antica*) and 1759 (*Roma moderna*), was painted for Monsignor Claude-François Rogier de Beaufort-Montboisier de Canillac, chargé d'affaires of the Embassy of France to the Holy See.
Items corresponding to the Choiseul version appear in the catalogues of sales of his collection in 1786 and 1787 (not in his sale of 1772). In both they are grouped with two other compositions for Choiseul, the *Exterior of St. Peter's* and the *Interior of St. Peter's*, of similar size but different in concept. From the provenances it appears that the New York pair formed a set with the *Exterior of St. Peter's* now in Berlin (1754) and the *Interior of St. Peter's* in Washington (De Grazia and Garberson 1996: 193–98), while the Stuttgart and Boston (1757) paintings formed a set with the Duke of Sutherland *Exterior of St. Peter's* (datable 1756) and the Boston Athenaeum *Interior of St. Peter's*. From the dates it is apparent that the two versions of the *Exterior of St. Peter's*, and presumably also the versions of *Interior of St. Peter's* were commissioned first, while the two sets of *Roma antica* and *Roma moderna* came slightly later in 1757. Which of the two sets was sold in 1786 and 1787 is unclear; presumably it was a different set in each sale; if so, the assertion that the Stuttgart, Boston, Boston Athenaeum and Duke of Sutherland set was already in America in 1780 when owned by Jacques Donatien Le Ray de Chaumont needs investigation. It seems likely that the New York, Washington, and Berlin set was the one owned by Hubert Robert, the *Roma antica* and *Roma moderna* appearing in Robert's sale 1809. The other two were sold to separate buyers at his wife's sale in 1821, although they were together in Lord Lowther's collection in 1887. The identity of the protagonist of the Louvre pair as Monsignor de Canillac was established by Brunetti (1964: 176, 193, no. 33): the *Roma antica* depicts him in ecclesiastical dress; the *Roma moderna* in secular dress. The identity of the figures in the Choiseul version is less clear cut. In the Stuttgart *Roma antica* there is a well-dressed standing figure holding brush and palette, who is clearly Pannini (or Panini), as he is depicted palette in hand, wears the cross of the Cavaliere dello Speron d'Oro, for which he had been sponsored by Cardinal Valenti Gonzaga (Schütze 1992; Arisi 1986: 213), and resembles his other self-portraits. According to Mrs. Jameson (1844: 111) he is applying the finishing touches to his copy of the *Aldobrandini Wedding*. Arisi, developing this narrative interpretation, argues that the figure immediately behind the chair is the Duc de Choiseul, who, in the New York version of the same subject, changes places with the artist whose turn it is to retire behind the chair. The seated figure in the New York *Roma moderna*, Arisi argues, is Pannini: having been displaced as the protagonist of the *Roma antica* in the Stuttgart/Boston pair he becomes the protagonist of the *Roma moderna* in the New York pair.
There are a number of objections to this reading. First, the painter is standing in front of the *Aldobrandini Wedding*, rather than actively completing it. Nor can we be sure that it is to be understood as a copy by Pannini. The views of ancient buildings may be understood to be paintings by Pannini; but the antique statues are to be understood as real, and an ancient painting might likewise be understood to be real. Pannini and his patron might wish to celebrate Pannini's ability as a *vedutista*, but would be unlikely to celebrate his ability as a copyist. If the focus on the *Aldobrandini Wedding* has significance, it is likely to be that Pannini has equalled or surpassed the finest paintings of antiquity, as modern Rome has equalled or surpassed the glories of ancient Rome. Second, the man behind the chair, and the main in profile behind him, are virtually identical in both Stuttgart and New York versions of the *Roma antica*, and seem to be portraits of the same person. He has the slightly intent stare and three-quarter view of a self-portrait. But if this means he is Pannini in the New York version, there would be two depictions of the painter in the Stuttgart version.
Similarly, in the Boston *Roma moderna* the expensively dressed seated figure is undoubtedly the Duke of Choiseul. The figures around him are deferring to him, and he is seated in a way expressive both of his rank and of the informality that is the privilege of that rank. The supposed figure of Pannini in the New York version is likewise seated. But whereas one can accept that a patron like the Duke of Choiseul could in the Stuttgart picture welcome the depiction of his artist standing upright, dressed formally, wearing his honors, and holding the tools of his trade, it is difficult to accept that he could accept him depicted as seated, being deferred to by other gentlemen courtiers. Besides, the protagonist of the Boston *Roma moderna* and both New York pictures is the same person, and can be identified as Choiseul from

his other portraits. (The man with a sheaf of drawings in the *Roma moderna* may be young Hubert Robert, who accompanied Choiseul to Rome.)

The *Roma antica* and *Roma moderna* depict magnificent imaginary interiors hung with paintings of the monuments of ancient Rome. Pannini's model was his earlier depiction of a picture gallery, the *Picture Gallery of Cardinal Valenti Gonzaga*, now in the Wadsworth Athenaeum, Hartford, Connecticut. Whereas tha depicted a real collection, although hung in an imaginary space, here Pannini depicts imaginary picture galleries hung with his own paintings, although only some of the paintings shown existed as independent compositions. He thus presents a comprehensive survey of his adopted city, as Canaletto had done for Venice, and as Piranesi was doing with his large *Vedute di Roma* under way from the late 1740s. That Pannini was alert to Piranesi's achievements is evident from the way that, although he includes a view of Santa Maria Maggiore based on his painting for the *caffeaus* in the Quirinal Gardens of 1742, in depicting the Piazza del Quirinale (upper left) he ignores his own rather static composition of 1733, and presents instead a newer composition in which the antique Horsetamers are the protagonists, as they are in Piranesi's *Veduta della Piazza di Monte Cavallo*. Pannini then repeats the invention in his view of Piazza Barberini.

Pannini was interested in architecture as a setting for human activity, and hence his finest topographical compositions are his views of piazze and other spaces composed of various buildings, most of which he repeats here, such as the view of Santa Maria Maggiore, Piazza di Montecitorio, Piazza Navona (all second column from right); Piazza del Popolo (fourth column from right), Four Rivers Fountain (left, as in cat. no. 75); Piazza San Pietro, the Spanish Steps, and Trevi Fountain (first column left, cat. no 444, Boston Pannini Trevi Fountain). He was less interested than Piranesi in dramatising views of single monuments: the column of such views at the far right – the façade of San Giovanni in laterano, the Acqua Paola, the Quirinal caffeaus, and in front the loggia of the Villa Madama – are by Piranesi's standards pedestrian in composition, and do not correspond to known paintings, not even the caffeaus, which, unlike the representation in the *Charles III of Bourbon visiting Pope Benedict XIV at the Caffeaus in the Quirinal-Gardens* (cat. no. 200) is topographically correct.

Although the arrangement of the scenes is often controlled by formal consideration – the monuments in a column at the far right of the *Roma moderna* are variations on the theme of an arcade seen from a viewpoint to the right of centre – the row of statues down the central aisle sets up certain hierarchies because of its selectiveness. Perhaps odd for the modern viewer is the prominence of Flaminio Vacca's statue of the Medici Lion, then in the Villa Medici but now in Florence, which was closely based on an antique prototype. And Michelangelo's Moses (San Pietro in Montorio) is more prominent than Bernini's David and Apollo and Daphne (both Villa Borghese). This choice may reflect Choiseul's tastes, since De Canillac's version modifies the Choiseul version in favor of Bernini. Bernini's Habakkuk and the Angel (Santa Maria del Popolo), extracted from its niche, is added to the row of statues, while the foreground is given over to a celebration of Bernini's other works, while the foreground is given over to a celebration of Bernini's other works, many of which do not appear in the Choiseul version.

The Trevi Fountain, built by Salvi from the 1730s but arguably the last great work of the Bernini tradition, replaces the loggia of the Villa Madama by Raphael and Giulio Romano in the most prominent position in the right foreground.

De Canillac seemed to prefer the Berninian Baroque to the Renaissance. Borromini gets short shrift in both, but does slightly better in De Canillac's version, where Sant'Ivo alla Sapienza is brought out of the shadows to cut Bernini's elephant obelisk down to size.

The architectural settings are subordinate to their function of providing fields for paintings, and so are not fully realised in strictly architectural terms.

Moreover, the illusionistic painter in Pannini tends to usurp the architect. In the Stuttgart version of the *Roma antica* two canvases representing the Pantheon – one of Pannini's most popular compositions – and Santa Costanza are hung at the top of bevelled piers of a building which is essentially a Greek cross in shape Subsequently Pannini must have recognised the illusionistic possibilities that the rounded vaults of these buildings presented; in the Metropolitan and Louvre versions, these extend upward into the space occupied in the Stuttgart version by cross-vaults. As a consequence the shape of the vault has been left undetermined, and the paintings – especially *Saint Costanza* seem to hollow out the masses of the piers, in a way that sets up an eerie conflict between the fictive space of the depicted painting and the "real" space of the gallery.

DRM

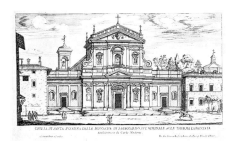

3 T
Giovanni Battista Falda
View of the Façade of Santa Susanna, Rome in Giovanni Battista Falda, *Il nuovo teatro delle fabbriche et edifici su prospettiva di Roma moderna*, Roma 1665–69, pl. 11
Oxford, Ashmolean Museum
Engraving
171 x 286 mm (plate); 151 x 285 mm (image)
BIBLIOGRAPHY: Apolloni Ghetti 1965; Hibbard 1971; D'Amico 1976; Insolera 1980; Bellini 1983; Fozzi 1991; Margiotta 1995

An engraving executed for Falda's 1640/48–78 collection of churches and palaces published in the 1660s that portrays the façade of Santa Susanna (1597–1603) designed by Carlo Maderno. The façade, generally acknowledged to be the first structure to embody the new principles of the Baroque was, by 1660, thought to be "più bella quasi di quante ve n'è in Roma"; (Mola, fol. 141; Noehles 1966: 89). The three layers or planes of the façade carried through both storeys, with increasing relief and increasing width in each bay toward the central portal, as well as the taut balance between continuous vertical and horizontal elements was revolutionary, as were the placement of triangular and segmental pediments above panels, aedicules and windows that weave diagonal patterns across the façade.

The façade in the engraving differs very little from the building, but it differs from the flanking wings, which each lack a crowning balustrade and panels in the attic level. Also, the entrance doorways of the flanking wings are capped by lintels rather than semicircular arches. Hibbard (1971: 113) notes that "it is difficult to determine at what point the wings left and right of the church were built." Hibbard also notes that both wings are shown in drawings of 1656 by Eric Jönson Dahlberg. It might be argued that Falda followed an earlier design for the wings, but, if there were an earlier drawing, it too should have included a balustrade. Hibbard (1971: 114) argues that the balustrade on the raking cornice of the pediment (scorned by Milizia) "could have been designed only in conjunction with the more normal balustrade at either side." The discrepancy between the print and the building as realized remains unexplained.

HM

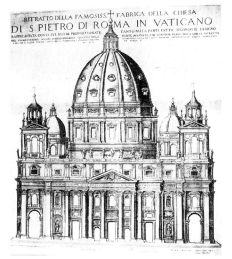

4 T
Matthaus Greuter
View of Carlo Maderno's Projected Façade Elevation for St. Peter's, Rome
1613
New York, Metropolitan Museum of Art, Harris Brisbane Dick Fund [45.82.2(13)]
Engraving
70.3 x 66 cm
BIBLIOGRAPHY: Thoenes 1963: 132–33; Hibbard 1971: 68–70; Hollstein 1983: 107; McPhee 1997: 19–21

On 30 June 1613 Carlo Maderno sent eight engravings of St. Peter's to Cardinal Maffeo Barberini, future Pope Urban VIII, in Bologna. The engravings, made a month earlier (dated 30 May 1613) by Matthaus Greuter (1566–1638), included four copies of the plan and four elevations to show the absent cardinal the projects Maderno had under way on the site. In the ensuing exchange of letters (Pollak 1913: 26ff.), Barberini singled out the elevation, shown here, and criticized the architect for including the entire dome. Seen from the piazza, he argued, the dome is largely invisible. But Maderno responded that the orthographic rendering shown in the engraving was made from the Ponte Sant'Angelo where the entire façade composition, dome and little domes included, reveals itself.

Greuter's engravings are essential documents for understanding Maderno's vision for the church. In an inscription at the base of the engraved plan, Maderno gave a summary history and justification of the events preceding the destruction of old St. Peter's and the decision to add a nave to the new church. He explained that the engravings produced by Greuter preserve his designs as they were submitted in successful competition to the Congregation of the Fabbrica. But the engravings record projects that were never completed.

When Greuter engraved the façade of St. Peter's in May of 1613, the seven central bays of Maderno's church had been completed for about a year (Hibbard 1971: 174). In fact, the portion of the façade across which the dedicatory inscription runs was originally planned to stand alone, at the end of Maderno's nave, without the flanking bell towers seen here. Foundations for the towers were begun in September 1612, providing a firm *terminus ante quem* for the drawing on which the engraving is based. Construction on the flanking towers continued until 1621 (Hibbard 1971: 163, 176–78; Corbo 1995: 242–53), when both towers reached the level of the attic. Both the profile of the outer corners and the width of the towers changed during construction (Thoenes 1963: 132–34). The single-storey belfries that were intended to crown these tower bases were never built. Thus Greuter's engraving preserves the authoritative version of what Maderno intended.

The Greuter engraving had an active life in later years. As Maderno explained in his letter to Cardinal Barberini, "s'è fatto il disegno proporzionato con le sue misure, aciò che ogni uno possi sapere quanto è alta et larga tutta la fabrica et ogni parte di essa" (Hibbard 1971: 70). During the 1645 architectural competition to complete the bell towers, Greuter's engraving served as the template for the façade. Competitors simply cut away Maderno's finials and drew in alternatives of their own.

Drawings on which the Greuter elevation engraving may have been based can be identified among the Italian drawings (originally part of the Museo Cartaceo of Cassiano Dal Pozzo) sold at auction in December 1990 by Phillips, London (Stirling and Maxwell, "Architecture" volume, lot 339, fols. 56–58). SM

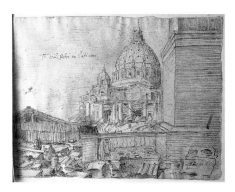

5 MAR
Unknown
View of St. Peter's under Construction
ca. 1611
BIBLIOGRAPHY: Hibbard 1971: pl. 53b

This anonymous drawing shows the façade of St. Peter's under construction in ca. 1611. Under Paul V Borghese (r. 1605–21), Carlo Maderno (1556–1629), who had been appointed architect of St. Peter's in 1603, lengthened the nave by three chapels and built the grandiose façade which the drawing shows being built. In fact, after a century of discussion about the ultimate form of the new church which had been begun in 1506 after a plan of Donato Bramante, it was finally decided that the centralized design, completed by the early seventeenth century, should be extended with a nave, narthex and façade. A first project for the façade was made in 1607 and was commemorated by a medal struck in 1608. However, this design seems to have been unsatisfactory, since in 1608 Maderno made a slightly revised design (see Hibbard 1971: 160) which was followed in the constructed façade we see today.

Maderno's façade for Santa Susanna (1597–1603) provided the model for the progressive layering of the façade from pilaster-framed outer bays to the four central engaged column, united beneath a triangular pediment (a residual image of the tetrastyle portico envisaged by Michelangelo). As completed, the colossal Corinthian order of the façade shelters a minor Ionic in the three major portals, which imitate Michelangelo's idiosyncratic trabeated openings in the palaces on the Capitol. The columnar window frames and lower niches follow Michelangelo's models on the flanks, with slight variations. The attic also follows the example of the flanks, but with broken pediments over some of the windows and with decorative Ionic corbels supported by cherubim on the pilaster strips, a modification of the forms on the upper niches of Santa Susanna.

It was only on the 18 November 1626, just 120 years after its inception, and 1,300 years after the consecration of Old St. Peter's, that the new basilica completed by Carlo Maderno was consecrated by Urban VIII Barberini (r. 1623–44). The obelisk from the Circus of Nero had in the meantime been moved to its present site by Domenico Fontana in 1586. Its base is visible on the right side in the foreground of the drawing. LC

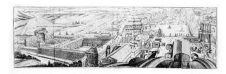

6 M
Israël Silvestre (1621–91)
View across the Vatican from the Dome of St. Peter's, 1641
Cambridge (Mass.), Fogg Art Museum, 1961.7
Graphite, gray, blue and brown wash on cream paper; 33.5 x 113.4 cm
PROVENANCE: The drawing was a gift of Mr. and Mrs. Philip Hofer, who acquired it in 1935 at Colnaghi's in London
BIBLIOGRAPHY: Fell 1936: 21–22; Millon 1962: 229–41, figs. 1, 2, 8, 9, 10; Kitao 1974: fig. 83; *Le Città immaginate* 1987: I, 34; McClendon 1989: 32–65, fig. 24; Marder 1997: 73, fig. 68; McPhee 1997: 71–72, figs. 67 and 69; Marder 1998: 73, fig. 66

This drawing by Israël Silvestre was made from the lantern atop St. Peter's dome in the spring of 1641. The view is composed of three sheets, joined and retouched by the artist. From right to left, the drawing presents the prospect looking due east down the ribs of the dome and along the spine of the nave toward the Borgo, northeast across the Cortile del Belvedere, bisected by the library of Sixtus V, and finally north toward the Nicchione at the summit of Bramante's court and the *prati* beyond.

The Silvestre view can be dated fairly precisely because of the extraordinary detail of the rendering and the specific architectural features it preserves. At the far right, Silvestre shows Bernini's ill-fated campanile under construction above Maderno's south tower base. The first two levels of the tower are nearly complete and the arms of Pope Urban VIII have been mounted above the second-storey arch. Scaffolding is in place for the third and final level, and small, temporary shelters have been built on the western edge to house materials or, perhaps, to cap spiral stairs ascending the tower. To the west of the tower, along the south flank of the church, temporary structures containing *burbure*, or winches, are cantilevered out from the building for lifting lightweight materials from the ground to the level of the nave roof, which served as a staging ground for the tower's construction. A wooden framework or scaffold, perhaps for lifting heavier materials, stands at the northwest corner of the tower.

In the spring of 1641 materials were being assembled for the construction of the third level of the tower known as the *ordinetto attico* which was designed to support a pyramidal helm. We know from documents and drawings that the attic storey was composed of 24 colonnettes following a rectangular plan with concave sides. In fact the shafts of the columns and capitals intended for the attic storey are visible in Silvestre's view, scattered on the nave roof in the shadow cast by the tower. In February 1641 payments begin for the cutting of those columns and winch payments for lifting them into place begin in

March (McPhee 1997: 122 no. 109). The drawing was previously dated 25 May–29 June 1641 (Millon 1962: 230). In light of this new documentary evidence, that date should now be moved back to March. For a detailed discussion of what the drawing reveals of the Borgo and the Vatican Palace, see Millon (1962). SM

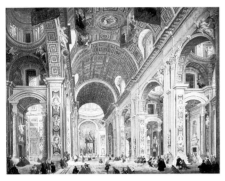

7 T
Giovanni Paolo Pannini (1691/92–1765)
(copy after)
Interior of St. Peter's, Rome
ca. 1754 or later
Venice, Museo Correr
Oil on canvas; 155 x 200 cm
PROVENANCE: Fondo Correr, 1830
BIBLIOGRAPHY: Levey 1957: 53–54; Arisi 1960: no. 240; Wunder 1962: 11–14; Arisi 1986: 452, no. 447, with additional bibliography

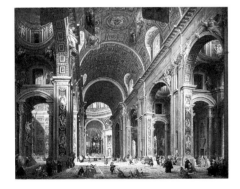

8 W–M
Giovanni Paolo Pannini (1691–1765)
Interior of St. Peter's, Rome
ca. 1754
Washington (D.C.), National Gallery of Art, 1968.13.2
Oil on canvas
154.5 x 197 cm
PROVENANCE: Possibly Étienne-François de Choiseul-Stainville (1719–1785), Duc de Choiseul, Château de Chanteloup and/or Paris; sale, Paris, 12 December 1787, no. 101 bis; possibly Hubert Robert (1733–1808), Paris; his wife, Anne-Gabrielle Soos (1745–1821), Paris; sale, Paris, 16–17 November 1821, no. 55; William Lowther, 2nd Earl of Lonsdale (1787–1872), London; sale, Christie, Manson & Woods, London, 18 June 1887, no. 912; Algernon George De Vere, 8th Earl of Essex (1884–1966), Cassiobury, Hertfordshire; sale, Knight, Frank & Rutley, London, 6 July 1923, no. 257; Sackville Gallery, London,

1924; Count Alessandro Contini-Bonacossi, Rome and Florence; Thomas Agnew & Sons, London, by 1968; acquired in that year with the Ailsa Mellon Bruce Fund
BIBLIOGRAPHY: Levey 1957: 53–54; Shapley 1979, I: 351–54; Arisi 1993: 84; Bowron 1996b: 193–98, with complete bibliography

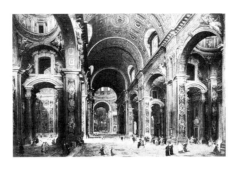

9 MAR
Giovanni Paolo Pannini (1691/92–1765)
Interior of St. Peter's, Rome
ca. 1730–42
Draguignan, Musée Municipal, Inv. 413
Oil on canvas
118 x 170 cm
BIBLIOGRAPHY: Levey 1957: 53–54; Arisi 1961: no. 133; 1986: 372, no. 280, with additional bibliography

Giovanni Paolo Pannini's (or Panini) earliest view of the interior of St. Peter's, signed and dated 1730 (Musée du Louvre, Paris; Kiene 1992–93: 138–139, no. 37; Arisi 1993: 84, no. 6), shows Cardinal Melchior de Polignac, visiting the basilica. One of several paintings commissioned in 1729 by the cardinal, French ambassador to the Holy See from 1724 to 1732, on the occasion of the birth of the dauphin, son of Louis XIV, it immediately became one of the painter's most popular compositions. Over the next thirty years Pannini produced at least six indisputably autograph versions in various sizes often paired with complementary or related views; many more repetitions of the composition were produced in his studio. In most of these, including the versions discussed here, the view looks toward the tribune and high altar from an elevated position above the nave near the entrance, and encompasses the right and left aisles of the basilica. Gian Lorenzo Bernini's colossal bronze *Baldacchino* over the grave of Saint Peter is visible in the crossing, and through it may be seen, as the climax to the progression from the nave to the altar in the apse of the church, the *Cathedra Petri*, also designed by Bernini.

Pannini recorded with unusual precision the architectural modifications to the interior of St. Peter's, particularly those made following the election of Pope Benedict XIV in 1740, and careful comparison of the numerous versions permits their arrangement into several chronological periods (Bowron 1996b: 194, 198, n. 10). The earliest group includes the views painted between 1730 and 1742, when Pietro Bracci's (1700–73) tomb of Clementina Sobieski, wife of the "Old Pretender," James III of England, was unveiled above the first doorway

in the left-hand aisle in December of that year. The tomb is missing from the view in Draguignan (not known to the present writer in the original), which enables a date before 1743 to be assigned to the painting.

One unusual feature of the Draguignan view is the presence of gonfalons hung from the ceiling of the basilica. These banners, usually painted on silk rather than woven, were created expressly for specific occasions such as canonizations and Holy Year celebrations. They occur in an interior view of St. Peter's by Pannini in the Detroit Institute of Arts, signed and dated 1750 (Arisi 1986: 434, no. 407, repr.), and thereafter, which suggests that those in the Draguignan version were also produced and erected for a canonization or other ceremony. In fact, little is known about these gonfalons, which bear images of the Virgin and Child, Philip Neri, Theresa, and other saints and holy figures.

The National Gallery's version belongs to a group of views painted between 1750 and 1754, the date of the installation in the niches of the main nave of the statues of Saint Theresa and Saint Vincent Paul by Filippo della Valle (1697–1768) and Bracci, respectively, on the order of Benedict XIV. The Washington painting can be dated on the basis of a signed and dated 1754 companion view of the square of St. Peter's, now in the Gemäldegalerie, Berlin (Schleier 1998: 412–13, repr.), from which the interior view was separated in 1887. The brushwork and the handling, as well as the treatment of the figures, leave no doubt that both canvases were painted by the same hand. Pannini employed a large workshop, and from the late 1740s his paintings often reveal the activity of more than one hand, particularly in works with multiple figures. Judging on quality alone, it appears that Pannini himself always participated in the production of signed and dated works, and that his patrons accepted these as autograph.

The *Interior of St. Peter's*, Rome, Museo Correr, Venice, is a copy of the National Gallery painting (Wunder 1962: 11-14, and Arisi 1986: 452, as autograph by both; Bowron 1996b: 197, as a copy). EPB

11 MAR
Giacinto Gemignani (1606–81) and Lazzaro Morelli (1619–91)
La Chaire de Saint Peter's Pulpit at Saint Peter's (Cathedra Petri), Rome
Vatican, Biblioteca Apostolica Vaticana, Archivio Chigi, Inv. 24924
Pen, brown ink and brown wash, highlights in white, charcoal, on beige paper
88.3 x 55.5 cm
INSCRIPTION: "incidatur / fr' Hyacinthus S.P.A. Mag.r" (on the altar's front)
PROVENANCE: Ariccia, Palazzo Chigi
EXHIBITIONS: *Bernini* 1981: 135–36, nos. 115 (engraving), 16 (entries by L. Falaschi), 29 (introduction by V. Martinelli)
BIBLIOGRAPHY: Fraschetti 1900: fig. 331; Brauer and Wittkower 1931: 108, no. 3; Martinelli 1983–84

V. Martinelli (*Bernini* 1981, and 1983–84) must be given credit for having first established the authorship and history of this spectacular drawing intended for an engraving, done to commemorate the solemn inauguration of the Cathedra Petri on 17 January 1666. Invoices found in the archives of the Fabbrica di San Pietro reveal it to be a two-handed work, the fruit of the collaboration between the painter Giacinto Gimignani (1608–81) and the sculptor Lazzaro Morelli (1619–91). In February 1666 the former was entrusted with drafting the pulpit and the sculpted figures surrounding it, the latter ending up carrying out the architectural dimension, while François (Francesco) Spierre dealt with the engraving, which was finished the following October, at which time Pope Alexander VII noted in his *Diario* that he, as well as Cardinal Chigi and Bernini himself, had admired it.

The pope and Bernini seem to have chosen together the three artists concerned by this prestigious endeavor. Lazzaro Morelli was one of the closest collaborators of the master, who entrusted him, beginning in 1660, with carrying out forty-seven of the ninety statues of saints overlooking the St. Peter's Colonnade, and subsequently one of the angels of the Saint-Ange Bridge. Between 1657 and 1665, Morelli worked on the stuccos of the pulpit at St. Peter's and supervised the execution while Bernini was away in Paris. The choice of Giacinto Gimignani may seem more surprising. Trained in Pietro da Cortona's studio, he nonetheless showed a great sensitivity for the "classical" procedures of Andrea Sacchi and Nicolas Poussin. Over the course of the 1660s, he drew closer to Bernini, following his son Ludovico, and took part in the pictorial decoration of his churches of Castel Gandolfo and Ariccia. As for Francesco Spierre, he was an obvious choice in light of the brilliant success of his engravings done in 1664 after Bernini for the third volume of *Sermons* by Father Oliva, general in the Company of Jesus.

The drawing and its engraved transposition show a remarkable mastery of the graphic means making it possible to translate the colossal theatrical machinery imagined by Bernini. The framework, centered on the steps of the altar and the entablature of the colossal Corinthian pilasters, just allows the niche holding the tomb of Urban VIII and the Michelangelesque window overlooking it to be seen. Against this rigorous architectural background, supple and elegant lines evoke the four Fathers of the western Church, the reliquary floating in the air, and the Glory framing the stained window adorned with the dove of the Holy Ghost. Whirling contours and clever gradations of light transcribe the thick clouds and angels of the upper register. The white highlights contrast with the generous washes, bringing about a perfect equivalence of contrasts between materials, colors and values which give the monument its visual and plastic richness. Faithful to Bernini's work, right down to the slightest detail, this drawing accomplishes a *tour de force*, expressing its visionary power by means of its utter technical perfection. ALPDS

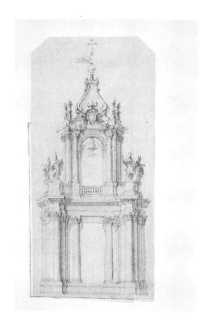

12 T
Gian Lorenzo Bernini (1598–1680)
Project Elevation for One of the Façade Towers of St. Peter's, 1645
Madrid, Biblioteca Nacional, B 8170
Pen and color-wash
57.5 x 27.9 cm

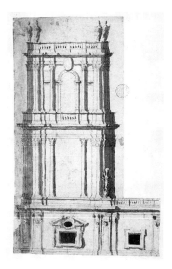

13 T
Carlo Rainaldi (?)
Elevation of Bernini's South Tower in St. Peter's
1645
Vatican, Biblioteca Apostolica Vaticana, Vaticano latino 13442, fol.1r.
Graphite, brown wash on white paper
49 x 31.4 cm
BIBLIOGRAPHY: Brauer and Wittkower 1931: 39–42; Kieven 1993: 156, no. 52; McPhee 1997: fig. 101

This elevation drawing, attributed to Carlo Rainaldi (Kieven 1993: 156), was made in 1645 and shows the bell tower Bernini built above the southern end of the façade of St. Peter's. The tower rises in two levels above a portion of Maderno's attic, the first level articulated with Corinthian columns and a trabeated opening at

center, the second with composite columns and an arch. The tower is capped at the summit by a balustrade on which four figures stand. The two lower levels were built according to Bernini's design. The balustrade and statues replaced a third storey and helm, rejected by the pope when they were unveiled in June 1641.

The date of the sheet can be deduced from the fact that it is contained in a volume held by the Vatican library, in which many of the drawings surviving from the bell tower competition of 1645–46 are collected. The volume is likely to have belonged to Virgilio Spada, Pope Innocent X's advisor in matters architectural, as it accords with an album listed in an inventory made after his death (McPhee 1997: 260), and has the same binding as two other volumes in the Vatican library which were certainly his (Ehrle 1928: 1).

The drawing appears to have served as a visual reference during the discussions of 1645. A more precise date is suggested by the fact that it is closely related to a second image, appearing on folio 21r of the same album, which shows a rendering of Bernini's tower in pen above the same portion of Maderno's attic. The attic section in this case, however, is not drawn but cut from the Greuter engraving of Maderno's façade. On 9 October 1645 architects invited to present alternative proposals for the bell tower did so using the Greuter engraving as a template, cutting away Maderno's proposed towers and replacing them with their own designs. This shorthand method provided a visual anchor to the extant building and an instant sense of scale. The drawing illustrated here reproduces that hybrid at a larger scale, consistent with other proposals in the volume, suggesting continuing discussion at a slightly later date.

The attribution of this drawing to Rainaldi (Kieven 1993: 156) has been made on the basis of style. Because the drawing represents a survey of Bernini's extant tower, it has led to the assumption that Rainaldi played an orchestrating role in the bell tower competition. One should be cautious here, for although Rainaldi was an active competitor, there is no contemporary evidence to support the idea that he played any kind of administrative role. SM

14 T
Gaspare Morone (or Morone Mola)
Medal for Piazza San Pietro in the Vatican
1661
Munich, Staatliche Münzsammlung
Silver
4.3 cm diam.
On the obverse of the medal, the northern arm of the colonnade; in the upper half of the

medal, the plan of the whole square on a scroll. "FUNDAMENTA EIUS IN MONTIBUS SANCTIS" (*Ps.* 86.1; along the upper border); below: MDCLXI

INSCRIPTIONS: On the reverse, the left profile of Pope Alexander VII (1655–1667) with tiara "ALEXAN. VII. PON. MAX. A. VII"; the artist's initials below: G. M. (Küthman and others 1973: 203–231. Cfr. Whitman and Varriano 1981: 102 and for a discussion about the original date of the image [1657–1659]; see also Varriano 1984: 71)

15 T–M
Gaspare Morone (or Morone Mola)
a) Medal for Piazza San Pietro in the Vatican 1666
Munich, Staatliche Münzsammlung
Silver; 4 cm diam.

b) Medal for Piazza San Pietro in the Vatican 1666
New York, The American Numismatic Society
Silver; 4 cm diam.
On the obverse, a bird's eye view of the square, the Basilica and surroundings "FUNDAMENTA EIUS IN MONTIBUS SANCTIS" (p. 86.1).
INSCRIPTIONS: On the reverse, the profile of Alexander VII with tiara along the border: "ALEXAN. VII. A. XII". The artist's initials below: "G. M." (Whitman, Varriano 1981: 103, for the origin of the image [1658–59]; Varriano 1984: 71).
BIBLIOGRAPHY: Brauer, Wittkower 1931: 84–87; Wittkower 1949: 129–34; Thoenes 1963: 97–145; Hager 1967–68: 201–02, 207–08, 214, 245, 252 pl. 181, 289, 303–304 doc. VIII; 1968: 239–314; Hibbard 1971; Küthmann, Overbeck, Steinhilber, Weber 1973: 227–28, 230–31; Kitao 1974: 49–66; Whitman, Varriano 1981: 99–103; Bauer 1984: I, 68–81; Varriano 1984: 68–81; Menichella 1985: 18–21; Krautheimer 1987: 99, 103, 187–88; Carloni 1992: VIII, part II, 654–91; Hager 1995–97: 337–60; Marder 1998: 127–49

Alexander VII turned his attention to the square of St. Peter's less than a year after his election to the papacy, 7 April 1655. On 31 July the commission to Gian Lorenzo Bernini was made official. This meant that none of the projects designed by Carlo Rainaldi under Innocent X were to be executed (Kitao 1974: 7, 86, no. 31; Marder 1998: 128). Instead, Rainaldi was entrusted with planning the second most important square in Rome, Piazza del Popolo (Hager 1968: 202, no. 35). A plan by Borromini for the square of St Peter's was also dropped (Sladek, under preparation). To begin at the beginning, after all the well-known, quickly discarded, attempts of trape-

zoidal, rectangular and circular plans, Bernini came up with an oval form before 17 March 1657 (Brauer, Wittkower 1931: 64–102). The architect himself specifies that it was actually the pope's idea (Marder 1988: 36). There was no colonnade as yet but an arcade, first with one, then two, passages (Kitao 1974: 15–17, pl. 17). This idea too was rejected and the arches replaced with coupled coloumns.
On 28 August 1657, Gaspare Morone cast two medals for its foundation (Withman, Varriano 1981: 99–100; Varriano 1984: 71, figs. 4i–j). The two medals show coupled columns and the "third arm" on a straight plan; the difference between them is that one shows only a single fountain, placed on a perpendicular axis. It is obviously a first project for transferring the fountain that Carlo Maderno had erected for Paul V in 1614, which was in the right (north) part of the square, to the north-east of the obelisk (Hibbard 1971: 62–63, 200–201, pl. 58a). However, this idea, already thought of by Papirio Bartolio in about 1620 (Marder 1998: 127, pl. 106) must soon have been abandoned because, in the second medal, there is not one fountain, which would visually have covered the base of the obelisk for those entering the square through the "third arm," but two, placed on the transverse axis of the oval. Therefore, the definitive solution, which was to be adopted almost a decade later, had already been proposed by this date (Withman, Varriano 1981: 108; Hager 1995: 357, no. 19).
With five bays in the "third arm," these two medals differ from a project in the Vatican Library, which shows only four bays crowned by a balustraded attic with statues, in the middle of which there is a shield for the papal arms (Carloni 1992: 656, 678, pl. 26.1). The straight plan of the pronaos seems to recall the initial state of the project, depicted by a sketch published by Kitao (1974: 12–14, pl. 15), where a square with semicircular sides was proposed for the Piazza instead of an oval. Alexander VII was responsible for the design of the two 1657 medals. It should be noted that there are only two passages in the colonnade (Marder 1998: 138–39, fig. 121).
In the autumn of the same year, this stage, too, was superseded by a plan with single columns (Varriano 1984: 71, 4-k), which facilitated the alignment on the peripheral circles and the axial orientation toward certain focal points in the square. It also offered the advantage of passages through the colonnade, whose aim was to welcome visitors into the square and not be a barrier tending to separate what was inside from the external world. This permeability was perceptible in the 1661 medal, conceived along one of the sight lines for whoever is in the square (Whitman, Varriano 1981: 102), and in Falda's view of 1665 (Hager 1995: 345).
Further modificatons were made during construction of the northern half of the arcades, begun in 1658 under the supervision of Marc'Antonio de Rossi (Menichella 1985: 18-20). These involved the side entrances and elaborating the end faces of the arms, treated in the same way, with specific measures in the coupling of pilasters, or of pilasters with projecting columns (Brauer, Wittkower 1931: 80, 82).

These details can be seen in Giovanni Battista Bonacina's famous engraving of 1659 (Kitao 1974: pl. 60), preceded by a still existing preparatory drawing, and by another highly accurate medal by Gaspare Morone of 1666, which was intended to update his preceding ones of 1657, although it would seem a bit late for what it portrays. This would lead one to surmise that it was either one of the usual annual medals or, more probably, that it was commissioned in view of the imminent completion of the northern arm (Whitman, Varriano 1981: 103; Varriano 1984: 71, 81 pl. 4-m).
The square has been drawn from a bird's-eye view, like the other two medals commemorating the foundation, and also consonant with topographical maps of the time. As Varriano (1984) has pointed out, the "third arm" is convex, following the curve of the perimeter of the colonnade. It had already been depicted like this on the scroll of the 1661 medal (Varriano 1984: 4-l), where, however, it lacks the central projection present instead in Bonacina's plan of 1659; this form of projection appears in the medal, however, with single columns and only at the internal, side entrances in the middle of the two wings of the colonnade. Instead, the 1666 medal depicts double columns projecting at the sides of the central entrance of the "third arm" and on the terminal ends of the arms of the colonnade; this detail was apparently established for the "third arm" only in the planning stage represented by Bonacina's plan. Not even this can still be considered definitive for all the details and neither can the 1666 medal, which is identical to it, as far as is technically possible. In both cases the pediments, which crown the ends of the colonnade, are characteristically missing from the "third arm," while they are present in Falda's view of 1665. Here the ends of the wings and the "third arm" seem almost identical: the pediments function as crowning elements to a tetrastyle structure, which gives access to the three passages; the centre one being wider and flanked by columns. The only difference in Falda's engraving lies in the columns projecting on the end sides, which make the tetrastyle entrance appear as a projection; this arrangement would have been inappropriate for the "third arm" due to its shortness from the sides to the central entrance.
Bonacina in 1659, and Morone like him in 1666, show four bays of column on each side of the central projection; they are still close therefore to a plan by Bernini's workshop in the Vatican Library where the bays of the columns flanking the entrance were still only three (Hager 1995: 350–51, pls. 26 and 27). Falda's 1665 view, which shows the "third arm" as "equivalent" to the lateral ones, seems therefore to represent Bernini's last word; well understood while the "third arm" remained on the perimeter of the oval. The problem of the "third arm" soon came to a head, beginning when the pope decided to give precedence to paving the square in 1667. At this point, Bernini, convinced of the need, due to optical reasons, for a smaller square before the entrance to the "piazza Obliqua," moved the "third arm" outside the perimeter of this square and into Piazza Rusticucci, as a structure in its own right on a rectilinear plan, like a triumphal

arch. Initially, like the colonnade, it was only one storey; his final idea, conserved in a sketch, showed an added level (Wittkower 1949: 129–34; Kitao 1974: 49–56, pls. 68, 71–74). On Alexander VII's death in 1667, the southern arm of the colonnade was also finished, but the pope did not live to meditate over his architect's final ideas; nor over the much more radical ones of Carlo Fontana, which were published in 1694. Neither the former nor the latter were executed. Clement XI (1700–21), toward the end of his pontificate, meant to return to Bernini's concept of the "third arm" on the oval perimeter, but the problem of the Maestro's authentic project emerged. Those responsible in the Fabbrica believed they were helping the pope by unearthing two drawings (no longer recoverable), believed to be by Bernini; they were translated into a model in 1720, which presented two alternatives, instead of a single project. The left side seems to be based on a project close to the one represented in Falda's view, with a triangular tympanum, while the right side seems to recall the one in the above-mentioned plan in the Vatican Library (Hager 1995: 349–51). The triangular tympanum with the pope's arms above the entrance seems to be an addition from Clement XI's period. A further drawing, also from this period, recently discovered by Rosella Carloni at Matelica (1992: 659, 684, figs. 26–28), returns instead to a rectilinear form, possibly in view of a position advanced towards Piazza Rusticucci, and emphasizes a clock motif above the central entrance. In 1721 Clement XI's death brought an end to research and execution, although we do not know of which of these alternatives. The brief pontificate of his successor, Innocent XIII (1721–24), not only frustrated any progress in building, desired by the pope too, but left the situation unresolved for ever. If it had been realized, the "third arm" would have returned on to the perimeter of the oval, as planned originally by Bernini. (Hager 1995: 351.) The medal dated 1661 was used on 9 December of that year by Cardinal Girolamo Gastaldi in the foundation ceremony for Santa Maria dei Miracoli in Piazza del Popolo (Hager 1968: 207, 303–304, doc. VIII). HH

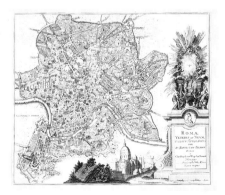

16 M
Christoph Weigel (1654–1725)
A map of modern Rome, with a view of St. Peter's Basilica, 1719
Montreal, Collection Centre Canadien d'Architecture – Canadian Centre for Architecture

10 M
Jean-François-Thérèse Chalgrin
Interior of Saint Peter's in Rome
New York, The Pierpont Morgan Library
Pen and brown ink, gray and brown wash; 41.9 x 29.4 cm
INSCRIPTION: "Chalgrin fecit Romae 1763" (lowef left)
PROVENANCE: Charles Fairfax Murray; J. Pierpont Morgan
EXHIBITIONS: *Exploring Rome* 1989 (1993–94): 189, no. 107
BIBLIOGRAPHY: *Artistes en voyage* 1986: no. 12

Student of Boullée and later of Servandoni, Chalgrin (1739–1811) was awarded the Grand Prix for architecture in 1758, and left for Rome the same year, where he remained until May 1763. Upon his return to Paris, he obtained a number of large commissions in the capital. In 1765, he was put in charge of the construction of the church of Saint Philippe-du-Roule. In 1775 he was put in charge of finishing the façade of Saint-Sulpice and the circular chapels beneath its towers, and was named architect of Monsieur le compte de Provence.
This drawing, which dates from the early months of his stay in Rome, is comparable to any number of views of the interior of St. Peter's carried out by French painters and architects who passed through the Eternal City. Amongst them, depictions of the basilica during the ceremony of the Illumination of the Cross – which took place on Good Friday – stand out. This exceptional event, filling the grandiose space with dramatic lights and shadows, caught the particular attention of Louis-Jean Desprez. He captured the rite's mysterious dimension with great panache in color-highlighted engravings (London, Royal Institute of British Architects) and drawings (Louvre and National Museum of Warsaw), which give some idea of his talent as a set-designer – on the basis of which he was appointed to the Swedish court as theater architect and decorator. The Louvre possesses a drawing on the same subject by Victor Louis (from the former Mariette Collection), and the Besançon Musée des Beaux-Arts has another by Pierre-Adrien Pâris. Chalgrin too was fascinated by the ceremony, which he depicted in another drawing very closely resembling the New York sheet, nevertheless adopting a slightly different point of view on the casement and the canopy (*Artistes en voyage* 1986: no. 13).
This carefully yet quickly drawn view is less concerned with the accuracy of architectural description than with capturing the general lines and the contrasts of space and light. The framing emphasizes the arches and their cornices, the dome, as well as the canopy. In all these aspects, the drawing exhibits close analogies with a sheet attributed to Desprez (Bowdoin College, see *Old Masters' Drawings...* 1985: no. 92). It must thus be seen in the context of the fascination Bernini exerted on French artists in Rome between the mid-1750s and the 1780s – one of the most eminent of whom was Charles de Wailly (see Rabreau and Gallet 1971 [1974], and *Charles de Wailly* 1979). ALPDS

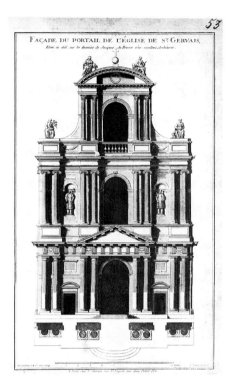

17 T
Salomon de Brosse, architect (ca. 1571–1626); Claude Lucas, engraver
Church of St. Gervais, Paris
Elevation of the West Façade
1718
Paris, Bibliothèque Nationale de France, Cabinet des Estampes Va
Engraving
BIBLIOGRAPHY: Blondel 1752–53: II, Book IV; Dumolin 1933: 45–56; Brochard 1936; Boinet 1962: 380; Coope 1972: 135–46, 266–67; Minguet 1988: 142

Notwithstanding it now looks like a polite essay on the orders, the façade of St. Gervais was a bold challenge when it was designed by Salomon De Brosse (ca. 1571–1626) in 1615–16 (construction was finished by 1622). Like most Gothic churches, St. Gervais had been under construction for over a century. The nave was begun in Gothic flamboyant style, but absorbed Renaissance elements in the later sixteenth century, and the last three bays of the nave were built in the early seventeenth century and sealed with a provisional façade. In 1615, the churchwardens, or *marguilliers*, resolved to build a proper façade. After selecting a design, they commissioned an enormous wooden model, almost fourteen feet tall: "Sur lequel desseing pour plus grande sureté et plus facilement exécuter lesdicts ouvrages lesquelz sieurs marguilliers auroient faict faire ung modelle de treize our quatorze pieds" (Coope 1972: 135). The model survives in excellent condition in the baptistery chapel, the first chapel on the left, where it is normally in shadow and difficult to see, yet this impressive structure deserves to be recognized because it is one of the oldest surviving French models and it embodies the ambitions of French architecture in the early years of the

seventeenth century. The fact that it was necessary to test the validity of the scheme in a large-scale model indicates how unfamiliar and risky the design seemed. Given the interest in classical design, it is not surprising that the two *marguilliers* in charge were leaders at court: Jean de Donon, *contrôleur général des bâtiments du roi*, and Jean de Fourcy, *surintendant des bâtiments du roi*. These men helped to implement the royal building program under Henri IV and continued their responsibilities under the Queen Regent Maria de Médicis, who in those years was building the Palais du Luxembourg by Salomon De Brosse.

Donon and Fourcy hired De Brosse for their church façade. Located between a neighborhood of fine *hôtels* and the commercial center of the city, just east of the Hôtel de Ville, St. Gervais was on the route of civic and religious processions.

The royal officers saw an opportunity to project their church on the urban landscape. They wanted the façade not of a parish church, but of a bold and stylish monument.

The design problem was familiar in France: how to adapt classical forms to the extreme height of a Gothic church? De Brosse's stacking of Doric, Ionic, and Corinthian columns is so effective that it takes time to realize how tall the façade is; it rises over 130 feet. This was not the first time a French architect had explored the vertical relationship of the orders: Philibert Delorme's frontispiece at Anet was the prototype in secular architecture, yet whereas the delicacy and refinement of Delorme's forms manage to recuperate something of the Gothic effect, De Brosse's façade is massive, intimidating, and austere. In this way, the façade of St. Gervais provoked a rupture with the Gothic aesthetic.

The composition of St. Gervais reveals a sculptor's appreciation for plastic form: the cornice breaks forward and recedes in different ways on each level; the columns become more graceful as they rise (perhaps the Doric order is so bulky as to accentuate this tapering effect); and the central bay recedes further at each level, from pediment to a receding entablature and scooped-out pediment at the top. De Brosse's most ingenious decision was to treat the two lower floors as a nearly square block; this basic shape and the pronounced horizontality of the Doric frieze and row of projecting Ionic columns mask the vertical proportion of the Gothic church behind.

The young François Mansart must have found this building thrilling, not just for what it dared to do but also for how it failed. De Brosse could not sustain the rhythm of square metopes and inserted rectangular ones between coupled columns, which in turn produced glaring problems in the spacing of the mutules. This inconsistency is the most obvious of several weaknesses in De Brosse's handling of the orders and precisely the sort of problem Mansart rejoiced in resolving at Blois and Maisons. Mansart's first work, the church façade of the Feuillants is most explicitly indebted to St. Gervais, but generally speaking, De Brosse's building announced a theme

which Mansart brilliantly explored throughout his career, namely the systematic use of the orders to solve modern design problems.

The façade of St. Gervais may lack finesse, but it is an intelligent and effective design, and it marks a specifically French contribution to the Baroque age: the surprising marriage of Gothic proportions and classical forms. HB

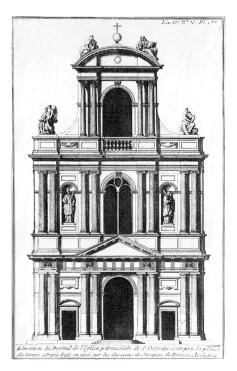

18 T
Anonymous
Church of Saint Gervais in Paris, elevation of the portal, in Blondel, *French Architecture*, 1752, tome II, IV, no. V, pl. 1
Washington D.C., Private Collection
Engraving
313 x 198 mm

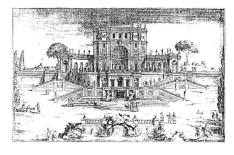

24 T–MAR
Alessandro Specchi (1668–1729)
Villa del Pigneto Sacchetti
invention by Pietro Cortona
in Giovanni Battista Falda, *Il nuovo teatro delle fabbriche e edifici in prospettiva di Roma moderna*, ed. A. Specchi, Roma 1699: IV, pl. 44
BIBLIOGRAPHY: Wittkower 1958 (Italian ed. 1972 and 1993); Noehles 1969a, 1969b; Merz 1990; Di Piazza 1997

Villa del Pigneto Sacchetti, built to a design by Pietro da Cortona for the banking family Sac-

chetti, was situated north of the Vatican, in the Valle dell'Inferno. Unfortunately, hardly any of it has survived.

However, numerous engravings, drawings and paintings show both the whole building and the various individual parts of it in views, ground plans and cross-sections, not all of which can be discussed here. Most of these, however, date from a time when the buiding had already been partly destroyed. Only two sketches in Pietro da Cortona's own hand have survived; these are connected with the grotto in front of the casino building (see the commentary on cat. no. 21).

The earliest known representation of the whole building is the present engraving by the architect Alessandro Specchi (1699), the designer of the (also ruined) Porto di Ripetta (1702–1705), whose curving ramps and stairways were clearly influenced by Pietro da Cortona's villa.

The well-known engraving by Giuseppe Vasi (made between 1747 and 1761) is just a copy of Alessandro Specchi's original. The finest sketch of this ensemble of fountains, grotto, stairways and casino in its organic setting in the landscape, built up step by step on the slope, is provided by Gaspar van Wittel (Vanvitelli), who is discussed in another part of this catalogue (see the contribution by Pete Bowron).

In all these representations the pictorial interest of the veduta is paramount. Ground plans and cross-sections made by the architect Pietro Bracci in 1719 (see cat. nos. 21, 23) and by Pier Leone Ghezzi in 1735 (see cat. no. 19) give a three-dimensional idea of the forms of the casino and grotto.

In the view shown by Alessandro Specchi (and therefore also by Giuseppe Vasi) there is a surprising inconsistency: the two double-sided stairways to the left and right of the grotto lead nowhere.

Did Alessandro Specchi perhaps not study the building *in situ*? At any rate, these pointless stairways do not appear in Bracci's later drawings.

The attractive arrangement of the ensemble on a slope is clearly related to Pietro da Cortona's proposed reconstructions of the Temple of Fortune at Palestrina of the years 1630–1636 (see cat. no. 27).

There, in his completion of an ancient complex, he strove for a decidedly classical style, as befitted his antiquarian purpose.

The Sacchetti Villa del Pigneto, by contrast, is modelled on sixteenth-century villa architecture, and in particular on Pirro Ligorio's Villa d'Este in Tivoli, with its naturalistic rock-fountains, pool, ramps, grottoes, and crowning casino.

But Pietro da Cortona masses this repertoire closely together to create a prospect which looks very much like a theater stage.

At the same time he translates the rigidity of the Mannerist model into the vigorously dynamic language of the High Baroque; this is most noticeable in the relationship between the convex curve of the stairway beside the grotto and the concave sweep of the lower

side-wing of the casino (compare also the ground plans by Pietro Bracci and Pier Leone Ghezzi).

It has been pointed out that the model here was the curved wing structures in the villas of Palladio (for example Villa Badoer, *I quattro libri*, II, 48).

But in the parabolic curve Pietro da Cortona creates an impression of something both frail and dynamic.

These freely curving stage wings contrast with the static middle block of the casino, and especially with the strict form of the large apsidal niche in the centre of the building, which introduces a solemn, almost sacral accent to this prevalently joyous ensemble; a motif which clearly alludes to the "Nicchione" of the Vatican Belvedere.

Earlier scholars assigned the design and the actual construction of Villa del Pigneto Sacchetti to a date ca. 1630, on the evidence of a number of sometimes contradictory sources.

The archives consulted by Merz (1990), however, indicate that construction did not begin until late 1638, that the first parts to be built were the fountain and grotto, and that they were erected in front of an already-existing country house (Casaletto Pius V).

According to Merz, it was only during a later phase of construction (from the year 1648 onward) that the house was incorporated into a modification and extension of Pietro da Pietro da Cortona's original composition (see cat. no. 21).

But it is likely that the overall design had already been drawn up before the work on the grotto began, for the grotto is an integral part of the conception of the whole ensemble.

Undoubtedly Villa del Pigneto Sacchetti was much smaller than it is shown in Alessandro Specchi's engraving and in all other later representations (some of which are listed in Noehles 1969a: note 48).

The maximum extent of the casino was only 172 Roman palms (37.9 m). Pietro da Cortona's rival Gian Lorenzo Bernini is said to have sneered: "Little Pietro wants to build a Christmas crib."

However, his remark is also aimed at the markedly theatrical appearance of the work. It is no coincidence that a design of a stage set from Pietro da Cortona's circle uses the villa as a background (Noehles 1969a: fig. 16), while the wings recall the Quarantore scenery of 1633, also designed by the architect Pietro da Cortona.

The high regard in which the perspective effect of Pietro da Cortona's architecture was held in the eighteenth century is demonstrated above all by Nicola Salvi's display wall of the Trevi Fountain (1732–62), which varies the theme of the monumental niche in combination with a fountain.

Nicola Salvi, however, emphasizes the resemblance to triumphal-arch architecture more strongly than Pietro da Cortona. The theatricality of the layout is emphasized by the emergence of the figure of Neptune from the depths of the space.

KN

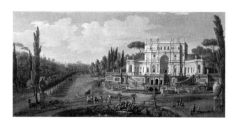

20 T–M
Gaspar van Wittel (1652/53–1763)
View of the Villa del Pigneto Sacchetti near Rome, ca. 1720–30
Rome, Marchese Sacchetti
Oil on canvas; 47 x 97 cm
PROVENANCE: Rospigliosi family, Rome
BIBLIOGRAPHY: Briganti 1966: 214, no. 121; *Fasto Romano* 1991: 132, no. 42; Briganti 1996: 202, no. 195, with earlier bibliography

Pietro da Cortona's earliest work in the field of architecture and large scale decoration was carried out for the Sacchetti family in a seaside villa near Ostia. Toward the end of 1623 or the beginning of 1624, Cortona became the favored artist of the Sacchetti, a Florentine family whose members held important posts under Urban VIII, and introduced him to the Barberini family. From 1625 to 1629 Cortona directed the building of the Villa Sacchetti (now Chigi) at Castel Fusano, which he also decorated with a team of artists. In 1631 the family acquired land for their Villa del Pigneto in the so-called Valle dell'Inferno, northwest of the Vatican walls. Around 1638 Cortona added a grotto and fountain to an already existing casino on the property and between 1648 and 1650 he remodeled the whole complex (Merz, Blunt 1990).

The villa was set into a hillside and used a system of ramps and terraces to allow visitors to ascend to the level of the central casino. Cortona broke with the standard Roman format of villas in the form of porticoes with corner towers and returned to Bramante's exedra in the Cortile del Belvedere. The casino's most memorable features – the monumental niche in the façade and the curving flights of steps – also reflects motifs from ancient Roman architecture, such as the Temple of Fortuna Primigenia at Palestrina. The large semicircular rooms at either side of the casino are based on the solaria of ancient baths. "A showpiece in the best sense of the word," the casino expresses "the tone of lively, eclectic invention" that characterizes all of Cortona's architecture" (Connors 1982: I, 455–56).

Nearly nothing remains of the Villa del Pigneto; only the grotto was left standing by modern times, and that was destroyed in World War II. Da Cortona's scheme for the villa complex is known only from old prints, plans, and painted views, the finest of which is this painting by van Wittel (1652/53–1736), the great innovator and, for all practical purposes, inventor of view painting in eighteenth-century Italy. Van Wittel's view is itself a "reconstruction" of the villa, based in part on an engraving of 1699 by Specchi (G. B. Falda, *Il primo libro del nuovo teatro delli Palazzi in prospettiva di Roma Moderna*, IV, Roma, A. Specchi 1699: pl. 44, where the casino is described as in ruins).

EPB

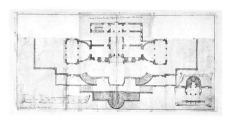

21 M
Pietro Bracci (1700–1773)
"Ground Plan of Palazzo al Pigneto [...] by Pietro da Cortona"
1719
Montreal, Collection Centre Canadien d'Architecture – Canadian Centre for Architecture
DR 1966:001:109
Black pencil, gray color-wash; 40.4 x 85.7 cm
BIBLIOGRAPHY: Merz 1990; Di Piazza 1997

As on the drawing of the façade (see cat. no. 22), Bracci again affirms that he made his drawing *in situ*. Presumably his ground plan of the villa is on the whole more accurate than his elevation. At any rate, he can give a credible representation of the rear façade of the casino, including the position of the staircase. For P. L. Ghezzi (1735) this was no longer possible (see cat. no. 19).

Ghezzi's plan, however, has the advantage of making clearer the position of the grotto below the casino. Ghezzi also made an extremely detailed drawing of the grotto in ground plan and longitudinal section (not in the exhibition; Merz 1990: fig. 6). Evidently this part of the building was still very well preserved in 1735. On the basis of these drawings it was possible to identify two holograph drawings by Cortona as sketches of the grotto (Merz 1990: fig. 4 and 5 and V; Di Piazza 1997: cat. nos. 7, 1 and 2). One of the two sketches has on the *verso* a preliminary sketch of Lascivia for the picture of Temperanza in the great fresco in the Salone of Palazzo Barberini.

Therefore it may be taken as certain that the two sketches of the grotto date from ca. 1638 (Merz). However, it is very unlikely that these were sketches for the grotto made before it was built.

Quite clearly, Cortona is using these sketches to try and assess the effect of the ensemble after its completion, rather as he did in 1637 in the case of the still unfinished building of Santi Luca and Martina (Noehles 1969b: fig. 91). There, too, he used the *verso* of the leaf in his notebook for a sketch of a figural composition. One of his sketches of the grotto gives a view into the conch of the nymphaeum with the four columns and the spring, the other shows the view out from the grotto through the triumphal arch in front of the building and into the wooded landscape. Here he is the quintessential painter, capturing the optical appearance of his architecture.

In Bracci's ground plan some walls are shown in a darker color. Merz, perhaps rightly, sees this as an indication of two different building-periods.

Possibly the more darkly drawn walls belong to the older, sixteenth-century building, which

434

Cortona had to incorporate in his plan. Presumably his chief modification to the existing building lay in considerably thickening the front wall, so as to form an avant-corps and make it possible to build the "Nicchione" into it (Merz).

Moreover, he adds to the central block the two lateral wings with their apses and porticoes, the shape of the wings resembling that of the grotto.

Thus he creates a joyously relaxed setting with a classical atmosphere. The lateral wings, in particular, make Villa del Pigneto a sort of "maison de plaisance" *avant la lettre.* KN

enna, Graphische Sammlung Albertina, Rom LVII, nos. 1271 and 1274). So Bracci has altered the overall proportions of Cortona's architecture: the central block undoubtedly towered more dominantly above the curving wings. Specchi's representation is therefore more authentic in this respect. Evidently the real form of Cortona's architecture no longer corresponded to the eighteenth-century taste of Bracci. It is significant that in the sometimes free reconstructions of the classicists Percier and Fontaine (*Choix des plus célèbres maisons de plaisance de Rome et de ses environs* [...], Paris 1809) the villa is depicted with Bracci's proportions. KN

However, in the architectural detail he seems to be striving for an accurate reproduction of what remained of the building. On the left of the drawing, where he shows the section through the "Nicchione," Bracci gives a larger-scale drawing of the outline of the entablature. The actual entablature (without the consoles and capitals with the *mutuli*) was very similar to that of the interior of the church of Santi Luca e Martina (Noehles 1969b: fig. 269). At the bottom right Bracci shows another architectural detail at twice the scale of the elevation. This is the statue niche, with the side wall broken up by pilasters. KN

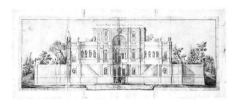

22 M
Pietro Bracci (1700–73)
"Prospect of Palazzo Sacchetti al Pigneto [...] by Pietro da Cortona", 1719
Montreal, Collection Centre Canadien d'Architecture – Canadian Centre for Architecture
DR 1966: 001:098
Black pencil, gray and multicolored wash
28.5 x 82.3 cm
BIBLIOGRAPHY: Gradara Pesci 1924: pl. XXXVI; Merz 1990: fig. 16

It is no coincidence that the sculptor Bracci devoted a period of intensive study to Villa del Pigneto in his youth. In Montreal there are six architectural drawings of the villa in his hand: the frontal view presented here, a ground plan (no. 21), a cross-section through a middle portion (no. 23), and three further cross-sections of the building (the view was first published by Gradara Pesci, the others have been published by Merz). Although Bracci declares in a note that he drew his picture on the spot ("in Faciem Loci delineavit"), he departs from the true appearance of the building in his day. However, the absence of those questionable stairways on the right and left in front of the parapet of the main terrace, which are such an irritating feature of Specchi's engraving (no. 24), is correct. But his drawing differs from Specchi's 1699 representation in showing the central block of the casino without the attic storey, and surmounts the upper floor with two alternative solutions, a ledge on one side and a balustrade on the other. However, the higher storey in the left-hand version (without balustrade), as well as a full attic storey above it, must have been still clearly recognizable in his day. As late as 1735 Ghezzi drew the window "with complete accuracy" in the same proportions as the left-hand version (*Exhibition of Architectural and Decorative Drawings*, The Courtauld Institute, 1941, no. 16, without illustration; on Ghezzi see no. 19). Moreover several *vedutisti* who give portrait-like renderings of the building at later dates leave no doubt as to the presence of a mezzanine floor above this window (e.g. Anonymous, washed pen-and-ink drawing, Vi-

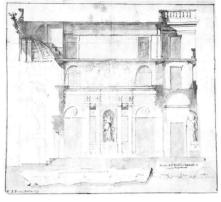

23 M
Pietro Bracci (1700–73)
Cross-section along the Central axis of the Casino of the Villa del Pigneto
1719
Montreal, Collection Centre Canadien d'Architecture – Canadian Centre for Architecture
DR 1966:001:59
Black pencil, gray wash
37.7 x 42.7 cm
BIBLIOGRAPHY: Merz 1990

Pietro Bracci shows a cross-section through the middle of the casino from the "Nicchione" of the façade, with the coat of arms above it, through the central room to the rear vestibule with its statue niche. The wall structure of the hall corresponds to the ground plans drawn by Bracci himself and Ghezzi. To what extent the ornamental details are authentic is uncertain. Much of the villa must have already been in ruins by 1719. As was explained in the discussion of the front elevation (cat. no. 22), Bracci was not sure about the shape of the attic floor and left it out. In this drawing, too, the third floor is missing. Presumably there were no longer any statues in the niches. At any rate, the style of the figures shown here corresponds to that of Bracci's own sculptures. Similarly, the decoration which is suggested on the surface of the barrel vaulting can hardly be a fresco by Cortona, as one would expect. The unstructured sprawl of hovering figures in illusionary space is uncharacteristic of him. Bracci adds things that were missing and changes things that had been poorly preserved, and evidently did so in conformity to his own eighteenth-century aesthetic.

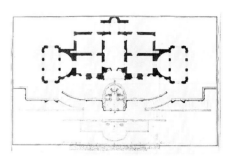

19 T
Pier Leone Ghezzi (1674–1755)
Plan of Villa del Pigneto Sacchetti by Pietro da Cortona
1735
London, Courtauld Institute of Art, Gallery, Inv. no.: Blunt no. 34
Brown ink and gray brush-strokes
35.5 x 58.7 cm
PROVENANCE: Formerly in the collection of Anthony Blunt
BIBLIOGRAPHY: Noehles 1969a: fig. 14 and 1969b: fig. 16; Merz 1990: fig. 11

The painter Pier Leone Ghezzi, chiefly known as a caricaturist, did some drawing in the grounds of Villa del Pigneto as early as 1727. In that year he made a virtuoso brush-drawing of the mausoleum of a donkey set in a beautiful landscape (Düsseldorf, Kunstmuseum, Graph. Sammlung, no. 3302). When he again turned his attention to the villa in 1735, he made an accurate drawing of the monument and narrated its history. The Sacchetti had buried, or pretended to bury, the faithful beast in an ancient sarcophagus, on a monumental substructure designed by Cortona (Incisa della Rocchetta, in *L'Urbe*, 3, 9–16; Merz 1990: 402–403, fig. 17). Droll though it may seem, this monument is extremely characteristic of the cultural climate of the Sacchetti circle in which Cortona worked.

The ground plan of casino and grotto presented here was drawn at the same time as the separate larger-scale plan and cross-section of the grotto (see cat. no. 21). There he states that he made these drawings on 8 October 1735 because no plan of the villa could be found in the Sacchetti house or anywhere else. Therefore he did not know Bracci's drawings or the ground plan by Filippo Juvarra (Biblioteca Nazionale di Torino, Riserva 59, vol. 4, 12 bis), on the *verso* of which is a drawing of the mon-

ument to the donkey (cited by H. Millon, *Filippo Juvarra*, Rome 1984: XVII, note 43). Juvarra had studied the building and measured it very precisely, as he had done with Cortona's church of Santi Luca e Martina. He made creative use of the motif of the concave wing in his own designs, with a multitude of variants. This ground plan (which only shows the right half of the building) is undoubtedly the earliest of all the drawings discussed here. It confirms, however, that the drawings of Bracci and Ghezzi give a correct plan of the villa in all important respects. KN

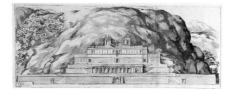

27 T
Pietro da Cortona (1597–1669)
Design for the Reconstruction of the Temple of Fortuna Primigenia at Palestrina
1630–36
Windsor Castle, Royal Library, Inv. no. 10384
Lent by Her Majesty Queen Elizabeth II
Black pencil, brown and gray ink, color wash;
45.0 x 103.84 cm
BIBLIOGRAPHY: Wittkower 1935: 137–43; Noehles 1969b: fig. 26; Kieven 1993: cat. nos. 47 and 48; Merz 1993: 409–50

The ancient Mount of Temples at Palestrina had already fascinated the architects of the sixteenth century: Pirro Ligorio, Palladio, and others drew more or less free reconstructions of the vast terraces. When Taddeo Barberini, after his accession to the principality of Palestrina (1629), began to renovate the baronial palace, which was situated on the top level of the temple, there was a revival of archaeological interest in the original form of the temple. This suited the antiquarian ambitions which had long been cultivated by the members of the house of Barberini. Between 1630 and 1636 Pietro da Cortona drew a series of large-format reconstructions of the whole Mount of Temples: there are extant drawings in Berlin, Kupferstichkabinett (KdZ 26441), in London, Victoria and Albert Museum (Inv. no. 92 D 46 / E 3006-1937), and the present one, in Windsor Castle. But there must have been other variants in his hand, for the archaeologically oriented work of the Jesuit J. M. Suares, *Praenestis antiquae libri duo*, Rome 1655, used sources which are not identical with the surviving drawings.
The scholarly study of Cortona's reconstructions began with Wittkower's 1935 essay; the most comprehensive discussion to date is that of Merz 1993. In the case of Cortona, of course, the term "reconstruction" does not mean that he attempts to produce an archaeologically accurate rebuilding of the ancient temple. Rather, he sketches a utopian, idealistic vision of the ancient temple, basing his design on historical sources, on earlier reconstructions (especially those of Palladio), and

on the state of the site as it was in his day. There is a nice balance between the struggle for antiquarian accuracy on the one hand and the desire for creative originality on the other. In this respect Cortona's reconstruction work is a forerunner of Fischer von Erlach's *Historischer Architektur* (printed in 1721). Clearly, Cortona owes much of the historically oriented approach in his project to Vincenzo Scamozzi's *L'idea dell'architettura universale* (1615). But despite his idealistic flights, Cortona seems to have considered the real possibility of using the reconstructed temple as a residence for the Barberini, as a palace in the classical style (Merz). His main models must have been the villas at Tivoli and Frascati, which were both built on slopes. More clearly than this drawing from Windsor Castle, the sketch in London (Kieven, cat. no. 48; Noehles 1997, cat. no. 112) shows that he followed the system of rising ramps and terraces with pools of water used at Villa d'Este; but through the classicism of the architectural structure he strives to do justice to his archaeological objectives. In his Villa del Pigneto (cat. nos. 20, 24), which has unfortunately not survived, Cortona planned a modern version of architecture embedded in nature, as a Baroque display. As Kieven 1993 rightly stresses, Cortona's Palestrina drawings are a remarkable example of his vision of a blend of architecture and landscape, an important achievement by the painter in the field of architectural design. KN

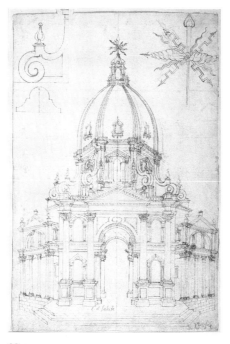

29 T
Unknown Artist
Façade of the Church of Santa Maria della Salute
Vienna, Graphische Sammlung Albertina, Inv. no. 298
Pen and dark ink
41.3 x 27.5 cm
INSCRIPTION: "C.d Salute" (at the base of the left-hand column of the portal)
EXHIBITIONS: *Venezia e la Peste*, Venice, 1980; *Longhena*, Lugano, Villa Malpensata, 1982

BIBLIOGRAPHY: Muraro 1977: XXI; Niero 1979: 307–308; Gemin 1982: 65; Biadene 1982: 106; Frank 1994: 196; Hopkins 1997: 455

This drawing shows the principal elevation and a foreshortened view of the lateral wings (minus the decoration of the niches on the latter). The lantern is crowned by a weather vane in the form of a knot of arrows (symbol of the plague). The attribution to Longhena advanced by Muraro (1977, XXI), is viewed with reservation by Niero (1979: 307–308) and Biadene (1982: 106). It has not been fully accepted by Gemin (1982: 65) or Hopkins (1997: 455), who are witholding judgment pending examination of the original drawing. Indeed, not only does the graphic technique not correspond to that found in other drawings that are firmly attributed to Longhena, but the differences with respect to the architect's thoughts as they emerge in his writings of 1631 (cat. no. 28) are too obvious; one need only note the "tabernacle" form instead of the paired windows opening out of the dome's drum, the small balustraded windows between the dome's ribs and the stairway with three instead of "thirteen steps to reach the level of the church." It is also curious that even Danese in his plan also shows only three steps (Frank 1994, 1996). Under such conditions, it is rather difficult to tie this sheet to the process of planning and constructing the church. It is legitimate to wonder hypothetically if it is not a surviving visual record of the wooden structure erected for the solemn procession of 21 November 1631 and recorded the same year by Ginanni in a pamphlet entitled *Liberatione di Venetia* (Niero 1979b: 306); this temporary installation may have been a free interpretation of the "model" publicly displayed after April 1631. According to Ginanni, this was shown again at the foot of the altar of the temporary church which was recorded in a now lost colored drawing by Longhena (Gemin 1982: 65). LP

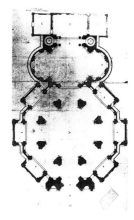

28 T
Baldassare Longhena (1597–1682)
Second Proposal for the Plan of the Church of Santa Maria della Salute
Rome, Congregazione dell'Oratorio di San Filippo Neri-Chiesa di Santa Maria in Vallicella, Inv. Cartella 2, VIII, disegno 170
Pen and ink retouched with blue watercolor;
71 x 44 cm
PROVENANCE: V. Spada (?), B. Castelli (?)
BIBLIOGRAPHY: Hopkins 1997: 460–63

The decision to erect a church in Venice dedicated to the Virgin, Santa Maria della Salute, who it was hoped would calm the plague that had raged through the city of Venice and the countryside since 1629, was taken by the Venetian Senate on 22 October 1630. This decision followed other attempts to obtain Marian intervention by means of imposing processional rites initiated by the patriarch Giovanni Tiepolo (for the history of the planning and actual construction of the church, see the fundamental contributions of Gemin 1982 and Hopkins 1997, which correct and complete all the preceding monographs on the topic, particularly those by Moschini 1842, Piva 1930, and Wittkower 1963, which though serious and undertaken with the best intentions are nonetheless lacking). With this gesture, the state confirmed its right to manage the religious as well as the political aspects of the city. It also gave new initiative to the "myth of Venice," in which the Virgin played a central role. This myth was also sustained by the annual combined celebration of the Feast of the Annunciation and the foundation of the city on 25 March (Hopkins 1997: 442–43).

A motion of 26 October charged three deputies with selecting a site for the church and provided for the superintendence of construction work. About two weeks later, on 7 November, eight sites had been individuated and by 23 November, the Senate was able to select one near the church of the Santissima Trinità and near the Dogana da Mar (Customs House). Although already occupied by older buildings, this site gave the new building a spectacular position dominating the *bacino* of San Marco. In connection with this, the Senate resolved on 3 December to entrust religious responsibility for the new church to the order of the Somaschi, founded in 1532 by Venetian nobleman San Girolamo Miani, and to employ the ambassadors from Florence and Rome in a search for architects and sculptors who could draw up plans and build a model of the church furnishings (on this point, particularly on the committment of Giovanni Pesaro, ambassador to the Vatican, see Frank 1998: 158–62).

The date for the placing of the cornerstone was set for 25 March 1631 (in the meantime, between 23 December 1630 and 2 January 1631 the demolition of the Scuola della Trinità was suggested). As a result of the grave illness that eventually killed Doge Nicolò Contarini, this deadline was immediately postponed until 1 April, when vice-Doge Giulo Contarini presided (for all of the above, see Gemin 1982: 194–221; Hopkins 1997: 444–46). Despite fear of being "poorly provided" with Venetian architects capable of taking on such an important project, the same fear that had prompted the search for Florentine or Roman masters, a competition was opened (probably as early as December 1630). Immediately following the ceremony for the laying of the cornerstone, eleven proposals awaited the judgment of the three deputies in charge of the construction site. They chose the proposal presented by Baldassare Longhena (Venice 1597–1682), which called for a central plan, as well as plans by Antonio Smeraldi (known as il Fracao), assisted by

Giambattista Rupertini for a longitudinal plan. They rejected proposals advanced by, among others, Matteo Ignoli, Bortolo Belli (Niero 1972) and Alessandro Varotari (known as Padovanino) (this can be seen in his painting of the *Madonna and Child* which was part of the temporary altarpiece built for the laying of the first stone and currently on display in the church of the Salute; it is illustrated better in the *memoria* accompanied with a sketch published by Dalla Santa in 1904). Longhena worked meticulosly and carefully. Not only did he build a model, which was put on public display in the Sala dei Pregadi in the Palazzo Ducale (this is depicted in the altarpiece of the *Madonna and Saints* by Bernardino Prudenti, now in the church of the Salute and also, with a few changes, in the engraving of Marco Boschini of 1644; cat. no. 35), but he also included a report and detailed estimate dated 13 April. His description of the church in the report – he emphasized his awareness of the symbolic content of the enterprise – noted that it was "in rotunda form, a new invention desired by many, of which there are no examples in Venice, ... the rotunda being in the form of a crown to be dedicated to the Virgin." At any event, it was just this *inventione nova* that created some perplexity, which was fomented by a polemic allusion to the construction difficulties incurred by having to vault a cupola with a central plan that Fracao and Rubertini made in the text that accompanied the submission of their project. When this observation was submitted to the judgment of eight *proti*, or foremen, who had been appointed for this purpose, Longhena's project received a negative opinion. The definitive judgment remained to be given by the Senate. Fracao, who had learned of the favor that Longhena's plan enjoyed in the Senate, rushed to present a central plan as an alternative to the longitudinal one he had already planned and designed, notwithstanding the reservations he had already expressed on this account. On 13 June 1631 the Senate decided by a large majority in Longhena's favor. In light of these events, Longhena was quick to publish a new report on his idea (Gemin 1982: 240–42), in which he postulated that in order to guarantee greater stability to the building, he would rework his original idea (see Gemin 1982: 28–171, *passim*; Hopkins 1997: 448–52).

When work finally began, another obstacle arose. Just after the vote in favor of Longhena, the placement of the church on the site of Santissima Trinità, which had already been approved, was revoked pursuant to doubts of the deputies. A close debate arose and Longhena produced yet another report in which he recapitulated the decisions already taken. Thus on 21 August work could resume under the direction of the architect. On 13 November 1631 it was decided to proclaim a solemn end to the epidemic with a ceremony in honor of the Virgin on the Feast of the Presentation the following 21 December. Doge Francesco Erizzo, together with the highest representatives of the nobility and the Senate, joined in a procession to the site of the church, where in honor of the occasion a "large wooden church" had been erected (as had been done for the laying of the first stone, Tassi-

ni 1915: 575; Hopkins 1997: 453–54; cat. no. 35). The condition that the Senate imposed on Longhena, which required him to adjust the plans as necessary throughout the course of the work, was put to the test almost immediately. In fact a request that the architect sent to the doge on 13 March 1632, in hope of obtaining an increase in his salary, reveals that after he sent "the design" for Santa Maria della Salute, "perfectly in accord with the site where the church was to be built," Longhena had undertaken an "obligation to adjust this model punctually" (Puppi 1983: 187–88). Now, if it is true that no graphic documentation of the original idea has come down to us, Longhena's writings dated 13 April and 13 June 1631 permit us to visualize and deduce well enough from the drawing exhibited here just what the first important adjustments that Longhena made really were.

Substantially, these modifications involved widening the walkway (apparently to give greater support to the weight of the dome), reworking the choir and better coordinating the design to the restricted land available at the site (for a circumstantial comparison among the initial design, the one shown here and the final spatial outcome, see Hopkins 1997: 454–59 Frank 1998: 168). LP

30 T
Baldassare Longhena (1598–1682)
Prophet and Sibyl for a Rib of the Dome of Santa Maria della Salute
Venice, Musei Civici Veneziani, Museo Correr, Raccolta Gaspari, I, 9
Pen and watercolor; 85 x 40 cm
EXHIBITIONS: *Longhena*, Lugano 1982
BIBLIOGRAPHY: Bassi 1962: 103; Bassi 1964: 3–7; Biadene 1982: 104, 14.1

When he summed up the state of construction of Santa Maria della Salute in 1679, Longhena noted that what remained to be done "on the interior of the dome" was to "stabilire [...] con ornamenti di stucco, e nel fondo di detti riquadri fare pitture a olio con armature delle colonnette insuso sostentate da appiccaglie, come si fece nel tempo che furono tolti li se-sti, e si fabricò la det-

ta cupola." This declaration is surprising in that the documentation relative to the process of finalizing and describing the building, yields no mention of provisions being made for the pictorial decoration of the interior of the cupola. It is clear that this decision was made when construction had already begun. It seems plausible that, since it is difficult to reconcile this with the architect's moods, this was the will of the authority superintending the work. As we will explain later, the "plaster ornaments" and the images of "oil paintings" could only refer to a specific programmatic intention. No documentary evidence regarding this intention has been found, nor has it been possible to figure out the chronology of such an intervention, which must surely have taken place before 1679 when Longhena drew up his list. We owe to Bassi (1964: 6–7) the identification of this sheet from the Raccolta Gaspari as a possible graphic study done by Longhena for the plaster and pictorial decoration of one of the ribs of the dome; this indeed seems more impressive than persuasive. It still remains to be seen just what sort of modified, comprehensive iconographical program the sibyls and prophets depicted here were part of; as it remains to be seen how this program fitted in with the glorification of the Virgin and Venice. LP

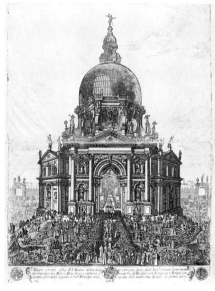

35 T
Marco Boschini (1613–78)
Procession of the Doge to the Church of Santa Maria della Salute
1644
Venice, Musei Civici Veneziani, Museo Correr, Inv. Stampe Correr 5161
Engraving
78.5 x 56 cm
INSCRIPTION: "unde origo / inde salus"; medallion at the lower right "Nicolao Contareno Princ[ipe] / Senatus ex voto MDXXXI" (in medallion at the lower left; taken from the medal commemorating the laying of the church's first stone); in the center is the seal of the Venetian Republic with the lion of Saint Mark. Between these runs the following inscription: "Tempio eretto alla B.V. della Salute / per voto fatto dall'Ecc[ellentissimo] Senato l'anno MDCXXXI /

dissegnato da Marco Boschini conforme il // modello di Baldissare Longhena, e Pompa con / cui processional[men]te si portò il Ser[enissimo] Principe alla // visita del medesimo tempio la prima volta." There is another impression of this print which differs only in the text of the dedicatory inscription (a copy of this may be found in the Kongelige Kobberstiksamling of the Statens Museum for Kunst, Copenhagen), which reads as follows: "the Most Serene Prince, The majestic church that Your Serenity has caused to have been built and dedicated to the Great Mother of God, commonly called of Good Health, is certainly worthy of the Regal Magnanimity which throughout the centuries has been inseparable from the religious Piety of this Most August Republic. I, Marco Boschini, inspired by a virtuous spirit have employed the past months in preparing this image, making particular use of the Model by the celebrated Architect Baldissera Lunghena and I have also engraved it afterward, not without laborious application. I offer it at the feet of Your Serenity in supplication with reverent humility that you may find pleasure in it as part of a supreme observance of your most faithful Subject and Servant, ready in any circumstance to shed blood as well as sweat in Public service. I bow humbly before you. With the Grace and Privilege of the Most Excellent Senate"
PROVENANCE: Correr
EXHIBITIONS: *Venezia e la Peste*, Venice, 1979; *Longhena*, Lugano, Villa Malpensata, 1982
BIBLIOGRAPHY: Muraro 1973; Niero 1979a; Biadene 1982: 107; Gemin 1982: 87–103; Hopkins 1996: 455, 464–65

The genesis of this engraving, which was printed by Lovisa in 1644, as records the inscription on the print run this example comes from, seems to derive from a desire to commemorate, even with "anachronistic" means, the founding of the votive church. Moreover, it was certainly intended, proof coming from the inscription on the later Copenhagen print, to render homage to the doge currently in power, Francesco Erizzo. On 10 April 1631, Erizzo succeeded Nicolò Contarini who had been doge during the plague and under whose aegis the final choice of the plan for the votive church had been made and construction begun. In any case, Boschini's work is, on evidence, inseparable from (and more probably supportive of) the initiative taken by Lorenzo Longo, who in 1644 published a poem *Sotería* that furnished an explanation of the church's detailed iconographical program. This was published when the construction of the church must have been sufficiently advanced (for an understanding of the actual situation see the drawings by Erik Jönson Dahlberg of 1655–56 now in the Kunlinge Bibliothek in Stockholm: Romanelli 1982: 35, 36, 37). This was coherent with the spirit of the times, as the abundant production of laudatory testimonials celebrating the magnificent destiny of the Serenissima bears witness (Doglio 1983: 176–82; Puppi and Rugolo 1998: 613–20).
The iconographic program was meant to tie Santa Maria della Salute to a representation of

a superior national religious identity that grew from the struggle against the plague (Gemin 1982: 88–89). The identities of the saints placed on the timpani is in this respect both eloquent and emblematic (in synthesis, see Biadene 1982: 107). This image contributes conspicuously to the concrete reconstruction of the architectural development of Longhena's plans for the church (the sculptural program suggested by Longo and visualized by Marco Boschini (Venice 1613–78), would never be realized). Once the programmatic superimpositions of the sculptural ornament and the doge's procession have been removed, this print, while not actually corresponding to reality (as Boschni himself noted) since work was not even finished at that point, still gives us a reproduction that is substantially faithful to the model that Longhena had prepared and retouched between April and June 1631. LP

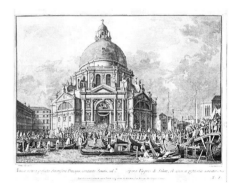

32 T
Antonio Canal called Canaletto (1697–1768) and Giambattista Brustolon (1712–96)
Votive Procession of the Doge to the Church of Santa Maria della Salute
Venice, Musei Civici Veneziani, Museo Correr, Inv. Molin, 1950
Engraving; 38.5 x 54.4 cm
INSCRIPTION: "Antonio Canal pinxit" and "J. Bap[tista] Brustolon incisit"; below "Annua votiva profectio Serenissimi Principis comitante Senatu, ad // Dei parae "Virginis de Salute, ob cives a pestilentia servatos" (lower margin with the signatures of the artists)
PROVENANCE: Molin Bequest
EXHIBITIONS: *Longhena*, Lugano 1982
BIBLIOGRAPHY: Pignatti 1972: 3–22 (with preceding bibliography); Constable and Links 1976: 673–74 (for additional bibliography); Biadene 1982: 111

This engraving belongs to a series of prints depicting the *Feste Ducali*, or ceremonies that "take place in Venice with the participation of the Most Serene Prince, the Doge." They were engraved by Brustolon after drawings by Canaletto and printed by Furlanetto, pursuant to a monopoly (*privilegio privato*) which he obtained from the Riformatori allo Studio in Padua on 6 August 1766, with the favorable intervention of Gozzi. The date of this print cannot be determined precisely but should not be later than the beginning of the 1770s (Marini 1997: 98). The drawing by Canaletto has been identified as one in the Roseberry Coll. in West Lothian (Pignatti

1972). For our purposes, the image has documentary significance in that with eloquent visual force it shows the annual solemn ceremony of thanksgiving in honor of the Virgin. This was instituted by vote of the Venetian Senate on 13 November 1631 and was celebrated annually on 21 November in remembrance of the liberation of the city from the plague. LP

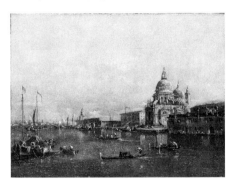

31 M
Francesco Guardi (1712–93)
View of the Church of Santa Maria della Salute in Venice
Ottawa, National Gallery of Canada, Inv. no. 6188
Oil on canvas; 71.1 x 94.9 cm
PROVENANCE: A. M. Fèbvre, Paris (1882); Liechtenstein Gallery, Vienna; Liechtenstein Collection, Vaduz; acquired by the National Gallery of Canada, 1953
EXHIBITIONS: *Meisterwerke aus den Sammlungen des Fürsten von Liechtenstein*, Lucerne, no. 43, 1948
BIBLIOGRAPHY: Simonson 1904: no. 267; Göring 1944: 65, 86; Morassi 1973: 402, no. 488

From Guardi's early attempts at view painting, the church of Santa Maria della Salute played a privileged role in his choice of subject matter. His presentation gradually changed; from the view inspired by Carlevarjis' engravings in which the church dominated the water, to the frontal views with the angles preferred by Canaletto and Marieschi, and finally to a wide variety of angles that liberated him from any model and left Guardi free to obey only his own fantastic and visionary fancy. This led him to enlarge the range of his view to take in the point of the Dogana (Custom House) and thus to enhance the presence of the church on the horizon, with the Bacino di San Marco spreading out beyond (Morassi 1973: 263–64; with its organization of various pictorial variations on the theme of Santa Maria della Salute, duly listed in the catalog: 397–403, nos. 462–96).
The painting featured here (in 1973, Morassi listed the painting in Vaduz in the collection of the princes of Liechtenstein, when in reality it had already gone to Ottawa in 1953; *Annual Report*, 1954: 13) belongs to a series of freely painted views of the church in an open-air context. If this was part of a series with two other paintings, the *San Giorgio with the Giudecca and the church of the Zitelle* (now in the Accademia, Venice) and *Piazza San Marco* (formerly in the Herzog Collection, Vienna; cf. Simonson 1904: 97) then the picture was produced later. It can be placed

chronologically at the end of the 1780s, since it is almost identical in its composition (it differs in the placement and type of the boats) to a work that belongs to Guardi's mature period, which is in the Wallace Coll. in London (Inv. no. 503). The preparatory study (and the graphic basis) for both paintings is a large drawing in the Art Institute of Chicago (Morassi 1975). LP

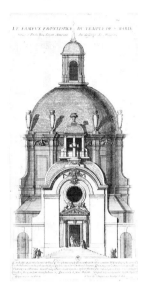

41 T
Antoine Pierretz
The Famous Frontispiece of the Temple of Sainte-Marie, ca. 1650
Paris, Bibliothèque Nationale, Cabinet des Etampes, Hd 191 fol.
Engraving; 515 x 293 cm
BIBLIOGRAPHY: Smith 1964; Braham, Smith 1973: II, pl. 116; Babelon, Mignot 1998: 15

The façade of the Visitation Sainte-Marie, whose originality led to numerous descriptions and criticisms right up until the end of the Ancien Régime (Smith 1964: 204), was one of the preferred motifs for seventeenth-century architectural prints. The large dimensions of Pierretz's plate, the model for which may have been the large semi-perspective elevation drawn by one of Mansart's close collaborators, distinguish it from those done of the same subject by Marot and Cottart. The frontal composition emphasizes the masses' pyramidal effect which gives the elevation its unmistakable vertical accent. The rotunda is surrounded by volumes of decreasing size: the separate porchway, which appears as a minor variation on the rotunda, the two small diagonal chapels, the large transversal chapels, and finally, the two inset sacristies framing the sanctuary, covered by a secondary dome. The framing dome is raised in relation to the double internal dome, enclosed in a cylindrical shell in the manner of a *tiburio*, an exception in France which Mansart shared only with Borromini (Sant'Ivo alla Sapienza). Contrary to the system inherited from the Pantheon, and adopted in Villers-Cotterêts by Philibert de l'Orme (1550), the church's principal entrance is not preceded by a portico. This portal is the modern transcription of a system well-known since the Middle Ages: a door is surmounted by a rose or other type of window,

and the whole thing is framed by arching (Hautecœur 1948, II: 643). The motif on the arched entablature, whose direct model is perhaps the neighboring portal of the Hôtel de Châlon-Luxembourg (ca. 1630), became a commonplace of seventeenth-century French architecture. It is to be found, notably, in the Irish Chapel, on the Rue des Carmes in Paris, built in 1735 by Pierre Boscry, the façade of which is a strange mixture – somewhere between the Visitation and Bernini's portico at Sant'Andrea al Quirinale. The dome of the Visitation, built shortly after the somewhat graceless dome of the Church of the Carmes Déchaussés (1628–30), was not the first in Paris. The comparison with the neighboring Great Jesuits Church (Saint-Paul-Saint-Louis) seems eloquent: despite the lack of distance, the Visitation stood out along the Rue Saint-Antoine due to the two low walls separating the portal from the adjoining buildings. Mansart thus devised an original solution to the problem of the street's alignment. At Saint-Louis-des-Jésuites, on the other hand, the internal volume could not be apprehended from the outside. The dome, which rose up at the crossing of the transept, is masked by the opaque screen of the high façade with its superposed orders, the work of Father Derand (ca. 1630). In many respects, Mansart remained faithful to the tradition of the Gothic builders. The buttressing system was made up of eight veritable "thrusting buttresses," jutting out sharply, with fire pots as a means of amortizement which emphasize the composition's verticalism while the volumes grouped around the rotunda's cylinder are laid bare and covered with a roof which sets them apart. The sculpted ornaments emphasize the munificence of Noël Brulart de Sillery (d. 1641). The two statues couchant on the portal's pediment – feminine allegories of Religion and Charity – recall Michelangelo. The large band above the rose window was done in keeping with the tastes of the second Fontainebleau school and is thus to be linked to the decor of the sanctuary's dome (Babelon, Mignot 1998: 140); it bears the arms of the Order of the Visitation – a heart pierced by two arrows. The motif of the eagle with its wings spread which reigns in the frieze in the drum returns as a leitmotiv in Mansart's career. The crowning fire pots are tapered and of colossal dimensions, as is the portal of the Church of the Minimes (1657–65). During a stay in Paris in 1635, Saint Joan of Chantal, co-founder of the order, left a scarcely veiled criticism of this deployment of decorative forms, condemning the fire pots "which are nothing but fanfare" for the buildings, also criticizing the statues and the portal columns which she judged incompatible with the spirit of poverty practiced at the Visitation (Lecomte 1996: 46–49). But Mother Chantal could not stand against the sumptuous tastes of the man commissioning the work and who advocated a skillful style of architecture. These sought-after feelings were emphasized in the verses to Mansart's glory on the lower part of Pierretz's engraving: "This temple all replete with marvels of art / Whither one comes to adore the Author of nature / Opens our eyes to so many pleasures in its structure / That he covers in glory Mansart." LLe

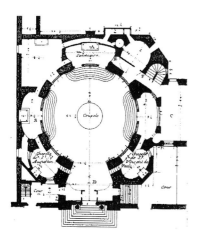

42 T
Jean Marot I (1619/20–79)
Floor Plan of the Church of Sainte-Marie near the Porte Saint.-Antoine in Paris, in *Recueil des Plans Profils et Elévations de plusieurs Palais Chasteaux Eglises Sépultures Grottes et Hostels bâtis dans Paris et aux environs par les meilleurs architectes du Royaume* (alias le *Petit Marot*) ca. 1670?
Turin, Biblioteca Reale
Engraving; 185 x 115 cm
BIBLIOGRAPHY: Hautecœur 1948, II: 21–22; Blunt 1953; Smith 1964: 145; Braham-Smith 1973: II, pl. 108; Pérouse de Monclos 1989: 176; Lecomte 1996: 48

Like the majority of his contemporaries – Silvestre, Pérelle, Mariette – Jean Marot, a Parisian architect and engraver, does not conform to the principle of exactitude characteristic of the architectural record in this plan of the Visitation Sainte-Marie. The substantial differences between this engraved plan and that of the building itself in its present state have often been pointed out (Braham, Smith 1973: 205). The sanctuary, whose mass protrudes into the cloister's interior, is not excessive in Marot's case, fitting in as closely as possible to the square formed by the church's perimeter. The form of the two sacristies – rectangular on the left, oval on the right – is probably of his invention. A complicated funneling device facilitates the accomplishment of the rites of monastic life: the priest follows a narrow passage behind the high altar to discreetly reach the confessional – situated in a small hall – and the *tour*, built into the thick stonework. Mansart was evidently looking for a way to accord the architectural conception with the rules in force at the Visitation: Saint Joan of Chantal, the order's cofounder, had had a template plan published in the first edition (1624) of *Coutumier et Directoire pour les sœurs religieuses de la Visitation Sainte-Marie* in order to ensure the order's architectural unity. This plan, accompanied by a so-called *Devis* – a copy of Saint Carlo Borromeo's treatise *Instructiones fabricae et supellectilis ecclesiasticae* (1577) – established a punctilious architectural program adapted to the needs of a congregation of nuns pledged to poverty and enclosure (Lecomte 1996: 24–41). The centered circular plan of the rotunda Sainte-Marie, the "little diminutive" of the Pantheon in Rome, replaces the modest church advocated by the *De-*

vis. For lack of space, the volumes were superposed upon one another: the peripheral chapels and the sanctuary were thus on the same level as the nuns' chorus (marked "C"), situated on the first floor of the main building on the right between the Hôtel de Mayenne and the rotunda. It can be noted that in this arrangement the Visitandines had no direct view of the high altar; they had to take a small passageway to go to communion at a portico (marked "E"). The large oblong steps which encroach upon the rotunda were installed during the construction of the great circular crypt in April 1665. It is not out of the question that Mansart, who died the following year, was the author of these steps whose Borrominian profile accords with the building's architecture. All these elements underscore the subjective nature of Marot's engraving: if the rather unsatisfactory movement-direction system, as well as the numerous markings on the ground, confirm the idea that Marot started out from one of Mansart's intermediary projects (Braham, Smith 1973: 205), the steps necessarily stem from the building's final modification. The rotunda is enveloped in a veritable belt of annexes, chapels and sacristies, arranged on the diagonals and on the transversal axis. The egg-shaped transversal chapels expand behind the large arcades, thus giving the impression of broadening along the sides. A short ante-nave (marked "D") faces the sanctuary, discreetly though perceptibly marking the presence of a liturgical axis. Contrary to Delorme or Lemercier, Mansart never traveled to Italy. Yet, due to a solid bookish culture, he was familiar with the achievements and experiments of the Renaissance on the theme of the centered circular floor plan. Historians have sought the Visitation's Italian sources: Santa Maria di Loreto by Antonio da Sangallo (Hautecœur 1948: II, 21) for the conception of the circle inscribed in the rectangle, and Michelangelo's San Giovanni dei Fiorentini (Blunt 1941) for the composition on the diagonals and the oval forms, as well as Montano's circular temples (Braham, Smith 1973: 28), probably all stimulated Mansart's imagination. But the Visitation Sainte-Marie's fundamental source of inspiration remains the Château d'Anet chapel, the first securely dated example (1550) of a domed central plan in French religious architecture since the Romanesque period. It is not known when Mansart made his excursion to see the Delorme rotunda, but the two buildings share too many common traits not to suppose that one served as the model for the other (Babelon, Mignot: 139–40). Several authors have sought to see in the Visitation with its different ground levels which "rise" progressively from the street to the sanctuary (Smith 1964: 211), as elements of Baroque rhetoric. It might be added that Mansart is the only French architect of his generation to have built on the oblique, to have played with directed light like Bernini, and to have insisted on the theatrical effect of the vaults like Borromini or even Guarini (Wittkower 1958). Was Mansart, the paragon of French Classicism, a Baroque architect? There is less of a contradiction in the question than one might suppose: "It is our depraved notions of 'Baroque' and 'Classicism' which lead us array" (Babelon, Mignot 1998: 91). LLe

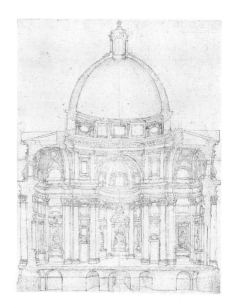

50 T
Pietro da Cortona (1597–1669)
Longitudinal Section of the Project of the Church of Santi Luca e Martina
1623–24
Munich, Staatliche Graphische Sammlung
Inv. no. 14411
Black pencil and brown ink, pen
54.5 x 41.1 cm
BIBLIOGRAPHY: Hubala 1962: fig. 1; Noehles 1969b: fig. 61; Portoghesi 1973: fig. 194; Blunt 1982: 3, 7; Merz 1991: 391, 88 no. 62; Kieven 1993: no. 44; Noehles 1997: 141 (with illustration)

Erich Hubala (1962) already recognized the connection between this holograph drawing by Cortona and the ground plan and elevation in Milan; he saw the project as a last preliminary step before the definitive design of the academy church of Santi Luca e Martina (1634–35). However, there are many reasons for dating this design a decade earlier (Noehles 1969b). The characteristics of the manuscript point to the early stages of Cortona's career (compare, for example, his drawings for the frescoes in Santa Bibiana).
The same is true of the latent classicism and neo-Cinquecentoism of the whole conception. The graphic representation of space is still very clumsy and betrays a lack of experience in architectural design; there are inaccuracies and inconsistencies, for example in the representation of the vaulting of the left and right arms of the cross. Incidentally, this interior view seems to vary the concept of the idealized central-plan building (with respect to the ground plan). In place of the flat apses (left and right) in the outer circle of the ground plan, there seems to be a traditional apse over the semicircle in the middle of this sketch, unless this is just a particularly glaring inaccuracy in the graphic representation.
But what makes the sketch particularly problematic is its use of the planned church of the Accademia di San Luca as a mausoleum for a pope, and perhaps his relatives. This may be explained by Cortona's well-attested efforts to

obtain the sponsorship of the pope, who was the patron of the Academy. To which particular pope the building was to be offered as a mausoleum cannot be established with complete certainty, as the coat of arms over the papal monument is flawed. As far as one can make it out, it looks most like the coat of arms of Gregory XV (1621–23). Presumably Cortona planned a double mausoleum on the model of the great papal chapels in Santa Maria Maggiore. It is conceivable that a second, similar tomb was envisaged on the opposite side for Gregory's successor, Urban VIII. The explanation of the flaw in the drawing of the coat of arms may be that the artist thought of presenting the drawing to the new pope as well, something which would only have had any prospect of success at the beginning of the Barberini pontificate (1623–24). This thesis has occasionally been rejected without explanation. Blunt 1982 and, following him, Merz 1991 state that the project belongs to the first planning phase of Sant'Agnese in Piazza Navona under Innocent X (1652). Kieven 1993 suggests that it was intended for the Chiesa Nova (between 1644 and 1652). But for stylistic and historical reasons a dating as late as the pontificate of Innocent X is quite out of the question (see also Noehles 1997). This is immediately obvious if one compares this project with the design of the church as it was actually built. KN

tinelli bequest of ground plans dating from soon after 1648 (Noehles 1969b: 106 and figs. 102a, b). So Giovanni Battista Falda must have known these plans of Pietro da Cortona's. The oblique angle of the outer axes gives the façade a more conciliatory form and takes account of the visual axes from real positions on Campo Vaccino (the Forum Romanum).

The tambour of the dome would also have looked more effective from these perspectives than it would have done with the originally planned box-like shell.

In the representation of some details (the pediment over the portal, the lunette windows in the dome) the *vedutista* Giovanni Battista Falda, as often in his engravings, takes some liberties; and the position of the neighboring buildings is shifted for pictorial effect. Nevertheless, the engraving is a striking visual record of how the building looked from the eighteenth-century level of the Campo Vaccino. The present-day level is markedly different, owing to the various excavations of the Forum Romanum which have taken place since the nineteenth century. KN

This gives the impression of a dynamic process created by pressure exerted from within by the shape of the interior.

However, the curve of the façade does not correspond to the apse that lies behind it (see cat. no. 45).

There is a formal similarity with the apses of the transverse arms, though this of course happens in reverse, i.e. in a concave curve. But the columns (in the basement of the façade), unlike those in the interior (in the apses), are not fully rounded shafts standing free in the niches; they all seem to be pressed into the mass of the wall, and only two-thirds of their volume actually protrudes out of the narrow hollows in the surface.

This is an extreme, anti-classical treatment of the elements of the *ordo*. The wall structures of the façade and the apses are similar, but not identical.

An appeal is made to the observer's visual memory: he encounters the stylistic repertoire of the façade once again in the interior, but in modified form. This too is a characteristic of Baroque rhetoric, which seeks variety in unity. KN

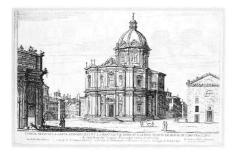

47 T
Giovanni Battista Falda (1643–78)
View of the Church of Santi Luca e Martina, in Giovanni Battista Falda, *Il terzo libro del nuovo Teatro delle Chiese di Roma date in luce sotto il felice Pontificato di N. S. Papa Clemente IX*, Roma (n.d.)
1667–69
Oxford, The Visitors of the Ashmolean Museum
Copperplate engraving
BIBLIOGRAPHY: Noehles 1969b: fig. 103

Giovanni Battista Falda shows the Academy church of Santi Luca e Martina in an artistically oblique view between the Arch of Septimius Severus, the church of San Giuseppe dei Falegnami (left) and the church of Sant'Adriano (the ancient Curia). The outer axes of the façade are represented not as being straight (as they are in Venturini's engraving, cat. no. 44) but as being cut off at an angle of forty-five degrees.

This version of the exterior also had to be abandoned for financial reasons.

That this is a reproduction of a later design by Cortona is proved by copies in the Mar-

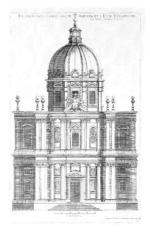

44 T
Giovanni Francesco Venturini (1650–1710) after a drawing by Francesco Bufalini
Façade of the Church of Santi Luca e Martina, in G. G. De Rossi, *Insignium Romae Templorum Prospectus*, Romae 1684
Oxford, The Provost and Fellows of the Worcester College
Copperplate engraving
BIBLIOGRAPHY: Noehles 1969b: fig. 88

In the outer form of the building Pietro da Cortona abandons the classical concept of his early design for a central-plan building that is identical on all sides.

The cruciform inner space is given a box-like outer shell. But only on the front façade does the church have a Baroque display-wall with two storeys. A dominant avant-corps was to be framed by subordinate side axes, but for financial reasons these were never actually built. So the façade that we see today is a torso. Between the paired pilasters of the avant-corps the wall projects forward from a deeper level, in flat convex sweeps, as far as the front level of the pilasters.

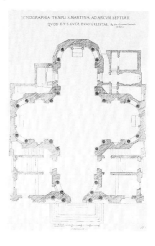

45 T
Giovanni Francesco Venturini (1650–1710) after a drawing by Francesco Bufalini
Plan of the Church of Santi Luca e Martina, in G. G. De Rossi, *Insignium Romae Templorum Prospectus*, Romae 1684
Copperplate engraving
BIBLIOGRAPHY: Noehles 1969b: fig. 86

The final version of the Academy church Santi Luca e Martina (begun 1634–35) is a breakthrough in Pietro da Cortona's stylistic development, the point where he first achieves the High Baroque art of illusion; it is thus a parallel to his pictorial masterpiece from the same period, the ceiling fresco in the Salone Barberini. We show the building in three engravings by Venturini, and a view by Falda. These engravings make clear the change that had taken place in Cortona's aesthetic ideas since his project of 1623–24. The theoretic-emblematic intentions and the explicit imitation of ancient and sixteenth-century models in that earlier project no longer interest him. The Manneristic superimposition of primary Euclidean forms has disappeared. So he reverts to the conventional scheme

of a domed central-plan church on the lines of Michelangelo's St. Peter's: a dome with pendentives over the crossing, the four arms of the Greek cross with orthogonal side walls and apses. Yet the apparent uniformity of the four arms of the cross is an illusion. The observer is deceived as to the unequal length of the arms of the cross – which are actually shorter in the transverse axis – and as to the flattening of the apses of the transverse arms. The only things that are identical in the four arms are the wall structure and the decoration of the calottes of the apses. This deliberate play with illusion corresponds to the maxims of the *acutezze* of Baroque rhetoric. Architecture is no longer represented as primarily rational in the agglomeration or combination of simple, static elements, as in the rotunda project; rather, it is meant to be experienced in its optical appearance. That applies to the wall structure too. The wall springs forward and backward in a rapid rhythm. The limbs of the classical *ordo* (pilasters and columns) are no longer applied to the smooth wall or placed freely in front of it. They are grouped in close clusters accompanying the forward and backward springs of the wall. Since all parts of the wall structure are painted uniformly white, the limit of space appears in dynamically differentiated chiaroscuro in the light which strikes it. Thus Cortona turns the limit of space into an area that must be experienced in a primarily optical sense. The flattened convex sweep of the façade now no longer flows from the shape of the space that lies behind it, as in the 1623–24 project, but leads a life of its own. Yet the inner apse on the arm of the cross seems to have a dynamic effect in the middle of the façade. In principle, however, the whole outer building is conceived independently from the shape of the inner space, as a shell that is complete in itself. Yet there are formal relationships between exterior and interior, in the spirit of the High-Baroque ideal of unity in variety. KN

collection. It is taken from the Palatine. On the left is the building of the Dogana della Grascia and then the road, which leads from the Consolazione to the church of Santi Luca e Martina. A flight of steps leaves this road for the Arch of Septimius Severus and then rises to the Capitol. The ruins of the Temple of Saturn are on the embankment with a house behind incorporated into the temple. At the back, the remaining columns of the Temple of Vespasian appear half-hidden and, in the middle, Palazzo Senatorio is visible. On the right, the church of the Arcoeli is lit up; half-way down the steps is San Giuseppe dei Falegnami with the silhouette of Trajan's Column in the distance. In the background, the Torre dei Conti rises behind Cortona's building, and in the middle is the Arch of Septimius Severus. Van Wittel's preparatory drawing is unknown to us, whereas there is an identical view of the same place done by Juvarra in 1709. Juvarra's drawing, now in the Museo di Roma, bears the following inscription: "Veduta del Campidoglio di Roma come al presente si trova disegniato da me/ Filippo Juvarra Ar.co nel dì 26 marzo/ del 1709." It was done during Juvarra's years in Rome. The existence of this drawing by the Sicilian architect further substantiates Vitzthum's hypothesis that there was a close relationship between the two artists. So far this has only been documented by the 18th-century biographer, Leone Pascoli, when talking of a view of Lisbon. Pascoli writes: "Fece il quadro del disegno fatto dal Juvarra del Regio Palazzo Chiesa Patriarcale di Lisbona un quadro in tela…" There is no trace of this view of Lisbon, but Vitzthum published one from among the sheets in Caserta showing the boats used in Sicily and these boats appear, identical, in Van Wittel's view of the Straits of Messina. Obviously there was an exchange of drawings between the two artists. (See L. Trezzani's introduction to our recent edition of G. Briganti's book on Gaspar van Wittel.) LL

Company, London, by 1926, purchased with the Moch Bequest Purchase Fund, 1926
BIBLIOGRAPHY: Constable 1989: I, pl. 71; II, no. 385; Spike 1993: 26–29, no. 9

In 1588, the Accademia di San Luca was given possession of the ancient church of Santa Martina in the Roman Forum. The following year the church was renamed San Luca after the patron saint of painters and plans were initiated for a new church, but funds for the undertaking were not available. In 1634 Cortona was elected "principe" of the academy, and he undertook to renovate at his own expense the crypt of the church, which was originally intended to serve as his mausoleum. During the course of the renovation, the remains of Saint Martina were found and the discovery attracted the interest and financial support of Pope Urban VIII and his nephew, Cardinal Barberini. Construction of Santi Luca e Martina began in 1635, and while the altar, façade, and vaulting seem to have been finished by the 1640s, at the time of Cortona's death in 1669 portions of the interior decoration remained unfinished. The church has been described as "the first of the great, highly personal and entirely homogeneous churches of the High Baroque" (Wittkower 1980: 241). The influence of Cortona's curved walls and theater-like façade was widespread and the freedom exercised by Cortona in dealing with the plastic mass of wall surfaces, pilasters, and columns reverberated throughout European architecture in the Baroque and Late Baroque periods. Canaletto made a visit to Rome in 1719–20 to help his father execute scenes for two operas by A. Scarlatti, performed there during the Carnival of 1720. While in Rome, according to A.M. Zanetti, one of the artist's earliest biographers, he abandoned the theater and began to draw and paint architectural views. There is no painting or drawing which can be said with certainty to have been produced by Canaletto in Rome, although a group of twenty-one drawings of views of the city inscribed with his name have been thought by some to be the work of the young artist. One of these drawings, attributed to Canaletto's early stay in Rome, but more probably a copy of one of his drawings (Spike 1993: fig. 12), is clearly the source of the composition of the Cincinnati painting with the Arch of Septimius Severus, erected in A.D. 203. There is no evidence of a second visit to Rome by Canaletto, although there are five large Roman views at Windsor – all signed "ANT. CANAL" and dated 1742 or 1743 – that were presumably painted on the basis of Canaletto's own drawings and sketches or those of his nephew, Bellotto (Links 1994: 133, 136, figs. 113–15). There is a derivative character to the Cincinnati painting, a sense that Canaletto had not studied the site closely, which accounts for the lack of precision in the depiction of the arch and the façade of the church. By comparison with Canaletto's depictions of St. Paul's Cathedral and the Royal Naval Hospital, his record of Santi Luca e Martina is marked by inaccuracies. Canaletto's painting does, however, provide an important record of the appearance of Santi Luca e Martina in its original urban setting. EPB

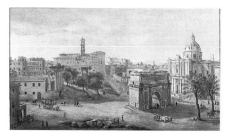

49 T
Gaspar van Wittel (1652/53–1736)
View of the Campo Vaccino, 1723
Rome, Private Collection
Oil on canvas; 38 x 68 cm
INSCRIPTIONS: "G. V. Witel 1723" (on one of the architectural fragments at the bottom on the left)
BIBLIOGRAPHY: *Views from the Grand Tour* 1983: no. 45; *Herinneringen aan Italie* 1984: 146, no. 76; *Paesaggi e nature morte* 1986: 28–29, no. 13; *Paesaggi, vedute e architetture del Grand Tour* 1988: no. 26; Salerno 1991: 78, no. 15; Briganti 1996: 150–51, no. 48

This view of Campo Vaccino (or Campovaccino) is a pair to a view of Ponte Rotto in the same

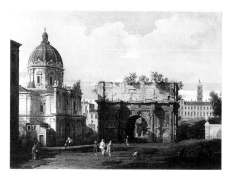

48 M–W
Giovanni Antonio Canal called Canaletto (1697–1768)
The Arch of Septimius Severus and the Church of Santi Luca e Martina, Rome, ca. 1742
Cincinnati, Art Museum, 1926.171
Oil on canvas; 52.6 x 71.2 cm
PROVENANCE: Captain Edward Purvis, Washington House, Reading, 1875; his sale, Christie, Manson & Woods, London, 19 July 1875, lot 46; S. Walker; sold by him in an anonymous sale, Christie, Manson & Woods, London, 31 July 1925, lot 116 (as Bellotto); Knoedler and

Borromini's Publication Enterprise
Joseph Connors

Francesco Borromini (1599–1667) is the best published architect of the Roman Baroque. There are dozens of plates of his work in each of the volumes of Domenico De Rossi's great *Studio d'architetura civile* of 1702–721, and in 1720–25 two of his buildings, Sant'Ivo alla Sapienza and the Oratorio dei Filippini, were published in magnificent folio volumes called *Opera del Caval. Francesco Boromino* or more popularly the *Opus Architectonicum*.

Borromini himself wanted to publish his work, though the kind of book that he envisaged changed radically over the course of his lifetime. His patrons took the initiative before he did. In 1646–47 he agreed to help the Oratorian priest Virgilio Spada draft a manuscript description of the Casa dei Filippini, Borromini's first large building, begun in 1637. Spada penned the text and assembled many drawings to illustrate it, but for reasons that remain unclear the publication never came to fruition.

In about 1650 a Spanish Discalced Trinitarian named Fra Juan di San Bonaventura wrote a similar monograph on the church and convent of San Carlo alle Quattro Fontane, the jewel of Borromini's early career (1634–1641), but once again Borromini could not be persuaded to supply drawings and the manuscript remained unpublished. Spada also drafted a short account of Palazzo Pamphilj, and Monsignore Cesare Rasponi wrote another on the restoration of the Lateran (both begun in 1646). But in these we only hear faint echoes of the architect's voice. In about 1655–56, however, Borromini took the publication project in his own hands. He assembled a team that worked together in complete harmony. Domenico Barrière (1610/15–78), his etcher, was a Frenchman from Marseilles who immigrated to Rome around 1640. He studied with Claude Lorrain and became one of Rome's foremost architectural etchers. An early effort is a large, rare print showing the façade of Santi Vincenzo e Anastasio at Piazza Trevi by Martino Longhi the Younger, dated 1648; his most splendid etching is a view of the Easter Festivities in Piazza Navona in 1650. By 1653 he had met Borromini and was already beginning to study Sant'Ivo della Sapienza.

The other member of Borromini's team was Fioravante Martinelli (1599–1667), a priest and polygraph who wrote many books about the churches of Rome and similar antiquarian subjects. Martinelli was an exact contemporary of Borromini. The two men became friends in the mid-1650s. The first description of Borromini's restoration of the Lateran occurs as a digression in Martinelli's book of 1655, *Primo trofeo della Santissima Croce*. In 1658, when Martinelli brought out the third edition of his popular guidebook, *Roma ricercata nel sito suo*, he included three small etchings of the Casa dei Filippini based on drawings that Borromini had furnished him. He even included a print after a Roman coin in the architect's collection. Martinelli became an intimate friend of Borromini and the architect's most eloquent spokesman. In the manuscript of another, more extensive guidebook that he drafted in 1660–63, *Roma ornata*, we find pencil annotations and corrections in Borromini's unmistakable hand. The guidebook includes what amounts to a monograph on the Sapienza, in which the author tries to justify Borromini's radical ideas. In the history of seventeenth-century architecture there was only one other relationship between a guidebook author and an architect that was this close, namely the friendship between Francesco Picchiatti of Naples and Carlo Celano, the author of the first great guide to that city, published in 1692. Martinelli died on 24 July 1667. In the course of the next week Borromini rewrote his will, burned some of his papers, and then committed suicide. The emotional stress of the architect's final days was probably exaggerated by the loss of this articulate and understanding friend.

Borromini's nephew and heir, Bernardo Castelli-Borromini, wrote a short biography in 1685 in which he describes his uncle's great publication enterprise, which can be dated around 1660. It would have included both built and unbuilt projects. Bernardo specifically mentions etchings by Barrière of the Sapienza ("la pianta giumetrale et in prospettiva," "l'alzata per di dentro et per davanti et per di dietro") and the Oratory ("la faciata del Oratorio de S. Filippo – con l'orologio"). He had the copperplates in his possession but let very few people see them. Somehow a few proofs had made their way, probably during Borromini's lifetime, to the library of the Dal Pozzo family. There they were studied by the publisher Giovanni Giacomo De Rossi, who redrew them awkwardly for inclusion in the 1684 edition of his *Insignium Romae templorum prospectus*. But in general Bernardo Borromini remained a tomb for his uncle's drawings and for the Barrière plates. Bernardo died in 1709 without doing anything to further the publication enterprise that his uncle had begun around 1660. The merit of carrying out that project goes to an otherwise unknown Roman publisher, Sebastiano Giannini. Giannini claimed to have access to "l'intero studio" of the late Cavaliere Borromini and there is every reason to believe his claim was true. Somehow or other he found, or possibly even acquired, the treasure trove of Borromini drawings, after Bernardo's death and before 1730, when the drawings were bought by Baron Philipp von Stosch, from whose estate they eventually passed into the hands of Maria Theresa of Austria. Giannini was an active editor who did everything to expand the material in his care and bring it up to date. He published the copperplates that Barrière had etched for Borromini in 1660. But he retouched them slightly. For example on the section of Sant'Ivo shown in cat. no. 61 he scratched out a baldacchino that had been shown hanging above the high altar, no doubt because this decoration was no longer in use in the church. He added a few "false-Barrière's" of his own making. But most importantly he redrew the entire church at a very large scale. Ten of these plates could be glued together to form an enormous elevation of Sant'Ivo, and ten more a section (Del Piazzo 196: 298–301). Strangely enough all of these large-scale prints show the church reversed. The drawings of Sant'Ivo which have recently come to light (cat. nos. 62, 63 and uncatalogued Albertina Az It 499c) correspond to Giannini's plates but are unreversed. They would seem to be the drawings done or commissioned by Giannini for his book.

When he prepared the second volume on the Oratorio dei Filippini, Giannini did some research in the archives of Santa Maria in Vallicella and found the manuscript of the "Piena relazione" that Spada and Borromini had drafted in 1646–47. He published the text with all the drawings redone and updated. To give his book international circulation he translated the "Piena relazione" into Latin, and it is by the high-sounding eighteenth-century title *Opus Architectonicum* that Giannini's work is generally known. Giannini also prepared six plates on San Carlo alle Quattro Fontane. But they were never published and now exist in only one proof copy in the archives of Archivio di Santa Maria in Vallicella. There was also to be a fourth volume of the *Opera del Caval. Francesco Boromino cavata da Suoi Originali*, though we are not told which building it would cover. Possibly the Lateran is the most likely candidate. Nor do we know why Giannini never advanced beyond Sant'Ivo and the Oratory, though we might surmise that he died, around 1730, before he could finish his grand project.

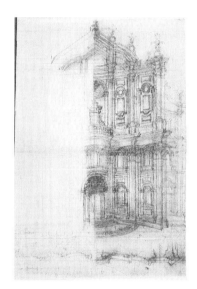

57 T
Francesco Borromini
Façade of the Oratorio dei Filippini, revised by the architect for publication
ca. 1660
Vienna, Graphische Sammlung Albertina, Az IT 291
Graphite
43 x 30.3 cm
PROVENANCE: Bernardo Borromini, Baron Philipp von Stosch
BIBLIOGRAPHY: Frey [1920]: pl. 3; Hempel 1924: pl. 38; Frey [ca. 1925]: pl. CXVII; Thelen 1958: 28, no. 70; Portoghesi 1964: fig. 25; 1967–84: fig. XXX; 1967: 16ff., no. 40; Koschatzky, Oberhuber, Knab 1972: 64, fig. 32; Blunt Schilling n.d.: 53ff.; Connors 1980: 266–69, no. 90; Kieven 1993: 64ff., no. 11
JC

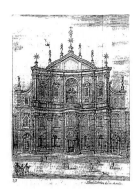

55 T
Domenico Barrière (1610/15–78)
Façade of the Oratorio dei Filippini, built by
Borromini in 1637–38, in Fioravante Martinel-
li, *Roma ricercata nel sito suo*, Roma 1658 (third
edition)
Etching
12.4 x 8.9 cm (plate mark)

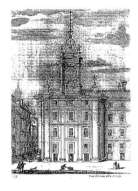

56 T
Domenico Barrière (1610/15–78)
Torre dell'Orologio at the Casa dei Filippini,
built by Francesco Borromini in 1647–50, in
Fioravante Martinelli, *Roma ricercata nel sito
suo*, Roma 1658 (third edition)
Etching, 12.4 x 8.9 cm (plate mark)
BIBLIOGRAPHY: Schudt 1930: 251ff., nos. 230–
55; Huelsen 1927: XLIII-XLV; D'Onofrio 1969: 19;
Connors 1980: 263–66, no. 89; 1998 JC

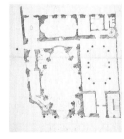

58 M
Pietro Bracci (1700–73)
Plan of the Church and Monastery of San Car-
lo alle Quattro Fontane
Montreal, Collection Centre Canadien d'Ar-
chitecture – Canadian Centre for Architecture
DR 1966: 006.105
Pen and brown ink over graphite with stylus
marks; 565 x 427 mm
PROVENANCE: Bracci Family archive; Phyllis
Lambert Coll.
BIBLIOGRAPHY: De Rossi 1683; 1720–21

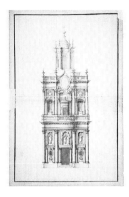

59 M
Pietro Bracci (1700–73)
Elevation of the façade of San Carlo alle Qua-
tro Fontane
Montreal, Collection Centre Canadien d'Ar-
chitecture – Canadian Centre for Architecture
DR 1966:006:103
Pen and brown ink and gray wash over
graphite; 489 x 741 mm
PROVENANCE: Bracci Family Archive; Phyllis
Lambert Collection
BIBLIOGRAPHY: De Rossi 1683; 1702–21

Before establishing his reputation as a sculptor,
Pietro Bracci studied architecture. A number of
Bracci's drawings from the 1720s document his
interest in the architecture of Francesco Borro-
mini. In addition to those on exhibition, he also
drew after the church of Sant'Agnese in Agone
and the lost portal of the Vigna Missori. The
1720s saw a revival of interest in Borromini's ar-
chitecture. The election of Benedict XIII Orsini
in 1721 coincided with the maturity of a genera-
tion of architects born around 1680, the year of
Bernini's death. Many of these young men stud-
ied architecture in the Academia di San Luca
during the years when Juvarra taught there and
encouraged the study of Borromini's buildings
In 1724 the possibility of implementing Borro-
mini's design for the façade of the Lateran Basil-
ica was even under discussion. Filippo Barigioni,
an older architect with whom Bracci may have
studied and with whom he later collaborated,
was one of several architects asked to prepare
drawings based on those of Borromini. The
work of numerous architects active in the 1720s,
including Francesco De Sanctis, Nicola Michet-
ti, Gabriele Valvassori, Ludovico Rusconi Sassi,
Pietro Passalacqua, and Domenico Gregorini,
shows a profound debt to Borromini, both con-
ceptually and in specific details.
The 1720s also saw the publication of two series
of illustrated books intended for architects in
which Borromini's work figured prominently:
Sebastiano Giannini's *Opera del Caval. Francesco
Boromino*, and the third volume of Domenico
De Rossi's *Studio d'architettura civile*. Architects
interested in Borromini's designs could also con-
sult the older compilation of prints issued in
1683 by Domenico De Rossi's father, Giovanni
Giacomo, with the title *Insignium Romae tem-
plorum prospectus*. Of course architects could
measure and draw the buildings themselves, as
Carlo Fontana encouraged Filippo Juvarra to
do. Prints from the De Rossi publications and
others like it undoubtedly provided models of

presentation which students were expected to
enrich with their own distinctive alterations and
embellishments. For example, Bracci introduces
delicate gradations of shading in his renderings
of the San Carlo façade. Bracci's façade elevation
closely resembles plate no. 14 in G. G. De Rossi's
Insignium Romae templorum prospectus, from
which it was probably copied. There are a num-
ber of minor differences, such as Bracci's intro-
duction of wrought-iron grates in the oval win-
dows of the lower storey where the print incor-
rectly shows blank fields. Conversely, Bracci
draws the roundels of the upper storey as blank,
whereas the print correctly places Trinitarian
crosses in them. In spite of these and other minor
discrepancies, the similarity of presentation and
the preponderance of congruent details in both
images – including the rather awkward render-
ing of the statues – strongly suggest that Bracci
closely studied the De Rossi plate.
Bracci's plan of San Carlo does not corre-
spond to the one published by G. De Rossi,
which is limited to the church, and does not
include the monastery. Much closer is one of
the plates intended for the third volume of Gi-
annini's *Opera*, which was never published.
While the Giannini plate represents both
church and monastery, there are numerous
differences between it and Bracci's drawing. It
also seems unlikely that Bracci would have
known the unpublished proofs of Giannini's
plates, which were kept in the library of the
Oratorio dei Filippini. Instead, Bracci seems
to have worked from some other source, per-
haps a survey drawing, and also to have taken
measurements of the site. JP, EK

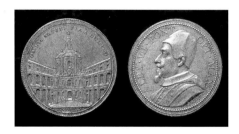

64 T
Gaspare Morone
Medal of Sant'Ivo alla Sapienza
1660
Munich, Staatliche Münzsammlung
Silver, 4.2 cm
INSCRIPTION: "ALEX. VII PONT. OPT. MAX." (ob-
serve); "OMNIS SAPIENTIA A DOMINO / MDCLX"
(reverse)
BIBLIOGRAPHY: Ciaconius 1677: IV, column
719–20, no. 16; Bonanni 1699: II, 641 and 686;
Del Piazzo 1968: 302ff., no. 32; Whitman and
Variano 1983: 112ff., no. 94; *Bauten Roms auf
Münzen und Medaillen*: no. 300

The medal was struck in 1660 as part of the
same campaign of represention that produced
the Barrière etchings, which served Morrone as
a model.
The tiny Chigi Monti shown flanking the cupo-
la correspond exactly to the first state of Bar-
rière's plate (London, British Library, King's
Library, vol. 134.g.11, fol. 14). JC

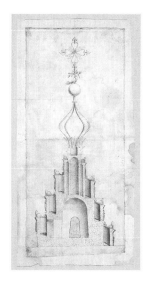

63 T
Anonymous draftsman working for Sebastiano Giannini
a) Section of the spiral of Sant'Ivo alla Sapienza
New Orleans, James Lamantia
Pen and ink
Done in preparation for the plate no. XXXVIII in the *Opera del Caval. Francesco Boromino* 1720
b) Half-elevation of the drum of Sant'Ivo alla Sapienza
New Orleans, Gallery, 539
Pen and ink
Done in preparation for the plate no. XXII in the *Opera del Caval. Francesco Boromino* 1720

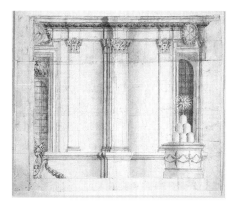

62 T
Anonymous draftsman working for Sebastiano Giannini
Quarter plan of the cupola of Sant'Ivo alla Sapienza, done in preparation for the etching in the *Opera del Caval. Boromino* in 1720
Vienna, Albertina AZ IT 499c
Pen and ink
38.7 x 36.9 cm
UNPUBLISHED

These three drawings, and in addition two others recently acquired by the Albertina (AZ IT 499a and 499b) seem to be drawings done or commissioned by Sebastiano Giannini preparatory to the publication of the large etchings after Sant'Ivo in the first volume of the *Opera del Caval. Francesco Boromino* in 1720. The etch-

ings all reverse the building while these drawings do not, which is what one would expect of preparatory studies. A further drawing in the same series is Albertina AZ IT 286a, a plan of the refectory vestibule of the Casa dei Filippini, which appears to be a study for plate LIX of volume II of Giannini's *Opera*. JC

60 T
Domenico Barrière (1610/15–78)
Sant'Ivo Seen from the Courtyard of the Sapienza
Etching
First state 1660, second state prepared by Sebastiano Giannini for the *Opera del Caval. Francesco Boromino* in 1720

61 T
Domenico Barrière (1610/15–78)
Section of Sant'Ivo alla Sapienza
Etching
First state 1660, second state prepared by Sebastiano Giannini for the *Opera del Caval. Francesco Boromino* in 1720
Page size: 53.3 x 39.3 cm; overall size, volume closed: 54.3 x 40.5 x 3.4 cm
BIBLIOGRAPHY: Blunt 1979: 117, fig. 84; Connors 1980; Raspe 1994: pls. 32–33; Connors 1998 JC

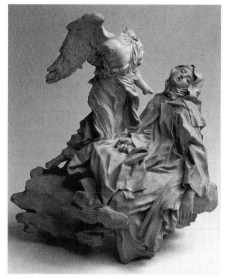

66
Gian Lorenzo Bernini (?) (1598–1680)
Bozzetto for the Ecstasy of Saint Theresa
St. Petersburg, State Hermitage Museum
Terracotta
47 cm (height)
BIBLIOGRAPHY: Wittkower 1955–97: 265–68; Matzulevitch 1963: 69; Fagiolo dell'Arco 1967: no. 130; Kauffmann 1970: 152, no. 70; Lavin 1980: 202; Dreyer in *Drawings by Gianlorenzo Bernini* 1981: 87-94; Androsov and Kosareva in Wardropper 1998: 68

This Bozzetto depicts the altarpiece of the Cornaro Chapel, the ecstasy of the Carmelite Saint Teresa.
The piece comes from the collection of the Venetian abbot Filippo Farsetti (1704–1774),

who amassed an impressive group of paintings, sculpture, copies, and casts while in Rome from 1749 to 1753, and again in the years 1766–1769. Farsetti's hopes to establish an art academy in his palace on the Grand Canal failed, but the collection had an important influence on visitors, such as Antonio Canova among others. Under financial pressure in 1799, the Farsetti heirs sold the collection to the tsars and sent it to Russia, although a few pieces remained in Venice and are now at the Accademia di Belle Arti and the Galleria Giorgio Franchetti.
(The works were temporary reunited for the exhibition "Alle origini di Canova" at the Ca' d'Oro in 1992.)
Because Filippo Farsetti acquired both original works of art and copies for study, debates have arisen regarding the authenticity of some works. The Farsetti Bozzetto for the equestrian statue of Constantine, in this exhibition, is generally accepted as an autograph Bernini. Recent scholarly opinion is divided on the subject of the Saint Theresa. Matzulevitch, Androsov, and Kosareva argue for its authenticity. Wittkower withheld judgement, while others (Fagiolo dell'Arco, Kauffmann, Lavin) have rejected the work as Bernini's. On the basis of a careful inspection in good light, I believe it to be genuine.
Inevitably, evaluations depend on the differences between the Bozzetto and the finished altarpiece and whether these differences are the result of the artist's changes or those introduced by a copyist. In this case the composition is the same, while differences in details correspond to those between other Bernini sculptures and generally accepted preparatory terracottas.
The drapery of the surplice and the folds of the wimple are arranged similarly in the terracotta and the marble, although Bernini's treatment of the marble is invariably more vital. Photographs of the Bozzetto tend to obscure a view of the saint's right foot between billows of a cloud, and in the presence of the piece the location of her left foot (now lost) is easily imagined.
In the Bozzetto the artist includes pin-pricks for the irises, which are extremely affecting when the piece is viewed from below; yet Bernini eventually decided to leave the eyes blank and rolled back.
Such a change strikes me as an unimaginable liberty Jor a copyist talented enough to produce this object.
The five autograph sketches on two sheets for the Saint Teresa that survive at Leipzig suggest to me that Bernini invented a good deal of the composition on paper.
If the Bozzetto represents an authentic preparatory stage in the artist's thinking, some of the developments in the finished work may be seen as comparable to those that originate with the only other surviving terracotta from this commission, an autograph bozzetto for the east wall of the chapel (Fogg Art Museum).
As a poignant depiction of the saint, the Farsetti Bozzetto is a revealing pendant to the Schwerin painting that depicts the full context of the chapel in spectacular detail. TAM

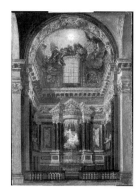

65
Unknown Artist
View of the Cappella Cornaro in Santa Maria della Vittoria, by Gian Lorenzo Bernini, Rome
Schwerin, Staatliche Museum Schwerin
Inv. G 930
Oil on canvas; 168.2 x 120 cm
BIBLIOGRAPHY: Lavin 1980: 77–140, 196–210; Marder 1998: 110–16

Bernini built the chapel for a Venetian cardinal, Federico Cornaro, in the years 1647–51. In the course of his career he came to support the Discalced Carmelites order, which included Saint Theresa of Avila. The visual focus of the chapel is the Ecstasy of Saint Theresa. The moment is complemented by Bernini's treatment of the vault, painted as though it were open to the heavens to admit the descent of the Holy Dove and a glory of angels. The gestures of the angels and the billowing clouds of the gloria partially overlap the real window in the upper reaches of the chapel, where scenes in relief from Theresa's life peak from behind the celestial commotion. In the lower zone of the chapel, the ecstasy is witnessed by figures of the Cornaro family, whose half-length busts emerge from stalls located on the side walls of the chapel. This is a memorial chapel to the family, but it also memorializes Teresa's sanctity, for eyewitness testimony verifying miraculous acts was an essential component in the canonization process. The notion that Saint Teresa's ecstasy takes place before our eyes is enhanced by the poses of the Cornaro family caught in movement, by the saint and her angel who appear to be suspended above the altar, and by the architectural features that bend and soar in empathetic participation over the miracle. The lavish use of expensive marbles was unprecedented in such a limited spacial context and serves to impart an otherworldliness to the setting. Irving Lavin has suggested that a large painting on canvas, referred to as "the modello of the chapel" in Cardinal Cornaro's inventory, may be the painting at Schwerin. Since all details down to the veining of the marbles are accurate, Lavin concludes that the painting is a record of the chapel and not part of the preparatory process. He points out that the pilasters of the nave, now Corinthian like those of the chapel, were originally Ionic; and that the glass in the window above these features was originally clear rather than colored. The painting would therefore be our most accurate record of Bernini's achievement before subsequent alterations took place. TAM

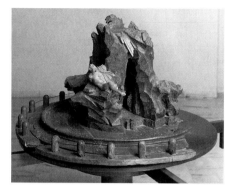

67
Gian Lorenzo Bernini (1598–1680)
Second Model for the Fountain of the Four Rivers
Bologna, Accademia di Belle Arti (deposited at the Pinacoteca Nazionale)
Cherry wood and terracotta; base 100 cm in diameter, rock 52 cm tall
BIBLIOGRAPHY: Zanotti 1739, I: 54; Zamboni 1968a: 11–25, figs. 1, 2, 3a, 4a-b, 5a, 6, 7, 8a-b; Zamboni 1968b: 11–12, figs. 1–5; Sestieri 1970: 17, 31, no. 37, fig. 12; Zamboni 1971: 31–43 (reprint of Zamboni 1968a); 1979: 301–302, no. 547, figs. 405–406; 1984: 426–27, no. X. 26; Harris 1990: 492, 495, fig. 13–9; Avery 1997: 200–201, fig. 286

This striking model was rediscovered in 1968 in the rooms of the Accademia di Belle Arti in Bologna by Silla Zamboni, who immediately recognized it as an autograph *modello* for the Fountain of the Four Rivers. Zamboni's research has revealed that it was donated to the Accademia Clementina in Bologna early in the 18th century and was given a place of honor in the *aula di architettura*, It was documented in two inventories of the academy's collection, compiled at the end of the 18th century and in 1803, but following a sequence of events – the suppression of the Accademia Clementina in 1804, the creation of the Accademia di Belle Arti in its place, the relocation of the new academy, and the transfer of its collections – the model was stored away and "lost" for more than a century and a half (Zamboni 1968a: 11–12). The model is in a relatively poor state of preservation. As Zamboni recognized, this model is a key document of the last phase of Bernini's preparatory work on the fountain. With respect to the shape of the rocky base and the disposition of the river gods, it is much closer to the final design than the only other extant *modello* in the Giocondi Collection; which is traditionally placed between late-1648 and mid-1649. So close is it, to the fountain as executed, that it may well have served as the definitive model for the carving of the base and statuary by Bernini's collaborators. In the light of the documentary evidence that the *scalpellino* G. M. Fracchi began carving the base in December 1649 and that the contracts with the four sculptors of the river gods were drawn up in February 1650, this model may be dated between the very end of 1649 and early-1650. In contrast to the rock and basin, which are carved in wood, the lone surviving river god, the Rio della Plata, is modeled in clay. Occupying a "rocky" ledge at the left of the west side of the *modello*, it is a figure of

concentrated energy and force, whose spiraling pose and gesture closely correspond to the *bozzetto* in the Ca' d'Oro and F. Baratta's finished sculpture. It is surprising to discover that Bernini carved the cactus (on the west side), the armadillo (on the north side), and the palm tree (on the east side) from the same cherry wood as that of the rock and basin. The winged serpent (on the east side), an attribute of the Ganges, was instead modeled in clay, as was the horse, an attribute of the Danube, whose rear half is visible emerging from the opening on the model's south side. Notwithstanding the late stage at which Bernini executed this model, Bernini altered a number of its features in the completed fountain. The basin, which here is circular in form, was transformed into an oval, as it had appeared in the Chigi and Windsor drawings. The openings in the rock became more irregular, increasing the sense of instability in the base. And the lean of the palm tree grew more pronounced, accentuating the diagonal thrust of the rocky mound. These changes bear witness to the fact that, even as the sculptors began carving the fountain, Bernini never ceased to experiment with its design. SFO

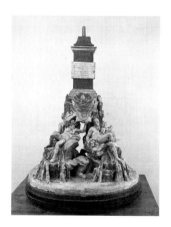

68
Gian Lorenzo Bernini (1598–1680)
First Model for the Fountain of the Four Rivers
1648–49
Rome, Private Collection
Wood and terracotta (polychromed and gilded in parts); 85 cm in diameter, 195 cm tall
PROVENANCE: Heirs of Gian Lorenzo Bernini (Giocondi-Forti Collection)
BIBLIOGRAPHY: Fraschetti 1900: 180, 206; Brinckmann 1924: II, 40–42, pls. 17–18; Brauer and Wittkower 1931: 48–49; D'Onofrio 1962: 204; Huse 1967: 27–33; Zamboni 1968a: 18; Huse 1970: 10, figs. 2–3; Kauffmann 1970: 181, figs. 90a–b; Sestieri 1970: 13–14, 23–28, figs. 7, 22–30, 32, 34, 36; Preimesberger 1974: 123–26, figs. 24–25; Courtright 1981: 108, 110, 115, no. 10, fig. 54; D'Onofrio 1982: 416–20, no. 31; Harris 1990: 492, 494, fig. 13–8; Testa 1991: 103–104, no. 4; Avery 1997: 196, fig. 275

This superbly crafted *modello*, the "Modello Giocondi" is the earlier of the two surviving models of the Fountain of the Four Rivers. Although it was recorded in a Bernini family inventory of 1771, it only entered the literature in 1900, when Fraschetti published it as an autograph model of the fountain. He placed it at a

very early stage in the preparatory process, associating it with the *modello* that Bernini's earliest biographers report he made in order to secure the commission for the fountain – an opinion subsequently reiterated by Brinckmann (1924: II, 40), Sestieri (1970: 13), and Harris (1990: 494). There is good reason to believe, however, that the *modello* belongs to a later moment in the design process, as Brauer and Wittkower have proposed. The complexity of its design and its close resemblance to the completed fountain clearly indicate that it was produced after the Chigi and Windsor drawings, in which the definitive program is not yet established. The model postdates the sheet in Leipzig, for it incorporates the final solutions that Bernini worked out on that sheet for the form of the rocky base and obelisk's plinth, as well as for the placement of the river gods. Moreover, this *modello* closely corresponds to the fountain as it appears on the foundation medal of 1649, and most likely served as the basis for its medallic representation. Thus the model may plausibly be dated between late-1648 and mid-1649 – that is, after Bernini's design for the fountain was approved in July 1648 and before the medal was struck late in the following year. This *modello* documents a crucial point in Bernini's development of the fountain. The four water deities are individualized as personifications of the four great rivers – the Danube, Nile, Ganges, and Rio della Plata – and are accompanied by a variety of attributes. The obelisk, which is missing from the later model in Bologna, is included here, with its hieroglyphics incised on its four faces; and the central block of the obelisk's plinth bears Latin inscriptions articulating the fountain's symbolic meaning. Another distinguishing feature of this model is the water which flows in great cascades from the rocky perches of the river gods. Water figures prominently in the Chigi and Windsor drawings, but here it assumes an even more dynamic role in Bernini's conception for the fountain. All of these aspects, along with its gilding and polychromy, distinguish this model from the other surviving preparatory work for the fountain, and suggest that Bernini's intention was both to present his patron with a clear image of the finished monument.　　　　SFO

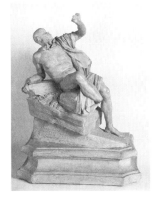

70 T
Gian Lorenzo Bernini (1598–1680)
Bozzetto for the Rio della Plata, Fountain of the Four Rivers
Venice, Galleria G. Franchetti alla Ca' d'Oro

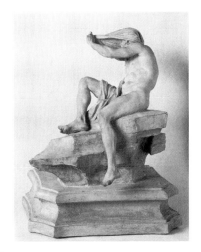

71 T
Gian Lorenzo Bernini (1598–1680)
Bozzetto for the Nile, Fountain of the Four Rivers
Venice, Galleria G. Franchetti alla Ca' d'Oro

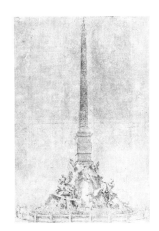

72 T
Gian Lorenzo Bernini (1598–1680)
First Design for the Fountain of the Four Rivers
Vatican, Biblioteca Apostolica Vaticana, Archivio Chigi Inv. no. 24926
Chalk, ink wash, and pen on grayish white paper; 67 x 38.6 cm
Provenance: Ariccia, Palazzo Chigi
Bibliography: Fraschetti 1900: 197–98; Brauer and Wittkower 1931: 47, pls. 25b–26; Grassi 1944: 8, fig. 13; Pane 1953: 52, fig. 93; D'Onofrio 1962: 204, fig. 176; Fagiolo dell'Arco 1967: 232, fig. 35; Huse 1967: 13–15; Zamboni 1968a: 17; Kauffmann 1970: 179–80, figs. 88a-b; Preimesberger 1974: 116–17, 119, figs. 20–21; Martinelli 1981: 8, pl. XXV, note to pl. XXV; Russo 1981: 125, no. 103; Harris 1990: 492–93, figs. 13–2a, 13–2b; Avery 1997: 197, fig. 281

The Fountain of the Four Rivers is one of Bernini's most celebrated works, as well as one of the most spectacular monuments of Baroque Rome. It was designed and executed between 1648 and 1651 for Pope Innocent X Pamphilj as a *mostra* for the Acqua Vergine (a primary source of water for the city), which the pope had conducted to the center of Piazza Navona. At one end of this vast oblong piazza – the site of the ancient stadium of Domitian –

is the Palazzo Pamphilj, which was rebuilt between 1645 and 1647. Immediately adjacent to the palace stands the church of Sant'Agnese, which, beginning in 1652, was transformed into a grandiose Pamphilj family chapel. The piazza thus served as a kind of *cour d'honneur* for the Pamphilj – a grand urban stage glorifying the papal family – and the Fountain of the Four Rivers was designed by Bernini as its monumental centerpiece. The central element of the fountain is an ancient obelisk unearthed in the Circus of Maxentius, capped by a bronze dove, symbol of the Pamphilj. The obelisk rises from a tall rocky base – a rustic, grotto-like *macchina* – pierced by irregular openings on all four sides. On each of the four corners of the rock sits a male figure; each personifies one of the four great rivers and, by extension, one of the four known continents of the world. The Danube representing Europe, and the Ganges of Asia occupy the south side, while Africa's Nile and the Rio della Plata of America are on the north side. Attributes of the river gods, in the form of animals and plants, populate the base; they include a horse, flowers, and herbs for the Danube; a serpent and various fronds for the Ganges; a lion and palm tree for the Nile; and an armadillo, a peony, and a cactus for the Rio della Plata. Two Pamphilj coats of arms appear directly below the base of the obelisk, on the north and south sides of the fountain; the one on the south is supported by the outstretched hand of the Danube.

Bernini's design for the fountain was officially approved in July 1648, and work began on the foundations immediately thereafter. The obelisk was transported to Piazza Navona in June and July of that same year, although it was not erected until August 1649. The great rocky base of travertine was carved *in situ* between late-1649 and mid-1651 by Giovanni Maria Fracchi, who was also responsible for the flora and fauna. The marble figures of the rivers, completed by mid-1651, were executed by Antonio Raggi (the Danube), Jacopo Antonio Fancelli (the Nile), Francesco Baratta (the Rio della Plata), and Claude Poussin (the Ganges), while Nicolò Sale carved the marble coats of arms and produced the models for the bronze dove that crowns the obelisk. After nearly three years of labor the fountain was finally unveiled on 12 June 1651 – to the delight of Innocent X and, as a *relazione* of the day records, "to the applause of all Rome."

This large presentation drawing records Bernini's earliest design for the fountain. It was most likely produced between April 1647 and July 1648, that is, some time after Innocent had decided to incorporate the obelisk in the fountain and before the official approval of a more definitive design. Here the obelisk ascends above a relatively small rocky base, which is hollowed out below and set in an oval basin. Directly below the obelisk, and seemingly to emerge from the rocky mound, is a half-length male figure, bearded and with long hair, representing a river god or water deity. Water flows from his chest into a broad shallow shell, from which, in turn, it cascades down into the basin. In addition to being the source of the water – or, as Preimesberger (1974: 119) called him, the

"Fons" – the bearded personification raises his arms laterally to support two shell-like cartouches bearing the papal coat of arms. And although only one side of the fountain is represented (and, consequently, only one river god and *stemma*), it is generally assumed that the design was to be repeated on the opposite side, with a second river god and coat of arms.

At this stage in the planning, as Brauer and Wittkower (1931: 47) first observed, the rocky base plays a subordinate role in the design. It appears more like a small grotto than the large island rock it would become, and it is dominated by the shell – a motif Bernini had used earlier in his Triton Fountain in Piazza Barberini (1642–43). The obelisk is the most prominent feature – more than double the height of the base – and, in contrast to its placement in subsequent designs and in the completed fountain, it is positioned so that its corners, rather than its sides, face the four main axes of the piazza. Bernini would later alter many of the elements of this design: notably, he would rotate the obelisk 45 degrees; increase the height and scale of the rocky base; expand the figurative elements; and remove the shell. But already at this early point in his development of the fountain he had established that its basic *concetto* would revolve around the contrast between a natural base and a mathematically formed obelisk, that is, between nature and art (see Huse 1967: 13; Kauffmann 1970: 179). SFO

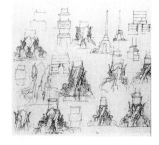

74
Gian Lorenzo Bernini
Studies for the Fountain of the Four Rivers
Leipzig, Museum der bildenden Künste, Graphische Sammlung, Inv. no. NI 7907
Black chalk, pen and brown ink; 32.1 x 34.5 cm
PROVENANCE: Acquired by the Stadtbibliothek, Leipzig from Prior Francesco Antonio Rensi in 1714; transferred to the Museum der bildenden Künste in 1953
BIBLIOGRAPHY: Brauer and Wittkower 1931: 49, pl. 28; Pane 1953: 52, fig. 95; *Christina Queen of Sweden* 1966: 461, note 1135; Fagiolo dell'Arco 1967: 247, fig. 83; Huse 1967: 24–27; Zamboni 1968a: 18; Sestieri 1970: 14, fig. 8; Kauffmann 1970: 181–82, fig. 91; Preimesberger 1974: 124; Harris 1977: XVIII, pl. 47; Courtright 1981: 108–17, note 19; Mehnert 1981: 23, note 24; Harris 1990: 494–95, figs. 13–10; Kieven 1993: 90, note 22; Avery 1997: 198, fig. 285

Following the Windsor drawing in which the river gods assumed a prominent role, Bernini focused his attention on developing his ideas for the rocky base and plinth below the obelisk. Those ideas are recorded on this sheet: it fea-

tures twenty individual *pensieri*, nineteen drawn in pen and ink, and one in chalk. The majority of the sketches show Bernini experimenting with the design for the rocky support and plinth; five are concerned with the plinth alone; four are structural studies for the arrangement of the travertine blocks from which the rocky base would be carved; and the last establishes the profile and measurements of one of the coats of arms. Discussions of this sheet have centered on deciphering the relationship among the individual studies, which, at first glance, appear to have been haphazardly drawn over the entire surface of the page. Brauer and Wittkower (1931: 49), who recognized that the sketches relate to the west side of the fountain, argued that Bernini drew them in two separate phases: in the first he studied the design of the rocky base and plinth, in the second he turned to the plinth alone. Huse (1967: 24–27) suggested a three-phase sequence, arguing that the first group of studies were concerned with the rock formation and the placement of the river gods, the second with the problem of constructing the base with blocks of travertine, and the third with the shape of the plinth. And whereas Brauer and Wittkower proposed no particular sequence for the sketches within the groups, Huse attempted to establish a definitive order of execution. Kauffmann (1970: 182) recognized two separate phases (although he rejected the possibility of determining a strict sequence of studies), and argued that Bernini intentionally juxtaposed a number of alternative solutions and later selected the one he liked best. The most convincing analysis of the sheet is Courtright's (1981: 109–13). Dividing the sketches into four groups (those listed above), she traced a logical order of execution within each of them. She observed that among the studies for the rocky base and plinth, the sketch in the lower right corner comes closest to the final design. Within the second group – those for the plinth alone – Courtright identified the study just to the left of center at the top of the sheet as the last and most definitive design. And among the four structural studies, the sketch in the upper right corner of the sheet represents Bernini's solution to the problem of arranging the blocks of travertine. All three of these final solutions were then translated into three dimensions in the so-called "Modello Giocondi" (cat. no. 00), which (as Brauer and Wittkower first proposed) was most likely executed immediately after this sheet.

In the course of developing his ideas for the design of the fountain's base, Bernini gradually increased the height of the rock formation and plinth. Simultaneously, he augmented the motif of the diagonally cleft rock, heightening the impression that the hollow was caused by a natural shift in the rocky mass. And as was typical of Bernini, who was deeply concerned with the dynamic interaction of elements in achieving visual unity (what he called "i contrapposti"), he also repeatedly experimented with the degree to which the rock should overlap the plinth and with the scale and position of the river gods and coats of arms in relation to the base. S.F.O.

76 T–M–MAR
Gaspare Morone (or Morone Mola)
Medal of Innocent X with Piazza Navona
Munich, Staatliche Münzsammlung
Silver
Diameter 3.9 cm
INSCRIPTION: "INNOCEN. X. PON. MAX. A. VI" (obverse); "VIRGINE /AGONALIUM CRUORE" (reverse)
BIBLIOGRAPHY: Bonanni 1699: II, XXVI; Venuti 1744: XVII; Lincoln 1890: 1105; Bartolotti 1967: E.652; Weber 1973: 152–53, no. 254; Michelini Tocci 1981: 288, no. 286; Whitman and Variano 1983: 93–94, no. 75b; Worsdale 1986: 99, no. 26; Harris 1990: 492, 494, 500, no. 22; Börner 1997: 245, no. 1125

This silver medal is the work of Gaspare Morone, chief engraver to the papal mint from 1640 to 1669. Designed as the foundation medal for the Fountain of the Four Rivers, it was struck – as its inscription states – in the sixth year of Innocent X's papacy.

It was most likely produced in conjunction with the erection of the obelisk in August of 1649; and given that Innocent was elected to the papal throne in September of 1644, the medal can not have been made before September of 1649, for only then did the sixth year of his reign begin.

The medal reproduces an early idea for the fountain, approximately midway through the course of its development. Zamboni (1968a: 18) and Weber (1973: 152) have observed that the fountain depicted on this medal closely corresponds to the so-called "Modello Giocondi", which dates between late-1648 and mid-1649, and a comparison between the medal and the north face of the model (see Sestieri 1970: fig. 22) bears this out. In both the personifications of the two river gods, the Ganges to the left and the Plata to the right, face the spectator and support a coat of arms, which is attached to the obelisk's plinth above their heads.

These elements – the outward-facing river gods supporting the coat of arms – were retained from an earlier stage in the fountain's design recorded in the drawing in Windsor; in that drawing, however, because the obelisk and its plinth are lower, the coat of arms is placed between the two figures, instead of above them.

As seen in the model from Bologna and in the finished work, Bernini would subsequently alter the poses of the river gods and, except for the Danube, relieve them of supporting the coat of arms.

In addition, the shells in which the river gods sit, and the dolphins below them, which ap-

pear in the Windsor drawing, do not appear here; instead the river gods sit upon a rocky base, hollowed at the center, as in the "Modello Giocondi", the Bologna model, and the final design.

Numerous examples of this medal are known. An early issue, dated to the fifth year of Innocent's papacy (thus struck between September 1648 and September 1649), was published by Whitman and Varriano (1983: 93, no. 75a).

The design of the reverse is the same as the Munich medal, but its obverse features the pope bareheaded and wearing a cope on which appears a papal procession, in contrast to this medal where he is crowned with a tiara and wears a cope decorated with an image of the standing Virgin.

The medal – with the same obverse and reverse as this one – was also issued as an annual in the seventh year of Innocent's reign (see Whitman and Varriano: 1983, 93, no. 75b); for the Holy Year of 1650 it was issued with "A. IVB." and "MDCL" added to its obverse inscription (see Börner 1997: 245, no. 1125); and in the pope's eighth regnal year (September 1651– September 1652) it was issued again to commemorate the fountain's inauguration.

The reverse of this last medal reproduces the earlier design with two modifications: the inclusion of highly schematized attributes for the river gods and an increase in the number of bollards, from six to twelve, in the railing around the basin.

A new obverse, however, appears on this medal, with the pope (now facing left) wearing a *camaurum* instead of a tiara (see Worsdale 1986: 99, no. 26).

Giacinto Gigli (ed. 1958: 409–10) records the issuance of this medal, providing a detailed description of both the papal portrait and the fountain in the piazza. SFO

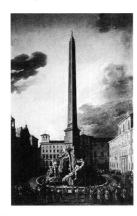

75 T-M-W
Anonymous Roman Painter
Pope Innocent X Visiting the Fountain of the Four Rivers
Rome, Museo di Roma, Inv. MR 35459
Oil on canvas
285 x 187 cm
PROVENANCE: Heirs of Gian Lorenzo Bernini; acquired by the Comune di Roma 1967
EXHIBITIONS: Fagiolo dell'Arco and Madonna 1985; Arisi 1986a: 23–24; Fagiolo dell'Arco 1997a

BIBLIOGRAPHY: Gigli 1958: 385–86; Pericoli Ridolfini 1967: 11–21; Pietrangeli 1971: 63; Ricci in Fagiolo dell'Arco and Madonna 1985: 259–60; Ricci in Fagiolo dell'Arco 1997a: 234–35, no. A14

Pericoli Ridolfini (1967) and Pietrangeli (1971) have argued that the painting shows, not the official inauguration of Gian Lorenzo Bernini's Four Rivers Fountain, but another visit by Pope Innocent X, possibly the one recorded by the diarist Gigli on 8 June 1751, four days earlier (Gigli 1958: 385–86; Ricci in Fagiolo 1997). Innocent X Pamphilj appears at right; the rider seen frontally on a rearing horse at left has been identified with Bernini. In the story told by Baldinucci and others, Bernini, in disfavor because of his Barberini associations and the failure of the tower of St. Peter's, with the connivance of Donna Olimpia Pamphilj, the pope's sister-in-law, arranged to display his silver model for the proposed fountain where the pope would see it.

The pope was suitably impressed, Bernini got the commission and was restored to favor. The prominence of the artist in the painting, the significance of the commission for his career, and the provenance of the painting, suggest that the person who commissioned it may have been Bernini himself.

The painter ostensibly shows the fountain along the axis of the Piazza Navona toward the south, but has rotated it forthy-five degrees so that the obelisk is seen edge-on. The main reason for the change must be pictorial. The shaft of the obelisk, seen frontally, would not be so easy to model effectively by an artist who, as the opposed sides of the piazza reveal, enjoyed bold contrasts of light and shade.

A diagonal view sacrifices one river god (the Danube) but allows the other three to be viewed without interference from those behind. This is one of the most satisfactory views of the monument: the divergent, rising forms of the Nile and it palm tree, the strong profile of the Ganges and its oar on the left and the violent reaction of the River Plate on the right; and the light-dark opposition of left and right even if, in normal daylight, the chiaroscuro is less dramatic.

The buildings in the background show the south end of the Piazza Navona. At the left is San Giacomo degli Spagnoli. Conspicuous on the pediment and flanking volutes are steps (or battens) and railings. These are visible in Sacchi and Gagliardi's painting recording the Festa del Saraceno in 1634 (Museo di Roma), where they are being used by spectators in search of a good view.

The gable battens and railing appear in views by Falda in the 1660s and De' Rossi in 1686 but after that are no longer to be found. Beyond is a house on the corner of the Via dei Canestrari built when the Palazzo Aldobrandini was demolished.

On the opposite side is the recently completed Palazzo Pamphilj, showing the pale blue stuccoes that were still to be seen in the eighteenth century.

At the far end of the piazza at the left is the sixteenth-century Palazzo De Torres-Lancellotti,

by Pirro Ligorio, accurate in most essentials. On the other side is the Palazzo Orsini, demolished at the end of the eighteenth century to make way for the Palazzo Braschi. The tower at the left, built by Antonio da Sangallo the Younger at the beginning of the sixteenth century, is shown with a closed top storey, with framing pilasters, balustrade and curved pediments over the windows. Fioravante Martinelli (D'Onofrio 1969: 236–37) in 1658 refers vaguely to the columns of the open loggia, visible in earlier views, like those by Sacchi and Gagliardi and Silvestre, as having been removed "a few years'" ago.

A drawing from the Chigi manuscripts in the Vatican collection seems to show this project, which perhaps points to a date after Alexander VII's accession in 1655. Yet it is difficult to believe that a painting depicting Innocent X would have been commissioned subsequent to his reign. DRM

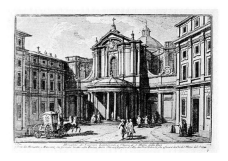

81 T
Giuseppe Vasi (1710–82)
Façade and Square of Santa Maria della Pace, in Giuseppe Vasi, *Delle magnificenze di Roma antica e moderna*
Roma 1747–61
Rome, Istituto Nazionale per la Grafica
Copperplate engraving
BIBLIOGRAPHY: Noehles 1969a: fig. 25; Ost 1971: fig. 31; Noehles 1997: fig. 129

The engraving shows the square and façade of the church of Santa Maria della Pace as seen by the eighteenth-century *vedutisti*.

The approach road is widened many times over and the square seems considerably larger than it really is.

This reduces the monumental impact of the façade of the church.

Giuseppe Vasi's engraving also attenuates the urgent plasticity with which the *tempietto* and the avant-corps protrude into the square.

However, the relationship between the wing elements of the façade, staggered one behind the other, is convincingly rendered in its perspective effect.

It also becomes clear that the square – which was known even at the planning stage as the "Theater of Peace" – was to serve as a stage for the "entrances" of the churchgoers.

The walls which disguise the heterogeneous houses of the square prepare for the church façade, yet are definitely subordinated to it by their flat pilaster subdivisions.

For the layout of the walls of the square, see the ground plan. KN

The Equestrian Statue of Constantine
Tod A. Marder

Bernini's equestrian statue of Constantine was commissioned in 1654 by Pope Innocent X Pamphilj (1644-55) in the last months of his papacy. At the Milvian Bridge, the Emperor Constantine won a key battle to vanquish the opponents of Christianity. His victory followed a miraculous vision of the Cross, accompanied by the words, "in this sign you shall conquer" ("in hoc signo vinces"). As an act of thanksgiving Constantine founded a church, St. Peter's, over the apostle's tomb and made the Christian faith legal to practice throughout the empire. By representing Constantine's vision before the battle, Bernini and his patrons sought to underscore the source of the emperor's victory and his temporal power in the realm of the spirit.

Bernini's statue was initially intended to be placed on a pier along the north aisle of St. Peter's, but the marble languished in the studio into the early years of Alexander VII's pontificate (1655-67). It was Alexander VII who decided to position the Constantine at the foot of the Scala Regia, where it has always stood. While the sculptor was at work, Queen Christina of Sweden visited him once and Alexander VII on two occasions. Bernini received the queen dressed in his "coarse and rough" work attire, claiming they were the only clothes he had that were worthy of his occupation. This gesture emphasized her status as monarch. When Christina insisted on touching Bernini's clothes as a sign of esteem for his art, she was also paying homage to his creation, for Constantine was the exemplum for all Catholic rulers, like herself, who supported the temporal and spiritual claims of the papacy.

In fact, the position and meaning of the equestrian group at the foot of the Scala Regia was meant to urge arriving rulers, dignitaries, and their ambassadors to acknowledge the true source of temporal power, which is spiritual. Because it is extremely unusual to find depictions of Constantine's Vision of the Cross with the emperor on horseback rather than on foot, Bernini and his patrons may have wished to suggest analogies with the more common equestrian monument, the *condottiere* tomb that heralds a military hero in the service of higher political and civic causes. Bernini manipulated the form and meaning of the traditional imagery to new effect. The essence of the *condottiere* funerary monument is a proud rider who dominates his powerful steed. Here, however, Constantine is dazed by the light of the vision and his horse is stunned by its power. The message of this vision is made more compelling for its contrast with the control the rider-warrior traditionally execises over his horse. Before the spiritual force of the Cross, Constantine seems temporarily powerless. Bernini began working hard on the Constantine in 1662. In early 1669, he claimed it had taken seven years of his time. While reportedly nearly finished in mid-1668, the equestrian was not completed until January 1669, when a wall of the studio had to be knocked out to remove the statue and transport it to the Vatican. It was hoisted onto its pedestal at the foot of the Scala Regia with the help of two huge winches and seven pair of

oxen. The instructive symbolism of Bernini's Constantine was complemented in the early eighteenth century, when an equestrian statue of Charlemagne was positioned at the south end of St. Peter's narthex. There it faced Bernini's statue so the visitor could see the two greatest advocates of the temporal power of the Church.

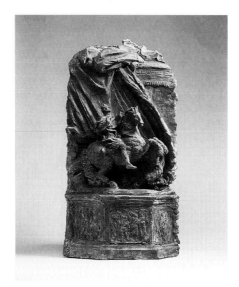

82 T
Gian Lorenzo Bernini (?)
Bozzetto for the Equestrian Statue of Constantine
Salzburg, Salzburger Barockmuseum, Sammlung Rossacher
Terracotta; 835 x 400 x 200 mm
BIBLIOGRAPHY: Wittkower 1955-97: 292; Rossacher 1967: 2–11; Courtright in *Drawings by Gianlorenzo Bernini*: 145, no. 33; Mehnert 1981: 45; Marder 1997: 175–76, 178

This terracotta piece shows the equestrian statue of Constantine much as it was executed. Both horse and rider are depicted in poses that are remarkably close to those of the executed version. Moreover, the patterns of the drapery behind the horse correspond closely (but not exactly) to those that were shaped in stucco and gilded on the site. The Salzburg terracotta also shows the horizontal lines and fringe of the baldachin that peaks out from behind the drapery. More problematic is the inclusion of a polygonal base or pedestal with three reliefs on it. There are no references to these features in documents pertaining to the Constantine statue or the Scala Regia. In addition, the use of a base or pedestal that blocks access to a back staircase of the palace (it stood there for centuries before Bernini's time) seems quite unlikely. Among other problems with this composition, there is the fact that the arrangement of the cloth backdrop seems almost finalized while the features of the base would still be in discussion. In the following drawing, thought by most scholars to be autograph, the reverse is the case: the drapery is not yet finalized while the base is. Documents tell us that Bernini continued to adjust the shape of the drapery well after the statue was set on the pedestal in its final shape.
 TAM

The Scala Regia
Tod A. Marder

The monumental staircase known as the Scala Regia was designed and executed by Gian Lorenzo Bernini in the years between 1663 and 1666. The purposes of the Scala Regia at the Vatican Palace are two-fold. First, the staircase serves as the principal ceremonial entrance to the palace, leading from Piazza San Pietro to the main reception halls and chapels in the fabric. Secondly, the Scala Regia provides the primary connection between St. Peter's Basilica and the palace, which was built to the north on higher ground. Two runs of stairs define the Scala Regia. The more frequently illustrated is the lower run because it is dramatically composed between subtly converging walls lined by columns that also converge as the stairs rise. Bernini proportioned the columns to diminish in size and had them set ever closer together along the ascent. A barrel vault over the main passage is also handled in a dynamic manner, for its radius decreases gradually to complement the diminution of the other components. The lower run is connected to the north corridor of Bernini's Piazza San Pietro by a short flight of stairs, labeled "A" in Carlo Fontana's engraving. From the base landing of the Scala Regia ("C" in the engraving), the stairs rise through five bays to an intermediate landing ("F"), and continue along five more bays to a double landing ("H"). At the double landing the visitor must make a 180-degree turn to the right. The ascent then continues along the upper run of stairs.

Bernini set upper run of stairs ("I") between two parallel walls, whose width corresponds to the summit of the lower stairs. By doing this, he insures a degree of formal continuity that might otherwise be overlooked. Moreover, the upper run of stairs is not as long as the lower one, so that distances seem progressively shortened. The straight, parallel upper stairs are flanked by walls divided into six bays by double pilasters. Above the pilasters, a barrel vault with a uniform radius is similarly divided into six sections. A visitor who traverses this portion of the Scala Regia will be brought to the largest audience hall of the palace, the Sala Regia ("K"). The walls of the Sala Regia, which Fontana depicts within stippled lines, lie perpendicularly over the lower portion of the Scala Regia.

For the approaching visitor, a system of dramatic illumination accompanies the ascent to the papal audience hall. Natural light from above floods the area of the base landing; and from a tall window at the intermediate landing, there is a source halfway along the first portion of the climb. Two windows at the double landing introduce a brilliant swathe of light, so strong as to act as a kind of beacon when seen from the north corridor far below. Complementing these features, finally, Bernini inserted large skylights in each of the six bays over the upper run of the staircase. These skylights are not shown in Fontana's engraving; by the nineteenth century all but two were dismantled and closed. The two that survive bear witness to a scheme in which the lower, wider flights of stairs were spotlit at the middle and the ends, while the much nar-

rower, parallel stairs of the upper run were uniformly and brightly lit from above.

From the time of Julius II and Bramante, and probably even earlier, there was a staircase in this place, but its dimensions and character differed from Bernini's arrangement. Archaeological and graphic evidence allows us to determine that the earlier stairs laid the path for Bernini's replacements, but took a different form. For in the early sixteenth century, the staircase was much narrower and it was uniform in width along its entire length. Buried deep in the walls of the palace and abutting the medieval structures that adjoined the basilica, this earlier staircase was not well lit, and it rose without a pause or break except at the same double landing that Bernini re-utilized.

Because the physical context of the sixteenth-century stairs differed from that of Bernini's monument, its principal functions differed too. Before Bernini's time, the Scala Regia connected the palace to the basilica and only secondarily to palace entrances. For, between the foot of the sixteenth-century stairs and Piazza San Pietro stood a myriad of structures. Thus, the staircase was far removed from the presence of the arriving visitor, who would find it only after going through a long sequence of preceding buildings and spaces.

Under the auspices of Pope Paul V Borghese (1605-21), the nucleus of new St. Peter's was extended and given a new façade. The architect of these changes was Carlo Maderno, who built the present nave and façade of the basilica, and was also responsible for adjusting the level of the Scala Regia to meet the new location of the basilica's entrance. Even after these changes, there was no direct connection between Piazza San Pietro and the Scala Regia, which therefore served as an essential processional route between palace and basilica but not primarily as a palace entrance. Only with Bernini's design of Piazza San Pietro, under the aegis of Pope Alexander VII Chigi (1655-67), could the Scala Regia assume the function of a major palace entrance. In the course of designing the piazza, Bernini invented two long corridors to connect the ends of his colonnades to the left and right ends of St. Peter's façade. In building the corridor on the right (north) from the colonnade to Maderno's façade, Bernini was careful to align the axis with the Scala Regia, so that a straight route of approach from the piazza to the palace stairs would result.

It is uncertain how early Bernini planned for the Scala Regia. His designs for the piazza (colonnades and corridors) were begun in 1656 and finalized by 1660. Demolitions for the north corridor next to the Vatican Palace had been under way since 1659, and the corridor was completed by the end of 1662. At the beginning of 1663, Bernini proceeded to complete the design and decoration of the Scala Regia

There is good evidence that carriages could and did enter the north corridor, a small portion of which appears on the right side of Fontana's engraving (in plan, "Parte delli Corridori," and in elevation, "Profilo di una Parte del Coridore"). The width of the corridor at the foot of the stairs permitted carriages to drop off passengers

bound for the palace and turn back to the piazza. In order to avoid a visual and functional bottleneck where the much narrower, pre-existing stairs began to rise, Bernini chose to increase the width of the sixteenth-century staircase so that it would conform to the broad dimensions of the corridor. To avoid the same awkward problems of form and function at the double landing of the staircase, Bernini progressively reduced the width of the Scala Regia to conform to the dimensions of the upper flight of stairs. By preserving the existing (sixteenth-century) width of the upper run of the Scala Regia, Bernini was able to leave crucial bearing walls of the palace structure intact. These walls were essential to the stability of the Sala Regia, Cappella Sistina, and Cappella Paolina, where damage or destruction was unthinkable. Bernini created a tapering lower run for the stairs by rebuilding the wall that is to the left of the approaching visitor (the lower wall in Fontana's engraving). The chief structural problem in this operation was to provide temporary support for the walls and floors above and around the Scala Regia before the new masonry was set. A complex system of temporary buttressing was therefore an essential prelude to Bernini's construction. Most of this work was carried out by arranging huge timbers in a bracing system that "astonished" the professionals of the day no less than casual on-lookers, according to Carlo Fontana's report of 1694.

Above the rows of columns along the Scala Regia there are walls, hidden above the vaults we do see, that offer lines of support to the pre-existing structures that lie over the staircase. The rows of columns are therefore structural elements of the composition. At the same time they have an expressive function, which is to enliven the prospect of the converging walls. Together, the walls and columns generate a perspective composition that gives greater apparent length to the lower run of the Scala Regia than would otherwise seem the case. By employing columns whose dimensions are subtly but constantly reduced along the ascent and by progressively reducing the radius of the barrel vault over them, the visitor is meant to perceive a staircase that appears longer than it is.

The deep treads on which the visitor steps and the relatively low risers that determine the gradient of the rise together enforce a stately pace that was the legacy of sixteenth-century stair design. It is particularly striking to learn how powerfully these proportions subvert the intentions of modern visitors to hurry along the processional path with quick strides. Indeed, the perspective of the ascent when seen from the base landing will lead one to imagine a climb that is longer and hence more arduous than is really the case. As a result the visitor arrives more quickly than anticipated, almost magically, at the summit of the first run of stairs. Bernini transforms sensory expectations into a surprise that is experienced viscerally. One anticipates a climb that in fact is accomplished with greater ease and speed than the visual clues would suggest. In the sequence of drawings exhibited here, it is possible to follow the steps by which Bernini arrived at a solution that is structurally sound, as well as visually and conceptually dynamic.

87 MAR
Carlo Fontana (?) (1638–1714)
Preliminary Design for the Scala Regia
Munich, Staatliche Graphische Sammlung, Inv. no. 34864
Graphite, brown pen, brown wash
332 x 215 mm
BIBLIOGRAPHY: Voss 1922: 12–14; Brauer and Wittkower 1931: 95–96, 174; Kieven 1993: 172; Marder 1997: 135–38; Marder 1998: 177–79

In this drawing, perhaps by the hand of Carlo Fontana (1638-1714) working in Bernini's studio, several problems were addressed. The earlier, sixteenth-century stairs have been widened to approximate the dimensions of the corridor which appears in the foreground. A line of pilasters continues those of the corridor into the upper reaches of the stairs. Free-standing columns bear heavy arches at the foot of the stairs, the middle landing, and the summit of the lower run. The motif of the Serlian arch clearly shown at the base landing may have survived in Bernini's mind from early planning stages at the piazza, when it was tested and discarded. Its symbolic value as an emblem of rulership is evident elsewhere in the Vatican Palace, most notably in the Sala Regia.

In his account of the building of the Scala Regia, Carlo Fontana claims to have been present and to have been charged by Alexander VII with recording the operation. Nevertheless, there is no reason to believe that he is responsible for the scheme. On the contrary, Fontana praises both Bernini and his capomastro, Simone Brogi without claiming part in the design process.

As Hermann Voss deduced by comparing this drawing to the Fontana engraving, the columns and heavy arches on this study sheet were located under the walls of the Sala Regia. He arrived at this conclusion by counting the steps from the base landing to the stippled walls indicated on Fontana's engraving, discovering that the same number of steps lay between the base landing and the columns under the arches on the drawing in Munich.

Another important element of the design in this drawing is the emphasis on natural light, whose effects produce diagonal lines of shadows across the steps and a contrast of lighter and darker portions of the architecture. Recognizing that the predominant light will enter

from the south (the left), the artist is presumably illustrating the effects of illumination at different times of day. The direction of the shadows from the lowest columns suggests that Bernini hoped to bring light into the composition from the narthex of the basilica.

There can be little question that the walls of the stair hall were conceived in this drawing as tapering from bottom to top. But one matter of scholarly disagreement is whether Bernini intended for the three sets of columns to be placed ever closer to the walls along the ascent. A close study of the drawing suggests that there is not an appreciable reduction in the space between the walls and the columns in the three isolated column groups. Therefore, Bernini appears not yet to have introduced the idea of columns arranged along a converging path. TAM

over the lowest portion of the stairs. With the stability of the structure foremost in mind, Bernini probably revised this scheme with a new set of measurements that incorporated an extra set of columns along the lowest portion of the ascent. Such a change involved recalculating the dimensions of all the components pertaining to the columns. For this kind of operation Bernini must have relied on his brother, Luigi Bernini, a gifted mathematician, mechanical engineer, and architect in his own right. We do not know the full extent of Luigi's collaboration on his brother's architectural projects. In addition to his well-known participation in building the ill fated bell towers of St. Peter's, Baldinucci specifically mentions Luigi's collaboration on the Scala Regia, as well as the placing of the obelisk on the Four Rivers Fountain at Piazza Navona. TAM

Now the support for rooms lying over the stairs did not need to be concentrated at three points (base, intermediate landing, and double landing), but could be continuous from bottom to top.

That Bernini's main interest was structural at this phase, and not decorative, is indicated by the use of hackneyed motifs, such as transverse ribs in the barrel vault and coffers with rosettes, that appear frequently elsewhere in his work.

Thus, while not part of the design process, the drawing for the commemorative medal bears witness to crucial moments in Gian Lorenzo Bernini's thinking.

The authorship of the drawing is not even securely his, but it must have been done under his auspices. TAM

86 MAR
Carlo Fontana (1638–1714)
Preliminary Plan of the Scala Regia
Windsor Castle, The Royal Collection 9923
Pen and graphite; 280 x 595 mm
BIBLIOGRAPHY: Braham and Hager 1977: 36; Marder 1997: 139–40; (*Domus Prospettivae*, forthcoming)

In this plan, recorded by Carlo Fontana among the albums of drawings collected by Pope Clement XI Albani (1700-21) that later came to Windsor Castle, we have evidence of Fontana's access to Bernini's working plans. For this sheet clearly represents a scheme preparatory to the one that was executed. Here, for example, the first flight of stairs is composed of four bays, rather than five as executed. Moreover, the plan appears to indicate a groin vault over the base landing, much like the one that was projected in the early drawings in Munich and the Vatican. Despite these differences, the overall dimensions indicated on Fontana's plan are quite close to those of the monument. The use of four rather than five bays along the lowest portion of the staircase in the preliminary drawing is significant. By spacing the columns more generously here and increasing the relative density of the columns in section above the intermediate landing – thus having four bays, then five bays – the effect of a perspective diminution of features would have been more marked than it is. The drawback of this design is that it lacks crucial structural support precisely where it is most urgently needed: under the Sala Regia, which lies

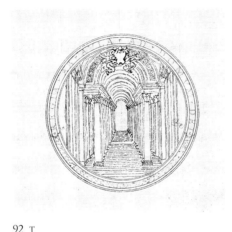

92 T
Gian Lorenzo Bernini (?) (1598–1680)
Preliminary Design for the Scala Regia Medal
Vatican, Biblioteca Apostolica Vaticana, Chigi J VI. 205, fol. 264
Pen and brown ink
201 x 272 mm
BIBLIOGRAPHY: Brauer and Wittkower 1931: 95-96; Harris 1977: XXII; *Bernini in Vaticano* 1981: 300-301; Whitman and Varriano 1983: 105; Marder 1997: 138-49

A prominent circle drawn over the Munich drawing reveals that the image was considered for the obverse of a medal or coin. The design and dedication of the Scala Regia must have been a matter of some urgency, since the present drawing differs so fundamentally from what was first contemplated for the use of the medallist.

The circle around the Munich sheet is evidence of the desire to commemorate the work even before the design was settled. Additional evidence of hopes for an early conclusion to the project may be construed from the fact that the preliminary design for the medal in the Biblioteca Apostolica Vaticana, which was used for the striking, was still not the final, executed scheme of the monument.

The drawing for the medal is our first evidence of Bernini's decision to employ a line of columns as the leitmotif of the Scala Regia, providing structural support for the floor above the stairs and a compelling visual image for the viewer.

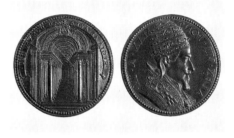

93 T
Gaspare Morone (d. 1669)
Papal Annual Medal Depicting the Scala Regia
Vatican, Biblioteca Apostolica Vaticana, Medagliere
Gold
41 mm
BIBLIOGRAPHY: Brauer and Wittkower 1931: 96; *Bernini in Vaticano* 1981: 300–301; Whitman and Varriano 1983: 105; Varriano 1984: 72; Marder 1997: 140–49

The papal annual medal struck in 1663 for the feast of Saints Peter and Paul (29 June) depicts the Scala Regia much as it appeared in a preliminary drawing in the Biblioteca Apostolica Vaticana.

The major changes from drawing to medal involve the clearer delineation of the foreground steps, the higher position of the figures of Fame and the papal escutcheon, and the new form of the inscription, which is now mounted on a banderole with curled ends rather than printed around the exergue.

In the medal and the preparatory drawing for it, a low groin vault over the base landing in front of the stairs is just visible at the edges of the design.

At this moment planners may have been discussing how to increase the height of the vault, for one sees in the progression of the schemes – from the Munich drawing (kept in Staatliche Graphische Sammlung; see cat. no. 87) to the Vatican drawing (Biblioteca Apostolica, Medagliere) for the medal (see cat. no. 92), to the medal itself – how the figures of Fame bearing the papal coat of arms are lifted successively above the profile of the barrel vault.

It has been suggested that the result enhanced an uninterrupted view of the receding vault, and indeed this is true.

But the raising of the vault may also have been intended to accommodate a huge window or light well that was designed to bring natural illumination down onto the equestrian statue of Emperor Constantine (see cat. no. 86), a symbol of Cristianity.

The inscription – "REGIA AB AULA AD DONUM DEI" – refers to the function of the staircase in connecting the "royal" papal palace to the house of the Lord, St. Peter's.

This message therefore emphasizes the role of the Scala Regia in consolidating the image of the palace-church complex rather than the function of the stairs as the principal entrance to the palace. TAM

88 T
Nicodemus Tessin the Younger (1654–1728)
Plan of the Scala Regia
Stockholm, Nationalmuseum, THC 2172
BIBLIOGRAPHY: Marder 1997: 139–40

This drawing is a record of the Scala Regia executed by the Swedish architect Nicodemus Tessin the Younger, made during one of his two visits to Rome (1673-78, 1687-88). Several details illustrate how exacting his record of the monument is. The varying sizes of the niches in the walls of the lowest flights are carefully detailed in shape and inscribed in the appropriate dimensions. The asymmetrical plan of the pedestal for Constantine is also faithfully rendered, along with the different dimensions that pertain to the spaces around it. TAM

89 T
Nicodemus Tessin the Younger (1654–1728)
Elevation of the Scala Regia
Stockholm, Nationalmuseet, Tessin-Hårleman Collection, THC 2173
BIBLIOGRAPHY: Marder 1997: 139–40

Nicodemus Tessin the Younger's (1654–1728) elevation of the first five bays of the Vatican Scala Regia is, like his plan, the best evidence we have for Gian Lorenzo Bernini's Scala Regia as built.

Unlike the plan, which it must have been in-tended to accompany, there are relatively few inscribed dimensions.

The equestrian statue of Constantine is only lightly sketched.

And the elevation of the architecture is complete only in its lowest parts, presumably those that Tessin could easily reach and measure without a ladder.

Even the tops of the niches flanking the steps are left without indications.

This limitation is all the more regrettable because it deprives us of an accurate and precise representation of the upper reaches of the vaults over the base landing and the portions of the stairs located under existing rooms of the palace. These are features that demonstrate an obvious and necessary concern for structure. TAM

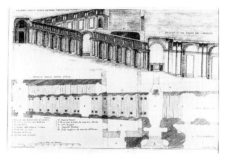

90 T–MAR
Carlo Fontana (1638–1714) and Alessandro Specchi (1668–1729)
Plan and Elevation of the Scala Regia
Engraving
BIBLIOGRAPHY: Marder 1997: 19, 29, 64, 125, 130, 132–33, 136–39, 143, 155–56, 161, 253–55

The plan and elevation of the Scala Regia were drawn on a single plate by Fontana and engraved by his pupil Specchi. The plate was engraved to be included in Fontana's publication *Templum vaticanum et ipsius origo* (1694). There are later engravings of the plan and elevation, but this is perhaps the most widely diffused and significant representation of these features, not least because of its lack of correspondance to the monument as built in some details. Among the incidental features that differ from the scheme as built, we could mention the shape and dimensions of the pedestal for the statue of Constantine, the niches flanking the lowest portion of the stairs, or the double landing. In all of these particulars, Tessin's record conforms more closely to the monument as built. On the basis of such details, it is likely that Fontana's drawing was made from a preliminary study that was later superseded in the design process. Thus, we may surmise that the skylights, amply documented in construction records, were not shown on the upper run of the stairs perhaps because they were not yet invented on the drawing that Fontana copied. In the *Templum vaticanum* he writes that he was asked to compose both the engraving and description by Alexander VII himself, and that they be done "together with Bernini." This context would explain how Fontana gained access to plans and elevations from intermediate stages in the design process. For a visitor on the site,

one of the most impressive features of the whole design is a window located above the junction between the base landing and the north corridor (below the word "Profilo" in the engraving). The window admits a huge stream of natural light to illuminate the statue of Constantine. Space was made to insert this window by raising the vault over the base landing, yet no such space is visible in Fontana's engraving. Was the lighting system for the Constantine statue developed after the design moment represented on the engraving, or is there some other explanation for this and other features that do not correspond to the monument as built? Whatever the case, Fontana's engraving is important for its early date and for the otherwise embracing nature of the representation of both plan and elevation, given with an accurate idea of the spacial context. TAM

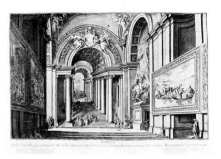

91 T
Francesco Pannini
View of the Scala Regia and the Statue of Constantine from the North Corridor of Piazza San Pietro
Rome, Bibliotheca Hertziana
Engraving
BIBLIOGRAPHY: Marder 1997: 232–35

This is one of the rare views that helps us understand the use of the Scala Regia, for it shows the monument as it was prepared for the feast of Corpus Christi. At this time in the later eighteenth century the corridor was hung with the tapestries designed by Raffaello for the Cappella Sistina. On the right is the tapestry depicting the "Miraculous Draught of Fishes," and on the left is "Sant Paul Preaching at Athens" and the "Death of Ananias." The highlight of the Corpus Christi feast was a procession that began in the Vatican Palace and continued down the Scala Regia, through the north corridor and colonnade of the piazza, traversing the streets of the Vatican Borgo, and returning to the basilica by way of the south colonnade and south corridor. Pannini's engraving wonderfully reveals all major components of the monument, distorting relatively little and showing some features, like the arms of Alexander VII in the window at the top of the stairs, that have now disappeared. On Corpus Christi the pope led the procession down the stairs whose perspective composition enshrined his presence much like a perspective tabernacle enshrines the Host on an altar. In this way the staircase and the corridor provided an ideal setting for the symbolism of the feast, where Christ's dispensation – illustrated in the tapestries – becomes the setting through which the Host is paraded and venerated. On other occasions in the

eighteenth century, a tapestry version of Leonardo's *Last Supper* was hung near the statue of Constantine and, alternatively, next to Charlemagne on the south side of the portico. TAM

94 MAR
Hubert Robert (1733–1808)
The Scala Regia at the Vatican
Besançon, Musée des Beaux-Arts, Inv. D. 2912
Pen and black ink, gray wash, on white paper glued directly onto cardboard mounting (previously blue); 31 x 20.7 cm
PROVENANCE: Collection Pierre-Adrien Pâris; bequest to Bibliothèque municipale de Besançon; consigned to the Museum in 1843
EXHIBITIONS: *Hubert Robert* 1933: no. 59; *Masterpieces* 1954: no. 32; *Dessins français* 1959–60: no. 90; *L'Italia vista dai pittori francesi* 1961: 148, no. 291; *Dessins français* 1977: no. 37; *Charles de Wailly* 1979: 115, no. 53
BIBLIOGRAPHY: Lancrenon, Castan 1879: no. 630; Castan 1889: 132; Cornillot 1957: no. 134

During his stay in Rome (November 1754– June 1765), Hubert Robert paid particular attention to the ruins and vestiges of antiquity, but also took interest in modern architecture. Amongst the prestigious buildings he dealt with in his drawings and paintings, St. Peter's Square and the Basilica held an eminent place. On several different occasions he depicted the portico and the Basilica, as for instance in the sanguine in the Louvre, signed and dated 1759 (Inv. RF 31266, see *J. H. Fragonard e H. Robert* 1990–91: 66–67, no. 17), St. Peter's Colonnade was the theme of a number of drawings, including a number of sanguines in the Valence Museum of Fine Arts (see *Les Hubert Robert* 1985: nos. 34–37), and a sheet executed in pen and wash which is conserved at the Besançon museum (D. 2914). The inside of the Basilica provided the inspiration for a series of sanguines, showing the building from different and often unusual angles, as for instance the spectacular *Vue de la voûte et de la coupole de Saint-Pierre* (Toronto, Art Gallery of Ontario Collection), or the *Vue embrassant le Saint André de Duquesnoy* and, in the distance, the monument of Bernini's Alexander VII (Musée de Valence, D. 85, see *Les Hubert Robert* 1985: no. 38). The artist's admiration for Bernini is evident in the sanguine in the Musée de Valence (D. 85, see *Les Hubert Robert* 1985: 82–83, no. 4), showing a pope's tomb resembling that of Urban VII, and in the sanguine of the Marmottan Museum (Inv. no. 4007) showing the *Chaire de saint Pierre* framed by the tomb of Paul III Farnese and that of Urban VIII (see *Le Temple* 1982: 210), and above all in the present drawing, one of the most beautiful Robert ever did in pen and wash. It shows the Scala Regia constructed by Bernini between 1663 and 1666, and, to the right, the equestrian statue of Constantine, placed there in 1668. Despite the virtuosity and freedom of the drawing itself, it shows a concern to remain faithful to the site's central lines and ornamental details, even if the sculptures above the arch protecting the equestrian monument are reinterpreted. Lastly, the work illustrates the encounter between two recurrent

motifs in Robert's drawn works, the stairway and the cradle-shaped vault adorned with casing, both of which enable striking effects of perspective. While the staircase holds decisive importance in the layout of a great number of drawings, the second theme nourishes the long series of Roman victory arches drawn by the artist, often in *vedute ideate* (for instance *L'Arche centrale de l'Arc de Septime Sévère*, Musée de Valence, D. 62). ALPDS

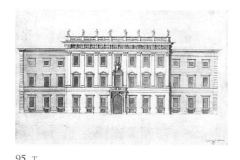

95 T
Carlo Fontana (1638–1714)
Elevation Project for Palazzo Chigi on Piazza Santi Apostoli, Rome
as designed by Gian Lorenzo Bernini
Vatican, Biblioteca Apostolica Vaticana, Chigi P VII 10, 78
Graphite, pen and wash with black and brown bistre; 374 x 504 mm
BIBLIOGRAPHY: Brauer and Wittkower 1931: 127–28; Sladek 1985: 439–503; Waddy 1990: 291–320; Habel 1991: 121–35; Kieven 1993: 170; Marder 1998: 155–56

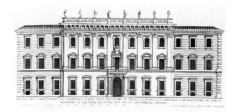

97 T
Giovanni Battista Falda (1648–1678)
Elevation of Bernini's Palazzo Chigi on Piazza Santi Apostoli, Rome
Engraving from *Il nuovo teatro delle fabriche et edificii in prospettiva di Roma moderna*, Roma 1665–99

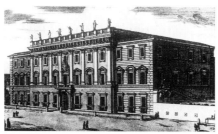

96 T
Alessandro Specchi (1668–1729)
View of Bernini's Palazzo Chigi on Piazza Santi Apostoli, Rome
Engraving from *Il nuovo teatro delle fabriche et edificii in prospettiva di Roma moderna*, Roma 1665–99

Carlo Fontana's drawing of Palazzo Chigi on Piazza Santi Apostoli must have been executed in Bernini's workshop. Like other Fontana drawings and engravings for Bernini projects (e.g. for the Scala Regia), this is sometimes taken for a record of the executed building when, in fact, this drawing represents an intermediate stage in the design process. When compared to the actual building or to seventeenth-century prints of it, many differences are revealed. Prominent among them are the alternating pattern of window pediments across the entire *piano nobile*, the arrangement of columns in the central window bay, and the shapes and moldings of the upper (mezzanine) windows. Fontana's drawing lacks the columns next to all of the windows on the *piano nobile*; the details of the heavy quoins on the ends of the building have been changed; and the rhythm of the brackets over the central section has been altered.

In Specchi's engraving the perspective vantage point of the artist offers a better sense than do the elevations of Bernini's intention to capture strong effects in texture and relief. In addition, Specchi's view includes a glimpse of a raised garden on the right with a fountain that is unremarked in the Bernini literature. To the left of the palace one can see the neighboring house on which, documents tell us, a perspective painting was arranged to align with a corridor through the main reception rooms of the Chigi. The scenic perspective vista was meant to be viewed along this axis, through a window that opened onto the adjoining property. The painting consisted of a river scene with human figures and boats and trees, all framed by fictive Doric columns.

The history of Palazzo Chigi helps to explain the intentions of Bernini's design. When the Sienese Cardinal Fabio Chigi was elected pope and took the name of Alexander VII in 1655, he at first intended to renounce the age-old practice of nepotism and exclude his family from curial affairs. But soon he broke this resolution, either to silence rumors of disrespect for family or because he needed more trusted advisors than those in the Curia. With the arrival of the family in Rome came hopes of forging a Chigi compound on Piazza Colonna. The centerpiece of these dreams would have been a grand palace designed by Pietro da Cortona and incorporating a fountain display for the Acqua Vergine. This enormous scheme remained unexecuted, probably for lack of adequate funding.

In 1657, Alexander's brother, Don Mario and his wife, Berenice; their son Cardinal Flavio; their nephews Sigismondo and Agostino and Agostino's wife Virginia Borghese, had moved into a rented palace opposite the church of the Santi Apostoli. When the bulk of the family then transferred to the former Aldobrandini Palace at Piazza Colonna in 1659–60, the rented property at Santi Apostoli was purchased. In the years 1664–67, Bernini restructured the building as a palace for Flavio, the cardinal-nephew. The structure that became the Chigi Palace on Piazza Santi Apostoli had been in the hands of the Colonna family almost continuously since

the sixteenth century. During the brief ownership of the Ludovisi (1621–23), Carlo Maderno had added a courtyard and staircase which Bernini retained. Also preceding Bernini's presence were ambitious plans by Felice Della Greca to expand the palace through the city block to the west, where it would have a front on Via del Corso. Whether Della Greca's aspirations were meant to be read with Cortona's church of Santa Maria in Via Lata as a Chigi family palace-church complex remains to be proven, but it is a possibility.

What remains without doubt is the emphasis that Bernini and his patrons (especially Alexander VII, because Cardinal Flavio was in Paris) put on the public presence of the new palace, the flagship of family aspirations in Rome. To give form and logic to the façade, Bernini reached back to the key monuments of the Roman Renaissance. From Bramante's Palazzo Caprini came the distinction between the astylar lower storey and the upper storey with a colossal order of vertical members. The pilasters themselves were inspired by Michelangelo's Capitoline palaces, rather than the engaged columns that Bramante used on his palace. From Palazzo Farnese came the scheme of alternating segmental and triangular window pediments and the disposition of the escutcheon above free-standing columns in the central bay of the façade.

Many other sources of the design could be cited. As in other commissions, Bernini has digested his inspirations and reused them to entirely novel effects. Chanelled surfaces unite the three terminal bays of the palace, which are lower than and recessed against the projecting surface of the central seven bays. Other salient features of the central bays include the vigorous shape of the portal, the prominent balustrade, and the crowning statues, which were never executed. In this scheme, a vocabulary of familiar parts has been re-ordered; new expressive values have been culled from traditional shapes and surfaces; and the result has been organized to give rank and order to each ingredient. Giving form and logic to previously repetitive components, Bernini devised a compellingly hierarchic scheme for a palace façade, and his solution reverberated through centuries of European architecture.

Paradoxically, it was one of his admirers who supervised the addition that forever blighted the effect of Bernini's design. For in the 1740s Prince Odescalchi bought the palace and ordered it enlarged under the auspices of the architect Nicola Salvi. Salvi doubled the length of the central section, and he added a four-bay terminal feature on the right to mimic the three bays on the extreme left of the façade. As a result the concentration of the original effect was lost. The transformation of repetitive Renaissance features into a compelling hierarchical unity was reversed; the order and focus of the composition was lost; and its vocabulary reverted to redundance. In this context the early engravings by Falda (1643-78) and Specchi (1668-1729) played an especially important role in transmitting Bernini's ideas to later eras. TAM

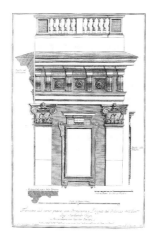

98 T
Domenico De Rossi
Window with entablature of Palazzo Chigi, Rome, by Gian Lorenzo Bernini
Engraving

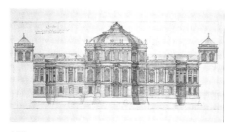

103 T–MAR
Pietro da Cortona (1597–1669)
Project Elevation for the East Façade of the Louvre
Paris, Musée du Louvre, Dépt. des arts graphiques, Recueil du Louvre I f16
Pen, ink, and brown wash on paper
62.2 x 107.3 cm
INSCRIPTIONS: "Secondo Disegno-La Facciata Principale del Castel del Louvre"
PROVENANCE: Bâtiments du Roi
BIBLIOGRAPHY: Noehles 1961: 40–74; Portoghesi 1961: 243–68; Fréart de Chantelou [1985]

In April 1664 Colbert instructed Elpidio Benedetti, his agent in Rome, to show Le Vau's design of the Louvre to Bernini, Pietro da Cortona (1596–1669), and Carlo Rainaldi, and to solicit their ideas about the palace. Benedetti first approached Bernini; only after Bernini agreed to make a design of the Louvre did Benedetti fulfill Colbert's mandate and contact the other Italian architects. Benedetti succeeded in obtaining designs from three Italians, in addition to Bernini. Those by Carlo Rainaldi and a mysterious figure named Candiani were sent to Paris in July 1664, while the ailing Cortona dispatched his scheme in September. Once before Cortona had designed a building in Paris: a project for Cardinal Mazarin's Collège des Quatre Nations in 1660, when the project was in its formative stages. It is unclear if that drawing was ever sent to Paris, and it does not appear to survive, but this episode is relevant because Cortona's design of the Louvre suggests some familiarity with French architecture.

Three elevation drawings of the Louvre by Cortona are preserved in the Recueil du Lou-

vre, an extraordinary album of the schemes Colbert considered during the 1660s. They depict the east façade, the court façade of the east wing, and the west façade facing the Tuileries. The title written on the last drawing, "Quinto disegno" indicates that Cortona sent two other drawings which are lost; according to an early biography of Cortona, his Louvre drawings entailed four façades and one plan (Noehles 1961: 45) thus the missing drawings would be another elevation and a plan, although it seems more likely that Cortona supplied two floor plans, as did the other architects. In any event, the number of presentation drawings and their high quality indicate the importance Cortona attached to the project. Obviously he was unaware of the momentum gathering in Paris around Bernini.

Cortona absorbed the French pavilion system in his east façade which is organized in five discrete units with differentiated roofs. The most prominent feature is the strange dome over the projecting central block. Its hemispherical base appears cinched by a ring of windows that stand free from the sloping coffered wall behind it, which in turn supports a pinnacle looking something like an inverted goblet with a stem of an orb and fleur-de-lis, emblematic of the French Crown. The finial, which also appears on the end pavilions and on the west façade, was Cortona's attempt to devise an architectural iconography appropriate for the royal palace. Its derivation from church lanterns may account for Chantelou's complaint that Cortona's design looks "more like a temple than a palace" (1985: 326). Cortona has also tried to appeal to French taste, at least as he perceived it, by keeping the main façade flat, whereas the more private west façade includes curving walls.

Yet the French pavilion system has been rethought in Roman terms. The façade is unified by wide cornices, the crowning balcony, and the consistent treatment of the wall, window openings, and orders. The window surrounds in the projecting pavilions are contrasted with those in the receding wings, but these minor variations hardly diminish the overriding sense of uniformity. The system is only interrupted to dramatize the center, where the windows are taller and more richly decorated. As in Cortona's other architectural designs, the orders are handled with great sophistication. The effect of the façade depends on the tension between the emphatic trabeated frame, the varied openings in the wall, and the sculptural window frames.

The west elevation reveals that Cortona intended to demolish the historic west wing with Goujon's sculptures and replace Lemercier's Pavillon de l'Horloge with a domed pavilion similar to the one seen here. Chantelou objected that Cortona "had no regard to what was already in existence in the Louvre" (1985: 326), a strange complaint from the man who championed Bernini's designs, but it tells us that Cortona's reconception of the west wing obscured his underlying effort to assimilate French forms and to celebrate the monarchy in his design of the Louvre. HB

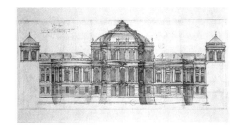

104 M
Pietro da Cortona (1597–1669)
Prospect of the façade fo the Louvre
Paris, Musée du Louvre, Départment des Arts
Graphiques, Recueil du Louvre

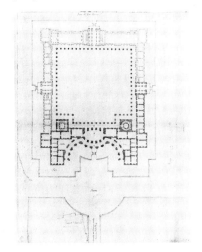

100 T
Gian Lorenzo Bernini (1598–1680)
Drawings for the First Design of the Louvre
Paris
Ground plan of the Cour Carrée
Paris, Musée du Louvre, Departement des Arts
graphiques
Pen, ink and gray wash; 52.9 x 76 cm
PROVENANCE: Bâtiments du Roi

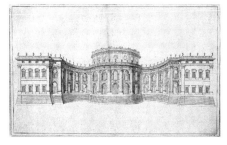

99 T–MAR
Gian Lorenzo Bernini (1598–1680)
Elevation of the East Façade
Paris, Musée du Louvre, Departement des Arts
graphiques, Receuil du Louvre I, fol. 4
Pen and ink on paper; 41.1 x 67 cm
PROVENANCE: Bâtiments du Roi
BIBLIOGRAPHY: Clément 1868: V; Fréart de
Chantelou [1885]; Mirot 1904: 161–288; Es-
monin 1911: 31; Hautecœur n.d.; Josephson
1928: 77–92; Schiavo 1957; Braham, Smith
1973: pl. 519; *100 Masterpieces* 1975: 160; Borsi
1980: 132–38; Gould 1982; del Pesco 1984: 205;

Millon 1987: 479–500; Bradford, Braham 1991:
no. 9; *Von Bernini bis Piranesi* 1993: 108–109;
Lavin 1993: 138–200; Marder 1998: 264–66

One of the most famous episodes in Baroque ar-
chitecture, Bernini's involvement with the Lou-
vre, crystallizes the clashing values of French and
Roman architectural culture, French ambitions
to rival the cultural supremacy of Rome, and
Jean-Baptiste Colbert's desperate search for a
grander style of architecture, a search which in-
volved numerous architects from Italy and
France and produced probably the most sub-
stantial body of divergent schemes for any one
seventeenth-century building. Thanks to
Chantelou's diary, we have an intimate portrait of
Bernini's personality and the difficulties he en-
countered at the French court, some of his own
making, while the surviving drawings vividly
record Bernini's design process and set forth
ideas which, though not executed at the Louvre,
were echoed in other French and European
palaces. The foundations of the entrance wing of
the Louvre were under construction in accor-
dance with a design by Louis Le Vau, the archi-
tect of Louis XIV, when Colbert halted work and
invited French and Italian architects to comment
on the scheme. In April 1664 Bernini accepted
an invitation to prepare a new design and sent
drawings to Paris in June. Often presented as a
radical departure from French norms, Bernini's
first project actually engages and thoughtfully re-
sponds to Le Vau's design. Despite claims that he
ignored the French scheme, Bernini's first pro-
ject should be understood as a revision of Le
Vau, not as a dramatic rupture. First and fore-
most, Bernini retained Le Vau's transverse oval
rotunda, but whereas Le Vau concealed it be-
hind a straight façade, Bernini dramatically ex-
pressed the oval on the exterior, both through
the swelling center section of the palace and the
rising clerestory. Though it may loosely evoke the
idea of a crown, the clerestory acknowledges the
domeless drum Le Vau had previously pro-
posed. Bernini modulated but did not abandon
the standard French differentiation of pavilions
and wings. On the one hand, he unified the
façade by means of the crowning balustrade and
invisible flat roof (the play of roof volumes of
various heights and pitches was a standard fea-
ture of French architecture). Nevertheless, he
preserved the distinction between the central
block and end pavilions which set up a play of
strong contrasts: skeletal structure versus planar
wall, void versus mass, sinuous versus straight.
Admittedly the curving façade and flat roof went
farther than any other building in France, but
these tendencies were already present in build-
ings designed by Le Vau and Le Pautre. Proba-
bly the most surprising element was the perfo-
rated façade whose quality of openness would be
reinterpreted in the Colonnade. Bending pliably
like a snake, the double-gallery created an image
of accessibility that Colbert considered inconsis-
tent with the majesty and strength of the French
king and at odds with his security. It is not sur-
prising that when Guarini used this design as his
point of departure for the Palazzo Carignano, he
eliminated this curving portico. The plan also re-
flects Bernini's restrained hand, at least relative

to his later designs. He left the older wings of the
Cour Carrée intact (indicated by lighter ink) and
completed the north wing in a manner consistent
with what was built. To unify the four different
courtyard façades, Bernini proposed a multi-
storey gallery, akin to what we see on the façade.
Even without a courtyard elevation, we can
imagine the stridently Roman effect of this de-
sign; French quadrangular palaces and chateaux
rarely had galleries. In plan, the east wing echoes
the Palazzo Barberini in several respects: the
twin staircases, one square, the other circular;
the relationship of central and enframing ele-
ments; and the oval figural form at the center of
the composition. Although some historians have
detected a subtle reference to the French origins
of Maderno's plan for the Palazzo Barberini, I
suspect the bipartite circulation system of the
Roman palace, which was designed for two pa-
pal nephews, struck Bernini as an appropriate
model for the palace of a king and queen. But
double stairs were at odds with royal ceremonial
which required one great processional stairhall.
Alone among Bernini's drawings for the Louvre,
this one shows his idea for a semicircular "piaz-
za" opposite the main entrance of the palace
which conceals the Gothic church of St. Ger-
main l'Auxerrois. Bernini's drawings reached
Paris in July 1664. Although Colbert did not re-
spond until September, the delay did not soften
his views. Instead of responding to Bernini's con-
cetto, Colbert compiled a tedious list of com-
plaints about programmatic and functional fea-
tures (Clément, *Lettres de Colbert*, V: 246). He
deemed the galleries and flat roofs unsuitable for
the French climate (Chambord had wonderful
roof terraces). The small courtyards behind the
façade served no purpose. The staircases were
not adequately lit, and above all, the king's apart-
ment could not be relocated from the wing fac-
ing the river, where it had historically been, to the
noisy but nobler east wing. Bernini did not take
Colbert's criticisms well: according to the Duc de
Créquy, the French ambassador in Rome, he
raged "that the faults which have been found
with his building were more numerous than the
stones which would be needed to build it; [...]
even if he were to do another plan it would be
the same story all over again" (Gould 1982: 16).
Bernini's reaction was surprisingly prophetic; the
wonder is that he made other designs for the
Louvre. Claude Perrault explained a big part of
the problem: "It would have been very difficult
to find two natures more opposed. The Cavaliere
never went into detail [...] Monsieur Colbert, on
the other hand, wanted precision" (Gould 1982:
13). But Benedetti put his finger on another,
deeper problem. In anticipation of Colbert's
hostile response, he tried to guide the minister's
reactions in the letter which accompanied Berni-
ni's drawings. Italians may not conform to
French preferences for the layout of rooms and
amenities, and indeed, Bernini's plan does not
accommodate the suite of rooms enfilade that
comprise a French royal apartment. But Be-
nedetti explained, Italian buildings possess mag-
nificence and nobility. Ultimately Colbert did
not find the magnificence he sought in Bernini's
first design, although he wrote only about prac-
tical details. HB

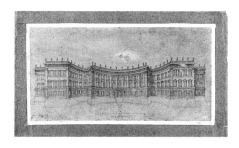

102 T
Gian Lorenzo Bernini (1598–1680) after a
drawing by Mattia De' Rossi
Design for the East Façade of the Louvre
Second Scheme, Paris
Stockholm, Nationalmuseum, THC 5146
Pen and brown wash; 25.2 x 50 cm
Scale: "200 palmi Romani"
PROVENANCE: Nicodemus Tessin the Younger
BIBLIOGRAPHY: Clément 1868; Fréart de
Chantelou 1885; Mirot 1904: 161–288; Esmonin
1911: 31; Hautecœur u.d.; Josephson 1928:
77–92; Brauer, Wittkower 1931: 130; Josephson
1930; *Masterpieces* 1982: 82–83; *Von Bernini bis
Piranesi* 1993: 110–11; Lavin 1993: 138–200;
Marder 1998: 264–66

The second design was finished in January
1665 and reached Paris in March 1665.
Bernini took Colbert's security concerns to
heart: he closed up the ground-floor arcade
and set the building on a rusticated podium
with an understated entrance – one simple
arched bay amidst a file of unadorned rectan-
gular windows.
The arcuated screen of the first design has
been transformed into a self-contained loggia
and confined to the central section of the
palace; the adjacent wings are no longer tra-
beated but share the mural treatment of the
end pavilions.
In the first design the portico opened path-
ways into the depth of the building; here it
implies only horizontal movement across the
façade.
Bernini retained the colossal order of half-
columns he had previously used, but instead
of articulating a dynamic S-shaped façade, we
encounter a stable composition based on two
concentric concave curves. The clerestory of
the oval salon has disappeared from the ele-
vation, which enhances the impact of the uni-
fying cornice and balustrade with standing
figures.
Since the corresponding plans do not survive,
we do not know if the oval was also eliminat-
ed in plan.
Altogether the façade has a stronger, more Ro-
man effect than the first somewhat delicate de-
sign, a shift which probably pleased Colbert.
However, the adjustments of the façade were
overshadowed by a major problem which this
drawing does not reveal: Bernini proposed an
extensive overhaul of the Cour Carrée.
Letters from Colbert and others indicate that
Bernini proposed to add another storey to the
existing buildings, double the width of the
south wing, border the courtyard with a three-
storey gallery, and change the shape from a

square to a rectangle by extending the east
wing 90 *pieds* to the east. (The strong projec-
tion of the east façade is visible on this view of
the façade.)
Although the king liked the façade, he indi-
cated a reluctance to rebuilt the entire palace,
a theme Colbert reinforced in another de-
tailed response (Clément, *Lettres de Colbert*:
V, 264). Colbert reminded Bernini of the his-
toric importance of the palace; in particular,
the Italianate galleries would obliterate the
view of Goujon's sculptures on the west wing.
But these reservations had no apparent effect
on Bernini, who showed increasing disregard
for the historic fabric of the French royal
palace. HB

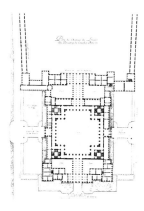

106 T
Jean Mariette (?1654–1742)
Jean Mariette
L'Architecture francoise ou Recueil des Plans,
Elevations, Coupes et Profils... de France
(vols. 4)
published 1727 , 1 vol. ill.
Mark J. Millard Architectural Collection
1985.61.2525

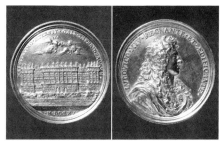

108 T
Jean Warin (Varin, 1606–72)
Medal of Bernini's East Façade of the Louvre
1665
Paris, Bibliothèque Nationale de France, Cab-
inet des Médailles, Séries royales 3080
2 gold plates joined; 112 mm
INSCRIPTIONS: Obverse: A bust of Louis XIV,
turned 3/4 to the right, with his head in profile;
the king wears a breastplate decorated with a
sun. Legend: "LVDOVICO . XIV . REGNANTE . ET.
AEDIFICANTE." Reverse: Bernini's third design
for the East Façade of the Louvre. Legend:
"MAIESTATI . AC. AETERNIT . GALL . IMPERII .
SACRVM." Exergue: "M.DC.LXV." The engraver's
signature appears on the base of the building:
"IOAN[NES] . VARIN . FECIT"

PROVENANCE: Royal Collection
BIBLIOGRAPHY: Menestrier 1691: 16; Delaroche
and others 1834: II, pl. 25, no. 1; Guiffrey 1881:
I, 102; Mazerolle 1932: I, no. 10; Forrer 1980:
VI, 372; Jacquiot 1970: no. 116; Fréart de
Chantelou [1985]; Jones, 1988 (1600–72): no.
239; Lavin 1993: 138–200; *Creating French Cul-
ture: Treasures from the Bibliothèque nationale de
France* 1995: 292–94

Bernini did not want to go to Paris. He was six-
ty-six years old and busy with papal commis-
sions, but diplomatic pressures compelled him
to leave Italy for the first time in his life. Late in
April 1665, soon after Alexander VII granted his
architect a three-month leave of absence, Berni-
ni left Rome accompanied by seven associates,
including his son Paolo and a trusted assistant,
Mattia de' Rossi. Louis XIV sent Bernini the
enormous sum of 30,000 *livres* for expenses dur-
ing the six-week journey. Other gifts and signs of
royal pleasure were forthcoming in Paris, but the
king's enthusiasm was not fully shared by Col-
bert, his advisors, and least of all by French
artists who rallied to undermine Bernini's au-
thority and prejudice Colbert. As Chantelou's di-
ary makes clear, Bernini's pride and disdain for
French culture compiled the problems. His
nearly four-month residence in Paris (2 June to
20 October 1665) was a personal fiasco, al-
though it helped Colbert to clarify his intentions
and certainly had an impact on French architec-
ture, particularly the late work of Louis Le Vau.
During his first two weeks in Paris, Bernini con-
ceived a new design for the Louvre. Although
only one workshop drawing survives – a partial
elevation of the south façade of the Louvre at the
juncture with the Petite Galerie (Louvre, Dépt.
des Arts Graphiques, Recueil du Louvre, fol. 62)
– the project is recorded in five engravings by
Jean Marot: a ground plan of the Cour Carrée;
elevations of the east, west and south façades;
and a section through the courtyard. The ground
plan illustrated here was probably intended to
complete the series since it shows Bernini's
scheme in relation to the *grand dessein*. (The en-
graved version was published in Jacques
François Blondel's *Architecture Françoise*, Paris
1752–56: IV, book 6, plate 3.)
It is surprising how little of Bernini's time in Paris
was actually devoted to the Louvre. After June
he was mostly busy with other projects, chiefly
the marble bust of the king, and upon its com-
pletion in October announced his intention to
return home. At that point discussions refocused
on the Louvre. Colbert continued to resist Berni-
ni's transfer of the royal apartments to the noisy
east wing and raised sundry practical problems.
For instance, he was concerned about provisions
for a hydraulic system to pump water in the
event of a fire – a relevant issue since a fire had
recently destroyed the Petite Galerie – but
Bernini resented questions about waterpipes.
Despite lingering issues, events were organized
to honor Bernini's departure which took place
on 20 October: Jean Warin (1606–72) cast a
medal celebrating the new east façade (Bernini
conferred with Warin on the medal but in the
end criticized its high relief) and on 17 October
1665, a cornerstone was laid with an equal mea-

sure of pomp and petty bickering among participants. Was the ceremony merely a charade to appease Bernini? I do not think so. Admittedly Colbert showed little sympathy for the third design, nevertheless his concerns did not stop him from entrusting Bernini with additional commissions – for an altar at the Val-de-Grâce, a mausoleum for the Bourbon kings at Saint Denis, interior furnishings for the royal library, and an amphitheater for the Louvre. Despite reservations, Colbert still intended to build Bernini's palace and the events that transpired after the foundation ceremony, discussed in the next entry, confirm this point.

Of the four projects Bernini produced in total, the third scheme is the only one he developed in Paris. Evidently contact with the site did not inspire respect for the historic buildings as Colbert had hoped; to the contrary, Bernini conceived even more extensive changes. Yet his reaction was not wholly negative in so far as he grasped the need for a truly monumental and majestic building. Bernini responded by designing a Roman palace. As the medal reveals, he straightened the façade, eliminated the loggia, and deployed a colossal Corinthian order that rises above a channeled ground floor. Compared to the second design, the central section has been elongated and the flanking sections contracted. The resulting composition reverses the effect of the first design where the end pavilions counterbalance the central motif by the principle of contrast; in the third scheme the ends are unaccented and reiterate the imagery of the central block. The result resembles Bernini's recent renovation of the Palazzo Chigi, with one major difference: the French royal palace rises from a podium of roughly hewn stone or *scogliera* (rocky mass), as in the Four Rivers Fountain, in order to imply that it sits atop a mountain. As Irving Lavin has argued, Bernini's *concetto* referred to Hercules' ascent of the Mountain of Virtue; significantly, figures of Hercules flank the entry portal. Thus Bernini's third scheme brilliantly translated the traditional iconography of the Gallic Hercules into monumental Roman form.

The plan envisions the westward extension of the Louvre on a slightly larger scale than the east end; recall that Bernini has enlarged it in the second scheme. In response to Colbert's complaints about inadequate lighting, Bernini expanded the light wells behind the first façade into gracious L-shaped courtyards on the east end and even larger rectangular ones on the west side. Triple-barrel porticos of imposing dimensions connect the outlying rooms (grouped in pendant apartments) to the Cour Carrée, which has become cruciform in shape as a result of large square stairhalls inserted in the corners. Despite persistent objections from the king and Colbert, Bernini retained the two-storey gallery around the courtyard precisely to obscure the original court façades.

The plan does not illustrate Bernini's grandiose proposal for the area between the Louvre and Tuileries Palaces. According to Chantelou's diary, Bernini envisioned an amphitheater for 20,000 nobles modeled on the Colosseum and the Theater of Marcellus, and with a splendid house in the middle fit for a visiting prince. The scale of the project was enormous: each column in the amphitheater would rise 100 *palmi* (or 66 *pieds*), and the amphitheater was longer in diameter than the façade of the Louvre. This scheme replaced an earlier idea "of putting up two columns in the space, like those of Trajan and Marcus Aurelius with between them a pedestal on which should have been an equestrian statue of the king inscribed non plus ultra, in allusion to the motto of Hercules" (Chantelou [1985]: 117).

Warin's splendid foundation medal was part of the medallic history of Louis XIV, a series conceived by Colbert to memorialize great events of the reign in the form of medals. Since time did not allow for the preparation of dies and puncheons, Warin decided to cast the medal in gold. Jean Chapelain, Colbert's primary literary advisor, devised the legend. Ironically the portrait bust of Louis XIV on the obverse evokes not the marble bust of Bernini but a rival one carved by Warin himself. HB

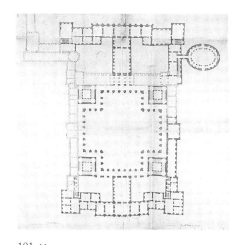

101 M
Gian Lorenzo Bernini (1598–1680)
Fourth Design of the Louvre with Oval Chapel
First-floor Plan
Paris, Musée du Louvre, Departement des Arts graphiques
Pen and ink on paper
PROVENANCE: Bâtiments du Roi
BIBLIOGRAPHY: Esmonin 1911: 33–34; Hautecœur 1927: 156–62; Brauer, Wittkower 1931: 131; Schiavo 1957: 35, 64–65; Borsi 1980: fig. 183; Del Pesco 1984: fig. 39; Fréart de Chantelou [1985]; Marder 1998: 279

On 18 October 1665 Bernini and Colbert reviewed the plans of the Louvre. At issue was the king's chapel. Bernini's third scheme provided for a large, low space about 100 *pieds* long on the north end of the west wing, where earlier plans had located a ballroom and banqueting hall. Colbert considered the arrangement impractical and uninspiring. Bernini railed against conflicting expectations: it was "clearly impossible" to "make a chapel as large as a church, which was for the King's private use but must also serve the public, [and] which further must be reached without using any available space." No wonder Bernini was vexed: Colbert had completely changed his mind. Now he authorized the architect to design a detached church and to "make it as magnificent as he like" (Chantelou [1985]: 310). Bernini proudly revealed his solution the next day, the eve of his departure: an oval chapel as spacious as the Pantheon. Colbert responded enthusiastically, and the two men amicably discussed a way to relocate the projecting mass of the sacristy which interrupted the exterior order and disturbed the oval form. "M. Colbert made it clear that these alterations suited him very well" (Chantelou [1985]: 315). The distinguishing feature of the first-floor plan is the oval church projecting boldly from the north side of the palace as a counterweight to the Petite Galerie on the other side. The plan relates to Bernini's earlier oval church, Sant'Andrea al Quirinale, albeit with many changes. An interior colonnade of bronze columns with gilt capitals (Chantelou discloses the materials) supports the royal gallery which the king would normally enter from the first floor of the palace; a corridor connects the church via two rooms to the west wing. Coupled columns mark the major axes, three of which serve as public entrances; single columns frame the intermediary bays. Bernini mentioned columns of lovely red and white French marble with capitals of Carrara marble to support the pediment, presumably on the exterior, but the plan does not clarify their location nor does it record the exterior order Colbert had praised. Because of these departures from the scheme as described in Chantelou's diary on Bernini's last working day in France and because the problem of the sacristy has been resolved, it seems most likely that the drawing was rendered once Bernini was back in Rome. It should also be noted that the plan includes other revisions of the third plan, most significantly the enlargement of the western courtyards. One purpose of the drawing is to highlight new construction (in dark ink) and clarify the extent of Bernini's interventions, in part because Colbert and the king were eager to preserve the old Louvre. The drawing demonstrates that three-quarters of the Cour Carrée would remain intact, yet more than any other image, it captures the overpowering presence of Bernini's buildings. HB

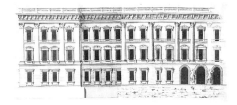

105 T–MAR
Gian Lorenzo Bernini (1598–1680)
Fourth Project for the Louvre, Paris
Half elevation of the East Façade after Mattia De' Rossi's small model
Stockholm, Nationalmuseet, Tessin-Hårleman Collection, THC 1244
Pen, ink and wash
59.3 x 131 cm
PROVENANCE: Nicodemus Tessin
BIBLIOGRAPHY: Josephson 1928: 83; Fréart de Chantelou [1985]; Millon 1987: 494; Marder 1998: 278

After reaching Rome on 3 December 1665, Bernini revised his scheme for the Louvre and in May 1666 Mattia de' Rossi returned to Paris ostensibly to oversee construction. Probably at the request of Colbert, De' Rossi built two models, one in wood, the other in stucco, of Bernini's fourth and final scheme. The models were completed on 5 November 1666 but Colbert put off seeing them for three months, until 25 February 1667. Evidently the models enabled him to reach a decision. Within weeks, Colbert constituted the Petit Conseil and by the time De' Rossi returned to Rome in May 1667, the king had selected the Colonnade design. By the time the Colonnade was completed at least four models of the Louvre and probably more were stored somewhere at the Louvre: one by Le Vau, another of the Colonnade, and Bernini's two models. The latter captivated Tessin during his visits to France, and as his own thoughts about the royal palace in Stockholm were taking shape, he felt the need to refer to Bernini's designs. Cronström sent Tessin Marot's engravings with a warning they were inaccurate. In 1695 Tessin commissioned drawings of Bernini's models: three survive; this half-elevation of the east façade is the most important. Cronström may have misjudged Marot's engravings. After all Marot had worked under Bernini's supervision, and Chantelou reports no objections, except when Marot took the liberty of drawing the Herculean figures which Bernini had intended to do. It may be that Crönstrom condemned Marot's engravings basing on their departure from the models without realizing they document different stages of design. We have no way to assess the changes in elevation between the third and fourth designs except by comparing Marot's engraving with this pen and wash drawing. The most significant change was a reduction in the overall height of the building. The third design had included a wide strip of blank wall above the second storey; it has been eliminated, and as a result, Bernini also had to remove the royal escutcheon above the central bay. This change responded to Colbert's request to lower the height of the main floor: he "wanted to make the rooms more comfortable, their excessive height being unusual in France." Even Chantelou agreed, but his reasoning also considered the arrangement of the façade: he found "too great a space between the second and third floors which is a result of the height given to the main floor, and it seems too empty." The driving consideration, according to De' Rossi, was not high ceilings but exterior proportions: the height of the colossal columns had to be twice the width of the intercolumniation. "For the same reason he was adding bands in the design on which he was now working in order to arrive at the correct proportion" (Chantelou [1985]: 133). The drawing after the model shows these refinements as well: the apparent height of the second and third floors is visually eroded by the window balustrades, the molding which runs across the base of the order, and the sculptural enrichment of the window surrounds. These changes succeed in bringing more tension to the relationship of wall to window, flat surface to sculpture in relief, and trabeation to mass. Fine adjustments to the order, which changed from Corinthian to

composite, and to the crowning cornice give the façade a convincing sense of resolution. Two other changes are more surprising and may reflect the shorthand of draftsman or model maker: at basement level, the rocky stone has been restricted to the central portion of the building and at roof level, no statuary is shown. Since none of the models of the Louvre survive, this drawing documents an otherwise lost dimension of Baroque representation. HB

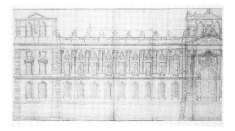

107 T–MAR
Louis Le Vau (1612–1670)
Project Elevation for the East Front of the Louvre, Paris
Paris, Musée du Louvre, Département des Arts graphiques, Inv. 26077
Pencil with notations in pencil on paper; 61 x 117.9 cm; 3 sheets with a strip added at top
PROVENANCE: Bâtiments du Roi
BIBLIOGRAPHY: Laprade 1960: pl. VI 8b; Whiteley, Braham 1964: 347–62; Petzet 1967: III, 160, pl. 35, fig. 2; Whitely, Braham 1969: 40–41, fig. 15; Berger 1970: 396–97; Hubala 1970: 251–53; Tadgell 1980: 330, fig. 64; Dufresne 1987: 41; Berger 1993: 88–89, fig. 59

After a year of inactivity at the Louvre (1666), Colbert definitively rejected Bernini's scheme in April 1667 and formed a small committee, known as the Petit Conseil, to prepare a new design for the east front of the palace. Colbert's earlier effort to obtain a collective design from Mansart, Le Vau and LeBrun had come to naught, at least in part because Mansart was not temperamentally disposed to design by committee. But the Petit Conseil was more likely to succeed in as much as its three members were adept courtiers comfortable with teamwork and pragmatic compromise. Only one was a professional architect: Louis Le Vau (1612–70). The two others were amateurs drawn to architecture by the challenge of the Louvre: Charles LeBrun, the royal painter, and the well-connected scientist Claude Perrault – his brother Charles was the personal secretary of Colbert.
The sequence of events is clear. In April 1667, the Petit Conseil showed Colbert two schemes, one with columns, the other without. He asked the committee to undertake additional work then presented the alternatives to the king in May. After the king chose the Colonnade, Colbert instructed the Petit Conseil to refine the design. That process was completed by November 1667 when a foundation medal was struck. However, in 1668, before construction had begun, the design was modified and the pavilions were enlarged because Colbert had decided to double the width of the adjoining

southern wing. This drawing is the earliest surviving image of the Colonnade. While the relatively narrow width of the pavilions date it to 1667, we may be able to pinpoint its date and role in the design process. One of the largest surviving drawings of the Louvre from the seventeenth century, the sheet has been cut on the left side and was therefore originally even longer. Far from a finished presentation drawing, it records an early stage in the design process when the architect was still having second thoughts and testing variant schemes. Note the tympanum inserted in the entry arch to lower its height and the upper pediment drawn over the balustrade at the top of the central pavilion and crowned with an urn. But what accounts for the unwieldy size of the drawing? After the Petit Conseil's initial presentation in April 1667, Colbert asked to see the two schemes on the model at Le Vau's studio. According to a register of the Petit Conseil's work, "this [request] was executed by applying the two façades to the [wooden] model" ("Régistre ou Journal des délibérations et résolutions touchant les Bâtiments du Roi" [in April-May 1667], 7 June 1667, originally published by Piganiol de La Force, *Description de Paris* [Paris 1742, II: 627–37], and reprinted by Robert Berger in *The Palace of the Sun*, 123–24). It is conceivable that in order to satisfy Colbert's request, the façade designs were rendered in wood and inserted into the framework of the model, but the more likely scenario (suggested by the syntax of the document, which mentions only the one model already at Le Vau's) is that large-scale drawings were pinned to the model. My hypothesis is that the elevation drawing dates from April 1667 and was used to gauge the general effect of the Colonnade on the model which would explain its surprising combination of largeness, informality, and irresolution. To test this hypothesis, it will be necessary to remove the drawing from its frame and examine it closely. Braham and Whitely (1964: 360) suggested this was the very drawing presented to the king in May 1667 on the basis of which he chose the Colonnade, but I tend to doubt that this unfinished pencil drawing was used in the all-important presentation which was to resolve the design of the Louvre.
Although this unsigned elevation was once attributed to Charles LeBrun, it is now firmly associated with Le Vau. The scheme reflects his architectural vocabulary: the reclining figures and coat-of-arms on (as opposed to within) the pediment relates to Vaux-le-Vicomte (which in turn quotes Mansart's design at Blois); the relationship of the main pediment to the attic storey also derives from Vaux; and the flat-roofed profile of the attic relates to the drumless dome on an earlier design for the Louvre (on this motif see Robert Berger, "Antoine Le Pautre and the Motif of the Drum-without-Dome," *JSAH* XXV/3 [1966]: 165-80). The iconography, which combines the face of Apollo with two globes, appeared in other Louvre designs and loosely refers to the king's impresa, *Nec Pluribus Impar* (although it had a single sphere).
While the attribution to Le Vau's studio is se-

cure, it remains debated who rendered the sheet: Le Vau himself; François d'Orbay, his chief draftsman; or an anonymous studio assistant. Overseeing many royal building projects and private work on the side, Le Vau must have operated a sizable studio, although we have no detailed knowledge about the number or identity of the architects he employed. Le Vau's signature on many drawings appears as a mark of approval, not of authorship; we simply do not know how he drew. The only hand we can firmly identify is that of d'Orbay. Laprade, Whitely and Braham, and Berger agree this elevation was not rendered by d'Orbay, but their assessment of his style depends on the use of wash (for example, Berger explains that "he is fond of chiaroscuro and abrupt light-dark contrasts [*The Palace of the Sun*: 87]). Reluctant to assign a drawing of this importance to an anonymous draftsman (he would not have been anonymous in his own time), Whitely and Braham attributed it to Le Vau himself, notwithstanding the absence of any hard evidence about the master's rendering style. I would like to renew the suggestion that d'Orbay drew this elevation. First, d'Orbay's preference for ink does not mean he never drew in pencil, and second, since the medium affects the style, we need to look for stylistic features that are transferrable from wash to pencil. The treatment of the decoration – the trophies on the roof balustrade, the coat-of-arms over the entry arch, and wall decorations – and the rendering of figures in this pencil drawing are consistent with signed sheets by d'Orbay for the Collège des Quatre Nations and for the Colonnade (AN O1/1667/4, no. 84; Berger, *The Palace of the Sun*: fig. 73).

The elevation relates to three other undated drawings of the Colonnade which were made between May and November 1667 when the members of the Petit Conseil individually developed the Colonnade scheme: 1) a variant elevation of the pavilion at the south corner in the same hand as the large elevation (Musée Carnavalet, Cabinet des Estampes et Dessins, Rés. D6944 no. 19); 2) a plan of the Cour Carrée with part of three courtyards extending to the north and with captions written by d'Orbay (Musée du Louvre, Dept. des Arts graphiques, Receuil du Louvre I, fol. 13); and 3) a plan of the Cour Carrée alone with annotations attributed to Claude Perrault (Nationalmuseum, Stockholm, THC 1240). This work resulted in the design recorded in the foundation medal, which was struck in November 1667 (Bibliothèque National Cabinet des Médailles, Séries royale no. 679); in its chief departure from the drawing, the medal features a traditional four-sided French dome which echoes the tall central pavilions of the other wings and serves to integrate the Colonnade with the Cour Carrée. Ever since the Petit Conseil was formed, writers have focused on the authorship of the Colonnade. To some extent this debate has entailed a fruitless attempt to locate the origins of the colonnade idea, fruitless because it is clear that schemes for a columnar façade go back to the time of Jacques Lemercier and were promoted by various architects in the 1660s, including

François Le Vau and Antoine Léonor Houdin. In attributing the drawing to Le Vau, Whitely and Braham concluded that it "showed how far Le Vau can be held responsible for the original design of the Colonnade itself" (1964: 347). But this claim does not logically follow; the fact that a particular drawing was produced in Le Vau's studio does not establish one way or the other the so-called origins of the colonnade idea. Moreover, this scheme already incorporates the ideas of other architects, most prominently that of François Mansart who had proposed a similar entrance with an arched opening rising the full height of the colossal order.

The attribution debate obscures the chief interest of this drawing, which illuminates the radical shift of French architectural style in the 1660s from the traditional French pavilion system toward the grander, more austere forms of Roman classicism which Colbert ultimately favored. Traditional features include the clear articulation of central and end pavilions; the tall pointed roof over the corner pavilion; the differentiation of the long wings and the pavilions which do not have an order; and the liberal use of rustication and quoining. On the other hand, the crowning balustrade without a visible roof behind it and the more severe decorative vocabulary in the wings relate to the emergent classicizing style. Even a detail like the garlands draped over the oval medallions stand between their wispy predecessors at Le Vau's Collège des Quatre Nations and the more muscular forms eventually built on the Colonnade. This splendid elevation captures a transitional moment soon to be blotted out by the executed design of the Colonnade. HB

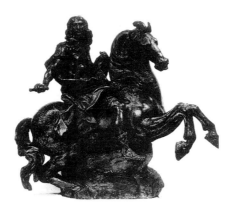

109 T
Gian Lorenzo Bernini (1598–1680)
Bozzetto for the Equestrian Statue of Louis XIV
Rome, Galleria Borghese
Terracotta
76 cm (height)
BIBLIOGRAPHY: Wittkower 1961: *passim*; Lavin 1993: 166–85, 197–200; Marder 1997: 176–78, 206–208, 210–12; 1998: 279–80; Herrmann *Bernini scultore* 1998: 310–29; *Effigies and Ecstasies* 1998: 144–45

Gian Lorenzo Bernini first mentioned his idea for an equestrian statue of Louis XIV while designing the Louvre in Paris in 1665.

Bernini envisioned the monument as part of an

urban ensemble flanked by triumphal columns like those of Emperors Trajan and Marcus Aurelius to be set on a square between the Louvre and the Tuileries.

An inscription on the pedestal – NON PLUS ULTRA – would have united the Hercules themes that Bernini incorporated in his Louvre designs with the venerable tradition of a horseman at his palace entrance.

The setting for the equestrian also recalls the two columns Bernini had hoped to set together at Piazza Colonna, between the Chigi and Montecitorio palaces. Like the Louvre, both of these designs included heavy rustication suggesting the rugged path of Hercules's virtue, much like the rocky base of the Bozzetto discussed here. Other proposals suggested locating the equestrian on a bank of the Seine or on a new bridge.

Gian Lorenzo Bernini returned to Rome in December 1665 and continued to work on the Louvre until mid-1667, when those plans were finally rejected.

At the end of the year Colbert reproposed the commission for the equestrian. Understandably, Gian Lorenzo Bernini stalled but by 1669 he agreed and in 1670 began to move forward, no doubt because a long promised pension from the king finally materialized.

In the early correspondence with Colbert the master pledged that he would himself make the terracotta model, and this has been identified with the Galleria Borghese *modello*. The marble statue was largely finished in 1673 and completed in 1677.

Because the statue was recarved after its arrival in France, the Bozzetto assumes special importance as a record of Gian Lorenzo Bernini's original conception.

In a statement saturated by contradiction, Bernini claimed that the equestrian statue of Louis XIV should look nothing like that of Constantine, which was just being finished in 1669–1670.

In truth, there are no rocky underpinnings to the statue of the emperor, yet the works are otherwise closely related in form and meaning (compare the Bozzetto of Constantine from St. Petersburg elsewhere in this exhibition). Both were essentially conceived in profile, and they share the idea of the equestrian as a symbol of rulership.

Several recent authors have recognized a common source in Bernini's drawing for the Trinità dei Monti (1660), which included an equestrian statue of the king. The statue there was intended to assert a foothold on Roman terrain that the French claimed as extra-territorial. Years later, this association encouraged hopes of transferring the equestrian to the Trinità dei Monti before it could be shipped to France.

In the end the statue was shipped to France in 1684, after Bernini's death. Unappreciated by Louis XIV, it was placed in the gardens of Versailles and re-carved as a Marcus Curtius. Ever the magnet of controversy, the statue was copied, reworked as the original portrait, and erected at the new entrance to the Louvre by I. M. Pei. TAM

The Chapel of the Holy Shroud
Giuseppe Dardanello

A ruin: this is what the chapel of the Holy Shroud looks like today, after the fire of 11 April 1997. It is still there; tower-spire-pagoda; airy cage filled with light as never before. In the first project on an oval plan begun by Ascanio Vitozzi and Carlo di Castellamonte (ca. 1710s), Carlo Emanuele I had asked for it to be "oro et negro." The capitals and bases of the orders were to be gilt bronze and the rest that black marble from Frabosa, "with some slight veining that resembles metal," which had been discovered when building began on the Santuario of Vicoforte (1595). Guarini had used this stone magnificently, skilfully changing its color from a funereal gloom of polished black in the lower level to a diaphanous gray in the radiant dome – unbounded flight toward a condition of salvation. "I would like you to go to Turin as requested by the Duke to design and realise a building to house the Holy Shroud. I have wanted to remind you that although the Duke intends to make for this a new church, all this is, however, a task that will last a long time, and therefore His Highness agrees with me not to hesitate in building now toward this aim the main chapel of the Cathedral in a more beautiful and larger form. And for this I must warn you that on this occasion you must be particularly careful that the sacred Sheet is placed in the said Chapel in such a way and in such a position that it is seen and that it can be seen by the people without having to move it too much and with much more respect than usual." Three conditions that will determine the planning history of the Chapel of the Holy Shroud can be seen in these recommendations from the future Saint Carlo Borromeo to his architect Pellegrino Tibaldi, in a letter of 16 Oct. 1583, a short while after the reliquary had been transferred from Chambery to Turin, in 1578. They are: the representational value of this object; the fragility of the woven material; its positioning in a place that expresses a symbolical equilibrium between the temporal power of the Savoy dynasty and the Church, guarantor of its authenticity. The first structure erected in the choir of the cathedral of San Giovanni dates to 1587. It was a tribune raised on four wooden columns with composite capitals housing an altar with the reliquary casket above this, protected and indicated by a circular ciborium with a dome supported by four seraphim. This arrangement, still recognisable in later modificatons in the interior view of the Cathedral of Turin engraved by Giovenale Boetto in 1634, established forever the viewing conditions for the reliquary: in a raised position in the choir. Carlo Emanuele I's desire to build a "new church" for the Shroud, in the area surrounding Palazzo Reale, was realised in Vitozzi's and Castellamonte's project, for which a wooden model was built of more than five metres. With excavations for the foundations begun from 1611 onward, known through a drawing by Castellamonte dated 1621, the project proposed an oval plan, raised a few steps above the level of the choir in the cathedral. The position of this oval chapel was strategic: within Palazzo Reale yet connected directly to the cathedral of San Giovanni, announced by the façade with tribune turned toward the choir, it was the perspective focus that the entire building complex of the metropolitan church looks at. Work on the columns and facing in black Frabosa marble continued beyond 1620, but building was interrupted just above ground level due to various military and political events. Interest was reawakened by Prince Cardinal Maurizio of Savoy in 1655, and Castellamonte's old project, together with a renewed one by his son Amedeo and a third proposal for a rotunda presented by the sculptor Bernardino Quadri, were brought under discussion. Quadri's round plan, begun in 1657, raised the level of the chapel to the *piano nobile* of the palace, and placed it in direct visual communication with the space of the cathedral by making a large opening in the end wall of the choir. A simple door separated it from the gallery of the *piano nobile*, while two staircases on an axis with the aisles connected it to the cathedral. Quadri's project expressed the complex equilibrium that the reliquary was to be placed in, and, by brilliantly resolving the problems of integrating the chapel into the palace, gave form to the intentions of celebrating the Savoy dynasty. A report of a survey on 10 September 1665 inside the chapel under construction cast serious doubts on the capacity of the walls raised according to the new project to "support and sustain the dome of the said Chapel." This "had to be very high and exceed that of the cathedral of San Giovanni". In this atmosphere of uncertainty, Guarino Guarini was asked to intervene in the spring of 1667. The restraints imposed by the existing construction and the patron's wishes – a very high dome had to be built on a cylinder of walls with a limited thickness – were skilfully exploited to transform the chapel into a sequence of towers. Guarini kept what had been built of Quadri's project. The architect raised the impost level of the drum almost to double the height of the main order, introducing the element of a truncated dome; really a complex structure of arched members that interweave, cleverly angled at the edges of the circumference. On the new impost level, reduced by a quarter of its width, he raised a drum opened by six large and very tall arched windows, with supports crossed by a gallery that divided and allowed weight and thrust from the dome to be channelled on to the external walls or on to the interior shell of the area underneath. The dome was formed by an external skeleton of twelve ribs that meet in the impost ring of the lantern, a small, hemispherical dome pierced by twelve oval oculi and surmounted by a pinnacle on three levels. A sort of upturned basket is anchored inside to this skeleton, made up of 36 arches arranged in such a way that they restore from the plan six levels of gradated hexagons in rotated superimposition, and is pierced by seventy-two openings of an irregular, depressed and lengthened shape. The whole structure is reunited at the top by a twelve-pointed, stone star arranged to screen the view of celestial glory with the radiant dove of the Holy Ghost, invested with intense light introduced through the oval oculi of the lantern. The dome was finished and covered in 1682, whereas the finishing work to the decoration on the interior carried on until 1694. In that year the reliquary was placed in the casket raised on high on the new baldachin-altar, built by Antonio Bertola in the middle of the chapel. Guarini's contribution went far beyond a functional answer to the established dictates fixed by the history of the chapel, and brought an extraordinary additional value to the visual impact, to the emotionally involving sequence of juxtaposed spaces, and to the narrative and symbolic interpretation of the Passion and its aftermath. From the moment of entering the Cathedral, the visitor's attention is directed to the reliquary altar raised to the upper level of the chapel and visible through the great opening at the back of the choir. Venturing forwards one's gaze travels over the dense allusive design on the surfaces of the truncated dome, to pass on to the disturbing surprise that is unveiled at the sight of the upper level: a wave of light passing through the enormous arched windows of the drum overturns the oppressively painful condition of the lower level, to reveal an allusion of celestial space. The open structure recalls late Gothic, "pierced" crossing towers. The idea of a tall lantern above a truncated dome derived, like Wren's Warrant design, from Le Vau's project for the Collège des Quatre-Nations. Nevertheless, more than for any of Guarini's other buildings, it is difficult to trace any significant sources for the Chapel of the Holy Shroud. We are in front of a sort of catalytic reaction produced by the application of geometric projections and stereometric knowledge from French theoretical disciplines, linguistic means and perspective tricks from Italian theater, and a dramatic use of light as an effective compositional instrument, combined with a personal aptitude for overturning image and structural function. "The element of surprise, the entirely unexpected, the seemingly illogical, the reversal of accustomed values, the deliberate contradictions in the elevation, the interpenetration of different spatial units, the breaking up of the coherent wall boundary with the resulting difficulty of orientation," are all means used to serve the one aim "of replacing the compact sphere of the old dome, symbol of a definite celestial dome, with a diaphanous dome, rich in mysterious suggestions of the infinite" (Wittkower 1958: 271).

BIBLIOGRAPHY: *Theatrum Statuum Regiae Celsitudinis Sabaudiae* 1682: 19; Guarini 1737; Rondolino 1898; Olivero 1928: 6-12; Midana 1929; Brinckmann 1931: 67–68, figs. 201–204; *L'ostensione della Santa Sindone* 1931; Passanti 1941; Portoghesi 1956; Solero 1956; Wittkower 1958: 268–75; Brinckmann 1959: 345–57; Passanti 1963: 163–94; Baudi di Vesme 1963–82; Carboneri 1964; 1966: 155–56; De Bernardi Ferrero 1966; Griseri 1967: 179–216; Pommer 1967: 7–12; *Forma urbana e architettura* 1968: 812–27; Tamburini 1968: 217–23; *Guarino Guarini e l'internazionalità del Barocco* 1970; Bertini 1970: 597–610; Carboneri 1970: 347–83; Cavallari Murat 1970: 451–96; Millon 1970: 35–60; Portoghesi 1970: 9–34; Griseri 1979: 19–38; Millon 1982: 268–70; Peyrot 1984: 19–60; *Theatrum Sabaudiae* 1984: 137, pl. 19; Robison 1985: 221–23; Dardanello 1988: 180–82; Meek 1988: 61–79; Robison 1991: 386–90; Dardanello 1993: 41–51; Klaiber 1993; Dardanello 1995: 63–134; Scott 1995a and 1995b; Momo 1997; Morrogh 1998.

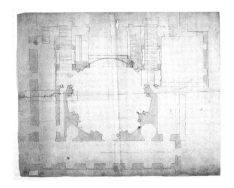

113 T

Bernardino Quadri (active 1640–95) with interventions by Guarino Guarini (1624–83)
Plan of the Project for the Chapel of the Holy Shroud
Turin, Biblioteca Reale, Disegni III 84 (previous classification: U-I-91)
Pen, pencil, brown ink, pink-violet watercolour; made up of two sheets glued along the vertical edges; 625 x 797 mm
Scale: *trabucchi* 5 = 247 mm
BIBLIOGRAPHY: Carboneri 1964: 95–109, fig. 3; Carboneri 1970: 347–83, fig. 1; Dardanello 1988: 180–81; Meek 1988: 61–67, fig. 51; Robison 1991: 386–90; Dardanello 1993: 44–49, fig. on p. 46; Scott 1995a: 609–37; Momo 1997: 80–105, fig. 67

The many small holes visible against the light, corresponding to wall edges and corners, indicate that the drawing has been outlined on the basis of important points taken from another sheet; it must therefore be a copy of a once existing original.
The plan of the circular chapel has been presented within the context of its relationship with Palazzo Reale and the Cathedral of Turin; raised to the piano nobile level of the palace and with a large opening toward the cathedral. Compared to the oval plan begun by Carlo di Castellamonte, it has been brought forward to occupy a large portion of the cathedral choir and taken back into the originally planned courtyard of the palace, making a gallery for communication between the different buildings of the complex out of the west wing. A direct entrance to the chapel and two spiral staircases, for the vertical connections of the new building, open from this gallery on the *piano nobile*. In the opposite direction, toward the cathedral, the chapel is accessible from two ramps of stairs leading off from the transept arms at the end of the aisles. Flanking the choir, each ramp has thirty-seven steps, with niches on columns in the walls; destined to frame the funerary monuments of the Savoy dynasty, the two ramps lead to two square vestibules, placed on the same level as the cylindrical body of the chapel. The rotunda is set on eight, regularly-spaced, pilasters of the major order, which are interrupted by a width equal to two bays by the side walls of the choir that lead to the large opening toward the interior of the cathedral. A minor order articulates the arches set on columns between the pilasters, corresponding to the three entrances to the chapel and the four altar recesses. On the north side, a

second gallery leads to the royal tribune, while there are two sacristies on the south: that of the cathedral, accessible from the transept on the ground floor; and that of the chapel, on the *piano nobile*, communicating with the gallery in the palace.
Interest in starting building on the chapel again was expressed in 1665 by Prince Cardinal Maurizio of Savoy, returning to words of praise for Carlo di Castellamonte's old oval design. Discussion of the project with the young Duke Carlo Emanuele II, his mother the Regent Christine of France, and undoubtedly not without the influential opinion of Filippo d'Agliè, had led to a new version being drawn up by Amedeo di Castellamonte, and then a third for a rotunda by Bernardino Quadri (active 1640–95). On the basis of comparison between the prepared wooden models, a decision was finally taken, in 1657, in favour of Quadri's project on a circular plan. A sculptor and stucco worker, with experience in the most important decorative Roman building sites of the 1640s, from the nave and aisles of St. Peter's with Bernini, to those of San Giovanni in Laterano, where a bitter argument with Borromini is remembered, Quadri had arrived in Turin in 1649 and had immediately been nominated court sculptor. The important decision to raise the chapel to a level with the *piano nobile* of the ducal residence – thus raising it to the rank of a palatine chapel – and to make it communicate directly with the cathedral, demolishing the whole length of the back wall of the choir from side to side, substantially modified the relationships between the two buildings, emphasising the visual prevalence of the chapel over the space of the cathedral. In front of the brilliant answers to symbolic, ceremonial and functional requirements for the reliquary's display, Quadri's arrangement shows clear naivety and weakness in its load-bearing ability for a structure that was to be raised in height above the dome of the cathedral. This could be seen in the extreme slimness of various walls, especially in the wall toward the gallery in the west wing, in an area weakened by the large hollow spaces destined to vertical connections by spiral staircases. The task of supporting the dome's thrust would seem to be too optimistically delegated to the reduced section of the eight pilasters of the major order.
The solidity of the structure built to this plan, and openly doubted by its same builders in 1665, was the first problem that Guarino Guarini (1624–83) had to deal with on taking the chapel project in hand, and he began by intervening directly on this sheet. In fact, in the sacristy area of the cathedral a slight pencil sketch can be made out where an idea for circular vestibules leading into the chapel, perhaps accompanied by a different idea for the stairs rotated to descend at the head of the choir, instead of the transept, begins to take shape. The study of a semicircular vestibule has been applied in a light pencil outline that can be seen in the area corresponding to the top of the south stair; verified by the measurements inscribed in a handwriting that is recognisable as Guarini's. With this new proposal, the whole ramp is transported towards the choir and slightly reduced in size, as the three

axis lines indicate, added to the drawing in pen, with the double aim of adapting it to the arrangement of the new vestibule and, perhaps, of aligning it better on the aisle axes.
A second re-thinking of the plan, of more uncertain attribution although certainly directed toward the decisions put into practice by Guarini, is to do with the search for a different practical solution for the large opening toward the cathedral. The innermost circumference of the chapel, at a tangent to the pilasters of the main order, has been outlined in pen as a curve of a circle drawn to penetrate the choir area, yet further reduced in depth by the arrangement on the cross of a new wall. The relationship between the two spaces has been overturned with this gesture: the rectangular volume of the choir with its angled pilasters no longer enters into the chapel; it is the cylindrical shape of the latter that now forcefully imposes itself on the space of the choir. This brilliant new idea is followed by an attempt, which does not find any following in Guarini's elaboration of the project, to articulate the delicate transition area between the cathedral and the chapel, repeating the system of pilaster flanked by a column of the minor order. GD

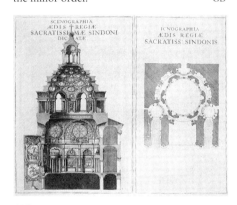

112 T

Giovanni Tommaso Borgonio (1618–1691)
a) Section showing the Internal Section of the Chapel of the Holy Shroud after Guarino Guarini's Project
ca. 1669–70
Engraving; 493 x 331 mm
INSCRIPTION: "SCENOGRAPHIA ÆDIS REGIÆ SACRATISSIMAE SINDONI DICATÆ"
b) Plan of the Chapel of the Holy Shroud after Guarino Guarini's Project
Engraving; 493 x 260 mm
INSCRIPTION: "ICNOGRAPHIA ÆDIS REGIÆ SACRATISS: [IMÆ] SINDONIS"
The two engravings were published side by side to make a single image (500 x 610 mm) in *Theatrum Statuum Regiae Celsitudinis Sabaudiae Ducis*, Amsterdam 1682 (the book exhibited here is a reprint published "a La Haye chez Adrian Moetjens, Marchand Libraire, MDCC")
BIBLIOGRAPHY: Brinckmann 1931: figs. 202 B, 203; Griseri 1967: 196–200; Bertini 1970: 597–610, fig. 2; Griseri 1979: 19–38; Millon 1982: 268–70; *Theatrum Sabaudiae* 1984: 137, pl. 19; Peyrot 1984: 23; Dardanello 1993: 43–50, fig. on p. 48; Scott 1995a: 618–21, fig. 16; Scott 1995b: 425–29, figs. 22–23; Momo 1997: 97, fig. 68

The documents dealing with the long and tormented publishing history of *Theatrum Sabaudiae* lead to a date of 1669–70 for the preparatory drawings by Tommaso Borgonio (1618?–91) for the plate showing the Chapel of the Holy Shroud; slightly more than two years after Guarini had been entrusted with the project. It is possible that the Theatine architect provided the illustrator with his own drawings, to facilitate the task of rendering this complex structure. Certainly Borgonio could count on the three-dimensional wooden model of the new project for the chapel, realised between 16 April and 13 August by the joiner Giovanni Rosso, with Guarini's direct help. In poplar wood, it was made up of a good 44 columns, 32 for the chapel and choir, 12 for the order in the drum, as well as the two great fluted columns facing the cathedral, and complete with statues and stucco decoration. The model was so large that scaffolding was needed to paint it. To give an idea of the importance given to this stage of the project, it is enough to remember that for 96 working days 18 people were employed full-time, among carpenters, joiners and apprentices, for a total sum of 3,440 lire. The engraving pays particular attention to the decorative richness in the surface treatment of the chapel, which includes the symbols of the Passion. This aspect was emphasised in the description accompanying the two plates, together with the value of the materials: "No architectural decoration has been neglected: bases, pilasters, columns, architraves, friezes, cornices, brackets, acroteria, jambs and other door ornament, projections, pediments, panels, sepulchral urns, niches, door frames, the dome itself, the apse, all the area between the cornices, whether square, polygonal, or arched in shape, everything shines of the black marble that, polished like a mirror, reflects all the objects. The sculptures that profusely adorn all the architectural elements, have been gilded [...]" The iconography of the Passion includes the *Exaltation of the Cross* and the *Resurrection*, in the two canvases on the walls of the choir; the *Crucifixion* and *Deposition*, in the paintings above the altars of the minor chapels; nails, hammers and pliers, appear in the dome area. In the pilaster niches of the drum, it is possible to make out figures of soldiers, recalling Carlo Emanuele I's intentions of having the Theban Legion martyrs to guard the Holy Shroud. An inscription runs along the frieze of the truncated dome, at the impost level of the drum: CAR. EM. II COEPIT ET MAR. IO. BAPT. CONIUX PERFECIT SACRA. The section cuts the chapel along the longitudinal axis of the cathedral of San Giovanni. It includes the ground floor, with the choir and high altar of the cathedral, the unspecified area of the *scurollo*, and the arcaded wing along the palace courtyard, with the gallery on the piano nobile and other rooms on the upper level. Within the dynastic promotion and celebration aimed for in the *Theatrum Sabaudiae*, the intention of showing that the chapel acts as a fulcrum between the Cathedral and Palazzo Reale is quite clear. Quadri's plan up to the cornice of the first order was kept, regularly cadenced by eight pilasters among which four minor chapels, the two entrances to the cathedral and one to the palace have been created. These were transformed by Guarini in the circular design of the colonnade which, supporting the tribunes, introduces them into the chapel. The shell of the truncated dome rises above the first level, pierced by six great circular oculi and distinguished by the development of three big arches that form three pendentives on a wide base at the impost. The cylinder of the drum is opened by six enormous arched windows that lead to the dome area, rising well above the impost level of this latter. Up to this level Borgonio's engravings illustrate a structure that rises through a juxtaposition of architectural elements according to a disconcerting sequence of autonomous expressions, which can be found in the chapel as built. From here upward, though, the section in the *Theatrum* shows the dome in a phase of elaboration that was still far from what was actually built. It is made up of seven turns of depressed arches laid on the key stone of the one below, arranged to create a sort of basket that still has a lot in common with the interwoven ribs of the dome-lantern designed by Guarini for St. Anne-la-Royale. In the areas between this densely woven network there are seven layers of oval windows, diminishing in size as the dome narrow toward the impost ring of the lantern. This follows a traditional scheme of a small circular temple opened by eight long windows, cadenced on the exterior by a ring of the same number of Corinthian columns. The shape of the dome represented here does not acknowledge the structural skeleton of twelve supporting ribs that were to be built on the exterior. The plan shows how the problem of the connection between the chapel and the choir was resolved: the large opening toward the cathedral has been slightly reduced, compared to Quadri's project, and the supports for the two freestanding columns of the main order, an introductory proscenium to an internal view of the new building, have been positioned on the ring that defines the cylindrical volume of the chapel within the rectangle of the choir. The two stair ramps have been transferred toward the choir in the cathedral, exactly as indicated by the pen lines added by Guarini to Quadri's plan. The steps are convex and follow the same radius as the circular vestibule. The wall articulation of the stair ramps has been changed: the niches for funerary monuments have been eliminated and sets of pilasters added toward the middle of the ramps. Quadri's spaces for spiral staircases have been filled in and the walls toward the exterior all around the chapel have been thickened. The choice proposed to Borgonio of representing in the same plan the level of the first order compared to the section of the drum emphasises the conversion of the support system from nine to six, showing that no correspondence exists between the image of the structure seen by the eye and the real load-bearing ribs of the building. The presence of the balustrade in the tribunes above the three entrances to the chapel and in the gallery on a level with the drum – the "different balconies of Palazzo Reale, by which the chapel is surrounded" – emphasises the theatrical feeling of the building, often referred to in documents as the "Theater of the Chapel of the Holy Shroud".

GD

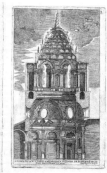

110–111 T

Jean Fayneau after a drawing by Guarino Guarini (1624–1683)

a) Plans on Many Levels of the Project for the Chapel of the Holy Shroud in Guarino Guarini's *Dissegni d'architettura civile et ecclesiastica, Inventati & delineati dal Padre Guarino Guarini Modonese, De Chierici Regolari Theatini, Matematico dell'Altezza Reale di Savoia*, in Torino 1686: pl. 2
Engraving; 355 x 215 mm (whole sheet); 253 x 163 mm (impression)
INSCRIPTIONS: "PIANTA DELLA CAPELLA DEL S. SUDARIO DI TORINO" (at the top, in the middle of the plan); "PIANTA DELLA CUPULA" (below, in the middle)

b) Section Showing the Internal Elevation of the Project for the Chapel of the Holy Shroud in Guarino Guarini's *Dissegni d'architettura civile et ecclesiastica [...]*, Torino 1686: pl. 3)
Engraving; 295 x 181 mm (impression)
INSCRIPTIONS: "FACCIATA INTERNA DEL S. SUDARIO DI TORINO" (at the top, on the right); "DEDICATA A VITTORIO AMEDEO DUCA DI SAVOIA PR. DI PIEM. RE DI CIP / DAD Guarino Guarini CR invenit Ioan Fayneau sculpsit" (lower border)
BIBLIOGRAPHY: Guarini 1737: pls. 2–3; Carboneri 1964: 95–109, fig. 4; Passanti 1963: 163–194; De Bernardi Ferrero 1966: pls. 2–3; Bertini 1970: 597–610; Carboneri 1970: 347–383, fig. 2; Millon 1982: 268–70; Robison 1985: 221–23; 1991: 386–90, figs. 2–3; Dardanello 1993: 41–51, fig. on p. 48; Momo 1997: 92–114, figs. 71–72

In the two plates published for the first time in 1686, Guarini presented his project for the chapel of the Holy Shroud in an ideal form of a sequence of the plan's geometries projected in the elevation in the three-dimensional development of his tower-reliquary. He did not consider the lower level with the pre-existing *scurolo*. He did though indicate the shape of the cylindrical curve that permitted free visual communication between the chapel and the cathedral. He emphasised the importance of the light sources and the presence of openings, eliminating the second level of the west wing of Palazzo Reale that might have darkened the large round window in line with the nave of the cathedral. He marked the internal cavities in the structure, accentuated the vertical thrust and appearance of a pierced pinnacle, and rendered the skeleton of arches and the outline of the load-bearing courses more explicit. The plan presents the sequence of all the geometrical planes that in elevation will con-

struct the three-dimensional form of the different superimposed levels of the structure. An equilateral triangle is set on the circle of the first level; this triangle uses only three pairs of support points from the inherited plan, creating a vaulting scheme that converts the scheme from nine to six bays. The internal surface of the ring of the drum has been reduced by a quarter compared to the circle at the base of the chapel, resulting in a distinct lightening of the upper levels. The thickness of the drum, passing from a round interior to an octagonal exterior, is opened by six large windows and eaten into by the gallery passage which crosses it, distinctly dividing each of the six supports into two. The dome laid on the internal edge of the drum is made up of six hexagons inscribed one on top of the other in rotated superimposition, and concluded at the top by a round oculus screened by a twelve-pointed star. In the vertical section, the drawing neglects many of the surface decorative details, the iconography and figurative decoration linked to the theme of the Passion, that characterise the image in *Theatrum Sabaudiae*. These plates were often entrusted to engravers not of the highest skills, like Jean Fayneau, a Frenchman active in Turin during the last quarter of the seventeenth century and author of these and many other prints in *Architettura civile*, published posthumously by Bernardo Vittone in 1737. The elevation shows how the restraints imposed by the pre-existing building have been ignored, if not ridiculed, when Guarini places ornamental shells on to what one had imagined were the load-bearing pilasters of his predecessor and then slightly above them arranges the great round oculi that pierce the truncated dome. Comparison with Borgonio's engraving, most probably based on the wooden model of the chapel realised in 1667, shows that the project for the dome has undergone changes during the 1670s as the building grew taller, and, with the exception of some minor details, is now close to the structure as built. The basket of arches has been hidden by the design of serpentines curving upward. The geometrical pattern of the hexagons in the plan can barely be recognised in the horizontal cornices that divide the space between the curves into two areas and determine a change in the shape of the openings: the oval oculi have been replaced by elongated windows arranged to follow the depressed curve of the arch, interrupted in the middle by a bracket that corresponds to the continuous development of the ribs of the external structural skeleton of the dome. The lantern is a small hemispherical dome, pierced above the imposts by a series of oval openings. Here there is a spiraling pinnacle, instead of the three-tiered spire that was actually built on the top of the chapel. This presentation of the project does not reveal much about the load-bearing structure of the building, preferring instead to demonstrate Guarini's considered decision to make structural function and apparent architectural form independent. The new type of elevation derives from a fascination with medieval towers and geometric projections, articulated in a three-dimensional form thanks to his knowledge of stereotomy learnt in France. It is as though "in

plan the tiers could be nestled within each other in brilliant kaleidoscope patterns and then – precisely because they did not have to be stacked in conventional sequences – could be projected or telescoped into place, like the sections of a tower, in the way that would best preserve these flat patterns in plan" (Pommer 1867: 10). The device of perspective diminution of the dome's six hexagons produces an effect of flight, demonstrating the validity of a principle of visual perception stated by Guarini in *Architettura civile*: "The place, or object, that is better illuminated seems larger than that which is dark, because the more the shadows of the objects bring out their projections, the more the view extends itself. And when the small parts are visible, the imagination, seeing many things, persuades itself that the area is very capacious." GD

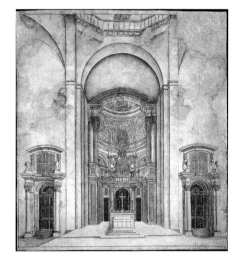

114 T

Draftsman active in Piedmont
Perspective View of the Transept and Choir of the Cathedral in Turin Looking toward the Chapel of the Holy Shroud
Turin, Archivio Capitolare, s.c.
Pen, traces of pencil, brown ink, gray, light blue, yellow gold and black watercolor
600 x 542 mm
BIBLIOGRAPHY: Olivero 1928: 6–12, fig. on p. 9; Midana 1929: 340; Passanti 1963: 163–94; *Forma urbana e architettura* 1968: 813, fig. 11; Scott 1995a: 609–37, figs. 8–9; Momo 1997: 98–104, fig. 77

This view has been deliberately studied to render the special visual relationship between the cathedral of San Giovanni and the chapel of the Holy Shroud: a relationship wrongfully compromised by the insertion of a large protective window wanted by King Carlo Felice in 1825–26. The vanishing point is marked by a hole at the foot of the cross on the high altar. The observer's eye is in a slightly higher position, in the middle of the nave, close to the arch in front of the crossing. His gaze takes in the transept walls, where the decorated portals leading to the stairs giving access to the chapel are, and rises just high enough to recognize the vaults and octagonal development of the drum of the late fifteenth-century cathedral by Meo del Caprina. Beyond the high altar it reaches

the tribune on columns and then sinks into the depths of the chapel on the upper level. The reliquary casket on the altar of the Shroud, protected by a baldachin culminating in a brilliant, gold sunburst around the cross, is the fulcrum of the composition. The excellent conditions found for presenting the precious reliquary, wished for by Carlo Borromeo and continued by the dukes of Savoy, have been created in the center of this spectacular new architectural set, with a spatial and visual distinctness far beyond all expectations.

This exercise in perspective representation with a very wide visual field has created certain problems for the draftsman, evident in the more foreshortened parts of the doors at the sides: the column plinths and above all the convex steps do not adapt to the single vanishing point, entering into strident conflict with the flat plane of the grilles. Further inconsistencies can be noted in the large arch and in the chapel, and there is a certain amount of insecurity in reproducing the complex design of crosses arranged on the curved surface of the pendentive of the truncated dome. In spite of these uncertainties, this drawing, like no other, renders fully the idea behind the name "Theatre of the Chapel of the Holy Shroud;" a name used often in the accounts for Guarini's building. The great arch at the back of the choir seems just like a real proscenium leading into the theatrical space of the chapel. Even the architectural lines of Guarini's building have been arranged to direct the spectator's attention on to the reliquary altar, endowed with a magnetic power for visual attraction. Its raised position and the effect of depth accentuated by the succession of planes, belong to the ephemeral repertoire for arrangements for the *Quarant'ore* and funerary catafalques. However, in this case it is not a fictitious space created by the optical illusion of stage sets, but a real space that is physically reachable, as signalled by the two grand portals on each side of the choir. The same cathedral is transformed into a monumental atrium centring on the chapel. Even the words accompanying the plate in *Theatrum Sabaudiae* testify to this: "The church of San Giovanni is divided into nave and two aisles, each ending in a marble backdrop; the two aisles finish in stairs to ascend to the level of the chapel, whereas the nave has a great arch that lets one glimpse its internal symmetry." Nothing like it had been seen before, not even in the paradoxical contents of architectural spectacle put on by Guarini: the great, pierced pendentive, applied to the surface of a truncated dome, traversed by passing light that hits the golden sunburst above the reliquary is pure architectural form without any relationship whatsoever to its original structural function.

The design of the high altar of the cathedral, which is not consistent with the one built by Antonio Bertola for Archbishop Michele Antonio Vibò at the beginning of the eighteenth century, dates this drawing to the 1690s, after completion of the reliquary altar, depicted here with detailed precision, followed by Bertola himself, and where the Shroud was officially placed in 1694. GD

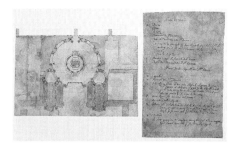

115 T

Pio Giulio Bertola (?)

Plan of the Chapel of the Holy Shroud (Turin Shroud)

Turin, Archivio Capitolare, s.c.

Pencil, gray ink, yellow and violet watercolor; the sheet of the drawing and the sheet of the explanation were glued on to a single piece of thick card, before restoration; 212 x 330 mm Explanation on a separate sheet (in pencil and brown ink; 330 x 220 mm):

INSCRIPTION: "Ground floor / A: Cathedral - / B Choir - / C Sacristies / D Preacher's room / E Stairs descending below the Cathedral - / F [...] wall filling, for the safety of the Chapel of the Holy Shroud o/ G [...] archives, one of Monsig. the Archbishop and the other of the Rev.mo Chapter / [Presb]ytery / The [Pa]lace of the King / K: Piazza in front of the Cathedral façade -/ L: Piazza del Duomo, called San Giovanni -/ Floor of the Chapel of the Holy Shroud – M: Chapel -/ N: Deposit of the Holy Shroud -/ O: Stairs that lead to the two aisles on the ground floor of the Cathedral, and rise to the floor of the Chapel part of the old Cathedral walls demolished, and two Chapels that were there to form the same -/ P: Window above the Sacristy of the Cathedral / Q: Sacristy of the Chapel -/ R: Galleries from the Royal Palace to the tribune in the Cathedral, and the old wall broken of the same in different places to make exits suitable for the tribune / S: Tribune / T: The dotted lines T: denote walls of the high altar of the Cathedral demolished to make the Chapel."

BIBLIOGRAPHY: Olivero 1928: 6–12, fig. on p. 12; Brinckmann 1931: fig. 202 A; Portoghesi 1956: fig. II; Scott 1995a: 609–37, fig. 12; Momo 1997: 115–21, fig. 81

This is a survey of the chapel of the Holy Shroud as built. The drawing of the entrance portals from the cathedral and the stairs is finally in its definitive form, with the three niches that cadence the steep flight of steps and the sophisticated variations introduced into the profile of the steps when they get to the round vestibules, and in the passage from these to the chapel. Compared to Quadri's plan, the internal plan on the level of the first order has remained unchanged in size and in the wall and support articulation, with the sole exceptions of the proscenium on free-standing columns that frames the side looking toward the choir of the cathedral, and the intrusion of the round vestibules into the chapel space. The altar built by Antonio Bertola after Guarini's death is in the centre of the chapel; the reliquary was definitively placed there in 1694. It is raised on a circular platform protected by a balustrade and accessible by two

flights of six steps, aligned at the extreme opposites along the axis of the cathedral nave and the entrance from the gallery of the palace. The real altar is rectangular, with plinths projecting on the diagonals, and two tables facing respectively the cathedral and Palazzo Reale, strengthening the position of symbolic equilibrium in which the reliquary is placed between the two powers. The balcony looking out toward the cathedral rests set back on the back wall of the choir to gain the necessary width to unwind the holy sheet along its entire length, as illustrated in an engraving by Bartolomeo Tasnière, after a drawing by Giulio Cesare Grampin, published on occasion of the Ostension in 1703.

This survey of the chapel complements another sheet conserved in the same Chapter Archives, showing the plan of the whole cathedral (660 x 460 mm), including the level below Guarini's building. The plan of the chapel was originally attached by three, still existing, paper hinges to the sheet showing the cathedral plan, to facilitate understanding of the complex articulation of the spaces on the two levels. On both sheets, a difference in wall color distinguishes cathedral jurisdiction, indicated in violet watercolor, from that of Palazzo Reale, indicated in yellow watercolor, which includes the walls of the chapel of the Holy Shroud. The explanation refers to letters on both drawings, making a distinction between the "ground floor" and the "floor of the chapel." The scale in *trabucchi* (8 units = 167 mm), marked at the foot of the entrance staircase to the cathedral, is naturally valid for both. Even if they are now separate, the two sheets thus refer to the same moment and are by the same author, who has recently been proposed as being the measurer, or surveyor, Pio Giulio Bertola. Payment for a survey by him of the cathedral in 1714 is documented (Momo 1997: 115–21).

The explanation would seem to reveal the historic intention of recording the work done by Guarini to strengthen the plan inherited from Quadri and to raise the height of his tower-like structure. It in fact notes the hollows filled "with masonry, for the safety of the chapel of the Holy Shroud," and the dotted lines indicating the exact lie of the choir of the late fifteenth-century cathedral, whose walls were partially demolished in the terms of the building history recently studied with much attention by Maurizio Momo. GD

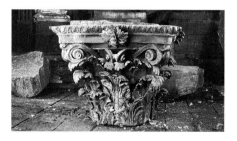

116a T

Simon Boucheron (active 1661–81)

Capital from the Minor Order of the Chapel of the Holy Shroud

Turin, Cappella della Sindone

Gilded bronze

60 x 80 x 80 cm (maximum volume)

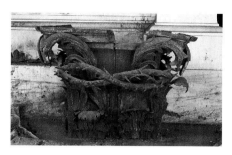

116b T

Bernardo Falconi (active 1657–96) after a drawing by Guarino Guarini (1624–83)

Capital from the Main Order of the Chapel of the Holy Shroud

Turin, Cappella della Sindone

Gilded bronze; 81 x 120 x 55 cm (maximum volume)

BIBLIOGRAPHY: Passanti 1963: 163–94, fig. 47; Baudi di Vesme 1963–82: 202–204 and 448–51; Griseri 1967: 196–200, figs. 124–26; Cavallari Murat 1970: fig. 1; Dardanello 1993: 83, pl. 19; Scott 1995b: 418–45; Momo 1997: 84 and 99

These two bronze capitals and a stone fragment from one of the great columns facing out toward the choir of the cathedral of San Giovanni still bear clear signs of the damage inflicted during the tragic fire of 11 April 1997. Both are Corinthian capitals: one, in the round, is from the columns of the minor order that link the interior of the chapel to the round vestibules; the other decorated the pilaster of the major order supporting the main entablature. Corinthian was a suitable option for the funeral importance of the chapel and associated right from 1607 with the choice of material – black marble from Frabosa for the stone facing and gilded bronze for the capitals and bases – wanted by Duke Carlo Emanuele I of Savoy when the first project for an oval chapel by Vitozzi and Castellamonte was being planned. The capital from the minor order is sculpted according to traditional conventions in the design of the Corinthian order. The bronze shape is hollow, strengthened by a solid filling of brick and mortar, and worked carefully in the finishing both of the surface details and of the junctions between the parts applied to the heart of the overturned bell. The capital belongs to one of the columns in the round vestibule at the top of the north stairs. They were introduced into Guarini's new project of 1667, and probably put in position at the beginning of the 1670s. The pattern, though, conforms to the order adopted by Quadri, if it does not date right back to examples of capitals cast in bronze during the work on Castellamonte's oval chapel, recorded in an assessment of material stocks when the building site was re-opened in 1657; eight "Capitals in bronze for the small Columns" were counted then (Turin, Archivio di Stato, *Camera dei conti*, Art. 195, mazzo 1, c. 7r). During Quadri's and Guarini's periods, the costly process of working the bronze was carried out by the founders Lorenzo Frugone (active 1661–81), from 1659 to 1660, and Simon Boucheron, from 1659 to 1681, for the capitals and bases of the main order. The latter's work for the building of the Shroud is officially noted, on 1 June 1661, in Carlo Emanuele

II's license nominating him "founder and general manufacturer of the big and small metal work" recalling the proof given of "his skill and profession, and that bases and capitals of bronze are continually needed to be decorated for the chapel of the Holy Shroud." The capital from a pilaster of the main order of the chapel is also Corinthian, at least in its syntactic compositional framework. It departs decidedly from the norms, though, to render a new symbolic-figurative interpretation of the order fitting to the context of Christ's Passion. A sharp crown of thorns winds around the whole capital; the nails of the cross are driven into the center and sides of the rosette of the abacus, which does not resemble traditional forms but rather a passion-flower. This plant was probably well known to Guarini, as Scott has suggested, possibly also through knowing a text by Giacomo Bosio published in Rome in 1610, *La gloriosa, e trionfante Croce*, which connected it to the theme of the Passion. A scroll with the inscription of the cross lies above the abacus: "Jesus Nazarenus Rex Judaeorum." The capital on exhibition fell from the first pilaster next to the northern vestibule of the chapel, where, resting on the collar, it enveloped the solid support in black Frabosa marble, supporting the entablature above. In the devastation caused by the fire several parts have been lost, like the scroll with the inscription and the passion-flower with the nails of the Passion; although damaged, the crown of thorns is more or less intact. Part of the surfaces visible to the eye have been finely chiselled to render the naturalistic effect of leaves, flowers and the crown of thorns; traces of gilding are still evident. Scott has presented a detailed report of the documentation on the manufacture of the ten capitals of the Passion; two for the large fluted columns looking on to the choir of the cathedral, and eight for the pilasters of the main order inside the chapel. Four date from the period when Guarini was working there (1667–83) and were probably made between 1669 and 1670. The other six were not made until after his death, and between 1688 and 1694. It should be noted that the accounts link the working of the "great capitals" of the main order to the prestigious name of the duke of Savoy's sculptor and bronze founder Bernardo Falconi, who was present in Turin in those two sets of years (1664–71 and 1688–89). With respect to the symbolic meanings that Guarini lavished on the design of the space, the geometric patterns, architectural figures and the surfaces in the chapel of the Holy Shroud, the symbols of the Passion are certainly one of the more comprehensible allusions, and in accordance with Vitruvius' anthropomorphic interpretation of the capital as the "head" of the human figure. The theme provided Guarini with the occasion to pursue his special interest for reinventing the elements of architectural vocabulary in an organic-naturalist way, abundantly illustrated in the more than twenty creative variations of ideas for capitals presented in the plates of *Architettura civile* (pls. XII-XIX). One of these is among the capitals in the external order of the drum in the chapel of the Holy Shroud; others were produced for the interior of San Lorenzo and in Palazzo Carignano in Turin. GD

Palazzo Carignano, Turin
Henry A. Millon

Emanuele Filiberto of Savoy, Prince of Carignano, (1628–1709) knew of Guarini's work at Racconigi, and at San Lorenzo and the Sindone Chapel. In 1679, as the chapel was nearing completion, Emanuele Filiberto commissioned Guarini to design an urban palace with regal airs for a possibile heir to the duchy of Savoy.
The palace was built on land that Emanuele Filiberto's father, Tommaso of Savoy-Carignano, had owned since the 1640s outside the walls of Turin toward the Po River. Gua-rini was paid for the design of the palace on 6 August 1679.
Excavations for the foundations were begun in January 1680. By October 1680 the vault of the entry was completed and the walls and roof were finished by late 1681 or early 1682. The vaulting of the oval atrium and *grand salon* occurred between July 1682 and the end of 1683. At some point, plans to complete the rear wing enclosing the courtyard were abandoned.
Decoration of the palace, begun in December 1683, was sufficiently complete to have its rooms blessed in the summer of 1683, but it was not finished until the early years of the eighteenth century. Work on the garden and stables, begun in March 1680, was ended in 1686. Further work on the carriage house and stable was carried out in 1697–98.
A number of Guarini's preparatory drawings for the Palazzo Carignano survive and chronicle the development of the design through four stages from a rectilinear structure with a square courtyard, to the grand curvilinear scheme that was constructed (which recalls Bernini's first design for the Louvre).
Guarini apparently knew Bernini's designs which had been on view in Paris in 1665 while Guarini was there at work on the construction of Sainte Anne-la-Royale. The drawings offer a rare insight into the development of Guarini's thought.
The façade reveals the presence of the oval atrium and the *grand salon* (behind a pair of curving stairs) in the baying forward of the central section with its separation (or split) in the center for the ground level entrance and declamatory balcony at the *piano nobile*.
Reverse concave curves join the seven bays of the convex central section to the four bays of the corner pavilions, uniting and stabilizing the whole.
In elevation, two main levels divide the façade, a rusticated ground floor (with mezzanine) and a *piano nobile* (also with mezzanine and an attic). The rusticated Doric pilasters of the ground level are changed to a giant order of Corinthian pilasters above. Between the pavilions and the entrance, in the curved central section, pilasters were doubled and the rhythm quickened by a progressive reduction of the width of the bays. The center was further emphasized by the progressive saliencies of pilasters and entablature approaching the open central bay.
The oval *grand salon*, the generator of the plan

for the central section, was vaulted by a spectacular ribbed dome with an oval oculus. Through the oculus, an apparently suspended domical surface, mysteriously lighted, contained a painted scene, the climax of the sequence of entry, stair, and vestibule.
Guarini's design did not disclose the verity of its structure. The painted surface was the underside of a suspended plaster surface supported from above by wood trusses (in the space of the oval clearstory) and illuminated by light from the oval windows of the clearstory reflected from the upper surface of the masonry vault.
The Palazzo Carignano was the most important palace design in Italy of the last quarter of the seventeenth century and the only palace in Italy in that period with a pronounced regal, rhetorical, and representational character.

BIBLIOGRAPHY: Chevalley 1921; Brinckmann 1931; Passanti 1945; Portoghesi 1957; Wittkower 1958; Bernardi 1963; Meck 1988; Cerri 1990

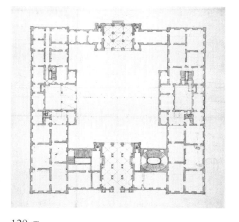

120 T
Guarino Guarini (1624–1683)
Plans for the Palazzo Carignano, Turin
Ground Floor (right), *Piano Nobile* (left)
Carignano I
Turin, Archivio di Stato, Az. Sav. Car., 51.1.9.9
Pen, brown ink, gray watercolor, over black chalk underdrawing. A small sheet (120 x 88 mm, Az. Sav. Car., 51.1.9.28, executed with the same materials), formerly attached to Carignano I, indicates a plan for the *gran salone* and balcony of the *piano nobile* above the atrium; 545 x 465 mm
INSCRIPTION: "10 [trabucchi]" (center)
BIBLIOGRAPHY: Brinckmann 1931: 76, no. 250; Passanti 1945: 180, fig. 46; Cravero 1951: 56 (detail), 60; Bernardi 1963: 16 (detail); Passanti 1963: 18; Marini 1963: 101; Millon 1964: I, 80–83; Lange 1970: 260–61, no. 55; Millon 1987: 482, fig. 10; Meek 1988: 92; Cerri 1990: 26 and fig. 4

The primacy of Carignano I in the sequence of drawings for the Palazzo Carignano was first established by Brinckmann (1931). It contains all the elements that were to be found in the final design, but in their initial forms. The south half of the plan (right) shows the ground floor, the north half (left) the *piano nobile*. The palace, a rectangular plan, includes a central

courtyard, centrally placed entrance and three-by-four-bay atrium flanked by stairs, an axial arcaded pavilion leading to the garden behind the palace, north and south central pavilions with mini- courtyards or light-wells that separate princely apartments to the west and east, and a slender gallery extending above the arcaded pavilion of the east wing to join the north and south wings. The ground floor of the eastern half of the north and south wings contain double-loaded corridors.

The presence of north and south wings or flanks of the palace are marked on the façade by four-bay pavilions set forward from the eleven-bay central section where the central three-entrance bays are emphasized by flanking paired columns. The east and west wings are indicated on the north and south façades by salient two-bay corner pavilions.

In Paris before coming to Turin, Guarini had designed a large palace for an unknown patron, perhaps an unsolicited proposal for a new Louvre palace that was under consideration in the mid-1660s. The earlier design may have been drawn upon by Guarini when he began to work on the plans for the Palazzo Carignano. The Paris palace, though considerably larger than the Carignano, included a square courtyard, stairs that flank a centrally placed entrance and atrium, an arcaded pavilion leading to gardens, salient flanking pavilions, and a three-bay entry marked by double columns, all found also in the plan of Carignano I.

Guarini was in Paris when Bernini was invited to Paris to prepare plans for the new Louvre. He is likely to have seen Bernini's drawings. The stages in the design of the Palazzo Carignano follow, to some degree, the phases of the development of Bernini's plans for the Louvre, but in reverse sequence. For a discussion of the possible relation between the two designs, see Millon 1987: 479–500.

Guarini most likely developed the designs for the Palazzo Carignano between February 1678 and June 1679. Guarini was in Mode-na from late-spring 1677 until 11 February 1678. The earliest secure date confirming Emanuele Filiberto's intention to build a new palace is a gift of 2,000 *ducatoni* on 18 April 1678 from the Madama Reale Giovanna Battista to Emanuele Filiberto specifically for construction of a suitable princely residence. As Augusta Lange has shown (1970), Guarini was already known in the Carignano household in 1677. In October of that year, although apparently in Modena, he received a reimbursement for expenses incurred in purchasing materials for the Cavagliere de Savoia, a seventeen-year-old nephew and ward of Emanuele Filiberto. Guarini may have taught the design of fortifications to the young cavalier to whom he dedicated his *Trattato di Fortificatione*, published in Turin in 1677.

Guarini's abilities as an architect were well-known to Emanuele Filiberto from San Lorenzo and the Sindone then under construction, but also from his work on the Castello at Racconigi, one of the prince's properties. Guarini's first recorded payment there is 1677, which indicates he may have already begun to redesign the *castello* in 1676. HM

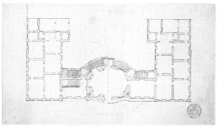

121 T
Guarino Guarini
Plans for the Palazzo Carignano, Turin
Ground Floor (left), *Piano Nobile* (right) Carignano II
Turin, Archivio di Stato, Az. Sav. Car., 53.1.9.7
Pen, brown ink, pink and yellow watercolor over black chalk. A small sheet trimmed to conform to the shape of the north (left) stair indicates the landings, stairs and vaults. When lifted, it reveals the configuration of spaces under the stair and openings to the *cortile*; 465 x 524 mm
INSCRIPTION: "5 Trabucchi" (center)
BIBLIOGRAPHY: Brinckmann 1931: 76, 251A; Passanti 1945: 145, 182, fig. 47; Passanti 1963: 19; Marini 1963: 102; Millon 1964: 83–85; Lange 1970: 262, no. 57a; Millon 1987: 483, fig. 11; Meek 1988: 93; Cerri 1990: 26 and fig. 5

Guarini's plan for Carignano II includes only the western half of the palace. The ground floor is shown on the left half of the drawing in yellow, the *piano nobile* on the right half in pink. The disposition of rooms on the north and south wings remain unchanged from Carignano I, except that the thinness of the central wing in Carignano II enables the addition of a second window in the middle room in both the north and south wings, an improvement retained in all later designs.

The rectangular atrium of Carignano I has been transformed into a domed lateral oval. The main stairs are symmetrically disposed on either side of the atrium, and the second flight assumes the curvature of the oval atrium as it ascends to the entrance of the *gran salone* on the central axis of the courtyard. The presence of the main stairs wrapped around the oval atrium on the courtyard façade produces a dominant convex mass in the courtyard that is retained in the later designs.

The small, circular service stairs next to the main stairs on the courtyard façade of Carignano I have been moved to the main façade and converted to ovals in the thickness of the walls that make a transition from the oval atrium to the rectangular vestibules on both levels. Those vestibules are reduced to three bays on the façade to accommodate the lateral oval atrium. The three-bay entrance to the palace retains the paired columns of Carignano I but is convexly curved to conform to the shape of the oval atrium. To either side, short convex curves above the outer pair of columns grasp the swelling bay of the atrium and link the oval central section to the rectangular spaces and walls to either side. This linkage is emphasized by the continuous balcony that extends the full width of the central section.

The flanking pavilions have pilasters at each cor-

ner as in Carignano I, but on the north and south flanks, the salient width of the corner pavilion has been increased from two to five bays, presumably to enable a symmetrical elevation when including the east half of the palace. The oval atrium with paired free-standing columns, a convex bay on the courtyard, symmetrical main stairs, axial entrances to the main stairs, a convex central section held within concave flanking curves, oval service stairs toward the main façade, and four-bay pavilions on the façades are elements of the plan of Carignano II that were retained in all future plans.

Below the central section of the palace are traces in black chalk of an alternative placement for the main stairs. They have been shifted toward the main façade, while still conforming to the shape of the oval atrium. This new location for the main stairs is also retained in all later designs.

The drawing was executed, as the others in this group, sometime between the middle of February 1678 and June 1679. HM

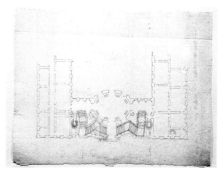

122 T
Guarino Guarini (1624–83)
Plans for the Palazzo Carignano, Turin
Ground Floor (left), *Piano Nobile* (right) Carignano III
Turin, Archivio di Stato, Az. Sav. Car., 53.1.9.6
Pen, brown ink, over black underdrawing, some incised lines and transfer holes, with black chalk additions; 380 x 503 mm
Watermark: monk(?) holding a tall staff with a cross, an oval purse at his hips and the letters B, heart, C within a rectangular outline at his feet. Similar, but not identical, to Heawood 1950: no. 1345
BIBLIOGRAPHY: Brinckmann 1931: 76 and 251B; Passanti 1945: 184, fig. 48; Bernardi 1963: 16; Passanti 1963: 21; Marini 1963: 102; Millon 1964: 85–94; Lange 1970: 262–263, no. 58; Millon 1987: 484, fig. 12; Meek 1988: 94; Cerri 1990: 26, fig. 6

The plan for Carignano III includes only the western half of the palace. The ground floor is shown on the left and central section, the *piano nobile* on the right. The façade portion was never completed in ink, though the two alternative solutions for the main stairs were finished. In the north and south wings the rooms have been lengthened from those in Carignano II to account for the new thickness of the central section. The courtyard pavilions in the north and south wings of Carignano I and II appear to have been eliminated in Carignano III. The oval

atrium protrudes into the courtyard as a central three-bay convex pavilion flanked by three-bay columnar stair vestibules aligned on the axis of the atrium. The paired columns of the atrium, which first appeared in Carignano II adjacent to the curved wall of the atrium, have been advanced toward the centers of the oval atrium. The small oval service stairs flanking the oval atrium on the main façade in Carignano II have been enlarged in Carignano III, and are entered from the vestibule of the main stair. The paths followed by the two main stairs not only animate the façade, but are also attempts to provide for the necessary number of risers between the ground floor and the *piano nobile*. The stairs include only 51 risers in the angular stair and 53 in the curved stair. In Carignano I the oval stair has 59 risers and the rectangular stair likely was intended to have 65 risers. The main stairs in Carignano II have 63 risers. In black chalk at lower right on Carignano III there is a calculation of the number of risers in the main stairs (12, 17, 11, 11) for a total of 51 risers, perhaps an alternative to the flights of 13, 16, 11, 11 shown in the drawing of the angular stair. The gain of two risers in the curved stair over the angular stair may have suggested to Guarini the single curved path for the stair drawn in black chalk to the left over the inked version of the curved main stair. Two alternatives for the façade of the main central section are drawn next to the outer edge of the two main stairs. Within a convex central bay, both include only a single (or possibly double) column flanking the entrance. A third alternative to the left, also in black chalk, follows the plan of the stair with a single curvature for some distance before returning to the plane of the façade. In the north wing, in the first space to the right (south) of the double-loaded corridor (absent in Carignano II), there is an internal stair to a mezzanine level. In the south wing a stair that opens on the main façade (likely leading to an upper level) is drawn in ink. The drawing was executed between the middle of February 1678 and June 1679. HM

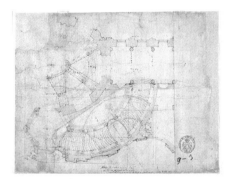

123 T
Guarino Guarini (1624–1683)
Plan for the Southern Half of the Ground Floor of the Central portion of the Palazzo Carignano, Turin
Turin, Archivio di Stato, Az. Sav. Car., 53.1.9.3
Pen, brown ink, pink watercolor, with additions in black chalk. The additional sheet containing a plan of the curving stair replaces a section cut from the larger sheet
298 x 392 mm

No scale, but dimensions indicated
INSCRIPTION: "Altezza di ciascuna gradino o[ncie] 3 1/2 / che da in 58 gradini da 203/ cio P[iedi] 168 o[ncie] per andar in 17 due gradini nella porta della sala oncie 7"
BIBLIOGRAPHY: Bernardi 1963: 17; Millon 1964: 194 no. 38; Lange 1970: 264–65, no. 62; Cerri 1990: 26 and fig. 11; Dardanello 1993: 107

Sheet 53.1.9.3 is a plan for the right (south) half of the central section of the Palazzo Carignano including an entrance vestibule, atrium, stair vestibule, main stair, as well as the entrance portal, the main façade and the courtyard façade of the central section. All but the upper portion of the main stair and the plan of the main façade is shown at ground level. That portion of the sheet containing a plan of the main stair was cut out and replaced by a new fragment upon which the stair is drawn. Guarini appears to have thought the plan to be nearing a final state, because dimensions are included in the entrance vestibule, atrium, stair vestibule, and main stair. The stair consists of two flights. The first flight has convex treads, the second concave, with an oval landing between the two flights. The stair is flanked by eight columns and balustrades to either side. There are 29 risers in each flight for a total of 58. Two additional risers are to be at the entrance to the *grand salon* making a total of 17 *piedi* (8.74 m) between the stair vestibule at ground level and the *piano nobile*. There were many changes to the plans yet to come. The height between the ground level and the *piano nobile* was set at 19 *piedi* (9.76 m), with six risers between the atrium and the stair vestibule for a total of 59 risers (6 + 27 + 24 + 2), with risers just under 4 *oncie* in height. In the atrium, the distance between the column pairs and the wall of the atrium was reduced from the "piedi 4 oncie 4" indicated in the drawing. The square pier between the atrium wall and the main stair, and the bits of wall to the south of the stair that support the wall of the vaulted vestibule on the *piano nobile*, were eliminated through thickening the wall of the atrium and by inserting a larger oval service stair in the area to the north of the main stair. The drawing shows on the façade a single column with a responding pilaster to the left of the entrance that were transformed when constructed into a pair of banded Doric columns. At the *piano nobile*, Guarini had apparently already decided on a pair of columns flanking a balcony. The first pilaster to the right of the balcony niche in the drawing has been doubled with the pilaster nearest to the niche stepped forward much as in the building. In the building as constructed, the next pilaster is doubled with the nearest pilaster to the entrance also stepped forward. The final pilaster, to the right toward the end of the reverse curve, is shown as it was designed and realized to the north, in the reverse curve of the façade to the left of the entrance, where the pilaster meets the side wall of the north pavilion. Toward the south pavilion the reverse curve is shallower with the final pilaster forming a corner with the pilaster on the face of the pavilion. Recognition of this anomaly (possibly an error in construction) is seen in drawing 53.1.9.15 where a correction to the drawing shows the junction as it was con-

structed. This drawing of the atrium and stair is the earliest to include a new salient pilaster placed on the courtyard façade of the atrium where the curved bay meets the wall of the stair vestibule. Additions in black chalk include at least one alternative path for the main stair, a curved stair of three flights, and possibly traces of an "L" shaped rectangular stair. Contracts for the stone work for the atrium columns and pedestals, the stairs, entrance columns and balcony columns were signed on 30 Sept. 1679. The drawing was done before that date. HAM

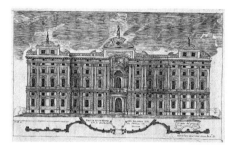

118 T
Antonio de Pienne (active 1660–95) after Guarino Guarini
Elevation and Partial Plan for the Palazzo Carignano, Turin, in Guarino Guarini's *Dissegni d'architettura civile et ecclesiastica [...]*, Torino, 1686, and in his *Architettura Civile*, Torino, 1737
1679
Engraving
176 x 297 (plate); 168 x 289 (image)
INSCRIPTION: "Trabucchi 8" (lower left); "FACCIA ESTERIORE DEL PALAZZO DEL/S.MO P. FILIBERTO DI SAVOIA" in/Torino (lower center); "Pianta del presente/edificio" (lower right); "Pianta" (lower center); "D. Guarinus Guarinius inven. In(?)m.us D." (lower right); "de piene. fet." (lower right in 1686 edition)

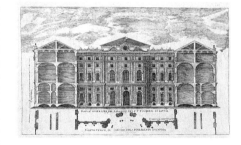

119 T
Antonio de Pienne (active 1660–95) after Guarino Guarini
Section and Partial Plan for the Palazzo Carignano, Turin
1679
Engraving
180 x 295 mm (plate); 172 x 289 mm (image)
INSCRIPTION: "Trabucchi 9" (left center); "PIANTA INTERIORE DEL PALAGGIO DEL S. P. FILIBERTO DI SAVOIA" (lower center); "D. Guarinus Guarinius in D" (lower right); "PIANTA VERSO IL CORTILE DEL S. P. FILIBERTO DI SAVOIA" (lower center; "De piene. fet." lower center in 1686 edition)
BIBLIOGRAPHY: Chevalley 1921; Brinckmann 1931; 1932; 1933; Argan 1933; Passanti 1945; Cravero 1951; Portoghesi 1956; Argan 1957;

Brinckmann 1957; Gabetti 1957; Wittkower 1958; Hager 1961; Millon 1961; Anderegg-Tille 1962; Bernardi 1963; Carboneri 1963; Passanti 1963; Millon 1964; De Bernardi Ferrero 1966; Griseri 1967; Pommer 1967; Norberg-Schultz 1968; Bertini 1970; Lange 1970; Millon 1987: 484, figs. 13–14; Meek1988; Cerri 1990; Dardanello 1993

The elevation of the façade and the section through the courtyard of the Palazzo Carignano were drawn by Guarini and engraved by Antonio de Pienne. The print of the façade is important in that it is the only representation of the entire façade of the palace executed during Guarini's lifetime, and the section is the only known section through the north and south wings of the palace. The engravings were included in the posthumous publication in 1686 of some forty-nine plates (without text) extracted from material Guarini had been preparing for publication. The initial eleven plates treat the orders, and the following thirty-eight plates (twenty-seven numbered) show Guarini's architectural projects. The palace was constructed between 1679 and 1693. Decoration and finishing continued for ten or more years. In the engraving, the columns that flank the arched entrance in the convex central bay of the façade are shown with smooth shafts rather than banded as in the palace as constructed. The banded columns were contracted for on 4 December 1679 and were erected by March 1681. The elevation drawn by Guarini that was used for the print of the façade must have been devised before December 1679. When the elevation was drawn, Guarini intended an additional level above the two central bays of each flanking pavilion and a central pedimental group over the main entrance bay. The central pediment and additions to the pavilions remained unrealized when construction was interrupted. The roof above the oval *grand salon* is hidden behind the central pediment or was omitted in the drawing, nor is any roof shown anywhere on the façade. The low attic with overlapping circular tiles merely simulates a roofing pattern on a vertical surface. The pilaster strips between the windows of the two central bays of the pavilion at the *piano nobile* were eliminated in the realization of the structure. Further, in the building there are ressauts above the Corinthian pilasters that mark the corners of the pavilions but are not shown on the engraving. Aloso omitted in the engraving are the ressauts that define the central two bays as a unit in the building as executed. In the engraving the entablature under that main cornice is unbroken throughout. In the engraving, the subtle and important increasing rhythm of ressauts in the central section of the palace approaching the entrance have yet to be devised. The plan below the elevation shows the hexagonal entrance vestibule with a reflected ceiling plan and indicated to the left and right are the two outer columns of the upper run of the curved grand stair. The section through the courtyard of the palace shows, as does the plan below, that Guarini intended double-loaded corridors on the north

and south wings, both of which were realized. The section includes mezzanine levels facing outward to the street in both wings, but not toward the courtyard. The roofline of the courtyard elevation includes, in addition to the cones and spheres at each extremity of the entablature to the north and south, crowning elements to either side of the broken pediment that mark the convex bay of the central oval atrium and *grand salon*. The drum and roof of the vault of the *grand salon* are low, hardly higher than the roofs of the north and south wings. As in the elevation of the façade, no roof is indicated above the central section to either side of the drum and roof of the *grand salon*. A change in the design of the vault of the *grand salon* had been made by October 1682 when the wood centering arches for construction of the masonry vault were in place. The new masonry vault was completed a year later in November 1683, and the new taller enclosing drum was roofed by the end of the year. In March and April 1684 work was begun and completed on the suspended cane and plaster vault that was to be painted and seen through an oval opening in the center of the masonry vault below. The changed design with its tall oval drum enabled the opening of light vertical oval windows in the drum. Light from the windows was reflected from the upper surface of the masonry vault to illuminate the painted undersurface of the wood and plaster vault. Guarini died on 6 March 1683. The masonry vault of the *grand salon* had been under construction from the previous October. The drawings for the engravings were prepared in late 1679 and do not include the new design for the vault of the *grand salon*. The change in the design of the masonry vault and the addition of the light-weight wood and plaster vault took place at some moment after December 1679 and before October 1682 when the centering for construction of the masonry vault was begun. There is little doubt that all the drawings for the vault of the *grand salon* preserved in the Savoy-Carignano section of the Archivio di Stato in Turin were done by Guarini or under his direction. HAM

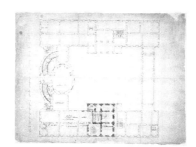

124 T
Guarino Guarini (1624–83)
Plans for the Palazzo Carignano, Turin Ground Floor (left), *Piano Nobile* (right) Carignano IVA
Turin, Archivio di Stato, Az. Sav. Car., 53.1.9.4
Pen, brown ink, with black chalk additions. An added small sheet, of different paper, gray ink and watercolor, covers most of the south wing courtyard pavilion, eliminating the light well; 588 x 439 cm

Watermark: a bunch of grapes in a lozenge shape, and at another location on the sheet, the letters IM
INSCRIPTION: "21 Trabucchi" (lower center)
BIBLIOGRAPHY: Cravero 1951: 57 (detail); Passanti 1963: 21; Millon 1964, 94–98; Grise-ri 1967: 202–204 and fig. 110; Millon 1970: 41–42 and figs. 12–15; Lange 1970, 266, no. 67a; Cerri 1990: 26 and fig. 7; Dardanello 1993: 225

The plan for the palace known as Carignano IVA includes the entire palace. The north half shows the ground floor, the south half the *piano nobile*. The east wing, separating the courtyard from the gardens to the east, is drawn in black chalk. Yet more lightly drawn on the central axis is a circular pavilion, perhaps as an alternative to the gallery, a return to the rectangular central pavilion in this location in Carignano I. Also as in Carignano I and II, the north and south wings have five-bay courtyard pavilions. The single columns of the porticoes at ground level found in the earlier designs of these pavilions are replaced by clusters of columns. A double-loaded corridor at ground level in the north wing is inexplicably absent in Carignano IVA, where the ground floor plan of the north wing replicates that of the *piano nobile* on the south. Most of the spaces in the west half of the south wing are dimensioned in black chalk, while only the width of the passageway north of the small courtyard in the north wing is given (*trabucchi* 1, *piedi* 2, *oncia* 1). The plan of the curved portion of the main façade shows two pairs of pilasters and two single pilasters in each half of the façade, as in the building and first seen on sheet 53.1.9.15. The pilasters closest to the entrance in each pair are not yet salient as in the building and as shown on the initial pair in the detail drawing of the stair (53.1.9.3). In the *grand salon*, the opening to the southwest leads to a chapel adumbrated in that location on sheet 53.1.9.15. The rectangular stair drawn in black chalk on the same sheet in the space between the north reverse curve of the façade and the north main vestibule is, on this sheet, rendered in ink on both the north and south. In the final design the rectangular and circular service stairs to the north and south are replaced by single oval stairs. On both the southeast and northeast piers of the oval *grand salon*, Guarini has included the third pilaster strip first inserted on sheet 53.1.9.15. Some of the staff assignments and uses of the spaces are indicated in the southwest half of the plan. At a later date, when construction of the east half of the palace was abandoned, alternative apartment plans to terminate the palace at the ground floor and *piano nobile* were laid down on the south wing over four of the five bays of the courtyard pavilion. The proposals were not executed. When work terminated, the north and south wings did not extend beyond the first bay of the courtyard pavilions, i.e., the west wall of the small courtyards in each wing. Without double-loaded corridors on the ground floor, the plan of Carignano IVA would appear to predate the drawings used for the two engravings, which were executed before December 1679. HM

The study of Antiquity

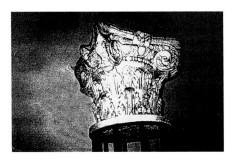

130 T
Unknown Artist
Hadrian's Villa, Composite Capital

This composite capital once decorated a peristyle or a room in Hadrian's Villa, although its exact original location in the complex is unknown. Although the composite is the only one of the five orders to have been invented by the Romans, it was paradoxically not mentioned by the Roman writer on architecture Vitruvius. At the time he wrote his *De architectura libri decem* (ca. 40–20 BC), the development of the composite had only just begun. It subsequently became generally accepted as a distinct variant of Corinthian, justifying the Renaissance view of the composite as an order in its own right. Essentially its capital is a standard Corinthian capital with the upper part replaced by a combination of echinus and corner volutes of the Ionic capital. The composite base, shaft, entablature and the overall proportions remain essentially interchangeable with Corinthian. The earliest examples of the composite capital appear on small-scale sculptural decoration. The most complete early set of composite capitals of medium size are known only out of context, having been reused in the fourth century AD for the construction of Santa Costanza. But the earliest examples of the fully developed form still *in situ* are probably all of the later first century AD, such as those on the Arch of Titus erected in the later first century AD and those of the Domus Flavia, the palace of Titus' brother Domitian on the Palatine. Simplified specimens discovered in the Colosseum seem to come from the colonnade which was erected round the top of the seating there at the same date or soon after. Other contemporary ones are found on the rebuilt Porta dei Leoni in Verona. By the second century, when Hadrian's Villa was built, the order became widely used throughout the Roman Empire and was particularly popular in Asia Minor. Potentially the most ornate of the orders, the composite was often chosen to convey opulence. According to the quantification of the use of the orders at Hadrian's Villa on the basis of the surviving evidence proposed by Macdonald, nine-tenths of the existing capitals and identifiable fragments are fairly evenly divided between Ionic and Corinthian. The remaining one-tenth of the surviving capitals are Doric and composite, the last being essentially found in the Peristyle Pool Building or Quadriportico con Peschiera, from where the capital here exhibited probably comes. LC

131 T
Unknown Artist
Hadrian's Villa, Fragment of Frieze

This fragment of frieze, which once was part of the decoration of Hadrian's Villa, is decorated with scrolls of acanthus leaves and two lions framing a protome carrying a basket of fruit. Its original location in the villa is unknown. It is unlikely, however, that this frieze was once part of the architectural decoration of the curved colonnades of the so-called Teatro Marittimo or Island Enclosure since their entablatures were originally decorated with friezes of winged putti driving chariots and accompanied by processions of marine animals, tritons and mythological figures. The architectural fragment here exhibited is also straight rather than curved confirming further that it did not make part of the decoration of the curved colonnades of the Teatro Marittimo, which was already in the Renaissance in several famous private collections. LC

143 T
Francesco di Giorgio Martini (1439–1502)
Hadrian's Villa, Plan of the Accademia and Elevation of the Temple of Apollo or Circular Hall
c. 1465–90
Florence, Galleria degli Uffizi, U 319 Av
Pen and ink
28.8 x 17.8 cm
BIBLIOGRAPHY: Maltese 1967: I, 286–87; Ericsson 1980: 55–62; *Francesco di Giorgio Martini* 1993: 331–33; Macdonald and Pinto 1995 (1997): 209, fig. 248

This drawing U 319 Av by the Sienese architect Francesco di Giorgio Martini (1439–1502) recording the so-called Accademia in Hadrian's Villa is part of an archaeological sketchbook (*Taccuino di viaggio*) made of 37 folio sides with annotated sketches of Roman antiquities in various cities, mostly in Rome and vicinity, and in Naples and environs. These rough sketches

now preserved in the Uffizi are essentially records of monuments taken on site. At Tivoli, Francesco di Giorgio made at least two measured plans: one representing the so-called Teatro Marittimo and the Greek Library and the other the Accademia with the Circular Hall or Temple of Apollo. These drawings, which can be dated between 1465 and 1490, are the earliest graphic evidence of direct study of Hadrian's Villa.

The Accademia had been also drawn by Palladio and Ligorio later in the Renaissance. The only recognizable part of the building in Francesco di Giorgio's drawing, is the Temple of Apollo which, with its cupola and two superimposed orders, can be considered a miniature version of the Pantheon. To the right of the plan, worked out in the perspective typical of the Sienese architect, is an elevation of the rotunda (marked on the plan with a small cross such as Francesco regularly adds on his drawings). The plan of the reconstructed building is clearly influenced by his perfectly symmetrical designs of palaces which appear in his treatises: a square peristyle with semicircular stairs added externally leads to the rotunda and beyond is a vast oblong "sala" (166 x 59 feet [the unit is certainly the Roman foot of 29.2 cm]) crossing the axis closed by two apses facing each other, and finally a smallish block of rooms (76 x 70 feet), with a finishing apse. A copy of this drawing by an anonymous draftsman is on folio 90v of the *Codex Salluziano 148* preserved in Turin. It shows a few emendations to the plan and to the dimensions and has been inscribed with the annotation "in tiboli." LC

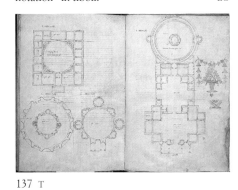

137 T
Unknown Artist
Hadrian's Villa, Fountain Court West and Island Enclosure, Tivoli
Plan in the *Codex Salluziano 148*
Turin, Biblioteca Reale
Pen and ink
BIBLIOGRAPHY: Macdonald and Pinto 1955 (1997): 210, fig. 249

Francesco di Giorgio Martini's drawings of ancient monuments made *in situ* preserved in his sketchbook now in the Uffizi were copied by an anononymous artist in the *Codex Salluziano 148* preserved in the Biblioteca Reale in Turin. Francesco's sketches are records of measurements taken on site, and the more finished drawings in Turin show numerous changes. In place of the dimensionless lines of the Uffizi sketches, the Turin drawings define spaces with walls of uniform thickness. This drawing shows a plan of the

so-called Teatro Marittimo or Island Enclosure and of the Greek Library or Fountain Court West and is a copy of U 319 Ar. The most remarkable departure from archaeological accuracy is the integration and alignment along the same axis of two architecturally distinct structures. The main differences with the drawing made *in situ* are the increased dimensions of the Turin drawing and the addition of a monumental pronaos to the Greek Library. In relation to the archaeological evidence, Martini transforms the central island of the Teatro Marittimo into a round temple. In the mid-16th century, Palladio made also a measured site drawing of the Teatro Marittimo and a finished drawing of it, which more accurately reflect the archaeological evidence than Francesco di Giorgio's. LC

139 T
Baldassare Peruzzi (1481–1536)
Water Court Nymphaeum of Hadrian's Villa and Basilica of Maxentius in Rome
Florence, Gallerie degli Uffizi, U 529Ar
Pen and ink
Bibliography: Licht 1985: 116–18, fig. 8; Macdonald and Pinto 1995: 213, fig. 254

Baldassare Peruzzi, who worked closely with Bramante, carried out an extensive survey of ancient buildings and a detailed study of Vitruvius' treatise on architecture, the *De architectura libri decem*. Among his numerous architectural drawings now in the Uffizi is this drawing U 529 Ar, containing three ground plans and two perspective views of corresponding interiors. Two of these drawings are renderings of a prominent feature of Hadrian's Villa: a plan and a reconstructed interior of the nymphaeum of the Piazza d'Oro or Water Court. The small centralized plan with the concave and convex colonnades in the upper right-hand corner represents this nymphaeum. Below this sketch is a reconstructed interior of the nymphaeum, which – in spite of its small size – effectively conveys the enveloping mural and vaulted systems, as well as a remarkable monumentality of scale. These two sketches of the nymphaeum are evidence that, like Bramante and Raphael who studied the remains of Hadrian's Villa (although no graphic records of their villa studies have been identified), Peruzzi also surveyed some buildings of the villa. Renaissance interest in Hadrian's Villa, however, peaked in the mid-16th century with the studies of Pirro Ligorio, who excavated the villa between 1550–68, and Palladio, who made at least three measured on-site drawings of various buildings of the villa. LC

144 T
Pirro Ligorio (ca. 1510–1583)
Libro o vero Trattato delle Antichità XXII di Pyrrho Ligorio Patritio Napoletano et Cittadino Romano nel quale si dichiarano alcune famose Ville et particolarmente della Città di Tibure e di alcuni monumenti
n.d. [1579 ?]
Turin, Archivio di Stato, Corte, Biblioteca Antica, 20, Ja.II.7
413 x 271 cm; binding in ivory-white parchment on cardboard with gold edges and engravings. Rosettes decorate the interior corner of the mirror, which bears a gold Savoyard coat of arms (Vittorio Amedeo I), framed in a crown of laurel. On the back of the book there is a red leather inlay with the author's name and title. The book is comprised of eighty-six light blue sheets of paper with filigree and intersecting arrows (Briquet 1907). The last six sheets are white, decorated only with designs, and numbered identically, twice, once in pen and once in pencil.
The collection of manuscripts by Pirro Ligorio, at the Bibioteca Antica of Turin comprises thirty volumes numbered 1 to 30 and labelled Ja. III.3 - Ja. III.15; Ja. II.1 - Ja. II.17. (Mandowsky, Mitchell: 1963; Wagenheim 1987; Cusanno 1994: 191–196)

Pirro Ligorio, noble Neapolitan and Roman citizen, as he referred to himself, worked in Tivoli as the "antiquarian" of Ippolito d'Este. As such, he was superintendent of the excavations being carried out in the Tiburtine territory, which resulted in the XXII book of *Antichità*, an organic study of the excavations. He provides an abundant and detailed description of the Villa Adriana. Page eighty-nine, one of the five white pages at the end of the book, which is otherwise almost totally comprised of azure pages, contains the map of a portion of Villa Adriana. The XXII book of *Antichità* constitutes one of the drafts that Ligorio dedicated to the description of Tivoli and Villa Adriana. The author himself begins by stating that "though it has twice been written by two remarkable gentleman, the observation of things nonetheless urges us or, rather, forces us to write it again a third time. The previous two will act as a prelude; the first, written by the illustrious Hippolito the Second, Cardinal of Ferrara, and the second by the illustrious Alexandro Cardinal Farnese. The third will be to

the glory of the eternal and divine Trinity [...]" (c. 1r). Beginning in 1549, therefore, Ligorio subsequently described the developments at Tivoli several times. As the author himself claims, there were two drafts drawn up for Ippolito d'Este, cardinal of Ferrara. The book in fact states that "the other two will act as a prelude for the illustrious Hippolito the Second [...]". The two drafts are mentioned in *Descrittione della superba et magnificentissima Villa Hadriana* and the more detailed *Trattato delle Antichità di Tivoli et della Villa Hadriana fatto da Pyrrho Ligorio, Patricio Napoletano, et dedicato all'Ill.mo Cardinale di Ferrara*. There are two unsigned copies of the first text at the Biblioteca Vaticana (Cod. Barb. Lat. 5219, cc. 130v–147v; Cod. Barb. Lat. 4342, cc. 41r–58v), one copy at the Corsini Collection in Rome (Corsini, 851, 33.A.18, cc. 180r–202r, ms. Ital. 4999), another one in Leyden (Bibl. Der Rijkuniversiteit te Leyden , Voss. Var. Ling. Qu 3), and two copies in Paris (Bibl. Nationale, Fonds Italiens, 625; Bibl.de l'Arsenal). Two unsigned copies of the *Trattato* are held at the Biblioteca Vaticana (Barb. Lat. 4849, cc. 8v–32; Vat. Lat. 5295, cc. 1r–32v), while a 17th century copy can be found at the British Museum (ms. Add. 22001, cc. 1r–42r). Cardinal Farnese also agreed that Ligorio was writing about Villa Adriana. Although the existence of this text was disputed (Salza Prina Ricotti 1973: 36), it is mentioned in Code 611 in the Trivulziana Library. Although it was lost following the last war, the Code's existence is confirmed by the *Catalogo dei codici manoscritti della Trivulziana* by Giovanni Porro (1884: 224). Number 611 of the catalogue reads: "Ligorio Pirro", Cod. Car. in fol. ms. of sec. XVI di carte 41, Fol. 1, *Trattato delle Antichità XLVII di Pyrrho Ligorio patritio Napoletano et cittadino Romano, nel quale si dichiarano alcune famose Ville et particolarmente dell'Antichità di Tivoli dedicato all'Illustrissimo et Reverendissimo Cardinale Farnese*. A brief description of the volume follows: "The Trivulziano Code is signed, on light blue paper, like the one used in Turin, and also deals with the antiquity of Tivoli and certain villas." Confirmation of this is provided by Montevecchi in the *Catalogo dei Codici epigrafici delle Biblioteche milanesi*, where it states "the Trivulziano Code is handwritten. It is dedicated to Cardinal Farnese and not, like many other volumes, to Alfonso d'Este. The paper is light blue, like that used for the volumes of Turin, and vol 20 deals with Tivoli and some villas." A letter written by Bianchini on July 2nd, 1880, mentioned by the two aforementioned authors, drew a comparison between the latter text and the Turin Code. These testimonials are very valuable, since Code 611 of the Biblioteca Trivulziana is no longer available. Finally, the XXII book of *Antichità* was written "to the glory of the eternal and divine Trinity," becoming part of the Savoyard collection for Duke Carlo Emanuele I in 1615. An additional 4 volumes were added to this collection in 1696 (Mercando 1994: 202–17). With this information on the texts, it seems possible to move away from Eugenia Salza Prina Ricotti's thesis according to which, the XXII book of *Antichità* kept in Turin is an apocryphal. On this point, in fact, the reasoning used

by the illustrious scholar to prove her hypothesis seems unfounded because it is based on a supposed lack of knowledge of the various drafts of the work written by the author of the XXII book of *Antichità*. Her view is that the author erroneously listed the drafts in the premise; however, on the basis of proof provided by Pirro Ligorio's Trivulziano Code, they seem to have been correctly reported. Neither can it be proven that a draft of XXII book of *Antichità* was drawn up by Ligorio's heirs following his death because the XXII book contains elements that date it back to the year 1579. To this end, there is an annotation recording the double birth of Siamese twins in 1579. Pirro Ligorio died on October 26, 1583. This information is recorded on the leaf of the back cover in the same volume. The thesis that the direct consequence of the book's lack of authenticity is based on a previously mentioned, but now missing, picture of the Theater of Villa Adriana, is also not tenable. Such a theory does not take into account the remaining pictorial completeness and richness of the volume, whose extraordinary pictures depict the villas and monuments, which Ligorio had cited. This book, then, is Pirro Ligorio's third rendition of Tivoli and its surroundings. In it, he provides extensive and detailed descriptions, enriching the archaeological information and studies of antiquity with pictures and explanations of the most architecturally relevant elements. The book serves as documentation on the Tiburtine villas and the Villa Adriana, the information drawn from his observations of the excavations following their abandonment and the subsequent decay produced by the centuries. Ligorio provides a detailed topographical description of Villa Adriana (XXII book: 29–59) aided by Elio Sparziano's texts (25, 5). Page after page, the villa's beauty is reflected by the variety of rooms and the wealth of statues, columns and precious marbles (Palma Venetucci 1992: 1–14; Romano 1992: 16; Palma Venetucci 1998) even if, at times, the information is generic and improper, given what is presently known on the subject thanks to the discoveries of continuing excavations. The architectural structure comprises several buildings, which Ligorio describes in their architectural end decorative detail (cc. 29v–58v). They include the *Pecile* with its *Hospitalia*, the *Heroon di Antinoo*, the *Sala dei Filosofi*, the *Teatro Marittimo*, the *Cortile delle Biblioteche*, the *Sala del trono*, the *Triclinio*, the *Teatro del Pecile* (cc. 30–37v; Winnefeld 1985: 54–96; Kahler 1950: 44–54; Aurigemma 1961: 51–68; Romano 1992: 16–23); the *Canopo e un Tempio Rotondo* (cc. 38–41v; Aurigemma 1961: 100–133); the *Accademia con il Teatro* (cc. 41–47; Salsa Prina Ricotti 1982); the *Cinosarge* (cc. 47–48) the *Liceo* (cc. 48v–50; Romano 1992: 19, note 23); the *Pritaneo* (cc. 50–53); the *Inferno* (cc. 53–54); Romano 1992: 19, note 24) and the *Valle di Tempe* (cc. 54v–58). The vast and detailed description lacks pictures, which would better illustrate and explain the text, though this is not the case for the rest of the volume. On page thirty-five of the book, the author refers to the next page, describing "a plant and lateral view" of the theater, "so that it can be visualized as it actually was;" however, as often happens in Ligorio's texts, the

page was left blank. Consequently, all that remains of the imperial villa in the book is a brown ink drawing, framed by page eighty-nine. It is a sketch of the area between the canal and the west belvedere, in which there are three spaces designated as piazzas. The first of these is adjacent to the Xysto, which Ligorio himself described as a place where "fighting was done in the open or against the factions that fought for the Prince's entertainment." The piazzas appear to be outlined by architectural structures, which were quickly sketched on the spot. As Macdonald and Pinto have noted, "the portico of the west belvedere is only slightly discernable and the non-orthogonal relationship between the walls that form the west terrace is not accurate" perhaps due to a lack of proper instruments (Macdonald, Pinto 1995: 218–219). On the other hand, Ligorio's descriptions of the piazzas richly detail the portico, as well as the marbles and statues that embellished the rooms. Recently, it was proposed that the picture in question could serve as an initial study of the villa's general map, which Ligorio refers to many times in his texts on Villa Adriana. IRM

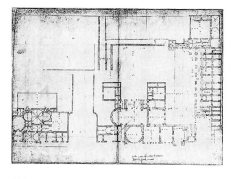

142 T
Andrea Palladio (1508–80)
Plan of Island Enclosure, Hadrian's Villa
ca. 1554
London, Royal Institute of British Architects
RIBA IX, 12
Pen and ink
BIBLIOGRAPHY: Zorzi 1959: 100, fig. 246; Macdonald and Pinto 1995: 215, fig. 257

This drawing RIBA IX, 12 is a finished version by the architect Andrea Palladio of the sketch made on site of the so-called Teatro Marittimo or Island Enclosure, which appears at the bottom of RIBA VII, 6r along with the Baths of Agrippa. At the top of the drawing here exibited are some sketches of arcades and a measured entablature. In the central part of the drawing is a plan of the Teatro Marittimo which appears to be based partly on an accurate survey and partly on Palladio's imagination. In this case Palladio, like Francesco di Giorgio, projected his principles of design and imagination onto the ruins, construing them in such a way as to confirm his artistic preconceptions. The general scheme of the building with the ring colonnade is accurate, but in the center of the structure, Palladio has imagined a colonnaded, square peristyle which never existed. Two other Renaissance drawings of the Teatro Marittimo survive: one by Francesco di Giorgio, who made a fanciful reconstruction of

it, and the other by an anonymous architect of the end of the fifteenth century, who drew the structure quite accurately in a drawing now preserved in the Albertina, in Vienna. This drawing is witness to the interest Palladio took in Hadrian's Villa. He also made at least two other measured drawings on the site of buildings of the villa: one representing various buildings such as the Greek Library and the so-called Accademia, and the other the Larger and Smaller Baths, though this survives only in its finished version. Palladio's guide to the antiquities of Rome – *L'antichità di Roma* – published in 1554 in Rome and in Venice included also a reference to the villa, which is based largely on the celebrated passage in the *Historiae Augustae* (Hadrian, XXXVI, 5). He writes: "Non voglio trapassare con silentio la villa tiburtina di Adriano imperatore la quale meravigliosamente fu da lui edificata tanto che in quella si ritrovano i nomi di provincie et luoghi celebratissimi, come il Licio, l'Accademia, il Pritano, Canopo, Pecile e Tempe." It was probably during his last sojourn in Rome in 1554 that Palladio made at Hadrian's Villa the sketch RIBA VII, 6r of the Teatro Marittimo. LC

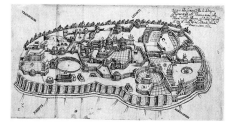

141 T
Gismondo Stacha after Giulio Calderone
Hadrian's Villa, Reconstruction
1657
Vatican, Biblioteca Apostolica Vaticana
Pen and ink
BIBLIOGRAPHY: Macdonald and Pinto 1995 (1997): 224, fig. 276

This drawing by Gismondo Stacha is made after a lost bird's-eye view of Hadrian's Villa painted by Giulio Calderone, which once adorned a palace in Tivoli. In Stacha's drawing, it is almost impossible to identify the major buildings of the villa, given their fantastic rendition. The drawing employs conventions of representation present in the prints reconstructing ancient Rome by Ligorio such as the ANTEIQUAE URBIS IMAGO published in 1561 and by Étienne Duperac. LC

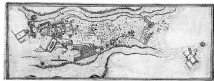

138 T
Francesco Contini (1559–1669)
Plan of Hadrian's Villa, Tivoli
1668
Copper engraving
BIBLIOGRAPHY: Salza Prina Ricotti 1973–74; Macdonald and Pinto, in *Hadrian's Villa and its Legacy*, 1995 (1997): 223–24, figs. 266–75

Francesco Contini (1599–1669), an architect active in the service of Cardinal Francesco Barberini, prepared the first general plan of Hadrian's Villa entitled *Pianta della Villa Tiburtina di Adriano Cesare già da Pirro Ligorio [...] disegnata e descritta dapoi da F. Contini [...]* published in 1668 and in a second edition in 1751. In the preparation of the plan, Contini benefited from the three descriptions and from the manuscript plan which the antiquarian and architect Pirro Ligorio (1513–1583) had prepared in the middle of the sixteenth century, while in the service of Cardinal Ippolito II d'Este. In fact, Contini made liberal use of Ligorio's manuscripts in the key that accompanies his plan, but the published plan is clearly the result of his own independent survey. The survey was undertaken in 1634 more than three decades before the publication of the plan in 1668, as attested by a graffito in a cryptoportico on the northwest flank of the residence. Furthermore, several payments to him in the Barberini archives in connection with the survey are recorded between 1634 and 1636. Another payment made in 1637 speaks of a finished plan which was sent together with its accompanying text (Libretto) to England. An inventory of 1649 records another plan of similar dimensions executed in pen and wash, also accompanied by its "Libretto delle descrittioni." According to Professor John Pinto this was in all likelihood Contini's original master plan on which the engraving of 1668 was based, and its presence in Cardinal Barberini's palace for at least fifteen years before the middle of the seventeenth century suggests that it would have been known to the artists and antiquarians who gathered there, men such as Bernini, Pietro da Cortona and Cassiano del Pozzo. Despite Contini's exacting efforts in his survey of Hadrian's Villa, the Roman painter and antiquarian Pier Leone Ghezzi vented his frustrations about the shortcomings of Contini's plan, following an extended visit to the site in 1742: "I took with me the plan made by Contini [...] and finding nothing in it that corresponds to what one sees, I conclude that it is made of ideas, just as is the palace invented by Monsignor Bianchini in the Farnese Gardens (Francesco Bianchini's reconstruction of the Palatine Palace published in 1738", Pier Leone Ghezzi, MS, British Museum, Department of Greco-Roman Antiquities, fol. 159, cited by 1993). LC

The painter, draftsman, antiquarian and musician Pier Leone Ghezzi made from 1720 onward many drawings after the antique – cameos, coins, vases, sculptures, architectural fragments and buildings – bearing witness to the contemporary interest in archaeology and collecting. He was one of the first 18th-century visitors to Hadrian's Villa to leave a substantial record of his antiquarian studies there. Although Ghezzi visited the site repeatedly, his dated drawings indicate that he made at least two extended stays, one in 1724 and the other in 1742. Both stays are recorded in two codices preserved respectively in the Vatican Library and the British Museum. It was during his first visit in 1724 that most of his architectural views were drawn, including this plan of the so-called Teatro Marittimo, or Island Enclosure, according to the new terminology of Macdonald and Pinto. In comparison with Palladio's drawing also exhibited, Ghezzi's plan shows some progress in the understanding of the inner structure of the Island Enclosure, suggesting that some excavations must have been undertaken during the 17th century or in the early 18th century. Rather than attempting a reconstruction, Ghezzi was concerned with recording things "as they actually appear," a frequent comment in his explanatory notes, and this is reflected in this drawing. LC

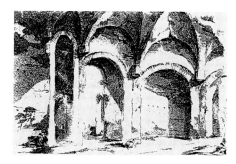

135 T
Robert Adam (1728–92)
Water Court or "Piazza d'Oro" Vestibule at Hadrian's Villa
ca. 1756
London, British Architectural Library Drawings Collection (RIBA), courtesy of the Trustes of Burghley House
Pen and ink

The 18th century was the golden age of antiquarian study at Hadrian's Villa. The numerous signatures surviving on the villa walls and vaults are a testimony of the numbers of artists, antiquarians and foreign travelers who visited the site. They constitute an impressive list of artists, including, Sebastiano Conca, Hubert Robert, Fragonard, Quarenghi, Piranesi, Charles-Louis Clérisseau, Robert Adam and the Danish architect Caspar Frederick Harsdorff, who drafted the *vedute* and plan here exhibited. The *veduta* of the Larger Baths rotunda is by Robert Adam. During his Roman sojourn, Adam had studied under Clérisseau, who had been resident at the French Academy in Rome since 1749 and a member of an international circle interested in the study of antiquity. In 1756 Adam (in Italy from Jan. 1755 to Oct. 1757) visited Tivoli "to view Hadrian's Villa, make drawings and inspect some people I have working there, as I am making an exact plan of it" (quoted in Fleming 1962: 204). During this visit he drew the vestibule of the Piazza d'Oro or Water Court here exhibited. At least twelve sheets by Adam depicting the villa survive. As pointed out by Pinto, many of these drawings resemble those of Clérisseau of the same subject, suggesting that they may have been drawn at his recommendation. The plan of the Southern Hall of Hadrian's Villa is by Harsdorff. He had trained at the Kongelige Danske Kunstakademi, and won the gold medal, enabling him to spend six years in Paris and Rome (1757–64). He was in Rome from the autumn of 1762 to the autumn of 1763 when he made a detailed survey of the most important buildings of Hadrian's Villa. This drawing is part of a sketchbook of 15 drawings of buildings of the villa now preserved in Copenhagen. LC

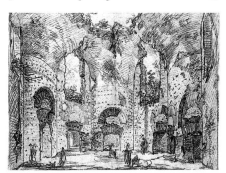

136 T
Giovanni Battista Piranesi (1720–78)
Hadrian's Villa, Octagonal Room in the Small Baths, ca. 1777
New York, The Metropolitan Museum of Art
Red chalk with touches of black chalk
39.4 x 55.3 cm
BIBLIOGRAPHY: *The Metropolitan Museum of Art* 1993–94

This magnificent large drawing is a preliminary study of plate 133 of the artist's two volumes entitled *Vedute di Roma*, published between 1745 and 1778. Ten plates in the *Vedute di Roma* depict Hadrian's Villa. The print that corresponds to the present drawing, which represents an octagonal room in the Small Baths, is one of the last in the series and was executed ca. 1777, a year

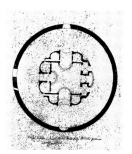

140 T
Pier Leone Ghezzi (1674–1755)
Hadrian's Villa, Plan for the Island Enclosure, Tivoli, 1724
Vatican, Biblioteca Apostolica Vaticana
Pen and ink
BIBLIOGRAPHY: Macdonald, Pinto 1995: 232, fig. 284

134 T
Caspar Frederick Harsdorff (1735–99)
Hadrian's Villa, Southern Hall, Tivoli, 1760s
Copenhagen, Kongelige Danske Kunstakademi
Pen and ink
BIBLIOGRAPHY: Lund 1982; Macdonald, Pinto 1995: 246, fig. 317

before Piranesi's death. With the exception of the disposition of the figures, the study corresponds very closely to the print. The octagonal room depicted in the drawing was almost certainly the central hall or atrium of the Small Baths. Piranesi's drawing shows part of the vaulting system of the room which was a dome of undulating but nearly regular form, consisting of four annular quadrant vaults, one rising from each convex wall to meet at the crown, producing semicircular sections along the cardinal axes. This drawing along with the ten prints depicting Hadrian's Villa in the *Vedute di Roma* witness to Piranesi's involvement with the villa over most of his career, as confirmed by dated graffiti of 1741, 1763, and 1765, as well as later by those of his assistant Benedetto Mori, of 1769 and 1774 and by his 13-year-old son Francesco, of 1771. Piranesi is also recorded on sketching expeditions there at various times during the 1740s and 1750s with Charles-Louis Clérisseau, Claude-Joseph Vernet, and Robert Adam. Piranesi's interest in Hadrian's Villa culminated in his plan of the complex drawn at a scale 1:1,000 and made up of six contiguous plates published posthumously by his son Francesco in 1781. Pinto has argued that in the last years of his life Piranesi was preparing a comprehensive publication of the villa which would have reused as illustrations the ten *Vedute di Roma* together with *vedute* of other monuments of the vicinity. LC

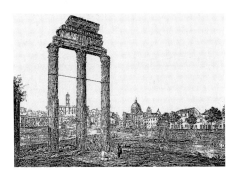

145 T
Giovanni Volpato (1740–1803) after Louis Ducros
Forum Romanum
Watercolor; 52 x 74 cm
BIBLIOGRAPHY: *Roma antica*: 164, no. 51

This view of the Campo Vaccino shows the temple of Castor and Pollux, known then as the Temple of Jupiter Stator. The three columns of this temple dominate the left side of the *veduta* while the right side shows the Via Sacra with a fountain designed by Della Porta. In the background are the Senate House and Santi Luca e Martina, the column of Phocas (seen through the columns of the Temple of Castor and Pollux), the three columns of the Temple of Vespasian and Titus, while the Tabularium on the Capitol Hill dominates the Forum. The Campo Vaccino had been frequently represented in the 16th century by draftsmen such as the Anonymus Esurialensis, Van Heemskerk, and Dupérac, and painted views of it were made as early as the 1630s by Swanevelt, Lorrain, and Tassi. In the 18th century, the subject attracted also the painter Pannini, and the etchers Vasi and Piranesi. LC

Royal palaces

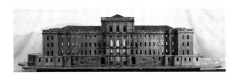

152
Carlo Maria Ugliengo (active 1712–33), master carpenter, after a drawing by Filippo Juvarra
Model of the Castle at Rivoli
1718
Turin, Museo Civico di Arte Antica-Palazzo Madama
Walnut, lime, poplar, and pine woods, with metal details, and markings made with a stylus; drawings in black pencil and brown ink in pen; walnut husk with protective wax coating
427.5 x 192.7 x 107 mm
BIBLIOGRAPHY: Casalis 1847: XVI, 386; Papi 1936: 8; Brinckmann 1931: 51; Rovere, Viale, Brinckmann 1937: 67; Carboneri 1963: 49; *Mostra di Filippo Juvarra* 1966: 66; Marocco 1971: 17; Boscarino 1973: 280–85; Tamburini 1981: 55; Bruno 1984: 30–35; 1985: 239–50; Gritella 1986: 91–115; Griseri, 1988: 33–37; Roggero Bardelli, Vinardi, Defabiani 1990: 262–66; Passanti 1992: II, 611–23; Gritella 1992: I, 390–427; 1994: 165–77; 1995: 232; Millon 1995a: 411–12; Severo 1996: 135

The wooden model of the Castello at Rivoli was made by Carlo Maria Ugliengo and shop in 1717–18 under the direction of Giovanni Battista Sacchetti, assistant to Filippo Juvarra. When work on the model ceased, it included all the walls, vaults, stairs, and surrounding terrace. It also included the stairs, terraces, and gardens (now lost, but recorded in early photographs) extending southward down the slope of the ridge to the village of Rivoli below. In addition to the model of the Castello, terraces and gardens to the south, there was a second model, now lost, that showed in multi-colors the large gardens of the Castello as they were to extend along the ridge toward the west (Gritella 1992: 397–98). Construction of this model, made in late 1717 following Juvarra's design, was supervised by Luigi Andrea Guibert, a colleague of Juvarra.
Construction of the Castello itself, following the new designs of Juvarra, began in 1715 and continued until 1720 when major construction at the site ceased, leaving the castle without an entrance hall, atrium, stairs, and *grand salon*, and without its entire west wing. Six large views of the exterior and interior of the castle, executed after drawings of Juvarra by the painters Giovanni Paolo Pannini, Marco Ricci, Andrea Lucatelli, and Massimo Teodoro Michela were painted in 1720–23, most likely to record the designs that might not be completed. If the drawings prepared by Juvarra for the views were done just prior to their being given to the painters, they may record a later stage of the design than the model. When work on the model was interrupted, it was unfinished and contained little of the intended decoration. Columns, pilasters, panels, and

pedestals were made for the grand central section of the castle, but are absent or only drawn on the east and west wings in the model. Even in the central section on the double grand stairs, the decoration is drawn on the wood surface, but not executed in paint or in three-dimensions. (These decorations were, perhaps, to be painted, as are sections of Juvarra's model for the sacristy of St. Peter's.) Had the model been completed, it may have been intended to be painted to accord with the model of the gardens to the west.
The model was made to be disassembled so that interiors, primarily the central section, might be viewed directly. It is also constructed to simulate the structure itself (walls, piers, columns, vaults, buttresses, etc.) and may also have been intended to be used as a guide in construction of the castle. There are a number of minor modifications to the earlier design of the model found in the later paintings, but the principal differences, as seen in the paintings, are found in the central section of the south elevation (preparatory drawing by Juvarra in the Kunstbibliothek, Berlin, and painting by Pannini in the Museo Civico, Torino.) The drawing and painting show matched stairs descending in single flights from the terrace to the carriage level where there is a rusticated tri-partite entry. The earlier model, however, includes matched stairs with double flights of steps descending to the carriage level where there is, instead, a five-bay entry with the central three bays not rusticated but flanked by pairs of Doric columns on plinths. At the attic level, the drawing and painting show a salient central three-bay section with a two-bay attic set behind to either side. The recessed section includes openings at this level. In the model, there is only one recessed bay flanking the central section and this bay contains only a panel. (On the north side of the central section, at the attic level, the model contains a volute to hide the roof behind, while the painting by Lucatelli of the north elevation shows a full attic bay in place of the volute.)
The model of the Castello at Rivoli, in its unfinished state, provides, when seen together with the model for the church and convent at Superga and the model for the sacristy of St. Peter's, all executed within a three-year period, testimony to the parallel working methods in Rome and Turin. The incomplete model of Rivoli represents a stage in the development of a model, a stage at which the major structural and decorative elements have been executed and when decorative detail could begin to be added. The model for the sacristy includes, in addition to decorative details in tempera, three-dimensional details in wax, stucco, and carved wood. It is not known whether the model for Rivoli was to include detail at this level, but if it were to have been completed in a similar manner, the drawings that remain of the model today would have been needed. A careful examination and comparison of these three models could lead to a description of the processes and techniques followed by Juvarra and his contemporaries in realizing these remarkable models. HM

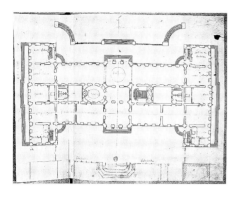

157 MAR

Robert de Cotte and Jules Hardouin Mansart (1646–1708)
Projects for Rivoli Castle, Plans, Elevations and Sections, 1699 or 1700
Paris, Bibliothèque Nationale, Cabinet des Estampes, Vb 5, 12
Pen and brown ink over pencil, with corrections, additions and annotations in pencil
350 x 464 mm; scale: in *toises*
INSCRIPTIONS: "Jardin du Costé du Nord" (at the top); "autre Cabinet," "grand Cabinet," "chambre," "2 antichambre," "1 antichambre," "cour" (left side of the building); "Gallerie," "chapelle," "Salle des garde," "Vestibule" (middle of the building); "Cabinet du Conseille," "grand Cabinet," "grande chambre,""chambre" (right side of the building); "porte" (?), "balustrade", "balustrade" (low down)

158 MAR

Robert de Cotte and Jules Hardouin Mansart (1646–1708)
Projects for Rivoli Castle, Plans, Elevations and Sections, 1699 or 1700
Paris, Bibliothèque Nationale, Cabinet des Estampes, Vb 5, 11
Pencil; 311 x 490 mm; scale: in *toises*
INSCRIPTIONS: "Salle des gardes", "tois"

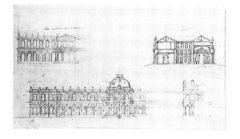

156 MAR

Robert de Cotte and Jules Hardouin Mansart (1646–1708)
Projects for Rivoli Castle, Plans, Elevations and Sections, 1699 or 1700
Paris, Bibliothèque Nationale, Cabinet des Estampes, Vb 5, 15
Pencil; 263 x 476 mm; scale: in *toises*
365 x 464 mm; scale: in *toises*
INSCRIPTIONS: "Coste du jardin par le boute" (on the left); "profil," "Salle," "p. du Cour," "galleries" (right); "Coste du Cour" (low down)
PROVENANCE: R. de Cotte family; M. Delaporte in 1810; Bibliothèque Impériale, then Nationale

BIBLIOGRAPHY: De Cotte n.d.; Brinckmann 1931: nos. 126B and 287C; Jestaz 1966;Pommer 196: 27, 146–49; Garms 1969: 184–88; Marocco 1971: 10–17; Kalnein and Levey 1972: 214, 374–175, no. 27; Gritella 1986: 77–82, 86 no. 2; Roggero Bardelli, Vinardi, Defabiani 1990: 263–64, 265–66 no. 14, 274–76; Neuman 1994; Foissier 1997: 678–80.

In 1691 Rivoli Castle, one of the residences belonging to Duke Vittorio Amedeo II of Savoy in the neighborhood of Turin, was burnt by French troops. Rivoli Castle rises on a morainic spur at the beginning of the Susa Valley, at the foot of harsh mountains but at the same time in an elevated position. It looks over both the small town of Rivoli, clinging to the steep slope, which acts as a base for the castle, and the vast plain that it dominates from this spur. Even before the fire and subsequent falls and sacks, the largely seventeenth-century building was probably not a very regular structure. The four rather narrow, tall towers that closed it in in the corners were probably not similar among themselves. There was also a long galleried body attached at a slant to the short side of the castle towards the west, the only side of the building with ground rising behind it. This gallery was saved virtually intact; but even substantial parts of wall in the castle escaped damage, above all the two towers toward the east and part of the framework in the adjacent body. The drawings conserved in the De Cotte Fund in Paris, neither signed nor dated, refer to two different but related projects for reconstructing and enlarging the castle, that would have led to demolition of this gallery. They were most probably drawn up in 1699 or 1700 and can be attributed to Robert de Cotte and Jules Hardouin Mansart), with De Cotte's personal intervention in the actual drawing (probably finished by collaborators) and in the annotations, and Mansart predominating in the conception of the project. The dating takes various circumstances into account. In 1699 there were contacts between Turin and Paris – documented by projects and explanatory notes from the Piedmontese side (Brinckmann 1931; Pommer 1967) – for another ducal residence near Turin, Venaria Reale, also damaged by French troops in the 1690s and at that moment the object of a great transformation and enlargement plan by Garove, the engineer-architect involved in almost all the ducal buildings during that period. Jules Hardouin Mansart's opinion had been asked for in respect of this project in 1699; as *premier architecte* to Louis XIV (as well as *surintendant*) Mansart was then at the apex of the great Bâtiments du roi. In the same year, Robert de Cotte, Mansart's son-in-law and close collaborator, had been nominated *architecte ordinaire* – that is second in the hierarchy – and director of the Bureau des dessins in Paris. Garove's drawings for Venaria Reale, with their relative explanations, are also conserved in the very rich De Cotte Fund. In 1696, brusquely changing sides, Vittorio Amedeo II allied himself to Louis XIV and thus placed an end to the war in Piedmont. This tactical reconciliation with France, crowned by the wedding of one of Vittorio Amedeo II's daughters to the duke of Bur-

gundy (son of the Dauphin) lasted only a few years: already from 1701 onward it was beginning to crack (after the beginning of the Spanish Succession War) and it was definitively broken in 1703, when Vittorio Amedeo II decided to go back into the coalition against the king of France. From 1701 Piedmont was again at war. Nothing was done at Rivoli until 1711. These drawings for Rivoli have always been associated with the consultancy requested for Venaria Reale and have generally been dated between 1699 and 1704, but interpretation of them has not been uniform. For Brinckmann (1931), who considered drawings 158, the first plan represents a simple re-ordering of the damaged building, while the second (157) proposes considerable enlargements that also made use of the pre-existing structure. Both were referred to Garove. For Garms (1969), who took into consideration Jestaz's observations (1966) about the handwriting, everything that is in pen had to come from Turin, while everything in pencil had to correspond to De Cotte's elaborations – even if Mansart is not excluded as a possible French interlocutor. Plan 156 would be the correction made by De Cotte to plan 157 from Turin, which, in its turn, might be the answer to an earlier criticism from Paris. Kalnein (1972), in passing, attributes the plan of drawings 157 and 156 to Mansart. For Gritella (1986) – as for Marocco (1971) – the more extended plan 158 would instead come before the narrower plan 157. For Neuman (1994), as for Garms, drawings 157 and 156 represent an alternative proposal, probably a project by De Cotte – his first for a *maison de plaisance* – without, however, excluding collaboration from others in the Bâtiments. Finally, for Foissier (1997) plan 157 would be Garove's proposal (with some corrections by De Cotte), followed by De Cotte's counterproposal with plan 158. The castle in plan 158 has a rather elongated, rectangular shape with double corner pavilions. This shape allows a considerable amount of the pre-existing walls to be included in the new building, since the two towers toward the east have been incorporated in the pavilions, and the depth of the building (that has been lengthened from east to west) and the position of the middle supporting wall have been kept. Other elements that appear pre-established are the new position of the entrance on the south side, and the intention to place a courtyard flanked by two wings in front of it. These elements, together with the new shape of the castle, as above, and the gallery to be demolished, appear in a general, very schematic plan (Vb 5, 7) accompanied by a *Renvoy* (Vb 5, 8), also conserved in the De Cotte Fund. This plan really seems to reflect a series of indications and information coming from Turin. Plan 158 is a study that obviously could not come from Turin. Completely in pencil, it contains traces of erased solutions and others left halfway as though they were not completely excluded options; for example, various ways of composing the transition between the ground floor of the castle and the external ground level. Here there is a clear preference for four terraces between the pavilions, on all four sides, which would enclose the building on a slight platform. The building contains two parallel series of rooms that give on

to the long sides; on the short sides, between the junctures with the pavilions, the thickness of the building is divided in three. The almost square entrance hall is positioned along the main axis, together with a much larger rectangular room; they are indicated on the exterior by very slight projections enriched with coupled columns, corresponding to the three central bays. The main sequence on this floor leads from the entrance hall, through three openings in line with the above mentioned bays, to the great reception room. The double corner pavilions are similar, almost as though radiating out from a centralised composition. Each has a large corner room with views in all directions and, in the semi-pavilions next to the long sides, there are narrow stairs and service rooms. The entrance hall is flanked on one side by a *salle des gardes*; on the other it opens on to the staircase hall with central well. Two symmetrical chapels follow, behind the bed-chambers. Plan 157 and the elevations 156 represent a project at a study stage that probably developed from the previous one. The part in pen is not at all accurate; some variations seem to be the result of carelessness rather than design. The handwriting in the numerous annotations recalls very strongly the handwriting in De Cotte's diary manuscript of his journey to Italy (1689–90). In the parts where the elevations have been sketched in, Jestaz (1966: 253) has also recognised De Cotte's hand. The areas in the preceding project that hampered the free unfolding of a sequence on the entrance hall side – that is the chapel and staircase hall – have now been symmetrically placed next to a new rectangular room, which has been inserted between the entrance hall and the corresponding space on the other side, thus acting as an effective hinge. In this new intermediate band two small internal courtyards have been symmetrically placed to let in light; two small service units come after them. With these elements in the middle between the two series looking out along the long sides, the body of the building increases in width (incorporating part of the pavilions) and is given a potential cross axis. The series of three rooms on the short sides, as well as increasing in width like the main body, have been pushed out to align with the corresponding façades of the pavilions. The building is therefore much more compact than the preceding one and, at the same time, it is almost made up of "wings" closely slotted together. The pavilions are no longer pavilions; they have become the projecting parts of the bodies that make up the sides. A cross shape is slotted into the middle, with the longitudinal axis predominating over the cross one, which, however, re-emerges strongly in the sides. It is a complex plan for a compact, symmetrical, but at the same time centralised, building on a rectangle – or, if one would prefer, on rectangles. Such control was no mean feat for a building of that size (the perimeter of the outer rectangle measures 110 by 60 metres). Recent experiences (like Marly) and more distant memories, although very present at that time (like Chambord), of centrally planned square or rectangular buildings, with common roots in the Italian Renaissance, might have influenced this planning process. Likewise, theoretical examples from late Renaissance treatises,

such as Serlio's variations on the same theme, and those on an H plan, which, with a thick crossing of three bands, is also latent in this composition, might also have been of influence. Five great *enfilades* dominate the plan: the first through the body of the building along the main axis; the other four through the external "wings" from one end to another, full of light that enters from the large, closely arranged openings placed along the entire perimeter. In this great slotting together, the sequences of rooms develop and slot into each other in their turn with perfect correspondence between form and function. The more public areas of two large apartments begin symmetrically from the entrance hall, with the second anterooms slotted into the side "wings", occupied by the heart of these apartments. From the entrance hall, with half-columns against the walls, and slightly wider and more projecting than the other rooms of the *enfilade*, one is more attracted along the main axis of the building: the room functioning as hinge is an amplification that invites one to proceed – but it also contains, on its cross axis, the chapel and stair hall, two rooms also with central functions although not predominating. After this interlude, the gallery widens out to occupy the whole of the other side culminating in the middle – that is on the main axis – in a deeper, higher and more noble "space within a space" symmetrical to the entrance hall. The great *cabinets* at the two ends of the gallery slot into the "wings" of the apartments like the second anterooms. The ducal *chambres de parade* lie between both of these, arranged on the cross axis of the building and slightly emphasised on the exterior, right in the middle of their respective façades. The four projecting heads of the sides contain private echoes of the middle rooms to a greater or lesser degree, together with small stairs. On the south side there are private bedrooms with secondary rooms (pencilled in), whereas on the north side there are another two *cabinets*, one for council meetings. From the elevation, it can be seen that the building has only one *piano nobile*, corresponding to the ground floor (and therefore only a "small staircase"), whereas almost a quarter of the upper floor, the part above the gallery, is only a low roof. The buildings to the sides of the entrance courtyard, outlined lightly in pencil as in plan 158, would probably have been service buildings. Therefore, there was to be a single, ground floor *piano nobile* with two ducal apartments and a gallery larger than the one at Versailles for this *maison de plaisance*, as it has rightly been defined by Neuman (1994: 78, 80). In the well-balanced plan, the gallery does not overwhelm at all; instead it bestows a noble and airy feel to the whole. In the elevations made to the plan (two studies of the fronts and a longitudinal section cut at the height of one of the inner courts), the external composition encloses these interconnections within a unitary form. A uniform system of openings repeats on all the façades; arches on the ground floor, windows with flat, slightly curved frames on the upper floor. An uninterrupted entablature encircles the building on the ground floor; similarly, a cornice surmounted by a balustrade hiding the roof does so on the upper floor. The corners of the side bodies are marked out by regular rusti-

cation from top to bottom, whereas rustication uninterruptedly covers the side façades on the ground floor from corner to corner. These façades and their continuation round the corner, pulled together and strengthened, in their turn enclose the more relaxed rhythm of the major façades. Two variations in the composition of the entrance front that provided for raised attics on the ex-pavilions – or, perhaps more correctly, on the entire side bodies – have been dropped or left unfinished. In any case, this idea is not taken up in the elevation of the side façade. A square dome on the main axis gracefully crowns the horizontal development. On the main façade, the three slightly projecting middle bays are framed by coupled columns on the ground floor and by pilasters on the floor above. Detached from the wall and with their own entablature, the columns are also high-standing pedestals for the statues they support. The pilasters are crowned by a lively, lightly curving, sculptural group. From the columns with statues to the crowning sculptures, the "antique" busts on brackets between the arches, and the slight reliefs (most probably trophies) in the panels between the windows, there is a rich but subtle passage from architecture to decoration, where one is essential to the other. Quite a few of the elements in the Rivoli drawings can be found in De Cotte's later compositions. On the other hand, his specific work as a designer in the period when the drawings for Rivoli were made rarely results officially, in that he was part of a work group headed by Mansart. However, even recognising De Cotte's direct intervention in these drawings, one thinks more here of some of Mansart's particular traits, rather than of a language common to both architects. The purity of Mansart's solids, the clear compactness that can also coexist with openings and lightness, the clarity of the plans and, finally, the importance of the sculptural decoration within the architectural composition: all of these features belonging to Mansart can be found to some extent in the project for Rivoli, and characterise it beyond the numerous elements taken from his work and from the tradition that preceded him. Mansart had never been to Piedmont, whereas De Cotte had spent some days in Turin in 1690 and had then travelled along the road that passes Rivoli. And yet this project for quite a low-lying, horizontal building, full of French grace, that was arranged *entre cour et jardin* on the relatively narrow spine of the moraine, would have been perceived as "imported", if seen in relationship to that overwhelming site where, by the way, the real building would have dominated very little. In any case, the project that was to lie at the origin of Garove's work at Rivoli from 1711 onward, and with greater commitment from 1713, would not have much in common with these two projects from the De Cotte Fund. If there had been something in that spirit before, then it must be concluded that it was not very congenial to Garove; and above all, that it was no longer congenial to his patron, who in the meantime had defeated the Sun King, and had himself become king. All this happened shortly before De Cotte – *premier architecte* since 1708 – would have sent projects and collaborators to the many European courts requesting his expertise. CP

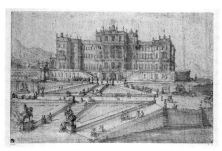

153 T
Filippo Juvarra
View of the South Side of Rivoli Castle
probably 1722–1723
Berlin, Staatliche Museen, Kunstbibliothek,
Hdz 993
Pen and brown ink, gray watercolor, squaring
in pencil, yellowed paper; 284 x 448 mm
PROVENANCE: Pacetti Collection
EXHIBITIONS: *Mostra del Barocco piemontese*
1963; *Filippo Juvarra, 1678–1736, 1994; Filippo
Juvarra. Architetto delle capitali* 1995; *Filippo
Juvarra e l'architettura europea* 1998
BIBLIOGRAPHY: Brinckmann 1919: 172; 1931:
no. 127a; Rovere, Viale 1937: 67–68; Viale
1950–51: 163–64; *Mostra del Barocco Piemontese*
1963: 49; *Filippo Juvarra Architetto e Scenografo*
1966: 66; Marocco 1971: 22, 25, 27; Boscarino
1973: 283–84; Jacob 1975: 147–48; Bruno 1979
(1985): 243–45; Gritella 1986: 91, 94, 96-97;
Arisi 1986: 80, 305; Griseri 1989: 33–34; Rog-
gero Bardelli, Vinardi, Defabiani 1990: 264, 266,
no. 24; Gritella 1992: I, 393, 398-400, 425 no.10;
Passanti 1992: 610–23; *Giovanni Paolo Panini.
1691-1765* 1993: 35– 36; *Filippo Juvarra, 1678-
1736* 1994: 384–85; *Filippo Juvarra. Architetto
delle capitali* 1995: 362–63, 411–12; *Filippo Ju-
varra e l'architettura europea* 1998: 222–23

In 1723 six large paintings depicting views of
Rivoli Castle were ordered from Rome, Venice
and Turin, certainly under Juvarra's direction. In
1725 they were already hanging in the castle as
part of its furnishings. They showed in the rich-
est, most varied and attractive ways what the cas-
tle would be like. Arguably the most important
painting, now conserved in Racconigi Castle,
shows the great front of Juvarra's castle as it
would have regally appeared to Piedmont. In its
execution, Pannini kept faithfully to Juvarra's
drawing. Faint traces of squaring in pencil over
the drawing testify that it was transposed. The
drawing is not dated; Juvarra might even have
done it some years earlier, and then provided it
later as a model for the painting. It has generally
been associated with Juvarra's documents for
this project or grouped with them for dating,
even when it has been explicitly considered as a
preparatory drawing for the painting. This draw-
ing is not a "pensiero" for a design, nor is it a pre-
sentation drawing (a beautified design). It has
been constructed in too "ingenious" a way to be
either one or the other. It is a perspective *tour de
force* – perfect in its turn for the perspective
painter Pannini – that bears no trace of any effort
whatsoever. Compared to the building in the
model, the building in the drawing contains
some different architectural elements. Apart
from the exclusion from the drawing of the first

access avenues, the biggest differences lie in the
different treatment of the middle part of the
building. Here, on the terraced level, there are
less central bays (in the drawing); they are differ-
ently framed architecturally and the stairs flank-
ing them also descend differently. On the façade
level, the shape of the "sets" framing the central
body is wider in the drawing (3 bays) than in the
model (1–2 bays). They seem to be two different
versions, harmonious in themselves. The one in
the drawing is more a Roman "villa" lying on an
elegantly rusticated terrace; the one in the mod-
el is more a *scenae frons*, more Roman-antique.
Since, of those qualifying differences, only the
small part actually built (a small, three-bay piece
of "set") during Juvarra's time, and two years af-
ter the painting had been ordered, followed the
version in the drawing and the painting, it might
be presumed that the version of the south façade
in the drawing was the definitive one of Juvarra's
project. But this is not certain either: master that
he was of the art of combining, in his definitive
conception for the south front Juvarra might
well have wanted to integrate some elements
from the drawing and the painting into his de-
sign for the model, with a significant impact on
the whole composition. And if the drawing of
the view had been done only a short time before
the painting was ordered in 1723, Juvarra might
have introduced here some design elements per-
haps considered even before the model, but then
dropped – a different idea for the terrace and its
relationship with the building and its central
part. He might perhaps have done this to create
a less loaded perspective image in his view, since
some parts were compressed. In this case the
splendid view, so unified and centralising for
whoever looks at it, would also include earlier
phases of Juvarra's design. CP

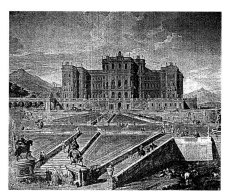

167
Giovanni Paolo Pannini (1691–1765)
View of the Rivoli Castle toward the South
Racconigi Castle
Oil on canvas
299 x 331 cm
BIBLIOGRAPHY: Viale 1950-51: 64; Griseri
1957: 43; Mallè 1961: 370–71; Carboneri 1963:
49; Vesme 1963–1982: 637, 775; Viale 1966:
66, fig. 116; Griseri 1967: 304–05; Arisi 1986:
80, 305; Gritella 1986: 91–114; Griseri 1989:
33–37; Roggero Bardelli, Vinardi, De Fabiani
1990: 262–266; Gritella 1992: I, 390-404; Pas-
santi 1992: 610–23; Arisi 1993: 35–36; Blasco
Esquivias 1995: 362–63; Millon 1995: 411–12;
Severo 1996: 138–39

The view of the Rivoli Castle's southern façade is
part of a series of six paintings, which comprise
four landscapes, the living room and the atrium,
which was under construction. Pannini was
commissioned to paint the canvas in 1723. In
1725, the painting was located in the rooms of
the northern wing of the castle, along with a
painted view of the western side of the edifice,
whose construction was interrupted in 1720. Ris-
ing above its terraced foundation, the royal resi-
dence has a tripartite central body, which ad-
vances imperiously, its dominance further pro-
nounced by its protrusion from the two pavil-
ions. The artificially modeled system of stairs,
terraces, ramps, fountains and coloured parter-
res are attached to this raised podium, extending
along the sloping slide of the sculpted hill. Pan-
nini's painting is faithful to the prospectus drawn
by Juvarra (Berlin, Kunstbibliothek), and the
chequered marks on the paper indicate that the
painter transferred the picture to the painting.
As in the drawing, the painting differs from the
wooden model, built in 1717. Of the six views
that were ably composed by Juvarra, this is un-
doubtedly the one that best represents the spec-
tacular grandiosity of the residence designed for
Vittorio Amedeo II. The impact of the perspec-
tive is emphasised by the surrounding scenery:
the regal majesty of the castle's dimensions is hid-
den among the shadows of a passing cloud. With
the Alps in the background, it protrudes from a
restless sky, which, in passing, brightens the busy
movements of the artificial slope in the fore-
ground. On this stage of ramps and terraces, the
painter creates the setting for a lively show. Here,
the human figures are characters that come and
go on their carriages, up and down the hills, ac-
tively interacting with the architecture. The
painter has certainly not swayed from Juvarra's
creative expression, but adhered to it very close-
ly. The cordial collaboration between the two
artists, who shared their experiences as land-
scape artists, is immortalised in the foreground,
where they are portrayed as two figures engaged
in a friendly conversation. CP, GD

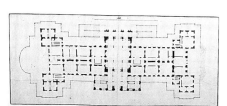

154 T
Collaborators of Filippo Juvarra
Plan of the First *Piano Nobile* of Rivoli Castle
according to Filippo Juvarra's Design; 1717–18
Turin, Archivio di Stato, Sezione I, Corte,
Palazzi Reali, mazzo I, fascicolo 3, Rivoli Castle
Paper mounted on canvas, pen and ink over
traces of pencil, additions in pencil, retouching
in gray watercolor; 440 x 1057 mm
Scale: 20 *trabucchi*
EXHIBITIONS: *Filippo Juvarra, 1678-1736* 1994;
Filippo Juvarra. Architetto delle capitali 1995; *Fil-
ippo Juvarra e l'architettura europea*, 1998
BIBLIOGRAPHY: Telluccini 1930: II, 194–96,
204; Brinckmann 1931: no. 127a; Bruno 1985:
243; Gritella 1986: 92–93, 107, 112, 120, 122–

23, 158; Passanti 1989: 134–35; Cousins 1992: 629–30, 635–36; Gritella 1992: I, 390–427; *Filippo Juvarra, 1678–1736* 1994: 384–85; *Filippo Juvarra. Architetto delle capitali* 1995: 362–63, 411–12; *Filippo Juvarra e l'architettura europea* 1998: 222–23

The plan by Juvarra's collaborators occupies a place very close to the model (1717–18) in the design history of the architect's project for Rivoli Castle. During the phase of work carried out in 1718, the building of a very small part of the central T-shaped body and adjacent rooms modified to some extent the indications in both, and the model remained unfinished as a result. The main ascertainable difference between plan and model lies in the different relationship between the terraced area and the great projection of the central body toward the north. In the plan, the "cage" of entrance hall and staircase has been held tightly in to the sides by the terrace; in the model it has been scenographically framed by flights of steps that connect the terrace level to the entrance level, with flights quite similar to the external ones on the south side. Consequently, the subtle "double-fronted" character of this building is more emphasised in the model, whereas in the plan a strong orientation of the central T body from north to south prevails. The drawing contains the comprehensive idea for the new design. The old, pre-existing parts toward the west, still to be demolished, are not shown, whereas several internal walls built a few years earlier by Garove or Bertola are still present in the composition. Following his plan, Juvarra would demolish these in 1719. The part of the building to the west of the central group contains several variations in the distribution compared to the part in the east where Juvarra was more bound by the pre-existing structures. From one part of the large central T to the other, the apartments and rooms connected to them seem to aggregate together in the four double pavilions and along the east, west and south sides. Almost in the middle of the two side bodies of the building there are service corridors; on the north sides, near the pavilions, there are two "centers" or entrance halls; half-way along the minor east and west sides there are another two smaller entrance halls separating the neighboring apartments toward the pavilions. Almost all these aggregations are quite separated right in the center of the building. The building is almost cut in half by the great central body containing two entrance halls, a double staircase and a *salone*. Consequently, on the first *piano nobile*, from east to west one would have been able to look into an enormous central void crowded with vaults and columns below. This plan, so complex, so rich in aggregations and centres, tensions and contradictions, guided axes and *bizzarria* is also a masterpiece of control. From the building to the terrace, which would have raised the castle on to a pedestal and at the same time held in and amplified its vigorous potential, to the further amplifications of ramps planned on the slope in front, this centralising control would have been extended over the majestic landscape all around, celebrating the regalness of the king who lived there. CP

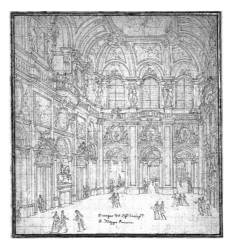

155 T
Filippo Juvarra and collaborators
View of the Salone of Rivoli Castle, 1722–23
Turin, Museo Civico di Arte Antica-Palazzo Madama, Collezione di disegni di architettura del Settecento, armadio 4, palchetto 13, cartella B "Juvarra"
Pen and gray ink, squaring in pencil; sheet glued on cardboard and strip of glued gold paper; 278 x 265 mm; support 343 x 329 mm
INSCRIPTION: "Dissegno del Sig.r Cavag.re / D. Filippo Juvara" (brown ink)
EXHIBITIONS: *Mostra del Barocco piemontese*, Turin 1963; *Filippo Juvarra*, Madrid 1994; *Filippo Juvarra*, Turin 1995
BIBLIOGRAPHY: Rovere, Viale, Brinckmann, 1937: 157; Viale 1950–51: 163–64; *Mostra del Barocco piemontese* 1963: 49; *Marco Ricci* 1963; *Filippo Juvarra Architetto e Scenografo* 1966: 66–67, 108; Marocco 1971: 22; Scarpa Sonino 1991: 34, 130–31; Gritella 1992: I, 408, 414; *Marco Ricci e il paesaggio veneto* 1993; *Filippo Juvarra, 1678–1736* 1994: 386; *Filippo Juvarra. Architetto delle capitali* 1995: 363

The writing on the drawing is certainly not that of Juvarra: it might have been added a short, or even a long, time after the drawing was done. This drawing corresponds to a painting by Marco Ricci now in the Racconigi Castle: one of the six large paintings made between 1723 and 1725 that depicted the "new" Rivoli Castle as it would appear. The two correspond perfectly except for a few details; Marco Ricci received in Venice from Turin some small models for six figures wearing various court dress or uniform painted on paper by Pietro Domenico Olivero, only a few months before finishing the painting. The close and very evident squaring on the drawing indicates that it was transposed. The drawing has usually been associated with Ricci's work, often being considered as a preparatory drawing for his painting; sometimes it has been attributed to Juvarra, at others to his collaborators. Juvarra drew in many different ways. Here, however, the hand of a draftsman trying to "Juvarrise" as much as possible can mainly be seen. Apart from different details in the decoration of the *salone* rendered rather generically the "vibrant" quality is missing – that quality in the strokes in Juvarra's drawing that makes life and light, in all its various intensities, vibrate, even where there are no pen

or watercolour shadows. Compared to the two drawings (vol. II of Juvarra's drawings, fol. 46 no. 93, and fol. 67 no. 134) and to the model, the three documents known to us of Juvarra's project for the *salone* (relating to the elevations), this drawing contains some new elements. It shows tall and deep alcoves high up in the side walls, but above all it contains these three phases of the project combined in a single representation. Simple in its perspective compared to the ingenious combinations in the drawing of the view of Rivoli in Berlin, this drawing too is a great assemblage. For example, the very tall caryatids in the first drawing of the *salone* are present; the articulation of the vault is more similar to that in the second drawing (where there are no caryatids and the vault, as in the model, has been set lower); then elements from the first and third phase (that passes through the second) have been combined together in the rather ambiguous composition of the long walls. The drawing seems to combine the various ideas of the *salone*'s design history into a single scenographic scene, which also resembles *quadratura* painting to an extent. Thanks to that small move backward that breaks the vertical continuity, the *salone* seems to widen out at the top in a larger space that looks on to a lower one and also opens into the space of the great musicians' gallery (as later in the *salone* in Stupinigi). The lunettes in the vault imposts allude to further small, spatial units, while larger, freer spaces extend behind the framework of the vault itself. Moreover, painted panels have been inserted in the walls – in the few stretches left free of the proliferations of openings and sculptures (often imitating the antique). Lower down and toward the back a rather indefinite space can be glimpsed, richly decorated with columns, balustrades, statues and hints at ramps that would allude to a staircase. Many of Juvarra's themes can be found in this drawing, from the history of his design and from his stage sets. Empathy can also be seen with the painter and scenographer Marco Ricci's themes. CP

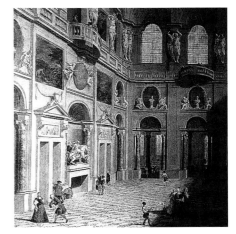

168
Marco Ricci (1676–1730)
The Salone of the Castello di Rivoli according to the Project of Juvarra, 1724
Racconigi, Castello Reale
Oil on canvas
292 x 274 cm (280 x 300 according to Scarpa Sonino)

PROVENANCE: Rivoli, Castello (1727); Torino, Palazzo Madama; Moncalieri, Castello
BIBLIOGRAPHY: Baudi de Vesme 1968: 925; Bruno 1984: 25, fig. 6; Gritella 1986: 111–15, fig. 87; Scarpa Sonino 1991: 34, 130–31, cat. 077, fig. 274 (with further bibliography); Gritella 1992: I, 414–15, fig. 560

This painting was executed for Vittorio Amedeo II, king of Sardinia, and is recorded in the accounts of the royal household (Archivio di Stato di Torino, Section III, Conti del Real Casa, published in *Schede Vesme* 1968: 925, and in Gritella 1968: 172, Doc. VIII-16). On 4 February 1723 Ricci, resident in Venice, was paid on account 333 *lire* 6 *soldi* and 8 *denari*, about one-third of a total price of 1000 *lire* for a "quadro d'architettura in servizio di S.M. per il Castello di Rivoli, rappresentante l'interno del salone di detto Castello." The rest (688 *lire*, 13 *soldi*, 8 *denari*) was paid on 14 August 1724, bringing the total payment to rather more than the agreed sum (1021 *lire*, 4 *denari*). On the same day is a payment for transporting the picture from Venice to Canonica, its final destination to be the Castello at Rivoli. On 6 March 1724, more than a year after the down payment to Ricci, the painter Pietro Domenico Olivero was paid 6 *lire* for "sei figurine sopra la carta": two represent women in court dress, another is of a woman wearing a cloak, one represents a bodyguard, one is of a footman, and one of His Majesty's Swiss Guard, which were sent to Venice to be copied by Ricci into his painting. The reason for doing this was not, presumably, that Ricci could not paint figures, but that they wanted to get the costume right. No drawings corresponding to the various gentlemen were provided by Oliveri; presumably their dress was not specific to the court and could be left to Ricci, as would have been the African page-boy, the pair of monks, and other subsidiary figures. It is tempting to suppose that the man in black in the doorway in the left middleground is Juvarra himself. The view adopted is toward the north-west and the *piano nobile* atrium, which is reached by flights of stairs at right and left; the latter is visible through the left-hand opening. This part of the palace was constructed by Carlo Randoni in 1793–94, with some changes to Juvarra's design, but was never finished (Gritella 1986: 114). The wall at the right exists today as a plain brick façade continuous with the wall of the partially completed second atrium below which terminates the completed wing of the building (Gritella 1986: fig. 105). Various recesses and relieving arches today indicate the positions of the fireplace, statue niche, and flanking doorways. The painting corresponds in most respects to a drawing in the Museo Civico di Torino, inscribed "Dissegno del Sig.r Cavag.re/ D. Filippo Iuvara" (Gritella 1992: I, 414, fig. 559). It is squared for enlargement, suggesting that it was the drawing that Ricci used; it may have been returned to Turin with the completed painting. The correspondences in perspective and architectural detail are exact; the molding around the fireplace is one of the few indications not taken up by Ricci. In his representation of the stucco figures Ricci has followed the indications of the drawing with more independence and has fleshed them out in distinctively Ricciesque rhythms. In the paintings in the attic zone, Ricci, now depicting works in his own medium, has not followed slavishly Juvarra's suggestions, presenting instead somewhat Magnasco-like scenes of figures in landscapes. The rearing equestrian statue over the fireplace, probably modelled on Bernini's *Emperor Constantine* in the Vatican or his equestrian statue of Louis XIV, and evidently intended to depict a king (Vittorio Amedeo II?), has been interpreted by Ricci along the lines of a Roman general in armor with a flying cloak behind. Its belly is supported by a prop, a detail found in other works by Ricci (cf. the etching in Scarpa Sonnino 1991: fig. 304). Ricci, with Oliveri's drawings at hand, not only ignores the disposition of Juvarra's staffage figures, but also enlarges their scale, and so weakens the effect of airy spaciousness that Juvarra's drawing so effectively conveys. Ricci also ignores the indications of a flat inscription on the oval framed by the stucco figures of trumpeting fames, treating it with some uncertainty as a kind of convex shield, gold or bronze-colored like the statue niche below. Juvarra's preparatory drawing lacks indications of lighting. The room would have been lit by the windows shown and by south-facing windows on the near side corresponding to the atrium openings on the far side, visible in Pannini's painting of the south façade (Racconigi, Castello; Gritella 1986: 95, fig. 65). Ricci would presumably not have known about these and so adopted a technically easier solution, lighting the room from the right side. A structurally implausible cast shadow puts the right-half of the room into deep shadow which is enlivened by two monks in white habits, shafts of light from the open double doorway, and the illuminated atrium seen through the right hand opening. It is continued as a shadowed zone between the end wall and the columns surrounding the stairwells, the alternation of lights and darks hinting at the scenographic mysteries of the staircase. To this effect slivers of atrium glimpsed between columns and piers also contribute, as a result of Ricci's decision to interpret the articulation of the openings as a compressed Serliana. Juvarra's drawing permits such an interpretation, but the wooden model suggests that Juvarra may have intended these columns to be set in curved recesses, which would have resulted in denser and less transparent piers. Two sketches by Juvarra (Museo Civico di Torino, vol. II, c. 67, no. 134 2054/DS, and vol. II, c. 46, no. 93 1964/DS, respectively Gritella 1992: figs. 557 and 558) employ a similar perspective to that used for the preparatory study, and were probably executed in preparation for it. Indeed, it seems likely that Juvarra, having stated his initial conception for the *salone* in the wooden model, used the production of the preparatory drawing for the painting as an opportunity to develop his idea on the interior in greater detail. Certainly the window and vault zone in the model are crudely developed, as if Juvarra had not at that point done much more than indicate the wall elevations. If so, we may place the sketches in a developmental series between model and preparatory study. But is one sketch more advanced than the other? Both make it clear that one of Juvarra's concerns was to make a feature of the central bay of the atrium wall and link it to the vault. In 1964/DS the verticals of the pilasters and atlantes are emphasised, these being bridged at balustrade level by a bulging balcony, and at the start of the vault by a kind of compound spandrel tied to the ceiling painting. In 2054/DS there is a similar emphasis on this area, but the atlantes are absent, the compound spandrel is a more conventional field for frescoes, and the vault fresco is rectangular. In 1964/DS the archways to the atrium are closed in the lunette spaces with glazing, which appear in the final design but not in 2054/DS. The side wall elevations are in most essentials the same in both sketches and painting. If there is a sequence it seems likely to begin with 2054/DS, which is then elaborated in 1964/DS with the addition of herms, glazed lunettes, and a fancier vault and balustrade; nevertheless, in the final design Juvarra reverts to the earlier rectangular vault fresco field. In both sketches there is a concern to create a quasi-oval room by bridging the corners of the room with a curvilinear balcony and by employing a vault design which reduces the upper-storey corners to niches. This is lost in the final version where the curvature of the balcony is restricted to bulges in the centre of each side and the corners of the upper storey are emphasised by running a rib from a canted corner pilaster to the framing of the ceiling fresco. The wooden model of the Castello made under the direction of Juvarra in 1718 by the carpenter Ugliengo represents Juvarra's initial ideas for the room (Gritella 1992: fig. 561). In the model the side wall is treated as a Serliana-like sequence of straight cornice sections interrupted by arches and the picture frames drop down to impost level, creating an alternating rhythm of short sections of impost molding and string-course. In the painting (and all three drawings), on the other hand, the bottom of the paintings are aligned with the string-courses beneath the roundels, and the door pediments are aligned with the arch imposts, so that the wall surface below the balustrade separates out into three bands. In the painting, the arched openings are bridged by the imposts, and stop short of the pilasters (on the end wall) and their equivalent on the side walls (the doorcase/painting/ balustrade projection units). This avoids the awkwardness found on the end wall in the model, where, in order to provide match for the impost moldings crossing the piers on the side walls, the pilasters are divided awkwardly by impost moldings in such a way that the lower part of the pilaster reads as an oversized pedestal to a squat shaft not much taller than itself. The lunettes formed by the bridging of the arches are shown glazed, while the rectangular spaces beneath open onto subsidiary spaces. Juvarra's plan of the terrace level (Gritella 1992: I, 292, fig. 510) shows what would have been intended on the side walls: smaller openings, a window in the nearer space, a doorway in the one further away, rather than the large glazed windows shown in Gritella's reconstruction, based in large part on the model (Gritella 1986: 112–13, fig. 89; 1992: I, 416–17, fig. 562). DRM

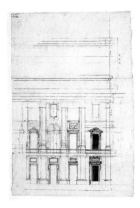

160 M
Carlo Randoni (1762?-1822)
Projects for the Castle of Rivoli
1792-93
Montreal, Collection Centre Canadien d'Architecture – Canadian Centre for Architecture, DR 1978: 0008: 001
Pen, brown and black ink on pencil, black water color; 412 x 283 mm

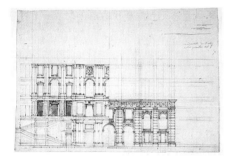

162 M
Carlo Randoni (1762?-1822)
Projects for the Castle of Rivoli
1792-93
Montreal, Collection Centre Canadien d'Architecture – Canadian Centre for Architecture, DR 1978: 0008: 004
Pen, brown and black ink on pencil, black water color; 274 x 410 mm

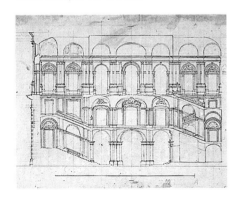

163 M
Carlo Randoni (1762?-1822)
Projects for the Castle of Rivoli
1792-93
Montreal, Collection Centre Canadien d'Architecture – Canadian Centre for Architecture, DR 1978: 0008: 0011
Pen and black ink on pencil
289 x 456 mm

165 M
Carlo Randoni (1762?-1822)
Projects for the Castle of Rivoli
1792-93
Montreal, Collection Centre Canadien d'Architecture – Canadian Centre for Architecture, DR 1978: 0008: 010
Pen, black ink on pencil and brown ink
600 x 438 mm

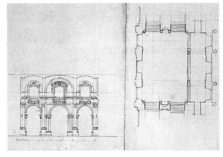

166 M
Carlo Randoni (1762?-1822)
Projects for the Castle of Rivoli
1792-93
Montreal, Collection Centre Canadien d'Architecture – Canadian Centre for Architecture, DR 1978: 0008: 006
Pen, black ink on pencil and brown ink
303 x 448 mm

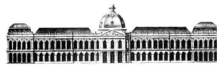

169 Ex catalogue
Robert de Cotte (1656/57–1735)
Projected Elevation for the Garden Façade of the Residenz, Würzburg
Berlin, Kunstbibliothek, Hdz 4682
Pen and ink; 31.6 x 63.5 cm

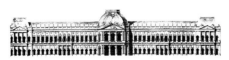

170 Ex catalogue
German Boffrand (1667–1754)
Projected Elevation for the Garden Façade of the Residenz, Würzburg
Berlin, Kunstbibliothek, Hdz 4683
Graphite, pen and ink, washes 23.2 x 94.7 cm

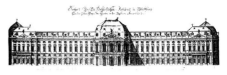

171 Ex catalogue
Balthasar Neumann (1687–1753)
Elevation of the Garden Façade (as Built) of the Residenz, Würzburg
Berlin, Kunstbibliothek, Hdz 4692
Pen and ink
BIBLIOGRAPHY: Sedlmaier and Pfister 1923: 25–41; *Germain Boffrand* 1986: 63–67; Neuman 1994: 67–72

The three drawings for the garden façade of the Würzburg Residenz bear witness to the complex history of one of the most celebrated palaces of the eighteenth century. Renowned for its combination of superb architecture and decoration, the building is an exceptional example of extensive collaboration in the creation of a palatial ensemble. No fewer than four principal patrons, five major architects, and a host of important painters and decorators contributed to its realization over some thirty-four years. Upon election as prince-bishop of Würzburg in 1719, Johann Philip Franz von Schönborn (ruled 1719–24) determined to abandon his lodgings in the Marienberg fortress above the city and take up residence in the town near the cathedral. The Schönborns were particularly interested in architecture, and thus two relations insisted on contributing ideas to the project – his brother Friedrich Carl, arch-chancellor of the Holy Roman Empire in Vienna, and his uncle Lothar Franz, elector of Mainz. They brought in various designers for consultation, notably the imperial architect in Vienna, Johann Lucas von Hildebrandt, and the elector's architect, Maximilian von Welsch. Nonetheless, the coordinating figure throughout construction was the Würzburg court architect, Balthasar Neumann (1687–1753), the most significant figure in German architecture of the period. He was present from the first design phase (1719) through completion of the building's shell (1744). Additionally, he oversaw decoration of the principal interiors, which include the famous sequence of four ceremonial rooms: the vestibule, imperial staircase (Treppenhaus), Weisser Saal, and Kaisersaal (1750–53). Neumann solicited the opinions of two royal architects who, as representatives of the latest fashions in architecture, were much sought after by European sovereigns for palace and villa designs in the first three decades of the century. As Premier Architecte du Roi, Robert de Cotte (1656/57–1735) had prepared plans for Schloss Schleissheim for Max Emanuel of Wittelsbach, elector of Bavaria (ca. 1714–15). For his brother Joseph Clemens, elector of Cologne, de Cotte created designs for the Residenz in Bonn and country houses at Poppelsdorf and Godesburg (1712–20). Also for Max Emanuel, Germain Boffrand (1667–1754) designed a hunting pavilion at Bouchefort (1705) and remodeled a house at Saint-Cloud (1713). Despite de Cotte's preoccupation with the affairs of his studio, he met with and greatly impressed Neu-

mann on several occasions: "I am unaware of whether de Cotte is known at all in Germany, [but] I find him and his son [Jules-Robert] to be very intelligent." The tenor of their meetings was different from those with Boffrand, "with whom," Neumann said, "I deal less formally." The rivalry between the two French masters was acknowledged by the German: "I didn't show either one the plans of the other, nor did I make positive comments, in order to prevent jealousy." In addition, Cardinal Armand-Gaston de Rohan-Soubise, one of the great art patrons of the period and the builder of a magnificent town house in Paris, received Neumann warmly, showing considerable interest in the Würzburg project and acting as liaison with de Cotte: "I myself am amazed that His Holy Eminence, the cardinal de Rohan, has invested so much effort [in the plans]." By 15 February Neumann met with the cardinal, who measured the drawings with a compass. In response to the architect's request, the cardinal provided drawings of his Château de Saverne in Alsace, where Neumann, on his way to Paris, admired the seventeenth-century imperial staircase. De Cotte's response to the project was recorded by Neumann. "After Monsieur de Cotte and his son, who is equally qualified, had inspected the plans, the father commented that the design showed many features in the Italian manner, and a few German ones." By Italian features he probably meant the oval chambers and the exterior elevations. He doubtless took the pinched size of the rooms and their sequence to be German. "He said that if he had a plan drawn in graphite [instead of ink], he could work on it," and so Neumann, unable to find an assistant, spent the night at the drafting table. De Cotte made several adjustments visible in a series of four extant plans: he eliminated one of the pair of imperial staircases on either side of the vestibule, enlarged the principal rooms in the apartments, placed them *en enfilade*, and added smaller rooms toward the interior courtyards. Two consecutive proposals by de Cotte for the garden façade remain. The second of these, exhibited here, consists of two storeys of arcades across the entire length of the façade, whose planar sweep is broken slightly by columnar projections on the upper floors of the wings connecting the pavilions. The two-storeyed pedimented frontispiece on axis, topped by a dome supporting a royal crown, derives from the French château tradition. De Cotte eliminated from the German project the mezzanine level between the two main floors, much to the patron's chagrin; following Italian and Viennese practice the prince-bishop wished to house his domestics there, and its inclusion rendered the main stair higher and more impressive. De Cotte emphasized the wings and pavilions as independent entities by virtue of the separate roofs and sharply contrasting articulation. It is evident that de Cotte saw his role as that of advisor, not designer. Neumann expressed disappointment with the Premier Architecte's inflexibility regarding the prince-bishop's wishes: "He did not adhere to Your Highness's stipulations, which I had indicated to him in the presence of His Eminence, the cardinal. I could not therefore make changes; the plans will serve to demonstrate [French] taste." The cardinal de

Rohan offered to intervene on the prince-bishop's behalf to persuade de Cotte to work further, but Neumann felt it useless to press "Monsieur de Cotte, who likes his own drawings best." Boffrand was more amenable to conforming to the wishes of the patron. Thus he was invited to travel to Würzburg; the trip took place between 24 June and 2 September 1724. He was conducted around various of the Schönborn palaces, such as Schloss Pommersfelden. He discussed the designs for the decor of the first episcopal apartment with the stuccoist Johann Peter Castelli, making corrections to some of the details, and he critiqued the plans for the Schönborn funerary chapel at Würzburg Cathedral. Boffrand's contribution to the project consists of the drawing exhibited here and six plates published later in his *Livre d'architecture* (1745), by which time the building had been constructed and his project represented an ideal solution. Boffrand's drawing of the garden elevation, shown here, consists of forty-five bays – eight bays more than the elevations of the other two architects. It accepts the German desire for mezzanines on both storeys, although they are concealed on the garden front. Despite these contributions by the French architects, the possibility of direct intervention from Paris came to an end with the untimely death of Johann Philip Franz in 1724, soon after Neumann's return from abroad. Construction entered a new phase in 1729 with the election of Friedrich Karl as prince-bishop (ruled 1729–46). He pushed for completion of the fabric and ensured the participation of Hildebrandt in the design of the elevations, especially on the courtyard side. Neumann's drawing of the definitive garden façade, exhibited here, comes from this period of intense construction (it is dated 1733). The elevation epitomizes his ability throughout the long design process to synthesize the contributions of the various collaborators and maintain continuity in overall proportions and lesser details between the various exterior façades of the building. Neumann yielded to the patron's desire for two mezzanines, despite their potential to threaten the monumentality of the façade and create a bourgeois impression. But the mezzanine system was a component of North Italian palazzo design, evidently known to Neumann, and here these lesser storeys are visually incorporated into two massive storeys – the ground floor delineated by means of channeled rustication, and the *piano nobile* emphasized by virtue of its height and classical adornment. The French character of the façade is apparent in the presence of pedimented pavilions on the ends, with their columnar balconies, and the large domed pavilion at the center, fronting the Kaisersaal, whose projecting surface is planar rather than oval. But the astylar walls of the flanking wings, so unlike their counterparts in the French designs, follow the lead of Hildebrandt and ultimately of Italy. When built, the façade was originally richly colored, the walls painted a warm yellow ochre, the architectural elements picked out in silver-gray, and the sculptural decoration highlighted in white and gold. In the final analysis, the three drawings suggest the intersection of several artistic traditions in palatial design. RN

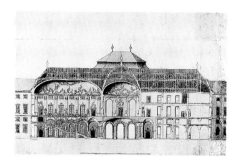

173 Ex catalogue
Balthasar Neumann (1687-1753)
Transversal Section of Würzburg Residenz
Berlin, Staatliche Museen zu Berlin, Kunstbibliothek, gift of Joseph Beitscher, 1926, Inv. no. Hdz 4701
Black lead, pen and india ink, gray wash
466 x 708 mm

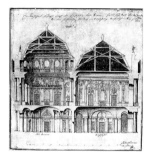

174 Ex catalogue
Balthasar Neumann (1687–1753)
Longitudinal Section of the Würtzburg Residenz
Berlin, Staatliche Museen zu Berlin, Kunstbibliothek. Hdz 4701 and 4690
Black lead, pen, india ink, gray wash
418 mm x 416 mm
PROVENANCE: Donated by Joseph Beitscher, Berlin, in 1926
EXHIBITIONS: Munich 1952: no. 81; Würzburg 1953: no. B23, fig. 20; Berlin 1966: no. 377; Berlin 1976: no. 5, fig. 4
BIBLIOGRAPHY: Herrmann 1928: 131–33, fig. 23; *Die Zeichnungen:* 29 and 39, pls. 9 and 19; Von Freeden 1963: 28–32, repr. pp. 30 and 31; 1981: 30 ss., repr. p. 33; Krückmann 1996: I, 48, figs. 5 and 6

The transversal section includes inscriptions which enable us to situate these drawings with accuracy in the genesis of both the residence's construction and Neumann's other projects. Signed in the lower right, the drawing is annotated in pen above: "Durchshnitt sowohl durch die Einfahrt, Sala terrena, Haubtsahl und Sal der gardes / Von der hochfürstl. Residenz in Würzburg verfertigt in Wien – 25 Febr. /1730/No. 8," and beneath the drawing on the left, "Sala terrena" and on the right, "Durchfahrt." Entrusted to Neumann in 1720 by the prince bishop of Würzburg, Johann Philipp Franz von Schönborn, the transformation of the small château into a grandiose residence went through many successive stages, while being also the object of numerous architectural debates involving and opposing Welsch, Dientzenhofer, Hildebrandt, not to mention the

Frenchman Robert de Cotte – for whom Neumann worked in Paris in 1723 – and Boffrand, who came to Würtzburg the following year. Construction underwent several interruptions, due as much to these various partisan arguments as to the succession of the prince bishops Christoph Franz von Hutten in 1724 and Friedrich Karl von Schönborn in 1729. In 1730, at the time when he was doing the transversal section, Neumann, architect and military engineer, finished the north-west building, and began the north wing (finished in 1731) and the south wing (finished in 1733). Despite the possible Bavarian models, the French influence remains potent, and the left-hand part of the drawing recall the Italian-style drawing room of the Palais Royal. Moreover, if one refers to Boffrand's *Livre d'architecture* (1745), one finds six plates engraved by Blondel devoted to the residence, as well as a *Profil du corps de logis entre cour et jardin* and a *Profil de l'escalier de Wurtzbourg*, very close to Neumann's drawings – apparently showing that he followed the ideas of Boffrand (Boffrand 1986: 63–68). The longitudinal section, dated by common consent to the years 1742–44, shows the work well under way, since the grand staircase seen on the drawing's left side (and to which Boffrand provided a symmetrical counterpart on the right-hand side) was begun in 1737, the 600 square meters self-supporting vault – the architect's crowning achievement – coming to an end in 1743. The size of the staircase (18 x 32 m), as well as its weight – set upon ground-level columns, each one of which bears 141 tons – make it the largest one of the château, as at Bruchsal and at Brühl. This project did not prevent Neumann, over the course of these same years, from working on other buildings or on the layout of Würzburg – of which he was the architect and urban planner. The drawing also shows the ornamental wealth of the apartments, the stuccos of Antonio Bossi amongst others, and the central square of the Weisse Salle. MRM

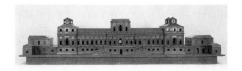

175 T–M
William Kent (1685–1748)
Projected Royal Palace, Richmond, Surrey
ca. 1735
Model
London, courtesy of Her Majesty the Queen
Pearwood; ca. 483 x 2362 x 1048 mm
PROVENANCE: Hampton Court Palace from 1773; Victoria and Albert Museum, London, by 1945; Bethnal Green Museum, London, by 1965; Kew Palace, Richmond (The Royal Collection Trust)
BIBLIOGRAPHY: Shaftesbury 1714: 395–410; Kimball 1932: 733ff., 800ff.; Jourdain 1948: repr. pl. 7; Wilton-Ely 1965: no. 5; Colvin 1968: 36–7, pl. 22; Wittkower 1974: 125; Harris 1981: 21–22; Wilson 1984: 171–72, repr. fig. 70; Wilton-Ely 1985: 70–72 (nos. 42-43)

A profound reaction in taste against the short-lived English Baroque style took place within the early years of the eighteenth century, closely bound up with the political ascendancy of the Whig party in politics which supported the constitutional Protestant succession of the Hanoverian George I and his successors. Already in 1713, a year before the death of Queen Anne, the Earl of Shaftesbury in his *Letter concerning Design*, addressed to Lord Somers, had been among the first to attack the achievements of Wren and his followers in the following words: "thro several Reigns we have patiently seen the noblest public Buildings perish (if I may say so), under the Hand of one single Court-Architect: who, if he had been able to profit by Experience, wou'd long since, at our expence, have prov'd the greatest Master in the World. But I question whether our Patience is like to hold much longer. The Devastation so long committed in this kind, has made us begin to grow rude and clamorous at the hearing of a new Palace spoilt, or a new Design committed to some rash or impotent Pretender." Within a few years, a response to Shaftesbury's call for a national style of design, untainted by associations with Catholicism and absolute monarchy, was launched by Colen Campbell's first volume of *Vitruvius Britannicus* of 1714. The 3rd Earl of Burlington, instructed in architecture by Campbell, used his considerable political influence and patronage to promote the Palladian revival not only in domestic buildings, but in royal as well as in government and public architecture. In 1732 Burlington had been asked to give an opinion on Hawksmoor's design for a new Parliament and, having initiated a fresh scheme, clearly encouraged Kent to develop it in the large group of surviving designs for this project, made between 1733 and 1739. It was about this time that Kent also appears to have been involved in the design for a royal palace for George II and Queen Caroline, as represented only by this surviving model. So far no contemporary documentation or drawings for this particular work have been found but many years later, according to the *Minutes and Proceedings of the Works* for 1 October 1733, it was: "ordered that the Model of a Palace (designed by the late Mr Kent) proposed to be built at Richmond which has been deposited in this office several years be sent to Hampton Court Palace" (information kindly communicated by Mr. John Harris). The model now lacks a dome over the central pavilion, similar to that on the Parliament design, and also shares many other features with the other project. The composition of Kent's palace displays that fragmentation into rigorously symmetrical and distinct units, such as pavilions and wings, characteristic of Palladian design (a *staccato* rhythm, in Summerson's words) in marked contrast to the highly sculptural and flowing movement over surface and silhouette of the Baroque designers. The design also contains the full range of Palladian vocabulary, including the emphasis on the *piano nobile* with an engaged Doric order over a rusticated basement, and a Serliana at the center of each major unit. The main staircase closely resembles that on the south front of Burlington's villa at Chiswick which derives from a Piedmontese source rather than from the Palladian canon. JWE

Caserta, Royal Palace
Jörg Garms

The Royal Palace of Caserta is the fruit of King Charles II of Bourbon's decision to create a residence that could contain all the ministries of the kingdom, far from the perils of a restless capital. With this aim in mind the king even removed the royal residence from the sunny holiday region between Vesuvius and the Bay of Naples – he in fact lived at Portici – though in doing so he was actually moving it nearer his beloved game preserves. For the purpose he summoned from Rome Luigi Vanvitelli who had built Ancona harbor and the great Augustinian monastery in Rome. Vanvitelli drew up the plans in the years 1750–51 and in 1751 moved to Naples. The foundation stone was laid on 20 January 1752 and Vanvitelli supervised the building until his death.

BIBLIOGRAPHY: Chierici 1937; Fagiolo dell'Arco 1963; Thoenes 1971: 587–612; Venditti, in *Luigi Vanvitelli* 1973: 101–29; Hersey 1983

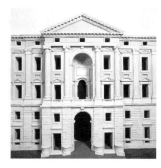

176 T–MAR
Model of the Central Part of the Façade, toward Naples and toward the Park
Caserta, Palazzo Reale, Museo Vanvitelliano
Inv. no. 3887
Painted wood; 75 x 215 x 50 cm
BIBLIOGRAPHY: *Mostra Vanvitelliana* 1973–74: no. 2; De Seta 1990: 113–28; *L'esercizio del disegno* 1993: 156, no. 3

This model was made on the orders of Vanvitelli by his trusted cabinet-maker, Antonio Rosz, a German of Dutch origin, and numerous assistants. Vanvitelli writes: "On the façade towards Naples in the middle, I have erected a pedestal and a column base […] With this pedestal I have determined the whole area and all the projections which adorn the Palace all round, and most of this is shown by the model which I have had made of one entire central part, all in strict proportion with the models of the Staircase and the Chapel. I may have a window made, too, with all its decorations[…]" (letter to his brother, 16 February 1760). The left half of the model corresponds to the façade toward Naples, the right half to that facing the garden. The model diverges from the actual building only in a few details inside the central niche, in the absence of the festoon over the lateral passages, and in the fluted jambs of the windows on the first floor on the garden side. On the pedestals at the sides of the main entrance and on the balustrade were placed some small wax statues by Solari. JG

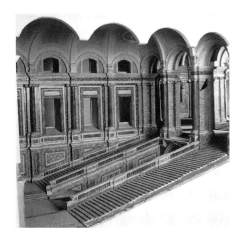

177 T
Model of the Central Nucleus: the two vestibules one above the other between the staircase and the chapel
Caserta, Palazzo Reale, Museo Vanvitelliano
Inv. no. 3869
Painted wood
122 x 82 x 100 cm, 108 x 128 x 58 cm and 90 x 218 x 70 cm
BIBLIOGRAPHY: *Mostra Vanvitelliana* 1973–74: no. 1; De Seta 1990: 113–28; *L'esercizio del disegno* 1993: 155, no. 1

The model was begun in 1756, after the printing of the *Dichiarazione*, but completed with the statuettes of Solari only in 1760. Vanvitelli's intention with this model was to convince and to impress. His hopes, which rested on the staircase, proved justified. It was reported to him that on the king's third visit in Jan. 1759 the view of the model filled the king with an emotion "fit to tear his heart from his breast." At the time of the royal couple's first visit to see the model, in 1797, Vanvitelli gave up, thinking it over-ambitious, the idea of making models of the gallery and the chapel too, but in 1758 he took up the idea of building a model of the chapel once again, "to see it all together, and to find a support to lighten the vault, so that it does not press too heavily on the columns of yellow marble (not a very strong substance)." The model, or rather models, were made by Rosz and his assistants (prominent was the gilder Ferdecchini). JG

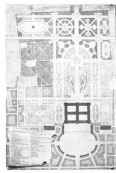

178 T
Overall Plan
Caserta, Palazzo Reale, Museo Vanvitelliano
Inv. no. 857
Pen and black ink, color-washed in gray and green; 605 x 915 mm

BIBLIOGRAPHY: De Seta, in *Luigi Vanvitelli* 1973: 298–99, no. 114/I; 1974: 287–96; *L'esercizio del disegno: I Vanvitelli* 1991: 120–21, no. 284 (A. Pampalone)

This drawing and the following ones were made for the use of the engravers of the plates of the *Dichiarazione*. This particular drawing relates to plate I. Another series of plans probably served for the presentation to the royal family; at any rate it precedes this one and shows slight differences from it (Inv. no. 3322=374a; Garms 1973: nos. 138–44); in no. 138 the fish-pond is still missing, and the flowerbeds are different. The plan, which has a detailed index (with forty-five entries), represents the new city around the great frontal square rather schematically. The square, which is modelled on St. Peter's Square, is the point of intersection of the roads to Naples (on the axis of the palace) and to Santa Maria di Capua Vetere (the Via Appia, parallel to the façade). The wings were intended to house the stables, the coach-houses, and the servants' quarters. JG

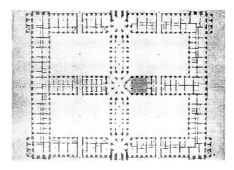

184 MAR
Plan of the Ground Floor of the Palace
Caserta, Palazzo Reale, Museo Vanvitelliano
Inv. no. 864
Pen and gray ink, color-washed in gray
684 x 915 mm
BIBLIOGRAPHY: De Seta, in *Luigi Vanvitelli* 1973: 299, no. 114/II; *L'esercizio del disegno* 1991: 121, no. 285 (A. Pampalone)

The quadrilateral, measuring 247 x 184 m, follows the tradition of the Italian palace as a closed block with an internal courtyard, with the difference that the large rectangle is here subdivided internally by two wings in the form of a cross, rather in the tradition of the monasteries and hospitals (for example, the Ospedale dei Poveri in Genoa). This scheme was preceded by half a century by two never-realized projects for royal palaces. The first (1698) was designed for the prince of Liechtenstein by Carlo Fontana, the leading Roman architect, successor of Bernini and teacher of the teachers of Vanvitelli. The second was designed for king Charles's father (Buen Retiro, in Madrid, 1712–15) by the chief architect to the King of France, the successor of Jules Hardouin Mansart. Vanvitelli's brilliant innovation, however, is the use of the central wing of the ground floor as an "optical telescope" to create an overwhelming sense of depth and to give a theatrical effect of enormous size. In the plan the palace is traversed by the axis of the road leading from the capital which continues as far as the mountain from which the waters that feed the fountains in the gardens flow. The central transverse wing contains the principal ceremonial rooms of the palace: the staircase, the chapel and the court theatre (added slightly later and not included in the plan). The three vestibules along the depth axis, especially the central one, have a distributive function – visual and practical – not only in the principal directions, but also in the diagonal. One drawing (Caserta, Inv. no. 1681; *L'esercizio del disegno*: no. 283) shows that in the original plan these compositional effects were more precise, for the entire structure, and consequently the internal courtyards too, had been planned as square (in a letter the architect mentions that he also proposed to decorate each of the four courtyards in a different manner). Eventually the main façade was lengthened by 27 (or 31) axes to 37. The drawing is preparatory to plate II of the *Dichiarazione*. In the second edition the theater was inserted in the east wing. In Inv. no. 3322 (=374b; Garms 1973: no. 139) the subdivision of the rooms is different and the lateral passageways are simpler. JG

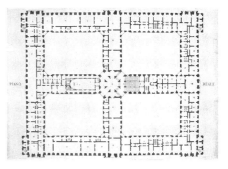

179 T
Plan of the First Floor of the Palace
Caserta, Palazzo Reale, Museo Vanvitelliano
Inv. no. 868
Pen and gray ink, color-washed in gray
583 x 804 mm
BIBLIOGRAPHY: De Seta in *Luigi Vanvitelli* 1973: 299, no. 114/III; *L'esercizio del disegno* 1991: 121, no. 286 (A. Pampalone)

On the first floor the reasons for the internal distribution become clear: from the upper central vestibule begin the *enfilades* of the two royal apartments with the halls of the guards (C-D), the antechambers (E-G), and the reception rooms (H-I).
The apartments continue along the façades; the king's apartments are on the city side, the queen's overlooking the gardens.
The west outer wing contains the private rooms with an internal communicating gallery (V); the east wing is reserved for the princes with an oval room with niches in the corners (VIII). The vestibule, on the transverse axis, is flanked by the entrance on one side and the chapel on the other.
The drawing is preparatory to plate III of the *Dichiarazione*.
In Inv. no. 3322 (=374c; Garms 1973: no. 140) the linking room (marked E in the *Dichiarazione*) is round, and the few steps between the stairs and the upper vestibule are in a less advantageous position. JG

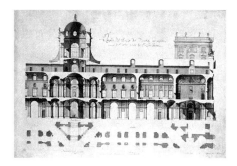

181 T
Section of the Central Wing, from the Front
Door to the Vestibule
Caserta, Palazzo Reale, Museo Vanvitelliano
Inv. no. 856
Pen and gray ink, color-washed in gray
588 x 896 mm
BIBLIOGRAPHY: De Seta, in *Luigi Vanvitelli*
1973: 300–301, no. 114/IX; *L'esercizio del disegno* 1991: 124, no. 292 (A. Pampalone)

This section shows the refined decoration of
the great portico and the vestibules above. One
can also see the decoration of the three antechambers giving access to the royal apartments. This decoration was later executed, in
about 1780, with slight modifications in a Neoclassical direction in the first two rooms and
with more significant changes in the third (the
Alexander Room).
The drawing is preparatory to plate IX of the
Dichiarazione. JG

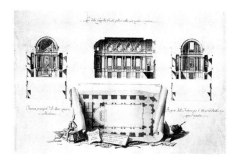

182 T
Chapel
Caserta, Palazzo Reale, Museo Vanvitelliano
Inv. no. 863
Pen and gray ink, color-washed in gray
598 x 895 mm
BIBLIOGRAPHY: De Seta, in *Luigi Vanvitelli*
1973, 301, no. 114/XII; *L'esercizio del disegno*
1991: 123–24, no. 294 (A. Pampalone)

In an early sketch Vanvitelli designed the chapel
with a central plan.
The final form, longitudinal and on two full
floors, imitates the chapel at Versailles (certainly on the orders of the king). In the building of the chapel the main change was in the
decoration of the vault, which was rendered in
a more classical style. The statues between the
columns were never made and the tabernacle
on the high altar was only made in the form of
a wooden model.
The drawing is preparatory to plate XII of the
Dichiarazione. JG

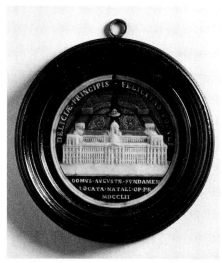

188 T
Model of the Medal for the Laying of the
Foundation Stone
Naples, Museo Nazionale di San Martino
wax; diameter 72 mm
BIBLIOGRAPHY: Garms 1974: 164–65; Schiavo
1978–79: 333–58; *Civiltà del '700* 1980: II, 84
and 236, no. 505; *All'ombra del Vesuvio* 1990:
320

The medal was deposited on 20 January 1752
in the foundations, in three copies (gold, silver,
and bronze), and the die was destroyed on the
king's orders. The model, the designer of
which is unknown, is therefore the only surviving evidence. The casting was carried out in
Rome by the papal engraver Ermengildo Hamerani, who was of Bavarian origin. The portraits of the royal family on the obverse were
modelled on a drawing by Giuseppe Bonito,
while the image of the palace on the reverse
was taken from a drawing by Vanvitelli himself. On the medal the view of the palace,
which is reduced to essentials and rigorously
frontal, is seen in a bird's-eye view, as in plate
XIII of the *Dichiarazione dei disegni del Reale
palazzo di Caserta: alle Sacre Reali Maestà di
Carlo Re delle Due Sicilie e di Gerus, Infante di
Spagna, Duca di Parma e di Piacenza, Gran
Principe Ereditario di Toscana, e di Maria
Amalia di Sassonia Regina* (printed at Naples in
1756, format 83 x 55.5 cm). Vanvitelli had the
same view engraved as a vignette on pl. I of the
work (in this representation the central dome
really has the shape of a crown). On the obverse is the inscription: "CAROLVS UTRIUSQUE
SICILIAE REX ET MARIA AMALIA REGINA," and in
the exergue "DOMUS AUGUSTAE FVNDAMEN[TA]
LOCATA NATALI OP[TIMI] PR[INCIPIS] MDCCLII;"
on the reverse is another inscription: "DELICIAE PRINCIPIS FELICITAS POPVLI", and an inscription on the frame states that the king gave the
model to Lodovico di Costanzo, duke of Paganico, in 1754. JG

The Model for the Great Kremlin Palace, 1769–73
Z. V. Zolotnickaya

In eighteenth-century Russian architecture an
important part in the planning of large constructions was played by the making of models
of the proposed buildings. Executed with great
accuracy, to a predetermined scale, the models
made it possible to get a realistic three-dimensional idea of the building, and to appreciate the
beauty of the composition, the regularity of the
proportions, the correlation between the forms,
and the precision of the details. In addition to
their practical usefulness, the original models
had an illustrative significance, in presenting a
clear picture of the future building, something
particularly important for the commissioner of
the project. Bazhenov had this to say about models: "In order to understand how beautiful and
excellent the building will really be, he [the architect] must inevitably imagine it in perspective; and in order to be even more convinced of
it, he must make a model for it, indeed the making of the model is considered to be half the
work." For the construction of the model of the
Kremlin a special model house was built, and a
team of craftsmen was hand-picked from the
staff of the Department for the Building of the
Kremlin. The extraordinary nature of the model, and the exacting standards of Bazhenov himself, who personally directed the work on it,
were matched by a high level of skill in its creators. The sculptor E. Uryadov, the medalist F.
Stoyanov, and the painters M. Maximov and I.
Nekrasov, were all students of the Academy of
Arts. The model was made of various materials
which were carefully chosen for their strength
and for the faithful reproduction of the design.
The basic structure was of lime wood, but the elegant molded cornices were carved from maple,
and for the internal decoration apple and pear
wood was used. The miniature details of the architectural decoration were cast in lead, which
made for greater precision. It is known that
Bazhenov requested the necessary specimens of
marble before the embellishment of the interiors
of the ceremonial rooms of the model with "imitation marble" was begun. Even during the construction phase the model was already one of the
great attractions in Moscow. After Bazhenov
had obtained the personal approval of Catherine
II, from May 1771 onward the public, "with the
exception of the common people," was admitted once a month to the model house. There are
records of inspections by such distinguished visitors as the khan of Crimea and the prince of
Prussia. The model has survived in two versions.
The first was completed in the years 1769–71
and is a model of the whole projected complex.
The second includes only the central part of the
palace with those changes to the project that had
been proposed by Catherine. It was made in the
years 1772–73. For the final ratification of the
project the model was transported in early 1774
to St. Petersburg, where it was displayed to the
Russian sovereign in a special building erected
for the purpose on St. Isaac's Square. After its
return to Moscow it was again placed in the
model house. Contemporaries and later genera-

Contemporaries and later generations have acknowledged the uniqueness of the model as an outstanding monument of the classical period. N. M. Karamzin made the following interesting comment: "In the Kremlin department a sight that really must be seen is the splendid model of Bazhenov's magnificent palace, the foundations of which were laid between the Archangel's Cathedral and the Moscow River, but which was soon abandoned because of the unsuitability of the site. [...] The plans of the architect Bazhenov were like Plato's *Republic* or Thomas More's *Utopia*: we can marvel at them only in our dreams, not in reality." The model has preserved for us a three-dimensional image of an unrealizable project as well as the beauty and perfect proportions of Bazhenov's architecture. The central part of the model can be taken apart and the observer is able to look at the ceremonial halls of the palace: the throne room, the oval galleries, and the vestibule. Very few of the interiors designed by Bazhenov have come down to us, so those in this model are particularly valuable.

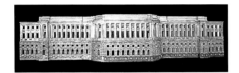

189
Vasily Ivanovich Bazhenov (1738–99)
Model for the Façade of the Kremlin Palace
Moscow, A.V. Shchusev State Research Museum of Architecture

190
Vasily Ivanovich Bazhenov (1738–99)
Model for the Stairway of the Kremlin Palace
Moscow, A.V. Shchusev State Research Museum of Architecture

191 T–M–W
Vasily Ivanovich Bazhenov (1738–99)
Model for the Throne Room in the Kremlin Palace
Moscow, A.V. Shchusev State Research Museum of Architecture

192
Vasily Ivanovich Bazhenov (1738–99)
Model for the Exedra in the Kremlin Palace
Moscow, A.V. Shchusev State Research Museum of Architecture

193
Vasily Ivanovich Bazhenov (1738–99), copy
Plan of the Third Floor of the Great Kremlin Palace
1769

Moscow, A.V. Shchusev State Research Museum of Architecture, RI-3984
Paper, double canvas, cardboard, india ink, wash, lacquer 85 x 73 cm
Copy from the workshop of V. I. Bazhenov
PROVENANCE: The Armoury Chamber, 1936
EXHIBITIONS: *Architektor V. I. Bazhenov*, Moscow, 1988; *Ekaterina Velikaya i Moskva*, Moscow, 1997; *Catharina die Grosse*, Kassel, 1997–98
BIBLIOGRAPHY: Michailov 1951; *Architektor V. I. Bazhenov*, 1988; *Ekaterina Velikaya i Moskva*, 1977

In 1767 Catherine II commissioned Vasily Ivanovich Bazhenov to design the College Block, an administrative building in the Moscow Kremlin, which was needed for the activities of the commission responsible for drawing up the new legal code. However, the architect went much further than this: driven by the high ideals of the Enlightenment and by his own desire to realize his creative potential, he proposed to the empress a far larger project, that of redesigning the entire Kremlin. "The foundation of these magnificent rooms is dedicated to the glory of the great empress, to the honor of her century, to the immortal memory of future ages, to the beautification of the capital city, to the delight and pleasure of her people:" thus Bazhenov expressed the significance of his project.
Although the project was never realized, it had an enormous influence on the Russian architecture of early Classicism. The exhibition includes just three drawings from the great series of plans, which covered all the different versions of the projected complex. They were all executed in the Department for the Building of the Kremlin, which was created for the planning and execution of the project. The plan shows us the dimensions of the new complex, which was to encompass the whole of the Kremlin and even extend beyond its limits. The main part of the building, the palace, occupies the whole riverside sector from the Spassky Gate to the Borovitsky Gate. The center of the composition was to be an oval square with three radial avenues leading off to the other gates of the Kremlin. In order to enhance the grandeur of the square, Bazhenov intended to adorn it with a triumphal column and four obelisks. Facing on to the square were the main palace gate and the theater doorway. VR, ZVZ

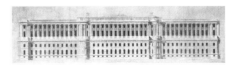

197
Studio of Vasily Ivanovich Bazhenov
Great Kremlin Palace, Prospect
1769
Moscow, A.V. Shchusev State Research Museum of Architecture
Paper, double canvas, cardboard, india ink, wash, lacquer 85 x 73 cm
PROVENANCE: The Armoury Chamber, 1936
EXHIBITIONS: *Architektor V. I. Bazhenov*,

Moscow, 1988; *Ekaterina Velikaya i Moskva*, Moscow, 1997; *Catharina die Grosse*, Kassel, 1997–98
BIBLIOGRAPHY: Michailov 1951; *Architektor V. I. Bazhenov*, 1988; *Ekaterina Velikaya i Moskva*, 1977

This drawing of the façade shows Vasily Ivanovich Bazhenov's artistic style and his exceptional ability to conceive architectural forms on a grand scale. It demonstrates the strength of the two lower floors, a distinctive stylobate supporting the colossal mass of the palace. By varying the rhythmic and plastic composition of the orders, Bazhenov avoided the danger of monotony in the huge façade. The architect succeeded in achieving a harmonious balance between the majestic size of the building and the refinement of the decorative details. Behind this façade, on the two upper floors, he proposed to locate the great ceremonial halls of the palace: the throne room and two symmetrical antechambers. VR, ZVZ

194
Studio of Vasily Ivanovich Bazhenov
Section of the Oval Square of the Great Kremlin Palace, 1769
Moscow, A.V. Shchusev State Research Museum of Architecture
Paper, double canvas, cardboard, india ink, wash, lacquer 85 x 73 cm
PROVENANCE: The Armoury Chamber, 1936
EXHIBITIONS: *Architektor V. I. Bazhenov*, Moscow, 1988; *Ekaterina Velikaya i Moskva*, Moscow, 1997; *Catharina die Grosse*, Kassel, 1997–98
BIBLIOGRAPHY: Michailov 1951; *Architektor V. I. Bazhenov*, 1988; *Ekaterina Velikaya i Moskva*, 1977

This drawing presents a cross section of the oval square or, as it was called in Vasily Ivanovich Bazhenov's time, the Bolshoy Place. The square was planned as the center of the ensemble, so its great semicircular façade was adorned with a continuous colonnade. The base of Bazhenov's colonnade was a projecting four-stepped plinth, forming a huge amphitheater. This drawing is a faithful copy of the drawing bearing a note approving the project, dated 31 January 1769, in the hand of Catherine II. VR, ZVZ

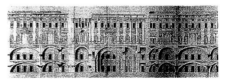

195 T–W
Vasily Ivanovich Bazhenov (1738–99)
Project for the Reconstruction of the Kremlin
Paris, Bibliothèque Nationale
Pencil; 68 x 255 cm

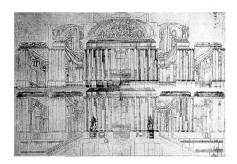

198 T–W
Vasily Ivanovich Bazhenov (1738–99)
Elevation of the Great Stairway in the Kremlin Palace

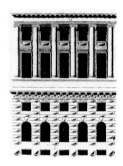

196 T–MAR
Vasily Ivanovich Bazhenov (1738–99)
Elevation of the Façade of the Great Kremlin Palace

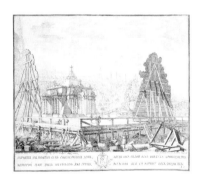

199 T
Matvei Fedorovich Kazakov (1738–1812)
Representation of the Decorative Buildings Erected for the Ceremony of the Laying of the First Stone of the Great Kremlin Palace
2 June 1773
Moscow, A.V. Shchusev State Research Museum of Architecture
Paper, pen, india ink, 51 x 59 cm
PROVENANCE: State Russian Museum, 1934
EXHIBITIONS: *The Architect M. F. Kazakov (for the 225th anniversary of his birth)*, Moscow 1963; *M. F. Kazakov (for the 250th anniversary of his birth)*, Moscow 1988; *Catherine the Great and Moscow*, Moscow 1997
BIBLIOGRAPHY: Michaylov 1951; Vlasyuk, Kaplun, Kiparisova 1957; *Ekaterina Velikaya i* 1997

The well-known Moscow architect M. F. Kazakov was Bazhenov's chief assistant in the planning and building of the Great Kremlin Palace. To him we owe two pen drawings which record two important ceremonies, those of the com-

mencement of the excavations and the laying of the palace foundations. These drawings are the only visual records of these events, which are highly interesting occasions in the architectural history of Moscow. Kazakov gives a very detailed view of the Kremlin after the demolition of the southern section of the wall in the summer of 1772. He was a skillful draftsman, and here he not only depicts the complex of the festive buildings in all its detail but also enlivens the drawing with numerous human figures, creating an impression of vigorous activity. The center of the activities of the ceremony was a wooden platform surrounded by boards adorned with allegorical animal images. In the middle of this platform was erected a triumphal building richly decorated with trophies of war, allegories of the four parts of the world, and figures of Fame. A wooden stairway covered by a scarlet awning led from the platform up to the Kremlin hill. On the day of the laying of the foundation stone the picturesque ensemble was completed by living trees and flowers. The sumptuous decoration and rich allegories were intended to extol the merits of Empress Catherine II and the might of the Russian army. It is known from a detailed description of the ceremony that a marble vase containing gold and silver medals, six marble blocks bearing the initials of Catherine II and her heir Paul, and a gilded plaque with a text recalling the laying of the foundation stone were placed in the earth. VR, ZVZ

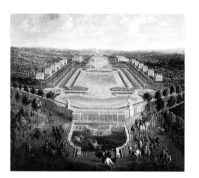

201
Pierre-Denis Martin (ca. 1663–1742)
Château de Marly, 1723
Versailles, Musée National des Châteaux de Versailles et de Trianon, Inv. M.V. 741
Oil on canvas; 137 x 155 cm
BIBLIOGRAPHY: *Versailles* 1951: no. 40; *The Sun King* 1984: no. 207; *Les chevaux de Marly* 1985; Pérouse de Monclos 1989: 299; Constans 1995: no. 3508; Lablaude 1995: 111

Work on the Château de Marly began in 1679 and was for all intents and purposes finished in 1683. In building this new palace only a short distance from Versailles, the king sought a more secluded residence, where he could spend short visits with family members and his closest courtiers. These relatively intimate sojourns were much coveted: an invitation to Marly was an envied sign of favor. The purpose of the new residence explains the original conception behind its design, which, contrary to Versailles, would be respected to the end. The composi-

tion was centered around a veritable axis of water, beginning with the waterfall which cascaded down from the hilltop behind the palace. A series of water pieces (known as the Winds, the Sheaves, the Great Piece, the Layers) followed one upon the other as far as the Watering Trough, set below the palace (in the foreground of the painting). The predominance of water, one of Marly's particularities, bears witness to the king's will to take advantage of an element which he found so lacking at Versailles. A central wing, reserved for the king and his close entourage, dominates the rest, while two lines of secondary wings connected by clipped hedges and intended for guests are set on both sides of the basins. The splitting of the building into separate wings, and the intimate fusion between the buildings and their plant environment count as the most innovative aspects of Marly's general conception, and had a very striking effect on people at the time. Louis XIV never ceased to enrich his gardens, permanently modifying the design and decor of the copses and flower beds, adorning them with an ever-increasing number of sculptures. The large commissions necessitated by the work made Marly the largest sculptural work site in the latter part of his reign. Martin's depiction shows the palace after the installation of two groups of the "Renommé du Roi" (King's Renown) the very famous *Chevaux de Marly* (Horses of Marly), delivered by Coysevox in 1702, and subsequently removed in 1719 to be placed at the far end of the Jardin des Tuileries. The Marly Palace, amongst Louis XIV's most beautiful and successful creations, was destroyed in the early nineteenth century FD

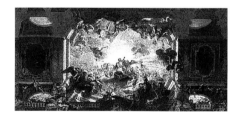

202 MAR
Antoine Coypel (1661–1722)
Assemblée des dieux
Angers, Musée des Beaux-Arts, Coll. Livois; Inv. 38 J. 1881
Oil on canvas; 95 x 195 cm
PROVENANCE: Sketched and painted in 1702 for the Palais-Royal ceiling, destroyed along with the Aeneas Hall in 1781, and carried out in 1703. Sold after the death of Charles-Antoine Coypel, 1753, no. 93, purchased by Philippe Coypel; sold after his death, 1777, no. 16; Collection Livois; entered the Musée d'Angers in 1881, at the same time as the sketch *Vénus demandant à Vulcain des armes pour Enée* also part of the Palais-Royal decor
EXHIBITIONS: Lille 1968e: no. 40; Brussels 1975: no. 29, repr. p. 77; Paris 1988: cat. 68, repr. p. 89
BIBLIOGRAPHY: Brice 1717: I, 204; Dezallier d'Argenville 1749: 7; Coypel 1752: 20–22; Papillon de la Ferté 1776: 580, 583; Jouin 1882: no. 38, and 1885, no. 18; Guiffrey-Marcel 1909: X,

XI; Dimier 1928: 111–14, 131, no. 43; Schnapper 1968: 343, repr. 4; 1969: 35, no. 5, 38–39, repr. 6; Blunt 1970: 238; Schnapper 1974: 116, 120, 121, 127, repr. fig. 267; Huchard 1982: 40, repr.; Garnier 1984: 137; *Louvre* 1987: 40, no. 48; Pons 1986: 210; Garnier 1989: no. 90 (including a complete bibliography), reprod. fig. 184; Scott 1995: repr. fig. 126

The ceiling of the Aeneas Hall at the Palais Royal, which would have been Coypel's principal work had it not been destroyed before the end of the eighteenth century, is known to us now only through preparatory drawings, sketches and engravings. Commissioned in 1702, finished in 1705 (the mural panels being added on between 1714 and 1717), its subject was *Vénus implorant Jupiter en faveur d'Enée*, but has been referred to as the *Assemblée des dieux*, because of the many figures which it brings together. It is presented as a fictional breach in the heavens, decorated with human figures around the edges and in its centre. On both sides of the breach, false architectural constructions and false arcades – probably done by Philippe Meusnier based upon drawings by Coypel – separate the central ceiling from added-on paintings which extended all the way to the cornice. The drawing of the sculptural works (trophies, cornice, painting frames) was done by Oppenord. N. Garnier (1989) has pointed out that this "mixed system, comprising at once added-on paintings and decorative *trompe-l'oeil* recalls the Farnesi Hall, which the artist had copied in his youth in Rome." Three of these archivolt paintings are also known to us through sketches of them: *Junon commandant à Eole de déchaîner les vents* in Arles (Garnier 1989: no. 91), *Quos Ego* in Angers (Garnier 1989: no. 92), *Vénus demande à Vulcain des armes pour Enée* (Venus asking Vulcain for arms for Aeneas) also in Angers (Garnier 1989: no. 93). To date, however, the sketches of the other three have still not been recovered: *Les vaisseaux d'Enée changés en nymphes* (Garnier 1989: no. 94), *Mercure envoyé par Jupiter pour dissuader Enée de s'établir à Carthage* (Garnier 1989: no. 95) and *Junon invoquant la Furie Alecto* (Garnier 1989: no. 96). The laudatory reviews of contemporaries as much as the superb preparatory drawings and the engravings make it possible to imagine the painting's original layout in the Gallery as well as their quality, making this decoration's disappearance – like the loss of the other elements done at the Palais Royal in the early eighteenth century – one of major losses of the time, comparable to that of the Ambassadors' Staircase in Versailles.　　　MRM

Landscapes and gardens

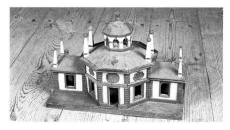

203　T
Johan Crämer, model maker
Jean de la Vallée (1620–96), architect?
Model for an Unidentified Pleasure Pavilion possibly for Skokloster Slott, 1750s
Uppsala, Skoklosters Slott, Inv. no. 6928
Wood: white walls, architectural details in gray; green roof; 27 x 39.8 x 21 cm
BIBLIOGRAPHY: Karling 1931: 468–77; Andrén 1948: 169–80; Reuther 1994: no. 363

No information on Johan Crämer is available. Reuther suggests the model is an early, rejected project for a pleasure pavilion located on the shore in front of Skokloster Castle, for which in 1669 Jean De la Vallée (1620–96) designed a rather grand harbor arrangement intended for the reception of guests and goods from the sea, the Sjögården. The Crämer model does not correspond with De la Vallée's design and seems not to be adapted to any of the functions of an expected harbor pavilion. There exists a drawing by Jean De la Vallée (Skokloster Archive) showing a project for a formal garden. This plan was never carried out, however, and as late as 1674 the Italian visitor Lorenzo Magalotti described the garden as still being in preparation. Pleasure pavilions were very rare in Swedish seventeenth-century garden architecture. A pavilion, the grotto, with an exterior rather similar to Crämer's model, was erected in the garden of Jakobsdal (now Ulriksdal) Palace outside Stockholm for Jacob de la Gardie, the queen's favorite, between 1647 and 1652 (still existing in 1821, but since demolished). The form of Crämer's pavilion with its octagonal central portion with a central clerestory and two small wings is rather intriguing, and seems to presume some special function. The eight obelisks that adorn the roof are a rare iconographical detail. The House of Nobility in Stockholm, completed in 1674 by Jean De la Vallée, is adorned with four obelisks on its roof. According to Ripa, the obelisk represents the *Gloria de' principi*, which suggests that this pavilion was meant as a memorial.　　　PB

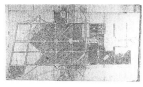

204　MAR
André Le Nôtre (1613–1700)
Plan for the Vaux Gardens (project)
ca. 1656–58
Paris, Bibliothèque de l'Institut de France, ms. 1040, fol. 14 (Réserve)

Plan washed in blue, green and gray; black pencil, brown ink; 132 x 75 cm
PROVENANCE: André Le Nôtre agency (Pierre Il Desgots ? died in 1688)
EXHIBITIONS: Badische Landesmuseum, Karlsruhe,1990, 28
BIBLIOGRAPHY: Cordey 1924; Ganay 1962; Hazlehurst 1980: 17–45; Weber 1985: 89–96, 266–68; Rostaing 1994: 45–53, 11 and V, 104–08; Moulin 1995: 1–34, 1

The magnificent watercolored plan of the Vaux gardens, invented by Le Nôtre for superintendent Fouquet, is of capital importance in the history of gardens. On the reverse side it bears a single hand-written annotation ("forecourt"), in an unidentifiable hand, but it seems to have been done entirely by Pierre Il Desgots, nephew and collaborator of Le Nôtre (see Chantilly's plans at the Musée Condé, in Chantilly: 81 Q 11, 83 M 47, or at the Nationalmuscet in Stockholm: THC 7803, THC 7924). Prior to the gardens' completion, interrupted by the owner's arrest, this project was never carried through to its conclusion, as is shown by Le Nôtre's hand-written caption, written on the overleaf: "plan of the palace of Vaux-le-Viconte belonging to Monsieur Fouquet and several others which were carried out." The end of the sentence ("and several others which were carried out"), written in darker ink and in a slightly different hand, was added later, and designates other of Le Nôtre's projects which have today disappeared. Was it of one of these very plans that Fouquet's brother proposed "to have somewhat inspected" in Rome in a letter dated 16 August 1655? In any case, the Vaux gardens became the primary expression of French "great taste." These gardens were created in one fell swoop, in spectacular conditions, which did not go unnoticed in their day, necessitating an operation which fully rivaled the mountains of earth moved in Versailles. Fouquet purchased the seigniory of Vaux on 1 February 1641. No sooner had work begun than the acquisitions of land increased between 1648 and 1653. Subsequently, and up until 1656, they concerned the land situated to the south, beyond the Anqueil, which was turned into a canal sometime around 1658. They therefore coincided with the beginning of the major earthmoving and water-channeling works undertaken as of 1652, before the construction of the palace (1656). The belvederes situated at the far eastern ends of the ponds are shown on the plan. The waterfalls (1657) and the grotto (Lespagnandel 1659) were built at the end of the worksite, as was the watergrill (Lespagnandel, April 1659), which does not appear on any of the plans. According to the evidence provided at Fouquet's trial, work was undertaken in 1658 on the avenue, the bridge, the reservoir and the aqueduct. On the plan, the access routes to the palace were only faintly penciled in. The commons were simply sketched in, and the grill, adorned with Lespagnandel terms, sculpted between 1660 and 1661, does not appear at all. The Royal flower-bed and meadow arrangements are identical both on the plan and in the views engraved by Silvestre. Unfortunately the only description of the gardens themselves is literary. Their state in 1664 is unknown to us: the king's

expert on buildings was refused entry when he came to evaluate the extent of the deteriorations suffered by the unfinished building, sequestered by order of the king. But a 1697 maintenance contract describes them planted with elms, pines, arbors, chestnuts, lindens, horse-chestnuts, yews and box wood. The Institute's document is amongst the oldest-known French garden designs; it is also the first overall plan for a 17th-century garden, and the first project to have been conceived by a gardener. No other major work is known to have existed previously which had been done by someone in the trade; those done by architects – Le Muet, Mansart, Le Vau – never got out of the shadows. Like Rueil and Liancourt, those in Meudon and Saint-Cloud in 1630–40 were without an author. King's gardener at the Tuileries since 1637 and draftsman of the gardens for the king and his bother Gaston d'Orléans since at least 1639, Le Nôtre signed his first masterpiece at Vaux. AR

the Institute's plan. Pouilly's future half-moon did not yet have its final form, which is to be seen on the plan of the Institute, superimposed on a penciled-in set-up of a bastioned form, apparently ending up in a ditch. The gazebos situated at the far eastern ends of the pond and the rondeau, which can be seen on the Institute's plan, are shown differently on the engraving. On both sides of the palace, one can see the edges of rooms which are absent on the Institute's plan, where this space is left blank. Water seems diverted and channeled toward the north-west, near the Twins; the wood projected for this site on the Institut's plan was never planted in the seventeenth century. On both plans, however, one sees the circular esplanade which was finally made part of the project. The plan drawn by Silvestre thus expresses an intermediary stage of work; it was probably engraved before the Institut's plan which came only later. AR

on the gardens, is simply masked behind a new stone façade, and can be seen at the end of the terrace. Two blocks jut out from the western extremities of the two new wings built to house the royal apartments – the queen's in the south, the king's in the north. The apartments themselves go from east to west, most of the rooms looking out on the basin: a large study, a small room, followed by a small study opening onto the terrace. The façade's design seems to have been the object of numerous hesitations and its paternity has not been established with certainty. Another project is conserved at the National Museum of Stockholm (Coll. Cronstedt: CC 271): its façade, punctuated by an order of colossal pilasters, is noticeably more squat than the façade actually built, with neither the forefront made up of columns, nor the sculpted tables, the balustrades or the trophies. Comparison reveals that the actual choices all tended toward enlargement – the construction of a square floor at the attic level, for instance – greater richness in terms of the decor. In constructing the hall of mirrors, begun in 1678 where the terrace had been, and eliminating the sculpted tables in order to raise the windows and give them their arched form, Mansart was to profoundly change the façade's rhythm and character. The water basin, never actually built as shown here, must in any case have been drafted prior to 1672, at which time an enormous manifold basin was dug with the intention of accommodating the famous "great commission" of twenty-eight allegorical sculptures, after drawings by Lebrun. Only after this project was abandoned in 1683 the basin took on the appearance it has today. FD

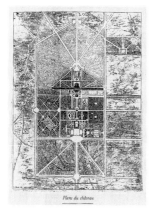

Plans du château

205
Israël Silvestre (1621–91)
The Vaux Gardens
Circa 1656 (date of the *privilège d'imprimerie*: 1659)
Paris, Bibliothèque Nationale de France, Département des Estampes. Ve 8, 90
Engraving; 50.7 x 38.2 (scale of 400 toises)
EXHIBITIONS: Paris, Bibliothèque nationale, 1964, no. 58
BIBLIOGRAPHY: Faucheux 1857: 292–94; Belin-Scart 1968; Moulin 1995: 1–5, 11

Israël Silvestre drew and engraved the most famous gardens of his time. After Rueil (1655) and Liancourt (ca. 1655), he devoted a series of plates to Vaux. This engraving is one of the first plans for the garden printed in the seventeenth century – a time when in most cases only partial or oblique views were depicted. The practical works of Claude I Mollet (d. 1647) and of his son André Mollet, published respectively in 1652 and 1651, contain few plans of the whole. Silvestre must have used a plan from Le Nôtre's atelier. It differs, however, from the Institute's plan, which corresponds to a much later stage: the canal is thus without the western half-moon and the circular basin (the "pan") which today constitutes its eastern far-end; it continues further along on the manuscript plan. There are also two rows of twelve square basins for the run-off, as opposed to two rows of thirteen on

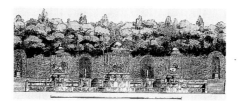

207 MAR
Anonymous
Les Bains d'Appollon in the Gardens of Versailles
1702–1705
Paris, Musée du Louvre

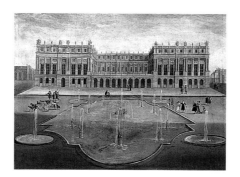

214 M–W–MAR
Anonymous Artist
The Palace of Versailles, West Façade of the Central Block Overlooking the Basin
ca. 1675
Versailles, Musée National des Châteaux de Versailles et de Trianon, Inv. M.V. 727
Oil on canvas; 135 x 154 cm
BIBLIOGRAPHY: *Le Nôtre et l'Art des Jardins* 1964: no. 110; Marie 1965: 145–46; *Louis Le Vau* 1970; *Versailles à Stockholm* 1985: no. C1; Berger 1985: fig. 6; Constans 1995: no. 5630; Bajou 1998: 136–37

The palace's west façade is shown here following the first expansions carried out by Le Vau and his collaborators between 1668 and 1670, but prior to the additions overseen by Hardouin Mansart, who only became involved in 1678. The earlier palace's main building, looking out

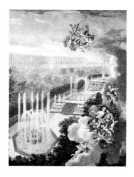

211 T
Jean Cotelle (1642–1708; attr.)
View of the Bosquet des Trois Fontaines in the Gardens of Versailles, 1668 ca.
Versailles, Misée National des Châteaux de Versailles
Watercolor on paper; 200 x 140 cm

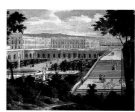

215 W–M–MAR
Jean-Baptiste Martin (attr.)
View of the Versailles Palace and Orangerie
late 17th–early 18th century

Versailles, Musée National des Châteaux de Versailles et de Trianon, Inv. M.V. 6812
Oil on canvas; 115 x 165 cm
BIBLIOGRAPHY: *Versailles* 1951: no. 2; *The Sun King* 1984: no. 107; *Les Jardins de Versailles* 1992: no. 68; Constans 1995: no. 219; Bajou 1998: 252–53

The north–south axis of the Palace of Versailles' gardens was finished only after the completion of the east–west axis, which leads from the Place d'Armes to the far end of the Grand Canal. It is linked to the considerably extended palace by the construction of the two so-called North and South Wings. Moreover, the renovations at the far south of this axis posed significant problems due to the slope and marshiness of the terrain. These problems were overcome by the construction of Mansart's Orangerie. The construction work linked to the new Orangerie began in 1679 and was completed in 1685. While such themes as the path of the sun and the rhythm of the seasons play a leading role in the composition of the east–west axis, the north–south axis plays above all on the symbolism of the elements and the points of the compass: waters, woods, nymphs and water-related divinities in the north, loves, flowers and fruits in the south. Beyond the Orangerie, the palace displays its immense façade. Comparison with the painting depicting the west façade at the beginning of the 1670s shows how Mansart managed to transform a composition organized around a terrace into an elegant backdrop for a composition which was to provide the framework for the celebration of the "greatest king in the world" and his court. FD

216 T
Giovanni Gloria (ca. 1684–1753) and/or Sante Benato (1717–60), after drawings by Girolamo Frigimelica
Venice, Museo Civico Correr, Inv. Cl. XIX, no. 173
Wooden Model of the Pavilion for the Garden of Villa Pisani at Stra
54 x 65 x 78 cm
PROVENANCE: Correr Bequest

217 T
Giovanni Gloria (ca. 1684–1753) and/or Sante Benato (1717–60), after drawings by Girolamo Frigimelica

Venice, Museo Civico Correr, Inv. Cl. XIX, no. 174
Wooden Model of the Tower in the Maze of the Garden of Villa Pisani at Stra; 46 x 35 cm
PROVENANCE: Correr Bequest
BIBLIOGRAPHY: Tognolo 1978–79: 161–73; Fontana 1988: 155; Corboz 1990; Puppi 1990: 137

These two works belong to the three-dimensional interpretations of drawings that Frigimelica prepared sometime after 1716 in connection with the renovation of the site that the Pisanis owned at Stra. The purpose of these models was twofold: to give an accurate, three-dimensional sense to the graphic rendition of the key parts of the architectural complex that Frigimelica invented and to be used during the actual construction. These models were to be found in his Padua residence on the eve of the architect's departure for Modena. Although there is no documentary evidence for the exact chronology of their manufacture (assuming they were not made simultaneously), there is reason to believe that either of Frigimelica's faithful associates (Giovanni Gloria, Santo Benato) made them between 1716 and 1720, when work on the garden was well advanced. There are records of Benato's frequent visits to Venice "to speak to the client about the things at Stra" (Archivio di Stato di Padova, AsPd, Privato Selvatico Estense, Famiglia Frigimelica, b. 306, fasc. 22, cc. 8–9, b. 528, April and May; Tognolo, 1978–79: 166ff.). Moreover, the model of the pavilion presupposes that a precise and detailed graphic definition of the layout of the garden must have been in place by the time this model was made, since this architectonic element would have had to correspond optically to the network of paths and walkways that gave form to the ideas of Pliny as interpreted by Felibien des Avaux (Corboz 1990). It is probable that if Frigimelica had reached the point where he could begin experiment with the three-dimensional appearance of the pavilion, then he must already have had a clear idea of the iconographic program and distribution of the statuary that would later be produced in the workshop of Giovanni Bonazza and Antonio Gai (Semenzato 1966; Tiozzo 1977). There is no doubt that the circular focus of the pavilion permitted the most uninhibited and even astonishing expression of Rococo fancy. This Rococo fancy intertwined cylinders punctuated with curvilinear white surfaces; these are decorated with barely visible ocher outlines of the spare geometric moldings, which outline the niches in a way that recalls Juvarra's *palazzina* at Stupinigi (Cavallari Murat 1962: 43–44). For the model of the tower for the maze, this Rococo fancy returns in the form of the surprising use of ironwork whose twists allude to the wandering paths of the labyrinth. Here, one can understand why Frigimelica's client hesitated over and eventually renounced applying these inventions, albeit in a more restrained form, to the noble residence, while still permitting them in the more playful context of the garden. In the end, such inventions were not just inadequate, but actually inappropriate to the rigorous patrician gentility that this architectonic manifestation was supposed to celebrate. LP

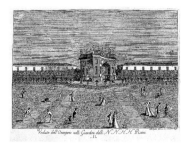

219a T
Giovan Francesco Costa (1711–72)
Pavilion and Orangery for the Garden of Villa Pisani at Stra
Venice, Museo Civico Correr, *Delle delizie del fiume Brenta [...] disegnate e incise da G.F.C. [...]*, Venezia, MDCCLVI: II, pl. 49, Inv. Stampe E36 (119)
Engraving on copper; 22 x 32.3 cm
INSCRIPTION: "Veduta dell'Orangerie nelli Giardini delli NN HH Pisani / II" (lower margin) "I.F. Costa del. et inc. con Privilegio" (immediately below the border of the plate)

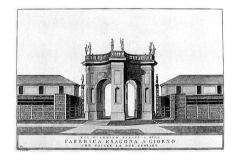

219b T
Giovan Francesco Costa (1711–72)
Exedra in the Park of the Pisani Villa at Stra
Venice, Museo Civico Correr, *Delle delizie del fiume Brenta [...] disegnate e incise da G.F.C. [...]*, Venezia, MDCCLVI: II, pl. 49, Inv. Stampe E36 (119)
Engraving on copper; 22 x 32.3 cm
BIBLIOGRAPHY: Mauroner 1939–41: 473–76; Gallo 1941: 172–73; Pittaluga 1952: 75–88; Tonini 1996a: 79–88; Pietrogiovanna 1997: 50–61 (along with the other bibliography entries)

This engraving is part of a group of *vedute* that Giovan Francesco Costa dedicated to the villa and gardens at Stra that belonged to the Pisani family. It is in the second volume of seventy prints which was a sequel to an earlier collection of an equal number of images depicting the *Delicie* of the landscape along the Brenta River; it is dated 1750 and contains images of sites between Lizza Fusina and Mira. The second volume, however, features images of sites scattered between Padua and Dolo; the Correr copy is dated 1756 (both collections have been issued in facsimile editions by Mazzotti 1974). Scholars are engaged in a complex debate regarding both the exact chronology of the various states of the prints and the actual dates when the two volumes were put into circulation (see the excellent synthesis and convincing argument of Tonini 1996a). For our purposes, it is worth noting that if Costa obtained a "privileged monopoly" for

prints from the Venetian Senate in 1748 (Gallo 1941), and if he inscribed this information on the edition of the series that came out in 1750, then by that date he must not only have begun the series' preparation, but he must also have actually begun engraving the plates included. Costa had probably also begun to plan some of the images that would appear in the second series, which was published on the eve of the expiration in 1756 of the ten-year privilege that the Senate had granted him. The group of images representing the Pisani property at Stra must have been ready around that same year, if one considers that the noble part of the residence (pl. 48), which appears to be in almost the definitive state planned by Preti, was declared finished in 1756. The view included here shows the pavilion completed to the plans Frigimelica made for the garden in the 1720s. LP

Paris. Nevertheless, a reasonable hypothesis is that Alvise Pisani, jr., commissioned them from drawings by Carboni that he took to Paris when he was ambassador there. His decision to have them engraved by Ransonette may have had a polemic inspiration, originating as it did during the precipitous events of the French Revolution, which decreed the end of the aristocracy and the fate of the French sovereign. This was shortly before diplomatic relations between France and the Serenissima were broken off and Pisani was forced to move to London (Tonini 1996: 95. Pisani was in Paris from July 1790 through August 1792 [cf. Marozzo della Rocca 1959: 92], and that these prints must have been completed during those two years. The image presented here permits an opportune comparison that demonstrates the fidelity of the execution of the wooden model to the actual building. LP

and architectural details; leaves stuck on to pages, album ca. 70 x 145; drawings ca. 50 x 70 cm
BIBLIOGRAPHY: Keyssler 1741; Galletti 1779; Tschira 1939; Möller 1956: 142–153, 256–259, 299–301 ("Explication"); Götz 1962: 13–24; Reuther and Berckenhagen 1994

Schloß Friedenstein in Gotha was built between 1643 and 1644 for Duke Ernst of Saxony-Gotha. In 1711 his grandson, Frederick II, had the smaller Schloß Friedrichsthal built just below the other castle. The courtyard of this smaller building opened on to the so-called Ordonnanz-garten on the hillside. This was the site of an orangery designed by Johann Erhard Straßburger, the chief architect of Gotha. In 1737–38 the same architect replaced the orangery with another in the form of a glass hothouse. In 1741 Keyssler reported of this building: "[...] the orangery is maintained in good condition, and contains many exotic plants, such as coffee and strawberry trees" (Keyssler 1741: 1140). However, shortly afterward, in 1744, the gardener complained that the shelter provided for the expensive plants was inadequate, and that they were in urgent need of proper protection, so Duke Frederick III decided to rebuild the orangery. In March 1745 Straßburger presented a financial estimate, and in 1746 produced further proposals for a larger orangery building; but these did not convince his client (Möller 1956: pls. 160–61). In April 1747 the duke summoned the renowned senior architect of Weimar, Gottfried Heinrich Krohne, to Gotha, so that he could discuss the project with him. Krohne brought some designs for an orangery to Gotha for their very first meeting (Album, nos. 12-13, Möller 1956: pls. 162–63), and these met with the duke's approval. In May 1748 Krohne delivered the model. To judge from the architectural models connected with the planning of Schloß Friedenstein (Reuther and Berckenhagen 1994: nos. 150–55), the making of models to give a clearer idea of a building project was common practice in Gotha. Krohne's commentary on the model shows a particular interest in questions concerning the solution of the problems presented by the terrain. His design shifted the central axis northward with respect to the earlier layout of the garden (Album, no. 1), thus aligning it with Schloß Friedrichsthal (Album, no. 11) and establishing a visual connection with Schloß Friedenstein, a possibility which had previously been neglected. The terrain not only rises along the westward axis, but falls away from south (the left-hand side of the model) to north (the right-hand side). In order to make use of newly purchased plots of land and to counteract the perspective foreshortening of the terrain, the architect designed a structure which ascended the slope in three terrace levels. These terraces had diverging trapeziform borders, along which the buildings themselves were aligned, to create a perspective illusion: "[...] so that this garden might seem larger, where parallel lines would have made it appear smaller" (architect's commentary, Möller 1956: 300). With respect to an earlier design of the whole garden (Album, no. 4), the first detailed plan (Album, no. 3) shows some variations, which change again in the later model. However, all have the

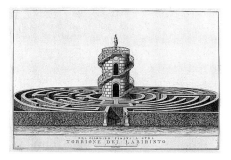

218 T
Bortolo Gaetano Carboni (doc. in 1791–97) and Pierre Nicolas Ransonette (1745– 1810)
Tower and Maze for the Villa Pisani at Stra
Venice, Musei Civici Veneziani, Museo Correr, Stampe Cicogna, no. 2583
Engraving; 31.6 x 48.4 cm
INSCRIPTION: "Nel Giardino Pisani / Torrione del labirinto" (lower margin); scale and measurements given in Venetian feet; the number XII (lower left-hand corner) and signature "B.G. Carboni del" (below along the plate mark)
PROVENANCE: Given to E. A. Cicogna by Benedetto Valmarana
BIBLIOGRAPHY: Bonollo 1993; Tonini 1996b: 94

This engraving belongs to a folio of thirteen prints engraved in 1792 by P. N. Ransonette, printer and "official designer for the brother of Louis XVI." He created various illustrations for Diderot and d'Alembert's *Encyclopédie* as well as the illustrations for the renowned *Histoire de la Sainte Chapelle* of 1790 (Tonini 1996b: 89). Of these prints, Ransonette signed only plates numbered I, X and XI and indicated their date and place of publication (1792 in Paris). These are based on drawings by B. G. Carboni, who signed all the plates. Little is known about Carboni except his activities as a technician for the Venetian government (Archivio di Stato di Venezia, AsVE, Provveditori alla Camera dei Confini, b. 180, for a map of Caprile dated 5 September 1791 in which he describes himself as a "captain engineer"; see also AsVE, Savi Esecutori alle Acque, Laguna, dis. 119, which is a survey of a portion of the river Brenta dated 30 August 1784). Nor is it clear why Ransonette was chosen as the engraver of the prints, nor why they were printed in

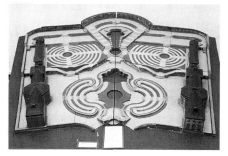

220
Gottfried Heinrich Krohne (1703–56)
Model of the Buildings and Garden of the Orangery, Gotha, 1747–48
Gotha, Museum für Regionalgeschichte und Volkskunde, Inv. 13798 G 34
Wood painted green, blue, gray, brown; the decoration of the building's elevations and fountains is in pen and wash on paper, which is stuck on to the wooden model. The model is composed of two halves meeting in the main axis of the garden; dimensions of the base: front width 142 cm, rear width 197 cm, maximum length 191 cm
EXHIBITIONS: Gartenbaumuseum Erfurt, 1991–96; since 1997 at the permanent exhibition of the Museum für Regionalgeschichte und Volkskunde

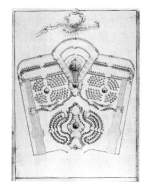

221 T–M–W
Gottfried Heinrich Krohne (1703–56)
Album of Drawings for the Buildings and Garden of the Orangery, Gotha, 1747–48
Gotha, Thüringisches Staatsarchiv, OO IV 74 b
21 ground-plans and elevations, cross sections

same general layout: the central axis of the garden is accompanied by steps and ramps through elaborate cascades and watercourses fed by a reservoir above the back wall of the garden, which is decorated with niches. The new buildings frame the lower and central parts of the garden: the sunken parterre of the lowest orangery is flanked by two orangeries; on the next level there are two greenhouses. Apropos of his first design Krohne speaks of about five hundred orange trees which could be distributed among the various open spaces of the garden in the summer; regarding the model, which shows a different arrangement of the terraces, he speaks of about seven hundred; an inventory of 1781 lists nearly three thousand precious trees and plants. Sculptures, vases and a little temple adorn the garden. The magnificent array of the garden was not only intended to give "an exceptional prospect from the royal palace" (Möller 1956: 300), i.e. a splendid view from Schloß Friedrichstal. It was also to be the setting for royal ceremonies, for which the lower parterre next to the pond of the grotto would be converted into a summer dining room in the open air. As was customary during this period, even the orangery buildings were turned to ceremonial use. Moveable partition walls were taken out, and dining tables were placed in the central oval salon and the adjoining rooms. As far as the corner pavilions were concerned, they were recommended for conversion into gaming-rooms, except for one which contained the gardener's living quarters. In order to level out the ground and conceal the falling terrain, and also to protect the sunken parterre, the right-hand (northern) orangery building was erected over a basement, which was to be used as a storage cellar. Krohne had worked with Johann Adolph Richter at Schloß Belvedere near Weimar and in 1739 had built an orangery there, which conformed to the "theater" type, with a central pavilion and wings which curved round in a horseshoe shape. For the wings at Gotha he chose the other type of orangery which was common in the German Baroque (see Tschira 1939); it is shown here in two versions. In the first sketches, which are influenced by Richter's plans for Belvedere and Straßburger's for Gotha (Möller 1956: pl. 36), Krohne feels his way toward the form which was to be the basis of the actual building. The ground plan is dominated by the central salon, which is emphasized on the exterior of both façades (though not in the shape of the roof) by a polygonal avant-corps. There are large windows on the south side, and additional mezzanine windows emphasize the corner pavilions, which are also accentuated by their curved, Chinese-style roofs. Both greenhouses are simple elongated buildings, whose fronts are almost entirely taken up by large windows. The pavilion-like west part was intended for the housing of particularly tall plants. Krohne had many other engagements elsewhere and was often absent during the construction. Only the outer structure of the southern group of buildings had been built to his designs when architect and client broke off relations with one another. His place was taken by the Saarbrücken architect Friedrich Joachim Stengel, but he too resigned only nine months

later without having made any progress with the building. Under Stengel's successor, Johann David Weidner, a pupil of Krohne, work was resumed in summer 1752. In 1766 he presented plans for the northern buildings, mainly following Krohne's designs. The building of the garden went on until 1772. After extensive damage in 1944 the orangery building was rebuilt and the greenhouses redesigned. According to Götz, Krohne's Gotha design for two greenhouses facing one another belongs typologically and stylistically to the French tradition of architectural theory (Jacques-François Blondel, *De la distribution des maisons de plaisance*, 1737–38), and is comparable to Ludwigsburg and the only partly completed garden in Großsedlitz. Its "Chinese" appearance and the structure of the façade is traceable, in his view, to the Japanische Palais in Dresden. IL

222 T
Anonymous
Model of the Park with Wilhelmstahl Castle near Kassel
ca. 1747
Wilhemstahl Castle
Wood; 210 x 151 cm (base)
BIBLIOGRAPHY: Schmidt-Möbus 1995: no. 3

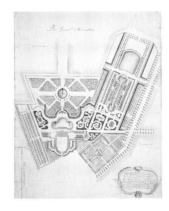

223 T
Simon Louis Du Ry (1769–99)
Project for the Garden of Wilhelmstahl Castle before May 1746
Kassel, Staatlichen Museen, Graphische Sammlung, Mgb. Dep. 26
Pen and ink drawing, color-washed
80.5 x 61.5 cm
INSCRIPTIONS: "Plan General d'Amelienthal;" signed "dessiné par S. L. Dury"
BIBLIOGRAPHY: Schmidt-Möbus 1995: no. 2

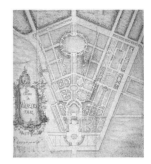

224 T
Johann Georg Fünck (1721–57, attr.)
General Plan of the Complex of Wilhelmstahl Castle
ca. 1752
Kassel, Staatliche Museen, Graphische Sammlung, Mgb. Dep. 9
Pen and ink drawing, color washed, mounted on canvas; 70.4 x 63.7 cm
BIBLIOGRAPHY: Schmidt-Möbus 1995: no. 4

Schloß Wilhemstahl, in the village of Calden, near the Resindenzstadt of Kassel, is a masterpiece of Central Germany Rococo. It was commissioned by the Landgrave Wilhelm VIII of Hessen-Kassel. The original country seat, Amelienthal, had belonged to his wife, who had died in 1743; he converted it into a modern *maison de plaisance*. Not until 1753, with the laying of the foundation- stone for the new *corps de logis*, was it officially renamed Wilhemstahl, in honor of the landgrave himself. Until recently no definite identification was possible of the architects responsible for the planning and building work, which was carried out from the mid-1740s onward (Bleibaum 1926, 1932; Hallo1930). Now, however, thanks to the research of Schmidt-Möbus (1995), the attribution of the various parts of the project to specific architects can be regarded as certain. The first ideas for a reconstruction of the country seat had evidently been formulated as early as the 1720s; a second phase had followed in 1731–32; and from about 1742–43 the plans began to take concrete shape and building work began. By 1749 the most important parts of the garden were either complete or well advanced. For a long time scholars overvalued the contribution made to the project by the Du Rys, a Kassel-based family of architects. The Du Rys did play some part in the planning and building work, but were not the chief architects. Charles Du Ry (1692–1757) was engaged in the project for many years, but as director of building, not as a designer. His son, Simon Louis, was only twenty years old when the first plans were drawn up; still a trainee, moving from place to place in foreign parts, he participated in the project as a novice, sending in several designs from afar. In 1746 he worked in Stockholm under the direction of Carl Hårleman on a design for the conversion of Amelienthal which he had begun in Kassel; in 1749–59, now in Paris, he worked on a second project. Not until 1756 did Simon Louis return to Kassel, where, on his father's death the following year, he succeeded him as director of building in Wilhemstahl, his job being to execute the definitive plans by François Cuvilliés. François

Cuvilliés the Elder (1695–1768; Hallo 1930; Braunfels 1986) was employed by the princes of Bavaria and occasionally worked for the bishop-prince Clemens August of Cologne, the brother-in-law of Prince Albrecht, in Brühl. Landgrave Wilhelm employed him as architect from the beginning of the planning stage, in other words perhaps from the early 1740s, and certainly from 1745 onward. Cuvilliés made some designs for a belvedere in a large, roughly star- shaped garden, which were later reproduced on engravings; the accompanying inscription clearly links the designs with Amelienthal, thereby proving his involvement in the building project even before he was personally acquainted with the difficult topographical situation. Cuvilliés was definitely the designer of the castle, but it is not certain whether the layout of the garden was also his work. Landgrave Wilhelm himself, who was very interested in artistic matters, seems to have contributed some of his own ideas. It is therefore possible that the garden had no single designer, but that the landgrave himself decided its shape, and commissioned a number of different architects to design the individual buildings contained in it. According to Schmidt-Möbus, a crucial role in the designing of the garden was played by Johann Georg Fünck, a pupil of Georg Wenceslaus von Knobelsdorff (1699–1 753) who came to Kassel from Berlin in 1746 to remain as director of building in Amelienthal until 1749. The general plan of the garden, probably drawn by Fünck, shows the layout of the hilly garden as a large pentagon, strongly reminiscent of the Karlsaue in Kassel, with three main axes converging on the castle: the central axis running from west to east, the axis of the south garden to the right, and that of the north garden to the left. The axis leading from Kassel-Wilhemshöhe in the south, which continues beyond the limits of the garden as an alley, ends in front of the garden façade of the castle. Opposite the forecourt of the castle, Fünck shows some stables and working quarters built on a semicircular plan, but these, like the central alley leading to the large zoo and hunting park, were never actually built. Individual buildings, with their associated garden areas, were constructed at various times, but the Seven Years' War interrupted the work, so that the design shown on the general plan was only partly realized. Du Ry's earlier design shows the castle grounds in something very similar to its old form, with the moat and with wings adjoining the old buildings. The old Dutch garden – three terraces for the cultivation of fruit-trees north of the castle – was to remain unchanged, as was the square kitchen-garden in Du Ry's plan. The large pond in front of the garden façade of the castle was also later built to a different design. However, the plan already shows the centerpiece of the south garden, the grotto; this opens on to a canal fed by a large pond. The landgrave seems to have been particularly interested in the garden, for he began the reconstruction of the country seat not with the main building but with this southern part of the garden. The irregularly sloping, hilly terrain made it possible to channel water for decorative cascades and to store it in several reservoirs, whose position is indicated on the wooden model and the general plan. The grotto, which served both as a *salon frais, as a point de vue* for the southern garden, and as a vantage-point, was designed by the Prussian architect Knobelsdorff. The landgrave had already requested material for the grotto from Dutch experts in 1744, and while it was being built in the years 1746–49, Pierre de la Potterie, who was working in Bonn at the time (Falkenlust and Poppelsdorf) was often called in for advice. By 1749 the grotto with all its statues was complete, as were the pond and the grotto canal. By 1747 at the latest, the adjacent area of the south garden above the grotto had been built as a poultry menagerie, a feature which can be seen both on the wooden model and on the general plan. The large pond contains two breeding-islands, opposite which on the shore, were erected two "Chinese houses." At about the same time, in 1747–53, a Chines pavilion, the so-called "Maison sans gêne," was built in Brühl, probably by Cuvilliés. That Cuvilliés was also the designer of the Chinese houses in Amelienthal is not certain, but probable. Above the duck-pond, four simpler, small buildings enclosed the actual poultry menagerie, which, like the Chinese houses, was destroyed in the late eighteenth century. To the north, in the direction of the Winberg, this area was delimited by the new Dutch garden with espaliers and a wall with heatable niches for delicate fruit-trees. In contrast to Du Ry's design, the wooden model testifies to a later stage in the project, though it still has some features in common with the ideal design set down in Fünck's general plan. The old parts of the garden near the castle are unchanged, and large areas, which Fünck shows as artistically arranged flowerbeds, are still completely undeveloped here. The model is not supposed to represent the country seat in its final state, and interestingly enough it even shows areas which clearly lie outside the actual garden. The purpose of the model was to fix clearly the direction of the main axes and the position of the main reservoirs, ponds and canals. IL

not specifically indicated) as well as afterward, as we know from Vanvitelli's letters. The model is datable to later than 1765. Missing are the statuary groups which accompany the ramps and the main statue of Juno's chariot, which was to crown the central cascade (and which was never put in place). The model indicates the underpass of a local road behind the exedra, and even shows the cryptoporticus which makes it possible to walk behind the veil of cascading water. The portico of the polygonal exedra is a fine example of Vanvitelli's style. JG

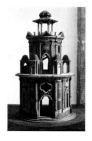

226 T–MAR
Model of a Chinese pavilion
Caserta, Palazzo Reale, Museo Vanvitelliano
Inv. no. 3871
Painted wood and stucco; 120 x 60 cm
BIBLIOGRAPHY: *Mostra Vanvitelliana* 1973–74, no. 6; *L'esercizio del disegno* 1993, 156, no. 3

The Chinese taste was introduced to the Neapolitan court by the Saxon queen, Maria Amalia, who had lived in Dresden, the European center of this fashion (Gabinetto delle Porcellane di Portici, now at the Museo di Capodimonte). In 1756 the queen asked Vanvitelli for "something in a totally Chinese style" for the garden of the royal villa at Portici and he replied to her, "I will transform myself into a Chinese architect, as if I had been commissioned to build for the Emperor of China" (letter of 1756). We do not know how the architect satisfied the queen's request, for this model is certainly much later and probably not even by Vanvitelli. JG

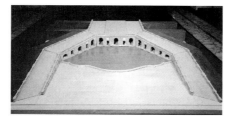

225 T
Model of the Fountain of the Winds (of Aeolus)
Caserta, Palazzo Reale, Museo Vanvitelliano
Inv. no. 3885
Painted wood; 21 x 246 x 200 cm
BIBLIOGRAPHY: Venditti, in *Luigi Vanvitelli Mostra Vanvitelliana* 1973–74: no. 4; Hersey 1983: 133–39

Situated about half way along the water-course in the park, the Fountain of the Winds is the most architecturally ambitious of the fountains. The planning of the fountains underwent several changes even during the engraving of the plates of the *Dichiarazione* (where this fountain is

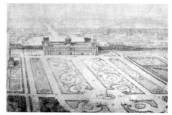

227 T
Bird's-eye View
Caserta, Palazzo Reale, Museo Vanvitelliano
Inv. no. 897
Pen and gray ink, color-washed in gray
585 x 893 mm
BIBLIOGRAPHY: De Seta, in *Luigi Vanvitelli* 1973, 301, no. 114/XIII; *L'esercizio del disegno* 1991, 124, no. 295 (A. Pampalone)

This view gives a better idea than the others of the grandeur of the complex: the almost crystalline block which dominates a large area of natural scenery with a gradual passage from the parterre to the groves, the woods, with roads

running through them, then the slopes of the mountain and finally the mountain itself, left in its natural state, completing the view. As the author writes in the legend, "with garden in the distance, somewhat different from the one that is actually made, as can be seen depicted in the general plan, plate I," changes were made to the realization of the less important areas of the garden. The course of the water is indicated in a general manner and the two belvederes on the hill were never built. The drawing is preparatory to plate XIII of the *Dichiarazione*. JG

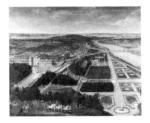

230 T
Anonymous Artist
View of the Saint-Cloud Palace
Turin, Palazzo Carignano

This general view of the domain of Saint-Cloud gives some idea both of the size of the palace of Monsieur Philippe d'Orléans, brother of Louis XIV, and or the approaches and particularly the gardens descending down to the banks of the Seine. In very traditional fashion, the artist painted a procession of visitors into the foreground: like us, spectators outside the painting, they are enjoying the exceptional view of the valley which had already established the reputation of the Gondi palace, built at the end of the sixteenth century. But the state in which the palace is shown has precious little to do with Jérôme de Gondi's construction. Indeed, poorly documented though the history of Saint-Cloud may be, we do know that numerous transformations were carried out over the course of the eighteenth century. In 1625, the archbishop of Paris, Jean-François de Gondi, repurchased the palace which had been sold to Jean de Beuil after Jérôme's death in 1654. The new owner, financier Barthélémy d'Hervart, also had major work carried out, but had to sell the domain on 25 October 1658 to the advantage of the king's brother, Philippe d'Orléans. Monsieur, in turn, was to modify profoundly Saint-Cloud until his death in 1701. Two important campaigns followed one upon the other: the first was led by Antoine Le Pautre; the second, from the late 1680s, by Jules Hardouin Mansart. Everything conspires to suggest that the painting depicts an intermediary state. Indeed, Le Pautre's most stunning achievement: the "grande cascade", built in 1664 or thereabouts, is clearly shown as is the large horseshoe-shaped basin, done in front of the southern façade of the palace's left wing which henceforth took on a U-shape opening onto the Seine. This waterfall is known to have left an impression on all those who saw it, eliciting admiration except from Bernini, who during his voyage in 1665 reproached it for its unnaturalness. Jules Hardouin Mansart's campaign was characterized by the renovation of the

façades and the installation in the south wing of a monumental staircase rivaling that of the ambassadors at Versailles. The garden represented include the adaptations and additions made by André Le Nôtre in 1665-67 following on the "grande cascade" of Le Pautre, as well as the canal that extends from the "grande cascade" toward the Seine added by J. H. Mansart. The period of Hardouin Mansart's involvement being somewhat vague, it is difficult to date the depicted state, which may however be situated in the whereabouts of 1690–1700. SG

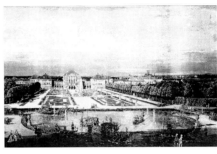

228
Bernardo Bellotto (1722–80) and Workshop
View of Nymphenburg castle, near Munich
ca. 1761
Washington D.C., National Gallery of Art, 1961.9.63
Oil on canvas; 68.4 x 119.8 cm
PROVENANCE: Art market, 1936; Dr. Gustav Mez, Switzerland; Rosenberg & Stiebel, New York; purchased 1951 by the Samuel H. Kress Foundation, New York; given to the National Gallery of Art in 1961
BIBLIOGRAPHY: Fritzsche 1936: 116, no. VG 120; Kozakiewicz 1972: II, 234, no. 295; Shapley 1973: 168–69, no. K 1864; Shapley 1979: I, 59–60; II, no. 114, pl. 34; *Venedigs Ruhm im Norden* 1991–92: no. 9; Bowron 1996a: 18–19; Rizzi 1996: no. 114

The history of this brilliant Baroque palace complex began when Elector Ferdinand Maria presented a new country house of Nymphenburg to his wife Henriette Adelaide on the birth of their son, Max Emanuel. The original building of 1664–74 by Agostino Barelli and Enrico Zuccalli, consisting of a central cube with terraced flights of steps, was an important source of the transmission of the architectural vocabulary of the Italian Baroque to Bavaria. This block was later redesigned by Joseph Effner, court architect in charge of the electoral country palaces. The galleries were added in 1704; then, from 1715 on, Giovanni Antonio Viscardi added the four staggered, cube-shaped side pavilions and the connecting buildings. As the palace grew, so did the park to the west. In 1715 Dominique Girard began to remodel the original small, geometrically arranged Italian garden into an ornamental park in the French Baroque manner, in which Venetian gondolas glided along the canal.
The Italian view painter Bernardo Bellotto (1722–80) made a brief visit to Munich in 1761 when he produced three large, carefully executed views of Munich and Nymphenburg for Elector Maximilian III Joseph for one of the

rooms in the electoral palace, the Residenz (Kozakiewicz 1972, I: 121; II: nos. 290, 292, 294). The subjects were a panorama of Munich from the village of Haidhausen, and two views of Nymphenburg, the elector's favorite summer residence, one from the approach from the city, the other from the garden side. The paintings were intended to decorate one of the elector's dining rooms on the upper floors of the Residenz that had been recently redecorated in 1760–63 by François de Cuvilliés (1695–1768). The view of Munich was placed on the central wall, opposite a window; the views of Nymphenburg Palace were placed on a corresponding side wall, their steep perspectives converging on the painting in the center and unifying the three views (*Bernardo Bellotto* 1990: 156).
Bellotto's three views (Residenzmuseum, Munich) were important as the first examples of architectural painting in the grand style produced in Munich, and their influence upon the local tradition of topographical painting was significant (Kozakiewicz 1972, I: 120-21). The views of Nymphenburg, in particular, mark a new phase in Bellotto's approach to the representation of palaces and gardens in a wider landscape background. He has created a powerful impression of space in the park landscape and in the expanses of sky by conceiving the view from an imaginary high viewpoint, which in reality could not have been reached by any spectator, and through an artificially constructed perspective. Nonetheless, his description of the formal gardens in the park and buildings of Nymphenburg was so meticulous that when the exterior of the palace was being restored, his paintings were consulted as guides to the original coloring. The view of the west face of Nymphenburg Palace, as Kozakiewicz has written, is "taken from an imaginary, high vantage point, somewhat to the north of the axis of symmetry, so that there is a very slight degree of foreshortening. The main building, flanked by the galleries that join it to the pavilions, rises in the deeper middle ground, just left of center; further wings and minor buildings are visible on either side, partly concealed by the dense trees in the park" (Kozakiewicz 1972, II: 233–34). The formal gardens are laid out in front of the palace in a pattern of parterres and walks; the fountain with a Flora group by Wilhelm de Groff (ca. 1680–1742) is in the center. The gaily decorated boats and gondolas on the pool in the foreground, with attendants dressed in blue and white, the Bavarian national colors, may record the festivities organized by the elector in September 1761 to honor the visit of his cousin, Elector Karl Theodor of the Palatinate, both of whom are visible at the lower right. The towers of the Theatinerkirche and Frauenkirche above the Munich skyline are visible in the distance at the right, and in the distance farther to the right snowcapped mountains may be seen.
The Washington painting is a reduced version of the large canvas in Munich, probably by a member of Bellotto's studio. It records the composition of the prime version almost exactly except for the omission of minor figures in the foreground. EPB

Private residences and villas

The Private Leisure of Architecture
Konrad Ottenheym

With the general application of the rules of classicism based on Vitruvius and made comprehensible by the published works of Serlio, Palladio and Scamozzi, architecture came increasingly to be looked upon as applied mathematics. Since architecture in this perspective was not a craft but a higher science, the discipline was considered appropriate, indeed a more or less essential ingredient, in the education of the higher levels of society. All over Europe a knowledge of architecture soon came to be part of a complete education, alongside fencing, horse riding, dancing, and music-making. There was also a particularly strong interest in the treatises on architecture in the seventeenth and eighteenth centuries. For the ordinary craftsmen simplified manuals had been available since the middle of the sixteenth century, with instructions on the application of the five orders of the column. The full-blown treatises, which were known not only in the original but through translations all over Europe, were usually rather expensive and suited only for the tiny elite of the world of architecture, especially for enthusiastic amateurs among the clients who commissioned new buildings. There are numerous examples in all European countries of this sort of amateur passion for architecture, which was commonly described as "one of the most agreeable pastimes" and with other similar turns of phrase. The highest pleasure was living in a house which one had designed oneself. The actual building of the house, however, was almost always described as the most awful part of the whole process. But devising an architectural idea and working it out on paper was regarded as one of the pleasures of the art. Discussing the plans with friends and professional architects was the next phase in this noble pastime. A striking example is provided by the correspondence of Godard Adriaan van Reede, the Dutch ambassador to Berlin, in 1678. He described the plans for the rebuilding of his castle at Amerongen in the province of Utrecht as "a costly doll." He sent his plans to his friend Johan Maurits of Nassau-Siegen, asking for his opinion. In his reply the latter, who was reputed to be the most knowledgeable connoisseur of architecture in his circle, also compared working on an architectural design to "playing with a doll." Another well-known example of the passion for architecture is provided by the members of the Schönborn family of Southern Germany. In their respective building projects in Bruchsal, Würzburg, Bamberg, and the surrounding area, they were continually giving each other advice and lending each other their personal architects. They humorosly referred to their passion for architecture as a greedy *Bauwurm*, a building-worm. In the course of the seventeenth century, when the upper bourgeoisie seems to borrow more and more of the aristocracy's habits, the tendency became noticeable in these circles too. In the second half of the seventeenth century a book by Goeree was published in Holland which was specifically intended for the commissioners of buildings, to improve their taste and increase their knowledge of architecture, thus equipping them to take an active part in a building project (Goeree 1681).

In almost all known cases there was a collaboration between a learned amateur and a professional architect. In some circles, especially in England, the participation of an architect was even considered supefluous. A gentleman of standing was considered to be capable of designing his own house himself, perhaps with the assistance of his close friends. Around the middle of the seventeenth century the gentleman-designer Sir Roger Pratt put it like this: " if you be not able to handsomely contrive it yourself, get some ingenious gentleman who has seen much of that kind abroad and been somewhat versed in the best authors of Architecture: viz. Palladio, Scamozzi, Serlio, etc. to do it for you" (Gunther 1928: 60). A few decades later Sir Roger North was even stricter on this point. He wrote in 1696: "I recomend principally that a man be his owne surveyor [...] Therefore working by surveyors is for princes, and great men, and not for private gentlemen, who have neither the purse nor interest to purchase such costly councell as theirs is, so that if they are not their owne surveyors, and that well also, it's better to sitt still, and be content with their great grandfather's old mansion" (Colvin and Newman 1981: 22, 24). At any rate, the close involvement of the client in the planning of his own house almost always resulted in a preparatory stage of the building project being very long drawn out. After the first ideas and sketches drawings were made, and on the basis of these the plan was discussed in detail. Pratt recommended that next a wooden model should be made: "Get a model of wood to be most exactly framed accordingly, and as you shall then like it, so go on with your building, or change it till it please you" (Gunther 1928: 60–61). North, too, suggested making a wooden model at this stage and discussing it both with the builders and with friends. The wooden model is thus the most elaborate form of the "architectural game" played by the amateur architects, a means of focusing the discussion with one's close friends on the details of the work that one had in view. During this last phase various further modifications might be made to the plan. For once the building had started, the plan could only be changed at great expense, and this was something to be avoided if at all possible. The models of private residences exhibited here cannot therefore be seen in isolation from the active involvement of the client in these projects, as has just been described. As "conversation pieces" these models must have long formed a central topic in the clients' talk and correspondence whenever they wished for a temporary distraction from their political, military or mercantile concerns.

BIBLIOGRAPHY: Goeree 1681; Gunther 1928; Colvin, Newman 1981

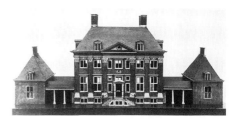

231 T
Pieter Post (1608–69)
Wooden Model of Villa Vredenburg, Beemster-Polder, ca. 1642
Middenbeemster, Museum Betje Wolff
(since 1946)
Oak, painted details; 110 x 47 x 45 cm
EXHIBITIONS: Utrecht, 1983 (Centraal Museum); Amsterdam, 1989 (Koninklijk Paleis); Haarlem, 1993 (Teylers Museum); Hamburg, 1993 (Museum für hamburgische Geschichte); Amsterdam, 1997–98 (Bijbels Museum); Vicenza, 1999 (CISA "A. Palladio")
BIBLIOGRAPHY: Tieskens 1983a: 33–35; Ottenheym 1989: 50–56; Terwen, Ottenheym 1993: 88–99

Vredenburg was the most Palladian country seat to be built in Holland in the seventeenth century. The man who commissioned the building, the Amsterdam merchant Frederik Alewijn, was renowned for his great love of architecture, as is shown by, among other things, the fact that the only Dutch edition of Palladio was dedicated to him in 1646 (it is actually only a translation of Pierre Lemuet's French edition of Palladio's *Libro I*). In 1639 he began to make plans to build a new country seat in the Beemsterpolder, after the style of the classical villas in the Veneto. For this purpose he got two promising young architects, Pieter Post and Philips Vingboons, to draw up different designs independently of each other. Several preliminary studies by both architects have survived, as well as the wooden model of Pieter Post's definitive design of 1642. The model of 1642 shows the building more or less as it was built in the years 1642–45. It consists of a rectangular main building with a basement, ground floor and first floor, covered by a roof sloping on all four sides. On either side of this main building is a smaller outhouse. The main building and the lateral outhouses are connected together at the front by a portico and at the back by a covered passageway. The classical orders were only used at the front: massive Corinthian columns on the main building and small Tuscan columns in the porticos. On the inside of the model the floors, walls, stairs and roof-beams can be seen. If one takes off the roof of the model this inner part can be taken out and examined in detail. In view of the many variants on the ground plan in the preliminary studies, it seems that Alewijn wanted to study this aspect of his mansion three-dimensionally, too, before giving it his final approval. The ground plan in the model corresponds to that in the prints by Post, published ca. 1655, having a square vestibule and a staircase behind it, two living-rooms on the right, and a large hall on the left KO

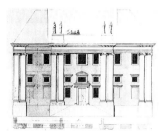

232 T
Pieter Post (1608–69)
Preliminary Studies for Villa Vredenburg at Beemster-Polder
Zeist, Rijksdienst voor de Monumentenzorg
Pen and ink, washed in red
13.7 x 20.1 cm
INSCRIPTION: "P. Post;" dated 21/22 July 1639

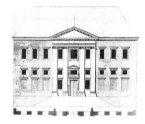

233 T
Pen and ink, color washed
25.6 x 35.9 cm
INSCRIPTION: "P. Post;" and dated 2 August 1639

234 T
Pen and ink, color washed
25.3 x 36.2 cm
INSCRIPTION: "P. Post;" and dated 2 August 1639

235 T
Pen and ink, 25.2 x 37.5 cm
INSCRIPTION: "P. Post;" dated 7 January 1642
BIBLIOGRAPHY: Terwen and Ottenheym 1993: 88–89; Gerritsen 1997

The number of preliminary studies that were made for Vredenburg is quite remarkable. The earliest drawings dated from 21 and 22 July 1639. These are different variations on a rectangular or sometimes square building with a large central vestibule extending right from the front

wall to the rear one, a plan inspired by the those of the Venetian palaces, which were known in Holland from editions of Serlio and Scamozzi. This layout no longer appears in the later drawings. From August 1639 onward Post worked on a ground plan which gave a larger space to the staircase, which now lay on the central axis, directly adjoining the vestibule, as can be seen in the final plan. In addition to the various ground plans, in July and August 1639 Post also drew a series of façades, all of the same width, about eighteen meters. Within this fixed measurement he designed façades with a number of windows varying between seven and nine, and with continual variations on the application of the colossal Ionic columns. One of these façades had double Ionic pilasters at the corners of the building and at the ends of the central avant-corps (an idea based on Scamozzi's Villa Pisani), crowned with a pediment, or, if the client preferred, an attic, behind which a terrace could be placed which would give a splendid view of the town. Another design for the façade, which is applied in various versions, shows a concentration of colossal pilasters on the central avant-corps, while the rest of the façade is left undecorated. This type of façade is directly inspired by Italian models such as Palladio's Villa Ragona or Scamozzi's Villa Rocca Pisani. Post's drawings of January and February 1642 give us an idea of the preparations before the definitive design, which was established during the course of that year. On 7 January 1642 Post drew a façade design which still shows two different possible variants. The left half shows a row of Ionic columns across the whole width, while on the right half the pilasters are limited to the central avant-corps. In the final version Post was to cover the whole width of the façade with the Corinthian order. During the first half of that year several more sketches followed. The corner outhouses and connecting porticoes which are so characteristic of the definitive design only appear in Post's sketches from February 1642 onward. In the course of that year, the wooden model must have been made on the basis of the latest designs, after which the actual building could start. KO

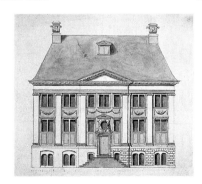

236 T
Philip Vingboons (1607–78)
Preliminary Designs for Villa Vredenburg, prospect
ca. 1641–42
Zeist, Rijksdienst voor de Monumentenzorg
Pen, ink and watercolor
29.4 x 37.4 cm

237 T
Preliminary Designs for Villa Vredenburg, elevation
Pen and ink, color washed
30.2 x 40.6 cm
BIBLIOGRAPHY: Vingboons 1648; Ottenheym 1989: 50–56; Gerritsen 1997

Not only Pieter Post but also Philips Vingboons made various studies, sketches and designs for Frederik Alewijn's country seat, Vredenburg, in the Beemster-polder. Since Vingboons did not date his drawings, they are not so easy to fit into the history of the designs. These drawings by Vingboons can be divided into two groups: sketchy preliminary studies of ground plans on the one hand, and finished drawings of ground plans, façades, and one cross-section, on the other. The first sketches probably date from 1639, i.e., from the beginning of the history of the designs. The finished proposals shown here probably date from 1641 or 1642; at any rate, they precede the client's choice of Post's definitive design. In the sketches of the ground plan it can be seen that Vingboons, too, began with a strictly symmetrical plan with a central hall running from the front wall to the rear one, just as Pieter Post did (see previous entry). Subsequently he developed a less strictly symmetrical layout with a more flexible subdivision of the plan into rooms of different sizes. However, when one entered the vestibule the appearance of a completely symmetrical arrangement was maintained. This series of detailed ground plans includes various very neatly drawn façade designs. The cross section offers a glimpse of the decoration of the rooms as Vingboons imagined it, with large mantelpieces in the style of the French designer Barbet (Paris 1633) in the rooms, and with a great triumphal arch in the rear wall of the vestibule opening on to the stairway. The colors used in these drawings indicate the various materials, as was customary at the time in Holland: red for brick, white for the stone parts, and blue for the slates on the roof. This design was evidently too grand and expensive for Alewijn. In order to reduce the costs Vingboons next produced a sober, unornamented façade, which is reproduced in the collection of architectural designs that he published in 1648. Alewijn evidently did not agree with the proposal of building a large house with a sober façade. He preferred a smaller house with a complete row of colossal pilasters. Vingboons therefore reduced his large plan of 64 x 50 feet to that of a shallower building of 64 x 40 feet. This plan, too, is reproduced in the 1648 publication. One of the side rooms has been removed and in the this new layout the hall occupies the whole width of the building to the left of the vestibule and the stairs. KO

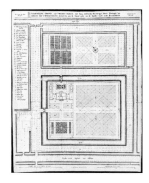

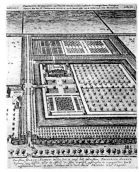

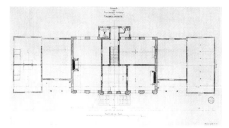

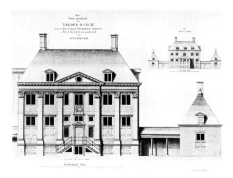

244–245–242–243 T
Pieter Post (1608–69), designer, Jan Mathijs, engraver
Villa Vredenburg, Design Used for the Actual Building in *Vreden-Burgh. Gebout door d'Heer Frederick Alewyn. aen de Noortsyde van de suyder wegh in de Beemster*, 1655 (?)
Leiden, Universiteitsbibliotheek Leiden, Collectie Bodel Nijenhuis, nos. P335-N231, P335-N232, IX-8-76, P335-N230
Four engravings
BIBLIOGRAPHY: Terwen, Ottenheym 1993: 88–99

A few years after the completion of the country seat, Pieter Pos had his final design for Vredenburg published in a series of four engravings. Together with the wooden model, these engravings give the best picture of the building that was erected in the years 1642–45 in the Beemsterpolder. It was a rectangular house of 64 x 40 feet,

flanked by two outhouses which were connected to the main building by galleries at front and back. Thus two inner courtyards were created, one on each side of the main house. The main building had a basement, a first floor and an upper floor. In the basement were the kitchens and the pantries. The main entrance on the first floor could be reached by a double stairway on the front façade. Behind the front door was the square vestibule with a wide staircase directly in front of the doorway. On the right of the vestibule were the two daytime living rooms for Alewijn and his family. On the other side of the vestibule, to the left, lay the great hall which extended from the front wall to the rear one (this ground plan of the main building is indeed very similar to that of Vingboons' last design; see previous entries). The hall was accessible from the vestibule and from the landing behind the staircase. The food and drink that was brought up via the service stairs from the cellars to the rear façade could thus be taken directly into the great hall or the large living-room. The upper floor had the same plan as the first floor, and it was here that the family's private rooms were situated. The attic above would have been used, as was customary, for drying washing and storing old household effects; this was also where the female servants' quarters were usually located. Both at the front and at the back there were open galleries linking the main building and the annexes. On the front side these galleries were decorated with sandstone Tuscan columns which contrasted strongly with the rich Corinthian pilasters of the main building. Although the detail of the orders accords with the precepts of Scamozzi, for the design of the building Post broadly followed Palladian models such as Villa Ragona. In his villas Palladio always used a "higher" order for the main building than in the annexes in order to indicate the difference in dignity between the respective buildings. According to the plan of Vredenburg the right annex was to accommodate the stables and the left one was to contain two apartments for the servants. But on the general plan of the whole estate the right annex is described as an "orangery," and the stables are housed in the old building on the land outside the actual estate. The Vredenburg estate consisted of two rectangular islands surrounded by ditches and dykes. These dykes were planted with four rows of trees to shelter the country seat from the wind. The house stood on the first, larger island, with an ornamental garden in front of it and a large orchard to one side. KO

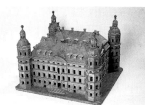

246
Barthel Volkland, model maker
Caspar Vogel and Nicodemus Tessin the Elder (1615–68), architects
Model for the Skokloster Slott, 1654–1657
Skokloster, Skoklosters Slott, Inv. no. 7331

Birch-wood; interior floors of fir-wood
41 x 58 x 58 cm (1/110)
BIBLIOGRAPHY: Eimer 1961: 138–50; Reuther 1985: 171–84; Reuther 1994: no. 362

The model was executed by Barthel Volkland of Pomerania, son-in-law of the architect of the castle, Caspar Vogel, from Erfurt. Each level forms one unit and demonstrates the distribution of rooms as well as the permanent organization and decoration of the walls. The model represents the castle as it was planned in 1653, including the changes suggested by Nicodemus Tessin the Elder of Stralsund until 1657. The building of Skokloster Castle was initiated by the constable of the realm, Carl Gustaf Wrangel. He originated from a noble German-Baltic family, mentioned for the first time in Dorpat (Tartu) in 1299.
In his youth Carl Gustaf Wrangel had studied shipbuilding in Holland. He had a partly French education and had successfully served in the navy, finally promoted to admiral. In 1660 Wrangel was appointed governor general in Pomerania, where he also appropriated a number of castles: the Bremervörde Archbishop's Palace (1646), Wrangelsburg outside Greifswald, the Ralswick and Spyker castles (where he passed away in 1676) on Rügen Island, and a town palace in Stralsund, erected by the Swedish military builder Nils Israel Eosander.
As one of the most successful military commanders of the Thirty Years' War, he assembled a considerable war booty, which he primarily kept at Skokloster and at his town palace on Riddarholmen in Stockholm. At Skokloster his extensive and varied library still remains, comprising approximately 3,000 volumes. Wrangel's strong interest in architecture is reflected in his collection of classical works by Vitruvius, Palladio, Du Cerceau, and Vignola as well as works by authorities of Northern Europe such as Andreas Böckler's *Architectura curiosa nova* (Nuremberg 1664), the whole printed production of Joseph Fürttenbach the Elder and Johan Wilhelm's *Architectura Civilis* from 1649. When Wrangel planned Skokloster he thus proceeded with solid experience and knowledge of his own–he can be labeled as an educated dilettante who both initially and during the entire building period was active in the planning of the castle.
Already in 1646, when Wrangel and Turenne stormed the Aschanffenburg Castle, he had prepared the new structure at Skokloster. Wrangel had in vain tried to engage Jean De la Vallée, the most important architect working in Sweden at the time. In 1653, however, he abandoned this idea, turning to Caspar Vogel who was then engaged in erecting Wrangelsburg in Pomerania. Vogel had entered Swedish service in the 1630s and had built locks for Gustavus II Adolphus.
Wrangel's aim was to realize, with Aschaffenburg as a model, a traditional – not to say old-fashioned – castle with four corner towers, a *Stammburg*, in accordance with the tradition of those of German regional princes. In 1640 an analogous project had been contemplated for

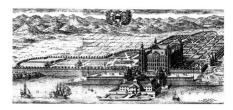

Friedenstein in Gotha, but was rejected as too old-fashioned by Duke Ernst the Pious of Sachsen Gotha. Friedenstein was erected in 1643–1646 by Andreas Rudolphi, Caspar Vogel, and Matthias Staudt.

With his experiences in Friedenstein, Vogel was of course the right man to assume the responsibility for the Skokloster project. He was old and infirm, however, and a visit to Sweden to conduct the building activity was absolutely out of the question. In April 1653 Wrangel chose to travel to Wrangelsburg himself in order to meet Vogel, who delivered the drawings in accordance with Wrangel's intentions. In November of the same year, the groundwork was started and in early spring 1654 the building's foundations were laid. The model was supposedly executed to complete Vogel's designs and help the Swedish builder Hindrich Anundsson, who was responsible at Skokloster, to carry out Vogel's intentions. Wrangel engaged Tessin early in the planning, and Eimer has been able to prove that Volkland had to make changes on the model on three occasions, obviously in accordance with Tessin's instructions. PB

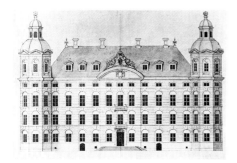

247 W
Nicodemus Tessin the Elder (1615–1681)
Studio drawing, or copy by Hindrich Anundsson
Exterior Elevation of Skokloster Slott
The Front toward the Sea
1655
Uppsala, Skoklosters Slott, Inv. no. 15923
Pen and brown ink, gray wash, indented
43.9 x 57. 6 cm
INSCRIPTION: "Skokloster Huus"
BIBLIOGRAPHY: Andrén 1948: 120ff., repr. 121; Eimer 1961: 142–150

The drawing represents the east prospect of Skokloster, bearing the modifications suggested by Tessin; it has been attributed to Hindrich Anundsson, who from the very beginning was responsible for the erection of the castle. At times he was addressed as *Architecteur*, generally, however, as *ingenieur*. He died in 1665.

From a letter from Wrangel to Anundsson of 13 July 1654 we learn that Nicodemus Tessin had already sent drawings with certain modifications to Vogel's project. In November of the same year Tessin sent a new drawing presenting his suggestion for the articulation of the façade, which may very well be this drawing. At the same time he suggests a rather radical change to the roof and the roofs of the towers, and insists on the chimney pots being moved inward toward the court, so as not to protrude above the roof ridge.

Wrangel does not, however, take these suggestions into consideration but expresses his satisfaction (*Vergnüglichkeit*) with Vogel's arrangement. This might comply with Wrangel's aesthetic approach, but he might also have taken into consideration the fact that the foundations were laid and the positions of the fireplaces already settled. Tessin's contribution was then limited to the rustication of the façades, which endowed the building with a modern look. This was, however, the case only with the exterior. The (inner) court kept the serious and spare look of Vogel's original design. PB

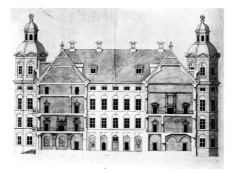

248 W
Nicodemus Tessin the Elder (1615–81)
Studio drawing, or copy by Hindrich Anundsson
Cross-section of Skokloster Slott toward the South, 1655
Uppsala, Skoklosters Slott, Inv. no. 15924
Pen and brown ink, gray wash, indented
43.9 x 57.6 cm
BIBLIOGRAPHY: Andrén 1948: 120ff., repr. 125; Eimer 1961: 142–50

This section was supposedly executed at the same time as the preceding drawing and shows that Tessin abstained from making changes on the court façade. When this drawing was executed, the east wing (left), was currently under construction. It was finished in 1657; the two towers acquired their roofs in 1659 and 1660 respectively. The west wing, oriented toward the garden, was not commenced until 1666. Tessin's project for the west entrance hall and the garden entrance were completed, although in a simplified form. The great problem was, however, the design of the Great Hall on the top floor and the mezzanine of the west wing where Tessin had suggested radical changes in Vogel's design. By 1668 the whole building had been fully roofed. The Banquet (Great) Hall was nonetheless an empty space and has remained so until today. When Wrangel died in 1676, details of some of the rooms on the upper floor had not yet been completed, and others have never been finished. Thus Skokloster Castle is by and large the work of Caspar Vogel. Nicodemus Tessin's contribution is limited to the design of the façade. Jean de la Vallée, who has traditionally been linked with the architecture of the castle, was never actually involved. His name is missing from existing documents. In 1669 he designed a project for the Sjögården, the sea pavilion, intended to be erected in front of the eastern façade, facilitating the approach from the sea. The pavilion was never executed, however PB

249 W
Erik Dahlbergh (1625–1703)
Suecia Antiqua et Hodierna, I, 140: Arx Skokloster, 1672–73
Washington, D.C., National Gallery of Art, Mark J. Millard Architectural Collection, David K.E. Bruce Fund. 1985.61.515
Engraving by A. Perelle after a drawing by Erik Dahlbergh; 58.5 x 25.5 cm
INSCRIPTION: "Arx Skokloster Illustriss Excell-mi Dni Comitis Caroli Gustavi Wrangelii"
BIBLIOGRAPHY: Dahlbergh 1924: 120; Andrén 1948: 16–20, 169–180; Dahlbergh 1966: drawings nos. 1185–1204; Magnusson 1986: 115–16, 194

This sheet is part of Erik Dahlbergh's work *Suecia Antiqua et Hodierna*, inspired by Matthaeus Merian's German topographies. The work contains 353 plates with 488 engravings for which some 1,000 drawings are preserved, most of which are kept in the Royal Library (Kungliga Biblioteket), Stockholm. Erik Dahlbergh was the quartermaster-general of the Swedish army and his drawings for the work form the most important pictorial documentation of its period in Sweden. *Suecia Antiqua et Hodierna* was the expression of a wish to present the new great power into which Sweden had been transformed through the result of the Westphalian peace treaty in 1648. Dahlbergh's autograph drawing for this engraving was certainly drawn after 6 September 1669. Proofs of the engraving were sent from Paris to Stockholm at the turn of the year 1672–73. Dahlbergh characteristically used a bird's-eye perspective to clarify the situation of a town or a country palace and its surroundings. In this engraving, he depicts the castle from Lake Mälar and with the planned, but never executed, sea pavilion of Jean de la Vallé in the foreground. Nor was Tessin's terrace ever realized. From these projects we can conclude Wrangel's appreciation of the strategic and attractive location of the castle on Lake Mälar with its direct contact with Stockholm and the open sea. The idealization of an otherwise modest reality, and the tendency to include suggested or projected additions or alterations was notoriously practiced in the engravings of the *Suecia Antiqua et Hodierna*. It was a publication of pure propaganda meant to spread on the continent knowledge of the powerful northern country.It was therefore of great importance when the so-called Leningrad volume, containing the main part of the studies and preparatory drawings by Dahlbergh and his collaborators, was discovered in St. Petersburg in the 1930s and acquired by the Royal Library (Kungliga Biblioteket) in Stockholm. In those the humble reality is carefully rendered and the "modification" of the engravings becomes obvious. The first edition of the work appeared in 1716. PB

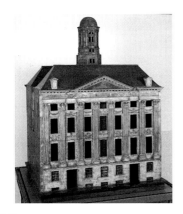

250 T
Justus Vingboons (1620/21–98)
Wooden Model of Trippenhuis in Amsterdam
1659–60
Amsterdam, Koninklijke Nederlandse Academie Van Wetenschappen
Oak covered with paper on which the ornamentation is drawn with pen and brush
117.5 x 106 x 159 cm
PROVENANCE: The model has probably always remained in the Trippenhuis (its presence there is recorded from 1811 onward). During the twentieth century it was on loan for some time to the Amsterdams Historisch Museum
EXHIBITIONS: Utrecht, 1983 (Central Museum); Amsterdam, 1989 (Koninklijk Paleis)
BIBLIOGRAPHY: *Het Trippenhuiste Amsterdam* 1983: 61–64; Meischke, Reeser 1983; Lammertse, Ottenheym, Zandvliet 1989: 96–99; Ottenheym 1989: 134–35

The Trippenhuis, the residence of the brothers Hendrick and Louis Trip, was built in the years 1660–62 and was the largest private residence in the Northern Netherlands. The 80-foot-wide façade built of natural stone with colossal fluted Corinthian pilasters, the carved ornamentation between the pilasters, the pediment, and the carved chimneys on the roof, show the immense wealth of the first owners. Such a rich architectural language, with all its pretensions to *magnificentia*, departed from the customary decorum of the leading citizens in the republic of that period and is akin in architectural style to the new Town Hall of Amsterdam and to noble palaces in towns elsewhere in Europe. This is all the more remarkable if one considers that the Trips were newcomers in Amsterdam and therefore could not be considered for posts in the city government, despite their wealth. The space behind the façade is divided with strict symmetry into two separate houses for the two brothers and their families. Each of these houses is designed on an extremely grand scale, but not unusual in layout within the typology of the houses of the Amsterdam ruling class. The dividing wall between the two houses ran precisely along the central axis and therefore met the façade along the line of the middle post of the central window. Each of the two houses has a central passage connecting up all the rooms, and each had its own courtyard which provided illumination for the staircase. The architect of this house was Justus Vingboons, a younger brother of Philips Vingboons. The Trip broth-

ers had probably met Justus Vingboons in 1653–56 in Stockholm. The wooden model, which was probably made shortly before building work began, in 1659 or 1660, will have helped the Trips to get an accurate idea of the splendor of their façade. The carved ornaments were meticulously drawn on paper, which was then stuck on to the façade. The model also gives a clearer impression of the arrangement of the interior, which can be taken out floor by floor. The domed tower on the roof of the model was never actually built. Probably during the building of the roof preparations were made for the possible erection of such a wooden watchtower. Since the model of the watchtower was made by a different hand from the rest of the model, it would appear to be a later addition, made ca. 1661, when the building of the roof was under way. KO

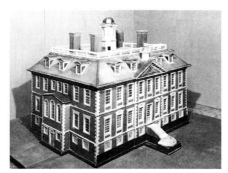

251 T–M
Jacob Astley and Thomas Fitch (?)
Model for Melton Constable Hall, Norfolk, ca. 1664–70
Norfolk, Norfolk Museum Service, Gressenhall, Dereham, GRSRM. 386.971
Pine exterior with oil-based paint; oak interior; glazed windows; 1150 x 1580 x 1280 mm
PROVENANCE: Lady Marguerite Hastings; Castle Museum, Norwich; Norfolk Rural Life Museum
BIBLIOGRAPHY: Knyff, Kipp 1708–15, pl. 51; Buck 1720; Blomfield 1808, IX: 415–26; Gunther 1928: 22–23, 60–61; Hussey 1928: 364–70, 402–409; Pevsner 1962: 196–97; Harris 1964: 31, fig. 58; Hill, Cornforth 1966: 38, 236, fig. 34; Wilton-Ely 1968: 252, fig. 1; Colvin, Newman 1981: 9, 55, 73, 74–76, 123; Bold 1983: 61, repr.; Summerson 1983: 261; Moore, Crawley 1992: 116, no. 47, repr.; Cooper 1999 (in press)

Country house architecture during the second half of the seventeenth century in England featured a unique and attractive formula in design which persisted until the closing decades of the century when the monumental vocabulary of the continental Baroque first appeared in the creation of great houses. Currently identified by scholars under the term Restoration House (referring to the period following the return of the Stuart monarchy under Charles II in 1660), this building type combined formal concepts of the Palladian classicism introduced by Inigo Jones before the Civil War, with continental influences from Holland and the Low Countries. The most important distinguishing feature of this type's external appearance, as determined

by revolutionary interior arrangements, was its solid rectangular nature, replacing the earlier E- or H-shaped plan – which had involved two wings on either side of a cross range and courtyards – with a more compact arrangement involving parallel ranges of rooms on the long axis of a rectangular block, either two-deep (then known as "double pile") or three-deep, that is "triple-pile." This change in the functional deployment of internal spaces represents the final stages of a major shift from the ancient pattern of owners living in company with their household and servants to one of segregation from them; a living pattern with more private and specialized accommodation on several floors, requiring communicating corridors and lobbies as well as separate staircases (see Platt 1994: 29–44). Such practically-ordered houses were frequently built of brick with stone dressings and decorative woodwork, particularly in counties such as Norfolk where stone was not readily available except brought from a distance. Externally this house type was also characterized by a prominent hipped roof, with dormer windows lighting the attic storey, which frequently culminated in a galleried walk on top with a central turret and cupola (lighting the center of the house), flanked by substantial chimneys. Associated with the gentry and middling degree of landowners who frequently took a major role in their design, these buildings were relatively modest in scale compared to the so-called prodigy houses of the Elizabethan and Jacobean eras, which preceded them, and to the later Baroque mansions of the leading nobility, designed by Talman, Hawksmoor, Vanbrugh and Archer.

Given the dominant role of the gentleman-amateur in the design of many Restoration houses, where the owner collaborated closely with a skilled craftsman, often in conception as well as construction, architectural models feature significantly in a number of surviving accounts. Indeed, in the absence of drawings for Melton Constable Hall, the model exhibited is the only surviving visual document to show the process of its design, although in this case comparatively few changes appear to have been made during construction. Moreover, this particular model is the earliest surviving one in Britain to show internal functions and divisions on all levels, and in exceptional detail rarely found in later domestic models. In surviving English seventeenth-century writings on architecture references to the importance of such models in determining and demonstrating design is given particular emphasis. For instance, the widely-traveled Sir Henry Wotton (ambassador to Venice between 1604 and 1623 and among the first to collect Palladio's drawings), paraphrased Alberti in his *Elements of Architecture* of 1624 when he urged upon his fellow country gentlemen the value of models in averting costly alterations since, as tersely put it, "a little misery in the Premises may easily breed some absurdity in the Conclusion" (Wotton 1624: 52). The advantages of this practical advice are borne out in the case of Sir Roger Townshend of Raynham in Norfolk (some six and a half kilometers distance from

Melton Constable), who appears to have been deeply impressed by various buildings in the classical style seen on recent travels in England and abroad, undertaken with his collaborator and mason, William Edge. As a consequence he halted building operations at an early stage in 1632 while another mason, Thomas Moore, is recorded as producing a model in deal for him (Harris 1961: 180).

A new generation of gentlemen-amateurs, traveling on the Continent to escape the Civil War conflict and aware of fresh developments in Northern Europe as well as in Italy, is epitomised by the career of Sir Roger Pratt (1620–85). After returning from a seven-year travel in the Low Countries, France, and Italy, during which he stayed with John Evelyn in Rome, Pratt designed a number of highly influential and sophisticated houses, mainly involving double-pile plans, before rebuilding his own seat at Ryston, Norfolk (some 17 kilometers from Melton Constable), between 1669–72, and was eventually the first Englishman to be knighted as architect. The practical value of models features prominently in Pratt's invaluable manuscript writings on building (some clearly intended for a treatise), which remain with the family at Ryston and were first published by R. T. Gunther in 1924. In an extensive passage Pratt not only discusses the history and advantages of models but also offers detailed advice on making them, as follows:

"As to a Model, the use of it hath been very ancient, being mentioned by Vitruvius, Cicero, etc. and is thought at this day to be so necessary by the Italians, the best architects of all others, that they will hardly ever undertake to build anything considerable, or of expense, without it, and do count it money saved, though otherwise the charge be great which is expended about it. Thus did the model of Saint Peter's in Rome of the invention of Antonio San Gallo, made by Antonio Laboco, cost 4184 crowns, and the architect as a present had 1500 more; the length of it was 22 feet, the breadth 16, and the height 13, which was in all about one 30th part of the whole work. Nor ought we to wonder at it, for that the model being often well considered and examined as it ought, it will not only prevent all future alteration in the building, a thing of a most vast expense, but will likewise avoid all complaint of the master, and abuse of the contriver, being that this will ever remain a justification of the invention of the one, and a most plain conviction of the consent of the other.

"Whereas all the other drafts aforesaid do only superficially and disjointedly represent unto us the several parts of a building, a model does it jointly, and according to all its dimensions. So that in one rightly framed all things both external and internal with all their divisions, connexions, vanes, ornaments, etc. are there to be seen as exactly, and in their due proportions, as they can afterward be in the work of which this is composed to be the Essay, but that the inward parts may so clearly appear to us, the sides of the model are so to be ordered, that the four corners of it remaining always firm, as to the rest they may be pulled up as occasion shall require; the rabbits [pulleys or lifting apparatus] for such motion being made in these corners, and in the base of the whole, and the like may be done in the roof where it shall be thought needful.

The estate of Melton Constable in northeast Norfolk was originally acquired by the Astley family of Warwickshire in 1236 when Sir Thomas Astley married Editha Constable, sister and heir to Sir Robert de Constable, and the Astleys remained in possession of the estate for the next twenty-two generations. Sir Jacob (1640–1729), builder of the new house, grew up during the tuburlent period of the Civil Wars and the interregnum. While his father Sir Edward Astley had taken part in the Parliamentarian opposition to attempts at increasing royal power, his maternal grandfather had been a fervent supporter of the king during the ensuing conflict. This latter fact probably led to royal favor at the Restoration in 1660 when Jacob, then barely aged twenty, was created a baronet and standard-bearer to Charles II.

Although there is no evidence of the customary travels abroad prior to this, his family had considerable contact with Holland and the Low Countries, his grandmother being Dutch and his mother was born in Holland during the Civil War period. Sir Jacob's responsibilities in Norfolk were to include forty-four years as a member of Parliament and service as Lord Lieutenant, the Crown's representative in the county.

In 1664 Astley demolished an earlier house at Melton Constable, severely damaged during the war, while retaining the original service block to the west. He appears to have begun construction shortly afterward, mainly using red bricks from the nearby kilns at Swanton Novers, set off by stone detail from a more distant source. The only other firm date surviving is that of the exceptional richly modeled plaster ceiling of the great parlor on the southwest corner of the ground floor, completed in 1687, and similar ornamental ceilings – one above the staircase well and another in the chapel – may also belong to the same period. Astley was to enjoy his house for another forty years, dying in 1729 at the age of ninety.

The earliest detailed account of the new building, as well as its preparatory model, at Melton Constable comes from the writings of a nearby landowner, Sir Roger North, who, like Pratt, left behind substantial manuscript writings on architecture which were first published in 1981 by Sir Howard Colvin and John Newman. While having practiced as a successful lawyer in London, North possessed both a great enthusiasm and a considerable competence in architectural matters, with Wren among his close friends. While his comments are more personal and informal than Pratt's, North was writing at about the same time when engaged as a gentleman-builder on the reconstruction of his own house at Rougham Hall, Norfolk (some 8 kilometers distance) in 1690–91. Adopting a somewhat conservative viewpoint, North was extremely critical, both of his neighbor and of his house, in identifying what were then seen to

be the disadvantages of the innovatory compact plan, especially in terms of ventilation, lighting and room proportions:

"A knight of the shire having had 30 years since 10,000 for the purpose of building an house sett his heart upon doing it in the best manner, and to the best advantage; and for that end, traveled with his bricklayer, whome he used also as surveyor, to the most eminent houses in England, to take patterns, and observe the modes of great houses. His caracter is avaritious, and mean spirited, and the bricklayer, for such a person, ingenious. The house they built was a new fabricke intire, of which a model was made and coloured, in great perfection. Now the marks of this man's humour were, first the model was as for a suburbian house, neer a square with a lanthorne, and a small courtyard, which is a citty-humour, and litle; and pleaseth on account of thrift, because the square figure hath most room for least walls, excepting onely the sphericall, which is not for houses. And this brings all inconveniences together, as want of light in the midle; the case is not the same, in great and small pyles, for a square will doe for the latter, but not for the former, which must be spread for air and light. Here the back staires open to the great staires, and those have no light, but from above the cornish [cornice, i.e. the top of the stair-well], which looks like a steeple. So here was a mixture of the gentleman, userer, and bricklayer, and the project proves accordingly" (Colvin and Newman 1981: 9).

North's extensive and revealing account of the internal arrangements and principal room functions of Astley's new house closely follows the detailed interior of the model which he could well have been describing. The latter is divided horizontally at each of the four floor levels to be examined from attic (or "garretts") level to the partly-sunken basement. Not only are all the divisions, doors, staircases and fireplaces shown but the catering arrangements in the basement are indicated in two separate kitchens, each with its respective cooking ranges.

While the construction of Melton Constable during the 1670s followed the major part of these arrangements closely, the model shows one intriguing feature which may possibly have been confused in North's memory when referring to the awkward gallery in the hall, no evidence of which survives. At the inner, western, end of the model's chapel is a raised or open mezzanine floor, appearing to be a gallery (or family pew), which is entered from a landing on the service stairs.

There is no evidence whether this was ever carried out. By 1734 the chapel had been converted into a saloon (the original stone floor being covered by a wooden one), this being the date of a conversation piece painted by John Theodore Heins showing the third baronet performing there in a musical party (Hussey 1928: fig. 14; Moore and Crawley 1992: 116, repr.). An arcade dividing this space from the staircase hall was eventually to replace the original entrance wall in 1857.

A number of other substantial changes took

place at Melton Constable from the mid-eighteenth century onward. Prior to this date, little change appears externally in some of the earliest known views of the house; the engraved bird's-eye view of the house from the northeast, with its formal gardens aligned on the south front, in Knyff and Kip's *Britannia Illustrata* (pl. 51), and a drawing of the house and gardens from the northwest made by the traveler Edmund Prideaux during a tour of Norfolk ca. 1725 (Harris 1964: 31, fig. 58). In 1757 an Ionic loggia was added to the east front at main floor level by the third baronet, and by this time the main south doorway had been replaced by one with fluted Ionic pillars (still shown as a plainly molded doorway in Buck's engraved view of 1720).

Moreover, during the same century the original wooden mullions and casements, shown in the model, were replaced by thin-barred sash windows, although the large round-headed window recessed on the western side of the attic roof to provide top lighting for the main staircase was retained. JWE

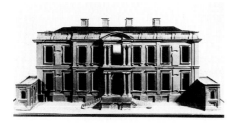

252 T
Nicholas Hawsksmoor (1661–1736)
Model for Easton Neston, Northamptonshire
ca. 1697–98
London, Lord Hesketh Collection
Oak with painted exterior; 590 x 355 x 260 mm
scale: 250 mm to 1.50 m
PROVENANCE: The Fermor family of Easton Neston
BIBLIOGRAPHY: Campbell 1715: pls. 98–100; Bridges 1791: 289; Tipping, Hussey 1928: 119–40; Webb 1931: 126; *The Wren Society* 1936: pl. 12; Whinney 1953: 209–11; Kenworthy-Browne 1964: 73ff., 143ff.; Wilton-Ely 1965; Downes 1966: 73–75; Wilton-Ely 1967: 29-30, figs. 7–8; 1968: 254, figs. 9–10; Colvin 1970: 968–71; Lees-Milne 1970: 138–47, figs. 221–22; Downes 1970: 31–42, fig. 18; Pevsner and Cherry 1973: 201–204; Haynes 1975: 14–15; Downes 1978: 156–159; 1979: 55–63, 274 (appendix H), 283, pl. 3a; Beard 1981: 19, fig. 7; Downes 1987: 50–76, figs. 13, 19 and 21; Colvin 1995: 475–76

Nicholas Hawksmoor's emergence from Wren's office as a fully-fledged designer of major importance in the English Baroque first appears with the creation of his first masterpiece at Easton Neston, Northamptonshire. The architect's surviving model has dual importance, both as an aid during the exceptionally complex design process itself and as a unique and critical document in the sparsely documented transition of the commission from an initial design by Wren to an executed work with the undoubted artistic signature of Hawksmoor.

Sir William Fermor, aged thirteen in 1661, inherited a house at Easton Neston which stood on a site to the south of the existing one. After taking a degree at Oxford in 1667, the baronet was eventually to acquire in 1691 the celebrated collection of antique sculpture, assembled by the Earl of Arundel in the first half of the seventeenth century, pieces of which were to feature prominently in the future house and gardens. He married three times and in March 1691–92, his third wife, Sophia, daughter of the Duke of Leeds, brought a substantial dowry and his father-in-law secured him the Barony of Lempster shortly afterward. Fermor's improved financial situation and rise in status probably gave the incentive to the creation of a new house which was substantially complete by 1702 (according to dates inscribed on the entablature of the east front and rainwater heads).

An initial design for the proposed house appears to have been provided by Wren – a distant relative of Fermor's by marriage – and is represented by drawing at All Souls' (*The Wren Society* 1936: pl. XII; All Souls': II, 83; also repr. Downes 1987: fig. 9). A letter by Wren to Fermor datable to 1685–86 suggests that the busy royal architect was giving advice from a distance, primarily on the garden design and out-buildings, but states: "I hope you provide to carry up one Story at least of the great house next year [since] it will be better worke & give it time to settle the stone & brick together" (quoted in Downes 1987: 52). However, further indirect evidence from other correspondence and from Evelyn's *Diary* (Downes 1987: 54) implies that work on the main house had still not begun before the autumn of 1694 when references in Hawksmoor's pocket notebook (quoted in Colvin 1970: 970) confirm that a new main water supply was being laid to the site from a source over a mile away and that Wren's assistant was now fully in charge.

Hawksmoor's role as designer at Easton Neston is confirmed in several diverse sources although it is only through close analysis by Downes that it seems likely that he was involved from the very start in constructing the main house between the recently-built flanking wings, designed by an unknown architect and not by Wren. (Only the north wing survives while the other was demolished probably before 1841.) Among early surviving sources, the first reference to Hawksmoor is in Campbell's *Vitruvius Britannicus* (1715), which illustrates a projected west elevation and plan and gives the completion date as 1713, while Bridge's *History of Northamptonshire* (published in 1791 from notes made before his death in 1724) states that the brick wings were produced by Wren some twenty years before 1702 when the house was completed to the design of Hawksmoor "who hath very much departed from the first design" (Bridges 1791, I: 289). Most significant of all is Hawksmoor's own statement in a letter of 1731 to the Earl of Carlisle of Castle Howard that: "we [...] went to my Ld pontefracts [i.e. the 2nd Lord Lempster was made Earl of Pontefract in 1721]. The Body of the House has some virtues, but is not

quite finished, the Wings are good for nothing. I had the honor to be concerned in the body of the house, it is beautifully and strongly built with durable stone. The State and Conveniencys are as much as can be in soe small a pavilion. One can hardly avoy'd loveing ones owne children" (Downes 1987: 87).

An undated plan of the main house at Easton Neston, together with sketches of the upper floors and partial north and west elevations, which were produced by a certain Colonel Thomas Colepeper (discovered by Colvin in the British Library; Harleian MSS 7588, fols. 512–17; 7597, fols. 99–100, repr. in Colvin 1970), are of critical importance. These amateur drawings (possibly made ca. 1697 from designs seen at Fermor's London house) show a major change of design from Wren's initial concept to Hawksmoor's, yet clearly predate the model design. While appearing to follow the relative dimensions of Wren's original main front, his central two-storey block is now extended laterally on both main storeys on the east and west to replace the flanking two-bay pavilions, making an overall nine-bay façade with a strongly horizontal roof-line.

At some point after this stage in design, Hawksmoor's model was produced with significant changes to the exterior as well as resolving the interlocking systems of interior spaces as finally built. Although no documentation for this key work survives (apart from a design for what appears to be the east frontispiece, in the Minet Library, Camberwell; see Downes 1987: 57, fig. 16), the comparative simplicity of the model's ornamental detailing and the exceptional care with which the interior floors are shown – all of them removable – with all their divisions and intercommunications, make it likely that the architect used this aid for resolving the functional and spatial complexity of his design as well as for communicating information to patron and builders. It could well have been used also to explore the manipulation of dramatic lighting inside which is such a memorable aspect of this remarkable house as the spectator is led through a series of unexpected spatial experiences from entrance hall to gallery.

As anticipated in the Colepeper version of the design, the division of the house into what the architect himself termed the "State" [rooms] and the "Conveniencys," or ancillary accommodation, is effectively demonstrated through the model. Set apart from the hall and four substantial rooms on both storeys, are placed the "Conveniencys" at each end of the building. In the northern half of the house on either side of the two-storey staircase space, Hawksmoor incorporated mezzanines to create two independent groups of rooms on four floors, each served by a separate staircase. Each of the three upper floors has a bedroom suite of chambers and, as Downes observes, makes the corners "in effect the *pavillons* of a French great house embedded within the silhouette of a single block" (Downes 1970: 37). To indicate this arrangement on the exterior of the north front, the architect increased the window bays from five in the Colepeper design to seven in the model,

and skillfully devised a fenestration system involving some twenty-eight windows of varying dimensions (including blind ones and niches in the model) in a composition which might be described musically as "contrapuntal" with no exaggeration. (Downes suggests the influence of an engraving of Ammanati's Collegio Romano façade, as a point of departure.) This formal complexity, which is repeated to a lesser degree, for similar internal reasons on the south front (where there is only an upper mezzanine), was first identified by Downes as confirming Hawksmoor's authorship of the controversial "Mannerist" façades on the King William dormitory block at Greenwich; uncharacteristic of Wren's designs and produced between 1699 and 1702 during Hawksmoor's period there as Clerk of Works.

Among other changes in design internally, shown in the model, the hall is considerably enlarged in all dimensions. Its center was moved southward and the entire space extended to the far south end of the house with single-storey bays at either end, separated from the central two-storey area by arcades. This space is also extended eastward toward the long axis of the house, causing the backstairs at the center to be turned 90 degrees to run lengthwise, instead of across the building as shown in the Colepeper version of the plan. The final result creates a centralized space with emphasis on two axes, as also a notable feature of Hawksmoor's church plans. This significant enlargement of the hall, as well as the far grander character of the main staircase, Downes suggests, may have been connected with the display of the Arundel marbles, arranged by Lempster around his property in 1708. (These were later sold by the 2nd Earl of Pomfret in 1753 and subsequently presented to the University of Oxford, where they are now in the Ashmolean Museum.)

Finally, while the entrance floor of both the Wren and Colepeper elevations is about 1.45 meters above ground, with an external terrace running across between the two flanking wings on the west front, Downes noted that this particular dimension has been increased in the model (as well as the executed house) to approximately 2.13 meters (1970: 61). Meanwhile, the terrace was removed in the model design to reveal the upper part of the basement (lit by a series of half-sunken windows) while the entrance floor is reached by a pair of lateral staircases at the center on the west front and a single, three-sided flight of stairs on the east, or garden front. Given that the ground plan remains unaltered from the earlier stages of design, this increased vertical accent externally introduces new sense of monumentality, crowned by the strong horizontal line of the balustrade.

The significance of the model within the development of Easton Neston's design is the way it reveals the architect's thinking as he moved toward an even greater monumentality in the executed design, for which no further designs survive. The most dramatic change by Hawksmoor to the model design was to convert the exterior from a virtually astylar two-storey elevation to one displaying a grandiloquent Corinthian giant order. On the west front the two-storey frontispiece (Corinthian over Ionic) of the main entrance is transformed to give magisterial emphasis by means of a pair of attached columns, crowned by an entablature bearing the Lempster motto, *Hora e Sempre*, and a segmental pediment containing the family coat of arms in relief. Meanwhile a system of pilasters articulates the remaining bays around the building, except for the shorter fronts on north and south where, predictably, the rhythms are more complex. As characteristic of a number of other domestic designs by Hawksmoor, no two sides of the house are the same. Yet the cohesion with which the giant order incorporates the complex rhythms of the fenestration patterns removes the last traces of the Wren design with which Hawksmoor had begun. The giant order also serves to bring unity to the irregular intervals between the windows, resulting from the complicated changes of room shapes within the façade during the evolution of the design. Making a virtue of this enforced irregularity, Hawksmoor underlines this progression of uneven window bays to either side of the central axis by a sequence of subtle projections and recessions, already shown in the model. This skillful progression of breaks in the massive entablature required by the giant order build up to a truly Baroque crescendo at the centre of the main façades. A string course immediately under the ground-floor windows, which creates the illusion that they descend to the floor (belied by the actual level of the main door's threshold 60 cm lower), is yet another optical refinement added between the executed façades and those of the model.

The house, which remains remarkably close to Hawksmoor's final solution, was constructed of brick and entirely faced with finely cut ashlar from the Helmdon quarries. While a letter from the architect to the Earl of Carlisle in 1731 (Webb 1931: 126) mentions that the house was not quite finished, Hawksmoor never realized his intentions for reconstructing the 1682 wings in a more imposing manner and adding a small tower with cupola as a central climax above the house (as shown by the engraving, presumably from a drawing supplied to Campbell, in *Vitruvius Britannicus*, 1715: pl. 100). In more recent times a significant change was carried out around 1900 to the hall when a floor was inserted to convert the upper half into a bedroom. Meanwhile, at the hall's northern end, which originally incorporated the space of the entrance bay, to the height of one storey, a partition wall was built to close the void originally framed by pilasters and a detached column on either side (as originally changed from triple arches at each end in the model). A partition wall was also removed on the other side of the main door to create a new entrance hall. The stately staircase, while no longer displaying the Arundel sculptures, however, still retains the monochrome wall paintings from the life of Cyrus of Persia, executed between 1709 and 1711 by Sir James Thornhill, then working with Hawksmoor at Greenwich. JWE

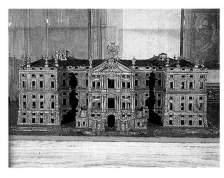

253 T–MAR
Giovanni Gloria (ca. 1684–1753) and/or Sante Benato (documented in 1717–60) after designs by Girolamo Frigimelica
Wooden Model of the Central Section of the Villa Pisani at Stra
Venice, Musei Civici Veneziani, Museo Correr
91.4 x 213.4 x 182.9 cm
PROVENANCE: Correr Bequest
BIBLIOGRAPHY: Tognolo 1978–79: 153–72; Fontana 1988: 155–56, 158 (for preceding bibliography); Puppi, 1990: 198–99

From at least 1615 onward, the Venetian noble family Pisani owned fifteen *campi* of land, at Stra, which by that time had been divided into walled gardens. A half century later the land appears to have contained a house, which in the 1780s and 1790s was remodeled and enriched with a loggia. This structure was composed of an oblique base and an elevation of two architectural orders and a surrounding garden (Gallo 1944: 128). Coronelli, in his collection of prints illustrating the villas along the Brenta River (pl. LXXXII, *La Brenta quasi Borgo della città di Venezia*, 1709) and J. Ch. Volkamer, in his *Continuation der Nürnbergischen Hesperidum* of 1714 (pl. XLI, cf. Concina 1979: 76), both depict the house in this state, though it was destined to be changed during the simultaneous remodeling of the noble Venetian residence of Alvise Pisani at Santo Stefano in Venice. Between 1699 and 1704, Pisani had been ambassador to France, where he was acquainted with Louis XIV. Nevertheless, we do not know exactly when concrete action on the project was undertaken.

The choice of Girolamo Frigimelica to design the new structure at Stra should be seen in this light. He was the scion of a venerable noble Padua family whose precocious dedication to humanistic pursuits and vast cultural horizons have been amply demonstrated (Tognolo 1978–79: *passim*; Finocchi Ghersi 1998: 543–54). An occasional dilettante, he decided to prove himself as a professional by opening a studio in his own palazzo and by participating in the debate about the renewal of the Duomo of Padua – for which he designed a façade – and by working on plans for a new library for the University of Padua, for which was the *Curatore* between 1691 and 1693 (Zaccaria 1939–41: 90–94; Tognolo 1978–79: 122ff.) Upon such a career, it is understandable that Alvise Pisani, who had been one of the *Riformatori allo Studio* in Padua, trusted him. He was probably already aware of the architect's

versatility and talent when he was ambassador in Paris and Frigimelica was in contact with the same political and cultural circles, with whom he had personal relationships (see his letters to *Madama la Contessa di N.N.* published in Venice in 1702; see also Archivio di Stato di Venezia, AsVe, Inquisitori di Stato, bb. 598–599). When he worked on the remodeling of the Venetian Palazzo di Santo Stefano (Masobello and Tarlà 1977), Frigimelica concentrated on the "invention of a 'grand salon' similar to ancient Egyptian rooms" based on Vitruvius (Archi-vio di Stato di Modena, AsMo, Cancelleria Ducale, Particolari, b. 4/2, 10 January 1732).

Little remains of Frigimelica's plans for the Pisani's villa except the three-dimensional models assembled by his trusted collaborators Sante Benato (doc. Padua 1717–60) and Giovanni Gloria (Padua 1784–ca. 1753). These represented the central portion of the villa (finished in 1782, 800 *ducati* were paid for it; Precerutti Garberi 1968: 151), the tower of the labyrinth, the pavilion and the belvedere (now in the Museo Civico Correr in Venice) and the rusticated portals of the garden entrance (now in the Cooper Hewitt Museum, New York). G. Carboni must have used these models as the basis for the series of engravings he published in Padua in 1792 and which were partially reproduced by Fontana (1988: 156). Sources suggest this was carried out around 1716, as there is a bill dated 12 September for "money spent on the manufacture of a model for His Excellency Alvise Pisani" (Archivio di Stato di Padova, AsPd, Privato Selvatico Estense, Famiglia Frigimelica, marzo XXXIV, b. 412, loose sheet). With the exception of the central block, we can infer that the original idea must have been duly executed (at least until 1721) under the direct supervision of Frigimelica himself. (Indeed, he left Padua in that year to move to Modena, where he died in 1732.) He may have delegated the work to his students Sante Benato and Giovanni Gloria (Bresciani Alvarez 1977a: 176), so that he could be kept informed about the progress of the work. Nevertheless, he did not fail to make short visits and by 1724 the work must have been far enough along if Montesquieu could admire the grandiose portals during his Venetian visit of the same year (Fontana 1988: 155). In 1720, work had begun on a "model" (which has not survived) of the "building (*fabrica*) at the far end of the garden" – the stables. At the time of his move, Frigimelica, aware of his responsibility regarding what was left "to be decided upon", anxiously assured his patron that he was leaving "various models, numerous drawings, and other material that would be useful for current and future operations at Stra" in the palazzo in Padua (*ibid.*). While Giovanni Gloria joined Frigimelica in Modena to "do drawings for the counts Pisani" (Sartori 1964: 312), Frigimelica himself also went for a few days "to Stra, to the site of the Pisanis who are anxious [about the work]." At the beginning of October 1726, he went with "signor Almorò" to look over the "garden" (AsMo, Cancelleria Ducale, Particolari, b. 472; To-gnolo

1978–79: 171–73, 1980). We can be reasonably certain that under the conditions presented here, all the architectural ingredients experimented with the models and the layout of the gardens were realized.

As Corboz (1987) has rightly pointed out, the layout of the garden was a tightly woven scheme that was inspired by the plan of Pliny's Tuscolo villa – as ideally reconstructed in the work of Felibien des Avaux published in 1699 (republished in 1706 and 1707) – and the principles of *La théorie et la pratique du jardinage* (1709) by Dezailler d'Argenville. In other words, it was coherent with the intellectual and cultural formation of the architect (and his Francophile patron), who was a habitual reader of Vitruvius in the version of "the worthy Monsieur Perault" (Tognolo 1978–79: XXXIX-XL). We are convinced that at the time of Frigimelica's death, the conclusion of the grandiose and magniloquent seat of the Pisanis at Stra lacked "only" the completion of the central portion of the noble residence (for a differing opinion, which maintains that Frigimelica's plan was executed by Preti, cf. Brusatin 1980: 159. This idea may be based on Haskell 1966: 391, who places the demanding architectural task undertaken for the counts Pisani in 1730).

It is probable that Frigimelica's invention, which survives only in the wooden model presented here, was put aside and eventually abandoned because the patron, initially puzzled by it, ultimately rejected the capricious indulgence that motivated the deliberately eclectic architecture: "the loggia is from the Palazzo Chiericati, the projection of the lateral wings was inspired by Bernini, and certain elements of the covered pavilion recall the addition to the Palazzo di Racconigi by Gua-rini" (Pilo 1962: 184). In the end the building was not sufficiently assertive about a crucial point: the image of classical grandeur that alone was capable of representing the patron's desire for self-aggrandizement. LP

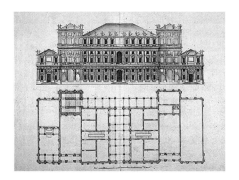

254 T
Francesco Maria Preti (1701–74)
First Proposal for the Central Section of the Villa Pisani at Stra
Treviso, Biblioteca Capitolare, F.M. Preti, *Opere*, II, HH 6, fol. 5
Pen and brown ink with watercolor
46.7 x 63 cm
Provenance: Bequest of Canon Carlo Adami
Bibliography: Puppi 1990: 198–99; Colonna-Preti 1997: 170, 208 (for preceding bibliography)

There is no documentary evidence regarding the circumstances under which Francesco Maria Preti was employed to elaborate on and prepare an alternative to the plan that Frigimelica had designed for the Villa Pisani at Stra. In any case it remains a fact that, although the minor aspects of his project were realized, there must have been a degree of perplexity surrounding his plans for the major aspects of the project; a fact proven by the suspension of his plan's execution. It is reasonable to suppose that no decision was made prior to the death in 1732 of the architect from Padua. On the other hand, it is possible that the election of Alvise Pisani as doge on 17 January 1735, with a celebration "of such grandiosity and magnificence as no man has seen" (Da Mosto 1983: 477–78) was the factor prompting the decision to take action and tear down the late seventeenth-century "villa," which had been used for patrician "vacations" until then.

The suggestion that someone new who was not only well-known but also from outside the world of Venetian architecture be entrusted with producing an alternative to the project presented by Frigimelica may have come from Preti's *maestro*, Giovanni Rizzetti. Rizzetti frequented cultured circles in *La Serenissima* and was also a resident of the *contrada* of San Samuele, which is near the Pisanis' Venetian palazzo (Cecchetto 1996: 16ff.; Colonna Preti 1996: 36ff.). In a manuscript history of the Pisani family dated 1732, Rizzetti himself reports that by that date Preti had executed a design for a "triumphal arch" for this same noble family. This could have been the precedent for the much more prestigious commission at Stra. Upon undertaking this important responsibility, Preti was careful to take into consideration the solution reached by his predecessor; he did not necessarily reduce or readapt the hypothetical direction Frigimelica had already taken (which had been determined by the needs of the patron), but used it as a reference point that would allow him to make an autonomous and unmistakable statement.

Preti engaged himself in a "dialogue" with Frigimelica, evidence of which appears in the first proposal's treatment of the elevation of the principal façade with its succession of the three canonical orders, Doric, Ionic and Corinthian. These are surmounted by a narrow entablature adorned with statues, which was to contrast with the weight and projection of the one that separates the ground floor from those above (the *piano nobile* and upper floors). The transition between the Doric order on the ground floor to the Ionic order of the *piano nobile* is punctuated by a frieze with triglyphs. Two smaller pavilions flank the wings of the central section; these are pierced by arches on the ground floor. These wings included the horizontal distribution of ten windows of simple geometrical form which are surmounted by ten smaller square ones whose sequence is interrupted by an arch on the second level. On this level, the even number of windows have timpani, which are separated from the small windows above by a thin strip. There would have been large windows, complete with timpani as

well, on the third level where the central portion that corresponds to the arches below presents itself as empty masonry. This space would doubtless have provided for the placement of the heraldic devices of the Pisani family.

The proposal for the rear façade is explicitly informed by the spirit of Frigimelica's thought with its focus on a system of loggias and its plastic movement. It has a vivacity of rhythm that seems destined to harmonize not only with the active and curving reference to the stables in front but especially with the fantastic effusions of the other architectonic objects and kaleidoscopic network of pathways in the garden. The planimetric aspect of the numerous interior spaces (the chapel on the ground floor and a vast salon on the *piano nobile*) obey the logic of the architect's search for symmetrical correspondences. His intent to establish an optical "channel" between the main and rear façades including the garden becomes clear and determined (Puppi 1990: 198–99). The reason why this project, for which Preti was careful to prepare a general report of his expenses (n.n. sheet, dossier of the Biblioteca Capitolare in Treviso), was abandoned is unknown. The excessive cost (around 230,000 lire) certainly contributed as did the regard shown for the previous plan and the inadequacy of its intent to "represent" classical and "Palladian" majesty. LP

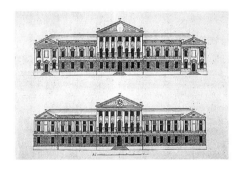

255 T
Francesco Maria Preti (1701–74)
Second Proposal for the Central Section of the Villa Pisani at Stra
Treviso, Biblioteca Capitolare, F. M. Preti, *Opere*, II, HH 6, fol. 1
Pen and ink with added watercolor
47.3 x 62.7 cm
PROVENANCE: Bequest of Canon Carlo Adami
BIBLIOGRAPHY: Fontana 1988: 158 (for the preceding bibliography); Puppi 1990: 198–99; Colonna-Preti 1997: 170

These are the drawings of the front and rear façades of the Villa Pisani as they were actually realized. They belong to folder containing four sheets (Preti, F. M., *Opere*, II, HH6, 1–4) that show the palazzo's ground floor and the first floor as well as the higher central section of the second floor with a view of the roofs of the two lower lateral wings as seen from above (Colonna-Preti 1997: 170). Preti's drawings present not so much the reworking of the first proposal as a complete reformulation of it. It is probable that these followed the first proposal shortly after in 1735 and that it was upon their completion that work on the building actually started. Indeed,

the date 1736 is inscribed on one of the stones in the façade of the chapel (currently located in the villa's entrance). Work would continue for another twenty years, until 1756, which is the date on another stone that was engraved to commemorate the termination of construction, prior to which other modifications were made to the layout of the project (Puppi 1990: 197; as to following events see Fontana 1988: 158). LP

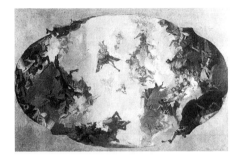

256 MAR
Giambattista Tiepolo (1696–1770)
Apotheosis of the Pisani Family
Angers, Musée des Beaux-Arts
Oil on canvas; 140 x 96 cm
PROVENANCE: Bequest of Jean Robin de Chalonnes, 1864
EXHIBITIONS: *Giambattista Tiepolo 1696–1996*, Venice 1996
BIBLIOGRAPHY: Pedrocco and Gemin 1995: 511 (for the preceding bibliography); Christiansen 1995: 320–24

This is a study for the ceiling fresco of the most important of the salons of the Villa Pisani at Stra. Tiepolo was working on it in 1760, when he mentions it in a letter to Algarotti (Fogolari 1942: 35–37). Tiepolo was still hard at work on the fresco in December 1761 and only finished it on the eve of his departure for Spain on 31 March 1762. It is plausible to identify the commissioner of this work with Alvise, Almorò III Pisani, who had been held by the Sun King when he was baptized in the Royal Chapel of Versailles and later filled the dignified post of *procuratore*. The painting depicts not only the four sons borne by his wife Paolina Gambara, portrayed in the protection of the personification of Venice and the nude figure of Truth (for the identification of the other members of the Pisani family, see Gallo 1945: 72–73), but also the Duke of Montealegre, the Spanish ambassador to Venice. Montealegre's presence alludes to the obligation that Tiepolo now had with respect to *el procurator* and records the duke's satisfaction over the outcome on 5 December 1761, of negotiations that would take Tiepolo to Spain (Battisti 1960: 80). Regarding the actual date of the commission, it is possible that it was given right after the builder delivered the completed central section of the villa in 1756.
The composition is divided into two connected episodes that are tied together by the "flickering" figure of Fame and the glimpse among the clouds of the figure of Divine Wisdom seated on a throne resting on an orb. She is attended by Faith, Justice, Charity and Fortitude. The figure of Italy, who wears a crown in the form

of a tower, is flanked by the liberal arts – Astronomy, Music, Sculpture and Painting – and leans over the figures of Venice and Truth, between which are ranged members of the Pisani family who are watched over by Peace and Abundance to the far side. On the other side, Europe majestically dominates Asia, America and Africa, while a subdued and pathetic group of arrogant Turks slinks away. Frightened figures of Discord and Heresy flee to the right. The political meaning is obvious; pacific Venice is the wise and civilized mediator between Italy and Europe, overseeing "the exercise of virtue" and "progress in the arts."
The painting exalts the celebration of conscious pride in the role of the aristocratic destiny that is entrusted to the younger generation of the Pisani family (for a penetrating reading of the larger significance of this work, see Mariuz 1978: 246–48; Levey 1988: 246–51; Christiansen 1996: no. 52). While it is true that the translation from oil sketch to the extended dimensions demanded by the fresco provoked minimal and irrelevant quantitative changes, it is equally clear that the chromatic energy that animates the sketch has been subdued; particularly in the well-calculated contrast between the calm and sunny tones of the episode that hinges on the portraits and the lively and convulsive rhythm of the episode hinging on the figure of Europe. LP

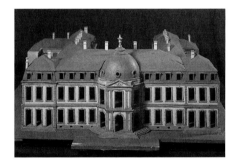

257 T–MAR
Robert de Cotte (1656/57–1735)
Working Model of the Palais Thurn und Taxis, Frankfurt am Main
Regensburg, Fürst Thurn und Taxis Zentralarchiv-Hofbibliothek-Museen, FZA, Museale Gegenstände
Painted and gilt wood; 93.5 x 99.5 x 37.5 cm
PROVENANCE: Transferred from Frankfurt to Regensburg in 1892
BIBLIOGRAPHY: Lübbecke 1955: 121–22, 164–76; Neuman 1994: 149–53; Reuther 1994: 71–72

This splendid wooden model served the purpose of helping Prince Anselm Franz von Thurn und Taxis, postmaster general of the Holy Roman Empire and the Netherlands (1681–1739), and his builders to visualize the French design of his new residence in Frankfurt am Main. Although the family had lived in Brussels, Charles VI persuaded this Catholic prince to relocate in Protestant Frankfurt, one of four cities in the empire possessing a free constitution. Hence the need for a new structure worthy of the status of the patron. In sending the initial plans prepared by a local architect to Paris for evaluation in 1727, the prince

joined the ranks of numerous European sovereigns and aristocrats who, recognizing the ascendancy of French design in the early eighteenth century, sought the assistance of Robert de Cotte (1656–1735) for palace and villa plans. Having trained under Jules Hardouin Mansart and having succeeded him as Premier Architecte du Roi in 1708, de Cotte oversaw a hierarchical system within the Services des Bâtiments du Roi that was based on the system of the monarchy itself and allowed the accomplishment of a great deal of work through the participation of many minds and hands in the conception and elaboration of each project. De Cotte normally worked on the initial ideas in drawings and rough sketches handed over to draftsmen to copy in finished form, and he drew up the accompanying *mémoire* (memorandum) and *devis* (specifications). He was also responsible for the execution by his assistants of wood, plaster, or wax models and of detailed construction drawings to be used on the site. The extraordinary degree to which de Cotte maintained a network of building operations across Europe, from Madrid to Constantinople, made the preparation of precise drawings and wooden models crucial to the proper execution of his ideas.

The Premier Architecte normally reviewed the progress of construction only in Paris and the Île-de-France. Otherwise, he made use of assistants sent out from the capital or of local architects as intermediaries between himself and the patron. De Cotte sent an assistant, Guillaume Hauberat, from Paris to oversee construction of the Frankfurt building between 1731 and 1740 on Grossen Eschenheimer Strasse, the avenue leading north from the medieval sector. Magnificently decorated by an Italian family of plasterworkers, the Castelli, and the South German sculptor Paul Engell, the building was inhabited little more than a decade. In 1748 the Thurn und Taxis moved their seat to Regensburg, the site of the Imperial Diet of Princes.

As was frequently the case, de Cotte rejected the local architect's design, rethought the problem, and returned his own project to the patron, accompanied by a defense of his project in a *mémoire* dated 8 September 1727. For the design de Cotte utilized the standard form of the Parisian *hôtel-entre-cour-et-jardin*, so that the street façade would project a dignified if sober appearance to the passer-by, while princely richness was relegated to the garden front and to the interiors, elements hidden from public view. Although its origins are not documented, the wooden model was certainly produced in Paris and shipped to Frankfurt some time between 1727 and 1731, most likely just prior to construction. This was the case for a documented but lost wooden model of a very similar structure, the Palais Rohan, Strasbourg, assembled by the de Cotte workshop and carried from Paris to Alsace in December 1728. The Frankfurt model consists of eleven pieces that can be detached so that the interior room arrangements may be inspected: the curved entry wing, with its classical portico; the ground floor of the left wing of the *cour d'honneur*; the

premier étage of the left wing of the *cour d'honneur;* the roof of the left wing; the ground floor of the right wing of the *cour d'honneur*; the *premier étage* of the right wing of the *cour d'honneur*; the roof of the right wing; the ground floor of the *corps de logis*; the *premier étage* of the *corps de logis*; the roof of the *corps de logis*; and the dome of the *salon* on the garden façade. The walls are painted silver-gray with architectural details like the orders, quoins, and window surrounds painted brick red. The roofs are slate-gray, while the dome is a coppery green, topped by a gilded finial. The model was restored in 1967.

In basing his design on the standard type of Parisian *hôtel-entre-cour-et-jardin*, de Cotte was not blazing new trails in urban architecture but was showing his conservative bent. Most of the motifs employed here, such as the concave street entry wing, the arcaded lateral wings of the courtyard, and the classical frontispiece, had been used by him in *hôtel* designs of the second decade of the century, and their origins can be found in seventeenth-century *hôtels* as well. One motif, however, was unusual – the domed *salon*. De Cotte considered this to be a princely motif and employed it prominently in palace and country-house design for patrons of the highest rank. His insertion of it on the garden side of the main block of the Palais Thurn und Taxis, therefore, was appropriate, although the oval *salon*, comprising two separate storeys, was not a true *salon à italienne*, which would normally be two storeys in height. In any case, the building, while traditional from the French point of view, stood in stark contrast to contemporary German town houses in overall massing and details. Thus the Palais Thurn und Taxis was significant because it communicated to a foreign audience the principles of French architecture in the realm of the large, private urban residence. Indeed, de Cotte was one of several French architects, such as Germain Boffrand and Alexandre Le Blond, who were hired by a far-flung European clientele to bring French design to the distant corners of the Continent. RN

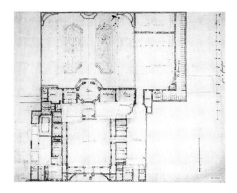

261 MAR
Robert de Cotte (1656/57–1735)
Palais Thurn und Taxis, Working Plan, *rez-de-chaussée*, with de Cotte's handwriting
Paris, Bibliothèque Nationale de France, Cabinet des Estampes, Vc 325, 1199
Pencil, ink
48 x 62.5 cm

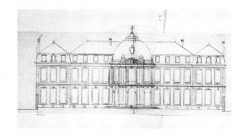

260 MAR
Robert de Cotte (1656/57–1735)
Palais Thurn und Taxis, Elevation, Garden Façade
Paris, Bibliothèque Nationale de France, Cabinet des Estampes, Vc 325, 1198
Pencil, ink
25.9 x 69.8 cm
PROVENANCE: Purchased from the de Cotte family by the Bibliothèque Impériale (Bibl. Nat.) in 1811
BIBLIOGRAPHY: Lübbecke 1955: 161–76; Neuman 1994: 149–53; Fossier 1997: 649–51

The drawings for the Palais Thurn und Taxis are preserved in the Fonds de Cotte in the Bibliothèque Nationale, Paris, one of the largest collections of architectural drawings to survive intact from the eighteenth century – nearly three thousand numbered sheets in all.

These drawings usually fall into one of five types – site plan, working drawing, presentation drawing, construction drawing, and record drawing. Six sheets relevant to this project, all of them working drawings, survive in Paris. The drawings sent to Frankfurt were not preserved. The building is rendered to scale, with the customary Parisian unit of the *toise* placed prominently. Because this was a foreign commission, a scale bearing the local unit of measure, the *pied de frankfort*, was also included.

We can determine the sequence of the drawings used to develop the project by looking closely at ink and graphite corrections and superimposed swatches of paper indicating alternatives.

As his *mémoire* indicates, de Cotte made major changes in the plans sent to him, following the principle of *convenance*, according to which the layout should suit the needs and the status of the patron: "Since my opinion has been requested, I believe upon reflection that, this being the house of a *grand seigneur*, it would be more appropriate to put but one *grand appartement* on the ground floor – this is where the seigneurs and the nobility assemble – and to put two *appartements* facing the garden on the *premier étage*, and others in the wings [...]"

The earliest plan of the ground floor (1199) combines sketchy pencil and ink to rough out the basic concept. Bits of pasted paper were used to incorporate changes or alternative solutions to the stair hall, the *salle*, and the chapel. The presence of several hands in the drawing and de Cotte's handwriting in the captions suggest a work-in-progress.

In laying out the interior, the architect, in accordance with the latest precepts in French do-

mestic planning, emphasized the separation of public and private spaces and introduced a circular rather than axial arrangement of the rooms. Thus it was de Cotte's consistent goal to make the most of a limited space in providing accommodation for a large princely household. A subsequent graphite plan (1198), which served as the basis for a presentation plan, neatly outlined the final solutions for such rooms as the chapel and the dining hall, as de Cotte noted: "I felt obliged to place the chapel on the ground floor, with its entrance at the back of the first *salle*; there is a tribune accessible from the *premier étage*; the entire staff of the house may easily hear Mass on the *rez-de-chausée*, even from the *salle*. Concerning the dining hall, since it is an important room where people frequently assemble, I thought that I must take care to situate it well, and that it must be sufficiently large. That is why I put it on the garden side to the right of the *antichambre*, in the *enfilade* of the *grand appartement*, also being accessible to the servants from the first *salle*: thus the table may be set and cleared easily from the service rooms and kitchen, which are situated much as in the plans mailed to me [...]"

Despite de Cotte's preference for a circular path of circulation, in the final layout of the house a door leading from the vestibule directly into the *salon oval* provided passage along the main axis, while two *appartements* of roughly equal size flanked the *salon*.

An unfinished plan, partially inked, for the *premier étage* still features superimposed flaps in an effort to determine the final layout of the upper floor (1200a).

Again, Robert de Cotte's concerns: "To the left of the vestibule I placed the great stair, which rises on the axis of the vestibule to the *premier étage* only, leading to the two *grands appartements* facing the garden on either side of the oval *salon*, and to other apartments in the wings. Additional stairs placed in various locations will lead to all the stories as well as descend to the *caves*."

An inked elevation of the garden front (1201) shows the planar frontispiece that held in check the energetically curving walls of the oval *salon*.

An early sketch for the central pavilion shows a curved forged-iron railing crowning the dome. The railing was changed to an urn-shaped finial in the definitive drawing and the wooden model.

As much as we may regret the loss of the presentation and construction drawings for the Palais Thurn und Taxis, the extant working drawings in Paris are extremely valuable for what they tell us about urban residences in eighteenth-century Europe.

Together with Robert de Cotte's *mémoire* and the wooden model, they reveal the architect's considerable efforts to accommodate the public and private needs of a German prince within a uniquely French domestic building type, the *hôtel*.

Furthermore, they preserve the memory of a remarkable structure that was largely destroyed in the twentieth century. RN

The Architectural Models at Regensburg
Peter Germann-Bauer

The City of Regensburg Collections possess a large number of architectural models which are preserved in the model room of the Old Town Hall. Part of these models are from the City Buildings Office, which is the authority responsible for all permits and measures relating to edifices constructed in the City of Regensburg. All these measures are written and recorded in the Buildings Office Chronicle together with a corresponding collection of plans. Owing to dislocation, at an earlier stage, in the systemization of the plan collection, in many cases it is no longer possible to identify the plans and models with any certainty.

One group taken from this model collection are models of timber-framed buildings (Reuthe, Berckenhagen: no. 314–22), as well as buildings with elaborately constructed roof timbering (loc. cit. no. 302) which can be identified through their corresponding plans as master entries of the carpenter. Similarly the builders' master drawings for a further group of models have also been preserved.

For quite a long time nothing has been known about the makers of these models. We can certainly exclude the possibility that the masters concerned carried out the plans themselves. The only that is actually signed in the City of Regensburg Collection bears the name of a sword sharpener (Reuther, Berckenhagen: no. 324). In the order of Master Builders there is no description either of the form or execution of the master entries.

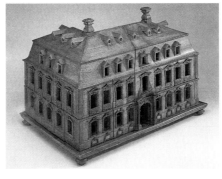

262 T
Anonymous
Model of a Mansard-roofed house
ca. 1760
Regensburg, Museen der Stadt Regensburg, Inv. no. KN 1999/7
Base: oak; model: limewood, hard wood and variously tinted fruit tree woods; base: 61 x 40.5 cm; model: 57 x 39 cm; height 41.3 cm
BIBLIOGRAPHY: Reuther, Berckenhagen 1994: no. 304

The two-storeyed house has an irregular L-shaped floor plan. The front façade and left side are both architecturally designed, while the right side and the rear are windowless. The centre axis of the front façade is characterized by a portal with jutting pediment, flanked by two columns stained in black; and also, above the doorway, by

a window with volutes at either side. The window in the mansard attic is also emphaszied by its form to continue the design of the façade up to the roof. The segmental arched windows of the ground floor are tall and rectangular. The upper floor windows have molded stone framing with contrasting pediments alternating in peaks and flats. The plinth band of these windows carries festoons. Both fronts facing the walled courtyard have segmental arches on the ground floor and unframed windows; on the upper floor the rectangular windows are framed with moldings. A fountain stands in the courtyard. All the ground floor rooms (with one exception) have removable vaulting. In the interior we recognize a number of furnishing items such as: the staircases, a brickwork wash-tub, three bases for tiled stoves, the fireplace with brickwork escape hood, a stable with two feed troughs and the lavatory. Both plans belonging to the Bauamtschronik are undated and unsigned. PGB

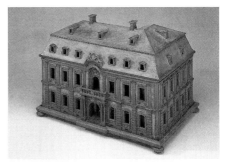

263 T
Caspar Gottlieb Ludwig
Model of a Mansard-roofed house
1767
Regensburg, Museen der Stadt, Inv. no. KN 1999/8
Base: oak; model: limewood and reddish fruit tree wood; base: 59 x 41 cm.; model: 55.5 x 39 cm; height: 40 cm
BIBLIOGRAPHY: Reuther, Berckenhagen 1994: no. 306

This two-storeyed house has an L-shaped floor plan; the front and right hand side are architecturally designed, while the left hand side and the rear are windowless. The seven- windowed front façade is characterized by a wide portal flanked by paired columns, and a balcony. In the center of the balcony the balustrade bears a cartouche with the initials "I.P.V." (the initials of the builder). A round arched doorway set in a deep niche richly decorated with shell devices opens onto the balcony. Above the niche runs the front cornice of the roof, surmounted by a segmental arched pediment where two seated female statues hold a cartouche with the crossed keys, emblem of the city of Regensburg. The architectural planning of the façade is characterized by pilasters set between the window axes, rusticated ashlar stonework on the ground floor, and smooth ashlars with volute capitals on the upper floor. The right hand side of the house has rows of five windows. Here the ground floor windows are framed in segmental arches, while the straight windows of the upper floor are supported by volutes. The corners of the front façade are

rounded. In the interior, all the ground floor rooms have variously shaped, removable vaulting (one missing). On the ground floor we see the kitchen fireplace with a brickwork escape hood, two bases for tiled stoves, a brickwork wash-tub with escape hood, the stable with two feed troughs, as well as the lavatory. In the upper floor we find another fireplace with escape hood, and three adjacent rooms with corner niches to accommodate tiled stoves. Both the plans belonging to the Bauamtschronik are by Caspar Gottlieb Ludwig, and signed and dated the 17th and 18th February 1767. The master builder Ludwig was granted hereditary citizenship of Regensburg. PGB

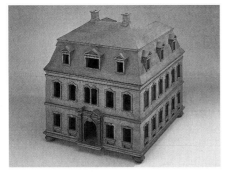

264 T
Anonymous
Model of a Mansard-roofed House
ca. 1770–80
Regensburg, Museen der Stadt, Inv. no. KN 1999/6
Limewod, hard wood and fruit tree woods
40 x 48 cm; 45 cm (height)
BIBLIOGRAPHY: Reuther, Berckenhagen 1994: no. 303

The floor plan of the house shows an irregular horseshoe shape, whose two wings vary in width. The front façade is on the narrow side, while one of the long sides is structured on architectonic lines. The principal façade is characterized by a wide portal flanked by columns below a richly decorated jutting pediment. Above the pediment on the upper floor there is a double window; the dormer window above it in the mansard attic is also of double width. There are two windows on both sides of the front entrance and, on the long side, rows of six windows on both ground and upper floors. The decorated stonework frames of the ground floor windows close the design of the whole façade at ground level. The upper floor windows are surmounted by shell-shaped devices; the framing of the dormer windows adopts a more simplified form than those on the ground floor. In the interior, a double-branched staircase leads to the attic floor (the roof truss was never made). The furniture items have not been preserved in their entirety. However, we can still see both kitchen fireplaces, one on each floor, immediately above the other, and two bases for tiled stoves on the ground and upper floors, as well as the lavatories. Two master entry drawings with similar plans are dated 1776, which justifies attributing a date of the 1770s, in spite of the façade which belongs to the first part of the century. PGB

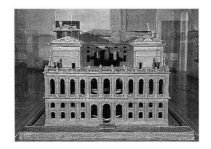

265 T–MAR
Domenico Rizzi
Wooden Model of the Palazzo Venier "dei Leoni"
Venice, Musei Civici Veneziani, Museo Correr
76.2 x 167.6 x 231.4 cm
PROVENANCE: Gift of the Counts Papadoli
EXHIBITIONS: *Ritratto di Venezia*, Venice, 1973
BIBLIOGRAPHY: Bratti 1915: 449; Bellavitis 1973: no. 142; Dall'Aglio 1981–82: 55–60; Biadene 1985: 134; Romanelli 1986: 54–55

The death of Lorenzo Boschetti on 24 April 1750 prevented the designer of the Veniers' "new palazzo" from completing the work that he had conceived and drawn up. This happened at the very moment that it seemed possible that Girolamo junior and Nicolò were assured success in their task of progressively and patiently acquiring and trading various buildings for the site identified in the engraving of the plan of "most noble palazzo" by Fossati. Even though the author of the project was no longer around, the two Veniers, who still lived in the old house (this remained until the last century), whose site was not included in the lot destined for the new one, busied themselves with obtaining from the municipal authorities, on 9 December 1752, authorization to construct a sort of warehouse (*casotto*) for storing building materials for the palazzo in San Vio in Campo Sant'Agnese. Work actually began more than a year later when stone from Rovigno and oak arrived at the casotto and their delivery was recorded in February 1754. In the meantime, the Veniers must have resolved the problem of who was to direct the building site, as on 1 March 1754 this job was given to Domenico Rizzi (doc. 1754–64) along with a monthly salary of ten zecchini. Until now, Rizzi was unknown to the history of architecture except in connection with his employment as "architect and public technician" for the lay sisters of the convent of Santa Maria Maggiore, which was attached to the church of Sant'Agnese (just a few steps away from the site of the Veniers' new palazzo). Rizzi must have been contacted by the Veniers somewhat before his official confirmation as head of construction for the new palazzo. He may have been required to modify and "adjust" the plans prepared by Boschetti, which were not so much abstract as absolutely lacking any indication regarding their practical use at the building site. However, an intermediate operational step was indispensable: the definition of a model. Thus, the actual document that confirmed Rizzi's employment specified that the work was to be carried out "according to his own [sic] model" (BcVe, Mss. Venier, b. 124, c. 68r). This is certainly the one that has

come down to us without significant damage despite unknowable vicissitudes. The model shows certain changes with respect to Boschetti's designs for both the layout and elevation. Without actually subverting Boschetti's eleven-part rhythm, Rizzi reduced the double half-columns and half-pilasters to one. This suppressed the extra decoration on the *piano nobile* – which consisted of vertical garlands and panels centered between the arches that flank the triple-arched unit standing over the palazzo's entrance on the level of the Grand Canal. To compensate, Rizzi redesigned the lateral windows of the second storey. Pediments substituted the frame with its keystone; their outlines became gently undulating and the timpani were enriched with garlands. At the same time, the windows of the cornice above were reduced to mere purely geometrical ovals. Even more clear, almost to the point of manipulation, are the modifications to the original order. Indeed, comparing them is almost pointless, given the strong suspicion that the main reason motivating these changes was the insufficiency of information provided by Boschetti, who probably limited himself to providing the two drawings engraved by Fossati. Nevertheless, work seems to have been started soon after the contract with Rizzi was signed. Work was far enough along by 21 May 1755, that the need for new stone to "proceed with building the façade on the Grand Canal" was recorded (BcVe, Mss. Venier, b. 124, c. 68v). It is probable that what had been constructed by this date were the "mezzanines resting on bases" which remain today and show these sport lions' heads that were quite absent from both Boschetti's drawings and Rizzi's model. No doubt the traditional name "dei leoni" (of lions) owes its origin to these spectral architectural fragments. (Another origin for this name is found in Tassini [1915: 670–71], which may refer to a lion – celebrated in bombastic Latin hexameters composed by a certain Nicandro Jasseo – that the Veniers had imported from Barbary in 1763. Freed on the site of the palazzo, which was covered with undergrowth, the lion "appeared to be quite mild-tempered in the midst of the dogs.") In 1757, the Veniers were busy trying to obtain the funds that may have been necessary to purchase additional stone. These attempts were fruitless and produced only disappointing results. Such are the circumstances that led to the decision made sometime during that year to "abandon the building project that had been undertaken only recently." This decision unleashed a series of lawsuits that the will and codicils of Girolamo Venier had made almost inevitable (BcVe, Mss. Venier, b. 124, c. 69r). We are ignorant of the outcomes of these suits, but it is a surprise to find that the addendum delivered to the notary Gabrielli with instructions that it be opened "twenty years after the reading of the will and its codicils," (which took place on 18 April 1735, on the death of Venier) was never opened. Indeed, it remained hidden among the "secret" wills (BcVe, Notarile, Testamenti, Not. A.M. Zuccato, b. 1275, fasc. "Chiusi," no. 18). When it was opened – too late and in vain – it revealed that Venier had specified that the funds that were destined for the construction of the

new palazzo were to go to the coffers of the Most Serene Venetian Republic in the case that the twenty-year term for the building's completion not be met. In the meantime, the land that was to have been the site of a "residence that would be an honor to the city and posterity" was now abandoned to weeds and brambles. With the Veniers' "historic habitation" in San Vio having become decrepit, the last of the hapless executors of a will that was fruitless and troublesome – the grandson also named Girolamo – moved to the *contrada* of San Felice where he lived in a house consisting of a ground floor and an attic, which in 1739 had been rented to "Domenico di Piccoli" (AsVe, X Savi alle Decime, Redecima 1740, Condizioni Dorsoduro, b. 327, no. 247). This now became his residence, where he died two days after having dictated his will on 26 January 1779. The will said nothing about the state of the "new palazzo" in San Vio or about the fate of the site where it was to have been proudly erected. At the beginning of the nineteenth century Maria Contarini Venier owned the area, on which could be seen the "foundations of a palazzo, now a garden." (AsVe, Catasto Napoleonico, 1807–1809. Sommario Dorsoduro, no. 7, particelle 15011). LP

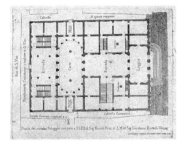

267 T
Giorgio Fossati (1706–85), from drawings by Lorenzo Boschetti (1670–1750)
Plan of the Lower Floor of the Palazzo Venier "dei Leoni"
Venice, Biblioteca del Museo Civico Correr, Stampe PD 2337
Engraving on copper; 34.5 x 27 cm

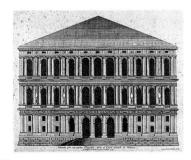

266 T
Giorgio Fossati (1706–85), from drawings by Lorenzo Boschetti
Façade of Palazzo Venier "dei Leoni"
Venice, Biblioteca del Museo Civico Correr, Stampe PD 2336
Engraving on copper; 41.6 x 35 cm
EXPOSITIONS: *Le Venezie possibili. Da Palladio a Le Corbusier*, Venice, 185
BIBLIOGRAPHY: Bassi 1962: 338; Dall'Aglio 1981–82: 55; Biadene 1985: 135, 4.6.7

As indicated by Fossati (Marcote 1706–85 Venice), these two engravings reproduce plans for a new palazzo that was to have been built for the Venier family in the *contrada* (district) of San Vio. Even now, not much is known about the circumstances surrounding the building's commission and its construction, which was interrupted leaving only the façade of the lower level which now forms part of the Peggy Guggenheim Collection of contemporary art. Likewise, little more than what Fossati stated in the captions of the images he engraved is known about the architect who was commissioned to build the palazzo. Nevertheless, it is worth noting the heretofore unpublished facts that have come to light in the course of research done for this occasion, beginning with information regarding Lorenzo Boschetti himself. We have no information regarding professional apprenticeship at any sort of institution. It is possible that he learned the rudiments of his profession from his Dalmatian father Domenico, who between 1690 and 1701 worked for the *Savi Esecutori alle Acque*. The fact remains that while Lorenzo was still quite young he presented a project (never carried out) with two variations for the rebuilding of the bridge of San Giobbe in the Canareggio quarter. This project originated in response to resolutions adapted on 11 June 1689 by the *Savi Esecutori alle Acque* (Biadene 1985: 116–17, with preceding bibliography). In 1692 he was hired by the *Magistrato alle Acque* as an assistant technician. His appointment was reconfirmed in 1695 and he retained this position until 1703 when he was asked to assume the position belonging to *vice-proto* (or vice-foreman) Lorenzo Benoni, who had recently died. He held this position for the rest of his life (Dall'Aglio 1981–1982: 6–7). Between 16 March 1698 and 20 December 20 1748 he produced a goodly number of reports (the register of these is recorded in Dall'Aglio 1981–1982: 96–124; copies of these and other original writings are located at the Biblioteca Nazionale Marciana, BMVE, Cod.it. IV 164=5642, 73r–78r; 111r–112v) that reveals him to have been a hydraulic technician possessed of up-to-date knowledge as well as a noteworthy intelligence both of which are revealed by the designs that he did for the *Savi Esecutori* and for other magistrates (see again the register in Dall'Aglio 1981–82: 126–60; a map of the territory of Verona reviewed by Paolo Rossi which is dated 23 April 1712 in Biblioteca del Museo civico Correr, Venezia, BcVe, Mss. PD c 2303/1). Surprisingly enough, in the meantime he also began studying law at the Collegio Veneto Giurista, which after 1680 began accepting students of Dalmatian origin. He received his degree (*utroque iure*) on 23 September 1704 (Archivio Antico dell'Università di Padova, AAU PD, reg. 79, 177). Thus it was as doctor *utroque iure* that he published a brief *Dimostrazione scenografica et ortografica di un nuovo riparo per li pubblici lidi veneti* with G. Albrizzi in 1707, which was illustrated with a drawing engraved by Carlo Zucchi. In 1709 he presented a proposal for another competition – again without success – for the design of the new façade of the church of San Stae. The competition was initiated pursuant to a bequest in the will of Doge Alvise II Mocenigo of

20,000 ducats to be used as necessary. The design that was published, with an erroneous indication of its author (N. rather than L. Boschetti), along with those submitted by other participants in the competition, Vincenzo Coronelli (*Proposizioni diverse de' principali architetti per la facciata di S. Eustachio*, Venice, 1710) shows only limited originality and almost slavish dependence on the manner of Domenico Rossi (the Gesù) and Giuseppe Sardi (the churches of the Scalzi and Santa Maria del Giglio). Finally around 1739, Boschetti won the commission to design the reconstruction of the church of San Barnaba (Moschini 1815: 273; 1819: 291; but cf. Zanetti 1835: 129) on which construction had already begun by 1750 (Livan 1942: 3). The professional activities that he carried out for the *Magistrato delle Acque*, his work as a consultant for other institutions that proposed him to the government of Venice and the surrounding territory as well as (most probably) his work for private clients were a source of economic satisfaction for Boschetti. Nor did he do less well by his wife Elena Bruchner: daughter of the late Giorgio Cristoforo she brought a considerable dowry from her family of German merchants of who she was ward. After dictating her will on 26 May 1732, she died the following June (AsVe, Notarile, Testamenti, Not. A. Bonamin, b. 74, no. 49). An assessment of 1740 records that in addition to living in a house that he owned in the *contrada* of San Vio, Boschetti also owned two other houses that were rented ("in *contrada* of San Martin, courtyard of the Vida") and in "*contrada* San Marcilian near the Ponte della Guerra," a country house ("a house built by me a few years ago") in "Villa di Mestrin in a place known as Le Barche," two small houses at San Donà di Piave as well as agricultural lands near Mirano, Noale and Castelfranco (AsVe, X Savi alle Decime. Redecima 1740, Condizioni Dorsoduro, b. 327, no. 92). This is a substantial patrimony, most of which had been dispersed by the death of Boschetti's son Antonio in 1781 (AsVe, Giudici di Petizion, Inventari, filza 476/141, no. 4). We now arrive at the problem, until now unresolved, of the circumstances surrounding such a prestigious commission. With a holograph will dated 19 March 1733 and submitted to the notary Carlo Gabrielli the following 16 May (Gabrielli died soon thereafter and was unable to put the will and its successive codicils "in public form," a task that fell to notary Alessandro M. Zuccato), Girolamo Venier son of the late "cavaliere and procuratore" Nicolò, charged his brothers Sebastiano (bishop of Vicenza), Giambattista, Lunardo and the latter's son Nicolò, in their capacities as heirs and executors to build a palazzo. With detailed instructions about where to find the necessary funds, he expressed his wish that "there be commenced the construction of a palazzo on the site in San Vio of our ancient residence, or at another suitable site in Venice that [they] may consider." Moreover, the will specified that, should this fail to come about within fourteen years of the date the will took effect, the sum of money put aside should be turned over to the Ospedale degli Incurabili (AsVe, Notarile, Testamenti, Not. A.M. Zuccato, b. 1276, cc. 151v–154r). A few months later, the nobleman

made his wishes more flexible. With another holograph codicil dated 21 July 1733 and delivered to notary Gabrielli on 3 August, Girolamo Venier decided in effect that "the first fifteen years after the will came into force be dedicated to settling on a plan, buying material and other preliminaries." Heading this list was that the building be started and finished within the lifetime of the executors (his brother Sebastiano had disappeared from the list). Should the last surviving heir be unable to finish the undertaking, the funds were to be destined for "another subject" such as a relative or friend (AsVE, Notarile, Testamenti, Not. A.M. Zuccato, b. 1276, cc. 154r and 156r). About a year later, Venier modified the disposition of his property again with a new codicil dated 30 May 1734, deposited with the notary 16 June. In this he expressed "doubt about whether he had completely and with sufficient clarity expressed his desires." After emphasizing his preference that the building be built in San Vio and after stating that if the sum set aside by him (more than 40,000 ducats) "were not enough, it would at least be near enough to complete construction," Girolamo fixed a twenty-year term during which the work was to start. He provided for the case that his wishes might be "neglected" by depositing with the notary an "addendum" in a sealed envelope that was "to be opened twenty years after the opening of his will and its codicils" (AsVE, Notarile, Testamenti, Not. A.M. Zuccato, b. 1276cc. 156r–158r). Girolamo passed away in his eighty-fifth year (he was born on 8 April 1650) (AsVE, Miscell, Codici. I. *Storia Veneta*: M. Barbaro, *Arborii de Patritii*; BcVE, Mss.Venier. b. 124, c. 66r). He had been a prominent figure in the political and diplomatic life of the Serenissima and had attained the honorable offices of *cavaliere* of San Marco and *procuratore*. After serving in varying capacities in several *magistrature*, he served as the Venetian Republic's ambassador to France (1683–84) and Germany (1689–92) and was also ambassador extraordinary to England in 1696 (Marozzo della Rocca 1959: 80–81, 118–19, 146). His desire to erect a "residence that would be an honor to the city and posterity" – as he himself expressed it in the codicil to his will dated 21 July 1733 – reflected the Venetian aristocracy's generalized impulse for self-aggrandizement which found expression in grandiloquent architectural representations of the magnificent destiny of the nobility's condition. The complex of buildings that included the "old" house "for [...] use and habitation with two small houses above the *fondamenta* [...], along with another small house nearby [...] in the San Vio *contrada*," which Girolamo's grandsons Nicolò and another Girolamo registered in 1740 (AsVE, Savi alle Decime. Redecima 1740. Condizioni Dorsoduro, b. 327, no. 247), were "archaic" in appearance and undeniably inadequate (a print by Coronelli and Visentini bears witness to this, as can be seen in a plate from the *Admiranda urbis venetae*: Bassi 1976: 356–57). Thus it was due to be replaced by a spectacle of stunning and sumptuous architectural rhetoric. It happened that the executors of the final wishes of this nobleman were extremely determined – especially Nicolò – to realize this wish. To begin with, since

1737 they had been collecting the debts listed by the testator so as to amass the considerable sum necessary to complete this project (BcVE, Mss. Venier, b. 124, c. 66v). Thus, as a result of purchases and trades made between 1739 and 1742 (BcVE, Miss. Venier, b. 124, c. 310v) in the area of San Vio near their "old" residence they were able to assure of the availability of the lots destined to be occupied by the "building of the [new] palazzo." It is probable that they brought in Lorenzo Boschetti at this point. His design – really only partial and limited in scope and perhaps only indicative rather than operative (see successive catalog entry) – was sufficiently advanced in 1749 to be published with fanfare and reproduced in the two prints by Giorgio Fossati discussed here. This idea is not characterized by any particular originality. As in the façade for the church of San Stae, and for the rebuilding of the church of San Barnaba, Boschetti did not go much beyond the passive adaptation of current fashion. On this occasion, he let himself follow the forceful influence of Giorgio Massari's production for the Grassi family at San Samuele, a graphic reproduction of which was already available in 1745 (Romanelli 1986: 55). LP

272 MAR
Pietro da Cortona (1596–1669)
Project for a Ceiling
London, Royal Institute of British Architects
Pen, ink and brown wash; 30.5 x 47 cm

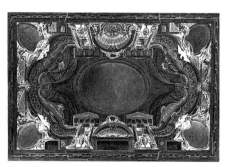

271 MAR
Angelo Colonna and Agostino Mitelli
Project for a Ceiling, 1658–60
Madrid, Museo Nacional; 187 x 281 cm

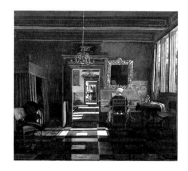

270 M
Emmanuel de Witte (ca. 1617–1691/92)
Woman at the Spinet
Montreal, Musée des Beaux-Arts, Museum of Fine Arts
Oil on canvas
97.8 x 110.2 cm

Emmanuel de Witte did not neglect genre scenes, as is proved by his opulent *Fish Markets* (Rotterdam, London, Moscow) or this *Woman at the Spinet* at the Montreal Museum of Fine Arts. For many years incorrectly attributed to Pieter de Hooch, this remarkable painting is a slightly larger echo of a celebrated canvas at the Boymans-van-Beuningen Museum in Rotterdam and can be dated to 1667. By establishing a subtle relationship between the discretion of the characters and the mathematical rigor of the space, the artist constructed a mysteriously charming image, which gives itself up to the viewer in the mode of progressive revelation. Indeed, as opposed to other interior scenes of the day here the feeling of the space, magnified by a crystalline treatment of light, initially seems to prevail over the life it shelters. The architecture, defined in keeping with a rigorous geometry, dominates the composition. The viewer's eye, beguiled by such mastery of geometric relations, is, in an initial *élan*, quickly led through to the back of the house, and comes to a halt in the room where the servant is seen sweeping. Becoming aware that this marvellous piece of architecture is inhabited, in the same way that a camera is brought into focus, the eye then returns to the foreground and, scanning the space, narrows in on the characters. A woman, seen from behind but whose hair-do is reflected in the mirror, is shown playing the spinet, while the darkness of the bed only just allows us to perceive a man stretching out, hinted at by his clothes and a sword thrown onto the armchair, just as the woman was hinted at by the musical instrument. Though they remain anonymous and lack psychological depth, the inhabitants are not mere accessories intended to bring the architecture to life; they are at once actors in a story, about which the artist refrains from providing the slightest clue. SA

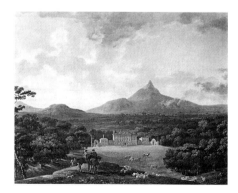

269 M-W
George Barret
View of Powerscourt, 1760-62
New Haven, Yale Center for British Art
Oil on canvas, 73,4 x 97,2 cm

Four Projects for the Marchese Carron di San Tommaso's "palazzo in villa"
Giuseppe Dardanello

The five drawings present four different projects for a single theme: an out-of-town residence for a prince or high-ranking person; a "palazzo in villa", according to a definition used frequently also by Juvarra to indicate a type of building that linked the comfort and pleasantness of a more casual and informal life in a country villa to the standards of architectural design required to represent the dignity and social status of the urban palazzo. Of the four projects, one shows an elevation and longitudinal section on the same sheet and the corresponding plan on a separate sheet (A); two compare plan and elevation on the same sheet (B and C); whereas only the plan of the last has been conserved (D). They show a range of deliberately different proposals commissioned by a definite patron for a clearly stated piece of land, perhaps to replace a pre-existing building of less importance no longer in keeping with the times. The four projects are in fact for the same existing site, bounded by a wall on three sides, with two passages open on an axis in an area immediately behind the place where the architect would lay out the new, planned building. The pre-existing structure is clearly indicated in grey watercolor in the plans of projects C and D; it is more difficult to see but equally clearly recognisable in the pencil lines of projects A and B. The rows of trees arranged in exedras in the plans of C and D suggest that the villa would have been positioned at the end of a long perspective down a straight drive. The discovery of these sheets in the *Fondo Carron di San Tommaso* in the Archives of the Cavour Foundation induced a well-grounded belief that this influential family of noble dignitaries of the powerful bureaucracy of the Savoy government, called to fulfil the role of secretary of state on several occasions, might have commissioned the building. The sheets were among documents relating to Pozzo Strada, an area in the country to the south-west of Turin, flanking the "great road to Rivoli." "Drawings for two country houses for the signor marchese di S. Tommaso" are recorded at the end of the *Catalogo dei disegni fatti dal signor cavaliere ed Abate don Filippo Juvara dal 1714 al 1735, compilato dal suo discepolo G. B. SACCHETTI* (Catalogue of drawings by Filippo Juvarra from 1714 to 1735, compiled by his pupil G. B. Sacchetti). The sketch of an emblem on the façades of projects A, B and C, although approximate and reduced in scale, hints at a St. Andrew's cross with a serrated profile. This is exactly the distinctive emblem of the Carron family, quartered in a serrated St. Andrew's cross, referable in those years to the eminent figure of Giuseppe Gaetano Giacinto Carron di San Tommaso (1670–1748), minister and first secretary of state after his father, from 1696. The hint to a collar with a medal, tied below the emblem, is a reference to the knighthood of the Savoy Order of the Holy Annunziata conferred on the Marchese di San Tommaso. Having confirmed that it was a Piedmontese commission for a "palazzo in villa", able to rival some of the royal palaces that Vittorio Amedeo II was building in the territory of the Savoy state, the variety of proposals presented here certainly demonstrate a highly cultured and up-to-date patron. Even more, they also seem directed to satisfy a personal need for an open mentality toward the new opportunities offered by the flowering of modern architecture in different cultural areas of Europe. Before anything else it is the vastness of the conception, the "thinking in big," the extension of the range of architectural images absorbed and returned in "a splendid mixture of diverse possibilities" to declare Juvarra as their author; even before the "hand" has made itself recognizable in the fluidity of the barely hinted treatment, in the synthetic incisiveness in the representation of the decorative details, in the choices modulated in the intensity of the rendering of planes and recesses and shadows created. An indicative date, around the middle of the 1720s, would lie between the last stages of his work at Rivoli Castle, which some of these projects are very indebted to, and the commission for a hunting lodge at Stupinigi (1729), for which project D must surely be a precedent. Two of the four projects (B, C) develop along an extended plan and are variously articulated on the site. The other two (A, D) are more compact, even if a radiating trend about to burst from a strongly centralised nucleus can be felt in the last. In the variety of the solutions offered, common characteristics can be found: the sureness of the symmetries and the mirror effect in the plan, set around a central *salone*, always arranged transversally to the longest axis of the villa; four pavilions always placed at the vertices of the main building; all the buildings arranged on a platform only slightly raised above the ground – confirming that the planned site was on level land – sometimes articulated in several levels of terraces with access ramps shaped to support the outline of the villa plan. The large central *salone*, which always coincides with the main entrance to the building and acts as an obligatory passage to reach the apartments, always communicates directly with the exterior: on both sides in project C; on the avant-corps in the main façade, with an opening into the gallery and verandas on the opposite side in project A; on the back front, preceded instead in the façade by an arcaded loggia, in project B; screened by two small vestibules with open arches in project D. In the elevation the *salone* develops through at least two, if not three, main floors, and in three cases (A, B, D) the ribbed structure of the vault is indicated in the drawing. The layout in the plan includes at least four apartments: the basic apartment unit is made up of the sequence anteroom, bedchamber, study; the smaller apartments, or single bedrooms, are arranged in the peripheral areas of the building. In all four projects ample space has been given to rooms open to light and air and actively communicating with the exterior: galleries (in B and C open on both sides); loggias (on three orders with terraces in B); verandas and belvederes (the vast covered roof terrace above the whole of the central block in A, and probably also the top area in project D). At least a couple of staircases provide for vertical connections inside the villa, always in different solutions, inspired by functional rather than ceremonial criteria. The task of representing status and rank is instead given to the architectural order, used in its own linguistic value to articulate – without ever repeating – rhythm, cadence, character and the hierarchy of volumes and façades. The roof coverings recall different areas of architectural culture: tiled gables following North Italian customs, in project A; pavilions dressed in copper or some other metallic material, following styles and techniques in use in middle Europe, in South Germany, Austria and Bohemia, in projects B and C. Juvarra has drawn up four possible interpretations from a single subject with common features that could not be more different among themselves. Some of the ideas from this rich catalogue of "palazzi in villa" have their origins in the themes of academic exercises from his Roman period, and direct counterparts in the architect's winning project for the Clementine competition of 1705. In his many studies for villas near Lucca – one of the rare occasions that Juvarra had to plan realisable buildings in the period during his stay in Rome (1704–14) – the architect puts into practice the articulation in plan and the aggregation in elevation of different models that are at the origin of the group of projects elaborated for the greater means at the disposal of the Marchese di San Tommaso. In Piedmont, the academic dimension has been succeeded thanks to the reality of his practical experience and an acquired maturity due to a wider and more direct knowledge of contemporary architecture the other side of the Alps. Considered together, the four "palazzo in villa" projects rehearse the distinctive qualities of Filippo Juvarra's artistic uniqueness: his prodigious capacity to make his own and manipulate with self-confident naturalness famous models, decorative styles, building customs from different cultural areas in different geographical countries of Europe, in order to come up with always new ideas divorced from the narrow limits of local traditions. This, united to that rare quality of knowing how to merge opposing and at some times divergent attitudes into inventions that transparently conserve a visual memory of their source – in this case from Mansart, Le Vau, Bernini, Guarini, Fontana, Fischer von Erlach, Hildebrandt, De Cotte, Boffrand – but that are completely new and original. The image of the Baroque that Juvarra gives us in these four projects for the Marchese di San Tommaso is no longer that of the inexhaustible richness of Roman repertoire – recorded in Gaspar van Wittel's *vedute*, or magnified in Giovanni Paolo Pannini's triumphs – but is that of the plurality of idioms in modern Europe in the cities painted in Bernardo Bellotto's views.

BIBLIOGRAPHY: Rovere, Viale, Brinckmann 1937; Pommer 1967, 61–78, 188, 189; Myers 1975, 30–31, nos. 36f-36g; Millon 1982: 519–33; 1984; Gritella 1992: II, 113–22; Passanti 1992; Barghini 1994, 20–21 and 112; Gabetti and Isola 1996; Dardanello 1997

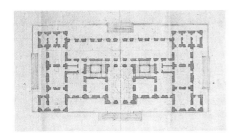

277 T
Filippo Juvarra (1678–1736)
Plan for a "palazzo in villa," projcct A
Santena, Fondazione Cavour, *Fondo Carron di San Tommaso*, mazzo 89, no. 1424
Traces of pencil, gray ink, red watercolor
Watermark: lily inscribed within a double circle below the mark "V"
412 x 535 mm
Scale: unit (*trabucchi*) 40 = 352 mm

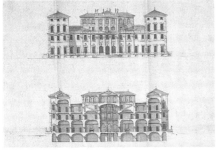

279 T
Filippo Juvarra (1678–1736)
Elevation and Longitudinal Section for a "palazzo in villa," project A
Santena, Fondazione Cavour, *Fondo Carron di San Tommaso*, mazzo 89, no. 1425
Traces of pencil, gray ink, gray, green and orange watercolor
Watermark: lily inscribed within a double circle below the mark "V"
407 x 545 mm
Scale: not indicated, but the one in the plan corresponds
BIBLIOGRAPHY: Gritella 1992, 113–22, figs. 110–11

The plan of the ground floor is arranged on a rectangular block between two side wings, bounded by four corner pavilions. The central *salone*, announced by the tripartite avant-corps, is laid across the main axis of the villa. A small vestibule of three pairs of arches crosses it, providing access to an enormous, airy gallery along the back front, which extends right up to the side wings. The two main apartments are reached directly from the *salone*, and from the adjacent vestibule two flights of stairs lead to the upper floors. Three bedrooms are aligned in each of the side wings; other minor rooms have been placed in the four end pavilions.
The rich but compact organisation of the plan is matched by a skilful development of jumps in height, with volumes arranged on several levels, in the elevation. The façade is divided horizontally in two. Above the cornice of the lower level, the majestic volume of the salone and gallery rises in the middle for four floors,

emerging from the tiled roofs; recognisable from the background by dense parallel lines in terracotta color. The four corner pavilions and the two side wings connecting them are taken to the same height.
The design of the façade is hierarchically announced in a crescendo from the sides to the center, seconded by an appropriate variety of wall treatments and organisation of the orders. The end pavilions have plain surfaces, vertically emphasised by solid corner pilasters; the next two bays are similarly treated, to draw back from the central body. Of seven bays, this is given emphasis by increasing projections and vertical jumps and is articulated by giant composite pilasters surmounted by blocks of entablature interrupted to leave space for the first floor windows. The order doubles up at the corner projections of the *salone* – open in three arches surmounted by busts and laurel wreaths – and is continued vertically above the entablature of the first level by a second order of pilasters, concluded by a balustrade and statues.
The section clearly shows the open framework of the *salone*: developed in height over three levels, there is a theatrical balcony on the first floor, and three orders of large window openings framed by supporting atlantes continuing into the ribs of the vault, following a similar decorative design illustrated in the well-known drawings and lively paintings for the interior of the *grand salon* in Rivoli Castle. The importance of the role played by light in Juvarra's architecture is stated here by the unnatural direction of the roof covering, inclined to descend toward the side walls of the *salone* so that the great windows in the vault can open directly to the sky.
Of the four projects for a "palazzo in villa", this is the closest to projects actually built by Juvarra for the Savoy residences near Turin. GD

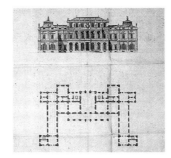

278 T
Filippo Juvarra (1678–1736)
Plan and Elevation for a "palazzo in villa," project B
Santena, Fondazione Cavour, *Fondo Carron di San Tommaso*, mazzo 89, no. 1426
Pencil, gray ink and red, gray-green watercolor; made up of two sheets glued along the edges; 578 x 540 mm
Watermark: lily inscribed within a double circle below the mark "V" (on both sheets, in one case damaged); scale: unit (*trabucchi*) 40 = 352 mm
BIBLIOGRAPHY: Gritella 1992: 113–22, fig. 115

This façade of fifteen bays is divided into two levels by superimposed orders: Tuscan accom-

panied by rusticated and banded surfaces on the ground floor; Corinthian with the walls articulated by a more elaborate design of bands, cornices and panels on the *piano nobile*. An attic storey with a crowning balustrade rises above the seven middle bays, preceded by an arched portico and then an open loggia and terrace on the upper levels.
The main body of the building extends laterally for another two pairs of bays, advanced by wider end pavilions with ornated, tripartite windows in a modern re-edition of the serliana, and covered by elaborately shaped roofs in copper – indicated by gray-green watercolor. The pavilions are crowned with trophies; celebratory statues and urns adorn the balustrades on the three main levels of the façade and pedestals on the main cornice. The Marchese's arms are in the middle with a saw-toothed cross, flanked by two figures holding the collar of the Annunziata.
The aggregation on the front of such a various design repertoire, in reality seconds the more developed articulation of the plan. A large, vaulted rectangular *salone* placed cross-wise to the main body of the building, looks directly out over the back court through three bays and also communicates with the two orders of the arcaded loggia on the main façade. Four apartments and the two staircases leading to the upper storeys are reached from the *salone*. Two luminous galleries back laterally on to the main building, with windows on both sides, and extend forward into a welcoming open courtyard. The four pavilions at the ends house four minor apartments. Isolated in the compact presentation of a frontal view, the seven bays of the open loggia of the central body of the building, flanked by the two recessed bays rather closed in by the lateral wings, recall the Roman façade of Palazzo Barberini. GD

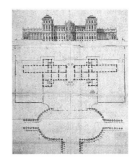

280 T
Filippo Juvarra (1678–1736)
Plan and Elevation for a "palazzo in villa," project C
Santena, Fondazione Cavour, *Fondo Carron di San Tommaso*, bundle 89, no. 1427
Pencil, ink and watercolor; made up of three sheets glued along the edges; 675 x 540 mm
Scale: unit (*trabucchi*) 40 = 345 mm
Watermark: lily inscribed within a double circle below the mark "V" (on each of the three sheets, in two cases damaged)
BIBLIOGRAPHY: Gritella 1992: 113–22, fig. 113

From the basis of a traditional plan, not far from the scheme in project A, Juvarra develops the

most original plan of the series. It distinguishes itself from the other projects for its unidirectional extension and marked horizontal development (if we can rely on the scale translated in *trabucchi*, the building extends for 140 metres), partially compensated by the remarkable vertical emphasis of the four corner pavilions. The *salone* in the centre of the composition traverses the entire building emerging in the convex semicircles swelling the external façade that are tripartite and opened on two levels by large windows. A balustrade with statues and the Marchese's arms crown the façade. The four tall pavilions, with an attic floor raised above two superimposed orders, covered by an elaborate copper roof, limit the main body of the building covered by a mansard roof. Two galleries open on both sides in a sequence of five windowed bays, with spaces above pierced by a second row of decorated windows, extend along the longitudinal axis of rooms aligned overlooking the back court, emerging from the flanks of the main body. Dividing walls, extended by the side ends of the front pavilions, stretch forward over the boundary of the pre-existing wall – indicated in gray – to form a court of honor, separated by a fence from the space in front of the villa where three entrance drives converge. The lengthened shape of this forecourt bounded by two tree-lined exedras echoes the axial articulation of the "palazzo in villa's" plan on the land. The thrust of the *salone* emerges on the façade due to the tension produced by the closed and regularly interrupted articulation of the pilasters throughout the main building, cushioned by a feeling of relaxation introduced by the sequence of large, arched windows in the two galleries, that spread out laterally stopped at the ends by minor pavilions with banded walls. This is the most innovative and least Italian of the four projects. The close rhythm of the dense repetition of the order, seconded by the series of openings, can refer to Imperial Viennese residences; the transverse *salone* emerging with strong convexity on the exterior is in current use in the residences of prince-bishops in the Catholic area of Central Europe and, again in Vienna, was used in the palace for Earl Mansfeld-Fondi, then for the Prince of Schwarzenberg, begun in 1697 by Johann Lucas von Hildebrandt and finished by Johann Bernhard Fischer von Erlach. GD

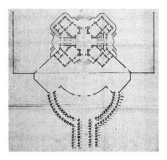

281
Filippo Juvarra (1678–1736)
Plan for a "palazzo in villa," project D
Santena, Fondazione Cavour, *Fondo Carron di San Tommaso*, mazzo 89, no. 1428

Pencil, ink and watercolor; made up of two sheets glued along the edges; 605 x 542 mm
Scale: unit (*trabucchi*) 20 = 172 mm
Watermark: lily inscribed within a double circle below the mark "V
BIBLIOGRAPHY: Gritella 1992: 113–22, fig. 118

The octagonal nucleus of the *salone* is the hinge and fulcrum of the whole plan. Four short radiating wings lead off from here along the diagonal axes, with four entrance vestibules on the orthogonal axes. Of the latter, the two in two wider wings of corridors along the axis leading to the side fronts are rectangular. The radial wings are articulated in four identical apartment units.
Each is composed of an anteroom, a chamber, two studies and smaller rooms, that give access to the transverse corridor wings housing the stairs. The architect has planned two different shapes for these, again with the idea of offering the widest range of solutions possible. Thus, modelled to form an X, and raised on a platform, the plan is cunningly softened at the junctions with the exterior by the welcoming curve of the outline of the two mirrored façades, whereas it is linked along the straight on the two side fronts.
From the sixteenth century an X plan had been associated with a hunting pavilion in an open space. This type of plan found particular success in Roman academic circles, due to its stimulating power of attraction connected to the difficult organisational problems of space that it posed.
Once again Carlo Fontana was a reference point for Juvarra: his proposal for the "Casino di Venetia" (1689) and his project – even closer to the plan for the Marchese di San Tommaso – for a building centered around an octagonal *salone* with four wings arranged on the diagonal, illustrated on two sheets of a sketchbook of Juvarra's early formation in Rome, recently discovered by Andrea Barghini in Vincennes (G.b. 25, fols. 20r and 21r). The architect took ideas from these models for his "royal 'palazzo in villa' for three people", with which he won first prize in the first class of the Clementine competition of 1705. Again during the decade of his stay in Rome (1704–14) he would practice this plan in the more concrete applications for villas near Lucca. In particular, his study for a "Palazzina to be built in Lucca near Viareggio for Sig.ri Guiniggi" (Metropolitan Museum of Art, New York *Rogers Fund* 69.655, fol. 75) develops a similar layout with an octagonal *salone* on two pairs of radial and orthogonal axes.
This challenge to creativity and imagination posed by a plan on an X had been taken up and had become an object for comparison from country to country among the protagonists of contemporary architecture: by Fisher von Erlach, in his project for Earl Althan's country residence in Rossau (1688–95); by Germain Boffrand, in his project for Leopold Duke of Lorraine at the Château de Malgrange (1711); and by Robert de Cotte, in his project, also not built, for a hunting pavilion for Louis XV at the Château de Compiègne (ca. 1729). GD

Rococo decoration

Rocaille or Rococo in French Art
Marianne Roland Michel

From the chapel of Versailles to the façade of Saint-Sulpice and on to the chapel of the Hospice des Enfants-Trouvés; from the Palais Royal to the Hôtel de Soubise, via the gallery of the Hôtel de Toulouse; from the Portières des Dieux to the Recueil Jullienne and the publication of the *Grand Oppenord*, a veritable explosion of decorative and ornamental art took place between roughly 1710 and 1750 in French art, defining its Rococo – or more accurately rocaille – period. As opposed to Germany, French architecture remained relatively unmarked by this so-called "new" or "picturesque" taste: the façades were more noteworthy for their pediments, their hooks and their lively consoles than for any new floor arrangements or modification of orders. Blondel denounced the "confused assemblage of the component parts [...] a shortcoming which stems from our forgetting that Architecture has to determine Sculpture." Yet it was in their capacity as architects – a title to which they laid claim – that Oppenord and Meissonnier were attacked. They were reproached with propagating Borromini's abuses in France: the former was designated "the Borromini of France;" as for the latter, "comparable to Borromini, he takes pleasure in being irregular in all his compositions." While the *hôtels* of Evreux, Lassay, Argenton, Peyrenc de Moras and many others testify to the evolution of taste, none of them displays an extravagance comparable to those of the same period in Bavaria or on the banks of the Danube. As early as the 1720s, Oppenord built an orangery for the Crozat park in Montmorency, but it was the Italian-style salon he built at the Palais Royal which best illustrates the new taste and which carried over into interior architecture. This can be seen in Boffrand's conception, in 1735–36, of the two oval salons in the Hôtel de Soubise: that of the prince on the ground floor, and that of the princess on the floor above.
The two are joined by a staircase decorated by Gaetano Brunetti. Eight canvases by Natoire, relating the story of Psyche, are done in cartouche-like form and inserted into sumptuous woodwork. It was also the joint effort of Boffrand and Natoire along with the Brunettis which led to the chapel of the Hospice des Enfants-Trouvés in Paris, inaugurated in 1751. A further instance of a rocaille interior which has today entirely disappeared is that of the salon "imagined, drawn and carried out under the supervision" of Meissonnier for Count Bielenski in 1734, and exhibited at the Tuileries in 1736 before being shipped to Poland. Its walls, paneling, paintings, ceiling and furniture constitute the prototype of an exceedingly rich decorative whole of unbridled invention, in which painting, sculpture, furnishings and decoration blend perfectly together. This unity, like the chapel of the Hospice, would be entirely unknown today were it not for the engravings we possess which enable us to imagine what they must have looked like. It is moreover an essential characteristic of the era that the volumes of plates devoted to both interior and exte-

rior architecture (Mariette, Blondel, Briseux, Daviler), like the plates in the *Encyclopédie*, show façades, elevations and gardens as well as the way apartments themselves were arranged, the layouts of the rooms, the paneling, piers and furnishings. The *Grand Oppenord*, published by Huquier from 1748 on, featured models of fountains, grills, hearths, and "different decorations for architecture and apartment." Just as in the case of Mariette or Blondel, some of the plates are models to be carried out, or upon which one can draw inspiration, while others are reproductions of existent mansions. Mariette's decor of the Hôtel d'Evreux gives us an example of one of the *Recueil Jullienne*'s functions, particularly as concerns the arabesques: to provide models for screens, overdoors and decorative paintings. Thus Watteau's thirty-odd chinoiseries engraved with the indication that they came from the king's cabinet at La Muette are generally considered to be overdoors and are copied as such.

It was only recently, with the resurfacing of one of the originals, that it became clear that they were actually small-format, brightly-colored compositions, in all likelihood included in the paneling of a single room. The same goes for the Arts and Sciences allegories painted by Lajoüe for the duke of Picquigny between 1734 and 1737, and immediately engraved with immense success and copied as overdoors, easel paintings, decorative canvases and even marquetry. However, it was not only Lajoüe's paintings which were engraved, but also his very numerous drawings of cartouches, vases, screens, pieces of architecture, landscapes and perspectives which decorators right across Europe wasted no time in grabbing up. In conclusion, it is worth coming back to the ornament's essential role and engraved distribution not only in French but in international Rococo. Between approximately 1710 and 1750, dozens of collections of ornaments were published in France, spreading the models of Béraine, Toro, Gillot, Meissonnier, Lajoüe, Fraisse, Boucher, Mondon, Bouchardon, Huquier, Christophe Huet, Peyrotte, Oppenord, Germain, Pineau and Babel, without forgetting either Watteau or Cuvilliès, conjointly published in Paris and Munich.

A list to which one might also add the Augsburg engravings based upon most of these series, or the collections published in London. They are just cartouches, arabesques, trophies, chinoiseries, rocaille shapes, ornaments intended for cabinet-making or ironwork, models of snuffboxes, for different uses or destined for artists and artisans. It is clear how theses fanciful compositions, created and reproduced by draftsmen and engravers, nurtured the decorative program of architects, painters and decorators. Rocaille art, both in France and abroad – in Sweden, England, Flanders, Germany and so on – was nourished by the forms it either invented or adapted. Whether a culmination of Louis XIV-style decor, according to some, or a consequence of the excesses of the Roman Baroque, according to others, it provided a decorative vocabulary which was not always new but which was differently organized than what was being done elsewhere, and exerted a powerful influence on the European Rococo.

282 MAR
Claude III Audran (1658–1734)
Bacchus – Drawing for the "Portieres of the Gods"
Stockholm, Nationalmuseet, Coll. Cronstedt, II, 166
Black lead, sanguine, watercolor; 370 x 248 mm; drawing has been squared
PROVENANCE: Purchased by Carl Johan Cronstedt in Paris, in the course of Audran's succession in 1734; Château de Fullerö; entered the Nationalmuseum in 1941 with the entirety of the Audran collection
EXHIBITION: Paris, Bibliothèque Nationale 1950: no. 134, repr. on the cover
BIBLIOGRAPHY: Cat. Stockholm 1942: no. 121

The drawings for this hanging – one of the most famous of those which were woven at the Gobelins factory – must have been commissioned from Audran in 1699, though he worked on it until approximately 1710, with the collaboration of Louis de Boullogne and Michel Corneille for the figures, Desportes for the animals. It was made up of eight pieces, the Seasons (in this case, the Autumn) and the Elements, personified by mythological gods or goddesses, shown in loggia or porticos with slim columns, accompanied by figures of children and various decorative elements. "He works in the taste of Raphaël, but he mixes in many things of his own invention, for he is very gifted," wrote Cronström to Tessin, only a few years previously, introducing Audran to him as the only successor to Bérain in the decorative realm. The drawing shown here is positioned as the tapestry would have been, and no doubt constitutes a first step in the composition, a second more colorful version of which (watercolor and gouache, 315 x 222 mm.) also belongs to the Cronstedt collection (II, 72, repr. pl. XXI, cat. Paris, 1950). The intentions of the two drawings seem different, the one exhibited constituting a veritable study with regard to the cartoon and its trim, the other intended as a picturesque evocation of the composition. MRM

283 MAR
Claude III Audran (1658–1734)
Half ceiling – Project
Stockholm, Nationalmuseet, Coll. Cronstedt, II, 22

Pen, blue, red and gold watercolor, on black pencil guidelines; 378 x 523mm
PROVENANCE: Purchased by Carl Johan Cronstedt in Paris, in the course of Audran's succession in 1734; Château de Fullerö; entered the Nationalmuseum in 1941 with the entirety of the Audran Collection
EXHIBITIONS: Paris, Bibliothèque Nationale, 1950: no. 20, pl. VII
BIBLIOGRAPHY: Cat. Stockholm 1942: no. 177; *L'Art décoratif* 1992: 171, repr.; Scott 1995: fig. 133

Amongst Audran's known works, ceilings were a constant throughout his career from 1690 to 1733: at the Hôtel de Soissons, at Anet for the duke of Vendôme, at the Ménagerie, at Meudon, at Sceaux, at Versailles for the apartment of the Princess de Conti, and at Anet once again toward the end of his life for the Duchesse du Maine. All these ceilings have disappeared, as have those painted for the Duchesse of Lude, Maréchal de Villars or the painter Massé. Though drawings remain, they are rarely annotated. Yet the Cronstedt Collection has kept the ceiling projects for the Duchesse de Bouillon, for Anet, Sceaux and Chantilly; most of them, as in this case, have ceilings, with two angles and a central rose, elaborate drawings which have only to be completed and transferred over by workshop assistants. Hence the importance of color in these projects – the execution of which was not necessarily under the inventor's control. In a letter written in 1698, Cronström suggested to Tessin that to replace Bérain's models, "ceilings, paneling and so on from Anet at the duke of Vendôme's, done by Audran and others" could be shipped to Stockholm. The model shown here is characterized by an ornamental overload, through which the background can scarcely be seen, a marked partitioning, a play of stripes constituting a veritable frame, and an astonishing mixture of animals, vegetables, various decorative motifs in which silhouettes of women-birds stand out. MRM

284 M
Pierre Edme Babel (1700/11–75)
Study for a Cartouche
New York, The Metropolitan Museum of Art
Inv. 1957. 57. 570.
Pen, brown ink, gray and brown wash; "Babel f." (lower left); 394 x 264 mm
PROVENANCE: Beurdeley collection, hallmarked in bottom right (W. 471); R. M. Light & Co., Cambridge, Mass.
EXHIBITION: New York 1992: no. 7
BIBLIOGRAPHY: Myers 1992: no. 7 (see for previous bibliographical references)

Line engraver, draftsman and wood sculptor, Babel was received at the Saint-Luc Academy as an "ornamentalist master sculptor."

He did engravings after Juste-Aurèle Meissonnier, Boucher, Boffrand, and in particular plates reproducing the ceremonial pieces from the Hôtel de Soubise in his *Livre d'architecture*, and made illustrations for Briseux and Blondel's architectural treatises, and Jeaurat's *Traité de perspective*.

The exhibited drawing is characteristic of his manner, with the multiplication of curves and counter-curves drawn in a total asymmetry, regrouping scrolls, fragments of shells, flowers, foliage. Babel's drawings can be dated, thanks to their engravings, to the years between 1745–50, which supposes a lack of personal inventiveness on the artist's part, given that his models took their inspiration from what others had been doing a decade before. MRM

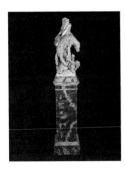

286 T
Ignazio (1724–93) and Filippo (ca. 1737–1800) Collino
Six Models for Hunting Trophies in the Palace of Stupinigi
Nichelino (Turin), Palazzina di Caccia di Stupinigi
Painted and gilt plaster (trophies); painted wood (stands); 84 x 29 x 29 cm (no. 1304); 85 x 29 x 29 cm (no. 1305); 83 x 29 x 29 cm (no. 1306); 80 x 29 x 29 cm (no. 1307); 80 x 29 x 29 cm (no. 1308); 85 x 29 x 29 cm (no. 1309)
BIBLIOGRAPHY: Gritella 1987: 181, no. 27; Ballaira 1994; Di Macco 1996: 127 and 140, no. 28

Originally white and probably varnished with wax, the plaster sculptures were painted green (imitation bronze) and partly gilded on two distinct occasions. Restoration, directed by Claudio Bertolotto of the Superintendence and carried out by the Rava laboratory in Turin, is recovering the original coloring given to the trophies so that they could be used as decorative furnishings. The pedestals on which the groups were displayed are also being restored. These are one meter high and painted to resemble marble.

The trophies depict either animals that had been hunted or animals trained to hunt, lying on the bases or tied to tree-trunks, dead and alive. There are also weapons, gadgets and instruments, easily recognisable as part of hunting equipment, which can also be seen inside Juvarra's Salone in Stupinigi, differently portrayed there in frescoes by the Valerianis or in Crivellone's still lifes for the fire screens of 1733. Translated on to a larger scale and into Frabosa marble, the plaster trophies return again among the

sixty-two groups placed on the pedestals of the balustrades of the eastern and western pavilions backing on to the main body of the hunting lodge. These trophies were sculpted partly by Ignazio (Turin 1724–93) and Filippo (Turin ca. 1737–1800), too, but they were mainly the work of Giovan Battista Bernero (last payments to this sculptor date to 1783).

As documented in a letter dated 14 November 1769, the trophies were intended to be "marble finishings" to the architecture, and were entrusted to the Collinos, who received the design for a pavilion façade from Ludovico Bo ("overseer" on the Stupinigi building site).

Realisation of these plaster groups, which probably functioned as presentation models, following a practice established for other works commissioned from the royal sculpture studio, directed by Iganzio Collino from 1767, must be subsequent to this letter although not documented.

For example, we know how the work was organised for the urns at Stupinigi. These were commissioned from the Collinos in 1767 and placed on the balustrade of the central body of the building. Models in terracotta were made to present to the King and the Collinos also ordered Andrea Martinez, employed as a painter of models in the royal sculpture studio, to paint cardboard cut-outs of them to be placed in position so that their effect could be judged (Gritella 1987: 166, 170 and 181; di Macco 1996: 120ff.).

A document of 1778 might possibly refer to these six plaster trophies. At that time the Collinos' studio was full of marble sculptures being worked on for the royal tombs at Superga; in this document they ask if various models can be moved elsewhere, indicating those that could be reused and those that could not. Being planned for a single position the following resulted unusable: "Numero sei modelli di gesso, li quali non possono servire per fare altre opere, per essere Scherzi di Troffei, che secondo li siti bisogna far Modelli nuovi". ["Six plaster models, which cannot be used to make other works, as they are Sketches of Trophies, because it is necessary to make new models according to the positions."] (A. S. T., *Relazioni a S.M.*, vol. 31, 1778, 1st semester, fo. 339, Report of 28 May 1778.) Expressly realised for the hunting palace of Stupinigi, these trophies, in their lively naturalistic portrayal, testify to influence felt by Ignazio Collino during his initial apprenticeship to the royal sculptor Francesco Ladatte.

Furthermore, in both the urns and the trophies, traces can be seen of his subsequent study of Baroque sculpture, during his academic formation in Rome, where the Collinos stayed for a long period right up to 1767. A drawing by Ignazio Collino of a dog's head, candle-bearer for St Dominick, a group sculpted in 1706 by Le Gros and placed in St Peter's for the series of founder Fathers of the religious orders, documents his desire to recall modern sculpture, selectively considered a reference model (this drawing is in the Biblioteca Reale in Turin, *Album di disegni di Ignazio Collino*, Ms. Varia 197). MDM

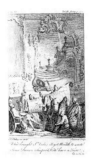

287 T–M
Simon-François Ravenet (1706–74) after Nicholas Blakey
Illustration for Alexander Pope's *Epistle on Taste*
Yale, Yale University, Beinecke Rare Book and Manuscript Library
Etching and engraving; 165 x 90 mm

The *Epistle*, published for the first time by Pope in 1731, is addressed to Lord Burlington as arbiter of good taste, but it was only between 1748 and 1751 that Blakey – an illustrator who often worked in collaboration with Gravelot – was to draw a number of plates for Pope's works.

This particular vignette dates back to 1748, and in it one is able to see how, in mockery of knight Visto's bad taste – the rich collector to whom dealers would present various objects – Blakey updated his representation, recreating a 1750s-style Rococo interior (the publication dates from 1751 and was translated into French in 1754).

Symbols of curiosity in the eighteenth century – Chinese objects, Egyptian mummies, porcelains, bones – are being shown him in a cabinet where a mirror and a large painting of a Lajoüe-style park are in extravagant Chippendale frames. An architect is unfolding the plan of a house that Visto may be considering having built; on it, the name Ripley can be seen – a second-rate architect, protected by Sir Robert Walpole but held in contempt by Lord Burlington. MRM

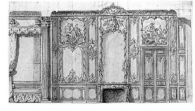

289 M
Germain Boffrand (1667–1754)
Hôtel de Soubise, Relevé de la Chambre du Prince
New York, Cooper-Hewitt National Design Museum, Inv. 1911-28-5
Pen and india ink, gray and green wash, white chalk on a black lead set-up
289 x 524 mm
INSCRIPTION: "Coupe de la Chambre a coucher de M. le Prince de Rohan/D. 4" (on the back)
PROVENANCE: Léchener Collection; Léon Decloux collection; bequeathed in 1911 by the Museum board
EXHIBITION: *Boffrand* 1986: 233 and ill. p. 231
BIBLIOGRAPHY: Pons 1986: 230–35

The apartments Boffrand created at the Hôtel de Soubise between 1735 and 1739 following the second marriage of Prince Hercule Mériadec de Rohan constitute the architect's last known interior decor, as well as the culmination of his ideas and his adhesion to the development of Parisian rocaille decor, in the period from 1730–35 – notably under the influence of Pineau and Meissonnier. Through the wealth of their decor, as well as the lightness which he managed to confer upon them by playing with the room's oval form, creating a continuity between the ceiling, cornice and wall, Boffrand made of the prince's apartment on the ground floor and the princess's apartment on the second floor, the paradigm of rocaille decor. The drawing shown here (which is a measured drawing giving the opposing view, intended to be engraved in Boffrand's *Livre d'architecture*) enables us to understand the novelty of the prince's room. If one compares it with the engraved plate of the princess's room, a first glance reveals a comparable layout, with the alcove on the one side, and on the other side, a door surmounted by a painting, stops adorned with a sculpted central cartouche separating them from the fireplace surmounted by a pier with a sculpted cartouche in its center. But the innovation consists in the bedroom's four paintings, situated between the mirror and the alcove, being set above new types of panels, which replace the false door usually situated as the counterpart to the real one, in order to give the room symmetry. MRM

out that if the exterior architecture accomplishes a synthesis of Borromini's work, the interior reflect those of Parisian homes of the 1690s. Given as a gift to Evrard Chauveau, a Parisian painter called to Stockholm in 1695, the drawings were attributed by A. Laine in 1972 to Chauveau's brother René, who had already been working in the Swedish capital for several years. The 1730 Tessin catalogue, however, clearly indicates the first name Evrard (associated with Jacques de Meaux); more particularly, Tessin's correspondence with Cronström (1964: 160, 164, and note 27, p. 156) makes reference to the arrival of Evrard Chauveau, who had been awaited with great anticipation for painting work.

In January 1697, Nicodemus Tessin spoke of decoration projects regarding his palace, of the role assigned to the "ornament painter" (clearly Evrard Chauveau), and his desire to "have any variety of grotesques done both on the ceilings and the walls of the Bedroom and Office, in color against a gold background." There is no reason to believe that these ceiling drawings, marked by Bérain's influence, were the work of a sculptor. Moreover, the bedroom project, the traditional iconography of which evokes the hours of the day in a decor heavily charged with arabesques with angular hasp heads, allegorical figures and painted bas-reliefs, was copied by Sébastien Le Clerc for engraving (cat. Jombert 1774: 1, no. 268; Préaud). MRM

than being attached to walls. The drawing makes one think more of a tapestry project, or a set design. Moreover, though Chevillon was to describe himself in 1747 as a "painter of ornaments, ceilings, arabesque cabinets, etc.," he worked at the Manufacture des Gobelins from 1746 to 1757 where he succeeded his master Perrot and drew models of Savonnerie carpets, portieres and tapestry edging. The *Recueil* held at the French national library actually contains models of seat backs, embroideries, decorative bandeaux etc. This drawing is probably a first attempt at a larger and more successful composition in color, highlighted in gouache, which is kept at the Hermitage Museum in St. Petersburg (Inv. no. 39595), the central part of which shows a garden with stairways and trees, while the two lateral panels reproduce Boucher's, *Vénus désarmant l'Amour* and *L'Amour caressant sa mère* (Ananoff 1977: nos. 241, 242) instead of the evocations of Flora and Zephyr which are shown here. For this reason, until recently, the Hermitage drawing was considered to be the collaborative work of Lajoüe and Boucher – the latter having highlighted the former's watercolors for the lateral compositions. This drawing was thus thought to have been a copy. It has subsequently been proven that Lajoüe's supposed collaborations with other famous painters of his day are pure myth (see Roland Michel 1984), and the drawing at the French national library, annotated by Chevrillon, furnishes proof for the attribution of the one at the Hermitage. MRM

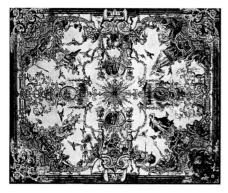

290 MAR
Evrard Chauveau (1660–1739)
Project for a Ceiling
Stockholm, Nationalmuseet, Inv. NM THC 5652
Black lead, pen, and black ink, watercolor, on two sheets glued together; pieces of paper were glued onto the right angles of the earlier sketch
435 x 550 mm
PROVENANCE: N. Tessin the Younger; C. G. Tessin -Royal Library, Stockholm
BIBLIOGRAPHY: Bjurström 1976 no. 318, as René Chauveau (see this note for previous bibliographical references); *L'Art décoratif* 1992: 158, ill. (as René Chauveau)

This is one of three ceiling projects kept at the Nationalmuseum for the palace Nicodemus Tessin the Younger built on the basis of his own plans in Stockholm, near the Royal Palace. B. Pons (*L'Art décoratif* 1992) points

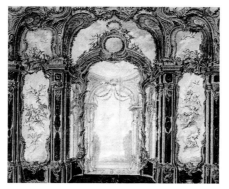

291 MAR
Jean-Baptiste Chevillon or Chevillion (? –1758)
Project for a Portable Drawing room
1752
Paris, Bibliothèque Nationale de France, Cabinet des Estampes, Hd 64 Rés.
Pen, wash and watercolors, on black-lead setup; 472 x 588 mm (?)
PROVENANCE: One of sixty-four plates of a collection dated 1752, entitled *Recueil de dessins pour meubles et pour ornemens exécutés en partie le surplus projetté* including drawings by Chevillon, Slodtz, Lajoüe and various anonymous artists
BIBLIOGRAPHY: *Les peintres français* 1930: 350, no. 52; Ananoff 1977: nos. 241, 242, repr. fig. 727; Roland Michel 1984: DD. 9, fig. 476; *L'Art décoratif*, 1992: 220, ill.

We have decided to stick to this drawing's usual title of "portable drawing room," which refers to a removable decoration set on trestles rather

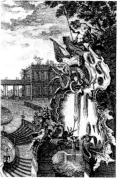

296 MAR
François de Cuvilliès (1698–1768)
Cartouche
Paris, Musée des Arts Décoratifs
Burin engraving by G. Roesch
BIBLIOGRAPHY: *L'Art décoratif* 1992: 339, repr.

Student of Robert de Cotte, the architect François de Cuvilliès, known as The Father, took up residence first in Munich in 1725 where he was named first architect of the Bavarian elector, and later in Cologne in 1738. He is known to have constructed the Falkenlust castle, the Amalienburge pavilion, and the hunting lodge of the Herzogsfreude, while at the same time, from 1738 on, pursuing a significant activity providing ornaments. His drawings were engraved by Roesch, Jungwierth, Lespilliez and above all by his own son, François de Cuvilliès (1731–77), an architect who built very little, engraver and publisher. It is to him that we owe the exceptional distribu-

tion in France of models done abroad, since his father's engravings, done in Munich, were immediately sold in Paris at Poilly's. The gigantic cartouche on the plate shown here functioned as a waterfall-fountain, set incongruously in a garden, the surrounding stairs and colonnade of which, directly evoke Lajoüe. It comes as no surprise to see Blondel accuse Cuvilliès and Mondon of being imitators of Meissonnier, Lajoüe, Pineau, and purveyors of bad taste in ornaments and architecture. MRM

297 MAR
Charles de Wailly
The Grand Salon of Palazzo Spinola, 1773
Paris, Musée des Arts Décoratifs

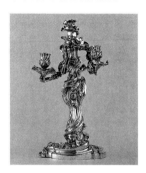

299 T
Claude Duvivier (1688–1747), after Juste Aurèle Meissonnier (1695–1750)
Silver Chandelier for the Duke of Kingston
Paris, Musée des Arts Décoratifs, Inv. 32632
385 mm (including the arm and the stopper); max. base diameter:190 mm; arm diameter: 215 mm; total weight: 3,622 kg
Master stamps (CD, an olive tree), from the same establishment (1734–35), preparing and finishing the work (1732–38)
The coat of arms of the duke of Kingston are engraved on the barrel, surrounded by the order of the Garter and surmounted by an English ducal crown
PROVENANCE: Evelyn Pierrepont, second duke of Kingston (Recollection of the dishes, 1737; Inventories of the duke of Kingston's silverware, 1743, 1746, 1755); sold in Paris, Drouot, 4 March 1911, no. 108; G. Le Breton, sold in Paris, G. Petit, 6 December 1921, no. 266; D. David-Weill; bequest to the Musée des Arts Décoratifs in 1937
EXHIBITIONS: Musée des Arts Décoratifs, 1926, no. 42; Paris, Orangerie 1950: no. 136; Paris, Orangerie 1953: no. 670; London 1984: cat. A-18
BIBLIOGRAPHY: Nocq 1927: II, 148; Messelet in *Bulletin des Musées de France* 1937: 71–73; Kimball 1942: 30; 1949:168; Nyberg 1969: 18–19, fig. 1; De Morant 1970: 370, fig. 600; Cattaui 1973: fig. 293; Fleming and Honour 1979: 255, ill.; Hawley 1978: 325–26, fig. 2; Mabille 1978: 188, fig. 2; Mabille 1984: no. 95; *Inventaire général [...] Vocabulaire* 1984, 395, fig. 1898; Alemany-Dessaint 1988: 185, fig. 2; *L'Art décoratif* 1992: 420, ill.; Fuhring 1993: 93, ill.; Fuhring (forthcoming), nos. 48, and 76–78 of the engravings

The chandelier is engraved in the opposite direction from the *Œuvre*, and serves as the title for the "Twelfth book" of its publication by

Huquier, entitled the *Livre de Chandeliers de Sculpture en Argent*. The plate, numbered "M 73," was signed "J. Meissonnier. inv. – Huquier. Sculp.," which made it possible to attribute the model to the silversmith. P. Fuhring (1994) considers the two plates numbered M 74 and M 75 – which reproduces very similar chandeliers – though without the arms and stoppers, refer to the same object. None of the engravings bear the name of the duke of Kingston, but references to the chandelier as well as to its counterpart in the inventories of silverwork belonging to him, like the fact that the Duvivier chandelier includes his coat of arms, makes its provenance obvious. The duke must have commissioned the work – no doubt along with the new silverware, delivered in 1737 – prior to 1734. MRM

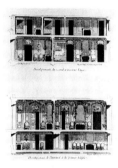

301 MAR
Gabriel Huquier (1695–1772), after Juste Aurèle Meissonnier (1695-1750)
Brethous House in Bayonne, Interior Section
London, Victoria and Albert Museum
Engraving; 125 x 217 mm and 0.97 x 240 mm
BIBLIOGRAPHY: Kimball 1949: 172, fig. 204-205; Hautecœur 1950: III, 194; Nyberg 1969: 28; Bruand and Hébert 1970: no. 951–52; Fuhring (forthcoming): no. 30, and engravings 3–13

Here we have the extension of the mezzanine and the first floor and the extension of the second and third floors of the Maison du Sieur Brethous in Bayonne. The engravings are signed "J. A. Meissonnier inv. – Huquier Scul. et ex. rue St Jacque C. P. R". They must have been published between 1742 and 1748, while the house's plan and exterior elevations were part of the first series of Meissonnier's work – publication of which began in 1734. In 1729, shipowner Léon Brethous, squire at the grand Venery of France, purchased a house situated on the corner of one of the banks of the Nive, and proceeded to have it enlarged by having the city of Bayonne grant him a certain amount of public land. To do so, he presented a plan prepared "by the most experienced persons in Paris." A new project was presented in 1732 and work was completed by the end of 1734. It would appear that, once he had given in his drawings for the house's exterior and its siting, Meissonnier played no further role in its construction; there are differences in the details between the engraved plates and the house as it stands today. The plates showing the interior decoration appear to reflect Meissonnier's drawings more than what was actually carried out. What is striking here is the mezzanine's and the third floor's relative simplicity, as much in terms of the moldings as of the fireplaces or the few seats. MRM

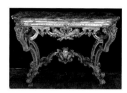

302
Filippo Juvarra (1678–1736)
Console, ca. 1730
Turin, Palazzo Reale
Carved and gilt wood
87 cm high x 130 cm long x 66 cm deep
PROVENANCE: In Palazzo Reale, Turin, from the first half of the eighteenth century
BIBLIOGRAPHY: *Mostra del Barocco Piemontese* 1963: 57; Griseri 1967: fig. 241; San Martino 1995: 252

Together with the wooden models designed by Juvarra for the Basilica of Superga and Rivoli Castle, the furniture commissioned by the court for Palazzo Reale also marked an important moment, within the apartments where the architect had created the masterpieces of the Scissors Staircase and the Chinese Room. It illustrated his preferences for dynamic structures matured in his drawings during his Roman stay, when he had seen works by Bernini and above all Borromini, updated with ideas from France, which Juvarra showed direct knowledge of; he was ready to support the elegance of the decoration with the robust vitality of his "ideas." The consoles still in the apartments today illustrate this. They are identifiable through comparison with autographed drawings and for the precision which stimulates our perception linking and anchoring it to the architecture. Lively modelling connects the grooved volutes decorated with flowers to the wonderful finishing motif of the symbolic shell, making one think of Juvarra's drawings (now Biblioteca Nazionale, Turin, ris. 59, 4 sheets 81–83), which have been carefully studied (Midana 1924: X-XIII; Griseri 1967: 16–241; San Martino 1995: 254–55).

These were the results of Filippo Juvarra's work in Cardinal Ottoboni's small theater and they anticipated the stucco decorations and *boiseries* that Filippo Juvarra produced in the decade 1720–1730.
Starting from the works realised in Palazzo Reale, a reference point for this console might be Carlo Emanuele III's wedding to Polyxena of Hesse Rheinfels in 1724. Carlo Emanuele was to be the moving force behind the work at Stupinigi.
This piece of furniture shows how Juvarra linked every detail to the whole, and how the creative profession was in anticipation of the Encylopedists, focusing on perception exalted by the natural light of gold, with freer results compared to the French decorators and Viennese masters (Griseri 1967: 283, 307). AG

303 T
*Giampietro Agliandi Baroni di Tavigliano
(1705–69)*
Console, ca. 1730–35
Turin, Palazzo Reale
Carved and gilt wood
84.5 x 135 x 65
PROVENANCE: In Palazzo Reale, Turin, from
the first half of the eighteenth century
BIBLIOGRAPHY: *Mostra del Barocco Piemontese*
1963: 59; Griseri 1967: fig. 261; Griseri, Angela
1988: fig. 37

This is one of three wall tables created in close
connection with the *boiseries* planned for the
modernisation of the royal apartments on the
first floor of Palazzo Reale in 1731–40. The
work was entrusted to Filippo Juvarra and con-
tinued by Giampietro Agliandi to a commis-
sion from Carlo Emanuele III, confirmed in
this console by the letters "C" and "E" inside
the small crown at the top.
This piece is distinguished by the double curve
resolving the architectural support, which thus
multiplies the decorative inserts, unlike Filippo
Juvarra's mode, with foliage and ornamenta-
tion linked to the top, from which cascades of
bellflowers unwind to finish in crowns of
flower garlands, typical of the style of Giam-

pietro Agliandi. Likewise, the linking motif in
the middle of the crossing, worked in Rococo
palmettes with a typical *espagnolette*, which
looks to Parisian models and replaces the
more architectural shell present in Filippo
Juvarra's piece, is worthy of notice.
More than one motif was, in fact, suggested by
the innovations introduced by the Slodtz,
working for King Louis XV in the castle of
Compiègne (see Verlet 1955 and 1982: 739)
and by elements in the work of Juste-Aurèle
Meissonier, Gilles-Marie Oppenord and Nico-
las Pineau, as has been pointed out in recent
years (Colle 1987: 188).
For this masterpiece, Giampietro Agliandi
proposed his own repertoire linked to Euro-
pean Rococo, showing his preference for the
pale light of gold, planned together with the
areas for the wall mirrors, thus influencing
new artisans, after the generation of Om-
ma, Vollé and Ugliengo, who continued in
Juvarra's steps with results of extraordinary
elegance. AG

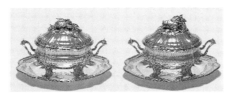

304–305 T
Paolo Antonio Paroletto
Pair of Soup Tureens and Stands
Private Collection
Engraved and embossed silver
46 x 38 cm (stands); 41.5 x 24 cm (tureens)
5.630 kg; 5.610 kg
BIBLIOGRAPHY: Bargoni, in *Mostra del Barocco
Piemontese* 1963: nos. 126–27, pl. 30–33; Gris-
eri 1967: pl. 214; Lipinsky 1979: 370, pl. 30;
Briganti 1986: 188; Fina 1997: 47, pls. 34 a-b

The hallmark of Carlo Micha, nominated as-
sayer at the mint in Turin in 1759, and the
counterhallmark of Giovan Battista Carron, as-
sayer from 1753, can be found on the lids and
bodies of these tureens, whereas Giovan Bat-
tista Carron's hallmark and Carlo Micha's
counterhallmark can be found on the stands.
The silversmith's mark belongs to Paolo Anto-
nio Paroletto, admitted in 1736 with the mark
of St. Francis Saverio dressed as a pilgrim. The
presence of these marks and maker's mark,
correctly identified by Bargoni, indicate the
work of an extraordinarily cultured silver-
smith, expert in his craft. Working within the
family workshop, his works produced from
1741 onward, right up to the unique results of
these two soup tureens of really exceptional
quality, show him to be one of the most impor-
tant silversmiths at that time. In 1741 he had
finished the altar frontal of the "Miracle of the
Eucharist," made for the chapter of the cathe-
dral in Turin to a design by Sebastiano Galeot-
ti (see Fina 1997: 13).
The dates relative to the hallmarks and coun-
terhallmarks, with the precise dates of 1759 for
Micha and 1753 for Carron, are stylistically
confirmed by these two masterpieces. They are
datable to about 1760 during the years of Car-
lo Emanuele III's interventions with Benedetto
Alfieri on the palace at Stupinigi. Juvarra's sug-
gestions for architecture and the fine arts were
still strongly felt, demonstrated by comparison
• with his drawings for the *surtouts* (now in the
Museo Civico d'Arte Antica in Turin, vol. 4)
and with his "ideas" for the capitals at Stupini-
gi, about 1730, which return in the trophies on
the tureens; especially the boar's head with the
hunting horn, a metaphor for victory and cele-
bration.
The conclusive moment of the naturalistic tro-
phy, with the hunted game presented on oak
leaves, was inserted into the whole worked
with architectural decorations on the lid wor-
thy of a *grand couvert*, supported by knotted
cornices, also present in the borders of the
stands, alternating with bean motifs and fes-
toons, while the feet and handles offered the
opportunity for leafy elements of pure Rococo,
very close to Alfieri's *boiseries*.
He was then at work on Palazzo Isnardi di
Caraglio. It is, in fact, these very lively details,

like the boar's head and the fowl, which bring
to mind a drawing by the sculptor Ladatte, al-
so active in the team at Palazzo Reale and
Stupinigi. Here, these table furnishings, ani-
mated by subjects taken from the hunt and
garden life, testify to a strong link with Piffet-
ti's furniture and its openness toward many
different cultures, just as Juvarra's and Al-
fieri's furniture was closely related to their ar-
chitecture. AngG

306 MAR
Georg Wenceslaus von Knobeldorff
Project for a Building in the Park of Rheins-
berg, ca. 1737–40
Potsdam, Stiftung Schlösser und Gärten Pots-
dam-Sanssouci

310 MAR
Charles Lebrun
Preparatory Sketch for the decorations of the
Apollon Gallery in the Louvre
Paris, Musée du Louvre, Cabinet des Dessins

311 MAR
John Linnell (1723–96)
Model for a Drawing Room Wall
London, Victoria and Albert Museum, Inv. E.
263, 1929
Pen, ink and watercolor; 260 x 265 mm
EXHIBITION: London 1984: no. M. 15, ill.
BIBLIOGRAPHY: Saumarez Smith 1993: no. 113, repr.

As opposed to the two following drawings,
which, like most of Linnell's known drawings are
devoted to objects, mirrors or pieces of furni-
ture, making him one of the most interesting and
original representatives of English Rococo, this
watercolor constitutes a veritable decorative
project for a drawing room (which, though not
identified, was no doubt in a London house). It
can probably be dated to around 1755, after
Woburn's and Badminton's works had enjoyed
such great success. Here, the ornamentalist re-
places the architect-decorator, taking charge – as
Kent and Adam were to do – of the wall decor,
the furniture and the objects. This role assigned
to the architect is perhaps emphasized with hu-
mor by the portrait hung above the fireplace, in
the place of a mirror but with the same frame,
and which probably depicts Inigo Jones painted
in the manner of Dobson or Van Dyck. The total
asymmetry of the rim should be pointed out:
with its mixture of dragons, Chinese vases, flow-
ers and foliage, it is close to the mirrors designed
and built by Linnell, as well as to the fireplace's
central motif and the extravagant plant-shaped
wall pendulum. On the other hand, the Rococo
couch is less boisterous than those invented by
Meissonnier some twenty years earlier. But it can
be seen here how Linnell adapted elements tak-
en from French or Italian ornamentalists to
modules specific to English Rococo. MRM

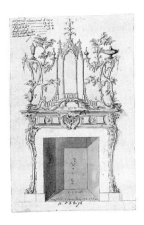

312 M
John Linnell (1723–96)
Rococo Fireplace Project, with a gothic-pavil-ion-shaped mantelpiece
Montreal, Collection Centre Canadien d'Ar-chitecture – Canadian Centre for Architecture
DR 1991: 0002
Pen, black ink, gray, blue and ochre wash
172 x 112 mm
INSCRIPTION: "Mr. Linnell. Lower part 6.10.0/ Upper Do... 13.6.0/ Glass to Do... 5.3.0/ pan-elling... 3.6 (upper left in brown ink)" and two lines without any indication of the price. Lower center, inside the fireplace: "Alt.3.2 high – 2.9 wide / must be three feet July 22.1754 / 3.3 high"

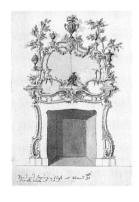

313 M
John Linnell (1723–96)
Rococo Fireplace Project with Chinese elements, surmounted by a mirror with a seated shepherd, cascades and garlands; on the back, lintel project
Montreal, Collection Centre Canadien d'Ar-chitecture – Canadian Centre for Architecture
DR 1991: 0003
Pen, black ink, gray blue and ochre wash
140 mm x 095 mm
INSCRIPTION: "Wood and carving & glass at about 30 L / Marble work"
PROVENANCE: These drawings come from an al-bum which belonged to J. Linnell, and later to his cousins Charles and Thomas Tatham; C.J. Shoppee Collection; Sold at Christie's, London, 19 December 1989, nos. 37, 38; Thos. Agnew & Sons, London; Acquired in 1990 by the C.C.A.
EXHIBITIONS: London, Agnew's, *English Wa-tercolours* 1990: nos. 2 and 7
BIBLIOGRAPHY: Hayward, Harris 1990: 99– 113, figs. 1–2; *L'Art décoratif* 1992: 428; Saumarez Smith 1993: no. 112; Thornton: pl. 273

In 1749, John Linnell joined up with his father, William, to design, build and sell furniture to a select clientele. In typically mid-century English tradition, they created a Rococo which amalga-mated the gothic and chinoiserie, as shown in these drawings which can be supposed to be the proposed models – to be adapted, priced and es-timated according to the desiderata of their clien-tele. Chippendale's *Gentleman and Cabinet-mak-er's Director* (1754) illustrates this double orienta-tion in furniture, and three years later, Chambers published his *Designs for Chinese Buildings* [...], a veritable bible of Chinese taste in architecture and decoration. As opposed to many of these books of models, Linnell's drawings include de-tails as to the materials as well as to how the mod-el invented could actually be built (I am grateful to Robert Little for the information he provided me regarding these two drawings). MRM

317 M
Laureolli after Juste-Aurèle Meissonnier
Title for the *Livre d'ornemens*
New York, The Metropolitan Museum of Art, Harris Brisbane Dick Fund, 1930 [30. 58. 2(136)]
Engraving.; 116 x 214 mm
INSCRIPTION: "Laureolli Sculp" (lower right)
BIBLIOGRAPHY: Guilmard 1880: 155; Berlin 1894: no. 16; *Les peintres français* 1930: 375, no. 1; Berlin 1939, no. 378; Kimball 1942: fig. 1; 1949, fig. 208; Bauer, 1962, pl. 15, fig. 35; Fuhring (forthcoming): no. 24 and engravings

The title *LIVRE D'ORNEMENS / Inventés & Dessinés / PAR J. O. MEISSONNIER / ARCHI-TECTE, DESSINATEUR / de la Chambre & Cabinet / DU ROI* is set in the center of a totally asymmetrical cartouche, whose right-hand part includes a staircase, the statue of a river and a wa-terfall. The plate bears the address of the "Veuve Chereau, on Rue St Jacques, at the Deux piliers d'or." The engraving is numbered above "D 10". This is one of the fifty plates engraved by Laure-olli and published by the Veuve Chéreau. The publication was announced in *Mercure* in May 1734, and Meissonnier had made a request for privilege the year before, a sure sign that he sought the distribution of his models, in merely drawn and/or completed form. Six of Chéreau's plates were taken up by Huquier in the full-scale publication of the *Oeuvre*, whose first suites can be no earlier than 1738 (Bruand-Hébert 1970: 488). The *Livre d'ornemens* notably contains models of snuffbox lids, apparently drawing their inspiration from painting projects, if one is to believe *Apollon sur son char*, or perhaps the *Enlèvement d'Hélène* in a surround done in *trompe-l'oeil* and comparable to those which support the Bielenski ceiling. MRM

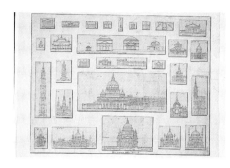

318 M
Juste-Aurèle Meissonnier (1695–1750)
Preparatory Drawing for Plate 1 of the "Parallèle Général des Edifices plus considérables depuis les Egyptiens, les Grecs jusqu'à nos derniers Modernes dessignés sur la même échelle par J. A. Meißonier"
after 1738 (?)
Montreal, Collection Centre Canadien d'Ar-chitecture – Canadian Centre for Architecture, DR1986:0746:001-029
Pen and black and brown ink over black chalk; 30 small pieces of laid paper pasted on paper within a frame; 42.0 x 56.6 cm (frame); 38.0 x 50.3 cm (drawing)
INSCRIPTIONS: "Divers monumens anciens et modernes" (in pen and brown ink, on a small piece of paper, bottom center)

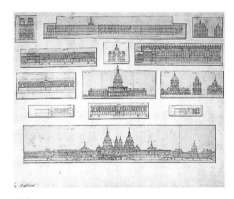

319 M
Juste-Aurèle Meissonnier (1695–1750)
Preparatory Drawing for Plate 2 of the "Pa-rallèle Général des Edifices plus considérables depuis les Egyptiens, les Grecs jusqu'à nos derniers Modernes dessignés sur la même échelle par J. A. Meißonier"
after 1738?
Montreal, Collection Centre Canadien d'Ar-chitecture – Canadian Centre for Architecture, DR 1986: 0744:001-013
Pen and black and brown ink with black chalk construction lines on 13 pieces of laid paper pasted on paper within a paper frame; 37.5 x 50.2 cm (sheet); 42.0 x 56.0 cm (frame)
INSCRIPTION: "Par Meissonier" (lower left cor-ner, in cursive hand in brown ink)

Although many authors, beginning with Jacques-François Blondel, have stated that a competition for the portal of Saint-Sulpice took place in 1732, several architects had submitted designs as early as 1726 (Blondel 1752–56: II, book III, chapter V, 37, note [a]; Sydhoff [1964: 24] situates the competition in 1731). On 3 June

of that year, the members of the Académie royale d'architecture decided on a "[…] portail d'église en plan, élévation et profil sur vingt quatre toises de face" for its Grand Prix competition. Lemonnier 1911–29, IV: 327 (3 June 1726). Jean-Marie Pérouse de Montclos (1984) illustrates two drawings, an elevation and a partial section of the *Premier Prix* won by François Carlier, and the elevation of the *Deuxième Prix* won by Charles Gilbert Lefranc (or Aufranc). Because it corresponds closely to the actual dimensions of Saint-Sulpice, scholars (notably Françoise Hamon 1976: 9) have suggested that this program was related to the completion of the church. A certain P. Varin, who Albert Mayeux believes to be one of Oppenord's collaborators on Saint-Sulpice, also submitted a scheme that year. Like Oppenord's final project, it features a bell tower in the center of its façade (Mayeux 1913: 133. The project by Varin was first mentioned in Besnard 1913). We can surmise that it is around the same time that the anonymous author of the drawing (elevation of a portal) must have conceived his project. In this curious scheme the author juxtaposes an extremely articulated frontispiece to the planar, pilastered walls of the bell towers. The coupled Doric and Ionic columns, the seated groups of statuary, the three levels of orders composed to screen the roof all recall Oppenord's scheme. Yet, by disposing fully three-dimensional orders on three receding planes, the anonymous draftsman attains a high level of plasticity, unusual in Parisian practice at this time. The clustering of columns, which emphasize the central axis of the church, recalls rather Roman Baroque designs, such as the innovative façade of Santi Vincenzo e Anastasio in Rome, built between 1646 and 1650 for Cardinal Mazarin by Martino Longhi the Younger. The most famous of all schemes produced around 1726 for the portal of Saint-Sulpice is undoubtedly the one submitted by Juste-Aurèle Meissonnier, architect and draftsman. It is documented in a drawing kept in the Rohschild Collection at Waddesdon Manor (published in *Baroque & Rococo* 1978: 139, fig. 196), engraved by Claude Charles Riolet (active in the first half of the eighteenth century) and collected as plate 105 in Meissonnier's *Œuvre*. Meissonnier (Turin 1695-1750 Paris), *orfèvre du roi* in 1724, *dessinateur de la chambre et du cabinet du roi* in 1726, appears to have been Oppenord's principal competitor at Saint-Sulpice before the arrival of Servandoni. His *Œuvre* contains several projects for this church. It includes a proposal for its principal altar, although Oppenord's design had already been selected by 1725 for execution; a remodeling of the Lady Chapel commissioned by Languet de Gergy in 1727, two years before Servandoni obtained the project and a wall monument for Jean-Victor de Besenval, colonel of the Swiss Guards, the only project Meissonnier completed at Saint-Sulpice. Although modest in size, Meissonnier's portal is by far the most Baroque of all proposals. Contrary to earlier schemes by Bullet de Chamblain or by Oppenord, Meissonnier's eschews tall lateral towers or a first-storey screen bridging the interval between the upper part of the nave and the bell towers. Instead, his design follows closely the

profile of the existing nave and side aisles. The Waddesdon drawing, however, includes an alternate solution in which short towers reaching to the height of the nave's roof surmount the elevations of the side aisles. This variation has been omitted by the engraver. This latter arrangement, realized by Jacques Hardouin Mansart de Sagonne at Saint-Louis of Versailles is featured in another, more restrained scheme attributed to Meissonnier and preserved in the Canadian Centre for Architecture in Montreal. Although completely orthogonal, this second composition is strongly reminiscent of Francesco Borromini's and Carlo Rainaldi's elevation of Sant'Agnese in Rome. The succession of curves and countercurves, the piling up of pilasters and engaged columns, the fanciful concave pediment, the undulating, almost vibrating bell tower, all features of Meissonnier's design engraved by Riolet point to Italian High Baroque sources. Meissonnier's summary history of architecture, published in two plates by the printmaker Gabriel Huquier sometime after 1745 and entitled "Parallèle Général des Edifices plus considérables depuis les Egyptiens, les Grecs jusqu'à nos derniers Modernes dessignés sur la même échelle par J. A. Meißonier" confirms this progeny (Nynberg 1969: 42). Indeed, in this innovative history of architecture – an early example of the "comparative" method made popular by architectural theorists later in the century – Meissonnier represents a large number of seventeenth-century Italian buildings. These include Carlo Maderno's and Carlo Rainaldi's façade for Sant'Andrea della Valle, Rome (pl. 1, no. 26), that by Pietro da Cortona for Santa Maria della Pace, Rome (pl. 1, no. 27), or that by Francesco Borromini and Carlo Rainaldi for Sant'Agnese, Rome (pl. 1, no. 28). The pronounced Baroque features of Meissonnier's design would quickly become distasteful to a new generation of French connoisseurs. Defenders of the simplicity of antiquity would readily associate Meissonnier with Borromini as the principal cause of the decline in architectural taste. In his discussion of Meissonnier's portal design however, the architectural theorist Jacques-François Blondel is surprisingly appreciative of Meissonnier's talents, not only as silversmith but also as architect. Yet, Blondel warns his students against excesses of imagination in the design of churches ("Le dessin du Portail que nous citons [that of Meissonnier for Saint-Sulpice] est peut-être un exemple qui prouve que le génie ne suffit pas, lorsqu'il s'agit d'un monument de l'espèce dont nous parlons, & que la simplicité, la régularité, la beauté des proportions doivent être préférées à tout ce que l'imagination la plus féconde peut suggérer à l'Architecte." Blondel 1771–77, III [1772]: 350). Influenced by the opinions of their eighteenth-century predecessors, some commentators have singled out Oppenord and Meissonnier as the principal creators of a Rococo public architecture in France. Neither of them seem qualified to play this role. Oppenord's restrained Saint-Sulpice façades belong readily to the Mansartian tradition, Meissonnier's finds its models from the great masters of the Italian Baroque, calling into question the very existence of a Rococo episode in French ecclesiastical architecture. JFB

320 M
Antoine Aveline (1691–1743), after François Thomas Mondon (1709–55)
Le Galant Chasseur
New York, The Metropolitan Museum of Art, Inv. 30. 58. 2 (65)
Etching
BIBLIOGRAPHY: Roland Michel 1979–81: 149–58; 1984a: 162; Park 1992: 25

Antoine Aveline – in conjunction with his son François Antoine – engraved some ten suites based on the drawings of Mondon, a draftsman, engraver and carver. This particular one is the *3ᵉ livre de formes cartels et Rocailles ornés de figures de modes*, seven plates numbered C. 1 to 7, published in 1736 and entitled *L'amour couronné, L'heureux moment, Le galant chasseur; Le Rendez-vous, L'amour guerrier, L'Officieux valet* (the seventh is lacking in the copies we were able to consult). The same year, Aveline engraved and published on the basis of Mondon's work a *Livre de trophées*, doubtless the first two undated books of rocaille form, the *4ᵉ livre de formes ornées de rocailles Cartels Figures Oyseaux et dragons chinois* as a *5ᵉ livre de figures et ornemens chinois* and the *6ᵉ livre de formes rocailles et cartels ornés de figures françoises*, dedicated to the duke of Chatillon, the heir apparent's governor. These titles encompass most of rocaille vocabulary, and the third book which contains the exhibited plate shows couples in various poses, Mondon having set them in an environment of gardens, fountains and waterfalls, designing cartels and other asymmetrical forms of rocaille from the period 1730–35. MRM

323 T–M
Johann Esaias Nilson (1721–88)
Pier Glass
New York, The Metropolitan Museum of Art, The Elisha Whittelsey collection, The Elisha Whittelsey Fund, 1955 (55. 503. 12)
Engraving
BIBLIOGRAPHY: Park 1992: 109, ill.

Shown by Park (1992) to date approximately from 1756, this engraving is interesting in that it constitutes at once a model of an edge for a mirror and perhaps for the back of a chair, and a genre scene, since the artist drew in a couple conversing in front of the console holding up the mirror, both to confer further interest on the composition and to provide a sense of scale. One is indeed struck by the pier's monumental proportions, the sculpted *putti* of which are almost the same size as the sitting man and woman. The small gesticulating children appear to be playing at holding onto the sculptural elements more than actually being part of it. Derived from Boucher's or Charles Antoine Coypel's cupids, which are entirely interchangeable, they illustrate Air, Autumn or Water, but with other attributes they could be used for any rudimentary symbolic system. As for the edge itself, it is perfectly symmetrical and stems straight from the ornamental vocabulary which was characteristic of what was being done at the time – particularly in Augsburg. It is worth emphasizing the use of leaves that have been added on, as if planted along the edge, the thickness of which, moreover, are emphasized by the shadow borne by the mirror. It is interesting to compare this engraving, as Park does, with another done by Nilson in approximately 1770, illustrating a plea against the rocaille, where the mirror was replaced by a tomb, and all the elements of which reflect a neoclassicism void of any fancy. MRM

324 T
Johann Esaias Nilson (1721–88)
Courtship
Turin, Private Collection
Engraving
36 x 50 cm

325 T
Johann Esaias Nilson (1721–88)
A Banquette
Turin, Private Collection
Engraving
36 x 50 cm

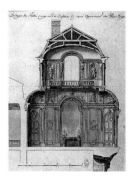

326 M
Gilles-Marie Oppenord (1672–1742)
Section of the Italian-style Drawing Room or Corner Drawing Room for the Palais-Royal, project
New York, Cooper-Hewitt National Design Museum, Inv. no. 1911-28-80
Pen, black and brown ink, wash and watercolor on a black-lead set up
578 x 428 mm
INSCRIPTION: "Coupe du Salon d'alignement à l'Enfilade du grand Appartement du Palais Royal" (signed in the lower left, annotated above)

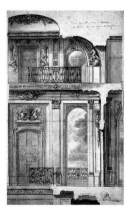

327 M
Gilles-Marie Oppenord (1672–1742)
Elevation of the Palais-Royal Staircase
Montreal, Collection Centre Canadien d'Architetcure – Canadian Centre of Architecture
Inv. DR 1993: 0010
Pen and black ink, gray and mauve wash, highlights in white gouache, on a black-lead set up
752 x 461 mm
INSCRIPTION: The far end of the balustrade was drawn on another piece of paper glued on by Oppenord. Signed in the lower right; annotated in upper right: "Coupe du grand escalier / au Niveau du grand appartement; and on the drawing, in the corresponding places: "Une des quatres portes – un des Quatre Oeils de boeuf – Gardemeuble – Première Porte des grands appartements du premier Etage – Une des Quatre croisées – Entrée à la salle à manger"; "28 pieds" (scale)
PROVENANCE: Ian Woodner Collection; sale of the Woodner family collection, London, Christie's, 2 July 1991, no. 152; Hazlitt, Gooden & Fox, Ltd., London
BIBLIOGRAPHY: Kimball 1936: 113–14; 1949: 127; Folliot, Paris, Carnavalet 1988: no. 42; Scott 1995: 110, fig. 111

Named first architect of the duke of Orleans in 1715 (he had been working for him since 1708), in 1716 Oppenord became his director general of buildings and gardens in charge of fitting out new apartment in the continuity of the Aeneas hall painted by Coypel. The duke of Orleans wanted to enlarge and outfit the large apartment whose Italian-style drawing room was at the end of the row, following upon four other rooms, referred to in the plans as the grand cabinet, bedroom or parade room, dining room, or antechamber, and antechamber bedecked with tapestries (see Kimball 1949: 119ff., figs. 129–35, and Folliot 1988: nos. 29, 30, 39, 48, 131). The Cooper-Hewitt Museum also has a drawing by Oppenord for the alcove of the S.A.R. bedroom. His masterpiece is the great Italian-style drawing room rising up to the full height of the building, situated in the corner of this hall, where the library had originally been. A drawing by Oppenord from the extremity of the hall was engraved in 1754 in Blondel's *Cours d'architecture*, and looking at the exhibited drawing, one understands the drawing room's success – now destroyed – as a finished work as much as a model. It constitutes in effect a perfect repertory of the decor at the turning point of Louis XIV's and the Regency's reign: symmetry of Ionic pilasters, soberly decorated panels, narrow doors, its ends framing the upper opening. On the other hand, the edging of the arched mirror, the lightness of the wrought-iron banister on the border of the tribune, the base of the chandeliers set on the chimney are imprinted with a gracious movement, marked by Italianism, which already contained Oppenord's rocaille invention. Kimball brought the arched doors into relation with those of the Hercules Hall in Versailles, and the lantern with that of the Marly drawing room, once again making reference to French models and Le Pautre's inventiveness. For all of that, when between 1748 and 1752, Huquier published the *Grand Oppenord*, he included several plates of the Palais-Royal: the title plate of the *Livre de différents Fragments d'Architecture* was the Façade for the stables of the Palais-Royal while another plate regrouped the "Chimney shaft for the Palais-Royal project," the "Attic for the Italian-style drawing room of the Palais-Royal" and the "Door keys for the stables project at the Palais-Royal;" the *Livre de différentes décorations d'architecture et appartemens* contained two sections of the "project made for the reconstruction of the Palais-Royal"; the *Livre de différentes décorations d'apartements* included "Fireplaces and paneling for an Italian-style drawing room at the Palais-Royal," attic and door projects for that same drawing room, as well as a plate of "fireplaces and paneling for the large apartments of the Palais-Royal." Moreover, Bénard engraved several of Oppenord's drawings for the Palais Royal in the "Architecture" section of the *Encyclopédie*. All these plates are precious inasmuch as they provide an idea of the grand architectural decor which has since disappeared and testified to the proliferation of projects Oppenord elaborated for the prestigious building he was in charge of renovating. The drawing of the two-level stair-

case is clearly linked with the Italian-style drawing room. For this reason, it is difficult if not impossible to know where it was intended to be built. The various known plans showing the large first-floor apartment as well as the small ground-floor apartment show no signs of being linked by any stairway. The one reproduced by Kimball (fig. 134), similar to Blondel's, shows the chapel with its access steps coming back from the antechamber to which it is separated by a courtyard; this may well have been one of the intended sites for the staircase. Today, this drawing has the double interest of being the only known document of a project of this kind, and of illustrating once again the wealth and the variety of Oppenord's inventiveness. MRM

to us through the engraving of the *Grand Oppenord*, where the ornamentalist-architect followed at once the whims of his imagination and the tastes of contemporary aesthetes, inventing a great number of models of fireplaces, mirrors, piers and decorated lintels – most of them bipartite and thus providing more possible models and combinations. Let it suffice to mention the two *Livres de cheminée et lambris de menuiserie et de sculpture* with six plates each, the two plates of the *Livre de décorations d'appartemens* or the six plates of the *Livre de différentes décorations d'architecture et appartemens*, devoted, for the most part, to the proposals for the Palais-Royal, which together provide a complete and diversified catalogue of possible fireplaces. MRM

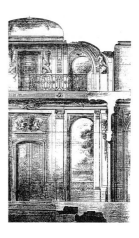

331 M
Gilles-Marie Oppenord (1672–1742)
Sketchbook of Architectural Features of the Farnesi Palace
Montreal, Collection Centre Canadien d'Architecture – Canadian Center of Architecture, DR 1996: 0013; acquisition made possible through a donation made by Mrs. Marjorie Bronfman
A ten-page volume, drawn on front and back, in black lead, pen and brown ink; 275 x 204 mm
Watermark: six-point star surmounted by a cross (on five sheets)
PROVENANCE: Swedish collection; sold in New York, Christie's, 10 January 1996: no. 184; acquired by the C.C.A. At the same sale, figured, as no. 187, four sheets drawn on both sides, which in all likelihood come from the same sketchbook. Drawn in black lead, pen, brown ink, brown and blue wash, they also reproduced details of the Farnesi palace
BIBLIOGRAPHY: Dee in Führing 1989: pl. II; Cannors in *Festsehrift für Matthias Winner Design into Art*. 1989: II: 79–80; Connors 1996: 598 and 610, note 6

328 M
Gilles-Marie Oppenord (1672–1742)
Fireplace Project for the Hôtel de Pomponne
New York, Cooper-Hewitt National Design Museum
Pen, black and red-brown ink on a black-lead set-up; 766 x 275 mm
INSCRIPTION: Signed underneath; annotated vertically in the center right "72 Hauteur de la grande glace... / Sy l'on l'assujettit aux deux trumeaux remettre les / joints de la ditte glace a même hauteur comme il reste des / raisons les Gdes glaces porteront 80 pouces sur 52"
BIBLIOGRAPHY: Kimball 1949: 113, fig. 110; Scott 1995: 215, fig. 240

This is one of the first interior decors which Oppenord devised in 1714 for the Hôtel de Pomponne, on the place des Victoires, which had been acquired by farmer-general Michel Bonnier. Though the design appears as a proposal to be approved, with two alternative models of fireplace and mirror edging, the great precision with which it is drawn is emphasized by the tight treatment of the hatching, the care taken in dealing with the shadows, the finesse of the penmanship, the exacting respect for dimensions and scale. The side paneling is decorated with fountains, branches, allegorical figures stemming from the tradition of Béran and Audran; a hasp head joins the mirror edging to the hook sitting on the chimney, and the mirror itself is set against a wood panel bordered by Greek frets. This is clearly a precise proposal, corresponding to the size of the drawing room and intended to be actually carried out. Here we see the difference between the numerous models proposed by Oppenord at this time or later, and which are known

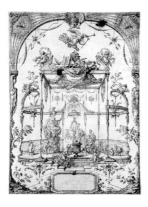

330 MAR
Gilles-Marie Oppenord (1672–1742)
Hommage à Apollon
Berlin, Staatliche Museen, Kunstbibliothek, Hdz 280
Pen and brown wash on black-lead setup
478 x 352 mm
PROVENANCE: Destailleur Collection: no. 916
BIBLIOGRAPHY: Berckenhagen 1970: 170 and 172; *L'Art décoratif* 1992: 204

The date as well as the destination of this sheet remain unknown: it depicts, in Italian-style arabesque surroundings, an arbor or a bower dedicated to the arts: architecture, drawing and painting, sculpture (Pons 1992, saw in it an allusion to the works of the sculptor Frémin in la Granja), as well as poetry, history, geography, astronomy and music under the surveillance of Minerva. It should be pointed out that putti and instruments are freely deployed in a frame which, though pure fantasy, is nonetheless totally symmetrical, and ordered around the figure of Apollo whose central statue marks off the successive depths of field of an audacious perspective of which neither Audran, Gillot nor Watteau attained the equivalent in the various portieres, bowers and arabesques they came up with.
The jerkinhead cartouche incorporated into the base of the drawing reinforces the impression that it is most likely a frontispiece project intended for engraving. The figure of Fame which soars above the composition is more or less identical to that which, the other way round, surmounts the title plate of the *Livre de Mr. Oppenord contenant des Tombeaux*, plate XL of the *Grand Oppenord*. MRM

Oppenord spent more than seven years in Rome (1692–99), in the course of which he shared the life of the residents at the French Academy, directed by La Teulière. Over the course of his stay, he prepared for his trade as an architect (and ornamentalist), filling sketchbooks with all manner of architectural and decorative motifs, at times mixed in with his own inventions, putting together a classical and baroque repertory which he was later to make use of in France. With the exception of a last album, which made up an illustration project for Ripa's *Iconologie*, all of them are more or less related to Rome: decorative motifs and architectural monuments, fountains – with a particular interest for Borromini – of which Oppenord drew the profiles, several elevations, architectural details of churches or palaces. A certain number of these drawings would be engraved by Huquier, and published after Oppenord's death in the *Livre de fragments d'architecture* or the *Petit Oppenord*. Though incomplete, the Montreal sketchbook testifies to Oppenord's interest in pre-baroque architecture. On the first page, the title, *Estude de Palais Farneise a Rome: par Oppenord* is inscribed in a large cartouche surmounted by a hasp-head. Below is a plan and some sketches of the alcove vault. The architect had inscribed: *fasse du coste*

E (regardant la?) Ville. (I am grateful to Myra N. Rosenfeld for her help with regard to this note.) The other drawings are devoted to measured drawings of colonnades, a few statues, various details and sections of the court cornice, windows, pilasters, capitals, elements of the ceiling of Sangallo. With the exception of one of the sheets of the Berlin sketchbook devoted to the Mascaronne Farnese Fountain, we have here the only known testimony of Oppenord's interest in Michaelangelo's cornice or in the hall's decor. The drawings regrouping the different details of the cornice, or showing the face and profile of the windows of the first and second floors are drawn in with a drafting pen, the volumes are rendered through regular hatching, and bear indications as to the size in feet and inches of the capitals or the bases of the columns (fol. 5r; fol. 4v; fol. 7r). Oppenord would sometimes add precise indications, such as 3 squared panels or separation of panels with pen strokes in order to indicate the separation (fol. 7v). In the sheets showing the alcoves and statues, he was more inclined to use wash, reinforcing the pictorial aspect. Like most architects' sketchbooks, he would draw various motifs on a single sheet, with neither order nor preconceived meaning. Note that Oppenord's choices are in no sense original, and that the details which caught his attention (cassoons, friezes, details of cornices) appear beneath the pen of all the draftsmen since the end of the sixteenth century right up to Letarouilly (see *Le Palais Farnèse – École française de Rome*, Rome 1981, 3 vols.). MRM

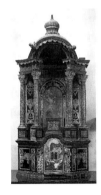

332 T
Pietro Piffetti (1700–77)
Templet-Tabernacle Depicting the "Last Supper," ca. 1760
Bene Vagienna (Cuneo), Confraternita di San Bernardino dei Disciplinanti Bianchi
Poplar wood veneered with violet wood, fruit wood, probably pear, ebony, ivory, mother-of-pearl, tortoiseshell; and marble encrustations
170 x 85 x 50 cm
PROVENANCE: From the church of the Capuchins in Carrù (Cuneo), dedicated to the Madonna degli Angeli, now closed to the public (Assandria 1899: 82–84)
BIBLIOGRAPHY: Griseri 1995: 113–19, ill. 120– 28

Assandria (1899) recalls the provenance of this templet with its important pair from the church of the Capuchins, a religious order sustained by court connections. It is important to remember the relationships between the province and the capital, testified to by the presence of artists active on the royal residences and working for the aristocratic families. These tabernacles, which lead to figures like Count Vittorio Amedeo Costa della Trinità, viceroy of Sardinia from 1755, demonstrate this, and it must also be remembered that Bene Vagienna became the principality of the Duke of Chiablese in 1763. Looking at this templet-tabernacle, it is clear that Piffetti was asked to produce something similar to the one he had already made in 1760 for the chapel in Palazzo Reale. The similarities can be seen in its straight and curved lines, the elegant Corinthian columns, the crown adorned with angel heads, which refer back to the royal tabernacle and directly to a drawing by Filippo Juvarra in the Museo Civico in Turin (Ang. Griseri 1995: 120). Even closer likenesses can be seen in the polychrome scene depicting the "Last Supper" on the small door, and especially in the depiction of "Christ in the Garden" in its pair; this was taken from the tabernacle in the royal chapel and shows only very minor variations in the landscape and figure groups. Juvarra's "ideas" had created an important model for altars and tabernacles. Starting from the drawings, these have been studied in recent years, especially that of Sant'Uberto in Venaria and in San Filippo (Millon 1960–61 and 1984; Dardanello 1989: 196 and 210). Juvarra's model served as an example for the chapels of villas and marked a turning point in the dynamic rhythm linked to natural elements in the decoration, which looked toward the garden and the theatre. In this sense, the spectacular scenographic element introduced by Juvarra into architecture has rightly been emphasised (Dardanello 1989). These models are interesting in their extremely close affinity to the architecture of Juvarra's later years, enriched with ivory decoration, inserts of cascading flowers, which continue in the cartouches on the side panels, demonstrating knowledge of Jean Berain's engravings. The "Crucifixion" in ivory is also important, showing references to sevententh-century models and perfectly inserted into the Rococo whole. In this case too "Piffetti's furniture will be looked at as one looks at a building: architecture on a reduced scale and sometimes a fantastic mirror of the inlay and modelling" (Gonzales Palacios 1986: 383). After Andrea Pozzo, this type of templet-tabernacle became a modern scenographic construction; with Juvarra it became a type of furnishing, then to be enriched by Alfieri and Tavigliano with decoration by Verberckt, Oppenord and Pineau (Colle 1987). They were very costly pieces: for example, 2,000 lire was paid in 1760 for the one in the Royal Chapel; a tabernacle with six alabaster columns was valued at the same price in 1779 when it was included in the list of an auction of furniture left by the master, which took place two years after the cabinet-maker's death, with estimates made by the architect Ludovico Bo. The description presented it "with a plinth, base and pilaster strips of squared panels; a cornice arching toward the front and a small door in carved ivory forming a picture of colored, sacred figures. The panels are surrounded by repeat ivory beading, beautiful woods, mother-of-pearl, cascades and bunches of flowers, with a finial twisted in the middle forming the foot of the cross, and an ivory Crucifixion." Similar structures were made by Tavigliano, active with Ladatte on the high altar in Santa Chiara in Carignano. This was transferred due to the suppression of the Poor Clares in 1880 to the parish church of Novalesa. Another one for the church of the Misericordia in Carignano had been worked on by the same artists in 1751 (Lusso 1971). Yet another, attributed to Piffetti by Gabrielli (1960–61) in the Santuario del Valinotto in Carignano, is similar to this one in Bene Vagienna for its marble columns, small gilt wooden capitals, inlays in colored ivory, mother-of-pearl and precious woods with praying angels on the base and in the Holy Trinity. Juvarra's model, elaborated by Piffetti and taken up by Alfieri, Vittone and Gallo, was widespread in the churches of the confraternities in the province. AngG

333 T
Pietro Piffetti (1700–77)
Prie Dieu, 1750
Turin, Palazzo Reale
Carved and gilt wood, veneered with tortoiseshell, inlaid with ivory partly coloured crimson, light blue and pink, and other inserts of mother-of-pearl and brass; 265 x 112 cm
PROVENANCE: The prie dieu is documented (1748–51) as furniture made for the apartment of the Duke and Duchess of Savoy, Vittorio Amedeo and Marie Antoine of Bourbon, on their marriage
BIBLIOGRAPHY: *Mostra del Barocco Piemontese* 1963: 18–19; Ferraris 1992: 52–55

Pietro Piffetti's prie dieu marked a turning point in the architect Benedetto Alfieri's work of modernising the second floor of Palazzo Reale in Turin, which reached its height in 1750 for the wedding of Prince Vittorio Amedeo, Carlo Emanuele III's son.
This piece was well documented from 1748 to 1751 (Ferraris 1992: 52–55, with previous bibliog.) as the last payment of 16 November 1751 shows "to His Majesty's cabinet-maker Pro Piffetti, in payment of the sum of 8.160 lire for marquetry work done on two prie dieus begun in 1748 and finished in 1750 destined for the apartments of their Highnesses the Duke and Duchess of Savoy in this city, and other; this takes into account the deduction of 6.550 lire paid in advance in three different moments, on 17 January 1749 for 1748, 16 June 1750 and 13 May 1751, as recorded on 5 August 1751" (Conti Real Casa 1751: ch. II, art. 124; see Ferraris 1992: 208). With this furniture Piffetti was on the point of establishing the novelties of Rococo in a freer style than the designs of those same interiors. Piffetti moved on from what he had been doing with Juvarra in 1731 on the

first floor of Palazzo Reale for Carlo Emanuele III and Polyxena of Hesse, producing tiered wall tables inlaid with rare woods, ivory, mother-of-pearl and bronzes sculpted by Ladatte; bizarre caprices much appreciated by travellers like Lalande (1765). He did not repeat the precious altar-frontals in mother-of-pearl made in 1747 for Benedetto XIV, and now in the Vatican Sacrario Apostolico (Gonzales Palacios 1991: 101; Ferraris 1992: 102–103), or the one made in 1749 for the church of San Filippo in Turin. The hereditary prince's marriage was the occasion for modernising furniture, ready to dominate taste and the ornamentalists' ideas, and to direct the craft's extreme elegance toward an evident naturalness. Along these lines Piffetti succeeded in celebrating both the wedding and religious iconography, summed up in the motto inserted in the carving: "Soli Deo Honor et Gloria." It is the fundamental point that gathers together all the cartouches in their easily comprehensible details, interrupted by flowers and figures of fantastic birds taken from Mannerism, and most of all the sequence of winged putti and angels, which we also find in the above mentioned altar frontals. Piffetti's sources remained the same: in Rome he drew on engravings and drawings, looking at the contributions of the Academy of France and that of San Lucca, combined for the richness of the ornamentation with influence from Boulle, Berain, Alexandre-Jean Oppenord (for which see Gruber and Pons 1992: 167) and from the Germans, culminating in Roentgen, as has recently been pointed out (Gonzales Palacios 1986: 382, 385). In the case of this prie dieu of 1750, the putti and angels refer to drawings by Giovanni Odazzi and Seiter, to Beaumont and directly to Ladatte, with whom Piffetti worked from the 1730s on. The plaque now in the Museo Civico d'Arte Antica and Palazzo Madama (see next entry) has correctly been re-assigned to this prie dieu (Ferraris 1992: 55). AG

334 T
Pietro Piffetti (1700–77)
Oval Plaque with the "Flight to Egypt"
1748–51
Turin, Museo Civico d'Arte Antica – Palazzo Madama
Plaque inlaid with tortoiseshell, mother-of-pearl and coloured ivory; 68 x 45.5 cm
PROVENANCE: As the central medallion, this was part of the prieu dieu described in the previous entry. An inventory of 1815 mentions the plaque as being inserted in that piece of furniture and refers to it as the "Holy Family;" an 1823 inventory indicates the subject as "Flight into Egypt."

The plaque came into the Museo Civico Coll. in 1968 on purchase by Pietro Accorsi, Turin
BIBLIOGRAPHY: Ferraris 1992: 55, with reference to the prie dieu. Attributed as an original work by Piffetti by Mallé 1972: 160; Antonetto 1985: 470

Stylistic comparisons place this work close to the scene inserted in the door of the tabernacle in the chapel in Palazzo Reale, Turin (1760), and illustrate the influence of devotional engravings after Roman paintings on Piffetti. AG

339 T
Anonymous
Equestrian Portrait of Louis XIV, 1740-50
Stupinigi, Palazzina di Caccia–Ordine Mauriziano, Museo d'Arredamento e Ammobiliamento
Marble; 140 x 85 x 40 cm

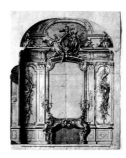

341 MAR
Antoine François Vassé (1681–1736)
Fireplace Project for the Far End of the Dorée Galerie in the Hôtel de Toulouse
Stockholm, Nationalmuseet
Black lead, pen and wash
INSCRIPTION: "Vassé del." (in pen lower right)
EXHIBITIONS: Paris, Carnavalet 1947: no. 368
BIBLIOGRAPHY: Kimball 1949: 128–30; fig. 124b; Scott 1995: 186–87, fig. 206

In 1717–18, Robert de Cotte was put in charge of renovating the hall of the former Hôtel La Vrillière for the count of Toulouse, grand admiral of France, master of the royal hounds and chief-of-staff of the navy – the sculptural ornaments having been entrusted to Vassé. It was then that the hall's square inner far end was made round, in keeping with the outer far end. Vassé seems to have taken his inspiration from Oppenord's drawings for the Palais-Royal. A first drawing – the right-hand side of which was scarcely even sketched in – studied in greater detail the trophies set on both sides of the glass, stretched asymmetrically on a vertical axis in the drawing shown here, and ultimately replaced by alcoves containing figures of Diana and Amphitrita. Like the central cartouche, asymmetrical and proliferating, with its flags and its figures

surrounding an anchor surmounting the count of Toulouse's coat of arms, it made way for a vertical rather than an oblique ship's prow. "Everything that sculpture and gilding were able to imagine of the greatest excellence was used," wrote Brice with reference to what is one of the great decorative monuments of the Regency, along with the Palais-Royal and Boffrand's Arsenal – also both modified in the course of this period – which was a turning point for the Regent and Louis XIV's two legitimate sons. MRM

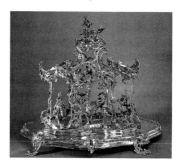

343 T
Bernhard Weyhe (d. 1782)
Plattménage
Munich, Bayerisches Nationalmuseum
Silver
BIBLIOGRAPHY: *L'Art décoratif* 1992: 221, repr.

"Plattménage" is the name given to the metal part of a table centerpiece which, above and beyond its decorative function, can also be used as a display-shelf. A drawing done in preparation of this one, belonging to the Städtische Bibliothek in Augsburg, where the silversmith spent most of his life, shows that its upper part was used to display lemons. It is likely that this openwork design, halfway between a kiosk and a barrel, symbolized winter, because of the lemons, the branches of dead trees which rise up on the right and the left above the ape musicians, and also because of the characters performing chamber music during the wrong season. The cartouche bearing a coat-of-arms at its base shows that the work had been commissioned, although it is unfortunately not known by whom. Dated 1761–63, this object which combines jagged forms without any architectonic links between them, as well as references to fountains, garden architecture and pagodas demonstrates the persistence of rocaille models in the last third of the eighteenth century. MRM

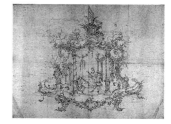

344 T
Bernhard Weyhe (d. 1782)
Preparatory Drawing for a Table Centerpiece
1755–60
Augsburg, Staats-und Stadtbibliothek
Pencil on paper; 90 x 120 cm (with frame)

Architectural books and portraits of artists

The Books of Baroque Architecture
Werner Oechslin

To present a small selection of books and at the same time evoke the broad range of cultural phenomena they represent is a difficult undertaking. Above and beyond general references to architects, our focus in this context is on the special status of the architectural model. Here, Alberti's double concept of the model provides a point of departure: for him, the terms *modulus* and *exemplar* designate both systematic, abstract qualities and the concrete physical entity that serves as a "model." The first aspect draws our attention to a purely theoretical, systematic, mathematical mode of observation, while the second reminds us that architecture numbers among the mimetic arts and is always aware of its own history. This distinction itself already suggests two entirely different orientations and areas of the architectural book, or of the book related to architecture. Naturally, wherever individual buildings, architectural complexes, or the entire oeuvre of an architect are considered exemplary they give rise to a literature virtually boundless in scope. This genre includes a broad range of possible modes of self-representation: the stairway of Versailles, for example, whose significance for the ceremonial of Louis XIV is well known, is deemed worthy of a luxury monograph in which each letter is engraved. Domenico De Rossi, on the other hand, presents as exemplary all of Roman architectural production since Michelangelo in a series of large-format engraved works. To this end, he makes use of traditional (easily comprehensible), systematic modes of architectural representation, isolating individual motifs (doors, windows), and rendering them in detailed images that enable readers to use them in their own architectural practice. Between the two extremes of the monumental display book – Félibien's presentation of the Invalides likewise consists of a luxury collection of engravings – and the detailed educational compendium, there are many variations. Seen in this light, (ideal) architectural patterns are innumerable. And of course even non-existent works of architecture can be models, as in Bacon's laboratory experiment of a world full of imagination, which he describes in a series of (model) buildings, or in the administrative "Act of Parliament" after the Great Fire of London, announcing the construction of fifty churches. The mere titles of the various illustrations and engravings supply confirmation of this exemplary character in every quire. As a "scheme," the (geometrically) regulated presentation of Stonehenge serves the same purpose as the *ectypon* provided in the engraving of the Clementinum in Prague, while the *optica projectio* of Kircher's reconstruction of Noah's Ark and the *forma fundamentalis* included along with the description of Melk differ little in the obligatory character to which they lay claim. The systematic branch of architectural study encompasses those theoretical and theory-creating works that categorize architecture – and its instruments – through abstraction and rami-

fication. The grounding of architecture in Euclidean geometry gives rise to an abundance of texts that systematically derive architectural form from the laws of geometry and perspective. The work of Revesi Bruti, originally published in Vicenza and, significantly, reprinted in England with a dedication to Lord Burlington, shows the high level attained – with the help of measuring instruments – by the geometric approach to the (ancient) variety of forms. Similarly, the complexity of the architectural problems capable of being represented with this method of drawing is demonstrated impressively by Ferrabosco (1620). Finally, Schübler shows that an actual art of invention – an *ars inveniendi* – can be developed on the basis of number and geometry. The attribution of woodworking or "the art of carpentry" to the realm of practice – as opposed to the (French) theory (!) of stonecutting or "coupe de la pierre" – requires a cultural-historical explanation. In any case, works by carpenters and woodworkers constitute a separate genre of architectural book, one that extends far into the nineteenth century and even into the modern era (Ostendorf). In procedure and method, their use of concrete patterns as models for orientation contrasts with the doctrine propagated in the books of Blondel and Perrault in France. In contrast to this, an extensive body of architectural literature is based on an historical, more precisely a sacred-historical foundation. Works devoted to the Temple of Jerusalem and to biblical architecture of every type from Noah's Ark onward demonstrates that this period was marked often enough by the desire for models other than those of classical Greek and Rome. If a common denominator underlying all these books from the "Baroque period" can be identified, it doubtless consists in their virtually unlimited variety and wide range of cultural contexts.

1. The teleological character of architecture

345a T

Johann Jacob Scheuchzer
PHYSIQUE / SACRÉE, / OU / HISTOIRE-NATURELLE / DE LA / BIBLE. / *TRADUITE DU LATIN DE* / Mr. JEAN-JACQUES SCHEUCHZER, / Docteur en Medecine, Professeur en Mathématiques à Zurich, Membre / de l'Académie Impériale des Curieux de la Nature, & des Sociétés / Royales d'Angleterre & de Prusse. / *Enrichie de Figures en Taille-douce, gravées par les soins de* / JEAN-ANDRÉ PFEFFEL, / Graveur de S.M. Impériale. / *TOME PREMIER.* / A AMSTERDAM, / Chez PIERRE SCHENK, / PIERRE MORTIER. / M. DCC. XXXII.
Amsterdam, 1732
Einsiedeln, Stiftung Bibliothek Werner Oechslin
Physica Sacra, 8 vols., Zürich 1721 (1ª French ed., Amsterdam 1732–37) WOe

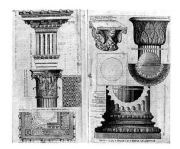

345b T

Jerónimo Prado and Johannes Baptista Villalpando
HIERONYMI PRADI / ET / IOANNIS BAPTISTAE / VILLALPANDI / E *SOCIETATE IESV* / IN EZECHIELEM / EXPLANATIONES / ET / Apparatus Vrbis, ac Templi / Hierosolymitani. / COMMENTARIIS / ET / IMAGINIBVS / ILLVSTRATVS / OPVS TRIBVS TOMIS / DISTINCTVM / *Quid vero singulis contineatur, quarta pagina indicabit.* / ROMAE / *Superiorum Permissu* / M D XC VI, [tomo] II: DE POSTREMA / EZECHIELIS / PROPHETAE / VISIONE / IOANNIS / BAPTISTAE / VILLALPANDI / CORDVBENSIS / E SOCIETATE / IESV / TOMI SECVNDI / EXPLANATIONVM / PARS SECVNDA / *In qua Templi* eiusque uasorum forma, / tum commentarijs, tum æneis quamplu: / rimis descriptionibus exprimitur. / Romae Superiorum permissu, & cum / priuilegijs ut in Apparatu. / Typis Illefonsi Ciacconij excudebat Carolus Vulliettus Anno Domini MDCIII; [tomo] III: TOMI. III. APPARATVS / VRBIS. AC. TEMPLI / HIEROSOLYMITANI / PARS. I. ET. II / IOANNIS BAPTISTAE / VILLALPANDI / CORDVBENSIS / E. SOCIETATE. IESV / COLLATO. STVDIO. CVM. H. PRADO / EX. EADEM. SOCIETATE / ROMAE / *Superiorum Permissu* / Typis Illefonsi Ciacconij excudebat Carolus Vulliettus Anno Domini MDCIIII
Rome, 1596–1604
Einsiedeln, Stiftung Bibliothek Werner Oechslin
The third volume includes the reconstruction of the Temple of Jerusalem and the demonstration of the order of Solomon. WOe

345c T

Der / Tempel / Salomonis / Nach allen seinen / Vorhöfen / Mauren / Thoren / Hallen / Heili- / gen Gefässen / Brand-Opfer-Altar / ehernen Meer / güldenen Leuchtern, Schau-Brodt-Tischen, Räusch-Altar, Lade des / Bundes, Cherubinen, und Stifts-Hütte Mosis, mit / ihrem Zubehör, / nebst allen und jeden / in folgender Beschreibung u. beygefügten Kupferstücken / enthaltenen Theilen desselben / in einem / eigentlichen Modell und materiellen Fürstellung / in dem Wäysen-Hause zu Glaucha an Halle / zu Erläuterung / sehr vieler Oerter der Heiligen Schrift, / ANNO M DCC XVII. aufgerichtet. / HALLE / in Verlegung des Wäysen-Hauses, Anno 1718.
Halle, 1718
Einsiedeln, Stiftung Bibliothek Werner Oechslin

345d T
Athanasius Kircher (1601–1680)
ATHANASII / KIRCHERI / è SOC. JESU / ARCA NOË, / IN / TRES LIBROS / DIGESTA, / QUORUM / I. *De rebus quæ ante* Diluvium, / II. *De iis, quæ ipso* Diluvio *ejusque duratione*, / III. *De iis, quæ post* Diluvium *à* Noëmo *gesta sunt*, / Quæ omnia novâ Methodo, / NEC NON / *Summa Argumentorum varietate, explicantur, & demonstrantur* / AMSTELODAMI, / Apud JOANNEM JANSSONIUM à WAESBERGE. / ANNO M DC LXXV. *Cum Privilegiis.*
Amstel, 1675
Einsiedeln, Stiftung Bibliothek Werner Oechslin

2. Geometry and perspective: the mathematical foundations of architecture

345e T
Ottavio Revesi Bruti
A NEW and ACCURATE / METHOD / OF / DELINEATING all the PARTS / Of the different / ORDERS / IN / ARCHITECTURE, / By Means of a well contriv'd, and most easily manag'd / INSTRUMENT; / WHEREON THE / Just PROPORTIONS of the Principal MEMBERS, / and of their several PARTS, are so disposed, as wholly to avoid the Difficulty / of the Fractional Parts that usually attend these OPERATIONS. / English'd from the Original ITALIAN of *OTTAVIO REVESI BRUTI*, / By *THOMAS MALIE*, Gent. / *LONDON*, / Printed for FLETCHER GYLES over against *Gray's-Inn Holbourn*, and THOMAS HEATH, / Mathematical Instrument Maker, next the *Fountain Tavern* in the *Strand*, MDCCXXXVII.
London, 1787
Einsiedeln, Stiftung Bibliothek Werner Oechslin
Ottavio Ravesi Bruti. *Archisesto*, Vicenza, 1627, English translation by Thomas Malie, dedicated to Lord Burlington. It is a mathematical classification of architectural forms. WOe

345f T
Pietro Accolti
LO INGANNO / DE GL'OCCHI, / PROSPETTIVA PRATICA / DI PIETRO ACCOLTI / GENTILHUOMO FIORENTINO. / *E della Toscana Accademia del Disegno*. / *TRATTATO IN ACCONCIO DELLA PITTURA*. / *IN FIRENZE*, / Appresso Pietro Cecconcelli. MDC XXV / *Con Licenza de Superiori. Alle Stelle Medicee*.
Florence, 1625
Einsiedeln, Stiftung Bibliothek Werner Oechslin

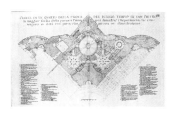

345g T
Giovanni Battista Costaguti
ARCHITETTVRA / DELLA BASILICA / DI S. PIETRO IN VATICANO / Opera di Bramante Lazzari, Michel'Angelo Bonarota, / Carlo Maderni, ed altri famosi Architetti / DA MONSIGNORE / GIO. BATTISTA COSTAGVTI / SENIORE / MAGGIORDOMO DI PAOLO V. / *Fatta esprimere, e intagliare più tauole da Martino Ferrabosco, e posta in luce* / *l'Anno* M. DC. XX. / Di nuouo data alle Stampe / DA MONSIGNORE / GIO. BATTISTA COSTAGVTI / IVNIORE / DECANO DELLA CAMERA / *Nell'Anno* M. DC. LXXXIV. / IN ROMA, Nella Stamperia della Reuerenda Camera Apostolica, M. DC. LXXXIV. / *CON LICENZA DE' SVPERIORI.*
Einsiedeln, Stiftung Bibliothek Werner Oechslin
Engravings by Martino Ferrabosco, 1620: examples of technical skill in rendering complex architectural works. WOe

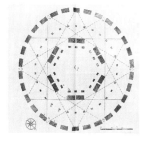

345h T
Inigo Jones (1573–1652)
The MOST NOTABLE / ANTIQUITY / OF / GREAT BRITAIN / Vulgary called / STONE-HENG, / ON / *SALISBURY PLAIN*, / RESTORED, / By INIGO JONES, Esq; Architect General to the King. / To which are added, / The CHOREA GIGANTUM, / OR, / *Stone-Heng* Restored to the *Danes*, / By Doctor CHARLETON; / AND / Mr. *Webb*'s Vindication of *Stone-Heng* Restored, / In Answer to Dr. Charleton's Reflections; / WITH OBSERVATIONS upon the Orders and Rules of ARCHITECTURE / In Use among the Antient ROMANS. / Before the whole are prefixed, / Certain MEMOIRS relating to the Life of *INIGO JONES*; / with his Effigies, Engrav'd by *Hollar*; as also Dr. *CHARLESTON*'s, / By *P. Lombart*; and four new Views of STONE-HENG, in its / present Situation: With above twenty other Copper-Plates, / and a compleat INDEX to the entire Collection. / *LONDON*: / Printed for D. BROWNE *Junior*, at the *Black-Swan* without *Temple-Bar*, and J. WOODMAN and D. LYON, in *Russel-Street*, *Covent-Garden*, M. DCC.XXV.
London, 1725
Einsiedeln, Stiftung Bibliothek Werner Oechslin
Geometrical representation of Stonhenge seen as a classical monument. WOe

345i T
Ferdinando Galli da Bibiena (1657–1743)
L'ARCHITETTURA CIVILE / PREPARATA SU LA GEOMETRIA, / E RIDOTTA ALLE PROSPETTIVE / CONSIDERAZIONI PRATICHE / DI FERDINANDO GALLI BIBIENA, / CITTADINO BOLOGNESE / ... / *DISSEGNATE, E DESCRITTE IN CINQUE PARTI*. / La prima contiene la Geometria, e avvertimenti, prima che à fabbricar si pervenga. / La seconda. Un Trattato dell'Architettura civile in generale, e le divisioni di essa molto facilitate. / La Terza. La Prospettiva commune, orizontale, e di sotto in sù. / La Quarta. Un brieve discorso di Pittura, e la Prospettiva per li Pittori di Figure, colla / nuova Prospettiva delle Scene Teatrali vedute per angolo, oltre le praticate da tutti / gli altri. / La Quinta. La Mecanica, ò arte di movere, reggere, e trasportar pesi. / ... / IN PARMA, / Per Paolo Monti M DCCXI. / *CON LICENZA DE' SUPERIORI.*
Parma, 1711
Einsiedeln, Stiftung Bibliothek Werner Oechslin
Stage design reached the rank of architectural science. Bibiena refers to the great masters. WOe

345j T
Johann Jacob Schübler
ARS INVENIENDI / sive / PARTITIO FAMAE. / Dast ist: / Die in dem Antiquen Progressions-Quadrat der Lunæ / durch Zahlen / Buchstaben und Linien verhüllte / ENTIA INVISIBILIA, / Welche / aus dem Pythagorischen Gedanken-Gemähld / oder / METATHESI / NUMERORUM, / vermittelst / Der entschleyerten Sphinx-Zahl 32. aufgesucht / und die Radices Figu- / ratorum der Exacten Delineation ausmachen / ja eine jede Ideam Characteri- / sticam, durch die / l'Expositionem Elementariam Linearum combiniren / so dass durch / Hülffe der Diagrammatischen Dreyangel / die Geometrische Proportion, / und die Regulaire Mahlerische und Optische / Erfindungs-Kunst / mit und ohne die / Logarithmische Linie / kan erlangt / Und alles / was die freye Hand-Zeichnung sonst gewöhnlicher / massen begreifft / unter sichern Gräntzen projectiret werden / mit vielen / theoretisch- und practischen Exempeln erläutert / und mit zierlichen Architectoni- / schen Vorstellungen, inventirt / gezeichnet und wohlmeynend als einen Prodromum, / der mathematischen universalen Zeichnungs- Kunst / ans Licht gegeben / von / Johann Jacob Schübler / Math. Archit. Pict. & Scupt. Cultore. / Nürnberg / zu finden bey Johann Christoph Weigels seel. Wittwe. / Gedruckt bey Lorenz Bieling / 1734.
Nuremberg, 1734
Einsiedeln, Stiftung Bibliothek Werner Oechslin

3. From praxis to carpentry: the architecture of Zimmermann

345k T
Friederich Unteütsch
Neues / Zieratenbuch / den Schreinern Tisch / lern oder Küstlern / und Bildhaüern sehr / dienstlich. / Durch M. Friederich / Unteütsch Stattschreinern zu / Franckfurth am Main heraus: / gegeben / Zu finden in Nürnberg Beÿ / Paulus Fürsten Kunsthandl.
Nuremberg, 1660 ca.
Einsiedeln, Stiftung Bibliothek Werner Oechslin

345l T
Johann Wilhelm
Johann Wilhelms / Architectvra Civilis / das ist: / Beschreib oder Vorreiss / ung der fürnembsten Fachwerck, / nemlich, hoher Helmen, Creutz- / tacher, Wiederkehrungen, Wel- / scher Hauben, so dann Keltern, / Pressen, Schnecken, oder Win- / delstiegen, und dergleichen. / Mit Röm: Kaÿss: Maÿtt: Freÿheit auf / Sechs Iahr lanng nit nach zu trucken. / Bisshero noch niemahln im / Truck gesehen. / Zum Drittenmal auffgelegt, und mit vielen Kupffern / geziehret vermehret und verbessert / Franckfurt am Maÿn / Beÿloh: Martin Vorssen in / verlegung des Autoris. / 1662.
Frankfurt, 1662
Einsiedeln, Stiftung Bibliothek Werner Oechslin
The volume begins with the description of wooden models. WOe

4. The Vitruvian and French doctrines

345m T
François Blondel
COURS / D'ARCHITECTURE / EINSEGNE' DANS L'A- / CADEMIE ROYALE / D'ARCHITECTURE / PREMIERE PARTIE. / OV SONT EXPLIQVEZ LES TERMES. / L'origine & les Principes d'Architecture, & les prati- / ques de cinq Ordres suivant la doctrine de Vitruve & / de ses principaux Sectateurs, & suivant celle des trois / plus habiles Architectes qui ayent écrit entre les Mo- / dernes, qui sont Vignole, Palladio & Scamozzi. / DEDIE' AV ROY. / *PAR M. FRANÇOIS BLONDEL DE L'ACADEMIE*

ROYALE / des Sciences, Conseiller Lecteur & Professeur du Roy en Mathematique, Pro- / fesseur & Directeur de l'Academie Royale d'Architecture, Mareschal de Camp / aux Armées du Roy, et Maistre de Mathematique de Monseigneur la / Dauphin. / A PARIS, / De l'Imprimerie de LAMBERT ROULLAND en la maison d'Antoine Vitré, ruë du Foin. / *Se vend,* / Chez PIERRE AUBOIN & FRANÇOIS CLOUZIER, prés l'Hôtel de Monseigneur / le Premier President, Court du Palais, à la Fleur de Lis. / Et chez les mesmes sur le Quay des Grands Augustins, à la Fleur de Lis d'OR. / M. DC. LXXV. / *AVEC PRIVILEGE DV ROY.*
Paris, 1675
Einsiedeln, Stiftung Bibliothek Werner Oechslin

5. The encyclopedic approach: architecture as a science

345n T
Johann-Heinrich Alsted
CVRSVS PHILOSOPHICI / ENCYCLOPÆDIA / LIBRIS. / *COMPLECTENS* / Universæ Philosophiæ methodum, serie præce- / ptorum, regularum & commenta- / riorum perpetuâ: / *Insertis Compendiis, Lemmatibus, Controversiis, Tabulis, Florilegiis, Figuris, Lexicis, Locis communibus & Indicibus: ita ut hoc / Volumen possit esse instar Bibliothecæ philosophicæ:* / Adornata / *OPERA AC STVDIO* / JOHANNIS-HENRICI ALSTEDII / Herbornæ Nassoviorum / TYPIS CHRISTOPHORI CORVINI. / Anno M D C XX.
Nassau, 1620
Einsiedeln, Stiftung Bibliothek Werner Oechslin

345o T
Johann Christoph Sturm
JOH. CHRISTOPH STURMII, / Philos. Natur. & Mathem. P.P. / MATHESIS / COMPENDIARIA / sive / TYROCINIA / MATHEMATICA / TABULIS / Matheseos Generalis / Architecturæ Militaris VI / Arithmeticis IV Architecturæ Civilis VI / Algebraicis III Chronologicis III / Geometricis III Staticâ sive Mechanicâ I / Trigonometricâ I Horologiographicâ I / Opticis III Chiromantica I / *comprehensa* / & Figuris æri incisis illustrata. / In tyronum usum pro Collegiis privatis / *adornata* / nunc quarta vice, correctior / *edita.* / *ALTDORFFI* / *Noricorum* / Typis HENRICI MEYERI / Universit. Typographi. / A. M D CCIII.
Altdorf, 1703
Einsiedeln, Stiftung Bibliothek Werner Oechslin
Introduction to mathematics in the form of a compedium. WOe

345p T
Nikolaus Goldmann
NICOLAI GOLDMANNS / Vollständige Anweisung / Zu der / CIVIL-Bau-Kunst / In welcher / Nicht nur die fünf Ordnungen / ... / Als auch / gantze Gebäude aus gewissen und leichten Reguln erfinden / und in guten Rissen vorstellen soll / Alles aus den besten Überresten des Alterthums / ... / Mit der / Ersten Ausübung der Goldmannischen Bau-Kunst / und dazu gehörigen XX. Rissen / nebst Erfindung der Sechsten und Teutschen Ordnung / vermehret / von / Leonhard Christoph Sturm / Math. Prof. Publ. / ... / Braunschweig / Gedruckt bey Heinrich Kesslern, 1699.
Braunschweig, 1699
Einsiedeln, Stiftung Bibliothek Werner Oechslin
A complete *corpus* of works of "civil architecture." WOe

345q T
Christian Rieger
UNIVERSAE / ARCHITECTURÆ CIVILIS / ELEMENTA / BREVIBUS RECENTIORUM OBSERVATIONIBUS ILLUSTRATA / CONSCRIPTA / A / CHRISTIANO RIEGER / SOC. IESU / VINDOBONÆ, PRAGÆ, & TRIESTÆ, / TYPIS IOANNIS THOMAE TRATTNER, CAES. REG. MAIEST. / AULAE TYPOGRAPHI ET BIBLIOPOLAE, / MDCCLVI.
Vienna, Prague, Trieste, 1756
Einsiedeln, Stiftung Bibliothek Werner Oechslin

6. The variety of architectural *exempla*

345r T
Francis Bacon
FRANCISCI / BACONI, / BARONIS DE / VERULAMIO, VICE-COMITIS / SANCTI ALBANI, OPERUM / MORALIUM ET CIVILIUM I Tomus. / Qui continet *Historiam Regni Henrici Septimi, Regis Angliæ. Sermones Fideles, sive Interiora Rerum. / Tractatum de Sapientiâ Veterum. / Dialogum de Bello Sacro. / Er Novam Atlantidem.* / Ad ipso Honoratissimo Auctore, præterquam / in paucis, Latinitate donatus. / Curâ & Fide *Guilielmi Rawley,* Sacræ Theologiæ Doctoris, olim / Dominationi suæ, nunc Serenissimæ Majestati Regiæ, à Sacris. / In hoc volumine, iterum excusi, includuntur *Tractatus de Augmentis Scientiarum. / Historia Ventorum. / Historia Vitæ & Mortis, / Cum Privilegio.* / LONDINI. / Excusum typis Edwardi Griffini; Prostant ad Insignia Regia in Cœ- / meterio D. PAULI, apud RICHARDUM WHITAKERUM, 1638.
London, 1638
Einsiedeln, Stiftung Bibliothek Werner Oechslin

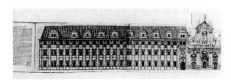

345s T
Martin Volckman
GLORIA / UNIVERSITATIS / CAROLO-FERDINANDEÆ / PRAGENSIS / TrIgInta TrIbvs enCoMIIs OrbI / DIVVLgata: / *FAVENTIBUS AUSPICIJS,* / AUGUSTISSIMI, & POTENTISSIMI / ROMANORUM IMPERATORIS / LEOPOLDI / HONORI *REVERENDISSIMI AC CELSISSIMI* / PRINCIPIS / AMPLISSIMI PERPETUIQUE / CANCELLARII, / RECTORIS MAGNIFICI, / SPECTABILIUM DECANORUM, / CONSULTISSIMORUM SENIORUM, / EXIMIORUM, CLARISSIMORUM, EXCELLENTISSIMORUM, DOCTORISSIMORUM, / PROFESSORUM [verso] // NEC NON / TOTIVS MAGISTRATVS / ACADEMICI / DICATA / à / *NOBILI AC DOCTISSIMO* / *DOMINO* / MARTINO XAVERIO / VOLCKMAN, / AA.LL. & PHIL: MAGISTRO, / DUM / *PRÆSIDE* / *REVEDENDO AC DOCTISSIMO* / P. GEORGIO / WEIS / è SOC. JESU AA.LL. & PHIL. DOCT. / EJUSDEMQUE PROFESSORE ORDINA- / RIO, PUBLICO; & / SENIORE. / THESES PHILOSOPHICAS / Tueretur / IN AULA CAROLINA / *Mense Septembri die.*
Colophon: "Pragae, Typis Universitatis Carolo-Ferdinandeæ in Collegio Societatis Jesu, ad S. Clementem."
Einsiedeln, Stiftung Bibliothek Werner Oechslin

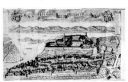

345 T
Anselm Schramb
CHRONICON / MELLICENSE, / *SEU* / ANNALES / MONASTERII MELLICENSIS, / *UTRUMQUE STATUM* / Imprimis Austriæ cum successione / Principum, Regimine, Prærogativis, Elogiis, / & Rebus memorabilibus à prima mundi ætate usque ad / novissimam anni nimirum sæcularis septigentesimi / supra Millesimum, / Deinde Exempti Monasterii Mellicensis, / Ordinis S. Benedicti inferioris Austriæ ex vetustissimis / Monumentis ibidem præcipuè M. S. codicibus / Bibliothecæ / COMPLECTENS / *AUTHORE* / P. ANSELMO SCHRAMB / Ejusdem Ordinis & Monasterii Professo, / & bibliothecario. / *VIENNÆ AUSTRIÆ* / Typis Joannis Georgii Schlegel, Universitatis / Typographi, Anno 1702.
Vienna, 1702
Einsiedeln, Stiftung Bibliothek Werner Oechslin

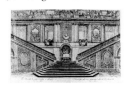

345u T
GRAND ESCALIER / DU / CHATEAU DE VERSAILLES / DIT / *Escalier des* / *Ambassadeurs* / ORDONNÉ ET PEINT / *Par Charles Le Brun Ecuyer premier Peintre du Roy* / CONSACRÉ A LA MEMOIRE / DE / LOUIS LE GRAND. / *SE VEND A PARIS* / *Chez Louis Surugue a l'entrée de la rue des Noyers vis-a-vis S.ʲ Yves.* / *AVEC PRIVILEGE DU ROY.*

Paris, 1726
Einsiedeln, Stiftung Bibliothek Werner Oechslin
The engravings are by Louis Surugue. The text by L. C. Le Fèvre is dedicated to Charles Le Brun's stairway at Versailles. WOe

345v T
THE / ACTS / OF / PARLIAMENT / Relating to the Building / *Fifty New Churches* / In and about / The Cities of LONDON / and WESTMINSTER. / AND / For / making PROVISION for the / MINISTERS thereof. / AS ALSO / His MAJESTY's Letters Patent, Appoint- / ing COMMISSIONERS for the Purposes / aforesaid. / *LONDON,* Printed by *John Baskett,* Printer to the King's most / Excellent Majesty, And by the Assigns of *Thomas Nexcomb,* and / *Henry Hills,* deceas'd. 1721.
London, 1721
Einsiedeln, Stiftung Bibliothek Werner Oechslin

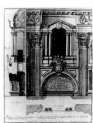

345w T
Domenico De Rossi
STUDIO / D'ARCHITETTURA CIVILE / *sopra gli Ornamenti di Porte e Finestre* / *tratti da alcune Fabbriche insigni di Roma* / *con le Misure Piante Modini, e Profili* / OPERA / DE PIU CELEBRI ARCHITETTI DE NOSTRI TEMPI / PUBLICATA / SOTTO GL'AUSPICII DELLA S.ᵀᴬ DI N.S. / PAPA CLEMENTE XI. / DA / *Domenico de Rossi erede di Gio: Giac: de Rossi* / *in Roma alla Pace* / con Privil. Del Sommo Pont. e licenza de Sup. / *L'ANNO M.D.CCII.* / *PARTE PRIMA.*
Einsiedeln, Stiftung Bibliothek Werner Oechslin

345x T
Jean-François Félibien
DESCRIPTION / DE / L'EGLISE ROYALE / DES / INVALIDES. / A PARIS. / MDCCVI.
Paris, 1706
Einsiedeln, Stiftung Bibliothek Werner Oechslin

7. Ephemeral architecture and the triumph of the book

345y T
Jacques-François Blondel
FÊTES PUBLIQUES / DONNÉES / PAR / LA VILLE DE PARIS, / a l'occasion du Mariage / DE MONSEIGNEUR / LE DAUPHIN. / *Les 23. et 26. Fevrier* M. DCC. XLV.

FÊTE PUBLIQUE / *DONNÉE* / PAR / *LA VILLE DE PARIS* / a l'occasion du Mariage / *DE MONSEIGNEUR* / LE DAUPHIN / *Le 13. Fevrier M.DCC.XLVII.*
Paris, 1747
Einsiedeln, Stiftung Bibliothek Werner Oechslin

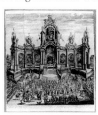

345z T
RELATION / DE L'INAUGURATION SOLEMNELLE / DE SA SACRÉE MAJESTÉ / MARIE THERESE / REINBE DE HONGRIE / ET DE BOHEME; / ARCHIDUCHESSE D'AUTRICHE & c. / *COMME* / COMTESSE DE FLANDRES, / Célébrée à Gand, Ville Capitale de la / Province, le XXVII. Avril 1744. / A GAND, / Chez la VEUVE PIERRE DE GOESIN, dans la Veltstraete, / aux quatre Evangelistes. 1744.
Gand, 1744
Einsiedeln, Stiftung Bibliothek Werner Oechslin

346 T
Carlo Fontana (1638-1714)
Caricature of Borromini
Rome, Private Collection
Watercolored drawing
28 x 19 cm (without frame)
53 x 41 cm (with frame)

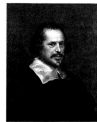

347 T
Pietro da Cortona (1597–1669)
Self-portrait
Florence, Gallerie degli Uffizi, Inv. no. 1713
Oil on canvas; 72.5 x 58 cm

348 T
Andrea Pozzo
Self-portrait
Florence, Gallerie degli Uffizi
Oil on canvas; 167 x 122.5 cm

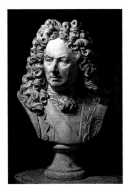

352 T
Antoine Coysevox
Bust of Sébastien Le Prestre de Vauban
Paris, Musée du Louvre, Département des
Sculptures, Inv. no. RF 1839
Gypsum; 64.7 x 39.5 x 25.5 cm

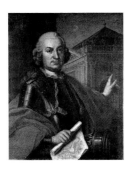

349 T
Anonymous
Portrait of Balthasar Neumann, 1727
Würzburg, Mainfränkisches Museum
Oil on canvas

350 T
Balthasar Neumann
Tools for architectural measurements, 1713
Würzburg, Mainfränkisches Museum
Brass

351 T
Johann Heinrich Burchart
Architectural tools, 1686
Kassel, Staatliche Museen, Museum für Astronomie und Technikgeschichte, Inv. no. G 24

Ephemeral architecture

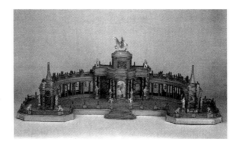

353 T–MAR
Juffrow Duijvenstein-Valckenaar after a drawing by Pieter de Swart
Model of a Temple of Peace for a Fireworks
Display Held on the Occasion of the Signing of
the Treaty of Aachen in the Royal Pond at The
Hague, 1749
The Hague, Historisch Museum
Wood, paper, gypsum; 93 x 63 cm, height 41
cm; scale about 1:50
EXHIBITIONS: Utrecht, Centraal Museum Utrecht,
1983; 's Hertogenbosch, Noordbrabants Museum, 1987
BIBLIOGRAPHY: Van Hasselt 1969: 26–28; Gruber 1972; Snoep 1983: 105–106; Dumas 1991:
152–63; Spagnolo-Stiff 1996; Schmidt 1997:
60–75

This model is a typical product of eighteenth-century home industry and at the same time a declaration of loyalty to the stadtholder Prince William IV. It was made by the papier-mâché artist Mrs Duyvenstein-Valckenaar as a copy of the temporary fireworks pavilion which was erected in June 1749 in the Royal Pond, opposite the government buildings in the Binnenhof in The Hague. The fireworks display, which was set off in this pavilion on 13 June, was to commemorate the signing on 18 October 1748 of the Treaty of Aachen, which had put an end to the War of the Austrian Succession. The war had made a significant contribution to the political revolution in the Republic in 1747–48 and the elevation of William IV to the rank of hereditary general stadtholder and commander-in-chief of the armed forces.
Although the Treaty effectively marked the end of the Republic as a great European power, the fireworks pavilion was the largest that had ever been built in the Netherlands. The designs for the architectural form of the Temple of Peace were supplied by William IV's royal architect Pieter de Swart (1709–73), who had just come back from a two-and-a-half year stay at the famous Ecole des Arts directed by Jacques-François Blondel (1709–73). There, through Blondel and his uncle Jean-François Blondel, he had become closely involved in ceremonial architecture, as is clear from, among other things, the drawings which he made for the festive decorations for the Porte Saint-Martin on the occasion of Louis XV's entry on 7 September 1745 (Gruber 1972: 186; Spagnolo-Stiff 1996: 117–18). This fireworks pavilion was an attempt to celebrate, in a form that was completely new for the Republic, the beginning of a new period

of wealth and prosperity after the horrors of war, a new age presided over by William IV.
The form of the pavilion follows in detail the model of French ceremonial architecture of the 1740s, mingled with some traditional Dutch elements. The Temple of Peace was of enormous size (100 x 24 m, and 31 m high), and was built of wood, straw, stucco for the statues, with chassinetten, symbolic images painted on transparent material, in the arches. The central section is a triumphal arch with a raised platform which formed the base for a seated statue of Fame, a detail which is changed in the model, where we recognize William IV mounted on horseback in triumph, with the inscription beneath: "Templi Pacis Effigiem, A se expressam ad exemplar, Hagae Publicitus Extractum Ad MDCCXLIX Pacis Moderatori, Sereniss. Guilhelmo IV Dedicat M. Duyvenstein-Valckenari vidua". On each side of the arch there is a low, forward curving colonnade of pairs of Ionic columns, adorned with festoons of flowers, vases, and putti, and ending in octagonal rotundas topped with tapering spires. FS

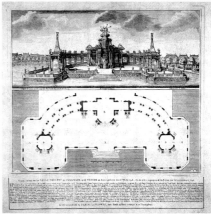

354 T
Iven Besoet
Front View and Plan of the Fireworks Pavilion,
The Hague, 1749
The Hague, Gemeentearchief, Historisch Topographische Bibliotheck
43.1 x 55.5 cm

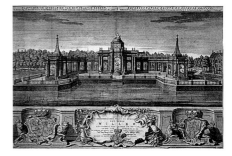

355 T
Jan Caspar Philips
View of the Fireworks Pavilion, The Hague
1749
The Hague, Gemeentearchief, Historisch Topographische Bibliotheck
58.1 x 88.6 cm

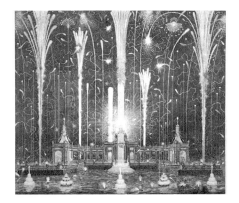

356 T
Jan Caspar Philips
View of the Fireworks Pavilion in the Hague, during the Fireworks Display held on 13 June 1749
The Hague, Gemeentearchief, Historisch Topographische Bibliotheck
38.2 x 44.8 cm

357 T
Iven Besoet
Fireworks Pavilion, The Hague, during the Fireworks Display on 13 June 1749
The Hague, Gemeentearchief, Historisch Topographische Bibliotheck
49.7 x 71.2 cm
BIBLIOGRAPHY: Souchal 1967; Dumas 1991: 154, fig. 1; 156, figs. 5, 6; 157, fig. 7

Prints of fireworks displays were often very precise and served not only as a record of the occasion but also as study material for architects. The publication of the two print series of this fireworks pavilion was connected with a dispute over the authorship of the design, which throws more light on the status of the architectural designer in the second half of the eighteenth century. On 11 June 1749, the first print, engraved by Iven Besoet after a design by Pieter de Swart, was published by Daniël Langeweg. The pavilion shown in it differs from the one that was actually built, in that the triumphal arch is not crowned with the personification of Fame but with a group of statues. However, in a newspaper article published the following day, and in a pair of prints engraved by Jan Caspar Philips and published shortly afterward by Anthonie de Groot, the artillery general Von Creuznach, who was in charge of the organization of the fireworks display, claimed that he himself was the designer. Not long after the fireworks display, two more prints of the fireworks pavilion were published by Langeweg. One was small and based on the

first edition of the print by Besoet; but it now correctly showed the seated figure of Fame and was provided with an explanation in both Dutch and French. The other was a new print in larger format of the fireworks display actually taking place. On both prints Pieter de Swart was again named as designer and draftsman. Other two prints by Langeweg followed, showing the back of the pavilion and the fireworks display, and both also bearing De Swart's signature. At the time when Creuznach made his accusations against Pieter de Swart, the latter was still an unknown designer and building supervisor. Despite his rank of royal architect, he was not in a position to assert his claim to the design. It would have seemed improper for a little-known architect to contradict an artillery general. For a high officer who was primarily responsible for the fireworks, the staff and the financial administration to lay claim not only to the organization but to the creation of the scenery, quite ignoring the other people involved was not an unusual occurrence (Souchal 1967: 391ff.). FS

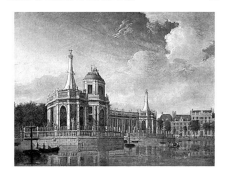

358 T
Jan ten Compe
View of the Fireworks Pavilion, The Hague 1749
The Hague, Haags Gemeentemuseum
Oil on canvas; 46.7 x 63.8 cm

359 T
H. J. Beguin
Medal of the Fireworks Pavilion, The Hague 1749
Leyden, Rijksmuseum Het Koninklijk Penningkabsuet
Silver; 6.6 cm
BIBLIOGRAPHY: Van Hasselt 1969; Oechslin and Buschow 1984; Dumas 1991: 152, 160, fig. 10; Spagnolo-Stiff 1996; Schmidst 1997

Like all ceremonial architecture, this building was only vouchsafed a short existence. After the end of the fireworks display the Council of State offered the pavilion to the stadtholder, but he declined the offer and suggested instead that it be sold for the benefit of the country. The great fire-

works pavilion on the Royal Pond is immortalized on commemorative coins, various series of prints, and a painting. The painting by Jan ten Compe shows the fireworks pavilion on the eve of the display. Behind the attic of the left-hand rotunda we see some figures inspecting the building or engaged in making the final preparations. Probably it represents the moment when the stadtholder William IV, one of the figures at the top of the steps in front of the Temple of Peace, visits the building. The Royal Pond, situated next to the Binnenhof complex, the seat of the government of the Republic of the United Provinces, had already been the scene of offical fireworks displays on several previous occasions (Van Hasselt 1969). In 1702 and 1713 the States General of Holland had erected fireworks pavilions to designs by Daniel Marot and Jacob Roman. These still had the form of scaffolding decked out with ornaments and symbolic decorations. The allegorical content had precedence over the architecture. Even an earlier fireworks pavilion designed by Pieter de Swart (Breda 1737) was still characterized by a conventional array of Dutch fireworks elements, quite separate from the ingenious structure (Schmidt 1997: 10–25). De Swart's studies in the years 1745–47 at Blondel's Ecole des Arts changed everything. This can be clearly seen from the fireworks pavilion of 1749. After his period of study under Blondel, Pieter de Swart returned to the Republic a complete designer. His fireworks pavilion broke with Dutch tradition in size, form, and underlying meaning. The ceremonial decoration of the earlier scaffoldings, which were usually built and adorned with perishable materials, as a frame for symbols and texts, gave way to a form which was associated with monumental architecture that was built for eternity. Pieter de Swart's French training was thus indirectly responsible for introducing classicism on the French model into Dutch ceremonial architecture. FS

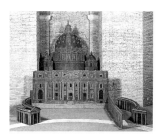

360 T–M
Model for Festival Lighting at St. Peter's
Rome, Vatican, Rev. Fabbrica di San Pietro
Painted wood; 320 x 282 x 500 cm
BIBLIOGRAPHY: Schiavo 1975: 486–91; *L'Arte degli Anni Santi* 1984: 454–56, no. XI (P. L. Silvan)

The festivals of the Luminaria at St. Peter's and the Girandola at Castel Sant'Angelo were celebrated every year on the eve of the feast of Saints Peter and Paul (29 June) and on various other occasions, for example in holy years. Vanvitelli was responsible for them from 1744 onward, and reformed them, increasing their magnificence, for the jubilee of 1750. This model was probably made during that period. The attribution to Vanvitelli is reinforced by the similarity

of the model to those of Caserta; it shows the same manner of painting the individual parts in tempera with the "real" colors of the stone.

The Luminaria was a very solemn event, well known to foreign visitors (it was frequently described in highly enthusiastic terms, for example by F. J. L. Meyer and by Karl Philip Moritz towards the end of the eighteenth century), which required a high degree of technical organization, because it involved the almost simultaneous lighting of 290 lanterns and 653 padella lamps by 251 men; and Vanvitelli was very proud of it. JG

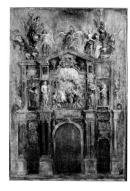

361 T
Peter Paul Rubens (1577–1640)
The Rear Face of the Arch of Ferdinand
St. Petersburg, State Hermitage Museum
Oil on canvas transferred from panel; 104 x 72.5 cm
PROVENANCE: P. H. Lankrink; Robert Walpole, first Earl of Oxford; Catherine II, Empress of Russia, acquired between 1774 and 1783
BIBLIOGRAPHY: Gevartius, 99; *Aedes Walpolianae* 1752: 70; Rooses, III: 313; Vertue, *Notebook*: 56; Martin: 156, no. 40a; Held 1980: 236–38, no. 160, with earlier relevant literature

Rubens' designs for the decorations for the triumphal entry of the Cardinal-Infante Ferdinand of Spain into Antwerp on 17 April 1635, represent the apogee of an old Netherlandish tradition. According to custom, whenever a ruler or new governor was officially welcomed into the city for first time, the streets of Antwerp were decorated with temporary arches, porticoes, false façades, and floats. Ad hoc and made of more than usually fugitive material, most of these decorations have inevitably disappeared. If we want to know how they looked we have to rely either on the commemorative books made for such occasions, or on the preliminary designs for them. In the case of Rubens' designs for the *Pompa Introitus Ferdinandi* of 1635 we fortunately have both. The regent of the Netherlands, Archduchess Isabella, had died at the end of 1633. Philip IV of Spain then chose his younger brother, Ferdinand, to replace his aunt, a personal friend and patron of Rubens. At the Battle of Nördlingen, Ferdinand had just gained one of the most important early victories over Protestant forces in the Thirty Years' War. Soon he made his triumphal entry into Brussels; and the City Fathers of Antwerp set about commissioning the designs for their own entry. The entry was planned for January 1635. In collaboration with

his learned friends Caspar Gevartius, town clerk of Antwerp, and Nicolas Rockox, ex-burgomaster, Rubens speedily prepared his designs for four "stages" (actually house fronts), and the backs and fronts of four triumphal arches. They were spectacular affairs. Both Gevartius and Rockox helped Rubens in devising their dense iconography of War, Peace, Prosperity and Abundance. The present model was painted in November 1634 for the reverse of the arch of Ferdinand. Though related in a general way to the arch of the English merchants for the triumphal entry of Philip II in 1549, Rubens' structure was both more modern and more innovative. Like several of the other arches, it consisted of a grand two-storey structure, with an elaborate broken pediment. It conveyed as much the effect of a city gate as of a triumphal arch. In it Rubens revealed his absorption of the work of Carlo Maderno, most notably of the façade of Santa Susanna in Rome. The central aedicule with a main arch below and an elaborately framed painted scene in the attic above, is flanked by two lesser gateways below, and open spaces for the statues above them. Rubens provides clear indications of the colors he intended for the architecture of this temporary structure, as well as a number of decorative and architectural alternatives. Some of the iconography is clear enough, but for most of the detail we have to turn to the sumptuous volume authored by Gevartius (and engraved by Rubens' pupil Theodoor van Thulden) to commemorate the occasion. In the main scene over the central arch, Ferdinand rides in triumph after the Battle of Nördlingen. A figure of Victory crowns him, while another Victory, paired with a figure representing Hope, flies overhead. Bound and cowed prisoners walk beside the chariot. The huge canvas painted by Jan and Gaspar van den Hoecke after Rubens' design still survives in the Uffizi in Florence. Above the central arch below is a cartouche intended to contain one of the many laudatory inscriptions that covered the face of the whole structure. Wreathed medallion heads representing Nobility and Youth – after all, Ferdinand was only twenty-six at the time of the victory of Nördlingen – were placed above the side arches. Just as in ancient triumphal arches, a rearing winged horse appeared at the very apex of the whole structure. It carried a personification of the laurel-leafed Morning Star (for some reason, this has been painted out in the modello), bearing a scroll proclaiming "Io Triumphe." On either side of this uppermost register come the trophies of War, each with elements derived from antique iconography, and each with bound prisoners crouching below them. They are attended by magnificent figures of Victory and Fame (on the reverse of the arch the equally traditional figures of the Dioscuri occupied this position). The more one looks, the more one finds; but every element in the arch – even the lions in the angles of the pediment above the main scene – testify to the supposed courage in battle of the newly-appointed governor of the Netherlands. It might all have seemed a little too much, and all too pedantic, had Rubens not invented for this arch one of the most splendid designs for a piece of temporary architecture ever seen in the Netherlands. DF

370 M
Unknown Draftsman
Elevation for a Rotunda
Montreal, Collection Centre Canadien d'Architecture – Canadian Centre for Architecture, DR 1970: 0005
Pen and brown ink with gray wash, some pencil lines visible, on laid paper with pen and ink border; 17.2 x 17.9 cm
INSCRIPTIONS: (by the draftsman?) in pen and brown ink: "Juvara" (followed by an illegible inscription "(Sicil)"?
BIBLIOGRAPHY: Millon 1974: part I; Gardin Berengo 1996: 58 and illustration

This drawing for a circular pavilion with fountains, has been attributed to the famous architect Juvarra, most likely on the basis of the inscription, which, however, could have been added later. Although the motif of the open domed rotunda appears in extant architectural fantasies by Juvarra (Millon, 1974: 14–15, 75, 121, 148, 149), the drawing exhibited here is rendered in a mechanical manner that seems unrelated to Juvarra's more spontaneous draftsmanship. The drawing exhibited here is a simple composition, rendering a circular domed, open structure on a raised base. Three flights of steps are visible; presumably there is a fourth flight on the far side. Between the steps on the side facing the viewer are two fountains. The stairs and the pinnacle of the dome are decorated with standing figure sculpture. Horizontal pencil lines are visible indicating the ruled precision of the base, steps, levels of the cornice and sculpture on the dome. The rotunda is articulated by Doric columns. The author of this design has rendered an architectural form frequently found in gardens of the 18th century or, in a more monumental form, as a focal point in an urban setting. SCS

362 M
Pierre Dulin (1669–1748)
Louvois Presents Louis XIV with the Plans for the Hôtel des Invalides, 1716–24
Versailles, Musée National des Châteaux de Versailles et de Trianon, Vmb 14188
Tapestry of vertical warp yarn; 505 x 665 cm
Grande série de l'histoire de France
BIBLIOGRAPHY: Fenaille: I, 101, ill. on p. 120; *Les Invalides* 1874: 46

This tapestry was made in the La Tour workshop, after a painting (Paris, Musée de l'Armée) by Pierre Dulin, ordinary court painter, who spe-

cialized in history paintings and was a member of the Academy. The creation of the Hospice Royal des Invalides – after Versailles itself, the largest construction project undertaken under Louis XIV – was an important episode in the reign of the Sun King. Here Dulin mixed allegory, mythology and contemporary history in order to better exalt the personage of the king. He had recourse to a rich iconography to which Rubens had held the key at the beginning of the century in his *Vie de Marie de Médicis* painted for the Palais du Luxembourg (Paris, Louvre). Louis XIV is presented as a sovereign concerned at once with the well-being of his people and the embellishment of his capital. The composition in frieze shows the king surrounded by courtiers and soldiers, in the process of examining the plans for the Invalides presented by Louvois. A winged Renown flies over the royal group, while on the right, a Glory guides old soldiers toward their sovereign.

In the background, the building's main façade can be seen: 195 meters long and marked in its center by a triumphal entrance surmounted by an equestrian bas-relief of the sovereign. Dulin anticipated the construction of the church whose dome behind the hospice was only to be constructed at a later date. PL

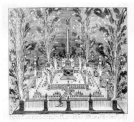

367 M
Anonymous
Fireworks Display on 19 October in Place au Vendredy, in *Relation de l'inauguration solemnelle de sa sacrée majestée impériale et catholique, Charles VI ...*, 1717–19
Etching on laid paper
48.7 x 52.8 cm (block); 53.5 x 61.1 cm (sheet)
Montreal, Collection Centre Canadien d'Architecture – Canadian Center for Architecture, DR 1982: 0240

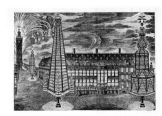

368 M
Jacobus Harrewijn (1662 – after 1732)
Lighting of the Hôtel de Ville with Fireworks from the bell tower, in *Relation de l'inauguration solemnelle ...*, 1717–19
Etching on laid paper
46.6 x 68.6 cm (block); 54.2 x 74.6 cm (sheet)
Montreal, Collection Centre Canadien d'Architecture – Canadian Center for Architecture, DR 1982: 0244

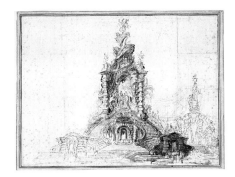

369 M
Juste-Aurèle Meissonnier (1695–1750)
a) Perspective of a Project for Fireworks Display (*recto*)
b) Alternate Scheme for the Central Portion of the Design on the Recto (*verso*)
1729–39
Montreal, Collection Centre Canadien d'Architecture – Canadian Centre for Architecture, DR 1986: 0738
Pen and brown ink with watercolor and white gouache over black chalk on five pieces of laid paper within a paper frame; 36.0 x 49.0 cm (drawing); 41.5 x 57.5 cm (frame)
INSCRIPTIONS: "Meissonnier" (lower left corner, in graphite)

The most brilliant silversmith of his generation, Juste-Aurèle Meissonnier became "dessinateur de la Chambre et du Cabinet du Roi" in December 1726, succeeding Jean II Bérain. A member of the "Administration de l'Argenterie, Menus, Plaisirs et Affaires de la Chambre du Roi" (better known as the "Menus-Plaisirs"), the *dessinateur* was responsible for all ephemeral decorations at court, those required for balls, spectacles, and ceremonies which included numerous fireworks. On 5 December 1729, to celebrate the birth of the Dauphin, son of Louis XV and Marie Leszczynska, Meissonnier executed fireworks in the forecourt at Versailles. Painted on 27 different frames disposed to form a perspective in the manner of a stage set, the illuminated scene represented the Palace of Jupiter. From this painted Olympus Minerva descended to Earth to announce the birth of the Dauphin to a personification of France. The design was etched by Gabriel Huquier as "Décoration du Feu d'artifice tiré à Versailles en 1729, a l'occasion de la Naissance de Monseign.ʳ le Dauphin, éxécuté sur les desseins de Juste Aurelle Meissonnier, Dessinateur de la Chambre et Cabinet du Roi." According to contemporary accounts, the event was disastrous. Writing after the death of the artist, Pierre-Jean Mariette explains that this failure ended Meissonnier's career as designer of such spectacles (Mariette 1750: 418). Meissonnier's printed *Œuvre* contains several unrealized designs for fireworks. A scheme for the birth of the Dauphin, commissioned by the Spanish ambassadors and held in Paris in January 1730, and one for the marriage of Marie-Louise-Elisabeth de France ("Madame Première," sister of the Dauphin) to Philip of Spain, which took place in Paris in August 1739, were lost to Giovanni Niccolò

Servandoni. One other project for fireworks is featured in the *Œuvre*. Meissonnier's engraved designs for the birth of the Dauphin and for the marriage of Madame Première present a similar structure. A pavilion, roughly square in plan, its concave faces terminated by twin columns, is supported by a grand horseshoe-shaped staircase.

We find the same essential features in the drawing shown here. It might thus be a preliminary sketch for either or both of these prints. A drawing preserved in the Département des Estampes et de la Photographie at the Bibliothèque Nationale in Paris (B. 11., Rés. Fᵗ 4, pl. 43), by or after Meissonnier, resembles this drawing even more closely. A pavilion, crowned with the same spiral, is framed by a grand colonnade in a rustic order. At its base, a flotilla of boats bear lanterns. Only the iconography varies between the two designs. The two generals in Roman armor shaking hands, commemorating the reconciliation of two nations, are replaced by the more generic concert of Apollo and the Muses. JFB

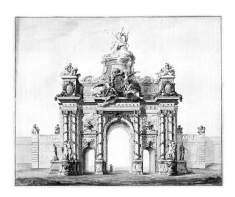

372 M
Gabriel Jacques de Saint-Aubin (1724-1780), after Jacques-Françoise Blondel
Project for the Decoration of the Porte Saint-Martin in Paris
1745
Pen, brown link, wash and gouache on laid paper; 27.8 x 35.2 cm
Montreal, Collection Centre Canadien d'Architecture-Canadian Center for Architecture, DR 1970: 0011

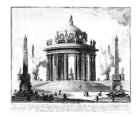

371 M
Louis-Joseph Le Lorrain (1715–59)
Design for the "prima macchina" of the Festival of the Chinea of 1747: The Temple of Venus Genetrix
Montreal, Collectíon Centre Canadien d'Architecture – Canadian Centre for Architecture, DR1988:0437:012
Etching with watercolor and white gouache on laid paper

Plate mark 39.6 x 46.9 cm; sheet: 45.7 x 61.4 cm (sheet of irregular shape)
INSCRIPTIONS: "J. L. Le Lorrain. irv. et fecit / 1747. Rome" (lower right corner of the image); "VENUS GENITRIX / Prospettiva della prima Macchina rappresentante il Tempio di Venere Genitrice che dall'antica gentilità si osserva anch'oggi dà suoi vestigij, esser vicino al Seno del Mare, che forma il rinomato por= / to di Baia al Nome della Dea creduta Tutelare de Parti; si viene però à rinovarne al presente l'Idea, applaudendo al felicissimo Parto della REGINA delle due Sicilie per aver dato alla luce un REALE INFANTE Primogenito / Vago, e Robusto, a sostegno della generosa Regia Prosapia sì come con ardentissimi Voti gl'hanno implorato dal Cielo, e sempre più fervidamente adesso gl'implorano una perenne preservaz.e li fedelissimi suoi Suddi-ti. / Incendiata tal Macchina da copiosi fuochi d'artificio d'ordine di Sua Ecc.za il Sig.r Pnpe. DON FABRIZIO COLONNA, Gran Contestabile del Regno di Napoli, Grande di Spagna di prima Classe, Gentiluomo della Real Cam.a | Cavaliere degl'Insigni Ordini di S. Gennaro, e del Toson d'Oro, come Ambasc.re estradinario di SUA MAESTÀ IL RE delle due Sicilie di Gerusalemme &c. &c. &c. à dover presentare il Censo, e Chinea la Vigilia de | Gloriosi SS. PIETRO, e PAOLO APOSTOLI à Sua Beatudine PAPA BENEDETTO XIV. l'anno 1747" (under image, etched); "Louis Le Lorrain inv. e inc. in Roma con lic. de Sup." (lower left); "Francesco Scardovelli Cap.o Bomb.e, e Cap.o fuo carcel.o di Cast. S. Ang.o" (lower right margin in pencil): "I / 1747 / II" "1747. (1.)" (*obverse*, upper right corner, in brown ink); "Duplicata" (below, in graphite). JFB

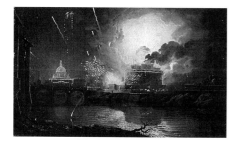

366 T–M
Joseph Wright of Derby
Fireworks Display at Castel Sant'Angelo
1774–75
Birmingham, Birmingham Museums and Art Gallery
Oil on canvas
42.5 x 71.1 cm

Military architecture

Introduction
Simon Pepper

Military exhibits of any period demand a wide canvas. For the Baroque age, the overall extent of the new fortifications, naval arsenals, and the urban improvements often associated with these *grands projets* is often very difficult to appreciate on the ground. The individual is dwarfed by their scale. In the case of the new bastion and rampart fortifications, moreover, an effective military design presented little to the external observer save featureless stone, brick or grassy slopes, and a bewildering maze of ditches. The geometry which fascinated military architects and their patrons only becomes readily apparent from the formal drawings which embellished the pages of the printed treatises on the early modern art of war.

From an early date, therefore, princes and popes, government councils and their committees, all made use of models to explain the local topography and urban context of fortifications. In an age of difficult and dangerous travel, the model represented the least ambiguous means of conveying the information needed to inform important decisions of state. It offered excitement too. Louis XIV of France, the senators of the Venetian Republic, and the Kings of Sweden were only the best known amongst Europe's early modern rulers to possess substantial collections of models which allowed them to travel vicariously along the defended frontiers of their dominions.

The best of these models illustrated the public and private buildings of the towns with extraordinary attention to detail. Frozen in time, they provide a window into the urban history of Europe. And they allow the contemporary observer to understand the scope, the controlling geometry, and the comprehensive vision that was needed to embark upon a scheme such as that for Vauban's fortress-town of Neuf-Brisach.

The collection of *plans en relief* in the upper floors of Les Invalides, and the smaller group displayed in Lille, are amongst the finest urban models to survive anywhere. Those in the Naval Museum in Venice, the Museo San Marco, and the collection of the Museo di Genio in Rome concentrate more on the fortifications and less on urban fabric. The same is true of the models surviving in Stockholm. We are fortunate in being able to present in Turin three examples (Neuf-Brisach, Canea in Crete, and the siegeworks of Ostend) which demonstrate the full range of the model-maker's art and which give a "feel" for the scale of Baroque military architecture.

Models are not so helpful in demonstrating the variety of activity in the arsenals and ports of Baroque Europe. These were by a wide margin the largest of the early industrial enterprises, "little cities" in the words of more than one historian.

When fully mobilised, they employed thousands of workers in the dozens of specialist trades needed to build, maintain, rig, arm and

munition the battle fleets. By our period most maritime powers were committed to specialist military fleets (rather than the dual-function warship and trading vessel which had prevailed until the 16th century). Naval dockyards became as much a symbol of state power as any fortress, and the artistic campaigns to celebrate these installations yielded pictures which were probably more effective than models in revealing the city life of the arsenals.

Documentary art of this kind combines features of city *vedute*, and romantic seascapes, with the concern for the details of shipping characteristic of northern marine art. In the wrong hands, it can be banal; but Vernet's great series of official paintings of French ports rises above these constraints to give us an insight into the "city life" of the arsenal.

Baroque urban improvements often marched hand in hand with military building. The new town of Livorno represented one such initiative, carried out on a scale which was both ambitious and successful, but which seems modest in its purely architectural aspirations when compared with the spectacular waterfront rebuilding of Bordeaux and Messina. Paintings, by editing out discordant features and focussing on the key components of the new schemes, are better than most modern photography in getting to the essence of urban planning. Here the old waterfront defences were dismantled, and replaced with ranges of colonnaded *hôtels* or palazzi.

At Bordeaux the ensemble focussed on the Place Royale, a provincial version of the squares which centralised monarchy had already inspired in Paris. In Messina the new curving waterfront was known as the *teatro marittimo*, which may have referred back to the circular structure at Hadrian's villa, but which certainly captured the theatrical quality of much Baroque design. St Petersburg eventually captured many of these qualities on the Baltic, although Le Blond's great scheme was stillborn before the emigre architect's premature death.

However, Peter the Great's ambitions are perhaps best represented in the little-known and eventually abortive scheme for a new port on the Sea of Azov, at Taganrog, the only trace of which remains to us in the design of the medal struck to reward the naval officer in charge of construction.

Here in low relief can be seen the new breakwaters and Vaubanesque fortifications, and half of a Renaissance ideal city, with its streets radiating outward from the centre of the waterfront into housing areas clustered around the subsidiary piazzette. Peter himself had been involved in the plans for Azov, but nothing is known of the design of this place. Probably, like other Russian towns, it would have been built in timber, with single storey cabins and wood-lined streets.

If the fortifications briefly took this shape, they would have been the most advanced in Russia. It is this aspiration which links Taganrog – on the far frontier of Baroque Europe – with the metropolitan centres of Paris, Rome and Turin.

373 T
Plan of the Fortress of Ostend
Florence, Museo di San Marco
BIBLIOGRAPHY: Parker (for the background) 1977: 234–36; 1972: 247–51; Israel 1982; Motley's 1851, provides a stirring Protestant account while contemporary accounts include Pompeo Giustiniani's *Delle guerre di Fiandra, libri VI*, 1609; Haestens 1615; Henrard 1890, gives much detail

It is not surprising that a model of Ostend should form part of the Venetian Republic's collection. Ostend's defence in one of the longest of all early modern sieges, like most of Venice's colonial defences, relied upon naval support. The San Marco model differs from most others in that it records not only the permanent defences of Ostend, but the temporary siege works constructed by both sides. The dispositions shown here correspond closely with those recorded in Giustiniani's splendid illustrations to *Delle guerre di Fiandra* (1609), and in other pictorial sources such as the portrait of the Archduke Albert (Anon, in the Aldermen's Room, Bruges) who was imperial governor of Flanders when Ostend fell. Here a bird's-eye view of the siege works appears behind the archduke, thus setting a trend for the depiction of sieges in high-art "battle honor" paintings that was to be developed much further in Velázquez's well-known view (painted 1634) of *The Surrender of Breda* (1625). Since the topography of Ostend is very flat and easily shown in plans, it is possible that the model was made as an aid to some form of documentary art. SP

374 T
Model of Venetian Fortress Canea, 1614
Venice, Museo Storico Navale
Wood and gypsum
BIBLIOGRAPHY: Gerola 1905; 1930–31; Preto 1975

The model of Venetian Canea in 1614 is one of sixteen timber and plaster models of the Republic's colonial fortress cities preserved in Venice's Naval Museum. The museum holds one other model of Canea dated 1608. Two more (depicting Orzinuovi and Peschiera, both on the Italian *terrafirma*) are on permanent loan to the Museo del Genio in Rome.
Venice had an established tradition of stone relief sculpture depicting its overseas military monuments which predated the first of the surviving wood and plaster models. The earliest stone relief dates from 1476, and forms part of the monument to the Doge Pietro Mocenigo in the church of Santi Giovanni e Paolo.
Venice can also claim one of the earliest publicly displayed instructional timber models. Basilio della Scuola, who had returned to the Republic's service in 1495 after many years in France, is reported in 1501 to have displayed in Venice a wooden model of a fortress, with the aim of showing "what is being done in France, Italy [...] Germany and elsewhere" (Buisseret 1998: 125). In 1521 the same engineer made a model of the fortifications of Rhodes, which was sent to the pope just before the decisive Turkish attack on the knights' stronghold (Faucherre 1989: 18). These were clearly functional models designed to convey accurate intelligence about distant places.
Crete fell to Venice as part of the Republic's spoils from the Fourth Crusade of 1204. The 1614 model shows the basic outline of the bastioned fortifications which had been built following the visit of Michele Sanmichele to Crete in 1538 during the Third Turkish War. These bastions modernised the fourteenth-century town wall, which in its turn extended the much smaller circular defended area (visible in the center of the model) which had been built in the 1250s when Venice had consolidated its control of the island from Genoa and other rival claimants (Gerola 1905, II: 155). Depiction of the houses and streets, however, does not show the same concern for detail as the later French models in the Musée des plans en relief. Both 1608 and 1614 models omit the vaulted arsenal bays which, as Gerola notes, were built in 1559. The bastions are also different in the two models; those in the 1608 version representing typical mid-sixteenth-century Italian bastions with straight flanks, those of 1614 showing curved "Dutch" flanks. The 1608 model shows circular *cavalieri* (raised platforms) inside the two corner bastions, while only one is shown in the 1614 model. In the second model the western rampart (right) has been straightened and an early (probably late fifteenth century) semi-circular bastion, which is shown on the 1608 model, has been removed. Early seventeenth-century plans show circular *cavalieri* behind each of the three main bastions on the southern walls (top), and confirm that the straightening of the western rampart was carried out at this time.
It is likely that both models were incomplete, or undergoing change at a time when there was likely to have been an active debate in Venice about the refortification of a strategic port which was threatened by rising Ottoman power. Canea would fall to the Turks in 1645 after a two-month siege, after which there was little to be gained by bringing the models up to date. SP

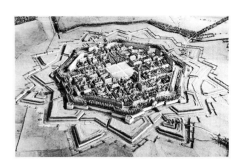

375
Sébastien Le Prestre de Vauban (1633–1707) and collaborators
Model for the Fortress of Neuf-Brisach
BIBLIOGRAFIA: Gerola 1930-1931: 217-21; Englund 1967: 11-52; Giuffrè 1974; Colletta 1981; Coutenceau 1988; *Les Plans en Relief* 1989; Faucherre 1989: 11-54; Buisseret 1998

Neuf Brisach was planned and built as a new fortress city between 1698 and 1720, following adjustments to the frontier required by the Treaty of Ryswyk (1697). France had been required to give up its foothold on the German bank of the Rhine at Brisach, but retained Fort Mortier on the French bank and was determined to support this outpost with a stronghold big enough to accommodate the refugees from old Brisach as well as a substantial garrison. In 1703 old Brisach was reoccupied by France, but by then the fortifications of Neuf-Brisach were already well advanced and the project was continued, albeit at a slower pace. Most of Vauban's numerous earlier projects had involved the modernisation and extension of pre-existing fortifications. Mont-Dauphin (Hautes-Alpes) and Mont-Louis (Pyrénées) were amongst the largest of the few exceptions, but both were built in mountainous terrain. The flat river plain on which Neuf Brisach was sited allowed the great French engineer - by then nearing the end of his active career - an opportunity to plan and build a model fortress, constrained only by the costs of what was to prove an enormously expensive undertaking. For the seven years (1698–1706) required to render the fortress fully defensible, never less than 1,200 to 1,500 laborers worked on the fortifications, shifting some 1,600,000 sq.m. of earth by shovel and wheelbarrow. They were supported by (at different times) six to eighteen battalions of infantry providing local defence and contributing to the haulage of stone from quarries in the foothills of the Vosges, for which purpose 40 kms of canal (2 m deep and 16 m wide) had to be constructed. The original cost estimate of 4 million livres represented half of the annual budget for all of the fortification projects of the kingdom (Coutenceau, 1988). This sum had been greatly exceeded by the time the fortifications, gates (by Jules Hardouin Mansart and Tarade), barracks, magazines, senior officers' quarters, and standardised blocks of housing for the different classes of bourgoisie had been built. The church (by Vauban's collaborator, Tarade) was designed in 1699 but completed only in 1731 (Giuffre 1974: 75). The town and its fortifications have survived largely unscathed by subsequent conflicts, but can be appreciated best of all from the

model which demonstrates both the complexity of the fortifications and outworks (described in the essay), and the planning and architecture of the garrison town.

In this last respect the programme of fortress modelling embarked upon by the French in the late 17th century was different from those of Venice, Sweden and Naples (Gerola 1930–31; Englund 1967; Colletta 1981) where other substantial collections of models were accumulated. Rough models were sometimes hastily prepared in an emergency, such as one of Luxembourg, made between 7 and 28 June 1684 which, as Vauban explained to Louvois, was "un plan simple, sans avoir pris ni hauteur ni profondeur, ne laisse pas d'être assex bien pour le peu de temps ..." (Faucherre 1989: 42). From an early date, however, the French model-makers were normally required to work on site, and to give minute attention to the buildings of the towns, domestic as well as public, and the details of the local topography such as roads, suburban structures, farms, hedges, crops and planting. The painted paper, card and papier mache demanded by detailed work of this kind was obviously more vulnerable than the carved wood used in most of the other programmes. Moreover, the larger models had to be made in different sections for transport and reassembly in the Tuileries, and later in the Musée des Plans en Relief de Les Invalides. All of this led to damage, of course, but the wealth of detail that emerges from the French models gives us an unrivalled record of urban development in addition to that of the fortifications. (Roux and others 1989; Buisseret 1998).

The model of Neuf-Brisach is listed by De Roux as being made in 1703–1704 by Jean-Francois de Montaigu (or Montaigue) an engineer active in royal service in 1681, and who disappears from the records (probably because of death) sometime before 1714. Details of the buildings in the exhibited model (notably the church) would seem to indicate either that it is a different, unrecorded version from that attributed to Montaigu, or a mid-18th century revision of a model by Montaigu which is dated in the archives of the Plans en Relief to 1703–1704.　　　　SP

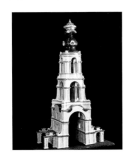

376
Nicola Michetti (active 1704–59, d. 1759)
Model for the Lighthouse at Kronstadt, Russia
St. Petersburg, Central Naval Museum
Wood and plaster painted ocher, white, green, gold, and blue; 163 x 102 x 56 cm; scale: 1:96
BIBLIOGRAPHY: Grabar 1909: 141–52; Lo Gatto 1935: 50–52; Pinto 1992: 536–37

Nicola Michetti, after establishing his career in Rome with designs for family chapels like that

of the Pallavicini-Rospigliosi in San Francesco a Ripa, was called by tsar Peter the Great to St. Petersburg, where he practiced between 1718 and 1723. Along with Domenico Trezzini, Michetti contributed substantially to realizing the tsar's grand vision for his new capital on the Baltic. Peter had fortified the island of Kotlin, twenty-five kilometers out in the bay to the west of the new capital, early in his campaign against the Swedes. The construction of a harbor and refitting docks at Kronstadt on the eastern end of the island began in 1712, and by 1719 work had begun on a canal to provide access to the inner harbor. The model shows the base of the tower to be a great triumphal arch, with a central span ample enough to accommodate the passage of the tall masts of sailing vessels. The second storey of the tower is set on a square base, the four sides of which were concave, with volutes sweeping out at the corners to effect the transition from the larger base to its smaller dimensions. The third storey is circular in plan, closely resembling the top-most level of the bell towers of Sant'Agnese in Rome. Above the third storey of the model is a flaring onion-shaped dome pierced by four oval windows, on top of which is a gilded crown resting on a cushion. The latter no doubt alludes to the royal foundation of Kronstadt and a play upon its name. Michetti's elevation and section, as well as Braunstein's view, show a different solution: a tall spire which nearly equals the height of the masonry structure below. Michetti's design fused a number of different sources, including the bell towers of Sant'Agnese and Sant'Andrea delle Fratte in Rome, the soaring spire of Trezzini's church of Saints Peter and Paul, and the multi-tiered towers placed over the entrances of Russian monasteries, thereby creating a compelling design of extravagant fantasy. The Kronstadt lighthouse design embodies many of the aspirations of Peter the Great's building program. Like St. Petersburg itself, the lighthouse was to be a symbol of Russia's new power and determination to play an active role in the commercial and political life of western Europe.　　　　JP

381
Nicola Michetti (active 1704–59, d. 1759)
Plan of the Kronstadt Lighthouse, Rusisia, second project, ca. 1723
St. Petersburg, The State Hermitage Museum
Pen, brush, india ink
25.5 x 39.8 cm

379 M-MAR
Nicola Michetti (active 1704–59, d. 1759)
Project for the Kronstadt Lighthouse, plan at base of third storey
Moscow, The State Hermitage Museum, OP 4741
Pen, ink and wash; 26.4 x 39.8 cm
INSCRIPTIONS: "N. Michetti" (at lower right)
Scale: at bottom; 10 *sageni* = 107 mm
BIBLIOGRAPHY: Voronikhina 1981: 64; Pinto 1992: 565

The plan drawn at the base of the third storey of the lighthouse reveals Michetti's play of convex curves set between the projecting diagonals of the corners. Michetti's drawing conventions – the use of thin ink lines ruled between stylus marks, stippled lines, the application of washes, the appearance and placement of scales of measurement, and the preparation of plans, elevations and sections to the same scale – show the influence of his training in the studio of Fontana.　　　　J.P.

377 M-MAR
Nicola Michetti (active 1704–59, d. 1759)
Project for the Kronstadt Lighthouse Elevation
Moscow, The State Hermitage Museum, OP 4743
Pen and ink with gray wash; 117 x 44.2 cm
Scale at bottom; 10 *sageni* = 106 mm
INSCRIPTIONS: "Niccola Michetti" (lower right) numbers 1–5, denoting plans at various levels
BIBLIOGRAPHY: Voronikhina 1972: 41; 1981: 64; Pinto 1992: 563

Michetti's elevation represents a number of decorative details not present in the model. These include a clock set between the main arch and the segmental tympanum above, a bell and wrought-iron screen in the second-storey arch, and the imperial eagle crowning the spire. Two groups of statues were to adorn the lighthouse, the lower four representing Prudence, Justice, Temperance, Fortitude; those at the base of the second storey were to personificate the four winds.　　　　JP

378 T
Nicola Michetti (active 1704–59, d. 1759)
Project for the Kronstadt Lighthouse, section
Moscow, The State Hermitage Museum, OP 4742
Pen , ink, gray and pink washes; 115 x 46.2 cm
Scale at bottom; 10 *sageni* = 107 mm
INSCRIPTIONS: "Nicola Michetti" (lower right);
numbers 1–5, denoting plans at 5 levels.
BIBLIOGRAPHY: Voronikhina 1972: 41; 1981: 64;
Pinto 1992: 563

Michetti's section reveals that the dome and
spire, in keeping with Russian practice, would
have been constructed of a metal-plated
sheathing supported by a wooden armature
and also shows the complicated system of in-
ternal stairs providing access to the upper
storeys of the tower. The use of pink wash to
indicate the cut through the masonry structure
is also worthy of note. JP

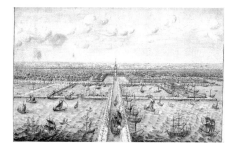

380 T
Johann Friedrick Braunstein
Perspective View of the Kronstadt Lighthouse
Moscow, The State Hermitage Museum, OP 517
Pen, ink, blue, brown, green, pink, and gray
washes; 41.1 x 67.7 cm
BIBLIOGRAPHY: Voronikhina 1972: 39–40;
1981: 29; Pinto 1992: 562

Braunstein, a German sculptor and architect
from Nuremberg, was active in St. Petersburg
from 1714 to 1728. He worked with Michetti on
garden pavilions for the tsar's summer palace at
Peterhof, and also in designing structures related
to the harbor at Kronstadt. Braunstein's drawing
is invaluable in providing an indication of the in-
tended context for Michetti's lighthouse. The
lighthouse was to have been situated straddling
the canal at the center of the inner harbor at Kro-
nstadt, and the height of the of the central arch
(over 130 feet) would have permitted the passage
of large warships. Braunstein's drawing is clearly
based on Michetti's project for the lighthouse,
since it agrees in every particular with Michetti's
drawings in the Hermitage. JP

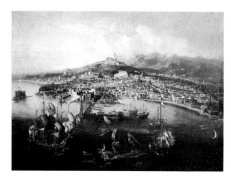

384 T
Jan van Essen
View of Messina, 16th century
BIBLIOGRAPHY: Santoro 1978: 169–253; Giganti
1979: 583–94; Giuffrè 1980: 49–55; Colletta
1981: 121–24; Giganti 1983: *passim*; Spinosa, Di
Mauro (for the Naples view 1989, 1993: 15, 187
no. 3; Trezzani (for biography) 1990: 3 and 382

A port of considerable importance, Messina had
been heavily fortified since Norman times. Jan
Van Essen's view gives prominence to the *teatro
marittimo* (built 1622–25 by Simone Gulli and
others), the impressive range of aristocratic and
wealthy bourgeois palazzi which give a splendid
scale and coherence to Messina's waterfront. Was
the name borrowed, one wonders, from the cir-
cular structure which formed part of Hadrian's
Villa at Tivoli? At first sight, the picture postdates
the citadel, but signs of overpainting in the citadel
zone and certain details and inaccuracies in the
later fortifications suggest that it may in its original
form have predated the revolt. The composition
very closely follows that of Abramo Casembrot's
painting (ca. 1670), in which the size of the lanter-
na (the tapering, square lighthouse in the fore-
ground) is also exaggerated. Other details (the
treatment of the Forte Matagrifone; the round
tower to the left of the citadel; and the group of
houses just to its right) appear to be taken from
the very detailed engraved view by Placido Doria
(1642). The circular tower and the houses on the
spit were demolished when the citadel was built.
The post-1678 citadel with its five bastions and
two ravelins – although correctly sited – is orien-
tated wrongly, and the area of city housing closest
to the citadel was cleared to open fields of fire. All
of this suggests two stages of painting and a re-
liance upon prior models. Little is known of Jan
Van Essen, beyond the fact of his apprenticeship
to the painter Bastiaen De Bruyn in Antwerp and
his presence in Rome in 1669. Later he settled in
Naples where he died in 1684. SP

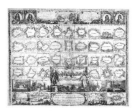

385 T
Marcus Doornick
Poster Showing the Netherlands Fortresses
and Events of 1672; ca. 1673
BIBLIOGRAPHY: Ekberg 1979; Rowen 1988; Is-

rael 1918; Neumann (for the poster) 1988: 338.
Note: I am grateful for the assistance of Pro-
fessor Israel in the interpretation of a number
of the incidents depicted in the panels

This poster was printed and published in Ams-
terdam shortly after 1672, the *annus terribilis*
when the Dutch Republic was attacked by an
Anglo-French alliance, supported by the prince-
bishop of Münster and the bishop-elector of
Köln. The Republic's enemies are illustrated in
the top row (left and right corners), and in the
big panel (center bottom) where the two kings
and bishops are shown mounted on drums and
cannons in front of scenes of a naval engagement
(above) and the entry of Louis XIV into Utrecht
(below). Groningen (bottom row, second from
left) is shown under bombardment from mor-
tars, wich have started a number of fires; while
another panel (bottom row, second from right)
shows scenes of mayem at Swammerdam and
Bodegrave illustrating the French destruction of
those villages and the massacre of inhabitants.
Such events played a crucial role in the propa-
ganda war from 1673 onward as examples of
French cruelty and tyranny. Other political
events are illustrated in the bottom two rows,
among them, the appointment of the prince of
Orange as captain general in February 1672, his
appointment as stadholder in July, Louis XIV's
rejection of the humiliating peace terms offered
by the Dutch in June, and the lynching of the
Witt brothers in August.
These choices of topic mark the document as
Orangist in tone. The title panel at the top de-
scribes it as a "Commemorative poster of the as-
tounding events which took place in the Nether-
lands in the year 1672." Its presumed propagan-
da value is not immediately clear because, for the
Dutch, the events of 1672 were a catalogue of
disasters. Although the Republic's provinces and
borders were studded with bastioned fortifica-
tions, many of them were poorly maintained, in-
adequately garrisoned and quickly lost as the
French and their German allies broke through
the frontiers. At sea, the Dutch more than held
their own against the Anglo-French fleet. On
land their defences collapsed in May, June and
July of 1672. Some Dutch fortresses were taken
by storm, others surrendered after short sieges,
yet others were abandoned without serious resis-
tance. If this poster was printed and published
for propaganda purposes it cannot have been to
brag of the impregnable Dutch defences but,
rather, to emphasize the plight of the Dutch Re-
public until the prince of Orange (who had been
recalled as captain-general in February 1672)
was able to stabilise the military situation along
the flooded polders of the "waterline" and, in Ju-
ly 1672, to respond to popular pressure by ac-
cepting presiding authority as stadholder. The fi-
nal image in the bottom right hand corner is dat-
ed 30 December and shows the recapture of Ko-
evorden, one of the most important Dutch
fortresses which had been lost on 12 July. The
tide had turned Orangist propaganda in this in-
stance casts an interesting light on the role of the
fortresses which feature so prominently in Mar-
cus Doornick's design. All of them were in fact
lost in the disastrous summer of 1672, their

arrangement being in date order of their capture. It is well to remember also that progress on the refortification of towns walls was still patchy in the second half of the seventeenth century. A number of the places illustrated in Doornick's drawing – notably Utrecht (row 4, left), Tiel, Amersfoort, Harderwyk and Hattem – retained substantial lengths of unmodernised medieval walls and round towers, while Kuylenburgh (row 3, left) appears entirely without modern defences and Het Tolhuys (row 2, right) is shown as a "domestic" château with a timber pallisade. Wesel, Rynberk, Emmerik, Bommel and Arnhem all retained lengths of older walls inside the new bastions and ramparts. This said, Marcus Doornick's poster (featuring here only those fortresses and towns which had been lost) gives a striking visual impression of the number of bastioned fortifications which the Dutch Republic had constructed since the mid-sixteenth century and now, in the seventeenth century needed to maintain, arm and garrison. SP

been awarded round gold medals, and enlisted men smaller round silver medals. The colonels' gold medals, however, were oval (like that for Taganrog) and mounted in an elaborate jewelled setting, topped by an imperial crown. The exhibited medal is a copy in silver, without the jewelled mount. It is signed on the front by Salomon Gouin, a Netherlandish medallist and engraver who was employed in the Moscow mint between 1701 and 1713. Gouin, however, specialised in medal portraiture and frequently worked in collaboration with Haupt, another emigré craftsman, who specialised in battle scenes derived from prints. Thus, it is likely that the depiction of Taganrog on the reverse of the medal is the work of Haupt. The medal was to be the most permanent legacy of Peter's Taganrog scheme. In 1711 Peter and his army were trapped on the Pruth by a superior Ottoman force; the price of their release being the return of Azov and Taganrog, whose new fortifications were dismantled by the Turk in 1712. Russia's entry to the Ottoman lake had to await the reign of Catherine II. SP

For his fortifications Le Blond seems to have copied the scheme employed by Vauban for Neuf-Brisach, the last and most costly of the great French engineer's works to be built. (It was practically complete when Le Blond went to Russia.) Behind the main inner circuit of ramparts and bastion-towers there appears to be a row of barracks and magazines running all around the city. France never tried to repeat the Neuf-Brisach scheme with its eight tower-bastions. Le Blond's proposals for St. Petersburg's main inner defensive circuit envisaged thirty-one bastions, plus seven more bastions in the crownwork (right)! As an example of Baroque urbanism, however, the interior plan used the full gamut of scenic and geometric devices pioneered in Palmanova, Turin, and Rome, in the "ideal" schemes illustrated since the 16th century in printed treatises, as well as in the early Parisian formal exercises of the Places des Vosges and the Place Vendôme. Peter's palace was to be the focus of the radial geometry in the biggest residential zone, Vasilevsky Island (centre left). Both residential zones contained a central market square, and a network of canals which alternated with roads to give each house its own dock. The idea was modelled on the canals of Amsterdam, where Peter had lived for some months during his Great Embassy. Large enclosed docks (apparently without lock gates) provided safe loading and unloading areas for the boats that supplied the city during the summer. Ice roads, of course, provided the fastest transport during winter when the rivers and lakes froze, but in other seasons St. Petersburg would depend on ferries for internal communications in the absence of bridges. Smaller squares and *rond-points* provided foci for the residential zones: churches were distributed in smaller spaces off the main circulation routes. Here, however, perhaps even Peter the Great was outfaced. Le Blond's posthumous contributions included a development plan for the tsar's retreat, the Peterhof, a formal French garden for the Summer Palace (which was subsequently replanned on more informal English lines under Catherine II), and the Nevsky Prospect, the city's main boulevard which ran straight for four kilometers joining the Admiralty with the Alexander Nevsky monastery. S.P.

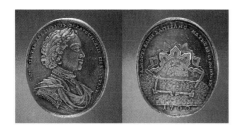

388 T
Salomon Gouin and Gottfried Haupt (?)
Taganrog Medal, 1709
BIBLIOGRAPHY: Ricaud De Tiregale 1772; Iversen 1872; Forrer 1904–30; Spassky, Shchukina 1974; Toderi, Vannel 1988

Peter the Great had two great geographical ambitions: to establish a Russian presence on the Baltic, and to open the "Ottoman lake" of the Black Sea to Russian shipping. After two disastrously unsuccessful Crimean Campaigns in 1687 and 1689, the capture of Azov from the Turks in 1696 was Russia's breakthrough in the south. It was followed by the construction of a new harbor and fortified city at Taganrog on the Sea of Azov, which was to serve as the open-sea base for Peter's planned Black-Sea fleet. The reverse of the medal shows an artificial harbor of moles built out into the sea, and a town laid out on formal lines apparently inspired by sixteenth-century Italian radial planning. Modern bastioned fortifications defend the base on the landward side. The medal was struck in 1709 in honor of Captain Matvey Simontov, the Russianised name of the Italian-born Matteo Simont (or Simone?), to mark his supervision of the construction programme, which ended in that year. On this medal he is styled captain: elsewhere he is later described as an admiral (Tiregale 1772: 29). The pattern of the medal presented to him was apparently modelled on those cast for the colonels present at the Russian victory over the Swedes at the Battle of Kalicz (18 October 1706). A naval captain ranked equally with an army colonel. All other officers at Kalicz had

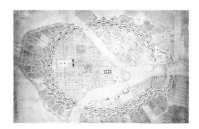

387 T
Jean-Baptiste Alexandre Le Blond (1679–1719)
Plan for St. Petersburg, 1707
BIBLIOGRAPHY: Massie 1981; Mosser 1986–87; Cracraft 1988

Jean-Baptiste Alexandre Le Blond died young after less than three years in St. Petersburg in the service of Peter the Great. The son of a painter and print merchant, he was a nephew of the intendant to the duke of Orléans, and partly brought up by his uncle (Mosser 1987: 284). By 1717 when he was engaged for service in Russia, he was already known for his books on architecture and formal gardens. As a former pupil of Le Nôtre and a member of the French Royal Academy of Architecture, Le Blond is generally considered to have been the most able of the foreign architects hired to bring western standards of design to Peter's new Baltic capital (Cracraft 1988: 158). The plan for St. Petersburg was such a project. The chosen site of the city – where the two main branches of the River Neva divided – was frequently flooded, and far removed from sources of high-quality building material and the thousands of laborers needed for its construction. It was also vulnerable to military and naval actions from the Swedes who had recently been driven out of Peter's foothold on the Baltic. Hence, no doubt the prominence of fortifications in Le Blond's scheme. The fortress of St. Peter and St. Paul was by 1717 already in being on the smallest island, the Admiralty and arsenal complex were fortified on the south bank, and there was a fort downstream at the main naval anchorage of Kronstadt. The rest was all new.

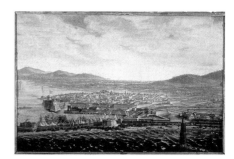

383 T
Lorenzo Fratellini (1694–1729)
View of Livorno, 1720s
BIBLIOGRAPHY: Greer (on Giovanna Fratellini) 1979: 27, 253, 276; Matteoni (for the view) 1985: 91, where it is printed back to front; *17a Biennale Mostra Mercato* 1991: 275

Fratellini's view is taken from the top of the Fanale, one of Livorno's famous lighthouse towers (right foreground). Beyond it the mid-seventeeth-century outer mole with its coastal defence batteries extends across the foreground, sheltering a mass of shipping in the outer harbor. The sixteenth-century arsenal basins are concealed between the two walls to the right of the *fortezza vecchia* (left), with Matilda's tower and banner, and the palace of the grand dukes. The bastioned fortifications are clearly shown, as is the central *piazza d'armi*. The *fortezza nuova* has already been replaced by New Venice, although this cannot be seen. The very high tower (left background) is the Florentine Marzocco, from which a number of other views of Livorno have been painted. Lorenzo Fratellini was the son of the much better-known Giovanna Fratellini (1666–1731), lady-in-waiting to Vittoria della Rovere, dowager Grand Duchess of Tuscany. Little is known of Lorenzo, but he was presumably trained as a painter by his mother. SP

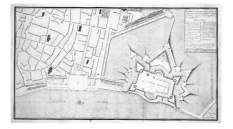

382 T-W
Jacques V Gabriel (1667–1742)
Plan: Place Royale and Château Trompette, Bordeaux, 1729
Paris, Archives Nationales
BIBLIOGRAPHY: Courteault 1922; Avisseau 1982: 104–11

Jacques V Gabriel's drawing of the proposed urban renewal of Bordeaux in 1729 presents two very different faces of the Baroque. Half of the drawing is dominated by the Château Trompette, the seat of royal authority since its construction in 1453 shortly following the capture of the city from the English. The fifteenth-century-château, however, occupied only the small area marked by the four round towers. The pointed bastions and ravelins had been begun in 1654 in the early disturbances of the Fronde (1654–80) but the revolt of Bordeaux in 1675 brought severe reprisals in the form of considerable enlargement of the fortified area and punitive property clearances in the zone surrounding the citadel. Gabriel's scheme, of course, emphasized royal authority by following a new tradition of public squares with statues of kings. Henri IV led the way with the Parisian Place Royale (1605), which by 1639 was graced by an equestrian statue of Louis XIII. The Place des Victoires (1685) and the Place de Louis le Grand (now Vendôme, 1686) inspired similar provincial undertakings by Dijon (1686-92), Pau (1688), Lyon (1713) and Rennes (1726). Although by no means a novel concept by 1729, Gabriel's scheme represented the work of a mature designer at the height of his powers. Bordeaux's Place Royale was half an octagon in plan, flanked by the Bourse (left) and the Hôtel des Fermes (Custom

House, right), and centered on Jean-Baptiste Lemoyne's equestrian statue of Louis XV. On each side the place opened onto the esplanades that were being developed along the river frontage. The central pavilion was set back somewhat and sandwiched between two new streets – the Rue Royale and the Rue St. Rémy – which would be driven through the tangle of medieval streets in the old town to converge at this point, focussing attention on the statue of the king. The converging street device would be used to spectacular effect by Valadier in his 1794 scheme for the Piazza del Popolo in Rome, and was already employed in Turin's extensions. When the scheme was completed in 1755 access was controlled by decorative iron grilles which allowed the long open views shown in Vernet's pictures, which were painted only three years later. By then the middle classes of a pacified Bordeaux enjoyed access to tree-lined avenues around the military zone of the citadel, on lines not unlike those suggested by Gabriel's 1729 proposals. SP

386 T
Ignazio Sclopis di Borgostura (1727–93)
Panoramic View of the City of Turin from the Porta di Susa
Turin, Private Collection
Oil on canvas; 146 x 45.5 cm
PROVENANCE: Palazzo Reale, Turin
BIBLIOGRAPHY: Astrua, in Pinto 1987: 85; Peyrot 1991: 19–20.

Fertile fields of wheat and busy harvesters, carts, travellers and wayfarers along the tree-lined road that led from the city to the castle of Rivoli, introduce one to this view of Turin from the Susa gateway. The ring of fortifications can be clearly seen, while, on the left, the whole group of the Quartieri Militari buildings stand out. These include the army barracks of San Celso and San Daniele planned by Filippo Juvarra to present uninterrupted arcaded fronts cadenced throughout their whole height by a giant order, topped by Ignazio Birago di Borgaro's attic of 1769–70. Further behind, in the middle distance, are the domes and bell towers of the old city and, on the extreme right, the pavilions of the Valentino. The hills stand out in the background together with the Villa della Regina, the Vigna di San Vito, aristocratic residences and the religious buildings erected by the Savoyard dynasty: the Basilica of Superga and the church and monastery on Monte dei Cappuccini. This painting is one of a series of four canvases, which can be identified with the *Four Views of the City of Turin* by "Conte Sclopis" mentioned in the 1882 inventory as being in the ante-room giving access to the fourth chamber of the Appartamento dell'Alzamento in Palazzo Reale in Turin (Astrua, in Pinto 1987: 86). The series represents panoramic views of Turin from the four cardinal points corresponding to the gates of the city – to the west Porta di Susa, to the north Porta Palazzo, to

the east Porta del Po, and to the south Porta Nuova. They are sophisticated illustrations of "picturesque subjects" produced according to the example in the introductory description of *Nuova guida per la città di Torino* by Onorato Derossi, published in 1781 and written with the help of that erudite Piedmontese, Giuseppe Vernazza. The picturesque subjects portrayed in the views are pointed out to the "lovers of Fine Arts" in the *Programma*, dated 3 January 1780, which was written with Ignazio Sclopis (Turin 1727–93) by Giuseppe Vernazza for the subscription to the *Vedute de Torino ed altri luoghi notabili degli Stati del Re delineate e intagliate dal Conte Sclopis Del Borgo.* This publishing program, which was only partly achieved, virtually crowned the court's project of presenting a new image of Turin and spreading it throughout Europe. This had already been begun with the publication in 1753 of Craveri's *Guida de' forestieri*, which, from the four gates of the city, described pleasurable trips on to the plain and into the surrounding hills (Comoli Mandracci 1983: 87). An important document, kindly made available for writing this entry, clarifies the 1780 program even better. It is a *Memoria*, addressed to the king and sent on 13 March 1780, in which Ignazio Sclopis asks the sovereign to subsidise the enterprise as there had not been sufficient subscriptions. Consequently Sclopis describes the project in detail and, as a guarantee of its success, summarizes his activities as a secret informer and surveyor for the royal services of the defensive structures, military systems and technical and productive instruments used in all the major European courts. "Count Ignazio Sclopis, after being commissioned by His Excellency Count Lascaris, then Minister at the Court of Naples, to make drawings, as he did, of all the fortifications of that kingdom, of Sicily and a Geographical Map of the Crater. On the orders of His Majesty King Carlo Emanuele, whose memory is ever glorious, the writer went to the Papal States where he made all the drawings relevant to that State's fortifications. Then he went to draw the fortifications in Tuscany and the forts on the mainland with the greatest accuracy possible, both in the Plans of these fortifications, and in the Sections, Elevations and Views of the same. He also added a detailed description of the troops needed to defend those forts, the size of the warehouses, and as much other information as he could glean on the spot without grave danger to himself in those circumstances. This he did with success since the said drawings are in the secret archives of His Royal Majesty. Then he went to Holland, London and Paris, and never ceased to communicate to Signor Cavaliere Raiberti drawings of the Dutch method for building dykes; machines for raising great weights; construction of ships; and everything it was possible to gather on his journeys […] Returning from his travels and noting a lack of engravers, he quickly engraved several documents for various regiments. Then he set himself to work and rediscovered the secret of painting in oil on canvas. Finally, to make this capital, with its royal villas, known to foreign nations, the writer has already published eight views of Turin within the walls, and one without, of the Porta di

Po, on two large sheets, and now is engraving the other three gateways. As well as a view of Stupinigi from the garden side, already engraved, and an external one still to be done [...]" Before listing the subscribers (thirty-one nobles headed by the king's sons) Sclopis asked the king "to grant him permission to dedicate the large views of Turin to His Royal Majesty, as he had already conceded for the first view, and to be able to dedicate the views of the royal villas to the royal princes, and to dedicate the remaining engravings to whoever the king regarded as suitable. Hoping that the king will grant him the favour of allowing him to bring the new drawings already done for the said collection for the king's perusal" (Turin, Private collection "Autografi e documenti raccolti da Federico Patetta"). The precise list of forty-three subjects, with information about the views already engraved and those still to be done (castles, royal and aristocratic palaces, some religious buildings), makes this document particularly valuable for explaining the incomplete transmission of the plates to us with respect to the series planned, due to suspension of the project. (For the different views of Stupinigi see Astrua 1986: 560.) Among these plates, the most important was the one depicting the view of Turin from the Porta del Po, dated 1777 and dedicated to Vittorio Amedeo III (mentioned by Sclopis in the *Memoria* as the first and only one engraved of a series of four, which were in the process of being made). This engraved version corresponds perfectly to one of the four painted canvases. After the edition brought out during the first half of the eighteenth century of a few chosen subjects of the city, Sclopis's project, including the four introductory panoramas, was the greatest and most up-to-date enterprise valorising the image of the kingdom, which, in this way, could thus renew its image, still widespread on account of the seventeenth-century plates of the *Theatrum Sabaudiae*. The four painted views are closely linked to this important initiative. Executed in this most noble technique and being unique copies for the king's enjoyment, they were to serve as reminders of the formidable task of making the city known through a painter-topographer's means; one who was aware of the most modern directions in taste during Vittorio Amedeo III's reign. The four views were also to document European modernisation of court culture on this theme and offer a model of representation, which, having a privileged relationship with the spectator, would correspond to the new visual customs and to the taste for the picturesque, which, even before becoming the subject of treatises and controversial theories, was being formed through traveling experiences. Sclopis, the landscape painter and topographer, tests himself here with a very different dimension from the one previously experimented when illustrating with sophisticated precision the city of Naples in close-up, shown in two engravings of 1764 (*All'ombra del Vesuvio* 1990: 422–23). The function of these *vedute* were in fact quite different since the two depicting Naples could be useful tools in military espionage, whereas the four views of Turin are charming panoramas to capture the spirit of the cultured observer. MDM

Public buildings

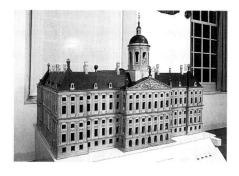

389 T-W
Unknown Maker after a design by Jacob van Campen (1596–1657)
Model for the Town Hall, Amsterdam, ca. 1649
Amsterdam, Historisch Museum, a 12023
Oak, brass, box; 138 x 181 x 157 cm
PROVENANCE: Kunstkamer, Amsterdam
EXHIBITION: Utrecht, Centraal Museum Utrecht, 1983

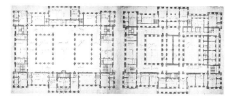

392a T
Unknown Artist after a design by Jacob van Campen (1596–1657)
Plans of the Ground and First Floors of Amsterdam Town Hall, ca. 1648.
Amsterdam, Gemeentearchief, Historisch-Topographische Afdeling, Inv. no. G110-10 and 11
PROVENANCE: City Archives, Stadsfabriek (Public Works)
EXHIBITION: Amsterdam, Koninklijk Paleis, 1982

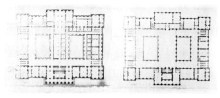

392b T
Daniel Stalpaert (1615–76) after drawings by Jacob van Campen (1596–1657)
Set of Prints of Amsterdam Town Hall
1650
The Hague, Koninklijk Huisarchief, K.I.6 (16-21)

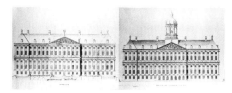

394 T
Cornelis Danckerts (I) (1603–56)
Section of Amsterdam Town Hall (in Vennekool 1661, fig. H), 1661
The Hague, Koninklijk Huisarchief

Engravings by C. Danckerts (I) and Dancker Danckerts after drawings by Jacob Vennekool
Etching, plate measuring 398 x 486 mm
INSCRIPTION: "Door Gesnede gevel van 't Amsterdams Stadt-Huys. Haer voor gevel ten Oosten wegh genomen" and an indication of rooms and functions
BIBLIOGRAPHY: De Roever 1888: 200–201; Noach 1936; Fremantle 1953; 1959: 193; Kuyper 1980: 213 and note 15; *Het achtste werelwonder* 1982; fig. 27; *Het kleine bouwen* 1983: 40–43

The design of Amsterdam Town Hall (1648– 65), by the architect Jacob van Campen, had a complicated history. The most important evidence for the design history of the definitive Town Hall as designed by Jacob van Campen is provided by a model and three series of prints. None of them shows the building in its final form, but only the theme on which variations were made during construction. Until 1654 Van Campen worked together with Stalpaert, but after that year Stalpaert alone directed the project. The final building is based on Van Campen's design, though this has been partly remodeled by Daniel Stalpaert (1615–56), the town architect who had taken over the direction of the building. The earliest evidence is provided by two prints of the Town Hall, which indicated the subdivision of the rooms and their functions. It is assumed that these prints were displayed at the meeting of the town council on 18 July 1648, when the allocation of functions to various parts of the building was discussed (Noach 1936). After this the general layout was not changed; the interior of the rectangular building was to be provided with a large hall with a system of galleries. However, some details of the design would later be changed. One of the most important modifications concerned the great staircases and the access to them from the galleries. On the front side of the building imperial staircases were planned with space for passages behind the façade. On the rear side there were winding staircases with similar passages. The access to both sorts of staircase was to consist of a centrally placed entrance flanked by half-columns. The Vierschaar, the chamber where the death sentence was pronounced, is still represented as having deep niches, as can be seen in the middle of the prints. Moreover, the side walls are plain and not adorned with pilasters. It is very interesting that the result of the aforementioned meeting is rendered in the form of prints. The next stage in the design is represented in a model of the Town Hall, which can be dated to the years 1648–50. The stage depicted in the model is more or less the same as that shown in the prints of 1650 (ca.). The most important difference lies in the stairs. The model here shows traces of alterations which indicate that at first the design of the prints described earlier was followed. The lines at the bottom of the stairwell show elements both of the first design and of that which was actually executed. Using first-class oak for the main part of the work, box for the carvings and brass for the capitals, the unknown maker set out to create a plastic image of the design. The construction is very careful, particularly in the middle section, where use was made of dowels and dovetail

joints. In order to determine where the openings and niches should go, a network of cuts was made on the wood, which made it possible to work quickly and precisely. This method of working shows strong similarities with the method by which Van Campen designed his architectural drawings. The model shows a fairly large number of details. The elevations of the external façades must already have been completely drawn on paper, as must those of the inner courtyards on the right and left, each of which has a different design. All the ground plans can be seen reproduced in the model. The interior has a standard decoration in most rooms, but some rooms are decorated according to a specific design; this happens in the Vierschaar, the Burgerzaal with the galleries, and the lantern. In the top order in the Burgerzaal the observer's line of sight has been taken into account: on the long sides the basements are higher than on the short sides of the room. This is necessary because of the projection of the cornice underneath and the different angles from which one can look upward. A total of thirty drawings containing the maximum amount of information would have been necessary, but it is not unlikely that there were many more. The drawings of the tympana may have been among these first drawings. The quality of the detail is so high that this not likely to have been a building model (a model made for use in construction). It seems more likely to have been a presentation model. Of a series of six prints published by Daniel Stalpaert, two are reproduced here: the front façade and the side one. The print showing the ground floor also reproduces a decree of the burgomasters and regeerders of the town dated 1 September 1650. The decree forbids anyone else to copy the prints without Stalpaert's consent, under penalty of a fine of 600 gilders and the confiscation of the copies. This suggests that the town had these prints published for publicity reasons. These prints show the same design stage as that which appears on the model, further developing it in two ground plans and four façades. The northern side façade is a counter-proof of the southern one, so we really only have five prints, not six. The exterior comes very close to the building as it was actually constructed. Only the tower is slightly different, as is the tympanum on the rear façade and a few other minor details. The cross-section is taken from a rather popular book about Amsterdam Town Hall. The first edition is dated 1661, but it is known that Sir Roger Pratt bought a copy of the book in December 1660. This print shows an early design by Van Campen, which dates from after 1650. The sculpture above the porch in the Burgerzaal shows the design which Quellinus executed, whereas the gods Jupiter and Mars in the galleries are different from those which he actually carved in 1653. Furthermore, two galleries are shown, one on top of the other, whereas only one was actually built. In other words, the print shows a stage at which Van Campen was working in collaboration with Quellinus. The presence of an excellent sculptor had a definite influence on Van Campen, as one can see from the greater amount of sculpture shown here as compared with the earlier prints and the model. The print shows a fine example of cooperation between the different arts. PV

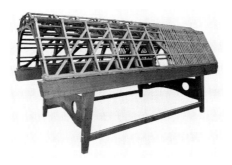

390 T
Hans Peterson the Elder, Adriaen de Jonge, Jochem van Gent
Model of the Roof Truss for the Burgerzaal in Amsterdam Town Hall, ca. 1678–1700
Amsterdam, Koninklijk Paleis
Oak and iron (the light parts date from the restoration of 1944, the dark parts are original); 88.5 x 121 x 235 cm
PROVENANCE: City of Amsterdam (the model had probably been in the building since it was made)
BIBLIOGRAPHY: Listingh 1701; Kroon: 97–100; Tieskens 1983: 72–76; Janse 1989: 267–69

The Burgerzaal in Amsterdam Town Hall was covered by a roof structure in 1660. The form of a mansard roof was adopted, for two reasons. First, the interior space would be free of beams, and secondly a belvedere could be made on top of the roof. However, the construction of the roof was structurally unstable. Before long the walls had pulled outward by 9 cm. Furthermore, the roof structure started to rot fairly quickly. The alarm was first given about the state of the wood in 1685, but no action was taken. In 1698 another examination was made by Hans Jansz van Peterson (the Elder), Herbert Kramer, Adriaen de Jong and Jochem van Gent. In the same year, 1698, action was taken. The treasurers, who were responsible for public works, asked the specialists (except Herbert Kramer, the town master builder) to draw up a design for the replacement of the roof. Designs were also contributed by others: the architect Steven Vennecool, Hans Peterson the Younger, and Nicolaes Listingh. It took a long time for the specialists to agree on the final project, but on 5 July 1700 the new design was completed. The drawings still exist (Amsterdam, Gemeentearchief, Historisch Topografische Afdeling, Inv. no. 103-4, 103-5, 103-6) and show the same design as the wooden model. This model must have been made during the construction of the roof, as it is not mentioned in the archival sources. The corner construction was improved and the roof joists were stiffened at the top by a truss pulled taut by iron braces. Nicolaes Listingh considered the replacement unnecessary: in his opinion the old roof could have been reused, altered, and improved by putting large semicircular windows in the sides. Listingh's efforts proved in vain: the town council decided in favor of the design by Peterson the Elder and his associates, possibly because the wood (Irish oak) had already been bought. A special committee was set up to supervise the project during the next few years. Listingh's criticism that the roof would be too weak has proved wrong, for it is still in place to this day. PV

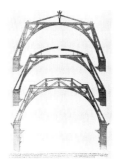

391
Nicolaas Listingh
Construction of the Roof Truss of Amsterdam Town Hallk, 1701
The Hague, Koninklijk Huisarchief
Engraving; 46 x 32 cm

398 T-W
Artus Quellinus (1609–68) after a drawing of Jacob van Campen
Allegorical Figure of Amsterdam, 1650–64
Amsterdam, Historisch Museum, Inv. b.a. 2453
Terracotta model, 43.5 x 27 cm
PROVENANCE: Gift A. Menger, Utrecht to Nederlands Museum voor Geschiedenis en Kunst, The Hague; 1878 gift to City of Amsterdam; 1878–88 on loan to Rijksmusum Amsterdam; on loan to Amsterdams Historisch Museum since 1935
EXHIBITIONS: Amsterdam 1985 (*La France aux Pays Bas*); Berne, Musée d'Histoire de Berne, Musée des Beaux-Arts de Berne, 1991; Antwerp, Hessenhuis, 1993; Amsterdam, Koninklijk Paleis, 1995
BIBLIOGRAPHY: Quellinus 1665; Gabriels 1930: 129–33, 138–40, fig. XXI; Fremantle 1959: 42–47, 146–150, 156–158, 163; Leeuwenberg, Halsemakubes 1973, no. 276 a-1; *Emblèmes de la liberté* 1991: no. 113; Antwerp 1993, no. 196A; Jonker, Vreeken 1995: 38-59, 192; Goossens 1995: 15–19

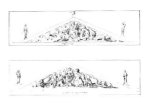

399 W
Jacob van Campen (1596–1657)
Designs for the Tympana of Amsterdam Town Hall, ca. 1648
Amsterdam, Rijksprentenkabinet, Inv. no. RP-T-1906-17 and 18
Brown ink over black chalk; 194 x 768, 197 x 768 (tympana of front and rear façades)

INSCRISPTIONS: "Rijckdom" and "vrede" (tympanum of front façade)
PROVENANCE: Possibly Delacourt, Antwerp; purchased from Fr. Muller & Co., Amsterdam 1906
EXHIBITION: Amsterdam, Koninklijk 1995
BIBLIOGRAPHY: Van Luttervelt 1950: 80–82, fig. 30; Fremantle 1953: 77, 79–91, figs. 2, 5; Fremantle 1959: 156–58, 171–74, fig. 185; Amsterdam 1977: p. 4, fig. 76; Jacob van Campen1995: 112, nos. 16a and 16b, 142, fig. 222; Goossens 1996: 23–25, fig. 25

These two drawings are typical of the work of Jacob van Campen. Sketches of this sort were handed over to artists, who would translate the sketches into the medium in which they worked. This was not always easy. In 1649 Huygens wrote to Amalia van Solms: "Van Campen, who expects his instructions to be followed precisely, marks them so obscurely that those who have to execute them are obliged to make new models with their own hands to see if they understand them". The tympana on the Mauritshuis and Paleis Nordeinde in The Hague show what happens to such a design when an artist does not know how to translate the draft from paper to stone. The Flemish sculptor Artus Quellinus evidently did possess this ability, as appears from the tympanum on the Dam side of the Town Hall. The terracotta model shows Quellinus' skill. It represents the patroness of the town with the imperial crown which the town was said to have received from Emperor Maximilian. In her left hand she holds the coat of arms of Amsterdam with the three crosses of Saint Andrew. The expression of the patroness, the folds of her dress, and the two lion's heads were created by Quellinus. The classicizing style that he had picked up in Rome as the pupil of Frans Duquesnoy came in particularly useful in Amsterdam. The town identified with the Roman Republic and sought a connection to classical antiquity, as is visible in the interior. In the Burgerzaal and the galleries there was an attempt to depict the existing world and the cosmos, partly by means of maps of the world and images of gods symbolizing the planets. This representation of the cosmos was intended to make clear the message which Amsterdam wished to convey, namely that the town had knowledge of the whole of creation and that Amsterdam was the center of it. The two notes on the drawing of the tympanum on the front façade hint at the expectations of the town of Amsterdam. On the top there was to be a statue representing Peace, and at the right-hand corner there would be another representing Wealth. Quellinus was more than just a worthy executor of Van Campen's ideas. While on the tympanum on the front façade he followed his draft, this was not the case with the one on the rear façade. One has the impression that it was Quellinus who provided this design, not Van Campen, something which is also suggested by the print of the tympanum. Since Van Campen had left the building project by the time the tympanum was made, Quellinus would not have met any opposition from him. In 1654 there had been a quarrel between Van Campen on the one hand and Quellinus and Stalpaert on the other, and it was the latter two who had prevailed. Why this had happened is not known. PV

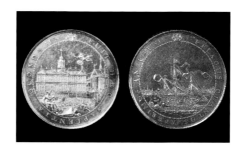

396 T
Juriaen Pool (d. 1669)
Medal commemorating the Inauguration of the Town Hall, 1655
Paris, Fondation Custodia, Collection Frits Lugt
Silver; 7.1 x 7.1 cm
INSCRIPTIONS: "Fuit Haec Sapientia Quondam" and "Huidecoper. Graef. Poll. Spiegel. Coss AED. Tulp. Dronel MDCLV" (on the front); "Pelagus Quantos Aperimus In Usus" (on the back)
BIBLIOGRAPHY: Fremantle 1959: 3, 58–59, 169–71, fig. 1; *La vie en Hollande*, 1967: no. 9

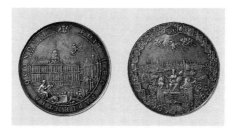

397 W
Juriaen Paul (d. 1669)
Medal commemorating the Inaugurating Amsterdam Town Hall, 1665
Paris, Fondation Custodia, Collection Frits Lugt

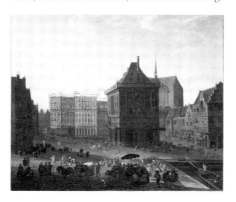

400
Johannes Lingelbach (1622–74)
The Dam, Amsterdam, with the New Town Hall under Construction, ca. 1670
Amsterdam, Rijksmuseum, on loan to the Amsterdam Historisch Museum, Inv. no. A 1916
Oil on canvas; 81 x 100 cm
PROVENANCE: Anonymous gift to the Rijksmuseum through the mediation of Dr. A. Bredius and the art dealer F. Kleinberger of Paris, 1900
EXHIBITIONS: Stockholm, 1955–56, Amersfoort 1957; Amsterdam, 1979; Amsterdam, 1982; Amsterdam, 1995; Amsterdam, 1997
BIBLIOGRAPHY: Van Thiel 1976: 550; Blankert 1975–79: 191-92; Peeters and others 1997: 38–39, fig. 4

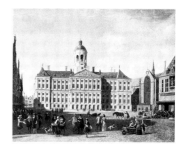

401
Gerrit Adriaensz Berckheyde (1638–98)
The Town Hall on the Dam, Amsterdam
1693 (signed and dated)
Amsterdam, Rijksmuseum, Inv. no. C 101
Oil on canvas; 52 x 63 cm
PROVENANCE: On loan from the City of Amsterdam (A. van der Hoop bequest) since 1885
BIBLIOGRAPHY: Haak 1969: 141, fig. 5; Van Thiel 1976: 111; Nordenfolk 1982; Lawrence 1991: 56–57, note 45

The first ideas for the building of a new Town Hall in Amsterdam originated ca. 1639. The Old Town Hall was dilapidated and too small. Many plans were drawn up, with constant changes in the size of the building area. On 18 July 1648 the area was fixed at 280 x 200 Amsterdam feet. Work on the foundations began on 20 January 1648 and lasted until 1649; 13,659 piles were driven into the ground. In the meantime the foundation stone was laid on 28 October 1648 by the sons and nephews of the current burgomasters. The building work had its ups and downs. Vennekool (1661: 3–4) tells of plagues of mice, spring tides, the English, insurrections, and the burning down in 1652 of the Old Town Hall, which had stood in front of the building site. The English War (1652–54) also seemed to have a negative effect on progress, but in reality it had a better effect than expected. The burning-down of the Old Town Hall led to the municipal offices being housed in temporary premises. This must certainly have given an impulse to the building work. On 29 July 1655 the building was formally inaugurated with a procession through the town, a church service in the Nieuwe Kerk and a ceremonial banquet in the building itself. The poet Joost van den Vondel wrote his *Inwijdinghe van 't stadthuis t'Amsterdam*. Silver medals were struck by G. Pool to commemorate the occasion. The names of the current burgomasters and the treasurers shine proudly on them. Such an offical inauguration might lead one to conclude that the building was complete. The medal certainly gives this impression, for the building gleams on it in all its glory. However, the reality was completely different. The top two floors were far from finished; the building of them was still vigorously proceeding. So Pool must have based his medal partly on the prints by Stalpaert published in 1650. On the obverse Mercury is portrayed with his cap of freedom, bringing abundance to the town; in the foreground Amphion, the father of cities, who teaches mankind gentleness and respect for the laws through their civilization. On the reverse is shown the ship Argo. The inscription "Pelagus Quantos Aperimus in Usus" is taken from Valerius Flaccus' *Argonautica* and was appropriate

to the situation of Amsterdam. Lingelbach's painting gives a pleasant impression of the situation in about 1655. Whether it is reliable as a historical source is, however, not clear. Blankert follows a long tradition in considering this work to be a late composition by Johannes Lingelbach (1622–74), dating from around 1670. Van Thiel attributes it to Jacob van der Ulft, but gives no date. Peeters makes no ascription but dates the work to 1656 on the basis of the scene represented. The building of the main structure was completed in 1660, with the roofing of the Burgerzaal. The commission for the tower was not issued until 1664, and the tower was finished in 1665. The project was now substantially complete. The interior decoration and the some of the details on the exterior probably continued into the following years. The painting by Gerrit Adriaensz Berckeyde shows the building in all its glory. The rectangular building is divided into eighteen bays in breadth and sixteen in depth. The corner pavilions and the central avant-corps on the front and rear façades give the building shape. Situated between the front and rear avant-corps is the very large Burgerzaal, a space occupying four floors, which receives light on the long sides from two inner courtyards. The façade consists of a basement and composite and Corinthian orders on two floors. The avant-corps were crowned by tympana with sculptures. The town of Amsterdam was proud of the new building, which soon came to be known as the "Eighth Wonder of the World." The complete covering of the façade in sandstone was exceptional for a work of this size in this region, which is totally devoid of natural stone. All the sandstone had to be imported and carried to Amsterdam via Bremen and Bentheim in Germany. The interior of the building was to be decorated with a sumptuousness that was quite unprecedented in the Low Countries. Large quantities of marble were imported from Italy, not only for Hubertus Quellinus' sculptures, but to cover the floors and walls. Foreign visitors praised this magnificence, but were particularly impressed by the marble floor of the Burgerzaal, which was adorned with a map of the Earth and another of the heavenly bodies. PV

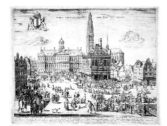

402
Jacob van der Ulft (1627–89)
The Dam in Amsterdam with the Weigh-House, the Town Hall, and the Nieuwe Kerk Tower, 1653
Amsterdam, Gemeentelijke Archiefdienst Amsterdam, Historisch-Topografische Atlas
Etching; 39 x 53.3 cm, signed
EXHIBITION: Utrecht, 1983 (Centraal Museum); Amsterdam, 1997 (Koninklijk Paleis)
BIBLIOGRAPHY: Tieskens and others 1983; Peeters and others 1997: cat. nos. 5a, 5b

In 1645 the Amsterdam town council decided to provide the Nieuwe Kerk with a tall tower. Five different designs for this project are known. The representation by Van der Ulft, which is known both in a gouache and in an etching, is one of these. The designer of the tower depicted here is unknown. In 1646 the pile-driving for the foundations of the new tower began, and in 1647 the actual building got under way. From 1648 onwards work was also going on simultaneously on the construction of the adjacent Town Hall. In the town council there was a marked division between on the one hand a strict Reformed Church party and on the other a more free-thinking, secular grouping. Van der Ulft's imaginary representation of the Dam with a new church tower dates from 1653, when the ecclesiastical party was trying by means of such "propaganda" to induce the council to resume the building of the tower. What is striking about this never-realized tower is its unusually Gothic style. This was intended to make it blend in with the Gothic architecture of the existing building, the greater part of which dates from the fifteenth century. Moreover, it is evident from this picture that the aim of the tower project was not simply to dominate the centre of secular power, the Town Hall. The new "Gothic" tower of Amsterdam would have been the very highest in the country, even higher than the 110 m-high fourteenth-century tower of Utrecht Cathedral, the highest ecclesiastical building in the Northern Netherlands. For this representation of the new Town Hall in 1653 Van der Ulft must have made use of the prints of the project which were made in 1650, when the building of the Town Hall had only got as far as the first floor. Only in 1665, with the building of the domed tower, which is already visible in Van der Ulft's picture, was the Town Hall completed. KO

403 T
Unknown, perhaps after a design by Van Campen
Model for the Tower of the Nieuwe Kerk in Amsterdam
ca. 1647–52
Amsterdam, Amsterdams Historisch Museum
Painted wood; 46.5 x 43.5 x 268 cm
PROVENANCE: Formerly owned by the city council
EXHIBITIONS: Utrecht, 1983 (Centraal Museum); Amsterdam, 1995 (Koninklijk Paleis)

BIBLIOGRAPHY: De Jongh 1973; Tieskens 1983b; Von der Dunk 1993; Ottenheym 1995

On the 11 January 1643 a great fire destroyed a large part of the Nieuwe Kerk in Amsterdam. The work of restoration began immediately and on 18 May 1648 the church was reopened. On 13 October, while the restoration of the church was in progress, the town council, under the leadership of Burgomaster Backer, decided to build a tall tower on the west side of the Nieuwe Kerk, as an "ornament to the city." This project is generally regarded as a religious counterpart to that of the new Town Hall on the Dam, a token of religious faith situated close to the center of secular power. The architect of the new Town Hall, Jacob van Campen (1596–1657) is named in a contemporary source as also having designed the new church tower: in a pamphlet of 1654, written by his friend Everard Meyster, Van Campen is praised as "the designer and father of the tower and of the Town Hall." However, Van Campen's own plans have not survived. Five different designs for the new tower are known. For two of these designs we also have wooden models, and one of them is shown here. In view of its classical details, it may well be based on the designs supplied by Jacob van Campen. All five designs, including the two wooden models, are in a more or less Gothic style. The model generally regarded as "the design of Jacob van Campen" consists, like several pure Gothic towers in the Netherlands, of two square sections and an octagonal openwork lantern, but in this case the lantern is crowned with a classical cupola. Moreover, there are classical festoons interspersed between the Gothic tracery of the windows. The Gothic pinnacles on the balustrades are also less prominent here than in the other four designs. With this mixture of Gothic structure and classical details the tower would have been ideally suited to its intended position, next to the west façade of the Gothic church, and alongside, and towering above, the new, classicizing Town Hall. The theory of *conformità*, the desire for unity of style in one building, which the classicizing Italian architects and treatise-writers had continued into the sixteenth century, still held good in seventeenth-century Holland. The foundations were laid in 1646, and the building of the brickwork began in 1647. In 1652, however, work on the tower was stopped (see following entry, cat. no.) so that only the lowest section was ever actually built. This section, which is still visible today as a porch on the west side, shows that it was the design attributed to Van Campen which was chosen by the town council. Between the quasi-Gothic tracery one finds unmistakably classical ornamentation: scallop motifs in groups of three, and neat Corinthian capitals on little columns. Since this bottom section of the tower is only roughly executed in the wooden model, we may infer that this model was not made until the bottom section had been completely built, or at least was in the process of construction, that is to say ca. 1650–52. The model probably served to provide information on, and as a preparation for, the work on the upper sections of the tower. KO

The City Hall of Salamanca
Ferdinando Marías

The City Hall of Salamanca is the center of the urban complex of the Plaza Mayor of Salamanca, the city's most important project in the eighteenth century and the most accomplished example of Spanish main-plaza architecture of the modern age. The Plaza Mayor of Salamanca was begun in 1729 at the initiative of the *corregidor* (chief magistrate) of the town, Don Rodrigo Caballero y Llanes, who in 1728 had composed a written request justifying his project as a response to the need for the "illumination and ornamentation" of the old, irregular Plaza de San Martín, and to provide the shelter "of covered arcades or porticoes" for the commerce and communications of individuals and vehicles. Caballero had reached the post of *intendente* of Valencia in 1711 and would be named *intendente* of Andalusia in 1736. During his term in Salamanca as *corregidor*, he also promoted the establishment of a hospice and a cloth factory, within the pre-Enlightenment political program begun during the reign of Charles II and continued with the arrival of the kings of the Bourbon House. In 1729 after the Real Consejo de Castilla secured permission for its construction, work began with the eastern façade (of the Royal Pavilion) and the southern side (of San Martín), concluding in 1733. The project was headed by the master architect of the cathedral Alberto de Churriguera, the youngest member of the celebrated family of architects from Madrid who initiated the vernacular Spanish Baroque trend called the "Churrigueresque" style; he worked in collaboration with his nephew Manuel de Larra Churriguera. From this date, work languished until 1741, when a new campaign was begun, focusing on the building of the City Hall on the northern side. After work was resumed in 1751, it was possible to inaugurate the new plaza in 1755; at the time its inner sides were completed, although it would not truly be finished until 1785. Alberto's design pooled the Spanish tradition of main plazas from the modern age, which *corregidor* Caballero had seen reflected in those of Valladolid (1561), Madrid (1580) and the Corredera de Córdoba, the latter promoted by his protector *corregidor* Ronquillo. They were regular in plan and homogenous in their elevations, with traits from French royal *places*, such as their closed character – only present in the Cordovan example – and its sculptural program that celebrated not only the "Glories of Spain," illustrious men (captains, wise men, and saints) of the nation's history, but also the Spanish monarchy since the Middle Ages to the Bourbon dynasty of the present, from Alfonso IX of León to Charles II of Austria and the current Bourbon King Philip V. The visual background of the plaza is composed of the City Hall, a block that along with that of the Royal Pavilion stands out from the unitary design of the sides of the plaza. Originally planned by Alberto, it was remodeled by his nephew Manuel de Larra Churriguera. In 1743, his designs were substituted after Rodrigo Caballero left Salamanca and had been replaced by a new *corregidor*. The new plans under which the work was executed were by architect Andrés García de Quiñones.

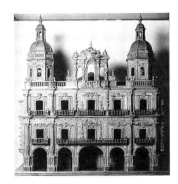

404
Andrés García de Quiñones (1709–55) and José García Berruguilla
Model of the City Hall of Salamanca, 1744
Salamanca, Museo de Historia de la Ciudad
Cedar, metal details; ca. 1075 x 1090 x 445 mm
Scale: not indicated, but approx.: 1 foot=3.8 m
PROVENANCE: City Hall, Salamanca
BIBLIOGRAPHY: De Santiago Cividanes 1936: 15; Gomban Guerra 1955; Rodríguez G. de Ceballos 1968: 107–10; Tovar Martín 1972: 271–85; Rodríguez G. de Ceballos 1977: 107–108; *Domenico Scarlatti* 1985: no. 230; Montes 1992

Executed in 1744 by Juan García Berruguilla, known as "the Pilgrim" because of his trips to Russia and Prussia, with the collaboration of sculptor José González Bordado and ironworker Francisco Caldevilla, and at a cost of 3,153 *reales* for city officials and 1,100 for Berruguilla, this model of the City Hall of Salamanca shows the project of Andrés García de Quiñones. This architect had presented it in 1743 as an alternative to the design of the Churrigueras, and it was converted into a model the next year after it was approved by the City Hall; with this model the building was finally constructed between 1751 and 1755 The project of the Churrigueras highlighted the importance of the intermediary sections of the façade, which were wider, that corresponded to the exit to the street and the entrance to the City Hall, while it accentuated the axis of the façade by means of ornamental elements. García de Quiñones, on the other hand, created a hierarchy in the horizontals and verticals of the architecture, widening the central arch and equalizing the lateral ones, and thus giving the façade a more homogenous appearance. He counterpointed the volumetric and rectilinear character of its gigantic order and powerful entablature with the flatness of the pilasters and the decorative excesses of the Churrigueras, accentuating the contrast of its façade with respect to the design of the sides of the plaza. The towers, square in plan, were converted into octagons and the flat belfry was substituted by a centralized building with a façade in the form of a triumphant arch, having lateral curved pediments with Michelangelesque echoes on broken columns, whose tall structures sustain atlantes, and with a central flaring semicircular opening turning into a pointed arch. The display of stonework and the ironic citation of the columnar system appear to be traits characteristic of an architectural culture as synthetic as that of Spain's. FM

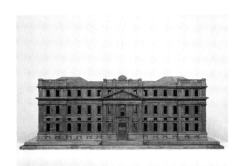

407 T
Unidentified Piedmontese master carpenter, after a drawing by Benedetto Alfieri (1751–56)
Model for the Palazzo del Senato (Curia Maxima), Turin, 1751–56
Turin, Museo Civico di Arte Antica di Palazzo Madama
Poplar, walnut husk with protective wax coating, 181 x 163 x 57 mm
BIBLIOGRAPHY: Michela 1841; Rovere, Viale, Brinckmann 1937: 70; Carboneri 1963: 56; Viale 1966: 70; Bellini 1978: 127–131; Gritella 1992: I, 514–520; Millon 1995: 413

The model, built after a design by Benedetto Alfieri (Bellini 1978: 131), has, according to Bellini, "leggere varianti" from Alfieri's Turin designs (The model, for example, does not have the Ionic capitals that Alfieri indicated in his drawing; Archivio di Stato, *Raccolta di disegni di varie fabriche R.i fatti [...] da me [...] conte Alfieri MDCCLXIII*). The construction works began in 1720 to designs by Juvarra. When works were interrupted in 1723, only the pavilion on the southeast corner and six bays on the eastern side (Via S. Agostino) were completed. Some documents indicated by Gritella (1992: I, 518–20, nos. 8–11) show that the corner pavilion and six bays of the east flank of the building were built through all three levels. (The completed southeast pavilion may be seen in a drawing of the state of the building in 1824 by Michela [Bellini 1978: 130, fig. 160].) When work began again on the palazzo in 1739–40, following Alfieri's designs, construction focused on the south wing (via Corte d'Appello) including the principal entrance and south-west pavilion. In this campaign not much more than the foundations were built (Michela 1841: 12) before work was interrupted in 1790. In 1788–90, G. B. Feroggia and G. B. Piacenza were able to build the south wing to the level of the top of the mezzanine windows before work was interrupted. Ignazio Michela completed the project in two further campaigns between 1824 and 1841. Michela preserved portions of the earlier designs but executed them in a more severe granite language. The model seems to have been commissioned at a time when there were no plans for construction at the palazzo, perhaps made to preserve Alfieri's design. The model is made to indicate with ease the allocation of spaces within the building for the Camera dei Conti (east flank), the Civil and Criminal section of the Senate (west flank) and living space for the uscieri in the northwest corner. The model is constructed in more than twenty sections so that it may be easily taken apart to display interior arrangements, structure,

and decoration. As it was never intended to be painted, care was taken to select pieces of poplar that would be consistent in texture and color. Contrasting wood tonalities were used to suggest different materials (columns of main entrance.) Sections of the base fit into one another with well-crafted splines, mortises, and tenons. The quality of sculptural and decorative detail on the interior indicate the interiors were intended to be viewed. Equal attention was paid to representation of the structure of walls, vaults, arches, piers, and columns. Considerable ingenuity is displayed in the selection of appropriate sections of the model to reveal significant portions of the structure. This model is an example of the developed expertise of model makers in the 18th century Italy. HM

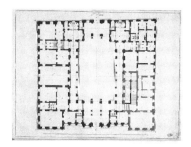

408a T
Studio of Benedetto Alfieri
Plan for the Ground Floor of the Palazzo del Senato Sabaudo
Torino, Archivio di Stato, Corte, Album disegni Alfieri
Pen, ink, watercolor over black chalk; 636 x 471 mm; watermark: PLZ, united as a cipher
INSCRIPTION: "P° Piano" (upper center); "20 Trabucchi" (lower center)
BIBLIOGRAPHY: Brinckmann 1931: 280; Carboneri 1963: no. 132; Bellini 1978: 127–31, fig. 147; Gritella 1992: 518, fig. 733/I

The plan of the ground floor of the Palazzo del Senato is one of four plans, at different levels, of the palazzo as redesigned by Alfieri in 1740. The plans are bound as folios 14–26 in an album of drawings of Alfieri's designs and are entitled "Disegni del nuovo R.I. Senato / fatti d'ordine di S.M. nel MDCCXLI e fondato in parte nello stess'anno / unito se ben con qualche variazione nell'esterno e nell'interno / all'esistente R.a camera de'conti / idea del celebre D. Filippo Juvarra distinta col rosso." A portion of the building, the southeast corner (lower right, in red), had been constructed following designs by Juvarra in the 1720s, but the remainder of his design was not executed. Juvarra's plans called for a roughly rectangular palace with a courtyard that was to house both the offices of the Senato (civil and penal) and the Camera dei Conti. The drawings by Juvarra for the palazzo are found in volumes in the Museo Civico and the Biblioteca Nazionale, Torino. They have recently been discussed by Gritella (1992: I, 514–20). Alfieri's design retained the portion constructed under Juvarra that held the Camera dei Conti. To unite that section to the new plans, Alfieri changed the order from Doric to Ionic, and added a balustrade above the attic that extended across the full length of the façade. Alfieri set aside the remain-

der of Juvarra's plans and proposed a Palazzo del Senato new in both plan and section, with both functions of the Senato to the west, the Camera dei Conti in its original location and quarters for the bailiffs to the northwest. Bellini (1978: 23ff.) calls attention to the considerable difference between Alfieri's exterior elevation and those of the varied interior elevations of the courtyard. The model was constructed following these plans in 1751–57. A limited portion of the main façade of the palazzo was built through the level of the plinth of the main order before work was interrupted. The building was built through the level of the mezzanine under G. B. Ferroggio and G. B. Piacenza in 1788, and finally completed under Ignazio Michela in 1841. HM

408b T
Studio of Benedetto Alfieri
Plan for the Basement of the Palazzo del Senato Sabaudo
Torino, Archivio di Stato, Corte, Album disegni Alfieri
Pen, ink, watercolor; 636 x 471 mm; watermark: PLZ, united as a cipher
INSCRIPTION: "Sotterranej" (upper center); "20 Trabucchi" (lower center)
BIBLIOGRAPHY: Brinckmann 1931: 280; Carboneri 1963: no. 132; Bellini 1978: 127–31, fig. 146; Gritella 1992: I, 520

The plan of the basement of the Palazzo del Senato is one of four plans, at different levels, of the palazzo as redesigned by Alfieri (1699– 1767) in 1740. The drawings are bound in an album of designs by Alfieri in the Archivio di Stato, Torino. Juvarra's design for the basement level is not known and in any case would only pertain to that portion of the plan beneath the Camera dei Conti in the southeast corner of the portion built under Juvarra's direction.The remainder of the plan represents Alfieri's proposal for the palazzo, only partially realized in his lifetime. HM

408c T
Studio of Benedetto Alfieri
Plan for the Second Floor of the Palazzo del Senato Sabaudo
Torino, Archivio di Stato, Corte, Album disegni Alfieri
Pen, ink, watercolor; 636 x 471 mm; watermark: PLZ, united as a cipher
INSCRIPTION: "2° Piano" (upper center); "20 Trabucchi" (lower center)
BIBLIOGRAPHY: Brinckmann 1931: 280; Carboneri 1963: no. 132; Bellini 1978: 127–31, fig. 148; Gritella 1992: 520

The plan of the second floor of the Palazzo del Senato is one of four plans, at different levels, of the palazzo as redesigned by Alfieri in 1740. The drawings are bound in an album of designs by Alfieri in the Archivio di Stato. The portion of Juvarra's earlier design that was constructed is shown in red at lower right. The remainder of the plan shows Alfieri's scheme for the spaces to be occupied by the Senato (west half of the plan) and the bailiffs (northeast corner). HM

Wren, Hawksmoor, and the Royal Hospital for Seamen, Greenwich
John Wilton-Ely

Nowhere else is the peculiarly English version of the Baroque style more triumphantly demonstrated, as well as the working of the social and political constraints that governed it, than in the building of Greenwich Hospital. In the evolution of Britain's greatest monumental classical composition, compromise was brilliantly exploited by Wren and expressive forms of great originality were fashioned by his assistant and amanuensis, Nicholas Hawksmoor. While, in many respects, the Hospital may be regarded as the cradle of the English Baroque style, the erratic and piecemeal construction history of this charitable foundation, created by stages over a period of over forty years and financed partly by donations and mainly by taxes and levies, still poses considerable problems of interpretation and authorship. The idea of an institution for retired seamen, based on the precedent of the Chelsea Hospital for military pensioners (1682–92), appears to have been first considered by James II. Fresh impetus, however, was given in 1692 when the surviving part of John Webb's palace for Charles II at Greenwich (a vacant shell since about 1670) was used to house the wounded from the naval victory of La Hogue. Sir Christopher Wren was consulted about a more permanent solution the following year in discussions with the Navy Commissioners, although the resulting scheme was never to be an official concern of the Royal Office of Works which he directed as surveyor-general. On 25 October 1694 the entire site of Greenwich Palace, except for Inigo Jones's Queen's House and the strip of land running from it to the river, was granted by William and Mary to the project, the Queen taking a particularly keen interest in the scheme, with a "fixt Intention for Magnificence" (in Hawksmoor's words), until her death the following year on 28 December. Eighteen months later, on 29 April 1696, a royal warrant was issued for the completion of the original Webb block and the addition of a base block behind. Wren, who gave his services without fee, remained surveyor from 1696 to 1716 when he was succeeded by Sir John Vanbrugh, followed in 1729 by Thomas Ripley. Vanbrugh had first become involved at Greenwich in October 1703 when he first attended a meeting of the directors of the Hospital in his capacity as "comptroller," the office of Wren's principal colleague in the Royal Works, but his contribution to the actual development of the design was comparatively minor. On the other hand, an increasingly significant role in the design was taken by Hawksmoor, who was continuously involved with the site from 1696 to 1735; first as Wren's personal assistant from 1696, then as clerk of Works from 1698 to 1735, and as deputy surveyor from 1705 to 1729. Wren's initial project, produced sometime before October 1694, was to be a grander version of his Chelsea Hospital with a cruciform hall balanced by a chapel to either side of a central domed vestibule. The existing King Charles Block (with a base block to its rear) was to be incorporated into the design as the furthermost of two wings on the west, toward the River

Thames, with matching wings across the court to the east (following the three-sided plan which Webb had projected for his palace but never built). However, this first project was problematic from the start since its central block with its prominent cupola was to be sited on the axis of the revered Queen's House by Jones (a Crown property and the official residence of the Earl of Dartmouth as Ranger of Greenwich Park from 1690) which was situated to the south, thus having its view to the river obscured. It would appear that Queen Mary objected to this defect in siting shortly before her premature death, and Wren's initial reaction in developing a second project was to move the entire composition to the east of the vista, leaving the original Webb building stranded. The overall plan would have consisted of a central domed block with chapel and hall as before, but with wings forming an open court facing the Thames on the north, and others creating a closed one to the south (see *The Wren Society* 1929: pl. X; 1931: pl. XXI). However, the centralized concept was abandoned altogether in favor of a third project, with an open vista, which retained the flanking wings toward the river from the first project, thus laying down significant constraints which were to determine the sites's subsequent history. The area covered by this third project would have occupied more land than the Crown was prepared to offer when the definitive site for the Hospital was granted in October 1694. In the third project, evidently datable prior to October 1694, the broad layout of the Hospital appears to have been established by Wren with a plan involving hall and chapel in their present positions to either side of the vista and each featuring a domed entrance. By 1696 Wren was officially surveyor to the Hospital and early in 1698 had produced designs for the great dining hall. Meanwhile, work on the King William Block, of which it forms the north side, had begun. Revisions, however, continued to be made and in a fourth project the concept of six parallel ward-blocks was reduced to four, and then to three. These latter were still to be on either side of the central vista as part of two balancing courts, closed by coupled colonnades which left the Queen's House spatially isolated: the King William Court to the west and Queen Mary Court to the east. The overall plan of the southern courts was changed yet again from a set of parallel dormitory blocks to those forming three sides of each court, having a building for officers on the fourth side, placed at the middle of each colonnade. By December 1698 the Fabric Committee evidently now felt the time was ready to publicize this fourth version or project as a definitive statement and decided to have engravings of the Hospital issued, including a plan by Nutting, a bird's-eye view from the north by Kip and a perspective from the south by S. Gribelin (this latter appears not to have been issued). In 1702 most of the carcass and external decoration of the King William Court, incorporating the hall, was finished to a design significantly different from that of Wren; a fact notably manifest in the western dormitory block. This part of the Hospital unequivocally suggests the hand of Hawksmoor, as Kerry Downes has effectively demonstrated. Although Hawksmoor had become deputy surveyor at Greenwich by 1705 and attended the directors' meetings in Wren's stead, he had been paid for work on the Hospital as Wren's clerk, or personal assistant, as early as 1796 when preparing drawings for his master. Although no drawings survive to document the highly idiosyncratic authorship of the west range of the King William Court in particular, Hawksmoor had clearly begun to take a significant role in design. The use of skilfully discordant elements of classical vocabulary, strikingly reminiscent of Italian Mannerism and displaying a skillful handling of solid geometry, were to become distinctive characteristics of the English Baroque style as it emerges in Hawksmoor's documented independent designs, as well as in his collaboration with Vanbrugh at Castle Howard and Blenheim. Hawksmoor's exceptional style of speculative draftsmanship, moreover, is quite discernible from the more restrained precision of his master's hand, even if Wren's final approval over any significant design decisions remained a necessary factor. Meanwhile, the Queen Mary Court opposite, containing the chapel, was only taken above its foundations under Thomas Ripley as surveyor between 1735–39 when it was carried out with a monotonous and uninspired regularity that contrasts so strongly with Hawksmoor's court opposite. Earlier, between 1700 and 1704, the carcasses of the Queen Anne Court, on the river front and balancing the King Charles Block, was completed to Hawksmoor's design but its arcaded ends (originally open) were not begun until 1716. Meanwhile, the west front of the Court, which was designed to respond to Webb's original palace elevation opposite, was not faced with stone until 1725 and 1728. Far earlier on, in 1711, a decision had been taken to double the northern end pavilions of the King Charles and Queen Anne Blocks using Webb's design four times along the waterfront but this was to be carried out over a number of years. As has been frequently observed, because of historic accidents Greenwich is a composition without a middle. No designer was more conscious of this lack of a Baroque climax than Hawksmoor, who clearly had developed a strongly creative attachment to the Hospital commission. From surviving drawings, Kerry Downes has skillfully reconstructed a sequence of at least three ideal schemes, devised mainly by Hawksmoor at some time between 1702 and 1711 on his own initiative and not for the Directors. These magnificent solutions would have involved a southern court, dominated by an imposing chapel and balancing the northernmost court bounded by the King Charles and Queen Anne Blocks. One of the projected courts has clear references to Bernini's oval piazza at St. Peter's while the chapel of another scheme derives inspiration from a wide range of sources including Bramante, Michelangelo and Borromini. The fact that there was no commission for this idea, let alone money for such a spectacular crescendo, clearly did not deter Hawksmoor, who was willing to block the river view of the Queen's House and, in one scheme, envisaged removing the Queen's House further south. He also played with the idea of devising an ambitious tunnel, inspired by the ancient Roman *Posillipo* near Naples, to carry the former public road to Woolwich under the intended vista. While these grandiose projects came to nothing, Hawksmoor continued to revise them well into the second decade of the new century when he published his *Remarks on the founding and carrying on of the buildings of the Royal Hospital at Greenwich* in 1728; the date of a new commission set up to finish the project. As the designer who had the longest association with the site, he pleaded for the completion of the Hospital on the scale originally envisaged by its founders. Although the Hospital's construction extended over a period of many years, by the end of 1704 accommodation was ready for the first pensioners and the initial intake of forty-two arrived in March 1705, two months after the official opening. There were 350 by December 1708, the year that Sir James Thornhill began the heroic task of painting the decorative scheme throughout the dining hall. Beginning with the Lower Hall, which was used by the pensioners, he produced on its ceiling a vast allegorical composition of his own devising, *The Glorification of William and Mary*, which not only celebrated Protestant constitutional monarchy but the triumphant role of England's naval power in countering Louis XIV's aggressive policies in Europe. Having completed this task in 1714, the artist proceeded to submit sketches for the Upper Hall, used by the officers. Since, in that year George I had succeeded Queen Anne, between 1717 and 1727 Thornhill painted a tableau on the west wall representing the new Hanoverian monarchy as well as patriotic fictive reliefs in grisaille on the flanking walls depicting *William of Orange landing at Torbay and George I arriving at Greenwich*. Hawksmoor continued as clerk of Works at Greenwich until 1735 during which time he was abruptly suspended during the political manoeuvres in the Royal Works, associated with Lord Burlington and the Neo-Palladian Revival's rejection of the principles of Baroque design. However, he had become disillusioned well before then over the Hospital commission with its frustrating delays and inadequate remuneration. Writing in 1726 to his patron, the Earl of Carlisle, he complained: "This place I desired the Lords of ye Admiralty to sink (as useless) and soe did all that were concerned for they knew that I had carryed on, and finished so much as was done of that fabrick; for little more than one hundred pds p annum" (Downes 1979: 249; letter, 28 May 1726). Also partly referring to this waste of opportunity represented by the great schemes unrealised at Greenwich, Vanbrugh wrote of Hawksmoor in 1721: "What a Barbarous Age have his fine, ingenious Parts fallen into. What wou'd Monsr: Colbert in France have given for Such a Man?" (Letters 1928, 138). The last major work on the Greenwich site took place later in the century when Wren's chapel, only completed in 1750, was gutted by fire in 1779. This was refashioned inside between 1780 and 1785 in a particularly ornate Neoclassical manner to the designs of James Stuart, surveyor to the Hospital from 1758 onward, who also replaced less prominent parts of the King Charles Block during these years, thus ending a century of architectural development at Greenwich.

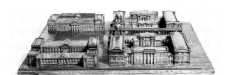

410
Nicholas Hawksmoor (1661–1736)
Site Model of Greenwich Hospital, ca. 1699
Greenwich, National Maritime Museum
Varnished oak; 114 x 70 x 577 mm
BIBLIOGRAPHY: *The Wren Society* 1929: 98, repr. pl. XXVIII; Wilton-Ely 1965: no. 2; 1967: 29, fig. 6; 1968: 254, fig. 8; Downes 1979: 87, fig. 25a; Beard 1981: 284; Beard; 1982: 62, fig. 47; Wilton-Ely 1993: 157, fig. 62

At Greenwich wooden models predictably fulfilled an important function in a commission which involved a complex site with a protracted construction history, a lengthy gestation period in design and changes in control, both in the Wren office and in the Fabric Commuter. This site model, of a relatively summary nature made of solid blocks with applied and incised detail, demonstrates the revised layout of the fourth project, as largely executed in stages over a number of years. By this stage in design the proposed dormitory blocks, flanking the vista running south from the chapel and hall to the Queen's House, are reduced in number and finally placed round three sides of courts – the King William Court to the west and Queen Mary Court to the east. These courts are closed by a colonnaded walk, flanking the central vista, together with substantial pavilions for officers' accommodation; the latter buildings were ultimately not built. Moreover, the model already shows the executed form of the controversial west block and linking units between the hall and south range, begun in 1699 and largely completed by 1702, which are stylistically attributable to Hawksmoor. The design of the two domes, meanwhile, shows the version as executed, having a richly columnar treatment of the drums with strongly broken entablatures and clusters of columns as four diagonal buttresses. While the corresponding ribbing on the roof surfaces, with oval windows between, are not shown, given the small scale of the model, these may have been painted on and subsequently obscured by later varnishing. This model is most likely to be the one referred to in a document recording that Hawksmoor was paid £15 in January 1699 for "making [i.e. causing to be made] the first Moddell of Greenwich Hospital. The maker of this model was probably the joiner John Smallwell. In 1700 he was paid a few shillings to provide a new box for "ye Moddle of Greenwich Hospll and mending ye moddle;" in March 1702 £4 for "making an addition to the gennerall modell and altering the same" and again in June 1707 for further repairs (Downes 1979: 87). This model is likely to have been the one which Wren took with him when he went, with John Evelyn and the archbishop of Canterbury, to discuss the Hospital with the king at Kensington Palace on 3 April 1700, since the diarist records that they showed William III "the Model & several drafts Ingraved" (*The Wren Society* 1929: 41; Evelyn 1955, V: 399). JWE

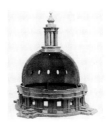

411
Nicholas Hawksmoor (1661–1736)
Greenwich Hospital
Sectional Model of Dome, ca. 1702
Greenwich, National Maritime Museum
Painted wood; 914 x 61 x 61 mm
BIBLIOGRAPHY: Wilton-Ely 1993: 157, fig. 61

This is among the earliest sectional models in British architecture and was probably among various such detailed works referred to in the building accounts. Although its maker is unknown, it is likely to be made by John Smallwell for who is documented as providing other models for Hawksmoor. As a demonstrational model for use in discussions by the Fabric Committee, it closely follows the final design, as executed by 1703, with the exception of the paired ribs on the roof which stop short of the drum entablature. JWE

415 MAR
Nicholas Hawskmoor (1661–1736)
Third Project for Greenwich Hospital
Working study for Dome and Entrance Vestibule of Hall, before October 1694
Oxford, All Souls' College, IV, no. 23
Pencil; 527 x 381 mm
PROVENANCE: Acquired for All Souls' College at a London auction in 1749 by Dr Stack, FRS
BIBLIOGRAPHY: *The Wren Society* 1929: 97, repr. pl. XXIII; Fuerst 1956: 91–95; Downes 1971: 114; 1979: 84 n. 4, 85, 281 no. 363; Beard 1982: 62; Downes 1982a: 109; 1982b: 94, no. 9

In this sheet, with its complex series of inter-related studies of the hall vestibule of Wren's third ("Seven Block") project, the hand of Hawksmoor can be seen at work, still essentially in the role as a collaborating draftsman. Although not to be clerk of Works at Greenwich until July 1698, Hawksmoor was paid for work as Wren's personal clerk over the previous two years. This exploratory drawing shows in particular the plan, elevation and section of the east entrance to the hall vestibule with a double-skin dome over it. Since the plan extends to the center line of the nearest pavilion ward to the south of the hall, of the six projected for this side of the King William Court, it also shows the pier bases of the arcaded loggia which was intended to link these buildings. At the top left part of the sheet a transverse section of the pavilion in question can be discerned. JWE

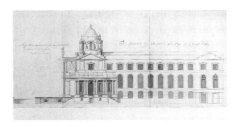

420 T
Nicholas Hawksmoor (1661–1736)
Fourth Project for Greenwich Hospital, Study for the North Elevation of the Great Hall, ca. 1698
London, Sir John Soane's Museum, I, 44
Pencil, pen, watercolor on 2 joined sheets, with patches pasted down; 360 x 825 mm
INSCRIPTION: "The Manner of the portico and steps into ye Great Hall / Refectory Grenvicani facies Septentrion / Is / cum porticu et Scala accessoria / Vestibulum ascende"
PROVENANCE: Acquired by 1831 from unknown source by Sir John Soane
BIBLIOGRAPHY: *The Wren Society* 1929, VI: pl. XXVII; Downes 1970: 43–44; 1971: 114–15; 1979: 84–85, 281 no. 366; *Soane* 1995: no. 11, repr.

In this elevation of the east façade of the dining hall, considerable attention is paid to evolving the composition of the domed vestibule. Among the four patches placed over earlier ideas, one shows a lower dome than a taller version underneath it; another shows the addition of a two-storey colonnade featuring a naval trophy, and two others indicate alterations to the podium for the circular pedestals around the dome. (These pedestals are reminiscent of the circular Roman altars Hawksmoor was to set at the east end of the Greenwich parish church of St. Alfege, designed in 1712.) In this phase of design, the first signs of a more dynamic treatment of drum and cupola at Greenwich begin to emerge, closer to Wren's western towers of St. Paul's and raising the issue of new developments within the later Wren style. Below the vestibule, the change of level from the upper courts to the lower one is no longer provided by a large flight of steps, as in the previous design but by two lateral flights of steps flanking a heavily rusticated door. The characteristic mark of Hawksmoor is also found in the inscriptions with frequent use of Latin. JWE

413
Nicholas Hawksmoor (1661–1736)
Study for Elevation and Half-Plan of Dome Lantern, Greenwich Hospital, ca. 1702
London, Sir John Soane's Museum
Pen and ink; 499 x 238 mm
PROVENANCE: acquired by 1831 from unknown source by Sir John Soane
BIBLIOGRAPHY: *The Wren Society* 1929: repr. 90; Downes 1979, 281 (no. 369); *Soane* 1995

This drawing from Hawksmoor's hand concentrates on resolving the aspects of the lantern crowning each of the domes and making it significantly higher than that in the previous design. While the profile of the finial comes close to the executed version, the console brackets at the base of the pilasters were to be omitted. JWE

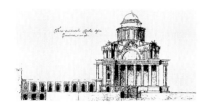

418 W
Nicholas Hawksmoor (1661–1736)
West Elevation of a Proposed Chapel, Greenwich Hospital
London, Courtauld Gallery, Blunt Collection
Pen and brown ink, some pencil and gray wash; 368 x 750 mm
INSCRIPTION: "Facies Occidentalis Capellae Regiae / Grenvicam anno 1711" (above); "Grand facia; Colonade; 200 feet high in all" [i.e. to top of dome]; "Original sketch by Sir John Vanbrugh" (lower and top right, added subsequently)
PROVENANCE: Gardner Collection (?); Prof. G. F. Webb; Courtauld Institute, 1960
BIBLIOGRAPHY: Courtauld Institute of Art 1961: 15 no. 21; Downes 1966: 52; 1970: 96–100; 1979: 94–96, 281 no. 356

In terms of the full expression of the Baroque style in English architecture, few designs rival those represented by the series of ideal projects for providing a fitting climax to the monumental composition at Greenwich, largely attributable to Hawksmoor and drawn up on his own initiative, sometime between 1702 and 1711 (only three of the drawings concerned are actually dated, and then to the latter year). Already when working as Wren's assistant in 1699, he appears to have considered some form of alternative terminal designs for the southern end of the vista, as expressed by two models (now missing), produced in 1699 in order to be added to the surviving site model. According to reconstructions by Kerry Downes of at least three distinct schemes, all the surviving drawings for this idea involve the creation of a further court south of the colonnades flanking the King William and Queen Mary Courts and balancing the riverside court at the northern end of the major axis. This new court was to feature a large central chapel which would have cut off the river view of the Queen's House: ironically the source of the visual dilemma in the first place. The design of the third scheme, which includes this and two other drawings dated 1711, would also have involved an exceptionally impressive chapel. Hawksmoor's structure, linked by extensions of the existing colonnades to the northern courts of the Hospital, takes the plan of a Greek cross within a square and is surrounded by a Doric peristyle, with a concave-sided attic storey, a circular drum and hemispherical dome. As in the previous (second) scheme, in order to accommodate such a vast addition to the existing site, the architect devised a large tunnel (shown entering a rusticated arch in the sectional part of the drawing) to take the former Deptford-Woolwich road underneath the chapel. Oval enclosures, some 80-feet-wide, would have opened out from it to either side of the chapel. Another sunken level, shown sectionally in the drawing, with triple arches under the arcade linking the chapel to the William and Mary Courts, may have been intended to accommodate the New Road (the present Romney Road) constructed further north from the other one. This drawing with its fluency and painterly qualities of line and washes shows Hawksmoor to be one of the most outstanding draftsmen of his time and reveals that powerfully pictorial and visionary imagination which found the limitations of the Greenwich commission both challenging as well as frustrating. J.W-E.

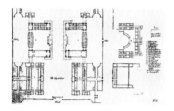

412 T
Nicholas Hawksmoor
Site Plan with proposed Infirmary on the West, Greenwich Hospital, 1728
Greenwich, National Maritime Museum, MS.9957, fols. 7
Pen and ink; 521 x 724 mm
BIBLIOGRAPHY: *The Wren Society* 1929: repr. pl. XLV; Downes 1979: 281 no. 362

By 1728 when a new commission was set up to complete the buildings of the Hospital, Hawksmoor was involved in designing an infirmary to the west side of the King William Court.
This block plan shows the site as largely existing today, with some relatively modest pavilions added to the southern ends of the William and Mary Courts (but never built) and the proposed infirmary with three wings round a court linked by a semicircular colonnade.
In the infirmary plan, which is shown in more detail in a drawing reproduced in *The Wren Society* 1929: pl. XLIX, Hawksmoor shows careful attention to the specialized accommodation required and also demonstrates his antiquarian interests in reviving the domestic forms of antiquity by providing a tetrastyle hall at the entrance. JWE

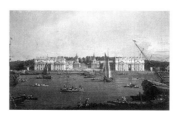

421 T-MAR
Giovanni Antonio Canal called Canaletto (1697–1768)
Royal Naval Hospital, London, from the North Bank of the Thames, ca. 1753

London, National Maritime Museum
Oil on canvas; 66 x 112.5 cm
PROVENANCE: Col. B. P. R. Thomson, Windsor; A. M. Thomson; Miss Beatrix Thomson; with Spink, London; Sir James Caird, by whom presented to present owners in 1939
BIBLIOGRAPHY: Constable 1989: I, pl. 75; II, 408–409, 738, no. 414, with additional bibliography; *Canaletto & England* 1993–94: 92, no. 30; Links 1994: pl. 173

Canaletto's views of Venice had by the middle of the eighteenth century established his reputation as one of the greatest topographical painters of all time, and a large number of these paintings had previously entered English collections. The outbreak of the War of Austrian Succession in 1741 significantly disrupted the flow of foreign visitors to Venice, and the demand for Canaletto's work on the part of the English declined considerably. So in an effort to rekindle the enthusiasm for his work among the English, the artist left his native city in 1746 for London. He returned briefly to Venice once during his English sojourn in 1750-51, and he appears to have left permanently sometime after 1755. The paintings of Canaletto's English period are as fresh and vivid as his Venetian views and for many their delicate luminosity (less blinding sun) and color (lighter blues and greens and earth tones) are equally appealing. His English patrons were some of the most influential men of their day, and the subjects of his English paintings included several views of the River Thames and many of the most important buildings and sights to be seen in London and its environs such as Old Somerset House, Westminster Abbey, Northumberland House, Vauxhall Gardens, Windsor Castle, and Eton College Chapel. The influence of these paintings on English landscape and topographical painters lasted well into the next century. *Royal Naval Hospital, London, from the North Bank of the Thames*, is a brilliant snapshot of the magnificent architectural ensemble which Samuel Johnson, visiting in 1763, found "too magnificent for a place of charity" and "too much detached to make one great whole" (quoted by Bold 1996: 623). Canaletto's view, one of the few examples of a London subject which remains largely unchanged today, is taken slightly to the left of center from the opposite bank. The composition is full of enlivening detail such as the hulls, masts, and poles that Canaletto has juxtaposed against the architectural backdrop. The foreground is deliberately darkened in contrast to the silvery light on the building façades, and it has been suggested that the scene has been depicted on a summer evening. EPB

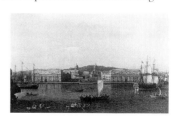

422
View of the Royal Naval Hospital, Greenwich
London, deposited at the Tate Gallery
Oil on canvas
54 x 94 cm

Hawskmoor, Gibbs and King's College, Cambridge
John Wilton-Ely

During the first half of the eighteenth century both the Universities of Oxford and Cambridge saw a series of ambitious building program undertaken – some projected and others partly executed – which involved Nicholas Hawksmoor and James Gibbs. In at least one commission at each university (represented by models and drawings in this exhibition) Hawksmoor's initial ideas were taken over by Gibbs and carried out in executed buildings, although they were considerably altered in formal terms according to a shift in contemporary taste away from the Baroque toward Neo-Palladian principles of design. Dr John Adams, provost of King's College, Cambridge, from 1712 to 1719, soon after his election to that position, decided to complete the college layout according to the intentions of its medieval founder, King Henry VI, as specified in the sovereign's "wille and entent" of 1448. In 1714 Adams launched a building fund with Queen Anne as a prospective donor, by which time he had already approached Wren as the principal royal architect. The latter evidently delegated the task to his assistant Hawksmoor, who drew up preliminary designs in 1712–13, as represented by a group of numbered drawings sent to the college, which remain in the library there. This scheme involved a large court, about 250 feet square, with Henry VI's impressive medieval chapel (constructed between 1446 and 1515) on the north side, the dining hall with kitchens in the same block, opposite to it on the south, and two further blocks of lodgings on the west and east; the latter block, or range, having the main college entrance facing the street. To the west of this large court was to be a shorter one, open to the river, with the provost's lodging behind the south range, and behind the north range was to be a cloister, facing the western approach to the chapel and incorporating a bell tower. Because of the great size of the chapel, Hawksmoor was clearly anxious to provide a group of impressive façades overlooking the east court and to diversify their appearance considerably, rather than unify them with a common design, in order to respond to the pictorial character of the dominant Gothic building.

In March 1713 Adams recorded three visits to Hawksmoor at Kensington, in London, (Wren and his son were present on one of these occasions) during which his initial designs were discussed. Also on one of the visits two wooden models were produced for the provost's inspection, and these appear to be the pair now housed in the College Chapel. According to Adams's account, he took exception to the columnar treatment of "ye upright model" as well as the arrangement of the studies and bedrooms of the accommodation block on the west side of the court. While it is important to stress that the "upright model" referred to was clearly a drawing, according to the terminology of the time, one of the two wooden models, which appear to represent the west range in question,

possesses a similar handling of columns, (although at the level of the second and third floors only). This same model also shows the room arrangement inside that the provost criticized. Adams's objections were met by Hawksmoor with another design for the same block in which the columns were replaced by a pilaster order at the center of each main façade, while the studies and bedrooms were shifted to the quieter, river front, overlooking the western court. Significantly, the other surviving wooden model reflects these changes, both externally and internally and was clearly used to clarify these alterations in design.

Although Adams' fund for the rebuilding had reached £ 3,000 by 1716, the death of Queen Anne as royal patron in 1714 and that of the provost himself in 1719, removed a considerable impetus from the project. Although Hawksmoor died in 1736, the fellows of King's College decided to consult James Gibbs instead about continuing the rebuilding project, particularly since the latter architect was already involved in drawing up plans for the University's Senate House by 1721. While Gibbs was to follow Hawksmoor's layout for King's College to a considerable degree, there was less funding available by this time and, according to the engraving published in 1741, he proposed a group of three blocks round the eastern court only. The block containing the hall and kitchens on the south side has a large Corinthian portico facing the medieval chapel, while two detached and matching fellows' buildings were to be located on the east and west sides respectively. In Gibbs's design the uniform character in each of the three elements reflects the far greater restraint of contemporary Neo-Palladian taste and, owing to lack of sufficient funds, only the eastern of the two fellows' buildings was eventually built between 1724 and 1732.

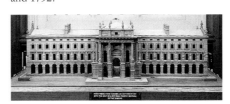

423 T
Nicholas Hawksmoor (1661–1736)
First Model for the Fellows' Building, 1713
Cambridge, courtesy of the Provost and Fellows of King's College
Pinewood; 5080 x 1520 x 177 mm
BIBLIOGRAPHY: *City of Cambridge* 1959: I, 103–104, pl. 37; Downes 1966: 114; Wilton-Ely 1968: 254–55, fig. 11; Downes 1970: 80–83; Pevsner 1970: 94–95; Downes 1979: 110–17, pl. 34a; Friedman 1984: 232, pl. 257; Downes 1987; Colvin 1995: 478

This is one of the two wooden models (as opposed to "upright models" in contemporary terms) which Provost Adams refers to in a letter as awaiting his inspection "ready made at Sir Christopher Wren's" (quoted in Willis and Clark 1886, I: 559). While the eastern exterior of the model indicates the initial boldness of

Hawksmoor's columnar treatment at the center, to which Adams objected, it shows a modification from the full giant Corinthian order of the initial design represented by sheet no. VIII to pairs of Doric columns on rusticated bases running the height of the second and third floors. The attic above is articulated by additional pilasters and urn finials. In terms of fenestration, apart from giving the windows of the *piano nobile* a trabeated rather than the arcuated form of the first design, together with the addition of molded window frames and keystones, the architect has also provided the attic storey with a series of long narrow windows.

JWE

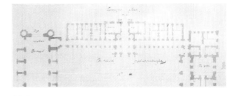

424 T
Nicholas Hawksmoor (1661–1736)
Projected Plan for the East Side of the Front Court, ca. 1713
Cambridge, courtesy of the Provost and Fellows of King's College, Inv. no. NH 1, no. IIII
Pen and wash; 490 x 1105 mm
BIBLIOGRAPHY: Little 1955: 63–64; *City of Cambridge* 1959, I: 103–104, pl. 37; Downes 1966: 114; Wilton-Ely 1968: 254–55, fig. 11; Downes 1970: 80–83; Pevsner 1970: 94–95; Doig 1979: pl. 1; Downes 1979: 110–17, pl. 34a; 1987: 278, no. 161–no. IIII of complete design; Colvin 1995: 478

This plan for the easternmost range of the entrance court is one of a sequence of five plans by the architect within a numbered set of drawings given by the architect to the college. The layout follows the founder's intentions to a considerable extent in terms of the size of the court, as well as the location of cloister and bell tower, west of the chapel in the other court. As Downes points out, the integration of the various buildings in the design is governed by intersecting axes and sight lines rather than through uniformity in appearance between the various buildings. At this stage in design, the eastern block was to have giant columns flanking the central bay on both its main façades while the major axis, running through the central arches of each block, was to be in line with a bridge over the river on the western perimeter of the site. JWE

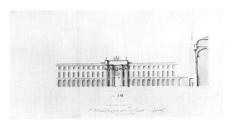

425 T
Nicholas Hawksmoor (1661–1736)
Projected Elevation for the East Front of Fellows' Building, ca. 1713
Cambridge, Provost and Fellows of King's College, Inv. no. NH 1, no. VIII
Pen and wash; 514 x 1080 mm

INSCRIPTION: "No. VIII / 'Another manner of / An Inward Front of the West side of the Great Quadrang.le / as first proposed to be built.'"
BIBLIOGRAPHY: Willis and Clark 1886: I, 556; *City of Cambridge*, I: 103–104, pl. 37; Downes 1966: 114; Wilton-Ely 1968: 254–55, fig.11; Downes 1970: 80–83; Pevsner 1970: 94–95; Doig 1979: pl. 7; Downes 1979: 110–17, 278, no. 164–no. VIII; Colvin 1995: 478

This is among the set of numbered drawings indicating the initial proposal for the new buildings and indicates the considerable height of the adjacent chapel, shown in section as attached to the north end of the proposed accommodation block. Clearly, in the architect's view, this monumental Gothic structure required the strong statement provided by the triumphal-arched center of his new range, with its paired giant columns in the Corinthian order, paralleled by a similar columnar treatment on the ranges of the two other sides of the court. Evidently, the practically-minded provost thought otherwise. JWE

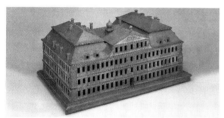

428 T
Philipp Marcus Österlin
Model for Rebuilding the Gymnasium Poeticum, Regensburg, 1728
Tinted hard wood; 35.6 x 112 x 18 cm
Regensburg, Museen der Stadt, Inv. no. KN 1999/9
BIBLIOGRAPHY: Gumpelzhaimer 1837: 598–607; *1542–1992. 450 Jahre evangelische Kirche in Regensburg*" nos. 160–161; Reuther, Berckenhagen 1994: no. 297 (model); Schmid 1995: 120–21 (with detailed bibliography); Spies 1995: 124–26; Bauer 1997: 321–324

The front façade of the model bears the words, "Elevation of a Gymnasium according to the model built for His Excellency, the Lord Chamberlain and Councillor in Regensburg / presented by his obedient servant Philipp Markus Österlin." This "Fronte gegen Mitternacht" shows a massive three-part structure, with the two side wings higher than the central body. The side wings have two-storeyed hipped roofs, embracing the main façade by means of a triangular pediment. This threefold building is further incorporated by the horizontals, accentuated through the use of rusticated ashlar stonework between the windows and as corner solution. Above the rather plain portal appears the coat of arms with the crossed keys, emblem of the city of Regensburg, the owner of the building, and the Sphaera that caps the pediment, representing the sciences taught at the Gymnasium. The model possesses five superimposed horizontal levels, which can be lifted out to demonstrate the respective divisions of the floor plans at one and the same time. The rooms are partially furnished with ta-
bles, tiled stoves; in levels 1 and 2 of the upper floors there is a considerable number of "secret closets" (water closets). Several rooms of the model, never to be built in this form, still have tabs stuck to the floor, where we can read their intended functions. This is explicit from the floor plan of the master builder Johann Georg Schlee, dated the 14th January 1726. The parts in black show the sections of the old building to be incorporated in the structure, while those in red show new construction. The most striking feature of the new building is the large theater auditorium in the west wing which, *inter al.*, includes "a machine for lowering the actors."
 MA

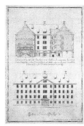

429 T
Johann Georg Schlee
Section and elevation of a project for the Gymnasium Poeticum, 1725
Regensburg, Museen der Stadt Regensburg
Drawing; 70.5 x 47.5 cm

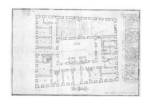

430 T
Johann Georg Schlee
Plan of a project for the Gymnasium Poeticum 1716
Regensburg, Museen der Stadt Regensburg
Ink; 47.4 x 83.5 cm

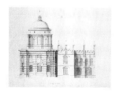

433 T
Nicholas Hawksmoor (1661–1736)
Fourth project for the Radcliffe Library, 1710-13
Oxford, The Visitors of the Ashmolean Museum
Pen and ink; 52 x 71 cm

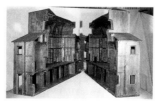

436
Alessandro Dori (1702–72)
Model of the Biblioteca Marucelliana; ca. 1740–50
Florence, Biblioteca Marucelliana
Popular and maple wood; 103.5 x 135 x 55 cm

As in the rest of Europe, the idea of public libraries in Italy initiated in the seventeenth century and reached its apex in the eighteenth. Due to the numerous presence of scholars and bibliophiles in Florence, two libraries were opened there in a very short space of time. Firstly, the Magliabechiana in 1747, provided for by Antonio Magliabechi and set up in a large room already used as a theater near the Uffizi. Secondly, the Marucelliana in 1752, conceived by Abbot Francesco Marucelli, who was born in Florence in 1625 and died in Rome in 1703. In poplar and maple wood, the model is made up of two symmetrical parts articulated into three distinct bodies. The highest one in the center houses the reading room while the great staircase, a flat and smaller rooms for the library's internal use are in the two lower lateral bodies. Traces of india ink on the exterior indicate both the façade of the library and the buildings next to it. The reason why the model can be opened up and therefore inspected inside is easily explained with the reasons that led to its making and conservation. It was, in fact, presented, together with the relative drawings, by the Roman architect, Alessandro Dori (Rome 1702–72), to Alessandro Marucelli. Alessandro engaged the architect Dori to design the building, in collaboration with the Florentine Innocenzio Giovannozzi. However, at the moment of starting work, another nephew, Francesco, the youngest of the family, who had initially been in favor of the project, suddenly changed his mind and presented an alternative design by the Florentine Giovanni Filippo Ciocchi. The argument was taken to the courts and only resolved after a long series of reports and surveys, for which the documentation produced by Alessandro in support of Dori's project was fundamental. Work finally got under way to Dori's plan and in 1752 the Biblioteca Marucelliana opened its doors to the public. RT

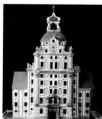

437 T
Johann Gotthard Hayberger (1695–1764), from a planimetry by Father Anselm Desing
Model of the Astronomic Observatory of the Abbey of Kremsmünster above the door known as Brückentor
ca. 1740
Kremsmünster, Astronomic Observatory
Wood with polychrome finish
78 x 64 x 34 cm
SOURCES: Desing 1759; Doberschitz, *Specula Cremifanensis*, 1764, Kremsmünster, Stiftsbibliothek, Cod. nov. 1048
BIBLIOGRAPHY: Klauner 1967; Krinzinger 1976: 259–87, figs. 163-64; Pühringer, Zwanowetz 1977: 42ff.; 1979: 135–72, figs. 137–64; Reuther and Berkenhagen 1994: 95, no. 223a; Klamt 1998

The model is of Father Anselm Desing's (1699–1772) first plan for the Kremsmünster's astronomic observatory, which was never built. He was the architect for both of the observatory's projects and he had probably entered into contact with the abbey of Kremsmünster after his appointment to the Benedictine University of Salzburg. To build an astronomic observatory in a Benedictine abbey was undoubtedly an unusual endeavor in the mid-eighteenth century. Since Charles VI had intended to build a Benedictine academy in Vienna, the Kremsmünster project could be interpreted as a consequence of this idea. The decision to place the observatory on the Brückentor was not determined so much by the fact that the main door to the abbey was particularly suited to the purpose, but, rather, that there was a need to logically fill the architectural void caused by Jakob Prandtauer's Baroque architecture. According to the sources, the model can be traced back to 1740 and it is attributed to Johann Gotthard Hayberger. It presents a solution that was autonomously developed from a plan made by Desing, who wrote out the project's every detail by hand, leaving a record for the ages. Desing's project provided for a "hohen Palast," a five-story palace topped by a terraced roof. This is a characteristic that the monks of Kremsmünster disdainfully compared to a molar. It also varies from the model in other areas. Aware of the criticisms, Hayberger designed the observatory as a tower, making it correspond with the two Baroque towers of the church's western façade. Located between two parastades, whose capitals are in the shape of a sun and a moon, the central forepart supports the astronomic observation room both visually and symbolically. As the sources state, the project for the observatory was abandoned in 1741. In its place, construction for an academy for the nobility was begun in 1743 on a design by Johann Blasius Franck. The observatory was finally built in Hofgarten between 1748 and 1758. It was based on a new project designed by Anselm Desing in which the building was projected as a freestanding element, similar to a Rococo "skyscraper" in its structure. A central protruding element, acting as a tower and formed by three sides of a polygon, dominates the lateral wings, which are topped by roof-terraces. The crown is composed of a two-story structure with angular pavilions and a central pavilion on the southwest side. Externally, the building is characterized by a series of vertical bands. The stringcourses above the second and fourth levels of the lateral wings create a horizontal accentuation. ASt

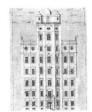

438 T
Johan Blasius Franck and others
Drawing for the model of the observatory, 1744
Kremsmünster, Sterwarte, Stift Kremsmünster
50 x 74 cm

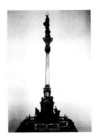

439 T
Johann Lucas von Hildebrandt (1668-1745) and Benedikt Stöber, sculptor
Sample Model for a Votive Column Dedicated to the Virgin Mary, 1710–11
Salisburgh, Salzburger Carolino Augusteum, Museum für Kunst und Kulturgeschichte, Inv. no. 4710/49
Wood with polychrome and gold finish; wax figurines in oil; figurine of the Virgin, not original, wax on plasticine (replaced in 1988)
191 x 93 x 93 cm; height of figurine: 35 cm
INSCRIPTIONS: dedication on three cartouches on the pedestal: "franc[iscus] anton[ius] / s.[acri] i.[mperii] princeps / [de]harrach / [archiep]is[copus] / salzburgensis / devot[um] erectum divae virgini / sine labe conceptae / agni immaculati / genitrici super omnes [sanctae] ecclesiae ... / inimicos triumphan[tae] [h]oc monumentum / posuit dicavit / et consecravit anno salutis mdccxi[i] archiepiscopatus quarto mensis dez. die viii"; on the pedestal itself: "superstito", "idolatria", "heresis" e "pec. origenal", in reference to the allegories.
BIBLIOGRAPHY: *Österreichische Kunsttopographie* 1914: 232; *Fischer von Erlach* 1956-57: 91, no. 25; Bauer 1988; *Triumph der Phantasie* 1998: 161ff., no. 39, fig.; Kern 1998: 79

Undoubtedly, the creation of Johann Lucas von Hildebrandt, the votive column, which probably dates back to 1710 or 1711, represents a model that was never actually built. The emblem and the inscription on the pedestal refer to Franz Anton Harrach, archbishop of Salisburgh from 1709. The date of the consecration is marked as December 8, 1712. The model was born of a collaboration between the court's carpenter, the Viennese Matthias Rueff, and the sculptor, Benedikt Stöber, to whom the sculpted wax portions of the model are attributed. The variety of the materials employed produces a contrast in colors, which, on the one hand, accentuates the tripartition and on the other, creates a relationship between the parts. Hildebrandt referred to a typology of the seventeenth century, which was used in the Marian column (Mariensäule) in Munich, for the formal presentation of the column of the Virgin Mary. That same column was used as a sample for his subsequent work. Comparisons can easily be drawn between the formal structure of the two monuments, as well as between the use of materials, which emphasize their functional nature. There is also a similarity, however, in the nonconformist characteristics of the iconography. In the Salisburgh model, the Madonna triumphs over superstition, idolatry, heresy and original sin. In terms of iconography, the Salisburgh monument belongs to the *"Purísima"*

style, which was very widespread in the seventeenth and eighteenth centuries, even if the Madonna depicted here differs from the prototype in Munich. Worked with the utmost care in its every most minute detail, the model is also fascinating for its variegated polychrome finish. From the model it can be deducted that the baluster, the pedestal and the column's shaft should have been made of a marble unlike that found in Salisburgh, and that the base, the capital and the figurines were intended to be made in bronze. ASt

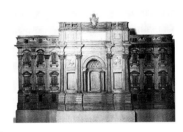

440
Nicola Salvi (1697–1751), architect and Carlo Camporese, model maker
Model for the Trevi Fountain in Rome
Rome, Museo di Roma
Painted wood and plaster; 180 x 340 x 67 cm; restored in 1953–54
PROVENANCE: Palazzo Albani del Drago, Museo di Castel Sant'Angelo
BIBLIOGRAPHY: Pistolesi 1855; Cooke 1956: 159; Schiavo 1956: 125–29; D'Onofrio 1957: 257; *Il Settecento a Roma* 1959: 264; Pinto 1986: 175–76; Pinto in Contardi and Curcio 1992: 70–75

In July of 1733, Nicola Salvi was reimbursed for his part in supervising the construction of a large wooden model of the Trevi Fountain executed at 1:15 the scale of the original. The carpenter Carlo Camporese fashioned the model, for which he was paid 120 scudi in June, 1735. Salvi's presentation drawing of 1732 corresponds to the model in every particular, including the absence of the crumbling corner pilaster that appears at the eastern corner of the fountain as executed. As a three-dimensional representation of the Trevi, however, the model illustrates one important aspect of Salvi's design that his two-dimensional façade elevation could not: the continuation of the fountain's façade around the corners of the lateral wings, where it extends back two bays in depth. The main façade of the Trevi, of course, was never allowed to envelope the recently constructed wings of the Palazzo Poli and remains a two-dimensional veneer. Salvi's model, however, shows how concerned he was as an architect to establish a more logical and coherent three-dimensional relationship between fountain and palace façade, and if his intentions had been followed, the appearance of the Trevi would have been considerably enhanced. The wrap-around extension of the main façade resembles Michelangelo's Palazzo dei Conservatori, especially in the way it was intended to convey an illusion of three-dimensional depth and continuity, while in reality being nothing more than a thin veneer applied to a preexisting palace. The two-bay extension of the façade toward the rear appears in many early prints representing the Trevi that were drawn after the model and not the monument itself. JP

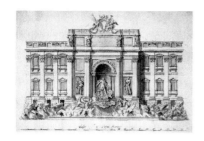

441 T
Nicola Salvi (1697–1751)
Elevation of the Trevi Fountain in Rome, 1732
Rome, Gabinetto Comunale delle Stampe, G.S. 880
Pen, ink, watercolor, pencil under drawing on heavy
cream-colored paper; 397 x 557 mm
INSCRIPTION: "Scala di Palmi Romani" along the
bottom border; scale = 240 *palmi*
PROVENANCE: Bequest of A. L. Pecci-Blunt, 1971
BIBLIOGRAPHY: *Il Settecento a Roma* 1959: 265; *Roma sparita* 1976: no. 34; Pinto 1986: 60–63; Kieven
1991: 68–70

Salvi's design, just as the executed fountain, fuses
the architectural forms with sculpture and water into a monomorphic unity. By simplifying the architecture of the centerpiece into the form of a triumphal arch replete with a projecting attic level, he
assures the dominance of the fountain. At the same
time, by continuing the colossal order across the
two wings Salvi effectively binds palace and fountain. With the exception of the pilaster base at the
right corner, which is not shown to be crumbling,
Salvi's rendering of the architectural component of
the fountain corresponds in every detail to the Trevi as it appears today. The basin and the artificial
marine reefs, or *scogli*, however, differ substantially
from the fountain as executed. Salvi's depiction of
the statuary, too, contrasts with what we see today.
The basin is smaller than at present, meeting the
façade at the midpoints of the lateral pavilions,
while as built it embraces all but the outermost bay
of each wing. Since Salvi's rendering is an orthogonal projection, it is difficult to judge accurately the
three-dimensional development of the *scogli* without a plan corresponding to his elevation. Although
Salvi repeatedly altered his design as work progressed, at least one feature of the *scogli* must have
been planned from the outset: the drawing shows
several plants, the flora eventually carved by G.
Poddi and F. Pincellotti, sketched on the surface of
the *scogli* and against the rusticated basement. JP

442 T
Virginio Bracci (1737–1815)
Copy after an Elevation of an Unexecuted Project
for the Trevi Fountain
Montreal, Centre Canadien d'Architecture–Canadian Centre for Architecture, DR:1966:001:102
Pen, ink, watercolor; 46.3 x 71.1 cm
BIBLIOGRAPHY: Gradara 1920: tav. 29; Pinto 1986:
119; Kieven 1987: 274; 1998: 97–98; Garms 1993:
74–77

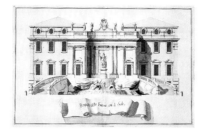

448 M
Virginio Bracci (1737–1815)
Copy after Two Variant Plans of the Trevi
Fountain
Rome, Istituto Nazionale per la Grafica
FN 32057 (6715)
Pen, ink, watercolor; 41.1 x 72 cm
BIBLIOGRAPHY: Rotili 1954; Cooke 1956:
156–157; Pinto 1986: 114–121; Kieven 1988:
97–98; Garms 1993: 74–77

The distinguished Roman sculptor and architect Pietro Bracci formed an extensive study
collection of drawings by his own hand and by
others, which was subsequently expanded by
his son Virginio. Eight drawings once in the
family archive relate to the Trevi Fountain; two
of these may be attributed to Virginio Bracci on
the basis of style, and are copies of lost originals
representing proposals for the completion of
the Trevi Fountain made between 1730 and
1732. Among the competitors for the commission to embellish the Trevi at this time were
Luigi Vanvitelli and Nicola Salvi, and scholarly
opinion is divided on which of these two architects was the author of the project depicted in
this plan and elevation.
The elevation is clearly generated from the right
half of the plan, which features a broad staircase curving out from the central fountain display. This project focuses on a colossal statue
personifying Rome, represented standing and
holding two symbols: an olive sprig and the
crossed keys of Saint Peter. Roma is set within a
deep exedra. A second embracing concavity,
formed by the stairs, frames the fountain itself,
which is adorned by statues of reclining river
gods. The elevation respects the existing fenestration of the Palazzo Poli façade while expanding the fountain laterally to overlap one
bay of each wing. The central pavilion projects
far beyond the two wings of the palace so as to
allow access to the curving staircase. Engaged
columns, as well as paired freestanding
columns within the exedra articulate the central
pavilion. In the attic zone of the wings appear
oval windows, while on the skyline of the fountain proper six statues of unidentifiable figures
gesture toward the papal escutcheon, which
provides a central vertical accent.
On the basis of style, Elisabeth Kieven has
identified the author of this unexecuted project
as Nicola Salvi. The inscribed banderoles present in both drawings further support the view
that Bracci copied an original drawing by Salvi.
Jörg Garms, on the other hand, has recently
proposed Luigi Vanvitelli as the author, making
comparisons to a newly discovered autograph
drawing by Vanvitelli for the Trevi, as well as to
later copies of competition projects. JP

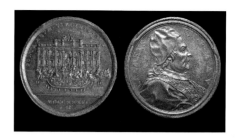

446 T-MAR
*Ermenegildo Hamerani (1683–1756) and Ottone
Hamerani (1694–1761)*
Annual Medal of 1736 with Trevi Fountain on Reverse, 1736
Philadelphia, Philadelphia Museum of Art
Bronze; 3.9 cm
BIBLIOGRAPHY: Bartolotti 1967: 151; *A Scholar
Collects* 1980: 139–40; *Roma resurgens* 1983: 183

The medals, struck in gold, silver, and bronze,
were distributed on the Feast of Saints Peter and
Paul (29 June) to dignitaries and church officials.
The Hamerani family dominated the papal mint
for several generations from the mid-seventeenth
through the early nineteenth century. The brothers Ermengildo and Ottone both carried the title
Incisore della Zecca and functioned as the medalists of the papal court for much of the first half of
the eighteenth century. The annual medal of 1736
celebrated the completion of the architecture of
the Trevi Fountain. In the course of 1736 the lateral wings had been finished and the façade of the
Trevi stood structurally complete, including the
large inscription at the center of the attic. The engravers included one notable detail of the fountain that did not appear on Salvi's earlier presentation drawing: the crumbling base of the northernmost pilaster. At the time the medal was
struck, the fountain's sculptural component had
not yet been finished. Antonio Bicchierari's temporary gouache paintings of the attic sculpture
had been replaced by finished statues and the papal escutcheon crowning the central pavilion was
secured in place. The sculpture that is represented below the attic level of the fountain in the
medal, however, must have been studied from
drawings furnished the die engravers by Salvi and
Maini. Neither had the *scogli* and the basin completed by 1736, so here as well the Hamerani
brothers must have worked from a drawing
recording Salvi's intentions. JP

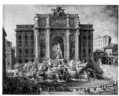

444 W-M
Giovanni Paolo Pannini (1691–1765)
View of the Trevi Fountain
Boston, Museum of Fine Arts
Oil on canvas; 45 x 65 cm
BIBLIOGRAPHY: Pinto 1986: 211–13; Arisi 1986: 440

In this small oil sketch representing the Trevi
Fountain, Pannini clearly aimed to achieve a
convincing impression of verisimilitude. The

sketch was certainly studied – if not actually executed – in front of the fountain. Significantly, there is no suggestion that Salvi's façade extends behind the fountain as it does on the wooden model. The dedicatory inscription of Benedict XIV visible in the frieze and the appearance of the sculpture permit us to date the sketch between 1744 (when the inscription was unveiled) and 1760 (when Maini's stucco figures were replaced by ones carved in marble by Pietro Bracci). The oil sketch provides a valuable record of the appearance of Giovanni Battista Maini's second set of full-scale stucco models of the Oceanus group, which were destroyed in 1759. Maini's figure of Oceanus holds both his arms close to his body and maintains a well-balanced stance, his feet firmly planted on the edge of the seashell. From his elevated position on top of the *scogli* Oceanus gazes upward, ignoring the action below him and leading our eye outward and away from the composition. The oil sketch documents other provisional aspects of the Trevi, notably the gouache paintings by Antonio Bicchierari representing Agrippa and the maiden Trivia in the lateral niches and bas-reliefs narrating the fountain's history above, which were executed in 1744. In a significant departure from Salvi's iconographical program, the lateral statues representing figures evoking the classical origins of the Aqua Virgo (or Acqua Vergine, the water supplying the Trevi) were replaced by allegorical statues of Abundance and Health by Filippo della Valle, which were set in place in 1760. Andrea Bergondi's bas-relief representing Agrippa inspecting the Aqua Virgo and Giovanni Battista Grossi's scene depicting Trivia leading Agrippa's soldiers to the source of the Trevi were both unveiled in 1762. Ferdinando Arisi errs in suggesting that Pannini's depiction of the two lateral statues must have been based on miniature figures set within the large wooden model of the Trevi. In the case of the oil sketch, it seems far more likely that Pannini recorded Bicchierari's fictive statues on the fountain itself.　JP

arms of his entourage indicate the kneeling figures of Caracciolo di Santobono and Salvi. Swiss guards with halberds provide a cordon of security around the pope. Ferdinando Arisi proposes a date between 1750 and 1756 for the painting, based on its perceived affinity to the Boston oil sketch and the dated commission of 1754 for the *Views of Modern Rome*, in which similar representations of the Trevi appear. The close correspondence between the painting and the specific papal visit to the fountain in 1744, however, argues strongly for a date closer to the event depicted.　JP

449　M
Pietro Bracci (1700–73)
Design for a Statue of Roma Sacra
Montréal, Musée des Beaux-Arts, DR 1985.85
Pen and black ink, gray wash, white gouache, black chalk; 363 x 267 mm
PROVENANCE: Arturo Pini di San Miniato
BIBLIOGRAPHY: Gradara (1920)

The drawing shows Roma Sacra rising from figures evoking the city's pagan past, including the Capitoline Wolf and a personification of the Tiber. An inscription on the *verso* ("Piedestallo di Monte Citorio") leaves no doubt that Bracci's sculptural group was intended to crown the Antonine Column, which, since its discovery in 1703, had stimulated architects to devise proposals for using it to adorn the Trevi Fountain. While the Virgin and Child, a play on Acqua Vergine, had figured in a series of proposals for the Trevi from the time of Bernini through Vanvitelli, the iconography of Bracci's group is inappropriate for such a setting.　JP, FK

petition submitted to Pope Benedict XIV in 1750, the initiative was launched by a group of nobles, who established an association with the citizens of Bologna whose scope was the collection of funds sufficient for such an endeavor. As a result of the title he had earned in Vienna as the "First Architect and Theatrical Engineer," Bibiena had received numerous offers to build new theaters when he returned to Italy. These offers included rebuilding the Teatro dei Rinnovati in Siena (1751–53) and the decoration of the Teatro della Pergola in Florence. During the same years, Antonio was admitted as a member to the Accademia Clementina, chosen as the architect of the Senate of Bologna and invited to submit a wooden model of his project. Still conserved at the theater of Bologna, this model is the first iconographical record of Antonio's project, which then underwent numerous changes.　MIB

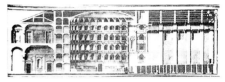

451　MAR
Antonio Galli da Bibiena (1700–74)
Plan of the Nuovo Teatro Pubblico in Bologna, Longitudinal section, 1758
Bologna, Museo Civico Medievale, Inv. B. 3697
Drawing in ink with watercolor, glued to board; 36 x 120 cm
INSCRIPTION: "Disegno del Teatro da eseguirsi in Bolog(na) / (si)mile in tuto ad altro spedito a Roma / [...] o dì 5 aprile, 1758 / Antonio Galli Bibiena" (upper left)
BIBLIOGRAPHY: Bergamini 1966; Lenzi 1975; Bergamini 1979

As a site for the new theater, Antonio suggested using land formerly occupied by the famous residence of the Bentivoglio family, which was destroyed in 1500. In March of 1756 the purchase of this land was approved and construction was immediately begun under the supervision of Bibiena himself.
As work progressed, the controversy which sought to take the job away from him exploded and resulted in severe compromises. As can be seen from this drawing, he slightly modified the bell plan, the proscenium, eliminated the rich ornamentation, unified the four tiers of boxes. This drawing also shows the rear of the theater as well.　MIB

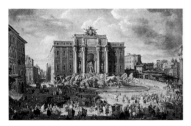

445　T-MAR
Giovanni Paolo Pannini (1691–1765)
Pope Benedict XIV visiting the Trevi Fountain
Moscow, Pushkin State Museum of Fine Arts
Oil on canvas; 107 x 167 cm
BIBLIOGRAPHY: Pinto 1986: 186; Arisi 1986: 441

Unlike Pannini's small oil sketch depicting the Trevi, this large easel painting situates the fountain within a far more expansive urban setting. It also represents the Trevi at a precise and significant juncture in its long history: the dedication ceremony in July, 1744. The pope's carriage and its attendants stand in the center foreground. The pope himself appears at the lower level of the basin, to the right of the fountain's axis. The outstretched

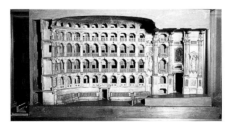

450
Antonio Galli da Bibiena (1700–74), architect, with Giovanni Battista Martorelli and Antonio Gambarini, cabinet-makers
Model for il Nuovo Teatro Pubblico in Bologna, 1756–63
Bologna, Archivio Storico della Fondazione Teatro Comunale di Bologna
Wood; 85 x 191 x 60 cm
BIBLIOGRAPHY: Bergamini 1966 and 1979; Lenzi 1975; Matteucci 1988; *Il teatro per la città* 1998

The idea of building a new theater in Bologna took shape after a fire in 1744 destroyed the theater in the Malvezzi house, until then the most important in the city. After receiving a positive response to the

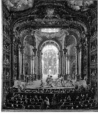

457
Pietro Domenico Oliviero (1676–1755)
Interior of the Teatro Regio of Turin
Turin, Museo Civico d'Arte Antica e Palazzo Madama, Inv. no. 420–534/D
Oil on canvas; 127 x 114 cm

BIBLIOGRAPHY: Viale Ferrero 1963; Wolff 1968; Viale Ferrero 1980: 153–54, 164, 195; *L'arcano incanto* 1991: 156–57, no. 114; *Meravigliose scene Piacevoli inganni* 1992: 119; Basso 1991; Lenzi 1992; *Il mondo di Casanova* 1998: no. 273

Olivero was a Piedmontese genre painter of popular scenes who also tried his hand at themes of a more noble character such as the representation of the Teatro Regio designed by Benedetto Alfieri. For many years it was assumed that this painting depicted the inauguration of the theater on 26 December 1740, when the opera *Arsace* was performed. However, a 1980 work by Mercedes Viale Ferrero says this painting depicts the final scene of *Caio Fabricio* and emphasizes the correspondence with the set that represents the "Luogo magnifico del palazzo del pubblico". It is interesting to read the picture as a record of the theatrical life of the period, to note the disposition of the musicians both inside and outside the space destined for them, the presence of a guard and of a footmen serving drinks to the audience in the orchestra seats. MIB

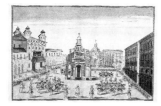

471 T
Giovanni Tommaso Borgonio (1618–91)
Gli Hercoli / Domatori de Mostri / et / Amore domatore degli Hercoli,/ Festa à Cavallo per le Reali nozze della / Serenissima Principessa / Adelaide di Savoia / e del Serenissimo Principe Ferdinando Maria / Primogenito dell'Altezza Elettorale di Bav / iera, Torino, 15 dicembre 1650
Turin, Biblioteca Reale, *Storia Patria 949*
Manuscript with illuminated plates, red leather binding with decoration and the Savoy arms in gold; 44 x 56.5 cm
PROVENANCE: Collection of ducal commissions
BIBLIOGRAPHY: *Relazione* 1651: 14; Claretta 1877; Viale Ferrero 1965: 51–57, pls. XII–XIV; *Biblioteca Reale di Torino* 1990: 156-59

Giovanni Tommaso Borgonio was the author of hand-written texts, friezes and illustrations of the various scenes. He was a calligrapher and ducal secretary, assistant in the Chamber and, in 1673, writing master to Prince Vittorio Amedeo. Borgonio was influenced by Tiranti's examples and those of Roman Mannerism supported by Cardinal Maurizio, which were linked to Medicean calligraphers like Spada. Through images the dynastic exaltation of historical events was introduced into the ballets, emphasising the celebrative occasions as can be seen in the codex dedicated to the "Hercules Tamers of Monsters and Love tamer of the Hercules." This was produced for the wedding of Adelaide, daughter of Christine and sister to Carlo Emanuele II, who married Prince Ferdinand of Bavaria in 1650. This ballet celebrated the fight against the Monsters, Hydras, Cerberuses,

Harpies and Whales won by the four main Hercules (the Hercules of the Alps, of Gaul, Ercinia and of the Celts), the emblems of the bride and groom's families. Forty-eight horsemen led by Carlo Emanuele II, Prince Tommaso and sons can be made out; they paraded at the end of the carousel in accordance with an *ars armandi*, which foresaw all the various figures of Love on the field: the Loves of Pleasure, dressed in green, symbol of joy and youth; the Loves of Desire; those of the Art of Loving dressed in yellow, symbol of Dominion, with silver nets, symbol of Passion; meanwhile the Flame of Love was fire-colored and the Lightening of the Spirit embodied amorous Pleasure. The figures in gray linen emphasised the favourite color of the Queen Mother while white indicated Happiness and Triumph. On a political level the costumes of the horsemen were differentiated too: white and red for the House of Austria; white and light blue for the Savoys. AG

464 M
Isräel Silvestre (1621–91)
Desctruction of the palace of Alcine, 1644-73
Montreal, Collection Centre Canadien d'Architecture–Canadian Centre for Architecture
Etching on laid paper
28.2 x 42.8 cm (block); 41.7 x 53.9 cm (sheet)

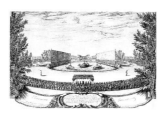

466 M
Isräel Silvestre (1621–91)
The palace of Alcine, 1644-73
Montreal, Collection Centre Canadien d'Architecture–Canadian Centre for Architecture
Etching on laid paper
27.4 x 42 cm (block); 41.8 x 53.4 cm (sheet)

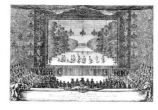

465 M
Isräel Silvestre (1621–91)
The princess of Elis, by Molière from *Les Plaisirs de l'Isle enchantee*, 1644–73
Montreal, Collection Centre Canadien d'Architecture–Canadian Centre for Architecture
Etching on laid paper
28.2 x 42.6 cm (block); 41.8 x 53.9 cm (sheet)

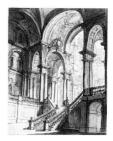

470
Ferdinando Galli da Bibiena (1657–1743)
Stage Design for a Staircase Hall in a Palace ca. 1700
Montreal, Collection Centre Canadien d'Architecture–Canadian Centre for Architecture DR 1965: 0002
Drawing with pen, brush, black ink and gray wash; 27.1 x 21.6 cm
BIBLIOGRAPHY: Monteverdi 1968; Monteverdi, Marani 1975; Kelder 1982: II, 149–53

The present drawing has not yet been connected with any specific opera, to my knowledge, nor has it been established firmly as belonging to Ferdinando. But it resembles very closely in style three drawings depicting various views of a palace interior, a monumental courtyard, and an atrium that are in the collection of the Museo Teatrale alla Scala in Milan (see Monteverdi 1968: cat. no. 4; Monteverdi and Marani 1975: cat. nos. 2, 3, and 4). The drawings in Milan are inscribed (*Pensiero Scenografico del Celebre Bibbiena*) prefixed by the numbers 2, 3 and 4, and are clearly related to the same production. It is clear that *pensieri* 2 and 3 are related views of the same palace and courtyard. The arches are supported by two pairs of columns on high bases; the courtyard has three storeys articulated with balustrades and the architectural details are closely related. The stage design exhibited here seems to represent a variation of the same project: perhaps a view into the monumental courtyard from a lower level; close correspondence can also be seen in the rendering of details such as the coffering under the arches, the design of the stair balusters, and the impost blocks above the columns. Our design has no visible inscription; it is possible that the drawing is cropped, or it may be a related *pensiero* that was discarded from the project. The Milan drawings have been dated to the earliest years of the eighteenth century, probably just before Ferdinando published his treatise on the "scena per angolo." SCS

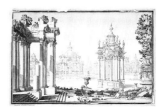

467
Anonymous after Giovanni Galli da Bibiena
Project for a stage design, 1740–50
Montreal, Collection Centre Canadien d'Architecture–Canadian Centre for Architecture
Pen, brown and black ink, brown, gray, blue wash on laid paper
34.3 x 53.8 cm

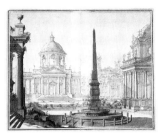

468 M
Giuseppe Galli da Bibiena (attr.) (1695–1747)
Architectural Fantasy
Montreal, Collection Centre Canadien d'Architecture–Canadian Centre for Architecture, DR 1976: 0006
Pen, brown ink, with brown wash and some blue watercolor on laid paper; 30.7 x 38.7 cm; watermark: Villedary and fleur-de-lys in a crowned crest
INSCRIPTIONS: "Giuseffe / Bibbiena (1696-1756)" (in graphite, modern hand), "il Signore joseppe [T?] ivoli" (graphite, modern hand) "292" (in a square), (graphite, modern hand)
BIBLIOGRAPHY: R. Wunder 1975: 26–27, cat. no. 21; (as Giovanni Carlo da Bibiena)

Giuseppe Galli da Bibiena (Parma 1696–1756 Berlin) was particularly enticed by the imaginative possibilities of the architectural fantasy, numerous examples of which are known to be by his hand. Nine of these were engraved by Andreas Pfeffel for Giuseppe's collection of stage designs, drawings and *teatra sacra* dedicated to Charles VI, for whom Giuseppe worked at the court in Vienna as theater architect and stage designer between 1720 and 1748 (*Architetture e prospettive*, 1740: plates part I: 6, 10; part II: 7, 10, part III: 6, 10; part IV: 7, 10; part V: 7). Drawings for a number of these engravings, very close in style to the design exhibited here, do not have the figures (which were added by the engraver) and exhibit rearrangements of the various architectural motifs that are present in the plates in *Architetture e prospettive* (Kelder 1968: nos. 37, 38, 39, 40). SCS

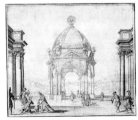

469
Carlo Galli da Bibiena (1728–87)
Design for a Perspective Stage-set, 1751
Montreal, Collection Centre Canadien d'Architecture–Canadian Centre for Architecture, DR 1961: 0003
Drawing with pen and gray ink, also pen, brown and black ink; wash, on laid paper
32.2 x 37.9 cm
INSCRIPTIONS: Bayreuth Ano 1753 (1?) di Carolus Bibiena al inventor delineavit. Fecit
PROVENANCE: Collection of Phyllis B. Lambert
BIBLIOGRAPHY: D. M. Kelder 1968: cat. no. 71; P. O. von Krückmann 1998: 92, fig. 36

Carlo Ignazio Galli da Bibiena, the last surviving member of the illustrious line of the Galli da Bibiena family of stage and theater designers, was the son of Giuseppe da Bibiena (who was one of the four sons of Ferdinando). In the case of the present drawing, a perspective design for a stage-set, an inscription and date support the attribution to Carlo ("Bayreuth Ano 1753 [1?] di Carolus Bibiena al invento delineavit. Fecit") and place the design only a few years after the completion of the opera house in Bayreuth. The drawing shows a centralized (perhaps hexagonal) domed temple or shrine in the center of the composition, which is Baroque in style and articulated by pedimented arches, open to the air. The composition is ornamented with figures in costume. In the background, faintly sketched landscape elements are visible. Between 1750 and 1756 Carlo worked with his father for the opera in Dresden, and his work during that period continued to follow the Baroque exhuberance of many of Giuseppe's own designs. After his father died in 1758 Carlo's commissions for the stage carried him to most of the major cities in Europe. As the trend toward the Neoclassical in architecture and stage design began to influence the taste of his royal patrons, Carlo became one of the first designers of the eighteenth century to move toward the more austere and formal style (Oenslager 1975: 70–71). S.C.S.

462 M
Giovanni Battista Natali III (1698–1765)
Design for a Stage-set
New York, The Metropolitan Museum of Art, Gift of Cornelius Vanderbilt, 80.3.627
Pen, brown ink, with brown and gray wash, laid on heavy paper; 137 x 102 mm
BIBLIOGRAPHY: Myers 1975: 37–40; nos. 52a, b

Giovanni Battista Natali III was the youngest member of a family of artists from Cremona. Primarily a painter of architectural decoration, Natali is known for at least one work of architecture (the portico of the church of San Francesco in Pontremoli, dated 1747), and he was identified as a stage designer by the French collector P.-J. Mariette (De Chenevières, De Montaiglon 1857–1858: 38). A pupil of the Florentine painter Sebastiano Galeotti, Natali worked on decoration projects for patrons in Lucca, Piedmont, Genoa and Naples, where he became painter to the court in the 1750s (Soprani, Ratti 1769: 370). This design for the stage and the one in the following entry were attributed to Natali jointly by Mary L. Myers and Elaine Evans Dee, and first published by Myers along with four other stage-set designs by the artist (Myers 1975: 38 and cat. nos. 52a and 52b). The first of our drawings shows a deep view into a multi-storeyed space through a series of

arches supported by paired columns on high bases. The drawing technique varies from delicate pen lines to dark heavy ink wash, and light sources are clearly indicated by means of dark shadows. The one-point perspective view is intended to suggest great distance, which is enlivened by the articulation of multiple openings through arches and columns. The style represented here has many characteristics in common with techniques employed by Filippo Juvarra, especially in the nervous sketchiness of the drawing and the heavy shading in ink wash. Both artists, trained as decorators (Juvarra as a silversmith), demonstrate a highly refined sensitivity to detail which, in drawings like this one, expresses itself in a multiplicity of fine pen lines that contrasts vividly with broadly applied areas of wash. S.C.S.

463 M
Giovanni Battista Natali III (1698–1765)
Design for a Stage-set
New York, The Metropolitan Museum of Art, Gift of Cornelius Vanderbilt. 80.3.629
Pen, brown ink, with brown and gray wash, laid down on heavy paper; 135 x 102 mm
BIBLIOGRAPHY: M. L. Myers 1975: cat. no. 52b

This drawing by Natali, similar in style to the one discussed above, depicts a one-point perspective view into a series of centralized spaces framed by barrel vaulted arches on groups of paired columns. The deeply receding space ends in an undefined opening that is filled with light. The light sources are again clearly defined by areas of dark shadow; the ink wash contrasts sharply with areas of fine pen lines that accent a myriad of details. This drawing and the stage-set discussed above are more heavily shaded with ink wash than the other four drawings attributed to Natali by Myers in her catalogue. SCS

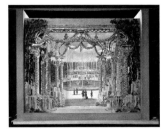

460 T
Piero Bonifazio Algieri (?–1764), after an engraving by Isräel Silvestre
Model of a Set Design for the first act of *Les Surprises de l'Amour*
Chambord, Collection Direction de l'Architecture et du Patrimoine, Château de Chambord

Five flats, painted in watercolor on cardboard with gold highlights, spangled with gold and silver; 425 x 535 mm
EXHIBITIONS: Bordeaux 1980: no. 173; Aix-en-Provence 1990: no. 2
BIBLIOGRAPHY: Schlumberger 1965: 20– 21; J. de La Gorce 1983: 430–31; Gousset 1995: 38–39; De La Gorce 1997: 29, cat. no. 2

The character of this set for an ornate landscape has been identified with the gardens of Amathonte, an ornamental bower with gilded gates, the setting for the first act of *Les Surprises de l'Amour* by Jean-Philippe Rameau. The opera ballet premiered on 27 November 1748, but according to La Gorce this model was made for the revival of the production on 31 May 1757. Interestingly, the backdrop was designed after the engraving by Israël Silvestre depicting the grove of the three fountains in the gardens of Versailles. The practice of engraving garden views in the late 17h and early 18th centuries with geometrical layouts and deep recession into distance lent itself to the invention of the garden view stage-set. Marvelous in this model is the designer's unique use of color. Favoring a variety of shades of blue, Algieri adds soft tones of pale green, red, and yellow in the backdrop, and frames the set with screening columns that are deep gold, the garlands spangled with silver. SCS

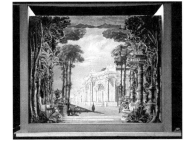

459 T
Piero Bonifazio Algieri (?–1764)
Design for Act II of *Les Fêtes de Paphos*
Chambord, Collection Direction de l'Architecture et du Patrimoine, Château de Chambord
Four flats, painted in watercolor on cardboard
425 x 535 mm
EXHIBITIONS: Aix-en-Provence 1990: no. 7
BIBLIOGRAPHY: Schlumberger 1965: 18; De La Gorce 1983: 434–35; 1997: 37–8, no. 15

This model has been identified by La Gorce as a scene for act II of *Les Fêtes de Paphos*, an heroic ballet by Jean-Joseph Cassanea de Mondonville, first performed on 9 May 1758. According to the libretto, the palace, decorated with numerous cupids, flaming torches of love, and garlands of flowers, is especially beautiful to the eyes of lovers. This *scena per angolo*, first introduced to the Italian stage by the Bibiena family in the first decade of the eighteenth century, was well known in France by 1750, and had been used by Algieri's colleague, Jean-Nicolas Servandoni. In this design, the Rococo is blended with a taste of the exotic: segmental columns with Tuscan capitals stand isolated; palm trees, urns, and lush foliage suggest a climate far from France; only the style of the architecture ties the design to its contemporary origins. SCS

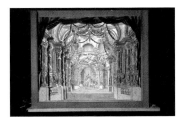

458 T
Piero Bonifazio Algieri (?–1764)
The Palace of Venus from *Les Fêtes de Paphos*
Chambord, Collection Direction de l'Architecture et du Patrimoine, Château de Chambord
Six flats in watercolor on cardboardspangles of silver and gold; 425 x 535 mm
EXHIBITIONS: Aix-en-Provence 1990: no. 8
BIBLIOGRAPHY: De La Gorce 1983: 435; 1997: 102–103, no. 97

This model for a monumental interior has also been identified with *Les Fêtes de Paphos*, performed in 1758. The viewer looks through an atrium lined with columns entwined with garlands into a high domed centralized space. La Gorce suggests that this model shares similarities with one of the tapestry scenes from the *Histoire de Psyche*, woven in Beauvais in 1741, designed by François Boucher (1983: 435; 1997: 103). SCS

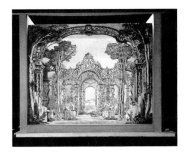

461 T
Piero Bonifazio Algieri (?–1764)
Model for Scene III of *Les Amours des Dieux*
Chambord, Collection Direction de l'Architecture et du Patrimoine, Château de Chambord
Five flats, painted with watercolor on cardboard, with gold highlights and spangles of silver; 425 x 535 mm
EXHIBITIONS: Aix-en-Provence 1990: no. 5
BIBLIOGRAPHY: J. de La Gorce 1983: 433–34; De La Gorce 1997: 74–75, no. 59

This model was created for scene III, depicting the gardens of Bacchus, of the heroic ballet *Les Amours des Dieux* by Jean-Joseph Mouret, when the production was revived in August 1757.
The libretto by Fuzelier describes the bower of gracious trellises set in the forest for Bacchus and his suite. A tall trellis composed of arches and a central dome, supported on columns resembling tree trunks wreathed in vines very much like those in Algieri's model, forms the major focus of the design. To the left and right in the foreground are trees and fountains decorated with sculpture, a compositional framing device very similar to the arrangement in Algieri's set. SCS

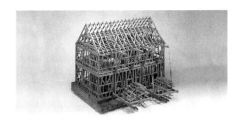

472 T
Anonymous
Model for a Grinding-, Grain Pulverizing-, and Crushing Mill, ca. 1700
Regensburg, Museen der Stadt, Inv. n. KN 1999/5
Conifer, oak, hard woods
63 x 49.5 x 57cm, jut of water-wheels 13.5 cm
BIBLIOGRAPHY: Reuther, Berckenhagen 1994: no. 323

The building shows elaborate half-timbering on one front elevation and down the long side; the building continues further on one of the narrow sides. The whole length of the interior is divided into three asymmetrical compartments: the first water-wheel operates a grinding machine with two grinding wheels. The second water-wheel operates the flour milling course in the middle of the building; then there is the front side with the crushing machine. The technical items displayed, such as the apparatus for raising and lowering the water-wheels, the gear ratios of the grinding machine, the swivelling mechanism for the flour funnel, and the crushing machine with two pairs of crushers are still functioning. The steps inside with their wooden slat banisters and the threshing attachments, are all built correct to detail. On the upper floor we find two box beds for the mill hands. PGB

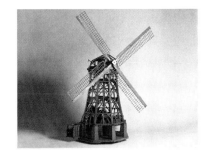

473 M-T-W
Anonymous
Model of the Windmill at Edam; 17th century
Edam, Museum de Waag
Oak; arm-span 150 cm; scale 1:14
EXHIBITIONS: Utrecht, Centraal Museum, Utrecht 1983
BIBLIOGRAPHY: Koeman-Poel (1978): 45–46; Colenbrander and others (ed.) 1981, 179–80; Keunen 1983: 79–81

For centuries windmills have characterized the North Holland landscape. The model shows a wooden, octagonal North Holland mill with internal mechanism, the type which was most commonly used in the drainage of the polders, and which continued to be built down to the present century. This type of mill was a variant, specially adapted to this situation, of the stone mill with internal mechanism which had been in use outside

the Netherlands since the fifteenth century. The base was formed by a wooden platform on a brick foundation supported by piles driven into the ground; on this stood the framework of eight vertical corner-poles held together by corbels and crosspieces; and this supported the circular superstructure. The cap of the windmill rested on a ring of wooden rollers, and could be turned according to the direction of the wind. This very detailed model was probably used for demonstration purposes. It can be taken to pieces to show how the various parts work and to display the state of windmill-building technology in the seventeenth century. The model was probably made before the building of a new mill for the drainage of the Zuidpolder east of Edam (ca. 1670), an area which had been created in the fourteenth century by the digging of a new canal to the Zuidersee (now the Ijsselmeer). In earlier times windmill models like this one were usually made in order to demonstrate technical innovations. The models of the late 19th and the 20th centuries, by contrast, were mostly made out of historical passion for a lost age in the cultural history of the Netherlands. FS

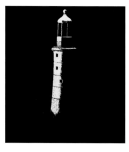

474 W
Josiah Jessop (d. 1760/61) (?)
Sectional Model in Wood of John Smeaton's Design for the Eddystone Lighthouse constructed in 1756–59
Edinburgh, National Gallery of Scotland, Inv. T.1859.414.C6
Overall size assembled: 625 x 370 x 270 mm
PROVENANCE: Collection of Robert Weston, principal leaseholder of the Eddystone
BIBLIOGRAPHY: Rowatt 1924; Mainstone 1981; *John Smeaton, FRS* 1981: 241; Simpson 1996; Waterston 1997: 69

This sectional model (to a scale of 1:48) is intended to show the internal construction and arrangement of the most famous lighthouse of modern times, designed and built by the civil engineer John Smeaton (1724-92) on the dangerous Eddystone reef in the English Channel. Smeathon described making several scale models of the lighthouse with his own hands in the course of evolving the design and to show to his client, to the Admiralty Board, and to the Elder Brethren of Trinity House (the lighthouse authority for England and Wales). One early model of the complete structure was retained by Smeaton and shown to innumerable visitors and dignitaries, including George III and Queen Caroline: it was purchased by Trinity House in 1899 (Smeaton 1791: 7; *Catalogue of the Special Loan Collection* 1877: 545; *John Smeaton, FRS* 1981: 251). Other models of the lower masonry

courses are at the National Museums of Scotland and at Leeds Museum, and there are references to other contemporary models which are not known to survive (Rowatt 1924: 20, 21). The much more elaborate model displayed here shows the fully developed scheme. The lowest part of the model shows the exposed portion of the central reef at low spring tide with the sloping surface of the gneiss cut into steps dovetailed to take the lower courses of masonry; the next two parts show the six incomplete courses of stone at the base of the tower and then the seven complete courses up to the main entrance level, all colored to distinguish the outer moorstone granite casing from the inner Portland limestone and with the interconnecting marble joggles. Five sections show successively the internal staircase, lower storeroom, upper storeroom, kitchen, and bedroom, each depicted with a chain set in the wall head to take the spreading load of the floor; and finally the balcony, glazed iron lantern and cupola. (The cupola is in wood, as are the eight vertical glazing bars, but the glazing is modern.) Smeaton's design became the prototype for subsequent isolated rock towers, and its success was only compromised by the eventual crumbling of part of the reef itself: it was replaced by a new tower (built on the same principles) in the 1880s, and the upper part of the structure was rebuilt on Plymouth Hoe (Merrett 1977; Palmer 1998). The drama and romance of the story of the Eddystone has made a strong imprint on British maritime consciousness, and Smeaton's lighthouse has become an icon for the triumph of engineering and enterprise over the destructive power of the seas. AS

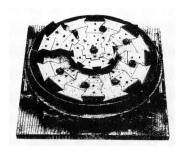

475 W
Josiah Jessop (d. 1760–61)
Model of a Course of Stones for Smeaton's Eddystone Lighthouse; 1757
Edinburgh, National Museums of Scotland, Inv. T.1859.414.C9
Wood; 50 x 190 x 190 mm
PROVENANCE: Robert Weston Collection
BIBLIOGRAPHY: Rowatt 1924; Turner 1974: 30; Mainstone 1981: 96; *John Smeaton, FRS* 1992: 29

Model (to a scale of 1:48) of the stones for the seventh course (together with the joggle stones and part of the eighth course) assembled on the wooden trial platform at the Plymouth shore base before being shipped to the lighthouse site. Constructed by Jessop to Smeaton's instruction for Weston in March 1757 (Weston 1811: 140). AS

478 W
John Rudyerd (d. 1713; attr.)
Elevation and Section of Rudyerd's Design for a Lighthouse on the Eddystone Reef 1704–1708 (constructed 1706–1708)
Edinburgh, National Museums of Scotland, Inv. T.1859.414.B1
Pen and wash
400 x 325 mm
PROVENANCE: Robert Weston Collection
BIBLIOGRAPHY: Rowatt 1924

John Smeaton's design for his lighthouse was strongly influenced by that of its predecessor, designed and built by John Rudyerd in 1706-1708, which stood securely on the Eddystone reef until destroyed by fire and demolished by the sea in 1755 (Smeaton 1791; Majdalany 1959; Stevenson 1959; Hague and Christie 1975; Palmer 1998).

This drawing from Weston's collection is thought to be an early study, perhaps by Rudyerd himself, and it differs in a number of ways from the structure actually built, notably in the arrangement of the stone and wooden courses in the base. Some alterations and key letters have been added and it apparently forms the basis for the modified drawing by Bernard Lens to the same scale for the published version. Part of the outer planking has been shown as removed and aspects of the inner structure of the base are also revealed.

Rudyerd is known only from this single commission, undertaken for Captain John Lovet, a member of the Irish Parliament, who with two colleagues purchased a 99-year lease of the Eddystone reef in 1704. Smeaton described Rudyerd as of humble Cornish origins, rising to become a silk mercer in London (Smeaton 1791: 19). He is believed to have died in 1713 (Nicholson 1995: 28). AS

476 W
Bernard Lens, engraved by John Sturt
"A Prospect and Section of the LIGHT-HOUSE on the EDYSTONE ROCK off of PLYMOUTH. Rebuilt pursuant to an Act of Parliament made ye 4th & 5th Years of ye Reign of Her Sacred MA-

JTY QUEEN ANNE. The Lights put up therein ye 28th July 1708"
Edinburgh, National Gallery of Scotland, Inv. T.1998.229.2
Engraving; 590 x 420 mm
PROVENANCE: Collection of the lighthouse historian D. Alan Stevenson
BIBLIOGRAPHY: Smeaton 1791; Majdalany 1959: 88; Stevenson 1959: 118

A view of Rudyerd's Eddystone lighthouse, dedicated by "J. Rudyerd Gent." to Thomas Herbert, 8th Earl of Pembroke and Montgomery, as Lord High Admiral of Great Britain and Ireland (appointed 1708). It is surrounded by an ornate frame with naval and maritime swags, Pembroke's monogram and arms, and representations of the winds and seas in the four corners. Three putti support an inset view of the complete structure, inscribed "This Light-house was Design'd and Built by Jon Rudyerd Gent." The main subject is a partly sectioned view of the tower shown at low spring tide, following the drawing attributed to Rudyerd. The artist has however embellished the design by, for example, adding windows to the unlit store-room and additional decorative smoke vents to the cupola. Four named warships provided by the Admiralty for protection and assistance in the undertaking are shown in the distance.
Smeaton said the engraving was scarce: he had a copy himself, but had not seen another (Smeaton 1791: 19). This example came from the collection of a great-grandson of the notable Scottish lighthouse engineer Robert Stevenson (1772-1850). AS

477 W
Unknown Draftsman
"A Section & Plan of the Lighthouse on the Edystone Rock off of Plymouth Rebuilt by John Smeaton Gent. The Lights put up there in the 16th of October, 1759"
Edinburgh, National Gallery of Scotland, Inv. T.1859.414.C3
Ink and wash drawing; 540 x 375 mm
PROVENANCE: Robert Weston Collection
BIBLIOGRAPHY: Rowatt 1924

Vertical section of Smeaton's lighthouse showing the disposition of the entrances and the chambers, together with a plan view of one of the lowest complete courses of stonework, to a scale of 1:72. The vertical section may be based on another to the same scale, reproduced by Smeaton in 1791, which he identified as the first fair section of the building shown to Weston and his colleagues in March 1756 (Smeaton 1791: 44, 195). AS

479 W
John Smeaton, engraved by Edward Rooker, (1712?–74)
Vertical Section of Smeaton's Eddystone Lighthouse
1763
Edinburgh, National Gallery of Scotland Inv. T.1859.414.C2
Engraving; 585 x 430 mm
plate-mark 505 x 350 mm
INSCRIPTION: in ink "Section of the Edystone Lighthouse upon the E. & W. Line Scale 6 feet=1 inch."
PROVENANCE: Robert Weston Collection
BIBLIOGRAPHY: Rowatt 1924; Mainstone 1981: 89

Proof-pull without titling of an engraved section in elevation of the lighthouse at low spring tide; subsequently published as plate 9 in Smeaton's 1791 account of the lighthouse where it is credited as "Engraved in the Year 1763, by Mr. Edwd. Rooker." An enlarged inset shows the communication by ladder between the two storerooms. The direction of the section is west to east, modified to some extent to show the entrance passage and the marble joggle stones in the solid lower section. AS

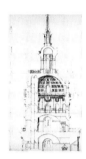

481 W
Louis de Foix (ca. 1530/38–1606 ca.)
Projected Section of Cordouan Lighthouse, France; 1594
Stockholm, Nationalmuseum, CC 2229
Ink on paper, blue wash; 26.7 x 49.6 mm
BIBLIOGRAPHY: Crozet 1955; Guillaume 1970; Ballon 1991; Faille 1993

Cordouan's architect, Louis de Foix, produced this design drawing while in attendance at the court of Henri IV; it corresponds to a contract of 18 June, 1594, which entailed a far more elaborate tower than the one he had originally been commissioned to build by Henri III. The precise measurements on the drawing suggest that it also served as the basis for a stone model of the tower referred to by the contract to be deposited for inspection at the Hôtel de Ville of Bordeaux (Guillaume 1970). This sectional

drawing – missing the bottom third of the first floor – reveals the most notable addition to Louis de Foix's original design, the domed chapel which, according to Guillaume, is the key to Cordouan's meaning as a monarchic monument (Guillaume 1970). The decorative use of royal emblems – HDV III (Henri de Valois) and HDB IIII (Henri de Bourbon) – in the escutcheons on the chapel's walls and in the coffers was meant to glorify the martyred Henri III, exalt the legitimacy of Henri IV, and emphasize the specifically Catholic character of the monarchy. Louis de Foix's drawing differs in one significant way from the tower as built. The cupola's oculus was widened, offering a view to a structurally daring stone crown suspended within the lantern which surmounts the dome. By incorporating Henri III's motto on the bottom of the lantern, it was evident that this third, celestial crown awaited him who wore the crowns of France and of Poland; Henri IV's sovereignty of France and Navarre led inevitably to the association that he, too, would be so crowned. EE

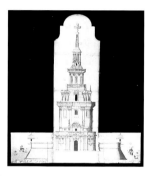

480 W
Anonymous
Elevation of the Cordouan Lighthouse, France
Paris, Archives de la Marine, ms. 144, pièce no. 66
Watercolor on paper
BIBLIOGRAPHY: Bélidor 1753: 152; Chastillon 1641; Crozet 1955; Guillaume 1970; Faille 1993; Allard 1883

The engineer Bernard de Bélidor was not alone in praising Cordouan's architecture while expressing regret it was "placé dans le lieu le plus ingrat du monde" (Bélidor 1753). The earliest accurate views of the remote lighthouse date to the 1606 visit of the royal topographer Claude Chastillon; he was sent there by the Duke of Sully to make repairs to the newly completed tower which was already damaged by the action of the sea and a thunderbolt. The drawing introduces an important correction to Chastillon, who depicted the engaged Doric columns surrounding the central portal and continuing in pairs around the first floor as pilasters. Though Crozet suggests the columns were added after Chastillon's visit, they were part of the original design, appearing to the right and left of the section cut in Louis de Foix's drawing (Crozet 1955; Guillaume 1970). Guillaume suggests that Louis de Foix's distinctive use of the Doric shows his awareness of the design of the Escorial Palace, which was being designed during his séjour as an engineer in Spain 1561–63. The

drawing's suitably large vertical format is balanced by two horizontal flaps which accommodate Cordouan's platform and sea wall; the latter is cut away in the center to reveal the tower's first storey. A dimensional scale and a key appear on the left and right flaps respectively, the corresponding letters indicated prominently on the tower. The telescoping mass of the tower is crowned by a stylized plume of smoke emanating from the elongated pyramidal flue which engages the upper lantern from where its light was emitted. Both images depict the attic above the broken pediment which does not, however, appear on Louis de Foix's drawing, though it was no doubt designed by him during the course of Cordouan's construction. The attic differs in style from the pediment, the staged protrusion of which responds to the circular form of the tower, as well as symbolically from the interconnected use of the emblems of Henri III and Henri IV on the balustrade surrounding the lantern and the busts of the two kings flanking the central portal. The escutcheon in the attic's pediment bears the crown of France and the coat of arms of Navarre, which refers exclusively to Henri IV. The two life-sized statues, said by Chastillon to represent War and Peace are, according to Guillaume, War and Triumph, attesting to the fact that Henri IV's legitimacy as king of France was more firmly established by the time the attic was added than when the tower was commissioned by him during a time of political turmoil.

EE

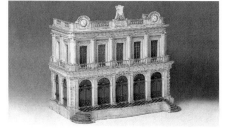

482
Jacques-Germain Soufflot (1713–80)
Model for the Façade of the Loge du Change
Lyons; 1748
Lyons, Musée Gadagne
Wood, painted white; doors painted red; floor tiles painted black and white; 45 x 50 x 32 cm
PROVENANCE: Gift of the Friends of Gadagne, 19 March 1935; prior to this, unknown
EXHIBITIONS: *Ville de Lyon. Espositions du Bimillenaire* 1958; *Soufflot et sons temps*, Lyons 1980
BIBLIOGRAPHY: Lerrant 1958; Rosenfeld 1974; Ludman 1975; Ternois 1980a; 1980b; 1982; Neuman 1994; Fowle 1996; Pérez 1996

The city of Lyons was an important center of commercial activity since the mid-fifteenth century. By the early eighteenth century, Lyons had become the principal center for the production of fine silks (Fowle 1996: 850). In the early seventeenth century, the merchants commissioned an exchange building that was erected between 1634 and 1653 on drawings and models prepared by the Parisian architect Simon Gourdet (Ternois 1980a: 88; Ternois 1980b: 64; Ternois

1982: 79; Neuman 1994: 159). In December 1747, the governor of Lyons, the Duc de Villeroy, gave his consent for the construction of a new Loge to replace the existing seventeenth-century building. Jacques-Germain Soufflot received the commission from the city consulate on 16 January 1748 (Ternois 1982: 81). Plans and elevations by Soufflot, mentioned in the documents, are lost (Ternois 1980b: 66, Ternois 1982: 82). Soufflot's wooden model shows a façade of five bays. The arcades of the first level are framed by Doric pilasters. The second storey is opened by tall rectangular windows separated by Ionic half-columns. The Loge is set on a raised platform with flowing stairs leading from left and right corners to the level of the place. Balustrades mark the cornices of the two storeys.

The roofline is broken by clocks to the left and right and a royal coat of arms, now damaged, prominently set in the center. The brightly painted doors now seen on the model are not present in the view of the Loge by Bellicard, engraved about 1750 after a drawing provided by Soufflot (Ternois 1980b: 64, 66; Ternois 1982: 82). The print shows the first level of the building as an open loggia, as is traditional of such exchanges, allowing for free passage by the numerous merchants. The fanlights and the doors on the model are similar to those now on the building, which were added when it was adapted for use as a Protestant church in 1803 (Ternois 1982: 85; Pérez 1996: 91). The fanlights and doors may have been added to the model at this time. Documents show that Soufflot's design took from the earlier building by Gourdet the two levels, the arcaded first storey, the Doric pilasters, the two return bays on the north and south façades, the vaulted gallery, the black and white pavement, and a prominent clock (Ternois 1980b: 64; Ternois 1982: 79–80). Soufflot expanded the four-bay loggia of Gourdet to one of five bays, organizing the whole with the powerful and severe Doric order of pilasters. He added the flowing stairs to either end of the façade. Above the arcade, Soufflot established an Ionic order of half-columns framing five rectangular windows and supporting a cornice of consoles resembling Doric triglyphs. The roofline is set with a balustrade adorned with two clocks and a central royal coat of arms. Statues representing the four parts of the world–Europe, Asia, Africa and America – are present at the chamfered corners of the upper level in Bellicard's print made after Soufflot's drawing, but are not found on the model or on the building. The original parts of the Loge behind the façade were demolished and rebuilt to accommodate a large central rectangular hall (Ternois 1982: 83–84).

The restrained classicism of the whole reflects Soufflot's early training in Rome in the 1730s, and recalls the five-bay exchange building for Lyons designed by Sebastiano Serlio and published in 1575 in Book VII of his treatise (Rosenfeld 1974: 408; Ternois 1980b: 64; Ternois 1982: 79). The model for the Loge du Change represents the expanding range of commercial architecture during the Baroque era.

CC

484 T
Robert de Cotte (1656–1735)
Project for the Place and Loge du Change, Lyons; 1700–11
Paris, Bibliothèque Nationale de France, Cabinet des Estampes, Va 69 t. 11, 620
Graphite, pen and black ink, brush and wash 55.7 x 42.4 cm
INSCRIPTION: lower left "Plan de la place du Change de la manière qu'il est proposé dans le Mémoire"

483 T
Robert de Cotte (1656–1735)
Projected Elevation for the Loge du Change, Lyons; first design; 1700–11
Paris, Bibliothèque Nationale de France, Cabinet des Estampes, Va 69 t. 11, 625
Pen, black ink, brush and wash; 31.5 x 28.2 cm
EXHIBITIONS: *Soufflot et sons temps*, Lyons 1980

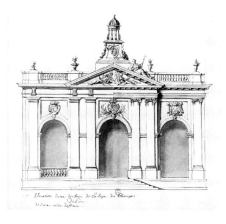

486 MAR
Robert de Cotte (1656–1735)
Projected Elevation for the Loge du Change, Lyons; second design; 1700–11
Paris, Bibliothèque Nationale de France, Cabinet des Estampes, Va 69 t. 11, 627
Pen, black ink, brush and wash; 32.5 x 34 cm
INSCRIPTION: "Elévation d'une des faces de la Loge du Change / de Lion. / de deux ordre diférent" (lower left)

485 MAR
Robert de Cotte (1656–1735)
Projected Elevation for the Place and Loge du Change, Lyons; third design; 1700–11
Paris, Bibliothèque Nationale de France, Cabinet des Estampes, Va 69 t. 11, 632b
Pen, black ink, brush and wash; 22.5 x 46.8 cm
INSCRIPTION: Scale at lower center
BIBLIOGRAPHY: Marcel 1906; Ludman 1975; Ternois 1980b and 1982; Neuman 1994; Fossier 1997

The drawings for a new Loge du Change in Lyons by Robert de Cotte (1656–1735) and his studio are preserved in albums in the Cabinet des Estampes of the Bibliothèque Nationale together with the four proposals by Francesco Fontana and three *mémoires*, one in Italian by Fontana, a French translation of this, and a third by De Cotte (Marcel 1906: 104; Ludman

1975: 383–84; Ternois 1982: 80). Ludman (1975: 386) places the date of the designs between 1700, when De Cotte arrived in Lyons to take personal charge of determining the location of the statue of Louis XIV, and 1708, the death of Francesco Fontana.

While in Lyons, deciding on a location for the statue of Louis XIV, De Cotte was apparently given Fontana's four proposals for a new Loge (Ludman 1975: 387; Neuman 1994: 159). De Cotte prepared three designs in response to those by Fontana (Neuman 1994: 159). His designs for the Loge were part of a larger proposal for a new place as the business center of Lyons (Neuman 1994: 159). Drawing 620 is one of three surviving drawings showing De Cotte working out ideas for the entire place (BN Va 69 t.11 619, 620, and 621; see Ludman 1975: figs. 120–22).The elevation in drawing 627 corresponds with the plan on drawing 626 (Ludman 1975: 385, and fig. 116) and presents De Cotte's second design for the Loge. In contrast to the open loggia of columns in drawing 625, the elevation in 627 shows a planar façade with three arched openings. Two articulative schemes are offered – Doric to the left and Ionic to the right. The delicate baldaquin atop the short bell tower appears out of proportion to the restrained massiveness of the loggia.

In drawing 632, De Cotte presents both a third design for the Loge and a proposal for the uniform articulation of all the buildings on the north side of a regularized square (Neuman 1994: 161). No surviving plan corresponds with this elevation. The Loge is rectangular, with only one set of stairs, set at the east end. Paired Doric pilasters on high bases frame the rusticated arches and support a heavy entablature and balustrade with statues and fleurs-de-lis. An ornate bell tower with a large clock is set in the center of the building. CC

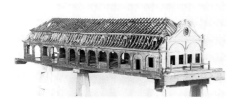

487 W
Georg Fink
Model for the Schrannenhalle at St. Moritz
Augsburg, Städtische Kunstsammlungen, Maximilianmuseum, Inv. no. 3460
Wood
PROVENANCE: Modellkammer of the Rathaus
BIBLIOGRAPHY: Reuther and Berckenhagen 1994: 44ff., no. 52

The so-called Schrannenhalle (market-hall) was designed and built ca. 1754 by the Augsburg Stadtmaurermeister Georg Fink. The model shows a long single-storey building with an arcade of thirteen arches on the long side, the middle three archways being emphasized by Tuscan pilasters. On one of the short sides there is a high façade, which has a simple adornment in the form of two blind arcades and a gable. Georg Fink's model shows that the

tradition of building models for functional public buildings, which had begun in the early sixteenth century, continued into the seventeenth century. The models may have served a number of purposes, but were probably primarily intended for inspection by the town council before a decision was taken on whether to go ahead with the project. Like most of the other models preserved in the Maximilianmuseum in Augsburg, the model for the Schrannenhalle came from the Modellkammer of the Augsburg Rathaus, which was, until its dissolution, one of the richest and most important model collections in the world. AL

498 MAR
Thomas Blanchet (1614–89)
Model for the vault of the Great Hall of the Hôtel de Ville, Lyons, 1655
Lyons, Musée des Beaux-Arts de Lyon
580 x 1253 cm

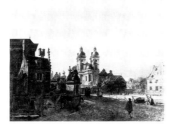

497 M
Sébastien Le Clerc (1637–1714) after Claude Perrault
Elevation of a Project for a Triumphal Arch on the Place du Trône, Paris; 1st June 1670
Montreal, Canadian Centre for Architecture, Collectíon Centre Canadien d'Architecture
DR 1986:0131
Pen and black ink with brown wash on laid paper, with construction lines in black chalk
42.6 x 60.7 cm
INSCRIPTIONS: "MODELE. DES. CARACTERES. QVI. DOIVENT | ESTRE EMPLOYEZ A LINSCRIPTION DE CET AARC DE | TRIOMPHE POVR EN AVGMENTER OV DIMINVER LA GROSSEVR SELON QVIL SERA TROVVE' A PROPOS | FAIT LAE PREMIERI IOVR DV MOIS DE IVIN DE | LANNEE MIL SIX CENTS SOIXANTE ET DIX" (within a tablet, in the center of the attic of the arch) lower right of the image, a printed collector's mark: "R," a wheat wreath, "F:" the mark of Raymond Ferrier (1845–1924), Lugt 2207a; *verso*, lower left, a printed mark: a swash "L" within a triangle (not in Lugt)
BIBLIOGRAPHY: Lemonnier 1911–29; Herrmann 1973; Préaud 1980; Petzet 1982: 145–94; Picon 1988

To celebrate victories in Flanders and in Franche-Comté made during the War of Devo-

lution against Spain, Jean-Baptiste Colbert, minister of Louis XIV, ordered in 1668 the erection of a permanent triumphal arch on the Place du Trône. Colbert asked the members of the Petit Conseil, formed in 1667 to advise the king on the design of the eastern façade of the Louvre, to propose designs. Louis Le Vau, first architect of the king, Charles Le Brun, his first painter, and Claude Perrault, a medical doctor and a member of the Academy of Science began with a common scheme. It consisted of a tripartite arch decorated with coupled columns, and surmounted by an equestrian statue of Louis XIV. A print by Sébastien Le Clerc (1637–1714) records Perrault's design and of the great model which stood on the Place du Trône for almost fifty years (Préaud 1980: 244, no. 884; reproduced on p. 246). Dated 1679, it was completed after the architect had complied with the changes requested by the Academy. A preparatory drawing by Le Clerc in the Louvre corresponds almost exactly to this print. The drawing presented here, dated 1 June 1670, is among those executed by the printmaker in anticipation of the construction of the full-scale model. It features the elongated proportions of the central archway of the pre-1678 scheme. It appears to have served to study the arch's decoration: the two halves of the drawings present different proposals. JFB

493 M
Pierre Puget (1620–94)
City Hall Project for Marseilles; 1663?
Marseille, Musée des Beaux-Arts, Inv. D 26
Pen and gray wash; 67.5 x 129 cm

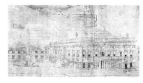

492 M
Pierre Puget (1620–94)
City Hall Project for Marseilles
Detail of the Fountain
Marseille, Musée des Beaux-Arts, Inv. D 269
Pen and black ink; 75.5 x 70 cm
PROVENANCE: Ricard Bequest, 1906
EXHIBITIONS: Marseille, 1920, nos. 420, 421; Marseille, 1950, nos. 103 and 104; Marseille, 1994, no. 104
BIBLIOGRAPHY: Bougerel 1752: 16; Piganiol de la Force 1753–54, V: 226; Emeric-David 1840: 7; Fabre 1867, II: 307–308; Lagrange 1868: no. 185; Rossi 1901: 14; Perrier 1897: 221; Auquier 1908: nos. 420, 421; Brion 1929: no. 115, 522–24; 1930: 68–70; Baumann 1949: 67; Busquet, Isnard 1951: no. 14, 30; Giraud 1955; Boisfleury 1972: nos. 33–34; Gloton 1972: 55–71; 1991: 88–91

These are the only original drawings of Pierre Puget's grand architectural projects to have been preserved. The first document – or "grand project" – is an ambitious composition in which Puget takes on at once the role of architect and urban planner. He took inspiration in particular from the palaces of the Capitol drawn by Michelangelo in 1538 (colossal pilasters, exterior stairways), construction on which had only just been completed. The extensive use of the colossal order suggests the edifice's kinship with the Roman palaces of the day (Chigi), while certain details in the design of the openings in the attic bring Borromini's art to mind. The design of the vast domed roofing can be compared to the enormous "keel" designed by Palladio for the Vicenza Basilica, an important reference in the fairly restricted field of classical building architecture. The building is endowed with two preferred façades. This arrangement, frequent in the villas of the Riviera Ligura built over the course of the previous century, can be likened to a design Le Vau came up with at the same time for the garden elevation of the palace of Versailles. It was to be taken up again in the definitive version of 1666, often attributed to either Pierre Puget or his brother Gaspard (who was in charge of its construction), though the attribution is a matter of controversy (exhib. cat. 1994). The second document is a detail from a drawing, doubtless done at a later date, known as the "petty project," which was probably submitted to the consuls once they had declined to follow the artist in his monumental designs. Of more modest proportions, the edifice was probably supposed to fit into the perimeter demarcated by the previously constructed foundations. To compensate for the relatively narrow lot, Puget drew an extremely vertically oriented *hôtel*, endowed with three high levels of elevation and topped off with a lantern in the guise of a belfry. This conception is in complete opposition to the markedly Roman horizontality of the "grand project." PL

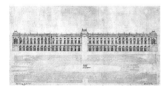

494 M
Studio of Pierre Puget
Project for a *place royale* in Marseilles
Marseille, Musée des Beaux-Arts, Inv. D 73
Pen, gray wash; 63 x 125 cm
INSCRIPTION: "Fait par Pierre Puget l'an 1686" (lower right, in pen and black ink)

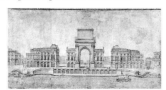

495 M
Studio of Pierre Puget
Project for a *place royale* in Marseilles. Interior elevation
Marseille, Musée des Beaux-Arts, Inv. D 74
Pen and gray wash; 63 x 125 cm

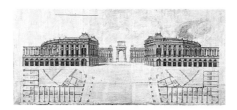

496 M
Studio of Pierre Puget
Project for a *place royale* in Marseilles. Perspective elevation facing the port and ground plan
Marseille, Musée des Beaux-Arts, Inv. D 75
Pen and gray wash
PROVENANCE: Borély; exchange Talabot; entry into the Musée des Beaux-Arts de Marseille in 1869
EXHIBITIONS: Marseille, 1920, nos. 417, 418, 419; Marseille, 1949; Marseille, 1950, nos. 108, 109, 110; Marseille, 1994, nos. 115, 116, 117
BIBLIOGRAPHY: Auquier n.d.: 99–101; Bougerel 1752: 47; Rabbe 1807: 59; Henry 1852: 136 and 170; Emeric-David 1853: 15; Lagrange 1868: no. 186; Auquier 1908: nos. 417, 418 and 419; Parrocel 1921: 112; Brion 1930: pl. 28; Chamfray 1932: 80, 16–19; Baumann 1949: 118ff.; Billoud 1950: nos. 11, 43; Bouyala d'Arnaud 1964: nos. 57, 8; Boisfleury 1972 (ms.): nos. 45, 46 and 47; Plouin 1972: 93–105; Gloton 1972: 55–71; 1991: 98

The *place royale* imagined by Puget was intended to fit into the background of the Marseilles roads, and mark the beginning of the large avenue today known as the Canebière.
As in his city-hall projects, Puget remained deeply influenced by Roman models, including Carlo Rainaldi's recent transformations of Piazza del Popolo and those of Bernini for St. Peter's Square. Above all, he turns once again to Michelangelo and the Capitol, from taking up its oval plan, the beaming ornamental tiling design in the center of which the equestrian statue of Louis XIV was to be placed, and the oblique lines of the pavilions which, crimping the perspective, mark the beginning of the new avenue. To the credit of Puget's genius, one must nonetheless acknowledge the powerfully scenographic and eminently Baroque conception of architecture in motion, in which the *place royale* seems to issue from the dilation of a triumphal thoroughfare linking the port and the city. On the basis of the three drawings shown here, the reticence of the king's architect is understandable. The port-side façades are singularly lacking in coherence: the central pavilion is cut into two by a gigantic doorway, while the lateral elevations hesitate between the curve and the straight line. The base, made up of arcades and lines furrowed into the surface – the motif of which is taken up on the quay – is the only element of continuity. PL

499
Jan Hiebel
Project for the ceiling of the Clementinum library, Prague; 1727
Prague, Clementinum Library
Oil on canvas; 199 x 47 cm

Religious architecture: altars, chapels, churches

Andrea Pozzo and the Altar of the Blessed Aloyisius Gonzaga in the Church of Sant'Ignazio in Rome: a Model between Projects and Studies
Maurizio Gargano

The Jesuit brother, Carlo Mauro Bonacina, using the experience he had gained in building the altar dedicated to Saint Ignatius in the church of the Gesù in Rome (1695–99), and designed by Andrea Pozzo, finished another altar between May 1697 and December 1699, that for the Blessed Aloysius in the Roman church of Sant'Ignazio. This annotation (Gargano 1988: 90–91), placed at the conclusion of a study about the altar dedicated to the founder-saint of the order, confirmed the professional collaboration of the two brothers of the Society of Jesus: the more famous Andrea Pozzo (painter, architect, scenographer, expert in the art of perspective) and the more obscure though no less determined Carlo Mauro Bonacina (superintendent, director of works and administrator for the building of the two aforementioned altars). That interrelationship of roles and expertise was hardly a minor one and is worth reflecting about especially regarding this analysis of the wooden model, and the projects and studies for the altar. There is relatively scarce documentation attesting to the events involving the project in question. On the other hand, a remarkable number of sources deals with the entire history of the chapel with the altar dedicated to Saint Ignatius from its conception to its realization. This "imbalance" suggests a first significant comparison between the two building projects, which may explain this disparity of information. First of all, it is important to keep in mind that the altar of Sant'Ignazio was destined for the church of the Gesù, where the saint's remains had been kept since 1587, and in particular for the new chapel. The patronage rights of that chapel, belonging to the Roman family of the Savelli, were the cause of obstacles and controversies, all of which were fully documented. These documents are to be added to those regarding the complicated preparation of the altar, which had been promoted by the VIII General Congregation of the Society of Jesus in 1644–46 at the expense of the order itself (Gargano 1988: 79–83). On the other hand, the altar to the memory of Aloysius, who had been buried since 1591 in the common tomb of the Jesuits in the church of the Santissima Annunziata next to the Collegio Romano (Pirri 1955: 27–39; Kerber 1971: 180; Metzger Habel 1981: 35–36; Contardi 1991: 23–24), was destined to occupy the space of a chapel which was not subject to any special conditions. Moreover, it was to be in a church constructed *ex-novo* in honor of Saint Ignatius, the building of which had started in 1626 under the supervision of a Jesuit, Father Orazio Grassi. Therefore, the premises for the two projects were different. The more favorable context of the work honoring the Blessed Aloysius was in sharp contrast with the difficulties of a "redemptive agreement" with the Savelli family in

order to build a chapel with an altar dedicated to Saint Ignatius in the pre-existing church of the Gesù. But there is more: starting on 4 December 1629, the events relative to the less turbulent history of the saint's altar became interwoven with Marchese Scipione Lancellotti's substantial economic support, only to create problems later on with his heirs – in exchange for the concession of a chapel in the new church of Sant'Ignazio (Contardi 1991: 23–24; Gargano 1988: cat. nos. 107–109). The construction of an altar in a church that was to be inserted in an articulated architectural complex – the renovated Roman College – organized and run autonomously by the order, did not necessarily entail a competition or public debate for the choice of the architect as had duly occurred for the other altar. The conditions binding the project of the Saint Ignatius altar were much more complicated than those for the Blessed Aloysius altar, and this would explain the greater amount of documentation. Apart from the accidental disappearance of documents, the reduced amount of information and time employed in the realization of the latter altar does furnish additional support to what has already been pointed out (Gargano 1988: 84–91) about the particular division of the work and areas of competence which the order had established on both building sites. The many projects, studies and models supplied by Pozzo, together with the efficient management of the two work sites, assured by Bonacina's surprisingly professional and organizational ability, throw light on a *modus operandi* within the Society of Jesus that was exceptional with respect to local standards. Indeed, it took just five years to build two richly and heterogeneously decorated altars, instead of the "not less than 25 or 30 years in keeping with the usual way of working here in Rome," as Carlo Mauro Bonacina himself proudly remembered (ARSJ, *Memoria*, 1706, Rom. 140, cc. 6r–33v; particularly cf. c. 18r). The effective metaphor of the complicated structure of an *oriuolo* (clock), "which can neither mark [the hours] nor strike correctly if all its wheels do not do their work well," chosen by Bonacina in order to explain to an ideal figure of "superintendent" how to manage works similar to "our chapel" of Sant'Ignazio (ARSJ, *Metodo che potrebbe osservarsi da chi volesse fabbricare una simil opera*, 11 febbraio 1706, Rom. 140, cc. 34v–41r, particularly cf. 40v–41r), is emblematic of the capillary organization on a site that had some five hundred people working together at the same time, among which artists, artisans and simple workmen. The number of workers certainly leads one to think that Bonacina was exaggerating in order to exalt his own organizational and professional ability. However, a list of the different master builders employed in single and specific activities, reconstructible from work contracts and payrolls, with the exclusion of the workers under them, numbers well over one hundred. If one considers that in the same period of time it took to build the altar in honor of Saint Ignatius, "Superintendent" Bonacina was also able to achieve in even less time the one dedicated to Gonzaga, one can then understand the vital function of his directive role. But in order to keep everyone under control," so as not to "not rush and bungle the works" and "to see that the work is finished" in "the allotted time," Bonacina refers to a study of the designs for the works to be built together with a perfect knowledge of their relative models. This passage refers directly to the central issues considered here: the projects, the studies and the wooden model for the altar of Aloysius, designed by Andrea Pozzo. If it is clear from the chronicles of the two work sites that the Jesuits desired to manage similar initiatives "autonomously," by entrusting the single and specific stages of the work exclusively to the order's brothers, then the role played by Andrea Pozzo also adds an important piece to the mosaic of that singular *modus operandi*. As for Pozzo, his role, and specific contributions, he was wont to complain and change his mind while carrying out the commission he had received for designing the altar dedicated to Saint Ignatius, which was prior to that given him for the Gonzaga altar. This emerges from his correspondence to Bonacina dated 31 May 1695 (ARSJ, Rom. 140, c. 166r). Ill-humor, squabbles, advice, reproof and encouragement overlapped with surprising continuity in the complex history of the altar dedicated to the patron saint and founder of the order. Although that correspondence reflects the heated debate about the Gonzaga altar, even outside of the order, it also attests to the repeated "obligations" and "plans" that Andrea Pozzo was bound to observe in his architectural composition. He had to draw up more than twelve solutions together with various models before he was able to satisfy the considerable number of "judges" within the order and the "lay experts:" "Cavalier Fontana, Signor Cavalier Mattia de' Rossi and Signor Giovanni Antonio de' Rossi" (ARSJ, FG, *Informationum*, vol. 138/494, c. 43v). A kind of material and project translation of the Jesuit *ruminatio*, as written in the *Spiritual Exercises* by the Founder of the Society of Jesus, takes shape in the remarkable number of surviving studies, designs and models by Pozzo. This is not a secondary result when one considers the educational practices typical of the specific professional "apprenticeships" that the order was already guiding in the sixteenth century (Pirri 1955: 160–69, 258; Balestreri 1990: 19–26; Levy 1996: 133–139). In the case of the altar for the Blessed Luigi Gonzaga, as it has already been pointed out, the execution time and difficulties were less than those for that of Saint Ignatius. In any case, the presence of various designs and a surviving wooden model, which is slightly different from the final result, seem to confirm a practice that was customary for the Jesuit Order in such works. Particular evidence supporting these general considerations is to be found by comparing the actual altar with the designs and model preserved in the Museo Nazionale di Castel Sant'Angelo in Rome. A medal dated 1699 (ref. NGA 1,422) by an anonymous author and obviously celebrating the inauguration of the altar for Gonzaga shows compositional solutions that are almost identical to those detectable in the final altar. The treatment of the fastigium, the projecting cornice of the entablature, the four twisted columns that wind, two by two, in the opposite direction with a spiral movement exactly like those of *verde antico* marble that characterize the altar, the placement of the urn, the high relief with an effigy of the saint that alludes to the final one: all this points to a precise graphic basis for the coining of the medal either just before or just after the approval of the design. The composition of the wooden model is not as faithful to the altar erected in the right transept of the church of Sant'Ignazio, although the model is finely decorated, accurate in every detail, and even includes its situation in the church (scale 1:15 to the actual altar). A detailed analysis of this model, based on one of Andrea Pozzo's designs, was made by Bruno Contardi who directed the last intervention of restoration-conservation on the model on the occasion of an exhibition held at the Museo Nazionale di Castel Sant'Angelo (Rome, 1991). Rather than examine Contardi's specific analysis which is interspersed with a synthetic yet exhaustive history of the events regarding the project (Contardi 1991: 23–40), it is necessary here to introduce the model in question into the general considerations discussed up to now. That is, to hypothesize what part models of this kind played in the creative and constructive process of those altars dedicated to prominent figures in the order's history. In the first place, besides demonstrating the final result of an artistic work to those less expert in the reading of designs and projects, they were to serve the "perfect" superintendent – to use Bonacina's words – to know by heart the works that had to be built "[…] and to master these and have them so to speak at his fingertips […]" Secondly, if one takes into account the number of changes that were "imposed" on the many documented designs that Andrea Pozzo had to produce in order to reach a favorable opinion from all the "judges," then there was all the more reason to justify the existence of detailed and faithful models of the approved solution in order to avoid further controversies. The fact then that the "surviving" wooden model for the altar does not correspond – as will be seen – to the final one, finds a likely explanation in the way Bonacina worked. The constant presence of models in the workshops for a daily check with the work in construction may have damaged and compromised the definitive wooden model. What is more, the "great crowd of workers" active at the same time, in spite of Bonacina's organizational ability, had turned the workshops into a "Babel" (comments following the visit of Pope Innocent XII, August 1697). These were certainly the reasons why the existing wooden model, obviously eliminated by the judges for architectural reasons, was able to survive that "Babel" unscathed (Gargano 1996: 164). In architectural and compositional terms, the altar represented by the model is quite unlike the final one. The alludes to the materials and marbles to be used in the altar is, however, almost identical. The dominant colors, masterfully alternated, are *verde antico* (present in the panels of the pedestals, columns and frieze) and *giallo antico* animating the architrave, fastigium and part of the plinths on which the columns rest, with the addition underneath of a high base

(destined to hold the table above the funerary urn) in veined *nero antico*. Only in this last section of the base does the actual altar differ, for it is now characterized by the ample use of alabaster, onyx, ancient *breccia* and veined *nero antico*. The white Carrara marble destined for the central high relief of the altar depicting *The Glory of the Blessed Aloysius Gonzaga* was similarly indicated in the wooden model by a monochrome, cm 42 high and cm 21 wide. The insertion of this high relief, iconographically and formally similar to the final result, makes it possible to place the model close to the approval stage of Andrea Pozzo's final design "finished and colored 2 April 1697" (Contardi 1991: 26). But the "four twisted columns in *verde antico* and the *salamonica* [...] first made in peperino [...] and then veneered," that characterizes the definitive solution, distance the wooden model from the final work, placing it somewhere between the latter and the various designs that Pozzo himself reproduced in his *Trattato*, together with some "nostalgic" regrets for the ideas that had been "criticized" (*Perspectiva Pictorum et Architectorum Andraeae Putei E Societate Jesu. Pars Secunda*, 1700; cf. pls.: 65 [ref. NGA 1,421 and 505], 62, 64, 66). Significant in this regard were Pozzo's descriptive comments, written in his own hand on plate LXIV of the Trattato: "This was the first idea conceived for the Altar; but confusedly proposed with the others, it was deferred to that with four columns. I shall say nothing about this choice, for I am not a good judge for my own cause. I shall only say that the slight projection seemed to me more suitable for the place, where it would have been more convenient and enjoyable. However that may be, it has remained without a master so that everyone may use it for his pleasure." The solution in plate LXIV comes close to that of the wooden model as far as its proportions, the shape of the fastigium with its sculptural insertions, the painted area destined for the high relief, and the presence of just one pair of columns for the altar (Contardi 1991: 25). However, the fact that the fathers of the order may have interfered is revealed by their rejection of the smooth columns of the model which were then substituted by the spiral columns (two in the plate but four on the actual altar). A representation of the saint between pairs of contrasting twisted columns in a print of 1607 may have induced the theologians of the order to request that these be adopted for the altar (De Feo 1996: 133–37). Apart from his "regrets" for the rejected designs and the use of smooth columns, in the case of the wooden model, Pozzo did show, however, an "autonomous" interest in that type of twisted column in his *Trattato* (pl. LIII B). Probably inspiration for the subdivision of that type of column into twelve decreasing parts derived from Vignola, to whom Bernini may also have referred in the Baldacchino of St. Peter's. Indeed, the altar is reminiscent of a baldacchino because of the use of four rather than two twisted columns entwined with gilded bronze tendrils. The analogy is reinforced (in this enormous aedicule which is, however, bidimensional that rises 17.4 meters above the floor) by its slight structural concavity, by the angle of less than 30 degrees between

the pedestals, and by the reproposed projecting cornice of the entablature which supports the crowning element. The latter has two overlapping pediments (round and tripartite of which the lower one has a projecting profile while the doubly curved one above soars upward). Similar complexities are also encountered in an analysis of sheet 1978–70–393 of the Philadelphia Museum of Art (ref. NGA 165). This specific case is a preliminary study for a fresco painting or for the altar itself, destined in both hypotheses to celebrate Saint Gonzaga (Pinto 1980: 11–12, n. 2; Levy 1990: 219–21; Contardi 1991 and 1996; Dardanello 1996: 130, no. 41). According to Evonne Levy, this study in sanguine is a sketch for the frescoed altar painted by Pozzo in the right transept of Sant'Ignazio, and later removed when the actual altar was built (ARSJ, Rom. 150a, *Origine del Collegio Romano e suoi progressi* [1551–1743]: 76). The fresco was complementary to that of the *Annunziata*, situated in the left transept of the same church (Montalto 1958: 670; Kerber 1971: 69, no. 137). What should be pointed out, in any case, about the Philadelphia study is the similarity of compositional solutions proposed therein with those reproduced in the wooden model. Just one pair of columns with smooth shafts, four allegorical statues on semi-circular bases connected to the high plinths of the columns, the sketch of two figures (probably the virtues of the Blessed) placed on the pediment of the altar, and the framing of the whole between high fluted pilasters that allude to those present in the walls of the transept of the church show the two solutions to be close to one another. What distances them, on the other hand, and places the wooden model closer chronologically to the actual altar, is the choice and the placement – in the Philadelphia study – of a hypothetical statue in the round of the Blessed supported by an urn, which in turn is supported by angels, above the mensa and situated in a kind of apsed niche. It is framed by a splayed arch with a continuous extrados slightly detached from the piers of the impost by means of a molded *segno* of caesura which is also reproduced beyond the projecting smooth columns in the splay of the pilasters behind that decrease toward the back wall of the transept. What distances that study-drawing from the final work is the iconographic theme of the sculptural group which was already liturgically "corrected" and substituted in the wooden model by the one alluding to the marble high relief of the actual altar. Another stage of creativity, therefore, to insert into the checkered history of Andrea Pozzo's designs for the altar of Blessed Luigi Gonzaga. Although an exact chronological reconstruction is difficult to establish, and may be of less importance, it should not distract, in any case, from the meaning and general aims of all those variations. In brief, with regard to the actual altar, the sculptural insertions attributed to Pierre Le Gros (*The Glory of the Saint* and probably also the two figures reclining languidly on the tympanum alluding to the virtues attributed to Gonzaga, Innocence and Penitence) also contribute to completing the picture of the above-mentioned choral participation of the different sectors that were,

however, always under the strict supervision of the Society of Jesus. Form, Space and Time – as has been underlined – were merged into the overall projects of the two altars, leaving nothing to chance. Andrea Pozzo's "guided" creative ability was matched by a technical knowledge that provided him with the necessary profundity so that he could move out of the confines of an imaginary compositional experiment. If the distinction of roles between the artist-inventor Pozzo and the Lombard organizer-administrator Bonacina may have raised doubts, on the one hand, about the painter's professional ability as an architect, it underscored, on the other hand, the effects that were so masterfully attained by exploiting their specific areas of competency. It was the result of the careful distribution and specialization of singularly cooperating roles, much like the modern division of work. All this is to be reconsidered when taking into account what Bruno Contardi wrote in the conclusion of his analysis of the altar of the Blessed Luigi Gonzaga, apropos of the "defeat" of Pozzo and the "administrative technique" of Bonacina, "at the dawn of the new century." Figures, according to Contardi, by now liquidated "by Fontana's equally programmed vindication of the subordination of the arts to the 'general technique' of architecture and its instruments of control, *in primis* drawing" (Contardi 1996: 111–12). If this explains Carlo Fontana's case at the beginning of the eighteenth century in Rome, it certainly does not imply that the "lesson" of those work procedures had been surpassed definitively; they are still current and reappear cyclically in the world of architecture. In those years, that *modus operandi* was specifically aimed at avoiding uncontrollable and unforeseeable occurrences that might undermine the singleness and exceptionality of undertakings and initiatives that were meant to triumph over any competition. The unplacated dynamics characterizing the stages relative to the contribution of ideas for the altar dedicated to Saint Ignatius in particular, had already shown what the objectives of the Society of Jesus were, and this is confirmed and supported by the incontestable reality of the two altars. In that way, the Society was also leaving a sign of its extraordinary efficiency "at the dawn of the new century." It was almost a reflection of the symptoms of the approaching decline of its religious power: that typical "excess of life" – choral and autonomously and masterfully orchestrated – that always precedes the inevitability of death. A veritable though crepuscular "Triumph of the Baroque" of Jesuit mark.

BIBLIOGRAPHY: Pozzo 1693-1700; Pirri 1955: 160–69, 256–58; Montalto 1958: 668–79; Kerber 1971: 54–74, 102–108, 181–86, figs. 53–55; Haskell 1980: 90–91; Pinto 1980: 11–12, no. 2; Metzger Habel 1981: 31 65; Gargano 1986: 210–16; De Feo 1988: 9–23; Gargano 1988: 77–109; Balestreri 1990: 19–26; Ferrari 1990: 208–209, figs. 25–28; Levy 1990: 216, no. 136, 219–21, nos. 138–39; Contardi 1991: 23–39; Pascoli 1992 (1730–1736): 691–715; De Feo 1996: 114–43; Gargano 1996: 156–67, 243–44; Levy 1996: 133–39; Dardanello 1996: 121–31; Contardi 1996: 97–112; Strinati 1996: 66–93

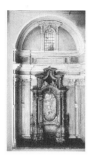

501
Andrea Pozzo (1642–1709)
Wooden Model for the Altar of the Blessed
Aloysius Gonzaga
Sant'Ignazio, Rome; ca. 1697
Rome, Museo Nazionale di Castel Sant'Angelo,
current inventory no. 371/IV; Inv. 1925, no. 832;
register Benigni, 1907, no. 1372 (in which "a two-
piece support" is mentioned measuring 144 x 53
x 125 cm which was lost or no longer attached to
the actual model in 1925 Contardi 1991: 23)
Painted Wood and red wax 195 x 112 x 25 cm
PROVENANCE: Gift of Attilio Simonetti
BIBLIOGRAPHY: Contardi 1991: 23–39

The model is composed of two wooden boards
glued together and reinforced by a double circle
of wooden rings placed in the upper arch. Its di-
mensions are: 195 x 112 x 25 cm. In particular, the
height inside the opening that houses the altar is
191 cm; its width including pilaster and wainscot
is 109 cm; the height of the altar is 116.5 cm; the
column shaft is cm 34 high; the monochrome de-
picting the *Glory of the Blessed Gonzaga* measures
42 x 21 cm. The entire altar is in wood painted in
oil on a stucco base; in red wax are: the four stat-
uettes (with the exception of the heads of the two
upper figures and the figure on the lower left,
from the beholder's point of view, which are in
wood and probably due for restoration), the cap-
itals of the two columns, the cornice of the altar-
piece depicting the saint, the decorations of the
pilasters, the ground of the tympanum, the
Corinthian capitals of the transept of the church,
and the two curved elements of the pediment of
the altar. In the window above the altar, the glass
panel, sky, trees and a bird in flight are painted in
oil on canvas. MG

508
Anonymous
Medal for the Altar of Blessed Aloysius Gonza-
ga; 1699
Oxford, Ashmolean Museum, Inv. no. VI.8.91
BIBLIOGRAPHY: Contardi 1991: 34

The medal depicts the altar to Saint Ignazio
(*recto*) built in the church of the Gesù in Rome
and the altar (*verso*) to the Blessed Aloysius
Gonzaga for the church of Sant'Ignazio. MG

Andrea Pozzo: Painted Architecture for the Vault of the Church of Sant'Ignazio in Rome
Maurizio Gargano

An anonymous undated document preserved in
the Archivium Romanum Societatis Jesu (ARSJ,
Rom. 140, cc. 104r–106r) deals with "Punti da'
considerarsi intorno al dipingersi la volta d.a
chiesa di S. Ignatio." There are five points worthy
of consideration: 1) whether said church should or
should not be painted or decorated; 2) by whom;
3) whether it should be done now, or in a few
years; 4) whether it [the painting] should start with
the minor parts or with the main vault; 5) and with
what design.". Payment for the large scaffolding
necessary for the painting of the vault was duly
noted in a register together with other expenses for
the "paintings in our church," in a period ranging
from 29 March 1687 to 10 August 1701 (ARSJ,
F.G. 1346, Libro Giornale, c. 92). The scaffolding
was installed some time between 16 December
1693 and 24 October 1694. That annotation, cou-
pled with what has been maintained by biogra-
phers of Pozzo, like Lione Pascoli (Pascoli
1730–36: 691–715), limits the time employed by
the Jesuit brother for the execution of the under-
taking to three years, including the various
preparatory studies. This *figura* was inserted
posthumously at the end of the "Parte prima" of
the 1693–1700 edition, published by the Stampe-
ria di Gio. Giacomo Komarek. Pozzo wrote:
"When this book of mine was printed for the first
time [1693] I had not yet perfected the painting of
the vault of Sant'Ignazio. Therefore I proposed
only its architecture in that [edition]. Now here is
the design of the entire work." As a reminder of
the conclusive admonition of those "Cinque pun-
ti," the drawing in gray and brown ink (ref. NGA
381) provides some hints in regard to that "I pro-
posed only its architecture." From a comparison
between the drawing in question and the architec-
tural framework of Andrea Pozzo's painting for
the vault of Sant'Ignazio, perceptible differences
would indicate that the drawing was meant to be
submitted for judgment. In the preparatory study
for the fresco of the vault (cf. NGA 255) and the
1702 engraving (cf. NGA 1,639), both complete
with "figures," the architecture shows a remark-
able affinity to that painted by Pozzo in the vault
of the church, whereas the exclusive focalization
on the architectural layout in the gray and brown
ink drawing (cf. NGA 381) makes it possible to
concentrate our analysis on that specific aspect of
Pozzo's work. The dialogue established between
the symbolic-allegorical figures and the architec-
ture containing them and projecting them heaven-
ward places this admirable pictorial undertaking
of Pozzo's in a singular position. The original
modalities of the work suspend it between the
more traditional *quadratura* painting and that of
the phantasmagoric Baroque which was adopted
and scenographically produced by the Society of
Jesus for the educational apparatus of the *Quaran-
tore*. Certain compositional solutions, "corrected"
later in the final work, emerge from an analysis of
the architecture of this precious, and perhaps
unique, preparatory study of the architectural
framework of the entire iconographical cycle.
There is an imaginary upward projection of the
space of the church nave both in the drawing and

in the fresco of the vault. However, in the drawing,
in proximity to the two privileged axes of the large
rectangular hall, the emphasis is placed on the
large central windows on the long sides, and, on
the minor sides, of the window on the entrance
wall and of the arch opposite it. In the drawing, in
fact, there is a kind of ideal "cross" which is em-
phasized by the doubling of the solid composite
columns toward the outside, which frame coupled
arches, thus giving an allusive form to the perime-
ter of the four pseudo-*baldacchini* that lack crown-
ing elements and, like the entire vault, open up to
the infinity of the sky. They look like four squared
apses, open above and laterally, that extend an in-
finity enhanced by the absence of architectural
confines in the direction of the four cardinal
points. This was the slightly projecting profile of a
balustrade in the drawing, which is placed just
above the height of the impost and which runs
around the entire perimeter uninterruptedly ex-
cept when it breaks through the drawing itself in
proximity to the huge arch opening onto the con-
tracted transept crowned by the false cupola in
perspective executed by Pozzo himself around
1685. The solution of the continuous balustrade
was not adopted at that time because of the struc-
tural problems that would have ensued as a result
of suspending a "walkway" adjacent to the above-
mentioned windows. The drawing, therefore, was
probably just prior to the final approved plan and
not later than 1690. Further differences are also to
be found in the solutions adopted for the system of
columns and pilasters that frame and support the
arches surmounted by curved tripartite pediments
that project from the moldings. The plinths sup-
porting the columns that frame the arches are iso-
lated from the continuous plinth-bases that hold
the counter-pilasters and the remaining series of
columns. The final work, the study (cf. NGA 255)
and the engraving (cf. NGA 1,639) show marked
affinities to each other in regard to this last com-
positional detail. Even the plinth of the paired
columns is reabsorbed into the plinth-base, which
has now become continuous, except when inter-
rupted by the balustrade of the open arches. The
infinity of the sky is rendered effectively both in
the brown and gray ink drawing and the study by
means of the visual impact created by the serrated
profile of the entablature. However, in the engrav-
ing and the final work, the architectural elements
are the very simple ones that Pozzo often em-
ployed in homage to the architectural orders of Vi-
gnola and Palladio, figures that were remembered
in the frontispiece of his *Trattato*. Simple elements
that were rendered complex by the multiple pro-
jections, alternation of columns and pilasters, and
continuity and discontinuity of the assemblages
that Pozzo usually adopted in his architecture.

BIBLIOGRAPHY: Pozzo 1693–1700; Pirri 1955:
160–69, 256–58; Montalto 1958: 668–79; Kerber
1971: 54–74, 102–108, 181–86, figs. 53–55; Haskell
1980: 90–91; Pinto 1980: 11–12, no. 2; Metzger Ha-
bel 1981: 31–65; Gargano 1986: 210–16; De Feo
1988: 9–23; Gargano 1988: 77–109; Balestreri 1990:
19–26; Ferrari 1990: 208–209, figs. 25–28; Levy 1990:
216, no. 136, 219–21, nos. 138–39; Contardi 1991:
23–39; Pascoli 1992 (1730–1736): 691–715; De Feo
1996: 114–43; Gargano 1996: 156–67, 243–44; Levy
1996: 133–39; Dardanello 1996: 121–31; Contardi
1996: 97–112; Strinati 1996: 66–93

503 T
Andrea Pozzo (1642–1709)
Study for the vault of Sant'Ignazio depicting "The Missionary Work of the Jesuits"
Church of Sant'Ignazio in Rome; ca. 1691–94
Rome, Galleria Nazionale d'Arte Antica, Palazzo Barberini, Inv. no. 1426
Oil on canvas, 344 x 173 cm (331 x 168 cm)
BIBLIOGRAPHY: De Feo 1988: 9–23 and 1996: 114–43; Ferrari 1990: 208–209, figs. 25–27; Strinati 1996: 66–93

The study for the vault of the church of Sant'Ignazio which was to depict, to use Pozzo's own words, "the propagation of the Christian faith throughout the world by means of the works of Saint Ignatius and the Society of Jesus." The study was exhibited at the Collegio Romano before the vault was painted. MG

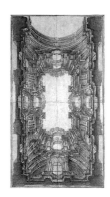

505 M–W
Andrea Pozzo (1642–1709)
Design for the decoration of the vault of the church of Sant'Ignazio in Rome
ca. 1685–90
Washington, D.C., National Gallery of Art, Inv. no. 1994.16.1
Pen, ink and gray wash; 50.4 x 91.2 cm
PROVENANCE: Gift of Robert M. and Anne T. Bass
BIBLIOGRAPHY: De Feo 1988: 9–23; 1996: 114–43

Drawing in gray and brown ink and gray wash on two sheets of pasteboard MG

504 T
Andrea Pozzo (1642–1709)
Sketch for the vault above the altar of the Blessed Aloysius Gonzaga, ca. 1797
Rome, Chiesa di Sant'Ignazio
Oil on canvas; 53.5 x 84 cm

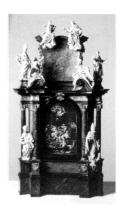

510 T
Frantishek Preiss (ca. 1696–1712)
Model of the High Altar in the Church of the Premonstratensian Monastery in Doksany before 1703
Prague, Kralovska kanonie premonstratu na Strahove, Inv. no. 54 (P13)
Polychromed and gilded limewood, figures with chalk surface; 115 x 66.5 x 26.5 cm (entire altar), incl. figures 20-25 cm; photograph of a painting by Petr Brandl (1703)
PROVENANCE: Church (with graveyard) at Doksany, originally belonging to the Premonstratensian monastery in Doksany
EXHIBITIONS: *L'arte del Barocco* 1966: no. 195; *Baroque* 1969: no. 11; *Umení cheskeho baroku* 1970: no. 52; *Arta Baroca* 1971: no. 19; *Barok* 1972: no. 19; *Le Baroque* 1981: no. 35; *Altars* 1992: 63; *Triumph der Phantasie* 1998: no. 22
BIBLIOGRAPHY: Blazhíchek 1958: 107; Neumann 1970: 50, 154–155, no. 134, 135; Blazhíchek 1981: 80–81, no. 35; 1983: 12; 1986: 89; 1988: 148, no. 414; 1989a: 311, 314, n. 98; 1991: 18; Koubová in *Altars* 1991: no. 63; 1992: 152, no. 98; *Strahovská obrazárna* 1993: 76; Vanchura 1993: 114-17; Ronzoni in *Triumph der Phantasie* 1998: 127, 129, no. 22

The model was made for the high altar in the church of the Nativity of Our Lady in the former Premonstratensian monastery in the village of Doksany, near Litomerice, and was installed in the main burial church in the village. The figural carvings for this model and the actual altar are the work of Frantishek Preiss (Blazhíchek 1958: 107), one of the most remarkable sculptors of the High Baroque active in Bohemia. The realized altar quite precisely reflects the model, although the latter is simpler in its decorative form; it is obviously the poorer for the loss of some decorative detail. In the interior of the monastic church, the two flanking figures standing between pillars are joined by a pair of Bohemian patron saints, Saint Wenceslas and Saint Vitus, who stand above the entrances to the back of the altar. The model exhibited here is a perfect example of demonstration models such as were produced on large-scale projects before the contract was signed with the wood carver and other artists. By lucky chance, three similar models have survived in Prague (National Museum); they were made for the realization of the enormous altars in the decanal church at Louny (1700–1706/1708) and Preiss was the principal contributor to their sculptural decoration. On the other hand, the

model for the high altar in the church in the Ursuline nunnery in Prague's New Town, which is mentioned in the contract of 1709 for the project, the last and grandest work of Preiss's shop, has unfortunately not survived. The production of such models, which often also served to support the studio's own work, must have been common practice in Preiss's studio (Ronzoni 1998: no. 22). The model displayed needs to be viewed from this angle. It is an entirely consistent sculptural work in its figural ensemble, which is seconded somewhat more modestly by the architectural form (Ronzoni 1998: no. 22); the latter, however, in no way detracts from the effective final result which the workshop achieved ultimately in the church itself. Certain obvious differences in the postures of figures and in the lines of drapery compared to the final carvings are attributable in our view to the very process of realizing such a project as the huge high altar, which was only manageable with considerable collaboration on the part of the studio. Preiss's notable entrepreneurial activity, mentioned in the sources, was aimed, of course, at a different objective. In 1709, together with the architect F.M. Kanka and the painter M. V. Halbax, he submitted a proposal for the establishment of an academy of art in Prague. It is remarkable that a representative of Prague realism in wood carving realized the significance of such training. No less surprising is the degree of understanding that a sculptor from the Bohemian tradition had for the formal sophistication of the pictorially expressive High Baroque style (Koubová 1992: no. 98). TH

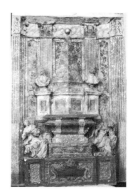

511 T–MAR
Nicola Michetti (d. 1759) and Giuseppe Mazzuoli called "il Bastarolo" (ca. 1536–89)
Model for the Monument to Stefano and Lazzaro Pallavicini, Cappella Rospigliosi Pallavicini in San Francesco a Ripa
Rome, Palazzo Pallavicini Rospigliosi
Painted wood, stucco, and wax; 79 x 53 x 14 cm
BIBLIOGRAPHY: Pinto 1976: 45–50; Negro 1987: 164; Negro in *Fasto romano* 1991: 106–08; Pinto in Contardi and Curcio 1992: 50–57

The model represents a preliminary design for the monument of Stefano and Lazzaro Pallavicini that occupies the left wall of the family chapel. It was made to be inserted into the large model of the entire chapel. There is documentary evidence that such models were prepared in connection with the chapel: in 1716 the model maker Vanelli was paid for his work on "modelli fatti p. li depositi che si fan-

no nella Chiesa de P.P. S. Fran. a Ripa." The dimensions of the smaller model, representing the recessed central portion of one of the lateral walls of the chapel destined to receive the sculptural decoration, are virtually identical to those of the same area in the larger model belonging to the Museo di Roma. In both models the height of the order is 76 cm; the width of the Pallavicini model insert is 53 cm, while that of the corresponding bay in the Museo di Roma model is 53.2 cm. The design of the sepulchral monument in the model differs from the executed sculpture in the Chapel in important respects, notably in the shift from three-dimensional portrait busts to oval reliefs and in the presence of the winged skeleton. On the other hand, the allegorical figures of Strength and Justice as they appear in the model closely resemble their counterparts in the chapel. JP

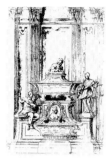

514 T
Nicola Michetti (active 1704–59; d. 1759)
Design for the Monument to Stefano and Lazzaro Pallavicini
Vatican, Biblioteca Apostolica Vaticana, Cod. Vat. Lat. 13645, fol. 24
Pen and ink with gray and brown watercolor touches
41.5 x 28.5 cm
INSCRIPTION: "nicola michetti" (at center under sarcophagus)
BIBLIOGRAPHY: Pansecchi 1962: 29

515 T
Nicola Michetti (active 1704–59; d. 1759)
Design for the Monument to Stefano and Lazzaro Pallavicini
Vatican, Biblioteca Apostolica Vaticana, Cod. Vat. Lat. 13645, fol. 30
Pen and ink with brown and gray washes
41.5 x 28.5 cm
INSCRIPTION: "nicola michetti" (under sarcophagus)
BIBLIOGRAPHY: Pansecchi 1962: 29; Negro 1987: 264

512 T
Nicola Michetti (active 1704–59; d. 1759)
Design for the Monument to Maria Camilla and Giambattista Rospigliosi
Vatican, Biblioteca Apostolica Vaticana, Cod. Vat. Lat. 13645, fol. 29
Pen and ink with gray and brown watercolor touches
41.5 x 28.5 cm
INSCRIPTION: "nicola michetti" (between legs of sarcophagus)
BIBLIOGRAPHY: Pansecchi 1962: 30

513 T
Nicola Michetti (active 1704–59; d. 1759)
Design for the Monument to Maria Camilla and Giambattista Rospigliosi
Vatican, Biblioteca Apostolica Vaticana, Cod. Vat. Lat. 13645, fol. 28
Pen and ink with gray and brown washes
41.5 x 28.5 cm
INSCRIPTION: "nicola michetti" under lid of sarcophagus
BIBLIOGRAPHY: Pansecchi 1962: 30

The format of four signed drawings by Michetti in the Vatican Library is defined by the same precise limits that enclose their three-dimensional counterparts in the model. Michetti's drawings apparently were made preparatory to the fashioning of a number of detailed models for the lateral walls of the chapel that were subsequently to be set into the larger model. These three-dimensional representations of the shallow lateral recesses were prepared by the modelmaker Giovanni Battista Vannelli following Michetti's drawings. They were then given over to Mazzuoli, who modeled the figures. The representation of the statuary in these models, using wax built up around wire armatures, is handled with a brilliance and ease comparable to the best terracotta bozzetti. They therefore definitely appear to be the products of a trained and gifted sculptor rather than an architectural modelmaker. JP

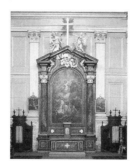

516 T
Carlo Giuseppe Plura (1677–1737) to a drawing by Filippo Juvarra (1678–1736)
Life-size Model for One of the Side Altars in the Chapel of Sant'Uberto at Venaria Reale
Agliè, Parrocchia Madonna della Neve e San Massimo
Carved wood painted in various colors to resemble marble; 8.47 (+ 2.23 height of the cross at the top) x 5.00 a 1.40 metres
BIBLIOGRAPHY: Dardanello 1989: 216–28, pl. 55; Gritella 1992: II, 7–12

In 1771, within a wider restructuring and enlarging program at Agliè Castle, the architect Ignazio Birago di Borgaro was designing the new parish church of Santa Maria della Neve e San Massimo in the square in front of the castle. Birago was a great admirer of Juvarra's work and in these years was engaged in finishing the work on some of the constructions started by Juvarra – at Stupinigi and in the Gallery of Diana in Venaria Reale. The church was built in a very short time and already in 1773 final work on the high altar and marble balustrade and other elements of the liturgical furnishings in the new church were being carried out. It is obvious that the two altars have been inserted with some difficulty into the architectural surrounds of the wall designed shortly before by Birago. They brusquely cut into the bases of the pilasters, which have in fact been cut into to make room for the new structures; the gables of the tympanum stick out laterally over the pilasters; a large part of the dado at the bottom and some steps that generally raise the mensa have been amputated to let the entablature of the altar front run at the same height as the cornice of the minor order. Between 1715 and the beginning of 1716 Juvarra was commissioned by King Vittorio Amedeo II to take in hand the project for the royal palace in Venaria, that sumptuous hunting residence begun by Carlo di Castellamonte for Duke Carlo Emanuele II from 1659, partially renewed by Michelangelo Garove from 1699. In the period between 1716 and 1729 the architect from Messina designed the new royal chapel dedicated to Saint Uberto, redesigned the interior and decoration of the Gallery of Diana and built the impressive "out-of-scale" double wing with the stables and *citroniera*. For the chapel of Sant'Uberto, begun in the spring of 1716, Juvarra elaborated a sequence of studies arranged on a centralized Greek cross with diagonal satellite chapels inserted into the piers and a luminous presbytery screened by columns, after the example of Palladio's Redentore. Unlike the superb academic lesson of Superga, theatrical spectacularity is the key to the interior of Sant'Uberto: here a multiplicity of views, demand for light and spaciousness, and the aerial qualities of the structure become the true substance of the architecture. The altars actively contribute to the success of this spectacle. The arrangement of the high altar is a reinterpretation of Bernini's for the chapel of the Sacrament in St Peter's: on a Roman-style mensa, isolated in the middle of the presbytery, a pair of angels raise the pierced Eucharistic temple, radiantly transfigured into a supernatural aura by the erosion of outlines created by light passing through the screened cage of the apse. The two side altars, on the end walls of the arms of the cross, rely on a classical niche scheme with triangular pediment. A majestic altar front on composite columns projects forward from the vertical plane, interrupted in the pediment to leave room for the curved cornice of the altar-piece and the fluid ornamental panel that develops, enveloping clouds of cherubs in relief. Figures of angels in devotional poses are arranged to the sides of the cross, at the top, on the gables of the tympanum; freestanding and emphatic in the space extended in depth of the raised gallery behind the altar. Between 1716 and 1719, the church was built up to

the level of the cornice of the drum, but then work stopped for lack of resources. The project was temporarily re-proportioned and only the indispensable work to make the chapel immediately "officiating" was planned for in the 1721 budget: plastering and stucco decoration on the walls, setting of the floors, window frames, an illusionary dome painted on a flat canvas above the drum, carving of the musicians' tribune and the construction of the altars in wood instead of marble. The costs estimated for these last, the high altar and the two side altars in the arms of the cross, indicate the intention to paint them, in imitation of marble. On 30 June 1721, Carlo Giuseppe Plura, "sculptor to His Majesty's Household" and "*machinista*" for the festival decorations for Holy Week, signed a contract for making "two wooden sculptured altars for the Royal Chapel in Venaria Reale," identified in the text as "the two wooden side altars." Payments to Plura for carving the altars in wood, that refer probably also to the high altar and the two in the minor chapels, were still recorded in 1722; in that year and in 1723, the gilder Giovanni Battista Negrone was paid "for the gray color given in Oil to the altar, Tribune, musicians' loft and windows" of the chapel (Turin, Archivio di Stato, *Camerale*, Art. 182, reg. 61, cap. 460; reg. 62, cap. 364). Meanwhile, Juvarra had been in contact with the most qualified painters in the Roman classical circle that had grown in the wake of Carlo Maratta for the altar-pieces in these chapels: Giuseppe Chiari, Benedetto Luti, Sebastiano Conca and Francesco Trevisani. In 1724 two paintings by Conca for the minor chapels and the great altar-pieces by Trevisani and Sebastiano Ricci, for the "orchestrated counterpoint" in the side altars, arrived in Turin. With the wooden altars temporarily set up inside the chapel, on 23 March 1724 Juvarra drafted instructions for making the high altar and those in the two side arms in "colored marbles from the Country and from Carrara" (transcribed in Dardanello 1989: 226–28). This is an extremely interesting document because it refers to the wooden altars built by Plura as "models" and discloses at least two basic functions for using a life-size scale in this three-dimensional instrument of the project. The model was considered an unmistakable reference point that replaced the abstract representation of the drawing and the executive details of the moldings; the fact that it was life-size allowed visual verification of the effect of the designed work in the space within which it was to be placed. With a contract of 1 September 1724, the "maestro Stone-cutter Carlo Piazzoli" was engaged to "make, and deliver, made and finished, during the whole of September of that same year one thousand seven hundred and twenty-five, [...] the High Altar and the two side altars for the arms of the Cross in the royal Chapel in Venaria, conforming to the respective Models of wood currently existing in the said Chapel," and to contact the sculptor from Carrara, Giovanni Baratta, for "the great Angels, little Figures, small Heads of Angels, Heads of Cherubs, Seraphims and others to make in white Carrara marble for the said altars." The subcontract, dated 28 February 1725, refers to sketches of figures exchanged by post, but left the sculptor free in his choice of pose for them, "as best seems to him, provided that they can stay in the designated site" (Turin, Archivio di Stato, *Camerale*, Art. 179, m. 3, reg. 8). Baratta sculpted these statues for the altars between 1725 and 1726 in his workshop in Carrara, without conforming to the ones in the model, which he had probably never had a chance to see in real life. On 14 December 1726 Juvarra tested and approved the "three altars of colored marble" made by the Piazzoli workshop, "although not perfect regarding the hardness of the stones and variety of colors." With that formal act the long design history of the altars for the chapel of Sant'Uberto came to a close. From that moment all the questions regarding the fate of the three wooden, life-size models begin. The probable succession of events that led to the installation of two monumental altars, identical in form but completely different in materials and construction techniques, inside the parish church of Santa Maria della Neve, might be as follows: with the church built, the possibility of reusing an existing wooden model, realized in its time for the chapel of Sant'Uberto, as an altar could be seen. The parts of the model were reassembled, and perhaps also partially rebuilt, and the altar was placed in the right arm of the church, as an inscription found on the back of the pediment gable during the initial phases of the restoration (still in progress) indicates: "The said icon was put in place above the new year [*sic!*] from 15 to all the 23 October 1773 Mastro G Chattocchio Mastro Ruva Mastro Pessa." On the example of the reassembled altar with its wooden sculptures, restored once more to its original function as a model, the second altar was built in masonry and plaster, and in polished stucco imitating the same marbles painted in the model, on the opposite arm of the transept. It distinguishes itself from the first only in a more modern style in the figures of the angels (the presence of the skilled modeller Giuseppe Bolina must be remembered in the building of Agliè Castle). The altar-model housing the altar-piece of San Massimo is neither self-supporting nor made in solid wood, but of hollow parts and flat boarding. The mensa, whose front has been remade recently with a simpler design in the panels than the original, and the pedestals of the columns rest on a brick-supporting structure; the different parts of the altar front, like the empty columns, in two pieces, are not able to support the pediment and have been made in individual parts attached to the wall; the vertical plane of the pediment has been built from a supporting board made up of planks slotted together, onto which up to two layers of boards have been fixed, 3 to 4 centimetres thick, to create the projections of the cornices of the drawing and the shaped moldings of the architectural surface ornament; the parts of the gables and pieces of entablature above the columns have been backed onto this panel. The shaped moldings have been executed admirably: they are made up of many carved parts perfectly put together, in the best way to obtain the line of the profiles. The only differences with respect to the altars erected in Venaria can be seen in the treatment of the molding of the arched cornice of the altar-piece and in the analogous band of ovolo molding in the pediment cornice: in the model, it is sophisticatedly carved; in the stone version, it is simplified. Local marble was used for the Sant'Uberto altars – the "colored marbles of the country" – some of which were experimented with for the first time in such quantity and delicate work: yellow marble from Frabosa; *persichino* from Val Casotto; green marble from Susa; Serravezza of Moiola for the column shafts, frieze and part of the tympanum; alabaster from Busca; and ash gray from Frabosa (Gomez Serito 1999). The first cleaning trials in the restoration in progress on the altar-model of Agliè, directed by Antonio Rava, have brought to light a coat of oil paint in dazzling colors, that restore the colors and graining of the local stones used in the side altars in Sant'Uberto with extraordinary faithfulness. The first mention of the wooden altars for Venaria, in the 1721 budget, indicated the intention to paint them "with the colors of stone" to simulate a stony appearance. We know that in 1722–23 they were painted in gray oil paint and, in Juvarra's instructions for the stone-cutters in 1724, hurried reference is made to the model of the high altar "coated in Gray." The color stratigraphies on the altar-model of Agliè have punctually confirmed the existence of a first layer in oil of a gray color (not a preparation, but a real layer of color) that covers all the visible surface of the model, even those parts not painted to resemble marble. Completion of the restoration will help clarify whether the model was painted in marble colors in Venaria, before being taken apart, at a later date, or when it was reused as an altar in the parish church of Agliè. Proof of a definite connection between the altar and the original model finally comes from the sculptures: the cherubim and two angels, their paper-like drapery, rather exagerated theatrical gestures, fixed in the emphatic but not too casual attitudes of their articulations, are all in Carlo Giuseppe Plura's unmistakable style. Here Plura gives the best of himself and can be compared with the works of the greatest moments in the interrupted production of the greatest Piedmontese workshop for wood carving in the first quarter of the eighteenth century.

GD

517 T
Sebastiano Ricci (1659–1734)
The Virgin with the Archangel Gabriel, Saints Eusebius, Sebastian and Rocco
Turin, Università degli Studi, Aula Magna
Oil on canvas; 435 x 255 cm
INSCRIPTION: "Sr Ricci f." (on the front)
PROVENANCE: from the Church of Sant'Uberto in the Castle of Venaria Reale
BIBLIOGRAPHY: Griseri 1963: II, 73, no. 113; Daniels 1976: 120, 126–27, no. 441; Griseri 1989: 39

The altar-piece was placed on the great altar on the right of the presbytery in the church of Sant'Uberto in Venaria Reale, opposite the one by Francesco Trevisani, which was on the great altar on the left. Two paintings by Sebastiano Conca were on the altars of the minor chapels. As Juvarra's direction wished, the pictorial furnishings inside the church of Sant'Uberto displayed the latest developments in taste. The high quality of the painters responded well to the sculptural furnishing in the presbytery, entrusted to G. Baratta for the statues of Sts. Augustine, Anastasius, Ambrose, John Chrysostom. In the initial project, dating from 1721, other artists were to have been commissioned to paint the altar-pieces for Venaria, among them G. Chiari and B. Luti. Then the commission was entrusted to S. Ricci. Juvarra had been directly involved in making sure that the work by Luti, Maratta's worthiest successor and also an early anticipator of Batoni's classicism, arrived from Rome. The choice of Luti was in keeping with the program of recording the image in tones of Arcadian classicism. It well accompanied the choice of Trevisani, who provided the altar-piece portraying the Immaculate Conception with St. Louis IX, King of France, and the Blessed Amedeo of Savoy, to be placed on the right altar of the transept. Trevisani's painting, so close to court taste, enjoyed great success as soon as it arrived in Piedmont, as Lione Pascoli let us know, "it pleased everyone who saw it so much that they could not take their eyes off it; as well as its price [Vittorio Amedeo II] gave him a beautiful service [...] all in silver lightly modeled with his arms adorned with a crown". Instead, intrigues and delays did not allow Luti to complete his canvas, finally left unfinished in 1724 by his death. The commission was alternatively given to Sebastiano Ricci who realised a work strongly set in the figurative tradition, choosing Veronese and Correggio, Rubens and Pietro da Cortona, as models. The pictorial decoration of the high altars in the monumental church of Sant'Uberto in Venaria Reale was therefore resolved with a face-to-face presentation of two works by such different interpreters of the color values of Venetian painting; from Trevisani's pasty brightness to Ricci's vibrant, fringed iridescence, here skilfully balanced by the use of diffused tones, in an orchestrated counterpoint that Juvarra wanted to repropose in the Basilica of Superga. Here instead, he chose Beaumont, Trevisani's best Piedmontese student, as a pair to Ricci. MDM

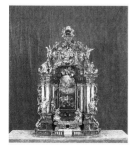

518 T
Anonymous
Model of an Altar on the theme of the Virgin's Assumption, 1739
Krems an der Donau, Weinstadtmuseum, Inv. no. S 70

Wood and original polychrome finish: pink, yellowish and blue columns; false green marble parastades; brown bases and trabeation; green cover with dark brown centre; golden ornaments and remains of the tabernacle; golden and partial polychrome drapes on the figurines
Oil on white latten
145 x 96 x 72 cm
INSCRIPTIONS: "Jo:Geo: Schmidt. Pinxit 1739"
BIBLIOGRAPHY: *1000 Jahre Kunst* 1971: 294ff., no. 262; Schemper-Sparholz in *Triumph der Phantasie* 1998: 189ff., no. 53 fig.

The charm of the recently restored model owes much to its accurate handcraftsmanship, and painstaking attention to detail, as well as to the fact that its original polychrome finish has been preserved. It presents a very rich architectural structure, bordered in its forepart by a baluster that runs in a concave-convex direction on the original pedestal. Four columns stand at each side, their depth graduated, on a floor plan that alternates between a concave and convex pattern. They support a trabeation with a dentiled frieze, cut by the altarpiece, which depicts the Virgin's Assumption. At its higher end, the painting is framed, as though it were in a niche, by a horizontal volute. Above the altar, its cover, formed by light volutes, portrays the Holy Trinity and, at the centre, is the crown, waiting to be given to the Virgin. In the sections that join the altarpiece to its cover, there are golden clouds and some angels who, bearing musical instruments, appear to be in direct rapport with the angels in the painting. At the top is portrayed a globe, surmounted by a sun, around which a snake is coiled. This is a typical reference to the Virgin also alluded to in the crown of stars. The statues of Saint Peter and Saint Paul are placed in front of the most external columns, while above the trabeation, to the left, Saint John the Baptist is depicted pointing down to the tabernacle, which no longer exists, and a saint dressed as a monk stands to the right. A cherub is shown pointing to the Holy Trinity. Saint John the Baptist is also the patron saint of the parish of Stiefern am Kamp, where the model was kept until 1918. It was used as an icon of worship, adorned by larger figures and relics. It is not clear for which church the altar was intended at the time that the project was being made, although one suggestion (Kühnel 1971) involves the church of the Piarists Unsere Liebe Frau a Krems (between 1616 and 1776 it belonged to the Jesuits). In any case, the model and the altar, dated 1756, differ slightly. Schemper-Sparholz, on whose research this study is based, has called attention to the parish of Krems, built in 1733 by Josef Matthias Götz, because of its similarity with the model's architectural structure. According to Schemper-Sparholz, even the ornamentation and figures can be compared with the work of Götz (I. Schemper-Sparholz in *Triumph der Phantasie* 1998). ASt

Chapel of St. John the Baptist in the Church of St. Rocco, Lisbon
Jörge Garms

This chapel represents the culminating artistic point in a long reign spent in an obsessive and quarrelsome *imitatio Romae*, especially in the field of ecclesiastical and liturgical privileges. In the artistic field the commissions of John V of Portugal (1707–1750) had become one of the main factors in the Roman economy, and the little side chapel of the church of the Jesuits in Lisbon (5.40, in width, 6.25 , in depth and 9.40 m in height), constructed entirely in Rome with all its sacred fittings and hangings, is perhaps the richest and most sumptuous commission of the century.

The instructions given on 26 October 1742 to the Commendatore Sampajo, then Portuguese ambassador at the papal court, read: "Have a plan made by the best architect who can be found in Rome at present... The form and the adornment of this chapel is left entirely to the capricious idea of the architect, provided that it be designed, as required, in the most sumptuous manner and the best taste. The architect may used the entire range of the rarest and most gaudy kinds of marble, both ancient and modern, as well as ornaments of gilded bronze, so that what is most resplendent in the said chapel is the costliness of the material with the bizzarreness of art". The chosen architect was Niccolò Salvi, the designer of the famous Trevi Fountain, who, because of his poor state of health, joined forces with Vanvitelli. It is extremely difficult to distinguish the respective contributions of the two designers, and the drawings that have survived are all by Vanvitelli. Later, despite the presuppositions that lay behind the commission, relations between the two Roman designers and the Royal councillors in Lisbon – the Jesuit father Carbone, a Calabrian, and the architect Ludovice, who was of German origin but had been trained in Rome – became very strained because of continual interference, harsh criticism, and counter-proposals from the Portuguese side. Both the councillors were extraordinarily well informed about things Roman and supported their arguments chiefly by reference to classical examples, or to the Roman chapels designed by architects from Raphael and Michelangelo to Bernini, Pietro of Cortona, Rainaldi, and most recently Andrea a Pozzo. Furthermore, they also drew attention to questions of propriety and to the philosophical foundations of architecture. The plans were sent to Lisbon at the end of 1742 and were later modified to such an extent that two separate plans can be distinguished, though the Romans refused to comply with all the Portuguese suggestions. The building of the chapel was already under way by spring 1743. The pope consecrated the altar on 15 December 1744, and in April 1747 the whole chapel was assemble and exhibited to the public. In July of the same year it was sent to Lisbon, where the consecration did not take place until 13 January 1751.

BIBLIOGRAPHY: Sousa Viterbo, Vicente d'Almeida 1902; Maidera Rodriguesz 1988; *The Age of the Baroque in Portugal* 1993: 280, no. 106; Garms 1995: 113–128

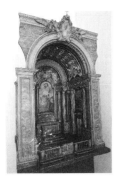

519 T-MAR
Model of the Chapel, 1743
Lisbon, Museu de Sao Roque, Santa Casa da
Misericordia, Inv. no. 1/our
Gilt and painted walnut, copper; 140 x 93 x 86 cm
BIBLIOGRAPHY: Maidera Rodriguesz 1988; *The
Age of the Baroque in Portugal* 1993: no. 196

This model was made, with the help of painters, by
the cabinet-maker Giuseppe Palms in the spring of
1743, in parallel with the construction of the
chapel itself. The only significant difference is the
absence of the twisted columns between the
balustrade and the lateral pilasters. The model
proved useful especially for the assembling of the
chapel, which was carried out by Roman specialists
who accompanied the work to Portugal. JG

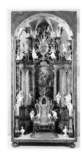

526 T
Jakub Eberle (1718 - after 1776)
Model of the High Altar in the Church of the Cis-
tercian Monastery at Zlatá Koruna, before 1772
Chynov, Decanal Church of the Holy Trinity
Lime wood, polychrome and gilt
Altarpiece: *The Assumption of the Virgin*, oil on
copper; tabernacle: *Saint Joseph with the Enfant
Jesus*, oil on paper, 116 x 59 x 38; 12–15 (figures)
Restored by N. Mashková (Prague) in the years
1997–98
PROVENANCE: Cistercian Monastery at Zlatá
Koruna (Southern Bohemia)
EXHIBITIONS: *Umení v Chechách* 1938: no. 944.
BIBLIOGRAPHY: Maresh, Sedláchek 1918: 191, no.
170; Blazhíchek 1948: 49; 1958: 261; 1977a: 72;
1977b: 122; *Umelecké památky* 1977: 557 (with
illustration); *Umelecké památky* 1982: 364;
Blazhíchek 1983: 17, 18, no. 24; 1989: 736

The once famous Cistercian abbey at Zlatá Ko-
runa in Southern Bohemia was last renovated in
the 1760s and especially after 1770. This renova-
tion was due to the last abbot, Bohumír Bylanský,
who with great élan refurbished the interior of the
monastery church of the Assumption of the Vir-
gin, for whose presbytery Jakub Eberle, the most
significant Baroque sculptor of Northwestern Bo-

hemia, designed a sumptuous plastic altar. The
contractual model of the high altar of the abbey
church stands today on the side altar in the interi-
or of the decanal church in Chýnov near Tábor.
The man who commissioned the work from Eber-
le, no doubt Abbot Bylanský himself, obtained
from the somewhat "toy-like" model (Blazhíchek
1983: 17) an otherwise perfect representation of
the form of the future high altar. The exhibited
modelletto, much reduced in scale, shows a mon-
umental portal type of altar with an open exten-
sion bearing a monogram of Mary's name. On the
definitive altar the plasticity of the beams is con-
siderably clearer, and the gilt reliefs showing
scenes from the life of the Virgin and of Saints
Benedict and Bernard are more highly elaborated.
Lastly, the figural decoration of particularly the
top storey, the high extension, clearly displays a
greater dynamism than it does on the model. The
main altar painting of the *Assumption*, which was
painted by C. Philippot (1854) when L. Plank's
original canvas was damaged in 1848 (*Umelecké
památky* 1982: 364), derives in composition from
the relatively high-quality original oil-on-copper
painting which has survived. On the high altar of
the abbey church, as on the model itself, the paint-
ing continues on the vaulted ceiling of the pres-
bytery – a small floral ornament complements a
contemporary fresco with the subject of the As-
sumption. Stylistic analysis of the sculptural deco-
ration of the church in Zlatá Koruna monastery,
worked on until 1772, reveals that Eberle was the
designer of the prevailingly stucco sculptures,
which were then superficially fashioned by assis-
tants, chief among them friar Tobias Feiler. The
master himself most probably restricted his work
at this late stage to doing preparatory work such as
sketches and models. Unlike the sculptures of
saints, which Eberle's workshop furnished for the
high altar in Dientzenhofer's church of St. Mary
Magdalene in Karlovy Vary (1752), impressive for
their sublime monumentality and the emphatic
character of their slow but generous movements,
the rendering of all the sculptures at Zlatá Koruna
is somewhat coarse and in places even primitive.
The momentousness and poise of the preceding
work is replaced, at Zlatá Koruna, by a failure to
convey volume; the subtly stylized surface has
softened uncertainly, and the facial typology oth-
erwise so expressive has been replaced by mere
masks. Jakub Eberle, born in North-western Bo-
hemia, moved to Prague to study as an apprentice
to the wood carver Simon Thaller. Trustworthy re-
ports inform us, however, that he concluded his
years of apprenticeship in Italy, where he supple-
mented his education and acquired a powerfully
developed sense for monumental forms
(Blazhíchek 1977b: 121). While in Rome, where
he was living in 1744–45, he married a Viennese
woman. After the supreme works for the Karlovy
Vary church, his workshop produced altar figures
for churches in Sokolov, Loket, Kynshperk nad
Ohrí, Masht'ov and Kláshterec nad Ohrí; in the
period from 1760 to 1770 his studio was em-
ployed on a commission for the place of pilgrim-
age Chlum sv. Marí (Mariakulm). Among the last
still remarkable products of the Eberle workshop
are the carved figures for the parish church of Li-
bochany near zhatec (1773), in which reflections
of his Italian apprenticeship are still discernible. It

is these Italianizing stylistic components which
clearly distinguish Eberle's work from the orienta-
tion of other sculptors in Bohemia in the second
half of the eighteenth century (Blazhíchek 1977b:
122). In the opinion of J. Neumann (1974: 70–71),
Eberle succeeded in combining the sculptural
legacy of F.M. Brokoff with the monumental Ro-
man art of the eighteenth century. The sculptures
of saints on the Karlovy Vary high altar moreover
show that they no longer derive from works by fol-
lowers of Bernini, nor yet from delicate Roman
Rococo: they derive instead from the lofty and
solemn sculpture of Giuseppe Muzzuoli, Pietro
Stefano Monnoto and most of all Camillo Rus-
coni, who created the series of Apostles in the Lat-
eran (Blazhíchek 1980: 501). TH

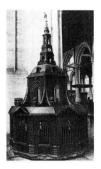

527 T
*Nicolaas Listingh (1630–1705), model probably
made by the carpenter Roelof Germeling*
Wooden Model of a Central-plan Church on
the Botermarkt in Amsterdam; 1684–95
Amsterdam, Oude Kerk
Oak and pine, small details in metal; section
280 cm, height 495 cm
PROVENANCE: Exhibited in the Oude Kerk
from 1729; from 1808 to 1960 in the Nieuwe
Kerk; since 1960 again in the Oude Kerk
BIBLIOGRAPHY: Listingh ca. 1695; Ozinga 1929:
141–42; Plantenga 1929: 16–17, 26–27; Van
Eeghen 1978: 83–85; Kuyper 1980; 187;
Tieskens 1983c: 82–83; Ottenheym, Vlaardin-
gerbroek 1999

The town of Amsterdam underwent an enormous
expansion in the 17th century, notably through
the creation of the great belt of canals. In the sec-
ond half of this belt of canals, which was created
from 1660 onward, the original intention was to
erect four new churches. Only one of these, the
most easterly, was actually built in stone; this is the
Ostkerk. As a temporary replacement for the
three other churches, a wooden church was built
in the middle of the new district, on the Am-
stelveld. In the ensuing years the town council
considered building a large new stone church in
this new district. The model shown here, by the
lawyer and amateur architect Nicolaas Listingh,
formed part of such a project. Listingh supplied
his design and the relevant wooden model at the
request of the burgomasters. His expenses on it
over the years 1684–95 were settled by the town
council in 1695. However, this great central-plan
church planned for the Botermarkt (now the Rem-
brantsplein) was never built, and the "temporary"
wooden church of 1668 on the Amstelveld has re-
mained standing to this day. Listingh's model
shows a large central-plan building, with a dodec-

ahedral gallery and a hexagonal core with a tambour. Sloping buttresses form the transition from the dodecahedral gallery to the hexagonal tambour. The hexagonal dome was surmounted by a tall tower composed of a gallery, a clock, a carillon, and, right on the top, a pomegranate with the four winds and a weather vane bearing the coat of arms of the town. The interior of the model shows continuous vertical profiles along the the six heavy pillars, from the floor to the dome. The dodecahedral gallery consists of six porches alternating with six compartments, each of which would have had galleries on three floors. The wooden model itself is the size of a small chapel; the projected building would have been of truly monumental size. The surface area was comparable to that of the other large churches in Amsterdam, but such a huge span had never before been constructed anywhere in Holland in a central-plan building. Listingh argued in his prints that it would be cheaper to build one large church than three smaller ones. Two earlier Protestant churches in Amsterdam, the Zuiderkerk and the Westerkerk, had a tall tower next to the main building. Listingh placed his tower on top of the dome. It would thus have reached a height which was quite unprecedented in Protestant church architecture in Holland. In the prints which accompany this model the ground plan is compared to those of the Pantheon, St. Peter's, and Hagia Sophia. It therefore seems likely that in his central-plan church in Amsterdam Listingh intended to create a head church of Calvinism which would rival those of the other religions in size as it would in all other respects. The architecture of the model conforms to the tradition of Protestant church architecture as it had developed in the Northern Netherlands since the end of the 16th century. KO

Nicolaas Listingh (1630–75) accompanied the presentation of his design for the central-plan church on the Botermarkt with a large model (discussed above) and with a series of almost equally large engravings. In 1695 he was handsomely paid by the Town Council for the wooden model and the series of seventeen prints (Oldewelt 1934: 162). A remarkable part of the series is the set of three engravings where the outline of the ground plan of the church is compared with those of other churches in Amsterdam. With these engravings Listingh means to demonstrate that, in surface area at least, his design does not depart from what had been customary in Amsterdam down to that time. In the bound copy of this print series which is preserved in the Amsterdam municipal archive, there is an additional ground plan on which Listingh succinctly explains why his proposal to build one big new church on the Botermarkt should be given preference over the original plan of three smaller new churches. Following this are two further print series, both in the same large format, of two buildings which Listingh clearly regarded as important parallels for his design. These are the Round Lutheran Church in Amsterdam, built to a design by Adriaan Dortsman in 1667, and Hagia Sofia in Istanbul. The print shown here comes from the first part of the series and shows a perspective view of the church and the ground plan. Listingh here shows the moment when the ground plan was to be traced out on the building-site by the surveyors. In fact the project never got to that stage. Nevertheless, this print unintentionally provides a rare pictorial record of the work of the surveyor, who had to measure out on the building site, in full size, the design shown on paper and in the model, in preparation for the actual building work. KO

er Saxony (Reuther 1971). The model is based on a drawing by Tommaso Giusti and, as the documents show, it was made in 1713. Giusti had arrived in Hannover in 1689, commissioned as a scene-painter in the theater, and he later developed his career as a scene painter for fairs and as an interior designer. Giusti had been commissioned to build the Clemenskirche by Agostino Steffani, vicar-apostolic of upper and lower Saxony. He, too, was originally from Venice, and he was able to ensure that the project be assigned to Giusti rather than to other very important architects, like Johann Dientzenhofer. The church was consecrated in 1718; however, due to lack of funds and, probably, also to its poor location, the cupola on the cross-vault and the towers of the choir were never erected. The wooden model can be dismantled into twenty-four parts so that the internal wall decorations can be easily seen, but it is not so much a work model as it is an illustrative object, as represented by the unusually precise and accurate manufacturing. According to the model, the building's layout is centered on a Greek cross pattern with a square cross-vault. The arms of the cross, whose ends are shaped like a polygon, extend in an east-west direction, thereby allowing a longitudinal axis to be fitted between the choir and the main portal. Flanked by two towers, the choir faces west, while the façades are simply constructed with flat buttresses, which lack any architectural decorations. Only the east entrance has a full decorative composition comprised of parastades, which indicates that Serlio's treatise on architecture, written in 1537, was used. Sloped roofs cover the church up to a baluster, which extends uninterrupted until it repeats the cross pattern of the layout. The octagonally shaped cupola of the cross-vault dissolves into a simple structure made of imposing pillars, a solution that was also applied in a more obvious manner to the upper parts of the towers, also octagonally-shaped. In this manner, a strong contrast is created between the massive structure and the smaller base below. Unmistakable comparisons can be drawn between this church and the sacred buildings made by Longhena in Venice, where Giusti's father had worked as an assistant in a building yard. The cupola's drum opens onto paired arches and volutes hold down the parastades that rest along the drum's pillars. Architectural comparisons can easily be made with Longhena's masterpiece, the church of Santa Maria della Salute in Venice. It had been described as a temple in Antonio Labacco's architectural critique in 1557 (*Book Concerning Architecture in Which Certain Important Antiquities of Rome are Mentioned*). The internal layout is essentially determined by the exterior's architectural structure. Even the internal composition, consisting of Ionic parastades with channelled shafts and a free-running cornice or trabeation, can be compared to some of Longhena's work, such as the main apse in the Cathedral of Chioggia. In the model, the link between the cross-vault and the octagonal cupola is carried out with very few supporting structures. An octagonal trabeation is used which is supported by massive voluted ledges. As Reuther has observed, however, the latter are completely off scale. ASt

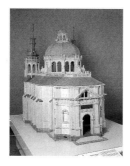

528 T
Nicolaas Listingh (1630–1705)
Print from *Niew Desseyn tot een Seer Groote, Stercke, en om te hooren, hoel beguame Coupel-Kerck met een hooge tooren daer midden uyt rysende; gansch dienstig en gevoeg-lyck te plaatsen op de Booter-Marckt: ontworpen door ordre, en vertoont, soo van Hout als in Prent, tot Glorie en Roem van de Eedele Groot Achtbaare Hoeren, de Heeren Burgemeesteren en Regeerders deser Stadt Amsterdam, de selve doende bouwen. alles, met onvermoeyden yver en langduyrigen arbeyd, uytgevonden, en, daar toe, in staat gebragt, door Mr. Nicolaas Listingh Advt*; 1689–95
Amsterdam, Gemeentearchief
Engraving, 56 x 84 cm
BIBLIOGRAPHY: Listingh ca. 1695; Oldewell 1934: 162; Van Eeghen 1976: 83–85; Kuyper 1980: 187; Tieskens 1983c: 82–83; Ottenheym, Vlaardingerbroek 1999

529 T
Tommaso Giusti (1644–1729)
Model for the Clemenskirche in Hannover
1713
Hannover, Historisches Museum am Hohen Ufer, storehouse of St. Clement's Roman Catholic Church
Wood, cardboard (partially covered in cloth) with a polychrome finish
153,6 x 106,9 cm; total height: 165,7 cm
BIBLIOGRAPHY: Reuther, Schlüter 1962: no. 75; Plath 1970: no. 97; Reuther 1971: 203–30, figs. 1–4, 6–7; 1975: 154ff., fig. 27; 1981: 105, fig.; Reuther and Berkenhagen 1994: 83, no. 177

According to Reuther, on whose research this review is based, Hannover's Clemenskirche is in a Baroque style, which was imported from Venice, and it remains the only sample of its kind in low-

The precedents of Clement XI's competition of 1715
Hellmut Hager

The problem of sufficient space for the sacristy, finally resolved with the building erected by Carlo Marchionni, was present right from the start in St. Peter's. Both the rectangular rooms next to the choir and the small circular temple from Caracalla's period, known as the Madonna della Febbre, that Gregorious XIII had destined to this function in 1575, were insufficient. When the area purposely built on the north side of Maderno's nave became the chapel of the Holy Sacrament in 1626 the problem emerged once again. Attempts at solving the problem under Alexander VII remained on paper. Clement XI energetically undertook new initiatives, and he dictated the subject of the new sacristy (Hager 1970: 11) for the 1711 Clementine competition with a clause that it must respect the temple. The pope, who meant to reach a definitive solution with this competition, using considerable expenditure of means, was frustrated by the fact that he had to use his funds in the war against the Turks in 1716. Better results were not seen even with his more immediate successors. Under Clement XII, Galilei produced a strange project that intended to back the sacristy on to the south side of Maderno's nave (Hager 1974: 48–49). A second project, a model attributed to Juvarra but untraceable since the break-up of the Museo Petriano, appears to have aimed merely at embellishing the temple, like Demangeot's earlier design of 1711 (Rovere, Viale, Brinckmann 1937: 95; Gritella 1992: 166). Another model that has come down to us only in a photograph, attributed to Juvarra by Gaus (1967: 77), an opinion not shared by this writer (1970: 44–46), and considered to be by an anonymous author by Gritella (1992: 167), has recently been shown to belong to a later period and to link up with the planning phase of Marchionni's time. For its relationship with a series of drawings attributed to the young Valadier, see Kieven (1992: 910–17). Filippo Juvarra was the most eminent of the architects taking part in the competition called by Pope Clement XI Albani. The other competitors were: Antonio Valeri, who would present a second project for the sacristy in 1723; Nicola Michetti; Antonio Canevari; Domenico Paradisi; and Lelio Cosatti, who would only be ready with his work in 1718 (Rovere, Viale, Brinckmann 1937: 127–29; Wittkower 1949: 158–61; Viale 1966: 55–56; Gaus 1967: 67–85; Hager 1970: 16–46; Boscarino 1973: 197–203; Gritella 1992: 130–168). There were no official winners out of all the participants in the competition proclaimed by Clement XI in 1715. Engaged in the war against the Turks in 1716, the pope probably could not come to a favorable decision for any of the projects. Perhaps he put the decision off until the end of the war, or perhaps he hoped that Cosatti's model, presented three years after the competition, in 1718, might represent an acceptable but less expensive solution. In 1720 the pope had ordered the Tempietto della Madonna della Febbre to be restored and was instead more inclined to building the "third arm;" realisation of this was suspended by his death. In retrospect Cancellieri was undoubtedly right when he declared: "In its greatness and magnificence, Cavaliere Juvarra's model beat them all".

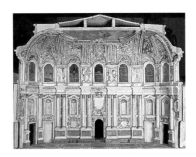

530
Filippo Juvarra (1678–1736)
The "Great Model" for the New Sacristy of St. Peter's; 1715
Vatican, Rev. Fabbrica di San Pietro (previously in the Museo Petriano)
Painted wood; ca. 276 x 330 cm; height to the attic 75 cm, to the top of the vault 115 cm
INSCRIPTION: "BASILICE SACRARIUM.ET CANONICORUM.AEDES. A FUNDAMENTIS.EXTRUXIT. ANNO. DOM. MDCCXV" (on the architrave) and "CLEMENTS. XI PONT MAX." (south front and corner projections)
BIBLIOGRAPHY: Cancellieri 1783; Loret 1936: 198–201; Rovere, Viale, Brinckmann 1937; Lange 1942; Wittkower 1949: 157–59; Spagnesi 1964: 165–67; *Filippo Juvarra* 1966: 55–56; Gaus 1967: 67–85; Pommer 1967: 142; Hager 1970: Boscarino 1973: 197–203; Paluzzi 1975; Millon 1984: XII, XIII, 246; Ciofetta 1991: 214–28; Gritella 1992: I, 130–68; Kieven 1992: 910–27; Hager 1995: 167–73; Rava 1995: 408 10; Sladek 1995: 147–58; Hager 1997: 137–83; Sladek and Bosel 1997: 136–42; Corbo 1998; Hager 1998: 105–20

The model was built by the carpenter Francesco Piccolini from the period 15 February to 3 July 1715. Piccolini was also responsible for transporting it, taking it apart and reassembling it both at the Quirinale and in St. Pietro à Tor de' Venti, that is in the "Nicchione" of the Belvedere, where, from 1704, the pope, aided by Fontana, had set up a museum of models of the Rev. Fabbrica. Vittorio Amedeo II of Savoy, for whom Filippo Juvarra was court architect from 15 December 1714, granted him permission to return to Rome to supervise construction of the model at the request of Cardinal Annibale Albani, prefect of the Fabbrica from 1712, who had seen "five drawings all different for the said Fabbrica, done by don Filippo while he was in Rome." These five drawings might be those in the Turin sketchbook (Biblioteca Nazionale, Riserva 59, 4). The right side of the model, which corresponds to the south-east side of the Basilica, is three-dimensionally articulated on the outside, while inside all the spaces are clearly represented. On the left side, the exterior articulation is merely painted, and the inside is empty. On the exterior, beige colors predominate; the roofs are red and the masonry, in the joins along the openings, is indicated in pink. Inside, gray predominates except, naturally, in the room of the shared sacristy. Here the model can be opened along the major axis. The model can also be opened along the main axis perpendicular to the Basilica. After several moves during the 18th and 19th centuries, a definitive setting seems to have been found for the models in the Museo Petriano, built by G. B. Giovenale (1923–24). This, however, changed its designation

during the Second World War and on that occasion the models were "eliminated" with disastrous results (Hager 1970: 708; 1995: 166). In 1966 the building was demolished to provide access to the Nervi Room. Among all the known projects for the sacristy, Juvarra's model of 1715 stands out for its geometrical relationship with the Basilica. It envelopes the south apse almost concentrically with a Berniniesque colonnade, and orientates the transverse rectangle of the Canonica, or canons' residence, parallel to the compositional axis of the church. For the first time, the link between the two buildings is made through two diagonal corridors, placed symmetrically, that join the planned building to the traditional entrances to the Basilica on this side; that is to Porta della Madonna della Febbre and to that of Santa Marta, flanking the south apse. During July and August of 1714, Juvarra was in Messina, where he had been called by the then new King of Sicily, Vittorio Amedeo II of Savoy, to complete the Royal Palace near the port. It had been planned around a square courtyard with corner projections, but it had been left unfinished by the Tuscan architect Andrea Calamech, who was in the town from 1565 to 1578. We know from drawings, discovered by A. Lange in 1942, that Juvarra meant to finish the building externally more or less as Calamech had planned it, limiting his intervention to adding a large reception room with portico on the garden front, already begun. In the right-hand wing, still to be built, he proposed a hall with two symmetrical staircases and a circular chapel on the floor above (Gritella 1992: 169–77). The project remained on paper since Juvarra, nominated in the meantime architect to the king, followed the sovereign to Turin in September. On the king's commission, he was in Livorno and then Rome in November. He returned to Rome in January 1715, as has already been mentioned. It is therefore conceivable that a certain amount of time went by between the drawings in the Turin sketchbook that might have originated from the competition of 1711, which had shown the pope's increasing interest in this problem, and the definitive design for the model, which, as we have seen, was the result of a new approach. This approach made use of his experience in Messina, whose effect, among other things, can be seen in the adoption of a very long building with corner projections for the canons' residence. While designing a sacristy integrated into the canons' residence and flanked by two rectangular rooms (secondary sacristies) for his model, the need to keep a certain distance from the Basilica suggested to Juvarra that he transform the straight portico at Messina into a curved colonnade in order to establish that almost concentric relationship with the south apse of the church, mentioned earlier–an allusion to the *genius loci*, Bernini. During this part of the planning process, that is the concave curving of the colonnade that would enrich the area with a second, smaller Piazza San Pietro, the frontal part of the northern arm of this building group is, as it were, pushed backward. This operation ushes the rectangles of the secondary sacristies, and with them also the corner projections, in a diagonal direction. The process results in an original and conceptually sophisticated arrangement. When choosing an identical layout for the projections on the south side, the architect seems to have been

well aware of this; in part he was following the dictates of symmetry, but he certainly had one eye on the advantages of an aesthetically facilitated situation, as far as the visual movement around the corners of the complex is concerned. A driving element behind a rethinking of the situation in general, and the link with the southern apse of the Basilica, was undoubtedly reflection on a precedent provided by Carlo Fontana in his plan of 1694 for organizing the area around the church of St. Peter's. One of the main elements in this were the two exedras opening around the transverse apses of the Basilica (Hager 1970: 2, pls. 18 and 19). Juvarra was also indebted to a pupil of Fontana's: Filippo Barigioni. The Accademia di San Luca has a project by him for a large *palazzo*, which won him first prize in a 1692 competition (Smith 1993: 133–39, pls. 21–24). In designing the symmetrical stairs that lead from a three-bayed hall, which perforates one of the long sides of the Royal Palace in Messina, Juvarra had already referred to this. Now Barigioni's plan inspired him in another respect. Turning toward the Basilica and adapting the length of the canons' residence to that of St. Peter's, without Maderno's nave, the sacristy would have been a rectangular building organized around an extremely large courtyard. The dividing wing, in the model, acts as a passage that communicates with an ambulatory, which, in Barigioni's design, exists only on the ground floor, while the upper floors look out on the courtyards with their external walls articulated by an order of tall pilasters. In the model these courtyards are rectangular; they are open not only on the ground floor, where the height of the openings had to remain rather low since this was the level predetermined by that of the Basilica, but especially on the *piano nobile*. Working on a square plan, Barigioni could apply the same scheme to all four sides of the courtyards: five axes of identical openings. On the ground floor, the ambulatory surrounds the open space on three sides. The fourth is part of the so-called "ground-floor room, which, in the central part and below the *salone*, leads from the main façade to the one opposite like a sort of free passage, making it independent from the rest of the building. The situation was a good deal more complicated for Juvarra since, departing from a rectangle, he had to synthesized sides of different length. In the case of the model, this permitted him to establish a scheme of four bays on the long sides and three on the short, leaving brief stretches of wall on both of them with narrow rectangular openings. In the position of Barigioni's *salone* on the *piano nobile*, Juvarra introduced a spacious hall to connect the room above the southern entrance of the canons' residence with the main sacristy. As for the southern side of the model, Barigioni's plan is still easily recognizable in the very long façade of the canons' residence, which stretches between the two corner projections, modified as described above. Likewise, for the equally remarkable differences, like the greater number of floors and the substructure necessary due to the presence of a moat around Barigioni's building, it must be borne in mind that, as Gil Smith has pointed out (1993: 134–35), this architect was still working within the tradition of Bernini's projects for the Louvre and in the French tradition of the period. The specific difference between this prototype and Juvarra's model therefore lies in the stratification, which Filippo wanted dominated by the *piano nobile*. This is placed on a very low elevation with Michelangelesque windows whose enlarged shape is found again in those of the last floor. Proceeding with the external articulation, the model diverges from Barigioni's design to approach clearly Nicola Besnier's project of 1711, where a stratification scheme similar to one already used by Juvarra in his drawings for the sacristy in the Turin sketchbook can be seen. It must be remembered that the 1711 competition fell during a period of much activity on Juvarra's part in the Accademia di San Luca (Hager 1970: 17) and, therefore, one must take into consideration the possibility that Besnier's project might instead reflect Filippo's influence. For reasons of space, this problem will be discussed on another occasion. In a certain sense, the courtyard arches of the model were announced in the elevation of Besnier's project. They can be found in the drawing in the long external corridors flanking the row of spaces of the sacristy and its related areas. Juvarra differs from Besnier in the bodies containing the staircases; these strongly project in the Frenchman's drawing and are closely compatible with the development increasingly characterising eighteenth-century palaces in Germany. One of the characteristics of the model is the way in which the upper part of the sacristy, proportionate to the height of the Basilica, rises above the level of the canons' residence. This effect had already been remarkably achieved by Nicola Besnier, whose building complex culminates in the very tall raised part of the sacristy. Reflecting on the merits of Besnier's project, one can imagine that Juvarra had already advised the young architect to change the orientation of his sacristy by ninety degrees to make it parallel to the longitudinal axis of the Basilica and thus correct the excessive projection of the overall design: its only "defect" and the reason it languished. Turning now to the model's *raison d'être*, that is the great room of the main sacristy, we can once more verify that something new is happening, which left both Besnier's work behind and the series of his own drawings in the Turin sketchbook, which represent a trend of ideas that do not find any continuation in the conception inside. The oval room is made up of a rectangle, which, on its short sides, opens into two semicircular spaces. The walls are articulated by coupled columns, which become single on the concave sides and enclose framed niches, obviously meant to house statues of the twelve Apostles, planned on a monumental scale, like those realised, at almost the same time, for Borromini's niches in San Giovanni in Laterano. As for the use of the columns on a similar plan, the plan seems to be inspired by a "Pianta di architecttura per un soffitto bislungo" by Andrea Pozzo (Hager 1970: 26). In its coloring and architectural arrangement, the sacristy is well inserted into the chapel tradition of the late seventeenth century, as represented, for example, by the Cybo chapel in Santa Maria del Popolo (1682–84) by Carlo Fontana; the effect in this chapel is also determined by the massive use of coupled columns of reddish, Sicilian jasper, which in the sacristy tend to gray in contrast with the African green planned for the walls. The wooden cupboards for the liturgical vestments are arranged in the continuous band of the base, which projects below the columns, and have brown doors framed in white marble. The attic rests on a light marble cornice, with window openings cadenced to the statue niches. Between the arched windows and attached to the wall, pairs of atlantes, taken from Andrea Pozzo (project for Santa Maria delle Fornaci, 1700, II, pl. 89), effect the transition between the columns of the lower level and the ribs of the vault. The rather heavy decoration is in well-planned harmony with the architectural articulation and the color scheme. As for its spatial aspect, the Roman *gravitas*, emphasized so vigorously in the sacristy as already mentioned, can be linked to the tradition of sumptuous chapels that were a frequent phenomenon in architecture during the last quarter of the seventeenth century in Rome. Therefore, to the Cybo chapel referred to above, we can add the Cappella del Sacro Monte di Pietà, whose internal decoration was begun by Giov. Ant. de Rossi, an institutional architect until his death (Spagnesi 1964: 165–67). What links the sacristy to these chapels is another version of an ovalizing type of plan; that is, a rectangle with rounded corners, which still belongs to the period of Giov. Ant. de Rossi (*Disegni di vari Altari e Cappelle*, pl. 46; cf. Mallory 1977: 39) published in 1690/91 (Ciofetta 1991: 217). The similarity in the shape of the pointed niches and their frames is also remarkable; so is the shape of the windows above the entablature in general. Contrast is found in the heavy tone of the stuccowork in the vault, lightened though both by the medallions above the windows, which in the sacristy appear only over the doors toward the corridor, and the one opposite toward the colonnade, and by the outline of the relief in the centre of the vault (Mallory 1977: pl. 69). These works were no longer by De Rossi but by his successor, Carlo Francesco Bizzaccheri, a former pupil of Carlo Fontana, who finished the decoration of the dome with the help of Lorenzo Ottone, Michele Maglia and others, between 1696 and 1698 (Carta 1980: 49-56; for a comprehensive re-examination see Scherner, in preparation), just a few years before Juvarra arrived in Rome in 1704. With the sacristy, he created an enlarged and even richer version of this chapel. It is possible to consider the Antamoro chapel (1708) as an intermediary, since it is there that Juvarra began to elaborate on the example of Bizzaccheri's vault, alternating compartments of white relief between very wide, decorated ribs (Carta 1980: pl. 1, and Gritella 1992: 110, pl. 69). Entering the staircase from the east side and turning toward the left, one would come to the chapel, a rectangular room from which the choir could be glimpsed through a dividing screen of Palladian shape and, in the background, the only altar. This was flanked by free-standing columns and doors and surmounted by an oval altarpiece, which it is connected to by a concave-sided pedestal. There are cross-bearing angels above it: a presentation of the painting already used by Bernini in San Tommaso di Villanova at Castelgandolfo and in the Fonseca chapel in San Lorenzo in Lucina; by Carlo Fontana in Santa Marta in the Collegio Romano; and by Juvarra himself in the Antamoro chapel, although here in a form as already suggested by Bernini in the *Gloria dello Spirito Santo* above the Cathedra Petri in the Basilica. HH

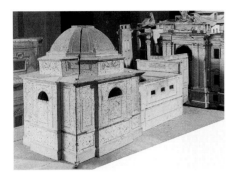

532 T
Nicola Michetti (ca. 1675–1758)
a) Model for the New Sacristy of St. Peter's, 1715
Vatican, Rev. Fabbrica di San Pietro (previously in the Museo Petriano)
Wood painted gray and beige; the inside is gray, with contrasting tones (for a comprehensive description of the details, see Pinto 1992: 58–69).
74 x 142.5 x 62 cm
Unfortunately only half of the original model described by Cascioli 1924: 44) has been conserved.
INSCRIPTIONS: "CLEMES [sic] XXI [sic] PONT MAX AN° MDCXV [sic]" above the entrance to the bridge, which led to the Basilica
BIBLIOGRAPHY: Cascioli 1924; Hager 1970; Pinto in *In Urbe Architectus* 1991: 58–69

b) Model of the Sepulchral Chapel for the Canons
Vatican, Rev. Fabbrica di San Pietro (previously in the Museo Petriano)
Painted wood; 38 x 51 (without corridor) x 31 cm
BIBLIOGRAPHY: Rovere, Viale, Brinckmann 1937; Hager 1970; Galassi Paluzzi 1975; Curcio in *In Urbe Architectus* 1991: 401–404; Pinto *In Urbe Architectus* 1991; Corbo 1998

As established by John Pinto (*In Urbe Architectus* 1991: 58–69; see plan and section 63), this was connected to the sacristy along the main axis by a sort of bridge (the corresponding one connecting the sacristy to the Basilica has not been conserved). The sacristy complex is organized around a circular, central space, with a dome, connected along the main axes to rectangular rooms identifiable, by the wall decoration, as sacristies. Ancillary spaces along the diagonals are also rectangular, but shorter and wider with side apses. The shape of the dome, without a lantern, merits particular attention; stepped on the exterior according to a Pantheon prototype, cadenced on the interior by ribs corresponding to the columns that articulate the inside of the cylindrical body, and sunk into the drum. In the seventeenth century this arrangement is found especially in Borromini's works. Without a lantern, the illumination depends entirely on diagonal channels, which let light in from the windows of the drum to the inside of the room. This method corresponds to Carlo Fontana's recommendations (*Il Tempio Vaticano*, Rome 1694: 303) and is also found in the Basilica itself (*ibid*: 359). On an octagonal plan, the sepulchral chapel, with dome opened by oculi, is reached from the sacristy by the above-mentioned bridge and is preceded by a square hall with three bays of arches on each side and a fountain in the middle. It is an ossarium, where skulls and remains of skeletons are tidily organized under the arches that cadence the interior. It was to continue the function of the underground areas of the old Rotonda, which had served as a burial place for the canons. It was in fact very close to the canons' residence ('g' in Tiberio Alfarano's plan of 1590; Galassi Paluzzi 1975: 384, fig. 492; Corbo 1998: 7–8). Attribution to Nicola Michetti has (ca. 1675–1758 Rome) been confirmed by stylistic comparison with documented works by this architect, which can be found, for example, in the complex of Palazzo Colonna in Piazza Sant'Apostoli in Rome. Let us also remember the Rospigliosi Pallavicini chapel in San Francesco a Ripa in Rome, projects for a church in St. Petersburg and for a palace in Strelnja, produced during his stay in Russia. HH

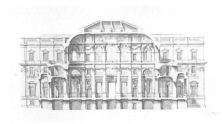

531 T-MAR
Filippo Juvarra
Elevation of the Sacristy of St. Peter's, 1714
Turin, Biblioteca Nazionale Universitaria
Pen, pencil, watercolor; 41.4 x 38 x 15 cm

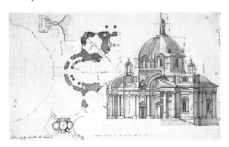

533 M
Carlo Marchionni (1702–86)
Partial plan, transversal section and elevation of the Sacristy of St. Peter's, 1776
Montreal, Collection Centre Canadien d'Architecture–Canadian Centre for Architecture
Pen, brown ink, gray wash on laid paper
24.9 x 42.6 cm

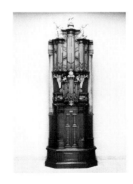

534 T-M
Jurriaan Westerman (d. 1746), sculptor; Gerrit Eijsmark, carpenter (?)
Wooden model of the Organ in the Nieuwe Lutherse Kerk, Amsterdam, 1715

Amsterdam, Rijksmuseum (on loan from the Evangelisch-Lutherse Gemeente, Amsterdam)
Oak, painted details; 145 x 105 x 350 cm
PROVENANCE: Long owned by the Evangelisch-Lutherse Gemeente; since 1889 on loan to the Rijksmuseum
BIBLIOGRAPHY: Scheurleer 1914; Kooiman 1941: 100–107; Snoep 1983

In the years 1668–70, the community of the Evangelical Lutheran church in Amsterdam built a spectacular central-plan church on the Singel in Amsterdam. The church consists of a central rotunda and a semicircular gallery made up of two floors of arcades. The central rotunda was surrounded by colossal Doric (half-)columns. The architect of this church, Adriaan Dortsman, had placed the pulpit directly opposite the semicircular arcades, against the wall of the rotunda. This was also the position of the main entrance from the canal, and the pulpit was so designed as to form part of the inner porch which screened this entrance. From sketches dating from the time of construction, possibly by Dortsman, it appears that the organ was originally intended to be in this position, directly above the pulpit. Therefore this complex consisting of, from top to bottom, the main entrance, the pulpit and the organ, was to form the liturgical center of the church. Because of financial problems, however, the construction of the altar was postponed for some time. Not until 1714, when the Lutheran church received a sizable bequest for this purpose, was the question again considered. In 1715 various designs were presented, from which one by the sculptor Juriaan Westerman was chosen as the best. Then Westerman applied for the commission to execute this work, together with the carpenter Eijsmark. Probably they worked together on making the wooden model which was exhibited at the meeting of the church council on 21 November 1715. In 1716 the contract with Westerman was signed and in 1719 the organ was finished. Meanwhile, the technical part of the organ, the actual instrument, was made by the Amsterdam organ-maker Cornelis van Hoornbeek, who had to fit in with Westerman's design for the outer form. The instrument was lost in the great fire of 1822. The model of 1715 shows the new organ in the form in which it was subsequently made. The lowest section of the model, the pedestal, is an addition made in 1770. So the original ground level was at the height of the foot of the Ionic porch. The porch, with Ionic pilasters on either side of the door, was part of the existing structure in 1715. So the makers of this model took the liberty of not representing this existing part exactly as it was. Instead of placing the pulpit above the door, they made the door itself higher. This made it possible to use the model as a cupboard, and apparently the architectural drawings and other documents were later kept in the cupboard space behind this door. Westerman's organ design is thus the section above the door, between two colossal Doric half-columns, which were part of the existing building. The organ consists of a large main structure against the rear wall and a smaller choir organ on the front side, directly above the pulpit. The organist's position was behind the choir organ, so that he would be practically invisible from the church, as was usually the case. KO

The Royal Church of Superga
Giuseppe Dardanello

Superga – a pronaos, a drum, a dome and two bell towers incorporated in the great rectangular block of the monastery situated on the brow of the hill overlooking Turin. A commemorative monument the victorious battle of Turin in 1706 built for show and celebration, Superga was designed to appear in the surrounding countryside as a symbolic focal point of Vittorio Amedeo II's reign. The design and building of the Superga complex, which includes the church, monastery, royal residence and, finally, the underground chapel for the tombs of the Savoys, involved most of Filippo Juvarra's years in Piedmont. The wooden model for the first project was made in 1716; the foundation stone was laid in July 1717; the dome was finished in 1726; the two bell towers were completed the following year; the church was decorated and capable of hosting religious functions in 1731; work on the underground chapel, instead, continued well into the century. Having resolved the problem of the church and the monastic building, together with the royal residence, into a compact, single block on the top of the hill, Superga then became an opportunity for the architect to rethink the "temple" of western religious architecture: a synthesis of designs adopted from the Renaissance onwards, analysed and re-proposed in an ideal "type." The result of Juvarra's research was the integration of a Greek cross with chapels on the diagonals into a strongly centralised space created by a high cylindrical nucleus which carried directly on into the dome. It was one of the only themes that Juvarra pursued constantly throughout his professional career; part of his drawings produced as a student and designer in Rome, it then became the most important theme in all his projects for centrally planned churches in his architectural work for the Savoys in Piedmont – from Superga to Venaria, from San Raffaele to Sant'Andrea in Chieri. The free-standing pillars, creating more space for the minor chapels on the diagonals, were taken from French ideas, in particular François Mansart's, then taken up by his grandson Jules Hardouin in the church of Les Invalides. The portico shows influence of the Pantheon through Renaissance interpretations and Bernini's and Rainaldi's solutions in Ariccia and Piazza del Popolo in Rome, whereas the dome is modeled on Michelangelo's dome in St. Peter's. The elaboration of the project is toward an "open architecture;" research on the practicability of uninterrupted vertical support structures, which question the Renaissance idea of the value of a containing and enclosing wall mass and assert an opposing concept of permeability between internal and external spaces that can be realized by building structures open to the passage of light and air. Having designed the shape of his ideal temple, Juvarra then amended his project in terms of visibility and an immediate identification of the "type" in the landscape. He articulated the passages between the volumes of the distinctive elements of the planned project – pronaos, drum, dome – to make the temple visually recognizable and identifiable from afar. The work emphasizes the overhangs and demarcation lines between the elements, and highlights the differences in depth between light and shade; the drum and dome were raised above the height of the bell towers; the form of the pronaos was clearly lengthened, streched forward to look out over the plain by three times more than its initial position in front of the body of the church. For its symbolic function as a celebratory monument within the territory, the pictorial view from afar was privileged over a sculptural one from close-up. The church presents a noble façade to the city, whereas, from the small space on top of the hill, the portico seems extremely foreshortened. The eye of the *vedutista* and landscape painter – educated in youth and through contact with Vanvitelli in Rome – intervened to create a stage set in scale with the landscape, and left a presence full of authority but one that was in harmony with the natural world. The series of drawings and engravings surviving for Superga cover a wide range of possible ways of thinking about and representing architecture: from the first rapid sketch of an "idea" roughly outlined in a notebook, to the sophisticated layout of engravings produced for the publication of a building that was by then famous and regarded as a monument. Between these extremes, the wooden model presents the first overall image of the complex.

BIBLIOGRAPHY
Maffei 1738; Telluccini 1912; Telluccini 1926: 35–40; Brinckmann 1931; Rovere, Viale, Brinckmann 1937; Wittkower 1958: 275–82; Carboneri 1963: no. 90; Peyrot 1965, I: 350–51; *Filippo Juvarra architetto e scenografo* 1966: 56–58, figs. 66–74; Griseri 1967: 287 fol.; Pommer 1967: 37–38 and 41–44; Boscarino 1973: 204–20; Carboneri 1979; Gabetti 1982: 674–78; Millon 1982: 519–22; 1984: 312, 345; Hager 1985: 63–91; Comoli Mandracci 1989: 53–74; *La Basilica di Superga* 1990; Gritella 1991: 91–107; Gritella 1992, I: 212–75; Blasco Esquivias 1995: 346–56; Bertana 1995: no. 46; Millon 1995: no. 131; Cuneo 1995: 100–9.

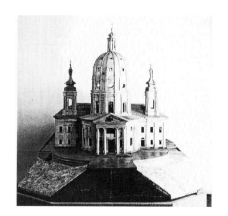

538 T

Carlo Maria Ugliengo (active 1712–33), master carpenter, after a drawing by Filippo Juvarra
Model for the Reale Chiesa and Convento di Superga, 1716
Torino, Convento della chiesa di Superga
Tempera painted wood; 300 x 150 x 110 mm
INSCRIPTION: "[IN] ONOREM DEI ET [BEA]TA MARIAE [VIR]GINIS VICTORIUS MEDEUS REX SICILIAE [JERUSALEM ET CYPRI EXTRUXIT] ANNO DOMINI MDCCXVI"
BIBLIOGRAPHY: Tellucini 1913: 13–150; Brinckmann 1919: 117–18; Tellucini 1926: 52; Brinckmann 1931: 64; Rovere, Viale, Brinckmann 1937: 63–64; Carboneri 1963: 47; *Mostra di Filippo Juvarra* 1966: 57; Pommer 1967: 150; Boscarino 1973: 204–20; Carboneri 1979: 8, 26, no. 39; Palmas 1990: 26, 31, no. 1; Gritella 1991: 102; Gritella 1992: 212–65; Millon 1995c: 412–13; Severo 1996: 123

The model for the Reale Chiesa e Convento di Superga, made by Carlo Maria Ugliengo in 1716 following designs of Filippo Juvarra, represents an initial phase of the final design. The complex includes the church to the west, which stands forward of the *campanili* (attached to the conventual building), the convent surrounding a square courtyard and, to the east, a rectangular block containing the royal quarters. The model differs in a number of respects from the building as constructed. When it was restored for the exhibition in Turin in 1963, it had lost the attic above the drum, the dome, the entire *cuspide* of the northwest *campanile*, the top of the *cuspide* of the *campanile* on the southwest, as well as the columns of the portico. The model had also lost whatever material had been used to indicate the slope of the hillside in front of and behind the church and convent (Carboneri 1979: pl. VIII, b). Missing portions of the model were replaced when it was restored for the exhibition. The model is painted a light yellow for architectural membering, most likely to simulate stone, and pale gray for wall surfaces, probably to indicate a stucco surface over brick. The roofs are colored light red to simulate terracotta tiles. Terrace walls are brick colored and the terraces gray. The interior of the model is unpainted. The model is made in several pieces and can be separated longitudinally to reveal the body of the church. Subsequent to the construction of the model are two plans (first published by Carboneri [1979: pl. VII, a and b]), and a section (Carboneri 1979: pl. VIII, a), all in the Archivio di Stato, Torino. These drawings and the plan and elevation drawn somewhat later by Ignazio Agliaudo, engraved by Francesco Zucchi, and published in 1738 by Scipione Maffei in his *Osservazioni Letterarie*, chronicle the modifications made to the design as it approached a definitive state. Though the general massing of the complex was retained, in approaching the final design Juvarra made significant modifications to the earlier design of the model. Changes included extending the size of the portico, elevating the church and convent on a raised terrace, raising and altering the shape of the openings in the body of the church, narrowing the space between the paired pilasters of the body of the church, adding a balustrade for the church and flanking wings under the *campanili*, inserting a base for the drum, an attic above the drum, substituting double columns for the paired pilasters of the drum, narrowing the windows of the drum, changing their pediments from segmental to semicircular, increasing the length of the courtyard by two bays, increasing the number of floors in the south wing from four to six, and varying the architectural membering and the articulation of both the north and south flanks of the convent, as well as of the Palazzo Reale to the east. These and other modifications added to the height of the church and convent giving it greater dominance and impressiveness both from the cleared level in front of the church and when viewed from a distance. HAM

546 T
Filippo Juvarra (1678–1736)
First "pensiero" for the Church of Superga
Turin, Museo Civico d'Arte Antica, Filippo Juvarra's Sketchbooks, II, fol. 29, no. 56
Pen and brown ink; 177 x 134 mm
BIBLIOGRAPHY: Rovere, Viale, Brinckmann 1937: pl. 36; Carboneri 1963: no. 90, pl. 77; *Filippo Juvarra architetto e scenografo* 1966: pl. 66; Pommer 1967: 37 and 42; Boscarino 1973: 204–206, fig. 150; Carboneri 1979: 8, pl. VIb; Gritella 1992: I, fig. 200; Cuneo 1995: 103–104

Rapidly sketched with a very thin nib, this small drawing is glued to sheet 29 of this sketchbook next to another drawing by Juvarra, which shows the arms of Innocent X Pamphilj, sculpted by Gian Lorenzo Bernini for the Fountain of the Four Rivers. It is the first known sketch in the design sequence for Superga and was perhaps drawn by Juvarra on first impact with the site on top of the hill overlooking the plain around Turin, probably in 1715. In both the plan and the elevation, the irregular contours of the slope are indicated; in this first "pensiero" for the votive temple of Superga they are important for conditioning the position of the buildings. The church, in fact, is isolated on the area of land available on the top of the hill; the monastery and royal residence have been placed lower down, behind and beside the church, perched on the greatest falls in the land around a rectangular and a square courtyard. This arrangement, which adapted the buildings to the irregularities of the site, was soon to be abandoned in favor of the decision to carry out extensive leveling and earth moving works to allow the architect to integrate church, monastery and royal residence into a single block. In the elevation, the temple form is recognizable in the presence of the tetrastyle pronaos and the two bell towers, already corrected in height during this first draft to make them even higher. The same happened for the dome, which, without any clear development of the drum, demonstrates less importance than the bell towers. The façade with a tympanum on columns is also proposed on the two lateral flanks of the church. The church is on a Greek cross plan around a central circular space completed with four satellite chapels. This sketch shows the direction Juvarra intended to take: a Greek cross integrated into a centralized cylindrical space. The difficulties inherent with this choice emerge: the system of supports to develop the height and connect the corner chapels with the central area is still not quite clear. The differences in level between the church and the other buildings posed problems in linking them, which are not resolved in this drawing.　　GD

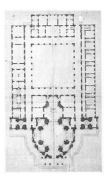

543 T
Filippo Juvarra (1678–1736)
Plan of the First Project for the Church and Monastery of Superga
Turin, Archivio di Stato, Corte, *Palazzi Reali, Superga Chiesa*, drawing 1
Pencil, gray and red ink, gray watercolor; made up of three sheets glued together; 1050 x 636 mm
Scale: unit (*trabucchi*) 20 = 50.4
Watermark: a monk, accompanied by a countermark of three numbers, repeated on the two larger-sized sheets (paper produced in Piedmont)
BIBLIOGRAPHY: Carboneri 1979: 8–9, pl. VIIb; Pommer 1967: 37–38, 42; Gritella 1992: I, 214–15, fig. 201; Blasco Esquivias 1995: no. 47

This is the presentation drawing in scale of Juvarra's first project, revised after the wooden model by Carlo Maria Ugliengo had been made in 1716. The plan of the lower level showing the church's foundations (Turin, Archivio di Stato, Corte, *Palazzi Reali, Superga Chiesa*, drawing 4) and the section along the longitudinal axis of the entire complex (Turin, Archivio di Stato, *Tipi e disegni*, Series II, no. 376) belong to the same moment, both drawn to the same scale and with the same precise technical treatment. They can be dated to about 1717 when building started. These drawings were executed in the smallest detail by Juvarra himself, concerned to clarify the coherence between all the various parts of the project, and not delegated to his studio. The awkward position of the church, monastery and royal residence as sketched out in the first "idea" for the project, has here been brilliantly resolved by an efficient compacting of the three buildings into a single block around a square courtyard of seven bays per side. The volume of the church, partially embedded into the building of the monastery, emerges from this imposing parallelepiped to look out over the plain toward the west. The royal residence emerges less strongly from the opposite end, at the east. Here, in the church ground plan, the initial idea of integrating a Greek cross with a circle, as anticipated in the first "pensiero" and further developed in the project illustrated by the wooden model, has been successfully resolved. The cylinder is declared as the solution to the geometric system: the Greek cross is incorporated within it in a unified plan, which also incorporates the satellite chapels on the diagonals. The system of vertical supports has become the heart of the project: by delicately cutting into them, slimming them down, and making them collaborate with the load-bearing ribs, Juvarra has gradually removed much of the wall mass, thus exposing the struc-

tural frame. The traditional crossing pillars have been opened up considerably to bind the chapels with the central nucleus. Giant columns directly support the entablature of the order, eliminating any mediating effect of pendentives and masking the octagonal arrangement of the pillars behind. The centralized nucleus of the presbytery in the classical form of an octagonal crossing, with an isolated high altar separating the space from the semicircular apse, is attached to the body of the church. This area, the two lateral chapels and the minor chapels, are all on the same level, raised one step above the area of the temple and entrance. Confessionals have been drawn in the side niches of the four minor chapels and in the walls of the passages between two of these and the side chapels. The monastery has five entrances: two on the façade; two on the opposite side to the east, aligned with the portico of the cloister; and a further portal on the transverse axis open toward the north in the wing including the great staircase, the refectory, kitchen, library and other rooms used for the communal life of the monastery. In the southern wing, there are six units on two levels for living quarters for the monks. The royal residence has an entrance from the cloister and an independent entrance on the east side, aligned on the same center axis; it has no grand staircase but two service stairs. The main differences with respect to the model, which was used more as a working model to modify the project than a finished product in itself, lie in the elimination of one of the two entrances and in a different articulation of the northern face of the monastery, while the royal residence has been made more compact by reducing the amount it projected toward the exterior. Variations to the church can better be seen in the section accompanying this plan, which clearly shows how Juvarra began to raise the base of the drum and rethink the dome and both presbytery and apse coverings.　　GD

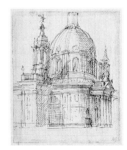

545 T
Filippo Juvarra (1678–1736)
Perspective Study of the Church of Superga
Turin, Museo Civico d'Arte Antica, Filippo Juvarra's Sketchbooks, II, fol. 82, no. 165
Pencil, pen and brown ink; 214 x 177 mm
BIBLIOGRAPHY: Telluccini 1926: 39; Rovere, Viale and Brinckmann 1937: pl. 38; Carboneri 1963: no. 90, pl. 78; *Filippo Juvarra architetto e scenografo* 1966: pl. 67; Pommer 1967: 42; Boscarino 1973: 204–206, fig. 152; Carboneri 1979: 10, pl. XVI; Gritella 1992: I, fig. 203

The drawing is glued to sheet 82 of the sketchbook next to a study by Juvarra for the Palazzo del Senato Sabaudo. This perspective view of the project

for the church and façade of Superga has been drawn from an imaginary point of view, on a diagonal to the west of the building and with a light source conventionally placed at forty-five degrees to the left, as the skilful and sophisticated treatment of the shadows, treated with different intensity and strokes, reveals. Rather than a design "pensiero," it can be described as a landscape painter's travel sketch. Juvarra is, in fact, rethinking the project as worked out thus far in visual terms on this sheet – very well-known and much published because it represents an image of ideal synthesis for Superga. Having clarified the whole arrangement, he is trying to see how the finished work will appear best. The choice of a totally casual point of view from very close-up serves to highlight the unitary compactness of the whole figure and the emerging power of the volume of the temple. In the series of project documents conserved for Superga, this drawing can be placed next to a frontal view of the church (Turin, Museo Civico d'Arte Antica, Filippo Juvarra's Sketchbooks, II, fol. 64, no. 129), where the same values of power and compactness are even more marked, making the cylindrical figure of the church emerge alone from the monastery façade. The two views were probably drawn between 1719 and 1721. With respect to the shape of the church in the model, there are some important differences: the lunette window above the side chapel has been replaced by a rectangular opening; the drum has been markedly raised on a higher impost ring; this rise has been partially hidden by the insertion of a balustraded attic decorated with statues running along the entire façade and linking the pronaos and bell towers to the body of the church. Furthermore, a base carrying a statue has been placed in the position of the two columns aligned on a level with the façade on the sides of the pronaos, visible face-on in an engraving published by Scipione Maffei in *Elogio del signor abate d. Filippo Juvarra Architetto* (1738). GD

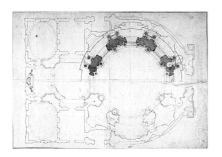

542 T
Filippo Juvarra (1678–1736)
Plan of the First Level and Study of the Drum of the Church of Superga
Turin, Archivio di Stato, Corte, *Palazzi Reali, Superga Chiesa*, drawing 3
Pencil, ink, watercolor; made up of 6 sheets glued at the edges; lined on the *verso*; 938 x 635 mm
BIBLIOGRAPHY: Carboneri 1979: 9–10, pl. XIII; Pommer 1967: 37–38 and 42; Gritella 1992: I, 224–30, fig. 238; Blasco Esquivias 1995: no. 49

This sheet has been worked on at different times. The plan of the first defined project for the church of Superga is the basis of this drawing, traced in gray ink probably by a studio assistant. On this

technically precise and detailed background, Juvarra developed the design of the upper part of the drum, using a compass, pencil, pen, brown ink. It is a rare document because it illustrates both the final solution and the path followed to reach it. It also reveals the architect in a moment when he was elaborating the essential elements of the project for the temple of Superga, in order to render it harmonious in terms of geometry, structure, architectural composition and decorative language. It deals with the relationship between the first and second levels of the church and between the interior and exterior of the drum. Both these relationships are bound up with the relationship between the two volumes based respectively on the geometric figures of the octagon and circle. Juvarra then placed 8 composite columns to develop the vertical continuity of the cylindrical articulation of the drum on top of the eight giant columns of the innovative open system on the first level, which in their turn directly support the circular ring of the main entablature. The irregularly spaced walls between the columns are united by placing a concave-convex niche in the larger openings, on the symmetrical axes of the plan. In their fluid movement, these niches derive from a Bernini prototype in the Cappella Cornaro. A study of the elements which help to resolve these delicate passages was anticipated in a rapid sketch by Juvarra, which shows a portion of the internal wall of the drum drawn flat, the plan of this and a detail with the proportions indicated of the niche columns with their lower third twisted (Turin, Museo Civico d'Arte Antica, Filippo Juvarra's Sketchbooks, II, fol. 50, no. 102). In the spaces between the windows on the exterior of the drum, regularly distanced on the radial axes of the cylinder, Juvarra replaced the pilasters of the first project, modeled on the example of Borromini's dome for Sant'Agnese, with eight pairs of freestanding columns. These had been anticipated in another of his "pensieri" and probably influenced by Michelangelo's drum for St. Peter's (Turin, Museo Civico d'Arte Antica, Filippo Juvarra's Sketchbooks, I, fol. 6, no. 12). Having established the shape and profiles of the supports for the drum, Juvarra filled the bays of the uprights with gray watercolor. Then, in Michelangeloesque style, he added another idea with strokes of brown ink and extended the section of the pilasters, buttressing them on the exterior in the spaces enclosed between the pairs of columns. A study in pencil for the dome of the presbytery detailed in brown ink with a profile of the moldings in section, probably also dates to this revision phase of the project (1719–21). This idea was later abandoned. Due to the rather large scale of the drawing, ideal for keeping different levels of the project under control, this sheet was jealously preserved and reworked several times by Juvarra himself. He used it to elaborate the design of other parts of the church in much later years, when the design for the façade with two side columns, as represented here, had long since been abandoned. In fact, a study for the high altar attached to the rear wall of the apse was added in about 1728–29 using the same, rather diluted, gray watercolor used by Juvarra for sketching his "pensiero" for the marble altarpiece with the statue of the Virgin illuminated by a chamber of light. GD

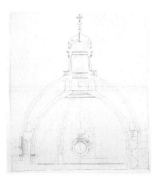

541 T
Filippo Juvarra (1678–1736) and collaborator
Section for the Dome of the Church of Superga and Study for its Internal Decoration
Turin, Museo Civico d'Arte Antica, previously Collezione Taibell, III-53
Pencil, gray ink; made up of 2 sheets glued; 568 x 496 mm; scale: unit (*trabucchi*) 6 = 305 mm; watermark: a monk (paper made in Piedmont)
BIBLIOGRAPHY: Carboneri 1979: 10–12, pl. XVII; Gritella 1991: 97–101, fig. 7; Gritella 1992: I, 230–48, fig. 249; Blasco Esquivias 1995: no. 51

The drawing shows the vertical section of a dome with a double shell and a cylindrical lantern. The draftsman, probably a studio assistant of a certain skill, has drawn over pencil aided by ruler and compass, in pen and gray ink to emphasize the outlines of the section. Some pencil lines in the geometrical construction of the dome can still be seen showing the use of authoritative proportional systems based on rules experimented and well known to Filippo Juvarra, also because they were published by his teacher, Carlo Fontana, in *Il Tempio Vaticano e sua origine*, published in Rome in 1694. In the section accompanying the definitive presentation plan of the first project (Turin, Archivio di Stato, *Tipi e disegni*, Series II, no. 376), Juvarra had proposed a dome with only one shell after the example illustrated in the plate with the "Dimostrationi e regole per construire le cuppole semplici" ("Illustrations and rules for building single domes") from Fontana's book (367). This example was reproduced with several variants by Juvarra himself on a page in a notebook glued to one of his sketchbooks, entitled "regola per le cupole" (rules for domes), Turin, Biblioteca Nazionale Universitaria, *Ris. 59.4*, fol. 101r). In this advanced revision phase of the Superga project, by now under construction, in about 1725, Juvarra studied and reinterpreted instead the "Settione della cuppola vaticana con tamburo piloni e lanterna" (Section of the Vatican dome with drum, pillars and lantern) by Michelangelo in St. Peter's, also illustrated by Carlo Fontana in *Il Tempio Vaticano* (331). After having introduced the element of coupled columns outside the drum and the attic at the impost of the dome, he also adopted the system of a double shell in a critically re-elaborated version for more structural solidity in which he inserted three chains placed in the exact position suggested by Fontana. Juvarra intervened at a later moment on the outlines in pen in the section, rapidly sketching in pencil, only on the central sector of the dome, all the decorative elements needed to complete the internal shell: the garland of leaves descending the ribs; the hexagonal coffers

with lengthened vertices arranged vertically; the cornice for the rose window on a level with the impost of the dome. To emphasize the perspective effect in height of the internal shell, the coffering and other decorative elements gradually diminish in size as they reached the top. In the space between the two shells, he sketched an ingenious solution for strengthening the wall sections to be placed in correspondence with the ribs, with round windows to compensate for the structural tensions between the internal and external shells. GD

tically by the thrust of the two orders of uninterruptedly superimposed columns (the pendentive linking elements having been eliminated) which continues into the ribs of the dome. Shafts of light indicate the hollow spaces of the minor chapels and the tribune enclosed between the supports and reveal the structural framework freed from the surrounding wall masses. Compared to the earlier study section of the design previously in the Taibell Collection, the dome with its double shell has been revised at the level of the impost. GD

Crespi and later in Paris. From 1751 he was copperplate engraver to the King of Sardinia and became the favourite illustrator of all the court festivals and ceremonies of the House of Savoy at the time of B Alfieri, who was Carlo Emanuele III's court architect. For Alfieri, Belmond engraved the book on the Teatro Regio, published in 1761. With all this activity, the skilful illustrations of the Superga plans are to be placed around the years 1747–49 and recorded, together with a twin print, identical in size, of a perspective of the façade. GD

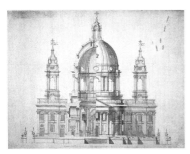

544 T
Filippo Juvarra (1678–1735) and collaborators
Elevation of the Façade of Superga with a Section of the Interior of the Church
Turin, Biblioteca Reale, Z-XVIII (78)
Traces of pencil, grey ink and grey watercolor; 652 x 864 mm; watermark: monogram made of the letters "P" and "L"
BIBLIOGRAPHY: Carboneri 1979: 12, pl. XX; Gritella 1992, I: 230; Blasco Esquivias 1995: no. 55

This drawing shows the elevation of the entire façade of the Superga complex, with the left half of the body of the church opened on to a section of the interior, as the project was during the final years of building, after 1730. The system of the conventional rules of orthogonal representation has been applied with a sophisticated graphic technique, especially in the precise and detailed accuracy of the linear strokes and above all in the rendering of shadow. Gray watercolor to render the variable intensity of the light modelling the volumes of the building was applied in an extremely unconventional way when the areas meant to merge into shadow are, in fact, highlighted in contrast and removed from the dark. Watercolor has been deliberately used to emphasize the three-dimensional qualities of the architectural space and convey the innovative elements of the building. This skilful rendering of shade highlights the additional value given to the design when contrasted with an elevation drawn on the same scale, with the same care for details, although only in linear outlines, by Pietro Giovanni Audifredi (Turin, Archivio di Stato, Corte, *Palazzi Reali, Superga Chiesa*, drawing 5). Audifredi directed the Superga building site from at least 1719 to 1740 and was probably an assistant in Juvarra's studio. The façade is articulated by giant Corinthian pilasters, which continue around to cadence the body of the church. The frontal view gives a hieratical prominence to the pronaos with its four columns proportional to the whole building. Integration of the plan resolved in the system of the cylinder has also been made very clear: the external one on the lower level, which incorporates the Greek cross, still recognizable in the section of the side chapel; and the internal one, extended ver-

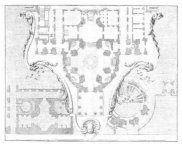

540 T
Giovanni Antonio Belmond (active 1736–75), after a drawing by Benedetto Alfieri (1699–1767)?
Plan of the Church and part of the Monastery of Superga, together with the Plans on different levels of the Dome, one of the Bell Towers and the underground level Housing the Tombs of the Savoys
Turin, Biblioteca Reale, Incisioni IV.209/2
Engraving; 610 x 890 mm (plate); 450 x 588 mm (impression); scale: unit 6 = 491 mm; watermark: "LUCHINATO / PINEROLO / 1788"; countermark: cage with two birds
BIBLIOGRAPHY: Peyrot 1965, I: 350–51; Carboneri 1979: 12, pl. XXIIIb; Gritella 1991: 104; Blasco Esquivias 1995: no. 61

The plan of the church of Superga is presented in the foreground on a sort of hanging stone scroll, framed by an architectural molding, cherubs and garlands, palms and acanthus flowers, which concludes at the bottom in a veiled mask; a funerary allusion to the Savoyard tombs. It is the plan of the church as built, identical to the plan of the final project with the projection of the dome and a celebratory inscription added in short strokes: "VICTORIOUS . AM . REX . AN . SAL . MDCCXXVI." The plan of the floor below ground housing the tombs of the Savoys; the plan of the dome divided into four segments on different levels to show the internal-external development of the drum, the double shell of the dome and the lantern; and the plan on two important levels of the upper area of the bell tower are all shown in the space behind, on the same scale, marked by a darker background. Through six levels of horizontal section the entire vertical development of the Superga "temple" is explained. The new elements in the structure, the passages that permit an uninterrupted elevation, integration of its functions and the secrets of the building techniques are all highlighted. The intelligence behind the graphic layout and the choice of sectioned floors bears witness to intimate knowledge of the plan of the building and an acquired historical awareness of the linguistic, technical and symbolic values of the architecture at Superga. G. A. Belmond, an engraver of repute, originally from Fossano, had studied under the Bolognese G. M.

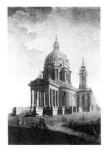

539 T
Giovanni Battista Bagnasacco
View of the Church of Superga
Turin, Palazzo Reale, Inv. 1965, no. 1933
Oil on canvas; 234 x 162 cm
BIBLIOGRAPHY: Telluccini 1926: pl. 2; Bertana 1995: no. 46

Superga has been painted from the angle first seen by visitors as they arrive up the steep road leading to the top of the hill. However, the viewpoint has been artificially raised to the base of the giant order to allow the painter to give a more suitable view of the whole complex, obtained with a strongly foreshortened perspective. The pronaos, under these optically altered conditions, lengthened by Juvarra to increase Superga's impact from afar, now seems abnormally large and hides the view of the church. An important fact recorded in this painting, also found in the model, are the colors of the building; a pale color to render the Gassino stone of the architectural members and cornices, delicately set off by a light bluish-gray for the wall masses. Not much is known of Giovanni Battista Bagnasacco. He was active at the court of Savoy at the end of the eighteenth century and several other views of interiors of the Savoyard residences are attributed to him. This painting dates to the end of the end of the eighteenth century. GD

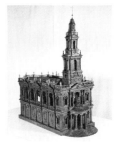

549 T-M-MAR
James Gibbs (1682–1754)
Model for St. Mary-Le-Strand, London
1714

Pearwood, boxwood; 740 x 310 x 830 mm
PROVENANCE: The Marquess of Exeter, Burghley House, Lincolnshire
BIBLIOGRAPHY: Gibbs 1728, VI–VII: pls. 16–23, 31; Donaldson 1843: 351ff.; Summerson 1945: 69; Whiffin 1946; Colvin 1950: 189–96; Holloway 1954; Lang 1954: 72; Whistler 1954: Appendix Two, 247–52; Little 1955: 33–37; Field 1962: 315–19; Wilton-Ely 1965: no. 6; Downes 1966: 98–105; Wilton-Ely 1967: 26–27, 30; 1968: 256–59, figs. 16–18; Friedman 1972: ("The 'Fifty New Churches' "); Pevsner and Cherry 1973: 83, 87, 311; Friedman 1973: 25, fig. 25; 1974; Bill 1979: 235–37; Beard 1981: 14; Friedman 1982: no. 23; Summerson 1983: 308–11; Friedman 1984: 40–53, 311–12, pls. 15, 18; Colvin 1995: 401–402; Worsley 1995: 102

When James Gibbs returned to London in 1709, after four years of study in Rome at the fountainhead of the Italian Baroque under Carlo Fontana, only Thomas Archer among his British contemporaries could begin to match his knowledge of current architectural developments and professional practice on the Continent. In 1711 the Tory government of Queen Anne had passed an Act for "Building [...] fifty new churches of stone and other proper Materials [...]." In May 1713 Gibbs submitted two unsolicited church designs for undesignated sites to the commissioners and provided models in pear-tree wood of these in June and July respectively. Only twelve completely new churches were eventually built – six by Hawksmoor, two by Archer, three by John James, and Gibbs's own contribution, St. Mary-le-Strand. Because of its situation at the center of the Strand – the ceremonial route from the court and Parliament in Westminster to the City and St. Paul's Cathedral – the church would be viewed from all sides and the commissioners were keen for the building to have as lavish a façade as finances permitted. Two months after his appointment, on 4 February 1714, Gibbs delivered the wooden model of an initial design. Pseudo-peripteral, like the previous model design, it was inspired by the Temple of Fortuna Virilis in Rome, and had a steeple behind the west portico. The nave was a single space, lit by round-headed windows, alternating with pilasters supporting an elliptical barrel vault. Unlike most other churches produced for the Act (each of which were required to house 2,000 parishioners), there were no galleries, and the chancel was a narrow semicircle, flanked by compact vestries. Archer's design was chosen in April 1714 and construction on it began. The importance of this particular church site was indicated by the fact that in April 1714 the commissioners "Resolvd, That instead of the [Queen's] statue designd [sic] to be put upon the 50 New churches" there was to be a more prominent statue for the Strand church "to perpetuate the memory of the building [of] the [...] Churches." Meanwhile as a result of meetings in July and October, Archer's design was replaced in favor of a second solution by Gibbs with fenestration and orders similar to his earlier project but both exterior and interior were to be given a far richer composition on two superimposed storeys. In Gibbs's words: "It consists of two orders, in the upper of which the Lights are placed, the walls of the lower, being solid to keep out Noises from the Street, is adorned with Niches" (Gibbs 1728). Rising above the portico was to be a short turret, clearly intended to balance but not detract from a 250-foot-high column which was to be sited further west along the Strand bearing a gilt bronze statue of the queen, 10 feet high, then being made in Florence by the sculptor Gian Battista Foggini. By July 1714, the commissioners had approved Gibbs's wooden model of the 250-foot-high "Corinthian pillar" (since lost) crowned by the statue. Although this was shown to the monarch, the grandiose idea had to be abandoned following the sudden death of the queen in August. In November both Gibbs and Vanbrugh submitted fresh proposals for the church and the former's modified version of his first design was approved in November as "most proper for the Situation;" a wooden model of it was made at the cost of £ 32.10.0. The executed design retained the superimposed orders on the exterior (and now continued on the interior walls) while the richer concentration of decoration resulting from a further narrowing of the main structure, with the addition of a prominent steeple at the west end (like Gibbs's other belfries much indebted to Wren) which further reduced the temple-like concept of the initial idea. Unlike the other church designs of the Act, which use the single giant order, the longer external elevations of St. Mary's involve a complex system of tabernacle windows with alternate pedimented and segmental pediments, incorporating a Venetian window-unit between each tabernacle. Summerson suggests debts to sixteenth-century Mannerism rather than the Roman Baroque and points to the inspiration of Raphael's Palazzo Branconio dall'Aquila. The roof of the single-storey west portico, taking the form of a half-rotunda (part inspired by Wren's transept porches at St. Paul's and also by Pietro da Cortona's Santa Maria della Pace), was intended to act as a platform for the queen's statue, but after 1715 it was surmounted by a flaming urn. The wooden model here exhibited appears to be a contemporary replica showing the building as illustrated in the plates of Gibbs's *The Book of Architecture*, of 1728 (pls. 16–23 and 31). In it attention is concentrated upon the exterior; only the most fundamental divisions are indicated within. It differs little from the executed building, apart from the statues occupying the niches of the lower arcade shown in Gibbs's engravings and, unlike the perspective view from the southwest in plate 21, has the urn on the entrance porch instead of the queen's statue. References to models are recorded during the construction of the church (although the ambiguity of the term, which sometimes refers to drawings, must be kept in mind), which had begun in April 1714. After the upper storey was nearing completion in March 1716, a model for the roof was delivered in July, and during 1717–18 a "Modell for the East End and an other for the portico [and] Altering the Section of the Portico" were produced. We are on safer ground when it was recorded that the joiner, John Simmons, received 6 guineas for "Making A Model of the Tower as agreed with Mr Gibbs" during 1722–24. JWE

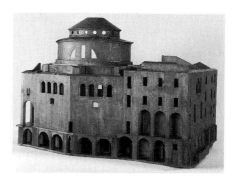

550 T
Joiner from Val Sesia (?) from a project by Guarino Guarini (1624-1683)
Model for the Parish Church of San Giacomo Maggiore in Campertogno
Campertogno (Val Sesia), Parish Church of San Giacomo Maggiore
Carved, engraved and in part painted wood
90 x 133 x 94 cm
BIBLIOGRAPHY: Benevolo 1951: 165–173; 1957; Carboneri 1963: 36, pl. 29; Molino 1985: 278–80; Gritella 1992: I, 470–81

The plan of the church presented in the model has been arranged on an irregular hexagon of pronounced length, with two pairs of chapels in the longer sides. A tripartite portico leads into the hall and a great, vaulted arch connects it to a rectangular, lengthened in depth, presbytery at the other end. There is an articulated system of stairs in this area connecting the hall of the church to the presbytery: a central flight descends directly into the crypt below the high altar; this, in its turn, is reached laterally by two ascending flights curving in a concave shape; another pair of stairs at the sides of the large vaulted arch serve to vertically connect the church, the various areas arranged on several levels at the sides of the presbytery and the galleries that weave around the hall on the upper level. A structure of ribbed arches rises from the four piers at the corners of the plan's elongated hexagon leading to a first ellipsoidal impost ring of the upper level. Externally, from this level, the construction develops vertically in an elliptical drum, opened by two large thermal windows on the long sides; internally, four large arches laid on the key stones of the arches of the area below sustain a second vault opened by a great ellipsoidal eye, marked by a wavy cornice. A second low, domed vault pierced by fourteen round openings on the impost level, which light up the painted sky surface of the dome lies above this structure. A small lantern used to top the dome; it was still visible in the photographs published by Benevolo (1957: figs. 5–6), but no longer present when the model was exhibited in the *Mostra del Barocco piemontese* in 1963. As well as the parish church and its service rooms, and the unusual presence of a crypt, the project of the model includes other spaces for the social and religious activities of the community: a large meeting room, probably the seat of a confraternity, on the raised level to the left of the presbytery, with an unusual vault composed of three irregular octagons irregularly arranged on top of each other and opened in the middle toward the upper space; a second vaulted room on the ground floor; and, on the side along the road,

arcades and loggias for shops and stores. Originally, the model could be taken apart in different sections and in several horizontal bands, in order to show the floor plans of the various levels of the building and the distribution of the complex's different functions. It was built to be looked at as though it was the "section" of a drawing, deliberately deprived of a quarter of the church. Many models have been made to be opened so that they can be studied internally, but this rare example in section furthers understanding in how the structure worked and the articulation of the adjacent bodies. It is also possible that some minor parts of the building are missing, together with the lantern and flight of steps leading to the façade portico, and that the model was never completely finished internally; in any case it has been tampered with and touched up. As it has reached us, the model was destined for the site where the parish church of San Giacomo Maggiore in Campertogno rises, because it includes the old sixteenth-century bell tower and it adapts to the steep ridge of the mountain that the church backs up against. Two technical observations have pointed out the environmental incompatibility of the building as designed in the model with the mountainous area of this village in Val Sesia. Firstly, the structure supported by load-bearing ribs could not have been realised in hewn stone, the only building material available in that area. Secondly, the very gentle pitch of the dome roofs would not have sustained the weight of the abundant winter snowfalls (Benevolo 1951, 166). The church as built preserves some memory of the plan presented in the model, but it differs in the elevation, eliminating the complex structure of the dome and integrating the hall to presbytery space in a more unified and fluent whole. The long history that led to the building of the new parish church between 1719 and 1735, to a project requested from Filippo Juvarra in 1719 on the instigation of the vicar-general of Val Sesia, Benedetto Giacobini (Gritella 1992), started with the programmes discussed by the community right from the beginning of the 1680s. In 1691 there was again much talk of the church building and on that occasion a payment of 7 *lire* was recorded to the carrier Giovanni Francesco Galitia, for "transporting the design of the Parish Church of Campartognio:" this was a considerable sum to pay for transport and it can reasonably be supposed that the "design" referred to in the document was none other than the wooden model of the church. The model has many points in common with Guarino Guarini's architecture, as has been astutely observed (Benevolo 1951), in its original structural layout, the plan's displayed geometry, and the special care taken in the articulation of the manifold destinations of the whole complex. Looking at it carefully, numerous features peculiar to the Theatine architect's work can be noticed: the double shell of the church within which the spaces for chapels, small tribunes and galleries running round the building have been inserted; the angled arrangement of the pilasters on the hexagonal of the plan, corresponding to the big diagonal arches, used for the first time by Guarini in Sainte-Anne-la-Royale in Paris, in 1662, and then in the truncated dome of the Chapel of the Holy Shroud and in the very influential project for the church of the Immaculate Conception in Turin; the dramatic sensitivity in the use of light – filtering, through the screens of the double shell in the lower area; diffused, in the space of the second truncated dome; reflected, through the round oculi partially hidden by the wavy cornice on to the light surfaces of the low terminal dome. The static system based on a network of ribbed arches that interweave in the peripheral areas of the structure and rest on the key stones of the arches below, as happens in the Chapel of the Holy Shroud in Turin, cannot be explained without a very precise knowledge of Guarini's design techniques and building practices. This framework of great ribs, which derives from the study of Gothic architecture and allows Guarini to develop flat geometrical schemes in elevation into a sequence of three dimensional volumes, assumes here in Campertogno a shape that is very similar to the design of the double elliptical vault of the *salone* in Palazzo Carignano, built from 1682 (Turin, Archivio di Stato, Azienda Savoia-Carignano, cat. 95.2.39.39). In the model, not only the geometry of the plan but also the projections of the great arches of the dome structure can be seen, partly engraved and partly traced out in pen with ruler and compass on the thin planks of wood that form the support for the elevation of the church. This direct relationship between flat geometrical schemes and their telescopic projection into the three-dimensional form of the elevation is typical of Guarini's design method. In spite of these numerous, convincing comparisons, some weaknesses in the architecture of the model remain; it is not on the same level as mature buildings like the Chapel of the Holy Shroud or San Lorenzo, and makes one think rather of an experimental period prior to these experiences. The system of ribbed structures hidden under the visible structures of those masterpieces is, instead, exposed and left visible here in the model for the church, and precisely for this can teach us many things about Guarini's methods of designing and building. The hypothesis that the model was realized to a drawing by Guarini without the architect's direct help, or after his death in 1683, by a skilful joiner from Val Sesia remains valid. A possible candidate might be Giovanni Battista Gilardi, from Campertogno, a master joiner active in Turin and documented in the construction of Palazzo Carignano when work was resumed again there to finish the building in 1693. G.D.

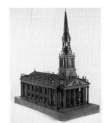

551
James Gibbs (1682–1754)
Model for St. Martin-in-the-Fields, London
1721
London, British Architectural Library, Drawings Collection, RIBA (on loan from the Vestry of St. Martin-in-the-Fields)
Pine and mahogany; 1,000 x 515 x 1,190 mm
PROVENANCE: St. Martin-in-the-Fields

BIBLIOGRAPHY: Gibbs 1728: IV–V, pls. 1–15, 29, 30; Maitland 1739: 731–37; McMasters 1916: 71; *Survey of London* 1940: chapter 3; Esdaile 1944; Summerson 1945: 70–72; Whiffen 1946: 3–6; Holloway 1954; Lang 1954: 72; Little 1955: 67–76; Wilton-Ely 1965: no. 7; Clarke 1966: 181–82; Wilton-Ely 1967: 30–31, figs. 11–12; 1969: 76; Friedman 1972 ("St. Martin-in-the-Fields and others"); Pevsner and Cherry 1973: 309, fig. 102; Friedman 1974; Beard 1981: 14, figs. 8, 9; Harris 1981: 24, pl. IX; Friedman 1982; Summerson 1983: 352–55; Friedman 1984: 55–73, pls. 40, 42, 49; Colvin 1995: 402; Worsley 1995: 60, 101, 102, 206, 280

By Spring 1721, for reasons of the narrow site available, Gibbs had begun to think of a smaller, rectangular building and to develop a more classical temple form using the giant order as a dominant feature. This idea, first introduced in his early proposals for the 1711 Act, represented one of two lost models (see Donaldson 1843: 351 ff.) and, as Friedman points out, was remarkably advanced for its time, even in Continental European terms, particularly with its reliance on antique forms such as the Maison Carrée at Nîmes and Temple of Fortuna Virilis in Rome. By this time Gibbs was also preparing several schemes under the 1711 Act for St. George's, Hanover Square (which was eventually built to a design by John James who had also been considered for St. Martin's). Gibbs's project for St. George's is represented by drawings in the Ashmolean Museum (repr. in Friedman 1984: pl. 36) in which he had to consider the visual as well as structural problems of placing a steeple in conjunction with a tetrastyle portico. While the foundation stone was laid on 19 March, at least three alternative schemes for St. Martin's were produced before 23 May when a further design was finally approved by the members of St. Martin's Vestry and a wooden model of it was ordered to be made at the cost of £71.10. 0. As exhibited here, this work of superlative craftsmanship was to be carried out with an unparalleled degree of detail, both internally and externally. By the time the building was consecrated on 20 October 1726, its total cost of £33,661. 16.7 3/4 (Gibbs's fee was £632 4. 6.) made it among the most expensive parish churches ever constructed in Britain and the model reflects this in the extent and nature of the detail indicated. Apart from showing the crypt (by means of a sectional view on the south elevation and a removable portion of the main floor inside), at least six portions of the roof can be lifted to show the nave interior, complete with pews, and the four spaces at the corners involving staircases and upper chambers. The two portions of the nave roof have the truss system drawn on their sides (on 29 January 1723 Gibbs approved the [additional] "Modell of a Truss for the Roofe [...] differing in some parts from [the carpenters] Originall proposall," Friedman 1984: 311) as well as the initial system of coffering on the barrel vault which was to be replaced by the magnificent plaster decoration carried out by Giovanni Bagutti, assisted by Chrysostom Wilkins. Moreover, the fact that the steeple can be removed from the model implies the possibility that alternative versions were prepared in three dimensions for consideration since he is known to have produced over a dozen solutions –

some indicated on flaps attached to his drawings and others engraved in the *Book of Architecture* (pl. 30). The concept eventually chosen was for a pseudo-peripteral structure, dominated by a giant Corinthian order, projecting at the west end in the form of a monumental hexatyle portico, and continuing round the façade in pilaster form. At the end bays of the long façades two whole columns are recessed *in antis*, the western pairs giving an effective visual reinforcement to the effect of the steeple rising immediately behind the portico (Friedman traces the origin of this motif to the bottom stage of Antonio da Sangallo the Elder's campanile at San Biagio, Montepulciano). These bays *in antis* are repeated at the east end for balance and provide secondary entrances. The steeple itself, deeply indebted to Wren as in Gibbs's other church designs, is a mastery display of diminishing classical forms. Within the aisle of five bays, the east and west ends are planned to create considerable symmetry on both axes; the vestries on the eastern angles corresponding with vestibules containing staircases on the western ones. In the marked restraint and "archaeological" sources in antique temple forms contributing to his overall design, Gibbs had clearly responded to the considerable change in taste with the Neo-Palladian antipathy for Baroque forms, and it is indicated even in such features as the use of the prominent Venetian window at the center of the east façade. The continuing of the classical temple form externally into the structural organization of the interior space was to take the form of a double row of giant columns, each carrying its own entablature. Above these entablatures spring semicircular arches, connected with saucer domes along each aisle, and intersecting with an elliptical barrel vault over the nave. Given the need to accommodate large congregations, galleries always posed a visual difficulty in handling the order, and Wren had attempted a range of solutions, including two tiers of columns with the gallery between or a high plinth supporting the gallery with the order above. Gibbs's boldness in attaching the gallery fronts directly to the sides of the column shafts gave integrity to the order as a unifying factor. Partly indebted to inspiration from Bernini is a skilful linking of the rectangular areas of nave and chancel by the insertion of twin, two-storeyed, concave bays which provide access at ground level to vestry-rooms and external entrances, while at gallery level they form tribunes or royal pews (the royal family lived within St. Martin's parish and George II gave a generous subscription toward the cost of the building). JWE

553 MAR
James Gibbs (1682–1754)
St. Martin-in-the-Fields, London
Longitudinal section from the south. "Round Church" design, 1720
Oxford, The Visitors of the Ashmolean Museum, Gibbs Collection, VII.4
Pen and wash
BIBLIOGRAPHY: Gibbs 1728, IV–V: pls. 1–15, 29, 30; Maitland 1739: 731–37; McMasters 1916: 71; *Survey of London* 1940: chapter 3; Esdaile 1944; Summerson 1945: 70–72; Whiffen 1946: 3–6; Holloway 1954; Lang 1954: 72; Little 1955: 67–76; Friedman 1972: "St. Martin-in-the-Fields

and others"; Pevsner and Cherry 1973: 309, fig. 102; Friedman 1974; Beard 1981: 14, figs. 8, 9; Harris 1981: 24, pl. IX; Friedman 1982; Summerson 1983: 352–55; Friedman 1984: 55–61, 265, pls. 35, 292–93; Colvin 1995: 402; Worsley 1995: 60, 101, 102, 206, 280

In the history of ecclesiastical architecture, Gibbs's church of St. Martin-in the-Fields was to prove one of the most influential designs throughout the English-speaking world of Protestant worship. By means of the engraved plates of the executed design in Gibbs's *Book of Architecture*, its impact was of major consequence, particularly throughout the North American colonies, as countless examples testify, from Charleston, South Carolina, to Providence, Rhode Island. In perfecting this concept, Gibbs was to be deeply indebted to Wren, who had empirically evolved an architectural formula for Anglican liturgy through an exceptional range of churches while rebuilding the City of London after the Fire of 1666, and had consciously perfected it in his separate commission for St. James's, Piccadilly, of 1676–84. Deploying classical forms and the orders with geometric lucidity, Wren adapted the conventional basilican interior to accommodate substantial galleries for large congregations to listen to sermons, while lessening the emphasis of the eastern sanctuary area. A substantial steeple, in classically modulated stages to simulate the tapering steeple of Gothic architecture, formed a key external feature of such buildings. In 1710 the parishioners of the dilapidated medieval building of St. Martin's had decided to replace their church and it was originally included on the Commissioners for Building Fifty New Churches's list of 1715. As nothing came of this, the Vestry petitioned Parliament independently in 1717 and an Act for rebuilding was passed that year and a special commission appointed to oversee the work. Gibbs was among the five architects, including John James and Sir James Thornhill, who submitted designs, and in November 1720 he was chosen as "the properest Person to be employed as Surveyor." His original scheme, represented by a set of drawings in the Ashmolean Museum, including these two, as well as three engraved designs later published in *The Book of Architecture* (pls. 8–15), shows a large church taking the form of a domed rotunda, entered through an impressive prostyle temple portico from which a high steeple rises. This impressive idea, involving a central space leading from a portico, was in part inspired by the Pantheon and, as Friedman suggests, Wren's Great Model design for St. Paul's, although the plan also follows one in Andrea Pozzo's treatise on perspective (an English edition had been published by John James in 1707). It was proposed by the architect as being most "capacious and convenient" to house a substantial congregation who were able to see the communion table and pulpit with equal advantage. While attracted by this unusual concept, the design was partly rejected on its substantial cost and the restrictions of the site available. However, by means of the dissemination of this highly original concept through the plates of *The Book of Architecture*, Gibbs's rejected design was to inspire a number of round church designs during the Neoclassical era, mainly produced between 1770 and 1800. JWE

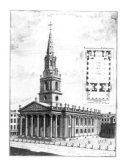

552
James Gibbs (1682–1754)
St. Martin-in-the-Fields, London
Ground Plan of the Executed Design, engraving from James Gibbs, *A Book of Architecture*, 1728, pl. 2
Unknown collection
BIBLIOGRAPHY: Gibbs 1728, IV–V: pls. 2; Maitland 1739: 731–37; McMasters 1916: 71; *Survey of London* 1940: chapter 3; Esdaile 1944; Summerson 1945: 70–2; Whiffen 1946: 3–6; Holloway 1954; Lang 1954: 72; Little 1955: 67–76; Clarke 1966: 181–82; Friedman 1972: "St. Martin-in-the-Fields and others"; Pevsner and Cherry 1973: 309, fig. 102; Friedman 1974; Beard 1981: 14, figs. 8, 9; Harris 1981: 24, pl. IX; Friedman 1982; Summerson 1983: 352–55; Friedman 1984: 55–61, pl. 44; Colvin 1995: 402; Worsley 1995: 60, 101, 102, 206, 280

As executed, this plan shows the revised design for the extended portico with additional columns between the west wall and front colonnade. The arrangement of the pews is indicated as well as the location of the pulpit on the south side of the nave, an important feature in Anglican worship. The plan, ultimately derived from Wren, was to be of profound influence on church design throughout the eighteenth century wherever the *Book of Architecture* traveled. The balance of vestries and staircases (these latter gave access to the royal pews above) at the eastern end with the vestibules and staircases at the western end shows Gibbs's skillful handling of symmetry on both axes; a notable feature also of Hawksmoor's chuches for the 1711 Act). These west structures provided a solid support to the tower and expressed it by the pairs of columns *in antis* framing entrances on the exterior, repeated at the other end of the façade. JWE

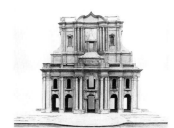

555 T-M-W
Ludovico Rusconi Sassi (1678–1736)
Model for the Competition for the Eastern Façade of San Giovanni in Laterano, Rome, 1723
Vatican, Rev. Fabbrica di San Pietro (formerly in the Museo Petriano)
Painted wood. The base measures 177 x 93 cm; the height from the portico to the top of the pediment is 115 cm. For its condition in 1937 see

577

Hager 1971: 49 pl. 14, and Kieven 1991: 113 pl. 39. See Contardi 1991: 16-22, for its current condition after restoration on the occasion of the exhibition in Castel Sant'Angelo, for which the missing columns were re-made: that is, in the lower part, those on the edges of the façade between the lateral bays; in the upper part, the coupled columns flanking the central concavity on the right. The photographs also show the loggia on the lower right part open: a device to let the corridors and benediction loggia be seen. This loggia is placed immediately above the central entrance, under a dome with a lantern. In some parts of the model, pieces of paper with drawings for the decorators have been glued on to the wood (Contardi 1991: 14).

PROVENANCE: Museo Petriano in the Vatican City (marked "K"). For the earlier provenance see Hager 1971: 36, 60 n. 3; idem 1997: 139-165
BIBLIOGRAPHY: Cerrotti 1860; Prandi 1994: 23–71; Schiavo 1956: 36–61; Golzio 1961: 450–63; Hager 1970 and 1971: 36–67; Kerber 1971: 188–92; *Bauten Roms* 1973; Wittkower 1973; Hager 1975: 105–107; Jacob 1975; Hoffmann 1978: 1–46; Kelly 1980 and 1981: 157–61; Scott Munshower 1981: 43–52; Kieven 1988; Contardi 1991: 9–22; Kieven 1991: 78–123; *Piranesi architetto* 1992; Carta 1996: 168–75; Hager 1997b: 137–83

Attribution of the model to Ludovico Rusconi Sassi is based on stylistic comparisons found, for example, in the Odescalchi Chapel in SS. Apostoli, realised by the architect from 1719 to 1723, where the plan anticipates the upper central part of this model. A written fragment conserved under the steps bears witness to the model being in the 1732 competition (Contardi 1991: 14). Rusconi Sassi's authorship is confirmed by reference to details of the model described by the judges of the competition The aim of the competition proclaimed by Clement XII on 16 April 1732 was to bring to an end the reconstruction and modernisation of the Lateran Basilica, begun by Borromini in view of Holy Year in 1650. Fifty years later, in view of Holy Year 1700, Innocent XII wanted to continue with a "new design," since Borromini's was no longer to be found. The copy of a drawing by Carlo Fontana remains to us of this initiative, also part of a competition. Here, the architect wanted to amalgamate a scheme deriving from the façade of San Marcello al Corso (1682–84), enlarged to the size of an enormous, very tall perspective backdrop, and re-using in the centre the arrangement of concentric circles for elements taken, this time, from the interior decoration of the basilica. Like, for example, the very narrow shape of the side bays, cadenced vertically by niches for statues, low rectangular panels and oval frames for paintings, or respectively windows, which can be found profusely applied in the lower part of the façade, next to the main entrance, over which reigns the benediction loggia. The front finishes with a monumental over-structure with pediment, framing a statue of Christ Resurrected, which is on a smaller scale compared to its backdrop and risks being lost in it. Fontana's Borrominiesque effects differed radically from those of Andrea Pozzo (1700: II, 85–87) who did not take part in the competition but developed the subject and, while keeping the pre-existing scheme in mind, let himself go rather on the effect of curves and counter-curves, emphasising the loggia by tall structures with domes. In 1705 the Accademia di San Luca had also explored possible solutions, probably on Clement XI's initiative. The second class of architecture then presented, represented by Ludovico Sammarco, first prize, a project that was inspired by the Palazzo dei Conservatori on the Capitoline, in the use of giant orders and architraved openings on the lower floor. Ferdinando Fuga was one of the architects who opted for the free double loggia. In this youthful work of 1722 he rendered homage to Borromini in the convex projections. Fuga's work is characterised by the use of a Hadrian type of arch, that is, one which rises above the level of the cornice, becoming part of this movement to give prominence to the benediction loggia. See, for example, the façade of Santa Maria in Via Lata by Pietro da Cortona. Ferdinando Fuga obviously expected his project to be carried out because, perhaps to force things a little, he offered to make a model of it in wood. Innocent XIII's death (1724) put a stop to this decidedly ambitious initiative for a twenty-three-year-old architect. The acquisition of Francesco Borromini's drawings, real or fake, by Cardinal Benedetto Pamphilj, dean of the Basilica, from the artist's heirs in 1723, resulted in further initiatives. Then under Clement XII a new competition, which produced our model, was proclaimed, as previously said, on 16 April 1732 and brought to a conclusion with unusual rapidity. In less than two months the competitors had to have their proposals ready, since the deadline was 6 June. At least twenty-six projects, including eight models, were brought to the Quirinale. Alongside Rusconi Sassi's model there were works by Cosatti, Galilei, Passalacqua, Gregorini, Salvi, Giov. Maria Galli da Bibiena, Dori, Dotti, Raguzzini, Rossi, Ruggeri, Theodoli, Fuga, Vanvitelli and Orlandi (Hager 1970: 37; Jacob 1975: 180–181). Criticism was not so much directed at Rusconi's work itself, as at its curved form and the "minute" amount of decoration, which rendered it rather more suitable to a square bounded by buildings. In the opinion of the majority of the judges the aim would have been better served by a straight structure, considering both what had already been built and the enormous open area in which it was to stand. This left Alessandro Galilei, with four votes, and Luigi Vanvitelli, with three, as the finalists. Having received the greater number of votes, Galilei was declared the winner by the Pope on 18 July. The strongest arguments in favour of Galilei's project, for example Ghezzi's, asserted that an open loggia on both storeys expressed the dignity of the building in a more fitting manner than a façade with a closed upper floor, as had been proposed by Vanvitelli (Hager 1971: 58), as the critics in favour of Galilei did not hesitate to stress. A drawing (Kieven 1991: 104, 107) and a bronze medal by Ottone Hamerani of 1733 are proof that rethinking continued even after the first stone was laid, since they show details before building that have been changed towards a greater openness. The graduated heights of the entrances towards the centre were to be unified; the benediction loggia, as built, rests on free-standing columns that are repeated above the balcony as part of a 'serliana' that distinguishes this loggia reserved for the Pope's appearances; the windows with the Pope's arms planned for the arches of the loggia were completely omitted, in order to increase the skeletal effect of the structure, in happy contrast with the massive block of the Papal Palazzo on the right, which, at the same time, was widened up to the façade of the Basilica, but given nothing to balance it on the left. This lack of symmetry led Giovanni Battista Piranesi (1720–1778) in his view of about 1750 (Connors 1992: 51–52) to tackle the subject diagonally and from the left. This allowed him to dramatise the three-dimensional effect of the church's façade, using perspective in such a way as to taper the front of the palazzo and make it appear subordinate. On the left of the view, Piranesi concentrates on the Corsini Chapel, conceived in the wake of Sixtus V and Paul V's chapels in S. Maria Maggiore. With its dome on a tall drum, it attracts the spectator's attention to this other work begun by Galilei in 1731, a year before the competition for the façade. The decision in favour of Alessandro Galilei's project was a wise one and, in comparison with the other proposals known to us, it appears the most suitable. Piranesi obviously thought so too as he emphasised in his view, drawn only a short time after the building was finished, all its most remarkable qualities. The façade has remained this architect's masterpiece; he lived only another two years after it was finished, dying in 1737. H.H.

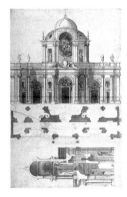

565 M
Andrea Pozzo (1642–1709)
Elevation of a project for the façade of San Giovanni in Laterano, 1699
New York, Cooper-Hewitt National Design Museum
Pen, brown ink, watercolor touches on two glued sheets; 74.4 x 48 cm

563 T
Ottone Hamerani
Medal of Clemens XII with the project for the façade of San Giovanni in Laterano, Rome, by Alessandro Galilei, 1733
Munich, Staatliche Münzsammlung
Bronze; 7.2 cm (diameter)

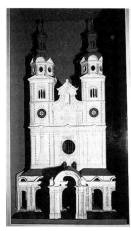

566 T
Stefan Föger
Façade of the Bressanone Cathedral
December 1746 - March 1747
Wooden model, polychrome; 260.5 x 135 x 84 cm
Bressanone, Museo Diocesano, Palazzo Vescovile, Inv. no. 426
BIBLIOGRAPHY: Leopold Peisser, "Diarium Über die Erbauung der hochfürstlichen Dom Kirchen zu Brixen. Zu drei Thaill abgethailt. Erster Thail," 16 August 1745–6 December 1746, Archivio Diocesano, Palazzo Vescovile di Bressanone, Codices Konsistorium: 95v, 184r, 196v; 1 January 1747–end December 1749, Archivio Diocesano, Palazzo Vescovile di Bressanone, Codices Konsistorium: 65r, 67v, 117v, 127r, 134v, 162r, 177r, 179r, 180r, 187r, 198v; Thieme, Becker 1907–50: XI, 343; Weingartner 1923: 26–28, figs. 12–13; *Im südlichen Tirol* 1980: 64; Wolfsgruber 1988: fig. 122; Reuther, Berckenhagen 1994: 59, no. 104; *Paul Troger* 1998: 86, no. 1.12; *Triumph der Phantasie* 1998: 228ff., no. 72.

For his sketch of the façade, Föger already received a payment of fifty guldens at the beginning of June 1746. Peisser mentions mid-August as being the moment when the decision was to be made whether or not to add the gold capital to Stefan Föger's façade model. The reference is only to the sketch and not to the wooden model. On the 29 November, Föger came to Bressanone with the sketch of the façade. At the conference of the Bressanone Cathedral Building Committee on the 3 December 1746, several modifications to the sketch were stipulated and Föger was commissioned to prepare a wood model of the façade. On the 15 March 1747, Föger brought the finished wood model to Bressanone and placed it in front of the knight's hall of the archbishop's residence, where the building commission's discussion was ongoing as to what sort of façade was desired. On the 18 March 1747, Föger was paid for his model and was promised he would be kept in mind for the manufacture of sculptures. Then committee member Peisser voiced criticism of the model, later seconded by the suffragan bishop Graf von Sarnthein; and in July 1747, both master builder Giuseppe Delai and the wall master Simon Rieder spoke out against Föger's style of façade. In December 1747, the building commission ruled to have the façade built in the course of 1748 on the basis of Föger's model. Peisser was still opposed to the idea. Late in the spring of 1748, the building of the façade after Föger's model got underway. Like his model for the nave, Föger's façade model was built out of wood with a layer of chalk and covered over in color. For the ornaments and molding, Föger used plaster, and wood veneer for the rustica of the steeple. The façade between the two steeples was built on the basis of Föger's model. The curved pediment, round arches and the large oval window are still visible on the cathedral today; the two window openings with arch-shaped terms beneath the oval windows are still there, though they have been walled up and hidden behind the roof of the current front building. There is today no trace of the installation of the planimetrical ornaments, and Föger's biodegradable pieces. The façade of the front building, which integrates the passageways to the central walk and the cemetery, consists of a pillared arcade with four arches. The central arcade, which leads to the church's entrance portal, juts out and is crowned in a gabled segment on the side. Pilasters provide the rustica-covering of the entranceway with rhythm, as well as supporting the entablature and attic. Above the arcades on both sides of the portal projections, railed openings are set in the attic area in the segmented and triangular gables. The façade of the front building was never actually built in this form. The entranceway to the Bressanone cathedral as it stands today was first built in 1783 on the basis of plans by Jakob Pirchstallers. (A wooden model of the entranceway is on display in the diocese museum.) Föger's model is made up of fourteen separate pieces. It is missing the statue on the façade's transom gable, the indicator of the hour on the fifth tower, the small columns at the northern and southern gothic triple-windows, several railing bars at the opening of the front building's façade as well as the three sculptures, which were built onto the roof of the front building's gable. PM

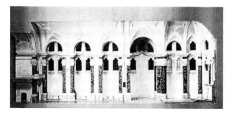

567
Stefan Föger
Model for the Bressanone Cathedral, longitudinal section
April–June 1746
Bressanone, Museo Diocesano, Palazzo Vescovile, Inv. no. 425
Painted wooden model
107.5 x 257 x 70.5 cm
BIBLIOGRAPHY: Leopold Peisser, "Diarium Über die Erbauung der hochfürstlichen Dom Kirchen zu Brixen. Zu drei Thaill abgethailt. Erster Thail," 16 August 1745–6 December 1746, Archivio Diocesano, Palazzo Vescovile di Bressanone, Codices Konsistorium: 76v, 79v, 81r, 95r, 100r, 102r ff., 135v, 201v; Thieme and Becker 1907–1950: XI, 343; Weingartner 1923: 22–24, figs. 3–4; *Im südlichen Tirol* 1980: 64, no. 106; Reuther and Berckenhagen 1994: 59, no. 103; *Paul Troger* 1998: 87, no. 1.13

This model was commissioned from Stefan Föger by the Bressanone Cathedral Building Commission on 8 April 1746. For twenty-four zechin, the Innsbruck-based sculptor was to build and deliver a model in keeping with his previously approved plans before Whitsuntide. On the 1 June 1746, the wood model was ready for discussion before the Conference. Delai expressed criticism on only a few points regarding the model, which the next day was looked over in the cathedral. The decision was made to stick to Föger's model, which essentially integrated Giuseppe Delai's plans, to which it merely added more marble and stucco. The model's basic structure was made out of wood, covered over with a chalk base and subsequently painted. Föger finished the capital and several ornaments with plaster, using wood with a layer of chalk for the other parts. The capital and the ornamentation were done in a light shade of pink; one ornament between the windows of the western side-chapel seems to have been painted over in gold paint – somewhat as if it were to be seen as an ornament on the high alter. He imitated the shine of the marble with streaks of lacquer, as can still be seen on the pilaster columns, the high alter or the flooring. The model was made out of two parts, from which the high alter can be removed. Föger was given Benedetti's sketch of the high alter in April 1746, on the basis of which to prepare his model. Föger of course set a high alter, done on the basis of his own sketches, in the model nave, which subsequently won the approval of the building committee. This wood model of the longitudinal section fitted together with the 1746–47 model of the façade into one single model. The barrel-vault in the nave, choir and transept were organized into panels by the frames of the various pieces. The tops of the side chapels are only slightly notched into the barrels, thereby creating large unified surfaces for the frescoes, as originally planned. The flanges, made out of pieces which prolong the wall pilasters from the vault to the pictorial field itself, is repeated in similar form in Troger's square painting. In the east walls of the pilasters (except for the one at the chancel) hollow round arches are set, which must have been planned for the confessionals, as can be deduced from the confessional set into the second niche. Today, two very similar confessionals are to be found in the east walls of both steeples in the interior space of the cathedral. The blind windows in the northern section of the transept and on the northern side of the choir lead one to suppose that Föger may have planned for an oratorium for this spot. Master-builder Giuseppe Delai did not respect this aspect of the project; moreover, the building committee was determined to avoid blind windows at all costs. The columns beneath the musicians' choir – originally planned as marble columns – are missing. This resulted from Silvester Polini's audience with the building commission, after Föger's model had been approved. The columns and statues of the high alter are also missing as is the choir entranceway, the floor of which extends to the chancel. In several capitals in the choir, the abacus ornaments and the abacus panels have been damaged. PM

568 T
Giuseppe Delai (?)
Longitudinal Section of the Bressanone Cathedral (southern half)
ca. 1745
Bressanone, Museo Diocesano, Palazzo Vescovile, Inv. no. 431
Wash on water-colored paper; 139.9 x 73.2 cm
BIBLIOGRAPHY: Thiene, Becker 1907–50: III 307ff.; Weingartner 1923: 20–22, fig. 2; *Im südlichen Tirol* 1980: 65, no. 111; *Paul Troger* 1998: 85ff., no. 1.11

On one of the three pieces stuck together to make up this sheet, whose outer and partially black edges are visible, a sketch shows a longitudinal section of the pilastered church. The drawing was sketched out in pencil and covered over with wash. The walls and the roof-framework are done in gray-hued watercolors, the wall surfaces and the flanges were left in the whitish tone of the paper. Beneath the watercolors, in the transept, the sketch of an altar is visible, while in the choir-stall, several volutes can be seen. An antique-style Episcopal statue is clearly visible above the front building on the west side, and a sort of podium on the ridge of the nave, which according to this plan was set to the west of the steeple, can still faintly be made out. On the pilaster columns and the horizontal lines between the cornices of the entablature, the artist used green and red spots to imitate the marble. The prominent Corinthian pilaster and the cornice above it subdivide the lower portion of the church space, linking and enveloping the choir, the transept, the nave and the space between the two steeples. The pilasters continue above the cornice around the arch in the form of reinforcements. Two further pilasters stand against each of the three pilasters of the nave; the pilasters in the transept, choir and the space between the two steeples are layered, and in these same areas, the vault's reinforcing arches also have a layered effect. From the measures given on the scale in the middle part of sheet beneath the longitudinal section, it would appear that the particulars were given in *Werkschuh* (work boots) in keeping with local Tirolean legislation (1 *Werkschuh* = 33.5 cm). From the ground to the vault, the nave stands some 64 *Werkschuh* high; the choir is 56 *Werkschuh* high. The three side chapels with their sketched-in alters reach a height of 30 *Werkschuh*, the lunette-windows of the chapel were to have been covered up from the rest by the 27 *Werkschuh*-high cloister in the south. Light was thus only able to fall in through the right-hand-corner window at the tip of the dome, the choir windows and the large lunette window in the transept. The nave was to be pulled toward the west of the steeple. This façade was part of the barrel-arched vestibule with a desk-roof. A window above this façade on the

vestibule was to provide light for the organ gallery and the inner space. The length of the combined domes in the central axis is approximately the same as it is today. Weingartner conjectures that Teodoro Benedetti was the author of this plan. It would seem, however, to have been the initial proposal of master builder Giuseppe Delai, who in 1745 was commissioned by Archbishop Kaspar Ignaz. Graf Künigle to deliver the blueprints for the planned renovation of the Bressanone cathedral. Delai is considered to have been the last important master-builder of a long line of architects in the Delai family. PM

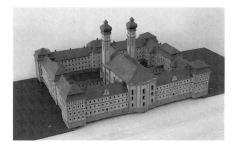

569 T
Dominikus Zimmermann (1685–1766)
Model of the Premonstratensian Abbey of Schussenried
Ulm, Bad Schussenried, Neues Kloster, vestibule of the library, property of Staatliches Schlösser und Gärten Baden-Württemberg
Wood, painted white, gray and red
ca. 57 x 112 x 90 cm
BIBLIOGRAPHY: Reinle 1951: 9–10; Kasper 1960: 60–62; *Barock am Bodensee* 1962: no. 228; Hitchcock 1968a: 78, 92; H. and A. Bauer 1985: 248–49; Reuther, Berckenhagen 1994: 137, no. 361

When Dominikus Zimmermann received this commission from the Premonstratensians of Schussenried (since 1966: Bad Schussenried), he was already well-acquainted with his patrons. His pilgrimage church of Steinhausen belonged to the nearby abbey at Schussenried, where his son Georg (Father Thaddäus) was a monk. On 20 March 1748 the abbot of Schussenried presented a plan for the proposed new monastery to the chapter. The chapter voted to have a model built on the basis of the plan; the model was then presented after Easter in the same year (Kasper 1960: 60). The documents expressly attribute the model's design to Zimmermann, but the identity of the craftsman who built it remains unknown. The model is painted inside and out. Each of the floors of the monastery lifts off separately, revealing the successive floor plans. The design envisaged a huge complex surrounded by four wings. The church stands in the center of the complex, its west façade with three doors bisecting the west wing of the monastery. Low passageways connect the church across the inner courtyard to the center of each of the other wings. The church features shallow transepts and a choir slightly narrower than the nave. The two towers stand in the exterior corners between transept and choir. The church is articulated with pilaster strips; along the nave these hint at a varied rhythmic development of the interior space. The monastery buildings are also simply articulated with pilaster

strips on the pavilions and continuous string courses between the storeys along the whole breadth of each wing. The pavilions are distinguished from the main block of each wing by their projection, their height (4 vs. 3 storeys), and their mansard roofs. Four small tower-like stairway units project into the courtyard. Zimmermann's design for Schussenried stands in the tradition of great Baroque monasteries such as Weingarten, Einsiedeln, and Ottobeuron; it dates toward the end of the Baroque revival of medieval orders across the countryside of the German-speaking Alpine lands. SK

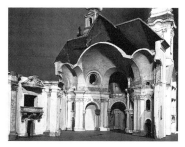

570
Matthias Gerl (1711–65)
Model of the Church of the Piarists in Vienna
1751
Vienna, Convent of the Piarists
Fir-wood; walls painted white, dark brown roofs, interior decoration in yellow; tower at right, not original, in natural wood; 134.5 x 140 x 86.5 cm
EXHIBITION: *Franz Anton Maulpertsch* 1974: 120, no. 198; *Triumph der Phantasie* 1998: 299ff.
BIBLIOGRAPHY: Grimschitz 1929: 251ff., fig. 15-16; Wagner, Rieger 1956: 57ff.; Voit 1965: 191; Hofmann 1968: 115; Rizzi 1976: 139ff.; Jelonek 1984: 753ff.; Fürst 1991: 43ff.; Reuther, Berckenhagen 1994: 149ff.; *Triumph der Phantasie* 1998: 229ff.

A decree by the Emperor Leopoldo in 1697 authorised the Order of Piarists to found a church in Vienna. After a brief waiting period, construction finally began, but the ambitious project was delayed due to financial difficulties. Grimschitz (1929) was the first to attribute the project to Johann Lucas von Hildebrandt, but his opinion is not accepted by everyone. Since the original plans of the project were not kept, conclusions concerning the project's creator can be based solely on modern sources. The original project can be dated back to before 1716, the year in which construction began. In support of Grimschitz's attribution to Hildebrandt, an affinity with the Laurenzkirche in Gabel has been cited many times. Built several years earlier, Laurenzkirche, which is certainly to be considered the work of Hildebrandt, is a free interpretation of the architectural style of Guarini, as is the church of the Piarists. Both churches contain a central area from which the annexed spaces are grouped in a cross pattern, enclosed within a quadrilateral block formed by secondary spaces. The most important difference is the ribbed cupola of the church, which should be classified as one of the most precocious design systems of its kind in German Baroque architecture. Unlike the most commonly used structure supported by

pendentives, the cap was embedded like a rib vault between the dowels of the arches, which delimit it, without separating the cupola's surface from that of the dowels. The impression of the ribbed cupola is given by the fact that the cap is separate from the crown of the arches. The inspiration for a ribbed cupola resting on a structure composed of eight arches with curved façades may have come from the church of the Castle of Smirice by Christoph Dientzenhofer (Fürst 1991). Franz Jänggl, who had already collaborated with Hildebrandt on some projects, has also been considered as a possible architect on the basis of an annotation in the monastery's archives, where he is mentioned as the "inventor" of the church. This citation, however, is often debated due to its vague meaning. Jänggl worked as an architect for the Piarists from 1716 to 1731, year in which he was fired for dissension with the order. The mode is attributed to the Piarists' new architect, Matthias Gerl. According to sources of the archives, it was made in 1751 and its correspondence with the constructed building. Nevertheless, the modern-day façade is completely different. The actual tympanum and the third floor of the towers were not completed until 1859, by Franz Sitte, in a neo-Baroque style. In addition, the façade on the model is missing the sculptures created for the pediment by Josef Mader in 1752. The model had several functions. First, it provided a visual of the general project; in addition, the model served to show the expected modifications: the expanded presbytery, the choir and the façade, including the second tower, which is still missing. Finally, the model was also to be used as a reference to help resolve queries concerning the altar and the internal decorations, which were frescoes painted by Maulpertsch. ASt

1741 and 1742, illustrates the grandiose general complex and fully restores the project for the entire conventual compound. Gerl drew the greater part of the original structures and the plan for the section of the monastery that had not yet been built. To the left of the piazza is the wing dedicated to the college with the summer refectory, while to the right is the wing reserved for the boarding house. Below a pencil sketch of the choir's expansion, the church's planimetry for the apse illustrates the layout in existence at the time. In 1749, the original semi-circular presbytery was demolished and rebuilt from the ground up, its external construction extended toward the wall of the garden. In the drawing, the originally planned isolated paired columns have been replaced by parastades.

Though it had commonly been thought that Gerl's planimetrical drawing of the church had been taken from Dientzenhofer's plan, some important differences have led Jelonek to conclude that the drawing is likely nothing more than an imprecise rendition. The degree of precision might be sufficient to determine the general factual condition of the project, but not sufficient enough to provide precise indications. Evidence of divergences is also seen in the architectural characteristics of the presbytery. In Gerl's planimetry the vaulted ceilings are delimited toward the sides and the apse by arches that run along the length of the plan, and there is a rib vault engraved with a nail-like pattern. Instead, the columns, which are once again included here, are completely independent of the ribbed cupola. According to Jelonek, Gerl's solution for the vault, which was never carried out, demonstrates that the architect had once again contemplated using columns (Jelonek 1984). ASt

considered to be a copy of the original project, the engraving represents yet another important source for reconstructing the initial project, which has been lost. It provides an almost orthogonal view of the church and, once again, as in Dientzenhofer's map, demonstrates the prime reason for the isolated paired columns. Much like a shield, the façade leans outward, convexly, toward the piazza, pushing aside the gigantic columns in front of it and breaking the ribbed arch pediment (Rizzi 1976). In the actual building, the convexity of the jutting central section converts laterally, in the opposite direction of the towers' concave walls. It is interesting to note that this characteristic is not apparent in Kleiner's drawing, since he usually emphatically exaggerates volumes in the direction of their depth. If this fact is viewed as an imprecision, then it must be attributed to the probable circumstance that Kleiner was obliged to make the drawing by referring only to project plans and sketches, since the church was still being constructed. This explanation must also serve to explain why Kleiner's may have had to copy his design, a practice that is so atypical of him. The central span of the façade is characterized by a double split shell, whose four layers are composed of columns, two sections of jutting wall and the wall's most internal layer (Fürst 1991). There is no agreement on whether the gigantic and imposing columns, which greatly contrast with the rest of the walls, might be integrated in a convincing manner in Hildebrandt's work. On the other hand, the motif seems to harmonize well with the cupola's motif. Since the new type of vaulted ceiling required the elimination of the imposing cupola, which would have provided a striking visual effect, the emphasis was transferred onto the towers, whose extended height favored the use of a gigantic order that embraces several floors (Rizzi 1976). Along the superimposed sections of the towers, the external structure was made compact and characterized by a wall that does not open onto a structured, pillared open-area. On the floor above, the wall dissolves, leaving room for the pillars with parastades, which are interposed with columns (Fürst 1991). The tympanum rises above the attic, like a closed wall, crowned by paired parastades. It is on this structure that Sitte later formulated the completion of the architectural project (from 1859). Jelonek noticed Kleiner's addition of the split tympanum and the third floor of the towers. At the time that the drawing was made, the façade had been completed only as far as the cornice; therefore, Kleiner would have had to complete the missing parts. As Kleiner's engraving shows, the piazza was open to traffic even though a row of small trees, alternately placed like statues along the foundations, provided an obstacle, albeit limited. The strict buildings that comprise the college flank the piazza and the boarding school, which is not evidenced by either architectural orders or jutting structures. It is the church's façade that provides the focal point of the piazza's layout, thereby integrating the piazza, open to the public, with the more private monastic structure. This in itself is an extraordinary innovation (Fürst 1991). ASt

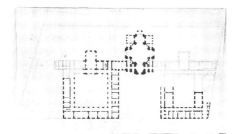

571 MAR
Matthias Gerl (1711-1765)
Plan of the Church and Monastery of the Piarists in Vienna, 1741-42
Vienna, Graphische Sammlung Albertina, Architekturzeichnungen, Mappe 36/7/1, Inv. no. 4927
Ink and gray watercolor; 50 x 80 cm
PROVENANCE: Niederösterreichisches Archiv.
BIBLIOGRAPHY: Wagner-Rieger 1956: 57, 61; Rizzi 1976: 139; Jelonek 1984: 708–21

Initially, the Piarists had entrusted the design of a church and convent to their architect, Bartholomäus Hochaltinger. Although his overly antiquated plan for a church was immediately refused, construction on his design of the monastery began in 1698. The planimetry, drawn by Mathias Gerl sometime between

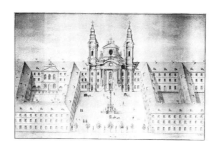

572 MAR
Salomon Kleiner (1703–61); Johann August Corvinus (1684–1738), engraver
View of the Church of the Piarists in Vienna, 1724
Vienna, Österreichische Nationalbibliothek
Engraving
23 x 34,7 cm
BIBLIOGRAPHY: Grimschitz 1929: 252ff., fig. 13; Wagner-Rieger 1956: 59ff.; Voit 1965: 199–202; Hofmann 1968: 117ff.; Rizzi 1976: 128; Jelonek 1984: 768ff.; Fürst 1991: 120ff.

First discovered in 1724 in Augusta at the residence of Johann Andreas Pfeffel, the engraving is based on a picture by Salomon Kleiner. It belongs to a series of reliefs that were made between 1721 and 1722. Located next to Kilian Ignaz Dientzenhofer's planimetry, generally

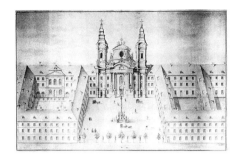

573 MAR
P. Cölestin Vogel (1738–1807)
View of the Monastery and the Church of the
Piarists in Vienna, 1772
Vienna, Piaristenkloster
Colored ink; 93 x 60 cm
EXHIBITIONS: *Franz Anton Maulpertsch* 1974:
116, no. 163
BIBLIOGRAPHY: Grimschitz 1929: 254, no. 58, fig. 14

Painted shortly after the church was consecrated,
Vogel's view of the church demonstrates that
Kleiner's engraved depiction of the façade and
the constructed model had already been aban-
doned and the jutting central portion radically al-
tered. The formal solution had initially been mod-
ified, replacing the isolated columns with paras-
tades. Instead, the model presents a façade with
semi-columns, which correspond with the final
construction. It is possible that Vogel's drawing
was intended as a presentation of a new modifi-
cation, aimed at correcting the imbalance in
height by reducing the upper levels of the towers.
Jelonek's theory, however, is that the towers of the
church of the Piarists were intended to have only
two levels from the start. Regarding the early 18-
century façades, the ones with horizontal parti-
tions are believed to have been characterised by
three-storey towers, while those in which the low-
er part of the façade is embraced by a single large
architectural order, supposedly had two-storey
towers. The elevated ends of the towers in Gerl's
model would have compromised the façade's
composition and should therefore be considered
as a variation of the architect's plan. In 1859, on
the basis of a design by F. Sitte, the towers were
elevated and the tympanum was modified ac-
cording to an engraving by S. Kleiner. ASt

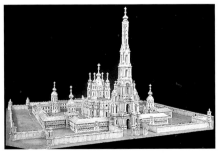

575 M–W–T
Francesco Bartolomeo Rastrelli (ca. 1700–71)
with the participation of Jacopo Lorenzo
Smol'ny Convent in St. Petersburg, 1748–56
St. Petersburg, Scientific Research Museum of
Academy of Arts of Russia
Wooden, painted, and gilded model
2.65 x 5.18 x 5.01 m

BIBLIOGRAPHY: Grabar 1903: 207–10; Matveev
1939: 129–48; Vipper 1978: 80–81, fig. 202;
Denisov and Petrov 1963: no. 298–324; Hamil-
ton 180–81, ill. 118

This model of Smol'ny convent, which is now in
the Russian Academy of Fine Arts, fully conveys
the intent of the ensemble's creator, the leading
master of the Russian Baroque of the mid-18th
century, Francesco Bartolomeo Rastrelli. Not on-
ly are all the components of this grandiose com-
plex, both those completed and those never built,
present, but the complete ornament of each
building has been elaborated in full. Moreover, to
a significant degree, they did not survive or were
redone, so we can judge their original appearance
primarily thanks to this model. Construction be-
gan on Smol'ny convent on 30 October 1748,
with the ceremonial laying of the first stone of the
Cathedral of Christ's Resurrection, with Empress
Elizabeth Petrovna in attendance. On the whole,
as the model shows, the ensemble demonstrated
an unusually well integrated and harmonious hi-
erarchy of spaces and masses that subordinated
itself to the clear movement toward the center.
This hierarchy was aided by the rhythmic struc-
turing of all the parts of the convent. The rhythm
mounted from the periphery toward the center,
as did the boldness and fullness of the buildings'
façades. The sedate rhythm of the wall's solid pi-
lasters was gradually replaced by a more staccato
alternation of apertures and piers in the blocks of
cells, concentrating finally in the luxuriant, bold,
and detail-saturated architecture of the cathe-
dral. Rastrelli maintained a perfect unity of style,
which was manifested on all scales and in all parts
of the ensemble. Some of the nuns' cells were
built in 1751, and in 1757 the cathedral was erect-
ed without any ornamentation. Later, as a result
of a lack of funds in the imperial treasury in con-
nection with the Seven Years' War, construction
came to a halt. Gradually the buildings were
completed in the 1760s, now under Empress
Catherine the Great. The model's chief distinc-
tion lies in the fact that its most interesting sec-
tion – the grandiose six-tiered bell tower, which
was supposed to rise above the ceremonial en-
trance to the convent and become the highest
structure in St. Petersburg – was never built. On
the whole, the model of Smol'ny convent conveys
the most important features of the Russian
Baroque of the mid-eighteenth century, the era of
Empress Elizabeth I, Peter the Great's daughter.
Here are combined a regularity of floor plan and
a precise hierarchy of spaces with an attraction to
magnificent opulence, monumentality, and the
luxury of innumerable details. The introduction
of typical Russian motifs, such as the multi-tiered
construction of the bell tower and the cathedral's
five domes, gave the entire composition a Russian
feeling. Likewise the treatment of classical forms,
which was much freer than among most Euro-
pean master-builders, and the vivid palette and
abundance of gilt, conveyed the spirit of the era
of Elizabeth I, which saw the flowering of the
Russian Baroque and which was later cut off by
the coming of the new reign of Catherine the
Great, who preferred Classicism and held a high-
ly negative view of the tastes of her most august
predecessor. DS

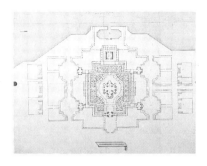

585 MAR
Francesco Bartolomeo Rastrelli (ca. 1700–71)
Smol'ny Convent, St. Petersburg
General Plan
Version with small external churches, 1748
Vienna, Graphische Sammlung Albertina, no.
5660
Gouache, pen; 117 x 150 cm
BIBLIOGRAPHY: Makarov 1938: 129; Denisov
and Petrov 1963: 76, 170, no. 298

This design by Rastrelli, who signed it "de R.,"
conveys the original concept behind his plan for
the convent and indicates the designations for all
the buildings. The drawing summarizes all the
preparatory work that had gone into creating the
ensemble, which went on from 1744 to 1748.
Subsequently, after it was shown to the empress,
changes were made in the design. The convent's
dimensions were altered, and the cathedral be-
came very different. The corner churches were
moved to other sites and construction was can-
celed on a separate section of the convent set
aside for the mother superior. At all stages of its
creation, the center of Smol'ny convent was the
cathedral "A" (according to the legend in Ras-
trelli's drawing). In this drawing, it is radically
different both from what was eventually built and
what we see in the model. This is how Rastrelli
himself wanted to build it. We know that the
change in the plan and appearance of the church
was made at the request of Elizabeth I, who want-
ed the structure of the building to resemble the
arrangement of the Dormition Cathedral in the
Moscow Kremlin. This plan for the cathedral
from the Albertine Collection is distinguished by
vividly expressed Baroque features which, how-
ever, correspond more to the Italian than the
Russian Baroque. The complex external contour,
the four projecting staircase towers, and, inside,
the overflowing of curvilinear spaces, evidently
seemed too "Roman" to the empress. The sim-
plicity of the plan, its regularity, and the predom-
inance of the right angle characteristic for St. Pe-
tersburg in the first half of the eighteenth centu-
ry, as well as the typical arrangement of the inte-
rior space of Orthodox churches that dated back
to Byzantine and ancient Russian cross-and-
dome churches – these were the qualities that the
empress did not find in this design of Rastrelli's.
In the general plan of 1748, the architect pro-
posed putting the cells around the cathedral in a
cross pattern "C". Between them and the cathe-
dral there were to be small separate gardens for
each nun (g). In this version, the four small
churches that Rastrelli had wanted to create for
the nuns' more solitary prayers were pulled away
from the main "cross" created by the blocks of

cells. In this extremely grandiose plan, Rastrelli put the large refectory (d) and the three housing blocks (e) allotted to the mother superior around a small separate palace located closer to the banks of the Neva than the main structures of the convent. The mother superior's residence looked like a separate palace set in front of a large harbor connected to the river. All this was subsequently eliminated, as were the very large regular gardens to the right and left of the convent. Rastrelli wanted to put in vegetable gardens (h) closer to it and beyond them places for residents of the city to take strolls. He put bathhouses "I" in the gardens near the Neva. At the very edges of the ensemble, he proposed building houses for the priests and their families. DS

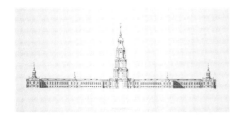

576 M
Francesco Bartolomeo Rastrelli (ca. 1700–71)
Smol'ny Convent, St. Petersburg
Main (Western) Façade of the Block of Cells with an Entrance in the Form of a Bell Tower
Version with small external churches, 1748
Vienna, Graphische Sammlung Albertina
India ink, pen
BIBLIOGRAPHY: Makarov 1938: 130; Denisov and Petrov 1963: 77, 171, no. 300

This drawing refers to the first, earliest, and most grandiose version of the design for Smol'ny convent, which Rastrelli created in the years 1744–48. Indeed, one of the main differences from the model is in the siting of the small churches, which were moved off to the side of the square of cells. This resulted in the master's beloved composition of precisely delineated upper sections on the sides of the façade, in the center of which there was supposed to be a bell tower. At the first stage of designing the ensemble, Rastrelli proposed making it four-tiered and topping it with a relatively low, curving spire. The bell tower looked like a vertical series of triumphal arches placed one on top of the other. This type of structure was traditional for imperial construction of the second quarter of the eighteenth century. Its origins extended back on the one hand to the Russian tradition of creating multi-tiered bell towers and, on the other, to the triumphal structures erected for coronations and for celebrating the victories of Russian troops. It should be noted that neither the architecture of the blocks of cells, which stretch in extended horizontal lines, nor the appearance of the bell towers erected above them frankly express Russian features. All the elements of the "language" Rastrelli used can be found in structures of the European, and especially the German, Baroque. Specific to Russia was the emphatically positive, triumphal character of the design, the strict regularity of the rhythm, and the predominance of straight lines. DS

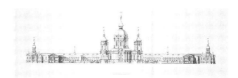

577 M
Francesco Bartolomeo Rastrelli (ca. 1700–71)
Smol'ny Convent, St. Petersburg
Western Façade of the Cathedral and Section of the Convent Courtyard
Version with small external churches, 1748
Vienna, Graphische Sammlung Albertina
India ink, pen
BIBLIOGRAPHY: Makarov 1938: 130; Denisov and Petrov 1963: 77, 171, no. 301

This drawing also belongs to the original design for Smol'ny convent – the version with small external churches. A section like this of the ensemble with the western façade of the cathedral was sent to Empress Elizabeth I in late 1748. Besides the disposition of the small churches, which is different from the version ultimately built, the cathedral has a completely different appearance here. For all the complexity of the placement of volumes and diagonally set towers, it nonetheless engenders an impression of a church that is more Western European than Russian. These distinctions from the characteristic structure of volumes in Russian churches evidently did not please the empress, who ordered the architect to look to the ancient structures of the Moscow Kremlin for examples. DS

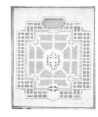

584 M
Francesco Bartolomeo Rastrelli (ca. 1700–71)
General Plan of Smol'ny Convent, St. Petersburg
Version with small external churches, 1748
Vienna, Graphische Sammlung Albertina, no. 5657
India ink, pen; 80 x 67.5 cm
BIBLIOGRAPHY: Makarov 1938: 132; Denisov and Petrov 1963: 78, 171, no. 302

This general plan refers to the second design for Smol'ny convent, which is usually called the version with small interior churches. The general outlines of the blocks of cells remain similar to Rastrelli's original design, but the small churches have been moved inside the ensemble to reinforce the intersection of the branches of the cross layout. The small individual gardens for each nun, on the other hand, have been moved outside between the inner wall and the cells. In the inner courtyard around the cathedral is the common garden. The plan of the cathedral remains as it was, retaining the complexity of contours and the curvilinearity of spaces that would be replaced in the version eventually built by the traditional Russian cross-and-dome system. DS

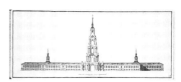

586 MAR
Francesco Bartolomeo Rastrelli (ca. 1700–71)
Smol'ny Convent, St. Petersburg
Western Façade of the Convent's Cells with an Entrance in the Form of a Bell Tower
Version with small interior churches
1748
Vienna, Graphische Sammlung Albertina, no. 5658
India ink, pen; 44.5 x 106 cm

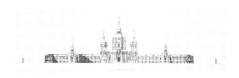

587 MAR
Western Façade of the Cathedral and a Section of the Convent Courtyard
1748
Vienna, Graphische Sammlung Albertina, no. 5659
India ink, pen; 53.5 x 142.5 cm

578 W
Francesco Bartolomeo Rastrelli (ca. 1700–71)
Western Façade of the Cathedral and a Section of the Convent Courtyard, 1748
Warsaw, National Library, AR - 99/2; copy of the same drawing from the Albertine Collection in Vienna
India ink, pen; 60 x 148 cm
BIBLIOGRAPHY: Makarov 1938: 132; Denisov and Petrov 1963: 79, 171, no. 305

These four drawings refer to the second stage in the creation of the design for Smol'ny convent by Francesco Bartolomeo Rastrelli. In all of them, the ensemble is shown with small interior churches (unlike their original placement outside the blocks of cells), but preserving the appearance of the cathedral and bell tower in front of it, above the main entrance to the convent, as the architect's conception at the beginning of his work intended. At the second stage of designing, Rastrelli began the process that would culminate in an alteration in the central cathedral. Shifting the small churches to the interior brought them closer to the church, helped concentrate the verticals in the middle of the ensemble, and made it more central and enclosed. Moreover, to an even greater degree, the importance of the inner courtyard, where "all five churches were gathered," as one of the documents proclaims, was heightened. Despite all this, the overall style of the ensemble changes little. The character of the ornamentation used remains virtually the same. However, even here the main stress has shifted in the finishing of the inner courtyard; from the inside around it the cells' façades have become fancier and have been given a row of double pi-

lasters. On the whole, it is the interior space of the convent in particular that has become especially rich and saturated. Unlike the imperial palaces he built, with their especially luxurious outer façades, here the characteristic Rastrelli effect of transforming architecture into a "monumental jewel" is focused on the inside. The front entrance, with its combination of a powerful triumphal arch and a grandiose bell tower, leads the viewer into the unusually vivid and lushly decorated interior space that embraces the opulent cathedral. DS

changed after Rastrelli created, at the empress's request, a new design for the Smol'ny convent cathedral. On the left, the contours of the installation are laid at the base, which is covered with piles. On the right, are merely general contours of the pile foundation without the walls of the cathedral. Around the darker area is a light area denoting the boundary between the shallower piles. In both drawings, a thin line indicates the boundary of the driven piles followed in the cathedral's original design. DS

galleries for bells. Rastrelli put the types of these two ancient buildings together when the empress ordered him to use Muscovite examples, but he combined them in a "different order." Rather than placing them side by side, as in the Kremlin, he built one on top of the other. While preserving the scheme of its Kremlin model, the lower part referred to the Russian triumphal arches of the first half of the 18th century. Thus, Rastrelli conveyed the theme of imperial triumph, so important for Baroque St. Petersburg, by crowning it with the symbol of Russia's ancient glory. DS

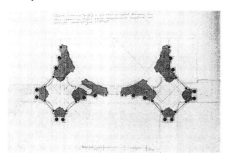

589 MAR
Francesco Bartolomeo Rastrelli (ca. 1700–71)
Smol'ny Convent, St. Petersburg
Plan for the Main and Side Cupolas, ca. 1760
St. Petersburg, Scientific Research Museum of Academy of Arts of Russia, A-11
47 x 68.5 cm
BIBLIOGRAPHY: Makarov 1938: 140; Denisov, Petrov 1963: 172, no. 324; *Gli Architetti italiani* 1966: no. 26

This drawing was done in 1760 and is obviously technical in nature. It was executed at the final stage of construction, when they turned to the cupola. The drawing shows the connection between the foundation of the main cupola and the bell towers. Note how the pedestals are turned under each bell tower. Although these diverse angles and bold flourishes are characteristic of Rastrelli, nonetheless they are fully present here specifically. DS

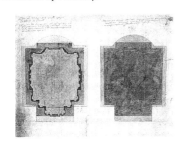

588 MAR
Francesco Bartolomeo Rastrelli (ca. 1700–71)
Smol'ny Convent, St. Petersburg
Plan for Changing the Pile Foundations
Executed Version, 1760
St. Petersburg, Scientific Research Museum of Academy of Arts of Russia, A-10
51 x 68 cm
BIBLIOGRAPHY: Makarov 1938: 140; Petrov, Denisov 1963: 171, no. 310

This drawing, which was probably done in 1750, shows the area that was supposed to have been reinforced by piles and that was

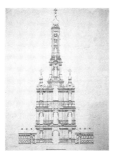

582 W
Francesco Bartolomeo Rastrelli (ca. 1700–71)
Smol'ny Convent, St. Petersburg
Façade of the Bell Tower; Final Version, 1749
Warsaw, National Library, AR - 84/4
61.5 x 46 cm
BIBLIOGRAPHY: Makarov 1938; Batowski 1939: ill. 6; Denisov, Petrov 1963: 83, 171, no. 307

This 1749 drawing shows the final design for the main entrance to Smol'ny convent and the bell tower above it, which Rastrelli executed after he submitted the original version to the empress for approval. It was done in connection with Elizabeth I's instruction to build a bell tower in the likeness of the "Ivan bell tower to be found in Moscow [...] and a large bell." She was referring to the famous bell tower of Ivan the Great, at the time the tallest building in Russia's ancient capital, and to the grandiose tsar bell cast for it. Rastrelli came up with a design for the most grandiose structure in 18th-century Russia. Construction began on the bell tower at the same time as the Smol'ny convent cathedral. Before proceeding to the second, the gigantic bell had to be cast and hoisted onto it. Construction came to a halt because no one was able to do this and the matter never did go any further before the death of Elizabeth I. Catherine II canceled the bell tower. Had its erection been seen through to completion, this bell tower would have been the most famous structure in St. Petersburg. It would have expressed to the very highest degree the pathos of the creation of Russia's new capital that was started by Peter the Great and taken to a brilliant state in the era of the Russian Baroque under his daughter Elizabeth II. The symbolism of this project was conveyed by the placement scheme of its parts. The architect utilized "quotations" from ancient Moscow monuments in a diverse manner. In Moscow, on the Kremlin's Cathedral Square, the focal point for the buildings that were symbols of Russian history and statehood, stand two bell towers: the elongated tower of Ivan the Great and next to it the so-called Kremlin belfry, a significantly lower building with several arched

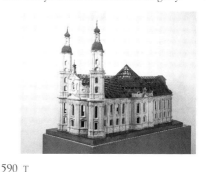

590 T
Gabriel Loser
Model of the Abbey Church of St. Gall
St. Gall, Katholische Administration des Kantons St. Gallen, deposited in the Stiftsbibliothek
Wood and plaster, painted white and gray
76 x 178.5 x 128.5 cm
PROVENANCE: Abbey of St. Gall
BIBLIOGRAPHY: Poeschel 1961: 108; *Barock am Bodensee* 1962: no. 167; Boerlin 1964: 41, 57–61, 109–12, 194; Gubler, in *Die Vorarlberger Barockbaumeister* 1973: 247–48; Duft 1985: 30–36; Reuther, Berckenhagen 1994: 133–34

The Benedictine abbey of St. Gall was one of the most powerful monasteries in Europe from its foundation in the eighth century until its dissolution in 1805. The fine model for the abbey church was executed toward the end of a design process which extended through four decades and occupied almost a dozen architects. Two documents clearly attribute the model to the Benedictine lay brother Gabriel Loser, a master cabinetmaker rather than architect; the model dates to 1751–52 (Boerlin 1964: 109). The carefully executed model, with carved details, is composed of eleven parts: the fragile roof (3), the main body of the nave (2), the west façade (1), and the east façade with its two towers (5). Fourteen distinct projects for the Baroque rebuilding of St. Gall exist in the abbey archives, beginning with Caspar Moosbrugger's of 1721. The only ones directly relevant to the completed building are numbers XII-XIV. The decisive phase of the design process, dominated by J. C. Bagnato and P. Thumb, began in 1749. Bagnato submitted project XIII in 1750, and Thumb followed with XIV. Loser's model incorporates features from the projects of both architects, yet seems also to introduce ideas from the cabinetmaker himself, such as the awkward interior articulation of the rotunda (Boerlin 1964: 111). A critique of the model was solicited from F. J. Salzmann, the Fürstenberg court architect from Donaueschingen, and presented on 20 April 1752. Salzmann's chief concern was Loser's

enormous cupola, which he claimed could not be constructed with the technical skills available in the German-speaking lands at the time; most later writers have affirmed Salzmann's judgment (Boerlin 1964: 109, 111, 182). The model roughly conforms to the building executed from 1755–66, with some substantial changes. The model has two storeys of windows (as executed: one tall storey), towers set diagonally (set orthogonally), the main entrance on the west façade (at the center of the north façade), and a continuous gallery inside (no gallery). SK

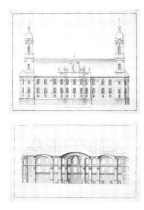

592–591 T
Johann Michael Beer von Blaichten
Project for the Abbey Church of St. Gall: Longitudinal Section and Elevation of North Flank
St. Gall, Stiftsarchiv, Karten und Pläne, Planmappe no. XII b (section) and XII d (elevation)
Pen and ink, gray wash, with traces of incised lines
38 x 56.5 cm (section); 44 x 56 cm (elevation)
BIBLIOGRAPHY: *Barock am Bodensee* 1962: nos. 159, 161; Boerlin 1964: 50–54, 99–106; Sauermost 1966: 44–57; Gubler 1972: 104–107; Gubler in *Die Vorarlberger Barockbaumeister* 1973: 245–46, no. 224

These two drawings are part of a group of four which presents the key project in the long and complex design process for the abbey church of St. Gall. Although the attribution and dating of the project remain somewhat controversial, a majority of scholars agree in assigning it to Johann Michael Beer von Blaichten (1700–67) around 1730. Compelling arguments support this attribution (Gubler 1973: 246). Beer was one of the most talented of the Vorarlberger architects active around St. Gall, and the innovative features of this project can convincingly be ascribed to him rather than to a lesser architect. The project presents a church which is symmetrical about both the longitudinal and transverse axes, and is dominated by a central rotunda; the shallow transepts express the rotunda in the curve of the central three bays of their northern and southern façades. Both the eastern and western ends of the church are treated as apses. Two towers (one not visible on the exhibited drawings) flank an eastern façade, and an additional tower at the northwest corner frames the northern façade with two towers as well. This northern façade is represented on the exterior elevation exhibited (XIId); the north flank of the church is of particular significance at St.

Gall because it was (and still is) the first part of the building visible to a visitor approaching from the town. The south flank, in contrast, was partly masked by monastic buildings and faced away from the town. A colossal order of Ionic pilasters articulates the north façade, including the lowest storey of the three-storeyed towers; the towers' middle and upper storeys bear Corinthian and composite pilasters respectively. Two ranges of large windows illuminate the nave, while underneath these, smaller oval windows open to the chapels. The tower bases serve as pavilions anchoring the ends of the façade, and the slightly projecting transept with central bulge and crowning pediment creates a focal frontispiece across the five middle bays. The two nave bays immediately adjacent to either tower are articulated only by the string courses which tie the entire façade together horizontally, but a pilaster sets off the bay flanking the transept on either side, further accentuating the frontispiece and reflecting the interior rhythm of the nave articulation. The architrave running above the central seven bays playfully curves around the top of the windows. A sturdy base, articulated as pedestals under the tower and frontispiece pilasters, supports the whole ensemble. The roof gives no hint of the rotunda dominating the interior. Various features included in Beer's project were adopted, in one form or another, in all later designs for St. Gall, including Bagnato's, Thumb's, and Loser's wooden model: the central rotunda, the symmetrical east and west arms, the two apses, and the paired towers flanking an eastern façade, among others. Further, in this project Beer presented an important early solution to the problem of developing church plans which reconciled centralized and longitudinal components, a major issue in eighteenth-century church design in the German-speaking lands. These drawings anticipate the most famous treatments of the problem, Balthasar Neumann's church at Neresheim and Johann Michael Fischer's at Rott am Inn, by twenty to thirty years. SK

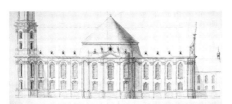

594 T
Peter Thumb (1681–1766)
Abbey Church of St. Gall
Elevation of the North Flank
St. Gall, Stiftsarchiv, Karten und Pläne, Planmappe no. XIV
Pen and brown and ocher ink, gray wash, traces of pencil; 50.5 x 117 cm
BIBLIOGRAPHY: Boerlin 1964: 57, 108; Hitchcock 1968b: 166–74; Gubler 1972: 102–106; Gubler in Die Vorarlberger Barockbaumeister 1973: 247, no. 226

Of all the extant drawings for the abbey church of St. Gall, Peter Thumb's elevation of the north flank corresponds most closely to the solution

presented in Brother Gabriel Loser's wooden model and can thus be dated 1751–52. This elevation is the unique graphic witness to this particular design phase: Thumb's other drawings for St. Gall diverge more markedly from the model. The attribution to Thumb is unquestioned, and the slightly dry, mechanical drawing technique can be observed in other drawings securely attributed to the architect (Boerlin 1964: 108; Gubler 1973: 247). Thumb's drawing style developed in over two decades as a draftsman in the studio of his father-in-law Franz Beer, the father of Johann Michael Beer von Blaichten. The enormous, expanded rotunda forms the salient feature of this design, as of the model. Only these two projects express the rotunda in the roof of the church; elsewhere, it disappears under the roofing timbers. Two features differ in comparison with the model, but correspond to Bagnato's earlier design: the eastern arm of the façade bears window pediments, which were eliminated in the model; and the crowning frontispiece of Thumb's western façade is only three rather than five bays wide (Boerlin 1964: 57). Which design preceded the other – Thumb's elevation or Loser's model – remains unclear. The two men most likely worked together, with Thumb the architect behind the model's design, and Loser furnishing ideas which went beyond the usual competence of a model builder. Thumb was the supervising architect for the construction of the St. Gall nave and rotunda from 1755 to 1760. Contrary to the abbot's wishes, the Chapter had decided in 1752 to retain the church's Gothic choir, so the east end of the church was not included in Thumb's campaign. By 1761 the abbot convinced the chapter to replace the choir as well, and work began on this in the same year under the direction of Johann Michael Beer aus Bildstein. If credit for the abbey church of St. Gall must be assigned to one architect, Peter Thumb is the obvious candidate. But in the light of the complex design process the church's design can be best understood as a collaborative effort. SK

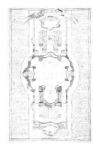

593 T
Brother Notker (?)
Plan of the Abbey Church of St. Gall with indication of ecclesiastical furnishings 1770
St. Gall, Stiftsarchiv, Karten und Pläne, Planmappe Varia
Pen and ink, pinpricks, traces of pencil; yellow, green, violet, gray and red wash; gold leaf
69 x 45 cm
EXHIBITIONS: *Barock am Bodensee* 1962; *Die Vorarlberger Barockbaumeister* 1973
BIBLIOGRAPHY: Gubler in Oechslin (ed.), exhibition catalogue; Einsiedeln 1973: 249, cat. 230

This elaborate presentation drawing, signed "F. Notkero" and dated 1770, shows the plan of the abbey church of St. Gall as built, and includes a full inventory of ecclesiastical furnishings. The otherwise unknown artist, undoubtedly a lay brother at the abbey as was Gabriel Loser, has documented an intermediate stage of the execution of these furnishings typical for a large abbey church: by 1770, some of these features were already installed, while others were just being commissioned, and still others remained unexecuted. Interestingly, the drawing depicts the church's original liturgical configuration: the main, eastern apse dedicated to St. Gallus and the western one dedicated to St. Otmar. A rood screen in the western arm of the nave separated the building into two separate "churches." This was eliminated in the early nineteenth century, and the drawing bears only a slight resemblance to the furnishings in the church today. SK

595 T
Johann Boye Junge
Model for the tower of St. Peter's in Copenhagen, 1756
Copenhagen, City Museum
Wood, 223.5 x 41 x 41 cm

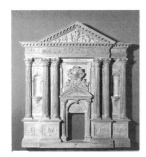

597 T
Simone Chiesura, after drawings by and with the "superintendence" of Giorgio Fossati
Wooden Model of the Façade of the Church of San Rocco in Venice
Venice, Scuola Grande di San Rocco
125 x 112 x 10 cm
EXHIBITIONS: *Le Venezie possibili. Da Palladio a Le Corbusier*, Venice 1985
BIBLIOGRAPHY: Zanotto 1856: 451–52; Livan 1942: 33; Palumbo Fossati 1970: 91; Maschio 1985: 108, 110 (3.21); Teseo 1993: 123–25, 126–32

In 1756, the chapter of the Scuola Grande di San Rocco decided to seek "various designs from the most celebrated architects" for the remodeling of the building's façade. They were aware that, in addition to not being structurally sound and in poor shape, the façade was no longer architecturally up-to-date, since its original form was based on slavish adherence to the types advocated by Codussi when it was erected by Bartolomeo Bon in 1494. In reality, this invitation was extended to only three architects: Ignacio Caccia, Giorgio Massari and Giorgio Fossati, the official foreman (or *proto*) of the Scuola. Since 1748, he had already followed the restoration and redecoration of the sacristy (Teseo 1993: 123). He presented a proposal based on "three different thoughts," which are described in detail in a memorandum dated 16 March 1756 (Teseo 1993: 123). In his proposal, Fossati presented one solution that used "two orders" and that would cost 28,850 *ducati* and two other possibilities of "a single order" costing 26,700 and 40,300 *ducati* respectively. This latter proposal was immediately translated into the architectural model that has come down to us with only the loss of its statuettes and it was the proposal preferred by the Scuola's heads on 22 July 1756. The "sole order" that was planned was composed of "six fluted Corinthian columns, two smaller columns that frame these as well as a cornice and an attic storey with a decoration on the timpanum. Above this is another complicated decoration that is worked into an inscription. Two large niches decorated with garlands are situated in the space between the columns. An architrave, frieze and decorated cornice and attic storey with its ornaments and four bases decorated with small pilasters support the four statues above. A large bas-relief on the historiated timpanum depicts Saint Roch in the act of healing the populace with his benediction. There is a large statue of the Virgin Mary at the top of the attic storey. Another eight statues are shown in this design; they form the entire ornament of this grand and majestic façade. The bas-relief and the porch over the door remain." All of this was to be realized in "marble from Istria of the best quality possible," and the execution of the statues, bas-reliefs and decoration would be entrusted to "excellent professors of the first order" (Archivio di Stato, Venezia, ASVE, Materie Ecclesiastiche, Scuola Grande di San Rocco, Appprovazioni e parti, I Consegna, no. 353; transcribed by Teseo 1993: 145, doc. 52). "Being in Padua on public business," (the destruction of the roof of the Palazzo della Ragione by a strong wind on August 17) Fossati did not hesitate to visit Poleni so that he could show him the design selected and solicit an authoritative consensus *super partes*. Poleni more or less granted this opinion, which he was pressured to make public. At this point there remained nothing for the leaders of the Scuola to do but to order work to begin. It then came out that the "records of the Scuola showed that when the church was built, foundations for a façade had been laid on the chance that some day one might be built." All the same, they deliberated until 28 September 1756, when they asked Fossati in his capacity of "general overseer of the Scuola" to "excavate the front of the church to see if there were such foundations and to report on whether they warranted further pertinent discussion" (Teseo 1993: 145, doc. 53). The architect did this with such alacrity that a few days after, 1 and 3 October, he confirmed the existence of "old foundations prepared a long time ago for construction, should it follow, of such a façade." It was decided to enlarge the foundations "in length as well as width." This work was to be done in a manner coherent with the demands posed by the plan and elevation that Fossati had prepared and that the Scuola had approved. There is good reason to believe that the "master masons" hired for the work – F. Cecchia and M. Ruggia – were put to work immediately. At the same time, it must be noted that while waiting for the arrival of spring, when the façade could be raised, the display of the wooden model must have provoked both controversy and perplexity. In the meantime, the architects T. Temanza and M. Lucchesi published a broadsheet dated 15 March 1753, in which they "expressed an opinion [somewhat critical] of the excess of overdone decoration." This perplexity could not have been without some weight if the Chancellery of the Scuola and the "representatives overseeing the construction of the façade" agreed that, since the "model corresponding to the chosen design [...] was completely decorated with bas-reliefs from top to bottom" and "with the doubt that the work might be more universally accepted without such adornments, but with raised panels of plain marble," another "model be made plain and without the bas-reliefs." LP

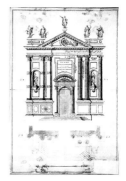

599 T
Giorgio Fossati (1706–85)
Plan and Elevation of the Façade of the Church of San Rocco
1757
Venice, Archivio di Stato, Scuola di San Rocco, II Consegna, b. 416
Drawing, pen and ink with watercolor
52 x 77 cm
EXHIBITIONS: *Le Venezie possibili. Da Palladio a Le Corbusier*, Venice, 1985
BIBLIOGRAPHY: Maschio 1985: 111, 3.23

This drawing must have been prepared immediately after the decision was taken by the Scuola di San Rocco on 13 March 1757. Its juxtaposition of pure geometric modulation and passages rich in decorative plastic relief was a response to the requirements advanced in the two solutions presented to the Scuola. Without a doubt, Fossati based his choice on the Scuola's governing body's implicit preference for the former approach. The architect worked this out in its definitive form in a drawing whose original is lost although it can be studied from a print that was published almost immediately thereafter. LP

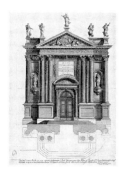

598 T
Giorgio Fossati (1706–85)
Plan and Elevation of the Façade of the Church
of San Rocco
Venice, Library of the Museo Civico Correr,
Stampe Gherro 1, I, 306
Engraving; 44 x 67.5 cm
INSCRIPTIONS: "Prospectus exterior Ecclesiae
que nunc extruitur Confraternitatis S[ancti] Roc-
chi Venetiarum quam adm[...] illustri ac magnifi-
co d[omino] Sancto Chechini eiusdem confrater-
nitas guardiano meritissimo nec non spectabili
cancelleriae et dominis deputatis ad ecclesiae
aedificandae malem, in animus argomentam ob-
sequientissimi dicat et vovet" (lower margin)
EXHIBITIONS: *Le Venezie possibili. Da Palladio a
Le Corbusier*, Venice, 1985
BIBLIOGRAPHY: Palumbo Fossati 1970: 91; Mas-
chio 1985: 110, 3.22; Teseo 1993: 125

By May 1757, the building site for the construc-
tion of the new façade for the church of San Roc-
co was open and active. By that date Fossati had
evidently already rectified and made available his
design for the "raised panels of plain marble."
This drawing was also to be the basis of the "oth-
er model on the already selected plan," which
had been "commissioned" by the governors of
the Confraternity the previous 13 March. A note
made by Pietro Gradenigo on 16 August 1757,
informs us that "the model chosen" was actually
made by Fossati and that Santo Cecchini, the
Guardian Grande of the Scuola, assumed the cost
of making it. Gradenigo also notes that "every-
thing was carried out in plaster," a material that
was fragile and not very durable, which explains
why this model has not survived. In addition, the
diarist reports that the members of the Scuola
who were responsible were anxious to display the
model during the feast of Saint Roch so as to
"make the enterprise visible and to allow anyone
to express his sentiments regarding it" during vis-
its from the doge – Francesco Loredan at the time
– and members of the Senate as well as members
of the populace at large. Moreover, since the
planning of the new façade was destined to en-
counter "rough seas" they would provide that
anyone intelligent could express his opinion, es-
pecially "the nobility and members of the Con-
fraternity." In addition, they would circulate to
the advantage of the Dominante (the Republic of
Venice), the copper engraving showing Giorgio
Fossati's "cleaned up" design of the new façade
(in addition to this one, another example can be
found in the Museo Civico Correr, Venezia,
BCVE, Stampe Cicogna, 477: 43.6 x 65.5 cm).
This was accompanied by "a manifesto of the ar-
chitect" printed on an attached sheet (Livan

1942: 33). The latter was punctiliously attacked
by Poleni in a text that the scientist had rendered
when Fossati visited him in Padua in August 1756
(BCVE, Cod. Cicogna, 2032/II). It is worth in-
cluding a transcription of Fossati's manifesto,
which has never been entirely published by schol-
ars, and which is often confused with the brief
caption at the foot of the engraving of the façade
(BCVE, Stampe Cicogna; another example also
found in Stampe Correr, PD 1432): "To the re-
spectable Gentlemen / *Guardian Grande*, Chan-
cellery and Deputies in Charge of Construction /
of the Façade of the Venerable Scuola / of San
Rocco/ in Venice. May it not seem strange to your
Esteemed lordships, if I find the courage to ded-
icate this copper engraving of the façade of your
church which is now being built according to the
model that I presented to you. My resolution is
born of the generous and magnificent idea that
your current, esteemed *Guardian Grande* had of
presenting the same elevation [as the model] to
the public. You Gentlemen, who are wise in
choosing and judging, well know how great is the
difference between an architect and a decorator;
between works of art in marble and on canvas.
However, not everyone is capable of such sound
and innate judgment. Thus, since the public was
unaware that my idea was approved by Marquis
Giovanni Poleni, celebrated professor at the Uni-
versity of Padua, and that the same idea was rig-
orously examined by the well-known Venetian ar-
chitects Tommaso Temanza and Matteo Lucch-
ese, who approved and accepted it, the public
might not judge my work so favorably given the
difference of the professors and the inequality of
the material. Thus it was necessary for my own
justification that I exhibit this work to the public.
At the same time I emphasize that if any criticism
is reasonable and opportune, I will not only be
the first – as befits any ingenuous person – to
agree with the criticism of whoever may have one,
but will also make it my task to correct my work
accordingly. Gentlemen, therefore, please accept
the small offering that I present to you along with
my honorable intention to carry it out. I remain
your most humble, devoted and dedicated ser-
vant, Giorgio Fossati, architect and technician."
In addition to the presentation of the plaster
model and the engraving with its attached sheet,
work on the façade was resumed with the place-
ment of the bases and pedestals for the columns
that were to support the showy architrave (Bassi
1962: 342–43; Maschio 1985: 108). However, the
grand ceremony of 16 August 1757, did nothing
to placate the anxiety that it was intended to dis-
solve. Indeed, on 30 August 1758, the *Inquisitori*
of the council of all the Grandi Scuole ordered
the leaders of the confraternity to "produce a
reckoning of expenses to see if they exceeded the
sum of [...] ducats per annum and to suspend the
work". It is difficult to understand the reasons
behind the liquidation of an undertaking that had
begun with such determination. However, we
may imagine that together with objective doubts
about the solidity of the structure and disagree-
ments about the iconographical program of the
decoration, worries surrounding the financial
handling of the building site, jealousy, conflicts of
interest and personal tensions also played a role
(Maschio 1985: 108–109). LP

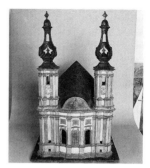

600 T–M–W
*Franz Alois Mayr (1723–71), commission and
design; Johann Georg Lindt (1733–95) design of
the altars; Franz Josef Soll (1739–98), design of
the model*
Model of the Pilgrimage Church of Mariae
Himmelfahrt, Marienberg near Raitenhaslach
ca. 1760
Burghausen, Filialkirchenstiftung Marienburg,
on loan to the Stadtmuseum
Wood, original paint: high altar gold, ceiling
pictures multicoloured, mirror set in the floor
to make it possible to view the ceiling pictures
70 x 68 cm, towers 108 cm high
BIBLIOGRAPHY: Krellinger 1976: 59, 71, 137,
147, pls. 41–54; Volk 1985: 129; Kreilinger
1992; Reuther, Berckenhagen 1994: 100, no.
236; Hopfgartner 1997: 203; *Triumph der Phan-
tasie* 1998: no. 89

The dedication of the original building model
to the church of Marienburg by Franz Anton
Glonner between 1820 and 1834 reads: "Franz
Anton Glonner, chief royal and town architect
in Burghausen, gives this model to the church
of S. Marienburg as a memento and for safe-
keeping, in the hope that it will be well received
and protected from damage. He assures the
Reverend priest of his continuing friendship
and affection." We have other surviving models
of buildings by the Trostberg architect Franz
Alois Mayr, for Baumburg and Michaelbeuern.
This one was for the pilgrimage church of
Marienberg, and Mayr presented it to his client,
Abbot Emmanuel II of Raitenhaslach, shortly
after the latter's appointment to the abbacy.
The model of Marienberg consists of a round
building with pilaster divisions and a west
façade developed into a portal area, whereas
the east façade has an imposing pair of stag-
gered twin towers which terminate in two pic-
turesquely molded onion domes. In the actual
building the west end with the main entrance is
flatter and more early classical in style, while
the towers at the west end are simplified and
have straight hip-roofs. The model can be
opened by lifting the triaxial entrance façade.
Inside one can clearly see the Late Baroque
decoration, with pews, oratories, pulpit and the
high altar, which already shows the obligatory
four-column arrangement, the Exodus, and the
Marian programme. The colorful, cheerful ef-
fect of the interior is rounded off by the ceiling
frescoes (though these were not actually paint-
ed in this form), the imitation stucco and the or-
gan. The miniature church with its colorfully
painted altar is the only complete model from
the South German Rococo (P. Volk). MK

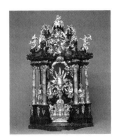

601 T
Johann Georg Lindt (1733–95), designer
Model of the high altar of the pilgrimage church of Mariae Himmelfahrt, Marienberg near Raitenhaslach, ca. 1760
Burghausen, Private ownership, on loan to the Stadtmuseum
Deal, figures and ornaments in lime-wood, polychrome painting, gilded; 63.5 x 40 x 18 cm
BIBLIOGRAPHY: *Zur 850. Wieder Kehr* 1996; 1997: 203–12; *Triumph der Phantasie* 1998: no. 90

The recently discovered model for the high altar of the pilgrimage church of Marienberg forms, together with the model of the church, one of the most significant model ensembles of South German Baroque. Its architecture, decoration and colored painting blend into an impressive "total work of art." It was made by Johann Georg Lindt, a sculptor from Kärnten who was resident in Bauhausen, for Abbot Emmanuel II of Raitenhaslach. The model, which was presented in application for the commission to build the high altar, represents a column-altar in miniature. The approach steps lead to the pedestal; above this rises the altar with its gilded tabernacle accompanied by angels. In the central intercolumn floats the Madonna on a terrestrial globe, which is held by angels. At the sides, below the miraculous statue, stand two "Marian saints:" on the left Saint Dominic, as teacher of the rosary prayer (with his dog by his side), on the right Saint Catherine of Siena (she is distinguished on the high altar by a cross). Between the outer columns are, on the left, Bishop Rupert of Salzburg, shown with a salt-cellar, and on the right Benno of Meißen with the fish: the two figures allude respectively to the spiritual and secular allegiance of Raitenhaslach. Above the pediment a "divine miraculous throne" with God the Father is placed in the center; this is topped by a baldachin, from which drapery hangs down, held apart by two angels like a sort of protective awning. MK

602 T
Gaetano Chiaveri (1689–1770)
Model I to replace the Drum and Dome of St. Peter's in Rome, 1748–67
Private Collection
Wood and lead; 680 x 457 mm; scale: ca. 1:100
BIBLIOGRAPHY: Chiaveri 1744; Poleni 1748: art. 509–17; 1767: VIII; Fox Weber 1989: 188

Poleni (1748: para. 452 and 509ff.) reports that Chiaveri's publication of 1744, sent to him in August 1744 by Vanvitelli (who most likely received it from Cardinal Annibale Albani as is suggested in the text on p. XII of Chiaveri's publication of 1767), included both a print and a description of Chiaveri's proposal for the rebuilding of the base, drum and dome of St. Peter's. Poleni notes that Chiaveri's print and description include round windows in the attic above the windows of the drum, as well as two rows of round dormer windows in the gores of the dome. That print, missing from the copy of the Chiaveri publication of 1744 in the Biblioteca Oliveriana in Pesaro, exists, as far as known, in a single copy appended to a volume published in 1744 entitled *Breve discorso in difesa della Cupola di S. Pietro* by an anonymous *capomastro muratore*. (The manuscript for this publication is discussed in Poleni 1748, arts. 420–432, where only one of the two plates of the printed edition is mentioned.) The text of the *Breve discorso* [...] cites plates I and II, but does not mention an unnumbered plate that precedes them, a plate apparently tipped in by an owner because it was thought to relate to the subject of the *Breve discorso* [...]. The engraving contains the lowered windows of the drum, the circular windows of the attic of the drum, and two levels of dormers in the dome, the single columns of the lanterns and the reinforced base with its arcane recesses between the buttresses all mentioned by Poleni as part of Chiaveri's description of his proposal. To judge from the engraving, Models I and II both postdate Chiaveri's design of 1744 and may have been made as Chiaveri mulled over the issue, perhaps only as he considered an eventual re-publication. The text of Chiaveri's *Breve discorso* [...] of 1767 states on p. VIII that he "hollowed out" (*cavato*) sixteen round windows in the attic "as may be clearly seen in [the] model that I keep with me" ("come si vede chiaramente in modello, che conservo appresso di me"). It seems likely Chiaveri was referring to Model I when he wrote, which, if true, establishes that the model predates the publication. Model I differs from the engravings of 1744 and 1767. Unlike the print of 1744 it has only single columns in the buttresses of the drum and does not contain the two levels of circular dormer windows in the drum. Unlike the prints of 1767 it has different moldings on the windows of the drum and circular windows in the attic. The exterior windows of the drum do, however, resemble the interior windows of the drum in the engraving on plate III in the publication of 1767. Unlike both the prints of 1744 and 1767, Model I has no platform at the top of the dome to receive the lantern. (There may possibly have been a platform under the lantern in its original state that is now lacking on the model.) The interior of the model is unarticulated. Chiaveri mentions that the dome was to be smooth to receive mosaic decoration. The interior of the drum in both plan and elevation in the four prints is shown with pilasters and window moldings. The model and engravings reveal an awareness of the dome Carlo Fontana constructed for the cathedral of Montefiascone with gores of reverse curvature between multiple ribs much as in Model II. The resemblance has been noted by H. Hager (1975: 157–60). HM

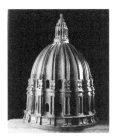

603 T–M
Gaetano Chiaveri (1689–1770)
Model II, to Replace the Drum and Dome of St. Peter's in Rome, 1748–67
Private Collection
Wood; 680 x 457 cm; scale: c. 1:100
BIBLIOGRAPHY: Chiaveri 1744; Poleni 1748: arts. 509–17; Chiaveri 1767

A second model, a sectional model of one half of the structure, for the drum and dome of St. Peter's in Rome (Model II) represents yet another alternative to the two found on the three engravings in Chiaveri's pamphlet published in 1767. The tall, rectangular arched windows of Model II are those shown on plates II and III of 1767, but the remainder of the design contains significant differences. While the base retains the circular shape of Michelangelo's design, the differences include a raised plinth, double consoles under the double columns of the drum buttresses, and longitudinal panels between the paired consoles and buttresses. The drum buttresses follow those of the paired column alternative shown in plan on plate II (and in elevation on the engraving from the pamphlet of 1744). The double columns are continued through double console buttresses at the attic level and double ribs in the dome, a detail found in no other representation of the dome by Chiaveri. Console buttresses reach the full height of the attic with superimposed candelabra rising above the level of the cornice, as in Model I, where decorative urns cap the tall consoles. On plates II and III, however, the urns rest on plinths at the base of the attic buttresses that then sweep upward and inward in an elegant smooth curve to join the cornice. The window moldings in Model II on the exterior are those of plates II and III, but the platform for the lantern is taller with a more complex profile than on plate III (or the engraving of 1744). Additional windows at the level of the consoles above the columns of the lantern are included in Model II but are not present in Model I nor in any other representation by Chiaveri. Judging from the engravings, Model II appears to be a later alternative to Model I. Chiaveri returned to Italy in 1748 and remained there for the remainder of his life spending most of his time in Rome. Given that both models are in private collections in Italy, it is probable that the models were made while Chiaveri was in Rome as he continued to refine and perfect his proposals for the preservation of St. Peter's. No evidence exists that Chiaveri's proposals were ever seriously considered by those charged with the care of St. Peter's. Nonetheless, the models and engravings bear witness to one Roman architect's preoccupation with the stability of the drum and dome of St. Peter's over more than a quarter of his lifetime. HM

607 T
Gaetano Chiaveri (1689–1770)
Partial Elevation and Plan of the Drum and Lower Portion of the Dome of St. Peter's in Rome Showing Model I in Elevation and Plan (lower right), Model II in plan (lower center) and Michelangelo's Drum in Plan (lower left) (plate II)
Engraving; pl. 349 x 227 mm; ill. 340 x 213 mm
Scale: 30 *palmi romani*
INSCRIPTIONS: "RAME II" (upper center); A. Pianta come si tro- / va presentemente, B. Pianta di forze con-/ trapposte con due Colonne, C. Pianta con una Colonna, / che stimo megliore per l'/alegerimento del peso al- / li arconi, D. Sito de Costoloni, E. Scala, che dalla platea / và sino al principio dell'ordine, F. Scala che và sino al / Lanternino, G. Linea della platea co- / me al presente, H. Linea della platea come / dovrebbe essere con forza / contrapposta con allegeri- / mento di più della metà / del peso con l'aggiunta de / vani di 16. finestroni nell'ordine Attico, I. Parte interna della Cu- / pola, L. Linea dello distacco fat- / to della platea dal Muro / del Tamburo, M. Linea delli Spicchi la- / vorati contrapposta, e Cen- / tinata, N. Finestroni nell'ordine / del Tamburo, che nell'Atti- / co rotondi per più forza, O. Distacco fatto delli Con- / trafforti dal Muro del / Tamburo (upper left); "Veduta nel mezzo di due Contrafforti di una sola Colonna / segnato in pianta lettera C." (lower center); "Gaetano Chiaverij Accademico di San Luca di Roma, ed / Architetto giubilato della Corte di Sassonia" (lower left); "Ubaldus, et Joannes fratres de Stephanis alternatim inci- /debant Pisauri die 24 Aprilis 1767" (lower right)

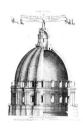

605 T
Gaetano Chiaveri (1689–1770)
Elevation and Section of Model I to Replace the Drum and Dome of St. Peter's in Rome (plate III)
Engraving; pl. 348 x 254 mm; ill. 340 x 248 mm
Scale: 100 *palmi romani*
INSCRIPTIONS: "RAME TERZO," "PARTE ESTERIORE, ED IN/TERIORE DELLA CUPOLA, E / LANTERNINO / L'UNA, E L'ALTRA ESPRES / SA SECONDO IL NUOVO IDEA-/ TO PROGETTO" (upper center); "Gaetano Chiaverij Accademico di S. Luca di Roma, ed / Architetto giubilato della Corte di Sassonia inventore" (lower left); "1767" (lower center); "Joannes, et Ubaldus fratres de Stephanis Pisaurensis alternatim inc" (lower right)

606 T
Gaetano Chiaveri (1689–1770)
Half-plan of the Drum of St. Peter's in Rome Showing a Partial Plan of the Drum by Michelangelo, and Two Alternative Proposals by Chiaveri for the Drum as Shown in Models I and II (plate I)
Engraving; pl. 319 x 210 mm, ill. 314 x 202 mm
Scale: 100 *palmi romani*
Washington (D.C.) National Gallery of Art Library, David K. E. Bruce Fund
INSCRIPTIONS: "RAME I" (upper center); 1. "Masso della Platea ad uso di arco a Terra contrapposto alla / Spingimento interno," 2. "Contrafforti centinati con una colonna, e con due" 3. "Finestroni" 4. "Ornato di dentro" 5. "Linea della larghezza della Platea di Michel'Angelo" 6. "Contrafforti, come sono ora" 7. "Muro du Tam / buro di Grossezza p. 14. com'è al presente" 8. "Platea del Lanternino" 9. "Pianta del Lanternino con Contrafforti / Centinati" (upper center); "Piante tre diverse, la prima se- / gnata A. è di Michel'Angelo, B. Pianta come si potrebbe fare / con due Colonne, C. Pianta, che si potrebbe fare con / una Colonna più leggiera, e di / meno spesa. Invenzione dell'Accademico / di San Luca di Roma / Gaetano Chiaverij Architetto giu- / bilato della Corte di Sassonia" (center right); "Vbaldus, et Joannes fratres de Stephanis Pisaurenses alternatim incidebant 1767" (lower left)
BIBLIOGRAPHY: Hempel 1956: 192–199; Portoghesi 1966: 425; Hager 1975: 157–60

The three plates (engraved by Joannes and Ubaldus di Stephanis) illustrate the text of a pamphlet published by Chiaveri in 1767 in Pesaro (*Breve discorso di Gaetano Chiaveri Romano Architetto giubilato della Corte di Sassonia, ed Accademico di San Luca di Roma, circa i danni riconosciuti nella portentosa Cupola di San Pietro di Roma, e le sue principali cause, con la maniera durabile, e più sicura per la reparazione*). The volume is testimony to Chiaveri's doubts that the additional chains (tension rings) placed on the drum and dome of St. Peter's in the 1740s would be adequate for the future. In 1744 (and perhaps earlier in 1742 in Rome) Chiaveri had already published in Dresden his recommendations for ensuring stability of the drum and dome of St. Peter's (*Sentimento di Gaetano Chiave-rij Architetto della Maestà del Re di Polonia ed Elettor di Sassonia ec. ec. sopra la pretesa Reparazione de' Danni, che suno stati riconosciuti sue fine dell'anno MDCCXLII nella famosa Cupola di San Pietro Vaticano di Roma*). The Dresden publication included a single engraving that showed Chiaveri's proposal. That engraving, noted by Poleni (1748: para. 517), in his discussion of Chiaveri's pamphlet of 1744 is known in only one copy. It differs from the en-

gravings in the 1767 pamphlet in that it represents a single proposal: Chiaveri's initial recommendation. Chiaveri later modified his ideas and prepared two alternatives for publication in 1767 as well as two models showing different recommendations. The round windows at the attic level in the engraving of 1744 are replaced by tall, rectangular arched windows in the engravings of the 1767 publication and, as well, in Chiaveri's second model for the drum and dome (Model II). Chiaveri's first model (Model I) retained the round windows and single columns of the lantern, both integral to the earlier proposal. (Hempel [1956: 260] cites an earlier Roman issue of 1742, also noted by R. Wishnevsky [1980: 647], Kelly [1982] and Rottermund [1996], that has apparently been seen by no one.) The first print shows in the upper eighth of the semicircle, labeled A, a plan of the drum and base as built under Michelangelo. The adjacent eighth, labeled B, locates in double hatching the position of the ribs of the dome above the drum. It also includes Chiaveri's proposal for strengthening the buttresses to counter the outward thrust by filling in the area between the paired columns and the drum wall behind. In this section Chiaveri also indicates how the wall of the drum should be thinned between the buttresses where the windows of the drum occur to reduce the weight or mass of the drum. The space between the buttresses becomes a deep concave niche. In a like manner, Chiaveri reduces the weight of the base beneath the drum by removing portions of the base to fashion concave recesses that respond to the deep niches of the drum. The lower quarter of the plan of the drum, labeled C, shows Chiaveri's plan for a yet less massive (and less expensive) drum buttress with a single column replacing the pair of columns of Michelangelo's buttress. The plan also includes deeper recesses in the base under the drum, further lightening the whole. The reflected plan of the lantern shows the reduced size of the oculus and the single columns proposed by Chiaveri to lighten the lantern's weight. The plan of the buttress with a single column, deep niches between buttresses, and concave recesses in the base between buttresses can also be found in Model I. The plan including the buttress that retains the double columns of Michelangelo's design, the deep niches between the drum buttresses and the semicircular recesses in the base between the buttresses matches Model II in all except the base, where in Model II the recesses are absent and pairs of consoles have been added to the base. The second print includes a plan of Michelangelo's buttress and two adjacent plans showing Chiaveri's alternative proposals for the buttresses of the drum. Above the plan is a rendered elevation of the alternative that employs a single column in the buttress. The moldings of the windows at both levels in the print are followed in Model II. The window moldings on the interior of the drum on plate II resemble those on the exterior of Model I. The windows with triangular pediments may be related to the exterior windows found on the engravings from the pamphlet of 1744. The single columns, single ribs in the dome and urns on pedestals in the attic are found on Model I, but in both models at the attic level there are promi-

nent consoles (pairs on Model II) extending the full height of the attic where they are capped by urns (Model I) or candelabra (Model II). The third print is a section/elevation of the entire structure. It extends from the base to the top of the lantern. The section/elevation includes the base with its increased thickness and concave recesses between the buttresses fashioned in three levels of increasing width. The buttresses, drum, attic and windows at both levels are as shown in the detail elevation of the drum found on the second print. The dome has single ribs. The concave niche between the buttresses of the drum continues its reverse curvature into the outer structure of the dome between the ribs. The inner dome of Michelangelo's design has been eliminated and the rise of the outer dome increased for stability. The inner surface of the dome is unarticulated to serve as a field for mosaic decoration. The lantern with its smaller oculus and single columns may be reached through the spiral stairs shown in the buttresses on the second print. The exterior of the dome, lantern and base are much as shown in Chiaveri's Model I, though the several levels of the base shown in the print are absent in Model I, which has only a cornice, plinth and a vertical panel on the salient face. The windows at both levels in the engravings of 1744 and 1767 match those in Model II. Chiaveri's texts and the four prints from the publications of 1744 and 1767, together with the two models, provide the most complete description known of one of the many proposals, either requested or unsolicited, that Benedict XIV and his consultants received in 1742–43 for the preservation of Michelangelo's drum and dome of St. Peter's. The well-known drum and dome model, with the drum and inner dome built under Michelangelo's direction, which is now preserved in the new Museum of St. Peter's, and which includes within one of its buttresses Vanvitelli's proposal for strengthening the drum, is the only other known model from the period containing a proposal for strengthening the drum and dome. HM

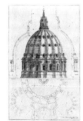

604 T–MAR
Gaetano Chiaveri (1689–1770)
Plans, Elevations and Sections for the Drum and Dome of St. Peter's in Rome
Washington, National Gallery of Art
Engraving; pl. 338 x 219 mm; ill. 333 x 213 mm
Scale: 100 and 50 *palmi romani*
Elevation of proposal by Chiaveri for the drum and dome of St. Peter's in Rome (center); sections through St. Peter's including the base and drum by Michelangelo, the dome and lantern by Della Porta (left) and the proposal for base, drum, dome and lantern by Chiaveri (right); half-plan of the base and drum of St. Peter's by Michelangelo, the lantern by Della Porta, half-

plan of the base, drum and lantern of St. Peter's as proposed by Chiaveri (center); half-plan of the lantern of St. Peter's by Della Porta (lower left); half-plan of the lantern of St. Peter's as proposed by Chiaveri (lower right); plan of the base and two buttresses of Chiaveri's proposal for St. Peter's (lower center).
BIBLIOGRAPHY: Poleni 1748: arts. 452 and 509–17; Chiaveri 1767: XII; Hempel 1956: 192–99; Portoghesi 1970: 425; Hager 1975: 157–60

This engraving of Chiaveri's (1689–1770) proposal for the rebuilding of the base, drum, dome, and lantern of St. Peter's in Rome was appended to his *Sentimento [...] sopra la pretesa Riparazione de' Danni, che sono riconosciuti sul fine dell'Anno MDCCXLII. nella famosa Cupola di S. Pietro Vaticano di Roma*, published on 23 April 1744 in Dresden. (A copy of this fourteen-page pamphlet, lacking the engraving, is in the Biblioteca Oliveriani, Pesaro.) The presence of cracks and lesions in the drum and dome of St. Peter's that were brought to the attention of Pope Benedict XIV in 1742 prompted the pope to appoint a group to study the situation. Chiaveri was impelled to write the pamphlet and provide the illustration because, as he says, being in Dresden in the service of the King of Poland, he was unable to present his ideas verbally to the consultants in Rome assembled at the request of Pope Benedict XIV (Chiaveri, *Breve discorso* [...], 1767: XII). Chiaveri reports the king liked his analysis and proposal, asked for a large drawing (perhaps in addition to the print), and sent several copies with the drawing to Cardinal Annibale Albani in Rome. Albani replied to the king that it had already been decided to add chains, or tension rings, to stabilize the drum and dome of St. Peter's, and while Chiaveri's proposal could no longer be considered, he would have Chiaveri's pamphlets and drawing sent to the archive of St. Peter's. G. Poleni (1748: arts. 452 and 509–517), in his survey of manuscripts and pamphlets concerning the causes of lesions in the drum and dome of St. Peter's and proposed remedies that were submitted for consideration and turned over to him at the request of the pope, includes Chiaveri's pamphlet which Poleni reports was given to him by Luigi Vanvitelli, architect of St. Peter's in August 1744. In his discussion of Chiaveri's publication, Poleni registers Chiaveri's description of his proposal and states that a "drawing" (print?) accompanied the text. Chiaveri's theory of opposing forces (*forze contrapposte*) is described in the text and shown in the elevation, sections and plans of the engraving. He recommends several actions be taken to limit outward thrusts by reducing the wall thickness between buttresses of the drum and in the base; discarding the interior dome, while increasing the height of the single dome; and reducing the weight of the lantern by decreasing its diameter and substituting single for double columns. To counter the remaining outward thrusts Chiaveri suggests increasing the thickness or depth of the base and splaying its lower section to receive the thrusts of the buttresses of the drum; enlarging the width of the buttresses of the drum and uniting the buttress-

es throughout their height with concave apsidal niches that would resist outward thrusts; adding buttresses at the attic level to assist in opposing the outward thrust of the ribs of the dome; and diminishing the weight of the attic through the insertion of round attic windows. The inner surface of the dome is to remain smooth to receive decoration in mosaic. Two rows of circular windows in the dome provide light and lessen the weight of the dome gores as they continue the concave reverse curvature between the buttresses below into the area between the ribs. For additional light, Chiaveri counsels also lowering the windows of the drum. Carlo Fontana constructed a drum and dome, though smaller in diameter than St. Peter's, for the cathedral of Montefiascone in 1670–74. In reinforcing a pre-existing octagonal drum, Fontana added thickened buttresses to the corners of the octagon and united the buttresses with concave niches. These concave shapes also extended into the gores of the dome between the ribs, much as in Chiaveri's proposal for St. Peter's. It seems likely Chiaveri knew of Fontana's designs for the cathedral of Montefiascone as well as the structural reasons (*forze contrapposte*) for his unusual solution (Hager 1975: 175–160). Between the publication of his proposal of St. Peter's in 1744 and his restatement of the issues in his pamphlet of 1767, with its accompanying three plates, Chiaveri modified his notions, designing two alternatives and had models built of each. HM

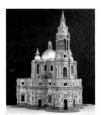

608
Antonio Rinaldi (ca. 1709–94)
St. Isaac's Cathedral, St. Petersburg, 1768
St. Petersburg, Scientific Research Museum of Academy of Arts of Russia
Wooden painted model; 3.10 x 2.45 x 2.08 m
BIBLIOGRAPHY: Grabar 1903: 308; Lo Gatto 1953: III, 137; Kiuchariants 1976: 73–74; Russian State Historial Archivio 1994: 146; (RGIA), fol. 485, op. 2, no. 1105; Lo Gatto 1979: I, 137

The model of St. Isaac's cathedral in St. Petersburg is the chief source of our notions about one of the foremost works by the Italian architect Antonio Rinaldi, who worked in Russia from 1752 to 1790. The history of the creation of St. Isaac's cathedral in St. Petersburg is fairly complicated. It was founded in 1710, in honor of St. Isaac of Dalmatia, the saint considered one of St. Petersburg's divine protectors. In 1717, construction was conducted by the German architect Georg Matarnovi and later Nikolas Gerbel. In 1763, the cathedral was dismantled by the Russian architect Savva Chevakinsky, who did a new design, which Catherine the Great rejected. In 1767 she instructed Rinaldi to come up with a new design, although she ordered him to preserve Chevakinsky's overall concept. On 8 August 1768 there was a stone-laying ceremony for the cathedral

based on Rinaldi's design, but the construction was completed only in 1802, after the architect's death, by another Italian architect, a favorite of Emperor Paul I, Vincenzo Brenna. Brenna altered Rinaldi's intent by creating a single cupola instead of five, lowering the bell tower, and using stuccoed brick instead of stone and marble. In 1818 the cathedral was dismantled and construction began on the new and significantly more imposing building, based on a design by the Frenchman Auguste Montferrand. Rinaldi's model for St. Isaac's cathedral could be said to be the culmination of Baroque's development in the architecture of Russia. Unlike the Baroque structures of St. Petersburg of the 1750s, the ornament in it is "regular," subordinated to the classical order, utterly "European." Here the somewhat "barbaric," emphatically positive quality of the works of Rastrelli, who was the leading architect of the Russian Baroque, disappears. At the same time, Rinaldi follows them in creating a peculiarly Russian character for the church; he makes it five-domed and before it places a multi-tiered bell tower. Both facts correspond to the Russian tradition that was asserted in the church architecture of St. Petersburg in the mid-18th century at the behest of Empress Elizabeth I. The model displays the features of Rinaldi's personal signature, his love for marble facing, which created an elegant color scale. The master was the sole architect of 18th-century St. Petersburg who endeavored to make extensive use of marble. DS

609 T–M–W
Antonio Rinaldi (ca. 1709–94)
Plan of St. Isaac's Cathedral, St. Petersburg
ca. 1760; copy from the late eighteenth cent.
St. Petersburg, Scientific Research Museum of Academy of Arts of Russia
India ink, pen; 60.2 x 47.6 cm
BIBLIOGRAPHY: Kiuchariants 1976b: 73–75

The plan for St. Isaac's Cathedral based on Antonio Rinaldi's design was rooted in the experience of the churches created by architects of the Russian Baroque during the era of Empress Elizabeth I. It is based largely on the structure of churches characteristic of the Orthodox tradition. Undoubtedly the Italian architect had studied the cathedral at Smol'ny convent built by Rastrelli. However, once he had taken the basic features of the plan's structure from his predecessor, Antonio Rinaldi changed the character of the building. Clarity and a subordination of fullness to the building's unitary mass predominate. One gets a distinct sense of the coming of Classicism, which arrived in Russia with the ascent to the throne of Empress Catherine the Great in 1762. However, for St. Petersburg in the first half of the 1760s, a retention of the features of Baroque is characteristic, especially the combination of the new Classicism with the features

from Rococo's brief existence in Russian architecture. The layout of St. Isaac's cathedral based on Rinaldi's design occupies an important place in the development of 18th-century Russian church architecture. This was one of the first examples of the structure of a church connected with the classical tradition being successfully adapted to the requirements of the Orthodox service. Throughout the entire second half of the 18th century, and even the first decades of the 19th century, a similar layout would prove popular, employed by architects such as C. Cameron, N. Lvov, and G. Quarenghi. DS

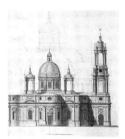

610 T–M–W
Antonio Rinaldi (ca. 1709–94)
Façade of St. Isaac's Cathedral
St. Petersburg, ca. 1760
St. Petersburg, Scientific Research Museum of Academy of Arts of Russia; copy from the late eighteenth century (?)
57.5 x 52.3 cm
BIBLIOGRAPHY: Kiuchariants 1976: 73–75

The drawing depicts Rinaldi's northern façade for St. Isaac's cathedral. This is one of the most vivid documents attesting to the gradual crowding out of the Baroque by Classicism in St. Petersburg architecture of the 1760s. Rinaldi is the foremost architect of the transitional era. He utilizes all the same elements to be seen in the buildings of the Russian Baroque of the 1740s and 1750s. In comparison with Rastrelli's cathedral at Smol'ny convent, the central cupola loses its monumentality, and the side bell towers become less decorative. The strong horizontals are preserved, but the rhythm of the verticals, so vivid in Rastrelli, seems effaced. The rationality of Classicism wins out, the regularity of all the elements prevail. Still, the overall impression remains Baroque. DS

612
Timofei Ivanov after a design of Antonio Rinaldi
Medal in Honor of the Stone-laying for St. Isaac's Cathedral, 1768
Florence, Museo Nazionale del Bargello, Inv. 8973
Bronze; diameter: 6.6 cm
BIBLIOGRAPHY: *Giacomo Quarenghi* 1994: no. 20

The medal was issued in 1768 in honor of the stone-laying for St. Isaac's cathedral from the design by Rinaldi. One side depicts Empress Catherine the Great in profile. The inscription on the medal consists of her name in Russian, her

title in Latin, and then the words "Autocrat of All the Russias," again in Russian. Especially eloquent is the inscription on the reverse, where the Rinaldi cathedral is depicted. Above it are the words: "Render unto God what is God's." Below, under the line, we find the second half of the phrase, "and to Caesar what is Caesar's." In other words, Catherine places first what is natural, her devotion to God, but then she qualifies this with the part about one's duty to Caesar (the emperor), thereby essentially emphasizing the significance of the "cult" of imperial power and memorializing the first emperor. DS

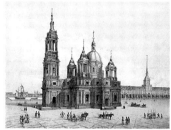

611
Auguste Ricard de Montferrand
St. Isaac's Cathedral, St. Petersburg
Early 19th century
St. Petersburg, Scientific Research Museum of Academy of Arts of Russia
Lithograph; 48.5 x 63.7 cm

This is taken from a lithographed album entitled *A Description in Architecture, Painting, and History of St. Isaac's Cathedral in St. Petersburg*, which was published in Paris at the Thierry brothers' studio in 1845. The lithograph was done from a drawing by Auguste Montferrand, the architect who built yet another grandiose St. Isaac's Cathedral on the same spot that exists today. In this drawing, Montferrand showed the cathedral laid out according to Antonio Rinaldi's design, as it never was in real life. Also, the depiction of the city around the cathedral is more of a reconstruction of the center of St. Petersburg in the late eighteenth century as Montferrand imagined it. In any event, he himself could not possibly have seen the city the way he has it here in the background. In particular, the Admiralty building and the boulevard are depicted to the right of the cathedral, and the Admiralty is shown as it looked in the eighteenth century. When Montferrand arrived in St. Petersburg, it was already entirely different, inasmuch as it had been completely rebuilt according to a design by the architect Adrian Zakharov. Thus Montferrand's depiction of St. Isaac's Cathedral from Rinaldi's design conveys an imagined view of this part of St. Petersburg. The cathedral itself was drawn by Montferrand, probably from the model in the Academy of Fine Arts, since neither the bell tower nor the upper section of the cathedral were built according to Rinaldi's design. The background, which presents St. Petersburg in the late eighteenth century, was more than likely envisioned by Montferrand with the help of Russian engravings from the middle of the century, especially views of the city engraved by Michael Makhaev. DS

Project and proposals for the church of St. Sulpice
Jean-François Bédard

The west front of the church of Saint-Sulpice was the most important religious building project to take place in Paris, and in France, in the first half of the 18th century. Before J.-G. Soufflot began his plans for the church of Sainte-Geneviève (now the Panthéon) in 1755, Saint-Sulpice, and more particularly the design for its principal portal, served to focus the debates on contemporary religious architecture. Proposals encompass the full spectrum of architectural practice during the 18th century. They range from schemes, in the tradition of the Bâtiments du Roi by J.-B. Bullet de Chamblain and G.-M. Oppenord; the unabashedly Roman Baroque project by J.-A. Meissonnier; G. N. Servandoni's partially completed design, hailed by contemporaries as a pioneering example of the "return to the Antique;" finally, proposals for its completion by P. Patte, O. de Maclaurin, and J.-F.-T. Chalgrin which modified considerably Servandoni's initial ideas. Together, these projects provide an overview of the transformation of taste in French monumental architecture during the 18th century.

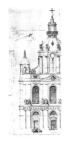

613 MAR
Gilles-Marie Oppenord (1672-1742)
Half-Elevation of the Projected Portal for Saint-Sulpice, Paris, between 1719 and 1731
Stockholm, Nationalmuseum, Tessin-Hårleman Collection, no. 7990
BIBLIOGRAPHY: Huard 1928: 325, "I. Dessins," no. 6, not repr.; Strandberg 1962: 244, note 2, not repr.; Sydhoff 1964: 25, fig. 3, repr.; Hamon 1976: 10, no. 8, repr.

The nomination of J.-B. Languet de Gergy as *curé* on 21 June, 1714, ended nearly forty years of inactivity at Saint-Sulpice. The construction of the present church had begun in 1645 to plans by Ch. Gamard, who was later replaced by L. Le Vau and D. Gittard. By 1678, when the work stopped because of lack of funds, Gittard and his predecessors had completed the choir, the transept, part of the nave, and the lower part of the façade of the north portal. In 1718, four years after his nomination, Languet de Gergy had obtained from the regent, Philippe II, Duc d'Orléans, authorization to complete the church. Either at the express demand of this patron or following his notorious political finesse, the priest selected as project architect Oppenord. Under his supervision the construction progressed swiftly: he laid the foundations of the south portal in 1719, and completed it by 1723. The same year, he excavated the foundations of the remaining portions of the nave. In 1725, Oppenord erected a bell tower at the crossing of the nave and the transept.

When, only six years later, this tower was found to endanger the stability of the vault, Oppenord was demoted. The drawing probably represents Oppenord's final solution for the portal. Sydhoff (1964) has argued that Oppenord's twin-towered scheme followed that by Bullet de Chamblain and was thus earlier than his single-dome variant. This seems to be confirmed by Oppenord's use of a superposition of Ionic, Corinthian, and composite orders in the earlier scheme, a sequence that matches the north portal that he completed according to Gittard's plans but not after the south portal, built entirely following his own design, and finished in 1723. This later portal features an Ionic order on top of a Doric one. It corresponds, with some variations, to a plan and a longitudinal section kept at the Bibliothèque du Musée des Arts Décoratifs. Oppenord adapted a composition he had developed for the south portal to the broader width of the main façade, a Doric ground floor with engaged columns, surmounted by Ionic pilasters, the central four supporting a pediment bearing the royal arms of France. Two small towers surmounting the second bay of the church contain spiral staircases that give access to the upper floors. JFB

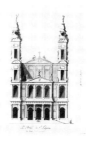

614 MAR
Unknown after Giovanni Niccolò Servandoni
Elevation of the Third Projected Portal for Saint-Sulpice, Paris, 1742
BIBLIOGRAPHY: Von Kalnein, Levey 1972: pl. 253, repr.

In 1732, shortly after the dismantling of the clock tower which resulted in the dismissal of Oppenord, Servandoni won the competition for its portal. Servandoni, who studied in Rome under the painter of ruins and landscape G. P. Pannini and the architect G. G. De' Rossi, is mostly remembered for his theatrical sets and fireworks displays (Blondel 1752–56: II, 37, note [a]). He was not new to Saint-Sulpice at the time of his taking charge of the works. In 1729 he had been asked to redecorate the Lady Chapel, presumably after Meissonnier's project had been rejected. It is possible that it is around this time that Servandoni began to petition Languet de Gergy regarding the portal (Sydhoff 1964: 27). The elevation shows three different stages of Servandoni's design. Although the elevation of the second projected portal is often identified as Servandoni's "first scheme," Beate Sydhoff has attributed the drawing for the first projected portal to him and placed it first in the sequence (Sydhoff 1964: 25–27). Narrower than the subsequent designs, it nevertheless features the essential elements fully developed in the second projected portal. Two towers flank a three-bay, two-storey portico surmounted by a pediment. In each case, the porti-

co consists of a lower Doric order of detached columns screening a porch. Above this order are engaged Ionic columns framing arcaded openings. The elevation of the first projected portal is the only drawing exhibited here which shows the third storey erected by Servandoni to screen the nave's roof. Constructed between 1752 and 1758, this screen recalls Oppenord's north portal, particularly the segmented pediment that Blondel condemned as too "Gothic." By January 1st, 1740, Servandoni had moved away from his earlier design. The architect now extended the Doric entablature the length of the façade, without breaks or projections. He also extended the porch from three to five bays. On the floor above, he freed the Ionic columns from the wall to create a loggia that he surmounted by a single pediment embracing not four, but eight columns. A companion section, showing the back elevation, reveals that Servandoni meant to complement the façade pediment with one crowning the back wall of the portal (Hautecœur 1950: 367, fig. 311). Servandoni ultimately decided against constructing either of these pediments and, reverting to his original idea, to cover the remaining portion of the roof with a screen. JFB

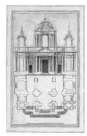

615 M
Juste-Aurèle Meissonnier (1695-1750)
Elevation and Plan of a Portal for Saint-Sulpice, Paris, between 1726 and 1732
Montreal, Centre Canadien d'Architecture – Canadian Centre for Architecture, DR1986:0740
Pen, ink, watercolor on graphite and black chalk; frame 57.8 x 42.5 cm; drawing 40.0 x 23.5 cm
INSCRIPTIONS: "Portail projeté pour comvenir [*sic*] à l'edification de St Sulpice par Messonnier [*sic*], les / plus habiles architectes présentèrent des projets, celuy de Servandoni fut préféré, mais / il n'a pas été suivi pour le couronnement des tours, ni le milieu du portail" (reverse) JFB

616 M
Jacob Cornelisz Cobaert called Giacomo Coppe (1535–1615) (attr.) and workshop of Gian Lorenzo Bernini
House-Altar with the Crucified Christ, 1775–1800
London, Colnaghi
Veneered in ebony, lapis lazuli, gilt and silvered bronze (Cross); base 71 x 95.5 x 24 cm; Cross,

h 98 cm; statues of Evangelists and Prophets: h 25.5 cm; Statues of the Virgin and St. John: h 23 cm; St. Mary Magdalen: h 21 cm; Corpus: h 45 cm

BIBLIOGRAPHY: Baglione 1649 [1975]: 1, 100–101; Bertolotti 1880: 209–21; 1881: 11, 120–61; Phillips 1939: 148–51; Battaglia 1942: 21–28; Wittkower 1964: 229, no. 57–2, fig. 79; Marini 1974: 483, 485–86 and 490; Schlegel 1981: 37–42; Ficacci 1982; Lombardi 1993: no. 13, 432–33; Montague 1996: 35–46, figs. 56–69, 219–22, nos. 52–85

This house-altar with the Crucified Christ is a rare example of the artifacts made in Rome by expert craftsmen during the later part of the sixteenth century and the early decades of the seventeenth for pontiffs, high-ranking prelates and noble families. On the one hand, these men were energetic defenders of the Catholic Church, implementing with the help of new religions orders the decrees of the Council of Trent, and overseeing, at the same time, that urban transformation of Rome whose purpose was to turn it once again into the most splendid city of Christendom "in majorem Dei et Ecclesiae gloriam." Because of its extraordinary facture and monumentality, the present house-altar can be compared to what are considered masterpieces of Roman craftsmanship of this period: the cabinet at Stourhead House in Wiltshire, and the Reliquary of the Passion of Christ given by Gregory XV Ludovisi to the church of San Francesco in Bologna. There is, however, a fundamental difference between these cabinets and the object under discussion. The house-altar is more severe, the stone inlay being limited to five panels of lapis lazuli and framed in gilt-bronze. Rather than through rich stone inlays, the effect of splendor is obtained by the superb quality of the gilt-bronzes, which include free-standing statues of the Evangelists and Prophets on the first order and the figures of the Virgin, St. John the Divine and Mary Magdalen at the foot of the Cross. They are undoubtedly by the same hand as the statues in gilt-bronze on the temple-like tabernacle, commissioned by Cardinal Matthieu Cointerel [i.e., Matteo Contarelli] for the chancel of the French national church – San Luigi dei Francesi – in Rome, sometime before his death in 1585. Incidental features, such as Herculean putti and garlands are similar on both objects. Basing her attribution on probability and what little is known about the artist, Montagu (1996: 45–46) suggests that Jacob Cobaert called "Coppe Fiamingo" – a member of Cardinal Cointerel's household – was the author of the bronzes on the San Luigi dei Francesi tabernacle. The veneer in ebony was executed to the highest standard, probably by a native of the Low Countries. Jan van Santen, called Giovanni Vasanzio, born around 1550 in Utrecht, was the most famous practitioner of this art at the turn of the seventeenth century in Rome. The Christ on the Colnaghi house-altar was cast in silver-gilt metal from a model of Bernini's "dead Christ" in St. Peter's. It is also found in gilt-bronze on the altar cross of the Pallavicini Rospigliosi chapel in the church of San Francesco a Ripa. DG

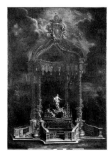

617 T–M
Domenico Piola (1627–1703)
Puget's "Immaculate Conception" beneath a Canopy
Turin, private collection
Oil on canvas; 171 x122 cm
EXHIBITIONS: *Kunst* 1992: no. 82; *Pierre Puget* 1994–95: 316–17, no. 147

In 1666, a group of marble sculptures depicting Immaculate Conception was commissioned from Puget to adorn the main altar of the Genoese church of Albergo dei Poveri, then under construction. The statue (on site) was transported to the Albergo in 1671. Already in 1667, Emanuele Brignole commissioned the sculptor to do a canopied high altar project, which was to serve as a setting for the statue (Parma Armani 1988, 1990 and 1992), which was never to be carried out. It is this little-known project which seems to be depicted in this painting, which M. Newcome Schleier (*Kunst* 1992) attributes to Domenico Piola, a Genoese painter close to Puget. It confirms the scenographic research undertaken in the high altar project for Santa Maria Assunta di Carignano, while at the same time asserting certain modifications. The Immaculate, borne by angels and cherubs, is no longer the crown on the canopy, but rather a sculpted altarpiece whose relation of continuity to the altar is comparable to Puget's proposal for the high altar of San Siro's. The physical and affective link between the statue and its architectural environment is analogous to the link which was to have been set up in the Carignano church. The canopy returns to Berninian roots: a four-column plane; a canopy with consoles and lambrequins beneath the cornice; a sober crown. But Puget's inventiveness is given full expression in the delicious fantasy of the motifs alluding to Marian symbolism. ALPDS

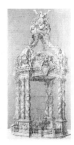

617b T–M
Pierre Puget (1620–94)
Project for the Canopied High Altar in Santa Maria Assunta di Carignano, Genoa
Aix-en-Provence, Musée Granet, Inv. 860–117
Pen, ink, wash, white highlights; the background was covered with blue gouache in the 19 century when the drawing was cut out, glued

to a new support and subsequently doubled with canvas; 186.3 x 97 cm
PROVENANCE: 1694, Fongate wing; sold by Pierre-Paul Puget on 21 Sept. 1758, acquired by M. Bourlat; Bourguignon de Fabregoules, bequeathed to the Musée Granet, 1860
EXHIBITIONS: *Dessins anciens* 1877: no. 123; *Collections de dessins* 1974–75: no. 30; *La Peinture en Provence* 1978: no. 174; *Genova* 1992: no. 211; *Pierre Puget* 1994–95: 186–87, nos. 64 and 65
BIBLIOGRAPHY: Pitton de Tournefort 1717: I, 12; Bougerel 1752: 29; De Chennevières and Montaiglon 1857–58: 226; Gibert 1867: no. 613; Lagrange 1867: 73, no. 166; Lagrange 1868: 303, no. 172; Varni 1877; Pontier 1900: no. 615; Walton 1964: 90; Preimesberger 1969: 50; Herding 1970: 68 and 154, fig. 104; De Boisfleury 1972: no. 27; Magnani, Boccardo, Gavazza, Lamera 1988: 115, fig. 116, 136–37

617c T–M
Marseille, Musée des Beaux-Arts, Inv. no. 264
Pen, ink, watercolor; 56.5 x 30.5 cm
INSCRIPTION: "Puget" (lower left)
PROVENANCE: Collection Emile Ricard, bequeathed to the Musée des Beaux-Arts in 1906
EXHIBITIONS: *Tricentenaire* 1920: no. 424; *Marseille* 1950: no. 41; *Genova* 1992: no. 212
BIBLIOGRAPHY: Rossi 1901: 546; Auquier 1908: no. 424; Walton 1964: 91; Herding 1970: 68, 154; De Boisfleury 1972: no. 28

After moving to Genoa in 1663, Pierre Puget received a number of large commissions for the city's churches. The first and largest concerned the interior decoration of Santa Maria Assunta di Carignano. From 1664 to 1668, Puget sculpted two colossal statues depicting The blessed Alessandro Sauli, which were arranged in the niches of the pillars in the crossing; but in 1663, he had already begun work on a high altar. It was this never-completed project which is depicted in the two drawings in Aix-en-Provence and Marseilles. The rather exceptional dimensions and the careful treatment of the first, whose vigorous depiction of shadow and light translates the monument's plastic effect, suggest that it may have been a working drawing used in the preparation of a scale model (*Genova* 1992). The Marseilles sheet may be nothing more than a reduced-format copy (Herding 1970) or a preliminary study (Walton 1964). Puget imagined an imposing canopied altar on a circular plane. Four pairs of twisted columns bear a broken entablature dominated by a monumental crowning whose voluted consoles are covered with sculpted ornaments. The dynamic lines of the canopy culminate in a statue of the Virgin at Assumption. In a typically Baroque spirit, the Virgin would have seemed to soar toward the light falling from the dome's summit, and the total spectacle offered the viewer would also have extended to the statues of the saints – physically and mentally associated with supernatural vision (Herding 1970). The project seems to pay little heed to the problems of statics which would inevitably have arisen, had it been carried out. Puget gave free rein to his creativity, conceiving the structure above all as a support for sculptures. ALPDS

620 T–MAR

Kilian Ignaz Dientzenhofer (1698–1715) and Karel Josef Hiernle (ca. 1693–1748)

Model of the Marian Statue at Kladno, 1739
Prague-Brevnov, Benediktinské Arciopatstvi, on loan to Národní galerie v Praze, Inv. P 5450
Limewood with original varnish
60.3 x 61.7 x 61.2 cm
PROVENANCE: Benedictine monastery, Brevnov
EXHIBITIONS: *Umení v Chechach* 1938: no. 433; *Baroque* 1969: no. 34; *Umení cheskeho baroku* 1970: no. 125; *Arta Baroca* 1971: no. 68; *Baroch* 1972: no. 109; *Iskusstvo chesskogo barokko* 1974: no. 109; *Le Baroque* 1981: no. 61; *Kilián Ignác Dientzenhofer* 1989: no. 104; *Tisíc* 1993: no. VII/12; *Svatý Vojtèch* 1997: no. 78
BIBLIOGRAPHY: Ziegelbauer 1740: 135; Wirth 1907: 84, 86; Blazhíchek 1946: 21, 46–47, 120; 1958: 175; Menzel 1964: 106, 119; *Sbírka starého umení* 1971: no. 400; Blazhíchek 1981: 97-98, no. 61; 1983: 16; Vilímková 1986: 122; Blazhíchek 1988: 145, no. 390; 1989b: 713; Vilímková, Preiss 1989: 203ff.; Horyna, Suchomel 1989: 118–19, no. 104; 1991: 88–89, no. 104; Blazhíchek 1991: 19; Koubová 1992: 142, no. 89; Horyna 1993: 142–43, no. VII/12 (with complete literature); Hladík 1997: 120–21, no. 78

Karel Josef Hiernle collaborated with architect Kilian Ignaz Dientzenhofer and mason Johann Baumgartner in the design of the Marian statue in Kladno, central Bohemia. Built under Abbot Benno Löbl (1738–51) in the center of an estate which the Brevnov Benedictines had purchased in 1705, the monumental statue was the compositional centerpiece of the grounds. The model shows the final design of architect and sculptor and the statue was constructed without deviating from any of its details. The work with its relatively massive two-storey pedestal, each storey consisting of four radial consoles, is characteristic in composition and detail of the late oeuvre of K.I. Dientzenhofer, one of the major artists of the Late Baroque in Bohemia. In terms of iconography, the central Mary figure of the Kladno statue, consecrated on 22 July 1741, combines the Madonna and Immaculata types. The lower portion of the statue is reserved for figures of monastic saints. They are supplemented by Czech patron saints, Saint Adalbert, original founder of the Brevnov monastery, and Saint John of Nepomuk, whose cult culminated in Czech Baroque era. Between the freestanding statues of saints, the console volutes are decorated with the figures of angels and with cartouches bearing in relief the emblems of the monasteries of Brevnov and Broumov. The model displayed here, which represents a preparatory phase of the work in which the architect and sculptor have reached a highly sophisticated solution, is fascinating for the decorative effectiveness of the elegant figures of the

Virgin, the saints and angels. They are characteristic in the vivacity of their variations of movement and in the fluency of all the lines. The modeling of the miniature sculptures reveals masterly and meticulous craftsmanship on the part of the wood carver. Thus they are an excellent example of the late style of K. J. Hiernle. Receipts signed by the sculptor for his fees prove that Hiernle made the sculptures in 1739 and 1740. TH

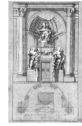

621 M

Pietro Bracci (1700–73)

Project for a Papal Monument in St. Peter's
Montréal, Musée des Beaux-Arts, Dr. 1985.100
Pen and brown ink, brown wash and white gouache with graphite underdrawing on prepared brown paper; 503 x 323 mm
PROVENANCE: Arturo Pini di San Miniato

The opportunity to add to the series of papal tomb monuments in St. Peter's constituted at once the greatest honor and the greatest challenge for generations of sculptors. After the death of Benedict XIV in 1758, six years passed before Bracci emerged as the winner of a competition and was awarded the commission for the Lambertini pope's tomb in St. Peter's. In 1765 work was under way, and the finished monument was unveiled in June 1769. In this carefully drawn presentation drawing, one of four such sheets, Bracci followed the convention of the preceding two centuries in showing the pope's statue enthroned. Standing allegorical figures of Faith and Ecclesia flank a sarcophagus placed above the portal. The background of the niche is illusionistically opened up by means of paired engaged columns which appear to frame openings; light descends from a fictive oculus at the top of the niche. At the bottom of the sheet Bracci provides a detailed plan that corresponds to the elevation, which succeeds in conveying both a sense of reflective marble surfaces and the spatial integration of sculpture and architecture. JP, EK

622 M

Pietro Bracci (1700–73)

Project for a Monument to James III, in St. Peter's
Montréal, Musée des Beaux Arts, DR 1985.86
Pen, ink, watercolor, gouache with white chalk on dark brown prepared paper; 424 x 218 mm
PROVENANCE: Arturo Pini di San Miniato
BIBLIOGRAPHY: Kieven 1993: 12-14, nos. 7-8

In St. Peter's, monuments were originally reserved for saints and popes. It was Urban VIII who extended the privilege of interment in St. Peter's to Catholic sovereigns. The royal tombs occupy the bays of the side aisles, thus differing in width from the broader aedicules of the papal tombs. The tomb for James III was intended to be erected in the south aisle across from that of his wife Maria Clementina Sobieska, which Bracci had executed in 1739 after the design of F. Bariagioni. One of four surviving drawings Bracci made for the monument, this sheet relates to an early stage in the development of his design. It depicts the arrangement of a seated allegory of Fortitude and an accompanying putto which was subsequently changed by introducing a sarcophagus and two flanking allegories. The asymmetrical handling is suitable to the architectural setting of the lateral niches in the aisles of St. Peter's and gives an impression of harmonically composed links of movement between the standing figure of the king and the seated allegory below. Though Clement XIII supported the idea that James III be interred in St. Peter's, he was not favorable to the ambitions of the king's sons. With the passage of time, however, the last Stuarts eventually received a monument in St. Peter's. JP, EK

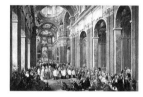

623 M-MAR

Giovanni Paolo Pannini

The Consecration of Monsignor Giuseppe Pozzobonelli as Archbishop of Milan in the Church of Santi Ambrogio e Carlo al Corso, Rome, 21 July 1743
Como, Museo Civico Storico Giuseppe Garibaldi, Inv. Comunale no. 451
Oil on canvas; 198 x 297 cm
PROVENANCE: Almost certainly commissioned by Pozzobonelli, and hung during his lifetime in the "sala della Croce" of the Archbishop's Palace in Milan; in his will of 1774 listed among pictures in the feudo of Arluno left to relatives; by descent probably by way of Marchese Porro Carcano, nephew of Pozzobonelli, to the Celesia family (Bona Castellotti: 94–95, no. 8); at Grumello, Villa Celesia; legacy to Museo Civico, Como, from Giulia Celesia, widow of Cays di Casalette, in 1955
EXHIBITION: Arisi 1993
BIBLIOGRAPHY: Chracas 1743: no. 4056, 21 July 1743; Castiglioni 1932; Arisi 1961: 174–75, no. 169, tav. VIII; Drago and Salerno: 1967; Natale 1981: 96–100, no. 40; Blunt 1982: 25–26; Arisi 1986a: 400, no. 338 (with earlier bibliography); Bona Castellotti 1991; Arisi 1993: 160–61, no. 41; Matitti in Fagiolo 1997a: I, no. A27; Matitti 1997

Monsignor Giuseppe Pozzobonelli (1696–1783) was consecrated as archbishop of Milan in the church of Santi Ambrogio e Carlo al Corso in Rome on 21 July 1743. He stands at the center of a group of archbishops, blessing the crowd, flanked by the officiating archbishops,

Monsignor Antonio Maria Pallavicino, arch-
bishop of Lepanto, and Monsignor Alberto
Guidobono Cavalchini, Archbishop of Filippi.
The painting has been dated by Arisi 1743–44
(Arisi 1961: 174–75, no. 169; Arisi 1986: 400, no.
338; Arisi 1993: 160–61, cat. no. 41), but may be
slightly later, around 1744–45, since preparatory
studies for it appear in the sketch-book in the
British Museum (acc. no. 1858-6-26-655, fols. 19,
20, 21, 25, 26) amid drawings for paintings of
Charles III's visit to Rome now at Capodimonte
which are dated 1745 and 1746. Other prepara-
tory studies of figures are in Berlin, Staatliche
Museen, Kupferstichkabinett, Inv nos. 15461,
15462, 17583c. Santi Ambrogio e Carlo al Corso,
the church of the Milanese nation, was built from
1612 by Onorio and Martino Longhi the
Younger following the canonization of Carlo
Borromeo, replacing an earlier church dedicated
to Saint Ambrose. It is most loved for the exteri-
or of its dome by Pietro da Cortona, and least
liked for its façade, designed by Cardinal Omod-
ei. It was one of the last of the great longitudinal
Counter-Reformation churches, unusual for the
way the aisles are continued into an ambulatory
running around the choir and apse, the begin-
nings of which are just visible here on the right.
The representation of a longitudinal church, all
orthogonals and diminutions, is an awkward
problem for a painter. Pannini here uses the solu-
tion he employed on other occasions. He has
chosen an ideal viewpoint well outside the façade
of the church so as to be able to include all the
nave bays and to reduce the diminution of the
width of the arches, which in any case is sup-
pressed empirically in the nearer arch. The view-
point is shifted to the left side, just far enough to
have the piers block any glimpses of the interiors
of the chapels on that side, so that an uncompli-
cated sequence of lit and shadowed planes re-
sults, while presenting on the other interesting
glimpses of the chapels and their frescoes; the lat-
ter Pannini has not attempted to represent accu-
rately. The figures are presented frontally, as if
they have entered the church from a non-existent
side door rather than through one of the front
doors (Natale 1985). Discussion of this painting
has been bound up with a painting of a similar
church interior formerly at Ca' Rezzonico in
Venice, which, as Matitti (1997) has shown, rep-
resents the *Consecration of Cardinal Carlo Rez-
zonico as Bishop of Padua in the Church of Santi
Apostoli on 19 March 1743* (London, Chaucer
Fine Arts). The attribution to Pannini of the Rez-
zonico painting proposed by Moschini in 1929
has long been rejected, Matitti suggesting
"School of Pannini," with figures by an as yet
unidentified, perhaps a French painter, and the
treatment of the apse in particular relates to Pan-
nini's style. A group of three bishops, several of
the acolytes, the depiction of the pope seated be-
fore the altar, and the general arrangement of the
foreground figures, are all derived from the Como
picture. Matitti has suggested that although the
event depicted took place four months later than
Rezzonico's consecration Pannini may have re-
ceived the commission for the Pozzobonelli paint-
ing first, and then entrusted to others the Rezzon-
ico commission, making available his drawings for
the Pozzobonelli picture. D.R.M.

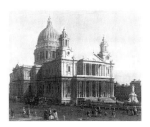

625 M-W
Giovanni Antonio Canal called Canaletto
St. Paul's Cathedral, London, 1754
New Haven, Yale Center for British Art (Paul
Mellon Collection), B1976.7.95
Oil on canvas; 52 x 61.6 cm
PROVENANCE: Thomas Hollis, 1754; Thomas
Brand (taking the name Brand-Hollis on inher-
iting Hollis's estate), 1774; Rev. John Disney,
1804; by family descent to Mrs. Edgar Disney;
her sale, Christie, Manson & Woods, London,
3 May 1884, lot 132; bought John Hay, United
States Secretary of State; Mrs. James Wads-
worth; Hirschl & Adler, New York; purchased
by Paul Mellon, 1961
BIBLIOGRAPHY: Constable 1989: I, LXXV– LXXVI,
pl. 207; II, 414, no. 422, with earlier literature;
Links 1994: 191, 197, pl. 169

St. Paul's Cathedral is the masterpiece of Sir
Christopher Wren. The building is memorable for
its colossal dome, visible in the 18th and 19th cen-
turies for miles around. Typically, Canaletto has
chosen a viewpoint that encompasses the entire
building and emphasizes its breadth and colossal
scale, and at the same time highlights a prominent
feature of Wren's design, the west front, with its
broad flight of steps and flanking towers. Wren's
entire complex is dominated by the dome, but
Canaletto has deftly captured the building's sub-
ordinate details such as the upper and lower
colonnades in Corinthian and composite orders,
and the balustrade along the top that was added
against the wishes of Wren. The golden glow and
carved decorative detail of the cathedral's Portland
stone has been vividly shown by Canaletto. This
view of St. Paul's belonged to one of the last major
commissions that came to Canaletto as his long
stay in England drew to a close. The classical bulk
of St. Paul's often dominated Canaletto's panora-
mic views of the Thames with London in the back-
ground. He painted several such views from dif-
ferent viewpoints, showing the great dome of the
cathedral, over the spires of Wren's other church-
es. The present painting is Canaletto's only view of
St. Paul's shown by itself, however, and probably
owes its format to the requirements of the com-
mission from Thomas Hollis. EPB

625a
Anonymous
Bell, 17th century
Vatican, Rev. Fabbrica di San Pietro
Sculpted and gilt wood
155 x 35 x 273

Architectural fantasies

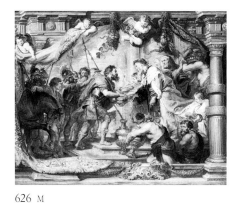

626 M
Pieter Paul Rubens (1577–1640)
Abraham and Melchizedek
Washington D.C., National Gallery of Art
Oil on wood, 66 x 82.5 cm.
PROVENANCE: Jean de Julienne Coll., Paris
1767; sold J.-B. Horion, Brussels 1788; sold La-
dy Stepney 1830; sold Lady Stuart, 1841;
Thomas Baring Coll., 1848; Lord Northbrook
Coll.; sold Walter Stoye, London, 1958
BIBLIOGRAPHY: Elbern 1954–55; Scribner
1975: 518–28; Held 1980: no. 12

Abraham, having vanquished over his nephew
Loth's kidnappers, meets the king and the high
priest of Salem, Melchizedek, who gives the war-
rior bread and wine. From the time of the Middle
Ages, the episode from *Genesis* had been inter-
preted as a prefiguration of the Last Supper, and
for this reason, in those countries profoundly af-
fected by the Catholic Reformation such as Flan-
ders, sparked renewed interest. Rubens tackled
the theme on three different occasions. Between
1615–18, he did a first large-sized painting, today
kept at the Caen Museum of Fine Arts. Toward
1620, the artist came back to the subject, painting
one of the ceiling compartments of the Saint-
Charles-Borromée Jesuit church in Antwerp.
Though destroyed by fire in 1718, the decor is
known thanks to a sketch in the Louvre. And last-
ly, upon the request of Archduchess Isabelle, he
painted the cartoons of the hanging known as the
Triumphs of the Eucharist for the Carmelites of the
Descalzas Reales in Madrid; one of the tapestries
depicts the meeting between Abraham and the
high priest. Instead of the noble yet static postures
of the first painting, here the composition goes
hand in hand with a broader overall movement, hi-
erarchizing the space of representation. The
rhythm is given by the combination of an *élan* of
upward movement from Abraham toward Mel-
chizedek and the old man's gesture. The stupen-
dous twisting motions of the men, reminiscent of
Michaelangelo, the crossing of the lances, the di-
versity of characters all conspire to give dynamism
to the image. The bozzetto is itself constructed
around a complex set of relations between a wo-
ven stage and an architectural setting. Held up by
putti, the make-believe tapestry does not unfold
behind an out-thrust column on the right, but in
front of two twin columns on the left. Despite the
ambiguity of the spatial representation, the image's
legibility remains intact, thanks to the vigor of the
touch and the drawing's decisiveness. SA

627 T
Gerard Houckgeest (ca. 1600–61)
Architectural Perspective
signed and dated 1638
Edinburgh, National Gallery of Scotland
Inv. no. 46
Oil on canvas; 131 x 152 cm
BIBLIOGRAPHY: Liedtke 1970: 15–25; De Vries
1975: 25–26; Wheelock 1975–76: 146–66;
Saenredam 1991: 164–67, no. 29

The simple perspective in the form of a gallery is only slightly displaced from the center of the picture. This is a secular, palace gallery, instead of the church nave, which was more traditional in the Low Countries. The gallery whose dimensions exceed those of the real architecture of the time is orchestrated by Ionic columns and architraves and divided by a dome. The tiles serve to create the effect of Renaissance perspective, whereas the compartments of the vault, by contrast, form a flat ceiling. The arches recall those of the early Christian basilicas. In the foreground the entablature passes into a frontal position, distancing the spectator. In its frieze one can clearly see some sprays of flowers which are more similar to northern medieval manuscript decoration than to the acanthus leaves of the classical period. Following the luminous perspective picture one can make out, behind the final arch, an architecturally constructed garden, surrounded by walls and containing a belvedere. JG

connection between the various spatial units nor the plan of the domed room is clear. Each of the four groups of four twisted columns alludes to the theme of the architectural baldachin. The twisted columns, known in Spain as "Solomonic" after the Temple of Jerusalem and omnipresent in the other Baroques, and the dome give the architectural ensemble a tinge of the sacral. *Balthazzar's Feast* can probably be identified with a picture commissioned by the merchant Juan de Sevilla in 1647. Completed in 1647, it is one of the earliest known works by this painter, together with *Herod's Banquet* (Prado, painted for a church in Madrid; duplicates), inspired by Veronese's Last Suppers. JG

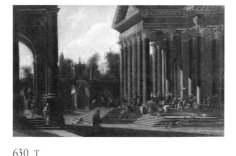

630 T
Viviano Codazzi (ca. 1606–70)
Expulsion of the Traders from the Temple
Turin, Collezione dell'Accademia Albertina
delle Belle Arti, Istituto di Alta Cultura, no. 440
Oil on canvas; 95 x 162 cm
PROVENANCE: Donations of Monsignor Vincenzo Maria Mossi di Morano, 1828
BIBLIOGRAPHY: Gabrielli 1933: 169 (attrib. to "maestro di Giov. Pannini"); Brunetti 1956: 54–55, fig. 17a (Codazzi and Miel, "first Roman period"); Griseri 1958: 87 (Codazzi); Briganti 1983a: 702, 726, no. 113 (Codazzi, late); Griseri 1983: 307, fig. 157; Marshall 1993: VC 122 (Codazzi and Cerquozzi, late 1650s)

During his years in Naples (before 1634 until 1647), Viviano Codazzi developed a genre of architectural piece which combined motifs based on well-known Roman ruins such as the Basilica of Maxentius and Constantine and the Colosseum with constructed architecture based on the representations of the orders in the treatises of Serlio, Palladio, and especially Vignola. The figures in his paintings were added by others, including D. Gargiulo, M. Cerquozzi, and F. Lauri. Codazzi's architectural conceptions have a monumentality rarely found in the works of other architectural painters, the result of the dramatic "realist" *chiaroscuro* and meticulous drafting of the architectural elements (Marshall 1993). Codazzi's formal vocabulary is characteristic of the later 16th century in Rome: the gable is loosely reminiscent of Vignola's portal to the Farnese Gardens, and the obelisks, flambeau, and small volutes are also Vignola motifs. There is no obvious precedent for such a scheme and it is probably Codazzi's invention. At the left of the *Flight into Egypt* is a triumphal arch. Beyond is a Doric pier-and-arch arcade based on Vignola's arcade with pedestals. Beyond can be seen a forest grove, a temple, and two columns supporting a section of entablature. In the foreground at left and right are pieces of fallen masonry, while at the centre the Holy Family are about to pass through the triumphal arch, guided by the angel caught by the shaft of light coming through the arch. Brunetti (1956: 54–55) suggested Jan Miel as the figure painter, referring to the two *Adorations* in the Galleria Nazionale, Rome of the 1650s (Briganti 1983b: figs. 4.41, 4.42), although, as Briganti points out, this is not really compatible with her dating to the period shortly after Miel's arrival in Rome in 1633. Certainly the flying putto angels in these works are similar to the ones in the *Flight*, but Cerquozzi's characteristic dark facial tones and handling are everywhere apparent, and many of the types are typical of Cerquozzi rather than Miel. DRM

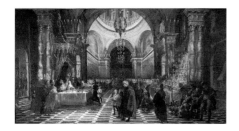

629 T
Juan Carreño de Miranda (1614–85)
Balthazzar's Feast
Barnard Castle, Bowes Museum
Oil on canvas; 172 x 328 cm
BIBLIOGRAPHY: Szobor 1955: 34–39; Barettini Fernandez 1972: 45–46; Rippidi 1985: 3–42 (38–39); *Carreño* 1986: 30–31; Brown 1991: 337

In this picture the painter underlines the sense of splendor: splendor of space, of architectural forms, and of objects, that is, of the porcelain of the Temple of Jerusalem brought to the feast by the king of Babylon. Across the full width of the painting a floor of square tiles in perfect symmetry imparts a grand sense of perspective depth. However, the author does not seem to have taken much care with the architecture on the vertical plane: neither the

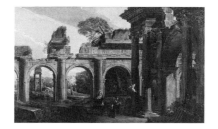

631 T
Viviano Codazzi (ca. 1606–70)
Ruined Triumphal Arch and Arcade, with the Flight into Egypt
Turin, Collezione dell'Accademia Albertina delle Belle Arti, Istituto di Alta Cultura, no. 440
Oil on canvas; 95 x 162 cm
PROVENANCE: Donations of Monsignor Vincenzo Maria Mossi di Morano, 1828
BIBLIOGRAPHY: Gabrielli 1933: 169 (attributed to "maestro di Giov. Pannini"); Brunetti 1956: 54–55, fig. 17b (Codazzi and Miel, "first Roman period"); Griseri 1958: 87 (Codazzi); Salerno 1977–80: II, 506, 509, fig. 83.4 (Codazzi and perhaps François Perrier); Briganti 1983a: 702, 726, no. 113 (Codazzi, late); Griseri 1983: 307, fig. 156; Marshall 1993: VC 123 (Codazzi and Cerquozzi, late 1650s)

632 T-M
Jan Erasme Quellin (1634–1715) and Jean Baptist Huysmans (1654–1716)
Mercury, Herse and Aglauros
Oil on canvas, 122 x 102 cm.
INSCRIPTIONS: "J...Q...L" (lower left); "J B" interwoven "Huysmans" (lower right)
Marseilles, Musée des Beaux-Arts
PROVENANCE: Permanent museum collection, of unknown provenance.
BIBLIOGRAPHY: *Le Siècle de Rubens* 1977: no. 105; Thierry, Kervyn de Meerendre 1987; *Les Peintres du Nord* 1989–90; *Parcours* 1990: 209

Mercury, seeing Herse and her sisters Aglauros and Pandrose on their way back from a party in the honor of Minerva, immediately fell in love with the young girl. Dead set on winning her heart, one

night he tried to make his way into her bedroom. But Aglauros, gnawed with envy and endeavoring in vain to garner his complicity, set herself between the two and stopped the god on the doorstep. Furious, Mercury hit her with his wand, transforming her into a stone – not a white stone but a black one, the color of her soul. This episode, related in the second book of Ovid's *Metamorphoses* (706–834), enjoyed a certain success in the seventeenth century amongst painters – particularly French and Flemish painters. Jan Erasme Quellin, on the other hand, focused on the final episode, that is, the metamorphosis itself. The painting in the Marseilles Fine Arts Museum provides a good indication of the artist's taste for complex stagings. As in his most celebrated works Quellin situated the metamorphosis in a whimsical, noble and almost pompous architectural setting. The Marseilles work bears not only the signature of Jan-Erasme Quellin, but also that of Jean-Baptiste Huysmans, whose involvement was probably restricted to the landscape on the right. SA

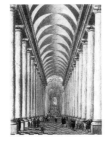

633 MAR
Wilhelm Schubert von Ehrenberg (1637–ca. 1676)
Architectural Fantasy Recalling St. Peter's in Rome, 1667
Hamburg, Kunsthalle, Inv. no. 748
Oil on canvas; 60.5 x 43.7 cm
BIBLIOGRAPHY: Fredericksen 1976: 114–15; *Phantasie und Illusion* 1995–96, no. 77

Schubert constructs a simple but effective perspective picture by rearranging and transforming architectural features from St. Peter's Square: the Portico of Constantine supplies the idea for the main perspective line; an interruption by a luminous area is suggested by the intersection with the atrium of the basilica, the point where Bernini placed the equestrian statue of Constantine; finally, the ascending continuation of the perspective is inspired by the Scala Regia. However, Schubert monumentalizes the "corridore de' portici," blending it with the colonnade of the piazza and placing the columns so close together that they form a closed wall: the columns differ from those of Bernini in having "Michelangelesque" Ionic capitals. The floor is made up of white and black squares as in the Dutch churches (compare the paintings of Emanuel de Witte); the vault recalls the cross vaults of the corridor and the barrel vault of Bernini's colonnade (both, however, lack apertures). In the intermediate luminous area Schubert interprets Bernini's arch as the base of a dome. Such a "Roman" invention is only conceivable in a Catholic region of Northern Europe and such a univocal perspective only in Vredeman de Vries's home town, Antwerp, where Schubert in 1662 became master of the corporation of St. Luke. JG

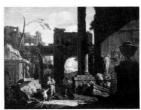

635 T
Marco (1676–1730), Sebastiano (1659– 1734) Ricci
Architectural Fantasy with Ancient Ruins
Vicenza, Direzione Civici Musei
Oil on canvas; 205 x 274 cm
BIBLIOGRAPHY: Scarpa Sonino 1991: 136, no. 109; *Marco Ricci* 1993: 221, no. 36

In this masterpiece Marco Ricci assembles various antiquities in front of a portico, the central part of which is structured like a triumphal arch. Behind the portico one can make out on the left the ruins of a large building which recalls the palaces of the Palatine, and in the center another, perhaps modern, building, similar to Palladio's Palazzo Chiericati. The picture is usually dated to the mid-1720s and probably forms a pair with a landscape with ruins belonging to a private collection in Geneva (Scarpa Sonino 1991: no. 42); Francesco Guardi later painted a variant of it. The elements which compose it recur in numerous paintings by this artist, but Panini, too, in a canvas of the same years, *Fantasy with Ruins* (dated 1727), uses similar accessories and differs only at the level of his personal poetics. JG

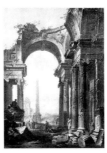

637 T-M
Giovanni Niccolò Servandoni (1695–1766)
Architectural Caprice with Roman Ruins
Lyons, Musée des Beaux-Arts; Inv. no. 122
Oil on canvas; 126 x 94 cm
BIBLIOGRAPHY: Roland Michel in *Piranèse et les Français* 1976: 475–98 (478); 1976: 329–34, no. 186; 1977: 21–34; Arisi 1986; Herzog 1989: 164–65; *Giovanni Paolo Panini* 1993: 120, no. 23

This painting is a variant, inverted and reduced, of the painting through which Servandoni gained admission, in 1731, to the Parisian academy of painting and sculpture, and is probably slightly later than that version. The picture is now firmly anchored in the oeuvre of the painter-scenographer-architect after previous attributions to Panini, De Machy and Clérisseau. It depicts a ruined "gallery", whose concluding arch opens on to a landscape of ruins and on to an obelisk placed on a high pedestal in the center. From the off-center position of the viewer the obelisk appears a third of the way along the pictorial field from the left and the vanishing-point is situated a quarter of the way across, at the left-hand limit of the opening of the arch, where the

vertical of the cornice meets the diagonal of the ground (which continues the line of the base of the columns on the right). It is likely that with this caprice Servandoni is alluding to another caprice with a similar purpose, by his teacher Panini, *Alexander visits the Tomb of Achilles*, an "academic gift" for his admission to the Accademia di San Luca in 1719 (where it is still preserved). JG

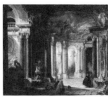

638 T
Jacques de Lajoüe (1686–1761)
Palace Interior Opening onto Gardens)
Munich, J. P. Brasseur and M. Gregor Kunstfonds und Galeriehandelgesellschaft
Oil on canvas; 80 x 99 cm
PROVENANCE: Perhaps the collection of Baron Papeleu de Poelwoorde, sold Brussels, 27 February 1875, no. 32; collection of Baron André Descamps, Brussels; Cailleux, Paris
EXHIBITION: Brussels 1925
BIBLIOGRAPHY: *R. A. A. M.* 1925: II, 205, repr.; Roland Michel 1982: repr. On the cover; 1984a: cat. P. 198, repr. fig. 170 and pl. 6

We have here a perfect instance both of Lajoüe's inventiveness and the rocaille conception of space, with the imbrication of inside and outside, real architecture and illusion. The couples which bring the architecture to life were lifted from engravings based upon Watteau, in this case the *Bal champestre*. The two console-fountains, from which a sheet of water flows, and which frame the composition, reinforce the feeling of an undefinable site, between interior and exterior, between a sumptuous home and a theater set; this mixture, derived from inventions of Watteau's (*Les Plaisirs du bal*), is characteristic of rocaille space and invention. MRM

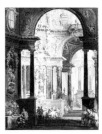

640 MAR
Vittorio Maria Bigari (1692–1776)
Balthazzar's Feast
Bologna, Pinacoteca Nazionale
Tempera on canvas; 119 x 95 cm
PROVENANCE: Accademia delle Belle Arti
BIBLIOGRAPHY: Rodriquez 1957; *La Peinture italienne* 1960-61; Emiliani 1967; *Architettura* 1979; Casali Pedrielli 1991

Considered one of the most skillful artists of grand Bolognese decor in the eighteenth century, Vittorio Maria Bigari did not neglect easel painting, producing a more modest body of work which is nonetheless of an undeniable charm and brilliance. Produced at the same time as his mas-

terpiece, the frescos of the Palazzo Aldrovandi in Bologna, this tempera on canvas, which dates from the 1740s, is characteristic of the painter's mature period. In this works, Bigari demonstrates stunning virtuosity and inventiveness – an ability in no was impeded by his experience as a decor painter. If the architecture painting in this work seems to rob history of its forefront position (to such an extent that the episodes shown are sometimes difficult to interpret), the wealth of the decor is not deployed against the coherence of the representation. The architectural constructions of Bigari remain organic, firmly affixed to the earth, and, to a large degree, "believable"; the overall "dreamlike" appearance is more the result of the effects of dilation, colors and the play of light. Refusing the aerial, "atectonic" character sought by certain rococo buildings, here the artist stresses certain leitmotif of the great Bolognese Baroque monuments. The free column, in *Balthazzar's Feast*, fulfills perfectly its double function: it is grandiloquent, in that it amplifies the heights; it is rhythmical, in that it determines the succession of focal planes. SA

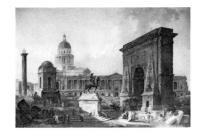

641 T-M
Hubert Robert (1733–1808)
Les Monuments de Paris
Montreal, Power Corporation du Canada
Oil on canvas
PROVENANCE: Salon of 1789, no. 32; sold Le Bas, Paris, 1793; sold Mrs. Ridgway, Paris, 1904; collection of the countess de Breteuil
BIBLIOGRAPHY: Gabillot 1895; De Nolhac 1910; Réau 1927; Sterling 1933: no. 152; Isarlo 1953; Sahut 1979

Beginning in 1767 with the *Port of Ripetta* (Paris, Ecole nationale supérieure des Beaux Arts), his reception piece at the Royal Academy of Painting and Sculpture, Hubert Robert, following upon his master Pannini, chose to represent imaginary urban views, made up of celebrated, antique or modern monuments. In the Salon of 1789, he exhibited two paintings as counterparts to this historical and picturesque vein: *The antique monuments of France* (current location unknown) and this view of the *Monuments of Paris*. The buildings present in this composite view were chosen neither by chance nor for their picturesque qualities: from the 1750s on, all of them were at the forefront of the Parisian artistic scene, and played a role in asserting, to varying degrees, the glory of great French architecture, at once in opposition to rocaille "poor taste" and with regard to foreign rivals – England in particular. The Louvre colonnade and the city gate Porte Saint Denis evoke *grand-siècle* French tradition, which was henceforth to be a reference point. The gate, built by Blondel, and always considered a marvel of majestic grandeur, of elegant simplicity

and of perfect balance between architecture and decor, stood like a question at the heart of Neoclassicism. The Louvre colonnade became, in the second half of the eighteenth century, one of the buildings most admired both by "antiquitizing" architects and public opinion. Lafont de Saint Yenne saw in it "the portrait of the character of the Nation", and Pate, "the triumph of French architecture". In this canvas, whose dimensions are worthy of history painting, Hubert Robert revealed his brilliant sense of composition. Manipulating perspectives and scales with boldness and flair, he established a continuity between these constructions of various sizes and eras: the surroundings of the colonnade and the enlarged fountain of the Rue de Grenelle only serve to better emphasize the two buildings' intimate harmony. Thanks to these small, brilliantly brushed "Panninian" figures, the painter gave life to his landscape, imbuing it with a welcome picturesque effect (the carriage passing beneath the Saint-Denis gate); playing with differences in proportion, he brought out the striking majesty of Paris' monuments. Two works can be compared with the painting of the 1789 Salon. On the one hand, there exists a drawing (location unknown; sold Morin, Hôtel Drouot, 1924), where the relations of perspective are different (the Fontaine des Innocents is closer, the Pantheon more present) and the statue indeterminate. On the other hand, in the literature, the 1788 painting has occasionally been confused with another, almost identical work, engraved by Régine Carrey, nevertheless more maladroit in its perspectives and in the rendering of shadows and light, where the royal statue has been replaced by Saint Mark's lion, transported from Venice to Paris in 1798. SA

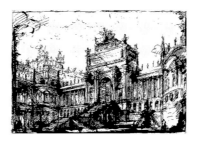

643 M
Giovanni Battista Piranesi (1720–78)
Architectural fantasy
New York, The Pierpont Morgan Library, gift of Mr. Janos Scholz
Pen and brown ink; 32.9 x 49.1 cm

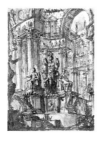

644 M
Giovanni Battista Piranesi (1720–78)
Architectural fantasy
Cambridge, Mass., Fogg Art Museum
Chalk, pen, watercolor on paper
52.9 x 38.9 cm

645 M
Giovanni Battista Piranesi (1720–78)
Architectural fantasy
Boston, Museum of Fine Arts
Pen, ink, watercolor; 15.4 x 21.7 cm

658 MAR
Giovanni Antonio Canal, known as Canaletto (1697–1768)
Palladian Caprice on the Rialto
Parma, Galleria Nazionale, Inv. no. 458a
Oil on canvas; 56 x 79 cm
BIBLIOGRAPHY: Puppi 1973, 299–302, no. 44; Barcham 1977: 142–43; *Canaletto* 1982: 73–75 no. 102 (L. Puppi); Corboz 1985: 16, 259, 336, 428–33, 470, no. 337; Constable, Links 1989: II, 436–38, no. 459

In a letter of 1759 Algarotti wrote that he had "made use" of "Canaletto's brush" to create a new "kind of painting:" "on the right of it [Rialto Bridge], has been placed Palazzo Chiericati. On the left of the bridge one descends into a square surrounded by porticoes and on one side enfolded by the canal; and in the middle of it rises the Basilica of Vicenza [...]." This is probably the original of this experiment, of which there are three other versions. It is a homage to Palladio and a proposal for an ideal Venice, an episode in the battle for "good architecture" in a reformed society. Thus a second idealized monumental pole was created to complement Piazza San Marco. In addition to the monuments listed in the description of his painting – where Algarotti strangely placed himself on the bridge looking toward the north – on the corner between Palazzo Chiericati and the bridge another, anonymous palace of the classic Renaissance type was placed instead of the great blocks of rented apartments. Canaletto had previously painted exactly the same view of the Rialto from the north. The latter picture is part of the series of thirteen panels painted for the British consul Smith, a friend of Algarotti's. Already in 1745 Smith ordered eleven more works from Visentini and Zuccarelli, this time with famous monuments of British classicism, mostly taken from *Vitruvius Britannicus* (in 1746 Canaletto himself was to go to England). This means that even the "English-style" modifications to Palazzo Chiericati (notably the short side of the portico, which is blind on the ground floor and open with columns on the first floor, on the analogy of the variation on Villa Rotonda used in Chiswick House) cannot serve as evidence for a later dating. The basilica, by contrast, is contracted, so as to fit into the space of the market, and verticalized. JG

Appendix

Architecture

1598-1647

Maderno, Santa Susanna, Rome (1593-1605)
Holl, Arsenal, Augsburg (1602-07)
Place Royale (Place des Vosges) Paris (1605-12)
Maderno, St. Peter's façade (1607-12)
Palais and Jardin du Luxembourg, Paris (1611-20)
Holl, Town Hall, Augsburg (1614-20)
De Brosse, St. Gervais, Paris (1616-21)
Jones, Banqueting House, Whitehall, London (1619-22)
De Mora, Plaza Mayor, Madrid, (ca. 1620)
Castellamonte, Piazza San Carlo, Turin (1621)
Bernini, Baldacchino, St. Peter's, Rome (1624-33)
Ricchino, Collegio Svizzero, Rome (1627)
Cortona, Villa Sacchetti del Pigneto (before 1629)
Bautista, Madrid Cathedral (after 1629)
Maderno, Bernini and Borromini, Barberini Palace, Rome (1629-31)
Jones, Covent Garden Square, London (1631-35)
Longhena, Santa Maria della Salute, Venice (1631-87)
F. Mansart, Church of the Visitation, Paris (1632-34)
Post and Van Campen, Mauritshuis, The Hague (1633)
F. Mansart, Château de Blois, France (1635-38)
Lemercier, Church of the Sorbonne, Paris (1635)
Cortona, Santi Luca e Martina, Rome (1635-50)
Borromini, Oratory of San Filippo Neri, Rome (1637)
Borromini, San Carlo alle Quattro Fontane, Rome (1638-40)
Borromini, Sant'Ivo alla Sapienza, Rome (1642)
F. Mansart, Château de Maison, Maison–Lafitte (1642-46)
Bernini, Cappella Cornaro, Santa Maria della Vittoria, Rome (1644-52)
Borromini, San Giovanni in Laterano, Rome (1646-49)
Tessin, Skokloster Slott, Sweden (1646-48)

1648-1682

Mansart and Lemercier, Church of Val–de–Grâce, Paris (1645-65)
Van Campen, Amsterdam Town Hall (1648-55)
Bernini, Fountain of the Four Rivers, Rome (1648-51)
Pratt, Coleshill House, London (1650-52)
Le Vau, Le Brun, Le Nôtre, Vaux-le-Vicomte, France (1656-61)
Cortona, Santa Maria della Pace, Rome (1656-57)
Guarini, Dsign for Our Lady of Divine Providence, Lisbon (1656-59)
Bernini, Santa Maria in Campitelli, Rome (1656-65)
Bernini, St. Peter's, Piazza colonnade (1656-67)
Guarini, Sacra Sindone, Turin (1657)
Bernini, Sant'Andrea al Quirinale, Rome (1658-70)
Tessin, Kalmar Cathedral (1660-73)
Vingboons, Trippenhuis, Amsterdam (1660-62)
Le Vau, Reconstructions of Versailles (1661, 1669, 1671)
Le Vau, Collège des Quatre Nations, Paris (1662)
Tessin, Palace at Drottningholm, Sweden (1662-1700)
Bernini, Scala Regia at Vatican (1663-66)
Longhena, Ca' Pesaro, Venice (1663)
Bernini, Projects for the Louvre (1664-65)
Bernini, Palazzo Chigi, Rome (1664-67)
Barelli and Zuccalli, Nymphenburg Palace, Munich (1664)
Van Bassen and Noorwits, Nieuwe Kerke, The Hague (1665)
Guarini, San Lorenzo, Turin (1666-80)
Le Vau, Perrault, D'Orbay, Colonnade, Louvre, Paris (1667-73)
Perrault, Observatory, Paris (1668-72)
Dortsman, Nieuwe Lutherse Kerk, Amsterdam (1668)
Caratti, Cermin Palace, Prague (1669-92)
Wren, St. Mary-le-Bow, London (1670-83)
Wren, St. Paul's, London (1675-1710)
Hamburg Opera House (1678)
Hardouin Mansart, Church of St. Louis at Les Invalides, Paris (1679-1707)
Guarini, Palazzo Carignano, Turin (1679-85)

1683-1713

Le Nôtre, Gardens, Palais des Tuileries, Paris (1664-79)
Hardouin Mansart, Place des Victoires, Paris (1685)
Moosbrugger, Disentis Abbey Church, Switzerland (ca. 1685)
Hawksmoor, Easton Neston, England (ca. 1690)
Church of S. Vincente, Braga, Portugal (1691)
Fischer von Erlach, Dreifaltigkeitskirche, Salzburg (1694)
Hardouin Mansart, Place Vendôme, Paris (1698)
Schlüter, Royal Palace, Berlin (1698-1716)
Hildebrandt and Gerl, Piaristenkirche, Vienna (1698-1753)
Wren, Greenwich Hospital (1699-1707)
Vanbrugh, Castle Howard, Yorkshire (1699-1712)
Frederiksberg Palace, near Copenhagen (1699-1730)
Hildebrandt, Belvedere Palace, Vienna (1700-22)
Prandtauer, Melk Benedictine Abbey (1702-36)
Building of St. Petersburg begins (1703)
Specchi, Porto della Ripetta, Rome (1703-05)
J. Dientzenhofer, Church of S. Nicholas, Prague (1703-11)
Fischer von Erlach, Schönbrunn Palace, Vienna (ca. 1704)
Vanbrugh, Blenheim Palace, England (1705-22)
C. Dientzenhofer, St. Margaret, Brevnov (1709-15)
Pöppelmann, Zwinger, Dresden (1709-32)
J. Dientzenhofer, Benedictine Abbey Church, Banz (1710-13)
Boffrand, Projects for Château de Malgrange, France (1712)
Fischer von Erlach, Clam Gallas Palace, Prague (1713)

1714-1762

Gibbs, St. Mary-le-Strand, London (1714-24)
Juvarra, Project for New Sacristy, St. Peter's (1715)
Batzendorf, Project for Karlsruhe (1715)
Tomé, University, Valladolid (1715)
Hawksmoor, All Souls' College, Oxford (1716-35)
Juvarra, Quartieri Militari, Turin (1716-28)
Fischer von Erlach, Karlskirche, Vienna (1716-37)
Juvarra, Basilica di Superga, near Turin (1717-31)
Juvarra, Castello di Rivoli (1718)
Juvarra, Palazzo Madama, Turin (1718-21)
Asam brothers, Aldersbach Abbey church (1718-29)
Frigimelica, Villa Pisani, Strà (1719-26)
Neumann, Residenz, Würzburg (1719-44)
K.I. Dientzenhofer, St. John Nepomuk, Prague (1720-29)
Ribera, Hospicio de San Fernando, Madrid (1722)
Gibbs, St. Martin-in-the-Fields, London (1722)
Michetti, Project for Lighthouse, Kronstadt (1723)
Pilgrimage Church of Bom Jesus do Monte, near Braga (1723)
De Sanctis, Spanish Steps, Rome (1723-26)
Meissonnier, Projects for St.–Sulpice, Paris (1724)
Gibbs, Fellows' Building, Cambridge (1724)
Hawksmoor, Christ Church, Spitalfields, London (ca. 1725)
Hildebrandt, Schloss Mirabell, Salzburg (1726)
Raguzzini, Piazza Sant'Ignazio, Rome (1727-28)
Lord Burlington, Chiswick House, London (1727-36)
Österlin, Gymnasium Poeticum, Regensburg (1728)
De Cotte, Palais de Rohan, Strasburg (1728-42)
Juvarra, Royal hunting lodge at Stupinigi (1729-33)
De Churriguera, Plaza Mayor, Salamanca (1729-40)
De Cotte, Thurn und Taxis Palace, Frankfurt (1730)
Kent, Projects for the gardens of Chiswick and Stowe, England (1730-40)
Boffrand, Oval Salon, Hôtel de Soubise, Paris (1732-09)
Projects for San Giovanni in Laterano, Rome (1732)
Juvarra, Chiesa del Carmine, Turin (1732-36)
Salvi, Trevi Fountain, Rome (1733-62)
Galilei, Façade, San Giovanni in Laterano, Rome (1733-36)
Marot, Royal Library, The Hague (1734-08)
Cuvilliès, Amalienburg (Nymphenburg park) (1734-09)
Juvarra and Sacchetti, Palace of La Granja, Spain (1735-09)
Kent, Holkham Hall, England (ca. 1740)
Knobelsdorff, Schloss Charlottenburg, Berlin (1740-06)
Dori, Marucelliana Library, Florence (ca. 1740)
Vittone, Santa Chiara, Bra (1742)
Neumann, Vierzehnheiligen, Germany (1743-72)
Garcia de Quiñones, Town Hall, Salamanca (1744-55)
Rastrelli, Smolny Institute, St. Petersburg (1744-57)
Van Knobelsdorff, Sanssouci, Potsdam (1745)
Zimmerman, Die Wies, Germany (1745-54)
Foger, Cathedral, Bressanone (1746-47)
Neumann, Projects for the Hofburg, Vienna (1746-47)
Neumann, Benedictine Church, Neresheim (from 1747)
J.M. Fischer, Benedictine Abbey Church, Ottobeuren (1748-66)
Boschetti, Ca' Venier dei Leoni, Venice (1749)
Rodríguez, Chapel of the Virgin, Church of Nuestra Señora del Pilar, Zaragoza (1750-65)
Junge, Tower, Church of St. Peter's, Copenhagen (1757)
Alfieri, Palazzo del Senato Sabaudo, Turin (1751-57)
Thumb and Beer, St. Gallen, Switzerland (1752-66)
Wood, King's Circus, Bath (1754-58)
Gabriel, Place Louis XV, Paris (1755-1763)
Bibiena, Nuovo Teatro Pubblico, Bologna (1756-63)
Vanvitelli, Palazzo Reale, Caserta (1756-74)
Rinaldi, St. Isaac Cathedral, St. Petersburg (ca. 1768)
Bazhenov, Great Kremlin Palace, Moscow (1769-1773)

Bibliography

s.d.-n.d. AELIUS SPARTIANUS. *Scriptores Historiae Augustae Hadr.*, 25.5 • BLUNT, ANTHONY. *Supplements to the Catalogues of Italian and French Drawings*, in *Schilling Edmund. The German Drawings in the Collection of Her Majesty the Queen at Windsor Castle*, London-New York • BORROMINI, FRANCESCO; SPADA, VIRGILIO. "Piena relatione", Roma, Archivio della Congregazione dell'Oratorio a Santa Maria della Vallicella, ms. C. II. 6 • DE COTTE, ROBERT. *Voyage en Italie*, Paris, Bibliothèque Nationale, Cabinet des Manuscrits, Ms. fr. 14663-14664 • FRITZ, R. *Das Stadt- und Straßenbild in der Holländischen Malerei des 17. Jahrhunderts*, s.l. • THORNTON, P. *Form & Decoration. Innovation in the Decorative Arts 1470-1870*

1559 CUNINGHAM, WILLIAM. *The Cosmographical Glasse*, London

1577 BORROMEO, CARLO. *Instructiones Fabricae Ecclesiasticae*, Milano

1583 ETIENNE, CHARLES; LIÉBAULT, JEAN. *L'Agriculture et maison rustique*, Paris

1584 BRUNO, GIORDANO. "De l'infinito universo e mondi", in *Dialoghi*, I, 51; III, 12 • LOMAZZO, G.P. *Trattato dell'arte de la pittura*

1590 LOMAZZO, G.P. *Idea del tempio della pittura*

1594 ERRARD, JEAN. *La Fortification démontrée et réduite en art*, Paris (Frankfurt am Main, 1602)

1596 TONSO, GIOVANNI. *De vita Emmanuelis Philiberti Allobrogum Ducis et Subalpinorum Principis libri duo*, Torino

1596-1604 PRADO, JERÓNIMO; VILLALPANDO, JOHANNES BAPTISTA. *In Ezechielem explanationes et Apparatus Urbis, ac Templi Hierosolymitani Commentariis et imaginibus illustratus...*, Roma

1607 ZUCCARI, F. *L'idea de' pittori, scultori et architetti*

1607 (1979) BOTERO, GIOVANNI. "Relazione di Piamonte", in *I capitani*, Torino (ripubblicata in *Decennale del Centro Studi Piemontesi*, a cura di L. Firpo), Torino: 33-47

1609 GIUSTINIANI, POMPEO. *Delle guerre di Fiandra, libri VI*, Anversa

1615 HAESTENS, H. *Le Nouvelle Troye, ou mémorable histoire du siège d'Ostende, le plus signale qu'on ait veu en l'Europe*, Leiden

1620 ALSTED, JOHANN HEINRICH. *Cursus Philosophici Encyclopaedia Libri XXVII complectens; Liber decimusquintus, In quo Architectonica*, Herborn

1623 TENSINI, FRANCESCO. *La Fortificatione*, Venice • LE MUET, PIERRE. *Manière de bâtir pour toutes sortes de personnes*, Paris (rééd. Aix-en-Provence, 1981)

1624 WOTTON, HENRY. *Elements of Architecture*, London

1628 DE VILLE, ANTOINE. *Les Fortifications*, Lyon

1641 CHASTILLON, CLAUDE. *Topographie Françoise ou représentations de plusiers villes*, Paris

1642 GEVARTIUS, CASPAR. *Pompus Introitus honori Serenissimi Principis Ferdinandi Austriaci Hispaniarum Infantis S.R.E. Card. Belgarum et Burgundiorum Gobernatoris ...*, Antwerpen, Ioannes Marseus

1644-1658 MARTINELLI, FIORAVANTE. *Roma ricercata nel suo sito e nella scuola di tutti gli Antiquarij*, Roma (1ª ed. 1644; 2ª ed. 1650; 3ª ed. 1658)

1647-1648 DÖGEN, MATTHIAS. *L'Architecture militaire moderne*, Antwerp

1648 RIDOLFI, CARLO. *Le Meraviglie dell'Arte*, 2 voll., Venezia • VINGBOONS, PHILIPS. *Afbeelsels der voornaemste gebouwen uyt alle die Philips Vingboons geordineert heeft*, Amsterdam

1649-1975 BAGLIONE, G. *Le vite de' Pittori, Scultori et Architetti dal Pontificato di Gregorio XIII fino a tutto quello di Urbano VIII*, Roma

1651 *Relatione delle solennità e feste delle nozze della Serenissima Principessa Adelaide di Savoia*, Torino

1655 MARTINELLI, FIORAVANTE. *Primo trofeo della S.ma Croce eretto in Roma nella Via Lata da S. Pietro Apostolo*, Roma

1656 RASPONI, CESARE. *De Basilica et Patriarchio Lateranensi Libri Quattuor*, Romae

1661 VENNEKOOL, JAKOB. *Afbeelding van 't Stadt Huys van Amsterdam, in dartigh coopere plaaten, geordineert door Jacob von Campen en geteeckent door Jacob Vennekool*, Amsterdam (bij Dancker Danckerts)

1662 WILHELM, JOHANN. *Architectura Civilis, das ist: Beschreib, oder Vorreissung fürnembsten Tachwerck...*, Frankfurt

1663 SANSOVINO, FRANCESCO. *Venetia città nobilissima et singolare ... con aggionta di tutte le cose notabili ...*, da Giustiniano Martinioni, Venezia

1665 QUELLINUS, HUBERTUS. *Secunda Pars. Praecipuarum effigierum ac ornamentorum amplissimi Curiae Amstelrodamensis maiori ex parte in cadido marmore effectorum per Artum Quellinium eiusdem Civitatis Statuarium*, Amsterdam

1668 ABRAHAM, COWLEY. *Plantarum Libri VI*

1672 BELLORI, GIOVANNI PIETRO. *Le vite de' pittori, scultori et architetti moderni*, Roma

1673 SAVOT, LOUIS. *L'Architecture Françoise des bastiments Particuliers... Avec des Figures & des Nottes de M. Blondel*, Paris

1674 (ma 1679) DI CASTELLAMONTE, AMEDEO. *Venaria Reale, Palazzo di piacere e di Caccia, ideato dall'Altezza Reale di Carlo Emanuele II Duca di Savoia, Re di Cipro &, Disegnato e descritto dal Conte Amedeo di Castellamonte l'anno 1672*, Torino, Zapatta

1677 GIACONIUS, ALPHONSUS. *Vitae et res gestae Pontificum Romanorum et S.R.E. Cardinalium ab initio nascentis Ecclesiae usque ad Clementem IX P.O.M.*, IV, Romae

1678 CARAMUEL DE LOBKOWITZ, J. *Architectura civil, recta y obliqua*, Vigevano

1681 GOEREE, WILLEM. *D'Algemeene Bouwkunde Volgens d'Antike en Hedendaagse Manier*, Amsterdam

1682 *Theatrum Statuum Regiae Celsitudinis Sabaudiae Ducis, Pedemontii Principis, Cypri Regis, etc.*, Amsterdam • BALDINUCCI, FILIPPO. *Vita del cavaliere Gio. Lorenzo Bernino, scultore, architetto e pittore*, Firenze

1683 DE ROSSI, GIOVANNI GIACOMO. *Insignium Romae Templorum Prospectus*, Romae (2ª ed. 1684) • PERRAULT, CLAUDE. *Ordonnance des Cinq Especes de Colonnes selon la Methode des Anciens*, Paris

1686 *Les Travaux de Mars ou l'Art de la Guerre*, I, Paris • MANESSON-MALLET, ALAIN. *Les Travaux de Mars ou l'Art de la Guerre*, Paris, I, 73

1688 IVANOVICH, CRISTOFORO. *Minerva al tavolino*, 2 voll., Venezia

1693-1700 POZZO, ANDREA. *Perspectiva Pictorum et Architectorum, Andraeae Putei E Societate Jesu. Pars Prima*, Romae 1693; *Pars Secunda*, Romae 1700 (*Prospettiva de' Pittori e Architetti...*, Parte Prima, Roma 1963; Parte Seconda, Roma 1700). Typis Joannis Jacobi Komarek Bohemi apud S. Angelum Custodem, Superiorum Permissu, Romae

1695 ALLARD, CAROLUS. *Neerlands veldpracht, of 't lusthof gesticht door Z.B.M. Willem III op't Loo ...*, Amsterdam, C. Allard • LISTINGH, NICOLAAS. *Niew Desseyn tot een seer Grote, Stercke, en om te hooren, heel bequame Coupelkerckmet een Hooge Tooren daer midden uyt rysende*, Amsterdam

1699 BONANNI, FILIPPO. *Numismata pontificum Romanorum*, Romae • LISTER, MARTIN. *A Journey to Paris in 1698*, London

1701 LISTINGH, NICOLAAS. *Nette Prent-Verbeeldingen vande Twee Kloecke Houte Modellen, inde Maandt Iuny 1699 vervaardigt*, t'Amsterdam by Petrus Schenk

1702-1721 DE ROSSI, DOMENICO. *Studio d'architettura civile ... Opera di più celebri architetti di nostri tempi*, Roma, 3 voll. (I, 1702; II, 1711; III, 1721)

1705-1738 DELAMARE, NICOLAS. *Traité de la police*, Paris

1706 *Geöffnete Baumeister-Academie*, Hamburg

1708-1715 KNYFF, LEONARD; KIP, JAN. *Britannia illustrata, or Views of Several of the Queens Palaces, also of the Principal Seats of the Nobility and Gentry of Great Britain (or Nouveau teatra de la Grande-Bretagne)*, London

1709 RINCK, G.E. *Leopolds des Grossen Röm. Kaysers Leben und Thaten*, Leipzig, 99

1711 MARPERGER, P. J. *Histoire und Leben der berühmtesten Europäischen Baumeister*, Hamburg

1711-1716 DECKER, PAUL. *Fürstlicher Baumeister, oder: Architectura civilis...*, Augsburg, Jeremias Wolff

1713 D'AVILER, CHARLES AUGUSTE. *Œuvres d'Architechture de Vincent Scamozzi...*, Leyden

1714 LEIBNIZ, GOTTFRIED WILHELM. *Monadologia*

1714-1716 *Nouveau théâtre de la Grande Bretagne, ou Description exacte des palais du Roy et des maisons les plus considerables des seigneurs & des gentilshommes de la Grande Bretagne: le tout dessiné sur les lieux, & gravé en quatre-vingt planches où l'on voit aussi les armes des seigneurs & des gentilshommes*, London, David Mortier

1715 CAMPBELL, COLEN. *Vitruvius Britannicus*, I, London

1717 CAMPBELL, COLEN. *Vitruvius Britannicus*, II, London • PITTON DE TOURNEFORT, J. *Relation d'un voyage du Levant...*, I, Paris • RUDOLPH, FRIEDRICH. *Gotha Diplomatica*, Frankfurt am Main-Leipzig

1720-1725 BORROMINI, FRANCESCO. *Opera del Caval. Francesco Boromino Cavata da suoi originali cioè La Chiesa, e Fabrica della Sapienza di Rome con le vedute in Prospettiva e con lo studio delle proporz[io]ni geometriche, piante, alzate, profili, e spaccati, ed. Sebastiano Giannini, Romae, 1720; Opera del Cav. Francesco Boromino Cavata da Suoi Originali cioè L'Oratorio, e Fabrica per l'Abitazione de PP. dell'Oratorio di S. Filippo Neri di Roma ... Opus Architectonicum Equitis Francisci Boromini ...*, Romae

1721 FISCHER VON ERLACH, J.B. *Entwurff einer Historischen Architectur*, Wien • WOLFF, CHRISTIAN. *Vernünftige gedanken von dem gesellschaftlichen Leben der Menschen*, Halle

1722 FLORINUS, FRANCISCUS PHILIPPUS. *Oeconomus prudens et legalis. Oder Allgemeiner Cluger und Rechstverständiger Haus-Vatter...*, Nürnberg, I, XXII

1725 "Description de l'Autel principal, & de la Coupole sous laquelle il doit être placé dans la nouvelle Eglise de S. Sulpice de Paris. Experience singulière faite à cette occasion", *Le Mercure de France*, 473-79

1726 KLEINER, SALOMON. *Représentation naturelle et exacte de La Favorite de Son Altesse Electorale de Mayence: en quatorze differentes vues et autant de plans sur les dessins ... pris sur les lieux ... Wahrhaffte ... Abbilding Der ... Chur Furstlich Mayntzischen Favorita ... nach Denen*, Augsburg, Aux dépens des héritiers du feu Jeremie Wolff • SWIFT, JONATHAN. *The Great Mystery or Art of Meditating over an House of Office, Restored and Unvelled*, London-Dublin (rééd. dans J. Swift. *La mécanique de l'esprit*, Paris, 1995)

1727 *L'Architecture françoise ou recueil des plans, élévations, coupes et profils des églises, palais, hôtels & maisons particulières de Paris & des châteaux & maisons de campagne ou de plaisance des environs, & plusieurs autres endroits de France*, Paris, Chez Jean Mariette

1728 GIBBS, JAMES. *Book of Architecture*, London • HAWKSMOOR, NICHOLAS. *Remarks on the founding and carrying on the buildings of the Royal Hospital at Greenwich*, London (reprinted in *The Wren Society*, VI, 1929, 17-27) • KLEINER, SALOMON. *Représentation au naturel des châteaux de Weissenstein au dessus de Pommersfeld, et de celui de Geubach appartenants à la maison des comptes de Schonborn: avec les jardins, les écuries, les ménageries, et autres dépendances ...*, Augsburg, Aux dépens des héritiers du feu Jeremie Wolff

1729 "Décoration et Feu d'Artifice, tiré dans l'Avant-Court du Château de Versailles le 5. Décembre, à l'occasion de la naissance du Dauphin, sous les ordres du Duc de Mortemar, Premier Gentilhomme de la Chambre du Roy, en Exercise; & sous la conduite de M. le Febvre, Intendant des Menus Plaisirs du Roy", *Le Mercure de France. Dédié au Roy*, 2960-63

1730-1736 PASCOLI, LIONE. *Di Andrea Pozzo*, in *Vite de' pittori, scultori ed architetti moderni (1730-1736)*, con note di G. Marini, Perugia 1992, 691-715

1731-1740 KLEINER, SALOMON. *Résidences mémorables de l'incomparable héros de nôtre siècle, ou Représentation exacte des edifices et jardins de Son Altesse serenissime monseigneur le Prince Eugene François Duc de Savoye et de Piedmont: première partie, contenant les plans, élévations et veües de la maison de plaisance de Son Altesse sere. située dans un de fauxbourgs de Vienne: le batiment a eté inventé et ordonné par le sieur Jean Lucq de Hildebrant ...: les jardins et toutes les eaux ont eté inventés par le sieur Girard ...*, Augsburg, Chez les héritiers de feu Jeremie Wolff

1732-1737 SCHEUCHZER, J.J. *Physique Sacrée, ou Histoire Naturelle de la Bible*, Amsterdam (ed. latina, *Physica sacra*, Augsburg-Ulm, 1732-1735; ed. tedesca, *Kupferbibel...*, Augsburg-Ulm, 1731-1735)

1734 VOLTAIRE, *Traité de Métaphysique*

1734-1739 BRETEZ, LOUIS. *Plan de Paris commencé l'Année 1734. Dessiné et gravé sous les ordres de Messire Michel Etienne Turgot*, Paris

1737 BLONDEL, JACQUES FRANÇOIS. *De la distribution des maisons de plaisance ...*, 2 voll., Paris • GUARINI, GUARINO. *Architectura Civile*, Torino

1738 MAFFEI, SCIPIONE. "Elogio del signor abate d. Filippo Juvara Architetto", in *Osservazioni letterarie*, III, Verona

1739 DE ROSSI, Z. *La Libreria Mediceo-Laurenziana*, Firenze • MAITLAND, W. *The History of London*, London • ZANOTTI, GIOVANNI PIETRO. *Storia dell'Accademia Clementina*, 2 voll., Bologna

1740 *Architetture, e prospettive dedicate alla maestà di Carlo Sesto Imperador de' Romani, da Giuseppe Galli Bibiena, suo primo ingegner teatrale, ed architetto, inventore delle medesime*, Vienna • ZIEGELBAUER, MAGNOALD. *Epitome historica ... monasterii Brzevnoviensis vulgo s. Margarethae ordinis S. Benedicti prope Pragam*, Coloniae

1741 KEYSSLER, JOHANN G. *Fortsetzung neuester Reisen durch Teutschland*, Hannover

1742 DEZALLIER D'ARGENVILLE, A.J. *L'Histoire naturelle éclaircie dans deux de ses parties principlaes ...*, Paris

1744 CHIAVERI, GAETANO. *Sentimento di Gaetano Chiaverj Architetto della Maestà del Re di Polonia ed Elettore di Sassonia, ec. ec. Sopra la pretesa reparazione de' Danni, che sonò stati riconosciuti sul fine dell'anno MDCCLXII. nella cupola di S. Pietro Vaticano di Roma*, Dresden •

GERSAINT, E.F. *Catalogue raisonné d'une collection considérable ... contenue dans les cabinets de feu M. Bonnier de la Mosson*, Paris • VENUTI, RIDOLFINO. *Numismata romanorum pontificum a Martino V ad Benedictum XIV*, Roma

1745 BOFFRAND, G. *Livre d'architecture contenant les principes généraux de cet art*, Paris • DEZALLIER D'ARGENVILLE, A.J. *Abrégé de la vie des plus fameux peintres*, 4 voll., Paris

1745-1751 ŒUVRE DE JUSTE AURELE MEISSONNIER *Peintre Sculpteur Architecte & c. Dessinateur de la chambre et Cabinet DU ROY*, Paris, Chez Huquier

1747 BLONDEL, JACQUES FRANÇOIS. *Discours sur la manière d'étudier l'architecture*

1748 POLENI, GIOVANNI. *Memorie istoriche della Gran Cupola del Tempio Vaticano*, Padova

1748-1751 OPPENORD, GILLES-MARIE. *Œuvres de Gille [sic] Marie Oppenord Ecuier Directeur General des Bâtiments et Jardins de son Altesse Royale Monseigneur Le Duc D'Orléans Régent du Royaume Contenant Differentes Fragments d'Architecture, et d'Ornaments, à l'usage des Bâtiments sacrées [sic], publics, et particuliers*, Paris, Chez Huquier

1749 DE BROSSES, CHARLES. *Lettres familières adressées d'Italie en 1739-1740*, Paris (trad. it. *Lettere familiari dall'Italia nel 1739 e nel 1740*, 1869) • VOLTAIRE. *Des embellissemens de Paris*, Paris

1750 MARIETTE, PIERRE-JEAN. "Mémoire manuscrit sur Meissonnier", in *Collection de pièces sur les Beaux-Arts, imprimées et manuscrites* (Collection Deloynes, cabinet des Estampes, Bibliothèque Nationale de France), 4, 45, 415-18 • WREN, STEPHEN. *Parentalia, or Memoirs of the Family of the Wrens*, London (reprinted, Farnborough, UK, 1965)

1751 D'ALEMBERT, JEAN-BAPTISTE. "Discours préliminaire" all'*Encyclopédie*

1752 BOUGEREL, J. *Mémoires pour servir à l'histoire de plusieurs hommes illustres de Provence*, Paris • ELLIOTT, GEORGE. *Proposals for Carrying on Certain Public Works in the City*, Edinburgh • WALPOLE, HORACE. *Aedes Walpolianae, or, a Description of the Collection at Houghton Hall in Norfolk*, 2nd ed., London

1752-1756 BLONDEL, JACQUES-FRANÇOIS. *Architecture Françoise, ou Recueil Des Plans, Élévations, Coupes et Profils Des Eglises, Maisons Royales, Palais, Hôtels & Edifices les plus considérables de Paris*, 4 voll., Paris, Chez Charles-Antoine Jombert, 4, 6, 7

1753 BÉLIDOR, BERNARD. *Architecture Hydraulique*, II, Paris • LAUGIER, MARC ANTOINE. *Essai sur l'architecture*, Paris

1754 BLONDEL, JACQUES-FRANÇOIS. *Discours sur la Nécessité de l'Etude de l'Architecture*, Paris • COCHIN, C.N. "Lettre d'une société d'architecture...", *Mercure de France*

1755 ALBERTI. *Ten books on Architecture*, VII/IV, London, 138 • COCHIN, C.N. "Lettre d'une société d'architecture ...", *Mercure de France* • LAUGIER, MARC ANTOINE. *Essai sur l'architecture*, Paris

1755 (1768) DEZALLIER D'ARGENVILLE, ANTOINE-NICOLAS. *Voyage pittoresque des environs de Paris, ou description des Maisons royales, châteaux et autres lieux de plaisance, situés à quinze lieux aux environs de cette ville*, Paris, Debure (3e éd., Paris, Debure)

1756 *Dichiarazione dei disegni del reale palazzo di Caserta etc. alla Sacre Reali Maestà di Carlo Re delle Due Sicilie*, Napoli • RIEGER, CHRISTIAN. "Syllabus Scriptorum Architectonicorum", in *Universae Architecturae Civilis Elementa*, Wien, 275 ss. • VOLTAIRE. *Des embellissemens de la ville de Cachemire*, Paris • WINCKELMANN, J.J. *Gedanken über die Nachahmung der Griechischen Werke der Malerey und Bildhauerkunst*, 67

1757 DEZALLIER D'ARGENVILLE, ANTOINE-JOSEPH. *Voyage Pittoresque de Paris, ou Indication De tout ce qu'il y a de plus beau dans cette grande Ville en Peinture, Sculpture & Architecture*, 3e ed., Paris, Chez de Bure l'ainé, libraire • SCHMIDT, STEPHAN. *Tabulae Architecturae Civilis, et Militaris*, Prag

1758 "Portail de l'Eglise de Saint Sulpice", *Le Mercure de France*, 167-72 • DE LA POIX DE FREMINVILLE, E. *Dictionnaire ou traité général de la police générale des villes, bourgs, paroisses et seigneuries de la campagne*, Paris

1761 WOOD, JOHN. *Description of Bath*, London (2nd ed.)

1762 MAZZUCCHELLI, G.M. *Gli scrittori d'Italia*, II, 3, Brescia

1764 (1734) SALMON, WILLIAM. *Palladio Londinensis*, London

1764 WINCKELMANN, JOHANN JOACHIN. *Geschichte der Kust des Alterturms*, Dresden

1765 LAUGIER, MARC ANTOINE. *Observations sur l'architecture*, L'Aja • PATTE, PIERRE. *Les monuments érigés en France à la gloire de Louis XV*, Paris

1767 CHIAVERI, GAETANO. *Breve discorso di Gae-*

tano Chiaveri Romano Architetto giubilato della Corte di Sassonia, ed Accademico di San Luca di Roma, circa i danni riconosciuti nella portentosa Cupola di San Pietro di Roma, e le sue principali cause, con la maniera durabile, e più sicura per la reparazione, Pesaro • GALLACCINI, TEOFILO. *Trattato sopra gli errori degli architetti*, Venezia

1768 MILIZIA, FRANCESCO. *Le vite de' più celebri Architetti d'ogni Nazione e d'ogni Tempo precedute da un saggio sopra l'architettura*, Roma

1769 PATTE, PIERRE. *Mémoires sur les objets les plus importants de l'architecture*, Paris, Chez Rozet • SOPRANI, R.; RATTI, C.G. *Delle Vite de' Pittori, Scultori, ed Architetti Genovesi*, II, Genova

1771-1777 BLONDEL, JACQUES FRANÇOIS. *Cours d'architecture, ou Traité De la Décoration, Distribution & Construction Des Bâtiments; Contenant Les Leçons données en 1750, & les années suivantes, par J. F. Blondel, Architecte, dans son Ecole des Arts*, III, Paris, Desaint

1772 RICAUD DE TIREGALE, P. *Médailles sur les principaux événements de l'Empire de Russie, depuis le règne de Pierre le Grand jusqu'à celui de Catherine II. Avec les explications historiques*, Paris

1773 BRETTINGHAM, M. *The Plans, Elevations, and Sections of Holkham of Norfolk; to which are added, the ceilings, and chimnery-pièces... statues, pictures and drawings*, London

1776 WINCKELMANN, JOHANS JOACHIM. *Geschichte der Kunst des Altertums*, Wien

1777 GIRARDIN, RENÉ LOUIS. *De la composition des paysages*, Genève

1779 GALLETTI, JOHANN GEORG-AUGUST. *Geschichte und Beschreibung des Herzogthums Gotha*, II, Gotha

1782 LEQUEU, JEAN-JACQUES. *L'Architecture civile, des instruments à l'usage du bon dessinateur*, Paris

1783 CANCELLIERI, FRANCESCO. *La Sagrestia Vaticana eretta dal Regnante Pontefice Pio VI*, Roma

1787 YOUNG, ARTHUR. *Voyage en France en 1787, 1788, et 1789*, sous la direction de H. Sée

1788 COMOLLI, ANGELO. *Bibliografia storico-critica dell'architettura civile ed arti subalterne*, Roma • QUATREMÈRE DE QUINCY, ANTOINE CHRYSOSTOME. *Encyclopédie méthodique, ou par ordres de matières, Dictionnaire historique de l'architecture*, 3 voll., Parigi

1788-1795 GOLIKOV, I.I. *Dejanija Petra Velikogo, nudrogo preobrazovatelja Rossii, sobrannye-iz-dostovernych istocnikov i raspolozennye po godam*, Moskva, I-XV; XVI, 204

1789 D'ONOFRI, P. *Elogio estemporaneo per la gloriosa memoria di Carlo III*, Napoli

1791 BRIDGES, JOHN. *The History and Antiquities of Northamptonshire*, I, Oxford • SMEATON, JOHN. *A Narrative of Building and a Description of the Construction of the Edystone Lighthouse with Stone*, London

1797 MILIZIA, FRANCESCO. *Dizionario delle belle arti del disegno*, Bassano

1802 FUESLI, H.R. *Annalen der bildenden Künste für die österreichischen Staaten*, II, Wien, 13

1811 WESTON, ROBERT H. *Letters and Important Documents relative to the Edystone Lighthouse*, London

1815 MOSCHINI, GIOVANNI ANTONIO. *Guida per la città di Venezia*, Venezia

1817 DAWSON, J. *The Stranger's Guide to Holkham Hall containing a description of the paintings, statues of Holkham House*, Burnham

1819 MOSCHINI, GIOVANNI ANTONIO. *Itinéraire de la ville de Venise*, Venise

1822 BOTTARI, GAETANO GIOVANNI. *Raccolta di lettere*, VI, Milano, 121-29

1830 CICOGNA, EMMANUELE ANTONIO. *Delle Inscrizioni veneziane*, III, Venezia

1837 GUMPELZHAIMER, CHRISTIAN GOTTLIEB. *Regensburg's Geschichte, Sagen und Merkwürdigkeiten von den ältesten bis auf die neuesten Zeiten, in einem Abriß aus den besten Chroniken, Geschichtsbüchern, und Urkunden-Sammlungen*, II, Regensburg

1840 GAYE, G. *Carteggio inedito d'artisti dei secoli XIV-XV*, Firenze

1842 MOSCHINI, GIOVANNI ANTONIO. *La chiesa e il seminario di S. Maria della Salute*, Venezia

1842-1856 GALILEI, GALILEO. *Opere*, Firenze, IV, 293

1843 DONALDSON, T.L. "Some Account of the Models of Churches ...", *The Architect, Engineer and Surveyor*, London, IV, 351 ss.

1847 CASALIS, GOFFREDO. *Dizionario geografico, storico, statistico, commerciale degli stati di S.M. il re di Sardegna*, Torino

1850 MICHAUD, POUJOULAT. *Nouvelle collection pour servir à l'histoire de France depuis le XIII siècle jusqu'à la fin de XVIII siècle...*, 9: *Mémoires du maréchal de Villars*, Paris-Lyon, Guyot frères, 1-447

1851 MOTLEY, J.L. *The Rise of the Dutch Republic*, New York

1853 SCHLAGER, JOHANN EVANGELIST. *G.R. Donner*, Wien

1855 BURCKHARDT, JACOB. *Der Cicerone: Eine Anleitung zum Genuss der Kunstwerke Italiens*, Basel • PISTOLESI, E. *Modello della Fontana di Trevi ridotto al 15° dell'originale attribuito a Nicola Salvi descritto da Erasmo Pistolesi esistente nella galleria del Conte Zelone al Palazzo Albani in Roma*, Roma

1856 ZANOTTO, FRANCESCO. *Nuovissima guida di Venezia e delle isole della sua laguna*, Venezia

1857 FAUCHEUX, LOUIS-ETIENNE. *Catalogue raisonné de toutes les estampes qui forment l'œuvre d'Israël Silvestre, précédé d'une notice sur sa vie*, Paris, J. Renouard • LUTTRELL, NARCISSUS. *A brief relation of historical and state affairs*, Oxford

1857-1858 DE CHENNEVIÈRES, PAUL; DE MONTAIGLON, ANATOLE. *Abecedario de P.J. Mariette, Archives de l'Art français*, IV, Paris

1858 CORRER, GIOVANNI. "Relazione della Corte di Savoia di Giovanni Correr tornato ambasciatore nel 1566", in E. Albèri, *Le relazioni degli ambasciatori veneti al Senato durante il secolo decimosesto*, serie II, V, 1-46

1860 CERROTTI, FRANCESCO. *Lettere e Memorie autografe inedite di artisti tratte dai manoscritti della Corsiniana*, Roma

1862 DE LEPINOIS, E.; DE MONTAIGLON, ANATOLE. "Lettres de Louis Fouquet à son frère Nicolas Fouquet (1655-1656)", *Archives de l'art français*, 2e série, 2 • FERGUSSON, JAMES. *History of the Modern Styles of Architecture*, London • GIBERT, M. *Musée d'Aix-en-Provence*, Paris (rééd. 1867)

1863 DE ROSSI, G.G. *Insignium Romae templorum prospectus*, Roma

1867 DE ROEVER, N. "De rariteiten-kamer verbonden aan 't Amsterdamsche gemeente-archief. III", *Oud Holland*, 6; 195-224 • KROON, A.W. *Het Amsterdamsche stadhuis. (Thans paleis) 1625-1700. Zijne geschiedenis naar onuitgegeven officiele bronnen bewerkt*, Amsterdam • LAGRANGE, L. "Pierre Puget", *Gazette des Beaux-Arts*

1868 LAGRANGE, L. *Pierre Puget, peintre, sculpteur, architecte, décorateur de vaisseaux*, Paris (rééd. 1993)

1872 IVERSEN, J. *Medaillen Auf Die Thaten Peter Des Grossen*, St. Petersburg

1873 TEISSIER, OCTAVE. *Histoire des Divers Angrandissements et des Fortifications de la Ville de Toulon accompagnée d'un Mémoire Inédit du Maréchal de Vauban*, Paris-Toulon-Marseille

1877 *Catalogue of the Special Loan Collection of Scientific Apparatus*, exhibition catalogue, 3rd ed., London, South Kensington Museum, 1876, London • *Dessins anciens*, Marseille, Cercle artistique • CLARETTA, GAUDENZIO. *Adelaide di Savoia, duchessa di Baviera, e i suoi tempi*, Torino • VARNI, S. *Spigolature artistiche nell'Archivio della basilica di Carignano*, Genova

1879 LANCRENON, P. *Catalogue des peintures, dessins et sculptures du musée de Besançon*, Besançon

1880 BERTOLOTTI, A. *Artisti belgi e olandesi a Roma*, Firenze

1881 BONNASSIEUX, PIERRE. *Le château de Clagny et madame de Montespan d'après les documents originaux. Histoire d'un quartier de Versailles*, Paris • GUILMARD, D. *Les maîtres ornemanistes, peintres, dessinateurs, architects, sculptures et graveurs*, 3 voll., Paris

1881-1901 GUIFFREY, JULES. *Comptes des Bâtiments du Roi sous le règne de Louis XIV*, Paris, Imprimerie Nationale, 10

1882 BONNAFFÉ, EDMOND. *Les amateurs de l'ancienne France. Le surintendant Fouquet*, Paris-London, Librairie de l'art

1883 ALLARD, ÉMILE. *Travaux-Publics de la France, 5: Phares et Balises*, Paris

1883 (1969) LANDUCCI, LUCA. *Diario fiorentino dal 1450 al 1516*, Firenze, Iodoco Del Badia (anastatica Firenze)

1884 PORRO, GIOVANNI. "Catalogo dei Codici Manoscritti della Trivulziana", in *Biblioteca Storica Italiana*, Torino, 224

1885 NICOLETTI, GIUSEPPE. *Illustrazione della chiesa e scuola di S. Rocco a Venezia*, Venezia • ZANETTI, GIROLAMO. "Memorie per servire all'historia della inclita città di Venezia", *Archivio Veneto*, XXIX, 97-148

1886 WILLIS, R.; CLARCK, J. *The Architectural History of the University of Cambridge*, Cambridge • WÖLFFLIN, HEINRICH. *Prolegomena zu einer Psychologie der Architektur*, München

1887 *Pis'ma i bumagi Imperatora Petra Velikogo. 1688-1701*, I, Sankt-Peterburg • GÖLLER, ADOLF. *Zu Aesthetik der Architektur*, Stuttgart • LLOYD, E.M. *Vauban, Montalembert, Carnot: Engineer Studies*, London

1887-1889 GURLITT, CORNELIUS. *Geschichte der Barockstiles, des Rococo und des Klassizismus*, 3 voll., Stuttgart

1887-1909 ROOSES, MAX; REULENS, CHARLES. *Correspondance de Rubens et documents épistolaires concernant sa vie et ses œuvres*, Antwerpen

1888 DE ROEVER, N. "De rariteiten-kamer verbonden aan 't Amsterdamsche gemeente-archief. III", *Oud Holland*, 6: 195-224 • ROSENBERG, M. "Silberne Terrinen nach Meissonniers Entwürfen", *Kunstgewerbeblatt*, IV • WÖLFFLIN, HEINRICH. *Renaissance und Barock. Eine Untersuchung über Wesen und Entstehung des Barockstills in Italien*, München

1889 CASTAN, AUGUSTE. "Histoire et description des musées de Besançon", in *Inventaire Général des Richesses d'Art de la France, Monuments Civils*, V, Paris

1890 HENRARD, P. *L'Histoire du siège d'Ostend 1601-4*, Bruxelles • LINCOLN, W.S. *A Descriptive Catalogue of Papal Medals*, London

1890 (1907) SYDENHAM, CLARKE GEORGE. *Fortification: Its Past Achievements, Recent Developments and Future Progress*, London, 278-95

1891 GURLITT, CORNELIUS. *Andreas Schlüter*, Berlin

1893 ILG, A. *G.R. Donner. Gedenkschrift zum 200. Jahrestag der Geburt*, Wien, 38 • LEMONNIER, HENRY. *L'art français au temps de Richelieu et de Mazarin*, Paris

1894 SCHMARSOW, AUGUST. *Das Wesen der architektonischen Schöpfung*, Leipzig • TESORONI, DOMENICO. *Il Palazzo Piombino di Piazza Colonna. Notizie e documenti*, Roma

1895 GABILLOT, C. *Hubert Robert et son temps*, Paris • ILG, ALBERT. *Die Fischer von Erlach*, Wien • WINNEFELD, H. *Die Villa des Hadrian bei Tivoli*, 3, Berlin

1896 *The Third Hundred of Paintings by Old Masters*, Galerie Sedelmeyer, Paris

1897 SCHMARSOW, AUGUST. *Barock und Rokoko, eine kritische Auseinandersetzung über das Malerische in der Architektur*, Leipzig

1898 RANDOLINO, FERDINANDO. *Il Duomo di Torino illustrato*, Torino

1899 ASSANDRIA, GIUSEPPE. *Memorie Storiche della Chiesa di Bene*, Pinerolo • BRUMME FRANZ, *Dorf und Kirchspiel Friedrichswerth*, Friedrichswerth

1900 FRASCHETTI, STANISLAO. *Il Bernini. La sua vita, la sua opera, il suo tempo*, Milano • PONTIER, H. *Catalogue du musée Granet*, Aix-en-Provence

1901 RIEGL, ALOIS. *Die spätrömische Kunstindustrie*, Wien • ROSSI, F. "Œuvres de Pierre Puget et de son école", *Réunion des Sociétés des Beaux-Arts des Départements*, XXV, 536-55

1902 LANCIANI, R. *Storia degli scavi di Roma*, I • SOUSA VITERBO, R. VICENTE D'ALMEIDA, R. *A Capela de S. Joao Baptista erecta na Egreja de S. Roque*, Noticia historica e descriptiva, Lisboa

1903 GRABAR', I.E. *Istorija russkogo iskusstva*, III, Moskva, 182, 207-10, 308

1904 DALLA SANTA, GIOVANNI. *Il pittore Alessandro Varotari e un suo disegno per la chiesa della Salute di Venezia*, Venezia • SIMONSON, G.A. *Francesco Guardi (1712-1793)*, London

1904-1930 FORRER, L. *Biographical Dictionary of Medallist, Coin, Gem, Seal-engravers*, London

1905 GEROLA, GIUSEPPE. *Monumenti Veneti dell'isola di Creta*, 3 voll., Venezia • SCHMARSOW, AUGUST. *Grundbegriffe der Kunstwissenschaft am Übergang vom Altertum zum Mittelalter, kritische erörtert und systematischen Zusammenhange dargstellt*, Leipzig

1906 DE BARCIA, ANGEL MARIA. *Catálogo de la colección de dibujos originales de la Biblioteca Nacional*, Madrid • MARCEL, PIERRE. *Inventaire des Papiers Manuscrits du Cabinet de Robert de Cotte, Premier Architecte du Roi (1656-1735) et de Jules-Robert de Cotte (1683-1767) Conservés a la Bibliothèque Nationale*, Paris • VAN BIEMA, EDUARD. "Nalezing van de stadsrekeningern van Amsterdam van af het jaar 1531.v", *Oud Holland*, 24; 171-92

1907 BRIQUET, C.M. *Les filigranes - Dictionnaire historique des marques du papier dès leur apparition vers 1282 jusqu'en 1600*, Paris • PEARSALL SMITH, LOGAN. *The Life and Letters of Sir Henry Wotton*, Oxford • WIRTH, ZDENEK. *Soupis památek historickych a umeleckych v politickém okresu kladenském*, XX, Praha

1907-1926 HOFSTEDE DE GROOTE, C. *Beschreibendes und kritisches Verzeichnis der Werke der hervorragendsten holländischen Maler des XVII. Jahrhunderts*, 10 voll., Esslingen

1907-1950 THIEME, ULRICH; BECKER, FELIX. *Allgemeines Lexikon der bildenden Künstler von der Antike bis zur Gegenwart*, Leipzig, Verlag von Wilhelm Engelmann

1908 AUQUIER, P. *Musée des Beaux-Arts de Marseille, catalogue des peintures, sculptures, pastels et dessins*, Marseille • DESHAIRS, LÉON. *L'architecture et décoration au XVIII siècle*, Paris • SCHUBERT, OTTO. *Geschichte des Baroks in Spanien*, Esslingen • RIEGL, ALOIS. *Die Entstehung der Barockkunst in Rom. Akademische Vorlesungen*, Wien

1909 ANDROUET DU CERCEAU, JACQUES. *French châteaux and gardens in the XVIth century*, a series of reproductions of contemporary drawings

hitherto unpublished. Selected and described with an account of the artist and his works, ed. H.W. Ward, London, Batsford • GRABAR, I.E. *The Architecture of St. Petersburg in the 18th and 19th Centuries*, Istorija russkogo iskusstva, III, Moskva

1910 DE NOLHAC, P. *Hubert Robert*, Paris • FLEISCHER, V. *Fürst Karl Eusebius von Liechtenstein als Bauherr und Kunstsammler*, Wien-Leipzig • MEYER, CHRISTIAN. *Die Hauschronik der Familie Holl insbesondere die Lebensbeschreibung des Elias Holl, Baumeister der Stadt Augsburg*, München • VOSS, HERMANN. "Berninis Fontänen", *Jahrbuch der Königlich Preußischen Kunstsammlungen*, 31: 99-129

1910 (1979) JANTZEN, HANS. *Das Niederländische Architekturbild*, Leipzig (ristampa Braunschweig)

1911 BRINCKMANN, ALBERT ERICH. *Deutsche Stadtbaukunst in der Vergangenheit*, Frankfurt • LEMONNIER, HENRY. *L'art français au temps de Louis XIV*, Paris • MOLMENTI, POMPEO. *Tiepolo. La vie et l'œuvre du peintre*, Paris • PINDER, WILHELM. *Deutscher Barock*, Düsseldorf-Leipzig

1911-1929 LEMONNIER, HENRY. *Procès-Verbaux de l'Académie Royale d'Architecture, 1671-1793*, Paris, Jean Schemit et Edouard Champion, 4, 7, 10

1912 HAUTECŒUR, LOUIS [a]. *L'architecture classique à Saint-Pétersbourg à la fin du XVIII siècle*, Paris • — [b]. *Rome et la Renaissance de l'antiquité à la fin du XVIII siècle*, Paris • PINDER, WILHELM. *Deutscher Barock*, Düsseldorf-Leipzig • PLANAT, PAUL A.; RÜMLER, ERNST. *Le style Louis XIV*, Paris • RIEGL A., *F. Baldinuccis Vita des G.L. Bernini*, hrsg. von A. Burda und O. Pollak, Wien, 34 • TELLUCCINI, AUGUSTO. *La real Chiesa di Soperga*, Torino • VALLANCE, AYMER. *The Old Colleges of Oxford*, London

1913 *Die Architektur der Barock-und Rokokozeit, in Deutschland und der Schweiz*, hrsg. von H. Popp, Stuttgart • *Österreichische Kunsttopographie*, X: *Die Denkmale des polit. bezirks Salzburg*, II, *Die Gerichtsbezirke Mattsee und Oberndorf*, hrsg. von P. Buberl, Wien • BESNARD, A. "Un projet de portail pour Saint-Sulpice", *L'architecture*, 26, 14, 105-7 • BRIGGS, MARTIN SHAW. *Baroque Architecture*, London • DESHAIRS, L. "Les Arabesques de Watteau", *A.A.F.*, 7 • MAYEUX, ALBERT. "Les vicissitudes de construction de l'église de Saint-Sulpice", *L'architecture*, 26, 17, 132-34 • POÈTE, MARCEL. *La promenade à Paris, au XVII siècle*, Paris • POLLAK, OSKAR. "Italienische Künstlerbriefe aus der Barockzeit", *Jahrbuch der k. Preußischen Kunstsammlungen*, 34, Beiheft • ROUCHÈS, GABRIEL. *Inventaire des lettres et papiers manuscrits de Gaspare, Carlo et Lodovico Vigarani. Papiers manuscits conservés aux Archives d'Etat de Modène (1634-1684)*, Paris, Honoré Champion

1914 *Österreichische Kunsttopographie*, XIII: *Die profanen Kunstdenkmäler der Stadt Salzburg*, Wien • BIERMANN, GEORG. *Deutsches Barock und Rokoko. Im Anschluss an die Jahrhundert-Ausstellung deutscherkunst 1650-1800*, 2 vols., Darmstadt • SCHEURLEER, D.F. *Het orgel der Nieuwe Luthersche Kerk te Amsterdam 1715*", *Tijdschrift der Vereeniging voor Nederlandsche Musiekgeschiedenis*, 9, 239-444 • SCOTT, GEOFFREY. *The Architecture of Humanism, A Study in the History of Taste*, Boston-New York • SIRÉN, OSWALD. *Nicodemus Tessin d.y:s studieresor*, Stockholm

1915 BELLUCCI, A. *Memorie storiche ed artistiche del Tesoro nella Cattedrale dal secolo XVI al XVIII*, Napoli • BRATTI, R. "Notizie d'arte e d'artisti", *Nuovo Archivio Veneto*, n.s., XV, XXX, III, 435-85 • BRINCKMANN, ALBERT ERICH. *Baukunst des 17. und 18. Jahrhunderts in den romanischen Ländern*, Berlin • BURG, HERMANN. *Der Bildhauer F.A. Zauner*, Wien • FRANKL, PAUL. *Die Entwicklungsphasen der neueren Baukunst*, Leipzig • TASSINI, GIUSEPPE. *Curiosità veneziane*, a cura di E. Zorzi, Venezia (5a ed.) • WACKERNAGEL, MARTIN. *Die Baukunst des 17. und 18. Jahrhunderts in den germanischen Ländern*, Berlin-Neubabelsberg • WÖLFFLIN, HEINRICH. *Kunstgeschichtliche Grundbegriffe*, München

1916 McMASTERS, J. *A Short History of the Royal Parish of St Martin-in-the-Fields*, London

1918 MARES, FRANTISEK; SEDLÁCEK, JAN. *Soupis památek historickych a umeleckych v králosttví ceském, XLI Policky okres krumlovsky*, Praha • MATSCHE, F. *Die Kunst im Dienst der Staatsidee Keiser Karls VI*, 2 voll., Berlin-New York

1919 BRINCKMANN, ALBERT ERICH. *Baukunst des 17. und 18. Jahrhunderts in den romanischen Ländern*, Berlin-Neubabelsberg

1920 *Tricentenaire de Pierre Puget*, catalogue de l'exposition, Marseille, musée des Beaux-Arts • GRADARA, C. *Pietro Bucci scultore romano, 1700-1773*, Roma • RÈ E., "Maestri di strade", in *Archivio della Società Rom.*, XLII, 5-102 •

TIETZE-CONRAT, ERIKA. "Ein Modell zur Wiener Pestsäule von 1687", *Kunstchronik und Kunstmarkt*, 25-26, 505

1920 (1922) WEINGARTNER, JOSEPH. "Der Umbau des Brixner Domes im 18. Jahrhundert", *Jahrbuch des kunsthistorischen Institutes*, XIV, Wien: 57-162

1921 CHEVALLEY, GIOVANNI. "Il Palazzo Carignano a Torino", *Bollettino della Società Piemontese di Archeologia e Belle Arti*, 1/2, 4-14

1921-1922 (1923) POPP, ANNY E. "Der Barberinische Faun", *Jahrbuch für Kunstgeschichte*, I (XV): 215-35

1921-1956 LUGT, FRITS. *Les marques de collections de dessins et d'estampes*, Amsterdam - Den haag, Vereenigde Drukkerijen - Martinus Nijhoff

1922 COURTEAULT, PAUL. "La Place Royale de Bordeaux", *Archives de l'Art Français*, XII • VOSS, HERMANN. "Bernini als Architekt an der Scala Regia und an den Kolonnaden von St. Peter", *Jahrbuch der preußischen Kunstsammlungen*, XLIII: 2-30

1922-1929 DACIER, E.; VUAFLART, A. *Jean de Jullienne et les graveurs de Watteau au XVIIIème siècle*, 4 voll., Paris

1923 BERKELEY, GEORGE. *Saggio di una nuova teoria della visione*, LXV, Lanciano, R. Carabba • SEDLMAIER, RICHARD; PFISTER, RUDOLF. *Die Fürstbischöfliche Residenz zu Würzburg*, München • VAN HOOGEWERFF, GODEFRIDUS J. *Jan van Scorel*, Den Haag • WEINGARTNER, JOSEF. "Der Umbau des Brixner Domes im XVIII. Jahrhundert", Sonderdruckaus, *Jahrbuch des Kunsthistorischen Institutes des Staatsdenkmalamtes*, XIV, Wien, 20-22, fig. 2

1923-1925 BRINCKMANN, ALBERT ERICH. *Barock-Bozzetti*, Frankfurt am Main

1924 CORDEY, JEAN. *Vaux-le-Vicomte*, Paris, Albert Morancé • DAHLBERG, ERIC JÖNSSON. *Suecia Antiqua et Hodierna*, ed. A. Rydfors; introduction by E. Vennberg, Sueciaverkets historia, Stockholm • GOODHART-RENDEL, H.S. *Nicholas Hawksmoor*, London • GRADARA PESCI C. *Pietro Bracci*, Milano • HEMPEL EBERHARD, *Francesco Borromini*, Wien • MIDANA, ARTURO. *L'arte del legno in Piemonte del Sei e Settecento*, Torino • PERRAUD-CHARMANTIER, ANDRÉ. "Acquisition par Nicolas Fouquet à Mme de Lyonne, de l'étang de Vaux-le-Vicomte et des terres avoisinantes", *Bulletin de la Société de l'Histoire de Paris et de l'Ile-de-France*, 2 • RIESENHUBER, MARTIN. *Die kirchliche Barockkunst in Österreich*, Linz • ROWATT, THOMAS. "Notes on Original Models of the Eddystone Lighthouse", *Transactions of the Newcomen Society*, V, 15-23

1925 LLOUD, NATHANIEL. *A History of English Brickwork*, London

1925 (circa) FREY, DAGOBERT [a]. *Die Architekturzeichnungen der Kupferstichsammlung der Oster. Nationalbibliothek*, Wien • — [b]. *Architettura barocca*, Roma-Milano

1926 BLEIBAUM, FRIEDRICH. *Die Bau- und Kunstdenkmäler im Regierungsbezirk Cassel*, VII, I: *Schloß Wilhelmstahl*, Kassel • NEKRASOV A.I. *Barokko v Rossii*, Moskva • TELLUCCINI, AUGUSTO. *L'arte dell'architetto Filippo Juvarra in Piemonte*, Torino

1926 (1988) GOTHEIM, MARIE LUISE. *Geschichte der Gartenkunst*, 2 voll., Jena (München)

1927 RÉAU, LOUIS. "Hubert Robert, peintre de Paris", *Bulletin de la Société d'histoire de l'art français*

1928 EHRLE, FRANZ. "Dalle carte e dai disegni di Virgilio Spada (d. 1662), Codd. Vaticani Lat. 11257 e 11258", *Atti della Pontificia Accademia Romana di Archeologia*, Serie III, Memorie IV (1978), 1-98 • GUNTHER, R.T. *The Architecture of Sir Roger Pratt. Charles II's commissioner for the rebuilding of London after the Great Fire: now printed for the first time from his Note-Books*, Oxford • HUARD, GEORGES. "Oppenord, 1672 à 1742", in *Les peintres français du XVIIIe siècle*, sous la direction de L. Dimier, Paris-Bruxelles, Les éditions G. van Oest, 311-29, 395 • HUSSEY, CHRISTOPHER. "Melton Constable Hall, Norfolk", *Country Life*, LXIV, 364, 402 • JOSEPHSON, RAGNAR. "Tessin in Deutschland", *Baltische Studien*, 27-58 • OLIVERO, EUGENIO. "La Reale Cappella della SS. Sindone", *Il Duomo di Torino, Periodico religioso storico-artistico*, II, 3, 6-12 • PINDER, WILHELM. *Das Problem der Generation in der Kunstgeschichte*, Leipzig • TIPPING, H.A.; HUSSEY, C. *English Homes*, IV, II, London • VANBRUGH, JOHN (SIR). *The Complete Works of Sir John Vanbrugh*, IV, *The Letters* (ed. G. Webb), London • ZELLER, GASTON. *L'Organisation Défensive des Frontiers du Nord et de l'Est au XVIIe Siècle*, Paris

1928-1930 *Les peintres français du XVIIIème siècle*, sous la direction de L. Dinier, Paris-Bruxelles, vol. 1, 1928 (Watteau, Coypel, Gillot, Oppenord, Pineau), vol. 2, 1930 (Lajoüe, Meissonnier)

1929 *The Wren Society (1924-43)*, a cura di A.T. Bolton e H.D. Hendry, VI, *The Royal Navy Hospital, Greenwich*, Oxford • CROCE, BENEDETTO. *Storia della età barocca in Italia*, Bari • GOLZIO, V. "L'Accademia di San Luca come centro culturale e artistico nel Settecento", in *Atti del I congresso di studi romani*, Roma, 1, 749 ss. • GRIMSCHITZ, BRUNO. "Johann Lucas von Hildebrandts Kirchenbauten", *Wiener Jahrbuch für Kunstgeschichte*, VI: 232-56 • MIDANA, ARTURO. *Il Duomo di Torino e la Real Cappella della SS. Sindone*, Torino • OZINGA, M.D. *De protestantsche kerkenbouw in Nederland. Van Hervorming tot Fransche tijd*, Amesterdam • PLANTENGA, J.H. *Verzamelde Opstellen*, II, Amsterdam

1930 *The Wren Society (1924-43)*, eds. A.T. Bolton and H.D. Hendry, VII, *The Royal Palaces of Wichchester, Whiteall, Kensington and St James's, 1660-1715, from collections at All Souls College, Oxford; The Pepys's Library, Cambridge; The British Museum; Sir John Soane's Museum; H.M. Office of Works; and the Royal Institute of British Architects Libray*, Oxford • GABRIELS, JULIANE. *Artus Quellien, de Oude. "Kunstryck belthouwer"*, Antwerpen • JOSEPHSON, RAGNAR. *L'Architecture de Charles XII. Nicodème Tessin à la cour de Louis XIV*, Paris-Bruxelles • PIVA, VITTORIO. *Il tempio della Salute eretto per voto della Repubblica veneta*, XXVI-X-MDLCCC, Venezia • SCHUDT, LUDWIG. *Le guide di Roma*, Wien-Augsburg • TELLUCCINI, A. "Il castello di Rivoli Torinese", *Bollettino d'Arte*, X

1930-1931 GEROLA, GIUSEPPE. [a]. "Le fortificazioni di Napoli di Romania", *Annuario della regia Scuola Archeologica di Atene*, XIII-XIV, 347-410 • [b]. "I plastici delle fortezze venete al Museo storico navale di Venezia", in *Atti dell'Istituto Veneto di Scienze, Lettere e Arti*, II, 217-21

1930-1955 VERTUE, GEORGE. *Note books*, The Walpole Society, 18, 20, 22, 24, 26, 29, 30, Oxford

1931 *L'ostensione della Santa Sindone, Torino - MCMXXXI*, a cura di C. Lovera di Castiglione e C. Merlo, catalogo della mostra, Palazzo Madama, Torino • *The Wren Society (1924-43)*, a cura di A.T. Bolton e H.D. Hendry, VIII: 32 large drawings for Whiteall, Windsor and Greenwich, 1694-1698. Original Wren drawings, purchased by Dr Stack, in 1749, being now volume V in the Collection of All Souls College, Oxford, Oxford • BRAUER, HEINRICH; WITTKOWER, RUDOLF. *Die Zeichnungen des Gianlorenzo Bernini*, 2 voll., Berlin, Römische Forschungen der Bibliotheca Hertziana, 84-87 • BRINCKMANN, ALBERT E. *Theatrum novum Pedemontii. Ideen. Entwürfe und Bauten von Guarini, Juvarra, Vittone wie anderen bedeutenden Architekten des piemontesischen Hochbarocks*, Düsseldorf • KARLING, STEN. *Trädgårdskonstens historia i Sverige intill Le Nôtrestilens genombrott*, Stockholm • LEMESLE, GASTON. *L'église Saint-Sulpice*, Paris, Bloud & Gay • LINFERT, CARL. "Die Grundlagen der Architekturzeichnung (Mit einem Versuch über französische Architekturzeichnungen des 18. Jahrhunderts)", *Kunstwissenschaftliche Forschungen*, 133-244 • WEBB, GEOFFREY. "Letters and Drawings of Nicholas Hawksmoor", *Walpole Society*, XIX

1932 BERNT, W. *Die Niederländischen Malerei des XVII. Jahrhunderts*, 3 voll., München • BRINCKMANN, ALBERT ERICH. "Von Guarini bis Balthasar Neumann", in *Jahresgabe des deutschen Vereins für Kunstwissenschaft*, Berlin • COURTEAULT, PAUL. *Bordeaux cité classique*, Bordeaux • KIMBALL, FISKE. "William Kent's Designs for the Houses of Parliament", *Royal Institut of British Architects Journal*, XXXIX

1933 *Hubert Robert*, catalogue de l'exposition, Paris, Orangerie • ARGAN, GIULIO CARLO. "Per una storia dell'architettura piemontese", *L'Arte*, XXXVI, 391-97 • BRINCKMANN, ALBERT ERICH. "La grandezza di Guarino Guarini e la sua influenza sull'architettura in Germania nel '700", *Atti della Società Piemontese di Archeologia e Belle Arti*, XV, 348-74 • MALBOIS, EMILE. "Oppenord e l'église Saint-Sulpice", *Gazette des Beaux-Arts*, 9, 140, 34-36 • STERLING, CH. *Hubert Robert 1733-1808*, catalogue de l'exposition, Paris, Musée de l'Orangerie

1934 DIGARD, JEANNE. *Les Jardins de La Granja et leurs sculptures decoratives*, Paris, E. Leroux • OLDEWELT, W.F.H. "Eenige posten uit de thesauriers-memorialen van Amsterdam van 1664-1764", *Oud Holland*, 51; 69-72, 162-65 • PETERMAIR, HANS. *Die bauliche Anlage der Stifte in Altenburg, Herzogenburg und Seitenstetten und ihre baukünstlerischen Beziehungen im Mittelalter und in der Barocke*, Magisterarbeit, Wien

1935 LO GATTO, E. *Gli artisti italiani in Russia*, II, Roma • WITTKOWER, RUDOLF. "Pietro da Cortonas Ergänzungsprojekt des Tempels in Palestrina", in *Adolf Goldschmidt zum 70. Geburtstag*, Berlin: 137-43

1936 *The Wren Society (1924-43)*, a cura di A.T. Bolton e H.D. Hendry, XII, *Drawings at All Souls College, Oxford*, 2, Oxford • DE SANTIAGO CIVIDANES, M. *Historia de la Plaza Mayor de Salamanca*, Salamanca • FELL, H. GRANVILLE. "Drawings by Israël Silvestre 1621-91", *Connoisseur*, 97, 18-22 • FRITZSCHE, HELLMUTH ALLWILL. *Bernardo Bellotto, gennannt Canaletto*, Bur-bei-Magdeburg • LORET, MATTIA. "Attività ignote di Filippo Juvarra a Roma", in *La Critica d'Arte*, VII, 198-201 • NOACH, A. "Een vergeten ontwerp voor het Paleis op den Dam", *Jaarboek Amstelodamum*, 33: 141-54 • PAPI, GIANNI. "Il castello dei Savoia in Rivoli Torinese", *Rassegna Mensile Municipale*, 6-7, Torino

1937 CHIERICI, G. *La Reggia di Caserta*, Roma • HEYDENREICH, LUDWIG HEINRICH. "Architekturmodelle", in *Reallexikon zur Deutschen Kunstgeschichte*, I, Stuttgart, col. 918-40 • PFISTER, RUDOLF. "Die Augsburger Rathaus-Modelle des Elias Holl", *Münchner Jahrbuch der bildenden Kunst*, n.s. XII, 90 • ROVERE, LORENZO; VIALE, VITTORIO; BRINCKMANN, ALBERT ERICH. *Filippo Juvarra*, Milano • WEBB, GEOFFREY. *Wren*, London

1938 *Umení v Cechách XVII.-XVIII. století. Pražské baroko 1600-1800*, eds. J. Vydrová-E. Sedlácková, exhibition catalogue, Praha, Umelecká Beseda • FREY, DAGOBERT. "Berninis Entwürfe für die Glockentürme von St. Peter in Rom", *Jahrbuch der Kunsthistorischen Sammlungen in Wien*, XII, 203-26 • MATVEEV, A. *Rastrelli*, Moskva, 129-48

1938-1939 JOSEPHSON, RAGNAR. *Tessin*, Stockholm, 2 vols.

1939 BATOVSKI, Z. *Arcitekt Rastrelli o svoich pracach*, L'vov, ill. 6-7 • MONTEVECCHI, LIANA. "Catalogo dei Codici epigrafici della Biblioteche milanesi", in *Epigrafica*, I, 75 • PHILLIPS, J.G. "Guglielmo della Porta. His Ovid Plaquettes", *Bulletin of The Metropolitan Museum of Art*, XXIV: 148-51 • TSCHIRA, ARNOLD. *Orangerien und Gewächshäuser. Ihre geschichtliche Entwicklung in Deutschland*, Berlin

1939-1941 MAURONER, FABIO. "Catalogue of the Etchings of Gianfrancesco Costa", *The Print Collector's Quarterly*, XXVII, 2, 470-95 • ZACCARIA, M. "L'architetto Girolamo Frigimelica e il suo progetto della Biblioteca Universitaria", *Bollettino del Museo Civico di Padova*, XIX-XXX [estratto]

1939 (1965) BACHMANN, FRIEDRICH. *Die alten Städtebilder. Ein Verzeichnis der graphischen Ortsansichten von Schedel bis Merian*, Leipzig (Stuttgart)

1940 *Survey of London*, XX, London • FOGOLARI, GIULIO. "Lettere inedite di G.B. Tiepolo", *Nuova Antologia*, 1, settembre, 32-37 • MAURONER, FABIO. "Michiel Marieschi", *The Print Collector's Quarterly*, XXVII, 179-216

1941 GALLO, RODOLFO. "L'incisione del Settecento a Venezia e a Bassano", *Ateneo Veneto*, CXXXII, 5-7; 153-214 • GIANNONE, ONOFRIO. *Giunte sulle vite dei pittori napoletani*, a cura di O. Morisani, Napoli, 181 • GIEDION, SIGFRIED. *Space, Time and Architecture*, Cambridge, Mass. • KOOIMAN, W.J. *De Ronde Lutherse kerk te Amsterdam*, Amsterdam • PASSANTI, MARIO. "La Real Cappella della Santa Sindone", Torino, 10-12 • PICO DELLA MIRANDOLA, GIOVANNI. *De hominis dignitate (1486)*, Firenze, Le Monnier

1942 BATTAGLIA, R. "Crocifissi del Bernini in S. Pietro in Vaticano", *Quaderni di Studi Romani*, XI: 21-28 • FOGOLARI, GIULIO. "Lettere inedite di G.B. Tiepolo", *Nuova Antologia*, 1, settembre, 32-37 • LANGE, AUGUSTA. "Tre disegni inediti di opere di Juvarra", in *Bollettino del Centro di Studi Archeologici ed Artistici del Piemonte*, • LANGENSKIÖLD, E.; MOSELIUS, C.D. *Nationalmusei Utställningskatalog. 79. Arkitekttuttiningar ... Carl Johan Cronsteds Fullerösamling*, Stockholm • LIVAN, L. *Notizie d'arte tratte dai notatori e dagli annali del N.H. Pietro Gradenigo*, Venezia • WHINNEY, MARGARET. "John Webb's Drawings for Whitehall Palace", *Walpole Society*, XXXI, 88-95

1943 (1949) KIMBALL, F. *The Creation of the Rococo decorative Style*, Philadelphia, (trad. française *Le style Louis XV, Origine et évolution du Rococo*, Paris)

1944 ESDAILE, K.A. *St Martin-in-the-Fields: Old and New*, London • GALLO, RODOLFO. "Una famiglia patrizia. I Pisani e i palazzi di Santo Stefano e di Stra", *Archivio Veneto*, LXXV, 65-228 • GÖRING, M. *Francesco Guardi*, Wien • GRASSI, LUIGI. *Disegni del Bernini*, Bergamo • PRANDI, ADRIANO. "Antonio Derizet e il concorso per la facciata di San Giovanni in Laterano", Roma, 22, 23-71

1945 PASSANTI, MARIO. *Architettura in Piemonte da Emanuele Filiberto all'Unità (1563-1870)*, Torino • SLOTHOUWER, D.F. *De paleizen van Frederik Hendrik*, Leiden • SUMMERSON, JOHN.

Georgian London, London • WITTKOWER, RUDOLF. "Lord Burlington and William Kent", *Archaeological Journal*, CII (reprinted in Wittkower R., *Palladio and English Palladianism*, ed. M. Wittkower), London-New York, 115-34

1946 *Architektur und Dekorations-Zeichnungen der Barockzeit aus der Sammlung Edmond Fatio*, Genf, Zürich • BLAZÍCEK OLDRICH, JAKUB. *Pražská plastika raného rokoka*, Praha • WHIFFEN, MARCUS. "The Progeny of St Martin-in-the-Fields", *Architectural Review*

1947 WEBB, GEOFFREY. "Baroque Art", *Proceedings of the British Academy*, XXXIII

1948 ANDRÉN, ERIK. *Skokloster. Ett slottsbygge under stormaktstiden*, Stockholm • BLAZÍCEK OLDRICH, JAKUB. *Rokoko a konec baroku v Cechách*, Praha • HAUTECŒUR, L. *Histoire de l'architecture classique en France*, I-II, Paris • JOURDAIN, MARGARET. *The Work of William Kent*, London • KRAUTHEIMER, RICHARD. "The Tragic and Comic Scene of the Renaissance: the Baltimore and Urbino Panels", *Gazette des Beaux-Arts*, XXXIII: 327 ss. • LANG, S. "Cambridge and Oxford Replanned; Hawksmoor as a Town-Planner", *Architectural Review* • NEURDENBURG, ELISABETH. *De zeventiende eeuwsche beeldhouwkunst in de Noordelijke Nederlanden*, Amsterdam • NISSER, WILHELM. *Die italienischen Skizzenbücher von Erik Jönson Dahlberg und David Klöcker Ehrenstrahl* (Vilhelm Ekmans Universitätsfonds, 51:1 und 2), Uppsala: figg. 83-83, nn. D. 10863, D. 10881 • PARKER, K.T. *Drawings of Antonio Canaletto in the Collection of H.M. the King of Windsor*, Oxford-London

1948-1950 HAUTECŒUR, L. *Histoire de l'architecture classique en France*, Paris, 2-3

1949 DORNER, A. *The Way Beyond Art*, New York • LANG, S. "By Hawksmoor out of Gibbs", *Architectural Review*, 183-90 • WITTKOWER, RUDOLF [a]. "Documenti sui Modelli per la Sacrestia di San Pietro in Roma", *Bollettino della Società Piemontese di Archeologia e Belle Arti*, III, 157-59 • — [b]. "Il terzo braccio del Bernini in piazza San Pietro", in *Bollettino d'arte*, s. IV, XXXIV, 129-34 • — [c]. *Architectural Principles in the Age of Humanism*, London • — [d]. "Un libro di schizzi di Filippo Juvarra a Chatsworth", *Bollettino della Società Piemontese di Archeologia e Belle Arti*, III

1950 *Dessins du Nationalmuseum de Stockholm. Collections Tessin et Cronstedt, I. Claude III Audran (1658-1734), II: Dessins d'architecture et d'ornements*, catalogue de l'exposition, Paris, Bibliothèque Nationale • *Marseille au temps de Pierre Puget*, catalogue de l'exposition, Marseille, Chapelle des Bernardines • COLVIN, H.M. "Fifty New Churches", *Architectural Review*, CVII, 189-96 • FRANZ, H.G. *Die Frauenkirche zu Dresden*, Berlin • HAUTECŒUR, LOUIS. *Histoire de l'Architecture classique en France, 3: Première moitié du XVIIIe siècle; le style Louis XIV*, Paris, Editions A. et J. Picard et Cie • KÄHLER, HEINZ. *Hadrian und seine Villa bei Tivoli*, Berlin • VAN LUTTERVELT, R. *Het raadhuis on de Dam*, Amsterdam • WINDISCH-GRAETZ, FRANZ. *J.Ch. Schletterer, ein Bildhauer des Wiener Spätbarock*, Diss., Wien, 153, 163 ss.

1950-1951 VIALE, VITTORIO. "Un dipinto del Pannini con la veduta orientale del Castello di Rivoli", *Bollettino della Società Piemontese di Archeologia e Belle Arti*, IV-V: 163-64

1951 *Dessins du Nationalmuseum de Stockholm. Versailles et les maisons royales. Trois cents dessins des collections Tessin, Harleman et Cronstedt. Tapisseries du Garde-Meuble*, catalogue de l'exposition, Château de Versailles • *Versailles et les maisons royales*, Château de Versailles • BENEVOLO, LEONARDO. "La chiesa parrocchiale di Campertogno", *Palladio*, I: 165-73 • CRAVERO, DAVIDE GIOVANNI. "Il Palazzo Carignano", *Atti e Rassegna Tecnica della Società Ingegneri e Architetti in Torino*, V, 55-63 • MARIACHER, GIOVANNI. "Il continuatore del Longhena e Palazzo Pesaro", *Ateneo Veneto*, CXLII, 1-7 • MICHAJLOV, A.I. *Baz'enov*, Moskva • REINLE, ADOLF. "Ein Fund barocker Kirchen und Klosterplane. II Teil. Süddeutsche Meister", *Zeitschrift für Schweizerische Archaeologie und Kunstgeschichte*, 12, 1-27

1952 PITTALUGA, MARY. *Acquafortisti veneziani del Settecento*, Firenze • SCHIAVO, A. "Progetto di Mario Gioffredo per la Reggia di Caserta", *Palladio*, I • STRAUB, H. *A History of Civil Engineering*, London

1953 BLUNT, ANTHONY. *Art and architecture in France 1500 to 1700*, Melbourne-London-Baltimore • DUBOIS-PICHLER, E.T. "Influence exercée en Angleterre par le Hortorum Libri VI du P. Rapin", *XVIIème siècle, Revue trimestrielle publiée par la société d'études du XVIIème siècle*, 20, 330-40 • FREMANTLE, KATHARINE. "Some Drawings by Jacob van Campen for the Royal Palace of Amstersam", *Oud Holland*,

68; 73-95 • HUYGHE, RENÉ. "Classicisme et baroque dans la peinture française au XVIIème siècle", *XVIIème siècle, Revue trimestrielle publiée par la société d'études du XVIIème siècle*, 20, 274-92 • ISARLO, C. "Hubert Robert", *Connaissance des Arts*, 18 • LANGER, SUSANNE K. *Feeling and Form*, New York, 96 • LEES-MILNE, JAMES. *The Age of Inigo Jones*, London • LO GATTO, A. *Gli artisti italiani in Russia*, Milano, II, 137 • PANE, ROBERTO. *Bernini architetto*, Venezia • POPHAM, A.E. "The Royal Collections II, the Drawings", in *Burlington Magazine*, LXVI, 218-28 • SUMMERSON, JOHN. *Wren*, London • VANUSCEM, JACQUES. "Baroque allemand et baroque français dans l'art de la fin du XIIème siècle", *XVIIème siècle, Revue trimestrielle publiée par la société d'études du XVIIème siècle*, 20, 306-18 • WATSON, F.J.B. "New Lights on Watteau's 'Les Plaisirs du bal'", *The Burlington Magazine*, 95, 104 • WHINNEY, MARGARET. *Archaeological Journal*, CX

1953 (**1986**) BRAUDEL, FERNAND. *Civiltà e imperi del Mediterraneo nell'età di Filippo II*, Torino

1953-1958 ROBERTS, MICHAEL. *Gustavus Adolphus: A History of Sweden 1611-1632*, 2 vols., London

1954 *Annual Report 1953-1954*, Ottawa, National Gallery of Canada • *Masterpieces of Drawing from the Musée de Besançon*, USA, Knoedler Gallery • ACKERMAN, JAMES S. *The Cortile del Belvedere*, Studi e documenti per la storia del Palazzo apostolico vaticano, 3, Città del Vaticano, Biblioteca Apostolica Vaticana • FAVARO, FABRIS M. *L'architetto Francesco Maria Preti di Castelfranco Veneto*, Treviso • FERRARI, ORESTE. "Leonardo Coccorante e la 'veduta ideata' napoletana", *Emporium*, 60, 9-20 • GRABAR', I.E. *Russkaja architektura pervoj poloviny XVIII veka. Issledovanija i materialy*, Moskva • HOLLOWAY, J. "A James Gibbs Autobiography", *The Burlington Magazine*, 147-51 • LANG, S. "Gibbs: A Bicentenary Review of his Architectural Sources", *Architectural Review* • LAVEDAN, PIERRE. *Représentation des villes dans l'art du Moyen Age*, Paris • MOSCHINI, VITTORIO. *Canaletto*, Milano • ROTILI, M. "Il progetto vanvitelliano per la Fontana di Trevi", *Samnium*, 27: 54-64 • WHISTLER, LAURENCE. *The Imagination of Vanbrugh and his Fellow Artists*, London • ZERI, FEDERICO. *La Galleria Spada in Roma*, Firenze, ill. 96-97

1954-1955 ELBERN, V.H. *Peter Paul Rubens: Triumph der Eucharistie, Wandteppische aus dem Kölner Dom*, Ausstellungskatalog, Essen, Villa Hügel

1955 *Fiamminghi a Roma 1508-1608*, a cura di N. Dacos, catalogo della mostra, Roma • CROZET, RENÉ. "Le Phare de Cordouan", *Bulletin Monumental*, 3: 153-71 • CZOBOR, A. "Remarques sur une composition de Jan Muller", *Bulletin du Musée Hongrois des Beaux-Arts*, 6, 34-39 • EVELYN, JOHN. *Diary*, ed. E.S. de Beer, Oxford • GOMBAÚ GUERRA, G. *Salamanca. La Plaza Mayor*, Salamanca • LITTLE, BRYAN. *The Life and Work of James Gibbs: 1682-1754*, London • PIRRI, PIETRO. *Giovanni Tristano e i primordi dell'architettura gesuitica*, Roma, 160-69, 256-58

1955 (**1982**) VERLET, PIERRE. *Les meubles français du XVIIIᵉ siècle*, Paris

1955-1997 WITTKOWER, RUDOLF. *Bernini, the Sculptor of the Roman Baroque*, London, 1955 (posthumous revised edition London, 1997)

1956 COOKE, H.L. "The Documents Relating to the Fountain of Trevi", *Art Bulletin*, 33: 149-73 • DAVIES, J.H.V. "The Dating of the Buildings of the Royal Hospital at Greenwich", *Archaeological Journal*, CXIII, 126-36 • DE BERNARDI FERRERO, D. *I "disegni d'architettura civile et ecclesiastica" di Guarino Guarini e l'arte del maestro*, Torino, 7-8 • FLEMING, JOHN. "The Pluras of Turin and Bath", *The Connoisseur*, CXXXVIII: 175-81 • FUERST, VIKTOR. *The Architecture of Sir Christopher Wren*, London • HEMPEL, EBERHARD. *Gaetano Chiaveri, der Architekt der katolischen Hofkirche zu Dresden; mit baugeschichten und zeichnerischen Beiträgen von Walter Krönert*, Hanau • HUGUENEY, JEANNE. "Les plans de villes de la façade de l'église Santa Maria Zobenigo à Venise", *La Vie urbaine*, 1 • LEVEY, MICHAEL. *The Eighteenth Century. Italian Schools*, National Gallery Catalogue, London • MILLAR, OLIVER. "The Whitehall Ceiling", *The Burlington Magazine*, XCVIII, 258-67 • MÖLLER, HANS-HERBERT. *Gottfried Heinrich Krohne und die Baukunst des 18. Jahrhunderts in Thüringen*, Berlin • PORTOGHESI, PAOLO. *Guarino Guarini 1624-1683*, Milano • ROSCI, M. "Filippo Juvarra e il nuovo gusto classico" in *Atti dell'VIII Convegno Nazionale di Storia dell'Architettura*, Roma, 239-57, ill. 1 e 2 • SCHIAVO, ARMANDO. *La Fontana di Trevi e le altre opere di Nicola Salvi*, Roma, 36-61 • SEKLER, E.F. *Wren and his Place in European Architecture*, London • SOLERO, S. *Il Duomo di Torino e la R. Cappella della Sindone*, Pinerolo • SUMMERSON, JOHN.

Architecture in Britain. 1530-1830, London, 155-70 • WAGNER-RIEGER, RENATE. "Die Piaristenkirche in Wien", *Wiener Jahrbuch für Kunstgeschichte*, XVII: 49-62

1956-1957 *Johann Bernhard Fischer von Erlach*, Ausstellungskatalog, Graz-Wien-Salzburg • AURENHAMMER, HAHS. *J.B. Fischer von Erlach*, Ausstellungskatalog, Graz-Wien-Salzburg • GALLO, RODOLFO. "Canaletto, Guardi, Brustolon", *Atti dell'Istituto Veneto di Scienze, Lettere e Arti*, CXV [estratto]

1957 ARGAN, GIULIO CARLO. *L'architettura barocca in Italia*, Milano • BENEVOLO, LEONARDO. *Le chiese barocche valsesiane*, Roma • BLUNT, ANTHONY. *Art and Architecture in France 1500-1700* • CORNILLOT, L. *Inventaire général des dessins des musées de province. Collection Pierre-Adrien Pâris*, Besançon • D'ONOFRIO, CESARE. *Le fontane di Roma*, Roma • FORTI, U. *Storia della tecnica dal Medioevo al Rinascimento*, Firenze • LEVEY, MICHAEL. "Panini, St. Peter's and Cardinal de Polignac", *The Burlington Magazine*, 99, 53-56 • LUIPOV, S.P. *Istorija stroitel'stva Peterburga v pervojcetverti XVIII veka*, Moskva • PARKER, K.T.; MATHEY, J. *Antoine Watteau Catalogue complet de son œuvre dessiné*, 2 voll., Paris • RODRIQUEZ, F. *Guida della Pinacoteca di Bologna*, Bologna • VLASJUK, A.I.; KAPLUN, A.I.; KIPARISOVA, A.A. *Kazakov*, Moska • WHINNEY, MARGARET. "Sir Christopher Wren's Visit to Paris", *Gazette des Beaux-Artes*, LI, 229-42 • WHINNEY, MARGARET; MILLAR, OLIVER. *English Art: 1625-1714*, Oxford History of Art

1958 BIEDERSTEDT, R. "Mitteilungen zur Geschichte der Familie Eosander", *Personhistorisk tidskrift*, 56 • BLAZICEK OLDRICH, JAKUB. *Socharství baroku v Cechách. Plastika 17. a 18. veku*, Praha • DAVIDSSON, AKE. *Katalog över svenska teckningar i Uppsala universitetsbibliotek*, Uppsala • FLEMING, J. "Cardinal Albani's Drawings at Windsor, their purchase by James Adam for George III", in *Connoisseur*, 142, 164-69 • GIGLI, GIACINTO. *Diario Romano (1608-1670)*, a cura di G. Ricciotti, Roma • HAWCROFT, F. *Eighteenth Century Italy and Grand Tour*, exhibition catalogue, Norwich, Castle Museum • HERMANN, W. "A. Desgodets and the Académie royale d'Architecture", *Art Bulletin*, 1958, 23-58 • LERRANT, JEAN-JACQUES. "L'Urbanisme a Lyon", in *Ville de Lyon. Expositions du Bimillenaire*, Lyon: 185-90 • MENEGAZZI, LUIGI. *Il Pozzoserrato*, Venezia • MILLAR, OLIVER. *Rubens: The Whitehall Ceiling*, London, Charleton Lecture • MONTALTO, LINA. "Andrea Pozzo nella chiesa di Sant'Ignazio al Collegio Romano", in *Studi Romani*, VI, 668-79 • PIGNATTI, TERISIO. *Il Quaderno di disegni del Canalletto alle Gallerie di Venezia*, 2 voll., Venezia • THELEN, HEINRICH. *70 disegni di Francesco Borromini dalle collezioni dell'Albertina di Vienna*, catalogo della mostra, Roma, Gabinetto Nazionale delle Stampe • WITTKOWER, RUDOLF. *Art and Architecture in Italy: 1600 to 1750*, Harmondsworth (trad. it. di L. Monaca Nardini e M.V. Malvano, Torino 1972)

1958-1964 BOINET, AMÉDÉE. *Les églises parisiennes*, Paris, 3 voll.

1959 *Bibliotheca Radcliviana: 1749-1949*, exhibition catalogue, Bodleian Library, Oxford • *City of Cambridge*, 2 voll., Royal Commission on Historical Monuments, Cambridge • *Il Settecento a Roma*, Roma • BASSI, ELENA. "Episodi dell'edilizia veneziana dei secoli XVII e XVIII: Palazzo Pesaro", *Critica d'Arte*, 32, 240-64 • BOURDIER, F. "L'extravagant cabinet de Bonnier", *C.d.A.*, 39 • BRINCKMANN, ALBERT ERICH. "Tre astri nel cielo del Piemonte: Guarini, Juvarra, Vittone", in *Atti del X Congresso di Storia dell'architettura*, Torino, 1957, 345-57 • CRISPOLTI, ENRICO. "Capriccio", *Enciclopedia Universale dell'Arte*, 3: 103-10 • FLEMING, J. "Mssrs. Robert and James Adam: Art Dealers" (I), *Connoisseur*, 144, 168-71 • FREMANTLE, KATHARINE. *The Baroque Townhall of Amsterdam*, Utrecht • GIOSEFFI, DECIO. *Canaletto. Il Quaderno delle Gallerie veneziane e l'impiego della camera ottica*, Trieste • GRIMSCHITZ, BRUNO [a]. *Der Brunnen am neuen Markt in Wien*, Stuttgart • — [b]. *J.L. von Hildebrandt*, Wien, 37 • HARRIS, JOHN. "Inigo Jones and the Prince's Lodging at Newmarket", *Architectural History*, 2, 26-40, • HELD, JUTTA. *Monument und Volk. Vorrevolutionäre Wahrnehmung in Bildern des ausgehenden Ancien Régime*, Köln-Wien • IL'IN, M.A. *Architektura XVII veka. Istorija russkogo iskusstva*, IV, Moskva, 60 • KUBLER, G.; SORIA, M. *Art and Architecture in Spain and Portugal 1500-1800*, Harmondsworth • LAVEDAN, PIERRE. *Histoire de l'urbanisme, Renaissance et temps modernes*, Paris (2ᵉ éd. augmentée) • MAJDALANY, FRED. *The Red Rocks of Eddystone*, London • MOROZZO DELLA ROCCA, RAIMONDO. *Archivio di Stato di Venezia. Dispacci degli Ambasciatori al Senato. Indice*, Roma • STEVENSON, D. ALAN.

The World's Lighthouses before 1820, London • VOSS, HERMANN. "The Painter of Architecture Alberto Carlieri", *The Burlington Magazine*, 101, 443-44 • ZERI, FEDERICO. *La Galleria Pallavicini in Roma*, Firenze, 446-47 • ZORZI, G. *I Disegni delle antichità di Andrea Palladio*, Venezia

1959-1960 *Dessins français du XVᵉ au XXᵉ siècle*, catalogue de l'exposition, Roma-Milano • BOYER, FERDINAND. "Les promenades publiques en Italie au XVIIIᵉ", dans *Vie urbaine*, 1959, 162-86; 1960, 241-71

1960 *Architectural Drawings from the Collection of the Royal Institute of British Architects*, exhibition catalogue, London • *Montreal Museum of Fine Arts*. Catalogue of paintings, Montreal • BATTISTI, EUGENIO. "Postille su artisti italiani a Madrid e sulla collezione Marazza", *Arte antica e moderna*, 9, 77-81 • BLUNT, ANTHONY; COOKE HEREWARD, LESTER. *The Roman Drawings of the XVII & XVIII Centuries in the Collection of Her Majesty the Queen at Windsor Castle*, London • COFFIN, DAVID R. *The Villa d'Este at Tivoli*, Princeton Monographs in Art and Archaeology, 34, Princeton (N.J.), Princeton University Press • DE LA CROIX, HORST. "Military Architecture and the Radial City Plan in Sixteenth-century Italy", *Art Bulletin*, 42, 263-90 • FRODL, WALTER. *Kunst in Südtirol*, München • FRASER, PRUNELLA; HARRIS, JOHN. *Architectural Drawings from the Collection of the Royal Institute of British Architects*, exhibition catalogue, • KASPER, ALFONS. *Bau- und Kunstgeschichte des Prämonstratenserstiftes Schussenried*, II, Schussenried • KURZ, OTTO. "Barocco: Storia di una parola", *Lettere Italiane*, 12, 414-44 • LEONHARDT, GUSTAAF. "Een Vingboonshuis geschilderd door Hondecoeter", *Jaarboek Genootschap Amstelodamum*, 52, 90-96 • LYNCH, KEVIN. *The Image of the City*, Cambridge, Mass., Cambridge University Press • NYBERQ, D.. "Meissonnier, an Eighteenth century Maverick", introduction à la réédition de l'*Œuvre de Juste Aurèle Meissonnier*, New York • PRINGER-ZWANOWETZ, LEONARD. "Die Bildhauer um J. Prandtauer", in *J. Prandtauer und sein Kreis*, Ausstellungskatalog, Melk, n. 240 • ROTHENBURG, G.E. *The Austrian Military Border in Croatia 1522-1747*, Urbana • STUTCHBURY, H.E. "Palladian Gibbs", *Ancient Monuments Society Transactions*, ns. VIII, 43-52 • THIERVOZ LE GENERAL. "Les Ports de France de Joseph Vernet", *Neptunia*, XLVII-XLIX, 6-14; 7-18; 8-16 • WATSON, F.J.B. "The Collection of Sir Alfred Beit", *Connoisseur*, CXLV,

1960-1961 *La Peinture italienne au XVIIIème siècle*, catalogue de l'exposition, Paris, Petit-Palais • GABRIELLI, NOEMI. "Ultime segnalazioni di opere d'arte in Piemonte", *Bollettino della Società Piemontese di Archeologia e Belle Arti*, XIV-XV: 67-68 • MILLON, HENRY A. "L'altare maggiore della chiesa di San Filippo Neri di Torino", *Bollettino della Società Piemontese d'Archeologia e Belle Arti*, XIV-XV, 83-91

1961 *Architectural Drawings from the Witt Collection*, exhibition catalogue, Courtauld Institute galleries, London, Courtauld Institute of Art • *L'Italia vista dai pittori francesi dal XVIII al XIX secolo*, catalogo della mostra, Roma, Palazzo delle Esposizioni, Torino • ARISI, FERDINANDO. *Gian Paolo Panini*, Piacenza • AURIGEMMA, S. *Villa Adriana*, Roma • BLOCH, P. *Zum Dedikationsbild im Lob des Kreuzes des Hrabanus Maurus. Das erste Jahrtausend*, 1, Düsselford • EIMER, GERHARD [a]. *Carl Gustaf Wrangel som byggherre i Pommern och Sverige* (Carl Gustaf Wrangel als Bauherr in Schweden und Pommern), Acta universitatis stockholmiensis, 6, Stockholm • — [b]. *Die Stadtplanung im Swedischen Östseereich 1600-1715. mit Beiträgen zur Geschichte der Idealstadt*, Stockholm • GOLZIO, VINCENZO. "La facciata di San Giovanni in Laterano e l'architettura del Settecento", in *Miscellanea Bibliothecae Hertzianae*, XVI, 450-63 • HAGER, WERNER. "Guarini. Zur Kennzeichnung seiner Architektur", in *Miscellanea Bibliothecae Hertzianae zu Ehren von Leo Bruhns, Franz Graf Wolff Metternich, Ludwig Schudt*, hrsg. von H. Keller, 418-28 • HARRIS, JOHN. "The Building of Raynham Hall, Norfolk", *Archaeological Journal*, CXVIII, 180 • MALLÈ, LUIGI. *Le arti figurative in Piemonte dalle origini al periodo romantico*, Torino • MILLON, HENRY A. *Baroque and Rococo Architecture*, New York-London • MUMFORD, LEWIS. *The City in the History*, New York, 421-22 • POESCHEL, E. *Die Kunstdenkmäler des Kantons St. Gallen*, 3 (Die Stadt St. Gallen: Zweiter Teil. das Stift), Die Kunstdenkmäler der Schweiz, 45, Bern • ROETHLISBERGER, M. *Claude Lorrain. The Paintings*, New Haven-London, nn. LV 54, 190-95 • SLUYS, FELIX. *Monsù Desiderio*, Paris • SMITH, A. *Europe in the Eighteenth Century, 1713-1783*, New York-London • THUILLIER, JACQUES. "Economie et urbanisme au XVIIᵉ siècle: Phi-

lippe de Béthune", *Art de France*, I, 311-12 • WITTKOWER, RUDOLF. "The Vicissitudes of a Dynastic Monument. Bernini's Equestrian Statue of Louis XIV", *De Artibus Opuscula XL. Essays in Honor of Erwin Panofsky*, ed. M. Meiss, Princenton: 497-531

1961 (**1979**) SWILLENS, P.T.A. *Jacob van Campen. Schilder en bouwmeester 1595-1657*, Assen (Arnhem)

1962 *Barock am Bodensee/Architektur*, hrsg. von O. Sandner, Ausstellungskatalog, Bregenz • ALVES DE ARAÁUJO, ILIDIO. *Arte paesagista e arte dos jardins em Portugal*, Ministeiro dos obras publicas, Lisbon • ANDEREGG-TILLE, MARIA. *Die Schule Guarinis*, Winterthur • BASSI, ELENA. *Architettura del Sei e Settecento a Venezia*, Napoli • BAUER, H. *Rocaille, zur Herkunst und zum Wesen eines ornament-motiv*, Berlin • BJURSTRÖM, P. "Claude Lorrains perspektiv", *Konsthistorisk Tidskrift*, 31; 67-81 • BRIGANTI, GIULIANO. *Pietro da Cortona o della pittura barocca*, Firenze (2a ed. 1982) • BUSIRI VICI, ANDREA. "Fantasie architettoniche di Alessandro Salucci", *Capitolium*, 37, 880-91 • CAVALLARI MURAT, AUGUSTO. "Interpretazione dell'architettura barocca nel Veneto", *Bollettino del C.I.S.A. A. Palladio*, IV, 77-104 • CONSTABLE, W.G. *Canaletto*, 2 voll., Oxford • CROFT-MURRAY, EDWARD. *Decorative Painting in England 1537-1837*, I, London • DAVIES, J.H.V. "Nicholas Hawksmoor", *RIBA Journal*, LXIX, 368 ss., • D'ONOFRIO, CESARE. *Le Fontane di Roma*, 2a ed., Roma • FIELD, J. "Early Unknown Gibbs", *Architectural Review*, 315-19, • FLEMING, J. *Robert Adam and His Circle*, London, 296-97 • GÖTZ, WOLFGANG. "Die Orangerie des Schlosses Friedrichstahl in Gotha", *Deutsche Kunst und Denkmalpflege*, 56, 13-24 • HERMANN, WOLFGANG. *Laugier and 18th-Century French Theory*, London, 50 • HUBALA, ERICH. "Entwürfe Pietro da Cortonas für SS. Luca e Martina in Rom", *Zeitschrift für Kunstgeschichte*, XXV: 125-52 • MILLON, HENRY A. "An Early Seventeenth-Century Drawing of the Piazza San Pietro", *Art Quarterly*, 229-41 • MURRAY, P. *A History of English Architecture*, II, Harmondsworth, 188 ss. • PANSECCHI, F. "Il modello della Cappella Pallavicini Rospigliosi in S. Francesco a Ripa", *Bollettino dei Musei Comunali di Roma*, 9: 21-31 • PEVSNER, NIKOLAUS. *The Buildings of England: Norwich and North-East Norfolk*, Harmondsworth • PILO, GIUSEPPE MARIA. "Qualche appunto sull'architettura barocca e rococò a Padova e a Treviso", *Bollettino del C.I.S.A. "A. Palladio"*, IV, 181-89 • REUTHER, HANS; SCHLÜTER, MARGILDIS. *Hildesia Sacra*, Ausstellungskatalog, Hannover, Kestner-Museum • SCHWEITZER, ALBERT. *G.S. Bach il musicista-poeta*, a cura di P.A. Roversi, Milano, Edizioni Scritti Zerboni • STRANDBERG, RUNAR. "Jean-Baptiste Bullet de Chamblain, architecte du roi (1665-1726)", *Bulletin de la société de l'histoire de l'art français*, 193-255 • WUNDER, RICHARD. "L'interno di S. Pietro del Panini a Ca' Rezzonico", *Bollettino dei Musei Civici Veneziani*, 7, 11-14

1963 *Enciclopedia Universale dell'Arte*, introduzione, a cura di H. Sedlmayr e H. Bauer, XI, Venezia-Roma • *Marco Ricci*, a cura di G.M. Pilo, catalogo della mostra, Bassano del Grappa, Venezia • *Mostra del Barocco Piemontese*, catalogo della mostra, a cura di V. Viale, Torino • *Svecia antiqua et hodierna*, Stockholm • *Teckningarna till Svecia antiqua et hodierna*, III, Uppland, Stockholm, Norstedt • BARBIER, AUGUSTO. "Argenti", in *Mostra del Barocco Piemontese*, catalogo della mostra, a cura di V. Viale, Torino, vol. III, 1-32 • BASSI, ELENA. "Episodi dell'architettura veneta nell'opera di Antonio Gaspari", *Saggi e Memorie di Storia dell'Arte*, 3, 57-188 • BERNARDI, MARZIANO. *Tre palazzi a Torino*, Torino • CARBONERI, NINO. "Architettura", in *Mostra del Barocco Piemontese*, a cura di V. Viale, catalogo della mostra, I, Torino, 1-201 • DE LA CROIX, HORST. "The Literature of Fortification in Renaissance Italy", *Technology and Culture*, 6, 30-50 • DENISOV, JU.M.; PETROV, A.N. *Zodcij Rastrelli*, Leningrad, 298, 76, 170; 300, 77, 171; 301, 77, 171; 302, 78, 171; 303-305, 79, 171; 307, 81, 171; 310, 171; 311, 87, 171; 313, 88, 171; 314, 171; 324, 172 • D'ONOFRIO, CESARE. *La Villa Aldobrandini di Frascati*, Roma, Staderini • FAGIOLO, DELL'ARCO M. *Funzioni simboli valori della Reggia di Caserta*, Roma • GRISERI, A. "La pittura", in *Mostra del Barocco Piemontese*, a cura di V. Viale, catalogo della mostra, Torino, II • MALLÈ, LUIGI. "Scultura", in *Mostra del Barocco piemontese*, a cura di V. Viale, Torino, II • MANDOWSKY, ERNA; MITCHELL, CHARLES. *Pirro Ligorio's Roman Antiquities*, London • MANKE, I. *Emanuel de Witte, 1617-1692*, Amsterdam • MARINI, GIUSEPPE LUIGI. *L'architettura barocca in Piemonte*, Torino • MATZULEVITCH, GIANNETTA. "Tre bozzetti di G.L. Ber-

nini all'Ermitage di Leningrado", *Bollettino d'arte*, XLVIII, 1-2: 67-74 • NEGRI ARNOLDI, FRANCESCO. "Prospettisti e quadraturisti", *Enciclopedia Universale dell'Arte*, 11, 99-116 • NOEHLES, KARL. "Briganti Giuliano, Pietro da Cortona o della pittura barocca", *Kunstchronik*, XVI, 95-106 • PASSANTI, MARIO. *Nel Mondo Magico di Guarino Guarini*, Torino • SYDHOFF, BEATE. "Un édifice religieux: l'église Saint-Sulpice", *L'information d'histoire de l'art*, 8, 2 • THOENES, CHRISTOF. "Studien zur Geschichte des Petersplatz", *Zeitschrift für Kunstgeschichte*, 26, 97-145 • VIALE FERRERO, MERCEDES. "Scenografia", in *Mostra del Barocco piemontese*, I, Torino • WITTKOWER, RUDOLF. "S. Maria della Salute", *Saggi e Memorie di Storia dell'Arte*, 3, 33-54

1963-1982 BAUDI DE VESME, ALESSANDRO. *Schede Vesme. L'arte in Piemonte dal XVI al XVIII secolo*, 4 voll., Torino

1964 *Herzogenburg. Das Stift und seine Kunstschätze*, Ausstellungskatalog, Herzogenburg • ARGAN, GIULIO CARLO. *L'Europa delle capitali: 1600-1700*, Genève, Fabbri-Skira • BONNIN, FRANÇOISE. *André Le Nôtre et l'art des jardins*, Paris, Bibliothèque nationale • BOERLIN, PAUL-HENRY. *Die Stiftskirche St. Gallen*, Bern • BORROMINI, FRANCESCO. *Opus Architectonicum*, 2a ed., Roma, ed. dell'Elefante, 38 • BOZZA, G.; BASSI, J. "La formazione e la posizione dell'ingegnere e dell'architetto nelle varie epoche storiche", in *Il centenario del politecnico di Milano, 1863-1963*, Milano, 59-62 • CANOVA, GIORDANA. *Paris Bordon*, Venezia • CARBONERI, NINO. "Vicenda delle cappelle per la Santa Sindone", *Bollettino della Società Piemontese di Archeologia e Belle Arti*, XVIII, 95-109 • COLVIN, HOWARD. *Catalogue of Architectural Drawings of the 18th and 18th Centuries in the Library of Worcester College*, Oxford • GRIMSCHITZ, BRUNO [a]. "Joseph und Franz Munggenasts Pläne für die Stiftskirche von Herzogenburg", *Alte und moderne Kunst*, 75: 20-23 • — [b]. "Der Planschatz des Stiftes", in *Herzogenburg. Das Stift und seine Kunstschätze*, Ausstellungskatalog, Herzogenburg: 95-107 • HALE, JOHN. "The Argument of Some Military Title Pages of the Renaissance", *The Newberry Library Bulletin*, 6, 91-102 • HARRIS, JOHN. "The Prideaux Collection of Topographical Drawings", *Architectural History*, 7, 19-108, • KENWORTHY-BROWNE, JOHN. "Easton Neston", *Country Life*, CLVII, 72-9, 142-49 • LAZAREV, V.N. *Drevnerusskoe iskusstvo: XVII vek*, Moskva • MENZEL, FRANZ BEDA. "Ein Blick in die barocke Welt der Äbte Othmar Zinke und Benno Löbl. Brevnov - Braunau 1700-1751", *Stifter - Jahrbuch*, 8, 87-124 • MILLON, HENRY A. "Guarino Guarini and the Palazzo Carignano in Turin", 2 voll., Ph.D. thesis, Harvard University • PORTOGHESI, PAOLO [a]. *Borromini nella cultura europea*, Roma • — [b]. *Borromini: Architettura come linguaggio*, Roma-Milano; english translation as *The Rome of Borromini*, Cambridge, Mass., 1968 • SARTORI, ANTONIO. "Un progetto di Girolamo Frigimelica per la Cappella del Santissimo nella Chiesa del Santo", *Il Santo*, fasc. III, 309-13 • SCANO, GAETANA. "L'architetto del Popolo Romano", *Capitolium*, 39, 118-23 • SMITH, P. "Mansart studies III: The church of the Visitation in the rue Saint-Antoine", *The Burlington Magazine*, 1, CVI, 202-15 • SPAGNESI, GIANFRANCO. *Giovanni Antonio De Rossi*, Roma, 165-67 • STAROBINSKY, JEAN. *L'invention de la Liberté, 1700-1789*, Genève, Skira • SYDHOFF, BEATE. "La façade de l'église Saint-Sulpice à Paris: son adaptation aux grands problèmes d'architecture religieuse discutés en France au XVIIIe siècle", *Kunsthistorisk Tidskrift*, 23, 12, 21-29 • WALTON, GUY. "Pierre Puget's projects for the church of Santa Maria Assunta di Carignano", *The Art Bulletin*, 89-94 • WEIGERT, ROGER-ARMAND; HERNMARCK, CARL. *Les Relations Artistiques entre la France et la Suède, 1693-1718*, Stockholm • WITTKOWER, RUDOLPH. *Gian Lorenzo Bernini*, London

1965 *Le Nôtre et l'art des jardins*, Paris, Bibliothèque Nationale (Paris 1964) • *Les Trésors des Églises de France*, catalogue exposition, Paris, Musée des Arts Décoratifs • APOLLONI GHETTI, BRUNO M. *Santa Susanna*, Le Chiese di Roma Illustrate, 85 • HALE, JOHN. "The Early development of the Bastion: An Italian Chronology c.1450-c.1534", in *Europe in the Late Middle Ages*, eds. J.R. Hale, L. Highfield and B. Smalley, London, 466-94 • LANG, S. "Vanbrugh's theory and Hawksmoor's buildings", *Journal of the Society of Architectural Historians*, XXIV, 127-51, • LEPINSKY, ANGELO. *Oreficeria e argenteria in Europa dal XVI al XIX secolo*, Novara • PEYROT, ADA. *Torino nei secoli. Vedute e piante, feste e cerimonie nell'incisione dal Cinquecento all'Ottocento*, 2 voll., Torino • SCHLUMBERGER, ÉVELINE. "Un genie d'opera, Ser-

vandoni", *Connaisance des Arts*, 162, 14-23 • SKELTON, RALEIGH. "Introduction", in *Civitates orbis terrarum*, Amsterdam: X ss. • SONOLET, JACQUELINE; MOLLARET, HENRITT. "La peste source méconnue d'inspiration artistique", *Jaarboek 1965, Koninklijk museum voor shone kunsten*, Antwerpen • VIALE FERRERO, MERCEDES°. *Feste delle Madame Reali di Savoia*, Torino • VOIT, PETER. "Der kunstgeschichtliche Ursprung der Minoritenkirche in Eger", in *Acta Historiae Artium*, Budapest: 176-203 • WILTON-ELY, JOHN. *The Architect's Vision: Historic and Modern Architectural Models*, exhibition catalogue, University Gallery, Nottingham

1966 *Christina Queen of Sweden: A Personality of European Civilization*, exhibition catalogue, Stockholm • *Filippo Juvarra Architetto e Scenografo*, a cura di V. Viale, testi di F. Basile e M. Viale Ferrero, catalogo della mostra, Messina, 55-56 • *L'Arte del Barocco in Boemia*, catalogo della mostra, Ente Manifestazioni Milanesi - Galleria Nazionale di Praga, Milano, Palazzo Reale • BERGAMINI, WANDA. "Antonio Galli Bibiena e la costruzione del Teatro Comunale di Bologna", in *Due secoli di vita musicale. Storia del Teatro Comunale di Bologna*, a cura di L. Trezzini, Bologna • BERGER, ROBERT. "Antoine Le Pautre and the Motif of the Drum-without-Dome", *Journal of the Society of Architectural Historians*, XXV/3, 165-80 • BRIGANTI, GIULIANO. *Gaspar Van Wittel e l'origine della veduta settecentesca*, Roma • CARBONERI, NINO. *Ascanio Vitozzi. Un architetto tra Manierismo e Barocco*, Roma • CARBONERI, NINO; GRISERI, ANDREINA; MORRA, G. *Giovenale Boetto architetto e incisore*, Fossano • CHAUNU, PIERRE. *La civilisation de l'Europe classique*, Paris (réed. 1984) • CLARKE, B.F.L. *Parish Churches of London*, London • DAHLBERG, ERIC JÖNSSON. *Teckningarna till Suecia antiqua et hodierna*, 2, ed. S. Wallin, Stockholm • DE BERNARDI FERRERO, DARIA. *I "Disegni d'architettura Civile e Ecclesiastica" di Guarino Guarini e l'arte del maestro*, Torino • DOWNES, KERRY. *English Baroque Architecture*, London • FRANCINI, ALESSANDRO. *Livre d'architecture*, Farnborough • HASKELL, FRANCIS. *Mecenati e pittori*, Firenze • HILL, OLIVER; CORNFORTH, JOHN. *English Country Houses, Caroline: 1625-1685*, London • JESTAZ, BERTRAND. *Le voyage d'Italie de Robert de Cotte*, Paris • LOCKE, JOHN. *Saggio sull'intelletto umano*, a cura di G. De Ruggiero, Bari, Laterza, 30 • MOLA, GIOVANNI BATTISTA. *Breve Racconto delle miglior opere d'architettura, scultura et pittura fatte in Roma...*, hrsg. von K. Noehles, Berlin • MORASSI, ANTONIO. *Michele Marieschi*, catalogo della mostra, Bergamo • PARSONS, TALCOTT. *Societies*, New York • PORTOGHESI, PAOLO. *Roma barocca: storia di una civiltà architettonica*, Roma • ROSCI, M. *Il trattato di architettura di Sebastiano Serlio*, Milano • SAUERMOST, HEINZ JÜRGEN. "Franz Beer und die Stiftskirche St. Gallen", *Das Münster*, 19, 44-57 • SEMENZATO, CAMILLO. *La scultura veneta del Seicento e Settecento*, Venezia • SUMMERSON, JOHN. *Inigo Jones*, Harmondsworth, 133, 139 • TRANCINI, ALESSANDRO. *Livre d'architecture*, Farnborough, Gregg Press

1967 *La Vie en Hollande au XVIIe siècle. Tableaux, dessins estampes, argenterie, monnaies, médailles et autres témoignages*, Paris • *Le Cabinet d'un grand amateur; P-J. Mariette, 1694-1774. Dessins du XVe au XVIIIe siècle*, catalogue de l'exposition, Paris, Musée du Louvre • BAUER, H. *Rocaille*, Berlin • BALLEGEER, J.P.C.M. "Enkele voorbelden van de invloed van Hans en Paulus Vredeman de Vries op de architectuurschilders in de Nederlanden", *Gentse Bijdragen tot de Kunstgeschiedenis en de oudheidskunde*, 20, 55-70 • BARTOLOTTI, FRANCO. *La medaglia annuale dei romani pontefici da Paolo V a Paolo VI: 1605-1967*, Rimini • BROCKHAGEN, E.; KNÜTTEL, B. *Katalog Alte Pinakothek III. Holländische Malerei des 17. Jahrhundert*, München • BURDA, HUBERT. *Die Ruinen in den Bildern Hubert Roberts*, München • CHIARINI, MARCO. *Paesisti, bamboccianti e vedutisti nella Roma seicentesca*, Firenze • DE BERNARDI FERRERO, DARIA. *L'opera di Francesco Borromini nella letteratura artistica e nelle incisioni dell'età barocca*, Torino • EMILIANI, A. *La Pinacoteca nazionale di Bologna*, Bologna • ENGLUND, BRITTA. "Fästningsmodeller Fran Erik Dahlberghs Tid: En preliminär undersökning", *Meddelenanden Fran Armemuseum*, 28, 11-52 • FAGIOLO DELL'ARCO, MARCELLO; FAGIOLO DELL'ARCO, MAURIZIO. *Bernini, una introduzione al gran teatro del barocco*, Roma • GAUS, JOACHIM. *Carlo Marchionni, Ein Beitrag zur römischen Architektur des Settecento*, Köln-Graz, 67-85 • GRISERI, ANDREINA. *La metamorfosi del Barocco*, Torino, Einaudi • HAGER, WERNER. "Uno studio sul palladianesimo di Elias Holl", *Bollettino C.I.S.A.*, IX, 88 • HARRIS, JOHN. "Le Geay, Piranesi and International

Neo-classicism in Rome 1740-1750", in *Essays in the History of Architecture Presented to Rudolf Wittkower*, eds. D. Frase, H. Hibbard and M.J. Levine, London, Phaidon Press, 189-96 • HIBBARD, H. "Di alcune licenze rilasciate dai maestri di strade per opere di edificazione a Roma (1586-89, 1602-1634)", *Bollettino d'arte*, n.s. 5, 52, 2, 99-117 • HUSE, NORBERT. "Gianlorenzo Berninis Vierströmbrunnen", *Dissertation* • KLAUNER, FRIDERIKE. "Der 'Mathematische Turm' des Stiftes Kremsmünster und die Gemäldegalerie", *Österreichische Zeitschrift für Kunst und Denkmalpflege*, XXI, 1: 1-16 • MALTESE, C. *Francesco di Giorgio Martini. Trattati di architettura e ingegneria e arte militare*, I, Milano, • MILLAR, OLIVER. "An Exile in Paris: the notebooks of Richard Symonds", in *Studies in Renaissance and Baroque Art presented to Anthony Blunt in hi 60th birthday*, London-New York, 157-64 • POMMER, RICHARD. *Eighteenth-Century Architecture in Piedmont. The Open Structures of Juvarra*, Alfieri & Vittore, New York-London, 142 • PORTOGHESI, PAOLO. *Disegni di Francesco Borromini*, catalogo della mostra, Roma • RIZZI, ALDO. *Luca Carlevarijs*, Venezia • ROBERTS, MICHAEL. "The Military Revolution, 1560-1660", in *Essays in Swedish History*, Minneapolis, 195-225 • ROSSACHER, KURT. "Berninis Reiterstatue des Konstantin an der Scala Regia: Neues zur Werkgeschichte", *Alte und Moderne Kunst*, XII, 90: 2-11 • SCHWAGER, KLAUS. "Unbekannte Zeichnungen Jacopo Del Ducas", in *Stil und Überlieferung in der Kunst des Abendlandes*, II, 56-64 • THELEN, HEINRICH. *Francesco Borromini. Die Handzeichnungen*, I, Abteilung: Zeitraum von 1620/32, Graz • WILTON-ELY, JOHN. "The Architectural Model", *Architectural Review*, CXLI, 26-32 • WITTKOWER, RUDOLF [a]. *Studi sul Borromini*, I, Accademia di San Luca, Roma, 134 ss. • — [b]. *Francesco Borromini. Die Handzeichnungen*, Herausgegeben H. Thelen, Akademische Druck • WOERNER, H.J. *Formuntersuchungen zur Bedeutung der Architekturdarstellungen für die Komposition in Werken französischer Malerei des 17 Jahrhunderts*, München

1967-1968 HAGER, HELLMUT. "Zur Planungs und Baugeschichte der Zwillingskirchen auf der Piazza del Popolo: S. Maria di Monte Santo und S. Maria dei Miracoli in Rom", in *Römisches Jahrbuch für Kunstgeschichte*, 11, 201, 202, 207, 208, 214, 245, 252, tavole 181, 289, 303, 304, doc. VIII

1967-1984 DEL PIAZZO, MARCELLO. *Ragguagli borrominiani*, Roma

1968 *Ausstellungskatalog Augsburger Barock*, Ausstellungskatalog, Augsburg • *Forma urbana e architettura nella Torino barocca*, a cura di A. Cavallari Murat, Torino • *Mostra dei disegni francesi da Callot a Ingres*, a cura di P. Rosenberg, Gabinetto Disegni e Stampe degli Uffizi, XXIX, Firenze, 78, 72-73 • BELIN-SCART, BRIGITTE. *Israël Silvestre, thèse d'Ecole du Louvre inédite*, 3 voll. • CAVALLARI-MURAT, AUGUSTO. *Forma urbana ed architettura nella Torino barocca*, Torino • COLVIN, HOWARD. *Royal Buildings*, RIBA Drawings Series, London • GUARINI, GUARINO. *Il Polifilo*, 10, 455 • Roethlisberger M., *Claude Lorrain. The Drawings*, Berkeley-Los Angeles, 454-55, 195-97 • HAGER, HELLMUT. "Progetti del Tardo Barocco per il 'terzo braccio' in piazza S. Pietro", in *Commentari*, 19, 229-314 • HITCHCOCK, HENRY-RUSSELL [a]. *German Rococo: The Zimmermann Brothers*, London • — [b]. *Rococo Architecture in Southern Germany*, London • HOFMANN, WERNER J. "Schloß Pommersfelden", in *Erlanger Beiträge zur Sprach-und Kunstwissenschaft*, 32, Nurnberg: 114-20 • KELDER, DIANE M. *Drawings by the Bibiena Family*, exhibition catalogue, Philadelphia, The Philadelphia Museum of Art • MARIE, A. *Naissance de Versailles. Le château, les jardins*, Paris • MONTEVERDI, MARIO. *Italian Stage Designs from the Museo Teatrale alla Scala*, Milan, exhibition catalogue, London, Victoria and Albert Museum • NORBERG-SCHULZ, CHRISTIAN [a]. *Architettura Barocca*, Milano, Electa • — [b]. *Kilian Ignaz Dientzenhofer e il barocco boemo* • PRECERUTTI GARBERI, MERCEDES. *Affreschi settecenteschi delle ville venete*, Milano • PUPPI, LIONELLO. *L'opera completa del Canaletto*, Milano • RODRIGUEZ, S; DE CEBALLOS, ALFONSO. "La arquectura de Andrés García de Quiñones", *Archivo Español de Arte*, 162-63, 105-30 • ROETHLISBERGER, M. *Claude Lorrain... The Drawings*, Berkeley-Los Angeles • ÜBERLACKER, FRANZ. *Sonntagberg. Vom Zeichenstein zur Basilika*, Sonntagberg, 128 • WILTON-ELY, JOHN. "The Architectural Model: English Baroque", *Apollo*, LXXXV-VIII, 250-59 • WOLFF, H.C. "Oper", in *Musikgeschichten in Bildern*, IV, Leipzig • ZAMBONI, SILLA [a]. "Gian Lorenzo Ber-

nini: un modello per la 'Fontana dei Quattro Fiumi' ritrovato", in *Da Bernini a Pinelli*, a cura di S. Zamboni, Bologna, 11-25 • — [b]. "Modello per la Fontana dei Quattro Fiumi", in *Mostra di sculture e disegni scenografici del Seicento e del Settecento della Accademia di Belle Arti di Bologna*, a cura di A. Parronchi e S. Zamboni, catalogo della mostra, Bologna, 11-12

s.d. ma 1968 TAMBURINI, LUCIANO. *Le chiese di Torino*, Torino

1969 *Baroque in Boemia*, exhibition catalogue, London, Victoria & Albert Museum; Birmingham, City Museum & Art Gallery • BERGER, ROBERT W. *Antoine Le Pautre*, New York • BRAUNFELS, WOLFGANG. *Abendländische Klosterbaukunst*, Köln, 265 • *Disegni teatrali dei Bibiena*, a cura di M.T. Muraro e E. Povoledo, Venezia • DEE ELAINE, EVANS. *The Two Sicilies*, exhibition catalogue, New York, Finch College Museum of Art • DI MATTEO, COLETTE. *Servandoni décorateur d'opéra*, Maîtrise spécialisée d'histoire de l'art, Paris, Université de Paris-Sorbonne • D'ONOFRIO, CESARE. *Roma nel Seicento*, Firenze • ELIAS, NORBERT. *Die höfische Gesellschaft. Untersuchungen zur Soziologie des Königtums und der höfischen Aristokratie*, Darmstadt • GARMS, JÖRG. "Der Grundriss der Malgrange I von Boffrand", *Wiener Jahrbuch für Kunstgeschichte*, XXII: 184-88 • GONZALEZ PALACIOS, ALVAR. *Il mobile nei secoli*, Milano • HAAK, B. "De nachtelijke samenzwering van Claudius Civilis", *Het Schakerbos op de Rembrandttentoonstelling te Amsterdam*, 4, 136-48 • KENNEDY, I.G. "Claude Lorrain and Topography", *Apollo*, 304-309 • KURTH, WILLY. *Sanssouci: Ein Beitrag zum Kunst des Deutschen Rokoko*, Berlin • LEVER, J. *Catalogue of the Drawings Collection of the Royal Institute of British Architects*, II, Farnborough • NOEHLES, KARL [a]. "Architekturprojekte Cortonas", *Münchener Jahrbuch der bildenden Kunst*, XX: 171-206 • — [b]. *La chiesa dei Ss. Luca e Martina nell'opera di Pietro da Cortona*, Roma (2a ed. 1970) • NYBERG, DOROTHEA. "Meissonnier, an Eighteenth-Century Maverick", in *Œuvre de Juste-Aurèle Meissonnier*, New York, Benjamin Blom • PREIMESBERGER, R. "Zu einigen Werken und der künstlerischen Form Pierre Pugets", *Vienneser Jahrbuch für Kunstgeschichte*, XXII, 86 • RAPAPORT, A. *House Form and Culture*, New York • VITZTHUM, WALTER. *Drawings in the Collection of the Art Gallery of Ontario*, exhibition catalogue, Toronto • WILTON-ELY, JOHN. "The role of models in church design", *Country Life Annual*

1970 *Disegni teatrali dei Bibiena*, a cura di M.T. Muraro e E. Povoledo, Venezia • *Guarino Guarini e l'internazionalità del Barocco*, Atti del Convegno internazionale promosso dall'Accademia delle Scienze di Torino, 30 stembre - 5 ottobre 1968, 2 voll., Torino • *Louis Le Vau: 1612-1670*, Musée Comtesse de Caen (Paris, l'Institut, 1970) • *Riti, cerimonie, feste e vita di popolo nella Roma dei Papi*, a cura di L. Fiorani et al., Bologna, Casa Editrice Licinio Cappelli • *Umeni ceskeho baroku. Soubor vystaveny roku 1969 v Londyne a Birminghamu*, exhibition catalogue, Národní Galerie v Praze, Praha • BERCKENHAGEN, EKHART. *Staatliche Museen Preußischer Kulturbesitz - Die Französischen der Kunstbibliothek Berlin*, Berlin • BERTINI, ALDO. "Il disegno del Guarini e le incisioni del trattato di 'Architettura Civile'", in *Guarino Guarini e l'internazionalità del Barocco*, Atti del Convegno internazionale promosso dall'Accademia delle Scienze di Torino, 30 ottobre 1968, a cura di V. Viale, 2 voll., Torino, 597-610 • BRANDI, CESARE. *La prima architettura barocca, Pietro da Cortona — Borromini — Bernini*, Bari • BRUAND, Y.; HÉBERT, M. *Inventaire du fonds français du XVIIIème siècle*, Bibliothèque nationale, 11, Greuze-Jahandier • CARBONERI, NINO. "Guarini ed il Piemonte", in *Guarino Guarini e l'internazionalità del Barocco*, Atti del Convegno internazionale promosso dall'Accademia delle Scienze di Torino, 30 settembre - 5 ottobre 1968, 2 voll., Torino, II, 347-83 • CAVALLARI-MURAT, AUGUSTO. "Struttura e forma del trattato architettonico del Guarini", in *Guarino Guarini*, Atti del Convegno internazionale promosso dall'Accademia delle Scienze di Torino, 30 settembre - 5 ottobre 1968, 2 voll., Torino, I, 451-96 • COLVIN, HOWARD. "Easton Neston Reconsidered", *Country Life*, CXLVIII, 968-71 • DEE, ELAINE EVANS. *The Two Sicilies*, exhibition catalogue, New York, Paris, Finch College Museum of Art • DE VRIES, L. "From Vredeman de Vries to Dirck van Delen: Sources of Imaginary Architectural Painting", Rhode Island School of Design Museum, 15-25 • DI MATTEO, COLETTE. *Servandoni décorateur d'opéra*, Maîtrise spécialisée d'histoire de l'art, Paris, Université de Paris-Sorbonne • DOWNES, KERRY. *Hawksmoor*, London • GUIDONI, E. "Modelli guari-

niani", in *Guarino Guarini e l'internazionalità del barocco*, a cura di V. Viale, Torino • GUILLAUME, JEAN. "Le Phare de Cordouan, 'Merveille du Monde' et Monument Monarchique", *Revue de l'Art*, 8: 33-52 • HAGER, HELLMUT. *Filippo Juvarra e il concorso di modelli bandito da Clemente XI per la nuova sacrestia di San Pietro*, Roma, Quaderni Commentari n. 2, 76 • HELD, JULIUS S. "Ruben's Glynde Sketch and the Installation of the Whitehall Ceiling", *The Burlington Magazine*, CXII, 277-81 • HERDING, KLAUS. *Pierre Puget. Das bildnerische Werk*, Berlin • HUSE, NORBERT. "La Fontaine des Fleuves du Bernin", *Revue de l'Art*, 7: 6-17 • KAUFFMANN, HANS. *Giovanni Lorenzo Bernini. Die figürlichen Kompositionen*, Berlin • KURTH, WILLY. *Sanssouci: Ein Beitrag zur Kunst des Deutschen Rokoko*, Berlin • LANGE, AUGUSTA. "Disegni e Documenti di Guarino Guarini", in *Guarino Guarini e l'internazionalità del Barocco*, a cura di V. Viale, I, Torino, 91-344 • LEES-MILNE, JAMES. *English Country Houses, Baroque*, London • LIEDTKE, WALTER. "From Vredeman de Vries to Dirk van Delen: Sources of Imaginary Architectural Drawings", *Rhode Island School of Design Museum Notes*, 15-25 • MACDOUGALL, ELIZABETH. *The Villa Mattei and the Development of the Roman Garden Style*, Ph. D. Thesis, Harvard University • MILLON, HENRY A. "La geometria nel linguaggio architettonico del Guarini", in *Guarino Guarini e l'internazionalità del Barocco*, Atti del Convegno internazionale promosso dall'Accademia delle Scienze di Torino, 30 stembre - 5 ottobre 1968, 2 voll., Torino, a cura di V. Viale, 35-60 • NEUMANN, JAROMÍR. *Das böhmische Barock*, Praha • NOEHLES, KARL. *La Chiesa dei SS. Luca e Martina nell'opera di Pietro da Cortona*, Roma • NORBERG-SCHULZ, CHRISTIAN [a]. "Lo spazio nell'architettura post-guariniana", in *Guarino Guarini e l'internazionalità del Barocco*, a cura di V. Viale, II, Torino, 411-37 • — [b]. *Existence, Space and Architecture*, London • PALUMBO FOSSATI, G. *I Fossati di Morcote*, Bellinzona • PEVSNER, NIKOLAUS *The Buildings of England: Cambridgeshire*, 2nd ed. • PLATH, HELMUT. *Hist. Museum am Hohen Ufer, Hannover*, Ausstellungskatalog, Hannover • PORTOGHESI, PAOLO [a]. "Il Linguaggio di Guarino Guarini", in *Guarino Guarini e l'internazionalità del Barocco*, Atti del Convegno internazionale promosso dall'Accademia dell Scienze di Torino, 30 settembre - 5 ottobre 1968, 2 voll., Torino, II, 9-34 • — [b]. *Roma barocca. The History of an Architectonic Culture*, Cambridge, Mass.-London • SCHIKOLA, GERTRAUD. "Wiener Plastik der Renaissance und des Barock", in *Geschichte der Bildende Kunst in Wien*, Wien, 102 • SESTIERI, ETTORE. *La Fontana dei Quattro Fiumi e il suo bozzetto*, Roma • VITZTHUM, WALTER. *Drawings in the Collection of the Art Gallery of Ontario*, exhibition catalogue, Toronto • WOODBRIDGE, KENNETH. *Landscape and Antiquity, Aspects of English Culture at Stourhead 1718 to 1838*, Oxford

1971 *1000 Jahre Kunst in Krems*, hrsg. von Harry Kühnel, Ausstellungskatalog, Krems an der Donau • *Arta Baroca din Boemia*, exhibition catalogue, Bucuresti, Muzeul de arta al R. S. Romania • *Catalogue of Drawings of the Royal Institute of British Architects*, ed. J. Lever, London • *François Mansart 1598-1666*, London-Hayward Gallery, Paris, Hôtel de Sully • *Shírka starého umení. Národní galerie v Praze*, exhibition catalogue, Praha, Národní Galerie v Praze • BASSI, ELENA. "Boschetti Lorenzo", in *Dizionario Biografico degli Italiani*, 13, Roma, 185 • BEAN, JACOB; STAMPLE, FELICE. *The Eighteenth Century in Italy*, New York, The Metropolitan Museum of Art, The Pierpont Morgan Library • BOUDRIOT, J. "L'artillerie de mer de la marine française 1674-1856", *Neptunia*, 101, 1, 1-8 • BRIGANTI, G. *Les Peintres de "vedute"*, s. l. • DOWNES, KERRY [a]. *Christopher Wren*, London • —[b]. "Wren and Whitehall in 1664", *The Burlington Magazine*, CXIII, 89-92 • GUINESS, D.; RYAN, W. *Irish Houses and Castles*, London • HAGER, HELLMUT. "Il modello di Ludovico Rusconi Sassi del concorso per la facciata di San Giovanni in Laterano", in *Commentari*, XXII, 36-67 • HIBBARD, HOWARD. *Carlo Maderno and Roman Architecture 1580-1630*, University Park-London • JACOB, SABINE. "Pierre de Cortone à la décoration de la galerie d'Alexandre VII au Quirinal", *Revue de l'Art*, 11, 42-54 • KERBER, BERNHARD. *Andrea Pozzo*, Berlin, 54-74, 102-108, 181-86, 188-92, ill. 53-55 • LUSSO, GIOVANNI BATTISTA. *Carignano: i luoghi pii*, Pinerolo • MALVASIA, CARLO CESARE. *Felsina pittrice*, a cura di M. Brascaglia, Bologna, 453 • MAROCCO, ANTONIO MARIA. "Un incompiuto juvarriano: il Castello di Rivoli", *Atti e Rassegna Tecnica della Società Ingegneri e Architetti di Torino*, 1, Torino • OST, HANS. "Studien zu Pietro da Cortonas Umbau von St. Maria della Pace",

Römisches Jahrbuch für Kunstgeschichte, XIII: 231-85 • REUTHER, HANS. "Das Modell der St.-Clemens-Propsteikirche zu Hannover", in 10, 203-230 • THOENES, CH. *Neapel und Umgebung* (Reclams Kunstführer, Italien VI), Stuttgart, 587-612 • WAGNER, HELGA. *Jan van der Heyden, 1637-1712*, Amsterdam-Haarlem • WHINNEY, MARGARET. *Wren*, London • ZAMBONI, SILLA. "G.L. Bernini: un modello per la Fontana dei Quattro Fiumi ritrovato", *Rapporto della Soprintendenza alle Gallerie di Bologna*, 7: 31-43

1971 (1974) RABREAU, D.; GALLET, M. "La chaire de saint-Sulpice. Sa création par Charles de Wailly et l'exemple du Bernin à la fin de l'Ancien Régime", *Bulletin de la Société de l'Histoire de Paris et de l'Ile-de-France*, 115-39

1972 *Barok u Ceskoj - L'Art du baroque en Bohême*, exhibition catalogue, Beograd, Narodni muzej • *Catalogue of the Royal Institute of British Architects Drawings Collection: Inigo Jones and John Webb*, ed. J. Harris, • *Great Drawings from the Collection of the Royal Institute of British Architects*, I. J. Harris, London • ANDROUET DU CERCEAU, JACQUES. *Le Premier volume des plus excellents bastiments de France ... [et Le Second volume des plus excellents bastiments de France]*, facsimile, Farnborough, Gregg Press • BARETTINI FERNANDEZ, J. *Juan Carreño pintor de Cámara de Carlos II*, Madrid, 45-46 • BORSI, F.; DEL PIAZZO, M.; SPARISCI, E.; VIATLE, E. *Montecitorio ricerche di storia urbana*, Roma, 25 • DE BOISFLEURY, S. *L'Œuvre dessiné de Pierre Puget, Mémoire manuscrit de l'Ecole du Louvre*, Paris • FRIEDMAN, TERRY; James Gibbs as a Church Designer, exhibition catalogue, Derby • GUBLER, HANS MARTIN. *Der Vorarlberger Barockbaumeister Peter Thumb 1681-1766. Ein Beitrag zue Geschichte der süddeutschen Barockarchitektur*, Bodensee-Biblioteck, 16, Sigmaringen • KALNEIN, WEND G.; LEVEY, MICHAEL. *Art and Architecture of the Eighteenth Century in France*, Harmondsworth • KENNEDY, I.G. "Claude and Architecture", *Journal of the Warburg and Courtauld Institutes*, 35; 260-83 • KOSCHATZKY, WALTER; OBERHUBER, KONRAD; KNAB, ECKHART. *I grandi disegni italiani dell'Albertina di Vienna*, Milano • KOZAKIEWICZ, STEFAN. *Bernardo Bellotto*, 2 voll., Greenwich • LINKS, J.G. *Townscape Painting and Drawing*, London • MALLÉ, LUIGI. *Mobili ed arredi lignei. Catalogo del Museo Civico di Torino*, Torino • MARIE, ALFRED; MARIE, JEANNE. *Mansart à Versailles*, I, Paris • MARTIN, JOHN R. *The Decorationsfor the Pompa Introitus Ferdinandi*, Corpus Rubenianum Ludwig Burchard, XVI, Bruxelles • MESURET, R. "Joseph Vernet et les ports Gascons, I: La vue de Bordeaux prise du châteaux Trompette", *Neptunia*, 106, 24, 17-28 • NIERO, ANTONIO. "Un progetto sconosciuto per la Basilica della Salute e questioni iconografiche", *Arte Veneta*, XXVI, 245-49 • PARKER, GEOFFREY. *The Army of Flanders and the Spanish Road, 1567-1659*, Cambridge • PIGNATTI, TERISIO. *Le dodici Feste Ducali di Canaletto-Brustolon*, Venezia • TOVAR MARTÍN, VIRGINIA. "Algunas noticias sobre el arquitecto Manuel de Larra Churriguera", *Archivo Español de Arte*, XIV, 179, 271-85 • VON KALNEIN WEND, GRAF; LEVEY, MICHAEL. *Art and Architecture of the Eighteenth Century in France*, Harmondsworth, Penguin Books Ltd • VORONIKHINA, A.N. *Peterburg i ego okrestnosti v chertezhakh i risunkakh arkhitektorov pervoi treti XVIII veka*, Leningrad

1973 *Catalogue of the Drawings Collection of the Royal Institute of British Architects: G-K*, Farnborough • *Der Vorarlberger Barockbaumeister*, hrsg. von W. Oechslin, Ausstellungskatalog, Einsiedeln • *Luigi Vanvitelli*, Napoli • AURENHAMMER, HANS. *J.B. Fischer von Erlach*, London, 113 • BELLAVITIS, GIORGIO. "Dalle case fondaco al palazzo", in *Ritratto di Venezia*, catalogo della mostra, Venezia • BOSCARINO, SALVATORE. *Juvarra architetto*, Roma, 197-203, tav. 349 e 350 • BRAHAM, A.; SMITH, P. *François Mansart*, vols. 2, London • CATELLO, E. e C. *Argenti napoletani dal XVI al XIX secolo*, Napoli • DE JONGH, EDDY. "'t Gotsche krullig mall. De houding tegenover de gotiek in het zeventiende-eeuwse Holland", *Nederlands Kunsthistorisch Jaarboek*, 24, 85-145 • DE SETA, CESARE. in *Luigi Vanvitelli*, Napoli, 65, 289; 70, 290; 72, 290; 73, 291; 74, 291; 75, 291; 114/I, 289-91; 114/II, 299; 114/III, 299; 114/V, 300; 114/VI, 300; 114/VII, 300; 114/IX, 300-301, 114/XI, 301; 114/XII, 301; 114/XIII, 301; 114/XIV, 301 • FREIHERR VON KRÜDENER, JÜRGEN. *Die Role des Hofes im Absolutismus*, Stuttgart, 13-17 • GARMS, JÖRG. *Disegni di Luigi Vanvitelli nelle collezioni pubbliche di Napoli e di Caserta*, catalogo della mostra, Napoli, 109, 99-100; 111, 100; 112; 113, 101; 114, 291 • GÜTHLEIN, KLAUS. *Der österreichische Barockbaumeister Franz Munggenast*, Magistertarbeit,

Heidelberg • HERMANN, WOLFGANG. *The Theory of Claude Perrault*, London, A. Zwemmer • LEEUWENBERG, JAAP; HALSEMA-KUBES, WILLY. *Beeldhoukwunst in het Rijksmuseum*, Den Haag-Amsterdam • MARIN, LOUIS. *Utopiques: Jeux d'espaces*, Paris, Les Editions du Minuit • MORASSI, ANTONIO. *Guardi. Antonio e Francesco Guardi*, Venezia • MURARO, MICHELANGELO. "Il tempio votivo di Santa Maria della Salute in un poema del Seicento", *Ateneo Veneto*, n.s., 11, 87-119 • PETRIOLI TOFANI, ANNA MARIA. *I grandi disegni italiani degli Uffizi di Firenze*, introduzione di A. Forlani Tempesti, Milano • PEVSNER, NIKOLAUS; CHERRY, BRIDGET [a]. *The Buildings of England: London*, I: *The Cities of London and Westminster*, 3rd ed., • — [b]. *The Buildings of England: Northamptonshire*, 2nd ed., • PORTOGHESI, PAOLO. *Roma barocca*, I, *Nascita d'un nuovo linguaggio*, Bari, I terza, 2 voll. • PUPPI, L. *Andrea Palladio*, Milano, 44, 299-302 • ROCOLLE, PIERRE. *2000 Ans de Fortification Française*, Paris • ROSSACHER, KURT. "Das neueröffnete Salzburger Barockmuseum", *Zeitschrift Alte und Moderne Kunst*, 128, 1-11 • SHAPLEY FERN, RUSK. *Paintings from the Samuel H. Kress Collection: Italian Schools XVI-XVII Century*, London • VENDITTI, A. in *Luigi Vanvitelli*, Napoli, 101-29 • WEBER, INGRID. *Bauten Roms auf Münzen und Medaillen*, Ausstellungskatalog, München • WITTKOWER, RUDOLF. *Art and Architecture in Italy, 1600-1750*, Harmonsworth

1973-1974 *Mostra Vanvitelliana. Catalogo dei documenti e dei modelli*, a cura di G. Fiengo, Napoli, 1, 2 • SALZA PRINA RICOTTI, EUGENIA. "Villa Adriana in Pirro Ligorio e Francesco Contini", *Memorie dell'Accademia Nazionale dei Lincei*, 17: 3-47

1973-1980 GENTILE, GUIDO. "Le chiese delle confraternite", in *Carignano: appunti per una lettura della città*, Carignano, III: 140 ss.

1974 *Franz Anton Maulpertsch*, Ausstellungskatalog, Wien, Halbturn, Heiligenkreuz-Gutenbrunn • *Iskusstvo cesskogo barokko*, Leningrad, Gosudarstvenyj Ermitaz • CASSIRER, ERNST. *La filosofia dell'illuminismo*, Firenze, La Nuova Italia, 30, 55-56, 139, 348, 361 • DENISOV, JU.M.; PETROV, A.N. *Zodcij Rastrelli: materialy k izučeniju tvorčestva*, Leningrad • DE SETA, CESARE. "I disegni di Luigi Vanvitelli per la Reggia di Caserta e i progetti di Carlo Fontana per il palazzo del principe di Liechtenstein", *Storia dell'Arte*, 22, 287-96 • EVANGULOVA, O.S. "K probleme stilja v iskusstve Petrovskogo vremeni", *Vestnik Moskovskogo Universiteta*, 3, 67-84 • FAGIOLO DELL'ARCO, MAURIZIO. "Tra Melodramma ed Eclettismo. 'Macchine' di Paolo Posi", *Psicon*, I, 9-104 • FRIEDMAN, TERRY. *In Praise of James Gibbs*, exhibition catalogue, Aberdeen • GARMS, JÖRG. "Beiträge zu Vanvitellis Leben, Werk und Milieu", *Römische Historische Mitteilungen*, 16, 164-90 • GIUFFRE, MARIA. *L'Architecture del territorio nella Francia di Luigi XIV*, Palermo • HUGHES, QUENTIN. *Military Architecture*, London, 151-230 • KITAO, TIMOTHY KAORI. *Circle and the Oval in the Square of St. Peter's. Bernini's Art of Planning*, New York, 49-66 • MARINI, M. *Io, Michelangelo da Caravaggio*, Roma • MAZZOTTI, GIUSEPPE. *Le Delizie del Brenta*, Venezia • NEUMANN, JAROMÍR. *Cesky Barok*, Praha • PREIMLSBERGER, RUDOLF. "Obeliscus Pamphilius. Beiträge zur Vorgeschichte und Ikonographie des Vierströmbrunnens auf Piazza Navona", *Münchner Jahrbuch der bildenden Kunst*, 25: 77-162 • ROSENFELD, MYRA NAN. "Sebastiano Serlio's Drawings in the Nationalbibliothek in Vienna for his Seventh Book on Architecture", *The Art Bulletin*, LVI, 3, pp. 400-409 • SPASSKIJ, I.; SHCHUKINA, E. *Medals and Coins of the Age of Peter the Great from the Hermitage Collection*, Leningrad • TURNER, TREVOR. "John Smeaton, (1724-1792)", *Endeavour* XXXIII, 29-33 • WATKIN, DAVID. *Sale catalogues of libraries of eminent persons*, IV: *Architects*, London • WITTKOWER, RUDOLF. *Palladio and Palladianism*, London-New York

1974-1975 *Collections de dessins et pastels du Corrège à Quentin de La Tour*, catalogue de l'exposition, Aix-en-Provence, musée Granet • OENSLAGER, DONALD. *Four Centuries of Scenic Invention: Drawings from the Collection of Donald Oenslager*, New York, The International Exhibition Foundation

1975 BIBA, OTTO. "Der Piaristenorden in Österreich. Seine Bedeutung für bildende Kunst, Musik und Theater im 17. und 18. Jahrhundert", in *Jahrbuch für österreichische Kulturgeschichte*, V, Eisenstadt • COOPE, R.; GODARD, C. *Cahiers d'architecture et d'histoire du Berry*, no. 41 • COSTAMAGNO, A. "Agesia Beleminio (G. G. Bottari) e l'Accademia dell'Arcadia nel Settecento", in *Quaderni sul Neoclassico*, 3, 43-63 • DE VRIES, L. "Gerard Houckgeest", *Jahrbuch der Hamburger Kunstsammlungen*, 20: 25-

26 • GALASSI PALUZZI, CARLO. *La Basilica di San Pietro*, Bologna • HAGER, HELLMUT [a]. "Die Kuppel des Domes in Montefiascone", *Römisches Jahrbuch für Kunstgeschichte*, 15, 144-61 • — [b]. "On a project ascribed to Carlo Fontana for the Façade of San Giovanni in Laterano", in *The Burlington Magazine*, 105-7 • HAGUE, DOUGLAS B.; CHRISTIE, ROSEMARY. *Lighthouses: their Architecture, History and Archaeology*, Llandysul, Dyfed • HAMILTON, G. *The Art and Architekture of Russia*, Baltimore, 180-81, ill. 118 • HAYNES, D.E.L. *The Arundel Marbles, Ashmolean Museum*, Oxford • JACOB, SABINE. *Staatliche Museen Preußischer Kulturbesitz, Italienische Zeichnungen der Kunstbibliothek Berlin. Architektur und Dekoration 16. bis 18. Jahrhundert*, Berlin • LENZI, D. *Pianta e spaccato del Nuovo Teatro di Bologna Offerto al nobil'uomo ed eccelso sig. senatore conte Girolamo Legnani da Lorenzo Capponi in Bologna Per Lelio della Volpe impressore dell'istituto delle scienze MDCCLXXI*, in folio, Bologna • LUDMAN, JEAN-DANIEL. "Projets de Robert de Cotte et de l'Agence des Batiments du Roi pour la Ville de Lyon", in *L'Art Baroque a Lyon*, Lyon: 375-94 • MARAVALL, JOSÉ ANTONIO. *La cultura del Barroco, una estructura histórica*, Barcelona • MONTEVERDI, MARIO. MARIANI, ERCOLANO. *I Bibiena: Disegni e incisioni nelle collezioni del Museo Teatrale alla Scala*, catalogo della mostra, Milano • MORASSI, ANTONIO. *Guardi. Tutti i disegni di Antonio, Francesco e Giacomo Guardi*, Milano • MYERS, MARY L. *Architectural and Ornament Drawings: Juvarra, VAnvitelli, the Bibiena Family, and Other Italian Draughtsmen*, New York, The Metropolitan Museum of Art • OENSLAGER, DONALD. *Stage Design: Four Centuries of Scenic Invention*, New York • PRETO, P. *Venezia e i Turchi*, Firenze • REUTHER, HANS. "Geschichte des kathol. Sakralbaus in Niedersachsen 1648-1789", in *Niederdeutsche Beiträge zur Kunstgeschichte*, 14, 127-74 • SCHIAVO, A. "L'illuminazione esterna di S. Pietro e Luigi Vanvitelli", *Studi Romani*, 23, 486-91 • SCRIBNER, CH. "Sacred Architecture: Rubens' Eucharist Tapestries", *Art Bulletin*, 518-28 • WUNDER, RICHARD. *Architectural, Ornament, Landscape and Figure Drawings Collected by Richard Wunder*, exhibition catalogue, Middlebury, Middlebury College

1975-1976 WHEELOCK, A.K. "Gerard Houckgeest and Emanuel de Witte: Architectural Painting in Delft around 1650", Simiolus, 8, 146-66

1975-1979 BLANKERT, ALBERT. *Amsterdams Historisch Museum. Schilderijen daterend van voor 1800. Voorlopige catalogus*, Amsterdam

1976 *Hollsteins German Engravings, Etchings and Woodcuts*, ed. F. Anzelewsky, xvii, Amsterdam • *Jacques de Létin*, catalogue de l'exposition, Troyes, musée des Beaux-Arts • *Luigi Vanvitelli*, Napoli • *Piranèse et les Français 1740-1790*, sous la direction de G. Brunel, catalogue de l'exposition, Rome-Dijon-Paris • *Roma sparita: Donazione Anna Laetitia Pecci Blunt*, Roma • ANANOFF, A. *François Boucher, catalogue des peintures*, avec la collaboration de D. Wildenstein, 2 voll., Paris • BASSI, ELENA. *Palazzi di Venezia*, Venezia • COLVIN, HOWARD; MORDAUNT CROOK, J. NEWMAN, JOHN. *The History of the Kings Works*, V, 1660-1782, London • CONSTABLE, W.G.; LINKS, J.G. *Canaletto. Giovanni Antonio Canal, 1697-1768*, 2 voll., Oxford • D'AMICO, FRANCA. "La veduta nell'incisione del '600 e '700 G.B. Falda e G. Vasi", in *'Il seicento', ricerche di storia dell'Arte*, 81-101, nn. 1-2 • DANIELS, JEFFREY. *Sebastiano Ricci*, Hove • DE FUSCO, R. *Vanvitelli nella storia e la critica del Settecento*, in Aa. Vv., *Luigi Vanvitelli*, Napoli, 30-31 • DENISOV, JU.M.; PETROV, A. *Rastrelli*, Leningrad, 298-324 • FREDERICKSEN, B. "Recent Gifts of Paintings. Wilhelm v. Ehrenberg: Ulisses at the Palace of Circe", *Getty Museum Journal*, 3, 103-24 • GAMBI, L. "La città da immagine simbolica a proiezione urbanistica", in *Storia di Italia*, VI, Atlante, Torino, Einaudi: 215-28 • HAMON, FRANÇOISE. "Les églises parisiennes du XVIIIe siècle. Théorie et pratique de l'architecture cultuelle", *Revue de l'art*, 32, 7-14 • HEIDEGGER, MARTIN. *Essere e tempo (1927)*, Milano, Longanesi, 136 • KJUCARIANC, D.A. [a]. *Antonio Rastrelli*, Leningrad, 73-74 • — [b]. *Antonio Rinaldi*, Leningrad, 73-75 • KRINZINGER, J.P. JAKOB. "Die Sternwarte - eine gebaute Idee", in *Kremsmünster, 1200 Jahre Benediktinerstift*, II Ausg., Linz: 259-87 • KREILINGER, KILIAN. "Der bayerische Rokokobaumeister Franz Alois Mayr", *Jahrbuch des Vereins für christliche Kunst*, IX, München • LEIDTKE, WALTER A. "The 'View in Delft' by Carel Fabritius, The *Burlington Magazine*, CXVIII: 61-73 • MAZZA, BARBARA. "La vicenda dei 'Tombeaux des princes': matrici, storia e fortuna della serie Swiney

tra Bologna e Venezia", *Saggi e Memorie di Storia dell'Arte*, 10, 81-151 • PEVSNER, NIKOLAUS. *A History of Building Types*, Princeton-London • PIGNATTI, TERISIO. *Le prospettive di Venezia di Michele Marieschi*, Venezia • PINTO, JOHN [a]. "Origins and Development of the Ichnographic City Plan", *Journal of the Society of Architectural Historians*, XXXV: 35-50 • —[b]. *Nicola Michetti (circa 1675-1758) and Eighteenth-Century Architecture in Rome and St. Petersburg*, Ph. D. Dissertation, Harvard University • RIZZI, WILHELM GEORG. "Die Kuppelkirchenbauten Johann Lucas von Hildebrandts", *Wiener Jahrbuch für Kunstgeschichte*, XXIX: 121-55 • ROLAND MICHEL, MARIANNE. "Le cabinet de Bonnier de la Mosson et la participation de Lajoüe à son décor", *B.S.H.A.F.* 1975, Paris • SEDLMAYR, HANS. *Johann Bernhard Fischer von Erlach*, Wien, 113 • STRAZZULO, F. *Le lettere di Luigi Vanvitelli della biblioteca palatina di Caserta*, 3 voll., Galatina • VAN EEGHEN, I.H. "De familieustukken van Metsu van 1657 en van De Witte van 1768 met vier levensgeschiedenissen (Gillis Valckenier, Nicolaas Listingh, Jan Zeeuw en catharina van de Perre)", *Jaarboek Genootschap Amstelodamum*, 68, 108-21 • VAN THIEL, P.J.J. *Alle schilderijen van het Rijksmuseum te Amsterdam*, Amsterdam-Haarlem • WILTON-ELY, JOHN. "The rise of the professional architect in England", in *The Architect: Chapters in the History of the Profession*, ed. S. Kostof, New York, 180-208

1977 *Dessins français du XVIII siècle*, catalogue de l'exposition, Graz, Sonderausstellung im Ecksaal des Johanneums, Besançon, musée des Beaux-Arts • *Italian Views for a private room in Holkham Hall*, exhibition catalogue, London, Jocelyn Fielding Fine Art: n. 7 • *Le Siècle de Rubens dans les collections publiques françaises*, catalogue de l'exposition, Paris, Grand-Palais • *The Architect. Chapters in the History of the Profession*, ed. S. Kostoff, Oxford • *The Architecture of the Ecole des Beaux-Arts*, ed. A. Drexler, London • *The Dutch Cityscape in the 17th Century and its Sources*, ed. B. Bakker et al., Amsterdam-Toronto • *Umelecké památky Cech* 1, ed. E. Poche, Praha, 557 (entry "Chynov") • ALEKSEEVA, T.V. *Russkoe iskusstvo barokko: materialy i issledovanija*, Moskva • APOLLONJ GHETTI, F.M. "Santi Ghetti, scarpellino e imprenditore", *L'Urbe*, 40, • BARCHAM, W.L. *The Imaginary View Scenes of Antonio Canaletto* (tesi New York 1974), New-York-London, 142-43 • BLAZICEK OLDRICH, JAKUB [a]. "Skulptur", in *Kunst des Barock in Böhmen*, exhibition catalogue, Essen, Villa Hügel, Recklinghausen, 35-72 • —[b]. "Skulptur", in *Kunst des Barock in Böhmen. Skulptur-Malerei-Kunsthandwerk-Bühnenbild*, Recklinghausen, 25-124 • BRAHAM, ALLAN; HAGER, HELLMUT. *Carlo Fontana. The Drawings at Windsor Castle*, London • BRESCIANI, ALVARO GIULIO [a]. "L'architettura civile del Barocco a Padova", in *Padova. Case e palazzi*, a cura di L. Puppi e F. Zulian, Vicenza, 141-80 • —[b]. "Le fasi costruttive e l'arredo plastico architettonico del Duomo di Padova", in *Il Duomo di Padova ed il suo battistero*, Padova, 87-138 • CVEKAN, PASKAL. *Virovitica i franjevci*, Zagreb • DI FEDERICO, F.R. *Francesco Trevisani. Eighteenth-Century Painter in Rome*, Washington • DOWNES, KERRY [a]. *Hawksmoor*, exhibition catalogue, Whitechapel Art Gallery, London • —[b]. *Vanbrugh*, London • FREMANTLE, KATHARINE; HALSEMA-KUBES, WILLY. *Beelden kijken. De kunst van Quellien in het Paleis op de Dam. Focus on sculpture. Quellien's art in the Palace on the Dam*, exhibition catalogue, Amsterdam • HALE, JOHN. "Printing and Military Culture of Renaissance Venice", *Medievalia et Humanistica: Studies in Medieval and Renaissance Culture*, n. 8, 21-62 • HARRIS, ANN SUTHERLAND. *Selected Drawings of Gianlorenzo Bernini*, New York • KUMMER, S. "Mailänder Vorstufen von Borrominis S. Carlo alle Quattro Fontane in Rom", *Münchener Jahrbuch der Bildenden Kunst*, 28, 153-90 • MASOBELLO, R.; TARLÀ, M. "L'architettura di Palazzo Pisani", in *Il conservatorio di musica "Benedetto Marcello" di Venezia*, a cura di L. Moretti, Venezia, 110-33 • MERRETT, L.H. "Smeaton's Tower", *Maritime History*, V, 136-47, 164 • MORENO CRIADO, RICARDO. *La maqueta de Cádiz*, Cádiz • MUMFORD, LEWIS. *La città nella storia*, Milano, 461 ss. • MURARO, MICHELANGELO. "Il tempio votivo di S. Maria della Salute a Venezia", in *Barocco fra Italia e Polonia*, Varsavia [estratto] • PARKER, GEOFFREY. *The Dutch Revolt*, London • PÜHRINGER-ZWANOWETZ, LEONORE. "Alte Modelle", in *Österreichische Kunsttopographie*, XLIII: *Die Kunstdenkmäler des Benediktnerstiftes Kremsünster*, I, Wien: 42 ss. • RODRÍGUEZ G. DE CEBALLOS, ALFONSO. *La Plaza Mayor de Salamanca*, Salamanca • ROLAND MICHEL, MARIANNE "De Panini à Servandoni –

ou la réattribution d'un tableau du Musée des Beaux-Arts", *Bulletin des musées et monuments lyonnais*, 6, 21-34 • TIOZZO, CLAUCO B. *Le ville del Brenta*, Venezia • WHEELOCK, ARTHUR K.JR. *Perspective, Optics and Delft Artists around 1650*, London-New York

1977-1980 SALERNO, LUIGI. *Pittori di paesaggio del Seicento a Roma*, 2a ed., Roma

1978 *Baroque & Rococo - Architecture & Decoration*, ed. A. Blunt, London, Paul Elek Ltd • *La peinture en Provence au XVII siècle*, Marseille, musée des Beaux-Arts • *The Origins of Italian Veduta*, E. Berns, D. E. Bonner, Providence, R. I. • BAZIN, GERMAIN. *The Baroque, Principles, Styles, Modes, Themes*, New York, W.W. Norton & Company, Inc. • BELLINI, AMEDEO. *Benedetto Alfieri*, Milano • BLUNT, ANTHONY. "Gianlorenzo Bernini: Illusionism and Mysticism", *Art History*, 1, 67-89 • BODROVA, E.I. *Biblioteka Petra I*, Leningrad, 41 • CARLSON, R. *Hubert Robert. Drawings and Watercolors*, catalogo della mostra, Washington, 21, 68-69 • CHASTEL, ANDRÉ. "Marqueterie et perspective au XV siècle", in *Formes, fables, figures*, Paris, Flammarion: 317-22, 497-503 • DOWNES, KERRY. "England" in *Baroque and Rococo Architecture and Decoration*, ed. A. Blunt, London-New York • HOFFMANN, VOLKER. "Die Fassade von S. Giovanni in Laterano", in *Römisches Jahrbuch für Kunstgeschichte*, 17, 1-46 • MARIUZ, ADRIANO. in Pallucchini Rodolfo, *Gli affreschi nelle ville venete dal Seicento all'Ottocento*, Venezia • NEWTON, ISAAC. *Ottica*, libro III, questione 28, Torino, UTET, 576-77 • PARTRIDGE, LOREN. "Divinity and Dinasty at Caprarola: Perfect History in the Room of the Farnese Deeds", *The Art Bulletin*, LX: 494-529 • PUGLIATTI, TERESA. *Agostino Tassi*, Roma • ROLAND MICHEL, MARIANNE. "De l'illusion à l'inquiétante étrangeté: quelques remarques sur l'évolution du sentiment et de la représentation de la ruine chez les artistes français à partir de 1730", in *Piranèse et les Français*, a cura di G. Brunel, atti del convegno, Roma 1976, Roma 1978, 475-98 • ROSENBERG, PIERRE. "Louis-Joseph Le Lorrain (1715-1759)", *Revue de l'art*, 40-41: 173-202 • SANTORO, R. "Fortificazioni bastionate della Sicilia", *Archivio storico siciliano*, IV • SCHULZ, JÜRGEN. "Jacopo de' Barbari's View of Venice: Map Making, City Views, and Moralized Geography Before the Year 1500", *The Art Bulletin*, 60: 425-74 • VINER, B.R. *Architektura russkogo barokko*, Moskva, 80-81, ill. 202 • ROSENFELD, MYRA N. *Sebastiano Serlio on domestic architecture*, pref. A.K. Placzek, introd. J. Ackerman, Cambridge, Mass.-London

1978-1979 SCHIAVO, A. "Notazioni vanvitelliane sulle regge di Napoli e di Caserta", *Archivio Storico di Terra di Lavoro*, 6, 333-58 • TOGNOLO, BIANCA MARIA. *Girolamo Frigimelica architetto dilettante padovano tra Seicento e Settecento*, tesi di laurea, Università di Padova

1979 *Architettura, Scenografia, Pittura di paesaggio*, catalogo della mostra, Bologna, Museo Civico • *Arte lombarda. Nuova serie*, n. 44/4, Milano • *Charles de Wailly (1730-1798), peintre architecte dans l'Europe des Lumières*, catalogue de l'exposition, Paris, Hôtel de Sully • *Die Metamorphose. Künstlerentwürfe des Barock. Dem Gedenken Gianlorenzo Berninis, Schriften des Salzburger Barockmuseums*, 4 • *William and Mary and Their House*, New York-London, The Pierpont Morgan Library, Oxford University Press • BALDINI, U. et al. *La cappella dei Principi e le Pietre Dure a Firenze*, Firenze • BERGAMINI, WANDA. "Antonio Galli Bibiena", in *L'arte del Settecento Emiliano. Architettura, Scenografia, Pittura di Paesaggio*, Bologna • BILL, E.G.W. *The Queen Anne Churches: A Catalogue of the Papers in Lambeth Palace Library of the Commission for Building Fifth New Churches in London and Westminster, 1711-1759* • BLUNT, ANTHONY. *Borromini*, London, Cambridge, Mass. • BONELLI, R. "Vanvitelli e la cultura europea: proposta per una lettura europeista della Reggia di Caserta", in *Luigi Vanvitelli e il '700 europeo*, Atti del Convegno internazionale di studi, Napoli, I, 135-47 • BRUNO, A. "Il modello di Juvarra per il Castello di Rivoli", in *Studi Juvarriani*, Atti del Convegno dell'Accademia delle Scienze, Torino, Roma • CARBONERI, NINO *La Reale Chiesa di Superga di Filippo Juvarra 1719-1735*, Torino • CONCINA, ENNIO *Ville giardini e paesaggi del Veneto nelle incisioni dell'opera di Johann Christoph Volkamer*, Milano • DERŽAVIN, O.A. *Panegiričeskaja literatura Petrovskogo vremeni*, Moskva, 297 • DI GADDO, BEATA. *Villa Borghese*, Officina Edizioni, Roma • DOIG, ALAN. *The Architectural Drawings Collection of King's College, Cambridge*, Cambridge • DOWNES, KERRY. *Hawksmoor*, London • DUFFY, CHRISTOPHER. *Siege Warfare: The Fortress in the Early Modern World, 1494-1669*, London, 182-85 • EKBERG, CARL J. *The Failure of Louis XIV's*

Dutch War, Chapel Hill NC, UNC Pres • GIGANTI, AMELIA IOLI. "Lineamenti di morfologia urbana di Messina nel Secolo XVII", in *La rivolta di Messina (1674-78) e il mondo mediterraneo nella seconda metà del Settecento*, a cura di S. Di Bella, Atti del Convegno, Università di Messina, 1975, Cosenza, 583-94 • GOTHEIN, MARIE LOUISE. *A History of Garden Art*, New York, Hasher • GREER, G. *The Obstacle Race: The Fortunes of Women Painters and their Work*, London • GRISERI, ANDREINA. "Urbanistica, cartografia e antico regime nel Piemonte Sabaudo", *Storia della città*, III-IV, 12-13, 19-38 • HARRIS, JOHN. *The Artist and the Country House*, London • MARTINDALE, ANDRÉ. *The Triumph of Caesar by Andrea Mantegna in the collection of Her Majesty the Queen at Hampton Court*, London • NIERO, ANTONIO [a]. "I templi del Redentore e della Salute: motivazioni teologiche", in *Venezia e la peste*, catalogo della mostra, Venezia, 294-98 • —[b]. "La pietà e i suoi templi", in *Venezia e la peste*, catalogo della mostra, Venezia, 299-318 • PÜHRINGER-ZWANOWETZ, LEONORE. "Bemerkungen zur Sternwarte des Stiftes Kremsmünster I, Das Projekt einer Sternwarte über dem Brückentor", *Wiener Jahrbuch für Kunstgeschichte*, 32: 135-72 • SAHUT, M.C. *Le Louvre d'Hubert Robert*, catalogue de l'exposition, Paris, Musée du Louvre • SAMMER, A. *Der Mariazeller Hochaltar von J.B. Fischer von Erlach*, Wien, 23 • SHAPLEY FERN, RUSK. *Catalogue of Italian Paintings: The National Gallery of Art*, 2 vols., Washington D.C. • ZAMBONI, SILLA. "Modello per la Fontana dei Quattro Fiumi", in *L'arte del Settecento emiliano: La pittura (L'Accademia Clementina)*, a cura di A. Emiliani et al., catalogo della mostra, Bologna: 301-302 • ZANGHERI, LUIGI. *Pratolino: il giardino delle meraviglie*, Firenze, Gonnelli

1980 *A Scholar Collects: Selections from the Anthony Morris Clark Bequest*, Philadelphia • *Civiltà del '700 a Napoli 1734-1799*, catalogo della mostra, Napoli, vol. II, 505, 84, 236 • *Im südlichen Tirol zur Zeit Maria Theresias*, Ausstellungskatalog, Brixen, Museo Diocesano • *Skokloster, the Castle and Collections*, ed. L. Rangström Uddevalla • *Welt im Umbruch, Augsburg zwischen Renaissance und Barock*, Augsburg • BAETJER, KATHARINE. *European Paintings in the Metropolitan Museum of Art by artists in or before 1865. A summary catalogue*, I, New York, The Metropolitan Museum of Art • BAUMSTARK, R. *Meisterwerke der Sammlungen des Fürsten von Liechtenstein. Gemälde*, Zürich-München, 158, 311-12 • BLAZICEK OLDRICH, JAKUB. "Italské podenty a ohlasy v barokoven socharství Cech.", *Umeni* XXVIII, n. 6, 493-504 • BONELLI, R. "Presentazione degli Atti del Congresso internazionale di studi Luigi Vanvitelli il '700 europeo", *Restauro*, 50, 46-55 • BROWN, JONATHAN; ELLIOTT, H.J. *A Palace for a King*, New Haven, 123, Marshall 1993, 68-82 • BRUSATIN, MANLIO *Venezia nel Settecento: stato, architettura, territorio*, Torino • CIATI, B. "Cultura e società nel secondo Quattrocento attraverso l'opera ad intarsio di Lorenzo e Cristoforo da Lendinara", in *La prospettiva rinascimentale: codificazioni e trasgressioni*, a cura di M. Dalai Emiliani, Firenze, Centro Di: 201 ss. • CIPRIANI, ANGELA. "Un'one 'studio del Cav. Bernini'", *Ricerche di Storia dell'arte*, 11: 75-78 • CONNORS, JOSEPH. *Borromini and the Roman Oratory: Style and Society*, New York-Cambridge, Mass.; trad. it. Torino, Einaudi, 1989 • ELÍAS, NORBERT. *La società di corte*, Bologna • ERICSSON, CHRISTOPHER. *Roman architecture expressed in sketches by Francesco di Giorgio Martini*, Helsinky • FUHRING, PETER. *Vredeman de Vries. Hollstein's Dutch & Flemish Etchings, Woodcuts 1450-1700*, XVIII, Rotterdam • GIUFFRÈ, MARIA. *Castelli e luoghi forti di Sicilia XII-XVII secolo*, Palermo • GROSSHANS, RAINALD. *Maerten van Heemskerck. Die Gemälde*, Berlin • HAGER, WERNER. *Welt im Umbruch, Augsburg zwischen Renaissance und Barock*, Augsburg, 276; 303; 261, 292 • HASKELL, F. *Patrons and Painters. A Study in the Relations Between Italian Art and Society in the Age of the Baroque*, New Haven, 2a ed., 90-91 • HAZELHURST, FRANKLIN HAMILTON. *Gardens of Illusion: The Genius of André Le Nôtre*, Nashville, Vanderbilt University Press, 17-45 • HELD, JULIS S. *The Oil Sketches of Peter Paul Rubens. A Critical Catalogue*. Princeton • INSOLERA, ITALO. *Roma. Immagini e realtà dal X al XX secolo*, Bari • JONES, COLIN. "The Military Revolution and the Professionalization of the French Army under the Ancien Régime", in *The Military Revolution and the State, 1500-1800*, ed. M. Duffy, Exeter, 29-48 • KELLY COOK, CATHIE. *Ludovico Rusconi Sassi and Early Eighteenth Century Architecture*, Ph. D. Thesis, Ann Arbor, The Pennsylvania State University • KUYPER, W. *Dutch Classicist Architecture*, Delft • LAVIN, IRVING. *Bernini e l'unità delle arti visive*, Roma, ed. dell'Elefan-

te • PINTO, J.A. "A Scholar Colletcs", in *Selections from the Anthony Morris Clarck Bequest*, a cura di U.W. Heisinger e A. Percy, catalogo della mostra, The Philadelphia Museum of Art, Philadelphia, n. 2, 11-12 • PRÉAUD, MAXIME. *Inventaire du fond français. Gravures du XVII siècle*, VIII: *Sébastien Leclerc I*, Paris, Bibliothèque Nationale • SCHREINER, LUDWIG. "Ein Gemälde von Hendrick Arts. Die Phantasiekirche", *Weltkunst*, 50, 882-84 • SCOTT MUNSHOWER, SUSAN. "Concorso Clementino del 1705, Second Class of Architecture, Design for Façade of San Giovanni in Laterano in Rome", in *Architectural Fantasy and Reality*: 43-52 • TANTURLI, G. "Rapporti del Brunelleschi con gli ambienti letterari", in *Filippo Brunelleschi, La sua opera e il suo tempo*, 2 voll., Firenze • TERNOIS, DANIEL [a]. "Soufflot et Lyon, État des Travaux et Problématique", in *Soufflot et l'Architecture des Lumières*, Cahiers de la Recherche Architecturale, 1980, 6-7: 80-101 • —[b]. "La Loge des Changes de Lyon", in *Soufflot et son temps 1780-1980*, catalogue de l'exposition, Musée des Beaux-Arts, Lyons: 64-67 • THIEME, BECKER. *Welt im Umbruch, Augsburg zwischen Renaissance und Barock*, Augsburg, 276; 303 • TOGNOLO, BIANCA MARIA. "Documenti inediti per la biografia di Girolamo Frigimelica", *Padova*, XXVI, 4, 3-9 • VIALE FERRERO, MERCEDES. "La scenografia dalle origini al 1936", in *Storia del Teatro Regio di Torino*, III, Torino, 153-54, 164-195 • WHISNEVSKY, ROSE. "Chiaveri Gaetano", *Dizionario Biografico degli Italiani*, vol. 24, Roma: 645-49 • WHITMAN, NATHAN; VARRIANO, JOHN. *Roma Resurgens. Papal Medals from the Age of the Baroque*, exhibition catalogue, Ann Arbor, The University of Michigan Museum of Art: 99-103 • ZWEITE, ARMIN. *Marten de Vos als Maler*, Berlin

1980-1981 GARRETSON, EDWIN P. "C. Adolph von Albrecht, Programmer at the Court of Charles VI", in *Mitteilungen der Österreichischen Galerie Wien*, Wien, 19

1981 *Arkhitekturnaaya grafika Rossii: pervaia polovine XVIII veka*, ed. A.N. Voronikhina, Leningrad • *Bernini in Vaticano*, catalogo della mostra, Roma, Braccio di Carlo Magno • *Drawings by Gianlorenzo Bernini from the Museum der Bildenden Künste Leipzig, German Democratic Republic*, ed. I. Lavin, with essays by I. Lavin, P. Gordon, L. Klinger, S. Ostrow, S. Cather, N. Courtright, I. Dreyer, Princeton • *John Smeaton*, ed. A.W. Skempton, London • *Le Baroque en Bohême*, Paris, Galeries Nationales du Grand Palais • *Of Building. Roger North's Notes on Architecture*, eds. H. Colvin and J. Newmann, Oxford • *The Panoramic Image*, eds. J. Sweetman et al., Southampton • BEARD, GEOFFREY. *Craftsmen and Interior Decoration in England: 1660-1820*, Edinburgh • BEIJER, AGNES. *Drottningholms slottsteater på Lovisa Ulrikas och Gustaf III:s tid*, Drottningholms teatermuseum & Stockholmsmonografier, 42, Stockholm • BIRKE, VERONIKA. "Die Dreifaltigkeitssäule in Wien", in *Mathias Rauchmiller*, Wien, 41 • BLAZICEK OLDRICH, JAKUB [a]. "Bildhauerrskizzen des böhmischen Barock", in *Imagination und Imago (Festschrift Kurt Rossacher)*, Salzburg, 9-18 • —[b]. "La Sculpture baroque", in *Le Baroque en Bohême*, catalogue de l'exposition, Paris, Galeries du Grand Palais, 71-105 • COLLETTA, TERESA. *Piazzeforti di Napoli e Sicilia, le "Carte Montemar" e il sistema difensivo meridionale al principio del Settecento*, Napoli • COLVIN, H.; NEWMAN, J. *Of Building. Roger North's Writings on Architecture*, Oxford • COURTRIGHT, NICOLA. "Four Rivers Fountain", in *Drawings by Gianlorenzo Bernini from the Museum der bildenden Künste Leipzig, German Democratic Republic*, ed. I. Lavin, exhibition catalogue, Princeton: 108-19 • DE NITTO, G. *I Disegni di Mario Gioffredo per la Reggia di Caserta presso la Biblioteca Nazionale di Napoli*, Napoli • HARRIS, JOHN. *The Palladians*, RIBA Drawings Series, London • HERSEY, G.L. "Ovid, Vico and the Central Garden at Caserta", in *Journal of Garden History*, I • KELLY COOK, CATHIE. "Accademico di Merito del 1724, Design for a Church Façade by Ludovico Rusconi Sassi", in *Architectural Fantasy and Reality*, 157-61 • LOUW, H.J. "Anglo-Netherlandish architectural interchange, c. 1600- c. 1660", *Architectural History*, 24, 1-23 • MAINSTONE, ROWLAND. "The Eddystone Lighthouse", in *John Smeaton, FRS*, ed. A.W. Skempton, London, 83-102 • MARTINELLI, VALENTINO. *Bernini. Disegni*, Firenze • MASSIE, ROBERT K. *Peter the Great*, London, 648 • MATSCHE, FRANZ. *Die Kunst im Dienst der Staatsidee Kaiser Karls VI*, 2 voll., Berlin-New York • MEHNERT, KARL-HEINZ. *Gianlorenzo Bernini. Zeichnungen*, Kataloge der Graphischen Sammlung 5, Museum der bildenden Künste Leipzig, Leipzig • METZEGER, HABEL DOROTHY. "Piazza S. Ignazio, Rome, in

the 17th and 18th Century", in *Architectura Zeitschrift für Geschichte der Baukunst/Journal of Architecture*, 1, XI, 31-65 • MICHELINI TOCCI, LUIGI. "Innocenzo X. Medaglia dell'anno viii, con la fontana di Piazza Navona, 1652", in *Bernini in Vaticano*, catalogo della mostra, Roma: 288 • MOSSER, M. "Architecture on display", *Daïdalos*, 2 • MUNSHOWER SCOTT, SUSAN. "Concorso Clementino of 1705, Second Class of Architecture, Design for Façade of San Giovanni in Laterano in Rome", in *Architectural Fantasy and Reality*, 43-52 • PATTERSON, RICHARD. "The 'Hortus Palatinus' at Heidelberg and the Reformation of the World. Part 1: The Iconography of the Garden", *Journal of Garden History*, 1, n. 1, 67-104 • REUTHER, HANS. "Wesen und Wandel des Architekturmodells in Deutschland", *Daidalos. Berlin Architectural Journal*, 2, 98-110 • ROLAND MICHEL, MARIANNE. "François Thomas Mondon, artiste 'rocaille' inconnu", *B.S.H.A.F.*, 149-58 • RUSSO, LAURA. "Disegno per la Fontana dei Quattro Fiumi", in *Bernini in Vaticano*, catalogo della mostra, Roma: 125 • SCHLEGEL, U. "Crocifissi degli altari in San Pietro in Vaticano", *Antichità viva*, XX, 6: 37-42 • SCOTT MUNSHOWER, SUSAN. "Concorso Clementino of 1705, Second Class of Architecture, Design for Façade of San Giovanni in Laterano in Rome", in *Architectural Fantasy and Reality*: 43-52 • SUCCI, DARIO. *Le incisioni di Michele Marieschi vedutista veneziano*, catalogo della mostra, Padova • TAMBURINI, LUCIANO. *Il Castello di Rivoli*, Rivoli • TURNER, TREVOR; SKEMPTON, A.W. "John Smeaton", in *John Smeaton*, ed. A.W. Skempton, London, 7-34 • ZANGHERI, LUIGI. "I giardini d'Europa: una mappa della fortuna medicea nel XVI e XVII secolo", in *Il giardino d'Europa, Pratolino come modello della cultura europea*, Milano, Mazzotta • ZIMMER, JÜRGEN. "Die Veränderungen im Augsburger Stadtbild zwischen 1530 und 1630", in *Welt im Umbruch*, III, Augsburg, 25-65

1981-1982 *Zeichnungen alter Meister aus polnischen Sammlungen*, Ausstellungskatalog, Braunschweig, Herzog Anton Ulrich Museum, Koburg, Kunstsammlungen • DALL'AGLIO, A. *Lorenzo Boschetti proto al Magistrato dei Savi ed Esecutori alle Acque (1670-1750)*, tesi di laurea, IUAV, Venezia

1982 *Canaletto. Disegni - Dipinti - Incisioni*, a cura di A. Bettagno, catalogo della mostra, Venezia, 102, 73-75 (L. Puppi) • *"Fochi d'allegrezza" a Roma dal Cinquecento all'Ottocento*, Roma, Edizioni Quasar • *Het achtste wereldwonder. De bouw van het stadhuis, nu Paleis op de Dam*, tentoonstelling catalogus, Amsterdam • *James Gibbs Architect, 1682-1754: a man of great Fame*, ed. T. Friedman, exhibition catalogue, Orleans House, Twickenham • *Le Temple. Représentations de l'architecture sacrée*, catalogue de l'exposition, Nice, Musée national Message biblique Marc Chagall • *Les Gabriel: ouvrage collectif*, Paris, Picard, 104-11 • *Umelecké památky Čech* 4, ed. E. Poche, Praha, 363-370 (entry "Zlatá Koruna") • AVISSEAU, J.-P. "La Place Royale de Bordeaux", in Gallet Michel, Bottineau Yves. *Les Gabriel: ouvrage collectif*, Paris, Picard: 104-11 • BEARD, GEOFFREY. *The Work of Sir Christopher Wren*, Edinburgh • BIADENE, SUSANNA. "Catalogo delle opere", in *Longhena*, a cura di L. Puppi e G.D. Romanelli, catalogo della mostra, Milano, 57-182 • BLUNT, ANTHONY. *Guide to Baroque Rome*, New York • BRENNINKMEYER-DE ROOIJ, B. "Notities betreffende de decoratie van de Oranjezaal in Huis Ten Bosch", *Oud Holland*, 96, 133-90 • COMOLI MANDRACCI, VERA. "La Capitale per uno stato", in *Guida all'architettura moderna di Torino*, a cura di A. Magnaghi, M. Monge e L. Re, Torino, 257-80 • CONNORS, JOSEPH. "Pietro Berrettini da Cortona", in *Macmillian Encyclopedia of Architects*, ed. A.K. Placzek, 4 vols., London, I, 455-66 • DEE ELAINE, EVANS. "Giles-Marie Oppenord", in *Macmillan Encyclopedia of Architects*, New York-London, III, 324-27 • D'ONOFRIO, CESARE. *Le Fontane di Roma*, 2nd ed. riv., Roma • DOWNES, KERRY [a]. *Sir Christopher Wren*, ed. K. Downes, exhibition catalogue, Whitechapel Art Gallery, London • — [b]. *The Work of Sir Christopher Wren*, Edinburgh • FERRETTI, M. "I maestri della prospettiva", in *Storia dell'arte italiana*, IV, Torino, Einaudi • FICACCI, L. "Jacob Cornelisz Cobaert", in *Dizionario biografico degli italiani*, Roma, XXVI • GABETTI, ROBERTO. "Architettura italiana del Settecento", in *Storia dell'arte italiana*, a cura di F. Zeri, II, *Settecento e Ottocento*, Torino, Einaudi, 661-721 • GARMS, ELISABETH; GARMS, JÖRG. "Mito e realtà di Roma nella cultura europea", in *Storia d'Italia. Annali 5. Il paesaggio*, Torino, Einaudi • GEMIN, MASSIMO. *La chiesa di Santa Maria della Salute e la cabala di Paolo Sarpi*, Abano Terme • HEIDNER, JAN. *Carl Fredrik Scheffer.*

Lettres particulières à Carl Gustaf Tessin 1744-1753, Kungl. Samfundet för utgivande av handskrifter rörande Skandinaviens historia, Handlingar del, 7, Stockholm • HOPPER, FLORENCE. "The Dutch Classical Garden and André Mollet", *Journal of Garden History*, 2, 25-40 • ISRAËL, JONATHAN. *The Dutch Republic and the Hispanic World 1606-1661*, Oxford • KELDER, DIANE L. "Galli Bibiena Family", in *Macmillan Encyclopedia of Architects*, New York-London, II, 149-53 • KELLY, CATHIE C. "Chiaveri Gaetano", *Macmillan Encyclopedia of Architects*, vol. 1, NewYork-London: 414-15 • LAVEDAN, PIERRE; HUGUENEY, JEANNE; HENRAT, PHILIPPE. *L'urbanisme à l'époque moderne XVIᵉ-XVIIᵉ siècles*, Genève-Paris, Droz • LIEDTKE, WALTER. *Architectural Painting in Delft. Gerard Houckgeest - Hendrick van Vliet - Emanuel de Witte*, Doornspijck • LUND, H. "Eine Vermessung des 18. Jahrhunderts der Villa Adriana", *Annalecta Instituti Danici*, X, 41-52 • MARTINELLI, VALENTINO. *Bernini Drawings*, transl. by K. Asbury Giacheti, Firenze • MILLON, HENRY A. [a]. "Guarino Guarini", in *Macmillan Encyclopedia of Architects*, ed. A.K. Placzek, II, New York-London, 265-79 • —[b]. "Juvarra Filippo", in *Macmillan Encyclopedia of Architects*, a cura di A.K. Placzek, New York, II, 519-22 • MORRICE, RICHARD. *The Buildings of Britain: Stuart and Baroque. A guide and Gazetteer*, London • NORDENFALK, CLAUS. *The Batavians' Oath of Allegiance. Rembrandt's only Monumental Paintings*, Stockholm • PETZET, MICHAEL. "Das Triumphbogenmonument für Ludwig XIV. auf der Place du Trône", *Zeitschrift für Kunstgeschichte*, 45, 2, 145-94 • PÜHRINGER-ZWANOWETZ, LEONORE. "Zur Baugeschichte des Augustiner-Chorherrenstifts Herzogenburg", in *Stift Herzogenburg und seine Kunstschätze*, St. Pölten-Wien: 49-94 • ROMANELLI, GIAN DOMENICO. "Baldassare Longhena, retorica e tecnica dell'architettura", in *Longhena*, a cura di L. Puppi e G.D. Romanelli, catalogo della mostra, Milano, 31-56 • SALZA PRINA RICOTTI, EUGENIA. "Villa Adriana nei suoi limiti e nella sua funzionalità", *Mem. Pont. Acc.*, XIV, 35-36 • TERNOIS, DANIEL. "La Loge du Change", in *L'œuvre de Soufflot à Lyon: Etudes et Documents*, Lyons: 77-97 • WILTON-ELY, JOHN. "Giovanni Battista Piranesi", in *Macmillan Encyclopedia of Architects*, ed. A.K. Placzek, New York, III, 422-34

1982-1983 *Claude Gellée dit le Le Lorrain*, a cura di D. Russell, catalogo della mostra, Washington-Paris, 29, 430

1983 "Enquête: Les maquettes d'architecture", *Revue de l'art*, 58-59, 123-43 • *Het kleine bouwen. Vier eeuwen maquettes in Nederland*, R.W. Tieskens, D.P. Snoep, G.W.C. van Wezel (red.), Catalogus, Utrecht, Centraal Museum Zutphen • *Het Trippenhuis te Amsterdam*, eds. R. Meischke, H.E. Reeser, Amsterdam-Oxford-New York • *Roma Resurgens: Papal Medals from the Age of the Baroque*, Ann Arbor • *Views from the Grand Tour*, exhibition catalogue, New York, Colnaghi: n. 45 • ALPERS, SVETLANA. *The Art of Describing. Dutch Art in the Seventeenth Century*, Chicago, The University of Chicago Press • BELLINI, PAOLO. "Per una definizione dell'opera di G. Battista Falda", *Arte Cristiana*, LXXI, 81-91, n. 695 • BLAZICEK OLDRICH, JAKUB. "Bildhauerskizzen des böhmischen Barock", in *Imagination und Imago*, Festschrift Kurt Rossacher, Salzburg, 9-18 • BOLD, JOHN. *Roger North's Notes on Architecture*, eds. H.M. Colvin, J. Newmann and H. Mutesius, The English House, Oxford Art Journal, V, 2 • BUSCHOW, A. "Irdische Götter des Straßenwesens. Das tribunale delle strade im Rom des 18. Jhs.", *Daidalos*, 10, 42-53 • CHERRY, BRIDGET; PEVSNER, NIKOLAUS. *The Buildings of England, Ireland, Scotland and Wales. London 2: South*, Harmondsworth • COAD, JONATHAN. *Historical Architecture of the Royal Navy: An Introduction*, London • COMOLI MANDRACCI, VERA. *Torino*, Le città nella storia d'Italia, Roma-Bari, Laterza • DA MOSTO, ANDREA. *I dogi di Venezia nella vita pubblica e privata*, Firenze • DE LA GORCE, JÉRÔME. "Twenty Set Models for the Paris Opera in the Time of Rameau", *Early Music*, 429-40 • DOGLIO, MARIA LUISA. "La letteratura ufficiale e l'oratoria celebrativa", in *Storia della cultura veneta*, a cura di G. Arnaldi e M. Pastore Stocchi, 4/1, Il Seicento, Vicenza, 163-87 • GIGANTI, AMELIA IOLLI. *Messina*, bari • HALLO, RUDOLF. "Zur Vorgeschichte des Schloßbaus von Wilhelmstahl", *Jahrbuch für Kunstwissenschaft*, 1930, ristampa in Hallo Rudolf, *Schriften zur Kunstgeschichte in Kassel*, hrsg. von G. Schweikhart, Kassel, 213-42 • HERSEY, G.L. [a]. *Architecture, Poetry and Number in the Royal Palace at Caserta*, Cambridge Mass.-London, 133-39 • — [b]. "Carlo di Borbone a Napoli e Caserta", in *Sto-*

ria dell'arte italiana, III, V *Momenti di architettura*, Torino, 213-64 • HOLLSTEIN, F.W.H. *German engravings, etchings, and woodcuts, ca. 1400-1700*, XII, Amsterdam • LEVER, JILL; RICHARDSON, MARGARET. *Great Drawings from the Collection of the Royal Institute of British Architects*, exhibition catalogue, London • McANDREW, JOHN. *L'architettura veneziana del primo Rinascimento*, a cura di R. Munman e C. Kolb, Venezia • MEISCHKE, R. "Trippenhuis te Amsterdam", in *Het Kleine bouwen. Vier eeuwen maquettes in Nederland*, eds. R.W. Tieskens, D.P. Snoep, G.W.C. van Wezel, exhibition catalogue, Utrecht, Centraal Museum, Zutphen, 61-64 • PUPPI, LIONELLO. "Nuovi documenti sul Longhena", *Notizie da Palazzo Albani*, XII, 1-2, 181-88 • ROSASCO, BETSY. "The Sculptures of Marly ant the Programme of Versailles: Considerations of their Relationship and Meaning", *Journal of Garden History*, 3, 4, 301-306 • ROSSACHER, KURT. *Salzburger Barockmuseum. Sammlung Rossacher, Gesamtkatalog*, Salzburg • SNOEP, D.P. "Orgel voor de Ronde Nieuwe Lutherse Kerk te Amsterdam", in *Het kleine bouwen. Vier eeuwen maquettes in Nederland*, eds. R.W. Tieskens, D.P. Snoep, G.W.C. van Wezel, exhibition catalogue, Utrecht, Centraal Museum, Zutphen, 33-35 • — [b]. "Nieuwe Kerkstoren te Amsterdam", in *Het kleine bouwen. Vier eeuwen maquettes in Nederland*, eds. R.W. Tieskens, D.P. Snoep, G.W.C. van Wezel, exhibition catalogue, Utrecht, Centraal Museum, Zutphen, 36-39 • — [c]. "Koepelkerk op de Botermarkt, het huidige Rembrandtsplein, te Amsterdam", in *Het kleine bouwen. Vier eeuwen maquettes in Nederland*, eds. R.W. Tieskens, D.P. Snoep, G.W.C. van Wezel, exhibition catalogue, Utrecht, Centraal Museum, Zutphen, 82-83 • WHITMAN, NATHAN; VARRIANO, JOHN. *Roma Resurgens. Papal Medals from the Age of the Baroque*, exhibition catalogue, Ann Arbor

1983-1984 MARTINELLI, V. "Il disegno della Cattedra berniniana di Giacomo Gimignani e Lazzaro Morelli per l'incisione dello Spierre del 1666", *Prospettiva. Studi in onore di Luigi Grassi*, 33-36, 219-25

1984 *Herinneringen aan Italie. Kunst en Tourisme in de eeuw*, exhibition catalogue, Bois-le-dus, Heino-Haarlem • *L'Arte degli Anni Santi. Roma 1300-1875*, a cura di M. Fagiolo e M.L. Madonna, catalogo della mostra, Roma, XI, 454-56 (P.L. Silvan) • *Le Faubourg Saint-Germain, La rue Saint-Dominique*, catalogue de l'exposition, Paris, Musée Rodin • *Master of Seventeenth-Century Dutch Genre Painting*, ed. P.C. Sutton, exhibition catalogue, Philadelphia • *Theatrum Sabaudiae (Teatro degli stati del Duca di Savoia)*, a cura di L. Firpo, Torino • BAUER, GEORGE. "Bernini e i 'modelli in grande'", in *Gian Lorenzo Bernini architetto e l'architettura europea del Sei-Settecento*, ed. G. Spagnesi e M. Fagiolo, vol. I, 68-81 • BAUER, ANDREA. *Il Castello di Rivoli. Storia di un recupero*, Torino • BRUNO, ANDREA. "Il modello di Juvarra per il Castello di Rivoli", in *Studi Juvarriani*, Atti del Convegno dell'Accademia delle Scienze, Torino, 1979, Roma: 239-50 • CIPRIANI, ANGELA. "Bozzetto per il Leone della fontana dei Fiumi", in *Roma 1300-1875. L'arte degli anni santi*, a cura di M. Fagiolo e M.L. Madonna, Milano: 427-28 • CORBOZ, ANDRÉ. *Canaletto. L'opera completa*, 2 voll., Milano, Electa • CROPPER, E. *Ideal of Painting. Pietro Testa's Düsseldorf Notebooks*, Princeton • DE VRIES, L. *Jan van der Heyden*, Amsterdam • FRIEDMAN, TERRY. *James Gibbs*, Paul Mellon Studies in British Art, New Haven-London • HAAK, B. *The Golden Age. Dutch Painters of the Seventeenth Century*, New York • JELONEK, M.A. *Franz Jänggl. Ein unbekannter Wiener Barockbaumeister*, Dissertationen zur Kunstgeschichte, 19, Köln-Wien • MILLON, HENRY A. *Filippo Juvarra. Drawings from the Roman Period, 1704-1714*, I, Roma • OECHSLIN, WERNER; BUSCHOW, ANJA. *Festarchitektur: Der Architekt als Inszenierungs Künstler*, Stuttgart • PARKER, GEOFFREY. *The Thirty Years' War*, New York, 205 • PEROUSE DE MONTCLOS, JEAN-MARIE. "Les Prix de Rome". *Concours de l'Académie royale d'architecture au XVIIIᵉ siècle*, Paris, Berger-Levrault-Ecole nationale supérieure des Beaux-Arts • PEYROT, ADA. "Le immagini e gli artisti", in *Theatrum Sabaudiae (Teatro degli stati del Duca di Savoia)*, a cura di L. Firpo, Torino, 19-40 • ROLAND MICHEL, MARIANNE [a]. *Lajoüe et l'art de la rocaille*, Paris • — [b]. *Wat-*

teau, un artiste au XVIIIᵉ siècle, Paris-London (*Watteau, an artist in the XVIIIth century*) • VARRIANO, JOHN. "The Architecture of Papal Medals", in *Projects and Monuments in the Period of the Roman Baroque*, Papers in Art History from the Pennsylvania State University, I, 68-81 • WILSON, MICHAEL I. *William Kent, Architect, Designer, Painter: 1685-1748*, London • ZAMBONI, SILLA. "Bozzetto per la Fontana dei Fiumi", in *Roma 1300-1875. L'arte degli anni santi*, a cura di M. Fagiolo e M. L. Madonna, Milano: 426-27

1984-1985 *Diderot et l'art de Boucher à David. Les Salons: 1759-1781*, sous la direction de M.-C. Sahut et N. Volle, catalogue dell'exposition, Paris • *The Sunking: Louis XIV and the New World*, Studies in Louisiana Culture, III, Louisiana, State Museum: The Corcoran Gallery Of Art: New Orleans, The Louisiana Museum Foundation • *Watteau 1684-1721*, sous la direction de M. Morgan Grasselli et P. Rosenberg, catalogue de l'exposition, Washington, D.C.-Paris-Berlin • ROLAND MICHEL, M. *Diderot et l'art de Boucher à David. Les Salons: 1759-1781*, a cura di M.C. Sahut e N. Volle, catalogo della mostra, Paris, 101, 343-46

1985 *A Trecentenary Tribute to William Kent*, ed. J. Wilton-Ely, exhibition catalogue, Ferens Art Gallery, Hull, University Gallery, Nottingham • *Bayerische Rokokoplastik. Vom Entwurf zue Ausführung*, hrsg. von P. Volk, München, Bayerisches Nationalmuseum • *Domenico Scarlatti en España*, catálogo de la muestra, Madrid • *Elias Holl*, Ausstellungskatalog, Augsburg, Regensburg: 328, n. 219 • *Estudios sobre Ventura Rodriguez (1717-1785)*, cuidad por Real Academia de Bellas Artes de San Ferneo, Madrid • *Gilded Scenes and Shining Prospects. Panoramic Views of British Towns, 1575-1900*, ed. R. Hyde, New Haven, Yale Center for British Art • *Les chevaux de Marly*, Musée-promenade de Marly-le-Roi-Louveciennes • *Les Hubert Robert de la collection Veyrenc au Musée de Valence*, catalogue de l'exposition, Musée de Valence • *Liechtenstein. The Princely Collections*, exhibition catalogue, New York • *Norfolk and the Grand Tour*, exhibition catalogue, ed. by A.W. Moore Norfolk: 117, n. 49 • *Old Master Drawings at Bowdoin College*, exhibition catalogue, Bowdoin College Museum of Art, Brunswick • *Prinz Eugen und das barocke Österreich*, Salzburg-Wien • *The Royal Picture Gallery-Mauritshuis*, ed. M.R. Hoetink, Amsterdam-New York's Gravenhage • *The Treasures Houses of Britain. Five Hundred Years of Private Patronage and Art Collecting*, exhibition catalogue, Washington-New Heaven-Yale-London: 264 • *Saint-Paul-Saint-Louis. Les Jésuites à Paris*, catalogue de l'exposition, Paris, musée Carnavalet • *Versailles à Stockholm. Dessins du Nationalmuseum, peintures, meubles et arts décoratifs des collections danoises et suédoises*, Paris, Hôtel de Marle, Uddevalla • ANTONETTO, ROBERTO. *Minusieri ed ebanisti del Piemonte*, Torino • BAUER, HERMANN; BAUER, ANNA. *Johann Baptist und Dominikus Zimmermann. Entstehung und Vollendung des bayerischen Rokoko*, Regensburg • BAUMAN, in *Liechtenstein. The Princely Collections*, catalogo della mostra, New York, 146, 129-133 • BERENGO, MARINO. "La capitale nell'Europa di antico regime", in *Le città ed atali*, a cura di C. De Seta, Roma-Bari, Laterza 3-15 • BERGER, ROBERT W. *Versailles: The Château of Louis XIV*, University Park (Penn.), London • BIADENE, SUSANNA. "Palazzo Venier dei Leoni", in *Le Venezie possibili. Da Palladio a Le Corbusier*, a cura di L. Puppi e G.D. Romanelli, catalogo della mostra, Milano, 134-35 • BONET CORREA, ANTONIO. "Utopía y realidad en la arquitectura", in *Domenico Scarlatti en España*, catálogo de la muestra, Madrid, 19-82 • BRUNO, ANDREA. "Il modello di Juvarra per il Castello di Rivoli", in *Studi Juvarriani*, Atti del Convegno dell'Accademia delle Scienze, Torino, 1979, Roma: 239-50 • CORBOZ, A. *Canaletto. Una Venezia immaginaria*, Milano, P 337, 16, 259, 336, 428-33, 470 • DUFFY, CHRISTOPHER. *The Fortress in the Age of Vauban and Frederick the Great, 1660-1789*, London • DUFT, JOHANNES. *Klosterbruder Gabriel Loser. Sein Anteil an den Barockbauten des Stiftes Sankt Gallen*, Bibliotheca Sangallensis, 8, St. Gallen-Sigmaringen • ERICHSEN, JOHANNES. "Überlegungen zum Augsburger Rathaus anlässlich der Ausstelung Elias Holl und das Augsburger Rathaus", *Kunstchronik*, 38/11, 486-502 • FARA, AMELIO. *La metropoli difesa, architettura militare dell'Ottocento nelle città capitali d'Italia*, Roma • GIROUARD, MARK. *Cities and People. A Social and Architectural History*, New Haven-London (trad. fr. *Des villes et des hommes*, Paris, Flammarion, 1987) • GLAZYCEV, V.L.; Zemcov, S.M. *Aristotel' F'oravanti*, Moskva • GRUBER, ALAIN-CHARLES. "Le décor des derniers sacres è Reims", in *Le Sacre des Rois: Actes du Colloque*

international d'histoire sur les sacres et couronnements royaux (Riems 1975), Paris, Les Belles Lettres, 273-81 • HAGER, HELLMUT. "Il significato dell'esperienza juvarriana nella 'scuola' di Carlo Fontana", in Studi Juvarriani, Atti del Convegno dell'Accademia delle Scienze, Torino, 1979, Roma, 63-91 • HAGER, WERNER. Ausstellungskatalog Elias Holl, catalogo della mostra, Augsburg, 1985, Regensburg, 1985, nn. 219-220, 328, 328 • HENNEBO, DIETER. "Tendencies in Mid-Eighteenth-Century German Gardening", Journal of Garden History, 5, n. 4, 355-70 • KOLLER, MANFRED. "M. Hefeles Modell für den Hochaltar von Sonntagberg", Alter und moderne Kunst, Heft, 201-202, 30, 5 ss., 9 • KRAUTHEIMER, RICHARD. The Rome of Alexander VII, 1655-1677, Princeton, University Princeton Press, N.J. • KREILINGER, KILIAN. "Das Idealmodell des Klosters Michaelbeuern von Franz Alois Mayr, 1768", in Benediktinerabtei Michaelbeuern. Eine Dokumentation anläßlich der Eröffnung und Weihe der neu adaptierten Räume für Internat, Schule und Bildungsarbeit, Michaelbeuern: 162-66 • LICHT, M. "I ragionamenti - Visualizing St. Peter's" J.S.A.H., XLI, 2, 116-18 • LOONSTRA, M. "Het Huijs int. Bosch". Het Koninklijk Paleis Huis Ten Bosch historisch gezien, Zutphen • MASCHIO, RUGGERO. "La facciata della chiesa di San Rocco", in Le Venezie possibili. Da Palladio a Le Corbusier, a cura di L. Puppi e G.D. Romanelli, catalogo della mostra, Milano, 106-12 • MATTEONI, DARIO. Livorno, Bari • MENICHELLA, ANNA. Matthia de' Rossi discepolo prediletto del Bernini, Roma, 18-21 • MOLINO, GIANNI. Campertogno. Vita, arte e tradizioni di un paese di montagna e della sua gente, Torino • PIPPIDI, A. "Essai d'un catalogue de l'œuvre de Frans Francken II", Revue roumaine d'histoire de l'art, 22, 3-42 • REUTHER, HANS. "Das modell des Schloßes Skokloster", in Niederdeutsche Beiträge zur Kunstgeschichte, 24: 171-84 • ROBISON ELWIN, CLARK. Guarino Guarini's Church of San Lorenzo in Turin, Ph. D. Diss., Cornell University • ROECK, BERND. Elias Holl – Architekt einer europäischen Stadt, Regensburg, 18, 158, 182 ss., 210 • SILCOX-CREWE, NIGEL. "Sir Roger Pratt. The Ingenious Gentleman architect, 1620-1685", in The Architectural Outsiders, ed. R. Brown, London, 1-20 • SLADEK, ELISABETH. "Der Palazzo Chigi-Odescalchi an der Piazza SS. Apostoli", Römische historische Mitteilungen, XXVII: 439-503 • VOLK, PETER. Bayerische Rokokoplastik. Vom Entwurf zur Ausführung, München, Bayerisches Nationalmuseum • WOODS-MARSDEN, JOANNA. "Pictorial Legitimation of Territorial Claims in Emilia: the iconography of the camera peregrina aurea in the Castle of Torrechiara", in Renaissance Studies in Honor of Craig Hugh Smyth, II, Firenze, 553-68 • ZEMCOV, S.M.; GLAZYCEV, V.L. Aristotel' F'oravanti, Moskva

1986 Artistes en voyage au XVIIIᵉ siècle, catalogue de l'exposition, Paris-Genève, galerie Cayeux • Carreño, Rizi, Herrera y la pintura madrilena de su tiempo (1650-1700), a cura di A. Perez Sanchez, catalogo della mostra, Madrid • Ciudades del Siglo de Oro. Las Vistas Españolas de Anton van den Wyngaerde, ed. R. L. Kagan, Madrid, El Viso • Dutch Landscape. The Early Years. Haarlem and Amsterdam 1590-1650, ed. C. Brown, London • Germain Boffrand 1667-1754: L'aventure d'un architecte indépendant, M. Gallet et J. Garms, Paris • Paesaggi e vedute nelle marte dall'Italia e dall'Europa del nord tra XVI e XVII secolo, catalogo della mostra, Roma, Galleria Cesare Lampronti: 28-29, n. 13 • ARISI, FERDINANDO. Giovanni Paolo Panini e i fasti della Roma del '700., Roma • ASTRUA, P. "Images que le royaume de Sardaigne offre à l'Europe", in Bâtir une ville au siècle des lumières. Carouge: modèles et réalités, catalogue de l'exposition, Torino, Carouge: 458-61 • BLAZICEK, O.J. "Modellpraxis in den böhmischen Barockskulptur", in Entwurf und Ausführung in der europäischen Barockplastik, Beiträge zum internationalen Kolloquium des Bayerischen Nationalmuseums und des Zentralinstituts für Kunstgeschichte München, 24. bis 26. Juni 1985, München, 85-90 • BRAUNFELS, WOLFGANG. François Cuvilliès. Der Baumeister der galanten Architektur des Rokoko, München • BRIGANTI, CHIARA. "Argenti Piemontesi al Quirinale", in Porcellane e argenti del Palazzo Reale di Torino, catalogo della mostra, a cura di A. Griseri e G. Romano, Milano, 18-203 • DE SETA, CESARE; FERRETTI, A. Imago urbis. Dalla città ideale alla città reale, Milano, Franco Maria Ricci • FERRETTI, M. "Casamenti seu prospective'. Le città degli intarsiatori", in Imago urbis. Dalla città ideale alla città reale, a cura di C. De Seta, Milano, Franco Maria Ricci: 73-104 • FRANZ, H.G. "M. D. Pöppelmann und die Architektur des Zwingers in Dresden", Kunsthistorisches Jahrbuch Graz, XXII, • GARGANO, MAURIZIO.

"Andrea Pozzo e l'altare di Sant'Ignazio al Gesù di Roma: l'architettura tra scenografia effimera e monumento perenne", in Enciclopedismo in Roma Barocca, Venezia, 210-16 • GONZALEZ PALACIOS, ALVAR. Il tempio del gusto, II, Milano • GRITELLA, GIANFRANCO. Rivoli. Genesi di una Residenza Sabauda, Modena • MAGNUSSON, BÖRJE. Att illustrera fäderneslandet, Acta universitatis upsaliensis, Ars Suetica, 10, Uppsala • PEPPER, SIMON; ADAMS, NICHOLAS. Firearms and Fortifications: Military Architecture and Siege Warfare in Sixteenth Century Siena, Chicago, 3-31 • PERNOT, J. F. "Histoire des plans-relief"; Faucherre, Nicolas. "Outil stratégique et jouet princier" in "Les Plans en relief", Monuments historiques, 148 • PINTO, JOHN. The Trevi Fountain, New Haven, London • PONS, BRUNO. De Paris à Versailles 1699-1736, Strasbourg • ROMANELLI, GIAN DOMENICO. "L'edificio: architettura e storia", in Romanelli G.D.; Pavanello G., Palazzo Grassi, Venezia, 12-17 • Transancos A.V., "Entorno a unos planos para el Palacio del Buen Retiro y su impacto en la Reggia de Caserta", in Archivo Español de Arte, nn. 233-36, vol. LIX, 69-76 • VILIMKOVÁ, MILADA. Stavitelé paláců a chrámu, Praha • WALTHER, A.; BETTAGNO, A.; BECHMANN, M. et al., Bernardo Bellotto. Le vedute di Dresda. Dipinti e incisioni dai Musei di Dresda, Venezia, Neri Pozza • WOODBRIDGE, KENNETH; Princely Gardens, New York, Rizzoli International Publications, 143-58 • WORSDALE, MARC. "Annual Medal of Innocent X, Year VIII, with the Fountain of the Four Rivers in Piazza Navona", in Vatican Splendour: Masterpieces of Baroque Art, eds. C. Johnston, G.V. Shepherd and M. Worsdale, exhibition catalogue, Ottawa: 99

1986-1987 Canaletto & Visentini. Venezia & Londra, a cura di D. Succi, catalogo della mostra, Venezia • MOSSER, M. "L'architecture entre pouvoir et lumières: l'example de la Russie", in La France et la Russie au Siècle des Lumières: Relations culturelles et artistiques de la France et de la Russie au XVIIIᵉ siècle, catalogue de l'exposition, Paris, Galeries Nationales du Grand-Palais

1987 Arsenali e città nell'Occidente europeo, a cura di E. Concina, Roma • Le Città immaginate: un viaggio in Italia. Nove progetti per nove città, Milano • ALPERS, SVETLANA. "The Mapping Impulse in Dutch Art", in Art and Cartography. Six Historical Essays, ed. D. Woodward, Chicago-London, The University of Chicago Press: 51-96 • ASTRUA, P. "Le scelte programmatiche di Vittorio Amedeo duca di Savoia e re di Sardegna", in Arte di corte a Torino da Carlo Emanuele III a Carlo Felice, a cura di S. Pinto, Torino: 65-100 • BLADE, TIMOTHY. The paintings of Dirck van Delen, UMI Press • CIPRIANI, ANGELA. "Un bozzetto per il leone della Fontana dei Fiumi", in Gianlorenzo Bernini e le arti visive, a cura di M. Fagiolo, Roma: 139-47 • COLLE, ENRICO. "L'elaborazione degli stili di corte", in Arte di corte a Torino da Carlo Emanuele III a Carlo Felice, a cura di S. Pinto, Torino, 185-198 • COMOLI MANDRACCI, VERA. "Il Palazzo di Città per una capitale", in Il Palazzo di Città a Torino, a cura dell'Archivio Storico della Città di Torino, Torino, 2 voll., I, 59-189 • DAMISCH, HUBERT. L'origine de la perspective, Paris, Flammarion • DOWNES, KERRY. "Hawksmoor's house at Easton Neston", in Architectural History, 30, 50-66 • HARVY, JOHN. English Medieval Architects, London, 50 • KIEVEN, ELIZABETH. "Rome in 1632: Alessandro Galilei, Nicola Salvi, Ferdinando Fuga", Papers in Art History from the Pennsylvania State University, 2: 255-75 • KRAUTHEIMER, RICHARD. Roma di Alessandro VII, Roma, 99, 103, 187-88 • LEVI MOMIGLIANO, L. "La capitale del nuovo regno: gli osservatori esterni e le guide locali", in Arte di corte a Torino da Carlo Emanuele III a Carlo Felice, a cura di S. Pinto, Torino: 129-84 • MILLON, HENRY A. "Bernini-Guarini: Paris-Turin: Louvre-Carignano", in "Il se rendit en Italie". Etudes offertes à André Chastel, Roma-Paris, 479-500 • NEGRO, A. "Nuovi documenti per Giuseppe Mazzuoli e bottega nella Cappella Pallavicini Rospigliosi a San Francesco a Ripa", Bollettino d'arte, 72: 255-75 • REUTHER, HANS. "Wesen und Wandel des Architekturmodells in Deutschland", Daidalos, II • TANANAEVA, N.T. "Nekotorye koncepcii man'erizma v izucenii iskusstva Vostocnoj Evropy konca XVI-XVII vv.", Sovetskoe iskusstvoznanije, 22, Moskva • THIERRY, Y.; KERVYN DE MEERENDRE, M. Les Peintres flamands de paysage au XVIIᵉ siècle. Le baroque anversois et l'école bruxelloise • WAGENHEIM, GISELLE. "Les inscriptions ligoriennes. Notes sur la tradition manuscrite", Italia medievale e umanistica, XXX, 200 ss.

1988 Capricci veneziani del Settecento, a cura di D. Succi, catalogo della mostra, Gorizia • Figure del Barocco in Piemonte. La corte, la città, i

cantieri, le province, a cura di G. Romano, Cassa di Risparmio di Torino, Torino • Il mondo nuovo. Le meraviglie della visione dal '700 alla nascita del cinema, a cura di C.A. Zotti Minici, Bassano del Grappa, Mazzotta • Paesaggi, vedute architetture del Grand Tour, a cura di L. Laureati, catalogo della mostra, Roma-Milano, Leasarte: n. 26 • Paul Troger & Brixen, Ausstellungskatalog, Brixen, Museo Diocesano • The Anglo-Dutch Garden in the Age of William and Mary, catalogue, eds. J.D. Hurt and E. de Jong, Journal of Garden History, 8, 2-3 • The Gardens of William and Mary, ed. D. Jacques and A.J. Van der Horst, London, Christopher Helm • The Military Revolution: Military Innovation and the Rise of the West, 1500-1800, Cambridge • Toeput a Treviso, a cura di S. Mason Rinaldi e D. Luciani, Atti del seminario, Treviso, 1987, Asolo • Travels in Italy 1776-1783 based on the Memoirs of Thomas Jones, exhibition catalogue, Manchester: 27-28, n. 24 • V.I. Baz'enov, Moskva • BALESTRERI, I. "L'architettura negli scritti della Compagnia di Gesù", in L'architettura della Compagnia di Gesù in Italia. XVI-XVIII secolo, catalogo della mostra, a cura di L. Patetta, I. Balestreri, C. Cascarella, D. Zocchi, Milano, Centro culturale San Fedele, 18 ottobre-3 novembre 1990, Brescia 1990, 19-26 • BAUER, GÜNTHER A. "Divae Virgini Sine Labe Conceptae. Das Modell des Immakulata-Säule nach einem verschollenen Entwurf des Lukas von Hildebrandt im Salzburger Museum Carolino Augusteum", in Das Kunstwerk des Monats, Ausstellungskatalog, Salzburg, Salzburger Museum Carolino Augusteum • BENOCCI, C. "Francesco Nicoletti e Paolo Anesi a Villa Doria Pamphilj (1748-1758)", Studi sul Settecento Romano, 4 • BLAZICEK OLDRICH, JAKUB. "Socharství", in Staré ceské umení. Sbírky Národní galerie v Praze. Jirsky kláster, exhibition catalogue, Praha, Národní Galerie v Praze, 134-50 • COUTENCEAU, ISABELLE. "Neuf-Brisach (1678-1705): la construction d'une place forte au début du XVIIᵉ siècle", Revue Historique des Armées, 171, 16-21 • CRACRAFT, JAMES. The Petrine Revolution in Russian Architecture, Chicago • DARDANELLO, GIUSEPPE. "Cantieri di corte e imprese decorative a Torino", in Figure del Barocco in Piemonte. La corte, la città, i cantieri, le province, a cura di G. Romano, Cassa di Risparmio di Torino, Torino, 163-252 • DE FEO, VITTORIO. Andrea Pozzo. Architettura e illusione, Roma, 9-23 • DONÒ, A.; MARINO, A. "Note su E. Rodriguez Dos Santos, architetto lusitano in Roma", Studi sul Settecento Romano, 5 • FOLLIOL, F. "Le Palais Royal (1692-1770)", in Le Palais Royal, catalogue de l'exposition, Paris, Musée Carnavalet • FONTANA, VINCENZO. "Villa Pisani. Stra", in Il giardino veneto. Dal tardo Medioevo al Novecento, a cura di M. Azzi Visentini, Milano, 154-58 • GARGANO, MAURIZIO. "L'altare sant'Ignazio nella chiesa del Gesù a Roma. La seconda Cappella", Schede in De Feo Vittorio, Andrea Pozzo. Architettura e illusione, Roma, 77-109 • GRISERI, ANDREINA. Il diamante. La villa di Madama Reale Cristina di Francia, Istituto Bancario San Paolo di Torino, Torino • GRISERI, ANGELA. Un inventario per l'esotismo. La Villa della Regina 1755, Torino • GÜNTHER, HUBERTUS. Das Studium der Antiken Architektur in der Zeichnungen der Hochrenaissance, Tübingen • HOPPER, FLORENCE. "Daniel Marot: a French Garden Designer in Holland", in The Dutch Garden in the Seventeenth Century, ed. J.D. Hunt, Dumbarton Oaks, Colloquium on the History of Landscape Architecture, XII • HUNT, J.D.; DE JONG, E. "The Anglo-Dutch Garden in the Age of William and Mary", Journal of Garden History, 8, 2-3 • HYDE, W.; WILCOX, S. Panoramania!, London, Barbican Art Gallery • JONES, J.R. "The Building Works and Court Styles of William and Mary", in The Anglo-Dutch Garden in the Age of William and Mary, catalog edited by J.D. Hunt and E. de Jong, Journal of Garden History, 8, nn. 2-3, 1-13 • KIEVEN, ELIZABETH [a]. Ferdinando Fuga e l'architettura romana del Settecento, Roma • — [b]. "Il ruolo del Disegno: Il concorso per la facciata di San Giovanni in Laterano", in In Urbe Architectus, Roma, 78-123 • LEVEY, MICHAEL. Giambattista Tiepolo. La sua vita e la sua arte, Milano • LUCAS, MICHEL. L'ancien site de Vaux-le-Vicomte: villages, hameaux, fermes et moulins disparus, Ed. Amatteis • MAGNANI, LAURO. Il tempio di Venere, giardino e villa nella cultura genovese, Genova, Sagep editrice • MAGNANI, LAURA; BOCCARDO, P.; GAVAZZA, E.; LAMERA, F. La Scultura a Genova e in Liguria dal Seicento al Primo Novecento, Genova • MAIDERA RODRIGUEZ, M. A capela de S. Joao Baptista e a suas coleçoes, Lisboa, • MATTEUCCI, A.M. L'architettura del Settecento, Torino • MEEK, HAROLD ALAN. Guarino Guarini and his Architecture, New Haven-London • MINGUET, PHILIPPE. France baroque, Paris, Hazan • NEUMANN, HARTWIG. Festungbaukunst

und Festungbautechnik, Koblenz • NUTI, LUCIA. "The mapped views by Georg Hoefnagel: the merchant's eye, the humanist's eye", Word Image, II: 545-70 • PARKER, GEOFFREY. The Military Revolution. Military Innovation and the Rise of the West, 1500-1800, Cambridge, 45-46 • PARMA ARMANI, E. "Pauperismo e beneficenza a Genova: documenti per l'Albergo dei Poveri", Quaderni Franzoniani, 69-180 • PICON, ANTOINE. Claude Perrault, 1643-1688 ou La curiosité d'un classique, Paris, Picard Editeur • ROWEN, HERBERT H. The Princes of Orange: the Stadholders of the Dutch Republic, Cambridge • SPINOSA, NICOLA. La pittura del Settecento a Napoli, 2 voll., Milano, Electa • TODERI, GIUSEPPE; VANNEL, FIORENZA. Medaglie russe del Settecento da Pietro il Grande e Caterina II, Firenze, Museo Nazionale del Bargello • TOLEDANO, RALPH. Michele Marieschi. L'opera completa, Milano • WOLFSGRUBER, KARL. Die Brixner Hofburg, Bozen • ZIMMER, JÜRGEN. Joseph Heintz, München

1988-1989 De Nicolo dell'Abate à Nicolas Poussin: aux sources du classicisme (1550-1650), catalogue de l'exposition, Musée Bossuet

1989 Architecture and its Image: Four Centuries of Architectural Representation, Works from the Collection of the Canadian Centre for Architecture, exhibition catalogue • Diana Trionfatrice. Arte di corte nel Piemonte del Seicento, a cura di G. Romano e M. di Macco, catalogo della mostra, Torino • Exploring Rome: Piranesi and his Contemporaries, exhibition catalogue, New York, The Pierpont Morgan Library, Montréal, Centre Canadien d'Architecture • Filippo Juvarra a Torino. Nuovi progetti per la città, a cura di A. Griseri e G. Romano, Cassa di Risparmio di Torino, Torino • Kilián Ignác Dientzenhofer a umelci jeho okruhu, exhibition catalogue, eds. M. Freimanová, M. Horyna and A. Rollová, Praha, Národní Galerie v Praze • Le Port des Lumières, La Peinture à Bordeaux 1750-1800, sous la direction de B. de Boysson, R. Mesuret et al., Bordeaux • Les Plans en Relief des Places du Roy, sous la direction de A. De Roux et al., Paris • Studi per il Piano Regolatore del Comune di Torino, Torino • Alberti, Leon Battista. L'architettura, Milano, Edizioni Il Polifilo, VII, 294 • BLAZICEK OLDRICH, JAKUB [a]. "Barokní socharství 17. století v Cechách", Dejiny ceského vytvarného umení, IV/1, Praha, 293-314 • — [b]. "Socharství pozdního baroka, rokoka a klasicismu v Cechách", in Dejiny ceského vytvarného umení II/2, Praha • BOLD, JOHN. John Webb. Architectural Theory and Practice in the Seventeenth Century, Oxford • COMOLI MANDRACCI, VERA [a]. "La proiezione del potere nella costruzione del territorio", in Filippo Juvarra a Torino. Nuovi progetti per la città, a cura di A. Griseri e G. Romano, Cassa di Risparmio di Torino, Torino, 53-74 • — [b]. "La città-capitale e la 'corona di delitie'", in Diana Trionfante. Arte di corte nel Piemonte del Seicento, a cura di G. Romano e M. di Macco, catalogo della mostra, Torino, 304-11 • CONSTABLE, W.G.; LINKS, J.G. Canaletto, Oxford, 459 e vol. II, 436-38 • CURCIO, G. "Giacomo e Giovanni Battista Mola: due diversi modi di essere architetti a Roma nella prima metà del XVII secolo", in Pier Francesco Mola 1612-1666, Milano • CURCIO, G.; SPEZZAFERRO, L. Fabbriche e architetti ticinesi nella Roma barocca, Milano • DARDANELLO, GIUSEPPE. "Altari piemontesi: prima e dopo l'arrivo di Juvarra", in Filippo Juvarra a Torino. Nuovi progetti per la città, a cura di A. Griseri e G. Romano, Torino, 153-228 • DESPRECHINS, ANNE. Langlard, un jardin au pays de l'illusion romanesque, XVIIème, Paris, 165, 401-16 • DESWARTE-ROSA, SYLVIE. "Les gravures de monuments antiques d'Antonio Salamanca, à l'origine du 'Speculum Romanae Manificentiae'", Annali di architettura, 1: 47-62 • FAUCHERRE, NICOLAS. "La Construction de la Frontière: De l'usage stratégique des plans en relief", in A. De Roux, N. Faucherre, G. Monsaingeon, Les Plans en Relief des Places du Roy, Paris, 11-54 • FOX WEBER, NICHOLAS. "Antiques: Architectural Models. Spectacular Achievements in Small Scale", Architectural Digest, 46, 3, 188-93, 246 • GARNIER, N. Antoine Coypel 1661-1722, Paris • GRISERI, ANDREINA. "Juvarra regista di una rivoluzione del gusto", in Filippo Juvarra a Torino. Nuovi progetti per la città, a cura di A. Griseri e G. Romano, Torino: 11-52 • HERZOG, GÜNTER. Hubert Robert und das Bild im Garten, Worms, 164-65 • HIMMELFARB, HÉLÈNE. "Comptes rendus", XVIIème siècle, Revue trimestrielle publiée par la société d'études du XVIIème siècle, 165, 446 • HORYNA, MICHAEL; SUCHOMEL, MILOS. "Sochari okruhu Kiliána Ignáce Dientzenhofera", in Kilián Ignác Dientzenhofer a umelci jeho okruhu, exhibition catalogue, eds. M. Freimanová, M. Horyna and A. Rollová, Praha, Národní Galerie v Praze, 97-145 • JANSE, HANS. Houten kappen in Neder-

land 1000-1940, Delft • LAMMERTSE, F.: OTTENHEYM KONRAD, A.; PASSANTI, CHIARA. "Sulla decorazione architettonica di Juvarra", in Filippo Juvarra a Torino. Nuovi progetti per la città, a cura di A. Griseri e G. Romano, Cassa di Risparmio di Torino, Torino • LANGDON, H. Claude Lorrain, Oxford • McCLENDON, CHARLES B. "The History of the Site of St. Peter's Basilica in Rome", Perspecta, 25, 32-65 • MURAWSKA, KATARZYNA. "Sui dipinti di Alberto Carlieri nelle collezioni polacche", Bulletin du Musée National de Varsovie, 30, 45-67 • OTTENHEYM, KONRAD A. Philips Vingboons (1607-1678). Architect, Zutphen • PASSANTI, CHIARA. "Sulla decorazione architettonica di Juvarra", in Filippo Juvarra a Torino. Nuovi progetti per la città, a cura di A. Griseri e G. Romano, Cassa di Risparmio di Torino, Torino • PENNINGTON, D.H. Europe in the Seventeenth Century, 2nd ed., London-New York, 28 • PÉROUSE DE MONTCLOS, J.-M. Histoire de l'architecture française. De la Renaissance à la Révolution. Paris, C.N.M.H. • RICCI, GIOVANNI. "Città murata e illusione olografica. Bologna e altri luoghi (secoli XVI-XVIII)", in La città e le mura, a cura di C. de Seta, J. Le Goff, Roma-Bari, Laterza • RIZZI, ALBERTO. "Una lettura del Bellotto varsaviense: la via Miodowa", Ateneo Veneto, 176, 239-46 • ROGGERO BARDELLI, COSTANZA. "Da Garove a Juvarra: progetti per la città", in Filippo Juvarra a Torino. Nuovi progetti per la città, a cura di A. Griseri e G. Romano, Cassa di Risparmio di Torino, Torino, 75-130 • SAUNDERS, ANDREW. Fortress Britain: Artillery Fortification in the British Isles and Ireland, Liphook, 130-208 • SKALECKI, GEORG. Deutsche Architektur zur Zeit des Dreissigjährigen Krieges- der Einfluss Italiens auf das deutsche Bauschaffen, Regensburg, 58 • VAN DER HEUVEL, CHARLES. "Il problema della cittadella: Anversa. La funzione dei disegni e delle relazioni nella seconda metà del Cinquecento", in Le città e le mura, a cura di C. De Seta e J. Le Goff, Bari, 166-86 • VILIMKOVÁ, MILADA; PREISS, P. Ve znamení brevna a ruzí. Historicky, kulturní a umelecky odkaz benediktinského opatství v Brevnove, Praha • ZANDVLIET, K. Het kunstbedrijf van de familie Vingboons. Schilders, architecten en kaartmakers in de Gouden Eeuw, Amsterdam

1989-1990 Les Peintres du Nord dans les collections du Musée des Beaux Arts de Marseille, catalogue de l'exposition, L'Isle-sur-la-Sorgue • BAETJER, KATHARINE; LINKS, J.G. Canaletto, exhibition catalogue, New York, The Metropolitan Museum of Art

1989 (1993) SPINOSA, NICOLA; DI MAURO, LEONARDO. Vedute napoletane del Settecento

1989 (1993-1994) Exploring Rome: Piranesi and his Contemporaries, exhibition catalogue, New York, The Pierpont Morgan Library, Montréal, Centre Canadien d'Architecture

1990 All'ombra del Vesuvio. Napoli nella veduta europea dal Quattrocento all'Ottocento, catalogo della mostra, Napoli, 320 • Bernardo Bellotto: Verona e le città europee, catalogo della mostra, Verona, Museo di Castelvecchio • Biblioteca Reale di Torino, a cura di G. Giacobello Benard, • Die Bildung des Offiziers in der Aufklärung. Ferdinand Friedrich von Nicolai (1730-1814) und seine enzyklopädischen Sammlungen, hrsg. von D. Hohrath mit R. Henning, Ausstellungskatalog, Stuttgart, Württembergische Landesbibliothek • "Klar und lichtvoll wie eine Regel". Städte des Neuzeit vom 16. bis zum 18. Jahrhunderts, Ausstellungskatalog, Karlsruhe • La basilica di Superga. Restauri 1989-1990, a cura di C. Palmas, Torino • Parcours: Catalogue-guide du Musée des Beaux Arts de Marseille, Marseille • Van Titian tot Tiepolo, exhibition catalogue, Rotterdam, Museum Boymans-van-Beuningen • The Dutch Garden in the Seventeenth Century, Washington, D.C., Dumbarton Oaks, Research Library and Collection • ACKERMANN, JAMES S. The Villa: Form and Ideology of Country Houses, Bollingen series, XXXV, 34, Princeton (N.J.), Princeton University Press • BALESTRERI, ISABELLA. "L'architettura negli scritti della Compagnia di Gesù", in L'architettura della Compagnia di Gesù in Italia. XVI-XVII secolo, a cura di L. Patetta, I. Balestreri, C. Cascarella e D. Zocchi, catalogo della mostra, Centro Culturale San Fedele, 18 ottobre-30 novembre 1990, 19-26 • BANDERA, MARIA CRISTINA. Pietro Paltronieri "il Mirandolese", Modena • BEAUMONT, MARIA ALICE. Eighteenth-Century Scenic and Architectural Design: Drawings by the Galli Bibiena Family from Collections in Portugal, exhibition catalogue, Alexandria, Virginia, Art Services International • CERRI, MARIA GRAZIA. Palazzo Carignano. Tre secoli di idee, progetti e realizzazioni, Torino • COMOLI MANDRACCI, VERA; ROGGERO BARDELLI, COSTANZA; BARGHINI, ANDREA. "Turin-Die Erfindung einer barocken Hanptstadt des Absolutismus", in "Klar und lichvoll wie eine Regel" - Planstädte der Neuzlit vom 16. bis zum 18 - jahrhundert, Ausstellungskatalog, Karlsruhe • CORBOZ, ANDRÉ. "Il parco di Stra: piste per una ricerca", in Il giardino come labirinto della storia, a cura di G. Pirrone, II, Palermo, 25-48 • DE ROUX, ANTOINE; FAUCHERRE, NICOLAS; MONSAINGEON, GUILLAUME. Les plans en relief des places du Roy, Paris, Adam Biro • DE SETA, CESARE. "La piccola Reggia", in FMR. Ephemeria, n. 78, 113-28 • ELLIOTT, JAMES. The City in Maps: Urban Mapping to 1900, London • FERRARI, ORESTE. Bozzetti Italiani dal Manierismo al Barocco, Napoli, 208-209, ill. 25-28 • HARRIS ANN, SUTHERLAND. "Bernini's Four Rivers Fountain as Permanent Theatre", in "All the world's a stage..." Art and Pageantry in the Renaissance and Baroque, eds. B. Wisch and S. Scott Munshower, Pennsylvania, State College: 488-516 • HARRIS, EILEEN; SAVAGE, NICHOLAS. British Architectural Books and Writers: 1556-1785, Cambridge-New York • HARRIS, JOHN. "A Digression on John Sanderson and the Rococo", Furniture History, XXVI, 99-113 • JACOBS, J.M.M. "Vitruvius moet wel geacht, maar niet alleen geloeft werden': De Amstelkerk en de architectuur van de 17de eeuw", Jaarboek Monumentenzorg, 48-70 • KELLY, CATHIE, C. "Ars moriendi in Eighteenth-Century Rome: Papal and Princely Catafalques, the Contribution of Paolo Posi", "All the world's a stage ..." Art and Pageantry in the Renaissance and Baroque, Papers in Art History from The Pennsylvania State University, University Park, VI, 2, 580-619 • KIENE, M. "Musique, peinture et fête", in Revue de l'Art, 21-30 • KIRBY, DAVID. Northern Europe in the Early Modern Period. The Baltic World 1492-1772, London-New York, 260 • KUHN, JEANNE R. "Measured Appearances: Documentation and Design in Early Perspective Drawings", Journal of the Warburg and Courtauld Institutes, LIII: 114-32 • LAZZARO, CLAUDIA. The Italian Renaissance Garden: From the Conventions of Planting, Design and Ornament to the Grand Gardens of Sixteenth-Century Central Italy, New Haven • LEVY, EVONNE. Saint, Site, and Sacred Strategy. Ignatius Rome and Jesuit Urbanism, catalogo della mostra, Roma-Città del Vaticano, Biblioteca Apostolica Vaticana, 216, scheda 136, 219-21; schede 138 e 139 • MAAG, MICHAEL; BERGER, KLAUS W. et al., "Klar und Lichtvoll wie eine Regel". Planstädte der Neuzeit vom 16. bis 18. Jahrundert, Land Bade-Würtenberg, Badisches Landesmuseum, Karlsruhe 15 giugno-14 ottobre 1990 • MERZ JÖRG, MARTIN; BLUNT, ANTHONY. "The Villa del Pigneto Sachetti", Journal of the Society of Architectural Historians, 49, 390-406 • MONTAGU, JENNIFER. Gold, Silver and Bronze. Metal Sculpture of the Roman Baroque, Washington, D.C. • MOSSER, M.; TEYSSOT, G. L'architettura dei giardini d'Occidente, Milano • PALMAS, CLARA. La Basilica di Superga: restauri 1989-1990, Torino • PARMA ARMANI, E. "Documenti per le statue dei benefattori dell'Albergo dei Poveri di Genova nei secoli XVII-XVIII", Quaderni Franzoniani, 159-95 • PORTOGHESI, PAOLO. F. Borromini, Milano, Electa, 13-19, 155 • PUPPI, LIONELLO. "Corpo centrale di Villa Pisani (ora Nazionale), 1732 ca.-1756. Stra-Venezia", in Francesco Maria Preti architetto e teorico, a cura di L. Puppi, Castelfranco Veneto, 197-99 • RIZZI, ALBERTO. La Varsavia di Bellotto, Milano • ROGGERO BARDELLI, COSTANZA; VINARDI, MARIA GRAZIA; DEFABIANI, VITTORIO. Ville sabaude, Milano • ROSSI, PAOLA. "I 'marmi loquaci' del Monumento Pesaro ai Frari", Venezia-Arti, 4, 84-93 • SCHULZ, JÜRGEN. La cartografia tra scienza e arte. Carte e cartografi nel Rinascimento italiano, Modena, Franco Cosimo Panini • STRAZZULO, F. Quaderni dell'Archeoclub di Massa Lubrense, Napoli, 59-70 • TAPIÉ, VICTOR L. Baroque et Classicisme, préface de M. Fumaroli, 5e éd., Paris, Hachette-Pluriel • TONGIORGI TOMASI, L. "Imago Etruriae'. Vedute della Toscana nel Settecento: tradizione e innovazione", in La Toscana descritta. Incisori e viaggiatori del Seicento, Pisa • TREZZANI, LUDOVICA. "Jan Van Essen", in All'ombra del Vesuvio. Napoli nelle vedute europee dal Quattrocento all'Ottocento, a cura di S. Cassani et al., catalogo della mostra, Napoli, Castel Sant'Elmo, Electa, 3, 382 • WADDY, PATRICIA. Seventeenth-Century Roman Palaces. Use and the Art of the Plan, New York-Cambridge (Mass.), London • WIED, ALEXANDER. Lucas und Marten van Valckenborch, Freren

1990 (1994) KEMP, MARTIN. The Science of Art. Optical Themes in Western Art from Brunelleschi to Seurat, New Haven-London, Yale University Press (trad. it. La scienza dell'arte. Prospettiva e percezione visiva da Brunelleschi a Seurat, Firenze, Giunti)

1990-1991 Die Baumeisterfamilie Munggenast, Ausstellungskatalog, St. Pölten • Fragonard e Robert a Roma, a cura di J.P. Cuzin, P. Rosenberg e C. Boulot, catalogo della mostra, Roma, 83, 136-37 • J.-H. Fragonard e H. Robert a Roma, catalogo della mostra, Roma, Villa Medici • KARL, THOMAS. "Stift Herzogenburg", in Die Baumeisterfamilie Munggenast, Ausstellungskatalog, St. Pölten: 69-75

1991 Altars in museum and gallery collections in Slovakia and Bohemia, exhibition catalog, Salon International des Musées et des Expositions, Paris, Grand Palais, 1992, Bratislava: 62-63 • 17e Biennale Mostra Mercato Internazionale dell'Antiquariato, Palazzo Strozzi, catalogo della mostra, Firenze • Dibujos de Arquitectura y Ornamentación de la Biblioteca Nacional, T.I. siglos XVI y XVII, Madrid • Die Baumeisterfamilie Munggenast, Ausstellungskatalog, St. Pölten • Die Dientzenhofer. Barocke Baukunst in Bayern und Böhmen, hrsg. von H.G. Franz, R. Franz und J. Brucker, Ausstellungskatalog, Rosenheim, Ausstellungszentrum Lokschuppen • Emblèmes à la liberté. L'image de la république dans l'art du XVIe au XXe siècle, ed. D. gamboni, G. Germann, F. de Capitani, exhibition catalogue, Berne • Fasto Romano, Dipinti, sculture, arredi dai Palazzi di Roma, a cura di A. Gonzalez Palacios, catalogo della mostra, Roma, Palazzo Sacchetti • In Urbe Architectus, a cura di B. Contardi e G. Curcio, Roma • L'Arcano incanto. Il Teatro Regio di Torino 1740-1990, a cura di Alberto Basso, Electa, Milano • Le Rouge et le Noir: Cent dessins français de 1700 à 1850, catalogue de l'exposition, Paris, Galerie Cailleux • L'esercizio del disegno: I Vanvitelli, a cura di C. Marinelli, catalogo della mostra, Roma, 223-225, 104; 226, 104; 284, 120-21; 285, 121; 286, 121; 288, 121; 289, 121; 291, 124; 292, 124; 293, 124; 294, 123-24; 295, 124; 296, 124 (A. Pampalone) • Perspectives: Saenredam and the architectural painters of the 17th century, eds. J. Giltaij and G. Jansen, exhibition catalogue, Rotterdam • Piranesi architetto, a cura di J. Connors et al., catalogo della mostra, American Academy in Rome, Roma • The Architecture of Western Gardens. A Design History from the Renaissance to the Present Day, ed. M. Mosser and G. Teyssot, Cambridge, Mass. MIT Press • Vedute romane del Seicento nella Raccolta Grafica Comunale, a cura di L. Cavazzi, A. Margiotta e S. Tozzi, Roma • ANDROSOV, SERGEJ O. Alle origini di Canova. Le terrecotte della collezione Farsetti, Venezia • ANSELMI, A. "Gli architetti della Fabbrica di San Pietro", in In Urbe Architectus. Modelli, disegni, misure. La professione dell'architetto. Roma 1680-1750, a cura di B. Contardi e G. Curcio, Roma, 272-80 • BALLON, HILARY. The Paris of Henry IV. Architecture and Urbanism, Cambridge, Mass., M.I.T. Press, London • BARICEVIC, DORIS. "Barokho kiparstvo sjeverne Hrvatske", in Tisucu godina hrvatske skulpture, Muzejsko galerijski centar, Zagreb • BAZIN, GERMAIN. Paradeisos: The Art of the Garden, London, Cassell Publishers Limited • BESTMANN, L. Die Galerie Alesanders VII. im Palazzo del Quirinale, zu Rom und ihre Beziehung zum ikonographischen Program der Decke der Sistinischen Kapelle, Hamburg • BLAZICEK OLDRICH, JACOB. "Modelová praxe v ceské barokové plastice", in Barokní umení a jeho vyznam v ceské kulture (Memoir of the symposium of the National Gallery in Prague), Praha, 1-21 • BOLARD, L. "La symbolique des ports chez Claude Lorrain: une révision", Gazette des Beaux-Arts, 118, 221-30 • BROWN, J. The Golden Age of painting in Spain, New Haven-London, 337 • CARLONI, ROSELLA. "Un inedito disegno settecentesco rappresentante il 'terzo braccio' in piazza San Pietro nella Collezione Piersanti di Matelica", in An Architectural Progress in Renaissance and Baroque, Papers in Art History from The Pennsylvania State University, VIII, II: 654-91 • CASALI PEDRIELLI, V. Vittorio Maria Bigari. Affreschi, dipinti, disegni, Padova • CIOFETTA, SIMONA. "Lo Studio d'Architettura Civile edito da Domenico De Rossi (1702, 1711, 1721)", in In Urbe Architectus, Roma, 214-28 • CIPRIANI, ANGELA. "Bozzetto per il leone della Fontana dei Fiumi in Piazza Navona", in Fausto Romano: dipinti, sculture, arredi dai Palazzi di Roma, a cura di A. Gonzáles-Palacios, catalogo della mostra, Roma: 104 • COLVIN, HOWARD. Architecture and the Afterlife, New Haven-London • CONTARDI, BRUNO. "Il modello di Andrea Pozzo per l'altare del Beato Luigi Gonzaga in Sant'Ignazio", in In Urbe Architectus. Modelli, Disegni, Misure. La professione dell'architetto, Roma 1680-1750, a cura di B. Contardi e G. Curcio, catalogo della mostra, Roma, Museo Nazionale di Castel Sant'Angelo, 23-39 • CONTARDI, BRUNO. "L'altare di San Luigi Gonzaga in Sant'Ignazio" e DARDANELLO G., "La sperimentazione degli effetti visivi in alcuni altari di Andrea del Pozzo", in Andrea Pozzo, a cura di A. Battistini, Atti del Convegno, 26-27 novembre 1992, Milano • CURCIO, G. "La città degli architetti", in In Urbe Architectus. Modelli, disegni, misure. La professione dell'architetto. Roma 1680-1750, a cura di B. Contardi e G. Curcio, Roma, 143-54 • DA GAI, E. "L'architettura dell'Annona (1680-1750)", in In Urbe Architectus. Modelli, disegni, misure. La professione dell'architetto. Roma 1680-1750, a cura di B. Contardi e G. Curcio, Roma, 291-95 • DE SETA, CESARE [a]. Il Real Palazzo di Caserta, con foto di L. Ghirri, Napoli • — [b]. Napoli fra Rinascimento e Illuminismo, Napoli, Electa Napoli • DESCARTES, RENÉ. Discorso sul metodo, a cura di E. Gilson e E. Carrara, Firenze, La Nuova Italia, 85 • FERRARIS, P. "Il contenzioso legale tra architetti e committenti", in In Urbe Architectus. Modelli, disegni, misure. La professione dell'architetto. Roma 1680-1750, a cura di B. Contardi e G. Curcio, Roma, 239-71 • FÜRST, ULRICH. "St. Laurentius in Gabel und die Piaristenkirche in Wien", in Schriften aus dem Institut für Kunstgeschichte der Universität München, 57, München: 43-137 • GALACTEROS-DE BOISSIER, LUCIE. Thomas Blanchet, Paris • GRITELLA, GIANFRANCO [a]. Juvarra. L'architettura, 2 voll., Modena • — [b]. "La cupola della chiesa juvarriana di Superga a Torino. Analisi della struttura e indagini sulle fasi costruttive", in Palladio, 7, 91-107 • HABEL, DOROTHY METZGER. "The Projected Palazzo Chigi al Corso and S. Maria in Via Lata: the Palace-Church Component of Alexander's Program for the Corso", Architecture, XXI: 121-35 • HAGER, HELLMUT. "Le opere letterarie di Carlo Fontana come autorappresentazione", in In Urbe Architectus. Modelli, disegni, misure. La professione dell'architetto. Roma 1680-1750, a cura di B. Contardi e G. Curcio, Roma, 155-203 • HORYNA, MOJMÍR; SUCHOMEL, MILOS. "Bildhauer aus dem Umkreis von Kilian Ignaz Dientzenhofer", in Die Dientzenhofer. Barocke Baukunst in Bayern un Böhmen, hrsg. von H.G. Franz, R. Franz und J. Brucker, Ausstellungskatalog, Ausstellungszentrum Lokschuppen, Rosenheim, 84-99 • KARL, THOMAS. "Stift Herzogenburg", in Die Baumeisterfamilie Munggenast, Ausstellungskatalog, St. Pölten: 69-75 • KIEVEN, ELIZABETH [a]. Ferdinando Fuga e l'architettura romana del Settecento, Roma • — [b]. "Il ruolo del disegno: il concorso per la facciata di S. Giovanni in Laterano", in In Urbe Architectus. Modelli, disegni, misure. La professione dell'architetto. Roma 1680-1750, a cura di B. Contardi e G. Curcio, Roma, 78-123 • KOUBOVÁ, VLADIMÍRA. in Altars in museum and gallery collections in Slovakia and Bohemia, exhibition catalog, Salon • KRAPF, MICHAEL. "Von der Universalität des Herrschens zur Selbstfindung im österreichischen Kaiserstaat", in Aus Österreichs Vergangenheit, Ausstellungskatalog, Österreichische Galerie im Schloß Halbturn, 15 • LAWRENCE, CYNTHIA. Gerrit Adraensz. Berckheyen 1638-1698, Haarlem Cityscape Painter, London, Davaco • LORENZ, H. Domenico Martinelli und die österreichische Barockarchitektur, Wien • LYNN, JOHN. "The trace italienne and the Growth of French Armies: The French Case", in Journal of Military History, 55 • MAC LAREN, N.; BROWN, CHR. National Gallery Catalogues. The Dutch School 1600-1900, I, London • MANFREDI, T. "L'architetto sottomaestro delle strade", in In Urbe Architectus. Modelli, disegni, misure. La professione dell'architetto. Roma 1680-1750, a cura di B. Contardi e G. Curcio, Roma, 281-90 • MANZELLI, MARIO. Michele Marieschi e il suo alter-ego Francesco Albotto, Venezia • MARSHALL, DAVID RILEY. "The Roman Bath Theme from Viviano Codazzi to Giovan Paolo Panini: Transmission and Transformation", Artibus et Historiae, 12/23, 1991 • MERZ, JÖRG-MARTIN. Pietro da Cortona. Der Aufstieg zum führenden Maler im barocken Rom, Tübingen • NAPPI, MARIA ROSARIA. Domenico de Nomé e Didier Barra, Milano • NONFERRAN, J.; CHARLES. "L'ecphrasis du livre du Télémaque de Fénelon, ou le détournement romanesque de la grotte de Calypso", XVIIème siècle, Revue trimestrielle publiée par la société d'études du XVIIème siècle, 387-99 • PASCUCCI, S. "L'architetto della Presidenza degli acquedotti urbani", in In Urbe Architectus. Modelli, disegni, misure. La professione dell'architetto. Roma 1680-1750, a cura di B. Contardi e G. Curcio, Roma, 296-300 • PASQUALI, S. "L'architetto del Popolo Romano (1680-1750)", in In Urbe Architectus. Modelli, disegni, misure. La professione dell'architetto. Roma 1680-1750, a cura di B. Contardi e G. Curcio, Roma, 301-12 • PINTO, JOHN. "Il Modello della Sacrestia Vaticana", in In Urbe Architectus, a cura di B. Contardi e G. Curcio, Roma: 58-69 • POLLAK, MARTHA D. [a]. Military Architecture, Cartography and the Re-

presentation of the Early Modern European City: A Checklist of Treatises on Fortification in the Newberry Library, Chicago • — [b]. *Turin, 1564-1680: Urban Design, Military Culture, and the Creation of the Absolutist Capital*, Chicago, 18-26 • RABREAU, DANIEL. "La promenade urbaine en France aux XVIIᵉ et XVIIIᵉ siècles: entre planification et imaginaire", in M. Mosser et G. Teyssot, *Histoire des jardins de la Renaissance à nos jours*, Paris, Flammarion, 301-12 (trad. it., Milano, Electa, 1990) • ROCCIA, R.; PEYROT, A. "Ignazio Sclopis del Borgo: l'uomo e l'artista", in *Vedute di Torino e di altri luoghi notabili degli Stati del Re delineate e intagliate dal Conte Sclopis del Borgo*, Archivio Storico della Città di Torino, Torino: 13-23 • ROBISON, ELWIN CLARK. "Optics and mathematics in the Domed Churches of Guarino Guarini", *Journal of the Society of Architectural Historians*, 50, 4, 384-401 • ROUCHÈS, GABRIEL. *Le théâtre du temps. Trésors des archives de Seine-et-Marne*, catalogue de l'exposition, 24 septembre-31 octobre • SALERNO, L. *I pittori di vedute in Italia (1580-1830)*, Roma • SCARPA SONINO, AMALIA. *Marco Ricci*, Milano: 109; 136 • TESTA, LAURA. "Bozzetto per la Fontana dei Quattro Fiumi", in *Fausto Romano: dipinti, sculture, arredi dai Palazzi di Roma*, a cura di A. Gonzáles-Palacios, catalogo della mostra, Roma: 103-104 • TOZZI, SIMONETTA. "Giovan Battista Falda e il Nuovo Teatro delle Fabbriche di Roma", in *Vedute romane del Seicento nella Raccolta Grafica Comunale*, a cura di L. Cavazzi, A. Margiotta e S. Tozzi, Roma, 25-35

1991-1992 *Disegni italiani di architettura e ornamentazione della Biblioteca Nazionale di Madrid secoli XVI e XVII*, Milano • *Venedigs Ruhm im Norden*, Ausstellungskatalog, Hannover, Forum des Landesmuseums, Kunstmuseum Düsseldorf im Ehrenhof

1992 *Altars in Museum and Gallery Collections in Slovakia and Bohemia*, exhibition catalogue, (Exhibition of the Slovak National Gallery in Bratislava, ed. Z. Bartosová), Salon International des Musées et des Expositions, Paris, Grand Palais, 12-19 January 1992, Bratislava, 1991, 62-63 • *Genova nell'Età Barocca*, catalogo della mostra, Genova, Galleria Nazionale di Palazzo Spinola, Gallerie del Palazzo Reale • *John Smeaton Civil Engineer 1724-1792*, exhibition catalogue, London, Institution of Civil Engineers, London • *Kunst in der Republik Genua 1528-1815*, Ausstellungskatalog, Frankfurt, Kunsthalle • *L'Art décoratif en Europe*, sous la direction d'A. Gruber, avec la collaboration de B. Pons, J.R. Ter Molen, V. Reinhardt et R. Fohr: *Classique et baroque*, Mazenod Citadelles • *Les dessins du Musée du Louvre*, 41, Paris. *Meravigliose scene Piacevoli inganni Galli Bibiena*, a cura di D. Lenzi, Bibbiena, Arezzo • *Les jardins de Versailles et de Trianon d'André Le Nôtre à Richard Mique*, Musée National des Châteaux de Versailles et de Trianons • *Meravigliose scene Piacevoli inganni Galli Bibiena*, a cura di D. Lenzi, Bibbiena, Arezzo, 119 • *Monarchs, Ministers, and Maps*, ed. di D. Buisseret, Chicago, The University of Chicago Press • *Panini. Exposition-dossier, Louvre*, sous la direction de M. Kiene, catalogue de l'exposition, Paris • *Peterhof*, sous la direction de A. de Gourcuff, Paris • *Pirro Ligorio e le erme tiburtine. Uomini illustri dell'antichità*, a cura di B. Palma Venetucci, I., 1, Roma • BATALOV, A.L.; SVIDKOVSKIJ, D.O. *Anglijskij master pri dvore Ivana Groznogo Archiv architektury*, I, Moskva, 22 • BURKE, PETER. *The Fabrication of Louis XVI*, New Haven • BUSIRI VICI, ANDREA; COSMELLI, FLAMINIA. *Giovanni Ghisolfi (1623-1683). Un pittore milanese di rovine romane*, Roma • CARLONI, ROSELLA. "Un inedito disegno settecentesco rappresentante il 'terzo braccio' in piazza San Pietro nella collezione Piersanti di Matelica", in *An Architectural Progress in Renaissance and Baroque*, Papers in Art History from the Pennsylvania State University, VIII, part II, 654-91 • CONNORS, JOSEPH, et al., *Piranesi architetto. Exhibition Catalogue*, American Academy in Rome, Roma • CONSAGRA, FRANCESCA. *The De Rossi family print publishing shop: A study in the history of the print industry in seventeenth-century Rome*, Ph. D. Diss, Baltimore, The Johns Hopkins University • COUSINS, W.S. "Filippo Juvarra and the Baroque Staircase", in *An Architectural Progress in the Renaissance and Baroque. Sojourns in and out Italy. Essays in Architectural History presented to Hellmut Hager*, eds. H.A. Millon and S. Munshower, Art History from the Pennsylvania State University, VIII, 2, University Park, Pennsylvania • DE ROBELIN, ROGER. "Gustaf III:s barndom och lekkamrater. Leka för livet", *Fataburen*, Stockholm • FERRARIS, GIANCARLO. *Piffetti e gli ebanisti a Torino 1670-1838*, a cura di A. Gonzalez Palacios, Torino • GARMS, JÖRG. "Der neapletanisches Architect Mario

Gioffredo (1718-1785) zwischen Spätbarok un Frühklassizismus", in *An Architectural Progress in the Renaissance and Baroque Sojourns In and Out of Italy*, eds. H.A. Millon and S. Scott Munshower, Paper in Art History from Pennsylvania State University, VIII, 857-87 • GRITELLA, GIANFRANCO. *Juvarra. L'Architettura*, 2 voll., Modena • JATTA, B. *Lieven Cruyl e la sua opera grafica. Un artista fiammingo nell'Italia del Seicento*, Bruxelles-Roma • KEINE, M. *Les dessins du Musée du Louvre*, Parigi, 41 • KIEVEN, ELISABETH. "'Sempre si fantastica per San Pietro'. Ein Projekt des jungen Valadier für dei Sakristei von St. Peter", in *Papers in Art History from the Pennsylvania State University*, VIII, 910-27 • KOUBOVÁ, VLADIMÍRA. "La sculpture baroque de Bohême", in *Galerie Nationale de Prague. L'art ancien de Bohême. Abbaye Saint-Georges*, catalogue de l'exposition, Paris-Praha, Réunion des musées nationaux-Národní Galerie v Praze, 132-55 • KREILINGER, KILIAN. *Ehemalige Pfarr- und Wallfahrtskirche Marienberg an der Salzach, Schnell und Steiner Kunstführer*, München-Zürich • LORENZ, HELLMUT. *J.B. Fischer von Erlach*, Zürich, 150 • MAGUIRE, ALISON; COLVIN, HOWARD. "A collection of seventeenth-century architectural plans", *Architectural History*, 35, 140-82 • MARDER, TOD A. "Bernini's Commission for the Equestrian Statue of Constantine in St. Peter's: A Preliminary Reading", in *An Architectural Progress in the Renaissance and Baroque. Sojourns in and out of Italy*, Papers in Art History from the Pennsylvania State University, Essays in Architectural History Presented to Hellmut Hager on His Sixty-sixth Birthday, eds. H.A. Millon and S.S. Munshower, University Park: 280-306 • MONTES, CARLOS. *Catálogo de Maquetas históricas españolas*, Roma • PARMA ARMANI, E. "Albergo dei Poveri (Istituto di ricovero Emanuele Brignole)", in *Luoghi del Seicento genovese. Spazi architettonici, spazi dipinti*, a cura di L. Pittarello, Bologna, 70-83 • PASSANTI, CHIARA. "Veduta, capriccio e progettazione in alcuni disegni di Juvarra", in *Essays in Architectural History Presented to Hellmut Hager on his Sixty-sixth Birthday. An Architectural Progress in the Renaissance and Baroque. Sojourns in and out of Italy*, eds. H.A. Millon and S. Scott Munshower, II, Pennsylvania, University Park, 611-23 • PINTO, JOHN. "Nicola Michetti and Eighteenth-Century Architecture in St. Petersburg", *Papers in Art History from the Pennsylvania State University*, 8: part 2, 526-65 • PONS, BRUNO. *Arabesque ou nouvelles grotesques*, in A. Gruber, *L'Art décoratif en Europe. Classique et baroque*, Paris, 157-224 • ROMANO, MARCO. "Villa Adriana", in *Pirro Ligorio e le erme tiburtine. Uomini illustri dell'antichità*, a cura di B. Palma Venetucci, I., 1, Roma, 15 sgg. • RUPÉREZ ALMAJANO, MARÍA NIEVES. *Urbanismo de Salamanca en el siglo XVIII*, Salamanca • TAFURI, MANFREDO. *Ricerca del Rinascimento. Principi, città, architetti*, Torino, Einaudi

1992 (1730-1736) PASCOLI, LIONE. *Di Andrea Pozzo, in Vite de' pittori, scultori ed architetti moderni (1730-1736)*, con note di G. Marini, Perugia: 691-715

1992-1993 *1542-1992. 450 Jahre evangelische Kirche in Regensburg*, Ausstellungskatalog, Regensburg, Museen der Stadt Regensburg • KIENE MICHAEL, *Panini*, catalogue de l'exposition, Paris, Musée du Louvre

1993 *Actes du Colloque International sur les Plans-reliefs au passé et au présent*, ed. A. Corvisier, Sedes • *Canaletto & England*, a cura di M. Liversidge e J. Farrington, catalogo della mostra, Birmingham, 76, 146-47 • *Exposición Salamanca. La cultura universal*, Salamanca • *Francesco di Giorgio Martini*, a cura di F.P. Fiore e M. Tafuri, Milano • *G.R. Donner*, Ausstellungskatalog Galerie in Szombathely, Wien, 366 • *L'esercizio del disegno. I Vanvitelli. Catalogo generale del fondo dei disegni della Reggia di Caserta*, a cura di C. Marinelli e G.M. Jacobitti, Roma, I, 155; 3, 156; 71, 290; 222, 103-104 (A. Pampalone) • *Marco Ricci e il paesaggio veneto del Settecento*, a cura di D. Succi e A. Del Neri, catalogo della mostra, Belluno, 36, 221 • *Strahovská obrazárna. Od gotiky k romantismu. Vybraná díla ze sbírek kláštera premonstrátu na Strahove*, eds. I. Kyzourová and P. Kalina, exhibition catalogue, Klášter premonstrátu na Strahove, Praha • *The Age of the Baroque in Portugal*, a cura di A. Levenson, catalogo della mostra, Washington, 106, 196, 280 • *The Utility of Splendor, Ceremony, Social Life, and Architecture at the Court of Bavaria, 1600-1800*, Chicago, XVI • *Tisíc let benediktinského klástera v Brevnove*, exhibition catalogue, eds. D. Hejdová, P. Preiss and L. Uresová, Praha, Benediktinské opatství sv. Markéty v Praze-Brevnove • ARISI, FERDINANDO. *Giovanni Paolo Panini, 1691-1765*, Roma, 100-103 • BECH-

TER, BARBARA. "Der Garten von Vaux-le-Vicomte: Geschichte und Restaurierung", *Gartenkunst*, 5, 1, 67-90 • BISCHOFF, S. "Das verkleinert opus recht vor Augen gestelt. Zur Geschichte der Bedeutung des Architekturmodells […]", in *Röm über die Alpen tragen*, hrsg. von W. Helmberger u. V. Kockel, Landshut-Ergolding, 33 • BONOLLO, G. *I giardini di Villa Pisani nelle incisioni del Ransonette*, Oriago • DARDANELLO, GIUSEPPE. "Il Collegio dei Nobili e la piazza del principe di Carignano (1675-1684)" e "La scena urbana", in *Torino 1675-1699. Strategie e conflitti del Barocco*, a cura di G. Romano, Torino, 15-120, 175-252 • FAILLE, RENÉ. *Les Trois Plus Anciens Phares de France, Cordouan, les Baleines, Chassiron*, Paris • GARMS, JÖRG. "Zwei unbekannte Zeichnungen Vanvitellis in österreichischem Privatbesitz", in *Von der Bauforschung zur Denkmalpflege: Festschrift für Alios Machatschek*, hrsg. von M. Kubelík, M. Schwarz, Wien: 65-77 • HORYNA, MOJMÍR. "Barokní sochari ve sluzbách brevnovsko - broumovského klástera", in *Tisíc let benediktinského klástera v Brevnove*, exhibition catalogue, Praha, Benediktinské opatství sv. Markéty v Praze-Brevnove, 130-49 • KIEVEN, ELISABETH [a]. *Exploring Rome: Piranesi and his Contemporaries*, eds. C. Denison, M.N. Rosenfeld, and S. Wiles, Cambridge, Mass. • — [b]. *Von Bernini bis Piranesi. Römische Architekturzeichnungen des Barock*, Stuttgart • KLAIBER, SUSAN ELISABETH. *Guarino Guarini's Theatine Architecture*, Ph. D. Diss., Columbia University • KLINGENSMITH, SAMUEL JOHN. *The Utility of Splendor Ceremony, Social Life, and Architecture et the Court of Bavaria, 1600-1800*, Chicago, XVI • LAVIN, IRVING. *Past-Present. Essays on Historicism in Art from Donatello to Picasso*, Berkeley • LOMBARDI, S. "La Scultura III.3. Altre sculture in edifici religiosi", in *Roma di Sisto V*, a cura di M.L. Madonna, Roma: 432-33, n. 13 • MARSHALL, D.R. *Viviano and Niccolò Codazzi*, Milano, VG 23; 99-100 • MERZ, JÖRG M. "Das Fortuna–Heiligtum in Palestrina als Barberini–Villa", *Zeitschrift für Kunstgeschichte*, LVI: 409-50 • MORASSI, ANTONIO. *Guardi. L'opera completa*, 3 voll., Venezia, Electa • MORASSI, GEMIN, MASSIMO. *Giambattista Tiepolo. I dipinti. Opera completa*, Venezia • PINTO, JOHN. "Piranesi Hadrian's Villa", *Studies in the History of Art*, 43, 465-66 • PRÉAUD, MAXIME. "Antoine Lepautre, Jacques Lepautre et Jean Lepautre", *Bibliothèque Nationale Inventaire du fonds français*, 11 • ROBOTTI, C. "I disegni di Mario Gioffredo architetto napoletano", in Robotti C. e Starace F. *Il disegno d'Arte, L'antico, i giardini, il paesaggio*, Lecce, 35-59 • SAUMAREZ SMITH, C. *Eighteenth-Century decoration. Design and the Domestic Interior in England*, London • SMITH, GIL R. *Architectural Diplomacy: Rome and Paris in the Late Baroque*, New York, The Architectural History Foundation • SMITH, JAY M. "Our Sovereign's Gaze: Kings, Nobles, and State Formation in Seventeenth-century France", *French Historical studies*, 18, n. 2, 396-415 • SPIKE, JOHN T. *Italian Paintings in the Cincinnati Art Museum*, Cincinnati • STOICHITA, VICTOR I. *L'instauration du tableau. Métapeinture a l'aube des Temps modernes*, Paris, Méridiens Klincksieck • SUCCI, DARIO. *Francesco Guardi. Itinerari dell'avventura artistica*, Milano • TARBUK, NELA. "Kiparstvo 17. i 18. stoljeca u sjevernoj Hrvatsko", in *Od svgdana do blagdana*, Museum of Arts and Crafts, Zagreb • TERWEN, J. JAN; OTTENHEYM KONRAD, A. *Pieter Post (1608-1669). Architect*, Zutphen • TESEO, G. "Ricerca storica e catalogazione: tecniche costruttive e restauri della chiesa di San Rocco a Venezia", *Bollettino d'Arte*, LXXVII, VI, 80-81 e 121-54 • VANCURA, VÁCLAV. "Frantisek Preiss", *Umení*, XLI, 2, 101-25 • VAN DER STOCK, JAN. *Antwerpen. Verhaal van een metropool (16e-17e eeuw)*, exhibition catalogue, Antwerpen-Gent • VON DER DUNK, THOMAS H. "Hoe klasiek de gothiek Jacob van Campen en de toren van de Nieuwe Kerk te Amsterdam. Een nieuwe nadering van een oude kwestie", *Jaarboek Genootschap Amstelodamum*, 85, 49-90 • WILTON-ELY, JOHN. "Wren, Hawksmoor and the architectural model", in *English Architecture Public and Private: Essays for Kerry Downes*, eds. J. Bold and E. Channey, London, 147-58

1993-1994 *Barock in Neapel*, Wien-Napoli • *Canaletto & England*, eds. M. Liversidge and J. Farrington, exhibition catalogue, Birmingham, Gas Hall Exhibition Gallery • *The Metropolitan Museum of Art. New acquisitions*, New York

1994 *Architetti e ingegneri militari italiani all'estero dal XV al XVIII secolo*, a cura di M. Viganò, Livorno, Istituto Italiano dei Castelli, note 55-57 • *Deutsche Architekturmodelle. Projekthilfe zwischen 1500 und 1900*, Berlin • *Filippo Juvarra 1675-1736. De Mesina al Palacio

Real de Madrid*, cuidado por B. Blasco • Esquivias y A. Bonet Correa, catálogo de la muestra, Madrid, Electa • *Giacomo Quarenghi*, cat. n. 20 • *La Galleria delle carte geografiche in Vaticano*, a cura di L. Gambi, A. Pinelli, Modena • *Luca Carlevarijs e la veduta veneziana del Settecento*, a cura di I. Reale e D. Succi, catalogo della mostra, Padova • *M. Hefele (1716-1794)*, Ausstellungskatalog Galerie in Szombathely • *Rinascimento, da Brunelleschi a Michelangelo. La rappresentazione dell'architettura*, a cura di H.A. Millon e V. Magnago Lampugnani, catalogo della mostra, Venezia • *Roma antica: Römische Ruinen in der italienischen Kunst des 18. Jahrhunderts*, hrsg. von B. Buberl, Ausstellungskatalog, Dortmund • ADAMS, NICHOLAS; NUSSDÖRFER, LAURIE. "Le città italiane fra il 1400 e il 1600", in *Il Rinascimento, da Brunelleschi a Michelangelo*, a cura di H. Millon e V. Magnago Lampugnani, Milano • ARONBERG LAVIN, MARILYN. "Rappresentazioni di modelli urbani nel Rinascimento", in *Il Rinascimento da Brunelleschi a Michelangelo. La rappresentazione dell'architettura*, a cura di H. Millon, V. Magnago Lampugnani, Milano, Bompiani: 676-80 • BARGHINI, ANDREA. *Juvarra a Roma - Disegni dall'atelier di Carlo Fontana*, Torino, Rosenberg & Sellier • BENEŠ, MIRKA. "The Social Significance of Transforming the Landscape at the Villa Borghese, 1606-1630: Territory and Agriculture in the Design of the First Roman Baroque Art", in *Il giardino islamico: architettura, natura, paesaggio*, a cura di A. Petruccioli, Milano, Electa • BLACK, J. *European Warfare 1660-1815*, London, 70 • BOUTIER, JEAN; TEISSERE-SALLMANN, L. "Dalla pianta prospettica alla pianta geometrica. Le modificazioni nella cartografia urbana in Europa occidentale dal XVI al XVIII secolo", in *Colloque du Groupe de travail international d'histoire urbaine*, Paris • CUSANNO, CHIARA. "Descrizione bibliografica dei Codice delle Antichità di Pirro Ligorio", in *I disegni di Pirro Ligorio all'Archivio di Stato di Torino*, a cura di C. Volpi, Roma, 191-96 • DUINDAM, JEROEN. *Myths of Power. Norbert Elias and the Early Modern European Court*, Amsterdam • ELKINS, JOHN. *The Poetics of Perspective*, Ithaca-London, Cornell University Press • ENEEVA, N.T. *Kategorija "velikolepija" v architekture F.B. Rastrelli Barokko v Rossii*, Moskva, 136-57 • FRANGENBERG, THOMAS. "Chorographies of Florence. The use of city views and city plans in the Sixteenth Century", *Imago Mundi*, 46: 41-64 • FRANK, MARTINA. "Inediti di Luca Danese rinvenuti in Canada. Disegni tra Roma e Venezia", in *Ristrutturazione urbanistica e architettonica di Comacchio 1598-1659. L'età di Luca Danese*, Atti del Convegno di Studi, Ferrara, 187-216 • FUHRING, PETER. *Un génie du Rococo, Juste Aurèle Meissonnier, 1695-1750*, Thèse de doctorat, Paris, consultée sur manuscrit et cité comme "à paraître" • GRITELLA, GIANFRANCO. "Fragmentos de arquitecturas incompletas: el Palazzo Madama en Turín, las residencias de Rivoli e Venaria Reale", in *Filippo Juvarra 1678-1736. De Mesina al Palacio Real de Madrid*, cuidado por A. Bonnet Correa, y B. Blasco Esquivias, Madrid, 165-77 • HAROUEL, JEAN-LOUIS. *L'embellissement des villes, L'Urbanisme au XVIIIᵉ siècle*, Paris, Picard • HOPKINS, ANDREW. "Longhena's Second Sanctuary Design for S.Maria della Salute", *The Burlington Magazine*, CXXXVI, 418-501 • KJUCARIANC, D.A. *Antonio Rinal'di*, Sankt-Petersburg, 146 • KRAPF, MICHAEL. "Plastik", in *Die Kunst des Barock in Österreich*, a cura di G. Brucher, Salzburg-Wien, 129 ss. • KRAUTHEIMER, RICHARD. "The Panels in Urbino, Baltimore, and Berlin reconsidered", in *Il Rinascimento da Brunelleschi a Michelangelo. La rappresentazione dell'architettura*, a cura di H. Millon, V. Magnago, Lampugnani, Milano, Bompiani: 233-57 • KUPPNER, SABINE. "Francesco Borrominis Aubildungsjahre an der Mailänder Dombahutte", in *Arte Lombarda*, 108-109 • LEIPIK, ANDRES. *Das Architekturmodelle in Italien: 1353-1500*, Worms • LINKS, J.G. *Canaletto*, London • MANEUVRE, LAURENT; REITH, ERIC. *Joseph Vernet 1714-1789: Les Ports de France*, Arcueil • MARIN, LOUIS. *La ville dans sa carte et son portrait. Propositions de recherche*, in *De la représentation*, Paris, Gallimard-Le Seuil: 204-18 • MARTIN, CAROLE. "Figures Baroques", *XVIIᵉ me siècle, Revue trimestrielle publiée par la société d'études du XVIIème siècle*, 185, 759-72 • MERCANDO, LILIANA. "L'opera manoscritta di un erudito rinascimentale: le Antichità di Pirro Ligorio", in *I Tesori degli Archivi: l'Archivio di Stato di Torino*, Firenze • MERLIN, PIERPAOLO; ROSSO, CLAUDIO; SYMCOX, GEOFFREY; RICUPERATI, GIUSEPPE. *Il Piemonte sabaudo. Stato e territori in età moderna*, in "Storia d'Italia", vol. VIII, t. I, Torino, UTET • NEUMAN, ROBERT. *Robert de Cotte and the Perfection of Architec-

ture in Eighteenth Century France, Chicago • NUTI, LUCIA. "The Perspective Plan in the Sixteenth Century: The Invention of a Representational Language", *The Art Bulletin*, LXXVI, 1: 105-28 • PICART, Y. *Michel Corneille (1601-1664)*, Paris • PLATT, COLIN. *The Great Rebuildings of Tudor and Stuart England. Revolutions in Architectural Taste*, London • RASPE, MARTIN. *Das Architektursystem Borrominis*, München, Deutscher Kunstverlag • REUTHER, HANS; BERCKENHAGEN, EKHART. *Deutsche Architekturmodelle. Projekthilfe zwischen 1500 und 1900*, Berlin, Deutscher Verlag für Kunstwissenschaft • ROECK, BERND. *Deutsche Architekturmodelle. Projekthilfe zwischen 1500 und 1900*, Berlin, 41, 38; 52, 44 ss. • SASSOLI GORI, MARIO. *Apparati architettonici per fuochi d'artificio a Roma nel settecento. Della Chinea e di altre "Macchine di Gioia"*, Milano, Charta • SESTIERI, GIANCARLO; DAPRÀ, BRIGITTE. *Domenico Gargiulo detto Micco Spadaro: paesaggista e "cronista" napoletano*, Napoli, 77, 193-94 • SKALECKI, GEORG. *Deutsche Architekturmodelle. Projekthilfe zwischen 1500 und 1900*, Berlin, 30, 41, 52; 34, 38 (con ulteriori riferimenti bibliografici), 44 ss. • SPICA, ANNE-ELIZABETH. "Les rêveries du promeneur enchanté. Symbole, Allegorie et Merveilleux dans le premier Versailles de Louis XIV (1664-1683)", *XVIIème siècle, Revue trimestrielle publiée par la société d'études du XVIIème siècle*, 184, 437-60 • STRAZZULLO, F. *La Cappella di San Gennaro nel Duomo di Napoli*, Napoli • THELEN, HEINRICH. "Francesco Borromini. Bemerkungen zur persönlichkeit", in *Come l'uom s'etterna. Beiträge sur Literatur-, Sprach- und Kunstgeschichte Italiens und der Romania. Festschrift für Erich Loos*, hrsg. von G. Staccioli und I. Osols-Wehden, Berlin: 264-94 • VAN DER HEUVEL, CHARLES. "Bartolomeo Campi Successor to Francesco Paciotto in the Netherlands. A Different Method of Designing Citadels: Groningen and Flushing", in *Architetti e igengneri militari italiani all'estero dal XV al XVIII secolo*, a cura di M. Viganò, Livorno, Istituto Italiano dei Castelli, 153-67 • WEDDE, NINA. *Isaac de Moucheron (1667-1744)*, Frankfurt 1994 (European University Studies 28/236) • Viganò Marino, Architetti e ingegneri militari all'estero dal XV al XVIII secolo, Istituto Italiano dei Castelli, Livorno, 25, note 55-57 • WINE, H. *Claude. The Poetic Landscape*, catalogo della mostra, London,15-18, 72-73 • ZIRPOLO, L.H. *Pietro da Cortona's frescoes in the Villa Sacchetti in Castelfusano*, Ph. D. Dissertation, Rutgers University, New Jersey

1994-1995 *Pierre Puget, peintre, sculpteur, architecte (1620-1694)*, catalogue de l'exposition, Marseille, Centre de la Vieille Charité, musée des Beaux-Arts • *The Glory of Venice: Art in the 18th Century*, eds. J. Martineau, A. Robison, London-Washington, D.C., Royal Academy-National Gallery of Art

1995 *Filippo Juvarra architetto delle capitali da Torino a Madrid 1714-1736*, a cura di V. Comoli Mandracci, A. Griseri e B. Blasco, catalogo della mostra, Torino, Fabbri • *Jacob van Campen. Het klassieke ideaal in de Gouden Eeuw*, eds. J. Huisken, K.A. Ottenheym, G. Schwartz, exhibition catalogue, Amsterdam • *Kunstjahrbuch der Stadt Linz 1994-95*, Stadtmuseum Linz-Nordico (mit Beiträgen von H. Karner und U. und L. Schultes) • *Soane: Connoisseur and Collector, Sir John Soane's Museum, London*, eds. H. Dorey, L. Fairbairn, M. Richardson and Ch. Scull, exhibition catalogue, • *The Military Revolution Debate: Readings on the Military Transformation of Early Modern Europe*, ed. C. Rogers, Boulder-San Francisco-Oxford • *The Renaissance from Brunelleschi to Michelangelo. The representation of architecture*, eds. H.A. Millon and V. Magnago Lampugnani, exhibition catalogue, Washington • BERTANA, CESARE ENRICO. "Giovanni Battista Bagnasacco. Veduta panoramica della Basilica di Superga alla fine del XVIII secolo", in *Filippo Juvarra architetto delle capitali da Torino a Madrid 1714-1736*, a cura di V. Comoli Mandracci, B. Blasco Esquivias e A. Griseri, catalogo della mostra, Milano • BIANCHI, L. *Disegni di Ferdinando Fuga e di altri architetti del Settecento*, Roma • BLASCO ESQUIVIAS, BEATRIZ. "La Basilica Reale di Superga", in *Filippo Juvarra architetto delle capitali da Torino a Madrid 1714-1736*, a cura di V. Comoli Mandracci, B. Blasco Esquivias e A. Griseri, catalogo della mostra, Milano, 346-56 • BRZUSKA, MELANIE. *Schloß Friedrichswerth. Ein Landschloß Herzog Friedrich I. von Sachsen-Gotha-Altenburg*, Magisterarbeit, Marburg • COLVIN, HOWARD. *A Biographical Dictionary of British Architects: 1660-1840*, 3rd ed., New Haven-London • COMOLI MANDRACCI, VERA. "La dimensione urbanistica di Juvarra per l'idea delle città-capitali", in *Filippo Juvarra architetto delle capitali da Torino*

a Madrid 1714-1736, a cura di V. Comoli Mandracci, A. Griseri e B. Blasco, catalogo della mostra, Torino, Fabbri, 42-67 • CONSTANS, C. *Musée National du château de Versailles. Catalogue. Les peintures*, I-II • CORBO, ANNA MARIA. *Fonti per la storia artistica romana al tempo di Paolo V*, Roma • CUNEO, CRISTINA. "La basilica di Superga", in *Itinerari Juvarriani*, a cura di V. Comoli Mandracci, Torino, 100-109 • DARDANELLO, GIUSEPPE. "Memoria professionale nei disegni dagli Album Valperga. Allestimenti decorativi e collezionismo di mestiere", in *Le collezioni di Carlo Emanuele I*, a cura di G. Romano, Torino, 63-134 • DUBOIS, CLAUDE-GILBERT. *Le baroque en Europe et en France*, Paris, Presses Universitaires de France, 61-63 • GARMS, JÖRG. "La cappella di S. Giovanni Battista nella chiesa di S. Rocco a Lisboa", in *Giovanni V di Portogallo (1707-1750) e la cultura del suo tempo*, a cura di S. Vasco Rocca e G. Borghini, Roma, 15, 124-25; 18; 20, 125; 21, 125; 22, 126; 23, 126-27; 113-28 • GOUSSET, JEAN-PAUL. "De la lumière à l'éclairage", *Monumental*, 9, 34-45 • GRISERI, ANDREINA. "Juvarra, un cantiere per la luce del Settecento", in *Filippo Juvarra. Architetto delle capitali da Torino a Madrid 1714-1736*, a cura di V. Comoli Mandracci, A. Griseri e B. Blasco, catalogo della mostra, Torino, Fabbri, 42-67 • GRISERI, ANGELA. "Arredi in linea con la corte. Il Piffetti", in *Un cantiere dopo la guerra del Sale. Francesco Gallo 1672-1750*, a cura di A. Griseri, P. Dell'Aquila e A. Griseri, Farigliano: 113-19 • GRITELLA, GIANFRANCO. "Brani di architetture incompiute: Palazzo Madama a Torino, le residenze di Rivoli e Venaria Reale", in *Filippo Juvarra architetto delle capitali da Torino a Madrid 1714-1736*, a cura di V. Comoli Mandracci, B. Blasco Esquivias e A. Griseri, Milano, 411-12 • HAGER, HELLMUT. "Il 'Modello Grande' di Filippo Juvarra per la Nuova Sacrestia di San Pietro in Vaticano", in *Filippo Juvarra architetto delle capitali da Torino a Madrid 1714-1736*, catalogo della mostra, Torino, 167-73 • JONKER, MICHEL; VREEKEN, HUBERT. *In beeld gebracht. Beeldhouwkunst uit de collectie vand het Amsterdams Historisch Museum*, Zwolle-Amsterdam • LABLAUDE, P.-A. *Les jardins de Versailles*, Paris • LÜBBECKE FRIED, *Das Palais Thurn und Taxis in Frankfurt am Main*, Frankfurt am Main • MACDONALD, WILLIAM L.; PINTO, JOHN A. *Hadrian's Villa and Its Legacy*, New Haven-London (trad. it. *Villa Adriana - La costruzione e il mito da Adriano a Louis Kahn*, Milano, Electa, 1997) • MARGIOTTA, ANITA. *G.B. Falda e i suoi divulgatori. Scenografie Urbane di Roma Barocca*, Roma • MARSHALL, DAVID RILEY. *Viviano and Niccolò Codazzi and the Baroque Architecture Fantasy*, Milano • MILLON, HENRY A. [a]. "Modello del Castello di Rivoli", in *Filippo Juvarra architetto delle capitali da Torino a Madrid 1714-1736*, a cura di V. Comoli Mandracci, B. Blasco Esquivias e A. Griseri, catalogo della mostra, Milano, 413 • — [c]. "Modello del Palazzo del Senato (Curia Maxima), Torino", in *Filippo Juvarra architetto delle capitali da Torino a Madrid 1714-1736*, a cura di V. Comoli Mandracci, B. Blasco Esquivias e A. Griseri, catalogo della mostra, Milano, 413 • — [c]. "Modello della Reale Chiesa e convento di Superga", in *Filippo Juvarra architetto delle capitali da Torino a Madrid 1714-1736*, a cura di V. Comoli Mandracci, B. Blasco Esquivias e A. Griseri, catalogo della mostra, Milano, 412-13 • MOORE, JOHN E. "Prints, Salami and Cheese: Savoring the Roman Festival of the Chinea", *The Art Bulletin*, 77, 4, 584-608 • MORROGH, ANDREW. "Guarini and the Pursuit of Originality. The Church for Lisbon and Related Projects", *Journal of the Society of Architectural Historians*, 57, 1, 6-29 • MOULIN, JACQUES. *Vaux-le-Vicomte. Etude préalable à la restauration des parcs et des jardins Bilan historique*, Paris • MYERS, MARY L. *Architectural and Ornament Drawing: Juvarra. Vanvitelli, the Bibiena Family, & other Italian Draughtsmen*, New York 1995. • NICHOLSON, CHRISTOPHER. *Rock Lighthouses of Britain: the End of an Era?*, Latheron, Caithness • OECHSLIN, WERNER [a]. "Le goût et les nations: débats, polémiques et jalousies au moment de la création des musées au XVIIIe siècle", in Pommier E., *Les Musées à la veille de l'ouverture du Louvre*, Paris, 365 ss. • — [b]. "Das Architekturmodell zwischen Theorie und Praxis", in Evers B., *Architekturmodelle in der Renaissance*, München, 40 ss. • OELGESCHLÄGER, MELANIE. "Vom hölzernen Modell zum ausgführten Schloß - Die Baugeschichte des Schlosses in Friedrichswerth" • OTTENHEYM KONRAD, A. "Architectuur", in *Jacob van Campen. Het klassieke ideaal in de Gouden Eeuw*, eds. J Huisken, K. Ottenheym, G. Schwartz, Amsterdam, 155-99 • PEDROCCO, FILIPPO. *Canaletto and the Venetian Vedutisti*, Firenze • PUPPI, LIONELLO. "'Chi può coman-*

dar'. Tasselli archivistici per Giambattista Tiepolo alla volta di Spagna", *Venezia-Arti*, 9, 148-50 • RAVA, ANTONIO. "Modello ligneo del progetto per la Sacrestia di San Pietro in Vaticano. Il restauro", in *Filippo Juvarra architetto delle capitali da Torino a Madrid 1714-1736*, catalogo della mostra, Torino, 408-10 • ROSTAING, AURÉLIA. *André Le Nôtre et les jardins de XVIIe siècle*, thèse d'Ecole des chartes inédite (Résumé dans Ecole des chartes. Positions des thèses soutenues par les élèves de la promotion de 1995 pour obtenir le diplôme d'archiviste paléographe, Paris 1995, 243-49) • SAN MARTINO, PAOLO. "Il mobile e il fantastico intuito di Juvarra", in *V. Comoli Mandracci, A. Griseri, B. Blasco Esquivias, Filippo Juvarra architetto delle capitali da Torino a Madrid 1714-1736*, Milano, 252-55 • SCHMID, ALOIS. "Das Gymnasium Poeticum", in *Gelehrtes Regensburg*, hrsg. von Universität Regensburg, Regensburg, 120-21 • SCHMIDT-MÖBUS, FRIEDERIKE. "Von denen Divertissements der großen Herren". *Schloß Wilhelmsthal: Gesamtkunstwerk im Rokoko*, Dissertation, Göttingen, microfiche • SCOTT, JOHN BELDON [a]. "Guarino Guarini's Invention of the Passion Capitals in the Chapel of the Holy Shroud", *Journal of the Society of Architectural Historians*, 54, 4, 418-45 • — [b]. "Seeing the Shroud: Guarini's Reliquiary Chapel in Turin and the Ostension of a Dynastic Relic", *Art Bulletin*, LXXVI, 4, 609-37 • SCOTT, R. *The Rococo Interior*, London • SLADEK, ELISABETH. "I progetti per la sacrestia di San Pietro presentati da Francesco Borromini e Francesco Maria Febei ad Alessandro VII Chigi. L'irresoluta questione tra restauro e integrale rinnovamento della rotonda tardoantica di Santa Maria della Febbre", in *Annali di Architettura*, 7, 147-58 • SPIES, UTA. "Die Umbaupläne", in *Gelehrtes Regensburg*, hrsg. von Universität Regensburg, Regensburg, 124-26 • SWAN, CLAUDIA. "Ad vivum, naer het leven, from life: defining a mode of representation", *Word & Image*, II, 4: 353-72 • VINARDI, MARIA GRAZIA. "Il castello di Aglié. Gli appartamenti ducali, in *Il Castello di Aglié. Alla scoperta dell'appartamento del Re*, a cura di D. Biancolini, Torino: 25-39 • VON KALNEIN WEND, GRAF. *Architecture in France in the eighteenth century*, New Haven, Yale University Press • WORSLEY, GILES. *Classical Architecture in Britain: The Heroic Age*, New Haven-London

1995-1996 *Architekturmodelle der Renaissance*, hrsg. von B. Evers, Ausstellungskatalog, Berlin, Kunstbibliothek Staatliche Museen zu Berlin, Preußischer Kulturbesitz, München-New York • *Phantasie und Illusion. Städte, Räume, Ruinen in Bildern des Barock*, Ausstellungskatalog, Paderborn-Oldenburg, 77

1995-1997 HAGER, HELLMUT. "Bernini Carlo Fontana e la fortuna del 'terzo braccio' del Colonnato di Piazza San Pietro in Vaticano", in *Quaderni dell'Istituto di Storia dell'Architettura*, n. 5, fasc. 25-30, 337-60

1995 (1998) ISRAËL, JONATHAN I. *The Dutch Republic: Its Rise, Greatness and Fall 1477-1806*, 262-67, 273-74

1996 *Andrea Pozzo*, a cura di A. Battisti, Milano • *Città d'Europa. Iconografia e vedutismo dal XV al XIX secolo*, a cura di C. de Seta, Napoli, Electa Napoli • *Das Capriccio als Kunstprinzip*, hrsg. von E. Mai, Ausstellungskatalog, Zürich-Wien-Köln • *Grand Tour. The Lure of Italy in the Eighteenth Century*, a cura di A. Wilton e I. Bignami, catalogo della mostra, 252, 290 • *Johannes Vermeer*, Washington, D.C., National Gallery of Art • *Las casas del alma*, Barcelona, Centre de Cultura Contemporánea • *Zur 850. Wiederkehr der Besiedlung des ehemaligen Zisterzienserklosters Raitenhaslach*, hrsg. von W. Hopfgartner, Ausstellungskatalog, Burghausen • BATALOV, A.L. *Moskovskoe kamennoe zodcstvo konca XVI veka*, Moskva • BOLD, JOHN. "Greenwich", in *The Dictionary of Art*, ed. J. Turner, 34 vols., London, 13, 623-24 • BOWRON, EDGAR PETERS [a]. "Bernardo Bellotto", in De Grazia Diane; Garberson Eric, *Italian Paintings of the Seventeenth and Eighteenth Centuries: The Collections of the National gallery of Art Systematic Catalogue*, Washington, D.C., 7-22 • — [b]. "Giovanni Paolo Panini", in De Grazia Diane; Garberson Eric, *Italian Paintings of the Seventeenth and Eighteenth Centuries: The Collections of the National gallery of Art Systematic Catalogue*, Washington, D.C., 188-98 • BRIGANTI, GIULIANO. *Gaspar Van Wittel*, a cura di L. Laureati e L. Trezzani, Roma • BRUNI, GIUSEPPE. *Opere letterarie e politiche*, a cura di P. Viti, Torino, UTET, 716-17 • BUCI-GLUCKSMAN, CHRISTINE. *Puissance du baroque. les forces, les formes, les rationalités*, Paris, Galilée • BUONARROTI, MICHELANGELO. *Rime*, Milano, BUR, 148 • CARTA, MARINA. "I progetti per San Giovanni in Laterano", in *Andrea Pozzo*, a cura di V. De Feo e V. Martinelli,

Milano, 168-75 • CASTELLERCIO, STÉPHANE. "Marly, un instrument de pouvoir enchanteur", *XVIIème siècle, Revue trimestrielle publiée par la société d'études du XVIIème siècle*, 192, 633-57 • CECCHETTO, GIACINTO. "Castelfranco tra '600 e '700: una 'quasi città' della Terraferma all'epoca di Giovanni Rizzetti", in *Giovanni Rizzetti scienziato e architetto*, a cura di L. Puppi e R. Maschio, Castelfranco Veneto, 1-32 • CHRISTIANSEN, K. "Apoteosi della famiglia Pisani", in *Giambattista Tiepolo 1696-1996*, catalogo della mostra, Milano, 320-24, n. 52 • COLONNA-PRETI, STEFANO. "La famiglia Rizzetti", in *Giovanni Rizzetti scienziato e architetto*, a cura di L. Puppi e R. Maschio, Castelfranco Veneto, 33-96 • CONNORS, JOSEPH. "Borromini in Oppenordt's Sketchbooks", in *Studi in onore di Matthias Winner*, Magonza, 598-612 • CONTARDI, BRUNO. "L'altare di San Luigi Gonzaga in Sant'Ignazio", in *Andrea Pozzo*, a cura di A. Battistini, Atti del Convegno 26-27 novembre 1992, Milano-Trento, 97-112 • CURCIO, G. "Le contraddizioni del metodo. L'architettura esatta di Domenichino", in *Domenichino 1581-1641*, catalogo della mostra, Palazzo Venezia, Milano, 151-61 • DARDANELLO, GIUSEPPE. "La sperimentazione degli effetti visivi in alcuni altari di Andrea Pozzo", in *Andrea Pozzo*, a cura di A. Battistini, Atti del Convegno 26-27 novembre 1992, Milano-Trento, 121-31 • DE FEO, VITTORIO. "Le cappelle e gli altari", in *Andrea Pozzo*, a cura di V. De Feo e V. Martinelli, Milano, 114-43 • DE GRAZIA, DIANE; GABERSON, ERIC. *Italian Paintings of the Seventeenth and Eighteenth Centuries*, Washington-New York-Oxford, National Gallery of Art-Oxford University Press • DE SETA, CESARE [a]. "L'iconografia urbana in Europa dal XV al XVIII secolo", in *Città d'Europa. Iconografia e vedutismo dal XV al XIX secolo*, a cura di C. de Seta, Napoli, Electa Napoli: 11-48 • — [b]. *La città europea dal XV al XVIII secolo*, Milano, Rizzoli • — [c]. "Città ideali, città virtuali e città reali nella seconda metà del Quattrocento", in *La città europea dal XV al XVIII secolo*, Milano, Rizzoli: 66-76 • DI MACCO, MICHELA. "Collino e Bernero. Vasi, trofei, divinità agresti e venatorie", in *Stupinigi luogo d'Europa*, a cura di R. Gabetti e A. Griseri, Torino: 115-41 • DOWNES, KERRY. "Christopher Wren", in *The Dictionary of Art*, 34 vols., ed. J. Turner, London, 33, 392-99 • FAGIOLO DELL'ARCO, MAURIZIO. *Jean Lemaire, pittore "antiquario"*, Roma • FLEMMING, VICTORIA; SCHÜTZE, SEBASTIAN. *Ars naturam adiuvans: Festschrift für Matthias Winner*, Mainz-am-Rhein • FOWLE, DIANA. "Lyon: Centre of production - silk", in *The Dictionary of Art*, 19, ed. J. Turner, London: 849-50 • FROMMEL, CHRISTOPH LUITPOLD. "Poussin et l'architecture", in *Poussin et Rome*, a cura di O. Bonfait et al., Atti del colloquio, Roma • GABETTI, ROBERTO; ISOLA AIMARO. *Juvarra dopo Juvarra*, in *Stupinigi luogo d'Europa*, a cura di Roberto Gabetti e Andreina Griseri, Torino, 196, pp. 9-26. • GARDIN BERENGO, SUSANNA. "Disegni italiani nel Canadian Centre for Architecture di Montreal", *Il disegno di Architettura*, VII, 13 • GARGANO, MAURIZIO. "L'altare di Sant'Ignazio del Gesù di Roma: committenza e cantiere", in *Andrea Pozzo*, a cura di V. De Feo e V. Martinelli, Milano, 156-67, e *Apparati*, 243-44 • GOOSSENS, EYMERT-JAN. *Schat van beitel en penseel. Het Amsterdamse stadhuis uit de Gouden Eeuw*, Amsterdam-Zwolle • HAGER, HELLMUT [a]. "Bernini, Carlo Fontana e la Fortuna del 'Terzo Braccio' del Colonnato di Piazza San Pietro in Vaticano", *Quaderni dell'Istituto di Storia dell'Architettura*, n.s., 25-30 (1995-1997): 337-60 • — [b]. "Clemente XI, il Museo di Modelli della Reverenda Fabbrica di San Pietro e l'origine del museo architettonico", *Rivista Storica del Lazio*, 7: 137-83 • HUNT, JOHN DIXON. *Garden and Grove: the Italian Renaissance Garden in the English Imagination, 1600-1750*, Philadelphia, University of Pennsylvania Press • KLEMM, DAVID. "Das Bildnis Balthasar Neumanns aus dem Jahre 1727", *Festschrift Fritz Jacob zum 60. Geburtstag*, hrsg. von O. Klodt et al., Münster, 99-117 • KRAPF, MICHAEL. "G.R. Donners Mehlmarktbrunnen: Seine Antiken-Rezption in formaler wie literarhistorischer Hinsicht", in *Kunsthistorisches Museum Vienna, Jahrbuch der kunsthistorischen Sammlungen*, 92, Wien, XCII, 63 • LECOMTE, LAURENT. *Sainte Jeanne de Chatal et l'architecture des couvents de la Visitation en France*, mémoire de D.E.A., C.E.S.R., Tours • LEVY, EVONNE. "Che cos'è un architetto gesuita? La Cappella di Sant'Ignazio e il problema del disegnare in comitato", in *Andrea Pozzo*, a cura di A. Battistini, Atti del Convegno 26-27 novembre 1992, Milano-Trento, 133-39 • MARSHALL, DAVID RILEY. "On the Monogrämmist GAE at Stourhead", *The Burlington Magazine*, 138, 685-90 • MONTAGU, J. *Gold, Silver & Bronze. Metal Sculpture of the Ro-*

man Baroque, New Haven-New York • MUNDY, BARBARA. The Mapping of New Spain, Chicago, The University of Chicago Press • NUTI, LUCIA. Ritratti di città. Visione e memoria tra Medioevo e Settecento, Venezia, Marsilio Editori • PÉREZ, MARIE-FÉLICIE. "Jacques-Germain Soufflot", The Dictionary of Art, 29, ed. J. Turner, London: 90-94 • PIGNATTI, TERISIO. Antonio Canal detto Canaletto, Firenze • RIZZI, ALBERTO. Bernardo Bellotto: Dresda, Vienna, Monaco (1747-1766), Venezia, Canal & Stamperia Editrice • ROTTERMUND, ANDRZEJ. "Chiaveri Gaetano", The Dictionnary of Art, vol. 6, London-New York: 571-72 • SEVERO, DONATO. Filippo Juvarra, Bologna • SIMPSON, ALLEN. "The Lighthouse Collection of the National Museums of Scotland", Northern Lighthouse Journal, 9-14 • STRATMANN-DÖHLER, ROSEMARIE; SIEBENMORGEN, HARALD. Das Karlsruher Schloss, Karlsruhe, G. Braun Buchverlag • STRINATI, C. "Gli affreschi nella chiesa di Sant'Ignazio a Roma", in Andrea Pozzo, a cura di V. De Feo e V. Martinelli, Milano, 66-93 • TONINI, CAMILO [a]. "Le delicie della Brenta' nelle acqueforti di Gianfranco Costa", in Immagini della Brenta, catalogo della mostra, Milano, 79-88 • — [b]. "Villa Pisani nelle stampe di Pietre Nicolas Ransonette e Bartolo Gaetano Carboni", in Immagini della Brenta, catalogo della mostra, Milano, 89-96 • WILTON-ELY, JOHN. "The Architectural Model", in The Dictionary of Art, London, 34 vol.

1997 Capolavori in festa. Effimero barocco a largo di Palazzo (1683-1759), catalogo della mostra, Napoli • Ekaterina Velikaja i Moskva, eds. L.I. Iovleva and L.A. Markina, Mosva • Grand Tour. Il fascino dell'Italia nel XVIII secolo, a cura di A. Wilton e I. Bignami, catalogo della mostra, Roma, 252, 300 • I Galli Bibiena, una dinastia di architetti e scenografi, a cura di D. Lenzi, Atti del convegno 1995, Bibbiena • Svaty Vojtech. Tisíc let svatovojtesské tradice v Cechách, exhibition catalogue, ed. M. Bartlová, Praha, Národní Galerie v Praze • AVERY, CHARLES. Bernini, Genius of the Baroque, London • BAUER, KARL. Regensburg. Kunst-, Kultur- und Alltagsgeschichte, V Augs., Regensburg • BONNEFOIT, RÉGINE. Johann Wilhelm Baur, Tübingen • BÖRNER, LORE. Die italienische Medaillen der Renaissance und Barock (1450 bis 1750), Bestandskataloge des Münzkabinetts Berlin, Berlin • BROUZET, DAVID. Recherches sur Jean-Baptiste et Pierre-Denis Martin, paysagistes et peintres de batailles, 2 voll., Mémoire de maîtrise inédit soutenu à l'Université de Paris IV-Sorbonne, sous la direction d'Antoine Schnapper, • COLONNA-PRETI, STEFANIA. Nuovi contributi sulla figura e le opere dell'architetto Francesco Maria Preti, Milano • DARDANELLO, GIUSEPPE. "Open Architecture". Un disegno per il salone di Stupinigi e una fantasia di Filippo Juvarra, in "Dialoghi di Storia dell'Arte", 4/5, dicembre 1997, pp. 100-115. • DE LA CORGE, JÉRÔME. Féeries d'opera: Decors, machines et costumes en France 1645-1765, Paris • DI PIAZZA, VALERIA. "La villa del Pigneto Sacchetti" in Pietro da Cortona e il disegno, a cura di S. Prosperi Valenti Rodinò, Milano: 134-37 • FAGIOLO, MARCELLO. Il Settecento e l'Ottocento. Corpus delle Feste a Roma, II, Roma, De Luca • FINA, GIANFRANCO. Maestri argentieri ed argenterie alla corte di Carlo Emanuele III e Vittorio Amedeo III, 1730-1796, Torino • FOISSIER, FRANÇOIS. Les dessins du fonds Robert de Cotte de la Bibliothèque natinale de France. Architecture et décor, Bibliothèque des Ecoles françaises d'Athènes et de Rome, fascicolo 293, Bibliothèque nationale de France - Ecole française de Rome • FUHRING, PETER. Vredeman de Vries. Hollstein's Dutch & Flemish Etchings, Woodcuts 1450-1700, XVLIII, Rotterdam • GERRITSEN, ETSKE. "De architectuurtekening in de 17de eeuw", in 'Soo vele heerlijcke gebouwen.' van Palladio tot Vingboons, eds. J. Boonstra, exhibition catalogue, Bijbels Museum, Amsterdam, 40-61 • HAGER, HELLMUT. "Clemente XI, il Museo dei Modelli della Reverenda Fabbrica di San Pietro e l'origine del museo architettonico", in Rivista Storica del Lazio, anno IV, n. 7, 137-183 • HLADÍK, TOMÁS. "Svaty Vojtech v ceském barokním socharstvi", in Svaty Vojtech. Tisíc let svatovojtesské tradice v Cechách, exhibition catalogue, Praha, Národní galerie v Praze, 47-59; 114-121 • HOPFGARTNER, WOLFGANG. "Wallfahrtskirche Marienberg: Die erhaltenen Modelle von Kirche und Altar", in Oettinger Land, 17, Altötting: 203-12 • HOPKINS, ANDREW. "Plans and Planning for S. Maria della Salute, Venice", The Art Bulletin, LXXIX, 440-75 • MAGNUSSON, OLAUS. "Trädgårdkonst", in Barockens Konst, ed. G. Alm et al., Lund • MARDER, TOD A. Bernini's Scala Regia at the Vatican Palace, New York • MARINI, GIORGIO. "Stampe da studio, più che da Galleria'. Incisioni di Casa Rosmini ed alcuni aspetti del collezionismo di grafica nel tardo Settecento", in Le Collezioni di stampe e di libri di Ambrogio Rosmini (1741-1818), a cura di S. Ferrari e G. Marini, Rovereto • MARSHALL, DAVID RILEY. "Early Panini Reconsidered: The Esztergom 'Preaching of an Apostole' and the Relationship between Panini and Ghisolfi", Artibus et Historiae, 137-98 • McPHEE, SARAH. "Bernini's Bell Towers for St. Peter's and the Politics of Architecture at the Vatican", Ph. D. Dissertation, Columbia University • MOMO, MAURIZIO. Il Duomo di Torino. Trasformazione e restauri, Torino • NOEHLES, KARL. "Cortona architetto", in Pietro da Cortona 1597-1669, a cura di A. Lo Bianco, Roma: 133-52, nn. 103-23 • OECHSLIN, WERNER. "Premesse a una nuova lettura dell'Idea della Architettura universale di Scamozzi", in Testi e fonti per la Storia dell'Architettura, II, V. Scamozzi, Vicenza, CISA, XIV • OTTENHEYM KONRAD, A. "Possessed by such a Passion for Building. Frederik Hendrik and Architecture", in Princely Display. The Court of Frederik Hendrik of Orange and Amalia van Solms, eds. M. Keblusek and J. Zijlmans, Den Haag-Zwolle, 105-25 • PALMA VENETUCCI, BEATRICE. "La fortuna antiquaria di Milone", Bollettino dei Musei Comunali, 11, 5 ss. • PEETERS, JAN; SUTTON, PETER. [a] The Royal Palace of Amsterdam in Paintings of the Golden Age, Amsterdam • — [b]. Het Paleis in de schilderkunst van de Gouden Eeuw, Amsterdam-Zwolle • PÉREZ-GÓMEZ, ALBERTO; PELLETIER, LOUISE. Architectural Representation and the Perspective Hinge, Cambridge, Mass.-London, The mit Press • PIETROGIOVANNA, MARI. "Giovanni Francesco Costa", in Tiepolo Canaletto Piranesi e altri. Incisioni venete del Settecento dei Musei Civici di Padova, a cura di F. Pellegrini, catalogo dellamostra, Padova, 50-61 • PUPPI, LIONELLO; RUGOLO, RUGGERO. "Un'ordinaria forma non alletta. Arte, riflessioni sull'arte e società", in Storia di Venezia dalle origini alla caduta della Serenissima, VII, La Venezia barocca, Roma, 595-699 • SLADEK, ELISABETH; BÖSEL, RICHARD. "Il Progetto di Francesco Borromini per la Sacrestia di San Pietro", in Annali di Architettura, 9, 136-42 • WARMOES, ISABELLE. Le Musée des Plans-Reliefs. Maquettes historiques de villes fortifiés, Paris, Editions du Patrimoine • WATERSTON, CHARLES D. Collections in Context: the Museum of the Royal Society of Edinburgh and the Inception of a National Museum for Scotland, Edinburgh • WHITE, ROGER. Nicholas Hawksmoor and the Replanning of Oxford, exhibition catalogue, British Architectural Library Drawings Collection-Ashmolean Museum, Oxford

1997-1998 Pietro da Cortona 1597-1669, catalogo della mostra, Roma, Palazzo Venezia

1998 Augsburger Stadtlexikon, Augsburg • Bernini scultore. La nascita del barocco in casa Borghese, a cura di A. Coliva e S. Schütze, Roma • Dalla dominazione francese alla ricomposizione dello Stato (1536-1630), a cura di G. Ricuperati, in Storia di Torino, III, Torino, Einaudi • Das Bild der Stadt in der Neuzeit 1400-1800, hrsg. von W. Behringer, B. Roeck, München, C.H. Beck • Effigies and Ecstasies. Roman Baroque Sculpture and Design in the Age of Bernini, ed. A. Weston-Lewis, Edinburgh • Filippo Juvarra e l'architettura europea, a cura di A. Bonnet Correa, C. Blasco Esquivias e G. Cantone, catalogo della mostra, Napoli • Francesco Borromini: L'Opus Architectonicum, a cura di J. Connors, Milano • From the Sculptor's Hand. Italian Baroque Terracottas from the State Hermitage Museum, ed. I. Wardropper, with essays by S. Androsov, N. Kosareva, D. Walker, I. Wardropper, Chicago • Il Mondo di Casanova, un veneziano in Europa, 1725-1798, Venezia, scheda 273 • Il teatro per la città, Bologna • Johann Wilhelm Baur: 1607-1642. Meniérisme et baroque en Europe, sous la direction de A.C. Haus, catalogue de l'exposition, Strasbourg • Paul Troger & Brixen, Catalogo della mostra, Bressanone, Museo Diocesano • Perspectives on Garden History, in Studies in Landscape Architecture, Dumbarton Oaks • Triumph der Phantasie. Barocke Modelle von Hildebrandt bis Mollinaro, hrsg. von M. Krapf, Ausstellungskatalog, Wien, Österreichische Galerie Belvedere, Wien-Köln-Weimar • BABELON, J.P.; MIGNOT, G. François Mansart le génie de l'architecture, Paris • BARIDON, MICHEL. "The Scientific Imagination and Baroque Gardens", Journal of Garden History, 18, n. 1 • BROUZET, DAVID. "Jean-Baptiste et Pierre-Denis Martin, peintres des Maisons royales", L'Estampille/L'Objet d'Art, 328, 64-82 • BUISSERET, DAVID. "Modeling cities in Early Modern Europe", in Envisioning the City: Six Studies in Urban Cartography, ed. D. Buisseret, Chicago, 125-43 • BUSHART, BRUNO. "Das neue Gesicht der Stadt und die zweite Blüte ihrer Kunst (1590-1650)", in Augsburger Stadtlexikon, Augsburg • CAVAZZINI, PATRIZIA. Palazzo Lancelotti ai Coronari, Roma • COMOLI MANDRACCI, VERA. "Le scelte urbanistiche", in Storia di Torino, III: Dalla dominazione francese alla ricomposizione dello Stato (1536-1630), Torino, Einaudi, 355-86 • CORBO, ANNA MARIA. I mestieri della vita quotidiana alla corte di Nicolò V (1447-1475), Roma • DE SETA, CESARE. Luigi Vanvitelli, Napoli, Electa, 305 • FINOCCHI GHERSI, L. "Frigimelica Roberti Girolamo", in Dizionario degli Italiani, 50, 543-47 • FRANK, MARTINA. Baldassarre Longhena (1597-1682), Habilitationsschrift, Wien, Universität Wien, I • FROMMEL, S. Sebastiano Serlio, Milano • FUHRING, PETER. "Juste-Aurèle Meissonnier: The Artist and His Work", in The Thyssen Meissonnier Silver Tureen made for the 2nd Duke of Kingston, Property of a Thyssen-Bornemisza de kaszon Family Trust, New York, Sotheby's, 10-49 • HAGER, HELLMUT. "Il 'Modello Grande' di Filippo Juvarra per la Nuova Sacrestia di San Pietro in Vaticano", in Filippo Juvarra e l'architettura europea, catalogo della mostra, Napoli, 105-120 • HLADÍK, TOMÁS. "Svaty Vojtech v ceském barokním socharstvi", in Svaty Vojtech. Tisíc let svatovojtesské tradice v Cechách, exhibition catalogue, Národní Galerie v Praze, Praha, 47-59, 114-21 • ISRAËL, JONATHAN I. The Dutch Republic: Its Rise, Greatness and Fall, 1477-1806, Oxford • KAGAN, RICHARD L. "Urbs and Civitas in Sixteenth- and Seventeenth-Century Spain", in Envisioning the City. Six Studies in urban Cartography, ed. D. Buisseret, Chicago, The University of Chicago Press • KAGAN, RICHARD L.; MARÍAS, FERNANDO. Imágenes urbanas del mundo hispánico 1493-1780, Madrid, El Vaso • KERN, MARGIT. "Die Rezeption des römischen Hochbarock unter Wahrung spätmittelalterlicher Frömmigkeitstraditionen am Beispiel ausgewählter Marienaltäre in Österreich", in Triumph der Phantasie. Barocke Modelle von Hildebrandt bis Mollinarolo, Ausstellungskatalog, Wien, 73-84 • KLAMT, JOHANN CRISTIAN. Sternwarte und Museum im Zeitalter der Aufklärung: der mathematische Turm zu Kremsmünster, Mainz • LAUPICHLER, FRITZ. "Pointing/Indicating", in Encyclopedia of Comparative Iconography: Themes Depicted in Works of Art, ed. H.E. Roberts, Chicago-London, 739-44 • LOOYENGA, A.J. "De orgelontwerpen voor de Ronde Lutherse Kerk", in Monumentale orgels van Luthers Amsterdam, eds. H. Donga, P. van Dijk, Zoetermeer, 163-231 • MARDER, TOD A. Bernini and the Art of Architecture, New York-London-Paris, 127-49 (trad. it. Milano, 1998) • OELGESCHLÄGER, MELANIE. "Modell des Schlosses in Friedrichswerth" in Von teutscher Not zu höfischer Pracht. 1648-1701, Ausstellungskatalog, Nürnberg, 322 • PALMER, MIKE. Eddystone 300: the Finger of Light, Torpoint • POLLAK, MARTHA D. "Military Architecture and Cartography in the Design of Early Modern City", in Envisioning the City: Six Studies in Urban Cartography, ed. D. Buisseret (ed.), Chicago, 109-24 • ROECK, BERND. Stadtlexikon, Augsburg, 799 • RONZONI, LUIGI A. in Triumph der Phantasie Barocke. Modelle von Hildebrandt bis Mollinaro, exhibition catalogue, Österreichische Galerie Belvedere, Wien-Köln-Weimar, 127-129 • SCHLEIER, ERICH. "Giovanni Paolo Panini: The Departure of the Duc de Choiseul on Saint Peter's Square", in Gemäldegalerie Berlin: 200 Masterworks, hrsg. von G. Asmus und R. Grosshans, Berlin, 412-13 • SCOTTI TOSINI, AURORA [a]. "La Cittadella", in Storia di Torino, III: Dalla dominazione francese alla ricomposizione dello Stato (1536-1630), Torino, Einaudi, 414-47 • — [b]. "Tre nuovi fogli per Giuseppe Galli Bibiena", Esiti, 16 • SKALECKI, GEORG. Augsburger Stadlexikon, Augsburg • VERTI, ROBERTO. Il teatro Comunale di Bologna, Milano • VON KRÜCKMANN, PETER O. Das Bayreuth der Markgräfin Wilhelmine, München-New York

1999 Zum Maler und zum großen Architekten geboren. Georg Wenceslaus von Knobelsdorff 1699-1753, Ausstellungskatalog, Berlin, Stiftung Preußische Schlösser und Gärten Berlin-Brandenburg • BRESCIANI ALVAREZ, GIULIO. Architetture a Padova, Padova • FÜHRING, PETER. The Rijksmuseum Collection of Ornament Prints, II: Seventeenth Century, Rotterdam-Amsterdam • GOMEZ SERITO, MAURIZIO. "I marmi colorati piemontesi nella decorazione", Atti e rassegna tecnica della Società degli ingegneri e degli architetti in Torino, 132: 15-25 • OECHSLIN, WERNER. "C'est du Palladio': un avvicinamento al fenomeno del palladianesimo", in Palladio nel Nord Europa. Libri, viaggiatori, architetti, catalogo della mostra, Vicenza, Ginevra-Milano, 64-65 • OTTENHEYM KONRAD, A.; VLAARDINGERBROEK, PIETER. "De architectuurmodellen van Nicolaas Listingh (1630-1705)", Bulletin KNOB, 98

In corso di pubblicazione COOPER, NICHOLAS. Houses of the Gentry: 1480-1680, New Haven-

London • MARDER, TOD A. "The Scala Regia in Perspective", Papers from the Domus Prospettivae, Istituto Svizzero, Roma • MARÍAS, FERNANDO. "Ferdinando Sanfelice, Juan Antonio Medrano y los Borbones de España: de Felipe v a Carlos III", in Intorno a Ferdinando Sanfelice: Napoli e l'Europa, Napoli • OELGESCHLÄGER, MELANIE. "Vom hölzernen Modell zum ausgeführten Schloß - Die Baugeschichte des Schlosses in Friedrichswerth", in Beiträge zur Schloßbaukunst des 17. un frühen 18. Jahrhunderts in Thüringen, hrsg. von U. Schütte (Studien zur Thüringischen kunstgeschichte, IV) • RODRÍGUEZ G. DE CEBALLOS, ALFONSO. "La Plaza Mayor de Salamanca en el contexto de la plaza europea", in La Plaza Eurobarroca, Salamanca

Index of names

Index of works

Photos credits

Jorg P. Anders, 232-233
Altitude Action Press Photo Agency Yann Arthus-Bertrand, 71 above, 216-317
Archivio RCS Libri S.p. A., 33 below, 34 below, 56, 58, 59, 62, 63, 73, 81, 94 above, 112, 114 to left, 115, 122-123, 125, 126, 127, 128, 129, 130, 131, 137, 152, 221, 222, 223, 229, 230, 242, 245, 246, 247, 248-249, 250, 251, 256, 262, 263, 266 above, 267, 268, 269, 279, 280, 281, 282, 288, 289, 300, 301, 304, 308, 309, 315, 318, 319, 321, 322, 326, 327, 328, 329, 333, 334, 335, 336 below, 352, 392, 397, 404, 405, 406, 412, 413, 414
Archivio Vasari, Roma, 49, 238-239
Andrea Baguzzi, 172, 174, 257, 347
Piero Baguzzi, cover, 20-21, 134, 136 to left, 139, 140, 141, 142, 144-145, 146-147, 148, 149, 150-151, 153, 156, 157, 159, 160, 161, 162-163, 164, 165, 166-167, 168-169, 170, 171, 332, 338, 339
Bardazzi Fotografia, 184, 340-341
Studio Basset, 276
Dean Beason, 266 below
Osvaldo Böhm - Venezia, 104, 323
British Museum, 43
Stephen Chapman, 198-199
Geremy Butler, 29, 71 below, 182,183
Mariano Dallago, 64, 65, 116, 120-121, 203
Arch. Pino Dell'Aquila, back cover, 14-15, 18, 67, 118-119, 132, 348, 354-355, 365, 366-367
Dephti, 231
Araldo Di Luca - Roma, 32, 34-35, 37, 39, 45, 54
Fachlabor Dormoolen Fotografie, 47
Mat Flynn, 272 below
Foto Erik Cornelius-Nationalmuseum, 82
Fototecnica, 243
Fouin Christophe, © Ville de Paris - C.O.A.R.C.., 201

Giraudon-Alinari, 24-25, 80, 90-91
Primo Gnani, 98, 99
Gonella Foto s.n.c., 117
Perry Hastings, 92, 93
Foto AA. Idini, 108-109, 314
Image Bank, © Daniel Barbier, 68-69, Guido Alberto Rossi, 83, 320
Mikael Kaas Reklamefoto, 180
© Foto Massimo Listri, 154-155, 158, 278
© LSH Fotoavdelningen - Samuel Uhrdin, 84-85, 87
Marka Phototèque, 296-297
David Mathews, 78-79
Elfriede Mejchar, 94 to left, 95
Brian Merret, 258-259
Stefan Müller, 192, 193
M. Napoli, 204
© National Maritime Museum Picture Library, 76-77
New Photo Center, 342
Foto Ernani Orcorte, 66 to right, 185, 356, 357, 268 above
© Lucianio Pedicini - Archivio dell'Arte, 96-97, 370, 372, 374, 375, 376-377, 379, 380, 381, 384, 385, 391, 395
Barbara Piovan - Mauro Magliani archivio fotografico, 38, 61
Peter van Poelgest, 175
Mario Quattrone, 224-225
Antonia Reeve, 254-255
Agenzia Fotografica Luisa Ricciarini - Milano © Schezen, 66 to left
© Photo RMN, 285, 324-325; Michèle Bellot, 70; Gérard Blot, 88-89; D. Arnaudet, 298-299; P. Bernard, 305
Fulvio Roiter, 30, 51, 52-53
© Foto Luciano Romano, 286-287, 312-313, 373, 382-383, 386, 387, 388-389, 393
Sky Photographic Service Ltd, 74
Photo © Fritz Simak, 396, 398-399
Vergani, 75